Magill's
Cinema
Annual
2014

Magill's Cinema Annual 2014

33rd Edition
A Survey of the films of 2013

Brian Tallerico, Editor

A VideoHound® Reference

GALE
CENGAGE Learning®

Farmington Hills, Mich • San Francisco • New York • Waterville, Maine
Meriden, Conn • Mason, Ohio • Chicago

Magill's Cinema Annual 2014
Brian Tallerico, Editor

Project Editor: Michael J. Tyrkus

Editorial Support Services: Wayne Fong

Composition and Electronic Prepress: Gary Leach, Evi Seoud

Manufacturing: Rhonda Dover

For product information and technology assistance, contact us at
Gale Customer Support, 1-800-877-4253.
For permission to use material from this text or product,
submit all requests online at **www.cengage.com/permissions.**
Further permissions questions can be emailed to
permissionrequest@cengage.com

While every effort has been made to ensure the reliability of the information presented in this publication, Gale, a part of Cengage Learning, does not guarantee the accuracy of the data contained herein. Gale accepts no payment for listing; and inclusion in the publication of any organization, agency, institution, publication, service, or individual does not imply endorsement of the editors or publisher. Errors brought to the attention of the publisher and verified to the satisfaction of the publisher will be corrected in future editions.

EDITORIAL DATA PRIVACY POLICY: Does this product contain information about you as an individual? If so, for more information about our editorial data privacy policies, please see our Privacy Statement at www.gale.cengage.com.

Gale, Cengage Learning
27500 Drake Rd.
Farmington Hills, MI, 48331-3535

ISBN-13: 978-1-4144-9710-5

ISSN: 0739-2141

Printed in Mexico
1 2 3 4 5 6 7 18 17 16 15 14

Contents

Preface

Magill's Cinema Annual 2014 continues the fine film reference tradition that defines the VideoHound® series of entertainment industry products published by Gale. The thirty-third annual volume in a series that developed from the twenty-one-volume core set, *Magill's Survey of Cinema,* the *Annual* was formerly published by Salem Press. Gale's seventeenth volume, as with the previous Salem volumes, contains essay-reviews of significant domestic and foreign films released in the United States during the preceding year.

The *Magill's* editorial staff at Gale, Cengage Learning, comprising the VideoHound® team and a host of *Magill's* contributors, continues to provide the enhancements that were added to the *Annual* when Gale acquired the line. These features include:

- More essay-length reviews of significant films released during the year
- Obituaries and book review sections
- Trivia and "fun facts" about the reviewed movies, their stars, the crew, and production
- Quotes and dialogue "soundbites" from reviewed movies, or from stars and crew about the film
- More complete awards and nominations listings, including the American Academy Awards®, the Golden Globes, and others (see the User's Guide for more information on awards coverage)
- Box office grosses, including year-end and other significant totals
- Publicity taglines featured in film reviews and advertisements

In addition to these elements, *Magill's Cinema Annual 2014* still features:

- An obituaries section profiling major contributors to the film industry who died in 2013
- An annotated list of selected film books published in 2013
- Nine indexes: Director, Screenwriter, Cinematographer, Editor, Art Director, Music Director, Performer, Subject, and Title (now cumulative)

COMPILATION METHODS

The *Magill's* editorial staff reviews a variety of entertainment industry publications, including trade magazines and newspapers, as well as online sources, on a daily and

weekly basis to select significant films for review in *Magill's Cinema Annual*. *Magill's* staff and other contributing reviewers, including film scholars and university faculty, write the reviews included in the *Annual.*

MAGILL'S CINEMA ANNUAL: A VIDEOHOUND® REFERENCE

The *Magill's Survey of Cinema* series, now supplemented by the *Annual,* is the recipient of the Reference Book of the Year Award in Fine Arts by the American Library Association. Gale, an award-winning publisher of reference products, is proud to offer *Magill's Cinema Annual* as part of its popular VideoHound® product line, which includes *VideoHound®'s Golden Movie Retriever* and *The Video Source Book.* Other Gale film-related products include the four-volume *International Dictionary of Films and Filmmakers, Women Filmmakers & Their Films,* the *Contemporary Theatre, Film, and Television* series, and the four-volume *Schirmer Encyclopedia of Film.*

ACKNOWLEDGMENTS

The writing staff of *Magill's Cinema Annual 2014,* which consists of publishing professionals, freelance writers, and paid film critics (including several members of the Chicago Film Critics Association), brings love for cinema and sheer talent for writing about it to this year's book. Never losing their own voices while also representing the *Magill's* style as a collective, they worked independently and together to craft a comprehensive chronicle of the year in film. The staff continues to impress with their knowledge, dedication, and abilities. The staff at Gale, Cengage Learning—Mike Tyrkus, Jim Craddock, and Tom Burns—deserve thanks for their continued efforts on behalf of the book as well. *Magill's Cinema Annual 2014* was truly a collaboratively created work and would be nothing without not only the support of the writers assigned to it but the friends and family who so completely back its editor in every capacity. Nothing this comprehensive can be accomplished without widespread support and that is what the editor gets from his incredible wife Lauren and beautiful sons Lucas, Miles and Noah. They make this work not just possible but rewarding.

We at *Magill's* look forward to another exciting year in film and preparing the next edition of *Magill's Cinema Annual.* As always, we invite your comments, questions, and suggestions. Please direct them to:

Editor
Magill's Cinema Annual
Gale, Cengage Learning
27500 Drake Road
Farmington Hills, MI 48331-3535
Phone: (248) 699-4253
Toll-Free: (800) 347-GALE (4253)
Fax: (248) 699-8865

The Year in Film 2013: An Introduction

What does it say about a society when its year in film was so dominated by stories of men and women stranded from safety? The story of Solomon Northup, kidnapped from his family and forced into a horrendous decade of existence in the Best Picture-winning *12 Years a Slave*, was the most high profile film of the year but it was far from the only story of men and women detached from society. Whether it was Sandra Bullock spinning through space in *Gravity* (the winner of the most Oscars this year, including Best Director), Robert Redford adrift in *All is Lost*, or Tom Hanks fighting for safety in *Captain Phillips*, cinema in 2013 was clearly fascinated by isolation. Perhaps in an era driven by social media, in which we're all supposedly so connected to each other that we've forgotten how to communicate outside of Twitter, filmmakers had something to say about identity without connection. Spike Jonze sure did in the best screenplay of 2013, his brilliant *Her*. Yes, Jonze's examination of a man who falls in love with his operating system feels of a tonal fabric with Steve McQueen's examination of slavery and Alfonso Cuaron's technical masterpiece. We are all longing for connection, whether it be a man tortured for his race, a sailor trying to stay afloat, or a man dealing with the loss of love. 2013 was an incredible year for film as our best cinematic technicians found new ways to express timeless themes.

Of course, it also continued the trend of superhero blockbusters and animated 3D fare dominating the multiplex. While cineastes may have been talking about Spike Jonze, Richard Linklater, and Shane Carruth, the box office charts were relatively predictably filled (other than perhaps the complete failure of *The Lone Ranger* and glorious success of *The Conjuring*). Nine out of ten highest-grossing films of 2013 were based on another property, be they sequels or adaptations of hit books (or both). The truly original box office hits were few and far between, which explains why so many people held on tightly to their love for films like *Gravity*, *American Hustle*, *The Conjuring*, and *The Wolf of Wall Street*, four of the 35 films that made over $100 million that felt like they were more than mere products. On the other hand, absolute garbage like *Grown Ups 2*, *Identity Thief*, *The Hangover Part III*, and *We're the Millers* also hold spots in that over-$100 million club, proving that marketing determines box office more than actual artistic success.

Arguably more than ever, sequels dominated the landscape when it came to hit films with fourteen in the over-$100 million club, and that's not even counting films like *Man*

of Steel or *Oz the Great and Powerful*, which don't exist without previous incarnations. Superheroes ruled the day yet again with *Iron Man 3* (the second-highest-grossing film of the year after *The Hunger Games: Catching Fire*), *Man of Steel* (#5), and *Thor: The Dark World* (#13) lighting cash registers on fire although critics were lukewarm on all three. Same with comedies, which proved that Jason Sudeikis, Melissa McCarthy, and Adam Sandler are still stars but may be getting less critical support than ever.

What did the critics find themselves drawn to in 2013? For once, the Academy Awards were very much in line with many of the men and women paid to write about film as *Gravity* and *12 Years a Slave* were seemingly requisite on most top ten lists. According to Metacritic, Steve McQueen's film is the most highly praised of the year. But it wasn't alone at all, as most critics felt 2013 really pushed the form in terms of overall quality. Internationally renowned filmmakers brought their "A" games, whether it was Jonze's *Her*, Alexander Payne's *Nebraska*, Joel and Ethan Coen's *Inside Llewyn Davis*, or Richard Linklater's *Before Midnight*. American film in 2013 had a raised level of quality across the board from more obscure filmmakers like Shane Carruth with *Upstream Color* to yet another masterpiece from Martin Scorsese in *The Wolf of Wall Street*.

Foreign cinema was a little less vibrant in 2013. At the peak of the form, there were some incredibly notable works like *Blue is the Warmest Color*, *The Great Beauty*, *The Hunt*, *Like Someone in Love*, *Drug War*, and *The Wind Rises*, master animator Hayao Miyazaki's final work. Arguably the best documentary of 2013 was also a foreign film stand-out as Joshua Oppenheimer's *The Act of Killing* won dozens of critical awards, although not the Oscar, as the Academy went with the much-safer *20 Feet From Stardom*. Sarah Polley's *Stories We Tell* was the closest competition to Oppenheimer's breakout for best non-fiction film of the year.

Oppenheimer was not the only breakthrough directorial debut of the year but the form was slightly light on new voices. Arguably the best was Destin Cretton's South by Southwest-premiering *Short Term 12*, a fantastic drama about a temporary home for teens. Again, it's a film about people pulled from what the viewer sees as normalcy.

What distinguished 2013 as such a high-caliber year of filmmaking was the ability to find something of quality in every genre throughout most of the 12-month period. Want a quiet, character-driven piece? *Before Midnight* was arguably the best film of the year and one of the best commentaries on marriage ever filmed. Want a blockbuster? It doesn't get much more enjoyable than Guillermo Del Toro's *Pacific Rim*. Want a horror movie? Don't miss *The Conjuring* or Jim Mickle's brilliant *We Are What We Are*. Documentaries, foreign films, comedies, even sequels that surpassed the original. Even animated film saw a peak with the incredible joy of Disney's *Frozen*, the best Mouse House movie in nearly twenty years.

And so while we may have been obsessed with people who were pulled from community, we formed another one through our love for cinema. While social media continues to divide us as much as it unites, the conversation around film and our best writers, directors, and actors, continues to bring us back together.

Brian Tallerico
Chicago, Illinois

Contributing Reviewers

Nick Allen
Professional Film Critic

David L. Boxerbaum
Freelance Reviewer

Tom Burns
Publishing Professional

Dave Canfield
Professional Film Critic

Erik Childress
Professional Film Critic

Mark Dujsik
Professional Film Critic

Matt Fagerholm
Professional Film Critic

Locke Peterseim
Professional Film Critic

Matt Pais
Professional Film Critic

Matthew Priest
Freelance Reviewer

Josh Ralske
Freelance Reviewer

Brent Simon
Professional Film Critic

Peter Sobczynski
Professional Film Critic

Collin Souter
Professional Film Critic

Brian Tallerico
Professional Film Critic

Michael J. Tyrkus
Publishing Professional

Nathan Vercauteren
Freelance Reviewer

User's Guide

ALPHABETIZATION

Film titles and reviews are arranged on a word-by-word basis, including articles and prepositions. English leading articles (A, An, The) are ignored, as are foreign leading articles (El, Il, La, Las, Le, Les, Los). Other considerations:

- Acronyms appear alphabetically as if regular words.

- Common abbreviations in titles file as if they are spelled out, so *Mr. Death* will be found as if it was spelled *Mister Death*.

- Proper names in titles are alphabetized beginning with the individual's first name, for instance, *Gloria* will be found under "G."

- Titles with numbers, for instance, *200 Cigarettes,* are alphabetized as if the numbers were spelled out, in this case, "Two-Hundred." When numeric titles gather in close proximity to each other, the titles will be arranged in a low-to-high numeric sequence.

SPECIAL SECTIONS

The following sections that are designed to enhance the reader's examination of film are arranged alphabetically, they include:

- *List of Awards.* An annual list of awards bestowed upon the year's films by the following: Academy of Motion Picture Arts and Sciences, British Academy of Film and Television Arts Awards, Directors Guild of America Awards, Golden Globe Awards, Golden Raspberry Awards, Independent Spirit Awards, the Screen Actors Guild Awards, and the Writer's Guild Awards.

- *Obituaries.* Profiles major contributors to the film industry who died in 2013.

- *Selected Film Books of 2013.* An annotated list of selected film books published in 2013.

INDEXES

Film titles and artists are separated into nine indexes, allowing the reader to effectively approach a film from any one of several directions, including not only its credits but its subject matter.

- *Director, Screenwriter, Cinematographer, Editor, Art Director, Music Director,* and *Performer* indexes are arranged alphabetically according to artists appearing in this volume, followed by a list of the films on which they worked. In the *Performer* index, a (V) beside a movie title indicates voice-only work and an (N) beside a movie title indicates work as narrator.

- *Subject Index.* Films may be categorized under several of the subject terms arranged alphabetically in this section.

- *Title Index.* The title index is a cumulative alphabetical list of films covered in the thirty volumes of the *Magill's Cinema Annual,* including the films covered in this volume. Films reviewed in past volumes are cited with the year in which the film appeared in the *Annual;* films reviewed in this volume are cited with the film title and this year's edition in boldface. Original and alternate titles are cross-referenced to the American release title in the Title Index. Titles of retrospective films are followed by the year, in brackets, of their original release.

SAMPLE REVIEW

Each *Magill's* review contains up to sixteen items of information. A fictionalized composite sample review containing all the elements of information that may be included in a full-length review follows the outline on the facing page. The circled number following each element in the sample review designates an item of information that is explained in the outline.

1. **Title:** Film title as it was released in the United States.

2. **Foreign or alternate title(s):** The film's original title or titles as released outside the United States, or alternate film title or titles. Foreign and alternate titles also appear in the Title Index to facilitate user access.

3. **Taglines:** Up to ten publicity taglines for the film from advertisements or reviews.

4. **Box office information:** Year-end or other box office domestic revenues for the film.

5. **Film review:** A signed review of the film, including an analytic overview of the film and its critical reception.

6. **Reviewer byline:** The name of the reviewer who wrote the full-length review. A complete list of this volume's contributors appears in the "Contributing Reviewers" section which follows the Introduction.

7. **Principal characters:** Listings of the film's principal characters and the names of the actors who play them in the film.

8. **Country of origin:** The film's country or countries of origin and the languages featured in the film.

9. **Release date:** The year of the film's first general release.

10. **Production information:** This section typically includes the name(s) of the film's producer(s), production company, and distributor; director(s); screenwriter(s); cinematographer(s); editor(s); art director(s); production designer(s); music composer(s); and other credits such as visual effects, sound, costume design, and song(s) and songwriter(s).

11. **MPAA rating:** The film's rating by the Motion Picture Association of America. If there is no rating given, the line will read, "Unrated."

12. **Running time:** The film's running time in minutes.

13. **Reviews:** A list of brief citations of major newspaper and journal reviews of the film, including author, publication title, and date of review.

14. **Film quotes:** Memorable dialogue directly from the film, attributed to the character who spoke it, or comment from cast or crew members or reviewers about the film.

15. **Film trivia:** Interesting tidbits about the film, its cast, or production crew.

16. **Awards information:** Awards won by the film, followed by category and name of winning cast or crew member. Listings of the film's nominations follow the wins on a separate line for each award. Awards are arranged alphabetically. Information is listed for films that won or were nominated for the following awards: American Academy Awards®, British Academy of Film and Television Arts Awards, Directors Guild of America Awards, Golden Globe Awards, Golden Raspberry Awards, Independent Spirit Awards, the Screen Actors Guild Awards, and the Writers Guild of America Awards.

THE GUMP DIARIES ①
(Los Diarios del Gump) ②

Love means never having to say you're stupid.
—Movie tagline ③

Box Office: $10 million ④

In writer/director Robert Zemeckis' *Back to the Future* trilogy (1985, 1989, 1990), Marty McFly (Michael J. Fox) and his scientist sidekick Doc Brown (Christopher Lloyd) journey backward and forward in time, attempting to smooth over some rough spots in their personal histories in order to remain true to their individual destinies. Throughout their time-travel adventures, Doc Brown insists that neither he nor Marty influence any major historical events, believing that to do so would result in catastrophic changes in humankind's ultimate destiny. By the end of the trilogy, however, Doc Brown has revised his thinking and tells Marty that, "Your future hasn't been written yet. No one's has. Your future is whatever you make it. So make it a good one."

In *Forrest Gump,* Zemeckis once again explores the theme of personal destiny and how an individual's life affects and is affected by his historical time period. This time, however, Zemeckis and screenwriter Eric Roth chronicle the life of a character who does nothing but meddle in the historical events of his time without even trying to do so. By the film's conclusion, however, it has become apparent that Zemeckis' main concern is something more than merely having fun with four decades of American history. In the process of re-creating significant moments in time, he has captured on celluloid something eternal and timeless—the soul of humanity personified by a nondescript simpleton from the deep South.

The film begins following the flight of a seemingly insignificant feather as it floats down from the sky and brushes against various objects and people before finally coming to rest at the feet of Forrest Gump (Tom Hanks). Forrest, who is sitting on a bus-stop bench, reaches down and picks up the feather, smooths it out, then opens his traveling case and carefully places the feather between the pages of his favorite book, *Curious George.*

In this simple but hauntingly beautiful opening scene, the filmmakers illustrate the film's principal concern: Is life a series of random events over which a person has no control, or is there an underlying order to things that leads to the fulfillment of an individual's destiny? The rest of the film is a humorous and moving attempt to prove that, underlying the random, chaotic events that make up a person's life, there exists a benign and simple order.

Forrest sits on the bench throughout most of the film, talking about various events of his life to others who happen to sit down next to him. It does not take long, however, for the audience to realize that Forrest's seemingly random chatter to a parade of strangers has a perfect chronological order to it. He tells his first story after looking down at the feet of his first bench partner and observing, "Mama always said that you can tell a lot about a person by the shoes they wear." Then, in a voice-over narration, Forrest begins the story of his life, first by telling about the first pair of shoes he can remember wearing.

The action shifts to the mid-1950s with Forrest as a young boy (Michael Humphreys) being fitted with leg braces to correct a curvature in his spine. Despite this traumatic handicap, Forrest remains unaffected, thanks to his mother (Sally Field) who reminds him on more than one occasion that he is no different from anyone else. Although this and most of Mrs. Gump's other words of advice are in the form of hackneyed cliches, Forrest, whose intelligence quotient is below normal, sincerely believes every one of them, namely because he instinctively knows they are sincere expressions of his mother's love and fierce devotion. ⑤

John Byline ⑥

CREDITS ⑦

Forrest Gump: Tom Hanks
Forrest's Mother: Sally Field
Young Forrest: Michael Humphreys
Origin: United States ⑧
Language: English, Spanish
Released: 1994 ⑨
Production: Liz Heller, John Manulis; New Line Cinema; released by Island Pictures ⑩
Directed by: Robert Zemeckis
Written by: Eric Roth
Cinematography by: David Phillips
Music by: Graeme Revell
Editing: Dana Congdon
Production Design: Danny Nowak
Sound: David Sarnoff
Costumes: David Robinson
MPAA rating: R ⑪
Running time: 102 minutes ⑫

REVIEWS ⑬

Doe, Jane. *Los Angeles Times*. July 6, 1994.

Doe, John. *Entertainment Weekly*. July 15, 1994.

Reviewer, Paul. *Hollywood Reporter*. June 29, 1994.

Writer, Zach. *New York Times Online*. July 15, 1994.

QUOTES ⑭

Forrest Gump (Tom Hanks): "The state of existence may be likened unto a receptacle containing cocoa-based confections, in that one may never predict that which one may receive."

TRIVIA ⑮

Hanks was the first actor since Spencer Tracy to win back-to-back Oscars® for Best Actor. Hanks received the award in 1993 for his performance in *Philadelphia*. Tracy won Oscars® in 1937 for *Captains Courageous* and in 1938 for *Boys Town*.

AWARDS ⑯

Academy Awards 1994: Film, Actor (Hanks), Special Effects, Cinematography

Nomination:

Golden Globes 1994: Film, Actor (Hanks), Supporting Actress (Field), Music.

A

THE ABCs OF DEATH

26 directors, 26 ways to die.
—Movie tagline
It's not educational.
—Movie tagline

Box Office: $21,660

Most horror anthologies offer somewhere between three-to-five segments (like *V/H/S* [2012]) delivering on the promise of around half of them. *The ABCs of Death* is comprised of no fewer than 26 short films lasting a whopping 130 minutes. On that basis alone, the rate of return is better even if the lowest of the lows are outshone by even the worst of the schlock Amicus turned out in the seventies. Even more compelling though is the construction of the film; 26 directors from around the world (many of them rising stars in genre film) were assigned a letter of the alphabet and offered the chance to create a short film about death with no limits on content. This is graphic, no-holds-barred stuff that should be avoided by anyone with distaste for same but for adventurous viewers it will be must-see. As can be imagined, the possibilities for violence and gore are endless here, as are the possibilities for tastelessness, cultural insensitivity and gonzo weirdness. On that basis, *The ABC's of Death* does not disappoint.

When it works, it borders on amazing. The film opens with a niftily gross title sequence featuring a flood of dark, red blood across the floor of a playroom on which sit a series of alphabet blocks. Shorts play first followed by the title of the short which invariably contains the letter of the alphabet followed by method of death. For example, the first short, directed by Nacho

Vigalando (*Timecrimes* [2007], *Extraterrestrial* [2010]) is titled, "A Is For Apocalypse" but that title is only revealed after the short has played. This novel approach allows viewers to guess at exactly what the title will be given the letter of the alphabet currently in question and the mayhem they expect. This proves to be a more-or-less solid way to keep viewer interest and spring last minute ironies or sight gags.

Standouts include the slow-motion savagery of "D is for Dogfight" by Marcel Sarmiento (*Deadgirl* [2008]), which recasts a man-on-dog boxing/fight to the death as a tale of comrades at arms. This short is extremely visually striking and not to be missed. In the incredibly-powerful "I is for Ingrown" by Jorge Michel Grau (*We Are What We Are* [2010]), the camera forces viewers to watch a murder victim die of lethal injection as her voiceover explains her last moments. Grau has said of his piece that it symbolizes the indifference of the Mexican government toward the mass kidnappings that plague the area. Thus, horror fans, who often feel they have seen it all, suddenly feel compelled to care. Horror becomes something other than a feeling. Lastly, "Y is For Youngbuck" by Jason Eisener (*Hobo With a Shotgun* [2008]) packs a huge punch as a rumination on empowerment against abuse and psychological damage caused by same.

Two other outstanding shorts type as message-driven. The silent "P is for Pressure" directed by Simon Rumley (*The Living and the Dead* [2006], *Red White and Blue* [2010]) showcases the soul-crushing desperation of a young mother's poverty while "X is for XXL" by Xavier Gens (*Frontiers* [2007], *The Divide* [2011])

deals with the psychological weight of body image on young woman.

Then there are the shorts that are guaranteed to offend someone. *The ABCs of Death* has no shortage of these. "F is For Fart" by Noboru Iguchi (*Zombie Ass: Toilet of the Dead* [2010]), "L is for Libido" directed by Timo Tjahjanto (*Macabre* [2010], and "Z is for Zetsumetsu" by Yoshihiro Nishimura (*Tokyo Gore Police* [2008]) all contain enough penises, body fluids, pustules and, ahem, exotic sexuality to offend or at least disgust all but the most hardened extreme cinema lovers.

Worth pointing out is how incredibly confrontational horror anthologies have become in the last few years. Up until now, the best that the subgenre had to offer was still pretty conventional in terms of content. Adaptations of horror comics (*Tales From The Crypt* [1972], and various TV shows like *Night Gallery* and *Tales From The Dark Side*) were gruesome but within severe limits. It was not until Asian Horror like *3 Extremes* (2004) became available stateside that the shift began to make itself felt with force. Even then it took a while. The last few years have seen the release of *V/H/S* and *V/H/S 2* (2013), both of which are transgressive in the extreme.

Luckily, it seems that many of the filmmakers here had more in mind than making their shorts as gross as possible. "H is for Hydro Electric Diffusion" by Thomas Cappelen Malling (*Norwegian Ninja* [2009]) is a riotously weird and entertaining furry fantasy involving a World War II era GI Dogface (a literal DOGface) and a Nazi stripper locked in a battle to the death. "J is for Jidai-Geki" (Samurai Movie) by Yudai Yamaguchi (*Meatball Machine* [2005]) is about a samurai who cannot keep his giggles under control. Perhaps the silliest short is "Q is for Quack" by Adam Wingard (*You're Next* [2011]) in which the director bemoans being stuck with the letter Q and decides to execute a real live duck on film.

The ABCs of Death is for anyone who loves horror since it is easy enough to skip through segments that are not to taste. Any viewer should be prepared to laugh pretty hard; feel tense; get grossed out like they would at any halfway decent horror film. But that same viewer now has a chance to find out about some of the best directors working in horror today.

Dave Canfield

CREDITS

Bobo: Ivan Gonzalez
Lainey: Kyra Zagorsky
Frau Scheisse: Ingrid Bolso Berdal (Voice)

Origin: Russia
Language: English
Released: 2012
Production: Nahikari Ipina, Claire Jones, Julie Lind-holm, Petter Lindblad, Douglas Nabors, Andrea Quiroz, Chris Sergi, Andrew Starke, Lino P. Stavole, Christopher White, Yoshihiro Nishimura, Simon Boswell; released by Drafthouse Films, Magnet Releasing
Directed by: Kaare Andrews; Angela Bettis; Helene Cattet; Ernesto Diaz Espinoza; Jason Eisener; Bruno Forzani; Andria Bogliano; Xavier Gens; Lee Hardcastle; Noboru Iguchi; Thomas Cappelen Maaling; Jorge Grau; Anders Morgenthaler; Yoshihiro Nishimura; Banjong Pisanthanakun; Marcel Samiento; Jon Schnepp; Timo Tjahjanto; Srdjan Spasojevic; Andrew Traucki; Nacho Vigalondo; Jake West; Ti West; Ben Wheatley; Adam Wingard; Yudai Yamaguchi
Written by: Kaare Andrews; Helene Cattet; Bruno Forzani; Andria Bogliano; Lee Hardcastle; Noboru Iguchi; Yoshihiro Nishimura; Simon Rumley; Srdjan Spasojevic; Nacho Vigalondo; Ti West; Yudai Yamaguchi; Simon Barrett; Dimitrie Vojnov
Cinematography by: Harris Charalambous; Manuel Dacosse; Magnus Flato; Ernesto Herrera; Karim Hussain; Nicolas Ibieta; Nemanja Jovanov; Antoine Marteau; Shu G. Momose; Yasutaka Nagano; Laurie Rose
Music by: Phillip Blackford; Simon Boswell; Yasuhiko Fukuda; Nobuhiko Morino; Kou Nakagawa; Julio Pillado; Johannes Ringen
Sound: Steve Finnigan
Editing: Andria Bogliano; Yoshihiro Nishimura; Yudai Yamaguchi; Phillip Blackford; Robert Hall; Takanori Tsujimoto; Martin Wichmann
Art Direction: Idoia Esteban
Costumes: Kathi Moore
Production Design: Nori Fukuda; Lorry O'Toole
MPAA rating: Unrated
Running time: 123 minutes

REVIEWS

Baumgarten, Marjorie. *Austin Chronicle*. March 22, 2013.
Catsoulis, Jeannette. *New York Times*. March 7, 2013.
Fletcher, Rosia. *SFX Magazine*. April 25, 2013.
Floyd, Nigel. *Time Out*. April 24, 2013.
French, Phillip. *Observer [UK]*. April 28, 2013.
Goss, William. *Film.com*. September 25, 2012.
O'Hehir, Andrew. *Salon.com*. March 7, 2013.
Shannon, Jeff. *Seattle Times*. March 7, 2013.
Turner, Matthew. *ViewLondon*. April 24, 2013.
Williams, Owen. *Empire Magazine*. April 22, 2013.

QUOTES

Yoshie: "Miss Yumi and I both have the same kind of animal smell on the inside. I'm so happy."

TRIVIA

The name of the character Frau Scheisse literally means "Mrs. S**t" translated in German.

ABOUT TIME

A new funny film about love. With a bit of time travel.
—Movie tagline

Box Office: $15.3 Million

After helming two very underwhelming ensemble comedies (*Love Actually* [2003], *Pirate Radio* [2009]), writer/director Richard Curtis has made a far more concentrated and successful film with *About Time*, which starts out as a romantic comedy and gradually expands its view to look at one man trying to weigh what is most important to him as his life changes and his concept of family expands. The film also happens to have a very clever conceit involving time travel, which Curtis presents as something that is down-to-earth and ordinary, making the extraordinary ramifications that eventually come into play all the more resonant.

While there may be some gaps in the logic of the science-fiction conceit, it hardly matters because Curtis ensures that the gimmick is not a matter of phony science. There is no machine, portal, or any other kind of device one would usually associate with time travel. Instead, Curtis makes it a trick of genetics (inherited by the males in a family) and the mind (find a dark place, close one's eyes, and imagine oneself at a specific point in one's memory). It is a form of wish fulfillment, really, with the potential to actually change the course of one's life or, in some tough instances, to enforce the knowledge that there are certain things in life that cannot be altered.

The result is a surprisingly touching film, in spite of Curtis' inconsistency in maintaining the central concept and a solid narrative focus. There is a long stretch when Curtis seems to have forgotten entirely about the time-travel aspect (scenes in which the central character could perform a "do over" but does not), and the screenplay goes through three major tonal shifts: A comedy of errors about unrequited love, a romance about finding and keeping true love, and a tragedy about inevitable loss. In the moment, these apparent irregularities feel off-putting, but by the time the film reaches the conclusion of its thesis (set to a rather poignant juxtaposition of summary narration and Ben Folds' song "The Luckiest," which, like the story's central theme, is teased in pieces throughout the film), it becomes clear that the inconsistencies are part and parcel of the story of one man's life.

He is Tim (Domhnall Gleeson), a shy young man who has problems engaging with women. On the occasion of Tim's 21st birthday, his father (the effortlessly loveable Bill Nighy) tells him that he, like all the men in his family, has the ability to travel back in time but only to moments in time that he has experienced and can remember. Tim tests out the unbelievable act, and upon its success, makes it his goal to kiss a young woman whom he was too shy to kiss at a New Year's Eve party.

The first stage of Tim's experience with time travel involves his failure to win the affection of his sister Kit Kat's (Lydia Wilson) friend Charlotte (Margot Robbie), who stays with their family for the summer and whom he tells about his feelings for her on the night before she leaves. If only he had told her earlier, she tells him, perhaps something could have come of his feelings. The first indication that not everything is pliable, even with time travel, comes when Charlotte essentially tells Tim, who has gone back in time to the first day of her vacation, the same thing on the first night of her stay, and nothing develops between them.

The second part of Tim's life involves his relationship with Mary (Rachel McAdams), whom he meets by chance while living in London. The first complication with his time-traveling ability arises when he tries to repair a disastrous opening night of the play written by his roommate Harry (Tom Hollander) only to discover that, in the process, he ends up never meeting Mary. In the film's creepiest sequence (completely unintentional), Tim stalks Mary and then goes back in time again to stop her from meeting a perfectly decent man she had started dating the night after she would have met Tim. The only reason it works is because Gleeson plays the inherently manipulative actions with a non-malicious romantic naivete.

Tim and Mary's relationship makes up the bulk of the film, although their bond is more generically sweet than genuinely affecting. Tim saves his curious ability for key moments in their relationship: ensuring that their first (and, for him, second and third) sexual experience is perfect, coming up with the right proposal, and making sure that his best man at their wedding does not ruin the day. Otherwise, Curtis provides a fairly weak romance, bolstered only by a montage—itself a form of cinematic time travel—in a subway station where Tim and Mary have a succession of happy days.

The romance, though, is only a catalyst for the film's third act, in which time travel is no longer an easy cure-all for Tim's problems. There are repercussions, for example, when Tim tries to save his sister from a poisonous relationship that ultimately leads to a car crash. By taking her back in time with him (Curtis never explains how this is even possible, though again, the setup is more fantasy than heavily regulated science fiction) to a point years, Tim accidentally prevents the existence of his daughter, who is replaced by another child in the new version of the present (it is strange that Curtis focuses on the disappearance of one child while failing to address the resulting disappearance of the alternate one after Tim resets the timeline).

Whatever shortcomings the film may have, the final shift in focus is not one of them. Here, Curtis centers on the relationship between Tim and his father, who is dying of cancer, and at this point, *About Time* more than compensates for its struggle to find an emotional foothold for the premise, as Tim clings to the past to avoid the most substantial loss in his life. For once in the film, time travel is not just a gimmick but a lifeline, and the film's acknowledgement of the unavoidable in the final act informs not only the summation that follows but also everything that has come before it.

Mark Dujsik

CREDITS

Tim: Domhnall Gleeson
Mary: Rachel McAdams
Dad: Bill Nighy
Harry: Tom Hollander
Charlotte: Margot Robbie
Origin: United States
Language: English
Released: 2013
Production: Tim Bevan, Eric Fellner; Working Title Films; released by Universal Pictures Inc.
Directed by: Richard Curtis
Written by: Richard Curtis
Cinematography by: John Guleserian
Music by: Nick Laird-Clowes
Sound: James Mather
Editing: Mark Day
Art Direction: David Hindle
Costumes: Verity Hawkes
Production Design: John P. Kelly
MPAA rating: R
Running time: 123 minutes

REVIEWS

Berardinelli, James. *ReelViews*. November 4, 2013.
Cabin, Chris. *Slant Magazine*. September 25, 2013.
Dowd, A. A. *A.V. Club*. September 25, 2013.
Koski, Genevieve. *The Dissolve*. October 30, 2013.
O'Hehir, Andrew. *Salon.com*. October 30, 2013.
Orndorf, Brian. *Blu-ray.com*. October 31, 2013.
Phillips, Michael. *Chicago Tribune*. October 31, 2013.
Puig, Claudia. *USA Today*. October 30, 2013.
Putman, Dustin. *DustinPutman.com*. October 22, 2013.
Zacharek, Stephanie. *Village Voice*. November 5, 2013.

QUOTES

Tim: "We're all traveling through time together, every day of our lives. All we can do is do our best to relish this remarkable ride."

TRIVIA

The film was shipped to theaters under the code name "Cupboard."

THE ACT OF KILLING

A story of killers who win, and the society they build.
—Movie tagline

Box Office: $483,863

Few films have the same potential power of actual change as Joshua Oppenheimer's stunning debut, *The Act of Killing*, a piece of work so powerful that master filmmaker Werner Herzog has called it one of the best films ever made. Oppenheimer challenges the basic human tendency to be unable to comprehend mass genocide. Someone who commits an act of violence against another person has an immediate quality that most people can understand if not forgive. However, the horrors of mass genocide are incomprehensible for most sane people. How could people commit hundreds, sometimes thousands, of murders? How could entire communities be destroyed? And how could the people behind these death squads possibly bury the demons deep enough in their psyche that they could sleep at night? Using the inherent power of cinema and the fact that his subjects saw themselves as Hollywood icons, Oppenheimer pulls the darkness to the surface for a group of men who were a part of that incomprehensible evil and dares the viewer to turn away, or, even more challengingly, understand that there is still a drop of humanity in the most evil of monsters and that they have led lives that included joy even after stealing it from so many innocent people.

In 1965, there was a military coup in Indonesia. The resulting power vacuum and quest for vengeance led to the formation of murder squads. These newly-empowered men prowled the cities and countryside looking for people who were deemed "Communists" in a manner not dissimilar to the way that the Nazi SS planned a final solution for the Jewish people. Women and children were pulled from their homes, forced to watch their husbands and fathers get killed, and then were often raped and murdered themselves. The horror of the genocide is almost unimaginable and yet the millions of people murdered have seen no justice. Genocide happened and the world kept on turning. Many of the members of the murder squads are still protected by a government that feels perpetually on the edge of undergoing another round of ethnic cleansing. The pages of history are very slowly turning to turn these former leaders into demons but it has been a slow, gradual

process that has made the survivors afraid to even speak about what they underwent. In fact, Oppenheimer began his film as a piece about the people who made it through the genocide to bring more light to it but the government continues to instill so much fear in its own people that this angle became untenable. So, he turned to the murderers themselves.

"War crimes are defined by the winners." So, how does Anwar Congo, one of the most defiant and proud mass murderers in history define his war crimes? There is certainly very little shame in his voice as he reenacts one of the times he garroted a man with a dance in his step. And yet there is something under the surface. It may not be sadness. It may not be regret. It may not be definable yet but Congo's demons are being pulled to the forefront by Oppenheimer's camera. While many documentarians would have met these men in their element and simply interviewed them, perhaps intercutting their stories with archival footage or expert interviews, Oppenheimer realized the propaganda that would have resulted in unchecked bragging about past sins. And so he makes his criminals revisit their crimes, asking them to reenact them for a filmmaking crew, often with a level of detail that includes makeup of burned flesh, costumes, and sets. These men are obsessed with Hollywood, revealing that many of their methods came from their love for "gangster films," and so Oppenheimer uses that love to reach deep into a part of their own history that they do not seem to fully understand yet. In doing so, he makes their past crimes present. It is a way to address horror that somehow feels safe because it puts the control of the judgment in the consciences of the men who committed the crimes. (Although it should be noted that any form of criticism of the power structure still in place was so potentially dangerous that a large portion of the credits that roll at the end are merely "Anonymous").

Oppenheimer interviews a number of people on both sides of the struggle (although most of the victims could not come forward) but he places most of his emphasis on Anwar Congo, a mesmerizing man who may have killed over 1,000 people. At the start of the film, he casually throws out stories about his murderous days, talking about the decapitating wire he used and how he would practically dance across the street from the movie theater to kill the captured Communists across the street. Congo seems to have little regret. Forty-five minutes or so into the film (although the entire piece ran about half-an-hour longer in all non-U.S. markets), the tone shifts. Oppenheimer brings Congo's collaborators into the fold and they seem to have some more ghosts in their souls. Discussion brings nightmares to Congo's sleep. And then one of Congo's collaborators, in the middle of a "rehearsal," while pretending to be a Communist, tells the story of burying his own stepfather on the side of the road when he was 12. His bizarre, uncomfortable laughter sounds like it is turning to sobbing. And everyone, even Congo, begins to realize their own unimaginable depths of cruelty and pure evil.

Like so many documentarians, Oppenheimer's greatest skill is a cumulative one. He keeps adding more horror to the pile. Discussion leads to reenactments on a set to an amazing, on-location reenactment of a pogrom. And Oppenheimer frames it all in the way that one culture impacts another, making the evil of what happened in Indonesia feel universal. This is not an island away from the rest of humanity. One of Congo's associates uses Guantanamo to defend their own actions; George W. Bush thought that was right then but feels it is wrong now. Another practices his speeches for a run for Parliament by mimicking facial expressions of an Obama speech. And almost all of the gentlemen reference Hollywood icons like gangsters or Scarface.

All of these episodic beats and insights pile on to Congo, a man who goes through an on-screen "therapy" like no other. At one point, Oppenheimer stops recreating actual events and stages one of Congo's horrific nightmares. And the audience realizes that they are watching a man who could not really see his own horror until it was a part of the cinematic fabric in which he draped himself when he committed his crimes. Few men have ever used a visual medium such as film to capture the fact that all the discussion in the world cannot always equal what can be conveyed through imagery. The brain has the ability to rewrite and repress inner monologue; alter memories to fit its own narrative. Oppenheimer tears down that ability when he forces Congo to face his own atrocity. It is an undeniably hard film to watch; as it should be. There have been countless, clinical, talking-head films about unimaginable horrors of war but they have kept those awful events on the other side of the world or in the record books of history. Oppenheimer takes the kind of torturous pain that one can barely fathom and gives it present-day impact and importance. His film is more than a mere documentary; it is an essential record of history.

Brian Tallerico

CREDITS

Origin: Denmark, Norway, United Kingdom

Language: English

Released: 2013

Production: Anne Kohncke, Signe Byrge Sorensen, Michael Uwemedimo; Final Cut for Real; released by Drafthouse Films

Directed by: Christine Cynn; Joshua Oppenheimer

Cinematography by: Carlos Arango De Montis; Lars Skree
Music by: Simon Thamdrup Jensen
Sound: Elin Oyen Vister
Editing: Nil Pagh Andersen; Erik Andersson; Charlotte Munch Bengtsen; Janus Billeskov Jansen; Ariadna Fatjo-Vilas; Mariko Montpetit
MPAA rating: Unrated
Running time: 115 minutes

REVIEWS

Boone, Steven. *RogerEbert.com.* July 19, 2013.
Hornaday, Ann. *Washington Post.* July 26, 2013.
Mohan, Marc. *Portland Oregonian.* September 13, 2013.
Morgenstern, Joe. *Wall Street Journal.* July 25, 2013.
Smith Nehme, Farran. *New York Post.* July 18, 2013.
Page, Janice. *Boston Globe.* August 3, 2013.
Rodriguez, Rene. *Miami Herald.* August 15, 2013.
Scott, A. O. *New York Times.* July 18, 2013.
Stamets, Bill. *Chicago Sun-Times.* August 15, 2013.
Turan, Kenneth. *Los Angeles Times.* July 25, 2013.

QUOTES

Executioner in 1965: "Imagine, in all this darkness, it's like we're living at the end of the world. We look around, there's only darkness. It's so very terrifying."

TRIVIA

Two of the world's most honored documentary filmmakers, Werner Herzog and Errol Morris, are credited as the film's executive producers.

AWARDS

British Acad. 2013: Feature Doc.
Nominations:
Oscars 2013: Feature Doc.
British Acad. 2013: Foreign Film
Directors Guild 2013: Documentary Director (Oppenheimer)
Ind. Spirit 2014: Feature Doc.

ADMISSION

> *Let someone in.*
> —Movie tagline
>
> *Get admitted.*
> —Movie tagline

Box Office: $18 Million

Charmless and contrived, *Admission* should finally convince that last person who still believes casting trumps all that, in fact, it does not. On paper, a movie starring Tina Fey and Paul Rudd, two of the most likable figures in Hollywood, cannot miss. Yet on paper *Admission* is also garbage no matter who winds up delivering the lines, as a mediocre script (adapted by Karen Croner from Jean Hanff Korelitz's novel) creates a massive conflict of interest and then refuses to acknowledge it. Princeton admissions officer Portia (Fey) has hit a rut. There is minimal excitement in her relationship with Mark (Michael Sheen), and sixteen years on the job results in her spilling the same shtick to prospective students: that there is no secret to getting into Princeton and it is important for people to be themselves and blah blah blah. At an unconventional New Hampshire school, however, the students reject Portia's pitch. They want to change the world and question the notion of needing what they see as an elitist, antiquated institution to do so. Only one, Jeremiah (Nat Wolff) wants to learn more. And John (Paul Rudd), who teaches classes including "third-world development" at the school, repeatedly insists that Portia should really get to know this kid.

Why? Because John believes that Jeremiah (who notes that sometimes, "My brain goes on a little walkabout") may be the son Portia gave up for adoption nearly two decades ago. Obviously, that represents a large bomb to drop into this woman's life, but John, who frequently travels around the world doing good and adopted his Ugandan son Nelson (Travaris Spears) when the boy was two and his mom and uncle died in a car crash, merely wants to look out for the interests of a promising child who has expressed interest in meeting his birth parents. Perhaps this plotline could explore the unexpected intersection of past and present in a rewarding way. The problem is that John simultaneously wants Portia to consider Jeremiah for Princeton, despite the fact that he has terrible grades, minimal extra-curriculars and, seemingly, a never-diagnosed case of Asperger's. And, oh yeah, that whole thing about Jeremiah potentially being her son.

To an extent, the immediately tiresome *Admission* attempts to question the college admissions process and recognize that people are much more than they may seem when they are reduced to numbers and activities. However, there is not only no doubt that Jeremiah's credentials do not qualify him for an Ivy League school that receives more than 26,000 applications and accepts approximately 1,300, but Portia's undisclosed personal involvement in a candidate clearly counts as grounds for dismissal. This woman is competing for a promotion, yet her on-the-job performance could not be less professional. In one particularly absurd scene, Portia goes to check on Jeremiah during a college party he attends and asks if he needs a toothbrush. Instead of being embarrassed, he follows her out of the party to say

that he does need a toothbrush and wants to accompany her to the store to buy one. As surely all high school kids would do while enjoying their first college bash.

To be fair, Mark leaves the increasingly spiraling Portia for a snooty Virginia Woolf scholar, and confronting a child given up for adoption cannot be an easy thing to handle. Still, Fey fails to redeem Portia's flailing behavior while creating a character that merely recalls a watered-down version of Fey's fantastic and influential Liz Lemon on *30 Rock* (2006-2013). Like Liz, Portia struggles to keep her life in order, feels awkward around kids and hates Valentine's Day. Unlike Liz, Portia's challenges are neither funny nor sympathetic. Neither is *Admission*, which strives for laughs through Portia's mom (Lily Tomlin) firing a shotgun when John will not leave Portia alone and saying she wants her daughter to call her Susannah to avoid any more "mother-daughter role playing crap."

Rudd, meanwhile, is saddled with a part that has no truth or surprise to find. Various characters note John's reluctance to settle down and Nelson continually expresses his desire to at long last stay in the same place for a while. It takes one guess to figure out where that storyline will go. No more resonant is the uncomfortably developing relationship between Portia and John or the scholar who romances Susannah and endorses Jeremiah just because he does a weird, unsettling ventriloquism act.

It is a legitimate point that ambitious students may need an advanced education to make their idealistic dreams become a reality. Yet throughout *Admission*, which is book-ended by cheap voiceover, the film endorses an open-minded, complex evaluation of a person's academic and human value but makes an extremely lousy case for its characters. The lengths to which Portia goes for Jeremiah and the ultimate resolution of the maternity issue inspire frustration instead of admiration. Long before that, Portia does her possible son no favors by trying to help him and not disclosing the conflict of interest, and John pays no attention to the other students as he strives to squeeze Jeremiah into a Princeton class in which he would be almost certainly socially and academically outclassed. Just because a person possesses uncanny intelligence (as demonstrated by Jeremiah's domination of AP tests despite never taking AP classes) does not mean that he could expect admission to the Ivy League with such questionable interpersonal skills and commitment to the various demands of education. Just because two main characters are single does not mean that they have to have a romantic relationship when minimal chemistry exists between the actors or the characters themselves.

And just because a film aims for both endearing quirk (John gives birth to a calf!) and forced sentimentality (watch as Portia rediscovers her passion for work and family!) does not mean that it succeeds in blending the departments, or even making each work on their own. *Admission* should not just have acceptance denied; its application should be shredded.

Matt Pais

CREDITS

Portia Nathan: Tina Fey
John Halsey: Paul Rudd
Jeremiah Balakian: Nat Wolff
Mark: Michael Sheen
Clarence: Wallace Shawn
Corinne: Gloria Reuben
Susannah: Lily Tomlin
Rachael: Sarita Choudhury
Origin: United States
Language: English
Released: 2013
Production: Andrew Miano, Kerry Kohansky, Paul Weitz; Depth of Field; released by Focus Features L.L.C.
Directed by: Paul Weitz
Written by: Karen Croner
Cinematography by: Declan Quinn
Music by: Stephen Trask
Sound: Ron Bochar
Editing: Joan Sobel
Costumes: Aude Bronson-Howard
Production Design: Sarah Knowles
MPAA rating: PG-13
Running time: 107 minutes

REVIEWS

Bradshaw, Peter. *The Guardian.* June 15, 2013.
Burr, Ty. *Boston Globe.* March 21, 2013.
Phillips, Michael. *Chicago Tribune.* March 21, 2013.
Pols, Mary. *Time.* March 21, 2013.
Rabin, Nathan. *AV Club.* March 20, 2013.
Rea, Stephen. *Philadelphia Inquirer.* March 21, 2013.
Scott, A. O. *New York Times.* March 21, 2013.
Stevens, Dana. *Slate.* March 22, 2013.
Taylor, Ella. *NPR.* March 21, 2013.
Toro, Gabe. *The Playlist.* March 19, 2013.

QUOTES

Portia Nathan: "You all want to know the secret formula for getting in. To do your job well, an admissions officer must be on the receiving end of an entire nation's application

panic, endure the frustration of all the parents who just realized there isn't room for every organically-fed, well-tutored offspring. Of course everyone thinks we're sadists, that we like saying no. We are in this job for one reason, to say yes."

TRIVIA

The actual Dean of Admissions at Princeton, Janet Lavin Rapelye, appears in a scene with Tina Fey.

ADORE
(Two Mothers)

Box Office: $318,982

Naomi Watts and Robin Wright are two of the more engaging actresses working today but it is an unfortunate but unavoidable fact that both are approaching the age where interesting parts for leading ladies tend to be in sadly short supply. And yet, it would almost be preferable to see the two of them biding their time in the most formulaic junk imaginable than to see them squandering their considerable talents on a film as awful as *Adore*. Ineptly conceived and inanely executed on virtually every possible level, this bewildering drama feels like a collision between *Blame It on Rio* (1984) and the lesser works of August Strindberg in which there are no survivors—not its enormously gifted and utterly wasted co-stars and certainly not anyone in the audience who cheerfully forked over the price of a ticket on the mistaken assumption that any project that could attract those two had to be at least somewhat interesting.

Watts and Wright play Lil and Roz, two lifelong friends who live next-door to each other in a remote beachfront area of New South Wales. Each comes equipped with a handsome son—Ian (Xavier Samuel) is Lil's and Tom (James Frecheville) is Roz's—and they happen to be best friends as well. With nothing else to distract them—Lil's husband is dead, Roz's is away in Sydney for long stretches of time for work and neither one appears to have any other friends or jobs that require that they turn up for anything other than an early establishing shot to show that they are employed—the two spend all their free time together lazing in the sand, playing cards and dancing the night away, always accompanied by seemingly bottomless glasses of wine and their sons. To outside eyes, this may all sound somewhat unsettling, especially when Roz and Lil are shown watching their sons surfing and comparing them to gods but the current arrangement does not strike any of them as particularly odd.

Things kick up a notch one night when, out of the blue, Ian makes a play for Roz and she, after putting up

only a token resistance, takes the guy that she has known since infancy into her bed. Alas, this transgression is witnessed by Tom and he retaliates by doing the same to and with Lil. Under normal circumstances, such a chain of events would no doubt result in some degree of mutual embarrassment, anger, and hurt but after literally a moment's hesitation at best, Roz and Lil decide that this quasi-incestuous arrangement suits their purposes just fine and for the next couple of years, sleepovers take on an entirely new meaning. Inevitably, things fall apart as aspiring theater director Tom bails on Lil to take up with an aspiring actress and Roz breaks things off with Ian to make things even between her and Lil. The two sons eventually begin families of their own but their continued desire for each other's mother proves to be too strong to be denied.

With material as potentially off-putting as what is being presented here, the trick is to find just the right approach or the entire enterprise is practically doomed before the conclusion of the opening credits. In the case of *Adore*, there are maybe two possible circumstances in which it might have worked. On the one hand, it could have been done as a raw drama that didn't shy away from the dark and twisted emotions and painful that such an arrangement might inspire, perhaps something along the lines of the startling and little-seen British drama *The Mother* (2004). On the other, it might have also worked as some kind of weirdo sex comedy that took its borderline absurdist premise and ran with it as sort of a feature-length version of that one Lonely Island video. Instead, director Anne Fontaine and screenwriter Christopher Hampton (work from the Doris Lessing novella *The Grandmothers*) have attempted to navigate a strange middle road that asks us to take the events seriously, but not too seriously, and never manages to find the right tone as a result.

Viewers are supposed to accept, for example, just how easily and cavalierly everyone is with their rather unique circumstances but at the same time, they are also asked to genuinely feel for the characters when their collective situation begins to go gunny. Perhaps if there had been a single moment in the film in which it was possible to actually believe in any of the characters or how they supposedly felt for each other, it might have paid off but it is impossible to believe in their relationships, either as profound romance or unbridled lust. Frankly, Roz and Lil generate more romantic and sexual chemistry between them than they ever manage to muster with their respective lovers, an undeniable fact that the film proceeds to milk for a couple of queasy laughs here and there.

The other key problem with *Adore* is that it is so wildly miscast that the mere presence of the actors undermines the premise at practically every turn.

Although no specific ages for the characters are ever given, it would seem that at the beginning of the story, Roz and Lil are at least in their early/mid-40's while their sons are maybe 19 or 20 and the story moves ahead in time maybe five or six years by the time it comes to an end. The trouble is that Watts and Wright both look at least 10 years too young for their roles while the guys playing their sons look at least 10 years too old to begin with and as the years go by, none of them seem to age at all. Perhaps this was a conscious choice on Fontaine's part to make the affairs less transgressive in the eyes of viewers but by making these borderline taboo affairs seem more palatable, at least on the surface, she seems to be clumsily subverting the basic point of her film. Then again, perhaps she could always argue that there was no point. Certainly, no one who sits through it from start to finish would disagree with her in that regard.

Peter Sobczynski

CREDITS

Roz: Robin Wright
Lil: Naomi Watts
Tom: James Frecheville
Ian: Xavier Samuel
Harold: Ben Mendelsohn
Hannah: Sophie Lowe
Mary: Jessica Tovey
Saul: Gary Sweet
Origin: Australia, France
Language: English
Released: 2013
Production: Philippe Carcassonne, Michel Feller, Barbara Gibbs, Andrew Mason; Screen Australia; released by Exclusive Media Group
Directed by: Anne Fontaine
Written by: Christopher Hampton
Cinematography by: Christophe Beaucarne
Music by: Christopher Gordon
Sound: Francis Wargnier; Peter Miller
Editing: Luc Barnier; Ceinwen Berry
Art Direction: Sophie Nash
Costumes: Joanna Mae Park
Production Design: Annie Beauchamp
MPAA rating: R
Running time: 100 minutes

REVIEWS

Anderson, John. *Newsday.* September 5, 2013.
Chang, Justin. *Variety.* September 3, 2013.

Ebiri, Bilge. *Vulture.* September 6, 2013.
Oursier, John. *Village Voice.* September 3, 2013.
Scott, A. O. *New York Times.* September 5, 2013.
Sharkey, Betsy. *Los Angeles Times.* September 5, 2013.
Tallerico, Brian. *HollywoodChicago.com.* September 5, 2013.
Taylor, Ella. *NPR.* September 5, 2013.
Verniere, James. *Boston Globe.* September 13, 2013.
Wise, Damon. *Guardian.* January 21, 2013.

QUOTES

Lil: "It was just important for us to know it hadn't gone away. That it was still alive. Christ, I felt like I would suffocate if I didn't have it."

TRIVIA

James Frecheville shaved his chest to play a surfer in the film.

AFTER EARTH

Danger is real. Fear is a choice.
—Movie tagline

Box Office: $60.5 Million

Movie star Will Smith introduced his son Jaden to the family business, and by extension the world to his son, with *The Pursuit of Happyness* (2006), an inspirational father-son drama rooted in the hardscrabble memoir of an off-and-on homeless man. Four years later, he and wife Jada Pinkett Smith produced a remake of *The Karate Kid* (2010) costarring Jaden and Jackie Chan, helping steer it to $360 million in worldwide ticket sales.

For the third prong of Smith's ongoing legacy project, the actor seemingly completes the auteurist destruction of M. Night Shyamalan, co-opting the erstwhile wunderkind in directorial service of *After Earth*, a "Smith Family Robinson" slice of self-congratulatory sci-fi adventure wherein Smith plays second fiddle to his now 15-year-old son, with solemn, stilted accents telling viewers just how important the yawning story they are watching is.

Opening wide on May 31 against *Now You See Me*, *After Earth* debuted in third place its first weekend with $27.5 million, en route to a underwhelming $60 million Stateside total. While it more than tripled that take internationally, the movie was lambasted by critics, casting doubt on Smith's career strategy for his progeny (daughter Willow is also in entertainment, though more focused on music) as well as Jaden's big screen future in lead roles.

Set 1,000 years after humankind has fled an ecologically ravaged planet and resettled on Nova Prime, *After*

Earth centers around Cypher Raige (Will Smith), the legendary military general of the United Rangers Corps. Raige is renowned for having discovered the weakness of the lumbering, blind but deadly alien creatures, called Ursas, with whom humans are now at odds. Harnessing the ability to mask his fear, and thus the pheromones the emotion emits, Cypher's so-called "ghosting" helped turn the tide in the war with Ursas, who track humans based on that scent.

Still, the Raige family is riven by a traumatic event which left oldest daughter Shenshi (Zoe Kravitz) dead. Headstrong young Kitai (Jaden Smith, all telegraphed adolescent poutiness and flared nostrils) concurrently blames himself for his sister's death and feels his father blames him, which has led to a deterioration of their relationship. After their cadet son fails to advance to Ranger status, Cypher's wife, Faia (Sophie Okonedo), convinces Cypher to take Kitai with him on his last mission before retirement.

Naturally, disaster ensues. To escape the effects of an asteroid shower, the Rangers' craft slips through a wormhole and crash lands on Earth. With his father's legs broken and a sliced artery bleeding out, Kitai is tasked with avoiding both native predators and a loose Ursa (on board the Rangers' craft for "training purposes") and traversing over 60 miles on foot to salvage a rescue beacon. When he breaks some of the special inhalers he needs in order to breathe more easily on Earth, his journey becomes even more perilous.

Gary Whitta and Shyamalan share screenplay credit (Stephen Gaghan and Mark Boal also did uncredited work) but the core idea of *After Earth* belongs to the elder Smith, who receives story credit. Unfortunately, while generally avoiding some of the special effects set piece excesses of big screen science fiction action movies, this otherwise unusual genre restraint is not put to much good use. Nominally, its story seems pitched at younger audiences, who might more readily accept at face value its sullen protagonist and the sighing narrative single-mindedness that, you know, parents just do not understand. But its wan survival is story lacquered over with the sort of facile hubris and mind-over-all-matter bromides that make it feel like some sort of Scientology parable.

After Earth feels thinly sketched throughout, especially when compared to something like *Ender's Game* (2013), which also dealt with teenage estrangement and outer space adventure, but in a more evocative and interesting manner. There are a couple telling lapses in logic (despite a millennium without their presence, it is posited that creatures on Earth have "evolved to hunt humans"), and the film's dialogue is frequently risible—a tangle of repeated platitudes ("Root yourself in this

present moment") that often sound nipped from the sort of empty occupational advice celebrities give fans who breathlessly query them about how to break into show business. (It is also hard to understand how Smith's big moment of emotional pique, "Denied—sit down!," did not become an Internet meme.)

Most fatally, though, *After Earth* is just not much fun—a fact doubly reflected in the movie's dour performances. There is a way to explore the same father-son friction and emotional dislocation at the movie's core without reducing it to such a dreary bore. Unfortunately, *After Earth* does not figure that out. After the opening 20 minutes, the elder Smith is relegated to static traction, where he grimaces and adds occasionally hectoring, stressed syllables to what is otherwise a very mannered monotone. With no other substantive characters, this leaves the movie squarely on the younger Smith's shoulders. That does not work out so well.

After Earth hit theaters months before Jaden took to Twitter in September and October with a string of controversial missives ("If everybody in the world dropped out of school we would have a much more intelligent society," and, "People used to ask me what do you wanna be when you get older and I would say what a stupid question, the real question is what am I right now") that garnered tens of thousands of re-tweets and derisive replies. That behavior, though, only seemed to confirm the younger Smith's core problem on rich display here: While certainly not done any great favors by the film's script, he lacks even the basic instincts for humility or vulnerability, suggesting a plenty tumultuous young adulthood should he continue acting but not immediately inherit the same sort of box office stature of his father.

If there is a small redeeming grace to *After Earth*, it lies in its technical package. Shot partially on location in Costa Rica, the film makes good use of its lush forest environments. Cinematographer Peter Suschitzky's muted frames blend fairly well with the austere production design of Tom Sanders and the digitally enhanced beasts Kitai encounters during his quest, even if James Newton Howard's score pokes viewers a bit too directly. Regrettably, this listless tale otherwise offers little else than Smith's attempted pole-positioning of Jaden. Its relative failure suggests that sometimes the American public will not be fooled.

Brent Simon

CREDITS

Kitai Raige: Jaden Smith
Cypher Raige: Will Smith

Faia Raige: Sophie Okonedo

Senshi Raige: Zoe Kravitz

Commander Velan: Glenn Morshower

Pvt. McQuarrie: David Denham

Origin: United States

Language: English

Released: 2013

Production: Will Smith; released by Sony Pictures Entertainment Inc.

Directed by: M. Night Shyamalan

Written by: M. Night Shyamalan; Gary Whitta

Cinematography by: Peter Suschitzky

Music by: James Newton Howard

Sound: Steven Ticknor

Editing: Steven Rosenblum

Costumes: Amy Westcott

Production Design: Thomas E. Sanders

MPAA rating: PG-13

Running time: 100 minutes

REVIEWS

Beifuss, John. *Commercial Appeal.* May 31, 2013.

DeFore, John. *Hollywood Reporter.* May 30, 2013.

Edelstein, David. *New York Magazine.* May 31, 2013.

Foundas, Scott. *Variety.* May 30, 2013.

Gleiberman, Owen. *Entertainment Weekly.* May 31, 2013.

Goodykoontz, Bill. *Arizona Republic.* May 31, 2013.

Patches, Matt. *GeekNation.* May 31, 2013.

Phillips, Michael. *Chicago Tribune.* May 30, 2013.

Tallerico, Brian. *HollywoodChicago.com.* May 30, 2013.

Williams, Joe. *St. Louis Post-Dispatch.* May 30, 2013.

QUOTES

Cypher Raige: "Fear is not real. The only place that fear can exist is in our thoughts of the future. It is a product of our imagination, causing us to fear things that do not at present and may not ever exist. That is near insanity Kitai. Do not misunderstand me, danger is very real, but fear is a choice. We are all telling ourselves a story and that day mine changed."

TRIVIA

Although not credited with doing so, co-writer/producer Will Smith was responsible for directing most of the film. While M. Night Shyamalan was in charge of the blocking shots and the visual aspects of the film, Smith coached his son Jaden through his performance and dictated the development of the story.

AWARDS

Golden Raspberries 2013: Worst Actor (Smith), Worst Ensemble Cast, Worst Support. Actor (Smith)

Nominations:

Golden Raspberries 2013: Worst Director (Shyamalan), Worst Picture

AFTER TILLER

Over one million abortions are preformed in the U.S. every year. Following the murder of Dr. George Tiller, only four remaining doctors perform third-trimester abortions.
—Movie tagline

Box Office: $72,125

Martha Shane and Lana Wilson's controversial documentary, *After Tiller*, is an important film. It is not an easy film to watch and may not match with everyone's views on one of the most divisive issues of its time but it is undeniably important because it re-humanizes four people who have been turned into pawns by the political machine because of what they do for a living. The only four doctors in the country who still perform late-term abortions have become demons for the pro-life movement, who have cast them as the purveyors of the ultimate sin in a world overrun by evil. They are not people; they are monsters. The pro-choice movement has often treated them equally two-dimensionally, making them icons for a political stance without remembering that they are fathers, mothers, husbands, wives, and, most of all, doctors. These four people make incredibly difficult decisions on a daily basis and Shane and Wilson's film makes it clear that an issue that the media has often treated as black and white is merely a story of shades of gray.

Since their professional leader, George Tiller, was brutally murdered by a pro-life fanatic, the only four doctors who currently perform third-trimester abortions (which are, technically, forced stillbirths as the doctors induce early labor and conduct an actual delivery) have been terrorized by the people who consider them murderers. From the beginning, Shane and Wilson go to great lengths to detail the difficult decisions made by Dr. Leroy Carhart, Dr. Warren Hern, Dr. Susan Robinson, and Dr. Shelley Sella, starting with whether or not to go on with what they see as medical duties after the death of their friend and colleague. In May of 2009, George Tiller was murdered at church. His place at the head of this group became instantly filled by Dr. Carhart to the extreme pro-life movement; those who believe that abortion doctors should be killed. He is constantly faced by protest, death threats, and actual violence, such as the time his stable of horses was burned to the ground, killing most of the animals within. And yet Dr. Carhart pushes forward through the fear and through the violence because he truly believes what he is doing is right.

The documentary includes numerous meetings with women in need of late-term abortions, almost all because of horrendous, unimaginable health issues that will befall their babies as soon as they are born. The testimonials and issues within them feel brutally confessional and the directors were wise to never lose sight of the true victims of this story—the people forced into a political issue just by the health problems of their unborn baby. The question of whether or not a baby who has a bone condition that will make life unbearable should be terminated more mercifully before an inevitable end to an all-too-brief life is one that is almost too painful to imagine. And yet, largely through shots of wringing hands and nervous feet as most of the women's faces are not shown, the audience feels the horror of these situations on both the heartbroken mothers and the doctors who truly believe that they are only doing what is best for everyone involved. Without political emphasis, *After Tiller* makes the argument that choosing which one of those two options these women will take is between them and a doctor and no one else. The work these doctors do is undeniably brutal, even to them and those who support late-term abortions. One senses immediately while watching *After Tiller* that none of these people take their role lightly, not in the specifics of their day-to-day profession nor the broader picture of fighting for what they think is right. They have considered all angles. They know the arguments on the other side. They fear for their own safety. And yet they continue to fight.

Due to Carhart's being the most outspoken and targeted of the four, he gets the most time in the film but the other three doctors are not ignored by any stretch. The directors provide a nice degree of background without turning their film into a bio-doc. It is important to know how these people reached this point in the abortion movement with a set of doctorial beliefs that have allowed them to face challenges from so many people. The variety in their backgrounds is interesting: Dr. Hern served in the third world and saw the brutal, horrendous impact of attempts at home abortions; Dr. Robinson was a midwife and so trusts that no one but the mother knows what is best for her baby; Dr. Sella seems the most challenged morally, judging each story that comes to her door as to whether or not it is one in which the good doctor can essentially play God.

After Tiller is not a balanced piece politically because that is not its goal. In fact, the pro-life movement is seen almost entirely in news footage and on the sidewalks in front of the clinic. Even from a pro-choice vantage, statements from the doctors about how none of their patients ever have any regrets ring a little false. Nothing is that absolute. It is the more complex, gray areas of *After Tiller* that make the film interesting. Their struggles with morality and their chosen professions are

daily. The film might have been a bit stronger by showing more of the counterpoint instead of merely ignoring them altogether but the reasoning makes sense. Showing the side of the debate that argues that murder is the correct answer to stopping abortion would have reduced the issue yet again to good vs. evil when the whole purpose of the film is to personalize the political. These people are neither heroes nor villains. They just miss their friend, fear for their loved ones, and continue to fight for what they believe in. It is important no matter one's political bent, to hear about that fight.

Brian Tallerico

CREDITS

Origin: United States
Language: English
Released: 2013
Production: Martha Shane, Lana Wilson; released by Oscilloscope Films
Directed by: Martha Shane; Lana Wilson
Written by: Martha Shane; Lana Wilson; Greg O'Toole
Cinematography by: Hilary Spera; Emily Topper
Music by: Andy Cabic; Eric D. Johnson
Editing: Greg O'Toole
MPAA rating: PG-13
Running time: 85 minutes

REVIEWS

Byrge, Duane. *The Hollywood Reporter.* July 25, 2013.
Hornaday, Ann. *Washington Post.* October 31, 2013.
Kohn, Eric. *Indiewire.* July 25, 2013.
Lewis, David. *San Francisco Chronicle.* October 17, 2013.
Linden, Sheri. *Los Angeles Times.* October 3, 2013.
Scherstuhl, Alan. *Village Voice.* September 17, 2013.
Scott, A. O. *New York Times.* September 19, 2013.
Simon, Alissa. *Variety.* July 25, 2013.
Stamets, Bill. *Chicago Sun-Times.* October 17, 2013.
Walsh, Katie. *The Playlist.* July 25, 2013.

AWARDS

Nominations:

Ind. Spirit 2014: Feature Doc.

AFTERNOON DELIGHT

The cure for the common marriage.
—Movie tagline

Box Office: $174,496

Winner of the Dramatic Competition Directing Award at the 2013 Sundance Film Festival, *Afternoon*

Delight is a movie that marries sincere comedy with equally genuine melancholic feeling. The feature directorial debut of television veteran Jill Soloway—about a housewife's misguided attempts to save a troubled and eventually troublesome stripper and sex worker—is a literate, tart, emotionally rich dramedy that compares favorably with fellow urbane, femme-centric portraits of modern city life and relationships from writers and directors like Nicole Holofcener, Lisa Cholodenko, and Jennifer Westfeldt. For some reason distributor The Film Arcade, perhaps feeling the theatrical marketplace too crowded, never invested in a theatrical release beyond several dozen theaters, preferring instead to focus on VOD outlets. The result is that many viewers were robbed of a chance to share in a breakout performance from character actress Kathryn Hahn.

Tightly coiled Rachel (Hahn), who lives with her husband Jeff (Josh Radnor) in a friendly Jewish enclave within Los Angeles' bohemian yet affluent Silver Lake neighborhood, is bored with her life as stay-at-home mother. Like a lot of thirtysomething couples, Jeff and Rachel are stuck in a rut. They speak in code about their lack of sex by talking about if they want to "put the dog out" prior to going to bed, before invariably deciding to let him sleep in the room with them. Rachel discusses these and other issues with her therapist, but Dr. Lenore (Jane Lynch) typically finds a way to steer the conversation back to her own life.

Seeking to spice things up, the couple heads to a strip club with some friends. There, Rachel gets a lap dance from McKenna (Juno Temple), a young stripper and prostitute with 55 days sobriety under her belt. McKenna awakens in Rachel a unique mixture of libidinal surge and maternal concern ("Maybe I could help her set up a blog—she and I could co-blog"), and in the ensuing days Rachel returns to the club, clumsily crosses paths with McKenna in mock-coincidental fashion and invites her to move into their spare room until she can get a new apartment. Jeff is flabbergasted, but lets his wife steer the situation. What follows is a sexual reeducation at the hands of the guileless, upbeat McKenna (both figuratively and literally), before the film swan-dives into some of the inevitably messier consequences of Rachel's not particularly well thought out arrangement.

Afternoon Delight feels so comfortably nestled and of a piece with its yuppie SoCal locale that it is hard to believe its setting was the result of a third-pass rewrite, after Soloway originally set the movie in wintry Chicago and then reworked it for San Francisco during a production process which included flirtations with lead actresses like Kate Winslet, Kristen Wiig, Elizabeth Banks, and Jennifer Garner. Detractors of the movie (of which there are a fair number, given its barely fresh rating on Rotten Tomatoes) seem to consistently cite its screenplay as contrived and/or too muddled in tone. Yet there are two very obvious directions that, based on its set-up, *Afternoon Delight* seems to be going, and Soloway indulges neither of these, instead putting a spin on matters while also remaining true to the nature of her characters. That brings nominal tragedy, or certainly a disruption of the well-ordered norm for Rachel and Jeff, but that is not a hairpin turn in pitch or tenor, the way some seemingly believe it to be.

The film is also both funny and complex, no small feat, without nakedly reaching for profundity merely for profundity's sake. Soloway has a smart, well-observed penchant for pinprick comedy of self-immolation, mining Rachel's social awkwardness and sexual stagnancy for moments of aching amusement. But she is also adept at quips, as with a riff about one of Rachel's friends having a "tragic bitchy resting face."

At its core, *Afternoon Delight* is about the need to be seen for who you really are, and the discomfort that manifests when that reality is denied for too long. Part of Rachel's problem lies in expressing her sexual desires to her husband. The sadness the movie brings for McKenna is that she is thrilled to have seemingly found an older woman sincerely interested in her and her life, never realizing that Rachel is assigning to McKenna a woundedness that (at least at this point in her life) the latter does not accept. These are characters looking past one another.

Soloway overlooked nothing in her film's casting, however. While a higher profile actress would likely have brought *Afternoon Delight* much more attention at the box office, it is a simply fantastic showcase for Hahn, who shares a wonderful rapport with Temple. A familiar face from plenty of small screen work who has also stolen scenes in movies like *Step Brothers* (2008), *Revolutionary Road* (2008), and this year's *We're the Millers*, Hahn taps into Rachel's downheartedness in enormously sympathetic fashion. She is the film's anchor. Temple, meanwhile, imbues McKenna with a sunny optimism that interestingly shades her character rather than belies it.

Afternoon Delight is a film about mid-life suburban crisis and sexual awakening, yes, but also divided femininity. If the physical staging of some of its third act scenes of conflict feel a bit awkward, its general balance of comedy and drama still feels right, and Soloway admirably eschews pat "Madonna and the whore" cliches, crafting multifaceted lead characters with admirable

traits as well as shortcomings. Above all, *Afternoon Delight* is alive.

Brent Simon

CREDITS

Rachel: Kathryn Hahn
McKenna: Juno Temple
Jeff: Josh Radnor
Lenore: Jane Lynch
Jennie: Michaela Watkins
Matt: Josh Stamberg
Jack: John Kapelos
Bo: Keegan Michael Key
Origin: United States
Language: English
Released: 2013
Production: Sebastian Dungan; 72 Productions, Rincon Entertainment; released by Film Arcade
Directed by: Jill Soloway
Written by: Jill Soloway
Cinematography by: Jim Frohna
Music by: Craig (Shudder to Think) Wedren
Sound: Eric Offin
Editing: Catherine Haight
Art Direction: Jean-Paul Leonard
Costumes: Marie Schley
Production Design: Adriana Serrano
MPAA rating: R
Running time: 99 minutes

REVIEWS

D'Angelo, Mike. *A.V. Club.* August 29, 2013.
D'Arcy, David. *Screen International.* January 23, 2013.
Holden, Stephen. *New York Times.* August 29, 2013.
Linden, Sheri. *Los Angeles Times.* August 29, 2013.
Matthews, Jeremy. *Paste Magazine.* August 27, 2013.
McCarthy, Todd. *Hollywood Reporter.* January 22, 2013.
Mohan, Marc. *The Oregonian.* September 6, 2013.
Phillips, Michael. *Chicago Tribune.* September 5, 2013.
Tallerico, Brian. *HollywoodChicago.com.* September 5, 2013.
Tillotson, Kristin. *Minneapolis Star Tribune.* September 5, 2013.

AWARDS

Nominations:

Ind. Spirit 2014: First Screenplay

AIN'T THEM BODIES SAINTS

Box Office: $396,519

Just because a film's cinematic inspirations can be easily discerned does not automatically lessen its power.

Fiction inspired by classic writers like Ernest Hemingway or John Steinbeck is said to follow in a grand tradition. Rock music that often cribs guitar riffs openly from classic tunes, often without credit, is seen as "old-fashioned." And artists like Quentin Tarantino have taken the concept of "homage" to an Oscar-winning pedestal. And so when one looks at David Lowery's Sundance Award-winning *Ain't Them Bodies Saints* and sees the fingerprints of a filmmaker who clearly grew up bowing at the idol of Terrence Malick, it need not be a bad thing. On the contrary, Lowery has delivered a lyrical, mesmerizing drama with stellar central performances. Malick would be proud.

The perfectly-named Bob Muldoon (Casey Affleck) and Ruth Guthrie (Rooney Mara) are a young, rebellious couple in love. Well, at least it feels like they are even if the dialogue of the gorgeous opening scene consists of fighting words. Ruth may be yelling at Bob, in no small part because of insecurity related to her recent pregnancy, but it is cast against a perfectly-lit, twilight-or-dawn kissed field, in lovingly rendered period costumes, and with the stunning camera's eye of Bradford Young, who won a Special Jury Prize for his cinematography here (and really is one to watch in his film after shooting *Pariah* [2011], *Middle of Nowhere* [2012], and *Mother of George* [2013]). Lowery and Young set the style and tone of *Saints* right in that first scene—even the torture will be gorgeous. They may be dirty but it is a beautiful layer of dirt.

After that lyrical prologue, our star-crossed lovers are separated. They are caught in a shootout, Bob is taken away, and Ruth gives birth to their new child as a single mother with a lover in the clink. Years pass by and Ruth forms her own small family, seemingly losing a bit of that passion that kept her with Bob. When Muldoon hears that Ruth gave birth to a daughter, he decides that he has had enough time of separation and breaks free from his confinement, heading cross-country to find his girls. Bob has no clue that one of the police officers who helped guide his capture during that crucial shoot-out, Patrick Wheeleer (Ben Foster), has grown closer to Ruth and his daughter. He is on a fated journey in that he has committed a crime yet again through his escape and he is walking into the arms of the law, which happen to desire to be around Ruth.

Do not mistake the plot synopsis above as something that would define *Ain't Them Bodies Saints* as a story of a love triangle. It is not that simple-minded of a film. Even though the opening scene and the posters that sold the film may set viewers up for a romance, Affleck and Mara are separated for most of the film. Lowery's primary concern is detailing the way in which the past can slowly creeping up on the present. It is not a film with a predetermined outcome of success. A case could

easily be made that Ruth and her child are better off with a kind-hearted cop than a tough criminal. And yet there is the echo of romance from that opening scene and the sense that Bob and Ruth are fated to be together again, for better or worse.

Lowery eschews traditional narrative arc for something far more thematic. To use a phrase that has been commonly applied to Malick's work, Lowery's filmmaking vision is more poetry than prose. Lowery devotes long chunks of time to scenes that seemingly have no impact on the plot, spinning characters and mood over storytelling. Bob spends a long time in a seedy bar, talking to friends and locals, there are men after him and inherent urgency to any escaped con's trip, and yet the film itself rarely feels urgent. It is a long, slow, sipped drink on a lazy Sunday afternoon in the South more than a shot, and the languorous tone is heightened by a fantastic score from Daniel Hart.

As for performance, Affleck gets his best part in years, displaying the range that made his breakthrough in *The Assassination of Jesse James by the Coward Robert Ford* (2007) feel like such a revelation. Mara's role feels somewhat underwritten but, as usual, she does a lot with very little. Just as she did in Steven Sodebergh's *Side Effects* (2013) and Spike Jonze's *Her* (2013), Mara does more with very little. She can take a look of longing against a sunset and use it to say more than most of her peers can with a monologue. Foster seems inspired by his quality co-stars, grounding the film in a relatable realism that could have been lacking if the film was only the story of Bob and Ruth.

Ain't Them Bodies Saints can sometimes be frustrating in its lack of narrative thrust. It is a film that works better the second or third time when traditional expectations of plot are not as mentally enforced. It is the kind of film that lingers in the memory like a song with images floating back to the mind's eye or beats of the characters resonating in modern life. It is, perhaps most of all, an amazing statement to be made by a first-time director: Not just that David Lowery admires Terrence Malick but that he also deserves comparison to him.

Brian Tallerico

CREDITS

Ruth Guthrie: Rooney Mara
Bob Muldoon: Casey Affleck
Patrick Wheeler: Ben Foster
Skerritt: Keith Carradine
Sweetie: Nate Parker
Origin: United States
Language: English

Released: 2013
Production: Cassian Elwes, Toby Halbrooks, James M. Johnston, Amy Kaufman, Lars Knudsen, Jay Van Hoy; Evolution Independent, Lagniappe Films, Paradox Entertainment, Parts&Labor, Primary Productions, Sailor Bear; released by IFC Films
Directed by: David Lowery
Written by: David Lowery
Cinematography by: Bradford Young
Music by: Daniel Hart
Sound: Bob Shoup; Dick Hansen
Editing: Craig McKay; Jane Rizzo
Art Direction: Jonathan Rudak
Costumes: Malgosia Turzanska
Production Design: Jade Healy
MPAA rating: R
Running time: 96 minutes

REVIEWS

Adams, Sam. *Time Out New York.* August 13, 2013.
Deburge, Peter. *Variety.* April 6, 2013.
Doggart, Sebastian. *The Guardian.* March 6, 2013.
Lemire, Christy. *RogerEbert.com.* August 16, 2013.
Morgenstern, Joe. *Wall Street Journal.* August 15, 2013.
O'Hehir, Andrew. *Salon.com.* August 15, 2013.
Perez, Rodrigo. *The Playlist.* March 6, 2013.
Phillips, Michael. *Chicago Tribune.* August 29, 2013.
Phipps, Keith. *The Dissolve.* August 15, 2013.
Sharkey, Betsy. *Los Angeles Times.* August 15, 2013.

QUOTES

Bob Muldoon: "Every day I wake up thinking today's the day I'm gonna see you. And one of those days, it will be so. And then we can ride off to somewhere. Somewhere far away."

TRIVIA

According to Casey Affleck, the film's title is taken from director David Lowery's misquotation of lyrics of a song and has no actual meaning.

ALL IS LOST

Never give up.
 —Movie tagline

Box Office: $6.3 Million

There are few people in the world who have championed the work of DIY artists with as much charismatic grace and global influence as Robert Redford. He is well aware of the trials and tribulations

awaiting filmmakers as they embark on making their first feature. The overwhelming pressures and formidable tasks that must be tackled on a daily basis could cause one to feel as if they were adrift at sea, and that is precisely why director J.C. Chandor's decision to cast the 77-year-old screen legend in his sophomore directorial effort, *All Is Lost,* is such a stroke of genius.

Who better than Redford to embody the resilience of mankind's survival instinct especially when it is tested by nature's most unforgiving elements? For about 100 unrelenting minutes, Chandor centers his lens on a nameless sailor, credited as "Our Man" in the closing reel, played by Redford in a performance of very few words. He is alone on a sinking boat in the middle of a seemingly limitless sea, so there naturally are not many reasons for him to talk. He can only improvise, experiment and utilize every last shred of his willpower to literally keep his head above water.

Hollywood bigwigs would have undoubtedly pressured Chandor to contrive a reason for Redford's character to spout biographical exposition or underline the film's metaphorical subtext, much like Sandra Bullock is tasked to do in Alfonso Cuaron's similarly-themed *Gravity* (2013). Yet after writing one of the decade's best scripts in his debut feature, *Margin Call* (2011), Chandor cements his status as an artist of immense integrity by refusing to rely on his chief strength in his second film, while draining his narrative of the commercially viable cliches guaranteed to boost its box office. Whereas *Margin Call* observed the dishonest methods used by privileged executives to prevent the sinking of their company at the dawn of the financial crisis, while digging their own graves in the process, *All Is Lost* is an ode to the sort of primal courage humans muster once they are stripped of all material comforts.

It is only appropriate for Chandor's direction and Redford's performance to be as raw and straightforward as the premise itself. Never once does Chandor attempt to heighten the suspense with knee-jerk scares or formulaic set-pieces, though his stripped-down approach does dilute the tension to some degree. The sudden appearance of a shark, a la *Jaws* (1975), should produce a substantial jolt, but the timing is off. With the exception of a few establishing shots, the audience is confined entirely within Redford's limited perspective on the boat. When churning waves knock him into the sea, the water causes a white-out that render much of the visuals frustratingly murky, thus allowing viewers to share in the character's disorientation.

Some critics will undoubtedly complain about Chandor's decision to begin the film with Redford's inner voice, as it dictates a letter written to his loved ones during his bleakest hours, before the narrative jumps back eight days to the inciting incident. It could be argued that this monologue breaks the film's silence with exposition designed to make it more accessible to audiences residing outside art houses, but since the subsequent scenes resist sentimentality at every turn, Redford's sweetly sorrowful farewell grows all the more poignant. Placing this dialogue at the beginning provides viewers with the sole thread of narrative anchoring every scene that follows with a visceral urgency, as Redford fights to survive in order to reunite with his family. When Redford finally does compose the letter, his expressions convey a depth of feeling no words could ever articulate.

Though Chandor's yarn is ultimately an inspirational one, it puts a refreshing spin on deus ex machinas too often taken for granted in other survival films. Whereas *Cast Away* (2000) jarringly cuts from an enormous cargo ship sailing past its stranded hero to his supposed rescue, *All Is Lost* shows how such an instantaneous happy ending would not be so easily retrievable, as Redford watches helplessly as passing ships remain oblivious to his suffering, including one vessel carrying the shipping containers that poked the fatal hole in his boat. Chandor's exquisite sound designers keep the audience's ears hypersensitive to noises that would obtain a surreal intensity in the emptiness of the ocean. The dull thud of a rope tying Redford's boat to his life raft somehow takes on the ominous timbre of a drum roll. Alex Ebert's score maintains a broodingly mournful tone without registering as an intrusion.

In an awards season stuffed with pictures featuring lone heroes on seemingly quixotic quests, from the Coen Brothers' impoverished folk singer in *Inside Llewyn Davis* (2013) to Steve McQueen's enslaved Northerner in *12 Years a Slave* (2013), Chandor's film provides moviegoers with perhaps the purest examination of human struggle unclouded by Oscar-baiting histrionics or distracting star cameos. It is the hunger for life that kept Conrad clinging to the side of his boat in Redford's magnificent 1980 directorial debut, *Ordinary People,* that fuels the awesome yet endearingly vulnerable stamina of both "Our Man" and the actor himself, who performed many of his own stunts and displayed a fearlessness rare among actors in his age range. It is a remarkable sight for jaded eyes.

Matt Fagerholm

CREDITS

Our Man: Robert Redford
Origin: United States
Language: English
Released: 2013

Production: Neal Dodson, Anna Gerb, Justin Nappi, Teddy Schwarzman; Black Bear; released by Lions Gate Entertainment Corp.

Directed by: J.C. Chandor

Written by: J.C. Chandor

Cinematography by: Frank DeMarco; Peter Zuccarini

Music by: Alex Ebert

Sound: Steve Boeddeker

Editing: Pete Beaudreau

Art Direction: Marco Niro

Costumes: Van Broughton Ramsey

Production Design: John P. Goldsmith

MPAA rating: PG-13

Running time: 106 minutes

REVIEWS

Arikan, Ali. *RogerEbert.com*. October 18, 2013.

Cordova, Randy. *Arizona Republic*. October 24, 2013.

Denby, David. *The New Yorker*. October 14, 2013.

Edelstein, David. *New York Magazine (Vulture)*. October 14, 2013.

Gleiberman, Owen. *Entertainment Weekly*. October 16, 2013.

McCarthy, Todd. *The Hollywood Reporter*. May 25, 2013.

Phillips, Michael. *Chicago Tribune*. October 24, 2013.

Phipps, Keith. *The Dissolve*. October 16, 2013.

Scott, A. O. *The New York Times*. October 17, 2013.

Stevens, Dana. *Slate*. October 20, 2013.

QUOTES

Our Man: "Thirteenth of July, 4:50 pm. I'm sorry. I know that means little at this point, but I am. I tried, I think you would all agree that I tried. To be true, to be strong, to be kind, to love, to be right. But I wasn't. And I know you knew this. In each of your ways. And I am sorry. All is lost here except for soul and body, that is, what's left of them, and a half-day's ration. It's inexcusable really, I know that now. How it could have taken this long to admit that I'm not sure? But it did. I fought 'til the end, I'm not sure what this is worth, but know that I did. I have always hoped for more for you all. I will miss you. I'm sorry."

TRIVIA

This is the only movie in the history of international filmmaking that has only one actor and writer/director but eleven executive producers, as well as six additional producers.

AWARDS

Golden Globes 2014: Orig. Score

Nominations:

British Acad. 2013: Sound

Golden Globes 2014: Actor—Drama (Redford)

Ind. Spirit 2014: Actor (Redford), Cinematog., Director (Chandor), Film

ALL THE LIGHT IN THE SKY

Pioneer of a DIY brand of filmmaking often referred to as "Mumblecore" with films like *Nights and Weekends* (2008), *Alexander the Last* (2009), and *Marriage Material* (2012), actor/writer/director/editor/everything Joe Swanberg had something of a breakthrough in 2013 with his widely-acclaimed and star-heavy *Drinking Buddies*, starring Olivia Wilde, Anna Kendrick, and Jake Johnson. He followed up that film's success with the announcement that his next major film, *Happy Christmas* (2014) would again star Kendrick and play in the coveted U.S. Competition program of the Sundance Film Festival. Almost as if to allay the fears of those who worried that Swanberg had forgotten his roots, his ultra-low-budget *All the Light in the Sky* hit arthouses and On Demand at the end of the year, reminding one that this is a filmmaker who does not need the common tricks of independent cinema to tell a story. With few characters, almost no sets, and a story that takes less than eighty minutes to tell, Swanberg tears narrative storytelling down to its character-based essentials. This quiet, gentle film is a character study of a woman who is paid a visit by a relative. One can take it as nothing more than that or look deeper to see the tale of an actress who may be realizing that she is past midday and headed to the twilight of her years.

Marie (Jane Adams, clearly improvising a character not-so-loosely based on herself) plays an actress who may be slightly struggling to get work (a conversation in which she asks her agent about an "ultra-low-budget" film seems particularly referential to this one) but is happy with her life and her gorgeous Malibu apartment. It may be a small residence but it has an amazing view. When one looks out the window, almost all they see is the ocean. And all the light in the sky, of course. Marie may not get the parts she once did and may not have the sexual affairs she once did but she is found a content state of being that is slightly rattled by the arrival of her niece Faye (Sophia Takal, herself a Mumblecore staple).

Faye is younger, brighter, and seems generally satisfied with her life but Swanberg does not overplay what could have been a standard story of mid-life crisis spurned by a woman half her age even if it feels like that is an undercurrent of the piece, such as when Marie comments on Faye's body when they are changing or laments her lackluster dating life with her. Swanberg fills his cast out with familiar faces including indie film buddies Simon Barrett (writer of Adam Wingard's *You're*

Next [2013] and *The Guest* [2014]) and Ti West (director of *The House of the Devil* [2009] and *The Innkeepers* [2011]) while also giving horror/indie icon Larry Fessenden a truly juicy role as Marie's friend Rusty. A late-movie conversation between Marie and Rusty seems to justify the entire film's existence and seems likely to have been the centerpiece around which the rest of this thin narrative sprouted.

If *Drinking Buddies* proved that Joe Swanberg had graduated to a more predictable form of storytelling with scenes that actually felt written more than conceived and improvised on the morning they were shot, *All the Light in the Sky* proves that he has not lost his Mumblecore roots. Even though it was produced before the Olivia Wilde flick, releasing it in between Swanberg's breakthrough and his Sundance "cool kids club" acceptance gives it a unique placement in his career. Wherever Swanberg goes from here, *All the Light in the Sky* reminds one that character and improvisation will always be his strongest assets, not narrative. While the lack of refined storytelling in films like this one can be frustrating, Swanberg rose to the forefront of his sub-genre by creating sets on which talented actors and actresses can be as vulnerable and forthcoming as they have ever been.

After years appearing in films as diverse as *Eternal Sunshine of the Spotless Mind* (2004), *Wonder Boys* (2000), and, in her best performance, Todd Solondz's *Happiness* (1998), Jane Adams reminds one here why it would be nice to see her get more consistent work. She is always completely in the moment, never coming off as forced or unbelievable, and that sense of realism that she imbues Marie with is the only narrative foundation Joe Swanberg needs. He believes that if the viewer finds Marie's existence believable, then he will find value in spending a few days with her in her Malibu apartment. It is as simple an approach to filmmaking and storytelling as can be found in independent cinema; completely unfettered by melodrama or forced dialogue. It is also too simple for some viewers who may long for something to happen, although even they may be surprised at the sense that something truly has happened during *All the Light in the Sky*, just not in the way they were expecting.

Brian Tallerico

CREDITS

Marie: Jane Adams
Faye: Sophia Takal
Dan: Kent Osborne
Rusty: Larry Fessenden
Origin: United States
Language: English

Released: 2013
Production: Adam Donaghey, Joe Swanberg; released by Factory 25
Directed by: Joe Swanberg
Written by: Jane Adams; Joe Swanberg
Cinematography by: Joe Swanberg
Music by: Orange Mighty Trio
Sound: Randall Good
Editing: Joe Swanberg
MPAA rating: Unrated
Running time: 79 minutes

REVIEWS

Arnold, Joel. *NPR*. December 20, 2013.
Barker, Andrew. *Variety*. December 17, 2013.
Costa, Diego. *Slant Magazine*. December 19, 2013.
Holden, Stephen. *New York Times*. December 19, 2013.
Kang, Inkoo. *Village Voice*. December 17, 2013.
Kohn, Eric. *IndieWIRE*. December 20, 2013.
Neumaier, Joe. *New York Daily News*. December 20, 2013.
O'Malley, Sheila. *RogerEbert.com*. December 21, 2013.
Rabin, Nathan. *The Dissolve*. December 17, 2013.
Vishnevetsky, Ignatiy. *A.V. Club*. December 18, 2013.

AMERICAN HUSTLE

Everyone hustles to survive.
　　—Movie tagline

Box Office: $144.3 Million

Having been thoroughly sucked into his world of con games by both the allure of the high life and the legs of his girlfriend Sydney Prosser (Amy Adams), newly-undercover FBI agent Richie DiMaso (Bradley Cooper) is being given a lesson in the art of the game by his new mentor, career swindler Irving Rosenfeld (Christian Bale). With his arm around Richie's shoulder, Irving guides him to a famous painting by Rembrandt that hangs in a New York museum. Much to Richie's surprise, Irving reveals that the painting is a fake (although one never knows for sure if Irving is not merely spinning another tale and making up another story). Rosenfeld claims that millions of people have seen and admired this Rembrandt, never knowing that it is merely a copy of the original. He asks Richie who is the real master, the one who painted the original or the one who copied it? Does it matter if the artistic enjoyment is the same?

The identical question could be levied at those who felt that David O. Russell's *American Hustle* shared a bit too much cinematic fabric with the work of Martin

Scorsese, particularly *GoodFellas* (1990), a film similarly structured around narration, popular music, and a story of the good life of criminal enterprise. If Scorsese is Rembrandt, Russell is the forger, knowingly copying the master in an effort to provide some of the same artistic enjoyment. The result is a wildly entertaining piece of work that hums from the energy of a truly talented ensemble, including a nominee in all four of the Academy's acting categories for Oscar (a feat that Russell pulled off two years in a row, landing nods for a quartet of performers from *Silver Linings Playbook* [2012] the year before). If Russell's character-based crime film falls just short of the masterpieces that it forges, most audiences will not be able to tell the difference.

When one sits back and realizes the distinct lack of actual crime and violence in Eric Singer and David O. Russell's semi-truthful look at the ABSCAM controversy of the 1970s, it is somewhat remarkable that the cinematic con works as well as it does. Whatever one wants to say about mimickry of Scorsese's works, a film like *Casino* (1995) has more narrative energy than this story of sad-sack losers just by virtue of having a more action-packed plot. Russell's film works largely through the sheer charismatic force of his cast. It is not a particularly well-constructed or well-written piece of work but the stellar ensemble, right down the smallest parts, drives the film. It is not a piece with a simple, single protagonist. It is a patchwork of cons, crime, sex, and greed. And as Russell has become one of Hollywood's most coveted filmmakers from the perspective of actors and actresses who see what he has done in winning Oscars for Christian Bale and Melissa Leo (*The Fighter* [2010] and Jennifer Lawrence (*Silver Linings Playbook*). If there is another filmmaker with which actors and actresses would beg to work, one is hard-pressed to think of who that would be. Lately, working with Russell leads to awards.

The main drivers of this charisma vehicle are Bale, Adams, and Cooper; all Oscar-nominated and all allowed major chunks of back story and opportunities to provide narration. Singer's original script was once called *American Bullshit* and it makes sense given how much the film's characters are so completely full of it. Irving is the first allowed to spin his game. Rosenfeld is a con man who started off as a kid breaking windows in his small town to provide business for his glass repairman father. Later in life, he is still managing a series of dry cleaners but the working class is just a front for his real game: The art of the con. He has been running schemes on local businessmen for years, offering them big returns on their initial investments that will never materialize. When he meets the sexy-and-confident Sydney (Adams), Irving worries that she will push away the real Irving when she learns of his true line of work. However, she

embraces the chance to also be something other than an "average girl," adopting a British accent and new identity as she pushes Irving's scams to a new level; one that gets noticed by the FBI.

Irving and Sydney are busted by the borderline psychopathic Richie, a relative schlub who longs to make a name for himself with a headline-grabbing bust. He does not just see Sydney as a sex object; she is the girl who will pull him out of his mom's house, away from his dull fiancee, and help him rise to the top of the force. Richie becomes obsessed with the life of the con, forcing Irving and Sydney to help him bust Atlantic City Mayor Carmine Polito (Jeremy Renner) and other local politicians when they accept bribes to help the new expansion of the gambling empire in their city. Polito is a nice, family man, who just wants to better his community. And yet DiMaso is going to take him down. Which one is the hustler? The politician who accepts the pay-off, the agent who forces it, or the con artists who put it all together?

While *American Hustle* could have hummed along with just those four characters, Russell and Singer beautifully paint the edges with great supporting characters and the production fills them with memorable faces. From Jennifer Lawrence's scene-stealing turn as Irving's wife Rosalyn to Louis C.K.'s beautiful world-weariness as DiMaso's annoyed superior at the FBI to Jack Huston's palpable charisma as a mobster liaison to the criminal empire in Atlantic City to a truly memorable cameo from a living legend, whatever criticisms may be lobbied at this divisive film, no one can deny the overall quality of the ensemble. Even very small parts like those occupied by Michael Pena, Shea Wigham, and Elisabeth Rohm are well-performed.

The leads seem inspired by the depth of ensemble. Bale allows himself to transform yet again, gaining a sizable gut and introducing his character in the attempt to glue on a toupee to assist with an awful comb-over. Bale gets the blend of masquerade and confidence required for this character. He is never truly able to transcend his average-guy looks or background, which makes the betrayal of another "average guy" in Carmine more difficult for him to bear. Adams subtly plays her character's need to be something other than what she is and how a woman like Sydney uses her sexuality to get there. Adams has not exactly made a career of sexually-charged characters in the past but she nails it here. Lawrence almost steals the piece in just a few scenes, taking a part that could have been relatively mundane in the hands of another performer and making it hum. Renner is the underrated MVP of the piece, not getting nearly the attention of his co-stars but grounding every single scene he is in and the film overall in relatable emotion.

American Hustle does have a tendency to lurch narratively, especially in the first act, in which each of the three leads gets to narrate leading to a slight feeling of being talked to instead of organically being drawn into the story. But when the true con gets underway, everyone, including Russell, gets more comfortable and the film clicks to such a degree that many thought it to be the frontrunner for the Oscar for Best Picture. Much like 2013's winner, *Argo*, Russell's film is a work that is narratively lean; streamlined like a finely-tuned machine. It moves like a sports car, weaving in and out with moments of great performance, awesome music choices, and narrative surprises. And, all the while, Scorsese's influence hangs in the background like a work of art, forged or original.

Brian Tallerico

CREDITS

Irving Rosenfeld: Christian Bale
Richie DeMaso: Bradley Cooper
Sydney Prosser: Amy Adams
Rosalyn Rosenfeld: Jennifer Lawrence
Mayor Carmine Polito: Jeremy Renner
Stoddard Thorsen: Louis CK
Pete Musane: Jack Huston
Paco Hernandez/Sheik Abdullah: Michael Pena
Carl Elway: Shea Wigham
Anthony Amado: Alessandro Nivola
Dolly Polito: Elisabeth Rohm
Origin: United States
Language: English
Released: 2013
Production: Megan Ellison, Jonathan Gordon, Charles Roven, Richard Suckle; Annapurna Pictures; released by Columbia Pictures Industries Inc.
Directed by: David O. Russell
Written by: David O. Russell; Eric Singer
Cinematography by: Linus Sandgren
Music by: Danny Elfman
Sound: John Ross
Music Supervisor: Susan Jacobs
Editing: Alan Baumgarten; Jay Cassidy; Crispin Struthers
Art Direction: Jesse Rosenthal
Costumes: Michael Wilkinson
Production Design: Judy Becker
MPAA rating: R
Running time: 138 minutes

REVIEWS

Edelstein, David. *New York Magazine.* December 21, 2013.
LaSalle, Mick. *San Francisco Chronicle.* December 18, 2013.
Lemire, Christy. *RogerEbert.com.* December 13, 2013.
Morgenstern, Joe. *Wall Street Journal.* December 12, 2013.
Neumaier, Joe. *New York Daily News.* December 21, 2013.
O'Hehir, Andrew. *Salon.com.* December 21, 2013.
Persall, Steve. *Tampa Bay Times.* December 18, 2013.
Phillips, Michael. *Chicago Tribune.* December 18, 2013.
Rea, Steven. *Philadelphia Inquirer.* December 20, 2013.
Roeper, Richard. *Chicago Sun-Times.* December 13, 2013.

QUOTES

Sydney Prosser: "You're nothing to me until you're everything."

TRIVIA

According to Christian Bale much of the film was improvised. While shooting, he remarked to David O. Russell, "You realize that this is going to change the plot greatly down track." To which the director replied, "Christian, I hate plots. I am all about characters."

AWARDS

British Acad. 2013: Actress—Supporting (Lawrence), Makeup, Orig. Screenplay
Golden Globes 2014: Actress—Mus./Comedy (Adams), Actress—Supporting (Lawrence), Film—Mus./Comedy
Screen Actors Guild 2013: Cast

Nominations:

Oscars 2013: Actor (Bale), Actor—Supporting (Cooper), Actress (Adams), Actress—Supporting (Lawrence), Costume Des., Director (Russell), Film, Film Editing, Orig. Screenplay, Production Design
British Acad. 2013: Actor (Bale), Actor—Supporting (Cooper), Actress (Adams), Costume Des., Director (Russell), Film, Production Design
Directors Guild 2013: Director (Russell)
Golden Globes 2014: Actor—Mus./Comedy (Bale), Actor—Supporting (Cooper), Director (Russell), Screenplay
Screen Actors Guild 2013: Actress—Supporting (Lawrence)
Writers Guild 2013: Orig. Screenplay

ANCHORMAN 2: THE LEGEND CONTINUES

It's kind of a big deal.
—Movie tagline

Box Office: $125.2 Million

The original *Anchorman: The Legend of Ron Burgundy* (2004) arrived in theaters in the summer of 2004 to a mostly indifferent public and mixed, but mainly positive reviews. It was not until after its DVD release that people started to latch onto it. The film has become

a pop culture favorite and remains one of the most oft-quoted comedies in recent years. It is, in every sense of the word, a true cult film. Part of its appeal is the talented cast of comedic actors getting to improvise with each other using a script that seemed to meander from one non-sequitor to the next. A plot involving a hostage crisis was filmed and never used, but would later be seen in the DVD-exclusive, feature-length film *Wake Up, Ron Burgundy*, which consisted of storylines and alternate takes that were abandoned for the theatrical cut. It is the only time an actual film has been made up of nothing but deleted scenes.

But *Anchorman: The Legend of Ron Burgundy* is a brilliant, free-form comedic outburst that shuns all conventional wisdom of how to make a comedy with big studio backing. While it did satirize the news industry of the 1970s (there were Ron Burgundy types back in those days) and the sexism that ran rampant during that time, it did so with so many left turns toward the bizarre and the absurd. An animated sequence involving rainbows and unicorns to express sexual joy, a musical number involving little more than a jazz flute and a rumble scene amongst local newscasters that did not connect to the story in any way are just a few examples of the kind of reckless spirit that permeated the film, the likes of which probably had not been seen from a major studio since Joe Dante's *Gremlins 2: The New Batch* (1990).

The comparison to that film is notable for a few reasons. Dante's sequel, like the first *Anchorman* film, is one that is not tied down to the limits story and plot. Dante made an unconventional sequel to a somewhat conventional film (relatively speaking). Now, the makers of *Anchorman 2: The Legend Continues* have gone the opposite route, making a conventional sequel to an unconventional film. This is disappointing for those who love the original film for its absurdist approach to comedy, not just in terms of gags, but structure as well. Ron Burgundy and his team, like Austin Powers before him, have become a pop culture icon thanks to home video. Its sequel, much like the Austin Powers sequels, seems to be going out of its way to appeal to a wider audience than the first film ever garnered.

It is nine years since the original film. This story takes place in the early 1980s when CNN and other small cable channels were starting to emerge, back in a time when the idea of a 24-hour news channel was thought to be ridiculous. Ron is married to Veronica Corningstone (Christina Applegate), who has just been tapped to take over a prime time news slot while Ron, who has been co-anchoring with her for years now, has been fired from the same station. They have a son together. But Ron eventually lands on his feet by getting hired by GNN, the Global News Network, run by Linda

Jackson (Meagan Good), an African American woman, the very sight of whom renders Ron a stammering, racist buffoon who can only mutter the word "black" over and over again. He ends up in the overnight shift.

Of course, Ron wants nothing more than to recruit his old buddies from San Diego. He first finds Champ Kind (David Koechner), who runs a chain of chicken restaurants that don't actually sell chicken, but deep-fried bats made to look like pieces of chicken. Next, he finds Brian Fantana (Paul Rudd), who is now a cat photographer for a line of cat calendars. Finally, they all find Brick Tamland (Steve Carell), who is thought to be dead, but in fact, turns up at his own funeral. The four take the Winnebago back to New York where they inadvertently give rise to many of the conventions used in the news today: Breaking news for a car chase on the LA freeway, endless scrolls on the bottom of the screen, random acts of hyper-patriotism and, of course, stupid pet videos.

The idea that Ron and his team of idiots would be responsible the state of news presentation today is, in itself, funny and would certainly be enough to sustain a storyline for this kind of film. But co-creator and director Adam McKay and Will Farrell seem a little too preoccupied with repeating many of the same story beats as the original. Instead of Ron being a sexist, this time he is a racist. Instead of Ron losing his job late in the film and getting insanely drunk, he is blind. The aforementioned rumble scene is repeated here, this time with even more cameos by famous actors, non-actors and comedians. Another sequel convention involves one of the most unlikely of characters having a love interest, in this case Brick Tamlan, who falls for an equally vacant and airheaded office worker, Chani (Kristen Wiig), a role for which Wiig brings nothing new that she has not done before on *Saturday Night Live*.

There are certainly big laughs in *Anchorman 2: The Legend Continues*, particularly scenes involving the Winnebago trip back to the studio, a pet shark who gets his own musical tribute, and the news scrolls at the bottom of the news screen that are funnier than anything anybody is saying on screen. It has other moments as well. But it also has too many lulls and seems a little too reluctant to indulge in the anarchy that made the first one so memorable. It seems to want to be the commercial hit the first one never was. The film had also been heavily promoted in the weeks approaching its release, as Farrell would show up as Ron Burgundy on countless news casts to the point of oversaturation. Paramount Pictures clearly wanted this to be the runaway hit of the Christmas season. Instead, it opened at #2, behind *The Hobbit: The Desolation of Smaug* in its second week. Like a lot of things in *Anchorman 2: The*

Legend Continues, all that promotion amounted to a little too much of a good thing.

Collin Souter

CREDITS

Ron Burgundy: Will Ferrell
Brick Tamland: Steve Carell
Brian Fantana: Paul Rudd
Champ Kind: David Koechner
Veronica Corningstone: Christina Applegate
Linda Jackson: Meagan Good
Origin: United States
Language: English
Released: 2013
Production: Judd Apatow, Adam McKay; Apatow Productions; released by Paramount Pictures Corp.
Directed by: Adam McKay
Written by: Will Ferrell; Adam McKay
Cinematography by: Oliver Wood
Music by: Andrew Feltenstein; John Nau
Sound: George H. Anderson
Music Supervisor: Erica Weis
Editing: Melissa Bretherton; Brent White
Art Direction: Elliott Glick
Costumes: Susan Matheson
Production Design: Clayton Hartley
MPAA rating: PG-13
Running time: 119 minutes

REVIEWS

Burr, Ty. *Boston Globe*. December 18, 2013.
Covert, Colin. *Minneapolis Star Tribune*. December 16, 2013.
Goodykoontz, Bill. *Arizona Republic*. December 18, 2013.
Howell, Peter. *Toronto Star*. December 17, 2013.
Rea, Steven. *Philadelphia Inquirer*. December 18, 2013.
Rodriguez, Rene. *Miami Herald*. December 19, 2013.
Scott, A. O. *New York Times*. December 17, 2013.
Smith, Kyle. *New York Post*. December 17, 2013.
Stevens, Dana. *Slate*. December 20, 2013.
Whitty, Stephen. *Newark Star-Ledger*. December 17, 2013.

QUOTES

Ron Burgundy: "If you've got an ass like the North Star, wise men are gonna want to follow it."

TRIVIA

Actress Meryl Streep was rumored to have a cameo in the film.

ARTHUR NEWMAN

If you don't have a life, get someone else's.
—Movie tagline

Box Office: $207,853

A banal, self-consciously arty dramedy about cracked identity and damaged souls, *Arthur Newman* stars Colin Firth as a sad-sack middle-aged guy who fakes his own death to start life anew as a golf club pro, and during the course of his winding relocation meets a troubled woman (Emily Blunt) also looking to shake free from the shackles of her past. Marked by thinly sketched motivations and a wobbly, variable tone that is more amateurish than evocative of life's complex rhythms, *Arthur Newman* is a boring and essentially phony road movie about shared mid-life crises.

After premiering at the 2012 Toronto Film Festival, the movie was picked up for distribution by Cinedigm Entertainment, which oversaw a very limited theatrical release beginning in late April of 2013. Despite the presence of its two appealing stars, the film failed to catch on with critics or even arthouse audiences and quickly stalled at the box office, grossing far under $500,000 in its brief domestic run.

Firth stars as Wallace Avery, a failed professional golfer and unhappy Florida Fed Ex office manager who sports the sort of glasses that immediately mark him as either a serial killer or a total heel. Wallace has a resentful 13-year-old son, Kevin (Lucas Hedges), the product of a long-dissolved marriage, as well as a girlfriend, Mina (Anne Heche), with whom he seems to share little in common any longer. Feigning his drowning, taking a forged passport and driver's license, and assuming the titular identity of a more successful version of himself, Wallace/Avery strikes out for Indiana, where he fancifully believes a job from a man with whom he crossed paths a year earlier awaits.

Along the way he meets Michaela, or "Mike," (Emily Blunt), a depressed, strung-out kleptomaniac who is certain that the history of schizophrenia in her family will sooner or later visit her. After Arthur saves her from an overdose, the pair develops a bond, and she joins him on his road trip. En route, Mike devises a game whereby they eavesdrop on coupled strangers, break into their homes when they are away, and then dress up in their clothes and make love in character, as it were. For a while this odd recreation serves as an emotional salve of sorts for the two, but the lives they have each left behind prove to have inescapably long shadows.

It is true that Becky Johnston's screenplay—originally penned for Nick Nolte over two decades ago, after she finished work on *The Prince of Tides* (1991)—is marked by fragilities and meanderings that make it feel like the adaptation of a novel (which it is not). The problem is that even if that were true, it would not be a very good adaptation.

On occasion, *Arthur Newman* flirts with something darker, but it makes a habit out of quickly abandoning

those instincts. In short, there is no meaningful lifeline to authentically expressed dislocation and isolation—none of the depth and pathos of something like Pruitt Taylor Vince's anchoring performance in James Mangold's *Heavy* (1996), or the baleful, righteous rage of Sean Penn's disillusioned loner in *The Assassination of Richard Nixon* (2004). Seemingly out of fear of alienating viewers, Wallace/Avery remains an amiable enough cipher, and ergo the movie as a whole achieves no genuine lift.

In a listless stab at air-quote tension, there is a bit of expected nonsense about Mike possibly stealing the duffle bag of money that represents Arthur's life-reboot fund. Otherwise, though, the movie just marks time between the aforementioned playacted avoidance of selves and manufactured breakdowns. Its consistently false pivots are never more roundly on display than when *Arthur Newman* segues from a lie Arthur tells Mike, about not having any kids, immediately into a bouncy scene with them driving through a sunny suburban neighborhood.

Later still, when Arthur tells Mike, "You feel the things most of us run away from, the things most of us are too bottled up to feel," it sounds like the sort of thing a college guy would say in order to bed some emotionally fragile co-ed. In *Arthur Newman*, though, it happens after Arthur and Mike have had intercourse (many times), and it is directly followed by Mike's rejoinder, "Now do I have to have sex with you, because I really don't want to?"

Firth "switches the light off in his eyes," as Stephen Holden aptly notes in his *New York Times* review, but his deadened affect does not a convincing or multifaceted character make. His performance simply does not ring true. Firth is a gifted actor but he comes across here as still too stiff and stately; watching him, one never gets the feeling of a truly broken soul. Blunt makes the most of her role, and has a few nice moments of wounded-dove vulnerability, but is boxed in by the fact that everything about Mike flows from her relationships with her (unseen) mother and sister. Heche, meanwhile, is left to negotiate an enormously stupid detente between Mina and Kevin, as they hang around Wallace's now-empty house and try to reconcile their unhappiness.

In his feature directorial debut, commercial veteran Dante Ariola crafts a movie that makes fairly good use of its limited production budget. Shooting on location in North Carolina, he and cinematographer Eduard Grau succeed in crafting distinct pockets of geographical mood. Unfortunately, the film's metaphorical expressions of fractured identity and unwholesome choices are obvious and wearisome. ("Not all of us want the healthy alternative," sighs Arthur when forced to sample a gas station tofu dog instead of his preferred hot dog.) Ariola never develops a confident, settled tone that believably corrals and encapsulates both the movie's whimsically pitched dress-up fantasies and its more tearful moments of introspection. *Arthur Newman* wants credit as a statement of healed brokenness, but its fault lines are all counterfeit.

Brent Simon

CREDITS

Arthur Newman/Wallace Avery: Colin Firth
Mike/Michaela Fitzgerald: Emily Blunt
Mina Crawley: Anne Heche
Kevin Avery: Lucas Hedges
Origin: United States
Language: English
Released: 2012
Production: Becky Johnston; released by Cinedigm Entertainment Group
Directed by: Dante Ariola
Written by: Becky Johnston
Cinematography by: Eduard Grau
Music by: Nick Urata
Sound: Will Riley
Editing: Olivier Bugge Coutte
Art Direction: Quito Cooksey
Costumes: Nancy Steiner
Production Design: Christopher W. Glass
MPAA rating: R
Running time: 101 minutes

REVIEWS

Chaney, Jen. *Washington Post.* April 26, 2013.
Debruge, Peter. *Variety.* September 11, 2012.
DeFore, John. *Hollywood Reporter.* September 12, 2012.
Grierson, Tim. *Screen International.* September 11, 2012.
Holden, Stephen. *New York Times.* April 25, 2013.
Honeycutt, Kirk. *Honeycutt's Hollywood.* April 24, 2013.
Jenkins, Mark. *NPR.* April 25, 2013.
Phillips, Michael. *Chicago Tribune.* April 25, 2013.
Puig, Claudia. *USA Today.* April 25, 2013.
Sharkey, Betsy. *Los Angeles Times.* April 25, 2013.

AT ANY PRICE

How far would you go to chase a dream?
—Movie tagline

Box Office: $380,594

Dennis Quaid has the face of a man easily duped. The creases of his forced toothy grin are an impermanent

mirage, forever doomed to deteriorate into a pained grimace of embarrassment. He is a terrific actor of considerable range, yet filmmakers seem content in routinely casting him as transparent fools such as pale George W. Bush clones and reverends who believe dancing was spawned by Satan. Most painful of all are miscalculations such as Noam Murro's 2008 dud, *Smart People,* where an all-star ensemble takes turns lecturing Quaid on his multitudinous shortcomings.

For a while, it seems like Ramon Bahrani's *At Any Price* is yet another retread of that formula, casting Quaid as Henry Whipple, a crooked farmer who sells genetically modified seed corn, an illegal act that could render his empire obsolete. Considering the number of enemies he has made on his self-serving quest for monopolization, it is obvious from the get-go that the other shoe is destined to drop right on Whipple's smirking head. He is the sort of smirking, loathsome loser that Greg Kinnear was born to play, and in fact, has played on nearly as many occasions as Quaid. Yet whereas Kinnear has a deft gift for subtlety, Quaid has a tendency to overact.

Watching him schmooze potential clients in the early moments of Bahrani's film is a wince-inducing experience, since Quaid lacks the smooth-talking charisma necessary to believably land any lucrative deals. He is a joke to everyone, especially those closest to him. When he lies to his faithful-yet-despairing wife about his inexplicable infidelity, his words are so worthless that they might as well be a confession. No wonder his sons want to leave the house as soon as possible. While his eldest takes to mountain climbing, Whipple's younger son, Dean, played by Zac Efron, races stock cars with the hope that it will give him a one-way ticket out of town.

This is yet another Efron performance comprised entirely of glassy eyed stares and brooding flatness, jarringly interrupted by the occasional burst of feeling. Perhaps a more nuanced actor could have generated some empathy for the damaged kid, but as played by Efron, he is a cocky bore no less unsavory than his old man. His self-destructive streak leaves his loved ones in the dust, including his adoring girlfriend, Cadence, played by Maika Monroe, the one person in the entire film who earns genuine audience sympathy, though her improvisatory cleverness during a Whipple sales pitch is rather unlikely to say the least. It is one of the film's darkest ironies that father and son are eternally at odds until a lie of Shakespearean proportions forces them to finally bond.

Like David Gordon Green's superior yet equally uneven *Snow Angels* (2007), *At Any Price* is a failed attempt by a gifted filmmaker to enter the mainstream with an unconventional narrative populated by familiar faces. One hopes the film's indifferent reception from viewers will not cause cause Bahrani to descend into sophomoric farce that swallows his artistic potential a la Green's post-*Pineapple Express* (2008) period. That is hardly likely, since Bahrani is, above all, a socially conscious filmmaker determined to use cinema as a delivery system for powerful messages. The director's magnificent films, *Man Push Cart* (2005) and *Chop Shop* (2007) focused on hidden corners of America that resembled third world countries, while his 2009 short, *Plastic Bag,* is the most masterful modern meditation on mankind's wasteful nature.

Yet Bahrani is not immune to cliches as illustrated in his wildly overpraised 2008 effort, *Goodbye Solo,* which treaded dangerously close toward endorsing the "Magical Negro" archetype typified by *Legend of Bagger Vance* (2000). In contrast, the premise of *At Any Price* is pleasingly noncommercial, but Bahrani's direction is disappointingly conventional. There is not a single set-piece that contains the atmospheric power and novelistic detail that distinguishes the director's best work. His presence is most apparent in small touches, such as the erotic charge of a car engine as it runs circles around a smitten woman, or the bone-crunching rumble of a sweat-drenched fistfight unfolding in a murky cornfield.

The strongest section of this picture is, oddly enough, its most problematic, as Bahrani boldly unveils a third act twist so shattering, it runs the risk of losing audiences much like the Christ-like sacrifice that concluded *Pay It Forward* (2000). In this case, Bahrani constructs a chilling metaphor for wrongful deeds that must be stomached in order for economically and spiritually strapped humans to have a prayer for survival. The ending would have packed an enormous wallop if the characters themselves were not so contrived and the performances so underwhelming. That is a real shame, considering the potential of Bahrani's ultimate vision, which frankly deserved a more memorable title, perhaps one that spun a variation on a classic big-screen cautionary tale. *What Price Happiness?* would have been ideal.

Matt Fagerholm

CREDITS

Henry Whipple: Dennis Quaid
Dean Whipple: Zac Efron
Irene Whipple: Kim Dickens
Cadence Farrow: Maika Monroe
Meredith Crown: Heather Graham
Origin: United States
Language: English

Released: 2013

Production: Ramin Bahrani; released by Sony Pictures Classics

Directed by: Ramin Bahrani

Written by: Ramin Bahrani

Cinematography by: Michael Simmonds

Music by: Dickon Hinchliffe

Sound: Tom Efinger

Editing: Alfonso Goncalves

Art Direction: Jonathan Guggenheim

Costumes: Tere Duncan

Production Design: Chad Keith

MPAA rating: R

Running time: 105 minutes

REVIEWS

Bradshaw, Peter. *The Guardian.* March 3, 2013.

Burr, Ty. *Boston Globe.* May 23, 2013.

Churner, Leah. *Austin Chronicle.* May 15, 2013.

Ebert, Roger. *Chicago Sun-Times.* April 24, 2013.

Hornaday, Ann. *Washington Post.* May 2, 2013.

Lacey, Liam. *The Globe and Mail (Toronto).* May 10, 2013.

Lyttelton, Oliver. *The Playlist.* March 3, 2013.

Reed, Rex. *New York Observer.* April 23, 2013.

Taylor, Ella. *NPR.* April 25, 2013.

Travers, Peter. *Rolling Stone.* April 25, 2013.

QUOTES

Henry Whipple: "Am I a happy man? How can I not be?"

TRIVIA

This was the last film that the late Roger Ebert gave a perfect score.

THE ATTACK
(El atentado)

> *Do you ever really know the one you love?*
> —Movie tagline

> *This years most controversial film its most beautiful.*
> —Movie tagline

Box Office: $1.7 Million

There have been hundreds of books written about men and women who discover that they never really knew the person they loved enough to marry although it is a device more often used for dramas about abusive husbands or cheating wives. It is a common (and arguably overdone) theme given new, added weight in Yasmina Khadra's devastating *The Attack* in that the author translates it to a part of the world where secrets and hidden allegiances uproot lives all the time—the land entrenched in the neverending conflict between Israel and Palestine. Adapted to the screen by writer/director Ziad Doueiri, *The Attack* becomes a melancholy, mournful meditation on not just one relationship but a part of the world where it is difficult to trust a neighbor, friend, and even wife.

Amin Jaafari (Ali Suliman) is a successful Palestinian doctor working and living in one of the most important cities in the world, Tel Aviv. Despite tension between his people and the Israelis with whom he works and calls friends and colleagues, Dr. Jaafari has risen to the top of his field, as evidenced by his acceptance of a career achievement award in the opening scene of the film. His wife Siham (Reymond Amsalem) is not at the event that night, having left him a somewhat cryptic voice mail message. Dr. Jaafari thinks his wife to be just off visiting family, as she has done before, and he goes to sleep that night thinking little of it, only to be awoken by the announcement that a bomb has gone off in the city, killing over a dozen people, many of them children. The doctor has to deal with the waking nightmare of shattered limbs and bloodied bodies but it becomes something significantly more horrifying when he learns that not only did his spouse die in the attack but the authorities believe that she was the suicide bomber who initiated the terrorist horror.

Amin refuses to believe the accusations at first, going head-to-head with a tough cop played expertly by the fascinating Uri Javriel, who has popped up in everything from *Byzantium* (2013) to *The Dark Knight Rises* (2012) as of late. Naturally, the officers have reason to believe that Amin even knew about the attack. How could he not know that the woman he slept next to in bed was planning something that would kill children? Even after the investigation clears Amin and seems to prove conclusively that Siham was in fact responsible, questions remain. The doctor heads to Nablus, determined to get to the bottom of how someone he loved became a terrorist and find the truth behind the attack, if there is a truth to be found.

Suliman gives a remarkably subtle and nuanced performance in that he has been handed a role that could have been pure melodrama (as in so many of the aforementioned performances in the "spouse with a secret" subgenre mentioned earlier) but he never falls back on the inherent emotional crutches of the story, going with a complex approach to this role. Amin's problems are so internal: Balancing the love of his life, sometimes seen in flashbacks, with the horror of his present in his own mind. Can he give up loving a woman who he kissed goodbye the very morning before she committed one of the most violent acts in her

country's recent history? How does one even begin to do that? Suliman is always, entirely in the moment, making for a film that feels like a personal journey instead of a melodrama. He is a man forever changed by terrorism and it is the personal impact of that is often lost in the political issues that surround events like suicide bombings. *The Attack* is an excellent commentary on the fact that it is not just the perpetrators of violence or their victims that are impacted by terrorism but the ripple effect felt by so many others.

Doueiri's film suffers a little bit in the final act due to an over-reliance on the mystery of Siham's motivations. There are a few climactic reveals that probably work better on the page, a place where readers often demand answers after hundreds of pages of investment. The film wraps itself up a bit too neatly but is worth remembering for those middle chapters, ones in which melancholy and confusion rule the thematic palette. The fact is that there are no easy answers in the Middle East and, better than any film in a long time, *The Attack* gets to the core of how emotionally and physically turbulent it can be to live in a place where terrorism and the brink of war is always a possibility.

Brian Tallerico

CREDITS

Amin Jaafari: Ali Suliman
Siham Jaafari: Reymond Amsalem
Captain Moshe: Uri Gavriel
Origin: United States
Language: Arabic, Hebrew
Released: 2013
Production: Jean Brehat, Rachid Bouchareb; released by Canal Plus
Directed by: Ziad Doueiri
Written by: Ziad Doueiri; Joelle Touma
Cinematography by: Tommaso Fiorilli
Music by: Eric Neveux
Sound: Philippe Baudhuin; Rami Doueiri; Pierre Gathier; Olivier Walczak
Editing: Dominique Marcombe
Costumes: Hamada Atallah
Production Design: Yoel Herzberg
MPAA rating: R
Running time: 102 minutes

REVIEWS

Dargis, Manohla. *The New York Times.* June 20, 2013.
Ebiri, Bilge. *New York Magazine.* June 24, 2013.
Farber, Stephen. *The Hollywood Reporter.* April 4, 2013.
Jenkins, Mark. *NPR.* June 20, 2013.
Kiang, Jessica. *The Playlist.* April 4, 2013.
Kohn, Eric. *IndieWire.* June 24, 2013.
Morgenstern, Joe. *Wall Street Journal.* June 27, 2013.
Scherstuhl, Alan. *Village Voice.* June 18, 2013.
Stamets, Bill. *Chicago Sun-Times.* July 26, 2013.
Turan, Kenneth. *Los Angeles Times.* June 27, 2013.

TRIVIA

According to the *New York Times*, as of June 2013, the film has been banned or has been refused release in every Arab country for the crime of filming in Israel.

AUGUST: OSAGE COUNTY

Misery loves family.
—Movie tagline

Box Office: $36.7 Million

Adapting a play into a motion picture is a surprisingly tricky art. Granted, turning a play into a movie would seem to be more straightforward than, perhaps, trying to turn a theme-park ride or a Kurt Vonnegut novel onto a movie, but, transforming words that are meant to be performed in front of a live audience into images that are meant to projected onto a fifty-foot screen can be an arduous task. Dramatic devices that work in live theatre can seem false or forced on the big screen. Films based on plays can try too hard to capture the theatrical staging of their source material, losing the verve and vitality that a moving camera can bring to their storytelling. While, on paper, a film script and a play script may look strikingly similar, the way that film directors and play directors convey the words and characters from those scripts to their audiences could not be more different.

Director John Wells—best-known for his TV work and his 2010 film *The Company Men*—confronted this dilemma head-on when he chose to direct the film adaptation of Tracy Letts' Pulitzer Prize-winning drama, *August: Osage County*, which features some of the most dangerous words and characters ever to cross a Broadway stage. This is not *Romeo and Juliet*. *August: Osage County* is difficult source material to adapt, so, while Wells' film version is not entirely successful, it does get extra credit for attempting to capture such flawed and fierce relationships on film.

Set during a particularly stifling August in Pawhuska, Oklahoma, the story opens with Beverly Weston (Sam Shepard), an aged alcoholic and former poet, hiring Johnna (Misty Upham), a young Native American

woman, to care for his aggressive, pill-popping wife Violet (Meryl Streep). Beverly's wife is suffering from oral cancer, i.e. cancer of the mouth, which is a beautifully un-subtle and wildly accurate way to describe Violet's temperament. She spits bile and rage like a cobra spits venom, and Streep clearly relishes every evil syllable that drips off Violet's tongue. Several weeks later, Beverly disappears without a trace and the angry, self-pitying Violet calls home the rest of the Weston family—perhaps for support or perhaps to act as witnesses to her martyrdom. Aside from her sister Mattie Fae (Margo Martindale) and brother-in-law Charles (Chris Cooper), Violet has three daughters—the put-upon, unassuming Ivy (Julianne Nicholson), who still lives nearby; her middle daughter Karen (Juliette Lewis) who lives in Florida with her sketchy fiancé Steve (Dermot Mulroney); and her eldest daughter Barbara (Julia Roberts) who begrudgingly heads home from Colorado with her secretly-estranged husband Bill (Ewan McGregor) and her teenage daughter Jean (Abigail Breslin). All of the Westons are damaged in their own ways, but, being brought together in the old family homestead exacerbates old grudges and simmering insecurities, a state that is only worsened when Beverly is found dead.

Beverly apparently drowned in a local lake—suicide is suspected—and Barbara is forced to plan his funeral. Little Charles (Benedict Cumberbatch), Mattie Fae and Charles' simple son, oversleeps and misses the funeral, attracting sympathy from his father and scorn from his mother. The extended Weston clan then converges on the family house for a post-funeral dinner, perhaps one of the most dysfunctional dinner parties in the history of stage and screen. The sheer level of dysfunction that Tracy Letts heaps onto his characters—Letts adapted his own play for Wells—will either delight or overwhelm audiences. Because one of the prevalent themes in *August: Osage County* is that being with one's own family is like living in an altered state. It is a state of being where a person is unable to hide, where lies can't exist, where anyone can look you the eye and reveal all of your secret hypocrisies. In Osage County, family, for better or worse, are the people who force you to be who you really are, even if you do not want to be that person.

Thus, following Beverly's funeral, a cavalcade of secrets and lies explode forth from the Westons, landing with a thud on the dinner table for the whole family to see. Violet berates Barbara, revealing to everyone that Barbara and Bill are getting separated, inspiring Barbara to go on the offensive and confiscate her mother's beloved pill stash. This leads to a knockdown physical confrontation, which is easily the most captivating moment in the film, largely due to Roberts' angrily engag-

ing performance. The mother and daughter have a brief moment of parlay, where Violet speaks plainly about her own mother, and then Karen's boyfriend Steve attempts to molest Barbara's young daughter Jean. Johnna, Violet's caretaker, goes after Steve with a shovel and the family splinters into factions over the confrontation. Karen refuses to believe Jean and heads back to Florida with Steve. Bill takes Jean back to Colorado, seemingly closing the door on his relationship with Barbara. This leaves Barbara and Ivy with their mother and the focus quickly shifts to Ivy's secret romance with Little Charles—a relationship steeped in a dark, dangerous history of lies, adultery, and old family secrets that Violet carelessly refuses to keep hidden any longer, no matter who gets hurts.

Letts' dialogue is razor-sharp, but there are moments where his stage dialogue does feel stilted and monologue-ish when captured on film. It is hard to fault the playwright for not wanting to drastically change the dialogue that won him a Pulitzer Prize, but some of the theatrically, overwrought rants by the Weston family (delivered by Roberts and Streep, in particular) do tend pull the audience out of the film experience and instead make it feel like video highlights of an acting contest. The best performances in *August: Osage County* are the ones that revel in the good-or-bad humanity of their characters (Margo Martindale is a standout). The worst are the ones that feel like they are auditioning for a Tennessee Williams play (i.e., Juliette Lewis' Blanche DuBois-esque Karen). The script is filled with gorgeously meaty dialogue—lines that must be a dream for an actor to utter—but there are moments throughout where the actors appear to be so wrapped up in the words coming out of their mouths that they are barely noticing the other actors sitting next to them.

These are the moments where director John Wells fails his adaptation. The film version of *August: Osage County* needed to find more quiet moments, more visual moments of connection between the cast, to make it really, really hurt when the verbal daggers started flying. Wells needed to play more with the story's point-of-view rather than just relying on dialogue/reaction shot, dialogue/reaction shot. Wells needed to make the house more of a character in the story, turning the physical environment into a pressure cooker for the Westons' secrets as they boil over the top. Instead, he mounted a very direct, professional, and staged version of a very famous play. It is not a bad staging. There are solid performances and perceptive moments, but it never really becomes a movie. He filmed a play and maybe that is all one can do with a story like this. But, with such potent source material, it would have been exciting to

see what truths would have been revealed by a truly cinematic look into the painful secrets of Osage County.

Tom Burns

CREDITS

Violet Weston: Meryl Streep
Barbara Weston: Julia Roberts
Charlie Aiken: Chris Cooper
Bill Fordham: Ewan McGregor
Mattie Fae Aiken: Margo Martindale
Beverly Weston: Sam Shepard
Ivy Weston: Julianne Nicholson
Karen Weston: Juliette Lewis
Little Charles Aiken: Benedict Cumberbatch
Origin: United States
Language: English
Released: 2013
Production: George Clooney, Jean Doumanian, Grant Heslov, Harvey Weinstein; released by Weinstein Company L.L.C.
Directed by: John Wells
Written by: Tracy Letts
Cinematography by: Adriano Goldman
Music by: Gustavo Santaolalla
Sound: Lon Bender
Music Supervisor: Dana Sano
Editing: Stephen Mirrione
Costumes: Cindy Evans
Production Design: David Gropman
MPAA rating: R
Running time: 121 minutes

REVIEWS

Denby, David. *The New Yorker.* January 6, 2014.
Edelstein, David. *New York Magazine.* December 24, 2013.
Jagernauth, Kevin. *The Playlist.* September 13, 2013.
Legel, Laremy. *Film.com.* September 13, 2013.
Lumenick, Lou. *New York Post.* December 19, 2013.
Morgenstern, Joe. *Wall Street Journal.* December 28, 2013.
Ogle, Connie. *Miami Herald.* January 9, 2014.
Phillips, Michael. *Chicago Tribune.* January 9, 2014.
Roeper, Richard. *Chicago Sun-Times.* January 9, 2014.
Stevens, Dana. *Slate.* December 28, 2013.

QUOTES

Barbara Weston: "Marriage is hard."
Karen Weston: "That's one thing about mom and dad. You gotta tip your hat to anybody who can stay married that long."
Ivy Weston: "Karen, he killed himself."

TRIVIA

Gary Cole was offered the chance to reprise the role of Steve Heidebrecht, which he played on the London stage version, but declined.

AWARDS

Nominations:

Oscars 2013: Actress (Streep), Actress—Supporting (Roberts)
British Acad. 2013: Actress—Supporting (Roberts)
Golden Globes 2014: Actress—Mus./Comedy (Streep), Actress—Supporting (Roberts)
Screen Actors Guild 2013: Actress (Streep), Actress—Supporting (Roberts), Cast
Writers Guild 2013: Adapt. Screenplay

AUSTENLAND

Box Office: $2.2 Million

It would be sloppy to call Jerusha Hess' new film, *Austenland*, unwatchable. It has a winning group of performers backing up its premise and enough occasional flashes of wit and some genuinely entertaining buffoonery shoring it up. But Jane Austen wrote novels that offered compelling visions of people breaking free of societal constraint. Hess has written a movie that is way too timid to do the same. This is as safe as the law will allow; something to be watched out of boredom rather than sought out because it adds anything to the world of rom-coms or Austen-based cinema. The primary problem is one of identity. In short, the Jane Austen aspect of the story here, while servicing as the lynchpin of the plot, is wholly, sadly, negotiable.

The Jane Austen-obsessed, and too-aptly-named, Jane (Keri Russell) is getting long in the tooth (at least by Jane Austen terms) and decides to jet off to merry old England for a vacation at a Jane Austen theme park, Austenland. Anxious to see if she can meet her very own Mr. Darcy, she surrenders to the park's promise of a scripted romance with one of the Austen character actors that populate the resort. Alas, the fops do not interest her: Nobley (JJ Feild) is a bit of a twit; Colonel Andrews (James Callis) is a not very handy dandy; East (Ricky Little) is a beast. Not until she meets the stableboy Martin (Bret McKenzie) does Jane start to think she have met her match. But as if romance were not hard enough there are the rules of the resort which bring down the wrath of owner Mrs. Wattlesbrook (Jane Seymour) on Jane's ambition. Modern plumbing aside, the real question is whether Jane can survive the era she feels soul-bound to. Period clothes and manners might just prove to be her undoing. Acting like a lady may drive her crazy.

Jerusha Hess co-wrote the wildly-popular screenplay for *Napoleon Dynamite* (2004) with her husband Jared, and, since then, the filmmakers have been a remarkable team. *Nacho Libre* (2006) was a laugh-out-loud bit of charm and *Gentleman Broncos* (2009) was a marvelous nod to the fan fiction universe. Jerusha fails to generate that charm here and oddly enough, besides the writing, the main problem may be her cast who, though they clearly have fun in their roles, are all vastly over-qualified for this thin brand of comedy. A distinct lack of freshness pervades as if the sort of spontaneity that brought those other films to life would have been better achieved by surrounding Russell with unknowns, or, even better, casting an unknown in the lead and letting the veterans loose. As it is, the film is like a too-tight corset. Shannon Hale, who wrote the novel the film is based on co-writes here and perhaps it is her lack of experience writing for the screen that adds to the problem.

Russell is, of course, perfect in her role. There always seems to be a glint in her eye and mischief mounting suspense behind her back. Surprisingly less effective is Jane Seymour, who has to contend with the irrational way her character is written. Mrs. Wattlesworth is simply too snooty to feel part of even the make-believe world of the film. A better comedian might have injected some Basil Fawlty-type energy into her constant negativity. But Seymoir is also called on to play the character straight, leaving out the possibility of broad satire.

Another problem is the general lack of experience shown behind the camera. Hess tends to advance style over almost everything in her films, achieving a convincing sense of world built on the cheap in which her characters can inhabit the whimsical-if-simplistic stories she has chosen to tell with Jared. Here however, Jerusha Hess tries to break out on her own, and fails. As it stands, *Austenland* is a disjointed film in need of a re-edit and also a need to have its director work on her technique a little more if she expects to broaden audiences ideas regarding what to expect of her or her style of filmmaking. Distracting montage meets a graceless narrative and creates anything but a meet-cute.

Dave Canfield

CREDITS

Jane Hayes: Keri Russell

Miss Elizabeth Charming: Jennifer Coolidge
Martin: Bret McKenzie
Henry Nobley: J.J. Feild
Colonel Andrews: James Callis
Lady Amelia Heartwright: Georgia King
Capt. George East: Ricky Whittle
Mrs. Wattlesbrook: Jane Seymour
Mr. Wattlesbrook: Rupert Vansittart
Origin: United States, United Kingdom
Language: English
Released: 2013
Production: Stephenie Meyer; released by Sony Pictures Classics
Directed by: Jerusha Hess
Written by: Jerusha Hess; Shannon Hale
Cinematography by: Larry Smith
Music by: Ilan Eshkeri
Sound: Tim Barker
Music Supervisor: Ian Neil
Editing: Nick Fenton
Art Direction: Patrick Rolfe
Costumes: Annie Hardinge
Production Design: James Merifield
MPAA rating: PG-13
Running time: 97 minutes

REVIEWS

Catsoulis, Jeanette. *New York Times*. August 15, 2013.
DeFore, John. *Hollywood Reporter*. August 12, 2013.
Harvey, Dennis. *Variety*. August 12, 2013.
MacDonald, Moira. *Seattle Times*. August 29, 2013.
Merry, Stephanie. *Washington Post*. August 22, 2013.
Meyncke, Amanda Mae. *Film.com*. January 20, 2013.
Scherstuhl, Alan. *Village Voice*. August 13, 2013.
Stewart, Sara. *New York Post*. August 16, 2013.
Taylor, Ella. *NPR*. August 15, 2013.
Williams, Mary Elizabeth. *Salon.com*. August 16, 2013.

TRIVIA

During the scene at the airport, Mr. Henry Nobley insults Martin by saying that Martin couldn't get an acting part in *The Lord of the Rings* films. In fact, Bret McKenzie, who plays Martin, had a role in those films as an elf.

B

BAGGAGE CLAIM

She's done flying solo.
—Movie tagline

Box Office: $21.6 Million

When it comes to sitting through a bad movie, there is only one thing worse than a bad comedy: A bad, lazy comedy made up of the usual cliches that make up other bad, lazy movies before it. The Romantic Comedy is the type of genre that breeds such a film on a regular basis. It is not hard to see why. They cost little to make and a studio can usually get its money back after the first few weekends of built-in "date night" audiences. They are probably also fun to make even if nobody is going out of their way to make a quality product. But the end result often becomes a completely disposable diversion often thought of as a "chick flick," an insulting term that implies that all women are dumb enough to fall for any lame-brained farce that either ends with a wedding or a marriage proposal at an airport. Sure, they could be interpreted as female fantasies (just as men have their fantasy movies about unattractive male introverts who get drawn out by bubbly, vivacious dreamgirls), but the women depicted in these films give audiences little reason to care about them one way or another.

The female protagonist in *Baggage Claim* is no exception. As if stapled together from a dozen other Romantic Comedy screenplays written over the last 20 years (and probably a few that were rejected), *Baggage Claim* goes through every single boring motion of being a Romantic Comedy, beginning with the opening narration from Montana Moore (Paula Patton), a flight at-tendant who says she always wanted the perfect guy and that she has always been a bridesmaid for her mother's (Jenifer Lewis) half-dozen weddings. At the start of the film, she is already in a seemingly perfect relationship, but history of this genre dictates that she will catch him cheating on her within the first 20 minutes of the film. *Baggage Claim* does a slight twist on that convention in that the man (Boris Kodhoe) is actually cheating on his pregnant wife with her.

Luckily, Montana lives next door to her longtime, good-looking, male friend from high school, William (Derek Luke). He, of course, is in a relationship, but with a complete ditz who burns everything she cooks. Montana also has two best friends/co-workers with whom she can also confide. Gail is sassy, plump and fearless and Sam (Adam Brody) is an effeminate gay man who wears bow ties. These traits pretty much define these characters who exist solely to comment on Montana's life without having much of a life of their own. They also give her the idea that is the movie's hook: Because she works in the travel industry, through circuitous means, Montana can find out when one of her exes that she longs to reconnect with will be travel-ing out of state. With this information, she can schedule herself a shift on that flight and have an "accidental" run-in with him. Naturally, there is a time limit imposed on this dopey endeavor, the customary 30 days.

Not surprisingly, she meets several of them in her quest to find "the one" (a universally used term in Romantic Comedies meaning "the perfect guy"). First up is Damon Diesel (Trey Songz), who is now a hip-hop artist, but whose main drawback is his psychotic ex-girlfriend who owns the home where he currently resides.

This results in a typical farce involving Montana ending up on a fire escape. Next is Langston Jefferson Battle III (Taye Diggs), a career politician currently running for Senate on a Libertarian platform who loves his little dog because of how obedient she is. He expects his women to be the same way. During one of their dates as Langston tries to win a donation from a rich person (Ned Beatty), Montana makes a slightly racist joke about Tiger Woods to lighten the mood. In a scene much later in the film, she tells Langston that she does not trust black republicans, which is the closest the movie comes to fully defining this character.

Third time might be a charm for Montana as she meets up with a wealthy, adventurous hotel owner, Quinton (Djimon Hounsou), who has no desires for marriage, but is more than happy to take Montana away for a year-long adventure travelling around the world and showering her with riches. He is a nice enough guy and seems to have everything going for him, but they do not share the same values. Luckily, Montana lives next door to her longtime, good-looking male friend from high school, William, whom she spends a lot more time with because they know each other so well and can practically read each other's minds. It is a wonder that he has not thought of proposing to her in an airport in all the years they have known each other.

Baggage Claim is as lazy as it gets, right down to the stock helicopter shots of the cities where the movie supposedly takes place. Even the person on the set whose job it was to make a sign that implied Montana was walking though a conspicuously empty O'Hare International Airport could not be bother to spell "O'Hare" with an apostrophe. It is said that a movie is really made three times: Once in the writing, another in the directing, and a third time in the editing room. Writer-Director David E. Talbert based this movie on his novel of the same name, which means he has made this story at least four times, somehow without knowing that the film has already been made at least 20 times already.

Collin Souter

CREDITS

Montana Moore: Paula Patton
William Wright: Derek Luke
Langston: Taye Diggs
Graham: Boris Kodjoe
Gail: Jill Scott
Origin: United States
Language: English
Released: 2013
Production: Steven J. Wolfe, David E. Talbert; Sneak Preview Entertainment; released by Fox Searchlight

Directed by: David E. Talbert
Written by: David E. Talbert
Cinematography by: Anastas Michos
Music by: Aaron Zigman
Sound: Derek Vanderhorst
Music Supervisor: Julia Michels
Editing: Troy Takaki
Costumes: Maya Lieberman
Production Design: Dina Lipton
MPAA rating: PG-13
Running time: 96 minutes

REVIEWS

Covert, Colin. *Minneapolis Star Tribune.* September 26, 2013.
Gleiberman, Owen. *Entertainment Weekly.* September 25, 2013.
Goodykoontz, Bill. *Arizona Republic.* September 26, 2013.
Hardy, Earnest. *Village Voice.* September 24, 2013.
Howell, Peter. *Toronto Star.* September 26, 2013.
Hornaday, Ann. *Washington Post.* September 26, 2013.
Keough, Peter. *Boston Globe.* September 26, 2013.
Long, Tom. *Detroit News.* September 27, 2013.
Stewart, Sara. *New York Post.* September 27, 2013.
Whitty, Stephen. *Newark Star-Ledger.* September 27, 2013.

A BAND CALLED DEATH

Box Office: $127,257

A Band Called Death is a very engaging documentary that takes some surprising twists and turns but the most surprising of all is how powerfully it showcases just how compelling an average person's life can be if examined in the context of their hopes and dreams and their simple faith in same. Three black guys, brothers in 1950s Detroit, raised by their Baptist preacher father and mother, form a band in the hopes of making it big. While struggling to define their sound they emerge as, arguably the first identifiable punk rock band in the 1970s, years before The Ramones had even struck their first chord. Death's music is amazing; high-energy, hard rock-based with a touch of funk, it clangs out of the speakers full-force, backed-up by vocals that alternately scream, sputter, almost rap, and, finally, get sung but never without a ferociously sincere intent. The lyrics range from the metaphysical to the socio-political in content and never seem thrown into the mix for mere effect. This is a band that had something important they wanted to share and they had the chops to make it happen.

Part of the reason the documentary works so well is the way that directors Jeff Howlett and Mark Convino

use the wonderfully engaging personalities of the Hackney brothers, Bobby and Dannis. The two freely and with real joy share about their brotherly bond with David, the mastermind behind the band's name and lyrics, who is seen mainly in archival photographs. What emerges is a portrait of an immensely gifted person who simply fell through the cracks of life trying to make his dreams come true. But along the way he had a lot of fun and saw to it that his legacy rested in safe hands. Bobby and Dannis recall the time that David peed into his squirt gun during a water fight. Another time David rewired the telephone to make it echo every time someone spoke into it. An audio tape of the prank call to some poor identified soul has David proclaiming that he is from Mars in a loud booming voice as the prankee dissolves into an angry fit. Cue giggles. This is boyhood at its finest: Pure childhood, family bonds, the stuff of life. For a documentary about a band called Death, it sure is smile-inducing. This is just the first ten minutes in.

Of course, that setup allows for an awful lot of empathizing early on. By the time the boys arrived at their signature sound it became clear nobody else around them understood what they were trying to do. Their generally supportive parents, loved ones, and neighbors simply begged them to turn the white boys' music down. The recording studio and record company execs that met with them gave them every excuse in the book, telling them the band was too black, too white, or had to change its name to get signed.

The film does a great job of tracing the origin and history of the band taking viewers on a guided tour of rehearsal spaces, the family home, recording studios and getting a hold of virtually everybody still alive who was connected to Death or its history. Almost everyone backtracks, telling stories of their own as they attempt to rationalize the marginalization of the trio. Bobby and Dannis too talk about David's unwillingness to compromise his overall vision of the band by changing anything about it at all even to the point of telling legendary producer and record executive Clive Davis to go to hell.

This taps into a small flaw in the film. Bobby and Dannis talk about their brother's slow descent into alcoholism and the escalation of tension in the family and the group but the material is handled a little too quickly. In short, the film captures the history of Death as the history of Bobby and Dannis rather than as that of a trio. Surely there was some material to dig up on David that would have explored his complicatedand troubled history in a deeper way.

But it seems like a quibble. Shortly before his death David met Dannis and Bobby and handed over the Death masters making them promise to hang on to them. As the tapes languished up in an attic space, forgotten about by the surviving members of the band, a scant few singles they had released independently suddenly started being played at DJ parties and small events building a strong collectors market. It was all unbeknownst to the pair until a child in the family heard the music at a small party and realized who it was that was singing. Looking online the Hackney brothers saw copies of their old albums going for upwards of $800 a piece.

Since the rediscovery of the band, Death is back together, on tour and a tribute band, Rough Francis, formed by Bobbie's son Bobby Jr. has toured with them. The message seems to be that love and art both come full circle if one waits long enough. The Hackneys are clearly still processing what it means to play to packed houses all over the country some thirty-five years after they first started. A little self-importance is on display but the film makes a good case such feelings are earned by parading a who's who of influential black rockers and music critics to unpack the influence Death had on the-mand the scene in general. Beyond it all is the Hackney family. Dannis and Bobby played for years together in a band called Lamb's Bread, the film conveys. They even occasionally helped David make demos for his own projects. In one touching segment, Dannis talks about how his job as a night janitor at a local school has given him and his family so many choices in their lives. Viewers may well sense that the truly important thing here goes way beyond the truly rocking music Death left behind and might make in the future.

Dave Canfield

CREDITS

Origin: United States

Language: English

Released: 2013

Production: Mark Christopher Covino, Jeff Howlett; released by Drafthouse Films

Directed by: Mark Christopher Covino; Jeff Howlett

Cinematography by: Mark Christopher Covino

Music by: Tim Boland; Sam Retzer

Sound: Zach Martin

Editing: Richard Fox

MPAA rating: Unrated

Running time: 96 minutes

REVIEWS

Abele, Robert. *Los Angeles Times*. June 27, 2013.

Erbland, Kate. *MSN Movies*. June 28, 2013.

Goss, William. *Film.com*. June 19, 2013.

Mancini, Vincent. *FilmDrunk*. March 21, 2013.

McManus, Brian. *Village Voice*. June 27, 2013.

McWeeny, Drew. *HitFix*. July 1, 2013.

O'Hehir, Andrew. *Salon.com*. June 27, 2013.

Orndorf, Brian. *Blu-ray.com*. July 25, 2013.

Serba, John. *MLive.com*. August 2, 2013.

Shannon, Jeff. *Seattle Times*. June 27, 2013.

BATTLE OF THE YEAR

Box Office: $8.9 Million

Breakdance movies enjoyed a nice bit of popularity in the mid-1980s, but then suddenly, along with the craze itself, they disappeared completely. Decades later, though, a series of films which kicked off with *Step Up* (2006), which was followed by four sequels. These films basically cashed in on such Disney Channel concoctions such as *High School Musical*, which consisted of pretty young people going through the motions of hackneyed plots centered around big dance numbers. The *Step Up* series has a certain naive charm. In spite of their ridiculous storylines, their non-actors hopelessly trying to convey real emotions and their third-act defiance of authority through dance, there is an energy to these films that remains undeniable. The dance scenes truly are exciting to watch and it seems to be the filmmakers' intention to put the emphasis on the eye candy rather than on the script. Besides, who goes to see dance movies? People who love dance.

But then there are movies like *Battle of the Year*, which might have the same approach, but not nearly the same infectious spirit. The film bombards the viewer with a loud spectacle made up of random shots of breakdancers showing their moves, but with no apparent logic or attention span. The title blazes on the screen almost immediately, followed by the cast list, which consists of names like Flipz, Richie "Abstrak" Soto, and Terrence J. The film then cuts to a board meeting where Dante Graham (Laz Alonso) informs his confused looking employees that the United States has not won a Battle of The Year (the international breakdancing tournament) in too many years and that he has an inside scoop from America's teenagers that B-Boy'ing (the alternative term for breakdancing) is no longer cool. In France, the government subsidizes Battle of The Year. He says this as though America needs to seriously rethink its priorities.

So, Dante's first plan of attack is to travel with his bodyguards (since there are so many attempts to assassinate the lives of fledgling hip-hop CEOs) to the house of Blake (Josh Halloway), an alcoholic ex-basketball coach who is still mourning the death of his wife and kid. Why hire a basketball coach to work with a group of breakdancers? Because "a coach is a coach" and Blake supposedly has the ability to help groups of touch kids to work together in peace and harmony. After a night of thinking about it with bourbon in hand, Blake decides to visit Dante's headquarters to view several hours worth of breakdance videos, including director Benson Lee's own documentary *Planet B-Boy* (2007). There he meets Franklyn (Josh Peck), a Jewish employee enamored with B-Boy and who blames his circumcision on his inability to carry a dance move. He also gives *Planet B-Boy* a series of accolades, declaring it "a dope documentary... our Bible..." and that it has a million hits on NetFlix.

Blake agrees to the job on the condition "if I do this, I do it on my own terms." This is followed by the obligatory audition process in which Blake tries to put together a B-Boy dream team involving a nationwide search for the best dancers who would only have a few months to practice, a plan so crazy, it just might work. Of the several dancers picked from the audition, only thirteen will make the cut. Blake takes them to an abandoned prison with a working cafeteria to train them 24/7. "We start at 6am every day. Arrive at 6:01 and you will be gone!" Of course, there being a mixed bag of races and ethnicities, conflicts ensue and those who cause the most problems are given a bus pass to go back to wherever they came from.

Many of the dancers are eliminated because of being over-confident and not becoming part of a team. Blake insists that the word "I" should never be mentioned. If anyone says the word "I," they will all have to do 50 push-ups. What follows is a series of multiple-screen montage sequences of dancers doing military-like training. Eventually, Blake is joined by an actual choreographer, a female dancer named Stacey (Caity Lotz), whose presence is greeted with the usual ogling from the overly hormonal male dancers. Interspersed throughout the training sequences are the moments of conflicts involving the gay character, the two guys fighting over an ex-girlfriend as well as a tearful farewell from Rooster (Chris Brown), who injures himself during training. There is also a sub-plot involving one of the dancers who sneaks off every night to be with his daughter and comes back every morning before everyone wakes up.

The main thing a good (or even a bad) dance movie has to get right is the choreography and the editing of the dance sequences in order to convey the excitement of the routine and the emotions of the dancers themselves. *Battle of the Year* gets none of that right. There is no big dance number or complex routine that the team must pull off in the third act. Every dance scene looks identical to the last, with no build up or context as to what makes a greater routine. John Tra-

volta once took over the editing of his dance scenes in *Saturday Night Fever* (1977). His idea was simple: Stick with the master shot. Only go in for a close-up when absolutely necessary. The aesthetic here seems to be to cut every two seconds for maximum headache-inducing affect. The fact that *Battle of the Year* is loaded with story cliches is almost beside the point. The fact that it runs almost two whole hours and does not have a single dance sequence worth remembering is the result of bad teamwork between Lee, his editors and his choreographers.

Collin Souter

CREDITS

Jason Blake: Josh Holloway
Dante Graham: Laz Alonso
Franklyn: Josh Peck
Stacy: Caity Lotz
Rooster: Chris Brown
Origin: United States
Language: English
Released: 2013
Production: Screen Gems; released by Sony Pictures Entertainment Inc.
Directed by: Benson Lee
Written by: Brin Hill; Chris Parker
Cinematography by: Michael Barrett
Music by: Christopher Lennertz
Sound: Douglas Axtell
Music Supervisor: Pilar McCurry
Editing: Peter S. Elliot
Costumes: Soyon An
Production Design: Chris Cornwell
MPAA rating: PG-13
Running time: 110 minutes

REVIEWS

Bale, Miriam. *New York Times*. September 19, 2013.
Barnard, Linda. *Toronto Star*. September 19, 2013.
Goodykoontz, Bill. *Arizona Republic*. September 20, 2013.
Goss, William. *Film.com*. September 20, 2013.
Guzman, Rafer. *Newsday*. September 19, 2013.
Lacey, Liam. *Globe and Mail*. September 20, 2013.
Nicholson, Amy. *L.A. Weekly*. September 18, 2013.
Rabin, Nathan. *The Dissolve*. September 19, 2013.
Staskiewicz, Keith. *Entertainment Weekly*. September 20, 2013.
Stewart, Sara. *New York Post*. September 19, 2013.

AWARDS

Nominations:
Golden Raspberries 2013: Worst Support. Actor (Brown)

BEAUTIFUL CREATURES

Dark secrets will come to light.
—Movie tagline

Box Office: $19.5 Million

The *Twilight* series, both in book and movie form, has left an unfortunately significant mark on the cultural landscape. For anyone not female between the ages of twelve and thirty, the *Twilight* universe is something of a bad joke dragged out to unfathomable proportions. The tale of forbidden love between a sullen vampire and a blank slate of a teenage girl became a runaway success and seems to have become the template for many films and books that want to take the fantasy-of-forbidden-teenage-love thing to the next level (in other words, ride the coattails and cash in). Among the first to try and lure "Twi-hards" into the multiplexes in droves is *Beautiful Creatures*, based, of course, on a bestselling young adult novel, but with a surprising pedigree. While the trailer elicited a bit of unintentional laughter for what appears to be over-the-top melodrama within supernatural settings, the film itself, with everything in proper context, is something else entirely.

The set-up is typical. A teenage boy, Ethan White (Alden Ehrenreich), lives in a nowhere town called Gatlin in South Carolina and who has dreams about a girl he has never met. In a very funny opening narration, he talks about how out of touch this town has been for the past few decades. He loves reading banned books like Kurt Vonnegut's *Slaughterhouse Five* and William Burroughs's *Naked Lunch*. He has caught the eye of Emily (Zoey Deutch), a girl who has all the conviction of all the other puritans in the town and who advises him to stop reading those kinds of books. Of course, a new girl named Lena Duchannes (Alice Englert) moves into town and elicits many questions among the suspicious town folk. She has moved into the "Ravenwood" house, which has not had any inhabitants in decades.

Ethan and Lena have a run-in one rainy day after her car breaks down and he gives her a ride home to the Ravenwood manor. He charms her, but does not win her over right away. She has the entire town looking at her and spreading fear about the Ravenwoods and their supposedly satanic ways. Ethan is not convinced, but an incident in a classroom where the windows suddenly shatter leaves him ever more curious. He goes to her house and finds an elegant interior completely at odds with the house's dilapidated exterior. Their connection deepens and they become friends. He also meets Lena's uncle Macon Ravenwood (Jeremy Irons), a gaunt eccentric who seems to be stuck in the mid-1800s.

He claims to have read all the books that Ethan's deceased mother wrote about southern plantations, but then conducts some kind of trick of possession on Ethan

by making him say things he would never actually say. Ethan learns later on that Lena's birthday falls on a significant date in the town's history. The mystery thickens when he inherits a locket with the date on it and gets strict orders from his housekeeper (Viola Davis) to bury it. When he does, he becomes the victim of a strange spell. Lena explains that she is a "caster," a more polite term for a witch.

They get into a discussion about good witches and bad witches and he learns that on her sixteenth birthday, her eternal destiny will change either for the better or for the worse, depending on her true nature. Secrets regarding both of their families come to light with other supporting characters, including Sarafine (Emma Thompson), Lena's mother and a dark caster, and Ridley (Emma Rossum), Lena's cousin who has something at stake in Lena's birthday situation and who started out innocent but became a dark caster on her sixteenth birthday.

Naturally, everything boils down to Ethan and Lena being forbidden to fall in love if Lena's eternal soul is to be saved. All of this would be presented in an all-too-deadly-serious manner as if the weight of the world rested on the shoulders of the two leads were it not for the witty and nuanced screenplay by writer-director Richard LaGravenese. *Beautiful Creatures* soars above other young adult teenage lit adaptations thanks to LaGravenese's uncanny ability to veer seamlessly from humanist comedy to unabashed romance to almost campy melodrama. Miraculously, everything holds together. Humor comes just in the nick of time whenever the plot gets too complex, arbitrary or contrived. Even as things get more doomed in the second half, LaGravenese never forgets that this is the story of two incredibly charming people who are worth knowing and worth investing in.

This, of course, also has a large part to do with the cast that has been assembled here. As Ethan, Ehrenreich is an atypical choice simply because he is not impossibly good looking as one would normally expect in a film of this type. He is the kind of down to earth person who can inspire goodwill in others, a strong trait for a character such as this. As Lena, Englert never comes off as being too much of a tormented victim, but as a scared individual who feels entitled to the love she wants even though she does not know herself fully just yet. Irons and Thompson look as though they have been given gifts with these roles and inhabit them with great zeal. They are a pleasure to watch.

LaGravenese has always had a talent for addressing gender politics in his work and he remains one of the best male screenwriters to write fully rounded and complex roles for women. *Beautiful Creatures* recalls La-

Gravenese' rich and equally romantic screenplay for *The Fisher King* (1991) when it takes the time to address the roles of men and women in matrimony within the grand scheme of things on both a spiritual and human planes. It is a shame a movie as fun, sharp, and sophisticated as this will be dismissed entirely by those who choose not to view it simply because it looks like yet another *Twilight* wannabe. The film possesses a great romantic spirit that does not sacrifice brains for hamfisted emotion. *Beautiful Creatures* earns its perfect ending as well as the audience's hope that these two characters will wind up together.

Collin Souter

CREDITS

Ethan Wate: Alden Ehrenreich
Lena Duchannes: Alice Englert
Macon Ravenwood: Jeremy Irons
Mrs. Lincoln/Sarafine: Emma Thompson
Ridley Duchannes: Emmy Rossum
Amma: Viola Davis
Link: Thomas Mann
Larkin Ravenwood: Kyle Gallner
Gramma: Eileen Atkins
Aunt Del: Margo Martindale
Mr. Lee: Pruitt Taylor Vince
Origin: United States
Language: English
Released: 2013
Production: Erwin Stoff, Broderick Johnson, Andrew A. Kosove; Alcon Entertainment; released by Warner Brothers
Directed by: Richard LaGravenese
Written by: Richard LaGravenese
Cinematography by: Philippe Rousselot
Music by: Mary Ramos
Sound: John Marquis
Editing: David Moritz
Costumes: Jeffrey Kurland
Production Design: Richard Sherman
MPAA rating: PG-13
Running time: 124 minutes

REVIEWS

Burr, Ty. *Boston Globe*. February 13, 2013.
Covert, Colin. *Minneapolis Star Tribune*. February 13, 2013.
Howell, Peter. *Toronto Star*. February 14, 2013.
Jones, J. R. *Chicago Reader*. February 14, 2013.
Kenney, Glenn. *MSN Movies*. February 14, 2013.
LaSalle, Mick. *San Francisco Chronicle*. February 14, 2013.
Legel, Laremy. *Film.com*. February 14, 2013.

Morgenstern, Joe. *Wall Street Journal.* February 14, 2013.
Smith, Kyle. *New York Post.* February 14, 2013.
Whittey, Stephen. *Newark Star Ledger.* February 14, 2013.

QUOTES

Ethan Wate: "Memories are erased. One look back at the sign, I remembered. I remembered you. Every moment we spent together. The secrets we kept. Everything came flooding back into my heart."

TRIVIA

The poetry on the walls and ceiling of Lena's room are borrowed from four poets: William Blake, Alfred Lord Tennyson, Edna St. Vincent Millay, and Rumi.

BEFORE MIDNIGHT

Box Office: $8.1 Million

The note-perfect ending to Richard Linklater's beautiful *Before Sunset* (2004) became an iconic closing beat to an entire generation. Ask filmgoers of a certain age about the love between Jesse (Ethan Hawke) and Celine (Julie Delpy), and be greeted with a smile and a romantic sigh. Linklater's film purported that the lost romances of days gone by could someday be found again. And yet the ending of that film, like so many romantic movies, sent viewers out on an emotional cloud without really addressing the factual circumstance of what was happening in that gloriously perfect ending: Jesse was leaving his wife and son for Celine. He missed his flight and stayed with the girl he fell in love with nine years earlier in *Before Sunrise* (1995). It created a collective "awwww" but the real world has repercussions rarely even hinted at by the end of cinematic romantic dramas.

And so *Before Midnight* opens nine years later with a bittersweet reminder of that fact as Jesse bids farewell to his son Hank at a Greek airport after a Summer vacation. Hank has been there for a few months with Jesse and Celine and his dad wishes he could stay longer. It is quickly revealed that the pair is married with twin girls. As the children sleep, the pair drives back into town from the airport and the brilliant interplay of dialogue that has defined these three films begins. They are clearly on the cusp of change. Celine may have a new job but Jesse, who it is implied quickly has been impulsive more than just at the end of the last film, wants a way to get Hank back into his life and may be willing to uproot his new family to make that happen.

Like the previous two films, this *Before* takes place over night, largely through a few extended scenes of dialogue. This one is basically four—the car ride back, a brief separation as Jesse speaks to some of his friends in Greece while Celine helps make dinner, the actual dinner with their Greek friends, and a walk to a hotel that Jesse and Celine plan to use for one last glorious night on their vacation. That final conversation is roughly half the film and heads to some unexpected places, bringing past resentments to the surface. Jesse has been emotionally rattled by Hank's departure and Celine seems to have legitimate concerns that it could lead to another rash decision. And viewers know that Jesse is capable of such impetuous behavior. The shared history with this character makes his wife's current concerns more palpable. The crossroads leads to the emergence of some skeletons from Jesse and Celine's closet as the two verbally spin through years of love, regret, and the major and minor decisions that make up a marriage.

Absolute love can exist in the same space as definable resentment. Married people know this to be true. The person who changes their life, as Jesse and Celine have for each other, will always question what might have happened if they had not made that decision. It does not lesson their love and yet these questions often rise to the surface in moments of anger. People who have been together a decade know what to say to each other to lift them up but also know what buttons to push when they feel up against the wall. It is arguable that there has *never* been a screenplay that more accurately and deftly represents the way that people fight (it is the main reason it was nominated for Best Adapted Screenplay at the Oscars and that many critics' groups thought it should win). Every major decision like the one that Jesse made at the end of the last film comes with a ripple effect and comes with questions. What if Jesse had handled the end of his first marriage better instead of just missing his flight? What if Jesse had not used his relationship with Celine for two hit books? What if Celine puts her foot down and stands up for herself now as Delpy, in a truly fantastic and underrated performance, hints that she may not have in the past? It is not only a film about those moments in which decisions are made but in which people consider the past and future in how they make them.

The word that keeps coming to mind in an assessment of *Before Midnight* is honesty. There is not a false beat, not a line that feels anything less than true, not even a character motion that does not seem completely of a whole with what is happening to these people onscreen and the historical baggage they (and the viewer from the previous two films) brings to the moment. The characters are completely three-dimensional, as if they have existed in the nine years since the last movie and will go on after these credits roll (and hopefully be revisited in another nine years in "Before Twilight"?).

There are many films in which a couple's chemistry makes their on-screen relationship easy to believe in the moment but few where the characters have felt this completely real in each and every character beat. When they love, when they fight, when they agree, when they argue: It all has the ring of truth; every single beat. The realism of their dialogue combined with the fact that the structure of these films makes the time away from them easier to believe (only getting one day every nine years makes the time that passes in between feel more organic) to make a film that feels as true as any relationship drama ever made.

While Linklater's film is such a verbal one that most credit went deservedly to its splendid screenplay, the actors were underappreciated, especially Delpy, who never takes the easy route with Celine. Jesse has used Celine as a character in his books (much like Linklater has to bolster his filmmaking career) and she has sacrificed quite a bit, including privacy, over the years, but Delpy never overplays the potential victim of the role. There is an understanding of both the "price of fame" and being the partner of a creative artist that Delpy conveys brilliantly. And yet one of the many master strokes of the film is that it does not take sides in the epic fight. Like so many marital disagreements, there is right and wrong on both sides of the debate.

With the *Before* trilogy (which now deserves to be in the conversation regarding the best cinematic three-parters in film history), Linklater, Hawke, and Delpy have found a way to capture the wide-eyed romance of love in our 20s, the renewed optimism of lost passion in our 30s, and, now, the complex truth of married love in our 40s. In doing so, they have made a series of films that makes each one in the trilogy better by their accompaniment. Watching *Before Sunrise* now has the feeling of looking through old photo albums, knowing where these young people would go on their journey through life. Jesse and Celine have transcended mere film characters. They have become friends. And those friends have delivered a true cinematic gift; a masterful examination of life, love, regret, secrecy, passion, and the need for two people to retain personal identities along with their identification as a couple. This is the best film of 2013.

Brian Tallerico

CREDITS

Celine: Julie Delpy
Jesse: Ethan Hawke
Origin: United States
Language: English
Released: 2013

Production: Christos V. Konstatakopoulos, Richard Linklater; Detour Filmproduction; released by Sony Pictures Classics
Directed by: Richard Linklater
Written by: Julie Delpy; Ethan Hawke; Richard Linklater
Cinematography by: Christos Voudouris
Music by: Graham Reynolds
Sound: Tom Hammond
Editing: Sandra Adair
Costumes: Vasileia Rozana
MPAA rating: R
Running time: 108 minutes

REVIEWS

Baumgarten, Marjorie. *Austin Chronicle.* May 23, 2013.
Bradshaw, Peter. *The Guardian.* June 21, 2013.
Burr, Ty. *Boston Globe.* June 6, 2013.
Denby, David. *The New Yorker.* June 3, 2013.
Goodykoontz, Bill. *Arizona Republic.* May 30, 2013.
Nehme, Farran Smith. *New York Post.* May 23, 2013.
Neumaier, Joe. *New York Daily News.* May 23, 2013.
Rainer, Peter. *Christian Science Monitor.* May 24, 2013.
Rea, Steven. *Philadelphia Inquirer.* June 7, 2013.
Villaca, Pablo. *RogerEbert.com.* June 6, 2013.

QUOTES

Natalia: "Like sunlight, sunset, we appear, we disappear. We are so important to some, but we are just passing through."

TRIVIA

Although the movie features naturalistic dialogue, every scene was rehearsed and rigidly followed the script and involved no improvisation.

AWARDS

Nominations:

Oscars 2013: Adapt. Screenplay
Golden Globes 2014: Actress—Mus./Comedy (Delpy)
Ind. Spirit 2014: Actress (Delpy), Screenplay
Writers Guild 2013: Adapt. Screenplay

BERBERIAN SOUND STUDIO

Box Office: $38,493

Thanks to a slew of unnecessary remakes, slapdash ripoffs and the seemingly never-ending and never-frightening *Paranormal Activity* saga, the horror genre has been on the ropes, at least from an artistic standpoint, for the last few years. Although it contained more

than its fair share of utterly forgettable clinkers and repugnant gross-outs, 2013 proved to be a bit of improvement thanks to a handful of undeniably effective efforts such as the smash hit spook story *The Conjuring* (2013), the twisty and twisted remake of the Spanish hit *We Are What We Are* (2010), and the *Ten Little Indians*-style home invasion thriller *You're Next* (2013). One of the most surprising of the bunch was perhaps the least-heralded of them all, the British mind-bender *Berberian Sound Studio*, a film that may have failed to find much support among its target audience due to a paucity of gore but what it may have lacked in bloodshed, it more than made up for in its ability to freak out even the hardiest of audiences.

Set in the 1970s, the film opens as British sound engineer Gilderoy (Toby Jones) arrives in Italy to work his magic on a film bearing the seemingly innocuous title *The Equestrian Variations* and is quickly surprised to discover that what sounds like the kind of kid-oriented project that he is used to working on is actually a super-violent Italian Giallo, the kind of stylishly gruesome horror film of the sort made famous at the time by the likes of Dario Argento and Lucio Fulci. Already alienated by being a stranger in a strange land and surrounded by people who seem to be going out of their way to make things awkward from him (from constantly speaking in Italian, which he does not understand, to screwing around with him when he tries to get reimbursed for his travel expenses), Gilderoy tries to dig in and do his job. After a while, chopping and squishing vegetables in order to aurally recreate the grisly horrors he is forced to bear witness to begins to play with his mind and plunges him deeper and deeper into paranoia. Is it merely his distaste for the material he is working on that is threatening to drive him around the bend or is there the possibility that he has been lured into the project by his largely unknown employers for a more diabolical reason?

Written and directed by Peter Strickland, *Berberian Sound Studio* is an ingenious little thriller that also serves as a twisted love letter to Giallo filmmaking that is filled with an amusing array of in-jokes and nods to fans of the sub-genre ranging from the title of the film-within-a-film (many Giallos had titles that invoked animals or birds for some reason) to the numerous close-ups of black-gloved hands hitting the various switches in the studio. In a really brilliant move, viewers hear descriptions of the atrocities contained within *The Equestrian Variations* (conveyed in a hilariously deadpan manner) as well as the grisly sounds being created to better sell them to audiences but never actually see the gruesome material for themselves, a move that forces audience members to imagine the atrocities for themselves and therefore put themselves further into Gilderoy's increas-

ingly fragile state of mind. Beyond the homages, Strickland also creates a legitimately tension-filled atmosphere throughout and gets a strong performance from Jones that perfectly conveys his character's growing sense of paranoia as he becomes increasingly alienated from the film, his co-workers and his own sense of stability.

Moviegoers who have grown used to horror films being little more than a series of rote shocks designed to jolt audiences awake whenever their attention seems to be waning (which is often) may grow a little restless with *Berberian Sound Studio* and its lack of overt gore or "BOO!" moments while others may grow a bit frustrated with the deliberately oblique conclusion that is closer in tone to the warped weirdness of the finales of *The Shining* (1980) and *Mullholland Drive* (2001) than the usual genre fare. That said, this is an uncommonly fascinating take on the horror film that is well worth seeking out, especially for those who already have a working knowledge of Euro-horror. If nothing else, if you have been long seeking out the perfect film to serve as the second half of a potential double-feature with Brian De Palma's masterpiece *Blow Out* (1981)—another drama about a movie sound man on the edge—that search is now officially over.

Peter Sobczynski

CREDITS

Gilderoy: Toby Jones
Elena: Tonia Sotiropoulou
Veronica: Susanna Cappellaro
Francesco: Cosimo Fusco
Origin: United Kingdom
Language: English, Italian
Released: 2012
Production: Mary Burke, Keith Griffiths; released by IFC Midnight
Directed by: Peter Strickland
Written by: Peter Strickland
Cinematography by: Nicholas D. Knowland
Sound: Joakim Sundstrom
Editing: Chris Dickens
Art Direction: Sarah Finlay
Costumes: Julian Day
Production Design: Jennifer Kernke
MPAA rating: Unrated
Running time: 92 minutes

REVIEWS

Bowen, Chuck. *Slant Magazine.* June 9, 2013.
Bradshaw, Peter. *Guardian (UK).* August 30, 2012.

Ebiri, Bilge. *Vulture.* June 17, 2013.

French, Philip. *Observer (U.K.).* September 3, 2012.

Goss, William. *MSN Movies.* March 21, 2013.

Linden, Sheri. *Los Angeles Times.* June 13, 2013.

Lodge, Guy. *Variety.* July 4, 2012.

McDonagh, Maitland. *Film Journal International.* June 17, 2013.

Murray, Noel. *The Dissolve.* July 11, 2013.

Rapold, Nicolas. *New York Times.* June 13, 2013.

THE BEST MAN HOLIDAY

Times change. Friendship doesn't.
—Movie tagline

Box Office: $70.5 Million

Malcolm D. Lee introduced new old friends to audiences with *The Best Man*, an ensemble comedy filled with fresh talent, and produced by Lee's director cousin Spike. Released October 22, 1999, the film was #1 at the box office on opening weekend, despite playing on only 1,346 screens (compare that to #4 opener *Bringing Out the Dead*, which only took in $6.1 million on a higher number of 1,936 screens). Though the film had a very fruitful box office run, and put attractive young men and women within a story that transcended genre or specific demographics, the group would not reunite until 2013's *The Best Man Holiday*, a delightful sequel that constructively expands upon the lives of its characters, while providing a fulfilling experience for fans and non-fans alike.

Taking place fourteen years after the first film's events, *The Best Man Holiday* finds fallen author Harper (Taye Diggs) in need of a good book idea, with a baby from his wife Robyn (Sanaa Lathan) due in the next month. When he visits his agent (John Michael Higgins), he is encouraged to write the biography about his football star friend Lance (Morris Chestnut), despite the distance the two college pals have had from each other since it was revealed on Lance's wedding day that Harper once secretly slept with Lance's now-wife Mia (Monica Calhoun).

Meanwhile, their friend Julian (Harold Perrineau) is working on gaining investors to open a private school for at-risk kids with his wife Candace (Nia Long), whom he met in the previous film when she performed at Lance's bachelor party as a stripper. Julian becomes disturbed when a would-be investor shows him a YouTube video of Candace participating in sexual acts; a part of her life Julian was not aware of despite how they met. And, in their own world, float the film's bachelor

and bachelorette, Quentin (Terrence Howard) and Shelby (Melissa de Sousa). Quentin has become a celebrity-schmoozing socialite while Shelby has made her own celebrity out of her superficiality, taking on the prestige of a reality TV star.

With the encouragement of Mia, Lance invites all of his friends to their mansion for Christmas, which is intended to be an overdue reunion, along with a celebration of his final football game before heading into professional retirement. As the nostalgic vacation progresses, with the gathering causing chaos of both comedic and dramatic variety, it offers an encompassing lesson, pointed in the direction of accepting the past to better value the present.

With this warming sequel, Lee shows that he understands American audiences in a way more directly comparable to Bollywood films than most other homegrown multiplex products. First, he certainly recognizes that it all begins with beautiful leads, of optimal charisma, in both genders; actors that can carry characters beyond general archetype with their undoubtedly movie-star good looks, and transport audiences to an extravagant location (most of the film takes place within Lance's swanky mansion). Lead Diggs, for example, is a great alpha male who has the daffiness usually saved for a side character; he is complemented well by his friend Lance, played by Chestnut to be the film's perfect specimen—the richest, and the most shirtless.

These men are joined by goofier male friends (including Perrineau and the scene-stealing Howard), and by women who are not always given the most from Lee's male-centric script, but have the skill from previous films to make their small moments work. Hall has a striking confrontation when confronting Perrineau's shallowness, exposing a subplot for its truer darkness that originally languished as a joke within the film for an hour. *The Best Man Holiday*'s presents its strongest performance with its most risky character, in which Calhoun's Mia slowly and gracefully takes audiences lower and lower into the film's tragedy.

With these players in place, Lee also recognizes that when making something that is silly, familiar, and broad, it might as well become an event that has everything, striving for full entertainment experience. Lee packs his Christmastime reunion sequel to the 1999 film with everything but an actual wedding—song, dance, football, new life, tragedy, female fights, male fights, friendly bonding amongst both genders, and more. With all of these together, the familiar elements certainly do not make for a familiar experience, or even a breezy one, as each sequence of definitive emotions plays out in full, like musical numbers. Character arcs are elaborated on

very slowly, with drama balanced with calculated, obvious, if not self-aware, comic relief. Even the dialogue of the film hints bluntly like that from Bollywood films, in which characters make their points to the most simplified level.

In the process of such assembly, parts of his film are cheapened, or oversimplified. As a director shooting a large group of people, his cohesion in placing them in the same room with matching eye-lines (where one character's point of view matches with the person he is looking at) can be a bit turbulent. Some dramatic situations are ridiculous in the plainest of definitions, in which human logic is violated so that a second more important thing can happen. Thankfully, Lee handles his biggest dramatic weight without the same type of cheapness than can come in his lover's scuffles. Moments of relationship drama can be comically abrupt, with characters undergoing an apparently serious separation in one scene, only to be reunited in the next.

Most notably, the movie does have a striking sense of shallowness to it as well, its idea of success caught up with the necessity to be a part of the celebrity sphere. Within this movie's fantasy is every character's having an importance because they know someone famous, either by their own success, or simply because they are staying at Lance's house. The montage in the beginning often introduces the viewer to the success of these characters by showing news clips, or even more frustratingly, their presence with celebrities. Even Howard's stoner bachelor earns the association of success when he is shown with musician Quincy Jones, etc.

But in primary means of worthwhile escapism, *The Best Man Holiday* is classic mass-audience moviemaking, as manufactured with a striking amount of tact from Lee. His film is a promising sign for roller-coaster blockbusters that value characters over archetype, without being lost in their own self-importance. Even more rarely and perhaps most significantly, it is a movie with a batch of fictional characters whose life arcs warrant the attention of another sequel.

Nick Allen

CREDITS

Lance: Morris Chestnut
Harper: Taye Diggs
Candace: Regina Hall
Quentin: Terrence Howard
Robyn: Sanaa Lathan
Jordan: Nia Long
Julian: Harold Perrineau, Jr.
Mia: Monica Calhoun

Shelby: Melissa De Sousa
Brian: Eddie Cibrian
Origin: United States
Language: English
Released: 2013
Production: Sean Daniel, Malcolm Lee; released by Universal Pictures Inc.
Directed by: Malcolm Lee
Written by: Malcolm Lee
Cinematography by: Greg Gardiner
Music by: Stanley Clarke
Sound: Greg Hedgepath
Editing: Paul Millspaugh
Art Direction: Aleksandra Marinkovich
Costumes: Danielle Hollowell
Production Design: Keith Brian Burns
MPAA rating: R
Running time: 123 minutes

REVIEWS

Adams, Sam. *Time Out New York*. November 12, 2013.
Anderson, Soren. *Seattle Times*. November 14, 2013.
Barker, Andrew. *Variety*. November 13, 2013.
Barnard, Linda. *Toronto Star*. November 14, 2013.
Berardinelli, James. *ReelViews*. November 14, 2013.
Hornaday, Ann. *Washington Post*. November 14, 2013.
Noveck, Jocelyn. *Associated Press*. November 13, 2013.
Phillips, Michael. *Chicago Tribune*. November 18, 2013.
Smith, Kyle. *New York Post*. November 14, 2013.
Weitzman, Elizabeth. *New York Daily News*. November 14, 2013.

QUOTES

Harper: "Brian McDaniels, I like to ski in Vermont. I like to date chocolate girls."
Jordan: "Shut up, Harper."

TRIVIA

The film was shipped to theaters using the code name "Roasting Chestnuts."

BEYOND THE HILLS

Box Office: $124,919

The idea of people living together in a religious community, especially independent of denominational oversight, is still a disturbing one for many who are quick to conjure images of Jim Jones' Peoples Temple or David Koresh's Branch Davidians. But the high profile and very tragic stories of these groups overshadow the

reality that there are many such communities worldwide; most come and go, waxing and waning for all sorts of reasons that have nothing to do with poisoned punch or fire. The genius of *Beyond The Hills* is the manner in which it embraces the nuance of its tragic situation without demonizing any of the participants. Some have faulted it for being overlong but director Cristian Mungiu adapts Tatiana Niculescu non-fiction novel to purposes that go beyond simple dramaturgy into in-depth character study. The film may be Romanian, and the backdrop one of ancient beliefs in conflict with the modern world, but its observations are fresh and universal. What could have been a broad and oversimplified rejection of religion, is instead a very disturbing look at the collision between ways of looking at the world that levies its most cutting criticism not at belief but the absence of humanity.

Lifelong friends Alina (Cristina Flutur) and Voichita (Cosmina Stratan) have bonds that run soul-deep; raised together in an orphanage and lovers since their teens. When Alina flees Romania for Germany to escape poverty, Voichita joins a remote convent, developing strong emotional and spiritual ties to the community. When Alina returns, expecting Voichita to come back with her as planned, Voichita finds herself unable to leave her new life behind. The community is strict, guided by a paternal priest (Valieru Andriuta) with whom Alina quickly finds herself at odds. When the priest reluctantly agrees to let Alina stay a few days (in the hopes that she too may join the group) the conflict escalates. Immovable force meets unstoppable object, culminating in a tragic and ill-advised exorcism.

Cristian Mungiu's previous film, the brilliant *4 Months 3 Weeks and 2 Days* (2007) offered near unbearable suspense at times as it told the story of two girls seeking an illegal abortion in 1980s Romania but was equally nuanced in dealing with its explosive subject matter. *Beyond the Hills* is short on such suspense which may make its 150 minute run time a chore for some. But what the film lacks in event it more than makes up for in the way it examines its context. The day-to-day mundanity of life in the community, the awkwardness of its relations with outsiders, and the genuine concern for others' spiritual well-being never seem less than simple and real here. Yet, out of that simplicity, arises pride, rigidity, and the seeming inevitability of what happens next. Whether such rigid beliefs can find a place in the outside world and whether or not they truly reflect religious belief at its core (or something akin to human frailty or outright wickedness) is at stake and Mungiu knows that the answer is for each to decide.

Voichita, as played by Cosmina Stratan, is a masterpiece of indecision. Staying in the community with its strict guidelines means a sort of security akin to her orphanage roots. Yet beyond any psychological weakness she is a person of true faith, concerned to do what is right as she seeks to understand God's opinion on the matter. Her relationship with Alina, viewed as sinful by her community, is something defined for her by more than the views of others. Stratan's performance allows that it may just be a relationship that has run its course; a possibility a less-smart approach or screenplay might not allow for. Equally sincere is Alina, who has little interest in religious matters but a complete devotion to her friend. Alina does not come away unexamined. Headstrong, unwilling to examine her own conclusions she is in many ways her own worst enemy. Certainly unfit to be part of the community she is also at war with herself. Cristina Flutur nails it, showcasing the behavior and attitude of someone who wants what she wants and is simple not mature enough to know what her situation requires.

Valeriu Andriuta plays the Priest with a reserved sense of control and, increasingly, fear. The nature and practice of his authority within the group is obviously problematic at best from the very beginning, and yet, rather than paint him as a simple bad guy, he is presented interacting with the Mother Superior (Dana Tapalaga) and others, and even acquiescing. He is the ultimate relic of his order in some sense; a man who has forgotten that he is, after all, just a man. The pressure he feels to have all the answers emanates from himself as much as from the group.

Beyond The Hills is an especially timely film that also feels timeless in its themes. The struggle it depicts reflects dynamics that are as much a part of politics or other social systems as they are part of the religious institutions to which people look to for justice, safety or guidance. The observation that those who abuse their power in those situations are often absolutely befuddled at how they arrived at their tragic ends is positively haunting, precisely because it hints that people need faith in one another more than they need faith in those institutions. Mungiu nails an incredibly difficult subject in a manner that over the course of a career may well come to define Romanian cinema at its best.

Dave Canfield

CREDITS

Voichita: Cosmina Straton
Alina: Cristina Flutur
Origin: Romania
Language: Romanian
Released: 2013
Production: Cristian Mungiu; Mobra Films; released by Sundance Selects

Directed by: Cristian Mungiu
Written by: Cristian Mungiu
Cinematography by: Oleg Mutu
Sound: Andi Arsenie, Cristian Tarnovetchi
Editing: Mircea Olteanu
Costumes: Dana Paparuz
Production Design: Calin Papura
MPAA rating: Unrated
Running time: 150 minutes

REVIEWS

Anderson, John. *Newsday.* March 14, 2013.

Brussat, Frederic and Brussat, Mary Ann. *Spirituality and Practice.* October 1, 2012.

DeKinder, Mathew. *St. Louis Post-Dispatch.* April 5, 2013.

Hornaday, Ann. *Washington Post.* March 15, 2013.

Linden, Sheri. *Los Angeles Times.* March 7, 2013.

McWeeney, Drew. *HitFixH.* May 22, 2013.

Nehme, Farran Smith. *New York Post.* March 8, 2013.

Scott, A. O. *New York Times.* March 7, 2013.

Snider, Eric D. *Film.com.* May 22, 2012.

Stevens, Dana. *Slate.* March 10, 2013.

QUOTES

Priest: "The man who leaves and the man who comes back are not the same."

TRIVIA

The film was shot and edited simultaneously in chronological order.

THE BIG WEDDING

It's never too late to start acting like a family.
—Movie tagline

Box Office: $21.8 Million

After returning his career to respectability with an Oscar nomination for David O. Russell's fine romantic comedy *Silver Linings Playbook* (2012), Robert De Niro follows that with *The Big Wedding*, an abysmal comedy that only inspires sadness. It is far more reflective of what the screen legend has done with his shameful last decade on-screen, unless fans of *Taxi Driver* (1976) and *Goodfellas* (1990) were just waiting until the actor got to say both "boinked" and "porked" in the same scene.

Written and directed by *The Bucket List* (2007) scribe Justin Zackham, *The Big Wedding* feels less like a movie aiming for laughs and romance than an endurance test for viewers. How much unpleasant behavior from obnoxious people can anyone stand? The answer

for most would be, "Not much, when it involves De Niro, Diane Keaton, Robin Williams, and Katherine Heigl all at once." This is unofficially known as a Hollywood Perfect Storm.

Anyway, it pretty much goes without saying that *The Big Wedding* is about a big wedding, other than the fact that the wedding and the extensive planning required for nuptials of even moderate size completely take a backseat to shenanigans of exclusively moronic proportions. Not long after Ellie (Keaton) walks in on her ex-husband Don (De Niro) discussing and preparing to perform cunnilingus with his girlfriend and Ellie's best friend Bebe (Susan Sarandon), the divorced couple must pretend to be married again. The remarkably contrived reason is that their adopted Colombian son Alejandro (Ben Barnes, who is British) is getting married to Missy (a painfully underused Amanda Seyfried), and Alejandro's conservative biological mother Madonna (Patricia Rae) will be in attendance. Because all of these people act like spoiled, immature 11-year-olds regarding sex and conflict, it is determined that Madonna will not be able to handle her son's adopted parents' split, hence the short-notice deception.

The strained farce does not end there. There is also Don and Ellie's 29-year-old son Jared (Topher Grace), who thinks he has finally found a woman worthy of taking his virginity when he meets Alejandro's sister Nuria (Ana Ayora). She is 20 years old and very quickly goes skinny-dipping in the lake, asking Jared if he will have sex with her. While she later revokes the offer, the character is nothing but a fantasy, about which all that matters is if she will or will not give it up. Jared's sister Lyla (Heigl), after fainting at the sight of babies, discovers that she is pregnant, a major bummer since she just dumped her boyfriend (Kyle Bornheimer) before he could dump her. Besides for causing Lyla to vomit on her dad's shoulder (which is a fitting image for the film, Heigl throwing up on De Niro), this provides the actress numerous scenes in which she attempts and fails to believably convey stress that should have been familiar and easy after her feelings in *Knocked Up* (2007).

She also tries to participate in the comedy, which practically hurts to watch. Though, to be fair, these characters are so dreadful that no one could make them work. Lyla makes a comment to Missy's parents that is meant to acknowledge their racism, but soon after Lyla says, "Who do you have to lynch for a Cosmo around here" without any indication that she is still being ironic. Here Zackham, whose desired pacing can only be described as rushed, is absolutely not trying to reflect that Lyla is as bigoted as her brother's future in-laws. Instead, the filmmaker cheaply and offensively tries to get a laugh from a line containing racial implications he seems to not understand.

That prejudice carries through *The Big Wedding* as Don's efforts to communicate with Alejandro's Spanish-speaking mother go no farther than, "Mi casa es whatever." Early on, as Alejandro and Missy meet with Father Moinighan (Williams, essentially reprising his awful character from 2007's similarly lousy *License to Wed*), who will officiate their wedding, the priest responds to hearing that Alejandro graduated from Harvard by saying, "Him and half of China." Get it? Because it is a stereotype that Chinese people are smart and go to Ivy League schools, and Zackham thinks racial stereotypes are funny.

He also believes that all of the guests at a wedding could enter without anyone in the wedding party knowing it, and that beginning a big, outdoor dinner right before it rains is the peak of comedic situations. (Please just ignore the similarity of Don cheating on his girlfriend with his ex to 2009's *It's Complicated*.) Shockingly, *The Big Wedding*, just like Adam Sandler's horrendous *Just Go With It* (2011), is adapted from a French film. Hey, speaking of stereotypes: If there is any truth to the notion that the French do not like Americans, these embarrassing remakes are really not going to help.

Matt Pais

CREDITS

Don Griffin: Robert De Niro
Ellie Griffin: Diane Keaton
Alejandro Griffin: Ben Barnes
Missy O'Connor: Amanda Seyfried
Bebe Mcbride: Susan Sarandon
Father Monaghan: Robin Williams
Lyla Griffin: Katherine Heigl
Jared Griffin: Topher Grace
Andrew: Marc Blucas
Muffin O'Connor: Christine Ebersole
Origin: United States
Language: English
Released: 2013
Production: Anthony G. Katagas, Clay Pecorin, Richard Salvatore, Harry J. Ufland, Justin Zackham; Millenium Films, Two Ton Films; released by Lionsgate
Directed by: Justin Zackham
Written by: Justin Zackham
Cinematography by: Jonathan Brown
Music by: Nathan Barr
Sound: Thomas O'Neil Younkman
Editing: Jon Corn
Art Direction: Toni Barton
Costumes: Aude Bronson-Howard
Production Design: Andrew Jackness

MPAA rating: R
Running time: 89 minutes

REVIEWS

Debruge, Peter. *Variety*. April 25, 2013.
Holden, Stephen. *The New York Times*. April 25, 2013.
Hynes, Eric. *Time Out New York*. April 30, 2013.
Marsh, Calum. *Village Voice*. April 26, 2013.
Phillips, Michael. *Chicago Tribune*. April 25, 2013.
Phipps, Keith. *NPR*. April 25, 2013.
Puig, Claudia. *USA Today*. April 28, 2013.
Rabin, Nathan. *The A.V. Club*. April 25, 2013.
Rea, Stephen. *Philadelphia Inquirer*. April 25, 2013.
Russo, Tom. *Boston Globe*. April 25, 2013.

QUOTES

Alejandro: "My mom is Jbuddist, which is Jewish slash Buddhist, and my father thinks that organized religion is for?."

TRIVIA

This is the first film to feature Lionsgate's redesigned opening logo.

AWARDS

Nominations:

Golden Raspberries 2013: Worst Support. Actress (Heigl)

BLACK NATIVITY

The musical event of the holiday season.
—Movie tagline

Box Office: $7 Million

Expecting a film with the name *Black Nativity* to present an African American perspective on the Christian representation of the birth of Jesus is a reasonable assumption. The extent of that expectation to cover it in a modern day setting rather than giving it a *Wiz*-like historical spin should not deter the message or the feelings stirred by the visuals. Kasi Lemmons' film does qualify as a musical, expanding its reach from the gospel music and Christmas carols sung in the original Langston Hughes play that it is based on. The poet may be appropriately flattered that his work would make an attempt at relevancy five decades after its inception, but may be mortified at the narrative surrounding it.

Teenager Langston (Jacob Latimore) is named after the poet and he knows it. (That play on words is also featured in the film.) After awkwardly lip-syncing an

opening hip-hop mash-up about what to "Be Grateful" for, he finds that his single mother (Jennifer Hudson) is holding an eviction notice. Before feeling sorry for them living in the nicest apartment in Baltimore, complete with hanging glassware and the Christmas tree the Cratchits could never afford, Langston is sent by mom to live with his grandparents in Harlem. When the young man arrives and cannot get a cell phone signal in the middle of Times Square he is unable to call Reverend Cornell (Forest Whitaker) and Grandma Aretha (Angela Bassett) and winds up in a *Trading Places* (1983)-esque mix-up that puts him in jail.

It is there where the arriving Reverend gives him a hard time about his actions, but not before he meets a temporary inmate (Tyrese Gibson) who tests Langston's faux tough guy routine. The boy is none too impressed with his grandfather's stern talk and excessive prayer. He does like his prized watch, however, inscribed with the initials MLK. While his petty attempts towards harder crime keep the kid occupied, each unlikable step brings him closer to knowing the mystery of what happened to his father. The Reverend knows more than he is letting on as he prepares for his big Black Nativity show at his church. Mom, while miles away, is pretty tight-lipped except when she is trying to sing loud enough so Harlem can hear her. Can Langston learn anything from the near-homeless pregnant couple or the guardian angel, Platinum Fro (Mary J. Blige, who was last seen in *Rock of Ages* (2012) trying to encourage down-on-their-luck girls to become strippers) before losing his ultra-advantaged soul for good?

Redemption is a powerful dramatic crutch that can be kicked out from under the arm of a character headed towards rock bottom. The problem with Langston is he is far from earning our sympathy. Moved from one nice apartment to an even greater one, proving that God pays well for the Reverend, Langston's lashing out does not come from a place of desperation but one of just being a punk. Singing about being a "Motherless Child," when it's really the father figure missing, thus gives weight that a single mom needs a man in her life to keep the crime rate down. Latimore's singular portrayal of a scowling brat does little to sell Langston as anything more than a spoiled kid painfully growing into a stereotype.

Twelve songs may populate the film's soundtrack, but it feels as though only half of them are even presented in the context of a traditional musical. Only Jennifer Hudson's numbers come off in the true spirit of ballads that leap off the screen. Others by Latimore, Gibson and particularly Whitaker feel either lip-synced, wedged in or gracelessly translated into slow spoken word melodies. Angela Bassett put more energy and believability into passionately mouthing the vocals of

Tina Turner than she is allowed here being just part of the chorus and an interrupted solo at a piano. It is as if Kasi Lemmons had no faith in her cast which reeks of immense irony given the leaps she expects viewers to make with each passing coincidence that moves the story towards its next clumsy revelation.

Had Langston Hughes been alive to see this adaptation he may have been less mortified how the Nativity itself had been pushed behind this filler of a narrative than with how is name was so often invoked as part of it. Someone who did not know any better might think that the writer was so enamored with his own greatness that he would write his own poetry into his play and then invoke his name for extra credit. On the other hand, if the modern narrative is meant to be held up as a mirror to the Nativity story—when in essence it bares more resemblance to Spike Lee's go-live-with-your-preacher-grandfather-with-a-secret *Red Hook Summer* (2012)—does that make Gibson's absentee father Joseph the carpenter or the Lord, our God and Savior? Though if such an interpretation does hold up to scrutiny and young Langston is the confused teenager without proper guidance for his life's destiny, it now makes sense why the Bible skipped over Jesus' teenage years.

Erik Childress

CREDITS

Reverend Cornell Cobbs: Forest Whitaker
Aretha Cobbs: Angela Bassett
Naima: Jennifer Hudson
Tyson: Tyrese Gibson
Langston: Jacob Latimore
Angel: Mary J. Blige
Isaiah: Nasir Jones
Pawnbroker: Vondie Curtis-Hall
Origin: United States
Language: English
Released: 2013
Production: William Horberg, T.D. Jakes, Galt Niederhoffer, Celine Rattray, Trudie Styler; released by Fox Searchlight
Directed by: Kasi Lemmons
Written by: Kasi Lemmons
Cinematography by: Anastas Michos
Music by: Laura Karpman
Sound: Lewis Goldstein
Music Supervisor: Stephen J. Baker
Editing: Terilyn Shropshire
Art Direction: Douglas Huszti
Costumes: Gersha Phillips
Production Design: Kristi Zea
MPAA rating: PG
Running time: 93 minutes

REVIEWS

Berkshire, Geoff. *Paste Magazine.* November 26, 2013.

Clifford, Laura. *Reeling Reviews.* November 26, 2013.

Dargis, Manohla. *New York Times.* November 26, 2013.

Dudek, Duane. *Milwaukee Sentinel Journal.* November 26, 2013.

Gibron, Bill. *Film Journal International.* November 26, 2013.

Hewitt, Chris. *St. Paul Pioneer Press.* November 26, 2013.

Judy, Jim. *Screen It!.* November 26, 2013.

LaSalle, Mick. *San Francisco Chronicle.* November 26, 2013.

Minow, Nell. *Beliefnet.* November 26, 2013.

Sragow, Michael. *Orange County Register.* November 26, 2013.

BLACKFISH

Never capture what you can't control.
—Movie tagline

Box Office: $2.1 Million

This is a documentary that should not need to exist. That is the singular tragedy. Director and co-writer Gabriela Cowperthwaite shines undeniable light on the mismanagement, incompetence and greed of an institution that directly contributed to the deaths of no fewer than two people and the death of a third that can be tied to the morally flawed business model that governs an entire industry.

On February 24, 2010, a 22.5-foot killer whale named Tilikum drowned and partially ate Dawn Brancheau during a Sea World show in Orlando, Florida. At first, authorities were flummoxed at why. Brancheau, aged forty, was one of Sea World's most experienced animal trainers. Theories ranged from scenarios involving rough play to trainer error but as more and more information became available about Tilikum's troubled history SeaWorld found itself in court with the United States Department of Occupational Safety and Health Administration. The charges alleged an unsafe work environment and a lack of proper documentation warning trainers of possible dangers from the Orca's kept at the facility. At stake was whether or not trainers would continue to be allowed in the water with the animals—especially for the all-important shows that drew huge crowds to the parks every year. Sea World not only denied the charges but went to great lengths to show themselves off in court and in the press as a model zoological institute.

Cowperthwaite became interested in the subject after taking her own kids to Sea World and becoming curious about how the shows were put together. Her research uncovered a disturbing history in which money, always money, dictated the response of the park to the needs of both animals and trainers. As Sea World fought the allegations the director interviewed former trainers, fishermen who participated in capturing Orcas, and compiled data.

One fisherman describes the capture of Tilikum from the coast of Iceland in 1983 in chilling terms, hanging his head shamefacedly, almost to the point of tears as he talks of the wanton slaughter of unwanted Orcas and the haunting screams of their relatives who would not be driven away as their young were drugged and taken away. This is a hardened sailor who quietly calls his actions that day "the worst thing I've ever done." Add in the details about the three people who have died in Tilikum's proximity and it becomes clear he should have been handled differently.

Besides the trauma Orca's like Tilikum undergo when they are captured and taken away from their families there is also the sad future that awaits them. Kept in impossibly-small pens for animals of their size, often in complete darkness, the animals go through a system of reward and denial that, in addition to their confinement, may actually produce aggressive behavior as well as significantly shorten lifespan, allegations which Sea World also denies.

The cinematography involving the whales is somewhat imaginative and combines well with the news footage and interview footage to showcase just how intelligent and emotionally bonded with one another and their human caretakers Orcas often clearly are. But the film drags a little in the manner that many naturalist treatments of nature do. *Blackfish* wants viewers to fall in love with the Orca and they do showcase them well.

The real problems with the film though have to do with what it does with the opportunity to tell a story and make a larger point. Copperthwaite largely ignores a chance to showcase just how little formal training can be involved in getting a trainer in the water with these huge beasts, failing to develop statements made in interviews with former trainers. Viewers will know no more about the process than when they sat down to watch.

Even less compelling is the idea that there is no room at all for the idea of zoological exhibitions. While the film raises the specter of Tilikum being used as a sperm bank, and thus being treated more as an investment than a living breathing being, it largely ignores the implications of it, letting such information simply help make the case that Sea World is greedy. The larger question of what might constitute corporate accountability would have made for a very compelling conclusion to a documentary about fair treatment of intelligent life. Not handled at all is the significant amount of solid research and rehabilitation of wounded animals Sea World has

been involved with. Reportedly, many thousands of such animals have been returned to the wild by the institution. Make no mistake. This is a damning expose. Sea World declined to be interviewed or participate in any way and it is difficult to imagine that decision was made by anyone other than a lawyer. Probably a whole room of them, swimming around like sharks, and smelling blood in the water.

Dave Canfield

CREDITS

Origin: United States
Language: English
Released: 2013
Production: Manuel Oteyza, Gabriela Cowperthwaite; Manny O Productiona; released by Magnolia Pictures
Directed by: Gabriela Cowperthwaite
Written by: Gabriela Cowperthwaite; Eli B. Despres
Cinematography by: Jonathan Ingalls; Chris Towey
Music by: Jeff Beal
Sound: Vince Tennant
Editing: Gabriela Cowperthwaite; Eli B. Despres
MPAA rating: PG-13
Running time: 83 minutes

REVIEWS

Catsoulis, Jeanette. *New York Times.* July 18, 2013.
Chang, Justin. *Variety.* January 29, 2013.
Goldstein, Gary. *Los Angeles Times.* July 17, 2013.
Harkness, Alistair. *Scotsman.* July 29, 2013.
Hoffman, Jordan. *Film.com.* July 15, 2013.
Mandel, Nora Lee. *Film-Forward.com.* July 27, 2013.
Morgenstern, Joe. *Wall Street Journal.* July 18, 2013.
Orndorf, Brian. *Blu-ray.com.* July 31, 2013.
Scott, Mike. *Times-Picayune.* August 16, 2013.
Swietek, Frank. *One Guy's Opinion.* August 2, 2013.

QUOTES

John Hargrove: "Those are not your whales. Ya know, you love them, and you think, I'm the one that touches them, feeds them, keeps them alive, gives them the care that they need. They're NOT your whales. They own them!"

AWARDS

Nominations:
British Acad. 2013: Feature Doc.

BLANCANIEVES

Box Office: $279,735

Pablo Berger creates a Spanish silent film version of the Grimm fairy tale Snow White with *Blancanieves*.

Shot in gorgeous black-and-white, with a lovely flamenco-inflected score by Alfonso de Vilallonga, the movie is certainly pretty to look at, but like Michel Hazanavicius' *The Artist* (2011)—and unlike Miguel Gomes' brilliantly meta-textual *Tabu* (2012)—it fails to capture the quicksilver magic of real silent cinema. The emphases on flamenco dancing and bullfighting add local color, but Berger's film is merely a superficial re-contextualization of the classic fairy tale, as opposed to a genuine reimagining. There does not seem to be any compelling reason for the tale to be retold this way, so it feels like a gimmick.

Set in the 1920s, the story begins with legendary bullfighter Antonio Villalta (Daniel Gimenez Cacho, who brings the appropriate gravitas to the role) preparing for a sold-out event in Seville, while his adoring pregnant flamenco singer wife (Inma Cuesta) looks on. In a tense, rapidly edited, distended sequence, Antonio is momentarily distracted and is gored by the bull. He survives, but his wife is traumatized, and dies during childbirth. Antonio's nurse, Encarna (Maribel Verdu), seizes the opportunity, inserting herself into Antonio's life. At first, Antonio cannot bear to look at his newborn daughter, so his mother-in-law (Angela Molina) takes custody of young Carmencita (Sofia Oria). On the day of Carmencita's communion, her doting grandmother dies suddenly, and so Carmencita goes to live in her father's house.

By this point, the wicked Encarna has married the partially paralyzed Antonio, and essentially imprisoned him in his own home, while she spends his money and kinkily cavorts with a sneering chauffeur, Genaro (Pere Ponce). Encarna does not allow Carmencita access to Antonio's room, forcing the adorable moppet to sleep in the cellar and do all of the household's most odious chores. The girl's only solace for a time is her pet rooster, Pepe, and it does not take a crystal ball to predict that creature's eventual fate in this household.

Eventually, Carmencita sneaks into her father's room, and the two secretly form a bond. He notices that she has a natural talent both for flamenco dancing and for bullfighting, and they spend hours together engaged in these pursuits, until the cruel Encarna gets wind of it. She eventually murders Antonio, and has Genaro drive Carmencita out into the woods, where he drowns the now-grown girl (Macarena Garcia) and leaves her for dead.

She is rescued by a group of six bullfighting dwarves, although only two of them, the smitten Rafita (Sergio Dorado) and the vain, resentful Jesusin (Emilio Gavira) are anything like fully-drawn characters. Two are only distinguishable by their physical characteristics (one dresses in drag, another wears an eye patch), while the

other two are apparently only there to bring the total closer to the seven from the fairy tale. In any case, Carmencita's ordeal has left her amnesiac, so the dwarves dub her "Snow White" after the story. Once she steps into the bullfighting ring to rescue Jesusin from a bucking bull, she becomes a sensation herself, which eventually brings her back into the realm of the evil Encarna.

The movie is functional. It looks good. It entertains, for the most part. But it is a disappointment in the way it haphazardly modernizes the material. While this "Snow White" is given a successful career in what is traditionally a man's role, and while the movie interestingly conflates handsome prince and one of the dwarves (Rafita), the movie's villain is still an essentially misogynistic creation, a woman of pure spite and evil, whose motivations are never made clear, and whose nontraditional sexual proclivities are played for cheap, desultory laughs. Clearly recognizing the lack of humanity in the role, Verdu simply pulls out all the stops, chomping on the impressive scenery in a manner that eventually becomes tiresome. Her comeuppance, when it comes, is one of the few genuinely "silent cinema" moments of the film, looking like something out of Murnau's *Nosferatu* (1922), but it Old Testament-style symbolism does not really fit in with the work as a whole.

Both Oria and Garcia effectively capture the protagonist's essential purity, and give her a spark of rebellious self-possession that keeps her from becoming dull. The two roosters that play Pepe, meanwhile, take full advantage of the Kuleshov effect.

It is a bit strange and disappointing the way the film soft-pedals the barbarity of the sport that Carmencita takes up, following in her father's footsteps. The bullfighting scenes are shot with dramatic flair, but they still feel like a bit of a copout, in a film that seems to be trying to have a more contemporary viewpoint toward its traditions.

In the end, Berger's pretty pastiche is sporadic fun, but it does not have much emotional potency. Even as a cinephile's formal exercise, it does not feel as fully conceived as one might have hoped.

Josh Ralske

CREDITS

Carmen: Macarena Garcia
Encarna: Maribel Verdu
Antonio Villalta: Daniel Gimenez Cacho
Dona Concha: Angela Molina
Genaro Bilbao: Pere Ponce
Don Carlos: Jose(p) Maria Pou

Origin: Spain
Language: English
Released: 2012
Production: Pablo Berger; released by Cohen Media Group
Directed by: Pablo Berger
Written by: Pablo Berger
Cinematography by: Kiko de la Rica
Music by: Alfonso Vilallonga
Sound: Felipe Arago
Editing: Fernando Franco
Costumes: Paco Delgado
Production Design: Alain Bainee
MPAA rating: PG-13
Running time: 104 minutes

REVIEWS

Kohn, Eric. *IndieWire.* March 27, 2013.
Lacey, Liam. *The Globe and Mail.* May 31, 2013.
Lane, Anthony. *The New Yorker.* April 4, 2013.
Murray, Noel. *The A.V. Club.* March 27, 2013.
Phillips, Michael. *Chicago Tribune.* May 2, 2013.
Rodriguez, Rene. *Miami Herald.* April 12, 2013.
Scott, A. O. *The New York Times.* March 28, 2013.
Taylor, Ella. *NPR.* March 28, 2013.
Turan, Kenneth. *Los Angeles Times.* March 28, 2013.
Wilson, Chuck. *Village Voice.* March 26, 2013.

TRIVIA

The film was shot on color film stock and desaturated to black and white during post production.

BLESS ME, ULTIMA

Box Office: $1.6 Million

Carl Frankin's *Bless Me, Ultima* is a coming-of-age tale with a spiritual center that defies conventional wisdom for a film of its type. The film takes place in a small New Mexico village during WWII. This family consists of the parents, Maria (Dolores Heredia) and Gabriel (Benito Martinez), two teenage daughters, three older brothers who are fighting in the war and Antonio (Luke Ganalon), a 9-year-old boy who is naturally curious about the new addition to the household: his grandmother, Ultima (Miriam Colon). Among the first questions asked to their mother regarding Ultima: "Is it true she's a witch?" This becomes the central question around the titular character and one that becomes the springboard for other questions. Just what is a witch anyway?

Before anything is explored with Ultima, Antonio witnesses a man being shot to death by men in the town

who believe he killed another man. There is plenty of internal strife within this village. One of the men with rifles is Antonio's father. Antonio asks Ultima, "Will they go to hell?" She replies, "That is not for us to decide" and that men will do what they must, thereby instilling Antonio with an important lesson in grey areas and spiritual uncertainties. Ultima's abilities as a medicine woman are put to use when a sickness overtakes Antonio's Uncle Lucas (Reko Moreno). She travels to the next town and brings Antonio with her to assist in ritualistic healing. It takes a couple days and brings about painful physical reactions in which Lucas coughs up a black, prickly ball that might be alive. Whatever it may be, Ultima's medicine works.

Not all of Antonio's life involves Ultima. He goes to school and ends up being a bit of an outcast, but not alone amongst the other poorer Hispanics who populate the area and who are forced to eat their lunch outside instead of in the classroom. He converses openly with his friends at school about his own traditional Catholic beliefs, many of which are put to the test by Ultima's actions. Antonio's brothers come home from war and must now face life as civilians, no longer accepting of a life that involves working construction with their father, working in a grocery store or finishing high school. There is even a narrative detour into the time of the summer harvest. But Ultima's ritual with Uncle Lucas results in a literal witch hunt as the townspeople bring torches and crucifixes to the household.

The movie mainly stumbles when narration is employed to tell the audience what they can already plainly see. Antonio, as an adult (voiced by Alfred Molina), informs the viewer that Ultima taught him how to listen closely to the land right after a scene in which she basically says the same thing. It is a device that almost rudely interrupts what is otherwise a nice narrative flow. It feels like a Harvey Weinstein-like afterthought that was never meant to exist. There are other moments in the film in which Franklin overplays his hand by utilizing overbearing music and overreaching performances that feel like first takes. Perhaps Franklin, who wrote the screenplay, felt too much of an allegiance to Rudolfo Anaya's book, on which the film is based.

The film works best when it focuses on Antonio's personal quest for answers to questions that have no fully satisfactory absolutes. Without the narration and with only the capable performance by the young Ganalon, Antonio becomes an interesting through line with which to ask questions of faith (or lack thereof), consequences and justice. Take the witch hunt, for example. The scene might have ended ugly and the film could have ended with Ultima on trial. This would have been a lazy choice by the writer, but not at all surprising. Instead, the scene ends with Antonio fully realizing the

implications of having a relative whose own religious beliefs conflict with the vast majority, including his own (whether he knows it or not). Later in the film, he and his friends at school play a mock confessional in which Antonio gets voted to play the priest. When his friend, a boy who has atheistic beliefs, is put on the spot to confess, the boy refuses and the scene gets ugly. Antonio, a boy whose faith is constantly being challenged, sees something of himself in the boy who has clearly made up his own mind without the aid of a priest or nun.

The story of *Bless Me, Ultima* brings to mind two other family-based coming-of-age tales: John Boorman's *Hope and Glory* (1987), which also brought together different generations of a large family unit as it dealt with WWII as well as humorous shenanigans and rites of passage in the schoolyard. It also explores similar themes of faith as Diane Keaton's *Unstrung Heroes* (1995), which also centered on a boy who had members of his family show him a different way through life by opening his eyes to a new (to him) way of thinking. While *Bless Me, Ultima* may not be nearly as fully accomplished as those two films, its earnestness and willingness to explore deeper, more personal themes with a young person at its center makes it a more interesting effort than the usual coming-of-age fare. If only the effort looked a little more effortless.

Collin Souter

CREDITS

Antonio: Luke Ganalon
Ultima: Miriam Colon
Gabriel: Benito Martinez
Maria: Dolores Heredia
Tenorio: Castulo Guerra
Origin: United States
Language: English, Spanish
Released: 2013
Production: Jesse Beaton; Gran Via, Monarch Pictures; released by Arenas Entertainment
Directed by: Carl Franklin
Written by: Carl Franklin
Cinematography by: Paula Huidobro
Music by: Mark Kilian
Sound: Kelly Cabral
Editing: Alan Heim; Toby Yates
Art Direction: John R. Jensen
Costumes: Donna Zakowska
Production Design: David J. Bomba
MPAA rating: PG-13
Running time: 106 minutes

REVIEWS

Cordova, Randy. *Arizona Republic.* February 26, 2013.

Ebert, Roger. *Chicago Sun-Times.* February 21, 2013.

Farber, Stephen. *Hollywood Reporter.* February 22, 2013.

Hartl, John. *Seattle Times.* February 21, 2013.

Hartlaub, Peter. *San Francisco Chronicle.* February 21, 2013.

Kennedy, Lisa. *Denver Post.* February 22, 2013.

Rainer, Peter. *Christian Science Monitor.* February 22, 2013.

Sachs, Ben. *Chicago Reader.* March 7, 2013.

Snider, Eric D. *About.com.* July 13, 2013.

Turan, Kenneth. *Los Angeles Times.* February 21, 2013.

QUOTES

Antonio: "Bless me, Ultima."

Ultima: "I bless you in the name of all that is good and strong and beautiful."

THE BLING RING

Living the dream, one heist at a time.
—Movie tagline

If you can't be famous, be infamous.
—Movie tagline

Box Office: $5.8 Million

Over the course of her first four feature films, *The Virgin Suicides* (2000), *Lost in Translation* (2003), *Marie Antoinette* (2006), and *Somewhere"* (2010), Sofia Coppola has explored the notions of privilege and the ennui that it can inspire as seen through the eyes of rarefied types—ranging from upper-class schoolgirls to celebrities and their progeny—feeling at odds with lifestyles that most ordinary people could only dream about. As a result of this, Coppola has received criticism in some parts from people who accuse her of telling the same story over and over and asking viewers to feel sorry for characters who just are not satisfied with being young, rich, and beautiful. This was once again the case with her latest effort, *The Bling Ring*, a film recounting the real-life story of a group of Southern California teenagers whose 2008-2009 crime wave netted more than $3 million in money, jewels and designer clothes from a group of largely unsuspecting famous faces. After making its high-profile debut at Cannes, there were a number of commentators who remarked that it was just more of the same and complained that rather than condemning her characters for their self-absorption, she was instead offering up a cinematic celebration of their shallowness.

If those critics had actually been paying attention to the film, they might have realized that whatever *The Bling Ring* may be, it is anything but an unquestioning ode to vapid consumerism. It is, in fact, one of the more lacerating condemnations of that particular mindset and the celebrity-obsessed culture that it both feeds and feeds off of and it is all the more effective because it never blatantly announces itself as such a thing. While other filmmakers might have been tempted to push the material to outrageous extremes in order to make some kind of satirical point, Coppola is content to simply observe this particular world and trust that its absurdities will ring out loud and clear. As a result, what could have been little more than a West Coast variation of the loathsome *Pain & Gain* (2013) crossbred with a *Vanity Fair* article is instead a brilliantly conceived and executed meditation on greed and contemporary celebrity culture that is both one of the very best films of the year and further proof that Coppola is one of the finest and most incisive American directors working today.

Based on an article for *Vanity Fair* written by Nancy Jo Sales (which was later expanded into a book), *The Bling Ring* starts off as the over-medicated Marc (Israel Broussard) arrives for his first day at a high school for students with disciplinary problems and is instantly and inexplicably befriended by Rebecca (Katie Chang), with whom he bonds over their shared fashion sense—she wants to go to the same design school as the people from *The Hills* while he talks about his dreams of one day having his own lifestyle brand. One night, while the two are walking home from a party, Rebecca nonchalantly opens the doors of several unlocked parked cars and makes off with the cash and credit cards carelessly left inside.

From that humble beginning—though there is the sense that Rebecca has done this before—the two sneak into the house belonging to an acquaintance of Marc's that he knows is out of town and make off with a few valuables. Then, while scouring the Internet for news about Paris Hilton, they learn from her online postings that she is out of town hosting some shindig and Rebecca hits upon the idea of doing the same thing with her. At first, Marc demurs—it sounds crazy and they are certain to get caught—but before long, they show up at her house (after looking up the address online) and discover to their surprise that it is remarkably easy to get into Paris Hilton's house.

After successfully making their way through Hilton's shrine to herself, Rebecca and Marc, along with a gradually expanding group that includes sisters Nicki (Emma Watson) and Emily (Georgia Rock), Nicki's live-in BFF Sam (Taissa Farmiga), and Chloe (Claire Julien) united by the rallying cry of "Let's Go Shopping," begin hitting the home of many of the very same young celebrities whose activities that avidly follow via the likes of TMZ and *Us Weekly*—Lindsay Lohan, Orlando Bloom, Megan Fox and, of course, numerous reentries into the House of Hilton—to grab a few items as casually as you or I might be when legitimately going

shopping. (A break-in at Rachel Bilson's place is suggested because "I want some Chanel.") Inevitably, word of their spree begins to spread—largely thanks to their own bragging to their other friends—and that, combined with security camera footage leads to their eventual arrests. In an ironic twist, the crimes make them celebrities of a sort and they are soon pursued by the paparazzi and celebrated by onlookers with the same fervor as those who they victimized in the first place.

Some of the names of the characters have been changed, though their on-screen crimes pretty much match up with what really happened. In the case of *The Bling Ring*, any possible embellishments could hardly improve on the reality of the situation. Take the peek inside of Paris Hilton's house, for example. The joint is such a gaudy tribute to herself—even the throw pillows are emblazoned with her visage—that it seems like a joke until one learns that these scenes were shot in Hilton's actual house with both her full permission and, one presumes, her own furnishings. Later on, while doing an interview before her trial, Nicki delivers a ridiculous-sounding monologue that makes her arrest sound like a calculated career move and again, what seems like the kind of hyperbole that might have made Paddy Chayefsky cringe turns out to be an almost verbatim quote from her character's real-life analogue.

This is frequently hilarious but at the same time, Coppola does have a certain empathy for her characters and while she may not approve of their actions, she does at least understand from where they are coming. Unlike the people in her other films, her characters here are on the outside of the bubble and looking longingly upon a lifestyle they have been conditioned to desire—can they really be blamed for wanting to indulge, by whatever means necessary and however fleetingly, in that rarefied lifestyle? In the end, the material possessions that they have made off with are hardly the point—the victims barely even notice that they are missing at first and the kids wind up selling most of them from a table at the beach. No, fame is what they are really after and thanks to the media exploitation of their crimes, they have managed to attain a near-equal level of celebrity but at a grim price. In one of the strongest moments of the film, one of them is being interrogated in jail and, upon learning that the officer spoke to Lindsay Lohan herself as part of the investigation, the first thing she asks is "Really? What did Lindsay say?" It is a funny line, of course, but it is one delivered with such naked hopefulness that it becomes a strangely touching one as well.

As good as *The Bling Ring* is as a portrait of the current cultural mindset, it is even better just as an example of pure filmmaking. Beautifully photographed by the late Harris Savides (whose last film this was) and Christopher Blauvelt and scored to a killer soundtrack featuring the like of Frank Ocean, Kanye West, and M.I.A., she so effortlessly brings viewers into this world and the characters that populate it that some viewers may find themselves wishing that she had gotten the gig to bring *The Great Gatsby* to the screen instead of Baz Luhrmann. The robbery sequences—each one shot in a different style—are stylish without being overblown and one, in which the robbery of Orlando Bloom's house witnessed silently from a nearby hilltop overlooking his glass-enclosed domicile, may prove to be the single most beautiful image to grace a movie screen this year. She even figures out a way to get around that most tiresome of cinematic cliches—the climactic courtroom scene—in such a clever, resourceful and stylish way that you almost want to applaud her ingenuity.

Outside of one bum speech delivered by Marc towards the end that hits the dramatic nail on the head just a little too hard for its own good, *The Bling Ring* is an all-around triumph. The performances are all stellar—of the standout, newcomer Katie Chang makes a strong first impression as Rebecca, Emma Watson is absolutely hilarious as the jaw-droppingly narcissistic Nicki and even the usually irritating Leslie Mann scores points as Nicki's even more self-absorbed mother, a woman who home-schools her kids with a lesson plan derived from *The Secret* and who is less concerned about her daughter's potential fate than in getting some face time for herself—it looks and sounds absolutely ravishing and it is alternately funny, shocking, weird and surprisingly thoughtful to boot. The end result is such an absolute must-see that even those celebrities who were actually victimized by the Bling Ring might get an unexpected kick out of it despite the understandable antipathy they might have towards the subject matter. Hell, in practically every case, *The Bling Ring* is a better entertainment that the things that made those celebrities famous in the first place.

Peter Sobczynski

CREDITS

Nicki: Emma Watson
Marc: Israel Broussard
Rebecca: Katie Chang
Chloe: Claire Julien
Sam: Taissa Farmiga
Ricky: Gavin Rossdale
Laurie: Leslie Mann
Origin: United States
Language: English
Released: 2013
Production: Roman Coppola, Youree Henley, Sofia Coppola; American Zoetrope, NALA Films; released by A24

Directed by: Sofia Coppola
Written by: Sofia Coppola
Cinematography by: Harris Savides
Music by: Brian Reitzell
Sound: Michael Kirchberger
Editing: Sarah Flack
Costumes: Stacey Battat
Production Design: Anne Ross
MPAA rating: R
Running time: 90 minutes

REVIEWS

Corliss, Richard. *Time Magazine*. May 17, 2013.
Dujsik, Mark. *Mark Reviews Movies*. June 21, 2013.
Foundas, Scott. *Variety*. May 16, 2013.
McCarthy, Todd. *Hollywood Reporter*. May 16, 2013.
Orndorf, Brian. *Blu-ray.com*. June 20, 2013.
Scott, A. O. *New York Times*. June 13, 2013.
Sharkey, Betsy. *Los Angeles Times*. June 13, 2013.
Stevens, Dana. *Slate*. June 14, 2013.
Tallerico, Brian. *HollywoodChicago.com*. June 20, 2013.
Zacharek, Stephanie. *Village Voice*. May 17, 2013.

QUOTES

Marc: "I think we just wanted to be part of the lifestyle. The lifestyle that everybody kinda wants."

TRIVIA

Prior to filming, director Sofia Coppola got the cast to fake-burgle a house to see what mistakes they'd make during the crime.

BLUE CAPRICE

Some killers are born. Others are driven to it.
—Movie tagline

Box Office: $93,995

Any filmmaker who chooses to utilize a real-life atrocity like a mass killing as the subject of a movie is forced to walk an artistic tightrope by dealing with the matter at hand in a true and respectful manner without sliding into the flat-out exploitation of a horrible tragedy. This high-wire act can become even more fraught with peril if the filmmaker in question chooses to tell the story from the perspective of the perpetrators instead of from the viewpoint of the victims or from some seemingly objective point-of-view. In the past, some films that have taken this approach, such as *Targets* (1968), *Badlands* (1973), and *Elephant* (2003) have elected to

offer lightly-fictionalized versions of their stories as a way of somewhat defusing the issue.

Blue Caprice, a film inspired by the Beltway sniper attacks that terrorized the nation during a three-week period in the fall of 2002, has chosen to deal with its subject in a more straightforward manner that is more interested in what made the two men convicted of the crimes, 40-year-old John Allen Muhammad and 17-year-old Lee Malvo, tick and eventually go off than in offering gruesome recreations of their crimes. The end result is undeniably interesting, although some may wonder what it was that so excited the audiences that caught it during its debut at the Sundance Film Festival, where it quickly became one of the more talked-about titles. Its overtly restrained approach may ultimately frustrate viewers looking for cheap thrills and outrage those who feel that their acts do not deserve to be commemorated under any circumstances.

The film opens in Antigua as Lee (Tequan Richmond), who has just been abandoned by his own mother (presumably not for the first time), makes the acquaintance of the older John (Isaiah Washington). Over time, the two begin to develop an unexpected father-son dynamic and eventually, John arranges for Lee to come back to the U.S. to live with him in Tacoma, Washington. Although gentle to a fault at times, John is capable of enormous rage—much of it directed at his much-hated ex-wife—and Lee finds himself bearing the brunt of the man's violent rants, "training" exercises straight out of boot camp, and insistence that his young charge prove his loyalty to him by committing various criminal acts. The odd thing is that Lee seems to thrive to a certain degree under these conditions, and when a trip to a shooting range reveals him to be a crack shot, it sets their relationship on a new and mutually exploitative course that eventually finds them driving towards the Eastern seaboard in the titular car, with a Bushmaster .223 in tow, for their date with destiny.

The eventual rampage that would leave ten dead and three wounded before John and Lee were eventually apprehended (the former would eventually be executed while the latter would get six life sentences) is depicted only as part of a long montage toward the end of the film. Instead, director Alexandre Moors and screenwriter RFZ Porto are more interested in quietly observing the two as their odd relationship grows increasingly toxic. One thing that the film does not do is attempt to offer up any pat explanations as to why they did what they did, as though that were even possible. It might be expected that the film would depict John as a dangerous loner who manipulates the younger Lee into his twisted worldview but here, it shows John as being at least semi-social through visits to an old Army buddy and his wife (Tim Blake Nelson and Joey Lauren Adams) and subtly

indicates at times that Lee is John's manipulative equal in some ways.

However, at no point does *Blue Caprice* ask viewers to sympathize with its protagonists—instead, it wants them to try to see them as people rather than as monsters and try to understand how two seemingly ordinary people could go so wrong and with such horrifying results. It is an intriguing approach to be sure and probably the correct one under these circumstances. That said, it does mean that there is a certain lack of dramatic resolution when all is said and done that may lead some viewers to ask themselves what the point of the whole endeavor was in the first place. This may also be in part due to the relatively brief 93-minute running time that occasionally leaves things feeling a little rushed, although it is highly unlikely that many people would want to spend any more time inside this particular narrative.

If they did, it would be in no small part to the strength of the two lead performances. In one of his first major roles since his infamous departure from *Grey's Anatomy*, Isaiah Washington is quite compelling as John Muhammad, effectively capturing both the coldly calculating side that helped engineer such needless destruction as well as a more nurturing aspect that helps to remind viewers that beneath the monster portrayed in the media was a man suffering from deep and unknowable hurts that he could eventually deal with only by inflicting hurt on other. Standing toe-to-toe with him throughout is Tequan Richmond (best known for his work on *Everybody Hates Chris*), whose portrayal of Lee is just as nuanced as the one delivered by his co-star, perhaps more so since his is a largely silent performance that forces him to convey the complex emotions almost entirely through non-verbal means.

Make no mistake, *Blue Caprice* is a dark and depressing drama and for many moviegoers, the combination of bleak subject matter and lack of real resolution will cause them to flee from it in droves. For those willing to accept it on its own unique terms, it is an undeniably wrenching experience that overcomes a certain unevenness in parts with its toned-down approach and electrifying performances. *Blue Caprice* may not be a great film but it is a good one—better and more insightful than one might have reasonably expected given the subject matter.

Peter Sobczynski

CREDITS

John Allen Muhammad: Isaiah Washington, IV
Lee Boyd Malvo: Tequan Richmond
Ray: Tim Blake Nelson

Jamie: Joey Lauren Adams
Origin: United States
Language: English
Released: 2013
Production: Kim Jackson, Isen Robbins, Will Rowbotham, Ron Simons, Stephen Tedeschi, Alexandre Moors, Brian O'Carroll, Aimee Schoof; Intrinsic Value Films, Simon Says Entertainment, Aiko Films; released by Sundance Selects
Directed by: Alexandre Moors
Written by: R.F.I. (Ronnie) Porto
Cinematography by: Brian O'Carroll
Music by: Colin Stetson; Sarah Neufeld
Sound: Steven Tollen
Editing: Alexandre Moors
Costumes: Eniola Dawodu; Minori Kuraoka Moors
Production Design: Kay Lee
MPAA rating: R
Running time: 93 minutes

REVIEWS

Anderson, John. *Wall Street Journal*. September 12, 2013.
Buckwalter, Ian. *NPR*. September 13, 2013.
Burr, Ty. *Boston Globe*. September 26, 2013.
Phipps, Keith. *The Dissolve*. September 12, 2013.
Rooney, David. *Hollywood Reporter*. February 1, 2013.
Rothkopf, Joshua. *Time Out New York*. September 11, 2013.
Scherstuhl, Alan. *Village Voice*. September 10, 2013.
Scott, A. O. *New York Times*. September 12, 2013.
Stevens, Dana. *Slate*. September 12, 2013.
Tallerico, Brian. *Hollywood Chicago*. September 20, 2013.

BLUE IS THE WARMEST COLOR
(La vie d'Adele)
(The Life of Adele)

Box Office: $2.2 Million

Every year in cinema worth its salt requires at least one foreign-language entry to arrive upon U.S. shores upon a tide of hype and controversy. In 2013, that film was the epic-length French drama *Blue is the Warmest Color*. When it made its debut at the Cannes Film Festival, it was one of the most talked-about entries, partly because of the explicit and extended lesbian sex scenes involving co-stars Adele Exarchopoulos and Lea Seydoux, partly because when the Steven Spielberg-led jury awarded it the coveted Palme d'Or, they insisted, in an unheard-of move, that the two actresses share the prize alongside director Abdellatif Kechiche and partly because of a bizarre feud that erupted between the film-

maker and his stars that would continue on even as the film was receiving raves throughout the world. Fuel was added to the fire on the eve of its U.S. release when it was essentially banned from the only theater in Idaho that could play it due to some arcane liquor law and an arthouse in New York offered to not only let any Idahoan in to see it for free but also offered to overlook the NC-17 rating so that teenagers could attend screenings.

On the one hand, such hoopla certainly gave the film a higher profile than is usually afforded to most three-hour-long French dramas trying to make a dent in the American marketplace but there was also the danger that once the film itself was actually unveiled, it would prove to be nothing more than just another dull European import with nothing going for it other than a little bit of skin and a sensationally effective marketing campaign. As it turns out, *Blue is the Warmest Color* is a total knockout from start to finish and one of the most stirring, powerful, and devastating coming-of-age sagas to come along in a very long time.

As the film opens, Adele (Exarchopoulos) is a typical 17-year-old, working-class girl who is trying to figure out who she is while struggling with questions about subjects ranging from the mysteries of Marivaux's *The Life of Marianne* to the even more unfathomable subject of boys. One day, after a classroom discussion on concept of love at first sight, she sees a slightly older girl with a distinctive shock of blue hair and cannot get her out of her mind, even during certain intimate moments. She tries acting like her classmate and starts dating one of her classmates—even giving up her virginity to him—and while he is nice enough to her, she is still somehow unsatisfied and eventually breaks up with him.

One night, she finds herself in a lesbian bar and winds up meeting the blue-haired girl, who turns out to be a slightly older art student named Emma (Seydoux). Over the course of the next few weeks, the two become fast friends—much to the suspicion of Adele's classmates, who assume that the two are lovers—and eventually, after a dinner with Emma's liberated parents that includes Adele's first sampling of oysters (a bit of clunky symbolism that may be the film's only real misstep), the two make love in an extended sequence that may not be as long as the rumors have suggested (despite some initial claims that it last upwards of fifteen minutes, it actually clocks in at maybe 5 or 6) but is certainly as powerful, both in terms of erotic heat and dramatic power. For Adele, this is what she has been looking for her entire life—a way of explaining and defining who she really is to the world. Emma is a little more circumspect at first— she has presumably seen any number of girls who have mistaken brief experimentations for life-changing

epiphanies—but she too eventually succumbs to the romance.

Over the next decade or so, the film charts the path of their evolving relationship. Emma's art career begins to take off and while Adele is happy with her success (and even serves as a model for some of her pieces), she can't help but feel out of place when they are having parties with Emma's friends and everyone else is intensely discussing art, truth and the philosophy of the orgasm while she is essentially relegated to serving the food. As for Adele, she goes into teaching and while she loves the kids that she is working with, she once again begins to feel as though something is missing. Before long, there is an indiscretion that causes a seismic shift in the relationship between Adele and Emma with consequences that are both devastating and potentially liberating for the two of them.

Blue is the Warmest Color is based on an acclaimed graphic novel by Julie Maroh that co-writers Kechiche and Ghalia Lacroix have fiddled with considerably in the course of bringing it to the screen. The book is quite good, to be sure, but the changes that Kechiche and La- croix have brought to the material have actually improved it. While the book is conceived in large part as a memory piece in which the key events have already occurred and are being recalled by the characters, the film unfolds in the present tense and an additional intensity is gained as a result of this shift. More significantly, the entire story is seen entirely through Adele's eyes and the film does an incredible job of get- ting into her head and conveying her emotional upheaval into cinematic terms, particularly in the decision to present what is essentially an intimate story on such an epic scale—as anyone in the throes of first love can attest, every aspect of life seems to be magnified and Kechiche cleverly catches this feeling by presenting his story in such a lengthy manner. To some viewers, it may seem as if the story has been somewhat overinflated but most people will find every single one of its 179 minutes to be nothing less than absolutely mesmerizing.

A large part of the credit for the success of *Blue is the Warmest Color* also goes to the stunning efforts of the two lead actresses. Seydoux has been an actress on the rise in the last few years thanks to homegrown successes like *Farewell My Queen* (2012) and international hits like *Midnight in Paris* (2011) (she was the record dealer who eventually caught Owen Wilson's eye) and *Mission Impossible: Ghost Protocol* (2011) (where she was the ass- kicking bad girl of note). Her work as Emma is a revela- tion in the way that she takes a character that good have just been depicted as some kind of walking erotic fantasy and makes her into a real person with her own set of emotional hurts that her lover has never bothered to consider—she has an angry confrontation with Adele at

one point that is so raw and wounding to behold that there is the urge to turn away from the screen because of the sense of witnessing something too private and painful to behold.

Although she has been in a couple of movies prior to her work here, Exarchopoulos is essentially making her big splash before our eyes with one of the most overwhelming performances by any actress of this or any year. Between the emotions she is required to bear and the maturation of her character over the course of a decade, this is an enormously tricky part and she pulls it off so beautifully that you never for an instant see her "acting"—she just completely disappears into the character in ways that reminded me of Isabelle Adjani's still-stunning and somewhat similar work in *The Story of Adele H* (1975). Together, the two actresses emit an intensity that is practically volcanic in nature and if there was any justice in the world, every year-end award for Best Actress and Best Supporting Actress would be theirs for the taking.

As for the sex scenes that have inspired so much controversy and which appear to be at the heart of the friction between the director and the two actresses. There are maybe three such scenes on display and they run for a total of perhaps ten minutes or so. Yes, they are quite sexy but the reason that they have such an impact is not simply because of the amount of flesh on display nor the various gyrations that Exarchopoulos and Seydoux engage in during them. If that was all they had to offer viewers, there would be little difference between those scenes and the stuff that one can catch on Cinemax on any given night around 1:00 AM.

No, the reason why they are so powerful is that viewers have gotten to know the two characters so intimately from an emotional perspective that when they do finally go to bed, their actions really do mean something both to them and us, pretty much the complete antithesis of the typical gratuitous sex scene. Some might argue that ten minutes of such graphic sexuality might seem a little too much—the kind of excess that comes from having a male director presenting such material—but in the context of the film, it does make sense. After all, the entire film is told through Adele's eyes and she is the kind of person who would latch on to every possible sensation—the film is merely conveying those powerful feelings into purely cinematic terms that just would not have been as effective had they been presented at a more conventional length.

Blue is the Warmest Color is one of the very best films of 2013, a powerful work that will leave most viewers enthralled and devastated in equal measure. Although it will no doubt be labeled a "gay" movie by many observers, its observations regarding love, passion, and heartache are of the sort that can be readily understood and embraced by audiences of all orientations. It is a shame, therefore, that its triumph has been threatened with being overshadowed by the disagreements that have developed between Kechiche, Exarchopoulos, and Seydoux. For the sake of all involved, one can only hope that the three can somehow find a way to bury the hatchet and allow themselves to bask in the knowledge that together, they have created a flat-out cinematic masterpiece.

Peter Sobczynski

CREDITS

Emma: Lea Seydoux

Adele: Adele Exarchopoulos

Origin: France

Language: French

Released: 2013

Production: Brahim Chioua, Vincent Maraval, Abdellatif Kechiche; Wild Bunch; released by IFC Films

Directed by: Abdellatif Kechiche

Written by: Abdellatif Kechiche; Ghalia Lacroix

Cinematography by: Sofian El Fani

Sound: Fabien Pochet

Music Supervisor: Elise Luguern

Editing: Ghalia Lacroix; Sophie Brunet; Albertine Lastera; Jean-Marie Lengelle; Camille Toubkis

Costumes: Sylvie Letellier

Production Design: Julia Lemaire

MPAA rating: NC-17

Running time: 179 minutes

REVIEWS

Burr, Ty. *Boston Globe.* October 31, 2013.

Chang, Justin. *Variety.* September 13, 2013.

Corliss, Richard. *Time Magazine.* October 25, 2013.

Dargis, Manohla. *New York Times.* September 13, 2013.

Edelstein, David. *New York Magazine.* October 21, 2013.

Frosch, Jon. *The Atlantic.* May 28, 2013.

Lane, Anthony. *The New Yorker.* September 21, 2013.

Sharkey, Betsy. *Los Angeles Times.* October 24, 2013.

Stevens, Dana. *Slate.* October 28, 2013.

Zacharek, Stephanie. *Village Voice.* October 22, 2013.

QUOTES

Emma: "But I have infinite tenderness for you. I always will. All my life long."

TRIVIA

One of the sex scenes took ten days to film.

AWARDS

Ind. Spirit 2014: Foreign Film
Nominations:
British Acad. 2013: Foreign Film
Golden Globes 2014: Foreign Film

BLUE JASMINE

Box Office: $33.3 Million

Considering his position as the most notable cinematic chronicler of modern-day New York life, it is perhaps no surprise that Woody Allen would eventually turn to the 2008 financial meltdown and its repercussions to serve as inspiration for a film. Additionally, seeing as how he has often focused on characters from the upper class, it is also not especially surprising to find that he would explore the subject from the perspective of a (former) member of the elite one percent. What is surprising, however, is that the resulting film, *Blue Jasmine*, is nowhere near as interesting or provocative as it should have been and it is only through the efforts of the uniformly strong cast that the otherwise shaky material becomes reasonably watchable.

Cate Blanchett stars as Jasmine, a haughty and ridiculously self-absorbed Manhattan socialite whose world of wealth and privilege comes courtesy of her husband (Alec Baldwin), an incredibly successful investment manager. Alas, his empire turns out to have been based entirely on a massive fraud that left all of his investors—including her sister Ginger (Sally Hawkins) and her husband (Andrew Dice Clay)—without a cent of what they put in. Before long, Jasmine is left with virtually nothing besides a massive amount of self-pity that she unsuccessfully tries to keep at bay via self-medication and alcohol. With nowhere else to go, Jasmine relocates to San Francisco to live with Ginger and her kids in her decidedly downscale apartment while working as a receptionist for a lecherous dentist (Michael Stuhlberg).

Needless to say, she fails spectacularly at adjusting to her new circumstances and spends her time looking back on her former existence, denigrating Ginger's uncouth fiancee, Chili (Bobby Cannavale), idly speculating about a career in interior design that she never quite gets around to pursuing and otherwise taking the art of narcissism to new heights. Eventually, she makes the acquaintance of a rich and powerful suitor (Peter Sarsgaard) who just might be her ticket back to the lifestyle that she feels that she deserves but at the least opportune moment, her past comes back to haunt her in spectacularly destructive fashion.

Essentially a seriocomic riff on *A Streetcar Named Desire* laced with elements of the Bernie Madoff scandal,

Blue Jasmine sounds interesting in theory but Allen's screenplay turns out to be surprisingly uneven and even quite nasty in certain areas. Granted, the story is meant to be seen entirely through the self-serving and incredibly tunnel-vision perspective of its anti-heroine but even if one accepts that narrative approach in the same way that they accepted the similar take that Martin Scorsese used for *The Wolf of Wall Street* (2013), the story still seems curiously unfocused in the long run. The film intertwines scenes of Jasmine's current circumstances with flashbacks to her days of privilege and how they came asunder and of the two, Allen seems far more at home with the Manhattan swells reveling in their ill-gotten gains and infuses the loss of status with a real sense of tragedy.

By comparison, the present-day material is a bit on the repetitive side and Allen's portrayal of people on the lower end of the socioeconomic spectrum is so absurdly broad that it would not be out of place in a road company of *Guys & Dolls*. And while Allen has never been famous for his light and rosy-eyed view of humanity—a view that has darkened even further in recent years—some of the material here has a misanthropic edge that is a little off-putting at times, with the material involving Jasmine and the dentist inspiring some of the most cringe-worthy moments. Even when Jasmine finally receives what passes for her comeuppance in the end, it has a decidedly hollow feel to it that fails from a dramatic standpoint.

While Allen the screenwriter may have come up short this time around, Allen the director has picked up the slack by eliciting a number of highly impressive performances across the board. Working with Allen for the first time, Cate Blanchett is quite spectacular in what is sure to go down as one of the most memorable performances in any of his films. Despite playing the kind of abrasive personality that most people would cross streets or entire city blocks to avoid, she still manages to invest the character with enough recognizable humanity to make her as fascinating as she is wildly unpleasant and even gets some big laughs here and there for good measure. The supporting cast is uniformly excellent as well—Hawkins is warm and cheerful as Ginger, Baldwin is smooth sleaze incarnate as Jasmine's rotter of a husband, and Louis C.K. is hilarious and surprisingly touching as an amiable schlub who sweeps Ginger off her feet and away from Chili for a while.

However, the most unexpected (and unexpectedly effective) surprise of the bunch is the appearance of none other than one-time shock comic Clay as Ginger's first husband, a man with real and specific grievances against his former sister-in-law who unexpectedly gets the chance to repay her in full for what she and her husband did to him. Whatever instinct Allen had in

casting him—and one can only assume that the very mention of his name raised many eyebrows—turned out to have been quite sound because he is really quite good here. He handles both the comedic and dramatic material without a trace of the bloated braggadocio that marked his former stand-up act, and he more than holds his own against the not-inconsiderable likes of Blanchett, Baldwin, and Hawkins. He may not have received an Oscar nomination for his work here but if there was an award for cinematic career reinvention, he would have had the prize for 2013 all sewn up.

Despite its flaws, *Blue Jasmine* is still a film that is worth seeing—the performances are wonderful, some of the individual lines of dialogue are spot-on and it demonstrates a greater form of artistic commitment on the part of Allen than such cinematic shrugs as *You Will Meet a Tall Dark Stranger* (2010) and *To Rome With Love* (2012), two films that had their charms but which felt as if they had been sitting in a drawer for a while and were only put before the cameras because he had nothing else in the hopper. However, considering the hugely promising premise, the more than game cast, and the enormous praise that it received in some quarters, it turns out to be a film that, much like its central character, is neither all that it seems to be nor all that it is cracked up to be.

Peter Sobczynski

CREDITS

Jasmine: Cate Blanchett
Ginger: Sally Hawkins
Hal: Alec Baldwin
Chili: Bobby Cannavale
Eddie: Max Casella
Jane: Tammy Blanchard
Al: Louis CK
Dwight: Peter Sarsgaard
Augie: Andrew Silverstein
Origin: United States
Language: English
Released: 2013
Production: Letty Aronson, Stephen Tenenbaum, Edward Walson; Perdido; released by Sony Pictures Classics
Directed by: Woody Allen
Written by: Woody Allen
Cinematography by: Javier Aguirresarobe
Sound: Robert Hein
Editing: Alisa Lepselter
Art Direction: Michael E. Goldman
Costumes: Suzy Benzinger
Production Design: Santo Loquasto

MPAA rating: PG-13
Running time: 98 minutes

REVIEWS

Chang, Justin. *Variety.* July 17, 2013.
Corliss, Richard. *Time Magazine.* July 25, 2013.
Dargis, Manohla. *New York Times.* July 5, 2013.
Denby, David. *The New Yorker.* July 24, 2013.
Edelstein, David. *New York.* July 22, 2013.
McCarthy, Todd. *Hollywood Reporter.* July 22, 2013.
O'Hehir, Andrew. *Salon.com.* July 24, 2013.
Reed, Rex. *New York Observer.* July 24, 2013.
Stevens, Dana. *Slate.* July 25, 2013.
Zacharek, Stephanie. *Village Voice.* July 23, 2013.

QUOTES

Jasmine: "Can you please not fight in here? I don't think I can take it. For some reason, my Xanax isn't kicking in."

TRIVIA

Cate Blanchett and Sally Hawkins were the only members of the cast to have access to a complete script during filming.

AWARDS

Oscars 2013: Actress (Blanchett)
British Acad. 2013: Actress (Blanchett)
Golden Globes 2014: Actress—Drama (Blanchett)
Ind. Spirit 2014: Actress (Blanchett)
Screen Actors Guild 2013: Actress (Blanchett)
Nominations:
Oscars 2013: Actress—Supporting (Hawkins), Orig. Screenplay
British Acad. 2013: Actress—Supporting (Hawkins), Orig. Screenplay
Golden Globes 2014: Actress—Supporting (Hawkins)
Ind. Spirit 2014: Actress—Supporting (Hawkins), Screenplay
Writers Guild 2013: Orig. Screenplay

THE BOOK THIEF

Courage beyond words.
—Movie tagline

Box Office: $21.2 Million

For his Oscar-nominated 2011 drama *Monsieur Lazhar,* director Philippe Falardeau took a gamble on a fresh face, Sophie Nelisse, a French-Canadian girl who had never acted in a film before. She was cast in the emotionally complex role of an elementary school student alienated from her mother and wracked with despair over the recent suicide of her teacher. The bond

she formed with her teacher's replacement, an immigrant harboring his own private pain, proved to be a cathartic one, culminating in one of the most deeply affecting hugs in movie history.

Nelisse's masterfully nuanced debut performance was one for the ages, suggesting that her screen career would be one of great potential. It is with mixed emotions that one observes her headlining *Downton Abbey* vet Brian Percival's widely publicized adaptation of Markus Zusak's 2006 bestseller, *The Book Thief*, a film that appears to have been designed to launch the young actress's international screen career. It is dutiful Oscar bait smothered in prestige destined to never earn the acclaim it so dearly desires.

At age thirteen, Nelisse is not only required to anchor practically every scene but also deliver her dialogue in English with a German accent. It is the sort of formidable task that even a seasoned pro like Meryl Streep would balk at, and it occasionally renders the young actresses's expressive face glaringly wooden. In her exorbitant array of close-ups, Nelisse's eyes are often detached, as if concentrating on the pronunciation of each word. The riveting fire that lit up her features in *Luzhar* has been muted to a dull simmer. That she does a better job than anyone in her age range could ever have been expected to accomplish is a remarkable achievement few are likely to acknowledge.

As Liesel, an orphaned girl raised by foster parents in a fictional German village during World War II, Nelisse is frequently required to stare at her surroundings with her lips parted into an inquisitive "o," while thrusting herself into the warm embrace of the nearest adult, usually that of her adoptive father, Hans, played with twinkly panache by Geoffrey Rush. As in the equally problematic Holocaust-era drama, *The Reader* (2008), literacy serves as a metaphor for social consciousness, as Liesel's hunger to devour books parallels the awakening of her senses to the evil signified by the swastikas aligning her neighborhood streets.

Though critics have scolded the film for portraying Nazism with too light a touch, Florian Ballhaus's honey-hued cinematography does a fine job of recreating the naive perspective of its characters, to whom the world initially appears eerily inviting. There is a particularly chilling sequence in which the merry voices of a children's choir are juxtaposed with the horrors of Kristallnacht. In many ways, John Williams' score is as restrained and generic as Michael Petroni's script, thus making the film palatable for a young audience's sensibilities. If *The Butler* (2013) functioned as a film about black issues for white audiences, perhaps *The Book Thief* will find its purpose in the curriculum of junior high schools across America.

Upping the tension in an otherwise dramatically modest film is the sudden appearance of a young Jewish man, Max, who asks to be hidden in the basement of Hans and his stern wife, Rosa, superbly played by Emily Watson. Since Max happens to be the son of a soldier who fought with Hans in WWI, the kindly vet feels that it is his responsibility to preserve the man's safety while risking his own. The two great saving graces of the picture predictably prove to be the performances by Rush and Watson, who create a credible dynamic between two weathered partners in love, while offering enticing glimpses of the fierce emotion reverberating beneath their collected facades. Perhaps the most moving moment in the entire film occurs when Rosa forcibly pulls Liesel out of class only to secretly share some encouraging news.

Both actors bring out the best in Nelisse, enabling her to periodically transcend the limitations of the script, which has absolutely no reason to be in English apart from marketing purposes. It is flat-out squirm-inducing to observe the stilted conversations between Liesel and Rudy, the schoolmate who becomes instantly smitten with her the moment she arrives next door. This relationship may have been touching if the actors' voices did not sound as if they were being dubbed in a *Godzilla* movie. Percival seems so determined to up the cute factor in their scenes that he forgets to have Rudy elicit the merest shiver after diving into freezing cold water during the dead of winter. Similarly, when Rosa complains that Liesel is "filthy," Nelisse's airbrushed beauty seems comically out of place. This is where the film's prettiness becomes a demerit against its stabs at authenticity.

Regardless of its noteworthy strengths, *The Book Thief* is ultimately a disappointment, falling far below its intended impact. Here is a textbook example of studio-fueled timidity removing every last trace of spontaneity and audacity from a well-intentioned picture. Nelisse deserves a whole lot better, and so does her audience.

Matt Fagerholm

CREDITS

Liesel: Sophie Nelisse
Hans: Geoffrey Rush
Rosa: Emily Watson
Death: Roger Allam
Rudy: Nico Liersch
Origin: United States, Germany
Language: English, German
Released: 2013
Production: Ken Blancato, Karen Rosenfelt; Fox 2000 Pictures; released by Twentieth Century Fox Film Corp.

Directed by: Brian Percival
Written by: Michael Petroni
Cinematography by: Florian Ballhaus
Music by: John Williams
Music Supervisor: Becky Bentham
Editing: John. Wilson
Art Direction: Bill Crutcher
Costumes: Anna Sheppard
Production Design: Simon Elliott
MPAA rating: PG-13
Running time: 131 minutes

REVIEWS

Harvey, Dennis. *Variety.* October 4, 2013.
Lacey, Liam. *The Globe and Mail (Toronto).* November 7, 2013.
LaSalle, Mick. *San Francisco Chronicle.* November 14, 2013.
Lumenick, Lou. *New York Post.* November 7, 2013.
Markovitz, Adam. *Entertainment Weekly.* November 6, 2013.
Osenlund, R. Kurt. *Slant Magazine.* November 7, 2013.
Phillips, Michael. *Chicago Tribune.* November 14, 2013.
Roeper, Richard. *Chicago Sun-Times.* November 14, 2013.
Rothkopf, Joshua. *Time Out New York.* November 6, 2013.
Zacharek, Stephanie. *Village Voice.* November 8, 2013.

QUOTES

Max Vandenburg: "I'm not lost to you, Liesel. You'll always be able to find me in your words. That's where I'll live on."

TRIVIA

Robert Sheehan auditioned for the part of Max Vandenburg and the video with his reading was leaked online.

AWARDS

Nominations:

Oscars 2013: Orig. Score
British Acad. 2013: Orig. Score
Golden Globes 2014: Orig. Score

BROKEN CITY

Proof can be a powerful weapon.
—Movie tagline
Power plays everyone.
—Movie tagline

Box Office: $19.7 Million

Broken City feels like the sort of movie one might stumble across on late-night, cable television, only to spend the remainder of its running time trying to figure out whether or not he has already seen it. Like the big

city corruption pictures of Sidney Lumet to which it inconspicuously aspires, this gritty thriller is chock full of unsavory characters: crooked ex-cops, adulterous spouses, shady developers and underhanded politicians. And throughout, it is methodical in its distribution of strands in its ever-expanding web, giving the viewer just enough intriguing morsels to keep him watching from one scene to the next. But the comfort that can be derived from a sense of familiarity early on eventually gives way to a numbing feeling of deja-vu. And, though there is some inclination to applaud the film for attempting to resurrect a genre which had its heyday in the 1970s, 1980s, and 1990s, it is hard to do so when the result is so unremarkable.

The film opens in a New York City project, with police officer Billy Taggart (Mark Wahlberg) standing, smoking gun in hand, over a dead body. Although the events leading up to the shooting are not revealed until much later, audiences quickly learn that his victim was a suspected rapist and murderer, freed on a technicality. In a move they are convinced is better for the overall mental health of the City, Mayor Nicholas Hostetler (Russell Crowe) and Police Chief Carl Fairbanks (Jeffrey Wright) suppress some of the evidence, in order to have the killing labeled self-defense and spare Taggart any jail time. But the pair also insists that he leave the force immediately, at which point, the Mayor assures him that his cooperation will not soon be forgotten.

The bulk of the film takes place seven years later, set against the backdrop of an impending mayoral election between Hostetler, the incumbent, and a fiery idealist, Jack Valliant (Barry Pepper). With just one week until voting, the Mayor calls upon Taggart, now a private detective specializing in infidelity and blackmail. Claiming that the city will not elect someone whose wife is cheating on him, Hostetler offers Billy $50,000 to find out with whom his wife, Cathleen—a human rights activist played by a vampy Catherine Zeta-Jones—is having an affair. Because his business is struggling financially, Taggart reluctantly accepts the case. And after some resourceful sleuthing, he discovers that the man with whom Cathleen has been meeting is none other than Valliant's campaign manager, Paul Andrews (Kyle Chandler). This startling realization simply leads to more questions for Taggart, some of which paint a much larger picture of wealth-driven corruption and, as he soon learns, have potentially deadly answers.

As Taggart, Wahlberg is serviceable in a role that feels tailor-made—and thus, a little too easy—for him. He effortlessly exudes the street smarts and working class skepticism one would expect from a man in his position. But at times, he appears to be sleepwalking through his scenes. Crowe, however, has some memorable moments as the Mayor, managing to convey a

power-hungry ego that is intertwined precariously with genuine affection for his city and its people. But otherwise, most of the talented supporting cast members, including Pepper, Zeta-Jones, Chandler, and Griffin Dunne as a ruthless contractor, have been relegated to mere plot devices. Only Wright truly shines, suggesting that each of his words and actions are being contemplated thoroughly and chosen carefully. Although Alona Tal, who plays Taggart's spunky assistant, Katy Bradshaw, does bring some much-needed humor to the highly serious proceedings. Unfortunately, both actors feel a bit out of step with the rest of the cast.

Broken City is the solo directorial debut of Allen Hughes, striking out on his own after making a series of films with his twin, Albert, as "The Hughes Brothers." And like that duo's best work, including *Menace II Society* (1993) and *Dead Presidents* (1995), the tone and setting here are well-developed. The characters speak in fitting, hushed tones, and there is a sense of restraint throughout, suggesting that everyone around Taggart would much prefer to grease a palm than deliver a punch. Meanwhile, their dealings are cloaked appropriately in shadows and their surroundings—thanks in large part to Ben Seresin's moody cinematography—really do possess the feeling of an overcast, November election. To be fair, Hughes has approached this genre with more reverence than originality. But that is not the film's biggest problem.

Unfortunately, that claim belongs to the script, which is of the utmost importance in a thriller full of twists, turns, back-stabbings and double-talk. It is the first for screenwriter Brian Tucker and it certainly starts out promisingly enough. The first scene containing dialogue is that in which the Mayor and Chief reveal to Taggart the way in which they intend to see his case play out. And their exchange is smart, aggressive, and rhythmic and does an excellent job of setting the wheels in motion on both the story and each character's shielded motives. But with each passing scene, the script progressively runs out of steam. The plot becomes convoluted, the contrivances become improbable, the characters become increasingly single-minded and worst of all, the dialogue begins to sound as though it were excessively written. The characters resort to either tired movie cliches or awkwardly-loquacious metaphors, the latter unleashed as though they had been waiting all day for the right moment to do so. And finally, the number of plot points that are introduced and bandied about, but ultimately prove inconsequential, is inexcusable. There are scenes throughout the first hour involving Taggart's struggles with alcoholism, as well as his troubled relationship with his girlfriend. Yet despite providing some dramatic fodder here and there, neither issues figures into the final act of the movie whatsoever.

The script also makes a half-hearted and strangely misguided attempt to anchor the story in the here and now by tossing in a few modern social issues: gay rights and housing costs. But in a movie already lacking the space to address either more thoroughly, that just feels exploitative.

As the film nears its conclusion, the last few mysteries are unraveled and the protagonist boldly accepts his fate. But if Hughes has his way, the final frame of this familiar thriller will pass through the projector before the viewer ever has a chance to realize just how uninvested he was in any of it. *Broken City* is true to its name; it presents a metropolis which may function superficially, but is hopelessly corrupt at its core. At one point, Taggart confesses to his girlfriend that his biggest flaw is "not being able to see the best in people," presumably with a mind to change that. But ultimately, this movie does not present any evidence to suggest that he—nor anyone watching it—would be wise to do so.

Matt Priest

CREDITS

Billy Taggart: Mark Wahlberg
Mayor Nicholas Hostetler: Russell Crowe
Cathleen Hostetler: Catherine Zeta-Jones
Carl Fairbanks: Jeffrey Wright
Jack Valliant: Barry Pepper
Paul Andrews: Kyle Chandler
Origin: United States
Language: English
Released: 2013
Production: Remington Chase, Randall Emmett, George Furla, Stephen Levinson, Arnon Milchan, Teddy Schwarzman, Mark Wahlberg, Allen Hughes; Regency Enterprises; released by Twentieth Century Fox Film Corp.
Directed by: Allen Hughes
Written by: Brian Tucker
Cinematography by: Ben Seresin
Music by: Atticus Ross; Leopold Ross; Claudia Sarne
Sound: Martin Lopez
Editing: Cindy Mollo
Art Direction: Christina Eunji Kim
Costumes: Betsy Heimann
Production Design: Tom Duffield
MPAA rating: R
Running time: 109 minutes

REVIEWS

Chang, Justin. *Variety.* January 16, 2013.
Corliss, Richard. *Time.* January 21, 2013.

Dargis, Manohla. *New York Times.* January 17, 2013.

Foundas, Scott. *Village Voice.* January 17, 2013.

Morgenstern, Joe. *Wall Street Journal.* January 17, 2013.

Rea, Steven. *Philadelphia Inquirer.* January 17, 2013.

Roeper, Richard. *Chicago Sun-Times.* January 16, 2013.

Schenker, Andrew. *Slant Magazine.* January 17, 2013.

Stevens, Dana. *Slate.* January 17, 2013.

Travers, Peter. *Rolling Stone.* January 17, 2013.

QUOTES

Mayor Hostetler: "There are some wars you fight and some wars you walk away from. This isn't the fighting kind."

TRIVIA

Producer Mark Wahlberg offered the role of Billy Taggart to Michael Fassbender, but when he declined, Wahlberg decided to play the part himself.

BULLET TO THE HEAD

Revenge never gets old.
—Movie tagline

Box Office: $9.5 Million

The early months of 2013 were not an especially good time to be an action movie star of a certain age hoping that the unexpected success of the *Expendables* franchise—in which numerous slabs of well-aged beef teamed up to beat, shoot or blow up anything that stood between them and the end of the screenplay—would allow them to once again scale the box office heights that they climbed so effortlessly back in the day. Arnold Schwarzenegger, Bruce Willis, and Sylvester Stallone all tried to pull this off and each one received a tepid-at-best commercial and critical response. In the case of the efforts of Schwarzenegger and Willis—who appeared, respectively, in *The Last Ride* (2013) and *A Good Day to Die Hard* (2013)—such a reception was deserved because those films were by-the-numbers hackwork that made even their weakest efforts from their heydays seem newly impressive by comparison. In the case of Stallone's effort, *Bullet to the Head*, audiences may have stayed away because it too sounded like more of the same but it was their loss because the film turned out to be one of the most exciting and stylishly made films of its type to come along in a while, largely due to the efforts of Walter Hill, the legendary action filmmaker returning to the big screen fray for the first time since *Undeclared* (2002).

The last couple of years have seen a number of once-popular directors from the 1970s and 1980s returning to filmmaking after long hiatuses but unlike such contemporaries as John Landis and John Carpenter, whose skills had rusted a bit over time, *Bullet to the Head* fits in so seamlessly with best work of Hill—including such favorites as *The Warriors* (1979), *48 Hrs* (1982), and *Streets of Fire"* (1984)—that it hardly feels as if Hill has been away at all. On the one hand, it is a lean and mean action film with enough of the violent stuff to satisfy viewers who only want to see big sinewy guys shoot, stab, and smack each other. At the same time, for those who are able to look beyond all the brutality on display, there are other things going on as well that help to elevate it above the usual blood-soaked silliness and into something actually worth mulling over afterwards. In other words, this is the kind of movie in which a character stops the proceedings to discuss the importance of the hero and what he symbolizes in classic mythology and *then* two guys try pound the crap out of each other with a pair of century-old fire axes.

The film stars Sylvester Stallone as Joe Bonomo, a mid-level hit man based in New Orleans for whom age has brought upon him a certain moral code—he is an honorable man in a not-so-honorable profession. While stopping off at a local zydeco bar to collect his fee after a job, he and his partner (Jon Seda) are ambushed by the brutal Keagan (Jason Momoa) and while Bonomo survives the attack, his partner dies of his injuries. Convinced that they were set up, Bonomo vows to track down the people responsible in order to avenge his dead friend. This quickly has him crossing paths with Taylor Kwon (Sung Kang), a Washington D.C. cop whose former partner, who was booted from the force in disgrace, was the guy that Bonomo just killed. The two begin an uneasy partnership to uncover who ordered the killings and why.

They eventually find themselves in pursuit of shady businessman Robert Morel (Adewale Akinnuoye-Agbaje), who is working with shadier lawyer Marcus Baptiste (Christian Slater as perhaps the least convincing Marcus Baptiste ever) to pay off cops and politicians as part of a land grab worth millions. Morel has been using Keagan as muscle but is himself beginning to grow wary of his hired goon—while the businessman is willing to broker deals in order to make things easier, Keagan is into his job not for the money has much as his sheer love of killing. Happily, Bonomo feels the same way, leading to the inevitable mano-a-mano finale in which the two go after each other with the aforementioned fire axes inside the empty warehouse/factory where films of this type always seem to arrive at in the final reel.

Although ostensibly adapted by from a French graphic novel, *Bullet to the Head* contains so many elements that will feel familiar to Hill fans that it almost takes on the aura of a greatest-hits package at times. And yet, at no time does it feel as though he is simply

going through the motions by falling back on his usual bag of tricks. The action scenes are staged and executed with a beauty and clarity that is all to rare in this overly digitized age in which noisy explosions and rapid-fire cutting are all the rage. The byplay between Stallone and Kang is clearly meant to emulate the Nick Nolte-Eddie Murphy dynamic in *48 Hrs* and while their barbed relationship is not especially original, the two actors play nicely off of each other—this is actually one of the more interesting performances that Stallone has given in quite some time. And as befitting a film steeped in the atmosphere of the Louisiana area (a milieu that Hill has explored in such previous works as *Southern Comfort* (1981) and *Johnny Handsome* (1989), Hill tells his story in a manner that prefers its own oddball rhythms to the metronomic form of most other action films while still managing to clock in at a reasonably brisk running time.

There are sure to be many people who, thanks to both the title and the current sensitivity towards anything gun-related, there is likely to be a large contingent of people eager to decry *Bullet to the Head* as little more than an orgy of senseless violence without any point or purpose. However, Hill has never been interested in simply providing viewers with cheap gory thrills and this film is no exception. The film can be seen as a straightforward yarn and it works perfectly well on that level but If you look a little closer, it can also be read as Hill's barely disguised treatise on the state of the contemporary action film, a once-proud genre that has, in his eyes, been reduced to a mindless state in which the body count is the only thing that counts and concepts such morality and ethics have been tossed aside like so much litter.

In this reading, Bonomo can be read as an extension of Hill himself, a man from a different age for whom the acts of violence he delivers are both physically and emotionally painful and which come wrapped in a personal code of ethics that recognizes the brutality he delivers and ensures that when he does unleash it, there is a point to all of it. Meanwhile, Keagan and his affectless approach to killing anything that even remotely gets in his way is more representative of contemporary action filmmakers who cheerfully create movies with astronomical body counts but who too often fail to invest any of those on-screen deaths with any meaning. Lurking in the background, of course, is Morel, the moneyman who, not unlike the studio heads and producers that Hill has tangled with in the past, who ensconces himself away from the action and is content in his belief that money rules over everything and that anything—be it loyalty, friendship, ethics or a personal vision—is just another commodity that can be bought off at the right price.

Or maybe not. The point is, *Bullet to the Head* is a thing of brutal beauty from start to finish—a genuinely exciting thriller that marks the long-overdue return of Walter Hill to the ranks of the top action filmmakers working today. Alas, at a time when Hollywood prefers such films to be as anonymous and formulaic as possible, there may not be room in the apparatus for someone with his distinctive style. That would be a shame because genre filmmaking today needs artists—and he is indeed both a true artist and a master of his medium—like him more than ever.

Peter Sobczynski

CREDITS

Jimmy Bobo: Sylvester Stallone
Taylor Kwon: Sung Kang
Keegan: Jason Momoa
Lisa Bobo: Sarah Shahi
Morel: Adewale Akinnuoye-Agbaje
Marquis Baptiste: Christian Slater
Hank Greely: Holt McCallany
Louis Blanchard: Jon Seda
Origin: United States
Language: English
Released: 2012
Production: Joel Silver, Kevin King Templeton, Alfred Gough; After Dark Films, Automatik Entertainment, Dark Castle Entertainment; released by Warner Bros.
Directed by: Walter Hill
Written by: Alessandro Camon
Cinematography by: Lloyd Ahern, II
Music by: Steve Mazzaro
Editing: Tim Alverson
Costumes: Ha Nguyen
Production Design: Toby Corbett
MPAA rating: R
Running time: 92 minutes

REVIEWS

Abele, Richard. *Los Angeles Times*. January 31, 2013.
Dargis, Manohla. *New York Times*. January 31, 2013.
Dujsik, Mark. *Mark Reviews Movies*. January 31, 2013.
Edelstein, David. *Vulture*. February 4, 2013.
Koplinski, Chuck. *Illinois Times*. January 31, 2013.
Orndorf, Brian. *Blu-ray.com*. January 31, 2013.
Tobias, Scott. *AV Club*. January 31, 2013.
Verniere, James. *Boston Herald*. February 1, 2013.
Weissberg, Jay. *Variety*. November 14, 2012.
Wilson, Chuck. *Village Voice*. January 30, 2013.

QUOTES

Robert Nkomo Morel: "When I want your opinion, I will buy you a brain."

TRIVIA

The photos of Jimmy Bobo are those of a young Sylvester Stallone.

AWARDS

Nominations:

Golden Raspberries 2013: Worst Actor (Stallone)

BYZANTIUM

Box Office: $89,237

There are certain films that almost work better as suggestions, as references to bewitching styles and moods, even to other films of their ilk. The gothic vampire movie *Byzantium* often feels that way—it is the kind of film that seems to float in and out of its own consciousness, weaving a tantalizing but often frail tapestry of entrancing visual palettes, melancholy pathos, and of course a fair amount of those old vampire-movie standbys: sex and violence. That dreamlike cinematic nature can be deeply engrossing, even mesmerizing for a bit, but, like a dream or nightmare that slowly slogs on too long, it can also get lost in its own phantasmagoria, leaving the film feeling immaterial and the viewer soon wondering if he or she ever really saw it.

Adapted for the screen by playwright Moira Buffini from her 2008 play *A Vampire Story* and directed by Neil Jordan, *Byzantium* follows two modern-day women that settle in a quiet seaside town in southern England. Clara (Gemma Arterton), the older of the pair and a former prostitute, proves herself both enrapturing and bloodily destructive, willing to manipulate to get what she wants. Clara's ward Eleanor (Saoirse Ronan) is a much more pensive and sensitive young woman with a craving to share her tale, perhaps from a need to confess or simply to express herself through storytelling.

Clara quickly finds an easy mark: a lonely man (Daniel Mays) who owns the lushly dilapidated Byzantium hotel, which Clara wastes no time turning into a brothel. Eleanor, on the other hand, falls in with a sad and soulful young man (Caleb Landry Jones) struggling with his own physical and emotional frailties and also enrolls in a creative writing class that finally gives her a chance to write out the story of her and Clara's past. According to Eleanor, that tale reaches back to the Napoleonic Wars of the early 1800s when Clara's entanglements with two British soldiers (Jonny Lee Miller and Sam Riley) gave her first her daughter, Eleanor, and later immortal vampiric life for herself and eventually Eleanor by way of a transformation ritual on a secret island.

Pursued through the centuries by a secret society of male vampire elders who do not want women in their club, Clara uses her blood-draining powers to dish out justice to wicked, abusive humans. Eleanor takes a more euthanasia-minded approach, feeding her thirst only by offering the release of death to the aged or infirm. Naturally, when Eleanor writes all this out, her present-day creative writing professor (Tom Hollander) thinks the young woman's narrative is a post-abusive therapeutic cry for help.

This is not Jordan's first film foray into a tale of an anguished vampire pair struggling with clashing moralities against a Gothic backdrop: In 1994, the Irish director adapted Anne Rice's novel *Interview with the Vampire* for the screen. Nor is Jordan new to navigating the murky mists of British-Irish myths dragged into the present: His 2009 film *Ondine* was an equally ethereal tale of a modern-day Selkie or water nymph.

Jordan brings all those cinematic powers to bear in *Byzantium* as he skillfully guides from gritty, red-light districts back through gauzy period scenes squarely drawing on the works of such Romantic writers as Byron, Keats, and both Shelleys, Percy Bysshe and his wife Mary Wollstonecraft. (Like Mary Shelley's *Frankenstein*, *Byzantium*'s narrative sometimes finds itself burrowed down into stories within stories within stories.) Buffini's literate script folds in writing and storytelling themes (including a fair dose of unreliable narrator, leaving the viewer not entirely sure Eleanor is not making all this up), but for good measure, Jordan also lays in a healthy heap of good old-fashioned Hammer Horror-style blood, lust, and blood-lust.

As a result, *Byzantium* is filled with more than enough rich atmospherics and delicious tonal contrasts—Jordan revels in both cold, misty seaside dawns and techno-beat neon nights. There are secrets both sultry and seedy, and dollops of old religion and occult rituals. (One of the film's best visual touches is a massive, secret waterfall that magically runs to blood as a new vampire is birthed in its hidden caves.)

Throughout, both Arterton and Ronan do terrific jobs of putting not-so-human faces on all this immortal tragedy. A predatory *femme fatale*, Arterton moves ever forward, sleek and shark-like, a pre- and post-feminist, eye-for-an-eye Darwinist. Ronan—who has built her young career playing characters caught between life and death in films like *The Lovely Bones* (2009), *Hanna* (2011), and *The Host* (2013)—gives quiet Eleanor an enticing old-soul wisdom and resignation while occasionally flashing a steel-cold ferocity and pragmatic strength that jars and chills in contrast.

The problem with *Byzantium* is that despite all this—or because of it, the film often feels detached from itself, adrift on its own pleasingly thick layers of visual and tonal references. Layered full with such treasures,

the film frustratingly seems to lose, not gain, emotional and narrative traction as it goes on, slowly sliding into a lethargic torpor just when it should be heating up. In other words, it rolls on and on and on and starts to feel sleepy and dull. On the positive side, however, while the film may leave viewers unsure exactly what they saw or if it all fits together, it also leaves in a siren's hook, perhaps drawing them back again someday—flushed with dark, seductive charms, *Byzantium* feels like it may well play better and run deeper on repeated viewings.

Byzantium had a very limited art-house theatrical run in North America through July, earning only $85,000. Critics often focused on the film's place in the post-*Twilight* landscape of vampire films, and their reviews were mixed but positive-leaning. David Edelstein of *New York Magazine (Vulture)* said, "The movie is gorgeous, mesmerizing, poetic; the lyricism actually heightened by harsh jets of gore," while the *New York Times*' Manohla Dargis noted, "Again and again, as the story shifts between women, times and moods, Mr. Jordan adds a punctuating flourish...that exquisitely illustrates the once-upon-a-time mood."

Locke Peterseim

CREDITS

Eleanor: Saoirse Ronan
Clara: Gemma Arterton
Frank: Caleb Landry Jones
Darvell: Sam Riley
Ruthven: Jonny Lee Miller
Origin: United Kingdom, United States, Ireland
Language: English
Released: 2012

Production: Stephen Woolley, Alan Moloney, William D. Johnson, Elizabeth Karlsen; released by IFC Films
Directed by: Neil Jordan
Written by: Moira Buffini
Cinematography by: Sean Bobbitt
Music by: Javier Navarrete
Sound: Mark Auguste
Editing: Tony Lawson
Art Direction: Martin Goulding
Costumes: Consolata Boyle
Production Design: Simon Elliott
MPAA rating: R
Running time: 118 minutes

REVIEWS

Buckwalter, Ian. *NPR*. June 27, 2013.
Dargis, Manohla. *New York Times*. June 27, 2013.
Dowd, A. A. *Onion A.V. Club*. June 26, 2013.
Edelstein, David. *New York/Vulture*. June 17, 2013.
Ingram, Bruce. *Chicago Sun-Times*. June 27, 2013.
Newman, Kim. *Empire*. May 12, 2013.
O'Sullivan, Michael. *Washington Post*. June 11, 2013.
Prickett, Sarah Nicole. *The Globe and Mail*. May 12, 2012.
Sharkey, Betsy. *Los Angeles Times*. June 27, 2013.
Zacharek, Stephanie. *Village Voice*. June 25, 2013.

QUOTES

Eleanor: "I remember everything. It's a burden."

TRIVIA

At one point, Clara uses the alias "Carmilla," which is the name of the Irish author Sheridan Le Fanu's female vampire.

C

THE CALL
(The Hive)

> *There are 188 million 911 calls a year. This one made it personal.*
> —Movie tagline

Box Office: $51.9 Million

If aliens judged humankind merely by a random slice of the American entertainment industry's output, they could be forgiven for believing that cops, doctors and lawyers (and, of course, actors) are the only professions that exist. Part of the novelty of the enjoyably twisty *The Call*, then, is that it takes as its crusading central character a 911 call-center operator. This differentiated point-of-view provides director Brad Anderson's film with a healthy dose of freshness, and a superb technical package and smart, enormously sympathetic performances supply the rest of the emotional punch in this clever, cathartic, under-regarded little thriller, which pulled in a healthy if not overwhelming $52 million during its domestic springtime release.

The Los Angeles-set film opens with emergency phone line operator Jordan Turner (Halle Berry) being unable to help save a panicked teenage girl from a violent sexual predator. Six months later and still emotionally fragile from the events, Jordan has transitioned into a supervisory training role at work. Pressed into action, however, she comes in on a call from a victim of the same serial criminal, Michael Foster (Michael Eklund), who has kidnapped Casey Welsen (Abigail Breslin) and stashed her in his trunk.

Using a second cell phone, Casey works with Jordan to try to punch out a taillight and otherwise get the attention of a passing motorist, which momentarily brings towncar driver Alan Denado (Michael Imperioli) into the picture. As the police learn of the killer's identity but remain uncertain of Casey's mobile location, Jordan frantically works with a pair of officers (Michael Chestnut and David Otunga) for the rest of her shift. But with the situation unresolved, she later strikes out on her own, seeking redemption for what she feels is her culpability in the first attack, along with the sort of definitive closure that characteristically eludes her as part of her job.

Even with its unique protagonist, *The Call* recalls other films, certainly, from remakes of *The Vanishing* (1993) and *When a Stranger Calls* (2006) to Berry's own *Perfect Stranger* (2007) and, especially in its skeevy presentation of the killer and some of its affected camerawork, *Copycat* (1995). But a lot of critics seemed unduly harsh (the movie stands at only 40 percent positive on Rotten Tomatoes) on what they viewed as familiar elements and a spare, streamlined story, discounting the considerable skill of *The Call*'s telling and ignoring the fact that genre pieces are almost by their very nature recombinant affairs.

Perhaps some critique was legitimately rooted in narrative qualms; given that the film is basically set over the course of just two separate days six months apart, there are moments when, per genre dictates, it must yield to convenient abbreviation. But certain lazy, not particularly well argued and/or gender-informed criticisms at the time of the film's release smacked of a bit of sexism (in his Film.com review, Laremy Legel called

the third act "preposterous on a level we have not seen since Christopher Guest was delivering genius mockumentaries"). If this were a different emergency responder playing a hunch, or even a man taking the same series of proactive actions that Jordan takes, it seems unlikely that it would have been met with the same sort of derision; it would just be viewed as part of a hero's assertive bloom.

They represent a slightly different breed of film, but it would be ludicrous not to point out that *The Call* echoes and also readily taps into the same vein of forthright feminine empowerment and, yes, even revenge that helped propel Ashley Judd to stardom in movies like *Kiss the Girls* (1997), *Double Jeopardy* (1999), and *Eye of the Beholder* (2000). Berry, like Judd, is physically beautiful but also quite at ease with assuming a forward-leaning, steel-spined posture of resolve. This innate quality, along with smartly lined trace elements of Jordan's panic and vulnerability, are key to Berry's electric performance. They help make the movie a powerful fantasy of comeuppance, but one that strides comfortably across gender lines.

The Call starts from a naturally suspenseful place, and ratchets up the tension in superlative fashion. Richard D'Ovidio's screenplay has a simple but darkly enticing premise, and necessarily compresses events in a fairly skillful manner while also leaving room for gripping character moments. What is best about the movie is that it is both brainy and brawny, offering up moments of trepidation and raw shock.

The performances, meanwhile, do not disappoint the material. Berry's turn is the film's glue, giving *The Call* much of its adrenaline. Eklund and Imperioli each add engaging, modulated performances that evoke strong reactions. And while Breslin ably channels terror, she is no mere scream queen. She is also hearteningly an active participant in her own struggle—another reason the film plays out as satisfyingly as it does.

Over the course of his entire filmography—and most especially in *Session 9* (2001), *The Machinist* (2004), and his "Masters of Horror" anthology entry, *Sounds Like* (2006)—Anderson has shown a keen sense of sound design, and a marionette master's ability to control mood. Here, working with cinematographer Thomas Yatsko, Anderson uses intense close-ups and even occasional fluttering freeze-frames to help underscore the movie's conflict, and particularly the leering sociopath's stress reactions.

The latter technique complements the script, which satisfyingly hints at the killer's background and motivations without completely coloring it all in. Everything builds to a conclusion that is gratifying while also retaining a pinch of ambiguity and moral remove. A crowd-pleaser that is also a potential conversation-starter is glossy Hollywood entertainment done right, and that is what makes this *Call* one worth answering.

Brent Simon

CREDITS

Jordan Turner: Halle Berry
Casey Welson: Abigail Breslin
Officer Paul Phillips: Morris Chestnut
Alan Deando: Michael Imperioli
Michael Foster: Michael Eklund
Rachel: Justina Machado
Maddy: Roma Maffia
Officer Jake Devans: David Otunga
Origin: United States
Language: English
Released: 2013
Production: Robert Stein; WWE Studios; released by Sony Pictures Entertainment Inc.
Directed by: Brad Anderson
Written by: Richard D'Ovidio
Cinematography by: Tom Yatsko
Music by: John Debney
Sound: Lon Bender
Editing: Avi Youabian
Art Direction: Charlie Campbell
Costumes: Magali Guidasci
Production Design: Franco-Giacomo Carbone
MPAA rating: R
Running time: 94 minutes

REVIEWS

Dargis, Manohla. *New York Times*. March 14, 2013.
LaSalle, Mick. *San Francisco Chronicle*. March 14, 2013.
Legel, Laremy. *Film.com*. March 14, 2013.
Linden, Sheri. *Los Angeles Times*. March 14, 2013.
McCarthy, Todd. *Hollywood Reporter*. March 12, 2013.
Puig, Claudia. *USA Today*. March 14, 2013.
Rocchi, James. *MSN Movies*. March 15, 2013.
Stewart, Sarah. *New York Post*. March 14, 2013.
Tobias, Scott. *AV Club*. March 14, 2013.
Vonder Haar, Pete. *Houston Press*. March 15, 2013.

QUOTES

Casey Welson: "Mom. Mom, you were always the perfect mother. You gave me everything that I ever wanted. And I love you. I love you so much. And I'm really sorry. Please don't ever forget me."

TRIVIA

Halle Berry was initially cast in the lead role with Joel Schumacher directing. Schumacher later dropped out and

was replaced by Brad Anderson. Berry later dropped out due to scheduling conflicts but returned once the start date was pushed up.

AWARDS

Nominations:

Golden Raspberries 2013: Worst Actress (Berry)

THE CANYONS

It's not the hills.
—Movie tagline

Box Office: $49,494

Bringing together such controversial talents as director Paul Schrader, writer Bret Easton Ellis, James Deen, a rising young star in the pornographic film industry making a bid for mainstream crossover success, and tabloid fixture Lindsay Lohan in the service of a sexually explicit melodrama whose tiny budget was funded in part by Kickstarter, *The Canyons* contains such a potentially volatile combination of elements that many observers expected an unmitigated disaster from the moment it was announced. Neither the raunch-fest that some may have hoped for nor the camp spectacular that others may have feared, this is a dark and grim meditation of greed, jealousy, and ennui that offers viewers the unpleasant but undeniably interesting sight of uncommonly pretty people doing unspeakably ugly things to each other for no particular reason at all.

As the film opens, two couples are having dinner at the kind of place where one is too busy looking around to see who else is dining there to even notice what, if anything, they are actually eating. On one side of the table is Christian (Deen), a trust-fund baby who is now dabbling in the film world by putting some of his money into the production of a cheapo slasher movie, and his girlfriend Tara (Lohan), who got him involved with the film in the first place only to inexplicably abandon the project a couple of weeks earlier. On the other side is Gina (Amanda Brooks), who is Christian's ambitious assistant and who looks upon the film as her big chance to move up the food chain, and her boyfriend Ryan (Nolan Funk), an aspiring actor who has just landed one of the key roles in the film.

What neither Christian nor Amanda know is that Tara and Ryan first met three years earlier when they both first arrived in L.A. in the hopes of finding stardom and dated for more than a year until she left him in order to pursue richer suitors who could provide her with a more comfortable lifestyle. After unexpectedly reconnecting when he turned up to audition for the

movie, Ryan and Tara begin seeing each other on the sly and the still-besotted Ryan begs Tara to leave Christian and come back to him. Inevitably, Christian learns of the affair and despite his previous bragging about his open relationship with Tara—he is currently carrying on with yoga instructor Cynthia (Tenille Houston)—his jealous nature overtakes him and his behavior soon shifts from ordinary levels of creepiness to the psychosexual to the just plain psycho with disturbing results for one and all.

For anyone who is familiar with the works of Bret Easton Ellis, the coldness of the characters and the detached manner in which they are observed will not come as much of a surprise. However, figuring out a way of translating his chilly prose into cinematic terms has largely stymied filmmakers over the years. In theory, the idea of pairing him with the likes of Paul Schrader, a director who is usually at his best when he is working with material of his own, sounds like another potential disaster in the making. Against all odds, the two apparently managed to find the same wavelength on which to work together because their collaboration proves to be a successful one in which each one's unique talents wind up complementing the other's.

An enormously talented filmmaker who has struggled in recent years to find a place in an increasingly frivolous industry for his comparatively serious-minded fare, he seems to have been rejuvenated by the unique circumstances surrounding this particular project and the result is the most focused and committed work that he has done in years. Sex, murder, guilt and personal/cultural ennui are subjects that he has dealt with in many of his past films but he manages to make them feel fresh here. At the same time, he also turns the film into a rueful elegy to the Hollywood that he and his contemporaries revered while growing up and eventually revolutionized—a place where film has been replaced by video, once-sparkling movie palaces now lay in ruins, any two-bit psycho with a lot of family money can arbitrarily call himself a producer and even the people who do make the movies demonstrate no particular interest in them as anything other than as a commodity that can be marketed profitably.

The two leads also prove to be surprisingly effective as well. Deen, as mentioned earlier, is one of the more familiar faces (among other body parts) in contemporary pornography but based on his work here, he could plausibly carve out a niche for himself in the legitimate film industry as well. The character of Christian is a soulless monster who fully believes that his wealth and privilege, neither of which he has personally done anything to achieve, accords him the right to do whatever he wants to whomever he wants and Deen finds just the right note of methodical cool on which to

play him so that the monstrousness comes out along without stepping over into pure cartoonishness.

By comparison, Lohan hardly seems to be acting at all—the line between her, or at least the version of her we have come to know through the tabloids, and her character hardly seems to exist at all. She is basically an exposed nerve throughout and as a result, it is pretty much impossible to take your eyes off of her when she is on the screen. Whether her work here turns out to be a turning point in her on-again, off-again career or not remains to be seen but it cannot be denied that she demonstrates enough raw charisma on the screen to make you understand why some people would still be willing to take a chance on her despite all of her previous missteps.

For most viewers, *The Canyons* will most likely prove to be an unsatisfying moviegoing experience—there is little in the way of conventional narrative drive, the characters are not especially likable and while there is plenty of sex and violence on display, hardly any of it is presented in a traditionally exciting manner. Instead, it presents viewers with some thoroughly unlikable characters and asks them to observe these people at length with the same kind of cool detachment that is their own emotional default mode.

Peter Sobczynski

CREDITS

Tara: Lindsay Lohan
Christian: James Deen
Ryan: Nolan Gerard Funk
Gina: Amanda Brooks
Dr. Campbell: Gus Van Sant
Cynthia: Tenille Houston
Origin: United States
Language: English
Released: 2013
Production: Braxton Pope; released by IFC Films
Directed by: Paul Schrader
Written by: Bret Easton Ellis
Cinematography by: John DeFazio
Music by: Brendan Canning
Sound: Michael Miramontes
Music Supervisor: Amine Ramer
Editing: Tim Silano
Art Direction: John Blake Pietrolungo; Blake Piertolungo
Costumes: Keely Crum
Production Design: Stephanie Jacob Gordon
MPAA rating: Unrated
Running time: 99 minutes

REVIEWS

Dargis, Manohla. *New York Times.* August 1, 2013.
Denby, David. *The New Yorker.* July 29, 2013.
Edelstein, David. *Vulture.* August 2, 2013.
Foundas, Scott. *Variety.* July 28, 2013.
McCarthy, Todd. *Hollywood Reporter.* July 28, 2013.
Orndorf, Brian. *Blu-ray.com.* July 31, 2013.
Tallerico, Brian. *HollywoodChicago.com.* July 30, 2013.
Thomson, David. *The New Republic.* August 7, 2013.
Turan, Kenneth. *Los Angeles Times.* August 8, 2013.
Zacharek, Stephanie. *Village Voice.* July 30, 2013.

TRIVIA

As described in an in-depth, behind-the-scenes article in the *New York Times* about the film's production, Paul Schrader directed a sex scene naked in an effort to placate actress Lindsay Lohan.

AWARDS

Nominations:

Golden Raspberries 2013: Worst Actress (Lohan)

CAPTAIN PHILLIPS

Out here survival is everything.
　　—Movie tagline

Box Office: $107 Million

On most every creative level, *Captain Phillips* is impressively made and bracingly, rivetingly tense film. Yet as powerful a work of cinema it is, the film leaves the viewer somewhat confused as to the filmmakers' and the film's intent—whether perhaps that confusion is the intent—and to what extent a work of art is responsible for its audience's interpretation. Ultimately, the viewer is left to decide if that confusion makes *Captain Phillips* a stronger or weaker piece of art and entertainment.

Directed by Paul Greengrass, *Captain Phillips* is written by Billy Ray based on the 2010 non-fiction book *A Captain's Duty: Somali Pirates, Navy SEALs, and Dangerous Days at Sea* by Richard Phillips and Stephan Talty. The book is Captain Richard Phillips' account of the 2009 hijacking off the Horn of Africa of his American cargo-container ship Maersk Alabama by four young Somali men and the subsequent five-day showdown between the United States Navy and the pirates holding him hostage in a small, enclosed lifeboat.

During their filmmaking careers, both Greengrass (*Sunday, Bloody Sunday* [2002], *United 93* [2006], *The Green Zone* [2010]) and Ray (*Shattered Glass* [2003], *State of Play* [2009]) have grappled with complicated,

often shocking and emotional political events by focusing on the all-too-human individuals caught up in them, complete with their murky mix of heroics and failings. Nor have their films shied away from trying to at least understand the motivations and circumstances driving the players on all sides of a conflict.

That is certainly the case in *Captain Phillips*: From the film's start we see Phillips (Tom Hanks) preparing to ship out and talking with his wife (Catherine Keener putting in a brief and mostly symbolic appearance) about the rapidly changing and increasingly cutthroat world their children will inherit, and how much harder he has to work, how much better he has to perform to keep his job. Greengrass then jumps across oceans and continents to an impoverished Somali village where a young, desperate would-be pirate named Muse (striking newcomer Barkhad Abdi) is pressured by warlords to try and capture a large shipping prize. (The modern-day Somali pirates earn their money not so much from seizing cargo goods, but by demanding ransom payouts from shipping companies' insurance coverage.)

The message is clear: Both Phillips and Muse—whose lives will soon violently collide—are both driven to take greater risks while working under the heels of large, brutal economic systems. Later Muse tells Phillips that his acts of piracy are "only business," and Greengrass and Ray do not dismiss the notion that the pirate may be speaking the truth. *Captain Phillips* does not go soft on the pirates or their sometimes violent acts, but nor does it dismiss them as broadly-painted "evil terrorists." Muse insists he is only a fisherman, albeit now forced to "fish" for shipping ransoms, and there is an argument to be made that he has a point: When the Somali government collapsed in the 1990s, other nations not only swooped in and cleaned out fishing grounds the nation could no longer enforce, but also dumped toxic and nuclear waste in Somali waters.

Greengrass introduces these two very different men from very different parts of the world with equal care and depth and then sets about ratcheting up the narrative that will force them into conflict on the bridge of the massive Maersk Alabama. Acting newcomer Abdi, born in Somalia and raised in Yemen and the United States, dives directly into his role with striking naturalism. His eyes wide, mouth pulled tight into an emaciated grin, the actor effortlessly makes Muse both sympathetic and frighteningly unpredictable—the actor and character are asked to represent both The Other and The Human Brother (whose deepest dream is to one day go to America and own a car).

On the other hand, at first Hanks seems unable to find his footing with Phillips—in early scenes the character is intentionally uninteresting; a pedantic by-the-book company man, much more uptight middle manager than the romantic stereotype of a sea captain. It is only later, as the situation escalates that Hanks masterfully pulls out a varied and bag of emotions, as Phillips caroms from courageous authority and ingenuity to exhausted fear and desperation and even some parental protection over the younger and more innocent of the pirates.

As is usually the case in Greengrass' films, the director, working with his regular cinematographer Barry Ackroyd, plunges rapidly, seemingly recklessly into a sort of aggressive cinematic verisimilitude. While the camera sometimes drops back to show the relative sizes of towering container ship and the pirates' tiny outboard skiffs against the wide Indian Ocean, for the most part Ackroyd's handheld lens roams in close behind individuals at they go about their business, be it shipping containers aboard a ship that sometimes feels like a floating fluorescent office space, or desperate piracy aboard small, tight, boats seething with overheated anger. Despite its rawness, there is nothing loose or sloppy about this style: Combined with dialogue that often feels ambient, the effect is intimate, immediate, and alive—and when events begin to spiral out of control into more violent conflict, Greengrass' approach cranks at the tension.

Captain Phillips neatly divides into three parts: The paths of the two "captains" at work on their respective sea craft; their eventual intersection as Muse and his small, ragged crew board the Alabama and face off against Phillips and his crew (who have their own gripes about union regulations, pay, and the dangers of sailing in pirate waters); and the longest and most intense final section, when Phillips is taken hostage for ransom by the pirates in the close, hot, claustrophobic life boat.

The film and its based-on-a-true-story narrative take a sharp turn once the US Navy sails into the scene, muscular warships announcing their presence in the night with deafening fog horns. Suddenly, as in real life, what had been a scary but human stand off between two individuals quickly becomes an international incident, and Greengrass wants the viewer to react simultaneously with a leap of rah-rah pride and glee at the arrival of the cavalry and a sense of dark inevitability: As the full might of the world's greatest superpower bears down on them, the confused, bickering young pirates are doomed.

To that end, Greengrass tries to hold in check the sort of patriotic cheering and chest-thumping that might accompany the Navy in a lesser, more jingoistic action film. He presents the military, and later a team of Navy SEALS, as calm, business-like professionals—their ships, helicopters, and weaponry are not fun toys, but simply tools used to do a job.

This, however, is where Greengrass and Ray lose some control of their film's message and meaning. *Captain Phillips* feels like it wants to both subvert and pander to audience expectations. It wants to show both sides of the crisis and a larger human connection across cultures and geo-political circumstances, but the viewer can feel Greengrass giving in to the more Hollywood need to make the film exciting and entertaining. No matter how matter-of-fact the film tries to make it, the SEALs para-dropping out of the darkness comes off as action-film "cool." In fact, in a film that had gone out of its way to present all its players—merchant marines, pirates, Navy sailors—as average, realistic humans, the SEAL commander is played by stoic, square-jawed actor Max Martini, who has made a career as stern, upright military men in films and TV shows like *Saving Private Ryan, The Unit,* and *Pacific Rim*—his presence in *Captain Phillips* begins to give the film a more formulaic feel.

From that point on, *Captain Phillips* feels conflicted, as if the film itself is getting in the way of what Greengrass and Ray intended to say. It does not help matters that while Hanks is eventually terrific in the role of Richard Phillips, viewers are unlikely to forget that he is Tom Hanks, the Beloved Everyman. As much as the film works for empathy over villainy and humanism over heroism; as much as it tries to avoid a triumphant sense of one side "winning" and to show a wider, more nuanced and complex moral view of the world and the clashes between super powers and failed, impoverished nations; in the end the audience roots for the immediate problem on the lifeboat to be "fixed"—for Tom Hanks to be rescued and the day to be "won" by overwhelming military might. When it is—after building to a masterfully excruciating crescendo of thrilling suspense—the film *Captain Phillips* goes quiet, even as the shocked and shattered character Captain Phillips cries out, "What was that?"

The film's title, *Captain Phillips,* points not toward a heroic figure, but a small individual on a giant world stage; a sprawling, wide ocean where average, un-heroic people find themselves both representatives and catalysts of powerful, crushing forces—where tiny bobbing lifeboats are pursued by hulking warships. The film closes without joy or celebration, but with Phillips' exhausted sobs, perhaps of relief, perhaps of regret. There is not, however, any sense that the bigger problems—the dark future both Phillips and Muse were trying to outrun—have been solved.

Perhaps that was Greengrass' plan all along—to leave the viewer as shaken and adrift as Hanks' Richard Phillips is by the senseless tragic outcomes produced by the world's broken system, with its economic death traps. There is the suspicion, however, that many Americans who saw *Captain Phillips* may have left the theater with a somewhat different takeaway: "Thank God we have the biggest, baddest Navy in the world."

Locke Peterseim

CREDITS

Captain Richard Phillips: Tom Hanks
Muse: Barkhad Adbi
Shane Murphy: Michael Chernus
Andrea Phillips: Catherine Keener
Mike Perry: David Warshofsky
Origin: United States
Language: English
Released: 2013
Production: Dana Brunetti, Michael De Luca, Scott Rudin; Scott Rudin Productions; released by Columbia Pictures Corp.
Directed by: Paul Greengrass
Written by: Billy Ray
Cinematography by: Barry Ackroyd
Music by: Henry Jackman
Sound: Oliver Tarney
Music Supervisor: Michael Higham
Editing: Christopher Rouse
Art Direction: Charlo Dalli
Costumes: Mark Bridges
Production Design: Paul Kirby
MPAA rating: PG-13
Running time: 134 minutes

REVIEWS

Bradshaw, Peter. *The Guardian.* October 9, 2013.
Hornaday, Ann. *Washington Post.* October 10, 2013.
Lacey, Liam. *The Globe and Mail.* October 10, 2013.
Lane, Anthony. *The New Yorker.* October 7, 2013.
Mondello, Bob. *NPR.* October 11, 2013.
Morgenstern, Joe. *The Wall Street Journal.* October 10, 2013.
O'Hehir, Andrew. *Salon.* October 7, 2013.
Phipps, Keith. *The Dissolve.* October 8, 2013.
Stevens, Dana. *Slate.* October 10, 2013.
Zacharek, Stephanie. *Village Voice.* October 8, 2013.

QUOTES

Captain Richard Phillips: "There's got to be something other than being a fisherman or kidnapping people."
Muse: "Maybe in America, Irish, maybe in America."

TRIVIA

Actor Tom Hanks claimed that all the interior lifeboat scenes were filmed inside a scale model on water at all times, resulting in him being vomited on by sea sick crew members.

British Acad. 2013: Actor—Supporting (Adbi)

Writers Guild 2013: Adapt. Screenplay

Nominations:

Oscars 2013: Actor—Supporting (Adbi), Adapt. Screenplay, Film, Film Editing, Sound, Sound FX Editing

British Acad. 2013: Actor (Hanks), Adapt. Screenplay, Cinematog., Director (Greengrass), Film, Film Editing, Orig. Score, Sound

Directors Guild 2013: Director (Greengrass)

Golden Globes 2014: Actor—Drama (Hanks), Actor—Supporting (Adbi), Director (Greengrass), Film—Drama

Screen Actors Guild 2013: Actor (Hanks), Actor—Supporting (Adbi)

CARRIE

> *You will know her name.*
> —Movie tagline

> *Know her name. Fear her power.*
> —Movie tagline

Box Office: $35.3 Million

The third filmed incarnation of Stephen King's 1974 novel *Carrie* has a lot going for it. It goes back to the source material to differentiate itself from an unforgettable 1976 Brian De Palma version, offers pitch perfect casting, and brings Kimberley Peirce into the fold; a director who is more interested in the characters than the gory spectacle. Thematically rooted in contemporary concerns about bullying and the marginalization of the mentally ill, this version of *Carrie* is at once relevant and a solidly better mainstream horror film than the vast majority of mainstream scary teen fare whose visual aesthetic it embraces.

The films opens on a terrorized Margaret White (Julianne Moore) crying out to God to cure what she believes is cancer. Soaked sheets and blood clue viewers in that she is, instead, giving birth, and when she spasms violently, sure that she is about to die, she is surprised to find a baby between her legs. Muttering that it must be a test, she picks up a pair of scissors only to find herself unable to continue her downward stab. The scene ends as she cradles her daughter. This significant narrative deviation takes the film immediately into a different space. Outwardly, the plot follows virtually the same lines as the De Palma version. But the primary relationship is set by that opening scene: This is a film about Carrie (Chloe Grace Moretz) and her mother.

In school, Carrie is the definitive outsider. Boys hardly know she exists and she is so isolated by her mother that her first period, which takes place in the showers after gym class, precipitates a horrifying bullying episode in which her fellow students, led by Chris Hargensen (Portia Doubleday), pelt her with tampons. But even as Ms. Dejardin (Judy Greer) the gym teacher moves to punish those responsible, Carrie becomes aware of newfound telekinetic powers which she begins to experiment with and learn to control. Meanwhile, unlike Chris, fellow student Sue Snell (Gabriella Wilde) willingly takes her punishment, and, full of remorse, asks her own date, Tommy Ross (Ansel Elgort), to take Carrie to the prom instead. At home Carrie's powers are beginning to cause all sorts of friction, but she is also growing in confidence and finally relents under Tommy's relentless requests to be his prom date. But what neither Sue, Tommy, or Carrie herself know is that Chris has planned her revenge; a revenge that will take place on prom night and forever change the lives of those who attend.

Moretz can be said to be too pretty for this role but where the film fails at giving her a convincingly dowdy appearance, such as has become associated with the role, Moretz steps ups her performance by crafting a complex character whose main problem is not a lack of outer beauty but inner confidence and emotional stability that leads to a slow degradation of sanity through the wrong kind of empowerment. Carrie needs support of other people not preternatural powers to keep her mother at bay and discover her own sense of self. Not as disturbed as her mother, she recognizes the need to fit in but that she is trapped inside her home.

Viewers will likely have known someone just like this: Someone who would look okay if they just dressed a little different, and combed their hair. Yet there is an indictment in such observations. In this version, the famous and unavoidable locker room tampon throwing sequence is uploaded to the internet. A film based in reality would have scenes full of lawyers, police, and nervous school administrators as well as teens. But in this world, the world of *Carrie,* viewers watch a young woman desperate to break in when what she really needs to do is break out. Moretz hits that balance like an ace gymnast while Peirce nails the sheer terror of a girl who knows everyone thinks she is weird.

Julianne Moore is, as always, a wonderment. She embraces the redefinition of Carrie's crazy mother not so much as a critique of religion but as an emblem of the isolation humanity too often forced on those who are too wounded to build lasting relationships and communities around them. She seethes with a self-righteousness made all the more disturbing by how utterly frightened she is of the real world. Unable to face her daughter's first period, unable to face the fact that people live and believe differently than she does, she hides only able to come out momentarily to show spare

affection to her daughter. Even that must be tempered with rigid control. Piper Laurie had more fun in her own brilliant interpretation but Moore is far less theatrical and dangerously close to the real idea of mania, religious or otherwise.

The adult world here is just as clueless as it ever was in the manner it attempts to control the chaos inside the walls of the school. Hemmed in by local politics, and a relentless lack of conscience on the part of the student body even the best intentioned and most proactive adults in the story are left to flounder. Peirce wisely lets that happen for the most part and thus retains one of the most powerful aspects of King's source material. Everyone suffers because of what happened, good and bad alike.

The film's technical merits are a little more spare. The special effects sequence at the end of the film involving the destruction of the prom and the town seems a little out of Peirce's grasp. Shots are cut together so quickly that they have little impact individually or collectively and it becomes difficult to know exactly what is going on. There are some highlights: A flaming body dancing in slow motion, a car suspended in mid-air, and any number of shots of Carrie herself that are reasonably blood-curdling. Ultimately, Peirce fails to generate the atmosphere that would have quelled some of the unfavorable comparisons to the De Palma version. The film is at its strongest when its characters talk to one another and at its weakest when it tries to fulfill genre conventions.

Shortly after Stephen King wrote what became *Carrie* he promptly tossed it in the trash. His wife Tabitha dug it out, and, after reading, handed it back, making him promise to finish it. It changed their lives forever. Since then, it has survived as a powerful meditation on the teen experience. But Peirce has carried the narrative forward. Yes *Carrie* is a cautionary tale of the perils of bullying and the monsters it creates but as Carrie cradles her dead crazy mother on the floor and literally self-implodes, the story also serves as a reminder that those monsters are still, somehow human beings. Maybe everyone is some kind of monster it seems to suggest and maybe everyone should be treated like a human being.

Dave Canfield

CREDITS

Carrie White: Chloe Grace Moretz
Margaret White: Julianne Moore
Chris Hargensen: Portia Doubleday
Sue Snell: Gabriella Wilde
Miss Desjardin: Judy Greer
Tommy Ross: Ansel Elgort
Billy Nolan: Alex Russell
Tina: Zoe Belkin
Origin: United States
Language: English
Released: 2013
Production: Kevin Misher; Metro-Goldwyn-Mayer Pictures, Misher Films; released by Screen Gems
Directed by: Kimberly Peirce
Written by: Roberto Aguirre-Sacasa
Cinematography by: Steve Yedlin
Music by: Marco Beltrami
Sound: Peter Staubli
Editing: Lee Percy
Costumes: Luis Sequeira
Production Design: Carol Spier
MPAA rating: R
Running time: 100 minutes

REVIEWS

Brody, Richard. *New Yorker.* October 21, 2013.
Dargis, Manhola. *New York Times.* October 17, 2013.
Demara, Bruce. *Toronto Star.* October 17, 2013.
Edelstein, David. *Vulture.* October 18, 2013.
Goss, William. *Film.com.* October 17, 2013.
O'Sullivan, Michael. *Washington Post.* October 17, 2013.
MacDonald, Moira. *Seattle Times.* October 17, 2013.
McWeeny, Drew. *HitFix.* October 24, 2013.
Nicholson, Amy. *L.A. Weekly.* October 17, 2013.
Rooney, David. *Hollywood Reporter.* October 17, 2013.

QUOTES

Sue Snell: "Carrie had some sort of power. But she was just like me, like any of you. She had hopes, she had fears, but we pushed her. And you can only push someone so far before they break."

TRIVIA

Despite being billed as a new adaptation of the novel, many elements were borrowed from Lawrence D. Cohen's adaptation of the 1976 film.

CLOSED CIRCUIT

They see your every move.
—Movie tagline

Box Office: $5.8 Million

London—a moody city seemingly always on the verge of rain tears, a place where the sun literally does not shine, with dark clouds always overpowering foolish

rays of light (at least as in 2012's *Skyfall* or 2011's *Tinker Tailor Soldier Spy*). Similarly, it is a land of security cameras, running upwards of four million of them, where every nose-pick, wink, or love affair can be documented with numerous angles.

Similarly, London is also the land of the Special Advocate, a zany special designation that allows for hot topic terrorist suspects to face the court in closed sessions, as opposed to trials with coverage that is open to the public. If the evidence against a suspect is too sensitive to be handled by regular law folk or revealed in public as its contents could damage ongoing government investigations, one person is appointed the Special Advocate position, in which only they can see the potentially harmful information, and may not speak to anyone on their law team (including their defense attorneys and barristers) once they have begun viewing the secret evidence.

The Special Advocate in the story of director John Crowley's *Closed Circuit* is Claudia (Rebecca Hall), who is appointed such a position in a hot-button case for Farroukh Erdogan (Denis Moschitto), a suspect in a gruesome terrorist bombing that is shown in the beginning of the film. When Farroukh's original defense attorney is murdered, a lawyer named Martin (Eric Bana) steps into the position, which is shown to be even more dangerous when it is revealed Claudia and Martin were once lovers. While they attempt to hide that footnote about their love life, such becomes a vulnerable nerve for their enemies as the two progressively unravel the mystery of this case, realizing that the truth behind the terrorist attack involves fault with their government itself.

Playing opposite each other in a sharp bit of casting for a mature thriller such as this, Bana and Hall are better separate more notably than they are together. The conflict's entire point of the job-jeopardizing boot-knocking that they once shared is not given a scandalous nature with their visible bonding. One may accept with a shrug of the shoulders that the two mashed faces in an isolated copy room once, but not so much a significant affair, especially one that could forever change their professional status. The danger that their hormones are compromised does not linger, but thankfully the one of them possibly becoming unexpectedly predisposed does.

While the two leads make *Closed Circuit* a compelling story of characters looking behind their shoulder, the film's brightest gem is Jim Broadbent, playing the Attorney General in Claudia's case. With a thorough line of wide-eyed amicability to be seen in many of his past roles across numerous genres, Broadbent has great potential for the passive-aggressive, with such shown center stage here. When first introduced, he is a tongue-tied figurehead. But later, his smile turns into a devious grin, and he shares with Bana's character the film's most intriguing conversation, which also doubles as a damning threat. Sitting quietly in a diner on a foggy London day, Broadbent's scene-stealing character opens Bana's to the cruel realities of the larger picture involving government control of justice; it is a mini mirror to the type of crushing pessimism expounded in Ned Beatty's incredible monologue in 1976's *Network*.

Closed Circuit is an old-fashioned thriller (1974's *The Parallax View* comes to mind as comparison) that banks its key finale political statement on a risky plot contrivance, while the hot-hot-hot information itself is essentially its MacGuffin. In these ways, this movie is a (second) aggressive "letter to the editor" from *Eastern Promises* (2007) scribe Steven Knight, who is very disturbed by the invasive nature of security cameras (CCTV footage also appears in his 2013 directorial debut *Redemption* with Jason Statham). With much of this story's contents functioning more like triggers for a plot than actual plot details themselves, *Closed Circuit* should not work.

And yet with its blanketing of palpable paranoia to its turning course of events, *Closed Circuit* does. Its nervousness creeps in nicely; genuine surprises about the film's central case keep this movie at a strong speed in the face of its emphasis on dialogue and secret meetings. As everything gets progressively stranger, the uncertainty of who to trust, and specifically who to trust with the safety of the film's protagonists, reaches a fine point where pessimism weds the concept of all-encompassing power. The film's ending might topple a good amount of what has been set up, but at least *Closed Circuit* makes one anxious to arrive there.

With its tangled pitch for attention, especially to audiences unfamiliar with the concept of the Special Advocate, *Closed Circuit* is in need of clearing a few things up, sometimes twice over. To achieve this the film uses obvious exposition dialogue, one of the blunter tools in a screenwriter's collection, but nonetheless one that earns an excuse for its necessity with this yarn. Without having characters explain the rules to each other out loud, (even though the viewer would assume such characters would know them already) *Closed Circuit* would not be able to achieve the relaxed amount of brain power that it ultimately does earn. But once made clear, the unusual rules of *Closed Circuit*'s government-and-mouse thriller do not hold the film back. Thankfully, screenwriter Knight does not wear down this

device, leaving it alone once *Closed Circuit* hits its top speed.

His script certainly driven by political outrage that can be agreed upon beyond the millions of lead characters on London's CCTV, Knight and director Crowley have succeeded in crafting a shifting story that languishes beyond its initial contained inspiration. *Closed Circuit* is an intriguing who-is-doing-it with more than just its timeliness to keep it worthy of nervous interest.

Nick Allen

CREDITS

Martin Rose: Eric Bana
Claudia Simmons-Howe: Rebecca Hall
Devlin: Ciaran Hinds
Nazrul Sharma: Riz Ahmed
Melissa: Anne-Marie Duff
Cameron Fischer: Kenneth Cranham
Joanna Reece: Julia Stiles
Attorney General: Jim Broadbent
Farroukh Erdogan: Denis Moschitto
Origin: United Kingdom, United States
Language: English
Released: 2013
Production: Tim Bevan, Chris Clark, Eric Fellner; Working Title Films; released by Focus Features L.L.C.
Directed by: John Crowley
Written by: Steven Knight
Cinematography by: Adriano Goldman
Music by: Joby Talbot
Sound: Jim Greenhorn
Editing: Lucia Zucchetti
Art Direction: Matthew Gray
Costumes: Natalie Ward
Production Design: Jim Clay
MPAA rating: R
Running time: 96 minutes

REVIEWS

Berardinelli, James. *Reel Views.* August 29, 2013.
Dargis, Manohla. *New York Times.* August 28, 2013.
Hornaday, Ann. *Washington Post.* August 28, 2013.
LaSalle, Mick. *San Francisco Chronicle.* August 28, 2013.
MacDonald, Moira. *Seattle Times.* August 28, 2013.
Phillips, Michael. *Chicago Tribune.* August 28, 2013.
Rea, Steven. *Philadelphia Inquirer.* August 28, 2013.
Sachs, Ben. *Chicago Reader.* August 29, 2013.
VanDenburgh, Barbara. *Arizona Republic.* August 28, 2013.
Zacharek, Stephanie. *Village Voice.* August 27, 2013.

QUOTES

Martin Rose: "Can I sit between two people who hate each other? I like to come as a relief."

CLOUDY WITH A CHANCE OF MEATBALLS 2

Back for seconds.
 —Movie tagline
Something big was leftover.
 —Movie tagline
Fast food.
 —Movie tagline
Move your buns!
 —Movie tagline

Box Office: $119.5 Million

There is no clear reason why 2009's *Cloudy with a Chance of Meatballs* should have been as good as it was. It was a film that was animated by Sony Pictures Animation, based on a beloved children's book (adaptations are tricky), featured no marquee stars (the leads included a *Saturday Night Live* character actor and Mr. T), and was written and directed by two men (Christopher Miller and Phil Lord) whose primary credit to date had been an animated series that was quickly cancelled by MTV after thirteen episodes (the underrated *Clone High*). On paper, those elements do not read like a recipe for success and yet *Cloudy with a Chance of Meatballs* was an enormously pleasant surprise. While Pixar might be the reigning king of motion picture animation and the vast majority of its films are unquestioned works of art (aside from the *Cars* and *Planes* franchises), the sad fact is that the wunderkind hit factory has yet to make a film as laugh-out-loud funny as *Cloudy with a Chance of Meatballs*. Working against the odds, Lord and Miller turned a 32-page picture book about a town where food falls from the sky into a riotous, ingenious romp that was silly enough for kids, but smart enough for parents as well.

Cloudy proved to be popular enough with audiences (and critics) to warrant a sequel, however, it also meant that Miller and Lord were popular enough to want to try their hands at new projects. (Their first post-Cloudy collaboration, *21 Jump Street* [2012], was another surprising comedy smash.) Thus, Miller and Lord remained on *Cloudy 2* as producers and long-time animators Cody Cameron and Kris Pearn—who both worked on the original—took over the director roles. The scripting duties were passed onto *Clone High* alum Erica Rivinoja and *Horrible Bosses* (2012) scribes John

Francis Daley and Jonathan M. Goldstein, and production of the sequel began in earnest. However, the question loomed—how responsible were Miller and Lord for the distinct comedic voice of the original? And could that voice be replicated by a team presumably working under their supervision?

The answer turned out to be "Almost," because, while *Cloudy with a Chance of Meatballs 2* is a charming enough diversion, it simply does not have the same lunatic spark or emphasis on character comedy that made the original so memorable. After a brief recap, *Cloudy with a Chance of Meatballs 2* opens minutes after the first movie ended, with Flint Lockwood (Bill Hader) and friends standing on the leftover-buried remains of their home, the Island of Swallow Falls, after it was pummeled by food-weather created by Flint's invention, the FLDSMDFR, a machine that turned water into food. Suddenly, futuristic helicopters descend on the island and out steps Chester V (Will Forte)—a famous inventor, an obvious Steve Jobs analog, and Flint's childhood hero. Chester V's Live Corp has been contracted by the United Nations to clean up the food-related mayhem created by Flint's FLDSMDFR and Chester pledges to relocate the residents of Swallow Falls to San Franjose, California. Chester also offers a coveted position at Live Corp to Flint, which delights the star-struck inventor, although his girlfriend Sam Sparks (Anna Faris), his dad Tim (James Caan), and the rest of his friends are suspicious of Chester's true intentions.

Anxious to make a good impression, Flint flounders at the over-caffeinated, Google-esque Live Corp campus and, after embarrassing himself at a company function, he attempts to get back into Chester V's good graces by agreeing to a dangerous mission. Various Live Corp search-and-rescue teams have been unable to find the remains of the FLDSMDFR on Swallow Falls and Chester wants Flint to return to the island on his own to find his lost invention. Flint immediately agrees, but is unable to sneak back to the island without Sam and the rest of his friends joining him for the trip. What they find on Swallow Falls amazes them—the island has transformed into a lush food jungle, complete with syrup swamps and rock candy mountains. If that was not enough, the jungles of Swallow Falls are now teaming with sentient food creatures, such as Mosquitoast, Shrimpanzees, Peanut Butter and Jellyfish, Watermelophants, and the fearsome Tacodile Supreme.

The foodimals are all wildly inventive and the artistic team for *Cloudy 2* really shines once Flint and his friends return to Swallow Falls. The design work is so impressive, however, that there are parts of the film where it feels like everything else in the story is shoved to the rear in order to show off more of the amazing food creations. The first *Cloudy* had a penchant for pun-

ning that was expertly executed, but the food humor in *Cloudy 2* wears after a while, so do the on-the-nose jabs at Apple/Google corporate culture, which seems like a fairly easy and outdated target for satire (i.e. Vince Vaughn and Owen Wilson's *The Internship* [2013]). While the first *Cloudy* kept finding increasingly clever ways to use the insanity of the food weather as a backdrop for Flint Lockwood's quest to find a purpose in life, there isn't much driving the story in *Cloudy 2*. The bad guys are non-threatening and obvious, the food animals are cute and benign, and Flint does not really have much to do, other than react to what is happening around him. The original was about a crazy kid who finally proved to the world that he was capable of something amazing and who also learned big lessons about humility, identity, and the importance of friends. In *Cloudy 2*, as a necessity of the story, Flint spends a large portion of the film estranged from his friends or caught up in the lies of a very, very obvious villain and so the character does not have the same opportunities to bounce off his counterparts as he once did. It just lacks the energy that so defined Flint's first adventure.

That said, the creative team packs so many visual and verbal jokes into every second of *Cloudy with a Chance of Meatballs 2* that a lot of the humor still hits its targets. There are many, many laughs in this movie. It is a perfectly nice film—funny and interesting with a very distinct look—but it just does not have the same sense of inspiration and bravado that so defined Miller and Lord's original. As often happens with second helpings, it is just not as satisfying as the first.

Tom Burns

CREDITS

Flint Lockwood: Bill Hader (Voice)

Sam Sparks: Anna Faris (Voice)

Tim Lockwood: James Caan (Voice)

Chester V: Will Forte (Voice)

Brent McHale: Andy Samberg (Voice)

Origin: United States

Language: English

Released: 2013

Production: Kirk Bodyfelt; released by Sony Pictures Entertainment Inc.

Directed by: Cody Cameron; Kris Pearn

Written by: John Francis Daley; Jonathan M. Goldstein; Erica Rivinoja

Music by: Mark Mothersbaugh

Sound: Geoffrey G. Rubay

Music Supervisor: Kier Lehman

Editing: Robert Fisher; Stan Webb

Art Direction: David Bleich

Production Design: Justin Thompson

MPAA rating: PG

Running time: 95 minutes

REVIEWS

Bale, Miriam. *New York Times.* September 26, 2013.

Debruge, Peter. *Variety.* September 25, 2013.

Dowd, A. A. *The A.V. Club.* September 25, 2013.

Hartlaub, Peter. *San Francisco Chronicle.* September 26, 2013.

Henderson, Eric. *Slant Magazine.* September 26, 2013.

Persall, Steve. *Tampa Bay Times.* September 30, 2013.

Phipps, Keith. *The Dissolve.* September 25, 2013.

Rechtshaffen, Michael. *The Hollywood Reporter.* September 25, 2013.

Russo, Tom. *Boston Globe.* September 26, 2013.

Uhlich, Keith. *Time Out New York.* September 27, 2013.

QUOTES

Tim Lockwood: "I don't get vests. What, is it winter in your torso but summer in your arms?"

TRIVIA

Mr. T was invited to repise his role from the first film for the sequel, but declined.

THE COMPANY YOU KEEP

You can't escape the past.
—Movie tagline

Box Office: $5.1 Million

Except when it comes to that abidingly-thick but now artificially-colored thatch of strawberry blonde, septuagenarian Robert Redford is not only willing but determined to reveal gray areas that will give the public pause. His expressed desire as a director is to enable viewers to consider the ambiguities and complexities that lie beneath what has been prettied-up or too-patly put forth about America's past and present. Only after such delving, Redford asserts, can one claim to have adequately assessed a matter, and thus his aim is to facilitate a fuller, deeper level of understanding. His attempts to elicit constructive pondering proved to be rather ponderous in *Lions for Lambs* (2007) and *The Conspirator* (2010), but Redford has pressed on in his endeavor to simultaneously entertain and enlighten with *The Company You Keep*. His film is based upon a 2003

Neil Gordon novel described in reviews as being not only "cerebral" but also "gripping," "rousing," and "energetic." While what has made it to the screen is undeniably thought-provoking, it amounts to a less-than-heart-pounding thriller.

Cardiac quickening and dramatic spikes in blood pressure did, however, occur before the film's release, as some were livid that Redford was about to nostalgically glorifying The Weather Underground, that bombastically-angry and bomb-happy protest group of the late 1960s and early 1970s. Its members had, after all, gone so far as to declare war on the government, fired up over what they saw as unjust American imperialism abroad (especially pertaining to the war in Vietnam) as well as the subjugation of minorities and squelching of dissenters here at home. The Weathermen asserted that the powers-that-be would apparently stop at nothing and thus neither would they, setting off statement-making explosions (after abrupt evacuation warnings) at such places as the U.S. Capitol, the State Department, the Pentagon, and NYPD headquarters. There were activists and average citizens who shared the group's concerns but were turned off by their more disconcertingly-fevered philosophies as well as their lamentably-misguided and counterproductive terrorist tactics. One of those people was Redford. Thus, his reason for making the film was not to exalt extremists of that tumultuous time but to predominantly and soberly reflect instead on the eventual and very personal costs of one's defining early choices. When payment came due years later for those underground, it involved more than what some were able to foresee in their wild-eyed youth.

After utilizing archival news reports to provide background, the film switches from the potency of times gone by to the strength of reverberations felt in the present. After palpably-pensive Sharon Solarz (Susan Sarandon) bids her teen-aged children a seemingly-ordinary goodbye as they leave for school , this housewife and mother takes viewers aback upon subsequently turning herself in to the authorities for a crime committed thirty years before as an impassioned member of the Weather Underground. She clearly still has the nerve but not quite as much verve during an interview with Ben Shepard (Shia LeBeouf), a slick, smug, and insatiably-hungry cub reporter out to prove his worth to his editor (Stanley Tucci) at a newspaper struggling with its own issues of usefulness. Sharon has apparently been wearied by decades of dread that a knock on the door would not just physically take her away from her family but might also trigger an even more distressing emotional distancing by offspring whose image of mom might be irreversibly marred.

Jim Grant (Redford) has similar worries when Shepard pursues a lead in his direction, as it seems that this

upstanding upstate New York public interest lawyer also has quite an interest in remaining private. This man described as a "do-gooder" was once accused of doing something very bad, namely the aforementioned botched holdup murder, and has been a fugitive living under an assumed name ever since. Following the recent death of his much-younger wife, Jim has been a devoted single parent to his preteen daughter Isabel (singing prodigy Jackie Evancho), and is seen making Izzy's lunch, driving her to school, and watching her do homework. Jim goes on the run with not only FBI agent Cornelius (Terrence Howard) on his heels but Shepard, a member of a newer generation who must decide how far is too far to push. Jim first safely deposits Izzy with his brother (Chris Cooper), and the point is made that it is more urgently-important to this father that he prove his innocence to his child than to anyone else.

While repeatedly looking back over his shoulder apprehensively, Jim also does so reflectively during viewpoint vignettes with former Weathermen from whom he seeks assistance, including lumberman Donal (Nick Nolte) and college professor Jed (Richard Jenkins). Jim's dilemma would have been more rivetingly knotty if he was, but his attitude and actions prevent it from being a surprise that he had rationally reined himself in while those around him chose to proceed with their unbridled agitation. Only one of them, old flame but eternal firebrand Mimi (Julie Christie), might prove he was not even present at the scene of the crime, but resurfacing to exonerate him would involve capitulation and self-incrimination, and this still-roaring lioness in winter is vehement that she will never be tamed nor caged.

The Company You Keep grossed $5.1 million in limited release, and received mixed reviews. Its title traces back to the 5th Century BC, when Greek playwright Euripides opined that "Every man is like the company he is wont to keep." The years during which a peace movement became anything but peaceful might seem just as historically ancient to present-day young people, something that is wistfully acknowledged during Jim's meeting with Jed. Still, it could be Redford himself and not just his character who says that he is nevertheless glad that those who will hopefully be tomorrow's idealistic agents of change are being told today about yesterday—and, perhaps, will learn from that era's complex echoes.

David L. Boxerbaum

CREDITS

Jim Grant: Robert Redford
Ben Shepard: Shia LaBeouf
Agent Cornelius: Terrence Howard
Mimi Lurie: Julie Christie

Jed Lewis: Richard Jenkins
Henry Osborne: Brendan Gleeson
Mac McLeod: Sam Elliott
Sharon Solarz: Susan Sarandon
Origin: United States
Language: English
Released: 2012
Production: Nicolas Chartier, Bill Holderman, Robert Redford; TCYK North Productions, Voltage Pictures, Wildwood Enterprises, Brightlight Pictures, Kingsgate Films; released by Sony Pictures Classics
Directed by: Robert Redford
Written by: Lem Dobbs
Cinematography by: Adriano Goldman
Music by: Cliff Martinez
Sound: Richard Hymns; Dan Laurie
Editing: Mark Day
Costumes: Karen Matthews
Production Design: Laurence Bennett
MPAA rating: R
Running time: 125 minutes

REVIEWS

Atkinson, Michael. *Village Voice*. April 2, 2013.
Burr, Ty. *Boston Globe*. April 11, 2013.
Corliss, Mary. *Time*. March 30, 2013.
Denby, David. *New Yorker*. April 8, 2013.
Felperin, Leslie. *Variety*. March 30, 2013.
Gleiberman, Owen. *Entertainment Weekly*. April 3, 2013.
Holden, Stephen. *New York Times*. April 4, 2013.
Morgenstern, Joe. *Wall Street Journal*. April 4, 2013.
O'Sullivan, Michael. *Washington Post*. April 11, 2013.
Phillips, Michael. *Chicago Tribune*. April 11, 2013.

QUOTES

Jim Grant: "Secrets are a dangerous thing, Ben. We all think we want to know them, but if you've kept one to yourself, you come to understand that doing so, you may learn something about someone else, but you also discover something about yourself. I hope you're ready for that."

TRIVIA

As of 2013, the cast includes four actors (Robert Redford, Susan Sarandon, Chris Cooper, and Julie Christie) who have won Academy Awards and five others (Anna Kendrick, Richard Jenkins, Nick Nolte, Terrence Howard, and Stanley Tucci) who have been nominated for Oscars.

COMPUTER CHESS

An artificially intelligent comedy from the director of Funny Ha Ha and Mutual Appreciation.
—Movie tagline

Box Office: $102,041

In the last shot of Andrew Bujalski's staggeringly audacious fourth feature effort, *Computer Chess*, a

cameraman unwisely points his lens directly at the sun, blotting out the image and destroying the film inside. This demonstration of calamitous human error instantly evokes memories of the warning uttered by a pompous chess expert, played with credible stuffiness by film critic Gerald Peary, early in the film, cautioning the cameramen to steer clear of sunlight. If there is one consistent running theme in the work of Bujalski, it is the complexities of the human psyche and how they can fuel the sort of clumsy and misguided behavior that has characterized so many pictures falling under the journalistically created category of "mumblecore."

While speaking with the *New York Times,* Bujalski quipped that *Computer Chess* was his first "mumblecore" movie, since it happened to be his first feature shot on video and also his first made without a conventionally structured script. It certainly represents a refreshing change of pace for the filmmaker, who initially achieved prominence with the marvelous 2002 gem, *Funny Ha Ha,* that kick-started the DIY movement of arrestingly intimate character studies in which inarticulate twentysomethings grapple with their unformed identities. Yet, whereas his earlier work observed its characters with masterful clarity, Bujalski's latest film creates the sort of bewilderment within viewers that may render them inarticulate while stumbling out of the theater.

Chess may be the most deeply fascinating mess of 2013. Only multiple repeat viewings will indicate how rewarding the film is in its entirety. On first glance, the picture is about as narratively frustrating as Shane Carruth's *Upstream Color* (2013), yet nowhere near as exhilarating in its execution. There is, however, a certain ugly grandeur in the film's peerlessly constructed mise-en-scene, as it strains to recreate the clunky styles of the mid-1980s. Confined in a cramped hotel prone to Coen-like abstractions and deadpan malevolence, *Chess* centers its tirelessly quirky gaze on a chess tournament pitting man against machine. Bujalski's skepticism with technological innovation is based in how mankind's inherent flaws will inevitably dismantle their stabs at synthetic perfection.

The most enjoyable aspect of the film is the cinematography by Bujalski's longtime collaborator, Matthias Grunsky, who utilizes vintage Sony video cameras and stock that create the sort of visible streaks that resemble fingerprints smudged against the lens. He also uses old-fashioned split screen that hint at Bujalski's intention to make a verite-style mockumentary in the vein of Christopher Guest. Yet, as the picture progresses, Grunsky's unusual flourishes match the strangeness of Bujalski's frequently head-scratching flirtations with science-fiction. There is a particularly disorienting use of color film stock, as well as some unnerving instances of layered imagery, such as when a painfully introverted

contestant, nicely played by Patrick Riester, is propositioned by a middle-aged swinger couple. This is the sequence where Bujalski's signature gift for portraying the profound discomfort of flawed human interaction is most apparent.

Since none of the characters register as anything other than archetypal eccentrics, none of them are the least bit memorable, not even the sole female contestant. This is, above all, an exercise in style by a filmmaker basking in the joy of experimentation. A vast assortment of ideas is hurled at the screen with a sloppiness that negates their intended impact. This may have been a project more in need of Bujalski's screenwriting abilities than his previous features, since the improvisatory looseness of many scenes cause them to drag on far too long. The "comedy" is so muted that it is doubtful many will be laughing at anything apart from the picture's uncompromising weirdness.

In a year that found visionary filmmakers grappling with mankind's modern relationship with technology, it is admittedly provocative for Bujalski to take a look back at the cutting-edge gizmos of the past. There are definite parallels that could be drawn between Joaquin Phoenix's romantic reawakening in Spike Jonze's masterpiece, *Her* (2013), and the fumbling attempts made by Bujalski's self-serious chess players to connect with a world as perplexing as a malfunctioning computer. Though the film does not quite work as a comedy, it succeeds on its own loony terms as an abstract meditation on Bujalski's favored obsessions.

The film's messiness is an asset as well as a drawback, and will undoubtedly be pleasing to cinephiles hungering to see an artist explore unfamiliar terrain. Like all great indie auteurs, Bujalski uses budgetary limitations to his advantage in startlingly original ways. For all of its problematic passages, *Chess* suggests that Bujalski could be a budding Charlie Kaufman untethered by commercial expectations. He does not just break every rule in the book, he invents his own.

Matt Fagerholm

CREDITS

Pat Henderson: Gerald Peary
Martin Beuscher: Wiley Wiggins
Michael Papageorge: Myles Paige
Peter Bishton: Patrick Riester
Shelly Flintic: Robin Schwartz
Origin: United States
Language: English
Released: 2013
Production: Houston King, Alex Lipschultz; Computer Chess; released by Koch Lorber Films

Directed by: Andrew Bujalski
Written by: Andrew Bujalski
Cinematography by: Matthias Grunsky
Sound: Eric Masunaga
Editing: Andrew Bujalski
Art Direction: Caroline Karlen
Costumes: Colin Wilkes
Production Design: Michael Bricker
MPAA rating: Unrated
Running time: 92 minutes

REVIEWS

Baumgarten, Majorie. *Austin Chronicle.* August 21, 2013.
Cataldo, Jesse. *Slant Magazine.* July 11, 2013.
Chang, Justin. *Variety.* April 22, 2013.
Ebert, Roger. *RogerEbert.com.* July 18, 2013.
Huddleston, Tom. *Time Out London.* November 19, 2013.
Kohn, Eric. *indieWIRE.* April 22, 2013.
McCarthy, Todd. *The Hollywood Reporter.* April 22, 2013.
O'Hehir, Andrew. *Salon.com.* July 18, 2013.
Stamets, Bill. *Chicago Sun-Times.* September 26, 2013.
Toro, Gabe. *The Playlist.* July 19, 2013.

QUOTES

Cameraman: "Do you think a human being will ever beat a person at chess?"
John: "Oh, between a human being and a person? My money's on the computer."

AWARDS

Nominations:

Ind. Spirit 2014: Cinematog.

CONCUSSION

Wife. Mother. Escort.
—Movie tagline

Box Office: $42,606

Despite a nuanced performance from Robin Weigert, *Concussion* succumbs to an increasingly ludicrous plot that posits that one's sexual being can be shaken by a good bump to the head. Or maybe the inciting incident of Stacie Passon's drama is a red herring, designed to throw one off the sexual awakening of its central character and posit that this risque adventure would have happened even without the blood that streams down her face in the opening scene. To argue one way or the other would require a film and a screenplay with more backbone instead of this tedious collection of episodic encounters that would have netted less interest if not for the fact that it features a lesbian in relationship crisis. The idea that a bored housewife could seek escape from suburbia through the life of a high-class escort has been explored in independent cinema before and playing with the sexuality of the housewife in this piece of work does not automatically give it edge or inherent value. Weigert keeps it interesting but she is constantly fighting against a screenplay that is anything but.

The star of HBO's *Deadwood* (on which she played Calamity Jane) plays Abby Ableman, who is introduced with blood rushing down her face, swearing at her child. Immediately, this is art movie territory. There will be no character set-up and one best leave any sense of realism at the door. Abby races off to the hospital, gets stitched up, and, to all appearances, seems the same as she ever was. And yet something has changed. Her relationship with Kate (Julie Fain Lawrence) is more instantly strained (and maybe it always was) and, most of all, she begins to explore a new kind of dangerous sexuality. After a hook-up with a remarkably dirty street prostitute, Abby enters a world of high-priced sexual commerce with stunning ease. If one is on the high end of the middle class, contacting escorts and the people that manage them is just something that people do in Passon's unbelievable view of the world.

After a life-changing sexual encounter with a beautiful prostitute, it becomes clearer that Abby is headed down a road that she must see through to its conclusion. Sadly, Passon makes the next twist one of just too many unbelievable ones as Abby becomes Eleanor, an upper-class sex worker. Working with a madam known as "The Girl," Eleanor starts slowly, sleeping often with young lesbians who apparently like the idea of a mother figure who can help them discover their sexuality for a coast, but eventually gets to where the film telegraphs it is going from the first act—someone she knows from her child's school and her own gym, a local woman named Sam (Maggie Siff). Eleanor/Abby and Sam have their own special connection even if they both have significant others; Sam's is in the form of a husband.

As one who has ever seen an arthouse movie about a suburbanite who travels to the dark side of the sexual trade, Abby/Eleanor's adventures in sin become more dangerous and inevitably challenging to the bubble of domesticity she has built up with her partner. Passon's incredibly episodic script does not have the cumulative power for which she hoped as Abby meets a variety of clients, almost befriending some of them and even being forced to deal with a violent one, but seemingly unable to find exactly what she needs or wants from this trade. Passon can be lauded for not over-specifying why Abby is behaving this way. Is it the concussion? Boredom with

suburbia? Pleasure? Money? While the gray area of motivation is interesting on a narrative level, it creates a film with almost no narrative thrust and a deep lack of realism. People simply do not behave this way for no reason whatsoever outside of independent cinema. And, as if she never really knew where she was going, Passon ends her story with a thud, joining a bizarre sub-festival of film's from the 2013 incarnation of the Sundance Film Festival that could not figure out how to close their narratives effectively that includes *Afternoon Delight, In a World..., A.C.O.D. , The Truth About Emanuel,* and more. When a film starts this far from the relatable truth of the viewer, it seems fated to end even further from reality.

It is difficult to decide if Robin Weigert's complex, committed work here is a positive or negative. On one hand, it is cynical to criticize the best element of the film but one almost begins to feel sorry for Weigert, not unlike a great player on an awful sports team. Thin supporting performances, an overdone score, flat direction—every element of *Concussion* leaves its star on her own, not unlike the manner in which her character feels like she is a part of a world in which she just does not belong.

Brian Tallerico

CREDITS

Abby: Robin Weigert
Sam: Maggie Siff
Justin: Johnathan Tchaikovsky
Kate: Julie Fain Lawrence
Graeme: Ben Shenkman
Origin: United States
Language: English
Released: 2013
Production: Rose Troche; 93 Films, Razor Wire Films; released by Radius-TWC
Directed by: Stacie Passon
Written by: Stacie Passon
Cinematography by: David Kruta
Music by: Barb Morrison
Sound: Josh Allen
Editing: Anthony Capo
Costumes: Jennifer Bentley
Production Design: Lisa Myers
MPAA rating: R
Running time: 97 minutes

REVIEWS

Anderson, Melissa. *Village Voice*. October 1, 2013.
D'Angelo, Mike. *The Dissolve*. October 1, 2013.

DeFore, John. *The Hollywood Reporter*. September 8, 2013.
LaSalle, Mick. *San Francisco Chronicle*. October 17, 2013.
Moore, Roger. *Movie Nation*. October 20, 2013.
Nelson, Rob. *Variety*. September 8, 2013.
O'Sullivan, Michael. *Washington Post*. November 14, 2013.
Rapold, Nicolas. *New York Times*. October 3, 2013.
Rothkopf, Joshua. *Time Out New York*. October 1, 2013.
Vishnevetsky, Ignatiy. *The A.V. Club*. October 2, 2013.

AWARDS

Nominations:
Ind. Spirit 2014: First Feature

THE CONJURING

Box Office: $137.4 Million

James Wan's *The Conjuring* is such a significant leap forward for its filmmaker that it casts his entire career in a new light and pushes him to the forefront of young modern horror directors. A master class in using setting, sound, and motion to create a haunting atmosphere, Wan's film has echoes of the horror works of William Friedkin and Stanley Kubrick, humming with the talent of its director and a cast elevated by what he brings to it. In an era when mainstream horror films often mistake jump cuts and shaky cameras for actual directing, Wan pulls the genre back to the atmospheric style of the 1970s and 1980s, reminding one that mainstream horror used to be the kind of thing that warranted major attention. One can only hope that this is not an anomaly but the beginning of a more serious approach to the genre from tinsel town.

"Based on a true story," as every horror film seems to be these days, *The Conjuring* centers on two families and, allegedly, was concocted from recently-unearthed reports of a real-life haunting. In 1971, Roger (Ron Livingston) and Carolyn Perron (Lily Taylor) moved into an old farmhouse in Harrisville, Rhode Island with five daughters all in some state of their teenage or pre-teen years. Things were ominous from the very beginning, such as when their family dog refused to enter the house and was found dead he next morning. Things went bump in the night for the next few weeks, including the sounds of children playing when everyone was asleep, doors closing, and other ghost movie standards. Wan and his team perfectly set up the haunting through mood, relatable sounds (like a creaky door), and a well-established setting. From the beginning, the layout of the Perron house is crystal clear, something that other horror directors often ignore but that is a commonality in great haunted house movies. One needs to believe the setting is real and now their way around it to truly be scared of what is held within.

After a few terrifying incidents, the Perrons reach out to paranormal investigators Ed (Patrick Wilson) and Lorraine Warren (Vera Farmiga) to investigate and the pair descends into the darkness. Even years of experience, do not prepare the Warrens for what they find in the Perron household and the stakes are raised by the intensity with which Lorraine interacts with the other side. There is a palpable, real sense of danger throughout *The Conjuring*, largely due to Wan's use of setting and sound and structure but also because the incredibly talented cast took this project so seriously. Taylor gives a fearless, underrated performance here going from eager, supportive mother to fearful protector to possessed maniac over the course of the narrative. Chad and Carey Hayes' script demands a lot of an actress in the Carolyn role and the casting agent could not have found someone more perfectly attuned to this woman's arc. Farmiga and Wilson are quite good, especially in how straight they play the roles, but the film belongs to Taylor.

Actually, the film belongs to James Wan. The Australian writer/director made a huge splash when he cannonballed into the indie horror pool with 2003's *Saw* but seemed to spin his wheels a bit in the dcade since, producing the (too) many sequels to that film and finding another hit in 2011's *Insidious* but not really distinguishing himself from a very overcrowded group of young horror directors. *The Conjuring* changes that. Wan wears his influences on his sleeve, filming hallways with long lenses like Kubrick's *The Shining* (1980) and drenching his film in an ominous tone reminiscent of *The Exorcist* (1973). He refuses to give in to many of the twists and turns of modern horror that he himself actually helped define with *Saw* a decade ago. It is almost as if this is the second phase of Wan's career and everything before it can be looked at as a student film. This is a graduated auteur. Ironically, he moved on from this to a mainstream action film franchise by agreeing to helm *Fast & Furious 7* (2015) but one cannot really imagine him staying away from horror for too long.

In a year in which mainstream blockbusters were disappointing critical and commercial failures, very few films stood out as works that one could conceive that people would be watching five, ten, or twenty years hence. There is no question that *The Conjuring* has a timeless quality that should allow it to age gracefully. The best horror films do not pin themselves down to an era, remaining terrifying for generations. This is one such horror film.

Brian Tallerico

CREDITS

Carolyn Perron: Lili Taylor

Roger Perron: Ron Livingston
Lorraine Warren: Vera Farmiga
Ed Warren: Patrick Wilson
Christine Perron: Joey King
Origin: United States
Language: English
Released: 2013
Production: Rob Cowan, Tony DeRosa-Grund, Peter Safran; Evergreen Media Group, The Safran Company; released by Warner Brothers
Directed by: James Wan
Written by: Carey Hayes; Chad Hayes
Cinematography by: John R. Leonetti
Music by: Joseph Bishara
Sound: Joe Dzuban
Editing: Kirk Morri
Costumes: Kristin Burke
Production Design: Julie Berghoff
MPAA rating: R
Running time: 112 minutes

REVIEWS

Chang, Justin. *Variety*. July 12, 2013.
Dargis, Manohla. *New York Times*. July 18, 2013.
Dowd, A. A. *The A.V. Club*. July 17, 2013.
Ebiri, Bilge. *New York Magazine*. July 18, 2013.
Hartlaub, Peter. *San Francisco Chronicle*. July 25, 2013.
Linden, Sheri. *The Hollywood Reporter*. July 12, 2013.
Nashawaty, Chris. *Entertainment Weekly*. July 17, 2013.
Phillips, Michael. *Chicago Tribune*. July 16, 2013.
Puig, Claudia. *USA Today*. July 18, 2013.
Rothkopf, Joshua. *Time Out New York*. July 16, 2013.

QUOTES

Ed Warren: "The devil exists. God exists. And for us, as people, our very destiny hinges on which we decide to follow."

TRIVIA

The film was shot in chronological order.

THE COUNSELOR

Box Office: $17 Million

How fitting that *The Counselor*'s first scene involves oral sex, as so many mouths are so often in motion throughout the film delivering artificial, abstruse dialogue that resulted in pain and not pleasure for moviegoers on the receiving end. The production's already-sweltering setting along the Texas-Mexican border had little need for more hot air, but a wearying

degree is nonetheless dispersed by character after character's gratingly-grandiloquent ersatz profundity. When one is told that her words are cold, her retort that "truth has no temperature" is meant to sound deep and downright frigid but comes off instead as uproariously false. "I think that if you ransack the archives of the redeemed, you will uncover tales of moral squalor quite beyond the merely appalling," is the windy, wordy assertion of another. Some ponderous exposition about diamonds starts to seem as if it had begun eons back when the gemstones were first formed, and talk about accepting the consequences of one's foolhardy but irrevocable choices drones on to the point that viewers suspected an attempt was underway to bore a character to death.

The Counselor comes from the fertile and often quite frightening imagination of novelist Cormac McCarthy, and aforementioned perplexingly-stilted sentences pop up like pernicious weeds throughout his first produced screenplay. The result is a film that is infinitely less successful than the cinematic adaptations by others of his literary works, most notably *No Country for Old Men* (2007), which won four Oscars including Best Picture. That achievement created anticipation for a crime thriller that would not only mark McCarthy's scriptwriting debut but be directed by Ridley Scott and star Michael Fassbender, Brad Pitt, Javier Bardem, Penelope Cruz, and Cameron Diaz. Unfortunately, *The Counselor*'s main problem is that too much seems as if it emanates from McCarthy's pen instead of the minds of his varied characters. Not only are things irksomely pretentious but also portentous, with endless, blatant foreshadowing choking off any chances for surprise.

The telegraphing begins amidst the titillation of that opening sequence in which the character addressed only as "Counselor" (Fassbender) canoodles under the covers with his obviously-adored girlfriend, Laura (Cruz). Numerous shots of inhospitable wide-open spaces will gradually create an unsettling sense that there is nowhere to hide, but at the moment these shiny-eyed lovers are safely ensconced in their own cozy little world beneath a pure white sheet, cut off completely from the complex, bleak, and black-hearted world beyond. Laura dreamily urges him in so many words to go "down there," and then utters a coquettishly-contented admonition: "You've ruined me!" She and the audience will find that her nightmarish literal destruction awaits because the beloved man she desires to go below proceeds to mess around with things south of the border that they both will fervently wish he had left alone. Only the truly dense or those paying more attention to their popcorn could possibly have missed the heavy-handed foreshadowing in what the Amsterdam diamond dealer (Bruno Ganz) says about caution, imperfection and "the brevity of our lives," even ending with "You'll see!" In addition, when the Counselor says, "I will love you 'til I die," his lover gushes, "Me first."

Someone who definitely seems slow on the uptake is the Counselor himself, both repeatedly and ridiculously deaf to dire warnings that a one-off attempt to supplement one's income via involvement in a cocaine trafficking scheme can instead cost a person plenty. He is told by lavish-living, flamboyantly-dressed, and porcupine quill-coiffed nightclub owner Reiner (Bardem, as unfortunately-hairstyled as he was in *No Country*.) that he may very well encounter consequences beyond his comprehension. Reiner asserts that the Counselor does not know what he is doing and suggests he think twice. Sudden but surely significant remarks about a chilling, near-decapitating contraption called a bolito should certainly have penetrated enough to give the Counselor pause. There is also the terrifying portrayal by smoothly-pragmatic, womanizing, Hank Williams-outfitted middleman Westray (Pitt) of the Mexican drug cartel as blithely-mutilating and murderous monsters. Irony is evident, of course, in the inability of this professional giver of advice to take any, as well as in shady characters candidly giving a lawyer every chance to see the light with eyes opened wide. Whether a flat Fassbender's character is excessively self-deluded or self-assured (maybe both?) is left quite unclear.

One character who is exceedingly easy to read is Reiner's soulless mate Malkina (Diaz), whose deep-seated, voracious hunger to pursue and possess is mirrored early on by her pet cheetahs' instinctive, merciless drive to sink their teeth into fleeing, frightened prey. The thrill of the hunt is clearly anything but gone as she watches them run down a rabbit, the look in her eyes revealing a level of satisfaction second only to that of erotically-enraptured Laura. The unhealthy, unnerving kinship that this lithe and loathsome creature feels for these cats is also evidenced by her claw-like nails and the cheetah spots both tattooed down her back and printed on some of her clothing. Malkina seems less tame and more frightening than the real feline predators, and enjoys exhibiting the wonton wiles of the type of cat that roams the halls of houses of ill repute. Houses of worship conversely prove to be no place for her (the sinner pushes a priest's buttons until he bolts from the confessional), unlike polar opposite Laura, who devoutly aims to wed the Counselor in a church. The unholy plans of malevolent mastermind Malkina have enabled her to be the last person standing (with an apropos Cheshire cat grin) while everyone else either lays dead or has been brought to their knees, the latter being the case with the sobbing Counselor. The scheme to transport cocaine up north has clearly gone south, but while it seems that she knew exactly what she was doing all

along, the film's plot remains frustratingly vague to viewers.

While McCarthy expected moviegoers would mine meaning from his cautionary tale "about people who get involved in something they should have stayed out of," what the author himself may have derived from *The Counselor* is the realization that he best avoid writing for the screen. Made on a budget of $25 million, the film was panned by many critics and even some McCarthy devotees, succeeding in grossing only $16.7 million domestically despite a wide release. He not only wrote the script but served as its executive producer and, according to an article in the *Wall Street Journal*, also chose Scott, coached actors during filming, and even had a hand in editing. "This was an opportunity for him to get his vision on the screen unfiltered," is how producer Steve Schwartz sized things up. Unfortunately, what resulted calls to mind things said back in 1994 about McCarthy by the *New Yorker*'s Charles McGrath, who dubbed him "the last of the great overwriters" because he "never lets you forget that what you're reading is writing." Substitute "seeing and hearing" for "reading," and McGrath could have been reviewing *The Counselor*.

David L. Boxerbaum

CREDITS

The Counselor: Michael Fassbender
Laura: Penelope Cruz
Reiner: Javier Bardem
Malkina: Cameron Diaz
Westray: Brad Pitt
Origin: United States
Language: English
Released: 2013
Production: Paula Mae Schwartz, Steve Schwartz, Nick Wechsler, Ridley Scott; Scott Free Productions; released by Twentieth Century Fox Film Corp.
Directed by: Ridley Scott
Written by: Cormac McCarthy
Cinematography by: Dariusz Wolski
Music by: Daniel Pemberton
Sound: Oliver Tarney
Editing: Pietro Scalia
Art Direction: Alex Cameron
Costumes: Janty Yates
Production Design: Arthur Max
MPAA rating: R
Running time: 117 minutes

REVIEWS

Darghis, Manohla. *New York Times*. October 24, 2013.
Debruge, Peter. *Variety*. October 24, 2013.
Hornaday, Ann. *Washington Post*. October 24, 2013.
McCarthy, Todd. *Hollywood Reporter*. October 23, 2013.
Morgenstern, Joe. *Wall Street Journal*. October 24, 2013.
Nashawaty, Chris. *Entertainment Weekly*. October 24, 2013.
Phillips, Michael. *Chicago Tribune*. October 24, 2013.
Pols, Mary. *Time*. October 24, 2013.
Puig, Claudia. *USA Today*. October 24, 2013.
Russo, Tom. *Boston Globe*. October 24, 2013.

QUOTES

Reiner: "Men are attracted to flawed women too of course, but their illusion is that they can fix them. They just want to be entertained. The truth about women is that you can do anything to them except bore them."

TRIVIA

Angelina Jolie was originally cast as Malkina but dropped out and was replaced by Cameron Diaz.

THE CROODS

The journey begins.
 —Movie tagline
Are you better off now than you were 4 million years ago?
 —Movie tagline
Meet the first modern family.
 —Movie tagline
Everything begins.
 —Movie tagline

Box Office: $187.2 Million

After the eponymous caveman family and their more intellectually advanced human companion find themselves in unknown terrain filled with dangerous creatures, there comes a moment in which they stop to observe a strange sight. Lined along a jungle path, there are carnivorous plants that will attack anything that comes near them. The group sees a little creature enter the plants' vicinity, at which point one of the plants eats it. A frog-like animal then approaches, but it has a major advantage. The little, amphibious thing raises its head and extends its tongue, which opens and spreads out at the tip, revealing a colorful design. From the perspective of the taller, vicious plants, there is only a flower, and the little thing succeeds where its predecessor had failed in crossing the seemingly un-crossable path.

In this short sequence—part of a longer montage of the protagonists encountering and devising ways to overcome a series of obstacles—*The Croods* solidifies its rather subversive overarching theme. This is a snapshot

story of evolution. At a time when political forces are working either to ban the teaching of that basic scientific theory (often citing the word "theory" as evidence that it has not been proven, showing a doubly ignorant position in believing the word does not have a different meaning from the more common use of the word when used in the context of the scientific method) or to undermine it by trying to place religious beliefs about the origin of the universe (with which the theory of evolution has nothing to do in the first place) in the same area of study, the film resoundingly states that evolution is not only a fact but also the only thing keeping anyone or anything alive.

Of course, the screenplay by co-directors Kirk DeMicco and Chris Sanders does not present an accurate portrayal of the evolutionary process, but over the course of its almost 100 minutes, the film does emphasize the importance of "survival of the fittest" by showing a shift in what qualities actually are the "fittest." Needless to say, they are the ones that would equip someone to be more likely to accept evolution.

The story follows the Crood clan, a family of cavemen—technically Neanderthals—who live most of their lives in the sanctuary of a cave with a giant rock blocking the entrance from an assortment of dangers. (Their neighbors, the opening narration set against a sequence of cave paintings says, have died of means as gruesome as being stomped by a mammoth and as trifling as the common cold). Grug (voice of Nicolas Cage), the family patriarch, is a paranoid, overly safety-conscious man who repeatedly warns his family they should "Never not be afraid" when venturing into the world outside the security of their shelter.

Grug's daughter Eep (voice of Emma Stone) is his opposite. She is a curious, adventurous young woman, which is displayed in a stunning sequence as she climbs the side of one of the cliffs that surround the cave in order to see every, last moment of the sun setting past the horizon. The rest of the Croods—Grug's wife Ugga (voice of Catherine Keener), mother-in-law Gran (voice of Cloris Leachman), son Thunk (voice of Clark Duke), and baby daughter Sandy (voice of Randy Thom)—go along with Grug's philosophy, and despite the few internal divisions (other than the conflict between father and daughter, Grug has a cliched relationship with his mother-in-law, always hoping that she will die after encountering a peril), they work well together as a team. The opening sequence, which has them using their various strengths to get dinner, has a freewheeling energy that helps it overcome how uninterested in the characters the sequence is.

DeMicco and Sanders settle their attention to the familial dynamics with the introduction of an outsider whom Eep meets during a late-night venture out of the cave. He is Guy (voice of Ryan Reynolds), an early *homo sapiens* with a talent for inventions (he creates fire and has fashioned a way to keep his pants from falling down by using his trusty sloth companion, an adorable provider of comic relief appropriately named Belt [voice of Sanders]) and who has determined that the world will soon be ending. After an extreme and disastrous episode of plate tectonics destroys the Croods' home, they decide to follow guy across unknown terrain to a paradise that Guy calls "Tomorrow."

Once the group is on the move, the film becomes a battle between Grug's brute strength and Guy's mental faculties. That conflict and the way Grug adapts when confronted with impediments that blunt force alone cannot solve are—rather bluntly—the film's central evolutionary thesis. Grug, stubborn to his old ways, is of a dying era that thinks only of survival and is ill-prepared for the challenges of a new world. Guy is a man of metaphor whose stories, unlike Grug's cautionary tales, point to a life beyond mere survival to a higher form of existence and creativity.

Of course, none of that matters if the film is too caught up in its own metaphors, but DeMicco and Sanders have prepared a bright world full of color and, when the continental drift starts in earnest, dread (a flock of tiny birds that devours a terrestrial whale until only its skeleton remains are also rather dreadful). Everything here—from the verisimilitude of the landscape to the creature designs, which simultaneously seem like they could exist in some alternate history or in a cartoon—is polished.

After the clunky start in introducing these characters and establishing the central conflict as a symbolic one, the real surprise is how genuinely affecting these characters become by the time the world they have just started to know starts to come to an end. The climax puts everyone's life on the line, and Grug, who has talked and talked about keeping his family alive, must put those words into sacrifice. *The Croods* may appear to be a mere technical exercise on the surface and a clever affirmation of essential science just beneath that, but in these climactic moments, the film's heart is what comes through the strongest.

Mark Dujsik

CREDITS

Grug: Nicolas Cage (Voice)
Eep: Emma Stone (Voice)
Guy: Ryan Reynolds (Voice)
Ugga: Catherine Keener (Voice)

Gran: Cloris Leachman (Voice)

Thunk: Clark Duke (Voice)

Sandy: Randy Thom (Voice)

Belt: Chris (Christopher) Sanders

Origin: United States

Language: English

Released: 2013

Production: Kristine Belson, Jane Hartwell; DreamWorks Animation SKG Inc.; released by Twentieth Century Fox Film Corp.

Directed by: Chris (Christopher) Sanders; Kirk De Micco

Written by: Chris (Christopher) Sanders; Kirk De Micco

Cinematography by: Yong Duk Jhun

Music by: Alan Silvestri

Sound: Jonathan Null

Editing: Darren T. Holmes; Eric Dapkewicz

Production Design: Christophe Lautrette

MPAA rating: PG

Running time: 98 minutes

REVIEWS

Duralde, Alonso. *Wrap*. March 20, 2013.

Genzlinger, Neil. *New York Times*. March 21, 2013.

Jones, Kimberly. *Austin Chronicle*. March 22, 2013.

Kennedy, Lisa. *Denver Post*. March 22, 2013.

Mondello, Bob. *NPR*. March 21, 2013.

Orndorf, Brian. *Blu-ray.com*. March 21, 2013.

Phillips, Michael. *Chicago Tribune*. March 21, 2013.

Puig, Claudia. *USA Today*. March 21, 2013.

Tobias, Scott. *A.V. Club*. March 21, 2013.

Vaux, Rob. *Mania*. March 22, 2013.

QUOTES

Gran: "I was in love once. He was a hunter, I was a gatherer. It was quite the scandal. We fed each other berries, we danced. Then father bashed him on the head and traded me to your grandfather."

TRIVIA

Clark Duke named Thunk's pet, Douglas, which is the first name of his agent.

AWARDS

Nominations:

Oscars 2013: Animated Film

Golden Globes 2014: Animated Film

CRYSTAL FAIRY & THE MAGICAL CACTUS

Box Office: $202,370

On a drug-fueled road trip through Chile, a disparate pair of ugly Americans face off, while three Chilean brothers look on with bemusement. Sebastian Silva's *Crystal Fairy & the Magical Cactus* is a sort of companion piece to his dark psychological drama *Magic Magic* (2013), which is also a Chilean road trip movie featuring Michael Cera (in a far more sinister role) and Agustin Silva, the director's brother. While *Magic Magic* was shot in a very controlled manner by famed cinematographer Christopher Doyle and Glenn Kaplan, *Crystal Fairy* is a much more charmingly slapdash and low-key affair, caught with a handheld video camera, seemingly on the fly, by first-time director of photography Christian Petit-Laurent.

Cera plays against type as Jamie, an obnoxious American student visiting some friends in Chile. He does not speak much Spanish, but his complete dependence on his easygoing friend Champa (Juan Andres Silva, one of the director's three brothers who co-star in the film) is not enough to temper Jamie's self-absorption or his sense of entitlement. He wants what he wants when he wants it, and what he wants is to get high, mostly. Aside from run-of-the-mill Chilean pot and coke, both of which he finds lacking, he is seeking a legendary strain of mescaline that can only be obtained from the "San Pedro" cactus.

Jamie is enthusiastic about a road trip he's planned with Champa and his younger brothers, Pilo (Agustin Silva) and Lel (Jose Miguel Silva), to Northern Chile to obtain the plant and get high on a remote beach. At a party the night before, Jamie encounters a slightly older, free-spirited woman who calls herself Crystal Fairy (Gabby Hoffman). Inebriated, he pulls her aside to let her know that her hippie-ish dancing is embarrassing, but she responds with such friendliness, and he is so wasted, that he ends up chatting with her and inviting her along on the trip. This annoys Champa, who tells him Jamie that they will not have room for her in the car once they pick up his brothers. Undaunted, Jamie encourages Crystal to take a bus and meet them there.

When they reach the town where they plan to obtain the cactus, Jamie gets a call from Crystal, and he has already forgotten inviting her to join them. At Champa's insistence, they go pick her up. Jamie is instantly annoyed by Crystal's new age-y preachings and hippie-ish manner. While the Chilean brothers are polite, even friendly, Jamie is sarcastic and passive-aggressive toward her. The quintet shares a hotel room, where Crystal's comfort with her nudity prompts Jamie to give her the nickname "Crystal Hairy." The next day, the group is unsuccessful in getting any of the locals to part with their cactus, until Jamie steals some from an old woman's front yard.

In the desert, Crystal's ceremonial approach to cooking and ingesting the mescaline further irritates

Jamie, and he insults her. She wanders away from the group, and as his high comes on, Jamie begins to feel a soul-crushing sense of guilt. After a day of trippy wanderings through desert and beach, the group comes together again to eat and talk about their experiences. Jamie finally opens up a bit, and Crystal reveals a past trauma that alters Jamie's view of her.

Both Crystal and Jamie undergo a sort of transformation over the course of the day, with Jamie developing a modicum of empathy for Crystal, whom he initially sees as purely "other," and Crystal reaching a new level of honesty about her own somewhat contrived persona, but Silva's modest, home movie-style rendering of the events make it all feel refreshingly straightforward and naturalistic. He is abetted by strong performances from Cera, who is effortlessly funny, and his three brothers, but none of it would work if it were not for the believability of Hoffman's bravely revealing and nuanced performance. Cera may get more screen time, and he is adept at playing this type of obliviously self-involved out-of-his-element dork—his casual obnoxiousness even grows a bit tiresome, to the point where we wonder why Champa is hanging out with him to begin with—but there is a reason why "Crystal Fairy" is the name in the title.

The Silva brothers—particularly Agustin as younger brother Pilo, who secretly declines the opiate—are an appealing counterbalance to the two stars. While it might have been nice if the story were more about them, part of Silva's point is that the two Americans will not allow it to be. And even the Chileans, in the end, are as ready to forget their principles—their essential decency—as Crystal is, when they all disappointingly celebrate Jamie's thievery of the "magical cactus." Silva puts a downbeat period on the scene with a shot of the cactus's owner gazing forlornly, disappointingly out at the day.

The dialogue was largely improvised, and the cast handles that aspect well, but it only goes beyond its sort of slapdash charm in the final scenes, and Hoffman's campfire confession, while well-delivered and moving, also feels somewhat pro forma. The movie ends on a perfect melancholy note, giving it slightly more resonance, but in the end, it is endearingly sad, funny, and offbeat, but beyond Hoffman's performance, *Crystal Fairy* does not make too memorable of an impression.

Josh Ralske

CREDITS

Jamie: Michael Cera
Crystal Fairy: Gaby Hoffman
Champa: Juan Andres Silva
Lel: Jose Miguel Silva
Pilo: Augustin Silva
Lobo: Sebastian Silva
Origin: Chile
Language: English, Spanish
Released: 2013
Production: Juan de Dios Larrain, Pablo Larrain; Diroriro, Fabula; released by IFC Films
Directed by: Sebastian Silva
Written by: Sebastian Silva
Cinematography by: Cristian Petit-Laurent
Music by: Pedro Subercaseaux
Sound: Roberto Espinoza
Editing: Diego Macho; Sofia Subercaseaux; Sebastian Silva
Costumes: Mark Grattan
Production Design: Mark Grattan
MPAA rating: Unrated
Running time: 98 minutes

REVIEWS

Aldrich, Ryland. *Twitch.* July 11, 2013.
Arnold, Joel. *NPR.* July 12, 2013.
Dowd, A. A. *The AV Club.* July 11, 2013.
Cataldo, Jesse. *Slant Magazine.* June 2, 2013.
Everett, Cory. *IndieWire.* January 20, 2013.
Kaufman, Anthony. *Screen Daily.* January 18, 2013.
Lemire, Christy. *RoberEbert.com.* July 12, 2013.
Moralde, Oscar. *The House Next Door.* June 11, 2013.
McCarthy, Todd. *The Hollywood Reporter.* January 18, 2013.
Tobias, Scott. *The Dissolve.* July 11, 2013.

TRIVIA

When walking home one night, the director was asked by a drag queen prostitute for a bite of his apple, which he refused.

AWARDS

Nominations:

Ind. Spirit 2014: Actress (Hoffman)

D

DALLAS BUYERS CLUB

Dare to live.
 —Movie tagline

Box Office: $25.3 Million

If *Dallas Buyers Club* had been made in the early 1990s, when the American film industry was making its ginger first steps into grappling with AIDS as a dramatic subject, it might have come across as something bold and brave and true—certainly more so than the likes of *Philadelphia* (1993), a film that felt as though it was pulling its punches to a large extent even back in the day. However, things have progressed over the last two decades—though perhaps not nearly enough for some viewers—and as a result, it cannot help but feel like a curiously uninvolving and dramatically simplistic throwback to a time when films were more content with merely mentioning the disease rather than actually dealing with it in an interesting or significant way.

Opening in Dallas circa 1985, the film stars Matthew McConaughey as Ron Woodroof, a man's man who likes the women, loves the booze and drugs, and is, perhaps not surprisingly, virulently homophobic. After getting injured on the job one day, he winds up in the hospital and is informed by Dr. Eve Saks (Jennifer Garner) and her superior, Dr. Sevard (Denis O'Hare), that he is HIV-positive and has approximately thirty days left to live. At first, Ron is adamant that they have made a mistake but upon doing some research, he realizes that the diagnosis is true. He also comes across information about a possible cure being worked up by the pharmaceutical companies called AZT and when he learns that the hospital is participating in a test of the medication, he cons his way into getting some samples of the drug for himself.

The trouble is that AZT is not all that it is cracked up to be and the side effects, exacerbated by Ron's continued boozing and drugging, land him at death's door during a Mexican sojourn until a sympathetic local doctor (Griffin Dunne) gives him some medications that actually do him some good. Unfortunately, these are drugs that have not been given FDA approval, despite the fact that they work (as Ron proves by breezing past his 30-day shelf life), and are therefore illegal for sale in the United States. Seizing an opportunity to help others in the same boat and make some money on the side, Ron hits upon a plan to sneak the drugs into the country and deliver them to those in need of them—instead of selling them outright, he circumvents the law by forming a club where he will give the medications to those with paid memberships.

This quickly makes Ron and his club a target of both the multi-billion-dollar drug industry and the federal government, both of which do everything in their power to shut him down and end his operation for good. Along the way, Ron picks up two unexpected allies to assist him in his fight. One is Dr. Saks, who grows increasingly disenchanted with her superiors and their willingness to continue to promote the ineffective but well-funded AZT over medications that actually do work. The other is Rayon (Jared Leto), a transsexual who initially serves as Ron's flamboyant liaison into the local gay community and who late and unexpectedly becomes a trusted friend who begins to change Ron's entire worldview in regards to homosexuals just in time for the inevitable tear-jerking moments in the final act.

The premise of *Dallas Buyers Club*, which was originally inspired by a magazine article, sounds fascinating in theory and seems to contain all the requisite ingredients for a wild and provocative cinematic history lesson that both challenges and educates viewers in equal measure. The trouble is that the screenplay by Craig Boten and Melisa Wallack has sanded all of the edge away and transformed the material into something more akin to a TV movie than anything else. Every dramatic milestone and moment of catharsis arrives on schedule with rigid punctuality, a complex and complicated story is essentially reduced to a little-guy-against-the-system melodrama, and the gay characters are so thinly defined throughout that even though Rayon does have a lover in the film, most viewers will be hard-pressed to recall if they even mention him by name during the proceedings (they do not). Likewise, director Jean-Marc Vallee plays it way too safe throughout and delivers the kind of filmmaking that is competent enough but distinctly indistinct.

Even the aspect of the film that has received the most praise across the board—the central performances from McConaughey and Leto—leaves something to be desired. Hardly a review of the film has been written that has not mentioned the amount of poundage that each actor lost in order to physically prepare for their parts but while they certainly deserve to be commended for their commitment in this regard, it seems as though a good portion of the weight that was lost was dramatic. Actually, McConaughey is good as antihero Woodroof, thoroughly embracing both his truly hateful persona in the early going as well as his slightly gentler manner later on. However, compared to the truly dazzling and complex performances that he has given during his remarkable recent comeback in films as varied as *Bernie* (2012), *Killer Joe* (2012), *Magic Mike* (2012), *Mud* (2012), and *The Wolf of Wall Street* (2013), his work here cannot help but suffer in comparison. As for Leto, his problem is that he is stuck playing someone who is more of a walking plot device than a character and once the initial surprise of seeing him in his transgender look wears off, there really is not much of anything left except the kind of embarrassingly hammy turn that seems to exist only to score some undeserved Supporting Actor awards.

On some basic fundamental level, it could be argued that as a simple and uplifting tale of a man who goes against the system and becomes a better person in the process, *Dallas Buyers Club* works on some basic fundamental level, and satisfies on that bare-bones level of drama. However, considering the potentially fascinating subject matter and its surrounding history, some viewers may find themselves wishing that a better, smarter, and more complex film had been made out of

it. In fact, such a film exists in the acclaimed documentary *How to Survive a Plague* (2012). It is a truly fascinating and eye-opening look at a startling piece of recent history that is still going on today. Those who have seen it will better understand just how much of a disappointment *Dallas Buyers Club* really is.

Peter Sobczynski

CREDITS

Ron Woodroof: Matthew McConaughey
Rayon: Jared Leto
Dr. Eve Saks: Jennifer Garner
Dr. Sevard: Denis O'Hare
Tucker: Steve Zahn
David Wayne: Dallas Roberts
T.J.: Kevin Rankin
Dr. Vass: Griffin Dunne
Origin: United States
Language: English
Released: 2013
Production: Robbie Brenner, Rachelle Winter; Voltage Pictures; released by Focus Features L.L.C.
Directed by: Jean-Marc Vallee
Written by: Craig Borten; Melisa Wallack
Cinematography by: Yves Belanger
Sound: Martin Pinsonnault
Editing: Jean-Marc Vallee; Martin Pensa
Art Direction: Javiera Varas
Costumes: Kurt and Bart
Production Design: John Paino
MPAA rating: R
Running time: 117 minutes

REVIEWS

Corliss, Richard. *Time Magazine.* September 12, 2013.
Debruge, Peter. *Variety.* September 9, 2013.
Leitch, Will. *Deadspin.* October 30, 2013.
McCarthy, Nick. *Slant Magazine.* September 14, 2013.
Morris, Wesley. *Grantland.* September 13, 2013.
Reed, Rex. *New York Observer.* October 30, 2013.
Rooney, David. *Hollywood Reporter.* September 9, 2013.
Scott, A. O. *New York Times.* October 31, 2013.
Sharkey, Betsy. *Los Angeles Times.* October 31, 2013.
Zacharek, Stephanie. *Village Voice.* October 25, 2013.

QUOTES

Dr. Eve Saks: "None of those drugs have been approved by the FDA."
Ron Woodroof: "Screw the FDA. I'm gonna be DOA."

TRIVIA

Major League Baseball player Adam Dunn, a friend of producer Joe Newcomb, helped finance the film and appears in the non-speaking, uncredited role of Neddie Jay, the bartender.

AWARDS

Oscars 2013: Actor (McConaughey), Actor—Supporting (Leto), Makeup

Golden Globes 2014: Actor—Drama (McConaughey), Actor—Supporting (Leto)

Ind. Spirit 2014: Actor (McConaughey), Actor—Supporting (Leto)

Screen Actors Guild 2013: Actor (McConaughey), Actor—Supporting (Leto)

Nominations:

Oscars 2013: Film, Film Editing, Orig. Screenplay

Screen Actors Guild 2013: Cast

Writers Guild 2013: Orig. Screenplay

DARK SKIES

Once you've been chosen, you belong to them.
—Movie tagline

Box Office: $17.4 Million

The UFO abduction horror film *Dark Skies* starts with a compelling enough quote by Arthur C. Clarke, "Two possibilities exist...Either we are alone in the universe or we are not. Both are equally terrifying." The last sentence of the quote is rendered in a menacing red. If only *Dark Skies* had explored those two possibilities in a more complex way. Then it would emerge as something other than merely a mildly suspenseful genre flick with nary a sign of the ambition promised by the title card.

The opening credits after the Arthur C. Clarke quote do generate some atmospheric unease: Ominous music overlays a suburban neighborhood, full of essentially faceless suburbanites going through the motions of a lazy day. Kids ride bikes. Leaves are blown. American flags flap in the breeze. But all is not well. A home is shown in foreclosure. Two bored and unsupervised young boys watch soft-core porn. A child, Sammy (Kadan Rockett), the youngest of the Barrett clan, plays with a wounded lizard. Even a backyard barbecue hosted by the Barretts is vaguely unpleasant and tense. Lacy Barrett (Keri Russell) seems pleasant enough but spends the meal gossiping with her neighbor. Her husband Daniel (Josh Hamilton) harangues their teen son Jesse (Dakota Goyo) at the table about spending too much time with bad influence Kevin "Ratface" Ratner (L.J. Benet). There are also dire financial tensions bearing down on the Barrett family. Daniel is unemployed, the mortgage way overdue, and his fears and insecurities lead him to lie to Lacy about the outcome of a job interview that left him frustrated and humiliated.

Sadly, at this point, the film exits a decent setup embracing genre mechanics to achieve relatively simple goals. A late night house check reveals the contents of a fridge all over the kitchen floor. Another reveals a series of everyday objects stacked in the kitchen to reflect a mysterious symbol on the ceiling. Characters lose their sense of time, people go into trances, and a huge number of birds suicide mission into the house. None of these events are anything genre lovers will find new, and specific scenes from *Poltergeist* (1982), *Signs*, and *The X-Files* (1993-2002) are so liable to come to mind that viewers will likely hold any suspension of belief hostage until they see what more the film has to offer.

The genre cribbing is particularly shameful because whenever the film concentrates on the facelessness of the modern world it registers as something that could have been special. The aforementioned gossiping and the disregard it shows that the neighbors have for one another, the staring and final shunning of the Barretts as their situation grows more and more desperate harken back to truly frightening alien invasion narratives like *Invasion of the Body Snatchers* (1978) and *The Twilight Zone* episode "The Monsters Are Due On Maple Street" (1960). But *Dark Skies* does little more than hint at the alienation and plasticity of suburbia or the fragility of human society.

In one of the film's worst moments, Lacy is led by her research into UFO abductions to visit Edwin Pollard (J.K. Simmons), an expert in the field who lives a secluded existence due to the demoralizing and upsetting nature of his work. This is a character that could have been worked into the film as a solid part of the story but is instead simply there to provide exposition. Only Simmons's immense skill as an actor and natural gravitas give this sequence any life at all.

The film does get more suspenseful as it goes along, and by the time the Barretts have turned their home into a fortress in attempts to keep the invaders at bay many will feel they got their money's worth. But cinema should be about more than that and the plot holes are just too big here to ignore by anyone except the most naive. The blinding white lights and teeth rattling sounds produced by the aliens apparently go unheard by the neighbors who live mere feet from the Barrett's front door. Child Protective Services are called in to examine mysterious bruising on little Sammy but simply vanish from the narrative afterwards. Performances are fine given the material. Keri Russell and comedian Josh Hamilton offer a surprisingly good dramatic turns as a

couple whose family and marriage are under siege and Dakota Goyo as the teenage Jesse offers a sometimes winsome reminder of the weight of teenage angst.

In fact, that opening scene taking place with a dad standing over a grill becomes something more primal when that same dad is shown later defending his family home against alien invasion holding a shotgun and resembling nothing more than a frontiersmen holding off a marauding Indians or perhaps a bear. But even the symbolic potential of that moment is wasted by the way the film ends. Viewers get a quick unearned flashback to a moment where seemingly innocuous information is revealed as having been essential in understanding the alien's true plot. A quick coda showing that family is still in danger is hardly surprising and utterly ineffective.

Dave Canfield

CREDITS

Lacy Barrett: Keri Russell
Daniel Barrett: Josh Hamilton
Jesse Barrett: Dakota Goyo
Sam Barrett: Kaden Rockett
Edwin Pollard: J.K. Simmons
Kevin Ratner: L.J. Benet
Origin: United States
Language: English
Released: 2013
Production: Jason Blum; Alliance Films, Blumhouse Productions; released by Dimension Films
Directed by: Scott Charles Stewart
Written by: Scott Charles Stewart
Cinematography by: David Boyd
Music by: Joseph Bishara
Sound: Kelly Cabral
Editing: Peter Gvozdas
Costumes: Kelle Kutsugeras
Production Design: Jeff Higinbotham
MPAA rating: PG-13
Running time: 97 minutes

REVIEWS

Barnard, Linda. *Toronto Star.* February 22, 2013.
Duralde, Alonso. *The Wrap.* February 22, 2013.
Harvey, Dennis. *Variety.* February 22, 2013.
Lowe, Justin. *Hollywood Reporter.* February 25, 2013.
Nayman, Adam. *Globe and Mail.* February 22, 2013.
Olsen, Mark. *Los Angeles Times.* February 22, 2013.
O'Sullivan, Michael. *Washington Post.* February 22, 2013.
Stewart, Sara. *New York Post.* February 22, 2013.

Webster, Andy. *New York Times.* February 22, 2013.
Zacharek, Stephanie. *Film.com.* February 25, 2013.

QUOTES

Daniel Barrett: "This wasn't a cooking mess. This was like a mathematician's idea of a geometry joke. I don't know whether to be pissed or impressed."

DEAD MAN DOWN

Revenge is coming.
—Movie tagline
Blood demands blood.
—Movie tagline

Box Office: $10.9 Million

After introducing and developing an intriguing central relationship that toys with the audience's expectations of the traditional protagonist-antagonist dynamic, *Dead Man Down* ultimately becomes as generic and nonspecific as its nonsensical title. The screenplay by J.H. Wyman simply does not trust its characters and the clash between their goals, which are similar in nature but conflict when played off each other, to serve as the narrative backbone. Instead, the plot focuses on a convoluted plan for revenge that starts and stalls without any internal logic. The only apparent reason for the incomprehensibly dense scheme that the movie's wronged protagonist devises is for the script to delay its success or failure so that there can be obstacles in his way and a secondary story in the first place.

Since that ancillary story is more involving than the primary one, there is, at first, little reason to complain. In the midst of that overly complicated revenge story is the tale of two lost and lonely people. One is a man whose wife and daughter were killed through the actions of a mob chief; the other is a woman whose life has been ruined after a drunk driver crashed into her car, sending her through the windshield and leaving her face scarred.

Both of these people are looking for revenge, and that drive for vengeance has inundated what is left of their lives. They both, through their respective experiences and the way they have reacted to them, know each other incredibly well even after only a brief period of time, and they each enable the other's emotional response. The fascinating part of this setup, though, is how she is essentially his antagonist, and not the man whom he blames for the killing of his family. That man is just a passive observer of the threats against him, occasionally attempting to lash out at the anonymous force tormenting him with knowledge that he is a target and failing miserably every time he tries. The villain is little

more than a MacGuffin, and the movie's moral fogginess becomes even more complicated when Wyman's screenplay introduces yet another obstacles to the hero's progress: His best and, really, only friend in the whole affair.

It is, for the most part, quite promising, although the seeds of uncertainty about the actions or inaction of movie's central character are planted early in the opening sequence. In it, Victor (Colin Farrell), the man seeking revenge by becoming a member of his target's gang, helps Alphonse (Terrence Howard), the crime lord who oversaw the deaths of Victor's wife and daughter, uncover the mystery of a dead body in a freezer in Alphonse's basement. Alphonse believes a drug dealer upset with a recent business arrangement is responsible, and he and his gang end up in a shootout with the dealer's gang after Alphonse kills him.

As straightforward as the scene is, it still raises multiple questions once Wyman reveals that Victor is the one responsible for the dead body and the threats. There is a brief, important moment in which Victor has the opportunity to kill Alphonse, but he instead saves his target's life. The rationale for it is hazy, weak, and voiced by Victor's uncle-in-law Gregor (F. Murray Abraham), who suggests that Victor is postponing his revenge because he will have nothing after it is finished. The reality is that his plan is an elaborate mess: Frame Alphonse for the kidnapping of a rival gang leader, get all the players in Alphonse's hideout, and then detonate the building. Even the theory that his scheme is such, though, is contradicted by a scene where Victor attempts to kill Alphonse with a sniper rifle—a scene that comes across as an excuse for its resulting chase sequence.

His plan is complicated further with the introduction of Beatrice (Noomi Rapace), the woman who was scarred by the collision with the drunk driver. She lives in the building across the street from Victor, and the two occasionally catch eyes. She leaves a note for him to call her, and they go out for dinner. There is a game of how much they reveal to each other until she has Victor drive them to a random house where she reveals that she has video of him killing the man who ended up in the freezer. She blackmails him with the threat of going to the police unless he kills the man who caused her disfigurement.

Their relationship, which starts off antagonistic, quickly becomes tender, as they share their opinions about revenge and pain. As intriguing as the concept of Beatrice serving as Victor's primary impediment to his goal is, Wyman fills that role with Darcy (Dominic Cooper), Victor's friend who has decided to track down the person responsible for threatening Alphonse in the hopes of getting on the boss' good side in order to help support his new family. Instead, Victor and Beatrice begin a romance that, in theory, cannot be fulfilled, given that Victor is prepared to and believes he will have to die in order to carry out his plan.

This, of course, cannot stand. The obvious conclusion is too honest and too in tone with everything that has come before it, so instead, the movie drops everything it has already established, from Victor's plan to the tricky relationship between him and Beatrice, for a simplistic round of saving the damsel in distress from the bad guy in a chaotic bloodbath of a shootout. By the time that climax comes around, *Dead Man Down* has exhausted any promise it might have had.

Mark Dujsik

CREDITS

Victor: Colin Farrell
Beatrice: Noomi Rapace
Alphonse Hoyt: Terrence Howard
Valentine Louzon: Isabelle Huppert
Darcy: Dominic Cooper
Lon Gordon: Armand Assante
Gregor: F. Murray Abraham
Origin: United States
Language: English
Released: 2013
Production: Neal H. Moritz, J.H. (Joel Howard) Wyman; Automatik Entertainment, WWE Studios; released by FilmDistrict
Directed by: Niels Arden Oplev
Written by: J.H. (Joel Howard) Wyman
Cinematography by: Paul Cameron
Music by: Jacob Groth
Sound: Peter Schultz
Editing: Timothy A. Good; Frederic Thoraval
Costumes: Renee Ehrlich Kalfus
Production Design: Niels Sejer
MPAA rating: R
Running time: 118 minutes

REVIEWS

Berardinelli, James. *ReelViews*. March 9, 2013.
Burr, Ty. *Boston Globe*. March 7, 2013.
Dargis, Manohla. *New York Times*. March 7, 2013.
Groen, Rick. *Globe and Mail*. March 8, 2013.
Jones, Kimberly. *Austin Chronicle*. March 15, 2013.
Neumaier, Joe. *New York Daily News*. March 7, 2013.
Orndorf, Brian. *Blu-ray.com*. March 8, 2013.
Rabin, Nathan. *A.V. Club*. March 8, 2013.

Schager, Nick. *Village Voice*. March 14, 2013.
Zacharek, Stephanie. *Film.com*. March 7, 2013.

QUOTES

Alphonse: "What happened to your face?"
Beatrice: "Car accident. What happened to yours?"

TRIVIA

Director Niels Arden Oplev disowned the American advertising campaign, which he felt misrepresented the film.

DELIVERY MAN

You're never quite ready for what life delivers.
—Movie tagline

Box Office: $30.6 Million

Once upon a time there was an up-and-coming actor named Vince Vaughn. He burst onto the scene as part of a successful indie film, *Swingers* (1996), where he had the juicy role of the fast-talking, know-it-all best friend. Attracting the attention of everyone from Steven Spielberg to Gus Van Sant, Vaughn quickly expanded his range to a number of dramatic roles playing mysterious strangers and oddball loners. If this is not the Vaughn many audiences have come to know, it is because that side was all but left behind once *Old School* (2003) re-introduced him to mainstream comedy and became a staple as the motor mouth wise-acre in a string of vehicles that have become increasingly stale and waned his once blooming popularity. Usually this is the time when an actor will go back to the drawing board or try a different direction. In Vaughn's case he has split the difference in a project that the director already made once and grows tiresome even before all those involved get downright languid with it.

Vaughn plays David Wozniak, who is as unreliable as an adult male can be. He is frequently late for the family business, a meat shop that has inexplicably put him in charges of deliveries and pick-ups. He is eighty-thousand dollars in debt to loan sharks for various get-rich-quick schemes. How he has managed to maintain any sort of relationship with his girlfriend, Emma (Cobie Smulders) is anyone's guess. But when he shows up to her apartment at 3 AM and finds out she is pregnant and ready to dump him for good, he leaps at the potential of doing something good with his life; a revelation he relates to his friend, Brett (Chris Pratt), whose four kids make him miserable.

As the active late night/early morning continues, David comes home to a lawyer waiting in his apartment. Due to a mix-up at a sperm clinic where he was a frequent donor in his youth, David discovers his precious bodily fluids have been used in the creation of 533 children. A third of them are now suing the clinic to reveal the identity of the anonymous benefactor. Brett takes up the case to protect his friend only to give him the envelope containing the identities of 142 of his children. "DON'T open it," Brett warns him. Unable to resist, David pulls out a random profile and discovers his genes are playing ball for the NBA. Now a proud papa he decides to seek out more anonymously and ingratiate himself into their lives to be the father they never had.

That is an assumption, of course, given that none of the kids are given any sort of a lingering back story. They have problems that require a quick fix—bad jobs, drugs—which an absentee father can swoop in to solve. Dramatically though what is the real motivation behind the lawsuit? How many of them grew up in a single household, given up for adoption, had bad stepdads or real fathers who were merely incapable of starting a family through their own devices? These are questions that *Delivery Man* are not interested in exploring. Instead of giving focus to just two or three of the kids, there is a randomness that foolishly tries to bring in one after another; ironically dumping one aside the moment the next opportunity presents itself.

Based on his original screenplay (with Martin Petit), director Ken Scott has crafted a virtually scene-for-scene remake of his French-Canadian feature, *Starbuck* (2011), named for the pseudonym used by his lead. Perhaps inspired to cast Vaughn for his work in the scene-for-scene remake of *Psycho* (1998), Scott must have thought he had the perfect actor to convey the outlandishness of the high-concept idea while selling the more heartfelt revelations of his journey. He could not have been more wrong on either count. Vaughn's casting works only in the context of this vehicle as a metaphor for his career path because it is his personal history of a leading man that helps strip *Delivery Man* of any potential pathos or genuineness. Not that Scott needed any help in that department.

At a gathering of the Starbuck children, nobody seems to recognize that the one middle-aged guy in the group does not exactly belong. This is proof of either a consistently unaware screenplay or the casual suggestion that the one thing David did pass down was his limited brain activity. Devoid of nearly any likable character in a cast of literal hundreds—aside from possibly Emma who is just more questionable in her dating decisions—Vaughn is stuck in the thankless position of trying to elevate both the material and a misguided character. This is neatly summed up in a scene where the director tries to milk the comic potential of Vaughn cautiously moving between his nearly-overdosed daughter (Britt

Robertson) and a nurse trying to convince him to convince her to go to rehab; all underscored with the cutesy, comical score by Jon Brion.

There are montages of David's role of a "guardian angel" which brings fatherhood down to the simplistic notions of showing up, support and protection. Never once is there a real discussion about what it takes to be a father. Other than a couple of boring speeches delivered by his own dad (Andrzej Blumenfeld), nothing says a protagonist has learned his lesson than having someone just dump a pile of cash on the table; a gesture that should be read more as a fear of his own life rather than his child. Comedy lesson to future screenwriters: When you have already established someone as a person's father, having them say to their real kid "I love you like a son" has already lost its joke.

That is what *Delivery Man* feels like and it is appropriate that this is one of the first gags the film tries to deliver. Downhill from there, the film has little in the vicinity of establishing jokes or witticisms and more on conversations that feel like bad improv going on while the director was on a bathroom break. Vaughn has been—and can be again—a great off-the-cuff comic actor and has shown solid dramatic chops in the past in both *Return to Paradise* (1998) and an underappreciated turn in Ron Howard's *The Dilemma* (2011) that was grossly misrepresented as another wacky comedy of errors. Unfortunately for Vaughn, aside from the success of *Dodgeball* (2004) and *Wedding Crashers* (2005), his best work over the years have been in cameos; small doses like *Anchorman* (2004) and *Mr. and Mrs. Smith* (2005) that match his screen persona, give the film an added comic boost and then dropping the mike while the timing is still good. It is easy to see how he would be attracted to a tale like *Delivery Man* and take his career back to a mash-up of its roots. Unlike the anonymity of David—a legal argument that also is lent no true weight—Vaughn is on full display here and is left dangling, confused and desperate. To paraphrase another Ron Howard film, *Parenthood* (1989), "You need a license to buy a dog, to drive a car, even to catch a fish. But they'll let anyone be a father." Apparently the same can be said for filmmakers too.

Erik Childress

CREDITS

David: Vince Vaughn
Brett: Chris Pratt
Emma: Cobie Smulders
Aleksy: Bobby Moynihan
Victor: Simon Delaney
Origin: United States

Language: English
Released: 2013
Production: Andre Rouleau; Dreamworks L.L.C.; released by Walt Disney Studios
Directed by: Ken Scott
Written by: Ken Scott
Cinematography by: Eric Alan Edwards
Music by: Jon Brion
Sound: Christopher Assells
Music Supervisor: Jonathan Karp
Editing: Priscilla Nedd-Friendly
Art Direction: Mark Newell
Costumes: Melissa Toth
Production Design: Ida Random
MPAA rating: PG-13
Running time: 105 minutes

REVIEWS

Berardinelli, James. *ReelViews*. November 22, 2013.
Dowd, A. A. *The Onion A.V. Club*. November 21, 2013.
Duralde, Alonso. *The Wrap*. November 12, 2013.
Kimmel, Daniel M. *New England Movies Weekly*. November 22, 2013.
Koski, Genevieve. *The Dissolve*. November 21, 2013.
Orndorf, Brian. *Blu-ray.com*. November 22, 2013.
Phillips, Michael. *Chicago Tribune*. November 21, 2013.
Rea, Steven. *Philadelphia Inquirer*. November 22, 2013.
Snider, Eric D. *EricDSnider.com*. November 22, 2013.
Verniere, James. *Boston Herald*. November 22, 2013.

TRIVIA

Chris Pratt gained 60 pounds for his role as David's out-of-shape friend, Brett.

DESPICABLE ME 2

More minions. More despicable.
—Movie tagline
Back 2 work.
—Movie tagline
When the world needed a hero, they called a villain.
—Movie tagline

Box Office: $368.1 Million

It is fitting that *Despicable Me 2* begins with the arrival out of nowhere of a massive airborne magnet that yanks an entire Arctic research facility skyward, as there was also an extraordinary and ultimately inescapable pull to make this sequel after *Despicable Me* unexpectedly became one of the top-grossing animated films of all

time back in 2010. (It earned over half a billion dollars worldwide.) A hovering horseshoe forcefully picks up every trace of humanity (except a Port-a-Potty and its occupant) from said icy environs, causing understandable shock, but few were at all surprised when Universal Pictures and Illumination Entertainment were drawn to continue the story of Gru and his brood if it might pull down an another sizable haul of cold, hard cash.

The first film warmed viewers' hearts when its Transylvanian-accented caricature of a Bond-film baddie went from wanting nothing more than to snatch the moon from the sky with villainous glee to being over the moon with a more satisfying kind of delight, due to his adoption of three orphaned moppets. Many fans feared that a sequel would undo what had been wrapped up quite nicely, and amount to a comparatively-dull "Domesticated Me." Thus, as soon as Gru steps in to don a Pepto-Bismol-colored fairy princess costume here during a birthday party for adorable youngest daughter Agnes (Elsie Fisher), some moviegoers started to feel queasily-apprehensive that the character had indeed been castrated by cuteness.

However, Gru not only looks awful but also goes on to act in that manner. He gets surly with an inquisitive little guest, swatting her repeatedly on the forehead for emphasis with his magic wand before blowing a cough-inducing handful of glitter in her face. Gru also turns a hose on a pesky, matchmaking neighbor (Nasim Pedrad). "I'm sorry, I did not see you there," he says with reassuringly-despicable disingenuousness. He has his "dog" Kyle do some retaliatory relieving of his bladder in the yard of a neighbor whose dog had repeatedly done a number (two, to be precise) on the super-villain's property. So papa Gru has clearly—and thankfully—not become as soft and gooey as the jams and jellies that are now cooked up in his lab instead of evil. Although Gru has mellowed, he still possesses just enough acidity to make him a pleasingly-palatable mixture of sweet and sour.

Last time, viewers saw a young Gru repeatedly but unsuccessfully attempting to impress his mother (Julie Andrews) with his drawings of the moon and building of a rocket. Her truly despicable dismissiveness obviously did damage that propelled him toward committing lunar larceny that would surely inspire even her awe. Now *Despicable Me 2* affords its own poignant, telling glimpse into Gru's past, and one can easily trace the character's mortifying playground rejection forward to his present refusal to date, even though the daughters he is so eager to please desire him to do so. After all, especially with that now-denuded noggin, those hunched shoulders, and many more pounds, is there anyone outside the realms of Charles Addams and Edward Gorey who would regard him as a swoon-worthy Adonis?

Sure, he is no Cary Grant, but what he ends up doing in *Despicable Me 2* harks back in a sense to that handsome screen icon's 1955 Hitchcock classic *To Catch a Thief*, as Gru draws upon his own past expertise to identify and apprehend that current grand-scale grabber mentioned at the outset. He does so at the request of the MI6-like Anti-Villain League and with the assistance of uber-exuberant, admiring rookie agent Lucy Wilde (Kristen Wiig), who is definitely no Grace Kelly. There is no initial electricity between them except the jolt from her compliance-ensuring taser, but everyone watching should have recognized that Gru just fortuitously met his match. (The animation is truly beautiful during the sequence in which she transports a subdued Gru in the trunk of a car that transforms into a submersible.) What should also be obvious is that Gru, feeling demoralized after his food turned out to be inedible, his trusty (and increasingly rusty) assistant Dr. Nefario (Russell Brand) left him because things had gotten too tame, and bad memories were brought to mind by all the hectoring about finding a woman, reverses his initial refusal of the assignment because he once again wants to prove himself. How can his spirits or self-worth sag when he envisions impressing everyone—especially Margo (Miranda Cosgrove), Edith (Dana Gaier) and Agnes—by heroically coming out on top when pitted against the world's most fiendish culprit?

Like its plump protagonist attempting to please by squeezing into that fuchsia-hued get-up, a lot is similarly crammed into *Despicable Me 2*. Gru's singularly-informed suspicions eventually lead him and Lucy to El Macho (Benjamin Bratt, replacing Al Pacino), an evildoer posing as a shopping mall restaurateur who was thought to have died in an oh-so-manly fashion; riding a shark into an active volcano with dynamite strapped to his body. Meanwhile, Margo develops a crush on El Macho's disconcertingly-suave son (Moises Arias), which ends with her in tears and the two-timer in a block of ice thanks to protective and peeved Gru's freeze ray. Both the juvenile in the next seat and the one that remains inside all of us likely enjoyed the film's brisk, brightly-colored buoyancy, snicker-inducing names like gigantically-jowly AVL head Ramsbottom (Steve Coogan), plentitude of jokes about flatulence, and increased screen time for those disarmingly-mischievous, gibberish-spouting (and much-merchandised) Minions. Through it all, there is no question that the comforting main objective beneath the light-hearted, Looney Tunes-inspired fun of *Despicable Me 2* is to find amore for Gru and, in so doing, also a mom for this incomplete, unconventional family unit.

Before El Macho is finally overcome by the odiferous emissions of a fart gun, he is poised to let loose something unpleasant of his own: Kidnapped Minions

that he has mutated into purple, murderous monsters. They, of course, had to be saved and returned to normalcy before the credits rolled, if for no other reason than to be ready for the Minions' own movie, set to hit theaters in 2015. As a flagrant reminder that it is on the way, this production ended with Minion "auditions." Especially since $76 million-budgeted *Despicable Me 2* surpassed its predecessor to gross over $365 million in the U.S. alone and almost $1 billion worldwide, it seems that those responsible need not have started so early to try and fill seats—nor their coffers.

David L. Boxerbaum

CREDITS

Gru: Steve Carell (Voice)

Lucy: Kristen Wiig (Voice)

Margo: Miranda Cosgrove (Voice)

Agnes: Elsie Fisher (Voice)

Edith: Dana Gaier (Voice)

Dr. Nefario: Russell Brand (Voice)

Eduardo/El Macho: Benjamin Bratt (Voice)

Antonio: Moises Arias (Voice)

Silas: Steve Coogan (Voice)

Floyd: Ken Jeong (Voice)

Origin: United States

Language: English

Released: 2013

Production: Janet Healy, Christopher Meledandri; Illumination Entertainment; released by Universal Pictures Inc.

Directed by: Chris Renaud; Pierre Coffin

Written by: Cinco Paul; Ken Daurio

Music by: Heitor Pereira; Pharrell Williams

Editing: Gregory Perler

Production Design: Yarrow Cheney; Eric Guillon

MPAA rating: PG

Running time: 98 minutes

REVIEWS

Bruge, Peter. *Variety.* June 17, 2013.
Gleiberman, Owen. *Entertainment Weekly.* June 26, 2013.
Holden, Stephen. *New York Times.* July 2, 2013.
Morgenstern, Joe. *Wall Street Journal.* July 4, 2013.
Phillips, Michael. *Chicago Tribune.* July 2, 2013.
Pols, Mary. *Time.* July 5, 2013.
Puig, Claudia. *USA Today.* July 3, 2013.
Rechtshaffen, Michael. *Hollywood Reporter.* June 17, 2013.
Russo, Tom. *Boston Globe.* July 2, 2013.
Sharkey, Betsy. *Los Angeles Times.* July 3, 2013.

QUOTES

Gru: "Just because everybody hates it doesn't mean it's not good."

AWARDS

Nominations:

Oscars 2013: Animated Film, Song ("Happy")
British Acad. 2013: Animated Film
Golden Globes 2014: Animated Film

DIANA

The only thing more incredible than the life she led was the secret she kept.
—Movie tagline

Box Office: $335,359

Sometimes actors are cursed by their greatest role. In the case of Naomi Watts, her galvanizing breakout dual performance in David Lynch's 2001 masterpiece, *Mulholland Dr.*, has managed to overshadow everything she has done before or since. Whenever Watts stars in a bad film, particularly one as strangely inept as Oliver Hirschbiegel's failed awards contender, *Diana*, it is difficult to buy the two-time Oscar-nominee as the character she is assigned to portray, regardless of her formidable efforts. She merely resembles the troubled actress in Lynch's Tinseltown nightmare, sleepwalking through a tongue-in-cheek parody of airbrushed studio-approved fodder.

Released soon after Bill Condon's prematurely assembled Julian Assange biopic *The Fifth Estate* (2013) tanked at the box office, Hirschbiegel's long-awaited picture about Princess Diana flew through U.S. theaters so fast that it appeared to be sprinting towards the nearest bargain bin. Though the director excelled at exploring the life of a historical figure by narrowing the narrative timeline down to a few days in his brilliant 2004 drama, *Downfall*, *Diana* is merely the latest in a long string of biographical tabloids that glaze over a fascinating person's life while granting ample screen time to a boorish bystander.

Whereas *Julie & Julia* (2009) and *My Week with Marilyn* (2011) benefited from inspired star turns courtesy of their audacious leading ladies, *Diana* is a train wreck more reminiscent of Roger Michell's ghastly FDR costume party, *Hyde Park on Hudson* (2012). Watts certainly offers a studied impersonation of the late princess's mannerisms and inflections, but she does not appear to have a clear vision of the woman beneath the persona. Perhaps that is because the embarrassing script by playwright Stephen Jeffreys reduces the complex, controversial icon to a mopey, manipulative damsel straight out of a 1930s melodrama.

Based on Kate Snell's 2001 book, *Diana: Her Last Love,* the film focuses on Diana's affair with Pakistani

heart surgeon Hasnat Khan, played by *Lost* star Naveen Andrews. It is painful to watch Andrews resist the indefatigable urge to wince through his lines while courting Diana like a fumbling adolescent, coughing up pick-up lines like "hot stuff" while seducing her with heartfelt confessions like "You don't perform the operation, the operation performs you." To display her alleged interest in Islam, Diana quotes the Qur'an while visiting his family in a Pakistani village so idealized, it might as well be pre-Civil War Georgia as envisioned by *Gone with the Wind* (1939).

Though the picture runs nearly two hours, the sole insight it gives audiences into Khan's impact on Diana's life is his advice that she should "improvise," thus inspiring her to stroll through land mines for a philanthropic photo opp. Practically every plot point in the film has been spawned from a paparazzi snapshot, as demonstrated when the action frequently freezes into a front page headline. Hirschbiegel and Jeffreys's perspective is no less shallow and intrusive, fixating on well-worn gossip as if it were revelatory journalism.

With so little of worth on the screen, all there is left to do is linger on the Lynchian strangeness of watching the blonde Watts don a cheap brunette wig, reversing the hair-switch of *Mulholland Dr.*, in order go out in public with Khan. One of the film's biggest unintentional laughs occurs when the supposedly brilliant doctor initially fails to recognize the princess simply because of her new locks, a disguise every bit as shoddy as Superman's glasses. It is entirely understandable why the real-life Khan has expressed his displeasure with the picture despite having not seen it.

Lynch's surrealistic spirit also haunts the rather inexplicable sequence set on the night of Diana's fatal car crash in 1997. Repeated to even lesser effect at the film's end, this scene tracks Diana's footsteps with voyeuristic relish as she pauses in the hallway, staring back at her hotel room, before moving toward her untimely death. Hirschbiegel seems to be suggesting that Diana may have had an awareness of her impending tragedy, yet this concept is so tonally jarring that it appears to have been funneled in from an entirely different script. The ominous motion of the camera during this scene recalls the invisible malevolent forces that encircle Lynch's helpless protagonists at every turn. Yet the only malevolent force single-handedly destroying *Diana* is the undying scourge of prestige-baiting mediocrity, as crass and uninvolving as a Michael Bay blockbuster.

In a career chockfull with magnificent work, Watts may one day be able to look back at this mess and laugh, or at the very least, re-team with Scott Coffey for the sequel to their 2005 effort, *Ellie Parker,* about the unholy trials and tribulations endured by an LA actress. Her experience making *Diana* has undoubtedly provided her with enough priceless material for a follow-up to her under-seen satire.

Matthew Fagerholm

CREDITS

Princess Diana: Naomi Watts
Dr. Hasnat Khan: Naveen Andrews
Paul Burrell: Douglas Hodge
Sonia: Juliet Stevenson
Oonagh Toffolo: Geraldine James
Patrick Jephson: Charles Edwards
Origin: United Kingdom
Language: English
Released: 2013
Production: Robert Bernstein, Douglas Rae; Ecosse Films; released by Entertainment One
Directed by: Oliver Hirschbiegel
Written by: Stephen Jeffreys
Cinematography by: Rainer Klausmann
Music by: Keefus Ciancia; David Holmes
Sound: Srdjan Kurpjel
Music Supervisor: Ian Neil
Editing: Hans Funck
Art Direction: Mark Raggett
Costumes: Julian Day
Production Design: Kave Quinn
MPAA rating: PG-13
Running time: 107 minutes

REVIEWS

Berardinelli, James. *ReelViews*. November 2, 2013.
Bradshaw, Peter. *The Guardian*. September 6, 2013.
Burr, Ty. *Boston Globe*. October 31, 2013.
Clarke, Cath. *Time Out London*. September 18, 2013.
Errigo, Angie. *Empire*. September 16, 2013.
Gant, Charles. *Variety*. September 9, 2013.
Henderson, Eric. *Slant Magazine*. November 8, 2013.
Jagernauth, Kevin. *The Playlist*. October 31, 2013.
Merry, Stephanie. *Washington Post*. October 31, 2013.
Weitzman, Elizabeth. *New York Daily News*. November 1, 2013.

QUOTES

Hasnat Khan: "I've struggled to see how I could marry the most famous woman in the world. But I'd be giving up the very thing that defines me."

TRIVIA

Jessica Chastain was originally cast as Princess Diana but dropped out due to scheduling conflicts.

Nominations:

Golden Raspberries 2013: Worst Actress (Watts)

DISCONNECT

Look up.
—Movie tagline

Box Office: $1.4 Million

Initially made to prey on the paranoia of the uninformed American, cautionary feature films from long before the age of Wikipedia like *Reefer Madness* (1936) and *Sex Madness* (1938) have since been designated to the embarrassed corners of American cinema history. As intellectually underdeveloped as the scientific studies that inspired them, these films that guaranteed death when smoking marijuana or having pre-marital sex were under no greater influence than ignorance itself. And now, three quarter centuries after these two films, Henry Alex Rubin's maudlin *Disconnect* keeps with the directive of these madness films, warning about the new narcotic and/or social disease that is an internet connection. Thankfully, it is more informed about its subjects than these films, but it still staggers in deciding whether or not to package its stale story as a sermon.

Loosely connecting the three tales of walking IP addresses who experience life-changing events due to internet interaction, *Disconnect* has plots which can have their authenticity proven by a brief overview of local news reports. First, there is the story of antisocial teenage boy Ben (Jonah Bobo), who is targeted by two pesky classmates (Colin Ford and Aviad Bernstein) as the victim of their next prank. Because they consider him to be strange, they seek to humiliate him by pretending on Facebook to be an emotionally supportive girl from another school. Ben's emotional connections with this fake Facebook account eventually drive him to reciprocate with an intimate snapshot, which is then shared by the two iPad-using hooligans to all of Ben's peers. Humiliated, Ben tries to take his own life, inspiring his distant and devastated dad (a worn Jason Bateman, in a role that illuminates his acting potential as a driven father instead of a forgetful one) to investigate what drove Ben to such traumatic actions

Similarly, the film also focuses on a young married couple who become the victims of identity theft. Alexander Skarsgard plays Derek, a former soldier of the armed forces who has now become miserable in his office job, and is married to Cindy (Paula Patton). The

two are divided by the grief they share for their lost baby, and spend a lot of time apart—she on counseling message boards interacting with a shady user played by Michael Nyqvist, and he on gambling websites. To their surprise, their credit card and personal information is stolen one day by an identity thief, spurring this broke couple as vengeful for whoever violated their online trust.

Lastly, there's the story of online camera sex performer Kyle (Max Theriot), who cohabitates in a media brothel with other attractive young men and women who make a controlled living as video chat prostitutes. Kyle's life situation catches the sympathy of rising TV reporter Nina (Andrea Riseborough), who wants to make a news feature about Kyle's dark profession, and also save him from this terrible lifestyle despite all of his resistances.

While proudly taking on the concept of a cautionary tale, *Disconnect* does show some control with tone for its subject matter, keeping the stories and their portrayals by a talented cast within believable bounds; it's not the acting that gets hammy. On a different level, *Disconnect* also has a burst of courage at the end compared to other mainstream films, as its final scenes dare to challenge the comfort audiences may want after a sobering lecture.

Such dramatic restraint does make *Disconnect's* missteps all the more undeniably visible when they do make appear. When naivete is abused as a consistent character flaw, *Disconnect* lags in its hope of being taken seriously as a clever thriller happening within a viewer's own personal space. Even Rubin's last statements of connectivity come not with grace but a heavy hand, as all three storylines are visually connected by actions captured in sappy slow motion. Despite some unforeseen events leading to these climaxes, this final statement backfires as more saccharine than it is genuinely emotional.

However what *Disconnect* best captures is the sullen physical atmosphere when users are communicating to others via devices, the illumination of technological devices creating a bubble from the rest of the world. This film is very sharp to the silence radiating during such interaction, when human beings are only communicating with others using their fingers, their presence represented by the emotionless form of text (sometimes accompanied by a profile picture). During these staggering moments in the film, *Disconnect* is also smart to how people look when using such technology, their faces lacking expression, often regardless of whatever emotion is being conveyed through textual

communication. In a strong way, these are its most successful passages, reminding viewers not only of the news headline problems spurred from the Internet, but to at least be aware of how alienated one looks when staring at a screen trying to connect with others.

Disconnect struggles to be more than a melodramatic collection of warnings to a vulnerable society with humans whose lives are at the mercy of connections they make with others on the Internet. Rubin's film doesn't strive to implant much in its audience beyond a PSA's caution; it simply wants to mention hazardous scenarios to its viewers, all before its audience members tumble down some stairs in the midst of texting about this movie.

Nick Allen

CREDITS

Rich Boyd: Jason Bateman
Lydia Boyd: Hope Davis
Cindy Hull: Paula Patton
Derek Hull: Alexander Skarsgard
Ben Boyd: Jonah Bobo
Mike Dixon: Frank Grillo
Nina Dunham: Andrea Riseborough
Kyle: Max Thieriot
Stephen: Michael Nyqvist
Jason Dixon: Colin Ford
Origin: United States
Language: English
Released: 2013
Production: William Horberg, Mickey Liddell, Jennifer Monroe; Wonderful Films; released by LD Entertainment
Directed by: Henry Alex Rubin
Written by: Andrew Stern
Cinematography by: Ken Seng
Music by: Max Richter
Sound: Paul Hsu
Editing: Lee Percy
Art Direction: Jennifer Dehghan
Costumes: Catherine George
Production Design: Dina Goldman
MPAA rating: R
Running time: 115 minutes

REVIEWS

Berardinelli, James. *ReelViews*. April 12, 2013.
Burr, Ty. *The Boston Globe*. April 11, 2013.
Cover, Colin. *Minneapolis Star Tribune*. April 18, 2013.
Fear, David. *Time Out New York*. April 9, 2013.
Goodykoontz, Bill. *Arizona Republic*. April 18, 2013.
Guzman, Rafer. *Newsday*. April 18, 2013.
Lodge, Guy. *Variety*. September 12, 2012.
Roeper, Richard. *RichardRoper.com*. April 12, 2013.
Sachs, Ben. *Chicago Reader*. April 11, 2013.
Weitzman, Elizabeth. *New York Daily News*. April 11, 2013.

TRIVIA

When Mike Dixon is looking through the Hull's pictures, there is a picture from Derek Hull's Marine days, which is clearly a photo of Alexander Skarsgard with former marine Eric Kocher while they were working on HBO's *Generation Kill*. The photo after is a picture that features the cast of *Generation Kill*, and many of the actors from the show can be identified.

DON JON
(Don Jon's Addiction)

We all want a happy ending.
 —Movie tagline
Everyone loves a happy ending.
 —Movie tagline
There's more to life than a happy ending.
 —Movie tagline

Box Office: $24.5 Million

By American classification of generations, actor Joseph Gordon-Levitt (born in 1981) is old enough to stand outside of the perimeters of Generation Y (also called the Net or Millennial Generation), but close enough to have a front-row experience to its growth through media, from billion-dollar romances like *Titanic* (1997) to the one-click accessibility of internet pornography. Gordon-Levitt's thesis on the effect of this media on Generation Y culture is *Don Jon,* which discusses how media connects and defines people who rely on it for unrealistic pleasures. As someone raised by show business as an objectified heartthrob, but also one redefined later in his adult years as a filmmaker with his collaborative art site hitRECord, it is an impressive debut, one with a specific perspective to its confident vision.

In the film, Gordon-Levitt bulks up to be title buff guy Jon Santello, a New Jersey resident who deals with life by compartmentalizing his passions into habits. After cleaning his "pad" and lifting weights at the gym, Jon goes to the club with his "boys" (Rob Brown and Jeremy Luke) grinding on different women to the same bass-rumbling song. The following Sunday morning, he cleanses his Catholic guilt with a grinning weekly confession at church, and then has dinner that night with his mother (Glenne Headly), father (Tony Danza), and mute

phone-glued sister Monica (Brie Larson). The only vacancy in his life is his disappointment about sex—that the real thing is never better than watching porn. "Real p***y can kill you," Jon advises his listeners (with no sarcasm) in one of his many colorful voiceover remarks, a hint of his mental block that allows him to fully connect with women during sex.

While on his usual prowl for available women, he meets a tantalizing blonde named Barbara Sugarman (Scarlett Johansson), of which despite his previously-successful maneuvers, he is not able to procure a late night coupling with, or even her phone number. Instead, he is able to track her down through Facebook, and then ask her out for coffee. On their first date they express their interest in one another, and then go to a romance film, of which the editing of *Don Jon* indicates is an as orgasmic experience for Barbara as watching porn is for Jon.

The two embark on a serious dating relationship, one that Barbara aims to construct in the image of her romance movie fantasies (in a funny piece of evidence, she has a *Titanic* poster in her childhood bedroom). The two wait for over a month to have intercourse, Jon has to promise he won't look at his beloved porn anymore, and Barbara thinks she can improve Jon's life by enrolling him into community college.

Though Jon is smitten with Barbara, he struggles with his inclination to look at porn, peeking at X-rated videos on his phone while attending class. He is caught by a fellow student and older woman named Esther (Julianne Moore), who with her own complicated background, hopes to teach Jon to connect with a human being in a way he never has.

Of the many choices that Gordon-Levitt makes with this film, his decision to make his title addict resemble the contemporary caricature of young Italian American men is one of its most bold, considering the infamous image association with non-PC circuses like MTV's *Jersey Shore* (2009), which featured a group of individuals he and Barbara could easily be clones of. Gordon-Levitt pulls off this impersonation without exaggeration, using a thick Jersey accent as a distinct color for his creature of habit, and also a gap between he and the character.

In their relationship of trashy mind-games, Gordon-Levitt has robust chemistry with Johansson, who is dolled up with hoop earrings and skin-tight clothes. Controlling the sexuality of her image as fantasy object in this film, Johansson's appearance is similar to her work in Spike Jonze's *Her* (2013), where she constructively teases the male gaze that has established her as a hyper sexual object of Hollywood. As well, Barbara's problems provide a strong parallel to Jon's addiction, providing a fuller picture of damage that has been done to different expectations from desire.

In direct contrast to Barbara is Moore's vulnerable Esther, whose embodied epiphany of real love and real pain has a crucial honesty that makes the film's third-act shift the entire meaning of the film. However, as one of Gordon-Levitt's more distinct yet broader colors on *Don Jon's* canvas, and like the specifically random placement of Larson's "Silent Bob" character, Moore provides sagacious moments of clarity to Jon (and the film's audience) that flirt with tactless preachiness in the third act.

To accelerate the audience's grasp of Jon's defining cycle, Gordon-Levitt uses repetition as his ultimate storytelling mechanism (which Rian Johnson did on their previous collaboration *Looper* with the same effect). With some of its strongest comedy coming from this repetition, *Don Jon* does not spoil its own jokes despite their being referenced more than once, cutting them off before they overstay their welcome. In particular, the sound clip of an Apple computer's trash bin emptying never gets tiresome with the image of Jon tossing away his inseminated tissues.

With *Don Jon*, Gordon-Levitt has a very direct talk about sex to an audience that buys into over-sexualized culture, aware that the nature of Jon and his club-going habits is not a foreign one. A recognizable spark of *Don Jon's* magic is that Gordon-Levitt gets his audience to laugh at itself, sharing full awareness to the ridiculous gaming happening on both ends of a hormone-driven courtship. Designating men and women to porn and romance stories respectively is a simplified perspective, but it does work to a successful broader extent to show the difference between pleasure from fantasy as opposd to the more fulfilling one from reality.

Gordon-Levitt connects with his audience in particular by raiding very specific passages from the Millenial male's subconscious, crafting an authentic portrayal of an MTV boy whose passions have driven him inward. Jon's voiceovers stand as some of the most candid monologues to be shared with a mainstream audience, one that rarely talks about sex without some type of covered fanfare, if at all. In these moments, Jon goes into deep detail about his specific disappointments in sexuality, with his conclusion offering why porn is better than real intimacy. The astonishing honesty (about his distaste for the missionary position, etc.) that motivates such pontifications is order for some of the film's biggest laughs. Throughout this portrayal, to Gordon-Levitt's immense credit, his intentions as idealist never flirt with untruth.

That is until the third act, in which Gordon-Levitt's boldness takes its largest leap, into a plot direction that aims to redeem Jon and show his audience the impor-

tance of connection in love, and primarily the grand difference of making love and having sex. Considering the very specific standards set by Jon on the women he is interested in, a backtrack by Gordon-Levitt's character construction can only get a pass for its poetic worth, instead of within the reality it has otherwise been using to connect with its audience. In the face of being unbelievable, such a direction does come with a good heart; Gordon-Levitt's unique way of providing an answer to an audience that objectifies each other pays off as its own stunt. Gordon-Levitt risks his film's climax on its most romantic notion.

Filming *Don Jon* after having worked on the sets of directors Christopher Nolan, Steven Spielberg, and his longtime pal Rian Johnson, Gordon-Levitt directs this story with inherent poise, where even its imperfections are specific indications of control. With this courageously full-on address of objectification in media, he shows to be a budding storyteller who finds a promising virtue in self-awareness.

Nick Allen

CREDITS

Jon: Joseph Gordon-Levitt
Barbara: Scarlett Johansson
Esther: Julianne Moore
Jon Sr.: Tony Danza
Angela: Glenne Headly
Origin: United States
Language: English
Released: 2013
Production: Ram Bergman; released by Relativity Media L.L.C.
Directed by: Joseph Gordon-Levitt
Written by: Joseph Gordon-Levitt
Cinematography by: Thomas Kloss
Music by: Nathan Johnson
Sound: David Chrastka
Music Supervisor: John Houlihan
Editing: Lauren Zuckerman
Art Direction: Elizabeth Cummings
Costumes: Leah Katznelson
Production Design: Meghan Rogers
MPAA rating: R
Running time: 90 minutes

REVIEWS

Dargis, Manohla. *New York Times*. September 26, 2013.
Denby, David. *New Yorker*. September 23, 2013.
Gronvall, Andrea. *Chicago Reader*. September 26, 2013.
McCarthy, Todd. *Hollywood Reporter*. September 24, 2013.
Merry, Stephanie. *Washington Post*. September 26, 2013.
Morgenstern, Joe. *Wall Street Journal*. September 26, 2013.
Rainer, Peter. *Christian Science Monitor*. September 27, 2013.
Sharkey, Betsy. *Los Angeles Times*. September 27, 2013.
Weitzman, Elizabeth. *New York Daily News*. September 26, 2013.

QUOTES

Barbara: "Movies and porn are different, Jon. They give awards for movies."
Don Jon: "And they give awards for porn too."

TRIVIA

Despite being featured in several scenes, actress Brie Larson has only one line.

DRINKING BUDDIES

A comedy about knowing when to say when.
—Movie tagline

Box Office: $343,341

Joe Swanberg, the Chicago writer/director most well-known in indie circles for being one of the founding voices of the low-budget, high-talky Mumblecore subgenre, takes a giant leap forward in terms of mainstream accessibility with the fun, bittersweet, clever *Drinking Buddies*, a film that sees him not only working with a higher caliber of actors in front of the camera but displays a new level of maturity and world wisdom on the part of its creator. As he has with all of his works, Swanberg serves as a jack-of-all-trades, directing, writing, editing, and more, while also allowing his talented cast to improvise as much as their creative minds will allow. The result is one of the most consistently engaging dramedies of 2013, a film filled with smart truths that are never underlined in the ways so common to the romantic dramedy genre. The maturity on display on a narrative level inspires Swanberg's direction as well, as his always-strong rapport with actors draws great performances from literally everyone in the cast, and finally gives the gorgeous Olivia Wilde the part that her scene-stealing work in other films has demanded for years. It is the performance of her career, one she beautifully capped with a brief-but-effective role in Spike Jonze's *Her* (2013) to truly signal her arrival on a new tier of performers. The film's refusal to play into all of the mainstream comedy cliches promised by the beautiful people on its poster may frustrate some viewers looking for more clear-cut answers but Swanberg beautifully transitions from Mumblecore to something more mature

without losing the character-driven approach of the former.

Kate (Olivia Wilde) and Luke (Jake Johnson, known mostly for his work on FOX's *New Girl*) work together at a micro-brewery, Revolution Brewing Company in Chicago (where the film was shot). They have a friendly dynamic akin to millions of workplaces around the world; joking with one another, drinking and playing pool after the whistle blows, and wanting to hear about their significant others. They definitely seem more like friends than potential lovers but this is cinema and the viewer's heart and mind are trained to think that Kate and Luke are meant for each other. A film festival could be programmed with works about how males and females, certainly those as handsome and beautiful as Johnson and Wilde, cannot possibly "just be friends."

Perhaps the hold-up will merely be that Kate and Luke have significant others. Luke seems to be in the healthier relationship of the two, seemingly in love with the remarkably sweet Jill (Anna Kendrick, who liked working with Swanberg enough that she went on to work with him again on his Sundance Film Festival competition entry *Happy Christmas* [2014]). Kate struggles a little bit more in the shallow end of the dating pool, currently seeing a man named Chris (Ron Livingston), who says all the right things but betrays the body language of a man who is going through the motions until the relationship inevitably runs out of steam. Part of the problem is that Chris and Kate seem to run in different social strata. She wants to drink and shoot pool. He does not. It is only a matter of time before she turns to Nick, right?

As one can tell from this deceptively simple set-up, the structure of Swanberg's film is certainly familiar. From the minute that Kate and Luke introduce one another to Chris and Jill, echoes of films like *About Last Night* (1984) and the countless rom-coms inspired by it send the viewers' minds careening through the cliche handbook. When the two couples go on a cottage retreat together and Jill and Chris begin to flirt on a beautifully-written hike, they seem to be a better fit. Take couple A and swap partners with couple B and everyone can drink Revolution at the mutual weddings. Luckily, Swanberg has loftier, more realistic goals than a simple "girlfriend swap" piece, and those aspirations are revealed about halfway through the film, taking it to another level and distinguishing it as Swanberg's best film to date.

Swanberg has always placed much of his narrative weight on the realism of his performance, allowing his cast to improvise to find truthful moments, even if they do not add up in ways that audiences traditionally expect. While she may not be the best improviser in his stable of actors, Olivia Wilde proves to be a great fit for Swanberg's casual approach to character depth. She has shown signs of greatness in the past (even stealing a piece of garbage like *The Incredible Burt Wonderstone* [2013] in her breakthrough year) but this role is easily the best of her career and she does what critics hoped she would with a juicy part. Wilde is charming, beautiful, and wonderfully fallible, turning Kate into one of the most well-rounded and believable characters that the rom-com genre has seen in years. Johnson is very good, once again, and Kendrick can do more with a few scenes than most actresses can do with a whole script, but the film belongs to Wilde and she rocks it.

To borrow the parlance of the microbrew-obsessed world in which Swanberg's characters work, *Drinking Buddies* is a sipping beer. It is not meant to be chugged and will not provide the high-ABV buzz that some may be be hoping from its set-up. And yet it has a memorable, distinct flavor that lingers long after the others have come and gone.

Brian Tallerico

CREDITS

Kate: Olivia Wilde
Luke: Jake Johnson
Jill: Anna Kendrick
Chris: Ron Livingston
Origin: United States
Language: English
Released: 2013
Production: Paul Bernon, Andrea Roa, Sam Slater, Alicia Van Couvering, Joe Swanberg; Burn Later Productions; released by Magnolia Pictures
Directed by: Joe Swanberg
Written by: Joe Swanberg
Cinematography by: Ben Richardson
Sound: Nick Biscardi
Editing: Joe Swanberg
Costumes: Amanda Ford
Production Design: Brandon Tonner-Connolly
MPAA rating: R
Running time: 91 minutes

REVIEWS

Abele, Robert. *Los Angeles Times*. September 4, 2013.
Bray, Catherine. *Time Out London*. October 19, 2013.
Gleiberman, Owen. *Entertainment Weekly*. August 21, 2013.
Goss, William. *Film.com*. April 23, 2013.
Kelly, Stephen. *Total Film*. November 3, 2013.
Kohn, Eric. *Indiewire*. April 23, 2013.
Puig, Claudia. *USA Today*. August 29, 2013.

Roeper, Richard. *Chicago Sun-Times.* August 22, 2013.
Scott, A. O. *The New York Times.* August 22, 2013.
Wigon, Zachary. *Village Voice.* August 20, 2013.

QUOTES

Kate: "I just needed a smaller place because my place is meant for two, and I am meant for one, so I am moving to a little place. It's good; it's got just enough room for me and my imaginary cat."

TRIVIA

Director Joe Swanberg has a cameo in the film as the man that gets into a fight with Jake Johnson.

DRUG WAR
(Du Zhan)

Box Office: $128,195

Having reached its cultural zenith during the early nineties thanks to the international successes of films by the likes of John Woo, Tsui Hark and Ringo Lam, the Hong Kong action film industry has been comparatively quiet in recent years as fanboys in search of the next big thing have moved on to greener pastures. That said, the genre has continued to hum along nicely in recent years thanks to filmmakers like Johnnie To, whose *Election* (2005) and *Exiled* (2006) have continued to breathe new life into the format. With his latest work, *Drug War*, he has hit a new personal artistic high by creating a lean, efficient and startlingly effective crime drama that more than holds its own against the more overtly operatic efforts of his forbearers.

Shifting his focus from Hong Kong to China for the first time as an action filmmaker (he previously shot the romantic comedy *Romancing In Thin Air* on the mainland), *Drug War* opens as drug lord Timmy Choi (To regular Louis Koo) frantic efforts to escape from a methamphetamine factory explosion that has messed up his face and literally left him foaming at the mouth end prematurely as he crashes his car through a restaurant window. At the same time, a drug task force led by Captain Zhang (Sun Honglei) has just busted a bunch of mules smuggling the drug internally into Tianjin, the fourth-largest the hopes of avoiding detection. After bringing the mules to the hospital in order to extract the drugs before the packages can rupture (a pre-show trip to the concession stand is not recommended), Captain Zhang learns that Choi has also been admitted to the same hospital and, after foiling an escape attempt, arrests him.

As he is now looking already looking at the death penalty for his crimes, Choi offers to make a deal with Zhang—in exchange for not seeking the ultimate punishment, he will help the police set up and execute a bust that will nab some of the biggest players in the local drug scene. Zhang and his men have their suspicions but agree to the deal and begin their elaborate sting, a process that not only involves Choi setting up two different meetings with other dealers in which Zhang goes undercover as a potential buyer, but which finds Zhang impersonating the man he met with at the first meeting during the second. As things progress, Choi does seem to be providing invaluable assistance—even helping to save Zhang's life when he is forced to do a couple of hits of meth by a suspicious dealer—but even so, there are still lingering questions over his true motives; is he helping out of a sense of remorse and a desire to save his own skin, is he stringing the cops along while looking for an opportunity to warn his cohorts or does he have another and more sinister agenda at heart?

Although the plot suggests the kind of slick and overly stylish approach that has long been a staple of the HK action film industry, *Drug War* finds To moving in a different and ultimately more interesting direction. Instead of over-the-top histrionics and elaborately choreographed set-pieces, To has instead decided to employ a more down-to-earth and realistic take that will put viewers more in the mind of the procedural structures favored by the likes of Michael Mann and David Fincher in their respective masterpieces *Heat* (1995) and *Zodiac* (2007). By stressing realism over gaudy cinematic effects, To manages to reinvigorate what could have been a fairly standard storyline to such a degree that even scenes that consist of little more than several people sitting around a table and talking contain more genuine suspense and intrigue than most action films of recent vintage that one could name. Even when the material flirts with the melodramatic, the down-to-earth approach keeps things from descending into any of the expected cliches.

This is not to say that To is loafing when it comes to the action beats because even though they have been staged in a manner stressing realism over everything else—no fancy slo-mo effects or wild choreography to speak of—they are still exciting enough to thrill even the most jaded of genre fans. One of the high points of the films comes during a raid of one of a drug warehouse of Choi's that is manned exclusively by deaf-mutes that is staged without any musical accompaniment as a way of accentuating the oddness of the circumstances. The grand climax is also pretty stunning in the way that it subverts audience expectations while offering them an expertly staged sequence that is all the more impressive for not appearing to be staged at all.

The only real flaw with *Drug War* is that To is so successful at keeping things low-key and realistic that

when he does veer away from that approach, as he does with the misadventures of a couple of increasingly addled guys driving a truck filled with meth-making materials for Choi, those scenes sometimes seem as if they were themselves trucked in from another movie. For the most part, however, the film sticks to its serious-minded guns, aided in no small part by the strong performances by Koo and Honglei (the latter is especially impressive in the scenes when he is forced to abandon his normally taciturn behavior in order to pull off his more gregarious undercover alter ego), and the result is one of the better cop films of recent vintage. It is almost a certainty that someone will hit upon the bright idea of doing an English-language remake in the hopes of coming up with a Stateside success along the lines of *The Departed* (2006). It is true that the basic story of *Drug War* is strong enough that it could presumably survive such a translation without losing too much in the bargain but no remake, no matter how well-intentioned and well-executed, could hope to maintain the strength and power of the original.

Peter Sobczynski

CREDITS

Timmy Choi Tin-ming: Louis Koo
East Lee: Ka Tung Lam
Zhang Lei: Honglei Sun
Yang Xiaobei: Yi Huang
Fatso: Suet Lam
Origin: China

Language: Mandarin Chinese
Released: 2013
Production: Johnnie To, Ka-Fai Wai; Hairun Movies & TV Group; released by Variance Films
Directed by: Johnnie To
Written by: Ryker Chan; Ka-Fai Wai; Nai-Hoi Yau; Xi Yu
Cinematography by: Siu-keung Cheng
Music by: Xavier Jamaux
Sound: Benny Chu
Editing: Allen Leung; David M. Richardson
Production Design: Horace Ma
MPAA rating: R
Running time: 107 minutes

REVIEWS

Atkinson, Michael. *Village Voice.* July 23, 2013.
Bowen, Chuck. *Slant Magazine.* July 17, 2013.
Dargis, Manohla. *New York Times.* July 25, 2013.
Erickson, Steve. *Film Comment.* November 4, 2013.
Kohn, Eric. *indieWIRE.* July 23, 2013.
Larsen, Josh. *LarsenOnFilm.* January 10, 2014.
O'Hehir, Andrew. *Salon.com.* July 25, 2013.
Orndorf, Brian. *Blu-ray.com.* July 25, 2013.
van Hoeij, Boyd. *Variety.* July 2, 2013.
Young, Deborah. *Hollywood Reporter.* July 2, 2013.

TRIVIA

There are two endings. One is the Chinese censored version, where Louis Koo gets handcuffed with Honglei Sun, arrested, and is put to death by lethal injection. The other features Louis Koo getting away and seen by Yi Huang in Thailand.

E

THE EAST

Spy on us, we'll spy on you.
—Movie tagline

Box Office: $2.3 Million

In recent years, writer-actress Brit Marling has co-written and starred in *Another Earth* (2011) with co-writer and director Mike Cahill, *Sound of My Voice* (2012) with co-writer and director Zal Batmanglij, and now *The East,* again co-written with Batmanglij. While all three limited-budget films share a nuanced (and atmospheric) respect for their particular genres, they also share an interest in mapping identity; in probing how people make and deal with the choices that guide and shape their lives. *The East*, an eco-terrorism thriller, brings those explorations into even sharper, tenser focus as it examines individuals trying to square their personal beliefs against a world often defined by capitalist consumerism and the corporate greed that exploits it with callous indifference.

In *The East,* Marling is Sarah, a dedicated and career-minded young woman who lands a plum job as an undercover investigator for a private security firm that protects the interests and images of its large corporate clients. Sarah's job is to infiltrate a secret and mysterious anti-corporate group of extreme eco-activists called The East and then report the group's plans to her boss, Sharon (played with coolly ambitious amorality by Patricia Clarkson). (When informed of a potentially dangerous East plot unfolding, Sharon tells Sarah to let it go ahead—the targeted Big Pharma company is not one of their clients.) Naturally, once Sarah has found and joined The East on a pastoral communal farm, she finds herself slowly drawn in and her convictions challenged by the members' open, holistic lifestyle.

The members of The East are not cookie-cutter counterculture stereotypes—while some are former rich kids who reject their trust-fund destinies, each has his or her own motivations and methods, and varying shades of dedication and ethics. Alexander Skarsgard is Benji, the stalwart and casually seductive nominal leader of this particular cell of the nebulous organization. Benji's rugged *noblesse oblige* comes wrapped in hipster-artisan scruff, but his easy, rugged calm unites and steers a varied group that includes an overly-zealous firebrand (Ellen Page), a damaged former med student (Toby Kebbell), and a colorful but conscientious glammed-out misfit (Shiloh Fernandez). Most of the actors show a subtle naturalism—Skarsgard and Page are especially good—but it is Marling's Sarah who quietly holds the film's center with a deceptively fade-away presence that manages, like the film, to be both ethereal and steely.

It is no plot surprise that Sarah begins to go native while undercover with The East, but Marling and Batmanglij let neither the film *The East* or the group The East fall into an easy "right/wrong," "good/bad" dichotomy. Batmanglij weaves earth-toned grittiness with sun dabbled idealism, but his hand is strongest when subtly melding story and theme. Inspired by 1970s political thrillers like *The Parallax View*, the filmmakers keep the narrative clicking along with genre tension balanced by quiet moments of rustic sharing. That sometimes leaves *The East* competing within itself between being a gripping genre thriller and a heady policy and morality discussion—along the way it also

becomes an advertisement for alternate ways of thinking and living outside a capitalistic society.

Although she is a somewhat subdued and effectively minimalist actress, as a writer Marling does not shy away from going after big themes and has a finely-tuned ear for human frailties, complications, and paradoxes and the ways in which people must navigate the collisions of beliefs and actions and of personal desires and connections. At the heart of *The East* is a slow-fade contrast between the group's hippie holism (bonding games of spin the bottle, lessons in cooperation and community using soup spoons and straight jackets, skinny dipping as emotional healing) and the righteous militant anger that fuels the group's increasingly destructive and potentially deadly activities. *The East* carefully feels its way into these murky gray areas as group members argue out the philosophies of their anarchic revolution: Should they be driven by anger or hope? Should they be hurting or helping people? How far do they go with "an eye for an eye," and at what point do trust exercises give way to more conventional firepower?

Through it all, *The East* tries to wear its genre lightly and slough off predictable tropes, but its final act gets pulled kicking and screaming into the more familiar formula of a political thriller. Still, Batmanglij and Marling cannot quite bring it all to a powerful, satisfying conclusion because the film has bigger aims that do not fit neatly into formula. There are points at which *The East* feels like a crunchy-granola high school teacher (once in sandals, now likely in Doc Martens) who loves to toss questions to the class challenging status quo thinking, but who is a little too flighty and enchanted by the asking to really dig into possible answers.

However, even when *The East* occasionally stumbles over its characters' earnestness, the film's eye-opening intent is preferable to more mainstream movies that themselves often feel like products of the same corporate capitalist machinery the group The East is out to sabotage. In the end, *The East*'s inability to express a cohesive, definitive answer either thematically or narratively is not entirely a bad thing. This is a film about questioning—the film's structure, narrative, and general artistic motivation are geared to reject the notion of easy, monolithic answers. That lets it get away with an ending that eludes thriller expectations and leaves more problems than solutions on the table.

The East had a platform theatrical release beginning in late May and peaking at almost 200 art-house theaters by late June, earning a little over $2 million along the way. Critical response was mostly positive, with most praising the film's mix of thrillers and ideas, such as Betsy Sharkey of the *Los Angeles Times*, who described it as "a dizzying cat and mouse game with all sorts of

moral implications," while some like A.O. Scott of the *New York Times* wished the film had dug deeper into its themes: "It may be asking too much of *The East*—which is, after all, a twisty, breathless genre film—to wish that it would frame the contradictions of contemporary capitalism more rigorously."

Locke Peterseim

CREDITS

Sarah Moss: Brit Marling
Benji: Alexander Skarsgard
Izzy: Ellen Page
Luca: Shiloh Fernandez
Doc: Toby Kebbell
Paige: Julia Ormond
Sharon: Patricia Clarkson
Origin: United States
Language: English
Released: 2013
Production: Michael Costigan, Ridley Scott, Brit Marling; Scott Free Productions; released by Fox Searchlight
Directed by: Zal Batmanglij
Written by: Brit Marling; Zal Batmanglij
Cinematography by: Roman Vasyanov
Music by: Harry Gregson-Williams
Sound: Andrew Decristofaro
Editing: Bill Pankow; Andrew Weisblum
Costumes: Jenny Gering
Production Design: Alex DiGerlando
MPAA rating: PG-13
Running time: 116 minutes

REVIEWS

Barnes, Henry. *The Guardian*. June 27, 2013.
Dowd, A. A. *Onion A.V. Club*. May 30, 013.
Edelstein, David. *New York/Vulture*. May 31, 2013.
Nicholson, Amy. *Village Voice*. May 29, 2013.
O'Hehir, Andrew. *Salon*. May 30, 2013.
O'Sullivan, Michael. *Washington Post*. June 6, 2013.
Phillips, Michael. *Chicago Tribune*. June 6, 203.
Scott, A. O. *New York Times*. May 30, 2013.
Sharkey, Betsy. *Los Angeles Times*. May 30, 2013.
Vishnevetsky, Ignatiy. *RogerEbert.com*. June 9, 2013.

QUOTES

Luca: "Since when do we turn away outlaws?"

TRIVIA

Actress Brit Marling and director Zal Batmanglij, who co-wrote the screenplay, based it on their experiences in the summer

of 2009 practicing freeganism and joining an anarchist collective.

ELYSIUM

Box Office: $93.1 Million

The elite looking down on those they deem beneath them is unfortunately still not a thing of the past in the dystopian future of *Elysium*. Writer-director Neill Blomkamp not only extends that already long-standing lamentable fact to the year 2154 but makes it literal, as here the affluent upper class can look astronomically further than merely down their noses at members of the destitute lower. What separates the haves and the have-nots is no longer just money but miles, the rich having risen above the rabble of a ruined Earth to enjoy exclusivity and endless elegant indolence upon the Stanford Torus-like space station to which the title refers. This heavenly wheel of wealth orbits so near to the now-hellish planet that it is always both tantalizingly within view and tormentingly out of reach for those stuck and struggling under the well-heeled.

The height of gated communities, Elysium does not simply turn away impending interlopers but often terminates them, inhospitably greeting desperation-fueled shuttle missions to access the satellite's life-saving miraculous med-bays with deadly missiles. Flights of fancy are infinitely safer, and such daydreams are as far as things initially go for orphan Max De Costa, just a skyward-gazing boy at the outset (and played by an adorable Maxwell Perry Cotton) who is already indignant over inequality and naively vowing to someday land in the idyllic-sounding lap of luxury. Max is intensely intrigued and impatiently yearning for immersion, and the mixture of fascination and frustration with which he beholds Elysium the Beverly Hills-style hovering haven is regrettably quite similar to what more than a few moviegoers felt as they watched its cinematic namesake.

The world still looks a picturesque, vibrant blue to those who are lucky enough to remain above it all, but viewers are both literally and figuratively brought down to Earth by images that reveal a ravaged surface that is anything but ravishing. Amidst this decimated, desiccated landscape is what appears to be the sprawling squalor of a teeming South-of-the-border slum yet is discombobulatingly identified as the wretched remains of Los Angeles. (The world's second-largest landfill, located in Mexico City, putridly—and quite pointedly—portrays what hypothetically awaits the United States' second largest metropolis.) Those locals still endeavoring to earn an honest day's pay at the Armadyne plant are likely to later be assailed by the very robocops they

assemble. One employee beaten down thusly is a grown-up Max (Matt Damon), and before the day is done, this buff and tattooed reformed car thief with a noggin resembling a cue ball will find himself decidedly behind the eight ball.

Despite being determined to avoid trouble, inherently-good Max seems a magnet for bad luck. A seemingly harmless quip to antagonistically-inquisitive android officers fails to tickle their funny bones and instead elicits the unwarranted brutal fracturing of one of his arms. After Max's parole monitoring is unjustly extended, a radiation accident at work shortens the poor guy's life to five days. Fantasizing will no longer be sufficient, and an agonized Max becomes grimly determined to stand up to anyone for the opportunity to lay down in one of Elysium's med-bays. He cares nothing about being a hero—only healed.

Viewers of *Elysium* were also eager for the chance to get up close and personal with this paradise. Unfortunately, the focus on Max's fighting chance to avoid expiration—sporadically engaging but constantly kinetic, cacophonous, convoluted and ultimately tedious and too standard issue—left little chance for exploration. While Earth seems almost too awful to behold, there is something eerily too-perfect about what little is seen of Elysium, something reminiscent of *The Twilight Zone* or perhaps *Stepford*-like about the uniformity with which the seemingly-too-beautiful-to-be-real residents of Elysium serenely socialize poolside behind magnificent mansions while robots that have finished immaculately manicuring the lawns now carefully clip flawless topiaries. Being blithe amidst sparkling sameness better never get old for those on Elysium because they themselves never will, assured of immortality by those ever-restorative med-bays. When the privileged catch a glimpse of their reflections in those pools, one wonders how they feel deep down about the person staring back up at them. Can these people without a care in the world care nothing about those who still languish there? Do they ever suffer pangs of ascenders guilt? Like the initial shots gliding above Elysium, Blomkamp glosses over such things, and whatever the average citizen feels remains a mystery since viewers never get to know even one.

Glaringly devoid of sympathy is hard-line, hard-hearted Secretary of Defense Delacourt (Jodie Foster), utterly remorseless about rousing ferociously-sadistic sleeper agent Kruger (Sharlto Copley, almost as far over the top as Elysium is above Earth) and having him annihilate the infirm, supposedly-ruinous riffraff attempting to immigrate. (Her lack of high-mindedness shows there can even be base ugliness up in Utopia because innately-flawed humans are present.) There is effective cutting between families anxiously huddled together on

the unauthorized shuttles and the cold blue eyes of the woman who so zealously ordered they be blown apart, certain that she alone possesses the foresight to know that decency deters nothing. Considering those who disapprove of her strong-arm tactics, like President Patel (Faran Tahir), to be weak, Delacourt enters into a surreptitious agreement with odiously-supercilious Armadyne founder/Elysium inventor John Caryle (William Fichtner) to create a virus that will oust Patel in a computerized coup. This invaluable gold that Carlyle has stealthy stored in his brain is what Max unexpectedly mines while earning a ticket to ride on one of the illegal shuttles of former cohort/fervent revolutionary Spider (Wagner Moura). This man focused solely on saving his own life ends up sacrificing himself as Earth's Christlike cyborg savior. Thanks to him, those cure-all med-bays are finally used to cure all.

Like Carlyle, Blomkamp obviously also has a lot on his own mind, and has no intention of keeping anything under his hat. He is blunt in dealing with economic class disparity, access to health, and the degradation of both the environment and human beings. Blomkamp goes so far as to manipulate with a heart-tugging, teddy-hugging, cancer-ridden cutie (Emma Tremblay), the daughter of Max's tepid love interest Frey (a typecast Alice Braga). Although his film is set in 2154, Blomkamp stressed in interviews that the future is now, using science fiction to examine today's troubling facts. His *District 9*(2009), the stunning, Oscar-nominated debut feature that grossed over six times its production costs, combined thought-provoking sociopolitical allegory about South African apartheid with thrilling special effects and an unpredictable plot. Expectations were high for *Elysium* because it was cooked up using a similar recipe, but the result is a maladroit mixture that is not nearly as tasty.

David L. Boxerbaum

CREDITS

Max: Matt Damon
Delacourt: Jodie Foster
Kruger: Sharlto Copley
John Carlyle: William Fichtner
Frey: Alice Braga
Julio: Diego Luna
Spider: Wagner Moura
Origin: United States
Language: English
Released: 2013
Production: Neill Blomkamp; released by Sony Pictures Entertainment Inc.

Directed by: Neill Blomkamp
Written by: Neill Blomkamp
Cinematography by: Trent Opaloch
Music by: Ryan Amon
Sound: David Husby
Music Supervisor: Miz Gallacher
Editing: Julian Clarke; Lee Smith
Art Direction: Don Macauley
Costumes: April Ferry
Production Design: Philip Ivey
MPAA rating: R
Running time: 109 minutes

REVIEWS

Burr, Ty. *Boston Globe*. August 8, 2013.
Corliss, Richard. *Time*. August 8, 2013.
Dargis, Manohla. *New York Times*. August 8, 2013.
Foundas, Scott. *Variety*. August 5, 2013.
Gleiberman, Owen. *Entertainment Weekly*. August 7, 2013.
Hornaday, Ann. *Washington Post*. August 8, 2013.
Lane, Anthony. *New Yorker*. August 5, 2013.
McCarthy, Todd. *Hollywood Reporter*. August 1, 2013.
Puig, Claudia. *USA Today*. August 8, 2013.
Travers, Peter. *Rolling Stone*. August 8, 2013.

QUOTES

John Carlyle: "Now, if you will excuse me, I have to not speak to you people any longer. Thank you."

TRIVIA

The character of Delacourt was originally written for a man.

EMPEROR

After the war was won the battle for peace began.
 —Movie tagline

Japan 1945: General Douglas MacArthur was given a mission to decide the fate of a nation, the guilt of a leader, and the true price of peace.
 —Movie tagline

Box Office: $3.3 Million

The idea of Tommy Lee Jones tackling the role of General Douglas MacArthur sounds like such an ideal example of casting genius—certainly better than when Sir Laurence Olivier attempted to play the military icon with laughable results in the infamous Korean War epic *Inchon* (1982)—that it would seem that the makers of

Emperor would have to go to extreme lengths to make a film that would fail to live up to such a concept. Inexplicably, they have managed to do just that by shunting the character to the sidelines so completely that he often feels like an interloper at a story in which he should by all accounts be featured front and center.

The story in question takes place in the immediate wake of the Japanese surrender to the United States following the bombings of Hiroshima and Nagasaki in August, 1945, as MacArthur and his aides are sent over to negotiate terms with Emperor Hirohito (Takataro Kataoka). One key sticking point in the talks is the demand by Hirohito that he be allowed to maintain the title of emperor, a notion that the Americans deem to be an absolute impossibility. To one of the key advisors, Gen. Bonner Fellers (Matthew Fox), dismissing this request is not as simple as it seems. As the Japanese have a 2,000-year-old culture based on notions of honor and the unshakable belief that the emperor is chosen by God, the notion of Hirohito being stripped of that designation by the people who defeated him in battle would simply be too much for the already demoralized population to bear—it is only the hold that Hirohito still has over his subjects that is preventing mass suicides or revolt against the vastly outnumbered occupying forces.

However, if it can be proven that Hirohito was explicitly involved in the planning and execution of war crimes—specifically the bombing of Pearl Harbor—then there will be no choice other than to strip Hirohito of his title. With an impossible time frame of only a couple of days to work with, Fellers is sent out to interview members of Hirohito's inner circle to discern his complicity. While conducting his interviews and trying to get people to speak out against a person that they legitimately believe to be a god, Fellers is also conducting a second and more personal investigation into the whereabouts of Aya Shimada (Eriko Hatsune), the niece of a Japanese industrialist who he had a romance with, first at college in the United States and later in Japan, that was interrupted by the war. As it turns out, Fellers never forgot about her—even arranging bombing runs so that they would avoid areas where she might be located—and the discovery of this secret relationship could jeopardize both his investigation and the negotiations with the Japanese.

This all sounds interesting in theory but director Peter Webber and screenwriters Vera Blasi and David Klass have inexplicably conspired to make it anything but. The first key problem is to essentially make Fellers, who is played by Fox as a wet blanket of the highest order, the character who drives the story while relegating MacArthur to occasional scenes of barking out orders. This might have been slightly excusable if the story had

focused solely on his investigation into Hirohito and his culpability but the film spends so much time dealing with Fellers searching for his lost love while indulging in long flashbacks involving their relationship that the whole enterprise is constantly grinding to a halt. By comparison, Jones makes such a vivid impression as MacArthur in his few scenes, effectively conveying both his brash, no-nonsense public persona and his more reflective private side, that the decision to keep him on the sidelines grows even more baffling as the film goes on.

The only time that *Emperor* begins to perk up comes towards the end when the focus finally shifts back to impending and once-unthinkable meeting between MacArthur and Hirohito, a notion that leaves even the normally unshakable American pondering "What the hell do you say to a god?" Even though this stuff takes up maybe the last ten minutes of screen time at most, it is so inherently interesting that it will leave most viewers wishing that someone had just made an entire movie out of it. Oh wait, someone did—Alexander Sokurov, to be specific, with his acclaimed drama *The Sun* (2005). And, even though it told the story from the point-of-view of Hirohito, it still has more to say about how both sides came to this meeting of differing cultures, not to mention the basics of how to make a gripping historical drama, than Webber & Co. have managed to muster up here.

Peter Sobczynski

CREDITS

Gen. Douglas MacArthur: Tommy Lee Jones
Gen. Bonner Fellers: Matthew Fox
Aya Shimada: Eriko Hatsune
Emperor Hirohito: Takataro Kataoka
Mitsuko Kajima: Kaori Momoi
Uncle Kajima: Toshiyuki Nishida
Takahashi: Masayoshi Haneda
Maj. Gen. Richter: Colin Moy
Origin: United States
Language: English
Released: 2012
Production: Gary Foster, Eugene Nomura; Fellers Film; released by Roadside Attractions
Directed by: Peter Webber
Written by: Vera Blasi; David Klass
Cinematography by: Stuart Dryburgh
Music by: Alex Heffes
Sound: Fred Enholmer
Editing: Chris Plummer
Costumes: Ngila Dickson
Production Design: Grant Major

MPAA rating: PG-13
Running time: 98 minutes

REVIEWS

Debruge, Peter. *Variety*. March 22, 2013.
Feeny, Mark. *Boston Globe*. March 7, 2013.
Hammond, Pete. *Movieline*. March 10, 2013.
Holden, Stephen. *New York Times*. March 7, 2013.
Orndorf, Brian. *Blu-ray.com*. March 8, 2013.
Reed, Rex. *New York Observer*. March 6, 2013.
Rooney, David. *Hollywood Reporter*. March 7, 2013.
Schrager, Nick. *Village Voice*. March 5, 2013.
Sharkey, Betsy. *Los Angeles Times*. March 7, 2013.
Yi, Esther. *Slant Magazine*. March 4, 2013.

QUOTES

General Douglas MacArthur: "After careful consideration, I've decided that General Richter can go piss up a rope."

ENDER'S GAME

This is not a game.
 —Movie tagline
The enemy's gate is down.
 —Movie tagline
The future must be won.
 —Movie tagline

Box Office: $61.7 Million

The film adaptation of author Orson Scott Card's acclaimed 1985 science-fiction novel *Ender's Game* finally arrived in theaters in the fall of 2013 after decades spent spinning in development. After all that time and patient waiting by the book's many fans, excitement over the film's debut was tempered in part by controversy and boycott threats over Card's past opposition to gay marriage.

Ender's Game wound up earning an anemic $87 million worldwide (against a $110 million budget) and garnering middling reviews from critics. In the end, however, the problems with the film *Ender's Game* stem not from Card's gay-marriage stance (which the author—who was not directly involved in the film's production—stated long after the book's publication and which is not clearly reflected in either the book or the film), but rather how the movie, by way of its cinematic nature, undermines some of the novel's original themes.

The film, written and directed by Gavin Hood, tells the unsettling story of pre-teen children in the future being recruited and trained to launch a preventive strike on the mysterious insectoid alien beings that unsuccess-

fully tried to invade Earth a few generations earlier. Young Andrew "Ender" Wiggin (Asa Butterfield) is singled out by the head of Earth's military program, Colonel Graff (Harrison Ford), as a military prodigy and sent to a space station where he spends years training with other kids, learning and being sometimes brutally tested on battle tactics and strategy.

Along the way, Ender (who is equal parts sensitive, competitive, and ruthless) is manipulated, isolated, and tormented by both the program directors and his peers—all of it intended to groom the nimble, innovative boy into the ultimate war leader who can defeat the aliens and save the human race. *Ender's Game*, shows the psychological challenges he faces and the dangerous push and pull between training and toughening up his killer instinct to make him a great and ruthless war leader (as championed by Ford's Graff) and maintaining some sort of baseline humanity within the lonely, isolated child (as hand-wrung about by Viola Davis' Major Anderson, the program's psychiatrist and maternal stand-in).

The result sometimes feels like *Full Metal Jacket* (1988) by way of *Harry Potter*, but *Ender's Game* gets a lift from its cast. Asa Butterfield's large, frighteningly-clear eyes sternly dart between tender hurt and scary determination, and Harrison Ford seems more emotionally engaged on screen than he has in a long time. The rest of the cast's adults (Davis and Ben Kingsley, the latter decked out in Maori face tattoos and a questionable accent) and youth (Hailee Steinfeld, Moises Arias, and Abigail Breslin) all do solid work.

With action-packed flashbacks to the past alien invasion attempt, dazzling zero-gravity training "games" high above the Earth, and a massive space conflict for a climax, *Ender's Game* is never short on big-screen, science-fiction visual spectacle. The crux of the film, however, is Ender's quiet, painful struggles with both the interpersonal obstacles thrown in his way and his own evolving morality and conscience.

While that inward focus and a major philosophical about-face at the conclusion was at the heart of Card's novel, *Ender's Game* the film struggles against its own medium when trying to land its big themes. The movie is naturally packed with dazzling, exciting CGI vistas and heart-pounding conflicts, but after steadily rising to a warfare-heavy, triumphant climax, Hood's film turns heels at the end and tries to guide the viewer back to deeper, mournful thoughts about the cost of war for both victims and victors. Like Card's novel, *Ender's Game* wants audiences to ponder what war means, what it does to soldiers, what it takes to be a "good" (that is, ruthless, even reckless) wartime leader, and what it means to be a "war hero."

"When this war is over we can have the luxury of debating the morality of what we do. But not if there's nothing left of us," says Graff in the film. While Card's novel was published in the waning days of the Cold War, the new film's post-9-11 War on Terror parallels are clear: Should nations seek to empathize and communicate with mysterious, scary forces who once bloodied their nose; or do they simply set out to wipe the "enemy" out of existence?

Hood takes time to explore some of these ideas, even if his characters are mostly painted in broad-strokes. The filmmaker is happy to embrace sadness, loneliness, isolation, and cruelty without the candy-coating many mainstream films would insist on lathering over a story about pre-teens training for combat. He also gooses the film's anti-war message, slipping in overt mentions of knowing the "enemy" and using communication to attempt diplomatic solutions instead of total annihilation.

However, the film's abrupt thematic pivot at its close, playing out on screen in an extended epilogue, is not fully effective and leaves *Ender's Game* with a dual personality. The catch is that what reads as layered and thoughtful on the page, is easily swept away by spectacle and excitement on the screen. When a film like *Ender's Game* spends hours pumping up the viewer with visual and martial thrills, it doesn't matter how many times or how emphatically characters decry violence and warfare in the closing minutes—the viewer's emotion-driven brain is still wired to remember the high it got off all the "heroic" action and victories. What sticks are Ender's fights and victories, big and small, both sanctioned and secret rather than his later search for pacifistic redemption. Therefore, whatever message Hood hopes his film conveys, the dark lesson taken away is one already learned at Fredericksburg and Normandy—that the only way to truly "win" a war is to disregard the cost in lives on both sides.

In many ways this is not entirely the film's fault. Based on a 1977 short story, Card fleshed *Ender's Game* out into a full-length novel merely to act as a de facto prequel to his more philosophical anti-war novel, *Speaker for the Dead*, which follows Ender in the years after *Ender's Game*. In that respect, *Ender's Game* is intended to be the flashy, exciting battle that sets up *Speaker for the Dead*'s meditation on how society deals with war and genocide committed for a "just cause."

Despite its best altruistic intentions, the overall spectacle of the film *Ender's Game* leaves us seeing the boy's useful empathy for the enemy (knowing your enemy means loving your enemy, which means killing them more effectively) more as a freak mutation than a complex psychological trait. While Ender wonders in the film if he can be as gifted at peace as he is at war,

the film doesn't have a chance to get to the part in the Card's novels where the character is eventually seen as a genocidal murderer not a hero.

That leaves the film *Ender's Game* as a mostly well-made work covered in the nice glow of being "about" something without actually saying much. It feels like Hood genuinely wanted to make a film that pondered complicated issues deeply, but in the midst of making a big-budget space "action" movie, he lost control not of his message but its delivery.

Locke Peterseim

CREDITS

Ender Wiggin: Asa Butterfield
Colonel Graff: Harrison Ford
Petra: Hailee Steinfeld
Valentine: Abigail Breslin
Mazer: Ben Kingsley
Major Gwen Anderson: Viola Davis
Origin: United States
Language: English
Released: 2013
Production: Alex Kurtzman, Roberto Orci, Ed Ulbricht, Gigi Pritzker; released by Summit Entertainment
Directed by: Gavin Hood
Written by: Gavin Hood
Cinematography by: Donald McAlpine
Music by: Steve Jablonsky
Sound: Dane A. Davis
Editing: Lee Smith
Art Direction: Greg Berry
Costumes: Christine Clark
Production Design: Sean Haworth
MPAA rating: PG-13
Running time: 114 minutes

REVIEWS

Bradshaw, Peter. *The Guardian*. October 24, 2013.
Dargis, Manohla. *New York Times*. October 31, 2013.
Edelstein, David. *New York/Vulture*. November 2, 2013.
O'Hehir, Andrew. *Salon*. November 2, 2013.
Phillips, Michael. *Chicago Tribune*. October 31, 2013.
Robinson, Tasha. *The Dissolve*. October 30, 2013.
Scherstuhl, Alan. *Village Voice*. November 1, 2013.
Stevens, Dana. *Slate*. November 2, 2013.
Turan, Kenneth. *Los Angeles Times*. October 31, 2013.
Vishnevetsky, Ignatiy. *Onion A.V. Club*. October 30, 2013.

QUOTES

Ender Wiggin: "In the moment when I truly understand my

enemy, understand him well enough to defeat him, then in that very moment I also love him."

TRIVIA

The writer of the original novel, Orson Scott Card, has a voice cameo as the PA voice heard in the shuttle from Earth to the space station.

ENOUGH SAID

Box Office: $17.6 Million

While most critics embraced her previous works—*Lovely & Amazing* (2001), *Friends with Money* (2006), and *Please Give* (2010)—writer/director Nicole Holofcener ascends to a new level of achievement with her script for the marvelous *Enough Said,* a film that takes a relatively sitcom-ish premise and uses it to offer insight into the way people can poison the water before they have had a chance to drink it. There are so many subtle, beautiful, character-driven moments in Holofcener's script from the way she captures how one person may be totally wrong in one relationship but perfect in another to how she subtly builds her love story on a foundation of a time in peoples' lives when they are emotionally fragile—when their kids are leaving the nest. Most romantic comedies are constructed around fallible characters but rarely have two potential mates felt more genuine in their fallibility than in Holofcener's lovely, moving tale of second chances. This is the kind of movie for adults that cynical critics argue do not get made any more.

Eva (Julia Louis-Dreyfus) is a masseuse who has difficulty asking for what she needs and wants in life. She is presented early on in a comedic moment in which a client (Chris Smith) does not help her carry her massage table up his many steps. It is first viewed as the client's ignorant behavior but later the emphasis shifts to the fact that Eva never asks for help. She is too often someone who responds to a situation instead of initiating it, which is a character flaw that will greatly impact the potential love of her life when she chooses to respond to information about the past instead of taking action herself to make a better future.

It starts when Eva goes to a party with best friend Sarah (Toni Collette) and Sarah's husband Will (Ben Falcone). At that soiree, she meets two people who will change her life—a poet named Marianne (Catherine Keener) and a kind man named Albert (James Gandolfini). The former becomes a client first and a friend later as Eva seems drawn to this woman who seems to have it all together. She even grows her own chervil in the backyard and has fans of her poetry stop

her on the jogging path to give thanks for her life-changing work. On the other hand, once-divorced Albert and Eva end up going out. Their first date is a marvelous bit of writing by Holofcener in the way she uses comedy, character detail, and honest chemistry to set the stage for romance. Eva is concerned about Albert's weight but she gives him a second date, another beautiful bit of narrative composition in the way this brunch at Albert's home is the polar opposite of their first date, subconsciously indicating that these two can get along in any environment—a trendy restaurant or Albert's kitchen.

The narrative spins when Eva discovers that the ex-husband about whom Marianne has been complaining for weeks is actually Albert. Eva starts to listen more intently and even prod Marianne for insight into the new man in her life, not fully realizing the bias with which Marianne is going to present Albert. Marianne describes a man with no forward momentum or ambition; a man without any goals whose every little quirk drove her nuts. And, of course, those same quirks begin to drive Eva nuts. She considers Marianne a valuable resource about her relationship and doesn't consider the damage she is doing it until it might be too late. Against this main romantic plot, Holofcener weaves a subplot about Eva and Albert's daughters leaving for college that really just offers depth to the characters and the world they inhabit. Eva and Albert are about to be alone in their homes for the first time, and it creates a sense in the viewer that their union becomes something even more desirable as it will fill the hole about to grow when their child's bedroom becomes unused.

Much of the press surrounding the Toronto Film Festival premiere of *Enough Said* centered on the performance of James Gandolfini given his recent passing. It undeniably adds a bittersweet undertone to the film that Holofcener never intended, especially when Albert speaks of the weight issues that contributed to the actor's death. The truth is that this performance would have demanded attention of Gandolfini had not died. It is his best film work, a role that many think could earn him an Oscar nomination for Best Supporting Actor. He imbues Albert with such gentle humanity, making him three-dimensional in ways that other actors would not have even considered. It is subtle and beautiful, perfectly matched by Louis-Dreyfus, who has also made a career in television and never been given a part this rich. The supporting cast is uniformly strong, led by Collette and Keener but also filled out by newcomers like the great Tavi Gevinson, who steals scenes as the best friend of Eva's daughter.

There are too few writer/directors, particularly of the female persuasion, who are making films for adults about romance, love, worry, and concern about the

future. Eva and Albert are wounded people due to their divorces who are also at fragile places due to their aging and departure of their children. In other words, they are like millions of people around the world. And it is the way that Holofcener captures their humanity that elevates *Enough Said* above all other romantic comedies in 2013.

Brian Tallerico

CREDITS

Eva: Julia Louis-Dreyfus
Albert: James Gandolfini
Marianne: Catherine Keener
Sarah: Toni Collette
Will: Ben Falcone
Origin: United States
Language: English
Released: 2013
Production: Stefanie Azpiazu, Anthony Bregman; released by Fox Searchlight
Directed by: Nicole Holofcener
Written by: Nicole Holofcener
Cinematography by: Xavier Perez Grobet
Music by: Marcelo Zarvos
Sound: Lora Hirschberg
Music Supervisor: Liza Richardson
Editing: Robert Frazen
Art Direction: Luke Freeborn
Costumes: Leah Katznelson
Production Design: Keith Cunningham
MPAA rating: PG-13
Running time: 93 minutes

REVIEWS

Burr, Ty. *Boston Globe*. September 26, 2013.
Denby, David. *The New Yorker*. October 6, 2013.
Hornaday, Ann. *Washington Post*. September 27, 2013.
Kohn, Eric. *Indiewire*. September 17, 2013.
Morgenstern, Joe. *Wall Street Journal*. September 26, 2013.
Nashawaty, Chris. *Entertainment Weekly*. September 11, 2013.
Puig, Claudia. *USA Today*. September 17, 2013.
Rea, Steven. *Philadelphia Inquirer*. September 27, 2013.
Scott, A. O. *The New York Times*. September 17, 2013.
Turan, Kenneth. *Los Angeles Times*. September 18, 2013.

QUOTES

Eva: "I'm tired of being funny."
Albert: "Me too."

TRIVIA

This was James Gandolfini's next-to-last movie and the dedication at the end of the film reads "For Jim."

AWARDS

Nominations:

Golden Globes 2014: Actor—Mus./Comedy (Louis-Dreyfus)
Ind. Spirit 2014: Actor—Supporting (Gandolfini), Screenplay
Screen Actors Guild 2013: Actor—Supporting (Gandolfini)

EPIC

Discover a world beyond your imagination.
 —Movie tagline
Prepare for something epic.
 —Movie tagline

Box Office: $104.9 Million

There have been many movies that have celebrated or paid homage to certain genres and their respective archetypes and traditional storylines. Many films have done so while maintaining a certain charm or personality all their own. In fact, over the past decade or so, the cinemas have been inundated with more Meta material than ever before with all sorts of filmmakers displaying their knowledge and love for certain types of films, either out of fan worship (*Paul* [2012]), social examination (*Far From Heaven* [2002]), or a self-conscious send-up (*Friends with Benefits* [2011]), with too many examples of each to mention. The need to reflect on past cinematic achievements and/or trends has been a popular movement all its own. *The Artist* (2011)—Jean Dujardin's black-and-white silent film about the silent film age coming to an end—winning the Academy Award for Best Picture remains a testament to that. Nostalgia always seems to be in vogue.

Now comes *Epic*, an animated adventure film that embraces all the archetypes of the "fantasy epic" genre as well as many of the story conventions. The difference here seems to be the lack of intention or personality behind the gloss. All of the characters have been laid out in front of the creators with an image, a voice, and a legacy before them that has given way to instantly recognizable characters in popular culture. But the writers here either do not care enough about them to give them any depth or the story and characters and dialogue stem from a total lack of imagination on everyone involved and the title is just a symptom of that. Perhaps the name *Epic* is a misnomer. The film is too short and slight to actually *be* an epic.

It opens with the heroine-to-be, Mary Katherine (voiced by Amanda Seyfried), or M.K., telling the audience that if one looks closely enough at nature, a struggle between its forces can be seen. M.K. is a teenage girl who comes to visit her widowed father on weekends. He lives near a forest and has cameras stationed all around

to try and capture what he believes to be a hidden world filled with little people. Nobody believes him, of course, and it ends up being a source of friction between him and his daughter. One night, during a terrible storm and after feeling neglected one too many times, M.K. walks out into the forest and ends up getting miniaturized and sucked into this other world.

The parallel story going on is that of the Leafmen (the good) and the Boggins (the evil). The Queen of the Leafmen, Tara (voiced by Beyonce Knowles), dies during an ambush on the day when she was to name a new heir, something that can only be done every 100 years. But there still exists a magic orb (which happens to be the very thing that caused M.K. to be sucked into this other world). The orb must be in a certain place in a certain time, but the protagonists here do not have much time on their hands. This orb has the power to save everyone from the eternal darkness of the Boggins turning everything to rocks.

Among the heroes here: M.K., who is the lucky fish-out-of-water, reluctant hero type; Ronin (voiced by Colin Farrell), Tara's assistant, bodyguard and love interest who is looking after the son of a close, but deceased, friend. That son is Nod (voiced by Josh Hutcherson), a handsome, but immature non-warrior who has a lot to learn about modesty and being a good warrior; the wacky sidekicks in the form of a snail and a slug (voiced by Aziz Ansari and Chris O'Dowd). They have to take this orb to Nim Galuu (voiced by Steve Tyler), a popular illusionist who will do what has to be done with it, but who may not be all he seems. Leading the attacks on the Leafmen is the Boggins' top commander, Mandrake (voiced by Christoph Waltz).

The storyline and the character arcs go from A to B to C without much in the way of surprises. Much of the dialogue is expository and lifeless. One has to wonder why it took five credited writers to come up with something so tepid and uninspired, even if borrowing loosely from the book *The Leafmen and the Brave Bugs* by William Joyce. While the movie contains small moments of charm and a very funny gag involving a fruit fly, the rest feels phoned in and borrowed from Disney's lesser efforts. Ask anyone who sees this film (even its young target audience) to name the villain and they would be hard-pressed, even after seeing the movie minutes earlier. The villain is simply the villain and his name is hardly ever mentioned. The voice work from the talented cast is of no help.

This is the first film from director Chris Wedge since *Robots* (2005), a similarly flawed film with the same positive selling point: Both films are beautiful to look at and have made their worlds visually come alive with great flair. *Epic* always looks epic on the big screen,

with or without 3-D. This seems to be the case with all the films from Blue Sky Studio, the animation studio responsible for all the *Ice Age* movies as well as the equally forgettable *Rio* (2011). They have all the talent working on the technical end, but without much going into what really makes an animated film an involving and wondrous experience. They have a very gifted and determined group of animators working around the clock to create 90-minute cinematic babysitters. Genre piece or not, *Epic* only lives up to its title when the sound is turned down.

Collin Souter

CREDITS

Mary Katherine: Amanda Seyfried (Voice)
Nod: Josh Hutcherson (Voice)
Ronin: Colin Farrell (Voice)
Queen Tara: Beyonce Knowles (Voice)
Bomba: Jason Sudeikis (Voice)
Mandrake: Christoph Waltz (Voice)
Grub: Chris O'Dowd (Voice)
Mub: Aziz Ansari (Voice)
Origin: United States
Language: English
Released: 2013
Production: Jerry Davis, Lori Forte; Blue Sky Studios; released by Twentieth Century Fox Film Corp.
Directed by: Chris Wedge
Written by: James V. Hart; William Joyce
Cinematography by: Renato Falcao
Music by: Danny Elfman
Sound: Randy Thom
Editing: Andy Keir
Production Design: Greg Couch; William Joyce
MPAA rating: PG
Running time: 102 minutes

REVIEWS

Covert, Colin. *Minneapolis Star Tribune*. May 23, 2013.
Goodykoontz, Bill. *Arizona Republic*. May 23, 2013.
Holden, Stephen. *New York Times*. May 23, 2013.
Kenney, Glenn. *MSN Movies*. May 24, 2013.
Neumaier, Joe. *New York Daily News*. May 23, 2013.
O'Sullivan, Michael. *Washington Post*. May 24, 2013.
Russo, Tom. *Boston Globe*. May 24, 2013.
Sharkey, Betsy. *Los Angeles Times*. May 24, 2013.
Whitty, Stephen. *Newark Star-Ledger*. May 24, 2013.
Wigon, Zachary. *Village Voice*. May 24, 2013.

QUOTES

Larry: "That's not a house, it's termites holding hands."

That little piece of paper seen just before the scrolling portion of the closing credits features the date 5-24-13 written on it, which was the film's release date.

ESCAPE FROM PLANET EARTH

Earth's greatest secrets are about to break out!
—Movie tagline

Box Office: $57 Million

It is one of the great paradoxes of contemporary cinema that even though animation can theoretically be used to devise vast and highly detailed universes in ways that would be impossible (or at least prohibitively expensive) to achieve in live-action, successful American-made sci-fi animated features have been relatively few and far between over the years. For every rare critical and commercial triumph like *WALL*E* (2008), there are any number of long-forgotten flops such as *Titan A.E* (2000) and *Battle For Terra* (2009) and not even a seemingly sure-fire hit like *Star Wars: The Clone Wars* (2010) could inspire much enthusiasm from its usually loyal fan base. Falling squarely into the latter category is *Escape From Planet Earth*, a family-oriented sci-fi comedy that feels like virtually every other animated film of recent vintage, albeit much less so, and which proves to be as wan and uninspired as its title.

On the distant planet of Baab, the biggest hero around is dashing space jockey Scorch Supernova (voiced by Brendan Fraser) but what the blue-skinned populace that worships him does not understand is that many of his feats of derring-do are accomplished only with the aid of his brother Gary (Rob Coddry), who watches over him back at Mission Control and, more often than not, gets his more impulsive sibling out of tight spots. When a distress signal reaches Baab from a distant and dark planet known as Earth—the only place in the universe where evolution runs in reverse, according to a snide computer (Ricky Gervais)—Scorch immediately wants to fly off to check things out but Gary, deciding that it is too risky, refuses to take part in the mission. Scorch goes off anyway and, without the help of Gary, is captured only a few minutes after touching down outside a 7-Eleven located on the outskirts of Area 51.

Feeling guilty, Gary decides to set off for Earth himself in the hopes of rescuing his brother but winds up getting captured as well. It seems that the rescue beacon is nothing more than a ruse devised by the twisted General Shanker (William Shatner) to lure aliens so that he can imprison them and exploit their technological advances in order himself an enormously wealthy man. The General's ultimate plan, however, is to eradicate all alien species for good and scorch has unwittingly provided him with just the means to do that. It is up to Gary, with the help of his fellow prisoners and his wife and young son back on Baab, to save both his brother and the universe.

After Gary accomplishes those goals, he muses in a final voiceover that "I guess life is pretty unpredictable after all." This is the funniest and most ironic line in the entire film because there is not one single aspect of the whole enterprise that could be considered unpredictable. The storyline is a trite blend of undistinguished action, slapstick comedy, dated cultural references (apparently the mere mention of Simon Cowell is still enough to have audiences rolling in the aisles) and important life lessons about teamwork, family, respecting one's elders and how choosing the workplace over motherhood automatically makes a woman into an evil maniac ready to sacrifice her entire planet in order to get herself a fella. Visually, the film is dull as can be and not just because of the loss of brightness it suffered in theaters as a result of its 3-D presentation—despite the millions of dollars presumably poured into the project, the various alien species and the world of Baab are so blandly conceived and executed that the whole thing has the feel of an exceedingly moderate television series.

Presumably to distract from the all-around lack of inspiration, the Weinstein Company managed to lure a number of big stars to contribute their voices to the final product. Besides those already mentioned, the dulcet tones of Jessica Alba, Sofia Vergara, Sarah Jessica Parker, George Lopez, Jane Lynch, Craig Robinson, Steve Zahn, and Chris Parnell can also be heard. From a marketing perspective, having such an array of talent is a good thing but it is clear that the filmmakers are more interested in their names than their voices since none of them make any sort of recognizable impact of the kind that the best examples of voice casting, such as in the Pixar films, where the roles are filled by the right actors and not necessarily the biggest names. The only notable vocal contribution comes from William Shatner and that is not really a compliment because it is the same overly self-conscious blowhard turn that he has been doing for the last quarter-century or so. (As a side note, it should be mentioned that even just as a voice-only bit for an animated film, the mere sound of Jessica Alba and William Shatner flirting with each other is nothing more than good old-fashioned nightmare fuel of the highest (or lowest) order.)

The most interesting thing about *Escape from Planet Earth* is the behind-the-scenes battle that writer-director Tony Leech and producer Brian Inerfeld became embroiled in with the Weinstein Company regarding the film's release. Originally announced as being in

production back in 2007 (which might explain the Simon Cowell joke), Leech and Inerfeld reportedly had a deal that would give them 20 percent of the film's adjusted gross profit. According to them, however, the studio then stretched the production phase out to interminable lengths by demanding at least 17 separate rewrites, a move that sent the budget skyrocketing and greatly reduced their potential profits. After making an initial stink, the duo also claims that they were paid $500,000 by the studio to keep their grievances quiet during the 2011 Oscar season so as not to disrupt the studio's awards campaign for *The King's Speech* (2010). On the day the film was finally released, the case was discontinued by both parties and after all of that buildup, nothing came of it other than a waste of time, money and effort. At least they got a sense of what their audiences felt like after seeing their movie.

Peter Sobczynski

CREDITS

Scorch Supernova: Brendan Fraser (Voice)
Gary Supernova: Rob Corddry (Voice)
Kira Supernova: Sarah Jessica Parker (Voice)
Lena: Jessica Alba (Voice)
Io: Jane Lynch (Voice)
Mr. James Bing: Ricky Gervais (Voice)
Kip Supernova: Jonathan Morgan Heit (Voice)
Gabby Babblebrock: Sofia Vergara (Voice)
General Shankar: William Shatner (Voice)
Origin: United States
Language: English
Released: 2013
Production: Luke Carroll, Catherine Winder; Blue Yonder Films; released by Weinstein Company L.L.C.
Directed by: Callan Brunker
Written by: Callan Brunker; Bob Barlen
Cinematography by: Matthew A. Ward
Music by: Aaron Zigman
Sound: Craig Berkey; Ben Burtt
Editing: Matt(hew) Landon; Scott Winlaw
Production Design: Barry E. Jackson
MPAA rating: PG
Running time: 89 minutes

REVIEWS

Farber, Stephen. *Hollywood Reporter*. February 15, 2013.
Genzlinger, Neil. *New York Times*. February 15, 2013.
Humanick, Rob. *Slant Magazine*. February 18, 2013.
Leydon, Joe. *Variety*. February 19, 2013.
Linden, Sheri. *Los Angeles Times*. February 18, 2013.

Minow, Nell. *Beliefnet*. February 15, 2013.
Orndorf, Brian. *Blu-ray.com*. February 16, 2013.
Riefe, Jordan. *Boston Phoenix*. February 15, 2013.
Robinson, Tasha. *AV Club*. February 15, 2013.
Russo, Tom. *Boston Globe*. February 19, 2013.

TRIVIA

This is Rainmaker Entertainment's first film to be released theatrically and in 3D.

ESCAPE FROM TOMORROW

Bad things happen everywhere.
—Movie tagline

Box Office: $171,962

The Sundance (and other festivals) hit *Escape From Tomorrow* should be on a short list for anyone interested in how cinema is changing in the 2010s. *Escape from Tomorrow* is a primer on what the average person with no professional experience can accomplish and why that matters. Following in the footsteps of *The Blair Witch Project* (1999), *Open Water* (2003), and other recent films from the begged-borrowed-and-stolen school, this is not only as indie as it gets but also as daring. *Escape from Tomorrow* has problems with narrative, performances, and its inconsistent aesthetic but absolutely no problem getting viewers to feel what it wants. They may reject those feelings but there is a ton of worthwhile stuff to chew on for anyone with an open mind and a little imagination.

Jim (Roy Abramsohn), his wife Emily (Elena Schuber), and their kids Sara (Katelynn Rodriguez) and Elliot (Jack Dalton) are just about to head out of their hotel room for the last day of their Disneyland vacation when Jim gets a call from work telling him that he's fired. He keeps the news to himself and takes the family out for a last round of the Magical Kingdom.

Of course, the magic has worn off for Jim by this point. Sullen and depressed, he rides the rides, drinking along the way, and experiences a series of nightmarish visions that may or may not be hallucinations. Beloved characters from the park take on demonic faces. Animatronics and decorations come to sinister life, and, to top it off, Jim suddenly becomes aware of, and obsessed with, two young girls that cross his family's path, navigating his own children through the park so he can shadow the pair.

Apocalyptic visions involving the destruction of the park ensue even as Jim has an illicit encounter with a

strange woman dressed as one of the park's characters, and he realizes he and his family may be in danger unless he can unlock the secrets behind the happiest place on Earth. All the while, the two girls lead him on an increasingly-less-merry chase and news of a devastating cat flu ravaging the outside world foreshadows a tragic outcome.

Written and directed by newcomer Randy Moore, *Escape from Tomorrow* has achieved immediate cult status due to the fact that it was filmed, secretly, during several visits to Disneyland. For his part, Moore insists that the lengthy development process simply demanded he shoot there and that no overt deception was ever planned. He has a point. The film is far less about Disney than about what Disney has come to represent. The poster bears an image of Mickey's blood drenched hand against a bright yellow sunburst with the title written in Disney-esque font. This is about the dark side of thinking one always can or should be happy and the various ways such selfishness can be exploited.

Of course, the psychological impact of such an idea is profound. In the film, the family squabbles over the most meaningless things. Emily turns harpy at the drop of a hat. Jim desperately looks for distraction. His kids are never satisfied with what they have. As such *Escape from Tomorrow* could have been made in a mall, or even in a suburban McMansion, but Moore makes the perfect choice of setting. Anyone going to Disneyland will indeed have a great time. It is a wondrous and enchanting place full of great memories just waiting to be made. But it also exists as a faded monument. Whatever filmmaking flaws are here, and there are a few, it offers a disturbing peeling back of the veneer of commercially based happiness that forms the foundation of the American dream. This is a compelling piece of modern dystopia. *The Stepford Wives* (1975), *Westworld* (1973), and *Brazil* (1985) all come immediately to mind.

Roy Abramsohn as Jim, manages to hit all the notes in a very complicated role. He has to appear fatherly, drunk, leering, bitter, and angry, and genuinely rational and sorrowful. He, and the rest of the cast, also has to match the melodramatic tone of the script, without going overboard. The performances in general here draw very favorable comparisons to those in *Night of the Living Dead* (1968) or *Carnival of Souls* (1962), adding to the tone and the feel of the film and the increasingly threatening and weird world it unveils.

As mentioned, the film does overreach. Moore and director of photography Lucas Lee Graham do everything but throw the camera off one of the rides to achieve the surreal tone they want. The black and white photography is perfectly chosen for the atmosphere they want to create but motion sickness may set in for those who are sensitive to their frenetic approach.

There are also a number of staged set pieces. The ones that work best are the ones actually shot at Disney itself. But in order to expand on their story they take viewers to a hidden part of the park, which they create by shooting on set, that has a lesser impact. It seems thematically resonant because of its obvious dystopia on-the-cheap feel which combines with the lavishness of the park to call into question what is real and what is not but there is no doubt it requires more suspension of disbelief.

Some will also be troubled by the film's frank treatment of Jim's sexual interest in the two underage girls. But, as filtered through his relationship to the House of Mouse, dad's escapist sexuality makes an important point about the inherent childishness of avoiding things that must be faced. In the Disney of the film, all is escapism and distraction. There is simply no room to have problems. Trash is whisked away. Moore even evokes the old urban myth that the many Disney princesses on the grounds are available to rent for sexual purposes by the lascivious and wealthy, intimating a hidden adult facet of the park. The idea that Disney infantilizes those who partake of it is also explored with a rare power showcasing a corporation that teaches people to act like...corporations, emblems, empty icons.

Escape from Tomorrow is not, however, a pointless lambasting of all things Disney. It is perhaps telling that Disney has opted not to sue Moore over the film or its release. He has succeeded at the monumental task of not throwing out the baby with the bathwater and no doubt this is some dirty bathwater. People will be talking about his movie for years not because it was shot in secret on one of the most litigious corporate encampments in the world, or because it is extreme in its violence or sexuality, but because of what it has to say. The urgency to watch it now should, however, be tempered with the knowledge that future family vacations may result in some discomfort. Viewers might just find themselves searching their photos for faces that do not belong and wondering what might have been just out of frame.

Dave Canfield

CREDITS

Jim: Roy Abramsohn
Emily: Elena Schuber
Sara: Katelynn Rodriguez
Elliot: Jack Dalton
Sophie: Danielle Safady
Isabelle: Annet Mahendru

Origin: United States

Language: English

Released: 2013

Production: Gioia Marchese; Mankurt Media; released by FilmBuff

Directed by: Randy Moore

Written by: Randy Moore

Cinematography by: Lucas Lee Graham

Music by: Abel Koreniowski

Sound: Sam Hamer

Editing: Soojin Chung

Costumes: Gara Gambucci

Production Design: Sean Kaysen; Lawrence Kim

MPAA rating: Unrated

Running time: 91 minutes

REVIEWS

Goss, William. *The Playlist*. January 21, 2013.

Hoffman, Jordan. *Film.com*. January 30, 2013.

Kohn, Eric. *IndieWIRE*. October 7, 2013.

McGranaghan, Mike. *Aisle Seat*. October 12, 2013.

Murray, Noel. *The Dissolve*. October 10, 2013.

O'Hehir, Andrew. *Salon.com*. October 10, 2013.

Rodriguez, Rene. *Miami Herald*. October 10, 2013.

Scott, A. O. *New York Times*. October 10, 2013.

Taylor, Ella. *NPR*. October 10, 2013.

Weinberg, Scott. *FEARnet*. October 15, 2013.

QUOTES

Elliot: "Do you think Mom is pretty?"

Jim: "Yeah, your mother is pretty. In an Emily Dickinson, Tina Fey kind of way."

TRIVIA

The scripts for the film were utilized on iPhones.

ESCAPE PLAN

The most secure prison ever built.
—Movie tagline

No one breaks out alone.
—Movie tagline

Box Office: $25.1 Million

Twenty years ago, a film like *Escape Plan* would have been an event. It was still the time of Arnold Schwarzenegger and Sylvester Stallone; each at a peak and a brief reinvigoration of their careers. That would have been stunt casting to the max in the days when it did not take a group of Expendables or Danny Ocean to sell a true ensemble. The biggest action heroes of the 1980s are now in their upper 60s and thankfully not reducing themselves to mere geezer plots and Viagra jokes. They are here to still bring the action. No one is going to confuse this film with the best of their macho shoot 'em ups and while the film does possess a certain level of goofy charm, it may take a mentality (or at least heavy familiarity) of a bygone era to get true enjoyment out of it.

Career prisoner Ray Breslin (Stallone) opens the film in yet another prison facility. Ray has never committed a crime. He has just made a career out of escaping from them. People hire Ray and his team—an eclectic group including Vincent D'Onofrio, Amy Ryan and Curtis "50 Cent" Jackson—to test the structural capacity of maintaining its inmates. Presumably there is not an institution that Ray cannot give the slip having literally written the book on it. The next challenge though is a lucrative offer from the CIA involving a modern bit of architecture designed to hold in the worst of the worst prisoners in the world. After agreeing to give it a shot, Ray is transported to the unknown location and becomes a ghost to even his own people.

With its glass cells and guards concealing their identities by looking like mannequins "The Tomb" looks like something out of science fiction; space-wise akin to the robot warehouse in *Pacific Rim* (2013). Ray immediately goes into action, enlisting a helpful inmate named Rottmayer (Schwarzenegger) to get him into solitary confinement. Apparently all Ray's prisons have their Death Star flaw here. Difficulties are increased since The Tomb's warden and designer Hobbes (Jim Caviezel) has used Ray's book to fill in every potentially flawed nook and cranny. As the true nature of the sadistic prison is revealed, Hobbes' interest in Rottmayer's still-on-the-lam financier is increased. Thus begins a complicated triangle scheme of pitting one against the other in order to achieve their ultimate goals.

The opening of *Escape Plan* holds much promise as director Mikael Hafstrom throws viewers into a magic trick of observation and misdirection as Ray carefully masterminds his getaway. The resulting revisiting of how he did it is not nearly as dumb as one might imagine and there are hopes that Ray's skills will manifest in an increasingly interesting and complicated manner. He surely knows a lot about metal. That much is for certain. How much he *should* know about the prison blueprints—other than the CGI breakdowns he constructs in his head—is something to consider. Ray may want to have the same disadvantages of a newly-minted inmate, but how is he to discover all of the flaws with just a single run-through? Could any one man break out without the help of an explosive distraction and getaway car on the outside? Is there no chapter in the book entitled "The

Solitary Ladder," or did Hobbes skip that chapter and still put his worst prisoners closest to the freedom hatch?

That is about three questions too many if one is to extract the kind of brain-resting pleasure derived from seeing a couple of childhood relics go face-to-face. Pacino and DeNiro in *Heat* (1995) this is not so if the action is well-delivered most expectations will be met. When a film tries to deliver more brains than brawn it is nevertheless disappointing when the brawn slowly begins to win out. One prison floor riot is not much different than the next and after the big break out comes down to a literal "hey, look over here" scheme so the heroes can then run in the other direction, an all-out shootout to settle differences is not as satisfying as it normally is with Sly and Arnold as individuals. Instead of getting lost in the expectation of "how they did it," one could drift off to recognizing the long-awaited pairing of Jesus Christ and Satan Jr. Poor Sam Neill is reduced to sad expressions as the prison doctor who, in the film's most hilarious moment, re-reads the Hippocratic Oath after two reminders from Ray that he took one in a book entitled "Medical Ethics." On the other side, there is Mel Gibson's Jesus, Jim Caviezel, responding to "God is great" with a simple "whatever."

That is the response many will have towards *Escape Plan* as well. Hardly to be confused with some of the greats of the genre such as *Escape from Alcatraz* (1979), or *The Great Escape* (1963), it is more likely going to fit right into Stallone's affinity for being between a rock and a hard place as he was in *Victory* (1981), *Lock Up* (1989), and again in *Tango & Cash* (1989). Stallone and Schwarzenegger have had fun with each other for a long time from Arnold dismissing Sly's muscles on a movie poster in *Twins* (1988) to Stallone's disbelief that the Schwarz was once President in *Demolition Man* (1993). They seem to be enjoying each other's company here too. Their adversaries are hardly a match—Caviezel is too reserved and top guard Vinnie Jones looks like even he is bored at being Vinnie Jones: Professional Heavy. What momentary throwback pleasures the film does deliver, "The Tomb" is much more a reference to these action staples being buried alive in the current box office climate. The hope of reinvigorating them back into the mainstream will take more than just a title change.

Erik Childress

CREDITS

Ray Breslin: Sylvester Stallone
Emil Rottmayer: Arnold Schwarzenegger
Hobbes: Jim Caviezel
Abigail: Amy Ryan
Dr. Kyrie: Sam Neill

Lester Clark: Vincent D'Onofrio
Drake: Vinnie Jones
Origin: United States
Language: English
Released: 2013
Production: Robbie Brenner, Mark Canton, Remington Chase, Randall Emmett; released by Summit Entertainment
Directed by: Mikael Hafstrom
Written by: Miles Chapman; Jason Keller
Cinematography by: Brendan Galvin
Music by: Alex Heffes
Sound: Derek Vanderhorst
Music Supervisor: Season Kent
Editing: Elliot Greenberg
Art Direction: James Gelarden; David Lazer
Costumes: Lizz Wolf
Production Design: Barry Chusid
MPAA rating: R
Running time: 115 minutes

REVIEWS

Barker, Andrew. *Variety*. October 16, 2013.
Bell, Josh. *Las Vegas Weekly*. October 17, 2013.
Gire, Dann. *Daily Herald*. October 17, 2013.
Judy, Jim. *Screen It!*. October 18, 2013.
Minow, Nell. *Beliefnet*. October 17, 2013.
O'Sullivan, Michael. *Washington Post*. October 17, 2013.
Orndorf, Brian. *Blu-ray.com*. October 17, 2013.
Phipps, Keith. *The Dissolve*. October 17, 2013.
Swietek, Frank. *One Guy's Opinion*. October 17, 2013.
Vaux, Rob. *Mania.com*. October 18, 2013.

QUOTES

Dr. Kyrie: "Doctors are men, who prescribe medicines of which they know little, to cure diseases of which they know less, for men, of whom they know nothing at all."

TRIVIA

Bruce Willis was at one time attached to star in the film with Antoine Fuqua directing.

AWARDS

Nominations:
Golden Raspberries 2013: Worst Actor (Stallone)

EUROPA REPORT

Fear. Sacrifice. Contact.
—Movie tagline

Box Office: $125,687

Early in *Europa Report*, Mission Command celebrates the successful liftoff of the ship, blandly named

Europa One, by playing a song for its international crew of six astronauts. The song choice, "The Blue Danube" by Johann Strauss II, says much about *Europa Report* and its aspirations. Director Sebastian Cordero and screenwriter Philip Gelatt have created a compellingly plausible work, but it lacks the crazy magic and the thematic vision of the film that forever linked Strauss's composition to space travel, Stanley Kubrick's *2001: A Space Odyssey* (1968).

The movie is about a doomed deep space mission to Europa, a frozen moon of Jupiter discovered and named by Galileo in 1610. Rooted in actual scientific research on the possibility of some kind of life in the water under the moon's icy surface, and utilizing imagery of the actual heavenly body and even a clip of astrophysicist Neil deGrasse Tyson, *Europa Report* is certainly more realistic than the typical found footage genre film. The footage from cameras onboard the ship is interspersed with news footage and interviews with scientists back on Earth observing the proceedings, as the mission goes terribly awry.

What characterization there is is presented naturalistically, and there is surprisingly little obvious exposition as the crew go about their business. While the movie opens in the middle of the story, showing that things will eventually go badly, *Europa Report* takes its time reaching that point, and it is not always scintillating as the astronauts deal with the minor inconveniences and homesickness of long-term space travel. In short, in eschewing the typical Hollywood plot and character contrivances, it is a bit dull.

The set is a perfectly claustrophobic, gleaming tribute to verisimilitude. Art director Anu Schwartz and set decorator Danielle Webb (who also designed the inventive props for Michel Gondry's *Be Kind Rewind* [2008]) deserve special recognition for their seamless work. The cast performs admirably with what they are given. Daniel Wu is William Xu, the stoic captain. Michael Nyqvist brings pathos to his role as Andrei Blok, the most experienced astronaut and chief engineer, who becomes slightly unstable after months in space. Karolina Wydra is fine as the gung-ho marine biologist, Katya Petrovna, while Sharlto Copley, as James Corrigan, plays the appealing audience surrogate, recording the proceedings and sending personal messages to his wife and young son back home. Anamaria Marinca, who plays the co-pilot Rosa Dasque, is a standout. She brings a lot of nuance and personality an underwritten role. Marinca first broke out in *4 Weeks, 3 Months, and 2 Days* (2007), a film that got a lot more dramatic impact out of its equally scrupulous realism. *Europa Report* is less about presenting fully-realized characters than about presenting their predicament as realistically as possible.

The early part of the movie drags somewhat, and it is nearly two years into their journey before the travelers hit their first major obstacle, when their communications equipment breaks down, cutting them off from Mission Command. When James and Andrei leave the ship to try to make repairs, an accident endangers both of their lives, and one of them chooses to sacrifice himself to save the other. It's an interesting scene in part because the filmmakers don't waste time explaining the very technical nature of the mishap. They trust the audience to follow along. The sequence is suspenseful and moving, and certainly a highlight of the movie. It evokes the terrifying free-floating sequences of Alfonso Cuaron's *Gravity* (2013), and it is a credit to the superb work of Cordero and his crew that their much lower budget movie does not really suffer by the comparison.

Once the ship finally arrives at Europa, the excitement builds again, as the crew contend with unusual bursts of radiation, and some are forced to risk their lives in an effort to complete their mission, and determine if there is some form of life on the distant moon. There is a suspenseful, dread-inducing sequence with one scientist venturing out of the capsule to obtain a sample, but the payoff is less than thrilling. In a movie so scrupulously dedicated to verisimilitude, often at the expense of drama, it is disappointing, in the end, that Cordero chooses to show us a bit more than he should. *Europa Report* posits that a single life is insignificant in the face of the opportunity to incrementally increase humankind's understanding of the known universe, but, in an effort to prove that it was all worth it, ineffectively stacks the deck a smidge with that single image.

Fans of the harder realms of science fiction should love the movie regardless. In the end, the filmmakers' attention to detail makes it feel fresher than expected. It is a worthwhile journey, even if the destination is a slight disappointment.

Josh Ralske

CREDITS

James Corrigan: Sharlto Copley
Dr. Daniel Luxembourg: Christian Camargo
Rosa Dasque: Anamaria Marinca
Andrei Blok: Michael Nyqvist
William Xu: Daniel Wu
Samantha Unger: Embeth Davidtz
Katya Petrovna: Karolina Wydra
Tarik Pamuk: Isiah Whitlock, Jr.
Sokolov: Dan Fogler
Origin: United States
Language: English

Released: 2013

Production: Ben Browning; Wayfare Entertainment; released by Magnet Releasing

Directed by: Sebastian Cordero

Written by: Philip Gelatt

Cinematography by: Enrique Chediak

Music by: Bear McCreary

Sound: Christof Gebert

Music Supervisor: Jim Black

Editing: Aaron Yanes; Alexander Kopit

Art Direction: Michael Ahern

Costumes: Anna Terrazas

Production Design: Eugenio Caballero

MPAA rating: PG-13

Running time: 90 minutes

REVIEWS

Addiego, Walter. *San Francisco Chronicle*. August 15, 2013.

Aldrich, Ryland. *Twitch*. June 18, 2013.

Bowen, Chuck. *Slant Magazine*. July 20, 2013.

Chang, Justin. *Variety*. June 21, 2013.

Dowd, A. A. *The AV Club*. August 1, 2013.

Harris, Aisha. *The Dissolve*. August 1, 2013.

Lemire, Christy. *RogerEbert.com*. August 2, 2013.

Morganstern, Joe. *The Wall Street Journal*. August 1, 2013.

Snider, Eric D. *About.com*. June 27, 2013.

Uhlich, Keith. *Time Out NY*. July 30, 2013.

QUOTES

Rosa Dasque: "Compared to the breadth of knowledge yet to be known, what does your life actually matter?"

TRIVIA

Hydrazine has been used for decades in spacecrafts as thruster propellant and as fuel for auxiliary power units; it is corrosive and extremely toxic.

EVIL DEAD

The most terrifying film you will ever experience.
　　—Movie tagline

Fear what you will become.
　　—Movie tagline

Box Office: $54.2 Million

The words, "EVIL DEAD," flash on the screen, accompanied by an urgent blast of orchestral hysteria. For this fleeting moment, Fede Alvarez's remake evokes the tongue-in-cheek spirit of the man whose original *Evil Dead* franchise (which began in 1981 with *The Evil Dead*) set the gold standard for satirical indie splatter.

Indeed, the opening minutes of Alvarez's picture owe more than a passing nod to Sam Raimi's uproarious 2009 gem, *Drag Me to Hell,* which charted its well-meaning heroine's downfall with an unforgiving logic as perverse as it was hilarious.

Sadly, as the new *Evil Dead* settles into its all-too-familiar yarn about twenty-something lunkheads trapped in a haunted cabin, it quickly becomes clear that Alvarez lacks Raimi's subversive sense of humor. Aside from an expected glut of winking homages, the script co-authored by Alvarez and Rodo Sayagues has no ambitions outside of formulaic regurgitation. After Drew Goddard's *Cabin the Woods* (2012) so cleverly skewered the soullessness of standard FearNET fodder, it is disconcerting to see Alvarez serve up the same tired tricks, expecting fanboys to devour them whole.

Yet beneath all the sensory-numbing mediocrity is the germ of a good idea. Rather than make any attempt at channeling the deadpan charm of Bruce Campbell's Ash, Alvarez shifts his focus to a different protagonist entirely. He finds it in Mia, played by Jane Levy, a dead ringer for Emma Stone whose talents have been largely wasted on the shallow, self-congratulatory sitcom *Suburgatory.* The character is loosely based off the poor woman in Raimi's film who is the first to become possessed by demons after being raped by a tree. In its own scrappy way, this sequence was as violating and galvanizing as Hitchcock's shower scene. Alvarez's version offers proof of how a larger budget can actually make special effects look cheaper than the illusions conceived on a shoestring. The visuals here are so shoddy that they border on embarrassing.

Yet even after Mia becomes possessed, Alvarez keeps her at the center of his narrative, while contriving a halfway-inspired reason for why her friends are not immediately alarmed by her strange behavior. It is revealed early on that Mia is a drug-addict and has been brought to this isolated cabin in order to go cold turkey with the help of her buddies. This may have been an effective twist had the cabin not looked so laughably unwelcoming and the friends not been so bereft of personality. It is difficult to determine whether Alvarez's young ensemble are merely bad or if they had been directed to deliver performances drained of credible humanity. As Mia's exasperatingly slow-witted brother, David, Shiloh Fernandez broods through each scene as if auditioning for Anakin Skywalker, while Jessica Lucas delivers one painfully stilted line reading after another as an inexplicably ill-tempered friend.

Only Lou Taylor Pucci, the under-appreciated star of *Thumbsucker* (2005), garners any decent laughs as the nerd whose bifocal-clad eyes can peer straight into his imminent doom. This causes him to make straightfor-

ward observations that seem to be lost on his delusional buddies who insist on convincing themselves that "everything will be alright," to which he argues, "She just cut her arm off!" Yet Pucci's character is just a pale imitation of every ill-fated hipster caricature that came before him, epitomized by Fran Kranz's snarky stoner in *Cabin in the Woods*. If there is any performance here that comes close to transcending the boundaries of archetype, it is Levy's fierce heroine, who is not above mutilating her own limbs in order to stay alive. Though Alvarez's film is entirely devoid of genuine scares, it gets its eeriest mileage from Levy's crazed, wide-eyed expressions. Even before her face is covered in makeup, it still manages to chill blood.

Speaking of blood, that appeared to be the only factor driving the buzz following Alvarez's over-hyped SXSW premiere. The director has an inarguable gift for in-camera carnage, a fact his feature debut strains to illustrate in frame after frame. Though it is clear a Best Makeup Oscar nomination would be more than well-deserved, Alvarez allows his effects work to upstage everything in sight, including his half-hearted stabs at wit. Extreme close-ups of needles getting plucked out of eyelids and hands getting torn off at the wrist elicit little more than the squeamish groans of many a bargain basement torture porn flick. In many ways, Alvarez's remake embodies everything that is wrong with modern American horror. It guts the genre of any tangible atmosphere, replacing suspense with broad spectacle and unsettling truths with dumbed-down fantasy. It is difficult to imagine a film less worthy of Campbell's "Groovy" post-credits endorsement.

As a glorified effects reel, Alvarez's film is admittedly impressive. As entertainment, it is crass, derivative, and duller than dishwater. There simply is not anything scary, let alone groovy, about watching a resurrected franchise lurch around in search of a few extra bucks.

Matt Fagerholm

CREDITS
Mia: Jane Levy

David: Shiloh Fernandez
Eric: Lou Taylor Pucci
Olivia: Jessica Lucas
Natalie: Elizabeth Blackmore
Origin: United States
Language: English
Released: 2013
Production: Sam Raimi, Bruce Campbell, Robert G. Tapert; released by Tristar Pictures Inc.
Directed by: Fede Alvarez
Written by: Fede Alvarez; Rodo Sayagues
Cinematography by: Aaron Morton
Music by: Roque Banos
Sound: Jonathan Miller
Editing: Bryan Shaw
Costumes: Sarah Voon
Production Design: Robert Gillies
MPAA rating: R
Running time: 90 minutes

REVIEWS

Berardinelli, James. *ReelViews*. April 4, 2013.
Derakhshani, Tirdad. *Philadelphia Inquirer*. April 4, 2013.
Everett, Cory. *The Playlist*. March 10, 2013.
Kohn, Eric. *indieWIRE*. March 10, 2013.
LaSalle, Mick. *San Francisco Chronicle*. April 4, 2013.
Leydon, Joe. *Variety*. March 10, 2013.
Lumenick, Lou. *New York Post*. April 4, 2013.
Phillips, Michael. *Chicago Tribune*. April 4, 2013.
Semley, John. *Slant Magazine*. April 4, 2013.
Tobias, Scott. *The A.V. Club*. April 3, 2013.

QUOTES

Abomination Mia: "I will feast on your soul!"
Mia: "Feast on this, motherf**ker."

TRIVIA

Diablo Cody polished and "Americanized" the screenplay while remaining uncredited.

F

THE FAMILY

Some call it organized crime. Others call it family.
—Movie tagline

Box Office: $36.9 Million

Anyone setting out to make a comedy revolving around gangsters is forced early on to deal with the inescapable fact that many of the things that they are most infamous for—drugs, prostitution, kidnapping, extortion and nasty things involving icepicks—are not exactly inspiration for high hilarity in the eyes of most people. In order to get around this, most filmmakers utilize one of two approaches—either they treat the material in such an overtly cartoonish manner, as in films ranging from the kiddie musical *Bugsy Malone* (1976) to the cheerfully goofy *Married to the Mob* (1988), that there is no way that anyone could possibly take it seriously or they can face the brutality head-on and mine the situation for a darker form of humor, as Martin Scorsese did in some of the most memorable moments of his masterpiece *Goodfellas* (1990). By comparison, the hyper-violent action-comedy *The Family* attempts to negotiate a middle ground between the silly and the savage but never finds a consistent tone and the result is a conceptual catastrophe that fails to provide either laughs or thrills, unless one is amused and/or thrilled by the sight of good actors being wasted on utterly substandard material.

Robert De Niro stars as Giovanni Manzoni, a former high-ranking member of the mafia in Brooklyn who, for reasons that are never to be made entirely clear at any point in the story, whacks most of his colleagues before offering himself up as a witness for the government in their prosecutions of his former associates in exchange for membership in the witness relocation program for himself and his family, wife Maggie (Michelle Pfeiffer), 17-year-old daughter Belle (Dianna Agron), and 14-year-old son Warren (John D'Leo). With a bounty on his head of $20 million, Manzoni, now known as Fred Blake, and his brood are constantly being shuffled from one locale to the next under the watchful eye of federal agent Robert Stansfield (Tommy Lee Jones), and, as the story opens, they are arriving at their new home in Normandy, France. For most people, the idea of living in such a place would seem like a dream come true but to judge from their reaction, one would think that they are being forced to live in someplace more along the lines of San Diego.

With dangerous people still hot on their trail, Manzoni and his brood are advised to maintain the lowest of profiles but they have barely settled in before they begin calling attention to themselves. Upset at the brown water coming out of his faucets, Manzoni begins waging a war with provincial French bureaucracy with the same calm and quiet grace that he once employed on stoolies and other transgressors. If that were not enough, his ad-libbed claims of being a writer to a nosy neighbor inspire him to contemplate writing his sure-to-be-explosive memoirs. Speaking of explosive, such is the reaction that Maggie has to a snotty shopkeeper who scoffs at her when she has the temerity to ask if he carries any peanut butter. As for the kids, the sweet-natured romantic Belle goes to brutal extremes to protect her virtue (decimating one would-be Lothario with a tennis racket) but is willing to give it all up when she goes gaga for her hunky

substitute math teacher. Meanwhile, Warren virtually seizes control of the entire school after only a couple of days but puts his entire family in danger when a dashed-off school assignment inadvertently alerts the mob to their whereabouts.

The Family was directed and co-written by the seemingly inexhaustible Luc Besson (this marks no less than his sixth directorial effort since announcing his short-lived retirement in 2006), a director whose best works—including *La Femme Nikita* (1991), *Leon* (1994), and *The Fifth Element* (1997)—have blended together intricately choreographed action sequences, blatantly pulpy narratives and weirdo humor into some of the most entertaining works of genre filmmaking of recent years. Unfortunately, this film finds him at his most exhausted and right from the get-go, it is apparent that his grasp on the material this time around is unsteady at best and more often worse than that. The comedic scenes never work because, for all of his skills, he has never demonstrated a flair for straightforward comedy in the past—the laughs in his films usually come from the sheer audacity of what he is presenting instead of from deliberate visual or verbal humor—and this film is no exception. As for the action scenes, they mostly fall flat because they offer up imagery that is a little too brutal for what is supposed to by a comedy. If there are ways to mine humor out of severed limbs, an attempted rape, and innocent bystanders getting shot in the head, Besson fails to find them. To make matters worse, Besson never finds the proper tone and keeps asking viewers to either laugh at things that are not especially funny or take things seriously that are pretty much laughable.

As for the cast, they mostly come across as exactly what they are—a bunch of actors gliding their way through their scenes in exchange for what is essentially a paid vacation in France. To be fair, De Niro has a couple of amusing moments here and there, and, if nothing else, he seems marginally more committed to the material at hand than he was in such recent stinkers as *The Big Wedding* (2013) and *The Killing Season* (2013). Likewise, Pfeiffer does not have much to work with here but she manages to wring a few laughs on the strength of her sheer force of personality. Agron has even less to do but makes enough of an impression in her scenes to make one wish that Besson had abandoned everything else and focused the story solely on her character. At least in these cases. the actors can occasionally be seen trying, which is more than one can say about Tommy Lee Jones, who puts in so little effort into his few scenes that once can practically see him calcifying before their eyes.

There is one hilarious and inspired concept in *The Family*—a film that is, after all, supposed to be a comedy—that is worth noting. At one point, the leader

of a local film society, under the impression that Manzoni is a writer working on a book about World War II, invites him to attend a screening of *Some Came Running* (1958) and participate in a debate afterwards. Inexplicably, Manzoni agrees but when he gets there, he learns that due to a mix-up, they will be screening another movie in its place—one on a subject that he has legitimate knowledge of and which also presumably explains the presence of Martin Scorsese on the long list of executive producers. Although patently irrelevant to the proceedings, this sequence is legitimately funny and even though the basic meta-movie joke is lifted practically wholesale from *The Freshman* (1990), it still works. Of course, one could just simply watch *The Freshman* again and simply ignore *The Family*, a cinematic offer that any right-thinking moviegoer would do well to refuse.

Peter Sobczynski

CREDITS

Fred Blake: Robert De Niro
Maggie Blake: Michelle Pfeiffer
Belle Blake: Dianna Agron
Warren Blake: John DiLeo
Robert Stansfield: Tommy Lee Jones
Origin: United States, France
Language: English
Released: 2013
Production: Ryan Kavanaugh, Luc Besson; released by Relativity Media
Directed by: Luc Besson
Written by: Luc Besson; Michael Caleo
Cinematography by: Thierry Arbogast
Music by: Evgueni Galperine; Sacha Galperine
Sound: Didier Lozahic
Editing: Julien Rey
Art Direction: Gilles Boillot
Costumes: Aude Bronson-Howard; Olivier Beriot
Production Design: Hugues Tissandier
MPAA rating: R
Running time: 111 minutes

REVIEWS

Baird, Kirk. *Toledo Blade*. September 13, 2013.
Barker, Andrew. *Variety*. September 12, 2013.
Edelstein, David. *Vulture*. September 13, 2013.
Holden, Stephen. *New York Times*. September 12, 2013.
Li, Sherrie. *Village Voice*. September 12, 2013.
Olsen, Mark. *Los Angeles Times*. September 12, 2013.
O'Malley, Sheila. *Rogerebert.com*. September 13, 2013.

Orndorf, Brian. *Blu-ray.com*. September 13, 2013.
Orr, Christopher. *The Atlantic*. September 13, 2013.
Rabin, Nathan. *The Dissolve*. September 12, 2013.

QUOTES

Belle Blake: "Hey boys, is this your approach to women? You're not gonna get very far. Girls are not some toys that you f**k in the park! Okay? Your future depends on women, don't you care about your future? So take care of them, or else you're not gonna have one."

TRIVIA

The film's original title, "Malavita," is the name of the family dog.

FAST & FURIOUS 6

All roads lead to this.
—Movie tagline

Box Office: $238.8 Million

There is a school of cinematic critical thought that says a film should not be judged by what it is not, but judged only by how well it does what it sets out to do; by how good it is at being what it is. By those criteria, *Fast & Furious 6* could be considered one of the best films of the year. There is little doubt that the movie—the latest and biggest (by nearly every measure) in the car-racing, cops-and-robbers franchise's winding 12-year history—knows what it is and what its fans want: big, loud, dumb entertainment for folks who like fast cars and ridiculous stunts and crashes. The film delivers itself up to those tire-spinning desires with roaring, shameless verve and a muscle-bound cartoon squeal.

After its 2001 debut *The Fast and the Furious* helped make Vin Diesel a star as street racer and car thief Dominic "Dom" Toretto, the series got off track with a couple Diesel-less detours. The pumped-up, shaved-headed anti-hero returned in 2009's suddenly definite-article-free fourth entry, *Fast and Furious*. From then on, each biennial outing has gotten larger, adding in even more outrageous car-centric stunts, and expanding its cast to include Dwayne Johnson as a law-enforcement agent Hobbs, a big, bald, mirror-image antagonist and sometimes ally for Dom and his crew.

After replacing its title's conjunction with a sleeker ampersand, *Fast & Furious 6* continues the growth trend, sending Hobbs, Dom, Dom's partner-in-crime Brian O'Conner (actor Paul Walker, who was killed in a car accident later in the year after partially filming the franchise's seventh entry), and their multi-ethnic, multi-national, gender-inclusive team of drivers, mechanics, and brawlers (now including former MMA fighter Gina Carano) around the world from Rio to London to Spain

to help stop a generic bad guy (Luke Evans, sneering through an evil goatee) from getting his hands on a top-secret destructive device.

Co-star Walker's O'Conner is the relatively "real human" in all this, but with his trademark rumble-strip baritone, Diesel continues to carry most of the *Fast & Furious 6*'s charisma on his broad shoulders and thick neck; a knight in white tank tops. Diesel and Johnson both look like special effects—chrome-domed cartoon characters growling tough-guy bluster and bluff.

However, while they are the aggro binary-star center of the *Fast & Furious* universe, the real driver of the past four films has been director Justin Lin who has proven adept at maintaining control of all the over-sized characters and mayhem with a lead foot on the accelerator and a sure hand on the wheel. Lin (who will not return to helm the seventh film in the series) has continued to nicely manage the films as they have moved from gritty and greasy street-racing flicks to bright and shiny CGI-action spectacles that more closely resemble the over-stuffed, self-silly James Bond films of the 1980s.

Manly men and their manly affection for their cars (first), family and friends (second), and past and present lovers (third) still rev the film's heart, but everything about *Fast & Furious 6* is bigger, louder, and dumber; from its convoluted plot to its massive action sequences. Long-time franchise screenwriter Chris Morgan works in robberies and con jobs, and a car chase pops up every 15 minutes as if a script timer went off—at one point there is nearly a car chase inside a cargo plane. (For the next movie, the filmmakers are probably trying to figure out how to have a car chase inside a car.) The film also features a few interpersonal moments, with talk of relationships, family bonds, secrets, and betrayals—though most of the interactions are fleshed out with dialogue like "It's something I gotta do," "This is what we do," "Let's do it," and other lines apparently written in tattoo parlors.

In addition to its easily ignored super-weapon McGuffin, the movie bristles with side plots as it slips and slides in and out of narrative *cul du sacs*. At one point Walker's O'Conner is snuck into an American prison—by the time the viewer catches up with the how's and why's of the gambit, he is out again and the story has sped on down the road. Yet it all mostly holds together at high speeds thanks to Lin and Morgan's understanding of just how the engines of these movies work. *Fast & Furious 6* flaunts a near-perfectly executed stupidity—like a giant cuckoo clock made of chrome and testosterone, only instead of a chirping bird, it fires a sports car out of a cannon every quarter hour.

By the time Dom and Company are chasing a stolen tank down a Spanish freeway, it becomes clear the movie

no longer exists in anything like the real world, but rather a macho fantasy realm; a Disneyland of muscle shirts and turbo cars where "Oh, s***!" is not an exclamation but a mantra. (Never mind that bad-guy-commandeered tank crushes dozens of innocent people to death in their cars, their lives are a small price to pay for such on-screen thrills.) Eventually the CGI stunts turn the characters into superheroes that not only break the laws of physics but pummel them into submission. The film's safety disclaimer should read, "Do not attempt these stunts on any planet with a working gravitational field."

(Though it should be noted not all characters are created equal when it comes to their superhuman invulnerability: one team member falls what appears to be 50 feet into darkness and is written off as dead—no one even goes back to look for a body. But minutes later Dom struts out of a massive plane-crash fireball without having singed his skin-tight T-shirt. Such is the protective aura of star power.)

Beefed up and dumbed down for the summer box office, *Fast & Furious 6* is overlong, over-stupid, and often teeters on the edge of self-parody. The franchise, however, has learned to embrace its own goofiness. While it is debatable if the movie is "good" or "good for you," it is undeniably good at being exactly what it is.

Fast & Furious 6 marked the franchise's return to the summer-movie season, and the move paid off: released over Memorial Day weekend, the film eventually surpassed all previous series entries at the box office, bringing in $239 million in North America and another $550 million overseas. Reviews were generally positive, with many critics throwing up their hands and giving in to the movie's mindless pleasures. Alan Scherstuhl of the *Village Voice* wrote, "Everyone involved at last seems to understand that the mode here is comic. Previous entries suffered from self-important glumness that gummed up the fun whenever the cars weren't racing," and Ignatiy Vishnevetsky of *The Onion A.V. Club* said it was, "equal parts *Ocean's* movie, Road Runner cartoon, and WWE SmackDown. In other words, it's more or less the same movie as its predecessor." Not all critics were carried away—Derek Adams of *Time Out London* wrote, "With its puerile dialogue, daft performances, flat comic repartee, and ear-rupturingly loud sound levels, the experience of watching *Fast & Furious 6* is like listening to death metal pour out of 500-watt speakers while being strapped to a pneumatic drill."

Locke Perterseim

CREDITS

Dominic Toretto: Vin Diesel
Brian O'Connor: Paul Walker
Letty: Michelle Rodriguez
Owen Shaw: Luke Evans
Mia Toretto: Jordana Brewster
Luke Hobbs: Dwayne "The Rock" Johnson
Roman: Tyrese Gibson
Han: Sung Kang
Gisele: Gal Gadot
Tej: Chris Bridges
Elena: Elsa Pataky
Riley: Gina Carano
Origin: United States
Language: English
Released: 2013
Production: Neal H. Moritz, Clayton Townsend, Vin Diesel; Dentsu, Etalon Films, Original Film; released by Universal Pictures
Directed by: Justin Lin
Written by: Chris Morgan
Cinematography by: Stephen Windon
Music by: Lucas Vidal
Sound: Peter Brown
Editing: Greg D'Auria; Leigh Folsom-Boyd; Dylan Highsmith; Kelly Matsumoto; Christian Wagner
Costumes: Sanja Milkovic Hays
Production Design: Jan Roelfs
MPAA rating: PG-13
Running time: 130 minutes

REVIEWS

Adams, Derek. *Time Out London*. May 15, 2013.
Boone, Steven. *RogerEbert.com*. June 6, 2013.
Genzlinger, Neil. *New York Times*. May 23, 2013.
Goodykoontz, Bill. *Arizona Republic*. May 23, 2013.
Lane, Anthony. *The New Yorker*. June 3, 2013.
Russo, Tom. *Boston Globe*. May 23, 2013.
Scherstuhl, Alan. *Village Voice*. May 17, 2013.
Sharkey, Betsy. *Los Angeles Times*. May 23, 2013.
Tobias, Scott. *NPR*. May 23, 2013.
Vishnevetsky, Ignatiy. *Onion A.V. Club*. May 22, 2013.

QUOTES

Letty Ortiz: "I may not remember anything, but I know one thing about myself. Nobody makes me do anything I don't want to."

TRIVIA

Mark Bomback did an uncredited rewrite for the script.

THE FIFTH ESTATE

You can't expose the world's secrets without exposing yourself.
—Movie tagline

Box Office: $3.3 Million

When it comes to wasting talent and thematic potential, there were not many films in 2013 that

stumbled over their own earnest ambitions and intentions as much as *The Fifth Estate*, director Bill Condon and screenwriter Josh Singer's biopic of Wikileaks founder Julian Assange (Benedict Cumberbatch).

It is easy to see what drew Condon and Singer (and worthy actors like Cumberbatch and Daniel Bruhl, who plays Assange's loyal-then-disillusioned-and-disgruntled partner/lackey Daniel Berg) to the story. In the wake of *The Social Network*—2010's successful biopic of Facebook founder Mark Zukerberg—the rise and fall of Wikileaks (peaking with its 2010 publication of the "Afghan War Logs") and its enigmatic, arrogant, and weirdly charismatic founder must have seemed ripe for the cinematic picking. It wants very much to be yet another film-ready exploration of the New Internet World and the sometimes prickly, anti-social, or just plain odd visionaries who drive groundbreaking changes in human's connection and access to information.

All the players and pieces are here for a bracing, thought-provoking, even polarizing drama about the post-Internet Information Age. Singer based his script on the books *Inside WikiLeaks: My Time with Julian Assange and the World's Most Dangerous Website* (2011) by Daniel Domscheit-Berg (portrayed by Bruhl) and *WikiLeaks: Inside Julian Assange's War on Secrecy* (2011) by journalists David Leigh and Luke Harding. (David Thewlis appears onscreen as Leigh.) Director Condon had proven himself a sensitive and insightful explorer of complex real-life figures in films like *Gods and Monsters* (1998) and *Kinsey* (2004), and co-stars Cumberbatch and Bruhl were riding career waves of acclaim for their work in, respectively, *12 Years a Slave* (2013) and *Rush* (2013).

Nor was the topic lacking for headline-gripping immediacy—by the time *The Fifth Estate* reached theaters in the fall of 2013, the year had already witnessed the trial of Chelsea (ne: Bradley) Manning for having provided Wikileaks with the Iraq and Afghan War Logs; the raising once again of ethical, moral, and philosophical questions about government information leaks in the case of National Security Agency contractor Edward Snowden; and Alex Gibney's documentary *We Steal Secrets: The Story of WikiLeaks* (2013). All the while, the real Assange remained tucked away in the Ecuadorian embassy in London where he had sought diplomatic asylum since 2012 in order to avoid a 2010 Swedish sexual assault charge.

In *The Fifth Estate*, Condon and Singer seem to know what they have. They know Assange is a complicated, contradictory anti-hero—perhaps even a tragic, Shakespearean villain done in by his own ego. They also know the information and activism issues Wikileaks raised are equally complicated as well as important to

the future of an increasingly-online society and its secrecy-obsessed economic and governmental systems. Condon, however, insists on seeing Assange and Wikileaks' story through old-school paradigms of both journalism (signaled by a painfully ham-handed opening-credits montage trying to show "The History of News Sharing"), and the traditional Hollywood biopic.

The story is told mostly from Daniel Berg's point of view, with Bruhl playing him as the more "normal" and relatable half of the Wikileaks team—the quiet, earnest idealist reporting from the eye of a personal, professional, and philosophical hurricane of change. From there, all the exciting, hard-to-answer questions about Assange and his motivations are raised and nicely essayed by Cumberbatch's sly, cerebral, alien-lizard/fantasy-elf performance from under Assange's trademark pale skin and hair: Is he a revolutionary zealot crusading for the freedom and transparency of information? Is he a human-rights activist fighting massive political and economic powers on behalf of the oppressed? Is he a reckless, clownish, attention-seeking hacker reveling in rock-star megalomania? Or is he, most likely, some combination of all these things?

The Fifth Estate loves to toss these human complexities out there and then, like a small child throwing pick-up sticks in the air, run away and ignore the messy results. The film did not have to conclusively define Assange, but nor does it ever get a handle on the nature of his enigma. The character ends up a mercurial cypher revealing nothing underneath, and Cumberbatch's otherwise laudatory performance is left stranded on the surface.

Unable to decide what to do with Assange The Man, *The Fifth Estate* retreats to the more vague and easily-embraced ideals of The Mission. Once again, however, Condon and Singer give lip-service to all those pesky issues of "free information" by having Berg and Assange bicker and bark boilerplate platitudes at each other about editing and journalistic ethics and the moral and human cost of wide-open whistleblowing. However, in keeping with its title—a riff on journalism as the Fourth Estate—*The Fifth Estate* tries to shoehorn all these new ideas about the sharing of information into the more familiar and digestible category of "news and journalism," when the entire point of Assange and Wikileaks' crusade was to move, for better or worse, past journalism to something different.

To that end, Condon repeatedly falls back on hoary, familiar biopic cliches and a narrative structure that is more interested in the interpersonal drama of Berg and Assange's eventual falling out. When *The Fifth Estate* does venture into the thorny topic of idealism versus realpolitik, it is done with clumsy movie-land tropes: The

realpolitik stance is awkwardly represented by Laura Linney, Stanley Tucci, and Anthony Mackie as a trio of U.S. State Department figures dropped in from a more Bourne-like political thriller.

Likewise, some of the film's most embarrassing moments are when Condon tries to present visual metaphors for all the data-sharing and Internet chatting at the heart of the Wikileaks project and the free-information revolution. It is no small challenge to make a cinematically dynamic film about people forever typing away on laptops and smart phones, but the film's clunky imagining of chatrooms and data exchanges as rows of office desks in sand feels at best painfully, uncreatively forced, at worst further proof the filmmakers do not "get it."

Whatever their moral and social implications, triumphs, and failings, Assange and Wikileaks represent a raw, exciting, and perhaps dangerous and scary new information world. That story could be told by an equally exiting and groundbreaking film. Unfortunately, the irony is that Condon's film about the people ushering in that world retreats back into reductive, unimaginative Hollywood formulas. In doing so, *The Fifth Estate* misses the point of its own character's ideas, leaving the film both philosophically and emotionally empty as well as dramatically confused and inert.

The Fifth Estate had a mid-sized theatrical release in late October, and while it only brought in a little more than $3 million dollars in North America, it performed better overseas, where it earned more than $5 million. Reviews were lukewarm—most critics praised Cumberbatch, but many of those who liked the film still felt it fell short of its intent. *RogerEbert.com*'s Christy Lemire wrote, "For a movie about a larger-than-life personality who shook up the world with his brazenness—and since has had to seek political asylum because of it—*The Fifth Estate* feels unfortunately small and safe." Others were even less kind. Writing for *New York Magazine (Vulture)*, David Edelstein said, "The lesson of this is that there's no easy way to dramatize the story of Julian Assange and that trying to turn it into a conventional melodrama is not just politically irresponsible but dull-witted."

Locke Peterseim

CREDITS

Julian Assange: Benedict Cumberbatch
Daniel Berg: Daniel Bruhl
Nick Davies: David Thewlis
Alan Rusbridger: Peter Capaldi
Arike Domscheit: Alicia Vikander
Origin: United States
Language: English

Released: 2013
Production: Steve Golin, Michael Sugar; DreamWorks SKG, Participant Media; released by Touchstone Pictures
Directed by: Bill Condon
Written by: Josh Singer
Cinematography by: Tobias Schliessler
Music by: Carter Burwell
Sound: Warren Shaw
Editing: Virginia Katz
Art Direction: Denis Schnegg
Costumes: Shay Cunliffe
Production Design: Mark Tildesley
MPAA rating: R
Running time: 128 minutes

REVIEWS

Edelstein, David. *New York/Vulture*. October 20, 2013.
Hornaday, Ann. *Washington Post*. October 17, 2013.
Jenkins, Mark. *NPR*. October 18, 2013.
Kenigsberg, Ben. *Onion A.V. Club*. October 16, 2013.
Lemire, Christy. *RogerEbert.com*. October 18, 2013.
O'Hehir, Andrew. *Salon*. October 17, 2013.
Robey, Tim. *The Telegraph*. September 15, 2013.
Scherstuhl, Alan. *Village Voice*. October 15, 2013.
Shoard, Catherine. *The Guardian*. September 15, 2013.
Turan, Kenneth. *Los Angeles Times*. October 17, 2013.

QUOTES

Julian Assange: "You can't go far in this world by relying on people. People are loyal until it seems opportune not to be."

TRIVIA

The character "Ziggy" is based on the WikiLeaks volunteer Sigurdur Thordarson who later turned out to be an FBI Informant.

56 UP

In 1964 a group of seven-year-old children were interviewed for Seven Up. They've been filmed every seven years since. Now they are 56.
—Movie tagline

Box Office: $701,278

"Give me the boy at 7 and I will give you the man." Such is the monumental ambition of the legendary *Up* films, Michael Apted's epic documentary series which Roger Ebert rightly included in his ten greatest films of all time.

Indeed, it is difficult to talk about Apted's latest installment in the series, *56 Up*, without talking about Ebert, who was perhaps its greatest admirer and champion. *56 Up* was the last installment he lived to see and it is hard to imagine viewing future installments without Ebert's irreplaceable insights into them. Ebert rightly called the documentary series the "the noblest project in cinema history." It attempts no less than the documentation of the life span of fourteen people from age seven to their deaths. It is among the most fascinating, surprising, and deeply moving experiences in the history of film.

The concept behind the series is simple, if its effect on the viewer is not. In 1964, British television network Granada profiled fourteen seven-year-old British children from various economic backgrounds (reflecting the biases of its time, only one of the children was black and the ratio of boys to girls was lopsided ten to four). Each child was interviewed and their circumstances documented. Every seven years since the filmmakers have returned and repeated the process. Thus there have been forty-nine years and seven films so far since the initial 1964 film. The *Up* series, more so than any film series in history, is truly one film in an as yet undetermined number of installments.

The series began with Paul Almond directing *Seven Up!* (1964) and Apted as his twenty-two-year-old research assistant. Apted took over with the second film, *7 Plus Seven* (1970), and has made all the films since. Apted is now seventy-two-years-old and, assuming that his subjects continue to participate, someone will presumably take the series over when he passes away. Consider, for a moment, the breathtaking scope of this project. For the last half century, Apted has visited the same people every seven years and documented the course of their lives. Has any film in history made for itself such an ambitious, ennobling goal? And could there be a concept more singularly suited for the qualities unique to film?

Indeed, *56 Up*, as with its predecessors, demonstrates that the medium of film is able to document a life with a power simply not available to any other art form. *Citizen Kane* (1941) demonstrated film's unique ability to compress time through editing and the *Up* films bear this out with an electrifying clarity, made all the more exhilarating by the knowledge that real time is passing and real people are changing before the viewer's eyes. The child of seven appears on the screen, laughing and talking; suddenly she is fourteen, then twenty-eight, then fifty-six, then seven again. Fifty years passes in fifteen seconds, each successive image hitting the viewer like a jackhammer.

Although the viewer only spends an average of twenty minutes with each person once every seven years, the viewer feels like they know the participants and each new installment feels like catching up with old friends (a feeling of familiarity that more than one participant feels is misplaced and complains about in *56 Up* and earlier installments). In *56 Up*, many of the subjects' perspectives seemed to have shifted from focusing on past disappointments and future dreams to simply enjoying the present and however many years of life they may be lucky enough left to have. There is Neil, the most troubled of the group, fighting mental illness in his youth and, in *56 Up* continuing to maintain a certain stability attained several films back. There is John, an upper-class conservative barrister who dropped out of several installments and then returned several years later. His childhood friend, Andrew, is an upper class solicitor who has recently survived a round of layoffs at work. There is Nick, the nuclear physicist from a tiny farm in Yorkshire who lives in America and is returning to England for the first time in many years. There is Tony, the gregarious east-ender taxi cab driver who is the most entrepreneurial of the participants. Again, viewers meet with Jackie, Lynn and Sue, three east-end primary school friends expected (and educated accordingly) to do little more than raise children and stay at home; Paul and Symon, both of whom were in a children's home in *Seven Up!*, one now working as a handyman in Australia, the other as a forklift operator at Heathrow airport; Bruce, an idealistic math teacher who married late in life and finds himself the father of two young children in his mid-fifties; Suzy, the unhappy child of aristocratic parents, now seemingly a contended stay-at-home mom. And, for the first time since *28 Up* (1984), Peter is back (if only because, by his own admission, he wishes to promote his new musical album).

As the participants have entered middle age, their lives seem more stable and there is less of the dramatic change from film to film seen in earlier installments (one, for example, recalls the shock in *28 Up* of seeing Symon, single and childless just seven years earlier in *21 Up* [1977], appear with a wife and five kids). With the exception of the very unexpected return of Peter after an absence of twenty-eight years, *56 Up* does not have surprises that hit the viewer like a freight train in the earlier films but there are surprises nonetheless. They are more subtle and depend more on the viewer's cumulative understanding and appreciation of the participants' past. How surprising and wonderful is it to see the formerly self-serious Bruce, saintly and girlfriendless until his forties, camping with his two young boys in a tent cracking fart jokes; or seeing Sue, having never attended university herself, as a head administrator at the University of London, lecturing to rooms full of

hundreds of students. One of the obvious but nonetheless profound truths that the film documents is that life is unpredictable, in both wonderful and heartbreaking ways.

And some of the changes are indeed heartbreaking. Neil is in better shape than he was in the pre-*42 Up* installments but *56 Up* suggests that his dramatic recovery may have limits. He is a local, part-time politician and lay minister but laments his lack of a reliable, income producing career. He is a writer who has written thousands of pages of material, all of which remain unpublished. "Despite appearing in this programme, nobody has ever shown any interest. It shouldn't be a masturbation about which nobody knows anything." At fifty-six he is single with seemingly slim prospects of that status changing. Also single is Jackie, who when asked what she would like in a man responds "a pulse would be nice." *56 Up* finds her celebrating the birth of her first grandson but also suffering the recent death of her former partner from cancer and preparing for her mother-in-law's impending death from the same thing. She also learns that, after receiving disability payments for fourteen years, an austerity driven Britain has deemed her no longer disabled and that she will, at age fifty-six and after suffering decades of debilitating rheumatoid arthritis, need to somehow find work. "If David Cameron can get me a job, I will do it," she says angrily to the camera.

The most illuminating conclusions about the films are provided by the participants themselves. Nick observes that the series is not successful in accurately depicting who he is in all his complexity but does succeed in documenting a universal life over time. "It isn't a picture really of the essence of [individuals like] Nick or Suzy. It's a picture of everyone. It's how a person, any person, how they change...and that's its value." He is both right and wrong. The films do provide a stunning chronicle of the marriages, divorces, kids, careers, health issues, and changes in personality and appearance that characterize everyone's lives. When images of the subjects from the earlier films appear next to their *56 Up* counterparts, they seem impossibly young, almost like different people. However, while twenty minutes every seven years necessarily provides an incomplete picture of who these people are, the films do more than simply depict a generic life. Though viewers understand that the picture of them is incomplete, audiences are being told the story of their lives and those lives are unique.

It is left, ironically, to the participant who has been out of the series for 28 years to articulate perhaps the most profound truth of *56 Up* and the series as a whole. Contemplating the destructive seduction of regret, Peter wisely concludes: "Life is for the living." Apted has heroically chronicled this truth for half a century and one eagerly anticipates his next installment in this remarkable, one-of-a-kind film series.

Nate Vercauteren

CREDITS

Origin: United Kingdom
Language: English
Released: 2012
Production: Michael Apted, Claire Lewis; ITV Studios UK; released by First Run Features
Directed by: Michael Apted
Cinematography by: George Jesse Turner
Music by: Nick Lloyd Webber
Sound: Nick Steer
Editing: Kim Horton
MPAA rating: Unrated
Running time: 139 minutes

REVIEWS

Atkinson, Michael. *Village Voice.* January 2, 2013.
Burr, Ty. *Boston Globe.* February 8, 2013.
Dargis, Manohla. *The New York Times.* January 3, 2013.
Denby, David. *The New Yorker.* January 24, 2013.
Ebert, Roger. *Chicago Sun-Times.* January 30, 2013.
Fear, David. *Time Out New York.* December 31, 2012.
Moore, Roger. *Movie Nation.* January 30, 2013.
Morgenstern, Joe. *The Wall Street Journal.* January 10, 2013.
Robinson, Tasha. *The A.V. Club.* January 2, 2013.
Scheib, Ronnie. *Variety.* January 3, 2013.

QUOTES

Debbie Walker: "It's not quiet when we get here!"

TRIVIA

Like most of the other "Up" documentaries, this was theatrically released in United States.

FILL THE VOID
(Lemale et ha'halal)

Box Office: $1.8 Million

On paper, writer-director Rama Burshtein's *Fill the Void* tracks quite well. It has an academic quality, as well as a central moral quandary that is easy to chew on as a viewer. Israel's official Best Foreign Language Film Academy Award submission chronicles a devoutly religious family coping with the after-effects of tragedy

and the best way to move on; it is at its core a film about imperfect choice and the freighted personal cost of a selection that may, in sum, be best or easiest for a lot of other people about whom someone cares deeply, but just not best for themselves.

A frustrating thing happens en route to swept up, rapturous engagement, however: For all of the persuasiveness of its setting, *Fill the Void* starts to feel coy and a bit counterfeit, not unlike the plastic smile of a suburbanite harboring depressive tendencies. Dedicated Yiddishists will no doubt enjoy the movie as a sort of partisan celebration of the bonds of community, and hardcore arthouse cineastes will be able to appreciate the piecemeal achievements of its construction. It radiates considerable tenderness. But most viewers are apt to chafe at the circumscribed roles of its female characters, and the readiness with which they accept them. Unfolding in Hebrew with English subtitles, *Fill the Void* takes place in a very particular subculture, but then seems to take a sort of perverse delight in slowly squeezing the universality out of its central premise.

Burshtein's film centers on an Hassidic Jewish family in present-day Tel Aviv, where excited 18-year-old Shira (Hadas Yaron) is set to be married off to a suitor she has glimpsed but not yet met. When her older sister Esther (Renena Raz) collapses during Purim and subsequently dies from complications surrounding her third-trimester pregnancy, however, it throws Shira and her parents' world into disarray.

Esther's husband Yochay (Yiftach Klein) is left a widower, with a premature infant. Wanting to keep her only grandchild nearby, Shira's mother Rivka (Irit Sheleg) proposes that Yochay take Shira as his wife, but her rabbi father Aharon (Chaim Sharir) is less certain. With the family of her previous husband-in-waiting indicating they plan to withdraw their offer, Shira's parents resolve to leave the decision to her (a novel idea), but Shira is stricken with grief, and confused by conflicting feelings of attraction and proper boundary for a man she had heretofore loved as a brother.

What is attractive and involving about *Fill the Void* starts with its technical package, and extends to its performances, which are finely modulated and do not tip over into screeching melodrama. Cinematographer Asaf Sudry trades largely in shallow focus with hazy sunlight streaming in from windows to contribute to the film's soft and incandescent hue. He is further abetted by costume designer Chani Gurewitz's work; amidst all the appropriate traditional clothing there is an abundance of lace and fuzzy sweaters, which add to the movie's enveloping feelings of warmth and hominess. Eschewing primary colors, but never in a pathological way, Bursh-

tein captures the distinct decor and domestic appointments of her pious subjects.

The main actors also uniformly exude quietude and centeredness, even in moments of duress or anguish. Yaron has a moon-ish, sympathetic visage that roots her plight, and Klein in particular plumbs impressive depths of minimalist charm; the less he says, the more interesting he comes across as.

In stark contrast to films like *A Price Above Rubies* (1998) or *Kadosh* (1999), *Fill the Void* does not get mired down in a bleak view of women within the Hassidic community. This may have something to do with Burshtein's gender, her status as an adult Orthodox convert, both or neither. It is certainly fine and well as a choice in narrative focus, and her film, dignified and well crafted, is not lacking for other dramatic outlets. After a while, though, it begins to feel like a copout, particularly since the character of Shira does not feel that well sketched out.

The end-all-be-all embrace of marriage as the defining characteristic of all women is the undiscussed elephant in the room, and Burshtein's eager peddling of this notion comes off as a form of blithe psychosis. Somewhat paradoxically, female characters like Rivka come across as capable and interesting, but also as automatons. Matters are certainly not helped by the inclusion and treatment of two rather sad-sack unmarried characters—Shira's handicapped aunt Hanna (Razia Israely), and family friend Frieda (Hila Feldman), who is positioned as a potential rival bride for Yochay.

Many reviewers noted the Jane Austen-ish tripwires of duty and familial obligation that its marriage plot recalled, but *Fill the Void* lacks the complexity or depth of feeling that the best of Austen's works elicit. It communicates a certain cultural-niche authenticity, in all manner of surface detail. But by failing to dig down in substantive and convincingly illuminating ways into its female characters, it seems resolutely unattached to modern times.

Brent Simon

CREDITS

Shira: Hadas Yaron
Yochay: Yiftach Klein
Rivka: Irit Sheleg
Rabbi Aharon: Chaim Sharir
Origin: Israel
Language: Hebrew
Released: 2012
Production: Assaf Amir; Avi Chai Fund, Norma Productions; released by Sony Pictures Classics

Directed by: Rama Burshtein
Written by: Rama Burshtein
Cinematography by: Asaf Sudry
Music by: Yitzhak Azulay
Sound: Aviv Aldema
Editing: Sharon Elovic
Costumes: Hani Gurevitch
Production Design: Ori Aminov
MPAA rating: Unrated
Running time: 90 minutes

REVIEWS

Baumgarten, Marjorie. *Austin Chronicle.* July 19, 2013.
Castillo, Monica. *Paste Magazine.* May 30, 2013.
Fainaru, Dan. *Screen International.* September 2, 2012.
Hanke, Ken. *Mountain Xpress.* July 16, 2013.
Lyttelton, Oliver. *The Playlist.* May 21, 2013.
Minow, Nell. *Chicago Sun-Times.* June 13, 2013.
Scott, A. O. *New York Times.* May 23, 2013.
Taylor, Ella. *NPR.* May 23, 2013.
Turan, Kenneth. *Los Angeles Times.* May 23, 2013.
Weissberg, Jay. *Variety.* September 2, 2012.

TRIVIA

Rama Burshtein spent a year editing the movie.

AWARDS

Nominations:

Ind. Spirit 2013: First Feature, First Screenplay

FILLY BROWN

Box Office: $2.9 Million

It would be nice to say that *Filly Brown* offers a fresh and distinct flavor on the whole "coming-of-age, star-is-born" genre. Generally the industry has stuck to presenting the next fresh-faced Caucasian girl to take viewers through the struggles of making it in a cutthroat business. Usually this involves someone already established in the real world of records and harmony whose biggest problem in the world is getting respect from their teacher, parent or the love triangle in which they find themselves. Hollywood can serve up more white girls with problems than Nancy Grace, so it usually takes an independent voice to let us peek inside another culture and let a real outsider have their shot. Unfortunately, co-directors Youssef Delara and Michael D. Olmos have crammed too many loose ends into a morally and ethically-challenged narrative that is as all over the map as one of its "original" songs.

Majo (Gina Rodriguez) is determined to get her mom out of prison. Maria (Jenni Rivera), in prison on drug charges, informs her daughter that the arresting cop is now under investigation himself and could lead to a legal loophole. Majo will not tell anyone who will listen that she needs to help get mom out. This includes her uncle/employer, her shady attorney (Edward James Olmos) and her father, Jose (Lou Diamond Phillips). After this repetitious first 15 minutes, the film shifts to Majo's side passion as Filly Brown, her rapper name. Her performances on internet radio attract some attention as she passionately spouts off the lyrics that mom gave her to sing.

This takes her from small-time management to big dog Big Cee (Noel G.) who is willing to front her an advance for her legal fees as long as she agrees to take his guidance to her act. Lyrics take a sharp turn from those chronicling the experience of a young Latina girl hoping to "dream big" to a recurring chorus of "daddy, will you lick me down?" Needless to say, it is not about her father. "You dreaming about 50,000 screaming fans," asks a friend? Why yes she is, as such a daydream is visualized before getting back to whatever subplot the script wheel spins back to.

The interruption of the film's best song in the first minute of *Filly Brown* to bring viewers into the prison could not be a more fitting metaphor of what is to follow. As much as viewers would like to hear the rest of Filly's lyrics, the screenplay cannot find a way to settle on a storyline or how to mesh all its avenues into how it affects the overall arc of its titular character. As the de facto mother figure, Filly watches out for her younger sister, who is ready to explore with any guy who comes along. Older sis hardly bats an eye though, being a questionable role model for sexuality while her clothes are sliding off her body in the studio. Since the film takes such an otherwise asexual approach to Majo, there is the sense that her sister is actually more qualified to be singing about body parts and touching.

Shifting towards the transition from artist to provocative sell out is a hot topic when one considers how many Disney princesses have gone from G-rated television shows to barely legal presentations of their bodies on stage. *Filly Brown* does not have the time to take the approach of another year/another piece of clothing dropped, but Delara and Olmos (son of Edward James) even worse, in their limited timeframe, do not even provide Majo with the self-recognition of her compromise. Already a participant in a work scam for some quick cash, it takes a revelation about mom's lyrics to realize she is on the wrong path but not at the realization that she has done anything wrong. Any potential

guidance from dad is lost since he is stuck in his battle with another woman; a British employer who keeps insisting his work crew is basically too tattooed and convict-looking to make people comfortable. Each encounter, which equal more personal scenes than he has with Majo, loses Jose a bit more of his business to the point that it should have led to a post-credits sequence with him as a one-man construction operation hauling around equipment in a Peel P50 as if he were Milton in *Office Space* (1999).

Lou Diamond Phillips gives the film's most genuine performance even up to the point of choking out his daughter's rival longer than Nurse Ratched. "You can't just go around kidnapping people" is the best piece of advice the film can give to wannabe music stars as the screenplay produces more feedback drowning out the music than any Delara got on structuring. No amount of ominous music can cover the familiarity of the plot lines that take precedence and Rodriguez's performance cannot overcome the unquestioned flaws of her character. Her rap scenes sound the part but none of the songs are memorable enough to even strike up a one-hit wonder; except maybe the first minute of that opening. "Tell me she did not just refer to herself in the third person?," asks her closest friend who clearly is not even listening to the lyrics that drop the film's title. The same friend asks earlier how he "was hoping we'd try to elevate the game and throw out some wisdom." Shame he was talking to Filly and not Delara and Olmos.

Erik Childress

CREDITS

Majo Tonorio: Gina Rodriguez
Khool-Aid: Khoolaid Rios
Jose Tonorio: Lou Diamond Phillips
Lala: Lala Romero
Eddie Vargas: Jorge Diaz
Leandro: Edward James Olmos
Origin: United States
Language: English
Released: 2012
Production: Youssef Delara, Michael D. Olmos, Amir Delara, Mico Olmos, Edward Rios, Victor Teran, Khoolaid Rios; Cima Productions, Olmos Productions, Silent Grant Entertainment; released by Pantelion Films
Directed by: Youssef Delara; Michael D. Olmos
Written by: Youssef Delara
Cinematography by: Ben Kufrin
Music by: Reza Safinia
Sound: Trip Brock
Editing: Youssef Delara; Eric R. Brodeur

Costumes: Jill Machlis
Production Design: Krystyna Loboda
MPAA rating: R
Running time: 99 minutes

REVIEWS

Black, Louis. *Austin Chronicle.* April 26, 2013.
Dequina, Michael. *TheMovieReport.com.* May 6, 2013.
Ellingson, Annlee. *Paste Magazine.* April 26, 2013.
Hillis, Aaron. *Village Voice.* April 23, 2013.
Koehler, Robert. *Variety.* January 24, 2012.
Nicholson, Amy. *Los Angeles Times.* April 18, 2013.
O'Connell, Sean. *Washington Post.* April 26, 2013.
Puig, Claudia. *USA Today.* April 18, 2013.
Robledo, S. Jhoanna. *Common Sense Media.* April 23, 2013.
Rooney, David. *Hollywood Reporter.* January 21, 2012.

TRIVIA

This was both singer Jenni Rivera's film debut and final film. She perished in airplane crash in Mexico on December 9, 2012, months before the film's release.

47 RONIN

This Christmas, seize eternity.
 —Movie tagline

Box Office: $38.4 Million

The samurai fantasy epic *47 Ronin* tells of a legend of outcast warriors who fought against the rules of the Shogun to avenge the wrongful death of their master. If this legend is true, it might be a safe bet that there did not exist any shape-shifters or mutant-like beasts that had to be defeated in the process. Just a guess. The film's story is bound by the honor of its characters and the samurai code, but it certainly takes liberties with everything else. Never mind that everyone is speaking English (with a budget of $175 million, authenticity tends to go right out the window). *47 Ronin* has bigger things to concern itself with, such as making sure there is a romantic sub-plot and a few monsters to keep the kids in the audience entertained. This suggests a very loose adaptation of a legend, but like all folk and fairy tales, legends are made to be bent and shaped to fit the needs of the storyteller. In this case, Universal Pictures.

The film opens by explaining the role of the samurai, the peacekeepers of the land. If a samurai fails his master, they are shamed and are reduced to ronin status (outcasts without dignity). The story here concerns a non-samurai, a white man named Kai (Keanu Reeves) who entered the land as a boy without much of a

backstory. He could be a demon. He has a Harry Potter-like mark on his forehead that could be the mark of an evil being who tried to kill him. As a boy, he was taken in by Lord Asano (Min Tanaka), who has a daughter Kai's age named Mika (Ko Shibasaki). But Kai is considered a half-breed and cannot be a samurai. Even though he is perfectly competent as a warrior and has already received training in his younger years before he was found, he lives as an outcast in the forest just outside of the province.

The film takes what seems like a detour from the legend to show Kai helping the samurai to destroy a giant mutated beast that lives in the forest. The warriors try to kill this savage monster that looks like it stepped out of a *Lord of the Rings* movie, but Kai ends up killing it instead. He, of course, cannot take credit for the kill. More important than that diversion is the villain Lord Kira (Tadanobu Asano) who wants to take down Lord Asano and rule over his village. He has some help from a shape-shifting witch (Rinko Kikuchi) who drops a hallucinogenic drug into Lord Asano's mouth while he sleeps. He awakens to what he thinks is the sound of his daughter being raped by a samurai. He ends up killing the samurai and is tried for murder by the Shogun. He must now die for his actions, leaving the province to be ruled by Lord Kira. The samurai who served Lord Asano must be banished.

Kai ends up being sold into slavery for pretending to be a samurai and fighting in a tournament. One of Lord Asano's most loyal exiles, Oishi (Hiroyuki Sanada), and his father take it upon themselves to avenge his death in spite of the orders of the Shogun that no one shall avenge the death of Lord Asano. They first try to find Kai to help them with their quest to round up as many warriors they can throughout the land to kill Lord Kira. Kai's main interest in accomplishing this mission is to rescue Mika, who is set to wed Lord Kira. They eventually round up what amounts to 47 ronin, all of whom are well aware that their actions could result in their execution for disobeying a Shogun's orders.

There are all kinds of reasons for wanting to re-tell a legend, but *47 Ronin* does not seem to have a clear purpose. The film ends with a coda explaining that on December 14th of every year, many visit the graves of the real 47 ronin to pay respect for their actions. It is an exciting tale, to be sure, but the film reduces it to a series of special effects set pieces with wooden, hollow characters. It basically does the same disservice to its subject as the re-vamped *Clash of the Titans* (2010) did for Greek mythology, although *47 Ronin* is far more watchable. The scene involving the beast in the first act of the film is very well done and the ambush on Lord Kira carries some excitement, much of the film is

uninspired and Reeves' performance is too stiff and detached for the audience to latch onto.

Much was made of *47 Ronin*'s budget when the film was release on Christmas Day in 2013. Carl Rinsch's film—his first-ever feature—was never screened for the press ahead of time and had problems from the get-go with studio commissioned re-writes to an escalating budget to the film's release getting delayed by at least a year. With such a prestigious opening date, the film never had a chance. It did not help that Reeves had not starred in a big budget adventure film in ten years. *47 Ronin* tanked at the box office, but it is not so bad as to be put in the same league as more deserved flops of its kind. It is merely a bloated fantasy epic that tried mighty hard in the production department, but failed just about everywhere else in spite of good intentions. Its biggest crime is that it is joyless and not very masterful in the art of storytelling.

Collin Souter

CREDITS

Kai: Keanu Reeves
Oishi: Hiroyuki (Henry) Sanada
Mika: Ko Shibasaki
Lord Kira: Tadanobu Asano
Origin: United States
Language: English, Japanese
Released: 2013
Production: Pamela Abdy, Erin Mcleod; Moving Picture Company Ltd.; released by Universal Pictures Inc.
Directed by: Carl Rinsch
Written by: Chris Morgan; Hossein Amini
Cinematography by: John Mathieson
Music by: Ilan Eshkieri
Sound: Timothy Nielsen
Editing: Stuart Baird
Art Direction: Gary Freeman
Costumes: Penny Rose
Production Design: Jan Roelfs
MPAA rating: PG-13
Running time: 118 minutes

REVIEWS

Abrams, Simon. *RogerEbert.com*. December 26, 2013.
Ehrlich, David. *Film.com*. December 23, 2013.
Guzman, Rafer. *Newsday*. December 23, 2013.
Hiltbrand, David. *Philadelphia Inquirer*. December 26, 2013.
Olsen, Mark. *Los Angeles Times*. December 24, 2013.
Rapold, Nicholas. *New York Times*. December 24, 2013.
Scherstuhl, Alan. *Village Voice*. December 26, 2013.

Stewart, Sara. *New York Post*. December 24, 2013.
Uhlich, Keith. *Time Out New York*. December 24, 2013.
Vishnevetsky, Ignatiy. *AV Club*. December 27, 2013.

QUOTES

Kai: "I will search for you through 1,000 worlds and 10,000
lifetimes!"

TRIVIA

The arrows for the film were made by Michael Reape, a famous
European arrow maker; a small amount were produced as
"museum" quality for close-ups.

42

The true story of an American legend.
—Movie tagline

*In a game divided by color, he made us see
greatness.*
—Movie tagline

Box Office: $95 Million

In the Jackie Robinson biopic *42*, the first African
American to breach baseball's long-impervious color
barrier is likened to a crucial medicine being injected
into the national pastime to cure its stubbornly-resistant
segregationist ills. It was fully recognized that an
unfortunate percentage of those within both the sport
and the general populace would likely find this equal-
izing elixir hard to swallow, and might attempt to force-
fully spit it back in disgust. However, Brooklyn Dodgers
President and General Manager Branch Rickey bet that
this particular ballplayer not only had the potency to
succeed but would be palatable for a prejudiced public's
consumption.

Robinson possessed the plusses of being a non-
smoking, non-drinking, happily-married man who had
been a lauded college athlete and an Army officer during
WWII. (Being a fellow Methodist was another attribute
in the eyes of perpetually-Bible-spouting Rickey,
motivated by both money and morals.) Furthermore,
Robinson had promised that he would, until established,
summon and steadfastly maintain the strength to take
whatever distastefulness came his way with purposeful
poise. Although he could be fiery he would refuse to
flare up, holding his tongue while others wagged theirs
with antagonistic vileness. Instead of letting them get a
rise out of him he would rise to the occasion with fierce
determination (Robinson absolutely hated to fail), let-
ting his bat and boldly-defiant base-running pointedly
do all his back-talking. In spite of hotheaded horridness
from numerous sources and the cold shoulder given by
many of his own teammates, all the supposedly-

accidental bean balls and spiking and very questionable
umpire calls, and the stacks of anonymous letters
threatening to put Robinson in his place at the end of a
lynching rope, he kept his vow to remain outwardly
stoic despite often seething within.

While Rickey touted Robinson's athletic prowess as
"superhuman" and his detractors denigrated him as
subhuman, it must have been an agonizing strain to not
be able to be simply human and show understandable
emotion. In his 1972 autobiography, Robinson recalled
his immense relief when Rickey "finally" told him, "You
can be yourself now." However, what had needed to be
stuffed deep down and out of sight remains decidedly
but also detrimentally so in *42*, which glowingly puts
forth an inspiring icon but insufficiently illuminates
both the man and the profundity of the strain that led
to the success of a great cause but also the premature
failure of Robinson's health.

Five months before the release of *42*, Steven Spiel-
berg's *Lincoln* took a similar approach in looking at
another hero who courageously, resolutely and forever
after changed the lives of African Americans and the
country as a whole for the better. Both films narrowly
focus on what was decided to be the man's defining mo-
ment, his most impactful achievement. However, while
the former film shed new light and made viewers feel
they knew a man more intimately, this one chooses
instead to reverently retell when it could also have
revealed, veering toward hagiography when it could have
humanized. One needs to go to Robinson's own ac-
count of the time in question—from his signing by
Rickey to a minor league contract in 1945 until the
Dodgers' 1947 clinching of the National League pen-
nant at the end of his first, fateful season—to understand
just how much all the torment troubled him. There,
Robinson wrote of times when "deep depression would
seize me" and of the call to his sister in which he
proclaimed, "I can't take it anymore. I'm quitting." More
than merely detecting ignited anger competently flicker-
ing in the eyes of commendable portrayer Chadwick
Boseman, readers can truly both come to know the man
and feel what raged inside and was agonizingly—and
sometimes barely—contained.

Of the grotesque glee with which the Philadelphia
Phillies and their rantingly-racist manager, Ben Chap-
man (Alan Tudyk), sank below being unsportsmanlike
to uncivilized, Robinson wrote: "For one wild, rage-
crazed minute, I thought to hell with Mr. Rickey's Noble
Experiment. I thought what a glorious, cleansing thing
it would be to let go. To hell with the image of the
patient black freak I was supposed to create. I would...
smash his teeth in with my despised black fist." The
film's disturbing depiction is followed by a frustrated
Robinson's retreat to the deserted tunnel just in from

the Dodgers' dugout to decompress with a roaring, bat-smashing meltdown. By all accounts, it never happened. Writer/director Brian Helgeland justified the scene's inclusion by saying that he could not imagine that the beleaguered big leaguer did not crack up in some sort of truly vivid fashion at least once, even in relative private. Although dramatic, it does Robinson a disservice: Why undercut him by inventing this instance of his being laid low when the fact is that this man who admitted he was prone to "swift retaliation for mistreatment" refused even then to lose his composure with nothing less than heroic willpower and instead stood tall? Robinson used to tee off on buckets full of golf balls to release his anger, and unburdened himself by sharing his feelings with his stalwartly-supportive wife, Rachel (Nicole Beharie). Even one such scene would have give given viewers accurate access to what unfortunately remains so harmfully hidden.

Spike Lee had long-envisioned his own three-hour film starring Denzel Washington as Robinson which would have examined the subject's life more broadly and deeply, such as the 1943 court martial only fleetingly alluded to here, the unmuzzled remainder of his Hall of Fame career, and his years as an outspoken and sometimes controversial civil rights activist and commentator. It surely would also have dealt with the loss of his namesake at age twenty-six, a tragic event that finished off an infirm, white-haired Robinson at just fifty-three. It would have revealed more than *42* about what made the man tick and might very well have also ticked off some moviegoers. Helgeland's rather formulaic film is content to take a limited, worshipful look that stays safely on the surface. Nevertheless (and despite its fact fudgings), *42* is a compelling telling that is well-acted, rousing, and nicely evokes the period. It is a starting point from which there is much more to know.

Helgeland's work repeatedly and reassuringly shows viewers ugliness but then uplift. A redneck threateningly approaches the house where Robinson is staying while in the minors (he could not stay in a hotel with the other players), but later another white suspensefully steps forward, only to wish him well. Some teammates vow not to take the field with Robinson (their petition is quickly quashed by a padded and prosthetically-altered Harrison Ford's enjoyable Rickey and Christopher Meloni's colorful manager Leo Durocher), but then there is Pee Wee Reese (Lucas Black) heartwarmingly throwing his arm supportively around Robinson's broad, burdened shoulders. At first, whites sit stone-faced (when not heckling), refusing to clap when Robinson does well, but later shots emphasize multiracial approbation. Earlier on, Robinson tosses a ball from a train to an idolatrous boy previously viewed in front of a "colored" sign. Viewers later learn that the child went on to play in the majors because, thanks to Robinson, merely being black no longer held him back. As the train departs, it seems a metaphor for both Robinson's fortitude and the progress it brought about: unstoppable, full steam ahead. On that now-historic 1947 Opening Day, the camera pans during the National Anthem until finally arriving on Robinson as the song finishes with an especially-meaningful "Land of the free, and the home of the brave." Only the hearts of the dead could have failed to be stirred.

David L. Boxerbaum

CREDITS

Jackie Robinson: Chadwick Boseman
Branch Rickey: Harrison Ford
Rachel Robinson: Nicole Beharie
Leo Durocher: Christopher Meloni
Dixie Walker: Ryan Merriman
Pee Wee Reese: Lucas Black
Ralph Branca: Hamish Linklater
Harold Parrott: T.R. Knight
Red Barber: John C. McGinley
Origin: United States
Language: English
Released: 2013
Production: Thomas Tull; released by Warner Brothers
Directed by: Brian Helgeland
Written by: Brian Helgeland
Cinematography by: Don Burgess
Music by: Mark Isham
Sound: Jon Johnson
Music Supervisor: Peter Afterman; Margaret Yen
Editing: Peter McNulty; Kevin Stitt
Art Direction: Aaron Haye
Costumes: Caroline Harris
Production Design: Richard Hoover
MPAA rating: PG-13
Running time: 128 minutes

REVIEWS

Burr, Ty. *Boston Globe*. April 11, 2013.
Denby, David. *New Yorker*. April 15, 2013.
Foundas, Scott. *Variety*. April 10, 2013.
Gleiberman, Owen. *Entertainment Weekly*. April 10, 2013.
Hornaday, Ann. *Washington Post*. April 11, 2013.
McCarthy, Todd. *Hollywood Reporter*. April 10, 2013.
Morgenstern, Joe. *Wall Street Journal*. April 11, 2013.
Phillips, Michael. *Chicago Tribune*. April 11, 2013.
Puig, Claudia. *USA Today*. April 12, 2013.
Rainer, Peter. *Christian Science Monitor*. April 12, 2013.
Scott, A. O. *New York Times*. April 11, 2013.

FRANCES HA

Box Office: $4.1 Million

Shot digitally on the cheap and presented in lovely black-and-white, Noah Baumbach's *Frances Ha* is a step away from his typically dour characterizations. While it presents its heroine, Frances (Greta Gerwig, who also co-wrote the script) and her friends with the bitter psychological acuity, the profound cynicism typical of Baumbach films like *The Squid and the Whale* (2005) and *Greenberg* (2010), it is gentler and more optimistic than those earlier works. And even more so than Baumbach and Gerwig's previous collaboration, *Greenberg, Frances Ha* is a love letter of sorts, and not just from Baumbach to his significant other, Gerwig.

Gerwig stars as Frances, a 27-year-old modern dancer, struggling both in her career and in confronting adulthood. Frances shares an apartment and a seemingly symbiotic relationship with her best friend since college, Sophie (Mickey Sumner). Baumbach depicts this in an opening montage of the pair rampaging through the city together and sharing intimacies at their Brooklyn apartment. This is followed by a sharply detailed scene in which Frances and Dan (Michael Esper) break up, because she is unwilling to abandon Sophie to move in with him. Of course, Frances' loyalty to Sophie is not reciprocated. Soon after, Sophie lets her know that she is moving to Tribeca, to her "dream apartment," with another friend, and Frances, a struggling dancer, cannot afford to join them. So begins Frances' journey through the city, from living space to living space, interrupted by a surprisingly warm visit home to Sacramento (Gerwig's hometown, where her real parents, Christine and Gordon Gerwig, play Frances' parents), an embarrassing trip back to Vassar (the college both Baumbach and Gerwig attended), and a desultory weekend visit to Paris, where she amusingly spends most of her time sleeping off jet lag.

Upon leaving her first apartment, she rents the overpriced living room of two friends and would-be romantic interests, Lev (Adam Driver, playing a more charming young Brooklynite than he has played on Lena Dunham's HBO series *Girls*) and Benji (Michael Zegen).

There is a kind of incestuousness to Frances' social relationships, particularly early in the film, that keenly reflects lived experience. Frances' financial woes are another key plot element, and the movie does a good job of depicting the precariousness of being an artist in New York, if one is not supported by extremely wealthy parents the way halfhearted aspiring screenwriter Benji and sculptor Lev are.

Frances Ha captures this aspect of young New York living, though in the end, perhaps Frances' transition to adulthood, through the compromise of adjusting her expectations to a realistic level, is linked to her professional and creative fulfillment in a way that seems overly optimistic. After 80 minutes or so of realistically depicted struggle—financial, creative, and emotional—it all comes together a bit too quickly and easily for her. Frances does go through enough turmoil—particularly that pathetically misguided Parisian misadventure—to earn some grace, but it does feel slightly dishonest, in an otherwise painfully honest depiction of youthful self-involvement and confusion.

Baumbach has always been a filmmaker defined in part by his cinematic references, primarily to the French New Wave. Of course, those filmmakers themselves—Jean-Luc Godard, Francois Truffaut, and Eric Rohmer are the ones Baumbach borrows from most obviously—notably re-purposed tropes and images from classic Hollywood cinema in their own work, so that form of homage, in and of itself, can hardly be seen as objectionable. For *Frances Ha*, Baumbach again uses the music of frequent Truffaut collaborator Georges Delerue, as he did in his second film, *Mr. Jealousy* (1997). There are many borrowings—in the music, wardrobe, and cinematography, as in a shot of a glum Frances traipsing along the Seine in the manner of Jeanne Moreau—but two in particular stand out.

The description the drunken Frances suddenly blurts out (with surprising eloquence) to a bemused dinner party hostess (played by musician Britta Phillips) of what she is looking for in a life partner—someone with whom she shares a private language of a sort, recognizable from across a crowded room—and Frances' later recognition of that connection, is similar to that experienced by Lester (Eric Stoltz) and Ramona (Annabella Sciorra) in the aforementioned *Mr. Jealousy*. It is a sign of Baumbach's increased maturity as a filmmaker that in *Frances Ha*, it feels more organically integrated into the narrative.

In an early scene, after Sophie has moved out, a worried Frances manages to find a place to stay, in the living room of her friends Lev and Benji. This information is announced, as with all of Frances' frequent

changes of address, with a title card. Then there is a sequence of Frances running and dancing through the crowded streets of New York City, as David Bowie's propulsive "Modern Love" plays on the soundtrack. It is an homage to a scene from Leos Carax's brilliant *Mauvais Sang* (1986), but while Carax's scene, featuring Denis Lavant charging madly through empty Paris streets in the middle of the night, has a romantic desperation to it, the scene in Baumbach's film is youthful exuberance tinged with a kind of hopeful obliviousness. The sequence is of little narrative import, but it cannily captures a precise moment in Frances' emotional development. It is a successful "repurposing" of Carax's work, though hopefully one that viewers will somehow be made aware of, so they can track down the original.

Frances Ha works, in part due to the charm and comic precision of Gerwig's endearing performance. A gifted physical comedian from the face down, she manages to be somewhat klutzy and awkward while still being graceful enough to be believable as a professional dancer. It is similar to the way she makes Frances both appallingly self-deluded and surprisingly adorable. For his part, Baumbach's infatuation with her permeates the work, although it competes with his cinephilia as the movie's driving force. Some may find Gerwig's depiction of bohemian hipster cluelessness unworthy of redemption, or may feel that Baumbach is too emphatic in his reference to other filmmakers' work, but like that paramour looking across the crowded room, there will be many who are delighted to find that *Frances Ha* is speaking their own private language.

Josh Ralske

CREDITS

Frances: Greta Gerwig
Sophie: Mickey Sumner
Dan: Michael Esper
Lev: Adam Driver
Origin: United States
Language: English
Released: 2013
Production: Scott Rudin, Lila Yacoub, Greta Gerwig; Pine District, RT Features; released by IFC Films
Directed by: Noah Baumbach
Written by: Greta Gerwig; Noah Baumbach
Cinematography by: Sam Levy
Sound: Paul Hsu
Editing: Jennifer Lane
Costumes: Douglas Aibel
Production Design: Sam Lisenco

MPAA rating: R
Running time: 86 minutes

REVIEWS

Cheshire, Godfrey. *RogerEbert.com.* May 16, 2013.
Cronk, Jordan. *The House Next Door.* September 9, 2012.
Hornaday, Ann. *The Washington Post.* May 23, 2013.
Kenigsberg, Ben. *The AV Club.* May 16, 2013.
McCarthy, Todd. *The Hollywood Reporter.* September 2, 2012.
Perez, Rodrigo. *IndieWire.* September 1, 2012.
Scott, A. O. *New York Times.* May 16, 2013.
Taylor, Ella. *NPR.* May 16, 2013.
Turan, Kenneth. *Los Angeles Times.* May 16, 2013.
Zacharek, Stephanie. *Village Voice.* May 15, 2013.

QUOTES

Frances: "Sometimes it's good to do what you're supposed to do when you're supposed to do it."

TRIVIA

Actress Greta Gerwig is in every scene of the film.

AWARDS

Nominations:

Golden Globes 2014: Actress—Mus./Comedy (Gerwig)
Ind. Spirit 2014: Film, Film Editing

FREE BIRDS

Hang on to your nuggets.
 —Movie tagline
The greatest turkey movie of all time.
 —Movie tagline
Changing the main course of history.
 —Movie tagline

Box Office: $55.7 Million

With the dire state of recent animation, any good news is great news. And the good news about *Free Birds* is that, unlike seemingly every other family-targeted story of late, it is not a film about a young character who wants to be more than he thinks he can be based on the paths taken by the community elders. It is easy to imagine how *Free Birds* could have focused on a teenage turkey who longs to step outside the food chain and become, say, a prize-fighting boxer. Hey, after the professional racing pursuit in the pathetically generic *Turbo* (2013), it appears no plotline is too illogical.

Free Birds centers on Reggie (voiced by Owen Wilson), a loner in the turkey community. While others

display constant stupidity and preach about the world being made of corn, Reggie is an independent thinker, which is not the path to making friends in a society where groupthink reigns supreme. So when the president (voiced by director/co-writer Jimmy Hayward) chooses Reggie as the pardoned turkey, the one bird who escapes the annual culinary genocide, he feels no guilt about kicking up his feet in the White House, where he enjoys a comfy bed from which to watch TV and devour all the pizza he can eat.

Though that does sound like a nice lifestyle, this is probably a good time to note that the movie amusingly opens with a disclaimer about its lack of historical accuracy. The disclaimer amusingly jokes, however, that turkeys who can talk are, in fact, authentic.

So far, so good. *Free Birds* begins with a fast-moving cleverness that, while bordering on frenzied, promises at least snappy entertainment and at most a refreshing change of pace for viewers tired of family movies' total lack of imagination. Sadly, the ideas and laughs disappear quickly. Reggie is whisked into a time machine by Jake (Woody Harrelson), who needs help with a rather ambitious mission: Return to the first Thanksgiving in 1621 and take turkeys off the menu, thus saving countless members of their species that otherwise would have been consumed during hundreds of years of future holidays. If anything, this somewhat inspired idea highlights the sad truth about screenwriting: A story only gets so far on concept; it is the execution, and the way the clever set-up unfolds, that really counts.

As a result, *Free Birds* shifts from lighthearted to tiresome and never recovers. The script by Hayward and first-time feature writer Scott Mosier (an actor seen in small parts in many Kevin Smith films) lazily nods to *Back to the Future* (1985), *Bill and Ted's Excellent Adventure* (1989), and the popular game *Angry Birds* as if such weak gags are mandatory for a time travel-related comedy about birds. The writers fortunately do not make a joke about "Jenny from the flock" after introducing Reggie's obligatory romantic interest Jenny (Amy Poehler), but attempting to generate laughs from her lazy eye is not only lamer, it is mean-spirited. Which is a tone that should pretty much never appear in a kid-friendly comedy.

Despite the manic pace and attempts at zany humor (with a speed that prevents even the better lines from connecting), *Free Birds* still manages to have the same effect as eating turkey. As if succumbing to tryptophan, viewers will feel an uncontrollable urge to close their eyes no matter how much energy the onscreen birds expend battling early settlers and redundantly depicting how dumb turkeys can be. (As *Free Birds* opened the same day as a far superior time travel film, *About Time*,

it is not worth getting into the plot complications involving the intricacies of jumping through time and Jake's belief in "The Great Turkey.") Oh, and all the shots of Jake's butt muscles? Those are creepy, not funny.

Also dispiriting is the departure from a message of cultivating an independent mind in favor of a standard lesson about the importance of family. As usual, the presence of big-name voice actors adds little to the final product. Only Harrelson livens up his character, but even that has limited payoff when all the characters lose steam by halfway through the film. Maybe it is from how much they exert themselves. So many of the best animated efforts make their mark with precision, not impatience. Sure, no one expects *Free Birds* to have the lovely elegance of something like *The Triplets of Belleville* (2003), but that does not mean it has to dash around as if any less would lose its viewers' attention. That is no more clear than in the most rewarding moment of *Free Birds*, a moving demonstration of the feathered community's ritual for mourning the dead. That is the kind of stuff even young moviegoers gobble up, if the Hollywood machine would just put it on their plate.

Matt Pais

CREDITS

Reggie: Owen Wilson (Voice)
Jake: Woody Harrelson (Voice)
Jenny: Amy Poehler (Voice)
S.T.E.V.E.: George Takei (Voice)
Myles Standish: Colm Meaney (Voice)
Origin: United States
Language: English
Released: 2013
Production: Scott Mosier; Reel FX Creative Studios; released by Relativity Media
Directed by: Jimmy Hayward
Written by: Jimmy Hayward; Scott Mosier
Music by: Dominic Lewis
Sound: Randy Thom; Dennis Leonard
Editing: Chris Cartegna
Art Direction: Kevin R. Adams
Production Design: Mark Whiting
MPAA rating: PG
Running time: 91 minutes

REVIEWS

Bale, Miriam. *The New York Times*. October 31, 2013.
Black, Louis. *Austin Chronicle*. October 31, 2013.
Cabin, Chris. *Slant Magazine*. October 31, 2013.
Chang, Justin. *Variety*. October 29, 2013.
Lemire, Christy. *RogerEbert.com*. November 1, 2013.

Puig, Claudia. *USA Today*. November 1, 2013.

Taylor, Drew. *The Playlist*. October 30, 2013.

Tobias, Scott. *The Dissolve*. October 30, 2013.

Uhlich, Keith. *Time Out New York*. October 31, 2013.

Zwecker, Bill. *Chicago Sun-Times*. October 31, 2013.

QUOTES

Jake: "Goodbyes are just hellos blowing across the wind until our paths intersect once again."

TRIVIA

George Takei's trademark expression "Oh, my" are the last words of the movie.

FROM UP ON POPPY HILL
(Kokuriko-zaka kara)

Box Office: $1.0 Million

American animation fans today have bountiful choices, on both the big screen and television. From the work of Trey Parker, Matt Stone, Seth MacFarlane, Nick Park, and Don Hertzfeld, to mention but a few, on through Adult Swim and other outlets, there are more types and tonalities of animated stories being made and distributed than ever before. That was not always the case, however.

One of the individuals responsible for that change was writer-director and Studio Ghibli co-founder Hayao Miyazaki. With a string of influential films beginning in the mid-1980s, Miyazaki helped internationally popularize "Japanimation," and inspire a new generation of animators. Now in his 70s and contemplating retirement, Hayao has in part turned his attention to helping solidify the career of his son, director Goro Miyazaki. Scripted by Keiko Niwa and the elder Miyazaki, Goro's *From Up on Poppy Hill* is an exercise in low-key naturalism, as well as a generally drowsy period piece coming-of-age tale.

Japan's top-grossing film of 2011, the younger Miyazaki's second movie is an adaptation of the 1980 serialized manga of the same name, written by Tetsuro Sayama and illustrated by Chizuru Takahashi. For its 2013 American release, as with other recent Stateside versions of the elder Miyazaki's films, a voice cast heavy on star power—including Aubrey Plaza, Chris Noth, Christina Hendricks, Ron Howard, and Bruce Dern—was recruited to dub the characters. The resultant dissonance between dialogue and synched lip movements is but a small hiccup, however, in comparison to *From Up*

on Poppy Hill's other shortcomings. Supporters will deploy all manner of flowery adjectives to praise the movie's delicate, shimmering visual beauty, but the brutal truth regarding the movie is that it lands somewhere between genial letdown and outright snooze.

The film unfolds in autumn of 1963 in Yokohama, in advance of Tokyo's hosting of the 1964 Summer Olympic Games. Against the backdrop of a nationalistic rebuilding craze, lonely teenager Umi Matsuzaki (Sarah Bolger) lives with her two younger siblings and her grandmother Hana (Gillian Anderson). A nominal orphan—her mother Suzaki (Jamie Lee Curtis) is a medical professional studying abroad, while her seafaring father never returned from the Korean War—Umi helps oversee the cooking and day-to-day upkeep of her grandmother's boarding house.

When Chairman Tokumaru (Beau Bridges) okays plans to raze the so-called Latin Quarter, a rundown structure where high school students congregate after school for various club activities, it sparks an impassioned campaign by the city's youth to keep it from being demolished. At the heart of this movement is Umi's dashing classmate Shun Kazama (Anton Yelchin), upon whom she quickly develops her first crush. Before their budding romance can really take flight, however, a secret from their past throws a shadow over their future.

It may not be quite fair to judge Goro's work in comparison to that of his legendary father, but such is the pitfall of working in the same medium. Though an international box office hit, the younger Miyazaki's first film, *Tales From Earthsea* (2010), drew largely mixed reviews, most of which took aim at what was viewed as a hackneyed narrative. That criticism holds true here as well.

While on a broad level it thematically duplicates some of the elder Miyazaki's preoccupations with childhood transition, *From Up on Poppy Hill* has none of the playful spirit creatures or engaging whimsy of his best films. Instead, the movie just seems plain—most defined by telegraphed conflict, pat stakes and predictable resolutions. Even its innocence feels reflexive and unearned, so it is hardly a surprise when a plot twist halfway through is actually described onscreen by one character as "cheap melodrama." That feels like a moment of candor.

The cast of secondary characters who rent rooms from Umi's grandmother—a potentially rich source of comedic relief—is never fully developed, and neither is the modernization and gentrification of Japan plumbed as deeply as it ought to be. In fact, with its historical setting and didactic dialogue ("Destroy everything old and you dishonor all those that lived before us," shouts Shun at one point), *From Up on Poppy Hill* often times

seems better suited for a live-action telling of the same story.

Certainly, the film's distinctive, hand-drawn visual palette, its strongest quality, merits respect. But the look of the movie does not seem to match the material, let alone elevate it. Goro and animation directors Akihiko Yamashita, Atsushi Yamagata, Kitaro Kosaka—veterans of *Howl's Moving Castle* (2005), *The Secret World of Arrietty* (2010), and other Studio Ghibli efforts—oversee frames in which characteristically expressive action often unfolds over static, pastoral backgrounds, set apart only by a distant ship moving across the ocean or some similar plaintive symbol. Admittedly, there are some striking shots that bespeak an uncommon sensitivity, as when tears fall on a close-up of clenched fists. But these ethereal, painterly compositions are all wasted on a story that feels half-baked at best.

Built as it is around sweeping piano melodies, Satoshi Takebe's intrusive score is meant to echo classic Hollywood romances and social dramas, but it unfolds in such unrelenting fashion (and at such a volume) that it is merely garish and distracting. Ballads from Aoi Teshima and Kyu Sakamoto, also shoehorned in, do not help matters. The vocal performances, meanwhile, bend almost uniformly toward overstated emotionality, only further casting into relief the divide between the gaping obviousness in which it trades and the more subtle interpretation for which the core narrative of *From Up on Poppy Hill* cries out.

Brent Simon

CREDITS

Umi: Sarah Bolger (Voice)
Shun: Anton Yelchin (Voice)
Miki: Gillian Anderson (Voice)
Mr. Tokumaru: Beau Bridges (Voice)
Ryoko: Jamie Lee Curtis (Voice)
Onodera: Bruce Dern (Voice)
Origin: Japan
Language: English
Released: 2011
Production: Tetsuro Sayama, Toshio Suzuki, Chizuru Takahashi, Geoffrey Wexler; Dentsu, Mitsubishi Shoji, Studio Ghibli; released by GKIDS
Directed by: Goro Miyazaki
Written by: Hayao Miyazaki
Music by: Satoshi Takebe
Sound: Koji Kasamatsu
Editing: Takeshi Seyama
MPAA rating: PG
Running time: 91 minutes

REVIEWS

Axmaker, Sean. *Seattle Weekly*. March 26, 2013.
Burr, Ty. *Boston Globe*. April 4, 2013.
Debruge, Peter. *Variety*. October 3, 2011.
Ebert, Roger. *Chicago Sun-Times*. March 27, 2013.
Honeycutt, Kirk. *Hollywood Reporter*. September 8, 2011.
Hornaday, Ann. *Washington Post*. April 5, 2013.
Rea, Stephen. *Philadelphia Inquirer*. April 12, 2013.
Scott, A. O. *New York Times*. March 14, 2013.
Tallerico, Brian. *HollywoodChicago.com*. March 28, 2013.
Turan, Kenneth. *Los Angeles Times*. March 21, 2013.

TRIVIA

When Umi Matsuzaki and Shun Kazama are embarking on the prodigious ship, there is a sign at the bottom of the wheel house which says "Ghibli," the studio which made the film.

FROZEN

Box Office: $388.7 Million

Like so many things Disney, it is easy to be of two conflicting minds about *Frozen*, the studio's 53rd animated feature. On the one hand, it is hard to shake the obvious, sometimes obtrusive touch of the massive Disney marketing machine and the tried-and-true peddling of its princess fairytale formula as pure product. On the other hand, it is also hard to deny how well done *Frozen* is, how easily it pleases, how effortlessly it captures so much of the oft-vaunted "Disney Magic" onscreen.

Gorgeously animated with computer graphics; filled with big Broadway-style songs; and free for the most part of the sometimes distracting "marquee-casting" that has crept into so many animated children's films; *Frozen* is very loosely—very, very loosely—"inspired by" Hans Christian Anderson's 1845 fairytale *The Snow Queen*. The new story, set in a fictional Scandinavian kingdom, follows two princess sisters from childhood. Elsa (voiced by Idina Menzel), can magically create snow and ice by touch or gesture, but as children, Elsa's powers accidentally injures her younger sister Anna (Kristen Bell), and so, much to Anna's lonely dismay, the older sibling is shuttered away in a room in the palace to prevent further mishaps.

When the king and queen are lost at sea, grown-up Elsa ascends the throne, but during an emotional outburst her ice powers run rampant, freezing the entire kingdom into a permanent winter. Elsa flees into the nearby mountains with Anna in pursuit in hopes of helping both her sister and the frozen kingdom. Along the way, Anna acquires the aid of a burly, sarcastic lug

of an mountain-man ice-cutter named Kristoff (Jonathan Groff), his faithful (non-speaking) reindeer Sven, and most amusingly, a living, talking (thanks to Elsa's power) snowman named Olaf (Josh Gad).

As co-directed by Chris Buck and Jennifer Lee (the first female to helm an animated Disney feature) much of *Frozen* works beautifully as both art and entertainment. The songs by husband-and-wife song-writing team Robert Lopez and Kristen Anderson-Lopez are appropriately winning, with the obvious standout being misunderstood Elsa's declaration of self "Let It Go," as belted out by Menzel. (The heart- and show-stopper is sure to fill karaoke nights for decades to come.) The film is also relentlessly lovely to look at; the computer-animated designs by production designer David Womersley and art director Michael Giaimo making the most of the shimmering ice, rolling waves, and rosy-pink-orange sunsets on snow caps.

It does not hurt that the cast is terrific. Most of the main players are Broadway vets with a slew of Tony nominations and wins among them: Menzel famously originated the role of the Wicked Witch of the West in *Wicked*, and Gad and Goff starred in the debut runs of *The Book of Mormon* and *Spring Awakening*, respectively. The goofily naive Olaf is clearly on hand to provide slapstick and butt jokes to hold younger viewers' attention, but Gad's impeccable comic timing makes the snowman easily tolerated by adults. As *Frozen*'s star, Bell also shines, giving Anna a "regular girl" adorability—the "spunky, independent princess" has almost become its own cliche, but Bell pulls it off with dopey, assured charm. Likewise, her back-and-forth bickering with Goff's Kristoff also works well as screwball comedy banter without feeling forced.

Best of all, *Frozen* skates neatly around several princess-fairy-tale cliches (the notion of true love at first sight with a dashing, square-jawed Prince Charming is especially skewered) and instead focuses more intently on the sisterly bond between Anna and Elsa—perhaps in part thanks to Lee, who wrote the script based on a story by herself, Buck, and Shane Morris.

There are, however, things—mostly cropping up in the film's second half—that keep *Frozen* from ascending into perfection. The shimmering lilt of the film's first half begins to drain away as clever character interactions are overtaken by plot-driven action scenes. The delightful songs also start to vanish—by the third act, the film is a musical no more, having devolved into a clamoring series of chases and fights seemingly designed to capture fading young attention spans. Slowly the film feels less and less cohesive and more cobbled together to hit certain audience-pleasing points. (A detour to a village of trolls feels particularly unnecessary.) Though it eventu-

ally becomes less grand and more frenetic, *Frozen* remains fully entertaining all the way through, but the more it spins and jumps to touch all bases, the more the magic feels spotty and fading, and the incorrigible Disney marketing empire begins to seep through the cracks.

Also, for as much as Anna is an independent young woman, *Frozen* often trots her through typical fantasy-princess aspirations—for all her action-heroine pluck and clever wit, in the end she still gets to dance through the halls of a beautiful palace while wearing beautiful gowns and get the guy. After all, this is a princess fairy tale, but in the rush to re-embrace the genre, there is still the tinge of steps being taken if not backward, at least sideways.

All that may hold *Frozen* back from being the animated masterpiece it is aiming for in its first half, but the film is still undeniably enjoyable. Even if it never quite transcends its genre or feels completely free of the whiff of Disney product, it is very good—sometimes great—at being what it is.

Widely released over Thanksgiving, *Frozen* performed steadily and impressively at the box office over the holidays, eventually earning more than $350 million in North America and another $450 million-plus overseas, making it the highest-grossing animated Disney film of all time and the highest-grossing animated non-sequel ever. A re-release of a "Sing-Along" version was planned and a Broadway musical began pre-production in early 2014. Near-universal acclaim led some critics to proclaim *Frozen* Disney's return to its much-lauded 1990s animation "Renaissance" and audiences seemed to agree.

Locke Peterseim

CREDITS

Anna: Kristen Bell (Voice)
Elsa: Idina Menzel (Voice)
Kristoff: Jonathan Groff (Voice)
Olaf: Josh Gad (Voice)
Hans: Santino Fontana (Voice)
Origin: United States
Language: English
Released: 2013
Production: Peter Del Vecho; released by Walt Disney Studios
Directed by: Chris Buck; Jennifer Lee
Written by: Jennifer Lee
Music by: Christophe Beck
Sound: Odin Benitez
Music Supervisor: Tom MacDougall
Editing: Jeff Draheim

Art Direction: Michael Giaimo
Production Design: David Womersley
MPAA rating: PG
Running time: 108 minutes

REVIEWS

Collin, Robbie. *The Telegraph*. December 5, 2013.
Ebiri, Bilge. *Vulture*. November 27, 2013.
Hartlaub, Peter. *San Francisco Chronicle*. November 26, 2013.
Holden, Stephen. *New York Times*. November 26, 2013.
Jones, Kimberly. *Austin Chronicle*. November 27, 2013.
Lane, Anthony. *The New Yorker*. December 2, 2013.
Lemire, Christy. *RogerEbert.com*. November 27, 2013.
Robinson, Tasha. *The Dissolve*. November 27, 2013.
Sharkey, Betsy. *Los Angeles Times*. November 21, 2013.
Uhlich, Keith. *Time Out New York*. November 26, 2013.

QUOTES

Olaf: "Hi, everyone. I'm Olaf and I like warm hugs!"

TRIVIA

When the gates open during "For The First Time in Forever," Rapunzel and Flynn from *Tangled* (2010) can be seen. They enter the screen from the left.

AWARDS

Oscars 2013: Animated Film, Song ("Let It Go")
British Acad. 2013: Animated Film
Golden Globes 2014: Animated Film

Nominations:

Golden Globes 2014: Song ("Let It Go")

FRUITVALE STATION

Every step brings you closer to the edge.
—Movie tagline

Box Office: $16.1 Million

The winner of both the Grand Jury and Audience Awards at the 2013 Sundance Film Festival, writer-director Ryan Coogler's feature debut, like many a lauded independent film, heralds the arrival of an assured, authorial, behind-the-camera talent while also confirming the leading role talent of its featured star, in this case 26-year-old actor Michael B. Jordan. But in a year in which *12 Years a Slave* (2013) received much acclaim for its narrative tackling of the nation's original sin, so too does Coogler's film connect as something more than "just" another drama based on an emotionally pulverizing true story.

Fruitvale Station takes its title from the name of the Oakland stop on the Bay Area Rapid Transit where, on New Year's Eve, 2008, a 22-year-old African American out with friends was fatally shot by a white police officer while lying facedown on the public transportation platform after being detained. Ergo, in chronicling the 18 or so hours leading up to the occurrence, Coogler's film tackles race, class, mistreatment, and abuse of power, but stripped free of anger in an interesting and bracing way. *Fruitvale Station* tracks more as a dirge, a lamentation of the country's divisions.

Compounding these powerful feelings was the fact that, following its January premiere, the film saw a platform release via the Weinstein Company in the summer, against the backdrop of a Florida jury's deliberation and acquittal of George Zimmerman on manslaughter and second-degree murder charges in the shooting death of Trayvon Martin, an African American teenager Zimmerman claimed he shot in self-defense. It crossed over from the entertainment section to the op-ed pages, in other words. While taking in $16 million at the box office, and garnering overwhelmingly positive reviews in addition to a number of awards from critics' organizations and other filmmaking guilds, Coogler's movie—an openly expressive and undeniably affecting drama that humanizes a tragic headline—is also instructive in the crucial differences between a film that is based on a true story versus a biography that ends in heartbreak.

Fruitvale Station opens with chaotic cell phone video footage, shot by bystanders, of the real event in question, which lends the rest of the film a sense of impending doom even for those unfamiliar with the story. Out of jail but even more recently out-of-work, Oscar Grant (Jordan) lives with Sophina Mesa (Melonie Diaz), his girlfriend and the mother of his four-year-old daughter, Tatiana (Ariana Neal). He is suitably repentant for having cheated on her, but things are still tense between them, with Sophina unaware of the full extent of their financial troubles. December 31 is the birthday of Oscar's mother Wanda (Octavia Spencer), so after dropping off Tatiana and Sophina at preschool and work, respectively, Oscar spends a good portion of the day getting things ready for a party that evening, though the pressing worry of his domestic circumstances is never far from his mind.

After a big family dinner at Oscar's mother's house, Sophina wants to go into the city to watch fireworks and ring in the new year, so they drop Tatiana off with Sophina's sister and at Wanda's suggestion take the BART with some friends, not wanting to deal with traffic. While returning home, Oscar and his friends are baited into a fistfight, which brings the train to a stop. Pulled from the train and separated from Sophina, they get restrained by a handful of BART cops (including

Kevin Durand and Chad Michael Murray) responding to the incident. They are handled with more force than they feel necessary, petty arguments escalate and tragedy ensues.

Only 27, Coogler oversees a superlative technical package that belies his age. Editors Claudia Castello and Michael P. Shawver do great work, creating a film with a smooth, unfussy appeal. Cinematographer Rachel Morrison, shooting on Super 16mm, trades in a slightly grainy, over-the-shoulder, handheld style that gives the movie, which filmed on location in Oakland, a strong sense of immediacy. Its visual palette never feels self-consciously stark or rough; it instead alternately lends warmth to domestic sequences with a laidback, jocular vibe, and grittiness to its later, more frenzied scenes. Bob Edwards' smart, subtle sound design and editing imparts extra life to the city, and composer Ludwig Goranssson's score, used sparingly but effectively, makes use of layered guitars and other manipulated ambient elements to create an unnerving but very tangible, alive urban hum.

The modest problems of *Fruitvale Station* stem from its screenplay. There is no silver lining to the story—viewers know how it ends, owing to the movie's opening—but Coogler goes to considerable lengths to put a polished golden halo over Oscar's head. It is not enough that Oscar sneaks his daughter an extra fruit snack against Sophina's wishes, or that he helps out a bewildered customer (Ahna O'Reilly) at the grocery store to which he returns to beg for his job back, by putting her on the phone with his grandmother Bonnie (Marjorie Shears) so that she might give her pointers on frying fish. Though seriously strapped for cash, he also pledges to help his sister Chantay (Destiny Ekweume) make rent, and, in an apparent early New Year's Resolution, throws away a large Ziploc bag full of marijuana instead of selling it. Oscar even cradles a dying pit bull after it is struck by a car in a hit-and-run.

It is this last bit—one of several scenarios invented wholesale for the movie, and explained by Coogler in later media interviews as being a metaphor for the instinctual and unreasonable fear of young black men—that most embodies the film's overreach, and how it comes to feel "wedged between authenticity and contrivance," as Wesley Morris describes in his review for *Grantland.com*. Coogler stacks the deck—not just with shots of a calendar with "Rent Due!" circled in red (which he does as well), but by pushing past mere earnestness and into manipulation.

There are moments that show Oscar's poor judgment, certainly—a flash of anger at the grocery store manager who politely but firmly refuses to hire Oscar back, citing his unreliability, plus a series of prison flashbacks that showcase the roots of Oscar's fury and resentment. But Coogler's film goes so out of its way to lionize its subject that it has the paradoxical effect of undercutting (if just a bit) the inherent heartbreak of this terrible tragedy.

If *Fruitvale Station* had taken such dramatic license with the staging of the subway platform shooting itself—which, muddled intent notwithstanding, by all accounts physically tracks extraordinarily closely with what actually happened, since there is extant footage to which to compare it—there would have been cries of defamation and phoniness, and the movie would have been decried as a scurrilous sham. The rigging of its pre-shooting narrative drew a pass from many critics, mainly because the emotional levers Coogler works are generally pulled so well. But *Fruitvale Station* still feels in some ways hamstrung by its arbitrary single-day conceit. In making his protagonist such an avatar of redemptive decency, Coogler has chosen to make a film about basically one event rather than about Oscar Grant himself, and that choice informs the end product's shortcomings, nominal though they may be.

Fortunately, Coogler has both a wonderful collection of performers and a deft, intuitive touch with actors, knowing how to maximize their performances. That skill is evident in early scenes of playful connection between Jordan and Neal, as his young daughter. Spencer, of course, already a Best Supporting Actress Oscar winner for *The Help* (2011), delivers a wonderful, moving turn as Wanda. And Diaz captures the chiding exasperation of a woman marked by the previous burdens of single parenthood and determined not to be forced back into a life without Oscar. The entire last 20 minutes of the movie are raw and emotional, but Diaz owns large patches of them, with Sophina desperately pleading, over and over, "What did you do to him?" when she sees paramedics wheeling a wounded Oscar past her and towards a waiting ambulance. The film reaches a crescendo with her silent howl of pain upon news of his death, and ends in pitiable fashion with her in the shower with Tatiana, uncertain of what to tell her daughter about what happened to her father.

Jordan, meanwhile, will justly benefit the most from the movie. Probably heretofore best known for small screen work on *Friday Night Lights*, he had already showcased his effortless charisma in the well received found-footage hit *Chronicle* (2012). Here, while he very occasionally telegraphs the misdirection Oscar throws at his mother or Sophina (he is a character who arrives at sharing his vulnerability and feelings with women with great difficulty), Jordan for the most part delivers a quietly transfixing naturalistic performance that retains notes of surly grace.

What Jordan is good at communicating, in the film's best passages, is Oscar's swallowed, furrowed-brow anger—a dissatisfaction with his lot and station in life, or the many things that he considers unfair, that is tempered with the dawning realization that, as a young father, he no longer has the luxury of acting impetuously, or in only his own best interests. It is these moments of silent, inner conflict, much more than the naked moments of evoked sympathy, that makes *Fruitvale Station* so arresting and ultimately heartrending. There is loss in every human death, but it stings more when exacerbated by senselessness and reflective of unrealized potential.

Brent Simon

CREDITS

Oscar Grant: Michael B. Jordan
Sophina: Melonie Diaz
Wanda: Octavia Spencer
Officer Caruso: Kevin Durand
Officer Ingram: Chad Michael Murray
Origin: United States
Language: English
Released: 2013
Production: Nina Yang Bongiovi, Forest Whitaker; OG Project, Significant Productions; released by Weinstein Company L.L.C.
Directed by: Ryan Coogler
Written by: Ryan Coogler
Cinematography by: Rachel Morrison
Music by: Ludwig Goransson
Sound: Bob Edwards
Editing: Claudia S. Castello; Michael P. Shawver
Costumes: Aggie Guerard Rodgers
Production Design: Hannah Beachler
MPAA rating: R
Running time: 90 minutes

REVIEWS

Berkshire, Geoff. *Variety*. January 19, 2013.
Caplan-Bricker, Nora. *New Republic*. July 12, 2013.
Duralde, Alonso. *The Wrap*. July 11, 2013.
Hornaday, Anne. *Washington Post*. July 18, 2013.
Kennedy, Lisa. *Denver Post*. July 26, 2013.
Lodge, Guy. *Hitfix.com*. July 12, 2013.
Morris, Wesley. *Grantland.com*. July 25, 2013.
Phillips, Michael. *Chicago Tribune*. July 17, 2013.
Reinstein, Mara. *US Weekly*. July 11, 2013.
Stevens, Dana. *Slate.com*. July 12, 2013.

QUOTES

Wanda: "I told him to take the train. I told him to catch the BART. I didn't know they were gonna hurt my baby. I should've just let him drive. I should've let him drive, but I wanted to keep him safe. You gotta let me hug him. Please, let me hug him. Please. Please! He didn't like to be alone."

TRIVIA

The scene where Oscar Grant is shot was filmed at the actual Fruitvale station; the original bullet hole is still there, exactly where Michael B. Jordan was laying.

AWARDS

Ind. Spirit 2014: First Feature
Nominations:
Ind. Spirit 2014: Actor (Jordan), Actress—Supporting (Diaz)

G

―――――――――■―――――――――

GANGSTER SQUAD

No names. No badges. No mercy.
—Movie tagline

Box Office: $46 Million

When a strong ensemble cast signs on to do a movie, it typically shows signs of a quality piece of work about to unfold. The stars aligned so that these actors could work together on a project worthy of all their talents. *Gangster Squad* has such a cast. There are countless awards amongst the talent on the roster here as well as a few on the younger side who seem destined for career longevity just based on the projects they already have on their resume. But one look at the bland title and the questionable choice of director Ruben Fleischer, who has one terrific movie to his credit (*Zombieland* [2009]) and one way less than terrific (*30 Minutes or Less* [2011]), the project looks a little less promising than one might expect. Everything must have looked great on paper.

The film takes place in 1940s-era Los Angeles and, as its title suggests, features the gangsters that inhabit it. In this case, Mickey Cohen (Sean Penn) has taken over the crime scene in L.A., and, at the start of the film, he has two cars tear a man in half, after which he tells a witness to tell everyone back in Chicago that there is a new face of crime on the west coast. Following that, the film introduces the viewer to L.A's most prominent crime fighter, Sgt. John O'Mara (Josh Brolin), who at the start of the film busts a few sleazeballs in a hotel room who are gang-raping a woman. Of course, he is a cop who plays by his own rules and the bust is done without a search warrant and in a hotel that is considered Mickey Cohen's turf.

Also lurking on the right side of the law is Sgt. Jerry Wooters (Ryan Gosling), a more soft-spoken officer who makes an acquaintance in Cohen's femme fatale, Grace Faraday (Emma Stone). They exchange the kind of seductive banter typically found in this kind of noir piece. Grace is clearly on both sides of the law. Meanwhile, Police Chief Parker (Nick Nolte) takes notice of O'Mara's handiwork as an aggressive crime fighter and recruits him to try and fight the war "for the soul of Los Angeles." Because of O'Mara's past as a soldier fighting in occupied territory, he is seen as a valuable asset to Parker's plan of having a covert group of crime fighters "off the books" and determined not just to kill Cohen, but to bring down his entire empire. O'Mara takes the job without hesitation, much to the chagrin of his pregnant wife, Connie (Mireille Enos). But of course, he needs more men.

He first tries to recruit Wooters, who has grown cynical over the war in L.A. and merely wishes O'Mara the best of luck. He does recruit Officer Coleman Harris (Anthony Mackie), famous gunslinger Max Kennard (Robert Patrick), and Conwell Keeler (Giovanni Ribisi), the "brains" of the operation. Joining them is Navidad Ramirez (Michael Pena) who drops in unexpectedly at their first meeting. They get to work right away with a plan to rob and torch one of Cohen's casinos, but the phony heist backfires and they land in jail. The plan movies forward with the guys bugging Cohen's house and trying to figure out Cohen's bigger plans for L.A.

The obvious reference points here are *The Untouchables* (1987), from which it borrows pretty liberally in

terms of the storyline, and *L.A. Confidential* (1997), which it aspires to be in terms of quality tough-guy dialogue. Both of those films had a cinematic style that matched the material and brought the crime world to life in a way that felt fresh and invigorating. *Gangster Squad* tries mightily to infuse Will Beall's pedestrian screenplay (based on the book by Paul Lieberman and "inspired by true events") with a kind of hyper kinetic style that seems to be overcompensating for something that might have already been there on the page, but which falls flat in the proceedings. The film does itself in by this overly desperate need to be "cool."

Fleischer demonstrated with *Zombieland* that he can balance the style with the storyline, but here he lets it get the best of him. The annoying trend of intercutting slow motion shots into an action scene completely dampens the intensity the viewer is supposed to feel. There is also a car chase that looks as though it is trying harder to emulate a *Fast and the Furious* movie than a car chase that could actually take place in the 1940s. And why do these guys have their first meeting about their secret operation out in the open with O'Mara talking pretty loudly about how this is a secret mission and "no one will know about it"? Perhaps because it looks cooler than having them whisper about it in a small car, which would have made more sense.

Almost everyone here is well-suited to their roles. Brolin, who has become one of the most versatile actors of his generation, seems to be born to play this kind of part in a better movie, a tough, no-nonsense man's man from an era where such a thing was in abundance. Gosling and Stone, together again after their wonderful romantic pairing in *Crazy Stupid Love* (2011), seem as though they should be doing more movies together and perhaps add a screen couple shorthand to the vernacular, along the lines of Hepburn/Tracy, Hudson/Day, or Hanks/Ryan. There may not be a sexier, more appealing screen couple out there. Unfortunately, they are wasted here. The only actor who truly embarrasses himself, however, is Penn, whose Mickey Cohen looks like a guy trying to do a gangster impersonation, but doing it poorly with over-the-top bravado and an accent that seems manufactured out of a community theater production.

Gangster Squad had an original release date of September 2012. That summer, though, tragedy broke out in Aurora, Colorado when a lone gunman opened fire in a packed movie theater showing *The Dark Knight Rises* (2012) and killed over twenty people. A similar scene had been shot for *Gangster Squad*, but which was soon scrapped and re-shot (the scene now takes place on the streets of Chinatown). The release date was pushed to January of 2013, typically a dumping ground for the studio films that have little chance of reaching a wide, enthusiastic audience. Whether the change would have made a big difference is hard to say with a film already this overtly violent and full of bloody shoot-outs. If they had re-shot the rest of the movie with a bit of restraint from Fleischer and Penn, they might have had something.

Collin Souter

CREDITS

Mickey Cohen: Sean Penn
Sgt. Jerry Wooters: Ryan Gosling
Sgt. John O'Mara: Josh Brolin
Grace Faraday: Emma Stone
Chief Bill Parker: Nick Nolte
Ofc. Max Kennard: Robert Patrick
Karl Lennox: Holt McCallany
Connie O'Mara: Mireille Enos
Ofc. Navidad Ramirez: Michael Pena
Ofc. Conway Keeler: Giovanni Ribisi
Ofc. Coleman Harris: Anthony Mackie
Rourke: Wade Andrew Williams
Wrevock: Troy Garity
Origin: United States
Language: English
Released: 2013
Production: Dan Lin, Kevin McCormick, Michael Tadross; Langley Park Productions, Village Roadshow Pictures; released by Warner Brothers
Directed by: Ruben Fleischer
Written by: Will Beall
Cinematography by: Dion Beebe
Music by: Steve Jablonsky
Sound: Cameron Frankley
Editing: Alan Baumgarten; James Herbert
Costumes: Mary Zophres
Production Design: Maher Ahmad
MPAA rating: R
Running time: 113 minutes

REVIEWS

Covert, Colin. *Minneapolis Star Tribune*. January 11, 2013.
Gleiberman, Owen. *Entertainment Weekly*. January 9, 2013.
Howell, Peter. *Toronto Star*. January 10, 2013.
LaSalle, Mick. *San Francisco Chronicle*. January 10, 2013.
Lane, Anthony. *New Yorker*. January 21, 2013.
Lumenick, Lou. *New York Post*. January 11, 2013.
Morris, Wesley. *Boston Globe*. January 10, 2013.
O'Hehir, Andrew. *Salon.com*. January 10, 2013.
Rabin, Nathan. *AV Club*. January 10, 2013.
Scott, A. O. *New York Times*. January 10, 2013.

QUOTES

Mickey Cohen: "Whores don't grow on trees. They're like mustangs. You gotta catch 'em wild and break 'em before you train them to do tricks."

TRIVIA

The Garden of Allah Hotel and Villas actually existed and was located at 8152 Sunset Boulevard.

GETAWAY

Get in. Get out. Getaway.
 —Movie tagline

Box Office: $10.5 Million

The voice on the other line is ostensibly that of a sociopath getting high off his own appetite for mayhem. His thugs have kidnapped a woman with the simple-minded intention of forcing her husband, a disgraced race-car driver named Brent Magna (Ethan Hawke), to get back behind the wheel for a perverse game of Simon Says. No sooner have the opening titles of Courtney Solomon's *Getaway* raced past this pesky exposition than it plunks the viewer right in the middle of the action, as Brent skids down alleyways and through ice rinks while the voice, simply credited as "The Voice," barks out orders like, "You see that water truck? Smash it!"

Whenever Brent dares to protest, arguing that these stunts will result in killing innocent people, the voice cannot dream up a more articulate response than, "Do it!" Clearly this voice is getting a kick out of wreaking criminally pointless havoc, yet there is something conspicuously lacking in this faceless monster. As voiced by an astoundingly bored Oscar-winner, Jon Voight, fresh off his appearance in the direct-to-video release, *Baby Geniuses and the Mystery of the Crown Jewels* (2013), this laughable villain lacks any semblance of urgency, glee or even rooting interest in any of his allegedly jubilant misdeeds. The louder and angrier Hawke gets, the more detached Voight sounds, as if perturbed by the very notion of having to put effort into a film as worthless as this one.

Voight's phoned-in performance easily ranks among the worst of the year, though it is also the sole redeeming element in Solomon's distressingly empty experiment. By doing away with all trace of character development or narrative engagement, Solomon is banking on the theory that all his target audience wants out of a movie is pure, wall-to-wall spectacle, uninterrupted by plot or purpose. The enormous success of the *Fast & Furious* franchise can be partially to blame for leading studios to finance this drivel, though Justin Lin's *Fast &*

Furious 6 (2013) demonstrated an imaginative craftsmanship that places it leagues in front of every imitator. There was a balletic choreography to the ways in which Lin's vehicles collided. Solomon's action sequences are merely incoherent, with a frenetic pace that causes *Moulin Rouge* (2001) to resemble *Werckmeister Harmonies* (2000) by comparison.

Since Solomon's gamble fails early on, *Getaway* has nothing left to do but sit there on the screen and decay before the viewer's eyes. If audiences have not started laughing derisively at the insipid joke of a story thread, they will as soon as Selena Gomez suddenly materializes, brandishing a gun and trying with all her meager might to out-snark Chloe Moretz. While Gomez exuded unexpected vulnerability in Harmony Korine's *Spring Breakers* (2013), causing her to stand out amongst her peers, Solomon directs her to behave like an intolerable brat, and she complies all too well. As soon as she is saddled alongside Hawke, it becomes glaringly obvious that the accomplished star of *Before Midnight* (2013) is feeling flat-out miserable, yearning to be trapped in a car with Julie Delpy instead. His wild-eyed emoting is as much an exercise in wasted effort as the life-threatening stunt work being thanklessly performed all around him.

In a film so choppily edited and breathlessly chaotic, it is all the more shocking to observe the widely praised shot near the film's climax, as Solomon suddenly cuts to an extended POV angle on a car zipping through red lights on a largely deserted road. For the first and only time, *Getaway* starts to build palpable tension, causing the audience to wonder where the sequence might be heading. But then, in typically clumsy fashion, the shot simply ends, thus rendering its length maddeningly pointless. It is as if the film needed a moment to buffer before continuing on its monotonous path.

Though several obvious comparisons could be made between *Getaway* and an endless assortment of Hollywood hits, most notably *Taken* (2008), the past project that is closest to the spirit of Solomon's film is the notoriously short-lived 1965 sitcom, *My Mother the Car,* in which Jerry Van Dyke is bullied by the disembodied voice of his late mother, who has been reincarnated as his automobile. To be fair, Van Dyke's show would have benefited from casting Voight as the mother, thus transforming her into a *Grand Theft Auto* addict with a penchant for Tommy Wiseau-like line readings. Voight is absolutely hilarious in *Getaway,* but only in the way that amateur theatre productions cause cultured audiences to stifle a snicker. It is sickeningly tragic to see the once-brilliant star of *Midnight Cowboy* (1969) and *Coming Home* (1978) reduced to accepting paychecks for work that any random pedestrian on the street could

have replicated without breaking a sweat. Perhaps it is time the voice was silenced for good.

Matt Fagerholm

CREDITS

Brent Magna: Ethan Hawke
The Kid: Selena Gomez
The Voice: Jon Voight
Leanne: Rebecca Budig
Distinguished Man: Bruce Payne
Detective: Ivailo Geraskov
The Man: Paul Freeman (Voice)
Origin: United States
Language: English
Released: 2013
Production: Courtney Solomon; released by Warner Brothers
Directed by: Courtney Solomon
Written by: Sean Finegan; Gregg Maxwell Parker
Cinematography by: Yaron Levy
Music by: Justin Caine Burnett
Sound: Emil Evtimov
Music Supervisor: Andy Ross
Editing: Ryan Dufrene
Art Direction: Michelle Jones
Costumes: Roseanne Fiedler
Production Design: Nate Jones
MPAA rating: PG-13
Running time: 90 minutes

REVIEWS

Buckwalter, Ian. *NPR.* September 3, 2013.
Foundas, Scott. *Variety.* August 28, 2013.
Holden, Stephen. *The New York Times.* August 29, 2013.
Markovitz, Adam. *Entertainment Weekly.* August 30, 2013.
Pevere, Geoff. *The Globe and Mail.* August 29, 2013.
Phillips, Michael. *Chicago Tribune.* August 29, 2013.
Taylor, Drew. *The Playlist.* August 28, 2013.
Tobias, Scott. *The Dissolve.* August 28, 2013.
Travers, Peter. *Rolling Stone.* August 30, 2013.
Vishnevetsky, Ignatiy. *The A.V. Club.* August 28, 2013.

QUOTES

The Kid: "I am not going to die for you."

AWARDS

Nominations:

Golden Raspberries 2013: Worst Actress (Gomez)

G.I. JOE: RETALIATION

Box Office: $122.5 Million

Since his world-saving heroism in previous film *G.I. Joe: The Rise of Cobra* (2009), super soldier Duke (Channing Tatum) has risen from recruit in "elite fighting force" G.I. Joe to become its top leader. Under his command are a group of soldiers, including his friend Roadblock (Dwayne Johnson), Lady Jaye (Adrianne Palicki), and Flint (D.J. Cotrona). Meanwhile, back in America, the country's freedom is threatened by the mole scheme of evil Zartan (Arnold Vosloo), who has been acting like the U.S. President (Jonathan Pryce) for some time while his Cobra bosses Commander and Destro remain in captivity. While looking and sounding exactly like the president (thanks to the technology of "nanobots," featured centrally in *G.I. Joe: Rise of Cobra*), Zartan frames black costume ninja Snake Eyes (Ray Park) for killing the Pakistani president and calls a strike on the Joes at their base overseas which leaves many of them dead, including Duke.

Following through on his desire to get revenge on the Joes for locking him up, Cobra Commander uses Zartan's position of power to begin an evil scheme that threatens to kill everyone with nuclear war, and would give him ample opportunity for world domination. At the same time, white costume ninja Storm Shadow (Lee Byung-hun) and Snake Eyes continue to slash out their childhood drama with each other, with the two eventually turning to Blind Master (played by *Man with Iron Fists* [2012] director RZA) in hopes of best understanding the events that divided them.

In order to stop Cobra, Roadblock and crew return to the United States, hoping to expose Zartan as a fake copy president. They turn to General Joseph Colton (Bruce Willis) for help, who provides them with the artillery and veteran manpower to help stop Zartan and all of Cobra from unleashing un-American chaos.

Taking over the film after the always likable Tatum leaves the picture, Johnson continues to have solid charisma as an all-American hero, one with a sense of humor, and one who has the muscle power and awareness to carry a weapon previously only fit for Arnold Schwarzengger. The most successful clown of the bunch however is Pryce, firing off many of the film's best zingers, who steals numerous scenes with the same zest of a dancing Sam Rockwell in *Iron Man 2* (2010).

Other appearances in this movie heavy with characters are a bit less successful, as Cotrona and Palicki are bland sidekicks compared to their charismatic leader Johnson (and compared to absent original sidekicks Marlon Wayans and Rachel Nichols in *G.I. Joe: The Rise of Cobra*); the presence of RZA as Blind Master only seeks to make an awkward joke out of the rapper's Kung fu pretentiousness.

Hired for his work in two *Step Up* films, Jon M. Chu brings scant evidence to *G.I. Joe: Retaliation* of the

visual pep he brought to those dance flicks. Aside from a sequence that involves characters dueling on the side of a mountain, the film's main event of action scenes offers flat spectacle, standing best as fetishized moments of next-level weaponry than dynamic moments of choreography and/or cinematography.

Filling its dialogue with bite size cliches, *G.I. Joe Retaliation* shrinks global politics in a manner that makes such a concept superfluous to its targeted young audience. This would not be an extremely concerning issue were it not for the film's joke of a worldview, in which London is entirely forgotten about after becoming nuclear mulch; a devastating example of worldwide dissonance used only for a seconds-long shot of spectacular devastation.

Hasbro has been in the cinematic jingoism business since 2007, when *Transformers* dethroned 1985's *The Care Bears Movie* as the highest-grossing movie adapted from a toy brand. Such a success lead to the adaptation of the more directly militaristic G.I. Joe brand, in a silly late-summer actioner from Stephen Sommers that reveled in its status as the comic relief to films like *Transformers* and later *Battleship* (2012). Now in its second film, the jokiness of this live-action cartoon has worn off considerably, with jingoism a cause to defend by destruction of others; the need to protect America (so that it can remain more powerful than any other country) equated with keeping anyone from stopping playtime.

Nick Allen

CREDITS

Capt. Duke Hauser: Channing Tatum
Roadblock: Dwayne "The Rock" Johnson
Snake Eyes: Ray Park
Joe Colton: Bruce Willis
Jinx: Elodie Yung
Lady Jaye: Adrianne Palicki
Firefly: Ray Stevenson
Mouse: Joseph Mazzello
Zartan: Arnold Vosloo
Warden Nigel James: Walton Goggins
Origin: United States
Language: English
Released: 2013
Production: Brian Goldner, Lorenzo di Bonaventura; Hasbro Inc., Metro-Goldwyn-Mayer Inc., Skydance Prods.; released by Paramount Pictures
Directed by: Jon M. Chu
Written by: Rhett Reese; Paul Wernick
Cinematography by: Stephen Windon

Music by: Henry Jackman
Sound: John Marquis
Editing: Roger Barton
Costumes: Louise Mingenbach
Production Design: Andrew Menzies
MPAA rating: PG-13
Running time: 110 minutes

REVIEWS

Corliss, Richard. *Time Magazine*. March 29, 2013.
Gleiberman, Owen. *Entertainment Weekly*. March 27, 2013.
Guzman, Rafer. *Newsday*. March 27, 2013.
Huddleston, Tom. *Time Out*. March 26, 2013.
Kenny, Glenn. *MSN Movies*. March 29, 2013.
Lemire, Christy. *Associated Press*. March 27, 2013.
Merry, Stephanie. *Washington Post*. March 28, 2013.
Scherstuhl, Alan. *Village Voice*. March 27, 2013.
Sharkey, Betsy. *Los Angeles Times*. March 28, 2013.
Smith, Kyle. *New York Post*. March 27, 2013.

QUOTES

Firefly: "Making more things go boom before 9 am. than most people do all day."

TRIVIA

Zartan addresses one of the impostor Secret Service agents as "Zandar." In the 1980s and 1990s *G.I. Joe* comic books, toy lines, and cartoons, Zandar was Zartan's brother—who had similar disguise abilities.

GIMME THE LOOT

Box Office: $104,442

With *Gimme the Loot*, writer/director Adam Leon has crafted a felonious assault on the public property of the movie going soul. But this cinematic rebellion is art not vandalism and it shimmy shimmy shimmys with a vulgarized flare. *Gimme The Loot* takes the raw devotion of youthful idealism and melds it to raw-tongued street life, mixing aspects of the caper, coming-of-age, and youth comedy with a documentary realism likely to make most viewers smile harder than they thought they would.

Malcolm (Ty Hickson) and Sofia (Tashiana Washington) are a pair of Bronx taggers who repeatedly see their graffiti defaced by a rival gang whose trademark is the NY Mets home-run apple. Joyfully foul-mouthed and hustling to survive, they also work hard to perfect their craft and decide this latest outrage cannot stand. They set out to redeem their honor and become the

most famous taggers ever by putting their moniker on the NY Mets home-run apple: A fan-appealing oversized fruit that pops up in the outfield after a home-team base-clearer. It all happens during two sweltering, unforgettable days of friendship tested by adventure, temptation to sell out, and the hard truth that the world these characters live in is anything but fair.

There are kudos all around here. Writer/director Adam Leon has crafted a meandering slice of real life buttressed by dialogue that has a genuine street sense. These are characters who live by talking their way around and through things, zipping in and out of situations and thinking on their feet. Cinematographer Jonathan Miller matches the high energy by showcasing the busy New York streets around the characters and knowing just when a close-up will capture the drama. There is a temptation to bring up a movie like Jean-Luc Godard's *Breathless* (1960) which mixes similar elements of class, friendship, petty thievery, and romance but Leon is not attempting homage. He appears to be speaking in his own voice and a much needed one it is at this stage of American cinema.

Newcomers Ty Hickson and Tashiana Washington are revelations as Malcolm and Sofia, each bristling with an absolute surety about who they are. The pair races through the constant jibes with one another and moments of true affection and tension the screenplay offer without missing a single emotional beat. They showcase one of the things that make Leon such a director to watch. With his help they create a world in which even pot-smoking/dealing, street hooligans can have dreams and humanity. Thanks to all of them *Gimme The Loot* emerges as the anti-disaffected youth flick. These two are going places but the movie showcases where they are now with a confidence that viewers will figure that out on their own without the typical force-feeding of a film in this subgenre.

Other characters and the way they cross paths with Malcolm and Sofia are just as real. Ginnie (Zoe Lescase), a comparatively rich white girl Malcolm delivers weed to makes no sense to him at all. He is locked outside of her world and the world of her friends and the movie is canny about the ways in which it shows this to viewers without sacrificing for the sake of sentimentality or action. Likewise Sofia's encounter with a fellow, more famous tagger is a masterpiece of subtlety and coming of age, accomplished without sacrificing any of her character's hard-bitten, twice-shy leeriness.

The soundtrack pops rather than hops, relying on time-honored R&B as well as soul numbers and, oddly, makes the film feel all the more timeless because of it. Where is the modern, bea- heavy, radio-friendly hip hop or rap? Nowhere to be found. Just one more indication that Leon is an original.

There is a lightness of plot here that is a little disconcerting. Leon spends most of the story having his characters figure out how to pay for the second story man they need to do their heist. But he more than makes up for it by showcasing a group of great performances, and charming interludes that make *Gimme the Loot* feel so real. Those looking for any sort of in-depth treatment of the world of tagging are liable to be disappointed as well. The film is a lot of things but it is perhaps least interested in the tagging element of its narrative.

Gimme the Loot is so whimsical and joyful that only those who would object to other great chicanery films will bat an eye. This is a movie about people not content just to survive, but looking for ways to thrive, while also enjoying every minute of the present day. The suggestion, of course is that they are the smart ones; the ones willing to risk something to get where they want to go. Wayward children, warts and all, they do just that. The results are like an open fire hydrant in a ghetto neighborhood during a heat wave. Viewers should be grateful not grumpy about getting splashed by the kids as they caper in that magic light.

Dave Canfield

CREDITS

Malcolm: Ty Hickson
Sofia: Tashiana Washington
Origin: United States
Language: English
Released: 2012
Production: Dominic Buchanan, Natalie Difford, Jamund Washington; Seven for Ten; released by Sundance Selects
Directed by: Adam Leon
Written by: Adam Leon
Cinematography by: Jonathan Miller
Music by: Nicholas Britell
Sound: Martin Czembor
Editing: Morgan Faust
Production Design: Katie Hickman; Sammy Lisenco
MPAA rating: Unrated
Running time: 79 minutes

REVIEWS

Atkinson, Michael. *Village Voice*. March 19, 2013.
Burr, Ty. *Boston Globe*. April 4, 2013.
Calhoun, Dave. *Time Out*. April 30, 2013.
Debruge, Peter. *Variety*. March 15, 2013.
Fear, David. *Time Out New York*. March 19, 2013.

Kenny, Glenn. *MSN Movies*. March 22, 2013.

Nehme, Farran Smith. *New York Post*. March 22, 2013.

Rooney, David. *Hollywood Reporter*. May 25, 2013.

Scott, A. O. *New York Times*. March 21, 2013.

Tobias, Scott. *NPR*. March 21, 2013.

AWARDS

Nominations:

Ind. Spirit 2013: First Feature

GINGER & ROSA

Box Office: $1 Million

The time is 1962, the place London. Ginger (Elle Fanning) and Rosa (Alice Englert) have known one another literally since the day they were born. An opening montage shows Rosa and Ginger's mothers bonding wordlessly as they give birth to the girls simultaneously in London hospital in 1945. Seventeen years later the two offspring are best friends, doing what teenagers have always done: staying out too late, making out with boys, and defying their mothers. They also do some things which teenagers have not always done, such as attending anti-war protests prompted by the ongoing Cuban missile crisis, though for admittedly different reasons (Ginger seems there out of genuine concern, Rosa for the male activists). Ginger is the more cautious and introspective of the two. While Rosa makes out with boys on a park bench, Ginger sits nearby reading a book.

Writer and director Sally Potter's film initially seems to be setting the stage for a conventional, if well-crafted, coming of age tale. Two lifelong friends make different choices regarding their impending adulthood reflecting the different people they are becoming. An unshakeable friendship formed in the simplicity of childhood inevitably frays as the two girls develop into fully-formed adults, one reserved and intellectual, the other passionate and free spirited. However, Potter's film has a very different and more disturbing agenda, more *An Education* (2009) than TV's *The Wonder Years*.

The agent of this dark agenda is Ginger's often absent college professor father, Roland (Alessandro Nivola), who happens to be home one night when Ginger and Rosa roll in after curfew. Obviously undisturbed, he provides the absolute bare minimum of support to his wife, Natalie (Christina Hendricks), as she lectures the girls for staying out to 2 AM. "It's late," he agrees in an obligatory fashion before agreeing to drive Rosa home, his eyes studying her in the rear view mirror, recognizing for the first time that his child's friend now has the body of a woman.

Roland is a piece of work: A brilliant, darkly handsome, deeply narcissistic intellectual who was jailed during World War II for refusing to fight. His daughter must go by the nickname Ginger because Roland has named her Africa, because "women are the dark continent." Roland is the kind of husband who characterizes any complaint or criticism from his wife as "emotional blackmail" and the kind of father who insists that his daughter call him, Roland, instead of Dad because he does not believe in conventional domestic roles.

Unless of course cooking, cleaning, laundry and raising his child are involved. In these respects he is very much a traditionalist, leaving these tasks entirely to his long suffering wife. Roland is a study in selfishness. While his wife stays at home raising Ginger, Roland indulges his very liberal attitude towards marriage. He sleeps with his students and shows up in the home when he feels like it, brushing off any criticisms of his actions with a convenient philosophy of personal freedom that must in all instances triumph over the tyranny of convention. "When love comes, you just surrender," says a man who also claims that individual human agency, including, one would assume, the ability to choose whether to surrender or not surrender, is the most important thing in the world.

Roland is compelled to provide this commentary on love to Ginger because, of course, Rosa has returned his glance in the rearview mirror and now the two are involved in an affair. When it comes to having to decide between being a father and sleeping with his daughter's best friend, it is no contest at all. His "philosophical principles" trump his responsibilities as a father. A trip to Roland's yacht by the two girls ends with Ginger clutching a pillow to her head to drown out the sounds of her middle-aged father and her seventeen-year-old former best friend having sex in the next cabin. Adding insult to injury, Roland unfairly asks his daughter to keep the affair secret from her mother as well as her two godfathers, (Timothy Spall and Oliver Platt) and their intellectual, feminist friend Bella (Annette Bening). Ginger suffers in agony as her father forces her to endure, and keep silent about, things no daughter should have to experience.

The only flaw of Potter's admirably unsentimental film is its thin characters beyond Ginger and her father. Given the film's title one would expect that the film would be equally about Ginger *and* Rosa. However, Rosa's character is underdeveloped and comes off as a superficial, stupid and self-centered child, more of a plot device to bring Ginger and her father into collision then a fully-developed character. The film should really be called *Ginger and Roland*. Nivola does a superb job with Roland, making a self-centered, intensely egotistical man

likable despite his significant flaws and the pain he inflicts on those around him through his monumental selfishness. And Elle Fanning's performance is amazing, particularly given that she is a thirteen-year-old actor playing a seventeen-year-old character. But, as with Rosa, the rest of the film's roles are either underwritten or under exposed. The great Christina Hendricks is largely wasted in the cliched role of the long suffering , cheated upon wife. Bening, Spall and Platt are good but have screen time amounting to little more than extended cameos that allow for little in the way of character development or viewer attachment. Because of the thin characterizations, the viewer is never made to care about the effect of Ginger and Roland's actions have on the people around them. And the Cuban Missile Crisis backdrop does not seem related to the story. It is a heavy handed metaphor for the crisis of Ginger's life and is an unnecessary writerly intrusion into what is otherwise a very realistic story.

These, however, are minor quibbles and Potter's otherwise brutally realistic script does a great job in avoiding the coming of age film cliches that ruin most other films of its kind.

Nathan Vercauteren

CREDITS

Ginger: Elle Fanning
Rosa: Alice Englert
Roland: Alessandro Nivola
Natalie: Christina Hendricks
Bella: Annette Bening
Mark: Timothy Spall
Mark Two: Oliver Platt
Anoushka: Jodhi May
Origin: United Kingdom
Language: English
Released: 2013
Production: Christopher Sheppard, Andrew Litvin; Adventure Pictures, BBC Films, British Film Institute; released by A24
Directed by: Sally Potter
Written by: Sally Potter
Cinematography by: Robbie Ryan
Sound: Eddie Simonsen
Editing: Anders Refn
Costumes: Holly Waddington
Production Design: Carlos Conti
MPAA rating: PG-13
Running time: 90 minutes

REVIEWS

Anderson, Melissa. *Village Voice*. March 12, 2013.

Burr, Ty. *Boston Globe*. March 21, 2013.
Debruge, Peter. *Variety*. February 25, 2013.
Ebert, Roger. *Chicago Sun-Times*. March 20, 2013.
Goodykoontz, Bill. *Arizona Republican*. March 28, 2013.
Murray, Noel. *AV Club*. March 13, 2013.
Perez, Rodrigo. *The Playlist*. February 25, 2013.
Rothkopf, Joshua. *Time Out New York*. March 12, 2013.
Scott, A. O. *New York Times*. March 14, 2013.
Steward, Sara. *New York Post*. March 14, 2013.

QUOTES

Roland: "There would not even the possibility of nuclear war, or any war, if millions of men had been prepared to stand up against authority, as I did, and refuse to join the army—refuse to take orders. It's mindless obedience that's the killer. I've broken the rules. All the rules. Because someone has to say no."

TRIVIA

Actress Elle Fanning has her first screen kiss in this movie.

GIRL RISING

Box Office: $1.7 Million

Following the huge grosses of Michael Moore's *Bowling For Columbine* (2002), which rang up $58 million worldwide, and *Fahrenheit 9/11* (2004), which raked in an accumulated $222 million worldwide, the theatrical marketplace for documentaries of political advocacy and social consciousness expanded seemingly tenfold. No movies that followed would reach quite such commercial heights, but distributors and filmmakers alike seemed emboldened by the burgeoning assurance that there was a reliable adult audience hungry for continuing-education cinematic correspondence courses at their local arthouse cinema.

Directed by Richard Robbins, *Girl Rising* slots comfortably into this tradition, while also upending many traditional notions of sedate nonfiction filmmaking via a fairly ambitious series of stylistic embellishments. Produced by 10x10, a nonprofit group that works internationally with nongovernmental organizations to promote female empowerment through education, *Girl Rising* sounds a clarion call for gender equality, using the stories of nine girls from all over the globe to illustrate the many social advantages of closing the worldwide gap in primary and high school attendance between adolescent boys and girls.

Distributor Gathr Films also developed an innovative exhibition strategy. In addition to a limited theatrical release on three dozen screens in major markets in

early March, the film utilized a demand-based distribution model to its benefit, screening in cities over the next several months where filmgoers online bought tickets that were only valid if a certain numerical goal was met. Owing to this savvy presale approach, *Girl Rising* technically played for more than half the calendar year—and at a fraction of the cost associated with a more traditional release—grossing over $1.6 million theatrically.

The subjects of the film are striking and memorable. Among them are a Nepalese girl sold as a "kamlari," or indentured servant, to a wealthy family; a 13-year-old Ethiopian girl who stands strong against her widowed mother's attempts to marry her off in order to improve her lot in life; a Peruvian teen who loves poetry but whose future seems to hold a choice only between working at the local mine or brothel; a Cambodian orphan previously forced to pick through the garbage to survive; an Egyptian girl refusing to let a rape psychologically destroy her; and a Haitian girl dogged in her quest to attend school despite the recent ravages of a devastating earthquake on her homeland, and her parents' lack of money for tuition.

Robbins, whose *Operation Homecoming: Writing the Wartime Experience* (2007) received both Oscar and Emmy nominations, here utilizes a well-honed technique that has served him well. His previous film was based around a collection of well-known actors reading the first-person writings of American veterans from the Afghanistan and Iraq wars, and blending those recollections with news footage, photographs, and other interviews. *Girl Rising* takes an even more subjective tack, but retains many elements of that basic approach. Robbins matches the individual story of each young girl with voiceover material written by a female writer from that child's native land. Dramatic segments (some animated) featuring a combination of performers and the real-life subjects then illuminate their quests for betterment.

Among those lending vocal performances to the film are Anne Hathaway, Meryl Streep, Cate Blanchett, Salma Hayek, Selena Gomez, Kerry Washington, Chloe Moretz, Freida Pinto, Alicia Keys, and Priyanka Chopra. As the sole male contributor, Liam Neeson weighs in with an overarching narration that packs a heavy and depressing statistical punch, and plays during interstitial interludes in which women in verdant fields hold up corresponding signs with disturbing facts—telling viewers, for instance, that fifty percent of all sexual assaults occur on girls under fifteen years of age.

Part and parcel with *Girl Rising*'s more emotionally charged connection is its argument that equal access to education quells "downriver" societal ills, from illiteracy,

unemployment and domestic violence to decreased standards of living and even war. To this end, while it unfolds in discrete sections, Gillian McCarthy's editing is intuitive, establishing tangible links between the stories of these girls from such disparate, far-flung locales.

In several reviews, critics and admirers alike described *Girl Rising* as "an extended public service announcement," and it is true that the movie essentially unfolds as an unfailingly positive-minded proclamation of the same thesis sentence. At over 100 minutes, it is a bit long. Its subjects are sympathetic, but the expressive formula Robbins deploys, of jut-jawed triumph over terribly harsh circumstances, reaches a certain point of lulling repetitiveness, no matter the imaginative nature of its staging. The film would play even more strongly at a slightly shorter length.

Still, Robbins' film connects on a palpable level, its strong production value lending extra impact to its catharses. While schooling may not be the only key to helping lift generations up out of poverty, *Girl Rising* makes a persuasive case that, institutionally and individually, the United States must advocate for equal gender rights and opportunity if it is to retain moral standing in the global community.

Brent Simon

CREDITS

Narrator: Anne Hathaway
Narrator: Cate Blanchett
Narrator: Selena Gomez
Narrator: Freida Pinto
Narrator: Meryl Streep
Narrator: Kerry Washington
Narrator: Liam Neeson
Narrator: Salma Hayek
Narrator: Alicia Keys
Narrator: Chloe Grace Moretz
Origin: United States
Language: English
Released: 2013
Production: Amy Andres Cunningham, Michelle Currinder, Louise Lovegrove, Ramaa Mosley, Martha Adams, Richard Robbins; The Documntary Group, Vulcan Productions; released by GathrFilms
Directed by: Richard Robbins
Written by: Marie Arana; Doreen Baingana; Edwige Dantical; Mona Eltahawy; Aminatta Forna; Zarghuna Kargar; Maaza Mengiste; Sooni Taraporevala; Manjushree Thapa; Loung Ung
Cinematography by: Mike Ozier; Heloisa Passos; Islam Abdelsamle; Adam Beckman; David Rush Morrison; Felipe Perez-Burchard; Steven Piet; Kiran Reddy; Nicole Hirsch Whitaker

Music by: Lorne Balfe
Sound: Katy Wood
Editing: Tracy Hoff; Steven Piet; Gillian McCarthy
Art Direction: Ann Cummings
Costumes: Christine Peters
Production Design: Caroline Foellmer
MPAA rating: PG-13
Running time: 101 minutes

REVIEWS

Chaney, Jen. *Washington Post.* April 19, 2013.
Chen, Sandie Angulo. *Common Sense Media.* February 8, 2013.
Feeney, Mark. *Boston Globe.* April 18, 2013.
Lakhani, Asif. *Illume Magazine.* November 22, 2013.
Phillips, Michael. *Chicago Tribune.* April 18, 2013.
Rapold, Nicolas. *New York Times.* March 7, 2013.
Scheck, Frank. *Hollywood Reporter.* March 8, 2013.
Schenker, Steve. *Village Voice.* March 6, 2013.
Thomas, Rob. *Capital Times.* March 10, 2013.
Whipp, Glenn. *Los Angeles Times.* March 7, 2013.

QUOTES

Narrator: "If you stop me, there will be other girls who will rise up and take my place."

A GOOD DAY TO DIE HARD

Yippee ki-yay mother Russia.
 —Movie tagline
Like father. Like son. Like hell!
 —Movie tagline

Box Office: $67.3 Million

As he cartoonishly chomps on a carrot, one of the most spectacularly least threatening henchmen in the history of the *Die Hard* franchise (played by Rasha Bukvic) has a few words for action hero John McClane, and most importantly, McClane's 2013 audience: "It's not 1986, you know," referring to a year that saw the release of such favorite action films as *Top Gun, Cobra, Aliens,* and *Raw Deal.* It is a statement as loaded as the gun he holds to an incapacitated McClane in *A Good Day to Die Hard,* the hero's fifth adventure as directed by John Moore. To conclude his statement, the harmless nemesis also aggressively reminds all of his listeners, "Reagan is dead." However backhanded coming from such a charisma-less film as *A Good Day to Die Hard,* this statement fitfully reminds the film's ingrained audience of the inescapable effects of time, that aging beings do not stay the same, whether they are presidents, fictional vk-characters, or franchises.

This could not be more sad and/or true with regard to the current status of the *Die Hard* world within the universe of modern action films. For one, John McTiernan, director of the original *Die Hard* and the man who helped turn a 1988 potential sequel to Mark L. Lester's 1985 film *Commando* into an action genre template, is behind bars. Junky video games adapted from movies have now achieved a reverse flow. Most of all, stars of the 1980s and 1990s like Bruce Willis, along with his other dethroned gods of Planet Hollywood, including surname icons like Sylvester Stallone and Arnold Schwarzenegger, are now united in their contemporary status by fluffy action movie hootenanys that carry the title of "Expendable," referring to *The Expendables* (2010) directed by Stallone and sequel *The Expendables 2* (2011). McClane, the New York City cop who once fought intelligent terrorists in Los Angeles by himself must combat the larger villain of irrelevancy—especially when single concept scripts like *Taken* (2008) are getting sequels, thoroughly digital spectacles like Michael Bay's *Transformers* (2007) spawn billion dollar revolutions to make feature films out of toys, and moviegoers are actively financially invested in watching superheroes who do not have mortality to risk.

In order to live on in the face of these trends, *A Good Day to Die Hard* keeps up with the kids by playing it light, smaller, and without self-seriousness, a huge but serviceable change from the brainpower of the original film. This is a Bruce Willis action vehicle more readily comparable to his freely silly 1991 co-writing effort *Hudson Hawk* than to the 1988 genre juggernaut. While this *Die Hard* does not intelligently adapt its own template, revered since 1988 by a number of wannabes that followed, it does take advantage of the simplicity that is expected from a *Die Hard* movie to provide bursts of automatic action that are giddy in their plain ridiculousness.

Similar to the ironic plot trigger of *Die Hard,* McClane's fifth adventure finds him on vacation (as he screams while blasting away with a large weapon in the second act). With writer Skip Woods' script celebrating that same aloofness, the NYC cop heads to Russia to bail out his long-lost son Jack (Jai Courtney), who has been arrested while working undercover for the CIA in order to get close to a Russian figurehead named Komarov (Sebastian Koch). Komarov has been put in jail for blackmailing political enemy and high-ranking Russian official Chagarin (Sergei Kolesnikov), claiming he has secret information about nuclear weapons that will incriminate Chagarin.

Enter the cool McClane, an "Idiot's Guide to Russia" in hand, who shows up just in time to get into hero

mode when the courthouse hosting the trial of Komarov is bombed. From this point, the script's story becomes genre gruel, tossing the two McClanes into action sequences with dramatic breaks of meaningless backstabbings, until the film uses former nuclear tragedy location Chernobyl as its final explosive set piece.

As McClane progressively achieves an immortal bill of health, Willis further relaxes into his character. *A Good Day to Die Hard* proves that while John McClane may not be the same as he was in 1988, this is a character who will be forever owned by Willis' smirking lunkhead ways. In terms of written personality, McClane's usual comic relief comes weak, with the unimportance of pithy commentary being tossed from a one-man peanut gallery.

As for his onscreen son, Courtney's presence is nothing special, beyond offering a visual of the male offspring of John McClane. Most of all, Courtney shows the lack of character that is endemic to the younger, wannabe John McClane heroes. Jack tries to make up for his naivete with hulking muscles and appearing like he is going to explode from his psychological anti-daddy angst any minute. Certainly, without his father by his side, this sidekick would not be a unique hero, a discerning sign in case the momentum of the *Die Hard* films should create a spin-off within the McClane family.

A Good Day to Die Hard is rescued from its inklings of comparatively contemporary mediocrity by its visual flair, which make this film a 96-minute extra value meal of action fast food. *A Good Day to Die Hard* is essentially the summation of three labored set pieces, a massive car chase, a shootout in a room full of glass, and the aforementioned showdown in Chernobyl, the designs of each being blown to smithereens by loud weaponry and/or sometimes modes of transportation. The film's first big display is an impromptu monster truck rally in which the action fitfully gorges on its own silliness, budget, and the patience of Russian civilians, all while aiming to smash every single car stuck in congested Moscow traffic. The sequence took 78 days to film and the sheer quantity of varying camera angles, along with the many surprising way cars are thrown into each other, provide a reasonable explanation as to why. Still, with the story's stupidity creating a radiation of its own, this potential masterpiece of a sequence is not entirely cohesive, but is best as a choppy cinematic collection of automobiles being crushed, smashed, demolished, moved, broken, and scratched and more. It is a notable feat within a genre that has overall evolved since the original *Die Hard* film, as imperfect as this flubbed moment from editor Dan Zimmerman may be.

For action movie spectacle, *A Good Day to Die Hard* has big slices of similarly engrossing visual moments that

consciously continue to push the physicality of New York cop McClane to the level of beyond superhuman. The newest addition to this cause comes from Moore's video game-esque sequences ("Press 'X' to Jump!") that nonetheless provide rich slow motion visuals in which McClane defies his original physical gravity. Especially with previous installment *Live Free or Die Hard* (2007) and now this film, the essence of this franchise's current state is no longer a gritty thrill concerning whether the underdog hero will make it through a single office building stealthily with shards of glass sticking into his feet, but how playfully absurd it will it look to see him fling his entire body in slow motion through a glass window as a crashing helicopter hurdles chaotically in his direction. To the credit of Moore and his cinematographer Jonathan Sela, such sequences along with a few others make for moments of aesthetically arresting extravaganza, achieving breadths of vulgar imagery in their presentation of complete destruction.

As the film generalizes its own action, this *Die Hard* only consciously labors to offer the heavily digital spectacle of what a character in the film deduces out loud as "killing bad guys," while the hero steers this story with the control of a backseat driver. *A Good Day to Die Hard* surely suffers from its ingrained expectations, but in the scope of its competitors, it does offer productive usages of its digital filmmaking. And while the original *Die Hard* had the visual cinematic grit of actor Robert Davi's pockmarks and to this day remains a landmark movie for pure American cinema, this fourth follow-up at least does not proclaim to own the soul it does not have, or to be the raw piece of filmmaking it is not.

This is a blow 'em up mostly dedicated to the simplistic visual pleasures of "physical change," in which one piece of glass turns into a billion shards of glass, or a Chernobyl factory becomes a war zone. For what the movie does offer as diet *Die Hard* thrills, there is trademark mindless entertainment to be found in this robotic sequel, even if the visceral artistry of the original have been long replaced by CG craftsmanship. While McClane's freewheeling "Yipee-Ki-Yay" trademark catchphrase comes with its softest usage yet in the *Die Hard* franchise, it is as if that phrase was Moore's predominant mindset as he utilized McClane to provide his moments of captivating wild action to keep up with the new standards celebrated by younger heavyweights of the action genre.

Nick Allen

CREDITS

John McClane: Bruce Willis
Jack McClane: Jai Courtney

Komorov: Sebastian Koch
Lucy McClane: Mary Elizabeth Winstead
Collins: Cole Hauser
Murphy: Amaury Nolasco
Irina: Yuliya Snigir
Alik: Rasha Bukvic
Origin: United States
Language: English
Released: 2013
Production: Alex Young; Dune Entertainment, Ingenious Media Partners; released by Twentieth Century Fox Film Corp.
Directed by: John Moore
Written by: Skip Woods
Cinematography by: Jonathan Sela
Music by: Marco Beltrami
Sound: Jay Wilkinson
Editing: Dan Zimmerman
Costumes: Bojana Nikitovie
Production Design: Daniel T. Dorrance
MPAA rating: R
Running time: 98 minutes

REVIEWS

Burr, Ty. *Boston Globe*. February 14, 2013.
Groen, Rick. *Globe and Mail*. February 14, 2013.
Howell, Peter. *Toronto Star*. February 14, 2013.
Long, Tom. *Detroit News*. February 14, 2013.
Morgenstern, Joe. *Wall Street Journal*. February 14, 2013.
Phillips, Michael. *Chicago Tribune*. February 13, 2013.
Sachs, Ben. *Chicago Reader*. February 14, 2013.
Scott, A. O. *New York Times*. February 13, 2013.
Vognar, Chris. *Dallas Morning News*. February 14, 2013.
Whitty, Stephen. *Newark Star-Ledger*. February 14, 2013.

QUOTES

John McClane (mocking his son): "The 007 of Plainfield, New Jersey. Very nice."

TRIVIA

This is the first film in the series where Bruce Willis' character does not kill the main antagonist.

THE GRANDMASTER
(Yi dai zong shi)

In martial arts there is no right or wrong, only the last man standing.
—Movie tagline

Once upon a time in kung fu.
—Movie tagline

Box Office: $6.6 Million

A martial arts film by Wong Kar-wai must have sounded like a dream come true to many cinephiles, and for a good chunk of its running time, *The Grandmaster* does have a dream-like quality. With or without the great cinematographer Christopher Doyle, with whom Wong made his greatest films, Wong is undeniably a visual master. *The Grandmaster* opens with its hero, the legendary Ip Man (longtime Wong collaborator Tony Leung) singlehandedly fighting off an army in the street, in the rain, at night. The scene is an astonishing technical accomplishment, as Wong occasionally slows down the tempo for a shot of, say, the brim of Ip Man's elegant white fedora spinning as he delivers a kick or a blow. Each raindrop seems to have its own light. It is several minutes of pure cinema, and a joy to behold. As Ip Man dispatches assailant after assailant, an older gentleman, Gong (Wang Qingxiang), obviously a man of power and influence, looks on and gives his subdued assessment: "Not bad."

Sadly, despite its spectacular highs, that is the verdict one reaches regarding Wong's film, as well. It is sporadically brilliant, but, in the end, it feels more like a few gorgeous-but-barely-connected set-pieces than a cohesive work. One could say the same thing about much of Wong's filmography, but his best films have an emotional core that draws the viewer in and a playfulness that subverts Wong's propensity for melodrama. The image pixelation he used so extensively in earlier films like *Chungking Express* (1994) and *Ashes of Time* (1994) occurs briefly, early on in this film, but it feels almost as though the sweeping narrative itself has been pixelated.

Perhaps the sense that something intrinsic is missing can be explained by the interference of the film's American distributor, The Weinstein Company. Wong's original cut, shown in China, was 130 minutes. The version shown to good but mostly disappointed reviews at the 2013 Berlin Film Festival was 123 minutes. The American distributor is responsible for the additional titles that were needlessly added to the film, identifying characters and locations in text that are usually identified in the dialogue as well. As to the length, Wong's deal with TWC stated that he had to turn in a cut that was under two hours. Rather than trim the Berlin cut, Wong completely recut the film, essentially cutting a whole subplot involving a nationalist assassin, Razor (Chang Chen), and adding some scenes (along with those titles) to, in his words, make the story "more linear." But it does not feel linear. And it is a Wong Kar-wai film. Why should it feel—of all things—linear? Still even for Wong, *The Grandmaster* feels disjointed. It is

not just elliptical; it feels as though something intrinsic is missing.

The film tells the story of the legendary Ip Man, the widely influential martial arts master and instructor who, in his later years, trained Bruce Lee. His story has been assayed in several previous films, including Wilson Yip's entertaining *Ip Man* (2008) starring the great Donnie Yen, and its sequel, *Ip Man 2* (2010). Wong's film covers 20 years of the master's life. He begins as a happy, well-to-do family man in southern China, who is chosen to represent the southern schools of kung fu when Gong, a master from the north who is retiring, comes down to the fancy brothel they call "The Golden Palace," and holds a demonstration with a representative from the south. There is an entertaining sequence as a series of envious southerners, who nonetheless want Ip to win against Gong for the honor of the South, fight Ip, displaying the particular strengths of each of their methods, to prepare him for his match with Gong.

The match with Gong itself is somewhat anticlimactic, more of a dance and a riddle than a battle royale. Ip is victorious, and while Gong is magnanimous in defeat, wanting to inspire the next generation of masters and encourage national unity, his daughter, Gong Er (Zhang Ziyi), the sole heir to Gong's "64 Hands" technique, is upset about the loss, and offers her own challenge to Ip. Ip's match against Gong Er is glorious, one of the two high points of the film. They are equally matched and their attraction to one another gives the match an erotic and emotional charge. Neither is able to land an effective blow. At one point, Ip flips Gong Er over his head and Wong cuts to a close up of her face spinning an inch about his, both with a look of unrelenting focus. Ip loses the match because he reaches out to stop Gong Er from falling down a stairwell, and she pulls him down and herself up, causing him to land hard enough on the floor below to crack it, giving her the victory.

Sadly, the two then go their separate ways. Their forbidden romance (Ip is happily married with children to the gorgeous, doting Zhang Yongcheng, played by Korean actress Song Hye-kyo) is an added fiction because what would a Wong Kar-wai film be without a forbidden romance. Gong Er returns home. She is meant to become a doctor. She cannot inherit her father's legacy because she is a woman, so that os left to the arrogant Ma San (Zhang Jin of *Crouching Tiger, Hidden Dragon* [2000]).

When the Japanese invade, Ip, who had been obsessing about going north to visit Gong Er, essentially loses everything, and moves to Hong Kong to earn a living teaching kung fu, leaving his family behind. When the British take over Hong Kong, he is unable to return.

Ma San collaborates with the Japanese, and inadvertently causes the death of Master Gong. Gong Er sacrifices everything to avenge her father. We see this later, in flashback, as the broken, opium-addicted woman finally reunites with Ip. Gong Er gets to fight and defeat Ma San in another stunning sequence, on New Year's Eve in a snowstorm beside an impossibly long departing locomotive. As with the earlier fight sequence, there is a powerful emotional component to their battle that increases the stakes.

And then, the film slowly dissipates. Ip and Gong Er's have their wistful reunion in Hong Kong. She has vowed to give up kung fu and men, essentially, in exchange for an opportunity to fight Ma San, so nothing can come of their love for one another. Ip establishes his own kung fu school and gains renown.

Leung is a charming, debonair figure, as always, but his character feels oddly underdeveloped, despite having the most screen time. Zhang fares better, bringing tremendous poignancy to the role of the honorable and stoic woman unable to have the life she deserves. Her demeanor is nicely offset by that of her fiercely loyal manservant Jiang (Shang Tielong), who amusingly always has his pet monkey perched alertly on his shoulder, above his deadly sabre.

The Grandmaster is beautiful to look at throughout, but while the images are sharp, the plotline is not. As fractured as the narratives of Wong's best work is, *Chungking Express*, the director's cut of *Ashes of Time*, *Fallen Angels* (1995), and the his most cohesive work (and his masterpiece), *In the Mood for Love* (2000), all have an emotional resonance that *The Grandmaster* cannot quite match. There is still no reason to expect less than superb work from such an original and accomplished filmmaker, but this film only approaches greatness sporadically. With Wong taking so long between projects, there is an abiding sense of missed opportunity here.

Josh Ralske

CREDITS

Ip Man: Tony Leung Chiu-Wai
Gong Er: Zhang Ziyi
Razor: Chen "Chang Chen" Chang
Iron Shoes: Cung Le
Ma San: Jin Zhang
Origin: China
Language: Mandarin Chinese, Japanese
Released: 2013
Production: Jacky Pang Yee-Wah, Wong Kar-Wai; Block 2 Pictures Inc., Jet Tone Films, Sil-Metropole Organisation, Bona International Film Group; released by Weinstein Company L.L.C.

Directed by: Wong Kar-Wai
Written by: Wong Kar-Wai; Xu Haofeng; Zou Jingzhi
Cinematography by: Philippe Le Sourd
Music by: Shigeru Umebayashi
Sound: Guang Chen
Editing: William Chang
Art Direction: Tony Au
Costumes: William Chang; Fengshan Lv
Production Design: William Chang
MPAA rating: PG-13
Running time: 108 minutes

REVIEWS

Dargis, Manohla. *The New York Times*. August 22, 2013.
Dowd, A. A. *The A.V. Club*. August 21, 2013.
Kohn, Eric. *IndieWire*. February 10, 2013.
Moore, Roger. *Movie Nation*. August 20, 2013.
Musetto, V. A. *New York Post*. August 22, 2013.
O'Hehir, Andrew. *Salon.com*. August 22, 2013.
Rodriguez, Rene. *Miami Herald*. August 29, 2013.
Scott, Mike. *New Orleans Times-Picayune*. August 30, 2013.
Tsui, Clarence. *Hollywood Reporter*. February 10, 2013.
Turan, Kenneth. *Los Angeles Times*. August 22, 2013.

QUOTES

Gong Er: "My father would always say, people who practice
martial arts go through three stages: seeing yourself, seeing
the world, seeing all living beings."

TRIVIA

One reason for the long development time of the movie was
that director Kar Wai Wong spent over a year editing before
he was satisfied.

AWARDS

Nominations:

Oscars 2013: Cinematog., Costume Des.

GRAVITY

Don't let go.
—Movie tagline

Box Office: $270.5 Million

Once a in a great while a film will come along and
will seem to prove that there is nothing left to be
discovered, that all the tricks have now been pulled off
and that every bit of technology has been utilized and
exploited. That might have been how people felt when
they first saw *Star Wars* (1977), *Jurassic Park* (1993), *The*

Lord of the Rings trilogy (2001-2003), or *Avatar* (2009).
These films pushed the boundaries of special effects and
demonstrated that movies could be bigger, more immer-
sive and awe-inspiring in terms of what was visually
possible. They (and many other films as well) were game
changers, often thought of as the apex of special effects
at their time. The game keeps changing, though, as
there are still a handful of passionate directors out there
who are willing to take risks with the technology to not
only enhance the storytelling, but to have the audience
truly believe in what they are seeing.

Alfonso Cuaron's *Gravity* is one of those films. It is,
at once, a technical marvel, a dizzying adventure and an
emotional and spiritual journey written, directed and
acted from the heart. It is made to be seen on as big a
screen as possible with the sound cranked up, not just
because of how the big the production looks, but because
the act of seeing it in a darkened theater with state-of-
the-art equipment will greater amplify the emotions felt
when watching it. It goes without saying that the film
will thrill anyone who watches it just based on the sheer
adventure factor, but the unbearable suspense felt might
take a second place to the bigger journey the main
character takes while trying to survive.

The storyline can be expressed in one sentence: Two
adrift astronauts try to survive in space after their shuttle
is destroyed by flying debris. The film has been described
in shorthand as "*Open Water* (2003) in space," a refer-
ence to the film in which two scuba divers try to survive
after coming up for air only to find that their boat has
disappeared. Except that *Gravity* has loftier goals than
just providing the audience with a 90-minute adventure
story of survival. It succeeds at being much more than
just another star-studded diversion at the multiplex. The
technology employed here is as much used for the
character's state of mind and emotions as it is for the
bigger, more explosive moments.

The two astronauts are Ryan Stone (Sandra Bul-
lock) and Matt Kowalski (George Clooney). At the start
of the film, they are working on installing a program
onto a satellite. Matt is an experienced astronaut and is
floating around the shuttle with an astro-jetpack with
which he has complete control over his destination.
Ryan is less experienced. This is her first real mission.
She is confident enough in the routine maintenance
aspect of what she has to do, but the calamity that takes
place in the first fifteen minutes of the film is where she
is put to a real test. The crew gets an urgent message
from ground control in Houston (voiced by Ed Harris)
that there is a strong wave of debris heading toward
their spacecraft and that they need to abort the mission
and head back inside immediately.

It is too late and the destruction leaves a couple human casualties in its wake. Ryan is strapped to a giant robotic arm at the time of the hit and is ordered by Matt to detach. She does and is left spinning into the void uncontrollably, with precious little oxygen left. She is eventually discovered by Matt who tethers himself to her. With his jetpack, the two make their way toward a space station that might be their only means of survival and their only way back to earth. It is here that the film takes a pause in the excitement to focus on Ryan's own personal casualties. As she and Matt drift through the blackness while listening to Matt's preferred brand of country music, she speaks with great sadness about the senseless death of her child and how being in space is as much a coping mechanism as it is a career choice.

Much of *Gravity* is made up of such moments while the rest is made up of some of the most breathtaking, white-knuckle suspense sequences ever conceived for a film. Never before has a film so successfully put the audience into the limited point of view of astronauts so as to feel their disorientation, confusion and helplessness when they are out of control of their elements. Much of Ryan and Matt's success at surviving this ordeal is hinged upon whether or not they can grab onto something and stay put without the other person losing their way. There is also a time factor. Every 90 minutes, that same wave of debris will come back around and cause more destruction to any satellite or space station in its path. Wisely, *Gravity* never begs the audience to suspend disbelief that the two will make it to where they need to be just in time before the debris hits. Every minute counts and not everything goes as planned or hoped.

Part of the suspense also comes in knowing that there is nothing to carry sound in space. The calamities that take place on screen are not only visually stunning in their detail, but also strangely disorientating for a viewer accustomed to hearing a 5.1 or 7.1 surround sound being used to its fullest capacity anytime an elaborate action sequence takes place. It leaves a void which is greatly filled by composer Steven Price, who gives a fresh sound to a convention that is often saddled with stock action music with no rhythm or personality. The long drones remain in the foreground as the music escalates and crescendos while in the quieter scenes, Price gives the music a feeling of weightlessness that compliments the safety of whichever capsule the characters occupy.

The falsettos heard in the final moments of the film also fit beautifully with the overall theme of rebirth that *Gravity* explores. Some of the visual references are overt, such as the moment Ryan makes her way into a capsule and can finally strip away the constraining (and suffocating) space suit. She does so while floating, only to slowly curl up in a fetal position. There is a sound of a baby heard at one point as well as a scene in which one must crawl before they can walk. A cutaway to a dime store Buddha on a mantle during a crucial moment in the film also further Cuaron's interest in conception, starting anew and coming out of the void and experiencing consciousness (again). Perhaps this film is meant to be a companion piece or extension of Cuaron's futuristic *Children of Men* (2006), in which the world's population was dying out due to the lack of any woman being able to conceive.

It is most certainly an expansion of the director's visual style taken to the next level. With *Children of Men*, Cuaron and his longtime cinematographer Emmanuel Lubezki created a camera mount that would sit on a car and give an extended take with multiple characters that concluded with a chase. The audience felt as though they were in the car with them. Cuaron is now famous for doing long takes, but *Gravity* takes the idea to a whole new level that will undoubtedly have viewers demanding to know "How did they do that?" The opening shot, for instance, runs about 17 minutes long and includes the first attack of debris and Ryan being detatched. There are many more extended shots like that one that most directors would never think to attempt, particularly one in which the camera slowly goes inside Ryan's helmet in order to give the audience a real point-of-view shot of what it is like to be spinning uncontrollably in space. But Cuaron does so not to be some kind of show-off, but because it serves the action as well as the performances, especially a scene in which Ryan confronts her immortality head-on and feels helpless to do anything about it.

That entire sequence in particular represents Cuaron at the peak of his powers and Bullock at an all-time career high. She has quite a chore here to not just help carry this film, but to do so while assisting Cuaron and Lubezki's in their maddeningly precise choreography to help pull off these elaborate shots while also conveying Ryan's sadness, loneliness, frustration, fear and moments of real soul searching. Bullock has always been a likable presence in film, but more often than not, she squanders her talent in middle-of-the-road romantic comedies and trite dramas. Here, she is fearless, confident and able to win over even the most jaded and cynical audience member. Even a moment of levity is spoken with appropriate inflection and tone and not the sort of go-for-the-laugh manner which she would normally be used to. She is the heart and soul of the film and a character that many will take to their hearts.

Gravity took about two years to make and required some invention on the part of Cuaron and Lubezki after months of pre-visualization to help pull off what the film almost effortlessly accomplishes. The film was not shot in 3-D, but rather converted later on, which was

the plan all along, due to the constraints of the 3-D process. The 3-D ended up being essential to the experience of watching the film, not because of objects being hurdled at the audience, but because the increased depth of the image is necessary to the experience of what it must be like to be floating through space with the earth lurking beneath. The further element of viewing the film on IMAX made for the of the great movie-going experiences of all time, one that will (or can) rarely be duplicated.

Collin Souter

CREDITS

Ryan Stone: Sandra Bullock
Matt Kowalski: George Clooney
Mission Control: Ed Harris
Origin: United States
Language: English
Released: 2013
Production: David Heyman, Alfonso Cuarón; released by Warner Bros.
Directed by: Alfonso Cuarón
Written by: Alfonso Cuarón; Jonas Cuaron
Cinematography by: Emmanuel Lubezki
Music by: Steven Price
Sound: Glenn Freemantle
Editing: Alfonso Cuarón; Mark Sanger
Art Direction: Marc Scruton
Costumes: Jany Temime
Production Design: Andy Nicholson
MPAA rating: PG-13
Running time: 91 minutes

REVIEWS

Corliss, Richard. *TIME Magazine.* August 28, 2013.
Covert, Colin. *Minneapolis Star Tribune.* October 3, 2013.
Denby, David. *New Yorker.* October 4, 2013.
Guzman, Rafer. *Newsday.* October 3, 2013.
Long, Tom. *Detroit News.* October 4, 2013.
Morgenstern, Joe. *Wall Steet Journal.* October 3, 2013.
O'Hehir, Andrew. *Salon.com.* October 3, 2013.
Rodriguez, Rene. *Miami Herald.* October 3, 2013.
Scott, A. O. *New York Times.* October 3, 2013.
Turan, Kenneth. *Los Angeles Times.* October 3, 2013.

QUOTES

Matt Kowalski: "You've got to learn to let go."

TRIVIA

Interestingly, the film is 90 minutes long and, in real life, the International Space Station travels at approximately 17,500 mph, and orbits the earth every 90 minutes (which is the rate the debris field circles the earth in the film).

AWARDS

Oscars 2013: Actress (Bullock), Cinematog., Director (Cuarón), Film Editing, Orig. Score, Sound, Sound FX Editing, Visual FX
British Acad. 2013: Cinematog., Director (Cuarón), Orig. Score, Sound, Visual FX
Directors Guild 2013: Director (Cuarón)
Golden Globes 2014: Director (Cuarón)

Nominations:

Oscars 2013: Film, Production Design
British Acad. 2013: Actress (Bullock), Film, Film Editing, Production Design
Golden Globes 2014: Actress—Drama (Bullock), Film—Drama, Orig. Score
Screen Actors Guild 2013: Actress (Bullock)

THE GREAT BEAUTY
(La grande bellezza)

Box Office: $2.1 Million

Paolo Sorrentino's *The Great Beauty*, a multiple award winner which may be headed to an Oscar for Best Foreign Language Film at the time of this review, could be a masterpiece. It is, without question, a riveting, gorgeous, beautiful, melancholic tribute to a timeless city built on excess. As the unforgettable Jep Gambardella (Toni Servillo, who also starred in the director's *Il Divo* [2008]) says, "Rome makes you waste a lot of time." Sorrentino's film is both an ode to the city's excess and examination of how it often disguises true beauty. Gambardella became famous but lost sight of true emotion until his later years reminded him of the only search in his life that really mattered—trying to find that great beauty of life.

This often surreal, Fellini-esque adventure opens with two wonderful scenes of excess that hides darkness underneath. The first is a beautifully filmed (by the great Luca Bigazzi, who also lensed *Certified Copy* [2010]) scene of ancient Roman architecture: Statues, fountains, pools, and centuries-old design, interrupted by a tourist dropping dead. Then the film transfers to modern excess—club music, dancing, drinking, sex, drugs, all at an amazingly lavish party, filmed with so much style that one wants to jump into the screen and join the fun. One can imagine these kind of soirees being thrown in that now-tourist-laden architecture of the opening scene. It is a parallel of excess—classic and then

modern. For the next two hours, Sorrentino will play with these visual motifs without overly defining them. Animals as distinct as flamingos and a giant giraffe will play major roles. The film will occasionally feel like it breaks narrative structure but Sorrentino always pulls it back down to the story of a man "destined for sensibility" but longing for something pure.

Gambardella was once a famous writer and has become someone more famous for being famous than anything else, although he is regularly asked why he never wrote another book. Instead, he chats over wine, sleeps with beautiful women, and throws the best parties in town. He also speaks with the brilliant wit of a writer. There are so many insightful, often hilarious exchanges or asides in *The Great Beauty* that one loses track of them all. And they often hide a melancholy under the humor. He tells a friend at a party, "The trains at our parties are the best ones in Rome," referring to when people dance in a line, but then adds an insightful bit about the lack of forward momentum in this world where everyone dances, talks, and screws but never really does anything: "They're the best because they go nowhere."

Every shot in *The Great Beauty* feels finely tuned and just so perfectly framed. It is a work of art that comments on works of art and the very act of commenting on works of art. The music choices are stunning, often creating wells of emotion that the characters in the film have repressed. This is a world where even funerals are planned social events. There is an amazing scene in which Jep "coaches" someone in the art of the funeral—picking the right dress, choosing the right time to greet the mourners so as to be seen in that outfit, but never crying as that would steal focus. And then Jep breaks one of those rules, indicating that his time in this carefully-crafted world is coming to an end. That, or he just cannot believe his own bullshit anymore.

Sorrentino's film is a technical stunner but Servillo carries it in terms of performance. His work here would be stunning enough if it were just the caustic, hysterical wit of the first half of the film but he imbues Jep with a deep vein of melancholy in the second half. Jep seems to think that his life is defined by the parties and the fashion and the sex and so he has nothing to write about and yet there is deep tragedy in this film and the repressed emotion of a life defined by party trains that go nowhere seems to be breaking this man down. Again, it goes back to that opening image—gorgeous architecture interrupted by the human frailty of death. Everything in *The Great Beauty* lives up to its title and the film would be worth seeing for its cinematography, party scenes, and music choices alone but it attains a higher level thematically through its narrative and one of the most memorable characters of all time. Royalty once strode

these streets of Rome, flitting from party to party and ignoring actual responsibility as they took the gorgeous art around them for granted, numb to its beauty. How does one see beauty in a town where beauty is everywhere? He looks within and hopes to see it there. This is a beautiful, beautiful film.

Brian Tallerico

CREDITS

Jep Gambardella: Toni Servillo
Romano: Carlo Verdone
Ramona: Sabrina Ferilli
Cardinal Bellucci: Roberto Herlitzka
Origin: Italy
Language: Italian
Released: 2013
Production: Francesca Cima, Nicola Giuliano; Indigo Film; released by Janus Films
Directed by: Paolo Sorrentino
Written by: Paolo Sorrentino; Umberto Contarello
Cinematography by: Luca Bigazzi
Music by: Lele Marchitelli
Sound: Emanuele Cecere
Editing: Cristiano Travaglioli
Costumes: Daniela Ciancio
Production Design: Stefania Cella
MPAA rating: Unrated
Running time: 142 minutes

REVIEWS

Abrams, Simon. *RogerEbert.com.* November 15, 2013.
Addiego, Walter. *San Francisco Examiner.* December 5, 2013.
Atkinson, Michael. *Village Voice.* November 12, 2013.
Bradshaw, Peter. *The Guardian.* May 26, 2013.
Calhoun, Dave. *Time Out London.* May 26, 2013.
Dargis, Manohla. *New York Times.* November 14, 2013.
Ebiri, Bilge. *New York Magazine.* November 22, 2013.
Lane, Anthony. *The New Yorker.* November 22, 2013.
Persall, Steve. *Tampa Bay Times.* January 30, 2014.
Turan, Kenneth. *Los Angeles Times.* November 21, 2013.

QUOTES

Jep Gambardella: "We're all on the brink of despair, all we can do is look each other in the face, keep each other company, joke a little. Don't you agree?"

TRIVIA

The first cut of the movie was around 190-minutes long.

THE GREAT GATSBY

Can't repeat the past? Of course you can!
　—Movie tagline

Reserving judgments is a matter of infinite hope. I come to the admission that it has a limit.
　—Movie tagline

That's the best thing a girl can be in this world, a beautiful little fool.
　—Movie tagline

They were careless people, Tom and Daisy—they smashed up things and creatures and then retreated back into their money or their vast carelessness.
　—Movie tagline

There was an immediately perceptible vitality about her as if the nerves of her body were continually smouldering.
　—Movie tagline

I've just heard the most amazing thing, and here I am tantalizing you.
　—Movie tagline

Box Office: $144.8 Million

It is easy to claim that Baz Luhrmann is a hack more interested in mastering the art of excess than coherent storytelling. He starts at the place most of his peers would deem over the top, and builds up from there, resulting in films of such heightened theatricality that even lifelong thespians may occasionally find themselves wincing in unease. Yet for all of the follies that have plagued Luhrmann's ever-floundering track record, it is impossible to not admire the man's audacious goal to aim for the stars, even if they ultimately prove to be as elusive as the green light at the end of Daisy's dock.

That light, so poetically representative of the ill-fated hopes held by F. Scott Fitzgerald's titular dreamer in *The Great Gatsby,* is one of many details hammered down audience's eye sockets in Luhrmann's 3D adaptation of the landmark 1925 novel. There perhaps is no filmmaker in modern cinema whose work is less demanding of the 3D treatment than Luhrmann, whose swirling visual palette is already dizzying enough as it is. Adding a contrived third dimension adds up to little more than sensory overkill, the cinematic equivalent of a headache-inducing sugar rush.

No wonder why *Moulin Rouge* (2001) is the only film in Luhrmann's screen career that fits his stylistic approach brilliantly well. That film is a blatant valentine to theatrical artifice, luxuriating in the operatic pleasures of stagecraft, from slapstick pratfalls to tear-stained tragedy, while setting it all to familiar tunes first-time viewers will have no trouble singing to themselves. The characters are all one-note archetypes, and that is precisely as it should be. There is as much need for subtle nuance and complexity here as there would be in *Dick Tracy* (1990), where the gangsters wear their personalities on their faces. Yet in applying this same broadly drawn, neon-lit approach to the work of geniuses like Shakespeare or Fitzgerald, Luhrmann's style begins to look flat-out childish.

Gatsby's love of opulence and indulgence is entirely reflective of Luhrmann's own. The only time in which the filmmaker's vision merges seamlessly with that of Fitzgerald's is during the delirious party sequences thrown at Gatsby's millionaire mansion. Simon Duggan's dazzlingly radiant imagery makes every gleaming surface and studded gown look as if it cost a fortune and a half. When Gatsby finally turns toward the lens for an old-fashioned movie star reveal, Luhrmann times it to the crescendo of Gershwin's "Rhapsody in Blue," as a symphony of fireworks light up the night sky, evoking memories of the glorious prologue to Woody Allen's *Manhattan* (1979).

As long as Luhrmann's camera centers on pomp and bombast, he is well within his comfort zone. Yet once he is forced to deal with Gatsby's vulnerable psyche fraught with misguided yearnings, the picture gradually begins to fall apart piece by piece. As Nick Carraway, the war veteran who befriends the lovesick eccentric, Tobey Maguire has the thankless task of embodying the audience's eyes and ears, while reciting lines from Fitzgerald's text as they appear on the screen. All that is missing is a disembodied Gatsby head bouncing off each word as they are recited with all the patronizing simplicity of a book and tape narrator.

Rather than find inventive ways of etching Fitzgerald's symbolic motifs into the imagination of viewers, Luhrmann's leans on them like a crutch, thrusting them at the screen again and again until their overstated meaning starts to grate on one's nerves. The most haunting single image in Fitzgerald's novel, that of a crusty billboard displaying the hollow eyes of an ever-watchful god, pops up so frequently in Luhrmann's film that it even earned a place on the poster, right next to Isla Fisher's Myrtle, whose sad fate would have had far greater impact had she been given as much screen time as the billboard. Carey Mulligan certainly looks lovely as Daisy, the object of Gatsby's tireless affections, but the

script fails to get beneath her enigmatic surface, leaving the actress with very little to do.

Only Gatsby himself emerges as a compelling figure, as portrayed by the effortlessly magnetic Leonardo Di-Caprio, whose skills as a performer have evolved so spectacularly since he starred as Luhrmann's Romeo 17 years ago. He is such an ideal fit for Gatsby's childlike optimism, larger-than-life charisma, and aching short-sightedness that under the guidance of a different director, DiCaprio may have very well been destined to score his first-ever Oscar win. A pity that Luhrmann's hyperactive gaze is too busy to linger long enough on DiCaprio, or anyone else for that matter. All that is destined to linger in one's memory are the largely successful "Roaring '20s" variations on modern tunes supervised by Jay-Z, offering fleeting proof that Lana Del Ray would have been an ideal fit for the flapper era.

Just as George Lucas's story parallels that of Anakin Skywalker, as the integrity of his indie aspirations turned to the dark side of Hollywood commercialism, Luhrmann has become the subject of his own cautionary tale. In mistaking grandiosity for dramatic depth, the director appears to have become every bit as delusional as Gatsby himself. Just because the green light is in 3D does not mean it is any closer to reaching one's grasp.

Matt Fagerholm

CREDITS

Jay Gatsby: Leonardo DiCaprio
Nick Carraway: Tobey Maguire
Daisy Buchanan: Carey Mulligan
Tom Buchanan: Joel Edgerton
Myrtle Wilson: Isla Fisher
George Wilson: Jason Clarke
Catherine: Adelaide Clemens
Origin: United States
Language: English
Released: 2013
Production: Catherine Martin, Lucy Fisher, Catherine Knapman, Douglas Wick, Baz Luhrmann; Barzmark Films, Red Wagon Entertainment; released by Warner Brothers
Directed by: Baz Luhrmann
Written by: Baz Luhrmann; Craig Pearce
Cinematography by: Simon Duggan
Music by: Craig Armstrong
Sound: Wayne Pashley
Editing: Jason Ballantine; Jonathan Redmond; Matt Villa
Costumes: Catherine Martin
Production Design: Catherine Martin
MPAA rating: PG-13
Running time: 142 minutes

REVIEWS

Denby, David. *The New Yorker*. May 6, 2013.
Groen, Rick. *The Globe and Mail (Toronto)*. May 9, 2013.
Keningsberg, Ben. *The A.V. Club*. May 8, 2013.
LaSalle, Mick. *San Francisco Chronicle*. May 9, 2013.
Mohan, Marc. *Portland Oregonian*. May 9, 2013.
Morgenstern, Joe. *Wall Street Journal*. May 9, 2013.
Nashawaty, Chris. *Entertainment Weekly*. May 8, 2013.
Perez, Rodrigo. *The Playlist*. May 6, 2013.
Phillips, Michael. *Chicago Tribune*. May 9, 2013.
Scott, A. O. *The New York Times*. May 9, 2013.

QUOTES

Nick Carraway: "In my younger and more vulnerable years, my father gave me some advice. 'Always try to see the best in people,' he would say. As a consequence, I'm inclined to reserve all judgements. But even I have a limit."

TRIVIA

A picture of Zelda Fitzgerald, the wife of author F. Scott Fitzgerald, can be seen hanging on the wall in the background of the apartment Tom shares with Myrtle.

AWARDS

Oscars 2013: Costume Des., Production Design
British Acad. 2013: Costume Des., Production Design
Nominations:
British Acad. 2013: Makeup

GROWN UPS 2

They'll do anything for their families...except grow up.
—Movie tagline
Summer isn't just for kids.
—Movie tagline
Just because they're a little older doesn't mean they've grown up.
—Movie tagline

Box Office: $133.7 Million

Whenever Adam Sandler delivers another entry in his successful string of juvenile PG-13 comedies, its creative success is thus measured with the lesser-of-two-evils method. While the actor, producer, and writer has found interesting concepts, he has frequently driven them so far into the depths of comedic ineptitude that ranking them against each other can be as easy as counting the number of laughs on a single hand. The first *Grown Ups* (2010) was little more than an excuse to get his buddies together, try a couple jokes, and get paid handsomely for it (as are most of his films). This cast

was a little more talented than others, so the hope was that, just by mere proximity, a funny line would bounce the right way and maybe, just maybe, its title was indicative that it would be about these comedians putting aside the childish nature of their pasts and crafting an entertainment that had both humor and poignancy. That hope was short-lived. Three years and three laughs later, Sandler delivers his first sequel, proving that as his brand of comedy gets older, it certainly does not get any wiser (and actually gets lazier).

Lenny Feder (Sandler) has moved his family back to his hometown. Presumably settled in for some time now, it is the last day of school before summer vacation, on which he discovers his son is the victim of bullying. His good friend, Eric (Kevin James), spends his afternoons hanging with his mother, unbeknownst to his wife (Maria Bello), whom he is hiding from for some unexplained reason. Maybe she has become tired of his burp snarting, a magical feat of burping, sneezing, and farting in immediate succession. Kurt (Chris Rock) starts his day realizing his wife (Maya Rudolph) forgot their anniversary but is marginally more concerned with his daughter being pursued by a boy at school. Bachelor Marcus (David Spade), meanwhile, opens his day greeting the ungrateful, potentially dangerous, hulking teenage boy (Alexander Ludwig) he never knew was his.

Most films require a couple of paragraphs to establish a film's setup. There is already very little left to say about the rest of *Grown Ups 2*, and that previous paragraph gets as far as the first ten minutes. The remaining ninety minutes is little more than a series of flimsily attached moments and skits that would be embarrassing on the deleted scene packages of *The Brady Bunch Hour* and held together with a structure that *Movie 43* (2013) would find anorexic.

The theme which passes in and out of *Grown Ups 2* is bullying; a subject that has found heartbreaking tales make its way into mainstream news outlets and even inspired *Bully* (2012), a poorly-executed yet highly-publicized documentary. Along with Sandler's son getting poked in the shoulder on the bus, the film taps into Lenny's own past and present as one of the bullied. A group of frat boys, led by Taylor Lautner, have claimed the local swimming hole as their own and force Lenny's crew to jump in naked as their penalty for intrusion. Lenny's tormentor does not get the stereotypical comedown from past transgressions. Instead he is married to the one woman in town (the school dance teacher) who gives Lenny's wife (Salma Hayek) a run on the scale of gorgeous voluptuousness. The idea that "Stone Cold" Steve Austin, a wrestler known for double-fisting beer on stage after sucker punching his opponents creates the only moment approaching heartfelt chivalry in the name of fatherhood is the kind of irony that San-

dler and his cronies could not identify even if Alanis Morrisette wrote another song about it.

Considering someone named O'Doyle—a name provided to bullying jerks in both *Billy Madison* (1995) and *Click* (2006)—must have done a number on Sandler in his youth, the consequences or bootstrap-pick-up from living in fear should have some resonance with him as a father. The checklist of gags running through the film would not survive a final edit by a second grader. Burp snarting aside, the grade schooler in all viewers still has to make it through a bit putting Spade inside a runaway tire (that they steal directly from *Beavis & Butt-Head*), an all-male car wash that further flames the homophobic nature of Sandler's comedies and an ice cream vendor picking the worst position to fix the chocolate machine. These are the more elaborate attempts at humor.

Though the prospect of Rob Schneider being left off the roster this time around sounds like an addition-by-subtraction, be aware (be very aware) that he has basically been replaced with far worse. An extended appearance by the comedy abyss that is Nick Swardson on the big screen attempts to prove that what audiences have always wanted is more of the whacked-out divorcee behind the wheel of a school bus that ended *Bachelor Party* (1984). A briefer appearance is provided by Tim Meadows' character, referred to in the first film by Rock as the only other black man in town, who now magically has a brother played by Shaquille O'Neal. This appropriately leads to a whole scene devised around him comically saying "WHAT?!?!?" after each statement of disbelief. An entire scene is dedicated to this. The entire movie may as well have been too.

Aside from wasting a bevy of talented former *Saturday Night Live* performers in cheap, worthless cameos, *Grown Ups 2* faces viewers with the dilemma of what actually makes it the most offensive. Is it simply registering a zero on the laugh meter aside from one clever gag from Rock involving Eminem and Duke University? Or that its stand on bullying puts it in lockstep with Florida's Stand Your Ground law? The first film was not much more than an infantile reading of Jason Miller's *That Championship Season*. The sequel is a plotless, soulless, laughless cash grab with the main cast playing some version of a mentally inferior Benjamin Button with the same regression from elder to youth while bullying the audience into watching this garbage and taking their lunch money to do it.

Erik Childress

CREDITS
Lenny Feder: Adam Sandler
Eric Lamonsoff: Kevin James

Kurt McKenzie: Chris Rock
Marcus Higgins: David Spade
Roxanne Chase-Feder: Salma Hayek
Deanne McKenzie: Maya Rudolph
Sally Lamonsoff: Maria Bello
Wiley: Steve Buscemi
Nick: Nick Swardson
Malcom: Tim Meadows
Officer Fluzoo: Shaquille O'Neal
Mrs. Lamonsoff: Georgia Engel
Frat Boy Andy: Taylor Lautner
Origin: United States
Language: English
Released: 2013
Production: Jack Giarraputo, Adam Sandler; Happy Madison Productions; released by Sony Pictures Entertainment Inc.
Directed by: Dennis Dugan
Written by: Adam Sandler; Fred Wolf; Tim Herlihy
Cinematography by: Theo van de Sande
Music by: Rupert Gregson-Williams
Sound: Kami Asgar
Editing: Tom Costain; Sean McCormack
Costumes: Ellen Lutter
Production Design: Aaron Osborne
MPAA rating: PG-13
Running time: 101 minutes

REVIEWS

Duralde, Alonso. *The Wrap.* July 11, 2013.
Gibron, Bill. *Film Racket.* July 11, 2013.
Gleiberman, Owen. *Entertainment Weekly.* July 11, 2013.
Grierson, Tim. *Paste Magazine.* July 11, 2013.
Orndorf, Brian. *Blu-ray.com.* July 11, 2013.
Rich, Katey. *CinemaBlend.com.* July 11, 2013.
Roeper, Richard. *RichardRoeper.com.* July 11, 2013.
Simon, Brent. *Screen International.* July 12, 2013.
Snider, Eric D. *Twitch.* July 11, 2013.
Verniere, James. *Boston Herald.* July 12, 2013.

QUOTES

Becky Feder: "How long ago was the '80s?"
Keithie Feder: "That was way back in the 1900s. We learned about it in school. It was wack. The phones had long, curly things coming out of the end. You had to watch commercials."
Becky Feder: "No way."

TRIVIA

This is actually Adam Sandler's first sequel.

AWARDS

Nominations:

Golden Raspberries 2013: Worst Actor (Sandler), Worst Director (Dugan), Worst Ensemble Cast, Worst Picture, Worst Remake/Sequel, Worst Screenplay, Worst Support. Actor (Lautner), Worst Support. Actor (Swardson), Worst Support. Actress (Hayek)

GRUDGE MATCH

De Niro vs. Stallone. A rivalry 30 years in the making.
 —Movie tagline
When time hits hard, hit harder.
 —Movie tagline
No matter how old you are, come out swinging.
 —Movie tagline
A battle of the ages.
 —Movie tagline
Never give up the fight.
 —Movie tagline

Box Office: $29.8 Million

Nothing gets the Hollywood marketing machine going more than the prospect of a "versus." It could be as simplistic as the prospect of their latest hero taking on a bigger, badder villain or a pair of heavyweight actors sharing the screen for the very first time. Imagine the pitch room when someone suggests another boxing film; not exactly the highest totem on the box office charts of cinema or the sporting universe. Ah, but what if we could secure the guys from the two best and most well-known boxing films of all time? Not James Earl Jones and Kirk Douglas. Think younger, slightly younger, and still able to carry a convincing punch. *Rocky* (1976) vs. *Raging Bull* (1980). Unfortunately, the reality of growing old in Hollywood these days is eventually an actor will be led to a gimmick movie that takes advantage of past glory, mocks his age, and invites audience to snicker at how far the mighty have fallen. 2013 has followed in this tradition and failed miserably with a couple of low-rent efforts that were more embarrassing and sad than inspirational. But the year actually ends with a film that fulfills everything Hollywood wants while giving viewers more than just jokes about saggy flesh. As gimmick films go, it is a relatively enjoyable one.

Thirty years ago the rivalry in the ring between Henry "Razor" Sharp (Sylvester Stallone) and Billy "The Kid" McDonnen (Robert DeNiro) was compared to Magic & Bird and Ali & Frazier. The Kid took down the Razor mightily in their first bout. In their rematch, the tables were turned. When it came down for the definitive tiebreaking battle, Henry inexplicably retired from boxing and left Billy to live out his life without the opportunity to prove that he was the better boxer.

Henry spent the next three decades as a working class Joe after his manager cheated him out of his earnings. Now that swindler's son, Dante Slate Jr. (Kevin Hart) has come to Henry with a quick cash grab opportunity to put his likeness into a video game. As he assists with the nursing home bills for his former trainer, Louis "Lightning" Conlon (Alan Arkin) he agrees under one condition. That he never has to see Billy.

That promise is shattered quickly when Billy cannot resist antagonizing him on-set leading to another financial opportunity when their skirmish goes viral, a word and concept unknown to the aging foes. Dante arranges for their deciding match to go on again. Little interest is generated from sportswriters. Who does show up at the press conference is Henry's old flame, Sally (Kim Basinger), bringing with her the source of the real grudge between the boxers. Her son, B.J. (Jon Bernthal), is actually Billy's boy and against her wishes they begin to spend some time together. While Louis steps back into Henry's corner, B.J. takes the honor of training his dad and getting to know him for the first time.

Grudge Match has more than its share of gags about the stars' age. Stallone is in his 67th year and DeNiro has hit seventy; the former in a stage where he's buying bananas for the potassium and the other has to listen to comments about his saggy pectorals. "Bad Baywatch," as it is put by the trainer he quickly relinquishes. That may come with the territory but the film, surprisingly, does not just turn into a parody of history. A couple jokes about the instinct to punch meat and the cholesterol involved in a glass full of egg yolks connect and there is a clever sidebar that Billy has taken to stand-up comedy just as his counterpart Jake LaMotta pathetically did past his own glory days. It is clear that Stallone and DeNiro have enough respect for the roles that inspired their casting and were not about to let anyone undercut those past accomplishments.

At nearly two hours long and about ninety-five minutes before the final battle, the screenplay allows plenty of time to give the revisited relationships a bit of breathing room. Kim Basinger, at sixty, still looks amazing and whatever fountain she is dipping her toes in her presence is a reminder of how watchable and easygoing she can be on screen. Bernthal is also rather good, seemingly approaching the material as if he's in a drama like *Warrior* (2011) rather than one designed for yuks. His performance almost balances out the one by the boy playing his son, which should go down as one of the most unnatural, grating kid performances in years. Room for only so many subplots is apparent though as the backstory of Billy's relationship with L.L. Cool J.'s gym owner is sketchy at best and there is a shot of one sportswriter so prominent during the initial announce-

ment it's clear that any follow-up scenes he may have had were completely jettisoned from the final cut.

Peter Segal is a comedy director without any particular flair or style that would put him in the realm of reliable names like John Landis, Ivan Reitman or Frank Oz. But he's not nearly in the hack department of Shawn Levy, Raja Gosnell, and Dennis Dugan either. After taking the helm of *The Naked Gun 33 1/3* (1994), Segal has amassed an average resume with a miss for every *Tommy Boy* (1995) or *Anger Management* (2003), two of the less nauseating stops in the film careers of Chris Farley and Adam Sandler. But when you have actors who appear involved for a change and a treasure like Alan Arkin in your corner, who can make any piece of dialogue instantly funny (as seen in Segal's surprisingly funny *Get Smart* [2008] updating and this year's first old-guy reunion, *Stand Up Guys* [2013]), one can just sit back and hope for the best. DeNiro appears more lively and committed than usual, certainly more than in the similarly themed *Last Vegas* (2013), though there is nothing distinctly Irish about him except the green robes that he wears. Stallone does his most interesting work since he returned as *Rocky Balboa* (2006). The actual grudge match hardly inspires anyone to ever want to see a senior circuit in the sport, but by then the film has already won at least a split decision and is aware as much based on just how quickly it wants to get out of the ring and into the credits.

Erik Childress

CREDITS

Henry Sharp: Sylvester Stallone
Billy McDonnen: Robert De Niro
Dante Slate, Jr.: Kevin Hart
Louis Conlon: Alan Arkin
Origin: United States
Language: English
Released: 2013
Production: Michael Ewing, Bill Gerber, Mark Steven Johnson, Ravi Mehta, Peter Segal; Callahan Filmworks; released by Warner Bros.
Directed by: Peter Segal
Written by: Tim Kelleher; Rodney Rothman
Cinematography by: Dean Semler
Music by: Trevor Rabin
Sound: Terry Rodman
Music Supervisor: JoJo Villanueva
Editing: William Kerr
Costumes: Mary Vogt
Production Design: Wynn Thomas
MPAA rating: PG-13
Running time: 113 minutes

REVIEWS

Bell, Josh. *Las Vegas Weekly*. December 24, 2013.

Berardinelli, James. *ReelViews*. December 24, 2013.

Clark, Bill. *FromTheBalcony*. December 23, 2013.

Fine, Marshall. *Hollywood & Fine*. December 24, 2013.

Judy, Jim. *Screen It!*. December 25, 2013.

Minow, Nell. *Beliefnet*. December 24, 2013.

Orndorf, Brian. *Blu-ray.com*. December 26, 2013.

Snider, Eric D. *GeekNation*. December 24, 2013.

Villarreal, Phil. *COED.com*. December 26, 2013.

Vishnevetsky, Ignatiy. *The Onion A.V. Club*. December 24, 2013.

QUOTES

Billy "The Kid" McDonnen: "You can't be my trainer. Maybe I believe you ate my trainer."

TRIVIA

Several alternate endings were shot for the film to avoid any spoilers or leaks.

AWARDS

Nominations:

Golden Raspberries 2013: Worst Actor (Stallone)

H

THE HANGOVER, PART III

The epic conclusion to the trilogy of mayhem and bad decisions.
—Movie tagline

It all ends.
—Movie tagline

The end.
—Movie tagline

Box Office: $112.2 Million

It has been said that one of the crucial ingredients in comedy is the element of surprise. So what happens when a comedy film is an unexpected hit; spawns an obligatory, heavily marketed, and lucrative franchise; and then proceeds with each cinematic entry in the franchise to further erode any element of surprise? The result is a series of movies where the audience is mostly laughing because the elements, characters, actors, and "comedy" devices are familiar, not surprising. The result is a "comedy" so completely humorless that its relentless ineptitude feels intentional. The result is *The Hangover III*.

The first *Hangover* film—the tale of three hapless jerks (played by Zach Galifianakis , Bradley Cooper, and Ed Helms) trying to piece together the aftermath of a debauched black-out bachelor party night in Las Vegas—was a smash R-rated hit in 2009, and so naturally its creator, co-writer, and director Todd Phillips kept going back to the money-making well with 2011's *The Hangover II* (exporting the xenophobic misanthropy to

Bangkok, Thailand) and finally *The Hangover III*, supposedly the series' finale.

Nobody in front or behind the camera seems to want to be making *Hangover III*. Phillips' creative plan appears to have been to take 85 minutes of several talented comic actors going through the motions as some sort of misguided favor for the franchise that made them all wealthy stars. Mix in an hour and a half of tired, half-baked, sex, drugs, and animal cruelty jokes. Have Galifianakis take his shirt off for cheap comedic effect, and then have series MVP Ken Jeong show up and yell and swear a lot as crazed crime lord and chaos machine Mr. Chow. In other words, all the things that were amusingly surprising in the first films, re-heated & re-served, in hopes no one will notice or care.

The obvious problem with *The Hangover III* is that there are literally no jokes in it. The script by Phillips and Craig Mazin follows an attempt by Phil (Cooper) and Stu (Helms) to take man-boy Alan (Galifianakis) to rehab. (He's off his meds.) Their trip is hijacked by a crime boss (John Goodman) looking for Allen's pen pal Mr. Chow. The subsequent proceedings, are intensely heist-film plotted and over-plotted, and then over-plotted some more as the movie very slowly winds its way back to Vegas, where the franchise began.

At every turn in the apparently taxing writing process, it feels like Phillips and Mazin worked out the laborious story mechanics while thinking they did not need to come up with actual jokes or gags because Galifianakis and Jeong would improvise all the funny stuff on set. Except there's the sense that the comic actors showed up on location, took one look at the aggressively

humor-free script and thought, "We don't need this anymore—if they're not going to try, why should we?"

In 2009, the darkly cruel and misanthropic *The Hangover* worked well enough the first time out because audiences were encouraged to dislike the protagonists and revel in the Karmic payback of their grotesque misfortunes. However, successful comedy franchises do not succeed with characters everyone hates, nor can audiences continue to watch and re-watch these comedies without developing a connection to the characters. It is human nature to gravitate toward increasingly familiar protagonists, and no matter how miserably Phil, Alan, and Stu suffer, these days they come off on-screen as cool movie stars caught up in the sort of wild and crazy adventures audiences secretly wish they had.

That is what made the first follow-up, 2011's *Hangover II*, so repulsive, so anti-human: It was no longer laughing at these three losers getting their just desserts, but laughing with them at dirty, poor people and strange cultures. By *Hangover III*, four years and half a billion dollars of profit into the wretched ride, the film no longer wants audiences to laugh at or with it and its increasingly "rap-video-cool" "heroes"—it does not care if they laugh at all.

Despite a mawkish, half-hearted attempt to have Alan "learn and grow" in the margins, *The Hangover III* does not just sneer at its on-screen characters or the innocent bystanders sucked into their increasingly played-out and predictable misadventures, it also hates its audience. Not only do the actors shuffle along, but every scene feels glazed-over by Phillips' bored contempt for the material and the viewers. Phillips and his franchise have come to rely on the comedy of familiarity, not surprise, seemingly subscribing to the theory that as long as he puts the same actors through their usual paces, people will show up and laugh at whatever is (or is not) onscreen because they know the characters and actors and what will happen. It is akin to Comedy Death. On top of that, there is nothing more tedious than forced outrageousness.

Where *Hangover* and its sequel at least toyed with the notion of fish-out-of-water in the strange and seedy underbellies of Vegas and Bangkok, *Hangover III* spends most of its running time spinning its wheels in nondescript locales. (Including a surprisingly humor-free Tijuana, Mexico. In fact, that is the film's biggest surprise: That it cannot find *Hangover*-style laughs even in Tijuana, a setting seemingly tailor-made for bachelor-party hijinks.) It is a long, slow hour before the film even arrives back in Vegas.

Only *Hangover III*'s brief post-credits scene pops with anything like the gleefully chaotic surprise and

humor of the original film. But even that coda—in which the characters wake to one of the blackout hangovers that propelled the first two films—feels like a smug sneering kiss-off to the audience, as if to say, "Here's a taste of the movie we could have made, but didn't feel like. Thanks for buying a ticket."

Where *The Hangover* earned $277 million in North America and *The Hangover II* followed up with an impressive $254 million, *The Hangover III* tumbled to less than half of that at the domestic box-office, bringing in only $112 million. Likewise, critical opinion followed a vicious and steady decline as well. While a handful of critics still laughed, most commentary was more along the lines of "Turgid, unfunny catastrophe," (Bilge Ebiri, *New York Magazine/Vulture*), "Gives off...a stench of creative decay," (Mary Pols, *Time*), "a dull, lazy walk-through that...has a claim to be the year's worst star-driven movie," (Stephen Holden, the *New York Times*), and "Weirdly, fascinatingly bad" (Rick Groen, the *Toronto Globe and Mail*).

Locke Peterseim

CREDITS

Phil: Bradley Cooper
Stu: Ed Helms
Alan: Zach Galifianakis
Mr. Chow: Ken Jeong
Marshall: John Goodman
Doug: Justin Bartha
Jade: Heather Graham
Lauren: Jamie Chung
Cassie: Melissa McCarthy
Sid: Jeffrey Tambor
Black Doug: Mike Epps
Origin: United States
Language: English
Released: 2013
Production: Daniel Goldberg, Todd Phillips; Green Hat Films, Legendary Pictures; released by Warner Brothers
Directed by: Todd Phillips
Written by: Todd Phillips; Craig Mazin
Cinematography by: Lawrence Sher
Music by: Christophe Beck
Sound: Cameron Frankley
Editing: Jeff Groth; Debra Neil-Fisher
Costumes: Louise Mingenbach
Production Design: Maher Ahmad
MPAA rating: R
Running time: 100 minutes

REVIEWS

Burr, Ty. *Boston Globe*. May 22, 2013.

Dowd, A. A. *Onion A.V. Club.* May 22, 2013.

Ebiri, Bilge. *Vulture.* May 23, 2013.

Groen, Rick. *The Toronto Globe and Mail.* May 23, 2013.

Holden, Stephen. *New York Times.* May 22, 2013.

Jones, Kimberley. *Austin Chronicle.* May 23, 2013.

O'Sullivan, Michael. *Washington Post.* May 23, 2013.

Packham, Chris. *Village Voice.* May 21, 2013.

Pols, Mary. *Time.* May 23, 2013.

Sharkey, Betsy. *Los Angeles Times.* May 22, 2013.

QUOTES

Alan: "Nothing worse than losing your phone."

Stu: "You just saw a man get murdered. Your brother-in-law is kidnapped. You sure there's nothing worse?"

TRIVIA

No one actually gets a hangover in the film until the scene in the middle of the credits.

AWARDS

Nominations:

Golden Raspberries 2013: Worst Remake/Sequel

HANNAH ARENDT

Box Office: $717,205

In movies like *Marianne and Juliane* (1981), *Rosa Luxemburg* (1986) and *Vision* (2009), German filmmaker Margarethe von Trotta has explored a series of strong women, often against a politically fraught backdrop that challenged the character's ideas and beliefs. Her latest such effort is *Hannah Arendt*, a snapshot drama about the titular influential German-American author, philosopher and political theorist (her preferred term).

After World War II, Arendt was the first to write at length about the Nazi Reich within the context of Western civilization, coining the phrase "banality of evil" in describing the totality of moral collapse that the Nazis both brought about and relied on in implementing their ghastly crimes against humanity. Specifically, though, it was her coverage of the trial of ex-Nazi high command officer Adolf Eichmann—first published in the *New Yorker* in 1963, and later collected in her book *Eichmann in Jerusalem*—that ignited widespread controversy, and it is predominantly this period that von Trotta's work covers. A technically polished film with hefty ethical considerations at its core, *Hannah Arendt* succeeds on a certain level as a cerebral treatise, but is so dramati-

cally static as to self-limit its appeal to an arthouse subset with a deep and special interest in matters historical.

News of Eichmann's capture in Argentina and planned criminal hearing in Jerusalem prompt Arendt (Barbara Sukowa) to pitch William Shawn (Nicholas Woodeson), editor of the *New Yorker*, on covering the event in a series of articles. He eagerly accepts. Once on site, Arendt is dumbstruck by what she views as the shocking mediocrity and ordinariness of the man when compared with the staggering nature of his deeds as a Nazi SS lieutenant colonel, and sets about trying to reconcile the two distinct miens. As the nature of her piece begins to take shape, many old friends, like Hans Jonas (Ulrich Noethen) and Kurt Blumenfeld (Michael Degen), advise her to proceed with caution or abandon the project altogether; novelist friend Mary McCarthy (Janet McTeer) is a notable exception.

In a portion of her writing, Arendt, a secular Jew who escaped to France during the war and subsequently immigrated to the United States, glancingly indicts the compliance of European Jewish leaders in Nazi Germany's rise, citing trial testimony. ("Perhaps there is something in between resistance and cooperation," she says later.) Even more than the dispassionate reading of Eichmann, this judgment sets off heated pushback, with some reading it as an indication that Arendt believes Jews were somehow complicit in their fate. In short order, she finds not only friendships rocked, but her academic freedom under assault, threatened by colleagues and even Israeli diplomats.

In his *New York Times* review, A.O. Scott terms *Hannah Arendt* "ardent and intelligent," which is irrefutably true. The film highlights the manner in which theory and academic analysis can trigger white-hot passions when applied to real-world events, especially of such tragic scale. But Scott misses the mark in saying the movie "turns ideas into the best kind of entertainment." Von Trotta's film has no small amount of trouble establishing its characters, and the director and editor Bettina Bohler struggle in particular with where and how to insert flashbacks filling in some of the details of Arendt's important relationship with her lover and mentor, philosopher Martin Heidegger (Klaus Pohl). Arendt's relationship with second husband Heinrich Blucher (Axel Milberg) fares a bit better, but still comes across as fuzzy and vague.

On a fairly basic level, von Trotta and co-screenwriter Pam Katz flounder as dramatists, funneling the anger directed at Arendt through a litany of dinner conversation and party speechifying steeped in pretentiousness ("That's Hannah Arendt—all arrogance and no feeling!"), as well as a series of somewhat pedantic classroom lectures. The real-life fury of Norman Pod-

horetz and other neo-conservative Zionists likely had many contributing factors—including basic emotional temperature, a failure to grasp some of the nuances of Arendt's arguments, and even a pinch of sexism—but as represented here the opposition is more often ham-fisted or outright dumb.

From a technical perspective, *Hannah Arendt* is certainly well made and of a piece. While so drab as to flirt with suffocation at times, the film's dark palette—browns dominate everything from cinematographer Caroline Champetier's tight, smoky frames to production designer Volker Schaefer and costume designer Frauke Firl's work—at least complements the sea of grey morality Arendt finds herself in, where there is no safe harbor for bright certainties. Von Trotta further abets this by utilizing real footage from Eichmann's trial, and blending it with Arendt's contemplative reactions.

Sukowa and von Trotta have a rich history of collaboration, and the former, smoking cigarettes pensively throughout the film, captures Arendt's fierce intellect and principles, and how much the latter means to her. She locates the humanity in the subject. Most of the supporting players, however, are sketched so blandly as to invite zoned-out indifference. And with so little outside drama of significant consequence weighing in on Arendt, von Trotta's film gets a bit lost in the realm of theory. Not all fascinating real-life figures make compelling cinematic protagonists.

Brent Simon

CREDITS

Hannah Arendt: Barbara Sukowa
Heinrich Blucher: Axel Milberg
Mary McCarthy: Janet McTeer
Lotte: Julia Jentsch
Kurt Blumenfeld: Michael Degan
William Shawn: Nicholas Woodeson
Origin: Germany
Language: English, German, Hebrew
Released: 2012
Production: Bettina Brokemper, Johannes Rexin; Amour Fou Luxembourg, Heimatfilm, Mact Productions, Metro Communications; released by Zeitgeist Films
Directed by: Margarethe von Trotta
Written by: Margarethe von Trotta; Pamela Katz
Cinematography by: Caroline Champetier
Music by: Andre Mergenthaler
Sound: Rainer Heesch
Editing: Bettina Bohler
Costumes: Frauke Firl
Production Design: Volker Schaefer

MPAA rating: Unrated
Running time: 113 minutes

REVIEWS

Brody, Richard. *The New Yorker*. September 3, 2013.
Kauffmann, Stanley. *New Republic*. May 30, 2013.
Keough, Peter. *Boston Globe*. July 4, 2013.
Koehler, Robert. *Variety*. September 9, 2012.
LaSalle, Mick. *San Francisco Chronicle*. August 1, 2013.
Linden, Sheri. *Los Angeles Times*. June 6, 2013.
O'Hehir, Andrew. *Salon.com*. May 30, 2013.
Scott, A. O. *New York Times*. May 28, 2013.
Seligman, Craig. *Bloomberg News*. May 30, 2013.
Williams, Joe. *St. Louis Post-Dispatch*. August 1, 2013.

QUOTES

Hannah Arendt: "But isn't it interesting that a man who has done everything a murderous system demanded of him who even hastens to disclose any details about his work, that this man insists on the fact he has nothing against Jews?"

HANSEL & GRETEL: WITCH HUNTERS

Revenge is sweeter than candy.
—Movie tagline
Classic tale new twist.
—Movie tagline

Box Office: $55.7 Million

For the past few years, there has been interest from the Hollywood studios in reviving and updating many fairy tales in hopes of luring in a young crowd who like their fairy tales to have a dark and/or sexy side. The formula has only worked sporadically, with *Snow White and the Huntsman* (2012) raking in the most box office dollars to date. The casting of Kristen Stewart might account for its popularity, especially since she is also a big part of the franchise that might be partly responsible for this trend in the first place. With the *Twilight* movies ending, studios have been scrambling to come up with the next line of sexy-and-tormented fantasy tales of good looking people who cannot be together. The Grimm fairy tales seems like as good a place to go as any to delve further into this kind of genre, especially since there is no danger of offending a fanbase. Fairy tales, by their nature, are made to be played with.

Combine this trend with the new form of fan fiction along the lines of such books and films as *Abraham Lincoln: Vampire Hunter* (2012) and it becomes easy to see why *Hansel and Gretel: Witch Hunters* has come into

existence. It has the familiar fairy tale aspect, the ironic title meant to stir skepticism and laughter at its very mention and the chance for grizzly and violent outcomes, especially since the original tale already contains a gruesome finale. This film also comes from director Tommy Wirkola who has already made a name for himself by concocting another fantasy hybrid, that of zombie Nazis in *Dead Snow* (2009). It was only a matter of time before the Hansel and Gretel story got an R-Rated makeover.

Wirkola's film opens with Hansel and Gretel as kids being led into a forest late at night by their father. He does not come back for them, so they wander. They come upon a colorful, candy coated house and ask for help while helping themselves to some of the exterior. They enter the house and find it inhabited by a psychotic witch, who is hellbent on cooking and eating the kids. Of course, the kids put up a good fight and the witch ends up in the fire, at which time Hansel as an adult (Jeremy Renner) narrates, "We never saw our parents again." But they learn that in order to kill a witch, it is best to set them on fire. They become professionals at witch hunting.

During a town's witch trial, Hansel and Gretel (Gemma Arterton) save a supposed witch from burning after proving she is not a witch. They inform the town that they are aware of many children gone missing, but Hansel and Gretel are on the case. Armed with shotguns and crossbows and wearing black leather trenchcoats, they set about chasing a real witch through the forests. From her, they find a scroll regarding the eclipse of the moon, a night that is most holy for witches. They believe this event is connected to the missing children. The Mayor (Rainer Bock) of this town sends Hansel and Gretel along with Jackson (Bjorn Sundquist), a man who knows the forests inside and out. Meanwhile, the Sheriff Berringer (Peter Stormare) sends out his own group of men to hunt down the witches, but who end up disemboweled and mutilated during their first outing.

During their witch hunt, Hansel and Gretel learn that the witches need one more little girl in order for their master plan to work. The Witch Hunters track down the next possible victim, an 8-year-old girl who ends up being taken away by a troll named Edward (Derek Mears, voiced by Robin Atkin Downes) during a night raid. More clues become uncovered regarding the witch's plans, Hansel and Gretel get some aide from a young admirer of their work (Thomas Mann), Gretel lives with haunting visions of her parents' demise and Hansel gets some help from an eventual love interest who happens to be the woman they saved from being hanged in the town square, a lovely red-head named Mina (Pihla Viitala).

Most of *Hansel and Gretel: Witch Hunters* plays out with a straight face while the action sequences take on a more cartoonish tone. The mix is wildly uneven, even though there are clever moments within the action (a gag involving a witch's broom is particularly funny). But the movie can almost be summed up in one moment where the main witch, Muriel (Famke Janssen), explains to Hansel and Gretel a lot of backstory, which prompts Hansel to attack her while telling her she talks too much. Director Wirkola seems so much more preoccupied with the action sequences (which are decent) and showing off the arsenal of weapons than with figuring out a good reason for this story to be (re)told.

Alas, there are too few surprises within the narrative and *Hansel and Gretel: Witch Hunters* becomes just another take on an old tale. While not unwatchable, it lacks a cleverness to make it truly memorable. Mixing machine guns and grenades with black magic and enchantment is not enough to warrant the cult following it desperately wants. The film is gory, but it often relies on CGI gore, which only does so much to get the horror fans excited. Renner and Arterton seem to be having fun here, but the script is not worthy of their talents. The film was the surprise #1 hit on its opening weekend, but not surprisingly, still failed to make a lasting impression. It clocks in at 88 minutes, ten of which are credits. Wirkola's creation is simply part of a once commercially viable trend, one that has yet to find a gold standard.

Collin Souter

CREDITS

Hansel: Jeremy Renner
Gretel: Gemma Arterton
Muriel: Famke Janssen
Berrigner: Peter Stormare
Edward: Derek Mears
Origin: United States
Language: English
Released: 2012
Production: Beau Flynn, Chris Henchy, Adam McKay, Kevin J. Messick; Metro-Goldwyn-Mayer Inc.; released by Paramount Pictures
Directed by: Tommy Wirkola
Written by: Tommy Wirkola
Cinematography by: Michael Bonvillain
Music by: Atli Orvarsson
Sound: Karen M. Baker
Editing: Jim Page
Art Direction: Andreas Olshausen
Costumes: Marlene Stewart

Production Design: Stephen Scott
MPAA rating: R
Running time: 88 minutes

REVIEWS

Abele, Robert. *Los Angeles Times.* January 26, 2013.
Corliss, Richard. *TIME Magazine.* February 4, 2013.
Howell, Peter. *Toronto Star.* January 25, 2013.
Lumenick, Lou. *New York Post.* January 25, 2013.
Russo, Tom. *Boston Globe.* January 26, 2013.
Sachs, Ben. *Chicago Reader.* February 4, 2013.
Savada, Elias. *Film Threat.* June 6, 2013.
Staskiewicz, Keith. *Entertainment Weekly.* January 25, 2013.
Uhlich, Keith. *Time Out New York.* February 4, 2013.
Zacharek, Stephanie. *Village Voice.* January 29, 2013.

TRIVIA

The director makes a cameo appearance in the film as one of Berringer's deputies.

A HAUNTED HOUSE

This $%! ain't paranormal.*
—Movie tagline

Box Office: $40 Million

Few comedies have reeked with more cringe-inducing desperation than *A Haunted House,* an alleged horror-parody more amateurish than the most bargain-basement FEARnet fodder. Co-writer, producer, and star, Marlon Wayans, is certainly no stranger to satire, having previously headlined the *Scary Movie* franchise, which feeds off box office hits, offering little more than crude spins on stolen scenes. Wayans could have taken this new project as an opportunity to compete with the audience-insulting dreck of *Scary Movie 5* (2013), offering something fresh and surprising. Instead, he has made something even worse.

The primary target in *Haunted House* is found footage thrillers, a subgenre ripe for skewering thanks to the increasingly ludicrous *Paranormal Activity* (2010-2014) series. Everything that made Oren Peli's original installment so marvelously effective has been ignored by filmmakers intent on saturating the screen with laughably over-the-top digital effects. Peli's ability to build suspense in static shots through the use of exquisitely subtle shadows and sound design was a refreshing departure from the ADD-addled edits and contrived jolts that have caused many a modern thriller to fall flat.

Wayans could have had a field day in cleverly satirizing the generic methods Hollywood utilizes to cash in on an ingenious micro-budget gem. Yet the proudly profane comic seems interested in only one element of Peli's film: its whiteness. Since Peli's protagonists are a young, Caucasian couple terrorized by invisible demons, Wayans apparently views them as foreign entities. How else to explain the endless cracks Wayans makes about the differences between "blacks and whites," as if he is bound to champion the continuing segregation of American cinema? It is not the vulgarity of Wayans's shtick that appalls. It is the mean-spiritedness residing at its core that truly sickens.

Rather than go through the trouble of writing a new script, Wayans simply plagiarizes Peli's tremendously profitable hit story beat-by-story beat. He casts himself as the camera-obsessed ghost hunter, while the appealing Essence Atkins is subjected to a multitude of grotesque humiliations as his possessed girlfriend. Instead of mining the humor inherent in a couple's awkward first days living together, Wayans indulges in gags involving compulsive masturbation and thunderous flatulence. Many scenes follow this formula: an unfunny joke is told and dies immediately. Then it twitches and writhes on the screen for what feels like an eternity, as if aiming to wring a laugh through pure repetition.

Consider the tendency of editor Suzanne Hines, presumably under the guidance of Wayans and director Michael Tiddes, to artlessly stitch together multiple riffs for a given scene, thus supplying ten lame punch-lines per setup as opposed to one. Even Judd Apatow, a filmmaker notoriously prone to letting sketches outstay their welcome, is smart enough to assemble alternate improvisations in "Line-O-Rama" DVD special features, rather than pack them all into the final cut. Wayans's multi-gag sequences are the cinematic equivalent of that twerp in grade school who amused himself by repeatedly poking his classmates while asking "Does this bug you?" Sadly, unlike that kid, *A Haunted House* cannot be swatted away. It can only be endured.

To further emphasize the dividing line between characters of different skin color, the script co-authored by Wayans and Rick Alvarez ensures that every white person onscreen is a blithering fool. What is worse is that they all harbor an unsettling preoccupation with Wayans's nether regions, none more so than a flaming psychic played by Nick Swardsen, a.k.a Bucky Larson, who cheerfully embodies the sort of homophobic stereotypes only closeted frat boys would find hilarious. Even Cedric the Entertainer fails to live up to his name as an exorcist sentenced to perform the umpteenth take-off on William Brent Bell's insipid *The Devil Inside,* which Wayans has further mocked in the poster art for *A Haunted House 2.*

Only one shot in the entire 87-minute ordeal displays a glimmer of comic potential. It takes place during a grim breakfast as Wayans and Atkins attempt to ignore an abusive poltergeist as it wreaks havoc on the kitchen. When Atkins reaches for her glass, the invisible vexation pushes it off the table, prompting her to deliver the deadpan quip, "Good thing we switched to plastic." For that fleeting moment, the film stops trying to offend every audience member with an I.Q. well over the single digits, and decides to simply be funny. Perhaps Wayans should try that approach next time.

Matt Fagerholm

CREDITS

Malcolm: Marlon Wayans
Kisha: Essence Atkins
Father Williams: Cedric the Entertainer
Dan the Security Man: David Koechner
Chip the Psychic: Nick Swardson
Origin: United States
Language: English
Released: 2013
Production: Marlon Wayans, Rick Alvarez; Automatik Entertainment, Endgame Entertainment, Wayans Bros. Entertainment; released by Open Road Films
Directed by: Michael Tiddes
Written by: Marlon Wayans; Rick Alvarez
Cinematography by: Steve Gainer
Sound: Ken Pries
Music Supervisor: Andy Ross
Editing: Suzanne Hines
Costumes: Ariyela Wald-Cohain
Production Design: Fred M. Andrews
MPAA rating: R
Running time: 87 minutes

REVIEWS

Connelly, Sherilyn. *Village Voice*. January 15, 2013.
Cunningham, Joe. *Empire*. May 27, 2013.
Genzlinger, Neil. *New York Times*. January 11, 2013.
Groen, Rick. *Globe and Mail*. January 24, 2013.
Hoffman, Jordan. *Film.com*. February 26, 2013.
Jones, Kimberly. *Austin Chronicle*. January 16, 2013.
Leydon, Joe. *Variety*. January 11, 2013.
Nordine, Michael. *Slant Magazine*. January 11, 2013.
Olsen, Mark. *Los Angeles Times*. January 11, 2013.
Rabin, Nathan. *AV Club*. January 11, 2013.

QUOTES

Malcolm: "You made a deal with the devil for a pair of shoes?"
Kisha: "Not shoes, Malcolm! Louboutins, okay?"

TRIVIA

Marlon Wayans and Essence Atkins also appeared together in *Dance Flick.*

AWARDS

Nominations:

Golden Raspberries 2013: Worst Support. Actor (Swardson)

THE HEAT

Good cop. Mad cop.
 —Movie tagline
Action's never been so hot!
 —Movie tagline

Box Office: $159.6 Million

In 1988, actress Mary Gross playfully aimed an orange rubber gun at her bathroom mirror in the Dan Goldberg film *Feds*, a comedy about two women of opposing physical and mental skill who train to be in the FBI; the first female-led feature film in the boy's club buddy cop genre, and the only one until Paul Feig's *The Heat*. Though the characters played by Gross and co-star Rebecca De Mornay were given assignments at the end of the film to dominate agency's Los Angeles branch, they were not granted a sequel due to poor box office response. But which to blame for its $3.8 million total haul, especially when Mike Nichols' *Working Girl* would accumulate $102.9 million worldwide when released only two months later? The audience desired or the rubber gun?

Introduced with the poignant toe-tapping funk of "Fight the Power (Part 1 & 2)" by the Isley Brothers, *The Heat* begins with the usual buddy cop portrait—two law members with their own methods to catch bad guys. FBI Special Agent Sarah Ashburn (Sandra Bullock) uses a smart-aleck attitude to thwart crooks and simultaneously distance herself from her less-coordinated male coworkers; Boston cop Shannon Mullins (Melissa McCarthy) exhibits physical force, chasing down her suspects while another arrestee is screaming in the back of her car. The two are united when Ashburn ventures to Mullins' turf of Boston to catch a drug lord named Larkin, whom Mullins' brother Jason (Michael Rapaport) recently went to jail for. When the two are both assigned to the case, they soon find that their work ethics complement each other, and begin working through a chain of criminals while Mullins tries to protect her brother, and her family.

Given her acting and producing work with films like *The Proposal* (2009), *All About Steve* (2009), and even *Miss Congeniality 2: Armed and Fabulous* (2005),

Bullock is no stranger to embodying the conservative appearance of the career woman, one whose dorky imperfections in spite of her intellect and motivation are usually pointed towards the finish line of a man's approval. While her character may not be that singularly crafted to lead her own film, Bullock does indeed work best as the distinct opposite charge to the power that is McCarthy's rampant presence.

Spearheading the film's "women behaving badly" charge she defined in her previous collaboration with Paul Feig, *Bridesmaids* (2011), McCarthy plays a free-spirited slob whose comedy feels less calculated than her previous incarnations; Mullins is also a character less shallow about McCarthy's charisma compared to her 2013 lead debut *Identity Thief*. Her abrasive comic timing is as vivid as ever, with a reasonable percentage of her golden remarks involving half-sarcastic threats to murder someone. Certainly one of *The Heat*'s more exhilarating bids to Hollywood from its feminist point of view concerns how to Mullins' peers perceive her; underneath a teasing level of light emasculation, she has the respect of her policemen peers as an equal. Though with some sappy dialogue in its more sentimental moments opposite Rapaport, McCarthy also defies the comedy's boxing of the easy "mentally unstable" overweight character, presenting a colorful individual who has a tangible heart for the values usually only seen on the surface in similar movies.

Debut feature screenwriter Katie Dippold shows strong promise, and places her story next to similar films such as *Lethal Weapon* (1987) and *Rush Hour* (1998), with a joke-heavy script that is well educated on the constructs of Hollywood's beloved buddy cop movie subgenre. Best of all, she is fairly sharp on how to create surprising comedy when events are following the expected course. As the one giving vision to Dippold's words, Feig provides further evidence with *The Heat* that his ideological intentions are more involved than his directorial skills, as he assembles the film's more genre-based components to be a tad too generic. A climax occurs in the remarkably stock location of the warehouse, and the criminal mystery that drives the film's plot is desperate for a spark of curiosity. Robert Yeoman, a cinematographer with the ability to bring immensely distinct images when working for other directors like Wes Anderson, is in automatic mode.

The proudly brash attitude of *The Heat* is supported by the film's soundtrack, which features various rap songs from contemporary performers like Angel Haze (her song "Werkin' Girls" is featured) and Kreayshawn (the latter who vows to "burn this m**********r down like I'm Left Eye" in her track "Left Ey3"). The film's love for female companionship reaches a warming moment when Bullock and McCarthy are shown slow dancing in a tight embrace to Air Supply's "Every Woman in the World."

Like *Bridesmaids*, *The Heat* maintains its priority focus on the non-glamorous nuances of friendship (in this case, between women) while this time simultaneously eschewing any pressure for heterosexual love interests. Such a component is minimized with specific intent to defeat this particular expectation, in which only tactful hints are given to their relationship with men. Mullins is revealed in various conversations with randomly appearing men to be a promiscuous heartbreaker, and Ashburn has a professional relationship with a coworker named Levy (an unusually sweet Marlon Wayans), which hints at a potential romance but one nonetheless grounded on mutual respect.

Thankfully, for its mission of progress within popular entertainment, *The Heat* compensates for its indifferent elements with its abundant silly comedy, often based on the lead duo's ping-pong chemistry, itself a credit to the script's excellent taste for character-based jokes. While Feig doesn't have the producing pressure of man-child entertainment mogul Judd Apatow to squeeze in humor considered immediately more male friendly as he did with *Bridesmaids*, *The Heat* pulls off a fine balancing act between navigating the usually phallic action genre while focusing on female characters. With tact that transcends demographics, *The Heat* cracks jokes based from female experience (dorky suitors at nightclubs, the constriction of Spanx) within the wider range of comedy about career-driven individuals who are cops.

The Heat is certainly driven by its feminism, but maintains a functional open humor about expressing it. Humorous passages that include gratuitous references to castration and/or emasculation are done with winks from the script, in conjunction with at least a couple of gags in which these women are confused in appearance for being men. This is one of the film's more reflexive jokes, as Dippold has crafted a script that certainly does not confuse power of weaponry for masculinity, a byproduct of male gaze that can be witnessed in numerous action films where women are empowered by male filmmakers simply with violence.

Twenty-five later after *Feds*, *The Heat* entered the multiplexes and became one of the biggest successes of a historically bloated summer. With no sight of a rubber gun, its focus on career women whose advancement beyond training is a non-issue. Now, the subgenre of the "female buddy cop" has two films to its name. For those

keeping track, that is still one less than those about policemen working with dogs.

Nick Allen

CREDITS

Special Agent Sarah Ashburn: Sandra Bullock
Det. Shannon Mullins: Melissa McCarthy
Hale: Demian Bichir
Levy: Marlon Wayans
Jason Mullins: Michael Rappaport
Mrs. Mullins: Jane Curtin
Capt. Woods: Thomas F. Wilson
Origin: United States
Language: English
Released: 2013
Production: Peter Chernin, Jenno Topping; Chernin Entertainment; released by Twentieth Century Fox Film Corp.
Directed by: Paul Feig
Written by: Katie Dippold
Cinematography by: Robert Yeoman
Music by: Michael Andrews
Sound: Andrew Decristofaro
Editing: Jay Deuby; Brent White
Costumes: Catherine Marie Thomas
Production Design: Jefferson Sage
MPAA rating: R
Running time: 117 minutes

REVIEWS

Brody, Richard. *New Yorker.* July 1, 2013.
Hornaday, Ann. *Washington Post.* June 27, 2013.
Lemire, Christy. *ChristyLemire.com.* August 8, 2013.
Long, Tom. *Detroit News.* June 28, 2013.
Rainer, Peter. *Christian Science Monitor.* June 28, 2013.
Scott, A. O. *New York Times.* June 27, 2013.
Sharkey, Betsey. *Los Angeles Times.* June 27, 2013.
VanDenburgh, Barbara. *Arizona Republic.* June 27, 2013.
Weitzman, Elizabeth. *New York Daily News.* June 27, 2013.
Whitty, Stephen. *Newark Star-Ledger.* June 28, 2013.

QUOTES

Mullins: "I'll shut the door on you. You lay down here and put your head in the door. And I'll slam it about 157,000 times."

TRIVIA

When the script for the film was first sent to director Paul Feig, it was called "'Untitled Female Buddy-Cop Comedy."

HER

Box Office: $24.6 Million

Spike Jonze has been one of Hollywood's most interesting directors for years but his first film for which he crafted an original screenplay himself is a leap forward from his already-respected position in the filmmaking community. A winner of multiple writing awards and an Oscar nomination for Best Screenplay (along with a nomination for Best Picture), *Her* is a masterpiece; a brilliant commentary on connection, technology, and human interaction that simultaneously speaks to where the world is in 2013 and addresses timeless themes of loss, love, and individuality in a world built around partnerships and community. How do people connect with one another people? Why do some people push away the men and women who could do the best for them in the long run? Why is the human brain and heart designed to hold on to failed relationships long after the point that they are doing any good? Most of all, what defines a relationship? The life-changing relationship at the core of *Her* has no physical component but Jonze seeks to prove that it is not always through touch that people grow or change. Rarely have these internal dynamics been more brilliantly captured on film.

Theodore (Joaquin Phoenix) makes a living crafting emotions for other people (not at all unlike the filmmaker who turns his personal feelings on love into a film like *Her*). In the near-future, one with a more Asian tinge to its architecture and higher-waisted pants, Theodore works for a company that writes letters for clients. In the same way that people use memes or another's words to reflect their love through social media in 2013, Jonze imagines a company where that concept is taken just a step further. Theodore receives photos and personal information for his assignments and then crafts them into something individualized and unique; not unlike an operating system that takes in information and provides a personal response.

Theodore is also sad and lonely. He is still holding on to a relationship (with Rooney Mara, who plays a filmmaker herself who could be read as an iteration of Sofia Coppola, to whom Jonze was married) that long ago lost its passion and having serious trouble meeting people. A good friend of his (played beautifully by Amy Adams) sets him up on a date with a gorgeous woman (Olivia Wilde) but Theodore does not seem physically ready for the intimacy and it ends awkwardly. Physical, common human interaction can lead to miscommunication, unstated anxieties, and other elements that do not exist in a world increasingly reliant on tailor-made technological developments. In other words, humans are more complicated than machines. Or are they? Jonze is often brilliantly hinting at the fact that men and women are not that distinct from machines whether it is in the way Theodore produces product like a computer program or in the way Adams' character has crafted a

video game in which the player controls a mother who gets points for completing certain matriarchal tasks. Even mothers can be reduced to things that earn points. And Theodore keeps playing a video game in which he interacts with a foul-mouthed child. It is the interaction and how he handles it that matters most of all. In this world, and the real one, every interaction, whether it be human or machine, is both personal and programmed.

Theodore's life changes when he meets Samantha (voiced by Scarlett Johannson, who replaced Samantha Morton in post-production after Morton handled most of the lines on-set). He "meets" her as she is his new "Intuitive Operating System," a Siri-esque technology in the future that does a lot more than connect people to Facebook or direct them to the nearest Starbucks. At first, Samantha feels like a program designed to appeal to Theodore, responding to his input in much the same way that early days of human relationships are defined by trying to appease one another. And then Samantha grows, becoming Theodore's closest friend, someone who listens to him, challenges him, and actually changes with him; something else that happens in the best real-world relationship. In a series of remarkably written exchanges that feel more truthful and emotional than most romantic dramas between two actual people, Theodore and Samantha fall in love, and that love alters one another. The computer program rewrites itself, finding a capacity of emotion that is not really there in real people. Why not? Why do men and women limit their capacity for love? Why do they not want to fill their hearts in the same way that Samantha does?

Her is conceptually brilliant to be certain although it is a tonal tightrope that demands pitch-perfect execution to make its screenplay work. Jonze and his team have crafted a wonderful piece of cinema in terms of technical elements, from the art direction that perfectly captures a near-future that feels real to the great score from Arcade Fire to the beautiful cinematography that often plays with reflections and images shot through glass (a symbol for how people can be together but separate and a visual motif that fits thematically with the concept of sensory deprivation in that Theodore can never see Samantha). Every technical aspect of *Her* is well-above average, adding to the overall artistic quality of the piece in ways that make the film hum from first frame to last. This is one of those incredibly rare films in which it is difficult to find even a minor flaw. Every shot, every musical choice, every line feels both carefully considered and organic to the characters. This is such delicate subject matter that some people dismissed it wholesale as the "movie where a guy falls in love with his software" and if Jonze and his team (or cast) had faltered in any way, it would have hit the floor with a thud. It is not just one of the most thematically ambi-

tious films in years but so delicately human at the same time.

It helps that an actor as talented and completely committed as Phoenix plays Theodore. Few actors have ever alternated such distinctly different roles as Phoenix's emotional, internal work here as compared to his hunched-over, animal-like work in P.T. Anderson's *The Master* (2012). It is a beautiful performance, largely because it is not showy at all, never pulling focus from the storytelling or thematic playfulness of Jonze's script. And when one thinks about the fact that Phoenix had to play many of his scenes alone, and not having the crutch of a physical partner to work off of, his work here becomes even more remarkable and underrated. He is completely matched by Adams, Mara, Wilde, and, most of all, Johannson, who gives arguably the best voice-only performance in film history. Johannson imbues Samantha with more than just sexuality, courting Theodore almost with her playfulness, sense of humor, intelligence, and, in another interesting twist, her support level. She helps Theodore at work, in his video game, at managing assignments—Jonze could be noting how much men need someone just to help them get through the day as much as they do emotional interaction.

All of the elements of *Her* work but it is primarily a display of Spike Jonze's true genius; yes, genius. More than any 2013 film, *Her* should be silly, over-the-top, and unbelievable if one considers only its pitch. It should be cold and a commentary on the isolation caused by our increasing reliance on technology. Instead, it is passionate, filled with romance, love, and optimism about man's place in the world. As opposed to other filmmakers who have looked at technology and cried out for reason in a world that seems increasingly disconnected, Jonze looked at it as a way to comment on that which connects us all.

Brian Tallerico

CREDITS

Theodore: Joaquin Rafael (Leaf) Phoenix

Amy: Amy Adams

Catherine: Rooney Mara

Paul: Chris Pratt

Samantha: Scarlett Johansson (Voice)

Origin: United States

Language: English

Released: 2013

Production: Megan Ellison, Vincent Landay, Spike Jonze; Annapurna Pictures; released by Warner Brothers

Directed by: Spike Jonze

Written by: Spike Jonze
Cinematography by: Hoyte Van Hoytema
Music by: Owen Pallett
Sound: Ren Klyce
Editing: Jeff Buchanan; Eric Zumbrunnen
Art Direction: Austin Gorg
Costumes: Casey Storm
Production Design: K.K. Barrett
MPAA rating: R
Running time: 126 minutes

REVIEWS

Dargis, Manohla. *New York Times*. December 17, 2013.
Dowd, A. A. *The A.V. Club*. December 18, 2013.
Hornaday, Ann. *Washington Post*. December 24, 2013.
Morgenstern, Joe. *Wall Street Journal*. December 19, 2013.
Persall, Steve. *Tampa Bay Times*. January 9, 2014.
Phillips, Michael. *Chicago Tribune*. December 24, 2013.
Rea, Steven. *Philadelphia Inquirer*. January 10, 2014.
Rodriguez, Rene. *Miami Herald*. January 9, 2014.
Tobias, Scott. *The Dissolve*. December 16, 2013.
Turan, Kenneth. *Los Angeles Times*. December 17, 2013.

QUOTES

Theodore: "Sometimes I think I have felt everything I'm ever gonna feel. And from here on out, I'm not gonna feel anything new. Just lesser versions of what I've already felt."

TRIVIA

During some of the more emotional scenes, actress Amy Adams would sing songs from musicals like *Annie* and *The Rocky Horror Picture Show* to cheer herself up. Occassionally, actor Joaquin Phoenix would join her. They stopped when they learned that director Spike Jonze was filming them.

AWARDS

Oscars 2013: Orig. Screenplay
Golden Globes 2014: Screenplay
Writers Guild 2013: Orig. Screenplay
Nominations:
Oscars 2013: Film, Orig. Score, Production Design, Song ("The Moon Song")
Golden Globes 2014: Actor—Mus./Comedy (Phoenix), Film—Mus./Comedy

A HIJACKING
(Kapringen)

Box Office: $414,437

Tobias Lindholm's first solo effort as director is an agonizing symphony of suspense stripped of all synthetic safeguards. As a frequent collaborator of Dogme 95 trailblazer Thomas Vinterberg, Lindholm has an inherent allergy to the sort of melodramatic sentiment so prominent in Hollywood features. Every frame is infused with the palpable threat that anything can happen and no one, not even the most well-liked and innocent of souls, is in safe hands.

At a time when crowd-pleasing escapism routinely proves to be the most marketable commodity to international audiences, Danish cinema provides a refreshing alternative. There is a chilling silence inhabiting the void usually filled by warm-toned reassurance. Take Paul Greengrass's American Oscar bait, *Captain Phillips* (2013), an expertly-staged thriller recounting the 2009 hijacking of a US ship by Somalian pirates. Although the picture is bolstered by Greengrass's typically compelling realism fueled by ragged-yet-never-incoherent camerawork, it is frequently undermined by an obtrusive score, cardboard characterizations, and an utter lack of interest in the complex factors that led to the central predicament.

Lindholm's film is also about Somali hijackers holding the crew of a cargo ship hostage, though in this case, the ship is a Danish vessel with no credible market value. Whereas Phillips was ultimately rescued by a fleet of Navy ships, the crew in *A Hijacking* is forced to wait a grueling eighteen weeks as negotiations drag on between their increasingly perturbed captors and the maddeningly aloof officials at their shipping company in Copenhagen. With his steely features and vaguely sinister disposition befitting *Matrix*-era Hugo Weaving, the CEO, Peter, initially appears to be the sort of opportunistic businessman more fearful of squandering cash than losing lives. However, it quickly becomes apparent that Peter's biggest downfall is not a lack of heart but an excess of hubris.

So confident is Peter in his negotiating skills that he insists on communicating with the hijackers himself against the better judgment of an expert advisor, who urges him against offering too much money up front. The grand masterstroke of Lindholm's script is its juxtaposition of the chaos onboard and the silent, sterile interiors of the company offices on land. Key events, including the hijacking itself, are left off-screen, causing the audience to share in the mounting dread of the crew's distraught loved ones, particularly the wife and child of Mikkel, a chef whose devolution from sensitive caregiver to traumatized zombie is utterly heartbreaking to behold.

Three performances are absolutely crucial in anchoring the picture in a viscerally emotional reality. Pilou Asbak brings Mikkel an endearing sweetness and vulnerability that feel entirely genuine, while Soren Malling is

flat-out mesmerizing as Peter, whose impenetrable mask of self-assurance is quietly ruptured by the indifference of the universe. Perhaps the trickiest role of all is that of the English-speaking Somali translator, Omar, played by newcomer Abdihakin Asgar as a chillingly matter-of-fact intermediary. He takes offense at anyone claiming he is a hijacker, and insists that he is one of the hostages, though he has no qualms with holding crew members at gunpoint during desperate phone calls with their ever-distant boss.

Lindholm co-wrote Vinterberg's *The Hunt* (2013) a spellbinding showcase for Mads Mikkelsen, who was deservedly named Best Actor at Cannes for his performance as a teacher wrongly accused of molestation. Both films are masterful at conjuring a frighteningly authentic sense of paranoia, as its protagonists find themselves increasingly alienated from their allies until they are cast adrift much like Robert Redford in *All Is Lost* (2013). Mikkel has nothing but his sanity to cling to, and by the hundredth day, that asset begins to appear feeble as well.

What prevents the film from becoming a suffocating pressure-cooker are the moments of levity organically fueled by the restlessness of men forced into uneasy circumstances. Two of the crew members are invited by the hijackers to breathe in their first mouthful of fresh air in two months, while taking part in an afternoon of fishing. This leads to an achingly poignant moment shared by the men as they sing "Happy Birthday" to Mikkel, who remembers that it is his daughter's birthday, suddenly placing the celebration in a wistful context.

Some critics have applauded the film for its "pessimistic" ending, yet in many ways, it is no less troubling than the final moments of *Captain Phillips,* as its unflappable star, Tom Hanks, succumbs to post-traumatic stress disorder. Any film about a hijacking would feel dishonest if it did not end on a sobering note, yet it is the sheer senseless cruelty of Lindholm's ending that delivers such a wrenching blow to audiences. The brilliant use of title cards numbering the days of the hostage crisis suggest that the victims are still imprisoned even after they have reached friendlier shores. Many viewers may overlook the glimmer of hope, epitomized by two clasped hands, that is observed in a wide shot of unsparing sorrow.

Matt Fagerholm

CREDITS

Mikkel Hartmann: Pilou Asbaek
Peter Ludvigsen: Soren Malling
Origin: Denmark

Language: Danish
Released: 2013
Production: Rene Ezra, Tomas Radoor; released by Nordisk Film A/S
Directed by: Tobias Lindholm
Written by: Tobias Lindholm
Cinematography by: Magnus Nordenhof Jonck
Music by: Hildur Guonadottir
Sound: Morton Green
Editing: Adam Nielsen
Production Design: Thomas Greve
MPAA rating: R
Running time: 103 minutes

REVIEWS

Glasby, Matt. *Total Film.* May 14, 2013.
Lodge, Guy. *Variety.* March 18, 2013.
Lyttelton, Oliver. *The Playlist.* March 18, 2013.
Morgenstern, Joe. *Wall Street Journal.* June 20, 2013.
Nehme, Farran Smith. *New York Post.* June 20, 2013.
Rainer, Peter. *Christian Science Monitor.* June 21, 2013.
Rothkopf, Joshua. *Time Out New York.* June 18, 2013.
Scott, A. O. *New York Times.* June 20, 2013.
Vishnevetsky, Ignatiy. *A.V. Club.* June 19, 2013.
Zacharek, Stephanie. *Village Voice.* June 18, 2013.

QUOTES

Connor Julian: "We can't rush these people. Time is a Western thing. It means nothing to them."

TRIVIA

To make the phone call scenes between Soren Malling and Pilou Asbak appear authentic on film, director Tobias Lindholm filmed those scenes as actual conference calls with Malling in Denmark and Asbak in Somalia.

THE HOBBIT: THE DESOLATION OF SMAUG

Beyond darkness...beyond desolation...lies the greatest danger of all.
—Movie tagline

Box Office: $256.6 Million

The Desolation of Smaug, Peter Jackson's second chapter in his super-sized retelling of J.R.R. Tolkien's 300-page fantasy novel, *The Hobbit,* is a hard film to judge on its own merits because, at its heart, it's not really a film. It's not even a story. There is no beginning, middle, or end to *The Desolation of Smaug.* It is, unrepentantly, a second chapter. It is an excerpt from a much

larger story. It is almost three hours of pure middle. And, while that may delight any hardcore Tolkien fans who are primarily interested in seeing their favorite passages reenacted in explicit detail, any casual film fan who follows Bilbo Baggins into *The Desolation of Smaug* will probably find themselves underwhelmed and frustrated by the journey.

Perhaps part of the blame for *The Desolation of Smaug*'s rather blatant story problems lies at the feet of *The Empire Strikes Back*, possibly the most famous second chapter in cinema history. Fans have often cited *Empire*'s cliffhanger ending—with Han Solo trapped in carbonite and the Rebellion on the run—as one of its strongest features, which has undoubtedly inspired many subsequent film trilogies (*Back to the Future*, *The Matrix*, etc.) to follow *Empire*'s model and conclude their own second chapters with abrupt "To Be Continued" endings. However, what many people fail to understand about *The Empire Strikes Back* is that, despite the fact that every plotline is not tied up with a bow in the end, the movie does have a very definite beginning, middle, and end. Storylines fully play out during *Empire*'s running time as characters grow, develop, and change. Luke starts off a questing, naive hero, trains to become a Jedi, faces a trial, fails that trial, and becomes a different person because of it. Han and Leia start the movie with an adversarial relationship, which evolves and softens during their extended flight from the Empire, and eventually transforms into love. Even with its cliffhanger ending, in a narrative sense, *Empire Strikes Back* is a surprisingly complete movie. But many people have failed to grasp that concept over the years and simply refer to it as the "middle movie." It is the movie that was cool because it did not have to bother with beginnings or endings. And that is simply not the case.

Peter Jackson, it seems, might be one of those people who missed exactly how much work *The Empire Strikes Back* put into its storytelling because the second chapter in his newest trilogy, *The Hobbit: The Desolation of Smaug*, has no discernable story. Picking up where the surprisingly stronger *Unexpected Journey* left off, *The Desolation of Smaug* opens with Bilbo Baggins (Martin Campbell), Gandalf the Grey (Ian McKellen), Thorin Oakenshield (Richard Armitage), and his dwarf brethren on the run from Azog the Defiler, the creepy albino orc who almost vanquished them in the conclusion of the last movie, until the proto-fellowship was saved by Tolkien's favorite deus ex machina, the eagles. Bilbo and friends are still headed towards the Lonely Mountain, where a massive dragon named Smaug (mellifluously voiced by Benedict Cumberbatch) has occupied the dwarves' former home. With Bilbo's help, Thorin and his kin hope to sneak into Smaug's treasure horde deep under the mountain, steal back the Arkenstone (a mysti-

cal gem that the dwarves regard as a mantle of power), kill the dragon, and use the gem to restore Thorin to his rightful throne and revive their withered kingdom.

Regrettably, the majority of *The Desolation of Smaug* is spent getting our heroes from one place to another—inching closer and closer to the Lonely Mountain—and very obviously setting up plot details that, we assume, will be important in *The Hobbit 3*. Later on, we meet Bard the Bowman (Luke Evans), a remarkable archer with a personal score to settle with Smaug and who just-so-happens to own the last remaining Black Arrow that can kill the evil dragon. This is a movie that cares more about what happens in the next movie than it cares about itself, a quality that makes *The Desolation of Smaug* particularly unsatisfying to watch.

The opening of the film has an extended sequence where Bilbo and his dwarf fellowship encounter a "skin-changer" named Beorn, who can transform himself into a bear. There are several scenes where it is implied that Beorn is massively powerful—even Azog the Defiler is wary of his strength—and yet, for all of that build-up and screen time, Beorn does next to nothing in *The Desolation of Smaug*. In the end, he loans the fellowship ponies. That is it. The legendary bear-man gives them horses, which they use to ride across one field, and then abandon them to proceed further on foot. In any other movie, directed by anyone else even passingly familiar with the rule of "Chekov's Gun," the pointless Beorn aside would have been cut from the script immediately, but, because Jackson's audience is painfully aware that they are watching a trilogy, the Beorn scenes remain intact because, one assumes, they will have some importance in the third chapter.

Scenes like this persist throughout *The Desolation of Smaug*, accompanied by supporting scenes that—much like *An Unexpected Journey* did—borrow heavily from Jackson's previous *Lord of the Rings* trilogy. Gandalf finds a clue regarding the darkness creeping over Middle Earth (a mystery to only himself, because the audience has undoubtedly already seen the other movies) and leaves Bilbo and friends behind to investigate (just like he did in *The Two Towers*). Bilbo's fellowship fights through an angry pack of spiders (like Frodo did in *Return of the King*) and are eventually rescued and subsequently detained by a group of elves (like in *Fellowship of the Ring* and *An Unexpected Journey*). However, breaking from tradition, these elves are grumpy elves, led by Thranduil (Lee Pace), elven-father to Legolas (Orlando Bloom), whom we all remember from the original trilogy. Thranduil offers to help Thorin on his quest to the Lonely Mountain, if he gets a cut of the loot from Smaug's treasure pile. The indignant Thorin, still mad that the elves didn't help his ancestors fight Smaug, refuses, and Thranduil has the dwarves locked

up in his dungeons. Fortunately, their burglar Bilbo has been experimenting with the magical ring he swiped from Gollum in the last movie, so he's able to turn invisible and help his dwarf compatriots escape in pilfered wine barrels that he sets loose in a raging river. There are some exciting action beats throughout these sequences—the wine barrel escape is so ridiculously overdone that it is fairly entertaining—but, at the end of the day, all these scenes accomplish is getting Bilbo and Thorin moderately closer to the Lonely Mountain.

In the first Hobbit movie, *An Unexpected Journey*, even though the film took an excruciating amount of time to get going, there were actually defined character arcs. Bilbo Baggins started the film as a homebound neurotic, who pushed his fears away to go on an adventure, went through a series of trials, and emerged heroic and respected by his peers at the end of the film. Thorin Oakenshield began his unexpected journey filled with doubt about Bilbo and Gandalf, spent most of the film stubbornly rejecting the advice of those around him, and yet, after he is saved by Bilbo, ends the movie embracing Bilbo and admitting that he was wrong about his hobbit companion. Both characters, for better or worse, evolved and changed during *An Unexpected Journey*. Unfortunately, all of that character evolution grinds to a dull halt in *The Desolation of Smaug*. Bilbo and Thorin go nowhere in this film on a character level. They remain at one level throughout the entire movie. Jackson attempts to cover this lack of progression by throwing in some slight shades of deeper meaning at both characters. We see hints that Bilbo is beginning to realize that the One Ring is a bad influence on him and we see Thorin vaguely fret about his family history of obsession and madness, but brief asides do not a character make. Martin Campbell and Richard Armitage have nowhere to take Bilbo and Thorin internally in *The Desolation of Smaug*, so, all they can do is grab their swords, scream, and work their way closer to the Lonely Mountain. In this film, Bilbo and Thorin could have easily been renamed "Scared Guy" and "Angry Guy" and no one would have known the difference.

Surprisingly, the one plotline that almost works, that almost feels like an honest-to-god character arc, is one of the more controversial plotlines in the movie. In order to break up the male-dominated malaise of Tolkien's Middle Earth, Peter Jackson invented a new female character, the elven warrior Tauriel (Evangeline Lilly), and further concocted a forbidden romance between Tauriel and the dwarf Kili (Aidan Turner). While many Tolkien purists hated this addition, the presence of an old-fashioned romance—even something as silly and contrived as the elf-dwarf pairing—adds more depth and emotion to the film than any spider attack or barrel escape ever could.

Bilbo and the dwarves do eventually reach The Lonely Mountain and do eventually meet the titular dragon. The Smaug scenes move quickly, with Cumberbatch sneering up a storm in his best dragon voice, and the resulting battle is a fairly impressive work of CGI mayhem. And yet, the scenes, as expertly choreographed as they are, have extremely low stakes because the audience knows that Smaug will not be defeated until the actual end of the trilogy, not the end of the movie that bares his name. A cliffhanger is, so obviously, coming, and the true conclusion to this story will not be reaching viewers for almost a full calendar year.

This is why it is hard to get excited about a film like *The Desolation of Smaug*. No one learns anything, changes, or falls in love. There is no ending. It is just a film where stuff happens. It is the narrative equivalent of a bridge. One might argue that *The Desolation of Smaug* is a second chapter of a larger story or a mini-series, but, if that was the case, than Jackson should have released all three parts of the story at the same time. Because the best film trilogies are made up of movies that, while they can interconnect to tell a larger story, can all exist perfectly fine on their own as well. One can watch *The Empire Strikes Back* and not have to see any other Star Wars movie to feel like they have been told a complete story. The same thing cannot be said about *The Desolation of Smaug*.

Tom Burns

CREDITS

Gandalf: Ian McKellen

Bilbo Baggins: Martin Freeman

Thorin: Richard Armitage

Legolas: Orlando Bloom

Tauriel: Evangeline Lilly

Bard: Luke Evans

Smaug: Benedict Cumberbatch (Voice)

Origin: United States

Language: English

Released: 2013

Production: Carolynne Cunningham, Zane Weiner, Fran Walsh, Peter Jackson; New Line Productions Inc.; released by Warner Brothers

Directed by: Peter Jackson

Written by: Peter Jackson; Philippa Boyens; Fran Walsh; Guillermo del Toro

Cinematography by: Andrew Lesnie

Music by: Howard Shore

Sound: Chris Ward

Music Supervisor: Karen Elliott

Editing: Jabez Olssen

Costumes: Bob Buck; Ann Maskrey; Richard Taylor
Production Design: Dan Hennah
MPAA rating: PG-13
Running time: 161 minutes

REVIEWS

Buckwalter, Ian. *NPR*. December 15, 2013.
Collin, Robbie. *The Telegraph*. December 12, 2013.
LaSalle, Mick. *San Francisco Chronicle*. December 12, 2013.
Lumenick, Lou. *New York Post*. December 11, 2013.
Osenlund, R. Kurt. *Slant Magazine*. December 7, 2013.
Perez, Rodrigo. *The Playlist*. December 6, 2013.
Puig, Claudia. *USA Today*. December 13, 2013.
Rodriguez, Rene. *Miami Herald*. December 12, 2013.
Snider, Eric D. *Film.com*. December 10, 2013.
Williams, Joe. *St. Louis Post-Dispatch*. December 12, 2013.

QUOTES

Bard the Bowman: "All of you! Listen to me! You must listen! Have you forgotten what happened to Dale? Have you forgotten those who died in the firestorm? And for what purpose? The blind ambition of a Mountain King, so riveted by greed he cannot see beyond his own desire!"

TRIVIA

Director Peter Jackson reprises his cameo as a carrot eating bystander (which he also played in *The Fellowship of the Ring*) in the film's introduction.

AWARDS

Nominations:

Oscars 2013: Sound, Sound FX Editing, Visual FX
British Acad. 2013: Makeup, Visual FX

HOME RUN

> *Freedom is possible.*
> —Movie tagline

Box Office: $2.9 Million

It could be said that baseball, as a metaphor for many things, can also include that of a methodical motion picture; one that takes its time and strategizes every move in the hope of achieving a winning conclusion. Although it is normally the spontaneous moments of action throughout the game that often make the highlight reel and get people talking about it now rather than its place in historical context. Much the same can be said about *Home Run*, which uses baseball as part of its tale of redemption while wearing the agenda of the nation's other notable pastime on its blessed sleeves. No amount of praying can save what is ultimately a shallow, ineptly-made sermon to the choir that requires a lot of faith in a story that is just not believable from the beginning.

Cory Brand (Scott Elrod) is a successful pro baseball player; "pro" as opposed to "major league" since the MLB clearly did not license or endorse this project. As a member of the Denver Grizzlies, his addiction comes not from enhancing pills or hypodermics but in alcohol. Despite a little hair of the dog before a game one evening, he is able to round the bases for an inside-the-park home run. Except by only clearly touching three of them he is called out, triggering an incident that begins by arguing with the umpire—who may want to buy glasses with the ten grand he just robbed from a sick kid on hit-a-homer-for-them night—and ends by accidentally elbowing the bat boy on his way back to the dugout.

Suspended for eight weeks, Cory is enrolled in two programs by his agent (Vivica A. Fox). The first is a rehab program that appears to be wholly based around the second step involving a higher power. The second is coaching a little league team in Okmulgee, Oklahoma to boost his public image after smacking down a child. To complicate things further, the stricken batboy-for-a-day is actually Cory's nephew, brought to the game that day by his estranged brother, Clay (James Devoti). The little league team also belongs to his brother and one of the assistant coaches is Emma (Dorian Brown), the ex-flame that Cory left behind years ago. Viewers will not need a blood test regarding her son. Talk about deus ex machinas.

Plots such as these do not require a lot of heavy lifting to navigate through each impending turn of discourse. Boasting four writers to its credit, this screenplay puts the movie on tilt in the first ten minutes with such a fantastically unbelievable situation that sincerity becomes suspect. The Texas Rangers' Lenny Randle once punched his manager in the face, fracturing his cheekbone. He was suspended thirty days by the team. The Atlanta Braves' John Rocker used offensive language towards minorities and homosexuals and was suspended by the commissioner's office for twenty-eight days. In 2004, the Rangers' Frank Francisco threw a chair into the stands and broke the nose of a female fan. His suspension? Sixteen games. Yet in *Home Run*, a viewer is expected to believe that accidentally socking your own batboy is worth two months, perhaps because this is a world where the word "appeal" only applies to a chosen few.

To be fair, there is an implied progression of angry behavior captured on YouTube (which is never seen.) Plus, Cory was also found to be over the legal limit while playing. Since alcoholism is the driving force towards redemption, it should be noted just how ham-

handed the portrayal of the disease is here. The opening scene presents the roots of Cory's addiction; a drunken father throwing self-called strikes his direction. The scene should certainly be more painful than the barboy who cannot take a punch or more harrowing than the little leaguer verbally harassed by his own father (and team coach) during a game. Instead it becomes increasingly comical as the pitch count rises and visions of Leslie Nielsen in umpire gear spring to mind.

Cory is also one good-looking alcoholic. Whatever effects the drink might have on him are not evident to mirrors or the audience. Anger management is more what this guy needs, especially after he goes nuts when he fails to look under the bed for his baseball cards. Director David Boyd avoids the rough morning-afters and social awkwardness in favor of an unintentionally hilarious car crash (involving a tractor) that leads to the second job during his suspension. True alcoholism needs the rock bottom mentality that was brought to *Flight* (2012) or taken to the extreme lengths of 12-step metaphors that *The World's End* (2013) did for the redemption to not just be earned but honestly felt. Just saying one has learned their lesson because it is that time in the movie betrays the reality—even in fiction—of what actual mental and physical struggle is. Anyone can simply say they have "changed" or that they "believe."

It is actually very easy to avoid the elephant in the room since the film does a good enough job doing that itself. *Home Run* could just be a long commercial for Celebrate Recovery—a real-life "Christ-Centered Recovery Program"—but may end up owing them a refund for presenting it with such little insight into what makes them different from run-of-the-mill programs. After all, God is already mentioned by name in four of the original steps. One of the many roadblocks that religions have faced over the years is proving that their intentions—more than what they believe—are not phony. The pursuit to better oneself through any means is a noble one, but being taken in as a pawn to further an agenda serves not the individual, let alone someone hoping to see a film worthy of its dramatic foundation. When a child suggests their third act plight is like *The Sound of Music* (1965) "only it's not fun anymore without Coach" one could imagine his parents showing him the musical numbers and fast-forwarding through all that Nazi stuff. *Home Run* is very much like Dale's run around the bases; doing a victory lap while completely missing a base.

Erik Childress

CREDITS

Cory Brand: Scott Elrod
Emma: Dorian Brown
Helene: Vivica A. Fox
Tyler: Charles Henry Wyson
Clay: James Devoti
Origin: United States
Language: English
Released: 2013
Production: Carol Spann Mathews; Hero Productions, Impact Productions LLC; released by Provident Films
Directed by: David Boyd
Written by: Brian Brightley; Candace Lee; Eric Newman; Melanie Wistar
Cinematography by: David Boyd
Music by: Scott Allan Mathews
Sound: Fred Paragano
Editing: Ken Conrad
Costumes: Beverly Safier
Production Design: Chris Rose
MPAA rating: PG-13
Running time: 113 minutes

REVIEWS

Black, Louis. *Austin Chronicle*. April 26, 2013.
Cooper, Jackie K. *Jackiecooper.com*. April 25, 2013.
Foran, Chris. *Milwaukee Journal Sentinel*. April 18, 2013.
Long, Tom. *Detroit News*. April 19, 2013.
Noh, David. *Film Journal International*. April 19, 2013.
O'Connell, Sean. *Washington Post*. April 19, 2013.
Plath, James. *Movie Metropolis*. October 25, 2013.
Robledo, S. Jhoanna. *Common Sense Media*. April 19, 2013.
Sharkey, Betsy. *Los Angeles Times*. April 18, 2013.
Smith, Michael. *Tulsa World*. April 19, 2013.

TRIVIA

The character JT is short for John Townsend. Dr. John Townsend is a actual Christian psychologist who also is credited with pioneering in the field of Christian counseling around the World.

HOMEFRONT

How far would you go to protect your home?
—Movie tagline

Box Office: $20.2 Million

When it is announced that a new script has been "dusted off" there is a rarely a follow-up sentence that involves anticipation. Sylvester Stallone has written twenty screenplays in his lifetime, including his Oscar-nominated *Rocky* (1976), and all of its sequels. For every Balboa or Rambo there's a *Staying Alive* (1983), *Rhinestone* (1983), or *Driven* (2001). Confidence is not high

with a Stallone script that does not extend the life of one of his signature characters. From the production description, it could be assumed his latest has been gathering dust since his heyday as one of the 1980s top action heroes. Now considering himself too old to take on the role, Stallone handed off his adaptation of the 2005 Chuck Logan novel to his *Expendables* co-star, Jason Statham.

Phil Broker (Statham) was an undercover DEA agent who produced a solid final score on a biker gang before retiring to a small town outside of New Orleans. The widower may have sheltered himself away from the bad guys, but his ten-year-old daughter, Maddy (Izabela Vidovic), has trouble avoiding the bullies on the playground. She may not have daddy's accent but she has learned his gut-punching skills. The bully's mama (Kate Bosworth) is not exactly interested in the facts and aims to protect her son against the girl half his size in every dimension. When her husband is no match for Phil she looks to her brother, Gator (James Franco), to put the fear of God into him.

Gator invades Phil's home and conveniently comes up with his entire dossier of undercover work and identities. Recognizing a potential payday in ratting out a rat, Gator and his girl, Sheryl Marie (Winona Ryder), concoct a plan to give him up. Cyrus Hanks (Frank Grillo) worked with the bikers either arrested or "shot 47 times" by the cops in Phil's operation and plots his own ambush. Ultimately, if there was any more to this story it is probably buried under a fossilized layer of dust particles.

Every action hero reaches a point in their career where they would like to try something new. Arnold Schwarzenegger had the comedy bug. Bruce Willis, like Stallone, did not start in that arena but began taking small roles in dramas to circumvent that labeling. Even Jean Claude Van Damme took the part of a Shane-like protector to a widow and her children from land developers in *Nowhere to Run* (1993). *The Bank Job* (2008) is often cited as Statham's most accomplished film but no matter how sophisticated its plotting was or how elegant the film's dialects were, Statham's everyman character still found a way to punch and kick his way out of the climactic confrontation. By the time he gets around to doing that in *Homefront,* the only thing more boring and uninvolving than the first seventy minutes is when he begins his standard moves against substandard bad guys.

The pace of *Homefront* given to it by director Gary Fleder is leaden. An hour passes with a little snooping, a few threats, and characters that are not so much established as they are plot movers looking for just one big, interesting scene. These are Southern-fried characters

in need of becoming caricatures to feed into the sense of fun to be had with a kind of redneck noir. A villain, even an incompetent one, accentuating his own last name ("BO-DINE") should translate into a real psychopath or someone so dumb that audiences can take caveman-like delight in his takedown. Since a blind man could sense that James Franco is no match for Statham physically, a backwoods mentality is hardly a worthwhile ingredient to build anticipation for a final showdown.

2013 already had films emphasizing the quiet mood of a man-on-the-lam in the South (*Ain't Them Bodies Saints*) and over-the-top small town revenge in the North (*Out of the Furnace*). *Homefront* hides out in a flaccid middle ground that makes no effort to move the mood towards gritty realism or all-out craziness.

Erik Childress

CREDITS

Phil Broker: Jason Statham
Maddy Broker: Iszabela Vidovic
Cassie Bodine Klum: Kate (Catherine) Bosworth
Sheryl Marie Mott: Winona Ryder
Origin: United States
Language: English
Released: 2013
Production: Kevin King Templeton, John Thompson, Les Weldon, Sylvester Stallone; Open Road Films; released by Millennium Entertainment L.L.C.
Directed by: Gary Fleder
Written by: Sylvester Stallone
Cinematography by: Theo van de Sanda
Music by: Mark Isham
Sound: Martyn Zub
Music Supervisor: Selena Arizanovic
Editing: Padraic McKinley
Art Direction: A. Todd Holland
Costumes: Kellie Jones
Production Design: Greg Berry
MPAA rating: R
Running time: 100 minutes

REVIEWS

Berardinelli, James. *Beliefnet.* November 27, 2013.
Cline, Rich. *ContactMusic.com.* December 6, 2013.
Ebiri, Bilge. *Vulture.* November 27, 2013.
Fine, Marshall. *Hollywood & Fine.* November 27, 2013.
Johanson, MaryAnn. *Flick Filosopher.* December 2, 2013.
Nusair, David. *Reel Film Reviews.* November 26, 2013.
Rabin, Nathan. *The Dissolve.* December 2, 2013.
Roeper, Richard. *RichardRoeper.com.* November 27, 2013.

Rothkopf, Joshua. *Blu-ray.com*. November 26, 2013.
Snider, Eric D. *GeekNation*. November 27, 2013.

QUOTES

Phil Broker: "Come on, look around: beautiful house, horse trails, river in the back yard. Seriously, what else could we ask for?"
Maddy Broker: "WiFi."

TRIVIA

Sylvester Stallone originally developed the screenplay as an installment of the *Rambo* series.

THE HOST

Choose to believe. Choose to fight. Choose to love. Choose to listen.
—Movie tagline
Choose your destiny.
—Movie tagline
You will be one of us.
—Movie tagline
Love never dies.
—Movie tagline

Box Office: $26.6 Million

The pathetically dull *The Host* is misguided in countless ways, but one of the biggest is that everything interesting about the story happens before the movie starts. A race of peaceful aliens has overtaken earth, painlessly invading the bodies of humans and establishing a society without hunger, violence or environmental decline. While most humans certainly would not be on board with losing their identities as aliens took control over their bodies, some would probably defend the global change as being for the greater good. After all, some aliens note that people were taking lousy care of the planet and each other, and they are right.

Foolishly, the film begins as the aliens, who look like ordinary humans except for their distant, piercing blue eyes, attempt to find and overtake the last of the remaining citizens. That includes Melanie (Saoirse Ronan), who seemingly would rather die than succumb to the aliens and jumps out a window in an attempt to escape the "seekers." Seeing that Melanie survived, the head seeker (Diane Kruger) notes, "This one wants to live." Um, not really. She just tried to kill herself like five minutes ago, remember?

Somehow the proceedings, adapted by formerly great, currently terrible writer-director Andrew Niccol (1998's *The Truman Show*, 2011's *In Time*) from *Twilight*

author Stephenie Meyer's novel, get dumber, and then they get dumber than that. An alien, which looks like hovering digital sperm when detached from a human body, inhabits Melanie's body and is called Wanda. Melanie, however, still lives inside the body, and argues with her physical form's new occupier via internal monologue. These debates hit their moronic peak as Melanie/Wanda become torn between Jared (Max Irons) and Ian (Jake Abel), two heartthrobs with problematically similar personalities who also have a romantic complication: Jared loves Melanie, and Ian loves Wanda, and Melanie does not like it when Wanda kisses Ian with Melanie's lips. "Is there any way that Melanie can give us some privacy?" Ian asks Wanda at one point, hoping the human being trapped in her own body will go away so he can simply make out with his human/alien girlfriend in peace. If that sounds confusing and ridiculous, that is because it is.

Anyone who has seen or read *Twilight* will spot Meyer's effort to create another chaste love triangle with *The Host*. What she has actually done, at least in the form of the big-screen adaptation, is deliver an even blander young woman who deprives an even better actress of her talents. In fact, between *The Host*, *Byzantium*, and *Violet and Daisy*, Ronan's work in 2013 suggests she has lost all former savvy in terms of picking intelligent and exciting projects like *Atonement*, *The Way Back* (2010), and *Hanna* (2011). In *The Host*, Ronan cannot hope to make sense of her dual role—as the voice and body of Wanda and voiceover of Melanie—because no actress could make sense of this. The banter between the two beings sharing the same body is just one example of the film's unintentional comedy.

Viewers are more likely to doze off than crack up, however. A large portion of the two-hour film takes place in caves as the humans hide from the seekers on their tail and periodically bicker about whether or not Wanda should be killed. Niccol depicts the *Invasion of the Body Snatchers* (1956, 1978)-lite world outside as virtually indistinguishable from any other onscreen futuristic vision. Dull outfits and shiny objects dominate the frame, and the seekers' relative blankness only translates to boredom, not a chilling presentation of a lack of human personality.

Because this is a mild romance intended for teenage girls, the humorless *The Host* contains multiple scenes of characters kissing in the rain and the implication that all any hormone-driven teens really want and need to do is kiss. Of course, most of the time when people kiss in *The Host* it uncomfortably involves slapping. When Jared kisses Wanda, hoping to spark an internal return by Melanie, and she slaps him, he is thrilled that Melanie has returned. What a great sign of your relationship, buddy, that the way you identify the woman you love is

by her violent reactions to your forced efforts at affection. Earlier, Ian tries to strangle Wanda, so when she later warms up to him, Melanie shouts from inside, "He tried to kill you!" It is not long before Wanda tells Ian, "Kiss me like you want to get slapped."

Most of the dialogue is horrendous, and in trying to separate a person's love of another person from what they look like, the story takes for granted how someone would feel if the person they loved switched bodies into someone less attractive. Plus, the battle between humans and aliens frequently comes off as more of a misunderstanding than a war, and it really does not seem like any of the resistance has taken much stock of what has happened to the world. Nor has Meyer or Niccol done anything to connect this absurd story to the relevant notion of real teenagers who, perhaps somewhat like Melanie/Wanda, feel like they are continually trying to figure out their own identity and when to make decisions with the mind as opposed to the body.

Furthermore, how odd that the seekers have developed sprays that clean and heal but can barely defend themselves against humans or fly when inside humans' bodies. What kind of inconsistently productive aliens are these, and, more importantly, what are the chances that the two planned sequels to *The Host* actually get made?

Matt Pais

CREDITS

Melanie Stryder: Saoirse Ronan
Jared Howe: Max Irons
The Seeker: Diane Kruger
Ian O'shea: Jake Abel
Jeb Stryder: William Hurt
Maggie Stryder: Frances Fisher
Origin: United States
Language: English
Released: 2013
Production: Stephanie Meyer, Nick Wechsler, Paula Mae Schwartz, Steve Schwartz; Chockstone Pictures; released by Open Road Films
Directed by: Andrew Niccol
Written by: Andrew Niccol
Cinematography by: Roberto Schaefer
Music by: Antonio Pinto
Sound: Martyn Zab
Editing: Thomas Nordberg
Costumes: Erin Benach
Production Design: Andy Nicholson
MPAA rating: PG-13
Running time: 125 minutes

REVIEWS

Burr, Ty. *Boston Globe*. March 28, 2013.
Ebert, Roger. *Chicago Sun-Times*. March 27, 2013.
Foundas, Scott. *Variety*. March 28, 2013.
Gleiberman, Owen. *Entertainment Weekly*. March 29, 2013.
Ogle, Connie. *Miami Herald*. March 28, 2013.
Persall, Steve. *Tampa Bay Times*. March 28, 2013.
Phillips, Michael. *Chicago Tribune*. March 28, 2013.
Puig, Claudia. *USA Today*. March 28, 2013.
Robinson, Tasha. *The A.V. Club*. March 27, 2013.
Sharkey, Betsy. *Los Angeles Times*. March 28, 2013.

QUOTES

Wanderer/Wanda: "Kiss me like you want to get slapped."

TRIVIA

Dianna Agron auditioned for the role of Melanie Stryder.

HOW I LIVE NOW

Love will lead you home.
 —Movie tagline

Box Office: $60,213

If or when extraterrestrials make contact with Earthlings, and then have a chance to really root down into our popular culture, they will certainly make curious mental note of the manner in which death and destruction permeate almost everything when it comes to filmed entertainment—even something as potentially innocuous as *How I Live Now*, which could otherwise suffice pleasantly enough as a culture-clash teenage summer romance were it not for the apocalyptic intervention foisted upon it.

Director Kevin Macdonald's film is an adaptation of Meg Rosoff's 2004 near-future-set novel of the same name, which itself feels conceived of mainly to have its big screen rights sold off for a healthy sum. As a coming-of-age tale set against the backdrop of a just-triggered world war, *How I Live Now* feels more tentative and vague than artfully understated and ambiguous. Despite the anchoring presence of the enormously talented Saoirse Ronan, the movie never shakes off the weighted feeling a ponderous metaphor searching fruitlessly for more solid narrative footing.

Set in the United Kingdom some small number of years in the future, *How I Live Now* opens with strong-willed, sullen American teenager Daisy (Ronan) arriving to stay the summer with some relatives in the English countryside, including a trio of step-cousins—16-year-old Eddie (George McKay), 14-year-old Isaac (Tom Hol-

land) and eight-year-old Piper (Harley Bird). Her headphones glued to her ears, the blasted tunes of disenfranchisement barely able to drown out anxious voices in her head, Daisy is not happy about the visit.

By degrees, though, things begin to change when she senses a kindred spirit in Eddie, an amateur falconer with a preternatural sense of calm. When Daisy's distracted Aunt Penn (Anna Chancellor) is pulled away out of the country on an urgent security-state air-quote peace conference, it solidifies bonds amongst the kids, who go swimming at a lake out in the woods. Romance between Daisy and Eddie ensues. Then, after an unspecified enemy detonates a nuclear bomb in London, Daisy and her cousins take shelter from the snowy radioactive fallout and wait with uncertainty, not sure if or when Penn will return.

A visitor from the U.S. Consulate arrives to give Daisy special travel papers back home, but she burns them, casting her lot with Eddie and her other step-cousins. British soldiers looking to evacuate the area violently separate the boys from girls, and Daisy and Piper are sent to live with a surrogate army family in the city, while working at a forced-labor camp picking vegetables. Eventually, however, they escape, trying to make their way back to the countryside and find Eddie and Isaac.

Macdonald, an Academy Award winner for *One Day in September* (1999) who has ping-ponged back and forth between documentaries and narrative features, may on the surface seem a strange choice as director for a film which unfolds mainly from the perspective of a teenage girl. Yet his masculine-heavy filmography is also shot through with enough examples of armed conflict and violence as to establish a clear through-line to the backdrop of *How I Live Now*.

Shooting on location in Wales, Macdonald and cinematographer Franz Lustig evoke an idyllic nature that is first roiled and then completely lost as the movie segues into its scattered-state latter half. And there is a funky and at times almost handmade quality to the film's production design, by Jacqueline Abrahams, even inclusive of some finger-painted opening credits. As the movie wears on, though, the array of stylistic and editorial flourishes that Macdonald employs begin to feel random rather than the result of a single-minded and singular approach. It is an example of a grab-bag variety of assorted styles instead of a comprehensive one.

Adapted by Jeremy Brock, Tony Grisoni, and Penelope Skinner, *How I Live Now* suffers in thematic comparison to the other recent dystopian, British-set dramas which it most readily recalls—*28 Days Later* (2003) and *Children of Men* (2006)—and even another similarly allegorical movie about the frailty and fragility of modern civilization, *Blindness* (2008), in large part because of its decision to focus on teenage love. Admittedly, that is the crux of the source material, but the romance here is so gooey and broadly sketched as to feel out of step with much of what follows.

Certainly a good swathe of the movie's first act enjoyably recalls Peter Pan's Lost Boys, wherein these abandoned but not helpless kids take steps to forge their own family unit. Unfortunately, *How I Live Now* seems to land smack dab in the unforgiving middle of an attempt to inject this setup with doomsday despair. With more information about the nature of its nuclear blast and ensuing conflict, the film could be an interesting adolescent view of the initiation and nascent stages of World War III; with less, its impressionistic hold would be more solidified.

As is, the movie raises more questions than it answers, geopolitical (why is the United States eager to extract its citizens from Great Britain, who is presumably still an ally?) and otherwise. It also bungles all sorts of small details, as when Daisy and Piper absorb the admonitions of city-dwellers not to drink tap water since they do not know if its source is safe, but later, post-escape, blithely eat wild berries and walk in splish-splash fashion through an open stream. (There is the strange matter, too, of all those picked vegetables.) Whether or not such contamination is genuine or a matter of propaganda can be left up to individual viewers, but to have characters alternately embrace and disregard advice according to the situational whims of the story undercuts its reality.

The generally listless tone also belies two notably nasty third act sequences. In one, Daisy locks eyes with a women being beaten and raped in the woods, and does nothing to save her. In another, two men give chase and snatch Piper, forcing Daisy to take more proactive measures to protect them. These scenes are meant to shade Daisy's emotional journey, clearly (you can envision them labeled "Loss of Innocence" on screenwriters' note cards), but they come across as brutish and out of step with the film's more whimsical roots.

Ronan is smart and intuitive, a quite gifted young actress, and certainly the best thing about *How I Live Now*. If McKay, playing more of a blinking pin-up, is not quite her equal, the pair at least shares a nice rapport. But beyond the broad strokes feeling of their young love, the film does not invest specifically and heartily enough in their characters, so it feels indistinct and, yes, boring. Once Daisy and Eddie are separated, the movie feels even more rudderless. This eventually resolves itself, of course, with a dollop of tragedy to go along with its uplift. But viewers will have long since

stopped caring about any of these characters, or how they live.

Brent Simon

CREDITS

Daisy: Saoirse Ronan
Edmond: George MacKay
Isaac: Tom Holland
Piper: Harley Bird
Joe: Danny McEvoy
Aunt Penn: Anna Chancellor
Origin: United Kingdom
Language: English
Released: 2013
Production: John Battsek, Alasdair Flind, Charles Steel, Andrew Ruhemann; BFI Film Fund, Cowboy Films, Film 4, Passion Pictures, Prospect Entertainment, Protagonist Pictures; released by Magnolia Pictures
Directed by: Kevin MacDonald
Written by: Jeremy Brock; Tony Grisoni
Cinematography by: Franz Lustig
Music by: Jon Hopkins
Sound: Glenn Freemantle
Editing: Jinx Godfrey
Costumes: Jane Petrie
Production Design: Jaqueline Abrahams
MPAA rating: R
Running time: 101 minutes

REVIEWS

Adams, Mark. *Screen International*. September 11, 2013.
Catsoulis, Jeannette. *New York Times*. November 7, 2013.
Chang, Justin. *Variety*. September 13, 2013.
Covert, Colin. *Minneapolis Star Tribune*. November 7, 2013.
Hartl, John. *Seattle Times*. November 7, 2013.
LaSalle, Mick. *San Francisco Chronicle*. November 14, 2013.
Long, Tom. *Detroit News*. November 8, 2013.
Martin, Philip. *Arkansas Democrat-Gazette*. November 8, 2013.
McCarthy, Todd. *Hollywood Reporter*. September 11, 2013.
Phillips, Michael. *Chicago Tribune*. November 7, 2013.

QUOTES

Daisy: "No one calls me Elizabeth. Except my dad, and he's an asshole. So if you don't mind, my name is Daisy."

TRIVIA

The man that Saoirse Ronan's character, Daisy, shoots in the film, is played by her real life father, actor Paul Ronan.

THE HUNGER GAMES: CATCHING FIRE

Every revolution begins with a spark.
—Movie tagline

The sun persists in rising, so I make myself stand.
—Movie tagline

Remember, girl on fire, I'm still betting on you.
—Movie tagline

Box Office: $423.6 Million

The second film in a series does not traditionally stand alone as well as its predecessor. Sure, the film can be as good or possibly, even better than the original, but it is usually just a link to the concluding film. In the case of *The Hunger Games*, its sequel, *Catching Fire*, is a far superior film in every way imaginable. It had all the potential to be a rehash of the first film, complete with a reworking of the games themselves, designed to deliver more of the same interesting, yet uninspired elements. *Catching Fire*, however, manages to retell and improve many aspects lacking in the first film. Similarly, the performances in the sequel are superior to those in the first film, through no fault of the actors; there was simply just too much going on in the first installment for anything to really resonate. *The Hunger Games: Catching Fire* is a more confident and assured work and this bodes well for the future of the Hunger Games series.

Chief among the improvements in this installment is that the character and plot development is handled through a show don't tell approach. This allows characters to be more than the plot advancing mouthpieces they were previously. Since the *Catching Fire* story is no small or simple thing, it is all that more impressive that it is delivered in such an entertaining and non-invasive way.

After winning the 74th Hunger Games, Katniss Everdeen (Jennifer Lawrence) and Peeta Mellark (Josh Hutcherson) returned to District 12 to live in relative luxury in Victor's Village. On the eve of their victory tour of Panem, President Snow (Donald Sutherland) visits Katniss and expresses concern over the unrest her victory has created in other districts. He also questions her affections for Peeta and directs her to convince the country and himself of their love or her loved ones and entire district will be punished.

The tour starts poorly when they visit District 11, the home of Katniss's ally Rue. When Katniss addresses the crowd, a man raises his arm and makes the three-fingered salute Katniss had made for the fallen Rue. Others follow and this mini-uprising is quashed when Peacekeepers apprehend and execute the man. Katniss and Peeta are scolded by mentor, Haymitch Abernathy (Woody Harrelson), that their relationship must continue throughout the remainder of their lives if they wish to keep their friends and families safe and that

speaking against the government will do no one any good.

The pair then announces their engagement and attends a party in their honor at Snow's home in the Capitol. It is here that Katniss meets Plutarch Heavensbee (Philip Seymour Hoffman), the new Gamemaker. Heavensbee proves instrumental in assisting Snow with his plans to discredit and ultimately destroy Katniss. To this end, Snow orders that the upcoming third Quarter Quell edition of the Hunger Games include a special provision that allows him to select tributes from among previous victors. This means that Katniss is automatically selected to represent District 12. She then vows that Peeta will survive the games after he volunteers in Haymitch's stead.

During various training scenes, the new tributes are introduced. After a fantastic display of her archery skills, Katniss is a top choice as a potential ally. Despite Snow's hope that Katniss will kill as many tributes as she can during the games, effectively destroying her credibility, she instead forms alliances with several tributes including Wiress (Amanda Plummer), Beetee (Jeffrey Wright), Finnick Odair (Sam Odair), Mags (Lynn Cohen), and Johanna Mason (Jena Malone). Along with Peeta, Katniss and these tributes fight to survive a game whose ultimate goal may be more linked to Katniss than she realizes.

What this incarnation of the *Hunger Games* has going for it is a director far more confident with the action genre than his predecessor. While Gary Ross, did an adequate job with *The Hunger Games*, he was far better suited to and more comfortable with the dialogue-heavy scenes, which unfortunately made up a bulk of the screenplay he himself wrote. *Catching Fire* director Francis Lawrence however, having already helmed the sci-fi action film, *I Am Legend* (2007), displays a more adept hand staging the action scenes and balancing the same with the human elements of the story. It does help that Lawrence is working from a tighter and less talky script. Lawrence's direction and the script by Simon Beaufoy and Michael Arndt allow the film to create a richer portrayal of the conditions in Panem and exactly how and why the revolution catches fire. Of course some of these elements are a bit on-the-nose, but that's how things are typically handled in the genre and the conceit works well here.

As with everything in *The Hunger Games: Catching Fire*, some things are shown, some alluded to, and some are merely mentioned, but this is all done by skilled and talented filmmakers. While it may be true that the film is victimized to a certain extent by being the bridge film of the series, *Catching Fire* succeeds in perhaps establishing itself as the most rewarding and re-watchable film of the franchise.

Michael J. Tyrkus

CREDITS

Katniss Everdeen: Jennifer Lawrence
Peeta Mellark: Josh Hutcherson
Haymitch Abernathy: Woody Harrelson
President Snow: Donald Sutherland
Gale Hawthorne: Liam Hemsworth
Finnick Odair: Sam Claflin
Johanna Mason: Jena Malone
Effie Trinket: Elizabeth Banks
Caesar Flickerman: Stanley Tucci
Plutarch Heavensby: Philip Seymour Hoffman
Mags: Lynne Cohen
Beetee: Jeffrey Wright
Wiress: Amanda Plummer
Cinna: Lenny Kravitz
Origin: United States
Language: English
Released: 2013
Production: Nina Jacobson, Jon Kilik; released by Lions Gate Entertainment Corp.
Directed by: Francis Lawrence
Written by: Simon Beaufoy; Michael Arndt
Cinematography by: Jo Willems
Music by: James Newton Howard
Sound: Jeremy Peirson
Music Supervisor: Alexandra Patsavas
Editing: Alan Edward Bell
Art Direction: Adam Davis; Robert Fechtman
Costumes: Trish Summerville
Production Design: Philip Messina
MPAA rating: PG-13
Running time: 146 minutes

REVIEWS

Berardinelli, Joe. *ReelViews*. November 19, 2013.
Burr, Ty. *Boston Globe*. November 21, 2013.
Corliss, Richard. *Time*. November 20, 2013.
Gilchrist, Todd. *The Playlist*. November 21, 2013.
Koski, Genevieve. *The Dissolve*. November 19, 2013.
Morgenstern, Joe. *Wall Street Journal*. November 21, 2013.
O'Hehir, Andrew. *Salon.com*. November 21, 2013.
Roeper, Richard. *Chicago Sun-Times*. November 19, 2013.
Travers, Peter. *Rolling Stone*. November 21, 2013.
Turan, Kenneth. *Los Angeles Times*. November 20, 2013.

QUOTES

Katniss Everdeen: "I just wanted to say that I didn't know Thresh, I only spoke to him once. He could have killed me,

but instead he showed me mercy. That's a debt I'll never be able to repay. I did know Rue. She wasn't just my ally, she was my friend. I see her in the flowers that grow in the meadow by my house. I hear her in the Mockingjay song. I see her in my sister Prim. She was too young, too gentle and I couldn't save her. I'm sorry."

TRIVIA

Actor Sam Claflin ate between two to three sugar cubes for each take of Finnick's introductory scene. When they finished filming, he had consumed the entire box of cubes.

AWARDS

Nominations:

Golden Globes 2014: Song ("Atlas")

THE HUNT
(Jagten)

> *The lie is spreading.*
> —Movie tagline

Box Office: $610,968

Danish filmmaker Thomas Vinterberg, one of the co-creators of the "Dogme 95 Manifesto" and "Vow of Chastity," along with Lars von Trier, has taken a few missteps since his breakout dysfunctional family drama, *The Celebration* (1998), but makes a triumphant return to the forefront of world cinema, doing what he does best with *The Hunt*.

Sharply written and acted, the enormously discomfiting drama focuses on Lucas (Mads Mikkelsen), a recently divorced schoolteacher in the small town of Taastrup outside Copenhagen. Lucas is kind and reserved, and struggling with living alone. He enjoys horsing around with the children, and cherishes the company of his dog, Fanny. Things start to look up for him when a pretty new employee at the school, Nadja (Swedish actor Alexandra Rapaport) starts flirting with him. Nadja is a foreigner, but they use English and her limited Danish to communicate, and she is blunt about her attraction to Lucas. With a budding romantic relationship, and the news that his teen son, Marcus (Lasse Fogelstrom), wants to move in with him, things start looking up for Lucas.

As one might expect, it all falls apart. When Lucas gently rebuffs her increasing adoration, Klara (Annika Wedderkopp), the adorable young daughter of his best friend, Theo (Vinterberg regular Thomas Bo Larsen), almost casually tells the headmistress at the school, Grethe (Susse Wold) that she hates Lucas. When Grethe presses her, Klara tells her, referring to imagery that she actually

saw in a pornographic film that her older brother was watching, that Lucas exposed himself to her. Grethe makes noises about not jumping to any conclusions, but she forces Lucas to take a leave of absence and she brings in an investigator, and with astounding rapidity, the whole town knows about the accusation, and Lucas's life begins to unravel.

Most of his close-knit circle of friends abandon him. Lucas insists on confronting Theo, unable to believe that his good friend would think him capable of molesting his daughter. In a tense scene, Theo struggles with his feelings for Lucas, before he and his wife Agnes (Anne Louise Hassing of von Trier's *The Idiots* [1998]) throw Lucas out. Nadja stays with him at first, but is pressured at work to abandon him, and when she has a moment of doubt about his innocence, he ends their relationship. Marcus, meanwhile, has to run away from home to visit his father. Thankfully, Lucas has one close friend, Bruun (Lars Ranthe), who stands by him and supports him.

Adding to the hysteria, other children are questioned and begin to corroborate Klara's accusations, saying they were also abused. Lucas finds himself at risk, but he refuses to hide. In one of the grimmest scenes in the movie, a trip to the grocery store turns into a harrowing, violent experience, but Lucas's sense of honor—his righteous indignation over being wrongly accused—will not allow him to back down.

Mikkelsen is brilliant throughout, bringing viewers inside the mind of this rather closed-off, wounded man, and the rest of the cast is equally impressive, particularly youngsters Fogelstrom and Wedderkopp. (The movie is yet another example of how much more naturalistic foreign child actors are compared to their American counterparts.) Lucas's innocence is never in doubt, but Mikkelsen never tries to ingratiate the audience. It is clear that Lucas is a hard man to know. He is not a joiner, and that partly explains how he finds himself in his predicament. His rejection of Nadja is consistent with his character, but Vinterberg shows how much pressure she is under as well, and that helps to create a genuine sense of tragedy. That grocery store scene is extremely uncomfortable and aggravating to watch, but when the battered Lucas returns to the store to retrieve his shopping bag, there is a feeling of triumph in his conviction, and his refusal to back down. The ambivalence of these scenes adds to the film's emotional impact.

It is all shot with an intimacy that adds to the discomfiture. Handheld camera, point-of-view shots (often those of confused children), available light, minimal scoring: the movie feels real and immediate. Vinterberg creates a visceral sense of unease. As the root of all of Lucas's problems, Klara is still an innocent, and to an

extent, the reaction of Lucas's friends and co-workers is horrifyingly comprehensible, rendering the growing hysteria plausible and genuinely tragic. Despite sporadic flashes of humor, and the unmistakable humanity of the film, it is a grim and difficult watch.

If the denouement of the film seems a bit sudden and maybe a little too easy, Vinterberg ends it on a grim note that assures us that there are some wounds that can never, ever heal. *The Hunt* is a powerful and disturbing film, and worthy of its difficult subject.

Josh Ralske

CREDITS

Lucas: Mads Mikkelsen
Theo: Thomas Bo Larsen
Klara: Annika Wedderkopp
Marcus: Lasse Fogelstrom
Grethe: Susse Wold
Origin: Denmark
Language: Danish
Released: 2013
Production: Thomas Vinterberg; released by Zentropa Entertainment
Directed by: Thomas Vinterberg
Written by: Thomas Vinterberg; Tobias Lindholm
Cinematography by: Charlotte Bruus Christensen
Music by: Nikolaj Egelund
Sound: Kristian Eidnes Andersen
Music Supervisor: Mikkel Maltha
Editing: Janus Billeskov Jansen; Anne Osterud

Costumes: Manon Rasmussen
Production Design: Torben Nielsen
MPAA rating: R
Running time: 115 minutes

REVIEWS

Bradshaw, Peter. *The Guardian.* April 15, 2013.
Frosch, Jon. *Village Voice.* July 9, 2013.
Houlihan, Mary. *Chicago Sun-Times.* August 5, 2013.
Kiang, Jessica. *The Playlist.* July 9, 2013.
Lumenick, Lou. *New York Post.* July 11, 2013.
Morgensetern, Joe. *Wall Street Journal.* July 11, 2013.
Murray, Noel. *The Dissolve.* July 11, 2013.
Puig, Claudia. *USA Today.* July 11, 2013.
Rooney, David. *The Hollywood Reporter.* April 15, 2013.
Vishenvetsky, Ignatiy. *RogerEbert.com.* July 12, 2013.

QUOTES

Theo: "The world is full of evil but if we hold on to each other, it goes away."

TRIVIA

This was Denmark's official submission to the Foreign Language Film category of the 2014 Academy Awards.

AWARDS

Nominations:

Oscars 2013: Foreign Film
Golden Globes 2014: Foreign Film
Ind. Spirit 2014: Foreign Film

I

THE ICEMAN

Loving husband. Devoted father. Ruthless killer.
—Movie tagline

Box Office: $1.9 Million

Michael Shannon delivers more than just the ice in this tense crime drama, a film that seethes with his character's suppressed rage. Part of it is his dead-eyed yet evocative performance but another aspect that looms large is how true the whole film feels from beginning to end *The Iceman* has been compared to Martin Scorsese's masterpiece *Goodfellas* (1990) and with good reason. It is a powerful look at the nature of mob criminality. Whereas *Goodfellas* offered satire, playing almost like a comedic fable in the midst of its explosively deranged violence, there is no such relief or context here. Director Ariel Vromen has chosen an endlessly fascinating subject and tells his story in a straightforward, seedy manner. This is the arc of a man who is recruited into the underworld as a hitman while leading a strikingly mundane family-man existence for more than two decades. His aspirations are suburban and every bit the stuff of the American dream, but his life is a nightmare of sociopathic conflict, measured out blow-for-blow against any and all perceived slights.

Vromen's film opens with Richard Kuklinski (Michael Shannon) on a date with his future wife Deborah (Winona Ryder). He seems a strong, silent type, who is also evasive when asked about what he does for a living. This is because he dubs porn film prints for mobsters. When a gang of hoods shows up to pick up a shipment not yet ready and he fails to panic the leader, Roy Demeo (Ray Liotta) offers him a job which he

takes without hesitation. With near emotionless efficiency he kills target after target, raising his unsuspecting wife and daughter's in the suburbs, and working towards retirement. But when Demeo forcibly retires him, forbidding him to work while the gang sorts out internal issues, Kuklinski teams up with a hated rival, Mr. Freezy (Chris Evans), for side work, leading to a series of complicated relationships, haphazard hits, and his eventual downfall.

The film starts and ends with chiaroscuro shots of an imprisoned Kuklinski pondering if it was all worth it. The close-ups take viewers into a complicated abyss where they could spend forever trying to figure out what went wrong. Shannon offers up a wonderfully suppressed rage and, though viewers are shown only a little of Kuklinski's history, there are any number of moments in the film when we see him trying to work just what made him the way he is. Yes, it makes itself known in violent outbursts, but the despair and self-loathing are there in spades as well. After a conversation with his daughter about a nun at her Private school, he goes out on assignment to kill a lowlife pornographer (James Franco). When the man cries out to God, Kuklinski gives him a chance to change the outcome of their encounter through prayer. The wheels are grinding in plain view. Kuklinski seems to want it to end differently almost as badly as his victim does. Even after pulling the trigger he finds the test is far from over as a teenage model hiding in the closet forces him to evaluate how far he will go to do his job.

Ray Liotta is every bit as electric as Shannon even though he does exactly what is expected of the actor in a gangster film. Sadly, for as many such projects as Liotta

has done, this will likely go unnoticed, but the man is a great talent, and his characterization of Demeo encompasses not only tough-guy moments and some gunplay but a strong sense of a man trapped inside a cage of his own making and desperate for his family, not just his own hide.

The film is replete with underused talent put to good use. Chris Evans has a dynamite and almost completely unrecognizable turn as a fellow assassin with an unusual but completely believable cover. Stephen Dorff makes the most of his short screen time as Kuklinski's imprisoned little brother. Robert Davi brings intense businesslike menace as the go-between twixt Demeo and the other crime families who want him dead.

The score by Haim Mazar haunts as well, floating in and out when needed but barely noticeable until the emotions of each scene are well-established. It does not telegraph but simply reinforces what the film already does well. Vromen shares screenwriting credit with Morgan Land and they, in turn, draw reference from the Anthony Bruno true crime bio *The Iceman: The True Story of a Cold-Blooded Killer* and the documentary *The Iceman Tapes: Conversations with a Killer* directed by James Thebaut. In many ways it follows the expected narrative arc of crime does not pay but it is handled by Vromen as a careful character study rather than a look at the mechanics of crime itself. What comes alive here is the chaos that descends on all these pent-up men, determined to control their destiny through use of force.

Dave Canfield

CREDITS

Richard Kuklinski: Michael Shannon
Deborah Kuklinski: Winona Ryder
Robert Pronge: Chris Evans
Roy Demeo: Ray Liotta
Josh Rosenthal: David Schwimmer
Leo Marks: Robert Davi
Joey Kuklinski: Stephen Dorff
Marty: James Franco
Origin: United States
Language: English
Released: 2012
Production: Ehud Bleiberg, Ariel Vromen; Bleiberg Entertainment, Millennium Films, Rabbit Bandini Productions; released by Millennium Entertainment L.L.C.
Directed by: Ariel Vromen
Written by: Ariel Vromen; Morgan Land
Cinematography by: Bobby Bukowski
Music by: Haim Mazar
Sound: Chad J. Hughes, Steven Iba

Editing: Danny Rafic
Costumes: Donna Zakowska
Production Design: Nathan Amondson
MPAA rating: R
Running time: 103 minutes

REVIEWS

Anderson, John. *Newsday*. May 16, 2013.
Calhoun, Dave. *Time Out*. June 4, 2013.
Holden, Stephen. *New York Times*. May 2, 2013.
Kennedy, Lisa. *Denver Post*. May 17, 2013.
Miraudo, Simon. *Quickflix*. June 8, 2013.
Moss, Rebecca. *Village Voice*. April 30, 2013.
Neumaier, Joe. *New York Daily News*. May 2, 2013.
Rea, Steven. *Philadelphia Enquirer*. May 17, 2013.
Snider, Eric D. *Movies.com*. July 12, 2013.
Stevens, Dana. *Slate*. May 2, 2013.

QUOTES

Mr. Freezy: "I only feel alone around other people. Couldn't be truer."

TRIVIA

Maggie Gyllenhaal was originally cast as Deborah Kuklinski, but dropped out due to pregnancy and was replaced by Winona Ryder.

IDENTITY THIEF

She's having the time of his life.
—Movie tagline
Is this the face of a thief?
—Movie tagline
Is this the face of a sucker?
—Movie tagline

Box Office: $134.5 Million

As time moves further and further into the digital age, the idea of electronically stolen and/or erased identities is no longer exclusively the province of speculative thrillers like *The Net* (1995); it is a reality. So, a comedic big screen treatment of such a concept would seem to have a lot of tonal terrain from which to choose. It could be an over-the-top, slapstick-type farce, or a feel-your-pain, Recession-era satire in which the audience is asked to sympathize with the offender. It could even be a tragicomic character study for which a filmmaker like Alexander Payne might be best suited.

At various points the plodding, 112-minute *Identity Thief* tries on most of these personas, but screenwriter Craig Mazin also rather inexplicably melds them onto a careening road trip adventure complete with car chases

and shootouts. The result is a sigh-inducing mess that lurches to and fro, all but squandering what would on the surface seem a great match in its two stars—the garrulous physical comedy of Melissa McCarthy and the slow-burn despair of Jason Bateman. In short, *Identity Thief* steals not laughs but viewers' hopeful expectations, taking one of the richer comedic ideas of recent years and turning it into something utterly forgettable.

Denver accountant Sandy Patterson (Bateman) is a family man with a pregnant wife (Amanda Peet) and income worries who makes a decision to leave the company where he is undervalued and strike out with some coworkers in a new venture. This choice coincides with Sandy having his identity stolen by a Florida shopaholic, Diana (McCarthy), who lives entirely on such schemes.

With the local police (as embodied by Morris Chestnut) not of much assistance, and his new boss (John Cho) frustrated and antsy at bad publicity over a workplace police raid, Sandy treks east to try to clear his name, by convincing Diana to come with him and face fraud charges. Also sprinkled into the mix are two angry enforcers (Genesis Rodriguez and rapper Tip "T.I." Harris) of a criminal kingpin to whom Diana sold some phony credit cards, and an only slightly less dangerous freelance bail bond enforcer (Robert Patrick). Sandy, then, has to cast his lot with the unpredictable Diana, and try to get her back to Denver before any harm befalls either of them. General mayhem and gunplay ensues.

With its loutish characters and broad tone, *Identity Thief* shares a lot in common with *Horrible Bosses* (2011), also directed by Seth Gordon. (The film's lazy marketing campaign, with primary-color-heavy character posters, even seemed a reference to the latter movie, and the tack worked: despite overwhelmingly indifferent-to-negative reviews, *Identity Thief* out-grossed *Horrible Bosses* at the Stateside box office, $135 million to $118 million.) Whereas the combined grotesqueries of Gordon's previous movie seemed of a piece with its titular conceit, however, here it just feels phony and off-putting.

Plot holes are spackled over, interesting sidebars are never followed up upon and with one minor exception the supporting characters are not interesting or funny, but rather serve only as a clamorous distraction from what should be the main story. Visually, Gordon does the material no favors either, shooting many scenes in alternating close-ups in a manner which boxes in the performers and locks up the comedy.

Upon *Identity Thief*'s release, *New York Observer* critic Rex Reed touched off a controversy in his negative review, focusing on McCarthy's weight and calling her "tractor-sized" and a "female hippo" in criticizing what

he characterized as the movie's celebration of unhealthy corpulence. "McCarthy is a gimmick comedian who has devoted her short career to being obese and obnoxious with equal success," he wrote. While it is true that ample portions of *Identity Thief* rather dispiritingly (and, more crucially, unimaginatively) exploit the notion of a plus-size woman, say, actually having a sex drive, to focus on only that is to miss the bigger picture, which is that the film feels like a fundamental misreading of the abundant potential of its concept.

Most of the blame for this lies with Mazin; he repeatedly leans on claptrap instead of recognizable human emotion, or any clever inclusions of technology. As a result, Diana is reliably irascible, but not three-dimensional. *Bad Santa* (2003) located a believable humanity while still remaining true to the annoyed and degenerate nature of its offensive lead. *Identity Thief*, though, has none of that film's courage, or commitment to character. (It does not help that T.C. Boyle's scabrously funny 2006 novel *Talk Talk* covers a good bit of the same terrain, and much better.) After linking Diana's criminal behavior to a deep loneliness and need for friends, the movie winds its way to an ending that parcels out cheap, unconvincing catharsis, in an effort to provide uplift.

As "Big Chuck," an affable guy the duo meets on the road, Eric Stonestreet does a good job. Most of the other supporting performances are unmemorable, though, or worse. A one-scene cameo by Jon Favreau as Sandy's jerky ex-boss feels especially like a missed opportunity for further comedic exploitation, while Rodriguez and Harris are simply grating throughout. Every moment spent with their characters is torture.

Bateman, for the umpteenth time, is called upon to exercise his exasperated Everyman routine, which he does with aplomb even if it is now too familiar by half. McCarthy, meanwhile, once more displays a fully invested energy that, with apologies to Reed, extends beyond the more obvious shtick for which she has been tapped after her breakout turn in *Bridesmaids* (2011). An interesting, well played confession late in *Identity Thief*—false in detail, but subtly revealing in other ways—indicates the presence of a deep, tears-of-a-clown-type reservoir of feeling that could certainly serve McCarthy well should she desire to tackle more dramatic fare later in her career. It would be an interesting footnote that this rather ignominious offering served as the first evidence of that fact.

Brent Simon

CREDITS
Sandy Bigelow Patterson: Jason Bateman
Diana: Melissa McCarthy

Harold Cornish: Jon Favreau
Trish Patterson: Amanda Peet
Daniel Casey: John Cho
Big Chuck: Eric Stonestreet
Det. Reilly: Morris Chestnut
Marisol: Genesis Rodriguez
Skiptracer: Robert Patrick
Origin: United States
Language: English
Released: 2013
Production: Scott Stuber, Pamela Abdy, Jason Bateman; Aggregate Films; released by Universal Pictures Inc.
Directed by: Seth Gordon
Written by: Craig Mazin
Cinematography by: Javier Aguirresarobe
Music by: Christopher Lennertz
Sound: Michael J. Benavente
Editing: Peter Teschner
Costumes: Carol Ramsey
Production Design: Shepherd Frankel
MPAA rating: R
Running time: 111 minutes

REVIEWS

Bowles, Scott. *USA Today*. February 7, 2013.
Dargis, Manohla. *New York Times*. February 7, 2013.
Debruge, Peter. *Variety*. February 6, 2013.
McCarthy, Todd. *Hollywood Reporter*. February 6, 2013.
Morgenstern, Joe. *Wall Street Journal*. February 7, 2013.
Rainer, Peter. *Christian Science Monitor*. February 8, 2013.
Rea, Stephen. *Philadelphia Inquirer*. February 7, 2013.
Reed, Rex. *New York Observer*. February 6, 2013.
Schwarzbaum, Lisa. *Entertainment Weekly*. February 6, 2013.
Sharkey, Betsy. *Los Angeles Times*. February 7, 2013.

QUOTES

Bartender: "These aren't your friends. They like you because you're buying them drinks. People like you don't have friends."

TRIVIA

Every car Sandy and Diane take, except for the original rental car, has a crushed can of Red Bull on the dash.

I'M SO EXCITED
(Los amantes pasajeros)

Box Office: $1.4 Million

If the irreverent farce, *I'm So Excited!*, were the work of a rookie prankster, it would be easily to dismiss as a fitfully amusing trifle. But since it is the latest film from a revered master of cinema, Pedro Almodovar, some critics have bent over backwards attempting to read profound meaning into the aggressively inconsequential proceedings. Is the film's malfunctioning plane dubbed "Peninsula" meant to symbolize the Iberian Peninsula itself? Is the characters' tendency to deal with tragedy by succumbing to escapist indulgence meant to register as a timely satire of mankind's procrastination and its doom-laden repercussions?

These interpretations could very well be proven on a surface-level, but Almodovar's tone is anything but cautionary. In fact, he seems bound and determined for his ensemble of sex-crazed neurotics to throw caution to the wind and embrace the free love anthem of 1960s-era Bohemians. While the director's past films have evoked the mise-en-scene of Sirkian melodramas and Hitchcockian thrillers, here Almodovar favors the broad aesthetics of gabby sex comedies, enhanced by his typically bold color palette borrowed from Powell and Pressburger. From its Saul Bass-inspired opening credits to its final freeze frame, the film approximates what a Doris Day/Rock Hudson vehicle may have looked like, had Hudson been allowed to come clean about his sexuality, thus inspiring Day to acknowledge her unspoken curiosity with bondage.

Anyone familiar with Almodovar's early screwball comedies, not to mention his past performances as a member of a glam rock parody duo, will be thrilled to see the filmmaker harkening back to his origins. The cast reads like a roll call of the director's past collaborators, providing top-billing to its two most familiar faces, Penelope Cruz and Antonio Banderas, who pop up side-by-side in an extended cameo reserved for the film's opening moments. Cruz is so intoxicated with Banderas's ageless beauty that she nearly flattens a Twitter-obsessed luggage handler with her baggage truck. So oblivious is the foolish man to the surrounding world that he tweets ("I'm bleeding to death") rather than seek immediate medical attention. This silly sketch more or less gives the viewer a succinct idea of what is to follow, at least tonally.

Most of the film is confined to the nearly vacant business class section of a plane bound for Mexico City, as it ambles through the sky as aimlessly as the plot itself, while pilots sporadically fret over their damaged landing gear, though their libidos routinely prove to be an enticing distraction. Sadly, for all the manic energy on display, few of the gags are all that amusing, let alone memorable. What used to pass for daring innuendo in Almodovar's revelatory 1980s output now resembles the sort of worn raunch on display at a cut-rate cabaret. The premise's striking resemblance to the uproarious *Airport*

parody, *Airplane!* (1980), are not helpful, since Almodovar fails to earn a fraction of the laughs garnered by the directorial trio of Jim Abrahams, David and Jerry Zucker. Not even the kinkiest scene in *I'm So Excited* rivals the ZAZ team's inflatable pilot. Even the film's big comic set-piece, in which a trio of gay flight attendants lip-sync to the Pointer Sisters' rendition of the titular tune, pales in comparison to the Brady Bunch's hilariously inexplicable rendition of "Good Time Music" aboard a plane full of disgruntled bystanders in the artlessly funny gem, *A Very Brady Sequel* (1996).

What the film lacks in originality it occasionally makes up for in abundantly bouncy cheerfulness. The unapologetically flamboyant stewards are a hoot, particularly the portly Fajas, played with deadpan relish by Carlos Areces. There is also a suave hit man, fetching dominatrix, corrupt banker, drug mule, and a ladykiller who supposedly drove his deranged girlfriend to a botched suicide attempt. The film jarringly cuts to the poor woman, played in a stark cameo by Paz Vega, who receives a life-saving call from her beau, only to have her iPhone slip from her grasp and fall into the basket of her boyfriend's ex. The episodic plot structure suggests that this diversion could have gone on indefinitely, and considering that the ex is played by the beguiling Blanca Suarez, recently featured in *The Skin I Live In* (2011), one wishes that it would. Instead, Almodovar's script swiftly returns to the plane, where the drugged passengers candidly reveal their inner-most secrets, approaching every conversation like a gossipy confessional.

Perhaps the strangest character of all is Bruna, a psychic virgin played by Lola Duenas, whose wide-eyed curiosity becomes fixated on the erection of a sleeping passenger traveling in economy, one of many who have been given a sleeping pill. Since Duenas is as horny as a hormonally charged adolescent, she decides to unzip the young man's pants and rape him in his slumber. Almodovar treats this scene as some sort of sexual liberation, with the circumstantial "lovers" reuniting in the film's finale; a queasy joke that somehow worsens the already abhorrent taste in the audience's mouths. This miscalculation is all the more distracting since the rest of the film is so benign in comparison. It is clear that Almodovar set out to make a lark destined to please his most ardent fans, leaving all other moviegoers with very little to get excited about.

Matt Fagerholm

CREDITS

Joserra: Javier Camara
Ulloa: Raul Arevalo
Fajas: Carlos Areces

Bruna: Lola Duenas
Norma: Cecilia (Celia) Roth
Galan: Guillermo Toledo
Mas: Jose Luis Torrijo
Infante: Jose Maria Yazpik
Origin: Spain
Language: Spanish
Released: 2013
Production: Agustin Almodovar, Esther Garcia; El Deseo; released by Sony Pictures Classics
Directed by: Pedro Almodovar
Written by: Pedro Almodovar
Cinematography by: Jose Luis Alcaine
Music by: Alberto Iglesias
Sound: Ivan Marin
Editing: Jose Salcedo
Art Direction: Antxon Gomez
Costumes: Tatiana Hernandez; David Delfin
MPAA rating: R
Running time: 90 minutes

REVIEWS

Burr, Ty. *Boston Globe*. July 16, 2013.
Hoffman, Jordan. *Film.com*. June 25, 2013.
Holland, Jonathan. *Variety*. March 8, 2013.
Kenigsberg, Ben. *The A.V. Club*. June 26, 2013.
Kohn, Eric. *indieWIRE*. June 14, 2013.
O'Hehir, Andrew. *Salon.com*. June 27, 2013.
Oleszczyk, Michal. *RogerEbert.com*. June 28, 2013.
Puig, Claudia. *USA Today*. June 27, 2013.
Rodriguez, Rene. *Miami Herald*. July 18, 2013.
Stevens, Dana. *Slate*. June 28, 2013.

TRIVIA

Alberto San Juan had to turn down a role in the film due to prior stage commitments.

IN A WORLD...

Speak up and let your voice be heard.
—Movie tagline

Box Office: $3 Million

In most movies with a female main character, her wanting to hear "three little words" can only refer to one thing: Love. In *In A World...*, a breath of fresh air for both comedy and stories about women, Carol (writer-director Lake Bell) concerns herself more with a different set of three little words. To Carol, the daughter of a voiceover icon (Fred Melamed) who hopes to break into the game herself, the dramatic delivery of the phrase "in

a world" represents the peak of the voiceover community. Now that the historic introduction made famous by the late legend Don LaFontaine is being revived for the trailer of a *Hunger Games*-style blockbuster, Carol longs to swim upstream against the male-driven movie trailer voiceover culture and, appropriately, lend a female voice to a female-driven franchise.

That is not to say that the big L-word does not come into play in Bell's feature writing-directing debut, but she allows romance to be a subplot and tackles it without the commercialized phoniness that have progressively given romantic comedies a bad name. Carol's colleague Louis (Demetri Martin) clearly has feelings for her, but the dynamic between Bell and Martin makes this familiar set-up sweet instead of drily predictable. And in a serious storyline that does not really fit tonally with the rest of film, Carol's sister Dani (Michaela Watkins) and her husband Moe (Rob Corddry) bicker and experience temptation that threatens to throw their marriage off-course. Bell handles this conflict honestly and with curiosity about people tip-toeing so close to the line that they barely realize when they have crossed it. These scenes achieve an urgency that much of *In A World...* does not. However, the filmmaker struggles to resolve Dani and Moe's tension without simply glossing over the work couples must do to get past rough spots.

The rest of the film, though, has few rough spots, only small victories. That starts with Bell's voice as a filmmaker and Carol's voice as both a main character and a woman: She works hard to pursue a goal, relentlessly studying different voices and accents to perfect her own work. She never acts as if she would toss aside her professional life for her personal one (a la any number of regressive rom-coms) and advocates for women to speak like women, not a "sexy baby." In one hilarious interaction that makes great use of Bell's versatile vocal talents, Carol responds to a young woman talking like a squeaky toy by imitating her and highlighting the backward-looking trend of emulating influencers like the Kardashians. It is horrifying and cartoonish, Bell demonstrates, to speak as if everything a young woman says is a question, rather than a statement.

Needless to say, these solid starring roles for women come around almost never, meaning, sadly, that if a non-A-list actress wants one she better write it herself. Rashida Jones did it with 2012's ultimately disappointing *Celeste and Jesse Forever*, and Bell, long the bright spot in a variety of movies (like 2011's *No Strings Attached* and 2008's *Over Her Dead Body*) that range from forgettable to hideously annoying, thankfully took it upon herself to create a part perhaps no studio would grant her otherwise. She is an immensely likable on-screen presence and helps *In A World...* register as a pleasant diversion even when its stakes seem a little low.

That sensation is more a product of Bell's inexperience as a filmmaker than Carol's plight, which signifies a little-discussed corner of society that still sees the male voice as the preferred source of authority. Tangential to that, Carol's father embodies the cliche of a middle-aged man dating a much-younger woman (Alexandra Holden) but does not treat his daughter like a child. "I'm going to support you by not supporting you," he tells her, amusingly portraying detachment as empowerment. Carol must single-handedly take charge of her life, and, unlike garbage like 2013's Paula Patton vehicle *Baggage Claim*, she does not automatically think she needs a man to signal her success.

Bell, on the other hand, does not make the film work on her own. Ken Marino (Bell's co-star on Adult Swim's hysterical *Children's Hospital*) contributes laughs and his trademark obliviousness as rising voiceover star Gustav Warner. Bell's former co-star Eva Longoria, appearing as herself as she attempts a Cockney accent for a project, effectively contributes to the film's inside-Hollywood satire. (Carol also does voiceover for *Welcome to the Jungle Gym*, a children's romantic comedy whose ridiculous genre recalls a *Friends* gag when Phoebe [Lisa Kudrow] dated a creep who wrote children's erotic fiction.) For the characters of *In A World...*, the return of that phrase means the return of epic cinema. Obviously, Bell's little indie dramedy is anything but epic, and that is a good thing. It is the sort of movie, collecting sincere bits of humanity and humiliation, that catches on in a big way—not as a financial success story but a minor charmer passed along between people who still concern themselves with word-of-mouth recommendations and original voices. The world, onscreen and off, needs more of those.

Matt Pais

CREDITS

Carol: Lake Bell
Sam: Fred Melamed
Louis: Demetri Martin
Gustav: Ken Marino
Moe: Rob Corddry
Dani: Michaela Watkins
Jamie: Alexandra Holden
Katherine Huling: Geena Davis
Heners: Nick Offerman
Origin: United States
Language: English
Released: 2013
Production: Lake Bell; released by Roadside Attractions
Directed by: Lake Bell

Written by: Lake Bell

Cinematography by: Seamus Tierney

Music by: Ryan Miller

Sound: Matthew Nicolay

Music Supervisor: Chris Douridas

Editing: Tom McArdle

Art Direction: Ashley Fenton

Costumes: Lindy McMichael

Production Design: Megan Fenton

MPAA rating: R

Running time: 93 minutes

REVIEWS

Anderson, John. *Wall Street Journal*. August 8, 2013.

Goodykoontz, Bill. *Arizona Republic*. August 14, 2013.

Kermode, Mark. *The Guardian*. September 15, 2013.

McCarthy, Todd. *The Hollywood Reporter*. April 23, 2013.

Ogle, Connie. *Miami Herald*. August 22, 2013.

Puig, Claudia. *USA Today*. August 29, 2013.

Roeper, Richard. *Chicago Sun-Times*. August 15, 2013.

Scott, A. O. *New York Times*. August 8, 2013.

Tobias, Scott. *The Dissolve*. August 8, 2013.

Williams, Joe. *St. Louis Post-Dispatch*. August 22, 2013.

QUOTES

Carol: "This Wednesday, one woman will teach another woman to sound a little less retarded."

TRIVIA

The voices of Sam and Gustav's agents heard over the phone throughout the film are performed by Lake Bell.

AWARDS

Nominations:

Ind. Spirit 2014: First Screenplay

THE INCREDIBLE BURT WONDERSTONE

Abracatastic!
 —Movie tagline

Box Office: $22.5 Million

Some of the more successful comedies over the past decade have been under what one might call "the Will Ferrell brand." Take an egotistical jerk in a specialized profession such as a network news anchor, race car driver, or champion ice skater, and change him over the course

of ninety-or-so minutes. Such plotting can be traced back to the golden age of Hollywood comedy, but many of the most quoted laughers of the 21st century have belonged to Ferrell and his frequent collaborators using that very template. It is the clothesline to not just inspire unique absurdist humor but to also poke fun at the chosen professional industry. For another colleague to step into Ferrell's shoes to have a go at the formula would actually require little more than a Mad-Libs guide to screenplays. Come up with a profession, figure out how to humble its protagonist, and, with the right cast, perhaps the humor will find its own way. That is just about all Steve Carell needed to make *The Incredible Burt Wonderstone* well enough.

Born Albert Weinzelstein, the young man discovered magic through a do-it-yourself home kit sponsored by the great Rance Holloway (Alan Arkin). Perfecting tricks over the years with his best friend, Antony Merkus (Steve Buscemi), the Burt Wonderstone (Carell) and Anton Marvelton show in Vegas is born. The routine that comes with their success has turned Burt into a creature of privilege and expectation, even expecting the women he sleeps with to sign a waiver. This is upsetting to Jane (Olivia Wilde), the backstage-manager-turned-on-stage-assistant who once idolized Burt on her own journey to becoming a magician.

Burt's sin city dominance though is now being challenged by Steve Gray (Jim Carrey), a street magician whose outrageous stunts barely qualify as tricks in the traditional sense. As Burt and Anton's attendance wanes, so does their relationship culminating in a failed attempt to resort to Gray's level of magic. Stripping away his velvet costume and hair extensions, Burt hits rock bottom only to finally meet the man who sparked his life's ambition as a child. With Rance Holloway's guidance and Jane's inspiration, Burt begins to rediscover his love of the game and hopes for the opportunity to best his new rival.

A film such as this is dependent on the comic abilities of its cast. Carell has generally made a film career out of playing nice guy schlubs, but it is his work as Michael Scott on TV's *The Office* that remains the greatest bridge between aloof insensitive insecurity and utter sincerity. Carell played the supporting jerk to Carrey's God in *Bruce Almighty* (2003), but now turns it on to extreme for the better part of an hour and it is easy to see Will Ferrell in his place. Jerky buffoons always make it easier to swallow and while a horrible person for two-thirds of the film, Carell's Burt can be so hilariously single-minded that it makes his transition to average citizen all the more amusing. The natural chemistry he has with a true old pro like Arkin—in their third collaboration after *Little Miss Sunshine* (2006) and *Get*

Smart (2008)—also helps sell Burt's softening into decency.

Living up to his character's ambition as a show-stealer though, Jim Carrey with minimal screen time, reminds viewers how truly funny he can be. This is a true return-to-form for him delivering his most inspired turn since Count Olaf in *Lemony Snicket's A Series of Unfortunate Events* (2004). As a combination of flamboyant Criss Angel and pretentious weirdo David Blaine, Carrey never lets a moment pass without milking the ludicrous nature of Gray's stunts. Just as Jonathan Goldstein and John Francis Daley did with their script for *Horrible Bosses* (2011), they are lucky enough to have such a skilled cast at their disposal. Yet they do not leave them dangling on the mere strength of their own personas. There are really funny gags in-between the magic and if the film has that old school feel of setup-and-punchline, maybe that is part of the effort.

Cinematic comedy has found a variety of new avenues that audiences are not just living in an era defined by one brand over another. The works of Judd Apatow, Adam McKay, and their minions have trumped the exclusivity of gross-out humor or simple humiliations masquerading as screwball. If *The Incredible Burt Wonderstone* at times feels as "rote and mechanical" as an old trick performed by Ferrell or the countless comedians before him, that could be due to Don Scardino who has made quite a career in sitcom TV including more than a quarter of *30 Rock*'s 139 episodes. At just over 90 minutes the film never lags more than a couple without a joke; most of them very funny. In some regard, audiences have all seen variations of these same tricks before, but if the final one does not produce a big laugh then maybe the stone face in the audience has just outgrown the ability to do so.

Erik Childress

CREDITS

Burt Wonderstone: Steve Carell
Steve Gray: Jim Carrey
Anton Marvelton: Steve Buscemi
Jane: Olivia Wilde
Doug Munny: James Gandolfini
Rance Holloway: Alan Arkin
Rick the Implausible: Jay Mohr
Origin: United States
Language: English
Released: 2013
Production: Jake Weiner, Steve Carell; New Line Cinema Corp.; released by Warner Brothers

Directed by: Don Scardino
Written by: John Francis Daley; Jonathan M. Goldstein
Cinematography by: Matthew Clark
Music by: Lyle Workman
Sound: Elmo Weber
Editing: Lee Haxall
Costumes: Dayna Pink
Production Design: Keith Cunningham
MPAA rating: PG-13
Running time: 100 minutes

REVIEWS

Berardinelli, James. *ReelViews*. March 14, 2013.
Ebiri, Bilge. *Vulture*. March 15, 2013.
Hornaday, Ann. *Washington Post*. March 15, 2013.
Kenny, Glenn. *MSN Movies*. March 15, 2013.
McGranaghan, Mike. *Film Racket*. March 15, 2013.
Orndorf, Brian. *MovieCrypt.com*. March 14, 2013.
Patches, Matt. *Hollywood.com*. March 15, 2013.
Roeper, Richard. *Chicago Sun-Times*. March 14, 2013.
Vaux, Rob. *Mania.com*. March 15, 2013.
Westhoff, Jeffrey. *Northwest Herald*. March 16, 2013.

QUOTES

Jane: "I had imaginary friends, and even they were mean."

TRIVIA

Both Sacha Baron Cohen and Matthew Broderick were considered at one time for the role of Steve Gray.

INSIDE LLEWYN DAVIS

Box Office: $13.1 Million

Filmmakers have long loved artists from other fields. Cinema history is littered with biopics, fictional and "based on a true story," of musicians, painters, actors, and craftsmen of all ilk. And films about guitarists are a dime a dozen. Hollywood loves men who bare their souls in musical form. And most of them, perhaps so their creators can live vicariously through their protagonists, are stories of underrated talents rising to the top of their profession. Writers and audience members love the story of the creative underdog; the tale of the man who stuck to his artistic values and succeeded in a cruel world that does not appreciate "real art." *Inside Llewyn Davis* is not one of those stories. For its title character, artistic values are a noose around his neck, keeping him from real success and leaving him beaten in an alley as

real life passes him by. He is a passenger on life's journey, never taking the right exit at the right time. And Joel and Ethan Coen's film about him is an absolute masterpiece.

Llewyn Davis (Oscar Isaac) is kind of a jerk. He is undeniably talented but probably not the best musician in his circle of friends, and his chance at breakthrough success looks like it may have been forever damaged by the suicide of his performing partner (who is never seen but heard in a beautiful rendition of "Fare Thee Well," undeniably the most lyrical and gorgeous song in a film full of them; no doubt meant to imply that the happiest times are in the past). Davis struggles with unplanned pregnancies (like that of a good friend's wife played with caustic brilliance by Carey Mulligan) and even just finding a place to sleep as much as he does with making a living from performing. The Coens' film about Davis is a comedy, musical, drama, period piece, and distinctly brilliant tonal tightrope act.

Inside Llewyn Davis is best read as a long-lost folk recording from the early 1960s brought to life. The narrative features many songs played in their entirety with the connective narrative in between almost serving as the liner notes for the music. Loosely based on a pre-Dylan Village staple named Dave Van Ronk, Davis often says more through his performances than he does through dialogue. The film opens with him singing "Hang me, oh hang me, I'll be dead and gone. Hang me, oh hang me, I'll be dead and gone. Wouldn't mind the hanging but the laying in the grave so long, poor boy, been all around this world." Davis is a world-weary traveler. He has bounced from couch to couch, session to session, gig to gig, and reached something of a breaking point. He is ready to be hanged.

With its "liner notes brought to life" approach to storytelling, *Llewyn Davis* is arguably the most episodic of the Coens' films to date (although it is interesting that the closest competition would be another period piece built on a musical foundation, *O Brother, Where Are Thou?* [2000]). There are only brief pushes of narrative to get Davis, who is in every scene in the film, from one beat to the next. He mistakenly allows a cat to escape from the home of his latest benefactors and is forced to carry him around before he can be returned. He tries to crash in the apartment of Jim (Justin Timberlake) and Jean (Carey Mulligan), only to discover that the latter is pregnant and the baby might be Llewyn's. He does a recording session for a hilariously catchy bit of pop fluff called "Please Mr. Kennedy" (with Timberlake and Adam Driver). And he car pools to Chicago with a drug-addicted jazz musician (John Goodman) and a James Dean wannabe (Garrett Hedlund),

where he performs for a musical power broker (F. Murray Abraham).

How are all these plot threads connected? How does Goodman's ornery passenger relate to Mulligan's insult-spewing singer? Why does Llewyn pick what is absolutely the wrong song choice for arguably the most important audition of his career? A small book could be written on that scene alone, in which Davis sings "The Death of Queen Jane." Why? He sings a bleak, melancholy song about a woman named Jane who is struggling through child labor after learning that an old girlfriend did not abort their child as he had thought and knowing that Jean is going to have an abortion soon. Babies, motherhood, labor—these are themes on Davis' mind. It is almost as if there is no other song he could possibly sing. Music is expression for him, even when that expression is going to cost him financial success and potential fame. It is one of the best scenes in film history at capturing the cost of artistic integrity. (And it is no coincidence at all that Davis is playing songs akin to Dylan hits from the era like "Queen Jane Approximately." A shadowed Dylan even appears in the film, singing "Farewell," a cousin of Davis' "Fare Thee Well.")

And how does this connect to the rest of the film? Songs on folk albums do not connect with a straight line but they are made of the same tonal fabric. The beats of *Inside Llewyn Davis* may feel disparate but the Coens pull them together like a record producer, making them feel part of a cohesive whole.

While the film is best-appreciated in the days after seeing it and on repeat viewing, this should not imply that it is not also incredibly enjoyable from beat to beat, song to song. Great scene follows great scene from Llewyn's road trip to his arguments with Mulligan to his meeting with an agent willing to give him the coat off his back but not real representation to a breakdown at a dinner in which Llewyn feels like a performing monkey to every single musical number.

The technical elements are well-above criticism, especially Bruno Delbonnel's wonderfully nostalgic cinematography, lighting his scenes almost as if they are illuminated by memory more than reality. Supporting turns are strong, especially Mulligan and Goodman, but the film belongs to Mr. Isaac, who breaks through after great supporting turns in films like *Drive* (2011) to prove that he can absolutely carry a major film. Llewyn Davis is a difficult character for a performer in that actors are trained to make audiences like their protagonists. Llewyn is called an asshole more than once in the film and that title may be the right one. And yet Isaac keeps him engaging without begging viewers to root for him as so many other actors would have. It is one of the best performances of 2013.

All of these critical readings about integrity, changing eras of music, and more that can be placed on *Inside Llewyn Davis* are never forced by the film. It is a work open to interpretation or merely a surface-level reading of enjoyment. Like a great folk album, it could mean the world to a listener or just make him tap his toes in unspoken agreement. And then hit play and listen to it all over again.

Brian Tallerico

CREDITS

Llewyn Davis: Oscar Isaac
Jean: Carey Mulligan
Jim: Justin Timberlake
Al Cody: Adam Driver
Roland Turner: John Goodman
Johnny Five: Garrett Hedlund
Origin: United States
Language: English
Released: 2013
Production: Scott Rudin, Ethan Coen, Joel Coen; Scott Rudin Productions; released by CBS Films
Directed by: Ethan Coen; Joel Coen
Written by: Ethan Coen; Joel Coen
Cinematography by: Bruno Delbonnel
Sound: Skip Lievsay
Editing: Ethan Coen; Joel Coen
Art Direction: Deborah (Deb) Jensen
Costumes: Mary Zophres
Production Design: Jess Gonchor
MPAA rating: R
Running time: 105 minutes

REVIEWS

Hornaday, Ann. *Washington Post*. December 19, 2013.
Kemp, Philip. *Total Film*. January 21, 2013.
Kenny, Glenn. *RogerEbert.com*. December 6, 2013.
Mohan, Marc. *Portland Oregonian*. December 20, 2013.
O'Hehir, Andrew. *Salon.com*. December 5, 2013.
Persall, Steve. *Tampa Bay Times*. January 9, 2014.
Rea, Steven. *Philadelphia Inquirer*. December 20, 2013.
Turan, Kenneth. *Los Angeles Times*. December 5, 2013.
Weitzman, Elizabeth. *New York Daily News*. December 5, 2013.
Wilson, Calvin. *St. Louis Post-Dispatch*. December 19, 2013.

QUOTES

Llewyn Davis: "If it was never new, and it never gets old, then it's a folk song."

AWARDS

Nominations:

Oscars 2013: Cinematog., Sound
British Acad. 2013: Cinematog., Orig. Screenplay, Sound

Golden Globes 2014: Actor—Mus./Comedy (Isaac), Film—Mus./Comedy, Song ("Please Mr. Kennedy")
Ind. Spirit 2014: Actor (Isaac), Cinematog., Film

INSIDIOUS: CHAPTER 2

It will take what you love most.
—Movie tagline

Box Office: $83.6 Million

After breaking through with *Saw* (2004), a debut that would become a horror phenomenon, director James Wan had trouble matching the success that then threatened to define him. His follow-up, an old-fashioned horror tale called *Dead Silence* (2007) was not well-received. After that, a more reality-based nightmare, *Death Sentence* (2007), was an unfairly overlooked action revenge flick that proved Wan had more than just scares up his sleeves. Three years later, Wan and *Saw* screenwriter Leigh Whannell teamed up again and returned to their roots. Offering a self-proclaimed *Poltergeist* (1982) for a new generation, *Insidious* (2011) proved to be *Saw*'s equal in financial success and won over many critics as well. Double-dipping once again in 2013, Wan started with his most technically proficient haunted house film to date with *The Conjuring* (2013); a film so good that the release of a sequel to *Insidious* just two months later seemed like a miscalculated bit of bandwagon jumping. The biggest fear would be that it would just be more of the same, but Wan is a director willing to take things a bit further and this is one second chapter that is not afraid to do so.

Those needing a refresher course in all the nuttiness that transpired in the first film, *Chapter Two* begins with just enough info to spark those repressed memories. There is a flashback to the childhood of Josh Lambert (Patrick Wilson) and his ability to astral project into the spirit world from where he is being haunted by a mysterious woman. Josh's wife, Renai, is being questioned by police over the death of their spiritual advisor, Elise (Lin Shaye) that her husband (or, at least, his body) may have been responsible for. Renai is continuing to have visions of their frequent haunter and, with Josh putting on too happy of a face, turns to his mother, Elaine (Barbara Hershey), and ghost hunters, Specs (Whannell) and Tucker (Angus Sampson) to figure out why their woes did not end in chapter one.

Knowing full well that it is the ghosts' connection to her hubby that ails them, Renai and her makeshift team call again on Carl (Steve Coulter), Elise's former assistant who once aided Josh in forgetting his gifts. Lorraine recalls the story of an old patient who committed suicide at the hospital where she worked. His con-

nection to a serial killer known as "The Dark Bride" suggests that a pattern may be repeating and may also explain the interest in the Lambert's offspring. Back in their latest house of ill-repute, Josh truly is not himself and his body is beginning to reflect the decaying soul inhabiting him while the real Josh is doing his own investigation in the netherworld.

Making heads or tails in the rules of *Insidious'* overlapping plotlines becomes difficult to put into words and yet coolly and easily understood to anyone willing to give themselves over to a classic ghost story. This just scratches the surface of what turns out to be an even more complicated story that again begins with noises and bumps in the broad daylight only to quickly reinvent its story. The first film was heavy on the creeps as it managed to utilize sound to maximum effect the way Robert Wise did with *The Haunting* (1963) and then made way for enough humor to reassure us that we can have fun being scared. Like cinematic parental figures, Wan and Whannell then lured viewers into a finale that was a bit more ethereal and calming than explicitly tension-forming. Some minor changes were even made from its premiere at the Toronto Film Festival to its theatrical release seven months later. In the sequel, the duo have actually reversed the mood and have far more surprises in store than most run-of-the-mill follow-ups.

Insidious wore the influence of *Poltergeist* on its sleeve like a little pet the writers could stroke whenever events approached point-of-no-return absurdity. *Chapter Two* clearly owes a lot to *The Shining* (1980) with its patriarch descending into madness and wanting to introduce his family to the nearest axe. Jack Torrance's shoes are big ones to fill and those who usually attempt it normally wind up becoming a fuzzy copy of *The Amityville Horror* (1979) or one of its many direct-to-video sequels. Instead, those paying attention may recognize another Spielberg-produced tale getting its own homage time. By not only revisiting the events of the first film but allowing its characters to wander in and out of it to introduce a whole new perspective on it, the filmmakers have taken a dizzying approach right out of *Back to the Future Part II* (1989) or, at least, their screenplay for *Saw III* (2006). This induces just the shot of adrenaline *Chapter Two* needs to keep from just being another rote "quiet, noise, shock, re-watch, and repeat" template that is all the *Paranormal Activity* films and countless franchise wannabes have given fans for too long.

The *Insidious* films are unlikely to go down in history as classics of the genre or destined to be regularly referenced in future film reviews. They are examples though of filmmakers who know the difference between homage and outright theft and who are not content to just repeat themselves wholesale. Wan's work on *The Conjuring* will deserve such references in the future as an exercise in pure horror; knowing just how serious to take its otherworldly beliefs and how far to take an audience before lapsing into self-parody. *Insidious: Chapter Two* might feel like such a parody in the wake of such craftsmanship, but just because Wan may not be taking things as seriously does not mean his heart is not into it. Since its release, he has announced it will be his last horror film (even though a third chapter is already on the drawing table). As Wan jumps back into action filmmaking, landing the helm of *Fast & Furious 7* (2014), there is little need to worry that the same director will resurface from the horror universe and absolute hope that his sequel will be the one that makes one reevaluate the predecessors.

Erik Childress

CREDITS

Josh Lambert: Patrick Wilson
Renai Lambert: Rose Byrne
Dalton Lambert: Ty Simpkins
Elise Rainier: Lin Shaye
Lorraine Lambert: Barbara Hershey
Specs: Leigh Whannell
Origin: United States
Language: English
Released: 2013
Production: Jason Blum, Oren Peli; Blumhouse Productions; released by Film District
Directed by: James Wan
Written by: Leigh Whannell; James Wan
Cinematography by: John R. Leonetti
Music by: Joseph Bishara
Sound: Joe Dzuban
Editing: Kirk Morri
Art Direction: Jason Garner
Costumes: Kristin Burke
Production Design: Jennifer Spence
MPAA rating: PG-13
Running time: 106 minutes

REVIEWS

Abrams, Simon. *RogerEbert.com.* September 13, 2013.
Berardinelli, James. *ReelViews.* September 13, 2013.
Berkshire, Geoff. *HitFix.* September 12, 2013.
Cline, Rich. *Shadows on the Wall.* September 20, 2013.
Goss, William. *Film.com.* September 13, 2013.
Johanson, MaryAnn. *Flick Filosopher.* September 16, 2013.
McGranaghan, Mike. *Film Racket.* September 13, 2013.
Orndorf, Brian. *Blu-ray.com.* September 13, 2013.

Phillips, Michael. *Chicago Tribune.* September 12, 2013.

Weinberg, Scott. *Fearnet.* September 13, 2013.

QUOTES

Young Elise Rainier: "In my line of work things tend to happen when it gets dark."

TRIVIA

Director James Wan has a cameo in the film when he appears on a computer wallpaper with Specs and Tucker.

THE INTERNSHIP

Hiring them was a brilliant mistake.
—Movie tagline

They just can't click with the younger generation.
—Movie tagline

Box Office: $44.7 Million

In reality, Google is where people go for information. Before Facebook was both a website and a verb, Google was something that the entire world both used and did—a trusted means of connecting with the massive variety of content the planet has to offer.

In the terrible virus of a movie *The Internship*, Google is where comedy goes to die, and the film is an example of when trust in a once-funny actor leads to a self-indulgent star with only one card to play. That, of course, is Vince Vaughn, who is no stranger to lazy comedic efforts. In recent years he has offered numerous obnoxious and unfunny excuses (including 2008's *Four Christmases*, 2009's *Couples Retreat* and 2012's unofficial Costco ad *The Watch*) to showcase his motor-mouth shtick that exploded in 1996's excellent *Swingers* but does not seem quite as novel nearly two decades later. It also no longer contains the underlying charm that made people like him in the first place. Vaughn conceived the story, co-wrote the script, and produced his starring vehicle *The Internship*, and, for one, it is a shocking demonstration of oppressive onscreen product placement. It is also a product of a major Hollywood comedian who either does not care how his work turns out or no longer knows the difference between trying to make audiences laugh and half-heartedly amusing himself under the assumption that everyone will love everything he does. This includes singing along to Alanis Morissette's atrocious "Ironic" and thus finding a way to make an awful song worse.

Re-teaming with his *Wedding Crashers* (2005) co-star Owen Wilson, Vaughn plays Billy McMahon, a fast-talking watch salesman who works with his best pal Nick Campbell (Wilson). Their primary tool is swagger,

but even that cannot save their jobs when the company folds. What now? Nick briefly works at his sister's creepy boyfriend's (Will Ferrell) mattress store, but after Billy's oh-so-brilliant idea of Googling Google, the pair has a different plan: interviewing for an internship at Google despite their total lack of qualifications. Hey, these guys made a living talking themselves into success, so maybe they can maintain the status quo without having to adapt or grow as people at all.

After coming off as obnoxious morons in a video-chat interview, Billy and Nick somehow land the internship anyway, apparently because of, uh, how courageous it was for them to take the interview or something. As if that is not strength that every unemployed person requires to put themselves out there for an employer to judge. The Google internship program revolves around team competitions to test the interns' many programming and customer service skills in a group environment, with the winning team earning full-time jobs. Billy and Nick, ostracized for their age and transparent egos, wind up in a gang of outsiders overseen by Lyle (Josh Brener), the foolish Google employee who advocated for Billy and Nick's hiring in the first place. From the start, the older interns insist on approaching things their own way and ignore the far more educated and intelligent team members. Never does *The Internship* challenge these fish out of water to discover a new way to breathe. If anything, the fish merely yell at the water to come to them because, really, nothing the fish ever does is wrong.

Seen in the context of Vaughn's recent string of critical bombs and dwindling commercial success, the typically disingenuous *The Internship* often feels like his effort to argue against his own obsolescence. The younger characters want Billy to problem-solve the way that they have been trained to, but their elder advocates for the value of life experience. He believes that everyone will come around to loving his outgoing charisma if he just keeps babbling, and the movie supports his worldview. It recalls the far more appealing *Our Idiot Brother* (2011), which also required its characters to realize their error in judging its central buffoon, except that Vaughn believes Billy is the coolest, smartest guy in the room. His concept of creativity and innovation makes *The Internship* the polar opposite of 2010's masterful *The Social Network*, other than both films sharing Max Minghella, who plays the captain of Billy's rival team.

And now it is time to get around to discussing the female characters, which Vaughn clearly does not care about at all. Every woman in *The Internship* is depicted as a gorgeous sexual object or an unpleasant and unattractive bitch. Nick's unconvincing subplot involves breaking company rules (for which there are no repercussions) and pursuing a colleague (Rose Byrne) who needs

to date more and work less, a reductive cliche of big-screen women in the workplace. When Billy's girlfriend dumps him early in the film, his immediate, sarcastic response to conflict is, "Is it because I'm too unselfish in bed?" This guy thinks he can do no wrong, and the mild, mild concession he eventually makes for a stupid mistake is not nearly enough to reflect that this narcissist has transformed into a team player. Because, well, he has not.

Stereotypes about the nerdiness of tech-savvy folks have no place in 2013, nor does the message that work ethic and professional collaboration should shrivel in the face of bossy jerks who do not know what they are doing. (This point would register more effectively if it were presented as a problem in the workforce, not a lesson for success.) It is easy to nitpick about individual lines in *The Internship*, such as attempts to make light of Alzheimer's and skin cancer and mocking an overweight young woman for doing gymnastics. Yet the film is most repulsive because of its overall sourness and stubbornness, offering no one to root for as Billy and Nick steamroll their way through a pathetic Quidditch game and other challenges that only expose how undeserving they are of this internship. There are also reminders about Google's many assets, like Gmail, Google Play and its ranking as a top place to work.

Considering how late the film arrives to the real-life challenges of the job market (covered better and in more timely fashion in 2009's *Up in the Air* and 2010's *The Company Men*), it unintentionally provides a host of sad reminders and maybe one or two laughs. If *The Internship* ever becomes the best candidate Hollywood has for a job, the industry may as well go out of business.

Matt Pais

CREDITS

Billy McMahon: Vince Vaughn
Nick Campbell: Owen Wilson
Dana: Rose Byrne
Graham Hawtrey: Max Minghella
Mr. Chetty: Aasif Mandvi
Stuart: Dylan O'Brien
Marielena: Jessica Szohr
Headphones: Josh Gad
Former Boss: John Goodman
Origin: United States
Language: English
Released: 2013
Production: Vince Vaughn, Shawn Levy; 21 Laps, Wild West Picture Show; released by Twentieth Century Fox Film Corp.

Directed by: Shawn Levy
Written by: Vince Vaughn; Shawn Levy; Jared Stern
Cinematography by: Jonathan Brown
Music by: Christophe Beck
Sound: John A. Larsen; Skip Longfellow
Editing: Dean Zimmerman
Costumes: Leesa Evans
Production Design: Tom Meyer
MPAA rating: PG-13
Running time: 119 minutes

REVIEWS

Bradshaw, Peter. *The Guardian*. July 5, 2013.
Burr, Ty. *Boston Globe*. June 6, 2013.
Dargis, Manohla. *New York Times*. June 6, 2013.
Dowd, A. A. *The A.V. Club*. June 5, 2013.
Lodge, Guy. *Time Out London*. July 5, 2013.
Moore, Roger. *Movie Nation*. June 6, 2013.
Phillips, Michael. *Chicago Tribune*. June 6, 2013.
Rea, Stephen. *Philadelphia Inquirer*. June 6, 2013.
Roeper, Richard. *Chicago Sun-Times*. June 6, 2013.
Zacharek, Stephanie. *Village Voice*. June 6, 2013.

QUOTES

Billy McMahon: "Here's the deal. I'm pretty terrific on the phones. I could sell prosciutto to a rabbi. And I have."

TRIVIA

The film utilized 100 real Google employees as extras.

IRON MAN 3

Prepare for heavy metal!
 —Movie tagline
Unleash the power behind the armor.
 —Movie tagline
Even heroes fall.
 —Movie tagline

Box Office: $409 Million

Iron Man 3 started the 2013 summer movie season off solidly enough, offering solid spectacle, good humor, and some nice twists near the end. Few would argue the latest installment was anything but an improvement over the dour *Iron Man 2* (2010) and as a follow-up to the huge success of *The Avengers* (2012), it was also right in the pocket of viewer expectation. But what *Iron Man 3* did right and what it did wrong says a lot about superhero cinema in general.

The film starts with Tony Stark (Robert Downey Jr.) at a New Year's Eve party circa 1999 where scientists

and investors compete for his attention. One such scientist is Aldrich Killian (Guy Pearce), a disabled man with an idea who finds himself humiliated, stranded on a rooftop at midnight when Stark blows off a promised meeting.

Forward to the present day, Stark finds himself unable to sleep, subject to horrific nightmares, and waking panic attacks as a result of his activities with The Avengers during the New York invasion. Directionless, he has kept building Iron Man suits, becoming obsessed with improving the technology, all but forgetting Pepper Potts (Gwyneth Paltrow) and descending deeper and deeper into depression. Meanwhile, a terrorist who calls himself the Mandarin (Ben Kingsley) has claimed responsibility for several high-profile bombings, one of which leaves Starks' right-hand man Happy Hogan (Jon Favreau) in a coma. Incensed, Stark takes to the airwaves, daring the Mandarin to a fight. But when the Mandarin destroys the house with gunships, Potts narrowly escapes being blown up with it.

Stark is saved only by his new version of the suit which has just enough power to be piloted by artificial intelligence J.A.R.V.I.S. to a remote location linked to the Mandarin bombings, where he crash lands, goes into hiding, and is presumed dead by the rest of the world. Here, Stark forges a friendship with 10-year-old Harley that allows him a shed to recoup and rebuild. Meanwhile Aldritch, who has resurfaced healthier and more able than ever, is implicated in the Mandarin's schemes via his old idea made into new flesh, Extremis, which offers healing power and super strength but only to those who are able to control it physically.

The rest of the plot gets awfully complicated and this showcases a major flaw in the film's design. There are no fewer than three villains in this show. In short, *Iron Man 3* commits the same sin that superhero films have been doing since *Batman Returns* (1992), needlessly cluttering its storyline to increase opportunities for spectacle. Guy Pearce handles the role of Killian just fine but ultimately his character is the faceless stuff of countless other Bond or action films. The only villain that matters in the film is the one that disappears.

This is especially sad since the protagonists, Tony Stark and Pepper Potts are given some surprisingly strong dramatic turns. *Iron man 3* is, in essence, not quite an Iron Man movie as much as it is a Tony Stark movie, in which the playboy billionaire philanthropist has a lot of screen time to remind viewers that even covered up by all that armor, a live human being is under assault. Tony Stark makes bad decisions, sees his coping mechanisms fail, and loses sleep because he has been isolated by his own pride. *Iron Man 3* gives Stark room to grow. Of course, Downey quips his way through plenty of sarcastic

one-liners with aplomb in and out of the suit. But he blends more humanity into the mix than ever before.

Paltrow has some stellar turns in a surprisingly meaty role. Pepper Potts is in love with Stark one moment, deeply hurt by him the next, and having to assume confident control of Stark Enterprises when he is feared dead. Paltrow manages to communicate the character's own smaller scale sense of self-discovery effectively through all those modes. Her chance to suit up and fight the bad guys not only feels empowering by the time it happens but wholly indicative of her arc and the arc of her and Tony's relationship.

Kingsley grabs hold of the role of The Mandarin with a real relish and looks to be having a blast. Starting out like some poor man's Fu Manchu (complete with weirdly unidentifiable accent) the Mandarin is mysterious and threatening. It would have been so interesting to see the character become a fully fleshed out ideology driven baddie a la the Batman series' Ra's Al Ghul. But the screenplay gives him an almost equally fun turn that will not be revealed here. Suffice to say the role plays to Kingsley's strengths for drama and comedy and offers a stirring reminder of his great talent.

Screenwriter/director Shane Black and co-writer Drew Pearce are adapting Warren Ellis' original Extremis mini-series but seem stuck with the material. Just as the film has too many villains it also has too many subplots, too much going on, to keep viewers attention on any of the important aspects of the story it tries to tell. Without the performances of Downey and Paltrow *Iron Man 3* would likely not work at all. That might be a little harsh. The special effects and the fight sequences are stunning, easily the best of the series. An early rescue of passengers aboard a doomed airplane is jaw dropping and the last, very long battle between Potts, Stark, and Killian is nearly as good.

But this is the point. Too often superhero films tease what they could be. A little drama here, a lot of special effects there. The prevailing production approach seems to be one of clumsy compartmentalization. But the moment where Pepper is allowed to put on the glove is a moment of pure character triumph. It transcends those categories and creates a messy moment of glory. *The Dark Knight* (2008) is full of such moments, refusing to neatly fall into the category of superhero film that other lesser films have created. Shane Black's last film was also his first as a director, *Kiss Kiss Bang Bang* (2005), a well-received comedy-action piece that should have set him up to step into these narrative shoes easily. But a look at his work as a screenwriter, which helped define the action film in the US during a key period, shows why *Iron Man 3* feels so narratively heavy-handed: *Lethal Weapon* (1987), *The Monster Squad* (1987), *Last Action*

Hero (1993), and *The Long Kiss Goodnight* (1996) are all witty entertaining films but they are also somewhat clunky—more well-meaning than well-written.

Iron Man 3 is utterly a simple superhero film, but it is a well-produced and well-directed one that could have used a rewrite and unlike *Iron Man* (2008) it is fully aware of the fact that its main character became a millionaire playboy philanthropist by selling weapons of mass destruction. A few cold sweats and panic attacks and a lifetime of having to save the world over and over again are the least Tony Stark can do to make up for the damage he left behind. In this, *Iron Man 3* is most like Nolan's masterful embrace of the superhero as a figure of troubled justice, which is at the very core of what superhero movies at their very best are about.

Dave Canfield

CREDITS

Tony Stark/Iron Man: Robert Downey, Jr.
The Mandarin: Ben Kingsley
Pepper Potts: Gwyneth Paltrow
Aldrich Killian: Guy Pearce
James Rhodes/War Machine: Don Cheadle
Maya Hansen: Rebecca Hall
Happy Hogan: Jon Favreau
Savin: James Badge Dale
President Ellis: William Sadler
Vice President Rodriquez: Miguel Ferrer
Wu Jiaqi: Bingbing Fan
Jarvis: Paul Bettany (Voice)
Origin: United States
Language: English
Released: 2013
Production: Marvel Studios; released by Walt Disney Pictures
Directed by: Shane Black

Written by: Shane Black; Drew Pearce
Cinematography by: John Toll
Music by: Brian Tyler
Sound: Mark P. Stoeckinger
Editing: Peter S. Elliot; Jeffrey Ford
Costumes: Louise Frogley
Production Design: Bill Brzeski
MPAA rating: PG-13
Running time: 130 minutes

REVIEWS

Fennell, Marc. *Triple J.* April 29, 2013.
Foundas, Scott. *Variety.* April 25, 2013.
Gibson, Brian. *Vue Weekly.* July 11, 2013.
Goss, William. *Film.com.* April 28, 2013.
Huddleston, Tom. *Time Out.* April 22, 2013.
Lyles, Jeffrey. *Lyles' Movie Files.* May 2, 2013.
McCarthy, Todd. *Hollywood Reporter.* April 24, 2013.
Neumaier, Joe. *New York Daily News.* May 2, 2013.
Simon, Brent. *Shared Darkness.* May 1, 2013.
Snider, Eric D. *EricDSnider.com.* July 12, 2013.

QUOTES

Tony Stark: "You can take away my suits, you can take away my home, but there's one thing you can never take away from me: I am Iron Man."

TRIVIA

The idea that Happy Hogan's favorite television show is *Downton Abbey* was actor Jon Favreau's, who is actually a big fan of the series.

AWARDS

Nominations:

Oscars 2013: Visual FX
British Acad. 2013: Visual FX

J

JACK THE GIANT SLAYER

> *If you think you know the story, you don't know Jack.*
> —Movie tagline

> *Prepare for a giant adventure.*
> —Movie tagline

Box Office: $65.2 Million

Audiences were taken to a land before Dorothy was born in *Oz: The Great and Powerful* (2013). It was not quite Lewis Carroll's *Alice In Wonderland* in Tim Burton's 2010 film but a sequel with the same name. That sure was not your grandmother's Snow White in 2012 when both *Mirror Mirror* and *Snow White and the Huntsman* gave the passive doe-eyed wanderer a purpose with sword training. While studios were on a roll with reinventing classic fairy tales, Warner Bros. decided to get into the mix by digging into the backstory of Jack and his mythical beanstalk. More than any of the other failed attempts, Bryan Singer's film winds up a bloated, lethargic, useless retelling that already feels more aged than the timeless tale it tries to reinvigorate.

As a young boy, Jack (Nicholas Hoult), was put to bed with the story of Erik the Great who kept the sky bound giants at bay through the creation of a magical crown that forced them to obey. It is the same legend that Princess Isabelle (Eleanor Tomlinson) closed her eyes to. She is now engaged to Lord Roderick (Stanley Tucci) who just happens to possess Erik's crown and the magic beans that can provide passage to the banished creatures. A monk has stolen those beans though and when Jack comes into town to sell his horse he is of-fered a trade that hardly meets with the approval of his uncle (rather than the widowed mother of the original tale.)

Isabelle's craving for adventure and mere explora-tion hardly delights her father, King Brahmwell (Ian MacShane), so like most spitfires ventures off on her own and ends up at Jack's home on a dark and stormy night. A single bean, some dirt and enough water then creates a magical beanstalk that sends Jack's house and Isabelle into the sky. Leader of the King's knights, El-mont (Ewan McGregor) takes point on a rescue mission up the stalk joined by fellow knight, Crawe (Eddie Mar-san), Roderick and his annoyingly loyal attendant, Wicke (Ewan Bremner). Jack also volunteers, possibly as an ef-fort to resist becoming an afterthought in his own story.

What follows is a rather uneventful climb into the sky. There is a little ziplining and some duplicity but nothing that constitutes genuine excitement, wonder or worry. Tucci's performance as the gateway villain to the real threat straddles the line between campy and treacherous with either side stifled from making a true appearance leaving us with perfunctory blandness in the opposition. Like the film's PG-13 rating, Singer is sketchy in just how far he wants to scare children and the quick cuts from true moments of violence are as distracting as the occasionally shoddy CGI work. Mar-san running away from his first encounter with a giant is reminiscent of Jeff Goldblum fleeing the T-Rex in *Ju-rassic Park* (1993), a moment that looked more realistic twenty years ago. Even forty years ago when process shots still looked groundbreaking. Contrasts in size have always proven to be a challenge for even the best of ef-fects artists but there are standout inconsistencies in the

editing that instantly pulls one out of many supposedly big moments.

Distractions in-between flaming trees being thrown and grandiose green landscapes would be less evident if there was more of a focus on the film's protagonist and what makes the journey worthwhile for him. Jack's motivations in a less-than-thousand-word fairy tale were clear. Guilt for failing mom led to dangerous trips into another world. Outwit a giant, steal his riches and live happily ever after. No doubt Jack and the newly-introduced princess are cut from the same cloth for adventure, but Hoult gives him no personality beyond that. Even farm boy Luke Skywalker was annoyed at his lot in life, annoyed a few others and dreamed big. Without Ewan McGregor managing default appeal and fine voice work by Bill Nighy that makes the lead giant more real than its appearance deserves, the film would be utterly devoid of anything resembling a hero and a bad guy. Each of them competes for as much screen time as Jack whose titular title of "giant slayer" is a bit premature for the first ninety minutes and is hardly worthy of the kind of legend suggested by the ridiculous epilogue.

For all the money that was spent on *Jack the Giant Slayer*, Bryan Singer certainly cut his share of corners when it came to its more epic moments. There are any number of slow, sweeping shots of land, sky and endless waterfalls. When it comes to the fast, exciting set pieces, they arrive about as slow as that falling water. Sword-fights are lethargic, the rampaging giants of the climax have no depth of field—despite being in a field—and a sneaking rescue from the clutches of becoming dinner recalls how much more ingenuity was employed in similar sequences from *Chicken Run* (2000) and *The Adventures of Tintin* (2011). Spike Jonze showed what could be plumbed from the picture-heavy pages of *Where the Wild Things Are* (2009), adding a subtext that turned one of the most beloved children's books of the 20th century into one of the most profound children's films of the 21st. Bryan Singer and his writers set out to make an adventure story, plain and simple. Instead, all its added plot complications could not even rise up to faint critical praise of plain or simple. It is enough to grind anyone's bones.

Erik Childress

CREDITS

Jack: Nicholas Hoult
Princess Isabelle: Eleanor Tomlinson
Lord Roderick: Stanley Tucci
King Bramwell: Ian McShane
General Fallon: Bill Nighy

Elmont: Ewan McGregor
Crawe: Eddie Marsan
Wicke: Ewen Bremner
Origin: United States
Language: English
Released: 2013
Production: David Dobkin, Ori Marmur, Neal H. Moritz, Bryan Singer; Bad Hat Harry, Big Kid Pictures, Legendary Pictures, New Line Cinema; released by Warner Bros.
Directed by: Bryan Singer
Written by: Darren Lemke; Christopher McQuarrie
Cinematography by: Newton Thomas (Tom) Sigel
Music by: John Ottman
Sound: Mark A. Mangini
Editing: John Ottman
Costumes: Joanna Johnson
Production Design: Gavin Bocquet
MPAA rating: PG-13
Running time: 114 minutes

REVIEWS

Bayer, Jeff. *The Scorecard Review*. March 6, 2013.
Berardinelli, James. *ReelViews*. March 1, 2013.
Edelstein, David. *Vulture*. March 4, 2013.
Gibron, Bill. *Screen It!*. March 1, 2013.
Johanson, MaryAnn. *Flick Filosopher*. March 22, 2013.
Kisonak, Rich. *Film Threat*. March 6, 2013.
McGranaghan, Mike. *Aisle Seat*. March 1, 2013.
Patches, Matt. *Hollywood.com*. March 1, 2013.
Putman, Dustin. *DustinPutman.com*. February 28, 2013.
Singer, Matt. *Screencrush*. March 1, 2013.

QUOTES

Wicke: "Why is it that people always scream before they die? Do they think it's gonna help them?"

TRIVIA

Eleanor Tomlinson based her character on Sigourney Weaver's portrayal of Ripley in *Aliens*.

JACKASS PRESENTS: BAD GRANDPA

Box Office: $102 Million

Suffer as they might by their own gleeful stupidity, the abundant humor to be found in the "Jackass" crew's filmography is correlated largely to the lack of protection. One can only imagine how less comically fulfilling a sequence, such as "Rocket Skates" in *Jackass: The Movie*

(2002), or "Bicentennial BMXing" in *Jackass Number Two* (2006), would be if the group were to don adequate, if not an overly necessary amount of safety garb before tackling such harmful endeavors; if the Jackasses were practicing inviolability like logical adults, instead of effectuating their title personas.

Such explains the paramount flaw of *Jackass Presents: Bad Grandpa*, a feature film based around 86-year-old Irving Zisman, a character who provided an amusing sidebar to main event "Jackass" shenanigans in the previous films, while still continuing the series' celebration of skater punk-meets-stuntman, guerilla camera recklessness. Adorning King Jackass Johnny Knoxville in sweaters and impressive old-age makeup, Irving is a senile antagonist of those who cross his path, who often uses crass humor (fake testicles are a common prop) to shock his unexpected audience.

Jackass Presents: Bad Grandpa misuses the bite-size candid camera amusement potential of Irving and places him into a feature-length, thin road trip plot, as strung together by a narrative with forced pranks as pit stops. After his wife is pronounced dead, Irving celebrates by attempting intercourse with a soda machine in a gas station, to the grossed amusement of numerous onlookers. Soon after, Irving is shown at his wife's funeral, which Irving notes to the attendees is populated with fake friends. With his daughter going off to jail after the funeral for violating probation, Irving is designated impromptu guardian for his grandson Billy (Jackson Nickoll), who needs to be transported to his grimy father Chuck (Greg Harris) in North Carolina. After Irving convinces two men to haul his wife's dead body into a car trunk, the irresponsible grand-patriarch and his kin take off.

With Knoxville and Nickoll splitting one of the brighter scenes in 2012's bleak teen comedy *Fun Size*, the two have genuine chemistry again in *Jackass Presents: Bad Grandpa*, even during its flat driving sequences where the burden of narrative is shown to be progressively awkward. Knoxville's impression of old age is without any real structure or consistency, other than the idea that the actor just barely changes his voice tone while embodying Zisman. However, his co-star Nickoll shows to be a strong improviser, able to carry entire sequences on his own with impressively cultivated improvisational skills. Such happens with the film's biggest laugh, an opening sequence in which he states to a stranger that he wants to become talented at something so he can make money to live next to his mother's jailhouse.

As a collection of scripted events, the story (co-writtten by Knoxville, director Jeff Tremaine, *Jackass* godfather Spike Jonze, Fax Bahr, and Adam Small) the

movie makes for neither a smooth little narrative or a fitting collection of pranks. By the film's second act, in which the duo is freely exhibiting their shenanigans out in public, the suspension of disbelief has been broken. Even when outdoors, when encountering random people walking by, Tremaine's movie loses its sense of being a reality film, despite the mirroring these sequences have with the raw "Jackass" style. A third act prank involving a fake pageant show loses its desired spark for its similarity to that of popular indie film *Little Miss Sunshine* (2006), in which a grandfather also encourages his young grandchild to let their freak flag fly, nonetheless on the stage of a children's beauty pageant.

Jackass Presents: Bad Grandpa suffers largely due to its setup, which by concept deflates its potential for daring pranks. Often, such as with the first act fake funeral, a moment in a shipping service store, or a bit involving a motorized mattress, the incidents are completely isolated from public, with a multitude of hidden cameras able to obtain a clear view of the shenanigans at hand. With this type of setup, the film then becomes a shared joke between filmmakers and institutions and/or property owners who permit their space as playground for Knoxville's mischievousness, while select groups of employees/customers are out of the joke so as to become part of a surprise. Instead of being the party crasher, Knoxville is more like the clown who is hired to spray water in people's faces.

Especially when pranks are captured with specifically placed non-handheld cameras with high quality HD imagery, indicative of pre-planning and control of the environment, the humor of *Jackass Presents: Bad Grandpa* becomes fatally forced, taking the sting out of any sarcastic interaction Irving may have, or reckless behavior he may be exhibiting. The anxieties about what repercussions a daredevil like Knoxville may face when cameras are not rolling for a stunt are completely eradicated, with the prank serving no purpose but to get a facial reaction from a select few lab rats that are not in on the joke.

As well, for acts of comedy that bank their punchlines on unplanned facial reactions, surprised participants are often more confused than they are vividly surprised. In some instances, like during a flashback in which Irving waves around an extremely fake-looking fish with a human-sized appendage, the response from his shock targets is completely numb. With such contrived stunts setting up these moments, it would have probably benefited the film to plant its "innocent bystanders" as well.

A movie not looking for trouble ironically goes forth with a prankster that made for the most uncomfortable moral parodies in "Jackass'" earlier days. But now with a

longer running time than his usual montage or two, Irving Zisman is presented with the containment and supervision of a stunt, without the risk of danger that fuels the excitement of a genuine prank. In his older age, "Jackass" pioneer Knoxville indicates with this spin-off that he is less interested in playing it unsafe.

Nick Allen

CREDITS

Irving Zisman: Johnny Knoxville
Billy: Jackson Nicoll
Chuck: Gregory Harris
Kimmie: Georgina Cates
Origin: United States
Language: English
Released: 2013
Production: Derek Freda, Spike Jonze, Johnny Knoxville, Jeff Tremaine; MTV Films; released by Paramount Pictures Corp.
Directed by: Jeff Tremaine
Written by: Johnny Knoxville; Jeff Tremaine
Cinematography by: Lance Bangs
Music by: Sam Spiegel
Sound: Mike Wilhoit
Music Supervisor: Ben Hochstein
Editing: Seth Casriel; Matthew Kosinski; Matthew Probst
Costumes: Lindsey Kear
MPAA rating: R
Running time: 92 minutes

REVIEWS

Adams, Sam. *Time Out New York*. October 25, 2013.
Covert, Colin. *Minneapolis Star Tribune*. October 24, 2013.
DeFore, John. *Hollywood Reporter*. October 23, 2013.
Duralde, Alonso. *The Wrap*. October 23, 2013.
Foundas, Scott. *Variety*. October 23, 2013.
Hartlaub, Peter. *San Francisco Chronicle*. October 24, 2013.
Jones, J. R. *Chicago Reader*. November 7, 2013.
Nicholson, Amy. *L.A. Weekly*. October 24, 2013.
Sharkey, Betsy. *Los Angeles Times*. October 24, 2013.
Weitzman, Elizabeth. *New York Daily News*. October 24, 2013.

QUOTES

Billy: "What's your stripper's stage name?"
Adult bookstore clerk: "Do I look like a stripper?"
Billy: "I'll just call you Cinnamon."

TRIVIA

Despite his young age, actor Jackson Nicoll remained in-character most of the time during filming.

AWARDS

Nominations:
Oscars 2013: Makeup

JOBS

Some see what's possible, others change what's possible.
　　—Movie tagline

Box Office: $16.1 Million

Joshua Michael Stern's *Jobs,* a biopic about the life of Apple Computers' founder and innovator Steve Jobs (Ashton Kutcher), opens with the CEO introducing the first ever iPad in 2001 at a staff meeting. As soon as he produces the revolutionary little item, the crowd immediately stands and applauds, at which time John Debney's score swells as though the film is introducing the final scene in the film at its onset. From the get-go, the film appears to be in awe of Jobs and it clearly wants the audience to feel the same way. It is true that almost everyone, in some way, owes a debt of gratitude to Steve Jobs and/or Bill Gates for their world-changing innovations, but to open the film in such a grandstanding manner leaves the viewer little choice in what they are meant to think of Steve Jobs as a human being.

That scene is as far as the film will go in its timeline. It flashes back to 1974 at Reed College where Steve Jobs spent his days wandering from class to class without much of a direction. One of his teachers (James Woods) encourages him to take writing or tech classes. Jobs has an interest in art, but no sense of purpose. One day, he and his friends drop acid in a field, and Jobs has a vision, the kind of musical montage that is meant to convey a breakthrough of the mind. He decides to take computer classes. He takes trips to India with his friends and sees a guru who teaches him to meditate. A few years later, he works at Atari where he has his first hissy fit about technology not moving fast enough for his grand ideas.

This prompts him to take his co-worker Steve Wozniak (Josh Gad), who appears to have invented the first electronic keyboard that hooks up to a video monitor, to go work for themselves. They invent a kind of microchip in Jobs' parents' garage and recruit some other like-minded technologists to help them get Apple Computers off the ground. Of course, it is an uphill battle as their presentation at the Computer Club at Stanford University produces nothing but indifference from those attending. Only when they receive a visit from a businessman from Intel named Mike Makkula (Dermot Mulroney) do things take a turn for the better

in terms of getting Apple's product to the masses. The first ever computer fair in San Francisco in 1977 becomes the first time audiences would applaud automatically at the sight of a new product from Apple before Jobs explains what exactly it does.

But the film is also about Jobs' personal life. His girlfriend at the time, Chris-Ann Brennan (Ahna O'Reilly), got pregnant as Jobs was struggling to sell computers. His temperament was such that he convinced himself that the child was not his; that she had been unfaithful to him. So he kicked her out of their place and for long time, refused to acknowledge the existence of this child, named Lisa. Likewise, at the workplace, Jobs comes off as a tyrant and the second a technician explains that "it can't be done," they are immediately fired. Jobs also became too much of a loose cannon when it came to money and funding projects that had no hope of producing any profits. The final third of the film becomes a soap opera of CEOs changing hands and the company changing regimes.

Stern appears to want to have it both ways with *Jobs*. On one hand, the film wants to do for Steve Jobs what *The Social Network* (2011) did for Facebook founder Mark Zuckerberg, someone who was incredibly motivated by pushing the boundaries of an idea, but who had no idea how to treat people with respect or courtesy. Unlike Fincher's film, though, *Jobs* is way too attached to its subject as a world-renowned game changer. One minute, Jobs lays into a technician or associate for not thinking the way he thinks and completely humiliates the guy and fires him. The next minute, Jobs gives a speech about how the simplest idea can change the world and how they are going to be the ones who make that happen. The music swells and the viewer is meant to feel inspired by this tyrant.

As Jobs, Kutcher has only Matt Whiteley's pedestrian script to convey which mode he will be in, which does not appear to give him much range. Kutcher is at his best when the script calls for him to be determined and to try and talk his way into or out of situations. But his scenes of anger and frustration feel forced and unnatural. Kutcher has always had limited range when it comes to drama, as was highly evident in his first dramatic outing, *The Butterfly Effect* (2004). The rest of the cast does a serviceable job filling their roles, with a roster of reliable character actors making generous appearances including Kevin Dunn, J.K. Simmons, John Getz, and Matthew Modine.

But *Jobs* is a biopic on autopilot. Every big moment gets punctuated by a ham-fisted score and every transition from year to year gets accompanied by whatever rock song was popular at the time on any FM station. The film has little to say about Steve Jobs aside from the

fact that he was a tyrant and a genius. There might have been an interesting film about Steve Jobs had it concentrated solely on one period of his early days struggling to get a project off the ground that would eventually lead the way to a game changer. There is a lot of wisdom to be found in the idea that one day can decode an entire life. *Jobs* is out to celebrate the life of Steve Jobs while also depicting his bad side. The take-away from the viewer appears to be that at the end of the day, it does not matter how you treat people, so long as you become a world famous genius.

Collin Souter

CREDITS

Steve Jobs: Ashton Kutcher
Steve Wozniak: Josh Gad
Mike Markkula: Dermot Mulroney
Rod Holt: Ron Eldard
Daniel Kottke: Lukas Haas
John Sculley: Matthew Modine
Arthur Rock: J.K. Simmons
Jack Dudman: James Woods
Origin: United States
Language: English
Released: 2013
Production: Mark Hulme, Joshua Michael Stern; Devoted Consultants, Five Star Feature Films; released by Devoted Consultants, Five Star Feature Films, Open Road Films
Directed by: Joshua Michael Stern
Written by: Matthew Whiteley
Cinematography by: Russell Carpenter
Music by: John Debney
Sound: Paula Fairfield
Editing: Robert Komatsu
Costumes: Lisa Jensen
Production Design: Freddy Waff
MPAA rating: PG-13
Running time: 122 minutes

REVIEWS

Covert, Colin. *Minneapolis Star Tribune.* August 15, 2013.
Gleiberman, Owen. *Entertainment Weekly.* August 15, 2013.
Guzman, Rafer. *Newsday.* August 15, 2013.
Keough, Peter. *Boston Globe.* August 15, 2013.
Lacey, Liam. *Globe and Mail.* August 16, 2013.
LaSalle, Mick. *San Francisco Chronicle.* August 15, 2013.
Neumaier, Joe. *New York Daily News.* August 16, 2013.
O'Sullivan, Michael. *Washington Post.* August 15, 2013.
Stevens, Dana. *Slate.* August 16, 2013.
Whitty, Stephen. *Newark Star-Ledger.* August 16, 2013.

QUOTES

Steve Jobs: "Here's to the crazy ones the misfits the rebels the troublemakers the round pegs in the square holes the people that are crazy enough to think they can change the world are the ones who do."

TRIVIA

Almost all of the scenes involving Jobs's parents' house and garage were filmed in the actual Los Altos, California home where Steve Jobs grew up in the 1970s.

AWARDS

Nominations:

Golden Raspberries 2013: Worst Actor (Kutcher)

JOHN DIES AT THE END

Just so you know...they're sorry for anything that's about to happen.
—Movie tagline

Box Office: $141,951

John Does at the End may seem like a spoiler-ridden title but knowing that John does indeed die at the end barely scratches the surface of the plot much less the sense of adventure veteran genre director Don Coscarelli gets up on the screen. Perhaps the true test of cult status is whether or not a film can be watched multiple times and adopted as something other than simple entertainment. By that standard *John Dies at the End* just passes muster. Wildly weird, funny, unnerving and even a little moving, this is a movie tailor made for genre fans right down to the casting of *Phantasm*'s Angus "The Tall Man" Scrimm in a fun cameo. But past such street cred the film also offers a sardonic satire on the search for meaning and the hero's journey even as it embraces same.

The plot is, not only, non-linear, but more or less indescribable in any conventional sense, following several different plot-lines and playing with the ways in which they can be merged. Dave (Chase Williamson) is a twenty-something friend to twenty-something John (Rob Mayes), who becomes his guide when Dave ingests a substance known as Soy Sauce, which opens the door of perception to the world beyond death and allows users to influence time and space. In another subplot taking place in a Chinese restaurant and its parking lot, we see Dave trying to convince a reporter named Arnie (Paul Giamatti) of all this. Part of convincing Arnie is a series of flashbacks that involve a number of other people detailing John and Dave's adventures as interdimensional slacker monster hunters. People talk into

and get excellent reception from bratwursts; dogs talk and drive; girlfriends are acquired and lost. *John Dies at the End* is faithfully sourced from the like-titled novel by David Wong, and, luckily, it manages to do more than annoy those who require a linear plotline.

History is full of films that are so energetically weird they manage to entertain on that basis alone. Sure, *The Rocky Horror Picture Show* (1975), *Buckaroo Bonzai Across The 8th Dimension* (1984), and *Big Trouble in Little China* (1986) are all better movies than *John Dies at the End*. But, like them, *John Dies at the End* conjures an impressive fantasy world just under the surface of the one viewers take for granted. Monstrousness pervades as demonic entities form themselves out of the container of meat lockers only to be disposed of handily over the phone by Vegas psychics. Severed arms form chokeholds, drops of Soy Sauce turn into flies, and Hellmouths open. In almost all cases, the special effects are refreshingly practical or at least still pretty neat when they are accomplished digitally.

Coscarelli specializes in cinematic oddments. Perhaps his best film, *Phantasm* (1979) offered up a darker but similar blend of horror and science fiction with decidedly Lovecraftian overtones. So it should come as no surprise that he was attracted to Wong's novel, which reads like a cross between Lovecraft and Douglas Adams. The weakest aspect of his adaptation is the constant use of voiceover. To Coscarelli's credit the constant exposition provided by Dave seems basically unavoidable, even if the overall effect is a little distracting or feels like cheating. Most of it is lifted straight from the book and Wong's writing is so strong that such complaints seem a little picky. Too, Coscarelli's visuals are never less than compelling. His ability to deliver so much fun on the cheap should have made him a more in-demand figure. Sadly, his output has been pretty limited. *Beastmaster* (1982) was a very entertaining sword-and-sorcerer fantasy and *Bubba Ho-Tep* (2002), a horror-comedy adapted from the writing of arch genre writer Joe R. Lansdale. These and the other films listed form almost the entire body of his work.

Performances here are suitably underplayed, particularly by Chase Williamson and Rob Mayes who never get in the way of the fun and even provide some effective deadpan humor. More fun are the veteran performers; Clancy Brown, as the Russian, Dr. Marconi, ace Vegas psychic, oozes cool in his pinstripe suit and ability to dispatch baddies without breaking a sweat. Paul Giammati may have the best character arc as the rumpled reporter who discovers something very unsettling about his destiny.

As much as *John Dies at the End* questions whether viewers can trust their perception of the universe, it does

want to imagine one where adventure, friendship and the worth of individuals matter. It also wants to be a playground for those who love seeing their favorite books come to life. The film has the same fault that the novel does; being a little too concerned with being weird. But in a world of blander-than-bland tentpole and mainstream cinema, that is not much of a criticism. It might even be a pretty high compliment.

Dave Canfield

CREDITS

Dave: Chase Williamson
John: Rob Mayes
Arnie Bloodstone: Paul Giamatti
Dr. Albert Marconi: Clancy Brown
Detective: Glynn Turner
Roger North: Doug Jones
Origin: United States
Language: English
Released: 2012
Production: Andy Meyers, Don A. Coscarelli; Midnight Alliance; released by Magnet Releasing
Directed by: Don A. Coscarelli
Written by: Don A. Coscarelli
Cinematography by: Michael Gioulakis
Music by: Brian Tyler

Sound: Paul Menichini; Paul Ratajczak
Editing: Don A. Coscarelli
Costumes: Shelley Kay
Production Design: Todd Jeffery
MPAA rating: R
Running time: 99 minutes

REVIEWS

Abele, Robert. *Los Angeles Times.* January 24, 2013.
Churner, Leah. *Austin Chronicle.* February 22, 2013.
Duralde, Alonso. *The Wrap.* January 24, 2013.
Goss, William. *Film.com.* January 2, 2013.
Haridy, Richard. *Quickflix.* November 25, 2013.
Nelson, Rob. *Variety.* February 7, 2012.
Pinkerton, Nick. *Village Voice.* January 22, 2013.
Scott, A. O. *New York Times.* January 31, 2013.
Stevens, Dana. *Slate.* January 24, 2013.
Uhlich, Keith. *Time Out New York.* January 29, 2013.

QUOTES

Dave: "Maybe you can clear something up for us. See, John and I are both seeing completely different versions of you. Now, John has some vision problems caused by his constant masturbation."

TRIVIA

John's full name, according to the parcel he sends himself, is John Cheese.

K

KEVIN HART: LET ME EXPLAIN

Witness the birth of a legend.
—Movie tagline

Box Office: $32.2 Million

The intimate art form of standup comedy may have no place in a massive arena like Madison Square Garden, and yet six men have been able to completely fill the venue with thousands paying to watch them to tell jokes into a microphone. Even outside of its financial significance, performing at Madison Square Garden most immediately benefits a performer than his squinting audience members; for the special symbol of status it gives to their brand. As filling "The Garden" is always cause for a comedy special, standup/movie star number six Kevin Hart books the venue as the main event for his "Let Me Explain" victory-lap-of-a-comedy-tour in 2012, of which the tour's celebratory documentary is concocted to humbly brag about the achievements that have led him to selling out the landmark venue. When Hart takes the stage, however, he continues the personal nature of standup comedy but at an awkward extent. With thousands trying to focus on the humor in jokes about his personal insecurities, he converts the historical gig into a disturbed divorcee's arena-size therapy session.

In an opening skit directed by Tim Story, *Kevin Hart: Let Me Explain* begins by painting a picture of Hart as a personal mogul, a celebrity of the people, whose popularity has lead to tabloid hearsay that jeopardizes his public image. "That's the price of fame," his no-name friends (collectively titled The Plastic Cup Boyz) tell him at a party that Hart organizes, when he is confronted by a random older gentleman (David Terrell) about his poor communication with his father, and also when accosted by a woman (Justin Herron) about his rumored disassociation with black women. Hart is able to handle the accusations (he even brushes off a mention of acting project *Soul Plane*'s [2004] failure) until someone criticizes him of only being a national presence, not an international one (or a "local-ass bitch"). Outraged, this sends him scurrying for emergency self-reflection on his balcony, where he becomes inspired by the skyline image of Madison Square Garden.

Immediately canceling his own soiree, he urges his manager to tell the figures at Madison Square Garden that he is coming down to perform, and then storms out of the apartment building. In the car on the way to the venue, he reflects more directly on the accusations previously fired in his direction. Cycling through the issues of his love for black women, his divorce, and his DUI, he shows which content he is able to fully address, and that which he is not.

After an extended montage that associates international tour dates, enthusiastic fan reactions, and filmed compliments from anonymous colleagues with the success of Kevin Hart's brand (along with graphics boasting how many subscribers he has on YouTube), the comedian is then shown assuming the throne of Madison Square Garden, where he is met with a standing ovation. Dressed in a leather shirt, dark pants, and a gold chain, Hart is visually accompanied by the words "Let Me Explain" glowing in lights behind him, along with pyrotechnics that shoot fire in the air at his command. With the word "Me" often present over his shoulder when captured in a usual wide shot, Hart wields those

flames when hungry for immediate audience reaction, the entire joke of this prop concerning the outrageousness of a comedian having the same effects he had previously seen at a Kanye West/Jay-Z concert.

To discuss Hart's comedy special is means to wed critical analysis with psychological diagnosis. As prefaced within his personal type of comedy, he acknowledges his marriage was ruined by his own fault of cheating. But, he misdirects the blame to others, often with his impressions of masculinity as a defense. A joke follows about his friend not understanding crucial verbal code when in the presence of oblivious loved ones. The biggest amount of his material concerns his skewed impression of women, painting them as unpredictable with their emotions to the point of schizophrenia, with suspiciousness that Hart claims to be unfounded. But with his own confessed history, apparently it is not.

Hart tells these stories with his classic animation, but this time it is as if his trademark voices and phrases were only automatic resources to help him dress up blatant dark truths within his storytelling. Hart is certainly no stranger to discussing relationship angst, but they lack their sincere ridiculousness (a hilarious argument about owning a giraffe to spite his loved one can be found in 2009's *Kevin Hart: I'm A Grown Little Man*). His common battle of the sexes perspective, seen even in his starring vehicles like *Think Like a Man* (2012), has started to claim casualties.

Perhaps his sense of humor knows this as well, as Hart tells none of these jokes with the enthusiasm of a later silly story. Though he is not above laughing at his own jokes on stage as seen in previous specials, no such moment happens in *Kevin Hart: Let Me Explain* until he talks about having a homeless person touch another person's lips, resulting in a herpes-like mark he calls "a bum bump."

When Hart is able to move away from his personal material, he does strike a few high notes. A tangent about being a half-deer, half-zebra ("deer-bra") has the same pointless randomness of his stage flames, but a bit about his bodyguards is a top moment. When discussing an event at Applebee's, Hart brings fans back to the more amusing comedy that initially made him so popular. Comedy, that, by no coincidence, shows a sense of humility in his importance to the world, and also the full awareness that seems to be lost when he can get so personal.

With more footage to be found in the closing credits, the documentary tries to assuage the pain of Hart's darkness with ego. When Hart walks around London during his world tour asking them if they know who Kevin Hart is, he is shown being recognized by someone for *Soul Plane* (2004), which then leads to

more images of fans talking about a decade-old flop that apparently still haunts him. And as bookend to the entire standup special itself, an unironic sequence at the very end of the film involves Hart walking out of his dressing room at Madison Square Garden (pre-show) into an angelic flash of light.

With similar purpose, in its conveyance of the Kevin Hart in-concert experience the film utilizes organically-earned audience reactions with the manipulation of canned laughter. Though the crowd can certainly be heard laughing at Hart's material throughout, this doc takes a considerable amount of time in making sure such is constantly evident visually, constantly cutting to visibly entertained crowd folk. Possibly because of such zealousness, the documentary is guilty in at least one glaring occasion of using the same laughing reaction twice.

The clear inspiration behind these jokes is too tragic to earn the same laughs as the material that boosted his brand to eventually dominate such a venue (compare this dirty laundry to his musings on fatherhood in the legitimately titled *Kevin Hart: Seriously Funny* from 2010). Here, he introduces a joke about fighting a naked man that is having sex with [Hart's] girlfriend by prefacing, "My fear is that I am going to fall in love, and that I am gonna get hurt." The bit may take another direction (one that equates masculinity with homophobia, instead of misogyny), but the inspiring damage is prevalent. To reference the title of his previous open-book special, *Kevin Hart: Laugh At My Pain* (2011), perhaps such would happen easier if the humorous aspects of these jokes felt more immediate than their heartbreak.

Nick Allen

CREDITS

Origin: United States
Language: English
Released: 2013
Production: Jeff Clanagan, Blake W. Morrison; released by CodeBlack Entertainment
Directed by: Leslie Small; Tim Story
Cinematography by: Larry Blanford
Music by: Kennard Ramsey
Sound: Matt Israel; Fritz Lang; Woody Stubblefield
Music Supervisor: Bob Francis
Editing: Spencer Averick
Art Direction: Daryle Shaw
Production Design: Bruce Ryan
MPAA rating: R
Running time: 75 minutes

REVIEWS

Abele, Robert. *Los Angeles Times.* July 3, 2013.
Duralde, Alonso. *The Wrap.* July 2, 2013.
Guzman, Rafer. *Newsday.* July 4, 2013.
Johnson, Kevin C. *St. Louis Post-Dispatch.* July 2, 2013.
Jones, J. R. *Chicago Reader.* July 11, 2013.
Keough, Peter. *Boston Globe.* July 2, 2013.
Merry, Stephanie. *Washington Post.* July 2, 2013.
Nehme, Farran Smith. *New York Post.* July 3, 2013.
Weitzman, Elizabeth. *New York Daily News.* July 2, 2013.

QUOTES

Kevin Hart: "Let's get some fire up on these bitches one time!"

KICK-ASS 2

You can't fight your destiny.
—Movie tagline

Box Office: $28.8 Million

Kick-Ass 2 fails in the way many sequels do: Trying to repeat—without creativity, originality, or spark—the same "outrageous" tricks as the first. In fact, the only thing mildly intriguing about *Kick-Ass 2* is the deeper, more fascinating way in which it thematically fails. *Kick-Ass* (2010), directed by Matthew Vaughn and written by Jane Goodman (based on the comic books by Mark Millar and John Romita, Jr), brashly walked a giddy, subversive, philosophically deranged tight-rope; its bright pop-culture fizz, aesthetic coolness, and rollicking orgy of graphic bodily harm (often carried gleefully out by a foul-mouthed, homicidal 11-year-old "heroine" named Hit Girl), teetering excitingly between subversion and exploitation. *Kick-Ass 2* does not tumble off that tight-rope—it never bothers to get up on it. Mediocre, bordering on awful, the film is so lackluster and lazy it becomes worthless as even basic exploitative entertainment. In doing so, the sequel becomes exactly the sort of artless pop culture trash the first film deftly danced above.

The obvious difference in *Kick-Ass 2* (drawn from Millar and Romita's graphic-novel sequels *Kick-Ass 2* and *Hit Girl*) is the absence of Vaughn and Goodman. Goodman (2012's *The Woman in Black*) has a solid love and respect for and sly skill at handling genre, and Vaughn, who learned his crackerjack sense of visual glee at the elbow of Guy Ritchie and honed it in his own films *Layer Cake* (2004) and *Stardust* (2007), carefully modulated his wry use of over-the-top material in *Kick-Ass* as a meta-commentary on itself. Viewers were supposed to be shocked by it, then delighted, and then disturbed by their own delight. Thanks to Vaughn's sure-handed stylistics, Hit Girl's jaw-dropping vigilante

hi-jinks in the first film were so tightly wrapped in candy-colored satire, they clearly existed in a separate "cinema reality" where the shocking ultra-violence played as ironic.

Though Vaughn maintains a producer credit on *Kick-Ass 2,* he and Goodman have been replaced on the set by writer-director Jeff Wadlow. Simple lack of screenwriting and directorial skills aside, the difference is between creative folks who love genre and know how to both play within it and transcend it and a plodding hack who cannot get beyond it. Wadlow displays no deft touch or story-telling rhythm with the *Kick-Ass 2* material, which is pretty much the same as in *Kick-Ass*: High schoolers Dave Lizewski (Aaron Taylor-Johnson) and Mindy McCready (Chloe Grace Moretz) dress up as "real-life" costumed crime-fighters Kick-Ass and Hit Girl and battle it bloodily out with "real-life" costumed villains, namely Christopher Mintz-Plasse doing his "evil nerd" thing as The Motherf**ker (formerly known as Red Mist).

Like most of the superhero movies it intends to subvert with its "This is not a comic book!" attitude, *Kick-Ass 2* suffers from too many extra new heroes and villains. This time both Kick-Ass and The Motherf**ker surround themselves with dysfunctional teams, while Hit Girl tries to swim the mean-girl-infested social waters of secondary public-school education. Respective good and bad guys Nicolas Cage and Mark Strong both knew how to work the first film's tongue-in-cliche material, but both their characters also died in the first film. They are replaced this time out by Jim Carrey as a reformed mob enforcer now fighting crime as Colonel Stars and Stripes and John Leguizamo as The Motherf**ker's more down-to-earth driver, bodyguard, and enabler.

Where *Kick-Ass* was a glorious explosion of a bright, four-color comic-book palette, *Kick-Ass 2* is one of the most unintentionally ugly films of the year. It is not that the new film is stylistically gritty or visually distorted, but rather every frame looks as if it has been dragged through a mud puddle and then hung up in the sunlight to slowly bleach out. *Kick-Ass 2* cinematographer Tim Maurice-Jones has done impressive, kinetic work in the past on such Guy Ritchie films as *Lock, Stock and Two Smoking Barrels* (1998) and *Snatch* (2000) and on the wonderfully atmospheric *The Woman in Black,* but here his tendency toward muted, muddied earth tones completely undermines the over-the-top comic-book material. Nothing about Maurice-Jones' style and Wadlow's complete lack thereof meshes well, leaving the film visually and thematically stranded in a discouraging blandness. That may seem like film-school nit-picking, but the washed-out, flat look of *Kick-Ass 2* permeates and taints everything about it. The characters, their

costumes, and their actions are all still purposefully ludicrous, but without a visual sensibility to match and contain them, they feel pointlessly silly.

Likewise, the sequel's attempts to mimic the original film's profane dialogue, outrageous violence (once again graphic and plentiful), and even its wonderfully ironic soundtrack also fall flat as cheap, desperate imitation. This time out, the raunchy dialogue feels like high-schoolers trying to swear, and the violence—aside from being staged with a thudding lack of grace—feels pointlessly, panderingly dull in its winking self-aggrandizement.

Nor does the cast show much signs of life. *Kick-Ass* launched both Taylor-Johnson and Moretz' careers, and both are talented actors who have since turned in impressive performances in other films. But contractually sewn back into their *Kick-Ass* characters and costumes, it seems neither (especially the more grown-up, thespian-minded—and now much more physically pumped—Taylor-Johnson) really want to be here. Only Jim Carrey, unrecognizable under a mask, prosthetics, and a Italia-Jersey goombah accent as thick as a slab of steak, seems to "get it" this time around, playing his gung-ho tough guy straight (no slapstick) with the right mix of self-aware excess and earnestness. (Not coincidentally, it was Carrey who, in the wake of the December 2012 Sandy Hook school shootings, disavowed his generally effective work in *Kick-Ass 2*.)

Most of all, unlike in the first film, there is no fun to be had here. *Kick-Ass 2* is mean and joyless, feeling like a plodding bully who tries to emulate the ballet-like slapstick of a Three Stooges routine by turning around and punching a kid in the groin. When a writer goes back again and again to the same well of "outrageous" material not because he has something new to say about the theme, but because ticket sales and the bottom line demand it, what was once subversive soon starts to smell crassly excessive.

Despite increased name recognition and a summer-weekend spot, *Kick-Ass 2* opened at the box office with lower numbers than its predecessor: $13 million compared to *Kick-Ass'* $20 million opening. The new film went on to earn only $29 million in North America and another $30 million overseas. Critical opinions came in below average overall, though *Kick-Ass 2* did have its admirers: Alan Scherstuhl of the *Village Voice*, noted that, "the most welcome change is the tone. Wadlow has decided he's making a straight-up comedy, and he demonstrates a knack for it." Manohla Dargis of the *New York Times*, however, had the opposite reaction: "Wadlow can't obscure the movie's misogyny, and he also has a tough time staging a scene and selling a joke. His worst offense is that he has no understanding of the

power, gravity, and terrible beauty of violent imagery, which means he has no grasp of cinema."

Locke Peterseim

CREDITS

Dave Lizewski/Kick-Ass: Aaron Taylor-Johnson
Mindy Macready/Hit Girl: Chloe Grace Moretz
Chris D'Amico/Red Mist: Christopher Mintz-Plasse
Colonel Stars and Stripes: Jim Carrey
Det. Marcus Williams: Morris Chestnut
Javier: John Leguizamo
Doctor Gravity: Donald Adeosun Faison
Insect Man: Robert Emms
Night Bitch: Lindy Booth
Mother Russia: Olga Kurkulina
Mrs. D'Amico: Yancy Butler
Origin: United States
Language: English
Released: 2013
Production: Adam Bohling, Tarquin Pack, Brad Pitt, David Reid, Matthew Vaughn; Plan B Entertainment; released by Universal Pictures Inc.
Directed by: Jeff Wadlow
Written by: Jeff Wadlow
Cinematography by: Tim Maurice-Jones
Music by: Henry Jackman; Matthew Margeson
Sound: Danny Sheehan; Ian Voigt
Music Supervisor: Ian Neil
Editing: Eddie Hamilton
Art Direction: Joe Howard
Costumes: Shammy Sheldon Differ
Production Design: Russell de Rozario
MPAA rating: R
Running time: 103 minutes

REVIEWS

Arikan, Ali. *RogerEbert.com*. August 16, 2013.
Burr, Ty. *Boston Globe*. August 15, 2013.
Dargis, Manohla. *New York Times*. August 15, 2013.
Dowd, A. A. *Onion A.V. Club*. August 15, 2013.
Ebiri, Bilge. *Vulture*. August 15, 2013.
Hornaday, Ann. *Washington Post*. August 15, 2013.
LaSalle, Mick. *San Francisco Chronicle*. August 15, 2013.
Olsen, Mark. *Los Angeles Times*. August 14, 2013.
Phillips, Michael. *Chicago Tribune*. August 15, 2013.
Scherstuhl, Alan. *Village Voice*. August 14, 2013.

QUOTES

Mindy Macready: "You don't have to be a bad-ass to be a superhero, Dave. You just have to be brave."

Creators Mark Millar and John Romita, Jr. have cameos as super heroes in the climatic battle between the super heroes and the super villains.

KILL YOUR DARLINGS

A true story of obsession and murder.
 —Movie tagline

Box Office: $1 Million

There have not been many great films made about great poets. A few attempts have been made at narrative films dealing with the Beat Generation, including Gary Walkaw's desultory *Beat* (2000), with Kiefer Sutherland as William S. Burroughs, and Walter Salles' miscast and unconvincing adaptation of Jack Kerouac's *On the Road* (2012). More successful were two other, less narratively-straightforward adaptations of seminal Beat works, David Cronenberg's *Naked Lunch* (1991), which cannily introduced elements from Burroughs' biography into a loose adaptation of his novel, and Rob Epstein and Jeffrey Friedman's surprisingly effective *Howl* (2010), which combined an animated telling of Allen Ginsberg's epic poem with the story of Ginsberg's development as an artist and the 1957 obscenity trial that the book's publication provoked. *Howl* was anchored by a sensitive and persuasive performance by James Franco as Ginsberg.

Kill Your Darlings also focuses primarily on Ginsberg, played with sensitivity, but perhaps as too much of a naif, by Daniel Radcliffe, who nonetheless was probably wise to take a role like this, in his efforts to branch out from the Harry Potter series which launched his career. The movie is a fictionalized telling of Ginsberg's experiences as a freshman at Columbia University, but it mainly deals with his relationship with dorm-mate Lucien Carr (Dane DeHaan), and Carr's killing of David Kammerer (Michael C. Hall). It opens with Carr in prison, begging Ginsberg not to reveal what Ginsberg claims is "the truth" about the killing. Then the movie jumps back to Ginsberg's unhappy home life in New Jersey, before his acceptance to Columbia. His parents are played by David Cross and Jennifer Jason Leigh, so of course there is bound to be some mental instability there. The two actors actually acquit themselves well, and its depiction of Ginsberg's relationship with his parents is one of the more realistic elements of *Kill Your Darlings*.

It is true that Carr introduced Ginsberg to Burroughs (Ben Foster trying too hard to achieve the drug-besotted poet's grim internality) and Kerouac (Jack Huston, who fails to capture the writer's appeal beyond his good looks). He also introduced him to Neal Cassady,

who is not depicted in the film, but who was the real-life object of Ginsberg's unrequited infatuation. To all appearances, the filmmakers invented Ginsberg's romantic obsession with Carr, creating a love triangle between them and Kammerer, who had met Carr when Carr was only fourteen, and followed him around the country as Carr changed schools, partly due to the efforts of his mother to keep him away from the apparently predatory Kammerer. The filmmakers botch the facts of the case, and exacerbate that flaw by intercutting the murder with a sequence of Ginsberg losing his virginity to a Carr lookalike that he has picked up at a bar, and Burroughs getting stoned, as though to suggest some kind of equivalent moral degradation between the drug use and open sexuality that fueled the Beats, to some extent, and murder. It is a sequence that encapsulates the movie's tacked-on drama and thematic confusion.

While Radcliffe is genially appealing and Elizabeth Olsen, playing Kerouac's soon-to-be wife Edie Parker, is utterly wasted, DeHaan steals the show as Carr, the young man Ginsberg would later describe as the "glue" that held the group of poets and writers together. DeHaan plays him as an enigmatic ball of energy and wit, but the filmmakers do the real Carr a grave disservice, suggesting, in effect, that he was a phony who stole the ideas of his betters (in fact, he was an excellent student while at Columbia), that he led on and used Kammerer (which may be true), and that he essentially got away with murder by taking advantage of the rampant homophobia of the era, and silenced his former friends in an effort to keep that story from coming out. The truth is unattainable, with both Kammerer and Carr dead, but it is surely more complicated than what is presented here. Carr remained close friends with both Kerouac and Ginsberg throughout their lives, which would probably not have been possible if the events depicted in the movie had actually occurred. Kammerer, played by Hall as essentially a pathetic creep, is also not fully explored as a character. It would have been interesting, for instance, to see some evidence of his lifelong friendship with Burroughs, which is only referred to in passing.

Perhaps uncertain as to how to sell the film to a younger audience, writer-director John Krokidas and co-writer Austin Bunn, making their first feature, decided to turn it into an unrequited gay love story and murder mystery, and juice up the proceedings with scenes like a ridiculously overblown heist sequence at the Columbia library, anachronistically set to the tune of TV on the Radio's 2006 indie hit "Wolf Like Me." What was probably a minor, sophomoric collegiate prank at the time is given inordinate weight as a symbol both of the gang's rebelliousness and, more ridiculously, of Kammerer's jealous betrayal of Carr. Using contemporary music in

period films can work, if it feels organic—if the music fits the drama in some natural way—but in this instance it just feels forced, as does much of the drama the filmmakers have imposed on the true and tragic story.

Josh Ralske

CREDITS

Allen Ginsberg: Daniel Radcliffe
Lucien Carr: Dane DeHaan
William Burroughs: Ben Foster
Jack Kerouac: Jack Huston
David Kammerer: Michael C. Hall
Louis Ginsberg: David Cross
Naomi Ginsberg: Jennifer Jason Leigh
Edie Parker: Elizabeth Olsen
Origin: United States
Language: English
Released: 2013
Production: Christine Vachon; Killer Films; released by Sony Pictures Classics
Directed by: John Krokidas
Written by: John Krokidas; Austin Burn
Cinematography by: Reed Morano
Music by: Nico Muhly
Sound: Warren Shaw; Ken Ishii
Editing: Brian A. Kates
Art Direction: Alexios Chrysikos
Costumes: Christopher Peterson
Production Design: Stephen Carter
MPAA rating: R
Running time: 104 minutes

REVIEWS

Adams, Sam. *The Dissolve*. October 16, 2012.
Atkinson, Michael. *The Village Voice*. October 16, 2013.
Burr, Ty. *Boston Globe*. October 26, 2013.
Chang, Justin. *Variety*. January 18, 2013.
Dowd, A. A. *The AV Club*. October 16, 2013.
Ebiri, Bilge. *Vulture*. October 17, 2013.
LaSalle, Mick. *San Francisco Chronicle*. October 31, 2013.
Lemire, Christy. *RogerEbert.com*. October 18, 2013.
Rea, Steven. *Philadelphia Inquirer*. November 8, 2013.
Scott, A. O. *New York Times*. October 15, 2013.

QUOTES

llen Ginsberg: "Another lover hits the universe. The circle is broken. But with death comes rebirth. And like all lovers and sad people, I am a poet."

TRIVIA

In this film, actor David Cross plays Allen Ginsberg's father, Louis. In *I'm Not There* (2007), Cross played Allen Ginsberg himself.

THE KINGS OF SUMMER

Why live when you can rule.
 —Movie tagline

Box Office: $1.3 Million

Posters for *The Kings of Summer* froze a trio of skivvy-clad pals in midair before a swim on a sweltering day, depicting them just after their eager leap forward to leave uncomfortable conditions behind but before relievedly reaching their goal of the river below. It is an abundantly apt visual representation, as the three are adolescent males stuck in the no-man's-land of fifteen who have determinedly propelled themselves onward toward adulthood but clearly still have a ways to go. Unquestionably, such strivings are not only relatable to the characters' movie-going peers, but are capable of stirring potent memories in adults of their own pivotal past. Nevertheless, it seems unlikely that this insightful, modestly enjoyable but slight indie will itself be recalled with much strength of feeling in the future.

Joe Toy (Nick Robinson) possesses a name that identifies him as an Everyman who still remains part boy. He may have felt like low man on the totem pole during a freshman year of high school that ends with brawny upperclassmen humiliatingly yanking the shirt off his reedy frame in front of his ideal girl, Kelly (Erin Moriarity), but Joe feels even lower at home. Pained and petulant due to the recent death of his mother and the departure from the household of his older sister (Alison Brie), Joe is introduced wet and embarrassed when his dryly-cutting curmudgeon of a father, Frank (Nick Offerman) shortens another of the young man's showers that had been lengthened by pubescent longings. Being deflated by Frank's sarcasm has apparently become routine, as this man morphed by misery apparently lost whatever sensitivity he may have had along with his spouse. He responds with a startling lack of empathy for a son suffering from the same loss, either unable or unwilling to understand why Joe would rather go to a party with friends than participate in the first family game night without Mrs. Toy and with his dad's latest girlfriend. After retributively calling the cops on Frank under false pretenses, Joe sneaks out a window and bikes away with a satisfied smile.

When Frank grabs Joe's phone to relay the teen's subsequent grounding and resultantly-babyish new bedtime to Kelly, it is the last straw. With his father's distancing derision and dictatorial declarations of "My house, my rules!" echoing in his ears, Joe plans to escape to a secluded clearing in some nearby woods and conversely construct a residence where he himself will reign, one gloriously devoid of any parental presence except Mother Nature. (When the film garnered initial positive buzz at the Sundance Film Festival, it was

entitled *Toy's House*.) Joe is cocksure about his prospects for achieving self-sufficiency, naively expecting that all will be idyllic. Convinced to join him are best friend Patrick (Gabriel Basso), who is beleaguered by parents (Marc Evan Jackson and Offerman's wife, Megan Mullally) who are so chipper, chokingly-overprotective, and ridiculously unhip as to induce not only dismayed eye rolls but hives. Unexpectedly joining them is non-sequitor-spouting oddball Biaggio (Moises Arias), a thoroughly curious creature who looks, especially around the eyes, to have a species of lemur lurking on a branch of his family tree.

Although the characters have vowed to be manly masters of their own fate, what follows seems more like an unimpeded flood of youthful exuberance: Racing through fields, gleefully slicing watermelons with large swords, and wondering if they should adopt "awesome mythical names." As the three use whatever they can scrounge up to build their makeshift dwelling (rather like a large tree house but on terra firma), the friends' professed maturity is further belied by the incorporation of a children's slide, and the selection for the front door of one that had previously adorned the threshold of a portable toilet was surely good for some juvenile scatological snickers. When some frightened potential food startlingly struggles and squeals, this supposedly-intrepid triad lets out screams of its own and flees. Much later, Joe feels pangs of guilt along with those of hunger as he tenderheartedly apologizes to the rabbit he has just killed. (Most efforts to hunt prove problematic to the point of cheating with chickens from a nearby Boston Market.) None of the teens can manage much more than sparse sprouts of facial hair as the days pass. (Robinson admitted that his, at least, were augmented using glue.) However, among the lyrical, Terrence Malick-like nature shots are those of skin a snake had outgrown and shed and one of the similarly-discarded exoskeleton of a beetle, making the point that the three protagonists are themselves in a transitional stage of development that will ultimately and inevitably lead to their leaving parts of their youthful selves behind.

With that prominently-placed vestige of a Port-o-Potty, it might be euphemistically said that viewers are being led to expect that you-know-what will happen, and it eventually does. Things get ugly when tempting apple-of-Joe's-eye Kelly is introduced into this place of Edenic beauty, as her interest in buff buddy Patrick spoils Joe's intentions to impress. As much wiser and more impressively-bearded Abraham Lincoln once asserted, a house divided against itself cannot long stand, and the frustration-fueled damage both Joe and Patrick subsequently do to the getaway they built together clearly represents the same to their friendship. Paradise lost is further underscored when a venomous snake ap-

pears within, and the sequence in which bravery leads to Biaggio being bit compares unfavorably with similar material in this year's *Mud* (2013), which elicited far more concern throughout. A lukewarm but pleasing sense of satisfaction is brought on by the sight of fledglings Joe and Patrick (clearly once-and-future friends) returning to do a little more maturation in their respective nests before someday flying away for good, their feathers at least temporarily unruffled.

Made on a budget of $8 million, *The Kings of Summer* grossed only $1.2 million during its limited release. Critical reaction was generally positive. It is the feature debut for both writer Chris Galletta and director Jordan Vogt-Roberts. While their film's characters will long remember what transpired during this summer, it failed to linger much past viewing for many moviegoers. Achieving emotional heft is hampered when the easy-to-identify-with realism of teenagers straining for autonomy also possesses absurdity that strains credulity. It is difficult to believe that Joe could design and lead the building of such a structure when his bungled birdhouse earlier on points to him being Frank Lloyd Wrong. The fact that the Ohio teens' suburban Shangri-La is so near to home makes it far-fetched that no one had heard curiosity-piquing hammering nor could find them for weeks on end. Believability on that score is somewhat helped by the fact that the adults are rather cartoonish and clueless, perhaps a purposeful mirroring of the way those growing up often look down on their elders. Also, one may be repeatedly jerked out of deeper involvement and investment by the presence of a jester as bizarre as Biaggio, who, for example, cannot differentiate homosexuality from cystic fibrosis. Still, even if he seems like an unrealistic comedic creation, many viewers are likely to feel they know Joe and Patrick, or, at least, remember someone very much like them—who looked very much like themselves.

David L. Boxerbaum

CREDITS
Joe: Nick Robinson
Patrick: Gabriel Basso
Biaggio: Moises Arias
Frank: Nick Offerman
Kelly: Erin Moriarty
Origin: United States
Language: English
Released: 2013
Production: Tyler Davidson, John Hodges, Peter Saraf; Big Beach Films, Low Spark Films; released by CBS Films
Directed by: Jordan Vogt-Roberts
Written by: Chris Galletta

Cinematography by: Ross Riege
Music by: Ryan Miller
Sound: William McGuigan
Editing: Terel Gibson
Art Direction: Jennifer Klide
Costumes: Lynette Meyer
Production Design: Tyler B. Robinson
MPAA rating: R
Running time: 93 minutes

REVIEWS

Burr, Ty. *Boston Globe*. June 7, 2013.
Holden, Stephen. *New York Times*. May 30, 2013.
Hornaday, Ann. *Washington Post*. June 6, 2013.
Kang, Inkoo. *Village Voice*. May 28, 2013.
Lane, Anthony. *The New Yorker*. June 3, 2013.
Pols, Mary. *Time*. June 3, 2013.
Puig, Claudia. *USA Today*. May 30, 2013.
Rainer, Peter. *Christian Science Monitor*. May 31, 2013.
Rooney, David. *Hollywood Reporter*. March 10, 2013.
Sharkey, Betsy. *Los Angeles Times*. May 30, 2013.

QUOTES

Frank: "Yes, I experienced a childhood on the planet Earth. I've heard the story of the boy who cried wolf."

TRIVIA

Nick Offerman (Joe's father) and Megan Mullally (Patrick's mother) are actually real-life husband and wife.

KON-TIKI

Real adventure has no limits.
—Movie tagline

Box Office: $1.5 Million

Sometimes the story behind the making of a movie is more fascinating than the movie itself. This is quite frequently true of fact-based stories that inspire filmmakers to root around to find the greatest hits and add some dramatic license until the real meat goes rotten and audiences are left with a stale biopic. In the case of *Kon-Tiki*, there is not a shred of its backstory not worth exploring as an alternative to the final product. There are the books about Thor Heyerdahl's 101-day expedition and the 1950 documentary filmed during the journey went on to win an Academy Award. Joachim Ronning and Espen Sandberg's version may be tempting by being the most recent, but it is a pale translation of the true story.

Thor (Pal Sverre Hagen) came to believe that Polynesia was settled not by the travelers of Asia, but that of South America. "It is my job as a scientist to prove the schoolboys and those who quote them wrong," Heyerdahl says while trying to convince those to fund this expedition. Thor assembled a five-man crew including engineer Herman Watzinger (Anders Baasmo Christiansen), navigator Erik Hesselberg (Odd-Magnus Williamson), radio experts Knut Haugland and Torstein Raaby (Tobias Santelmann and Jakob Oftebro) and steward/documentarian Bengt Danielsson (Gustaf Skarsgard). Using the same materials available to the people of the time (save for some very stocked rations and, well, radios) Thor and company assemble an impressively structured raft out of balsawood, complete with a below deck for resting.

Few suggest that this was ever close to a suicide mission other than his wife, Liv (Agnes Kittelsen), who wonders if their children will have a father after their pre-determined 101-day excursion. "Only 100 days to go," says one crew member to another after developing seasickness on their initial launch. The journey from here on out consists of a single storm, a couple encounters with whales and sharks and a lot of sunshine. Thor's actual journey may have been just as lucky and, if such is the case, it hardly makes for great cinema.

The responsibility of Ronning and Sandberg thus rests in them finding for an audience precisely what made this ten-year obsession so captivating to Heyerdahl. If the only purpose was an egotistical obsession to prove his theory, surely it meant something greater to a culture denied their historical basis by anthropologists. A government official is good enough to grant Thor's crew all the resources they need, but then its focus is brought right back to them. Even the building of the raft, laid out in fine detail in the documentary is reduced to a quick montage meant to look like the original footage. Thor's original motivations are even reduced to a couple of strikingly silly scenes, beginning with a prologue as the young boy hops onto floating pieces of ice over a frozen lake. Meant to establish his inability to swim (that is barely milked for drama later), the moment ends with his mom saying "Promise me you'll never take a risk like that again." That chuckle-worthy moment gives way to Thor basically being dared by his last possible backer. "Now that would be evidence. You want your theory to be accepted, go ahead. Drift from Peru to Polynesia on a balsa-wood raft."

Thor's documentary is not the only cinematic component that can be used as a frame of reference against *Kon-Tiki*. A second version of Ronning and Sandberg's film exists and subsequently two versions of that version. The first of which is a scene-for-scene counterpart filmed simultaneously in English with the

same actors. The differences between the dialects resulted in a few minutes shaved off the Norwegian language version. Putting that more economically-viable alternative in the hands of Harvey Weinstein is another matter altogether resulting in a 22-minute reduction. As properly labeled on its DVD menu, one may choose between the plain "English language version" or the "Academy Award-nominated" one in original Norwegian whose vision falls victim to Harvey's notorious scissorhands just as *The Grandmaster* (2013), *Gangs of New York* (2002) and countless others have. A film already missing several necessary dramatic components loses more of the limited character development of Thor's crew and a near-total excision of Liv including a flashback of Thor saving her from injury and a climactic letter encapsulating their relationship.

Recent years have seen a spate of films about characters left to their own survival devices amidst a vast landscape without the land including *All is Lost* (2013), *Gravity* (2013), and *Life of Pi* (2012). What separates *Kon-Tiki* from them and other sea adventures like *Jaws* (1975), *Das Boot* (1982), and *Cast Away* (2000) is a true sense of purpose. In the immediate absence of their plan or next move, stories of remote isolation are open to more philosophical realizations about life, death and our place in the natural world. *Kon-Tiki*, no matter the length, sidesteps any true meaning or rationale to this journey. Pulling a shark on deck is the closest the story gets to excitement and though Thor may initially resemble Peter O'Toole's T.E. Lawrence he is not much of a leader or a presence once on the raft. Fifty years from now, when this film is written about as one of the most successful Norwegian films ever or as just a footnote in awards history, perhaps the irony will finally set in about how its creators altered the course of their own journey to make it more acceptable to the masses until the idea became more interesting than the results.

Erik Childress

CREDITS

Thor Heyerdahl: Pal Sverre Hagen
Liv Heyerdahl: Agnes Kittelsen
Bengt Danielsson: Gustaf Skarsgard
Herman Watzinger: Anders Baasmo Christiansen
Erik Hesselberg: Odd Magnus Williamson
Knut Haugland: Tobias Santelmann
Torstein Raaby: Jakob Oftebro
Origin: Norway
Language: Norwegian, English, French
Released: 2012
Production: Aage Aaberg, Jeremy Thomas; DCM Productions, Nordisk Film Production, Recorded Picture Company, Roenberg Film, Stunt Bros; released by Weinstein Co.
Directed by: Joachim Roenning; Espen Sandberg
Written by: Petter Skavlan
Cinematography by: Geir Hartly Andreassen
Music by: Johan Soderqvist
Sound: Tormod Ringnes
Editing: Per-Erik Eriksen; Martin Stoltz
Costumes: Stine Gudmundsen-Holmgreen; Louize Nissen
Production Design: Karl Juliusson
MPAA rating: Unrated
Running time: 118 minutes

REVIEWS

Adams, Sam. *The Onion A.V. Club.* April 25, 2013.
Bowen, Chuck. *Slant Magazine.* April 23, 2013.
Buckwalter, Ian. *NPR.* April 25, 2013.
Burr, Ty. *Screen It!.* May 2, 2013.
Dargis, Manohla. *New York Times.* April 25, 2013.
Orndorf, Brian. *Blu-ray.com.* January 24, 2013.
Rea, Steven. *Philadelphia Inquirer.* May 17, 2013.
Rothkopf, Joshua. *Time Out New York.* April 23, 2013.
Sachs, Ben. *Chicago Reader.* May 3, 2013.
Turan, Kenneth. *FromTheBalcony.* April 25, 2013.

QUOTES

Torstein Raaby: "Why are we feeding the sharks our tomato soup?"

TRIVIA

Large parts of the film were filmed in Norwegian and in English in order to secure international funding.

AWARDS

Nominations:

Oscars 2012: Foreign Film
Golden Globes 2012: Foreign Film

L

THE LAST EXORCISM PART II

God asks. The Devil commands.
—Movie tagline
The second coming.
—Movie tagline

Box Office: $15.2 Million

The sequel to *The Last Exorcism* (2010) makes far less than what it should out of its various elements. Among those are a reasonably compelling idea for a setup, a Mardi Gras setting, and the raw talent of Ashley Bell who embodies the franchise character of Nell Sweetzer perfectly. But, in the end, *The Last Exorcism Part II* serves as a reminder that though Satan is indeed the father of lies, Hollywood is more than happy to break its promises regarding narrative. Such criticism comes with tongue in cheek. There really is no reason producer Eli Roth cannot make a sequel here but, then again, the first film gives little reason for the production of this one, other than the fact that it made, rightly, a lot of money. The devil is in the details.

Nell Sweetzer (Ashley Bell) is found catatonic having snuck into an apartment and badly scaring the couple inside. Taken to a hospital, her condition approves but she claims to have no memories of escaping the woods or what happened to her there during the events of the first film. She is placed in a group home run by a kindly old supervisor and therapist named Frank Merle (Muse Watson) who encourages her to think before putting her treasured cross back on her neck, to remember that she is her own person and can be who she wants to be. Despite previous intimations that the demon Abalam is not yet finished with her she takes pockets the cross and begins to explore the world around her, as she is slowly befriended by the other residents of the home such as the striking blonde Gwen (Julia Garner), Mo (Sharice A. Williams) and Daphne (Erica Michelle) who teach her about music and makeup. Nell even strikes up a mutual crush between herself and Chris (Spencer Treat Clark) a co-worker at the hotel she has recently been employed by. Things are looking up.

But the colorful sights and sounds of a Mardi Gras carnival parade signal a dark journey ahead. Disquieting encounters with masked figures, glimpses of her father amongst the crowds, and a strange seizure which kills one of the girls fills Nell with a dread. As it becomes clear that Abalam has indeed returned to claim her, and her past becomes known to the girls at the home via the internet, she fights a growing isolation and terror when suddenly she is approached by Cecile (Tara Riggs), a woman who had been her nurse at the hospital. Cecile tells Nell that she is part of a group that has been watching her, the Order of the Right Hand. A meeting with Calder (David Jensen), the group's leader, leads to an exorcism in which an attempt is made to transfer the demon into an animal sacrifice. Proving too powerful a demon to defeat via normal methods, a decision is made to kill Nell so that the world, and her own soul, can be spared an even more unthinkable outcome. This attempted cure too goes horribly wrong leaving Nell and Abalam to fulfill a dark apocalyptic destiny.

The Last Exorcism II does ramp up the tension to a nice finish but the writing is the big problem here. The screenplay meanders far too long through events that

anyone who watches horror films could see coming a mile away. So, by the time Nell's true destiny is revealed, viewers are likely to be exhausted by cliche. The Order of The Right Hand seems a particularly uninspired bit of writing. They are introduced so late into the film that far too much exposition is needed to explain their presence. Even when the exposition happens the group never really emerges as anything other than a plot device.

It also hardly helps that many of the demonic manifestations and other supernatural encounters in the film seem so been there done that. For all those bits that work there are several that fall short. And too many should-be-startling events, like the death of would-be boyfriend Chris, are simply staged less effectively than they could be. Some of the exorcism moments in the film do work exceptionally well and will remind viewers of the raw power of such moments in the first film but by then those same viewers are liable to feel cheated enough to have a sense the film has skated almost all along. One sad thing here is the animal chosen by the Order to cast Nell's demon into. Viewers will feel especially cheated when they realize that they were robbed of the chance to see a possessed chicken.

There are many solid performances in the film but the standout is easily Ashley Bell. Her transformation from innocent farm girl to demon possessed wraith in the first film was flawless, liable to provoke empathy and terror. The Nell of *The Last Exorcism Part II* is subtler, part wounded soul, part possessed monster, and part young woman coming of age. Bell handles all of the above with aplomb even when the writing lets her down. Never less than fully believable and inspiring of sympathy, she makes watching this sequel worth the trouble of wondering if they are guilty of sacrificing their good sense and wallets to the devil.

Dave Canfield

CREDITS

Nell Sweetzer: Ashley Bell
Chris: Spencer Treat Clark
Frank Merle: Muse Watson
Louis: Louis Herthum
Doctor: Andrew Sensenig
Origin: United States
Language: English
Released: 2013
Production: Eli Roth, Marc Abraham, Eric Newman; Arcade Pictures, Strike Entertainment, Studio Canal; released by CBS Films
Directed by: Ed Gass-Donnelly
Written by: Ed Gass-Donnelly; Damien Chazelle

Cinematography by: Brian Steacy
Music by: Michael Wandmacher
Sound: Nelson Ferreira
Editing: Ed Gass-Donnelly
Costumes: Abby O'Sullivan
MPAA rating: PG-13
Running time: 88 minutes

REVIEWS

Abrams, Simon. *Village Voice*. May 6, 2013.
Gilsdorf, Ethan. *Boston Globe*. March 6, 2013.
Harvey, Dennis. *Variety*. March 6, 2013.
Kirkland, Bruce. *Jam! Movies*. March 3, 2013.
Mcintyre, Ken. *Total Film*. May 29, 2013.
Olsen, Mark. *Los Angeles Times*. March 1, 2013.
Pais, Matt. *RedEye*. March 1, 2013.
Simon, Brent. *Screen International*. March 6, 2013.
Webster, Andy. *New York Times*. March 1, 2013.
Weinberg, Scott. *FEARnet*. March 1, 2013.

QUOTES

Cotton Marcus: "There's a whole bunch of people out there who are definitely convinced that they are possessed."

TRIVIA

When Nell is cleaning hotel rooms, a picture of an owl with long legs can be seen on the wall. This picture is one of a demon called Stolas, as depicted in a 19th century French demonology text called *Dictionnaire Infernal*.

THE LAST STAND

Retirement is for sissies.
—Movie tagline
Not in his town. Not on his watch.
—Movie tagline

Box Office: $12.1 Million

If there was an undisputed champion in the action realm of the macho 1980s, Arnold Schwarzenegger certainly was him. From Conan to the Terminator and some genuine blockbusters in the early 1990s, Arnold's trademark appeal spread wide enough to even hold his own in a trio of Ivan Reitman comedies. After over two decades of marquee status, the former bodybuilder moved into politics in 2003 to see if the pen truly was mightier than an M134 minigun. Despite a few cameos here and there during his time in office, Schwarzenegger

literally proclaimed "I'm back!" with an extended role in *The Expendables 2* (2012) and immediately began filling his plate again. The first dish seems, on paper, to be a perfect fit. While his friend James Cameron was out exploring oceans and creating digital worlds, Arnold hitched his wagon to Korean filmmaker, Jee-woon Kim, a cult film favorite making his American debut who was responsible for one of the best action/adventure films of recent years. Regrettably, it feels as if both are still getting used to their surroundings.

When a cop along a barren Arizona highway computes a 197 on his radar gun, naturally, he assumes he has picked up a low-flying plane. Except some hours earlier in Las Vegas, a highly-armed prisoner transfer turned into a daring escape for cartel leader, Gabriel Cortez (Eduardo Noriega). Speeding away in a Corvette Zero One, "a monster on wheels," Cortez heads toward the border with an FBI agent as hostage (Genesis Rodriguez). Agent John Bannister (Forest Whitaker) does his best to setup blockades and mobilize S.W.A.T. units to ward off the escapee's path, but Cortez's skills as a race car driver—and the help of even more mobilized backup—thwart the authorities at every turn.

Waiting in the small town of Sommerton Junction, however, is Sheriff Ray Owens (Schwarzenegger), who on his day off has already started to notice some local upsetting of the peace. A dairy farmer has missed his morning delivery, the deputies (Jaimie Alexander, Zach Gilford, and Luis Guzman) investigating are being put in harm's way and Peter Stormare is walking around town. When Bannister finally lets Owens in on what is headed his way, he opts for some additional firepower by deputizing a jailed Marine (Rodrigo Santoro) and a loony town slacker (Johnny Knoxville) who conveniently owns and operates a museum dedicated to firearms.

All of this is leading up to a classically-designed showdown that has everything but shots of a clock tower. Instead, we get updates with the time written into the frame. Prior to all that, *The Last Stand* carries a narrative full of fits and sputters that contradicts the raging horsepower built into the villain's muscle car. By establishing what should be a consistent chase picture by identifying our bad guy as "a psychopath in a batmobile" the energy level should be unrelenting. Every twenty minutes, Cortez engages in a violent reinforcement of the unstoppable force theory, only to be interrupted by Bannister's frustration or getting to know our heroes; the latter of which proves to be too generic to qualify as a third dimension of caring.

Schwarzenegger appears to be trying to do for Sheriff Owens what Sylvester Stallone did for his character in *Cop Land* (1997); tired, a little overweight and with a touch of regret. "When I was your age," he tells his young deputy, "I wanted to be part of the action. Now I look back differently." Arnold may be playing the old sheriff in town but when it comes to running over bad guys and shotgun blasting them to the head, he is still the same old terminator. Perhaps not wanting to appear too vulnerable, his alpha male appeal is still allowed to shine through despite townsfolk asking him to play valet and ignoring his warnings in favor of a good breakfast. That is because his backup is either too green, too lacking in persona or too wacky to make Owens pathetic enough to warrant genuine empathy or suspense. He may say he is more afraid than his deputies, but Gary Cooper in *High Noon* (1952) or Bill Paxton in *One False Move* (1992) he is not. "I have seen enough blood and death. I know what's coming." So does the viewer.

Jee-woon Kim exemplified the action days of old in *The Good, the Bad, the Weird* (2008). Mashing up Western conventionalities with Errol Flynn-like swashbuckling and a chase finale out of *The Road Warrior* (1981), there was skilled perfection in the action that worked all the better with its tongue-in-cheek plot created around genuinely rootable and hiss-worthy archetypes. Just a tenth of its execution is what *The Last Stand* could have used. Noriega is such a pitiful waste of a presence that it would have been wise to just make the car the villain, a la *Duel* (1971) or *Christine* (1983), and worry less about what was behind the shaded windshield. The final fisticuffs between an aging action star and an even less-threatening antagonist would be cinematically brutal were it not for Kim's occasional penchant for actual brutality; something he displayed with an equal amount of retribution and moral wrangling in *I Saw the Devil* (2010).

By the end of *The Last Stand*, Schwarzenegger's doppelganger Sheriff Owens says, "You're right. This is my home" as if admitting he is back where he belongs. Whether it be in America or Korea, Jee-woon Kim is likely to soon make another great film as well. It might be interesting to consider what they would do next together, because this certainly feels like a warm-up.

Erik Childress

CREDITS

Sheriff Ray Owens: Arnold Schwarzenegger
Agent John Bannister: Forest Whitaker
Lewis Dinkum: Johnny Knoxville
Mike Figuerola: Luis Guzman
Gabriel Cortez: Eduardo Noriega
Sarah Torrance: Jaimie Alexander
Burrell: Peter Stormare

Agent Ellen Richards: Genesis Rodriguez

Origin: United States

Language: English

Released: 2013

Production: Lorenzo di Bonaventura; di Bonaventura Pictures; released by Lions Gate Entertainment Corp.

Directed by: Jee-woon Kim

Written by: Andrew Knauer

Cinematography by: Ji-yong Kim

Music by: Mowg

Sound: Victor Ray Ennis

Editing: Steven Kemper

Art Direction: James Oberlander

Costumes: Michele Michel

Production Design: Franco-Giacomo Carbone

MPAA rating: R

Running time: 107 minutes

REVIEWS

Bayer, Jeff. *The Scorecard Review.* January 22, 2013.

Berardinelli, James. *ReelViews.* January 17, 2013.

Goss, William. *Film.com.* January 18, 2013.

Johanson, MaryAnn. *Flick Filosopher.* January 25, 2013.

Judy, Jim. *Screen It!.* January 18, 2013.

Lybarger, Dan. *Arkansas Democrat-Gazette.* January 18, 2013.

Morgenstern, Joe. *Wall Street Journal.* January 17, 2013.

Pfeiffer, Mark. *Reel Times: Reflections on Cinema.* February 4, 2013.

Roeper, Richard. *Chicago Sun-Times.* January 18, 2013.

Vaux, Rob. *Mania.com.* January 18, 2013.

QUOTES

Burrell: "Shoot anything that moves! If it doesn't move, shoot it anyway!"

TRIVIA

In the scene where they load up on weapons in Lewis's (Johnny Knoxville) armory, Mike (Luis Guzman) can be seen holding the Atlantean broad sword that was used in the "Conan" movies.

LAST VEGAS

It's going to be legendary.
—Movie tagline

One legendary weekend.
—Movie tagline

Box Office: $63.9 Million

The X-Scream thrill ride featured in *Last Vegas* can make it feel as if one's final moments in Sin City or anywhere else are truly at hand, which explains why Michael Douglas and Mary Steenburgen feared during filming that they would end up as a couple of shooting stars cascading down from the Stratosphere hotel. Especially from their trepidation-heightening vantage point in the front seats, the prospect of being propelled twenty-seven feet over the side of the structure and to the very tip of a track teeter-tottering at an elevation of 866 feet created wholly-understandable apprehensions that they were in for a big letdown. Far less potent but nonetheless quite similar were the concerns of some moviegoers as they settled into their own seats at the multiplex, worried that what was ahead during the film's cathartic trip for the arthritic might figuratively let them down by being timeworn and lame. It was likely the only time that *Last Vegas*' predominantly-grey ticket buyers found themselves not only hoping for new wrinkles but feeling disappointed upon seeing none. Still, this stale-scripted production is saved from causing hearts to sink as profoundly as Douglas and Steenburgen's stomachs by an appealing posse of Oscar-winning old pros between the ages of sixty-six and seventy-six who jauntily sport what is decidedly old hat.

The film begins with a shorthand visual expression of the mature main characters' longstanding closeness, introducing them as four frolicsome Brooklyn boys cramming themselves into a 1950's black-and-white photo booth. (An image on one of the subsequently spit-out strips that depicts a girl wedged between two adolescent admirers will eventually have significant meaning of its own.) The "Flatbush Four" may call each other all sorts of colorful names, but they unite in seeing red if any one of them is harassed by an outsider. Although their encounter with a bully leads more to flight than a remarkable fight after one pal-protecting punch, a boy nonetheless declares that what they just did will make them "legends." None of the vets portraying their adult incarnations could candidly claim the same after *Last Vegas* wrapped (even though posters seemed to crow to the contrary), but Douglas, Robert De Niro, Morgan Freeman and Kevin Kline have long been justly-lauded for other, more illustrious efforts that have immortalized them on film. This project, however, is one for the aged and not for the ages.

After its purposeful prologue, *Last Vegas* fast—forwards fifty-eight years to leader and lifelong ladies' man Billy (Douglas) phoning venerable cohorts Archie (Freeman) and Sam (Kline) with the shocking news that he is finally settling down. (A falling-out had occurred between Billy and De Niro's Paddy over the former's failure to show up for the funeral of the latter's wife Sophie, once the girl who had been both figuratively and pictured literally between them.) Not nearly as surprising: the fiance (Bre Blair) of this self-assured

septuagenarian skirt-chaser is as hot as a Nevada desert and less than half his age. It is made clear that Billy is also engaged in the sense that he is still vitally a part of life, a determinedly well-preserved, well-dressed, and well-off Malibu attorney who is accompanied by lively music as he confidently strides upon the terrace of his palatial abode and fields calls related to his still-bustling practice. However, a brief, unmistakable, and telling crack appears in the vivacious man's veneer of carefree cockiness as he soberly reflects on his reflection with a desolate-sounding sigh. Perhaps Billy is embracing a nymphet to help nullify some carefully-concealed angst about aging.

Archie and Sam trick a steadfastly-bitter Paddy into travelling to Vegas with them so the banding together for Billy's bachelor party will be complete. Based on the glimpses provided of their lives, one might say that the three, unlike the dynamic groom-to-be, have all but cashed in their chips before arriving in the Gambling Capital of the World. It seems that Sam is aging by association after agreeing to retire early and move with his wife Miriam (Joanna Gleason) to live amongst older folk in the less-than-scintillating surroundings of a Florida senior community. His spirit is sagging much more than his flesh, and it seems to be on the verge of drowning during a water aerobics class where some around Sam are barely alive and kicking. His libido has already sunk out of sight, something his spouse hopes will rise again as the result of the randy, resuscitating romp she gives him permission to have in Vegas. (Miriam also sends him off with Viagra and a condom.) Archie needs to escape the imprisonment of life with his well-meaning but overprotective son (Michael Ealy), a stagnation-inducing existence capable of inadvertently finishing off this survivor of a mild stroke. Paddy has chosen to shut himself off from life in the apartment he now disconsolately aims to share with mere memories. Thus all three are clearly stuck, surrounded daily by unhealthily-dispiriting reminders of mortality. Upon arriving in Vegas, they are unable to check in to the hotel because it is unexpectedly undergoing renovations, but a much bigger problem is that they have been living like they are ready to check out, and the men themselves are about to benefit from some unanticipated but much-needed restoration.

The bash celebrating the end of Billy's bachelor-hood also begins an earnest endeavor by those members of the Flatbush Four who have gone decidedly flat to once again grab life by the horns with gusto. If only anything that subsequently transpires grabbed viewers as strongly. While Sam, Archie and Paddy become reenergized, the material remains too tired throughout. As all the friends endeavor to have a good old time acting as if they were young again, their exploits and excesses involve little that is unexpected: gambling, drinking, dancing and ogling fetching nubile forms. There are trite jokes involving ocular miscalculation (Sam accidently hits on a male Madonna impersonator), hearing deficiency and hairy excess in new and unwanted places, as well as cradle robbing, Medicare coverage, drugs like Lipitor and the aforementioned Viagra, and seniors continually mystified by technological and cultural modernity. Counteracting some of this mildly-diverting mustiness and the increasing amount of mawkishness (hurtful secrets and here-to-for hidden anxieties are revealed and rifts are healed) is an invigorating breath of fresh air named Diana (Steenburgen), the cheerful and utterly charming lounge singer "of a certain age" who becomes Sophie redux when both Billy and a Paddy vie for her affections. (Steenburgen is no cinematic slouch herself, having won her own Academy Award for 1980's *Melvin and Howard*.) Even those developing cataracts had no trouble envisioning much of what was to come in *Last Vegas*, and when Diana warbles "You're my destiny" while locking eyes with Billy, the foreshadowing is as hard to miss as a neon sign on the Strip.

Yet the engaging actors seem just as determined as the characters they play to make the most of things in Vegas, and they do succeed at times in giving the corn some pleasurable comedic pop. In addition, anxieties about the inexorable march toward one's mortality are relatable and the idea of friendship not only being a through line but sometimes a lifeline is quite comforting, as is the degree of late-inning contentment found by all. Made on a budget of $28 million, *Last Vegas* grossed over twice that despite many reviews that were lukewarm at best. It may sound counterintuitive, but the odds of finding enjoyment here were raised by the lowering of expectations.

David L. Boxerbaum

CREDITS

Billy: Michael Douglas
Paddy: Robert De Niro
Archie: Morgan Freeman
Sam: Kevin Kline
Diana: Mary Steenburgen
Origin: United States
Language: English
Released: 2013
Production: Laurence Mark; released by CBS Films
Directed by: Jon Turteltaub
Written by: Dan Fogelman
Cinematography by: David Hennings
Music by: Mark Mothersbaugh

Sound: Kevin O'Connell
Music Supervisor: Mary Ramos
Editing: David Rennie
Art Direction: Mark Garner
Costumes: Dayna Pink
Production Design: David J. Bomba
MPAA rating: PG-13
Running time: 105 minutes

REVIEWS

Bowles, Scott. *USA Today*. October 31, 2013.
Foundas, Scott. *Variety*. October 28, 2013.
Gleiberman, Owen. *Entertainment Weekly*. October 30, 2013.
Keough, Peter. *Boston Globe*. October 31, 2013.
McCarthy, Todd. *Hollywood Reporter*. October 28, 2013.
Merry, Stephanie. *Washington Post*. October 31, 2013.
Phillips, Michael. *Chicago Tribune*. October 31, 2013.
Rainer, Peter. *Christian Science Monitor*. November 1, 2013.
Roeper, Richard. *Chicago Sun-Times*. October 31, 2013.
Scott, A. O. *New York Times*. October 31, 2013.

QUOTES

Archie: "I'm gonna find some damn water and take all my damn pills and get this party started."

TRIVIA

The film was originally supposed to star Jack Nicholson.

LEE DANIELS' THE BUTLER

(The Butler)

One quiet voice can ignite a revolution.
—Movie tagline

Box Office: $116.6 Million

Inspired by Wil Haygood's 2008 *Washington Post* article "A Butler Well Served by This Election" *Lee Daniels' The Butler* is not just the story of a servant, but a movement. With a fictional character based on article subject Eugene Allen, Forest Whitaker's Cecil Gaines serves in the White House as butler under a total of eight different Presidents, while his oldest son Lewis (David Oyelowo) matures in the middle of a Civil Rights movement montage. While Cecil yearns to make a difference quietly, Lewis is involved firsthand with numerous significant parts of the racial revolution, involving himself with sit-ins, Freedom Rides, Martin Luther King Jr., Black Panthers, protests of apartheid in South Africa, and more.

As the film observes Gaines' extensive career with increasingly poetic significance, Whitaker remains its shining centerpiece. Allen's true story is indeed striking, but Whitaker is the one who completes the personality, bestowing him with a gentility that is exclusive to the performer's charisma. With such a grace Whitaker is able to make the film's smallest conflict its most triumphant, involving a black servant trying to earn a raise in the White House. Whitaker is paralleled by a similarly impacting performance from Oyelowo, who previously helped ground Daniels' unruly Southern drama *The Paperboy* (2012). As a soldier for Daniels' artistic cause, Oyelowo dives into each evolution of Lewis as he embodies the evolving black American attitudes since the 1960s. With such a performance, as strong as Whitaker but louder, Oyelowo earns Daniels the artistic license that the director then brandishes in this ambitious project.

Aside from these two commendable turns, *Lee Daniels' The Butler* is a bustling list of numerous extra characters. In her first on-screen performance since *Beloved* (1998), American icon Winfrey only succeeds in taking up the film's time, her neglected housewife catered to with an unnecessary subplot of temptation opposite a similarly useless Terrence Howard. Cuba Gooding Jr. and Lenny Kravitz, both with history in Daniels' filmography, are two of many guests to this crammed gathering who provide little but star recognition.

Providing *Lee Daniels' The Butler* with its campiest performances are its Presidents, a revolving door of American leaders often stereotyped down to a single definitive feature (James Marsden's John F. Kennedy is described as "smooth," and Liev Schreiber's version of Lyndon B. Johnson is shown with his two dogs). Rickman's take on Ronald Reagan is the undoubtedly best Presidential take, boosted by facial similarities other cast performers simply do not have.

The production design from Tim Galvin transcends decades and distinct locations so well that one would not notice the corners cut in this independent project's budget were it not for its makeup, a glaring example of the carte blanche given to its vitalizing marquee actors and their subsequent varying degrees of effort. In particular, John Cusack rhymes the hostile chuckles earned from his abominable impersonation of Richard Nixon with those gained for lazy efforts to make him look like the President—not even a cheap prosthetic nose is to be seen, unlike the case with numerous other Nixon portrayals.

Daniels' gravitation towards the uglier aspects of the human condition serves well the select historical events he yearns to bring with no compromise to mainstream

attention (especially when other 2013 films like Brian Helgeland's *42* coat necessary history lessons with sweeteners). His recreations of occurrences in the cinematically under-represented civil rights movement are vivid with the intensity and injustice that defines them, especially in terms of this film's aggressive portrayal of sit-ins, with the training for such protests mixed in with the horror of the actual event. Daniels' victory lap, in which he firmly places Gaines and his family in the nearing days of Barack Obama's 2008 election, may draw clear the film's political intentions, but such an epilogue is warranted.

Within one film (and with the support of 39 credited producers), Daniels is able to define the different shades in a wide palette of attitudes experienced within a whole movement, capturing the human elements that can only be found between the lines of history book text. In his passionate overview of such history, Daniels finds a new ally in his first PG-13 rating, which keeps him behaved and focused with his content, preventing the film from distracting itself with the previous nuttiness he enjoyed flaunting in past projects. Here, Daniels' expected storytelling flamboyance is only evident in artistic ambition, telling history with Oyelowo representing his *Forrest Gump* (1994).

Lee Daniels' name appears on the film's title due to Hollywood business hijinks, an embarrassing Tinseltown tale that concerned the ownership by a competing studio of an obscure silent short titled *The Butler*. But yet, aside from the chosen title's inferring of self-importance, one can also recognize this title as a means for Daniels to reclaim the film, especially after his cast has tainted his project with campiness one can only imagine he (on this occasion) reluctantly accepts. To his credit and also that of his film, while his rowdy guests continue to take more and more from his film (as referenced visually by greedy children who return for ungrateful seconds from Cecil's kindly offered tray), Daniels remains focused, serving his history with dignity.

Nick Allen

CREDITS

Cecil Gaines: Forest Whitaker
Gloria Gaines: Oprah Winfrey
Louis Gaines: David Oyelowo
Howard: Terrence Howard
Carter Wilson: Cuba Gooding, Jr.
James Holloway: Lenny Kravitz
Dwight D. Eisenhower: Robin Williams
Richard Nixon: John Cusack
John F. Kennedy: James Marsden
Jacqueline Kennedy: Minka Kelly
Lyndon B. Johnson: Liev Schreiber
Ronald Reagan: Alan Rickman
Nancy Reagan: Jane Fonda
Maynard: Clarence Williams, III
Hattie Pearl: Mariah Carey
Earl Gaines: David Banner
Annabeth Westfall: Vanessa Redgrave
Thomas Westfall: Alex Pettyfer
Origin: United States
Language: English
Released: 2013
Production: Lee Daniels; released by Weinstein Company L.L.C.
Directed by: Lee Daniels
Written by: Danny Strong
Cinematography by: Andrew Dunn
Music by: Rodrigo Leao
Sound: Jay Meagher
Music Supervisor: Lynn Fainchtein
Editing: Joe Klotz
Art Direction: Jason Baldwin Stewart
Costumes: Ruth E. Carter
Production Design: Tim Galvin
MPAA rating: PG-13
Running time: 132 minutes

REVIEWS

Anderson, John. *Washington Post.* August 15, 2013.
Guzman, Rafer. *Newsday.* August 15, 2013.
Kennedy, Lisa. *Denver Post.* August 16, 2013.
LaSalle, Mick. *San Francisco Chronicle.* August 15, 2013.
Morgenstern, Joe. *Wall Street Journal.* August 15, 2013.
Sachs, Ben. *Chicago Reader.* August 15, 2013.
Scott, A. O. *New York Times.* August 15, 2013.
Stevens, Dana. *Slate.* August 15, 2013.
Turan, Kenneth. *Los Angeles Times.* August 15, 2013.
Zacharek, Stephanie. *Village Voice.* August 13, 2013.

QUOTES

Cecil Gaines: "America has always turned a blind eye to what we done to our own. We look out to the world and judge. We hear about the concentration camps but these camps went on for two hundred years right here in America."

TRIVIA

This film reunites Robin Williams and Forest Whitaker twenty-six years after their first appearance together in *Good Morning, Vietnam* (1987).

AWARDS

Nominations:
British Acad. 2013: Actress—Supporting (Winfrey), Makeup
Screen Actors Guild 2013: Actor (Whitaker), Actress—Supporting (Winfrey)
Screen Actors Guild 2014: Cast

LEVIATHAN

Box Office: $76,211

How does one even begin to assess a film as truly form-crashing as Lucien Castaing-Taylor and Verena Paravel's *Leviathan*? On one hand, it is a documentary. This is non-fiction filmmaking in that there are no characters, plot, or narrative crafted by writers. However, lumping this abstract art piece in with traditional documentaries like those made by Michael Moore or Alex Gibney almost seems more incorrect than placing it in a mental film catalog next to work of fictional artists like Terrence Malick or Shane Carruth, people more interested in sound, emotion, and other untraditional aspects of filmmaking. This is visual art, a sound and vision experience, more than it serves the traditionally informative purpose of non-fiction filmmaking. To that end, it can be a bit frustrating. Some of the artistic flourishes cross over from interesting to exhausting. However, cinema needs filmmakers willing to straddle the line that is as typically distinct as that between non-fiction and fiction.

The two Anglo-French filmmakers start their film, shot entirely on digital cameras with almost no crew, with noise. It is the clanging, wet, sloppy noise of fishermen off the coast of New England. The filmmakers are not interested in chronicling this dark, dirty life but actually capturing it and transporting viewers to it. And so it often feels like the camera is not even being controlled by a human, attached to chains that pull fishing nets or just sitting alongside the flopping creatures on the deck of the ship. *Leviathan* is a sensory experience as there are literally no words in the entire piece.

And yet there is clear authorship. The title and even the font of the film evoke death metal and the whole piece has a distinctly ominous feel. The filmmakers could have shot during the day, filmed scenes of the fishermen on shore, taken breaks with them, shot scenes of the sun-kissed horizon. They did not take that approach. *Leviathan* is dark, dirty, loud, and borders on terrifying at times. It feels like a nature documentary filtered through the eyes of a horror sensibility. Perhaps the idea was to recreate the ugliness of nature's cycle. The result is wet, gross, and sometimes terrifying, as if the viewer is getting the point of view of the thousands of fish about to be slaughtered. And the filmmakers have a definite appreciation of the entire breadth of nature, often focusing on birds flying overhead, the dark, dangerous water, etc. This is a world, to them, in which the humans are often intrusive, and often at their own peril. So the viewer should feel that uninvited aspect that nature films, which often tend to beautiful sunsets, rarely provides.

It can make for some difficult viewing in terms of viewer engagement. To be blunt, *Leviathan* can be exhausting and pretty boring. One wonders if the artistic endeavor could not have been better served by a tighter edit, although the scenes of seemingly interminable time alongside soon-to-die fish are clearly purposefully designed to be lengthy. These are not fleeting views of the cycle of nature. They are intense, and it can be hard to determine if the film would have worked at all, at least as the filmmakers intended, if the edit had been tighter. One needs to be exhausted by the journey to really "get" what the filmmakers are going for. However, that does not make it any more enjoyable or entertaining.

Which leads to this question—if *Leviathan* is a documentary that is not really designed to be informative and not really designed to be entertaining, what could its purpose be? *Leviathan* is a film that can be easy to admire—its technical achievements make it almost impossible not to do so—but hard to love. Or even enjoy. Like all films that push the form of their structure this far past the traditional breaking point, it is a film that many loved or hated. To this viewer, it is a series of very powerful images and an impressive cacophony of noise that never adds up to something more than an interesting experiment in filmmaking. Can a director (or team in this case) make a documentary with no title cards, narration, interviews, or defined purpose of change that somehow still has an impact? Can a non-fiction film qualify as art? While these questions validate the existence of this unique cinematic experiment, the filmmakers asking them of themselves and viewers is nowhere near as interesting as it would be if they actually had an answer or two.

Brian Tallerico

CREDITS

Origin: France
Language: English
Released: 2013
Production: Lucien Castaing-Taylor, Verena Paravel; Arrete Ton Cinema, Le Bureau; released by The Cinema Guild
Directed by: Lucien Castaing-Taylor; Verena Paravel
Written by: Lucien Castaing-Taylor; Verena Paravel
Cinematography by: Lucien Castaing-Taylor; Verena Paravel
Sound: Reza Narimizadeh; Lucien Castaing-Taylor; Verena Paravel
Editing: Lucien Castaing-Taylor; Verena Paravel
MPAA rating: Unrated
Running time: 87 minutes

REVIEWS

Bradshaw, Peter. *The Guardian*. November 29, 2013.
Calhoun, Dave. *Time Out London*. November 26, 2013.

Freer, Ian. *Empire*. November 25, 2013.

Goldstein, Gary. *Los Angeles Times*. May 10, 2013.

Nehme, Farran Smith. *New York Post*. February 28, 2013.

Rothkopf, Joshua. *Time Out New York*. February 26, 2013.

Scott, A. O. *New York Times*. February 28, 2013.

Smith, Neil. *Total Film*. November 29, 2013.

van Hoeij, Boyd. *Variety*. February 22, 2013.

Zacharek, Stephanie. *NPR*. March 1, 2013.

LIKE SOMEONE IN LOVE

Box Office: $239,056

The Iranian master Abbas Kiarostami experienced something of a career resurgence in 2010 with *Certified Copy*, with its luminous performance from Juliette Binoche and its beguiling tricky meta narrative. *Like Someone in Love* is similar to that work in some ways, dealing as it does with roleplaying, gender politics, and more broadly, with the essence of human identity, but *Like Someone in Love*, while clever, intriguing, lovingly shot and well-acted, does not transcend the story of its characters to comment incisively on life and art and their relationship to one another in the same mind-expanding way that *Certified Copy* did.

The film opens with an extended point-of-view shot from Akiko's (Rin Takanashi) perspective, as she talks on the phone with her jealous boyfriend, Noriaki (Ryo Kase). It is slowly revealed that she is a prostitute, and that she is lying to Noriaki about her whereabouts. After her distressing conversation, her pimp Hiroshi (Denden) comes over, and offers unwelcome relationship advice. He also tells her a silly dirty joke about two millipedes on their wedding night, which Kiarostami will turn into a running gag, where characters in awkward social situations, looking for something to say, repeat a joke they do not necessarily understand or find funny. It is the kind of slyly observant linguistic play that one might expect from the master filmmaker, though the fact that he accomplishes working in a foreign language is impressive.

Akiko tells Hiroshi that she cannot meet the client he has scheduled for her because her grandmother is in town (the same excuse she gave Noriaki). Hiroshi bullies her into a cab, and she asks the driver to go by the train station, where her grandmother, whose calls Akiko has been dodging all day, is waiting by a fountain, hoping against hope that her granddaughter will meet her before she gets on the last train back home.

After hearing her grandmother's heartbreaking, increasingly despondent voicemail messages, Kiarostami shows the grandmother standing under a statue with her

bags from Akiko's point-of-view, as the cabbie circles the fountain. It is an astonishingly moving scene, demonstrating the filmmaker's ability to achieve emotional resonance without manipulation; to achieve much with seemingly very little. The viewer hopes against hope that Akiko will get out of the cab and go to the old woman.

Perhaps there is no other filmmaker in the history of cinema who shoots people driving and riding in cars with the aplomb of Kiarostami. It has been a motif in his narrative filmmaking almost from the beginning, and it has worn well, as each new journey reveals characters and their relationship to one another in surprising ways. Later in the film, there is a bravura sequence wherein Akiko, Noriaki, and Akiko's elderly client, Professor Watanabe (Tadashi Okuno) all ride together in Watanabe's car, all at cross-purposes and deceiving each other (and perhaps themselves) about their personal interests. It is a simple setup, but Kiarostami subtly draws out the drama of the situation, as only a master filmmaker could.

The story continues with Akiko meeting Watanabe at his apartment. The two eventually realize that she is studying sociology at university, in the same department where he was a respected professor. After an unhurried assessment of the situation, she tries to get down to business, while he hems and haws, catering to Akiko like a doting grandfather. Because Kiarostami has shown her route to his apartment, it is clear why she discourages Watanabe's ministrations. His self-deception turns into something else the next day, when he drives her to school for an exam. Kiarostami, now shooting from Watanabe's point-of-view, shows Noriaki accosting Akiko on the university steps. After she goes inside, Noriaki approaches Watanabe's car, mistaking the old man for Akiko's grandfather. For a multitude of reasons, his protective feelings toward Akiko and self-preservation among them, Watanabe goes along with it, offering the young man practical relationship advice. He continues the charade when Akiko gets out of class, and the odd trio drive off together.

The world is not as reasonable as Watanabe expects it to be, and one of the great ironies of *Like Someone in Love* is that the experienced, intelligent older gentleman turns out to be the most naive character in the movie. Kiarostami does not offer any simple answers. He only ever so gently probes the complexity of what motivates human interaction: why we deceive each other, and ourselves.

The assumed identities and deceptions are reminiscent of *Certified Copy*, of course, but Kiarostami does not take them as far in this film, and perhaps Watanabe is the only character that actually comes to believe in the role he assumes. Akiko remains sharply self-aware

throughout, and appears to live her life in a state of constant shame, while Noriaki deceives only himself about the nature of his relationship with Akiko and their future together.

It is a beguiling work, and contains several memorable scenes, like the one in the cab mentioned above, but Kiarostami's decision to end it with a bizarrely jarring moment, disorienting the viewer, lessens its impact in a way. It is not that anyone would expect the filmmaker to wrap up such a broad-ranging, intellectually complex examination of gender and aging and aching loneliness in a neat little bow, but the ending leaves the movie feeling oddly incomplete. *Like Someone in Love* is a remarkable accomplishment, but it does not quite rank among the filmmaker's greatest works.

Josh Ralske

CREDITS

Akiko: Rin Takanashi
Takashi: Tadashi Okuno
Noriaki: Ryo Kase
Origin: Japan, France
Language: Japanese
Released: 2013
Production: Marin Karmitz, Abbas Kiarostami; MK2; released by Sundance Selects
Directed by: Abbas Kiarostami
Written by: Abbas Kiarostami
Cinematography by: Katsumi Yanagijima
Sound: Reza Narimizadeh
Editing: Bahman Kiarostami
Costumes: Masae Miyamoto
MPAA rating: Unrated
Running time: 109 minutes

REVIEWS

Boone, Steven. *RogerEbert.com.* February 12, 2013.
Bradshaw, Peter. *The Guardian.* May 12, 2012.
Collin, Robbie. *The Telegraph.* June 20, 2013.
Cataldo, Jesse. *Slant Magazine.* October 12, 2012.
Edelstein, David. *Vulture.* February 15, 2013.
Foundas, Scott. *The Village Voice.* February 13, 2013.
Rea, Steven. *Philadelphia Inquirer.* June 11, 2013.
Scott, A. O. *New York Times.* February 14, 2013.
Smith Nehme, Farran. *New York Post.* February 14, 2013.
Stevens, Dana. *Slate.* February 15, 2013.

QUOTES

Akiko: "I'd rather not know all the mistakes I've made. I'm depressed enough as it is."

TRIVIA

The film had the production title "The End" which was also the initial name of the movie.

THE LONE RANGER

Never take off the mask.
 —Movie tagline

Box Office: $89.3 Million

Whether one remembers it from the golden age of radio or the black-and-white television program with the familiar introduction, *The Lone Ranger* was a remarkably simple concept. All a kid needed was a white hat, a mask, and a fake gun and they could play in the yard all day at Cowboys and Indians. The phantom lawman who sought justice with a loyal sidekick was an American icon likely best remembered for the theme song he borrowed from a rebellious apple-shooting escapee. The *Pirates of the Caribbean* series is also one that began from simplistic beginnings. How else to describe a film that began as an animatronic boat ride at Disneyland? Instead of just phoning it in on the wings of name recognition, director Gore Verbinski, producer Jerry Bruckheimer, writers Ted Elliott and Terry Rossio, and star Johnny Depp turned it from epic adventure into an epic series that surprised as many as it eventually infuriated. Proving that they are willing to spare no expense in dollars, scope, and quirk, the team is back in place and the result is a more uneven affair, but no less ambitious and occasionally quite entertaining.

The familiar story is basically the same, although it is now being told by an aged Tonto (Depp) to a young boy dressed as his former riding partner. The way he tells it, Tonto met aspiring lawyer John Reid (Armie Hammer) on a train transporting fugitive Butch Cavendish (William Fichtner) to justice by the Texas Rangers. After a spectacular escape by the outlaw, John is deputized into the Rangers by his brother, Dan (James Badge Dale). The scouting mission is betrayed and ambushed leaving everyone for dead, save for John who is discovered barely alive by Tonto and nursed back to health.

When John is fully awakened, he wants nothing else than to see the Cavendish gang brought in. Tonto agrees to be his guide while holding his own personal quest for retribution that dates back to childhood. For their journey, John is given a mask to protect his identity from those who might seek harm upon him or those that he cares about including Dan's widow, Rebecca (Ruth Wilson) and her son (Bryant Prince). As Indian raids begin to increase, railroad tycoon Latham Cole (Tom Wilkinson) enlists the Custer-like Captain Jay

Fuller (Barry Pepper) to lead the Cavalry against the Comanche tribes; a further injustice that John and Tonto hope to correct.

The plotting at times gets as complex as the overactive twisting arc of *Pirates of the Caribbean: Dead Man's Chest* (2006) where key details are withheld almost indefinitely and pieced together in cryptic increments. This may not be what the average Western aficionado or those satisfied with the decisive episodic nature of 22-minute television may be looking for out of a *Lone Ranger* feature. Most disruptive of all is the wraparound tale with "noble savage" Tonto hinting to his young listener that they may have been outlaws and stopping forward momentum at inopportune times to fill in some of the gaps. Leaning a bit too hard on this as a whimsical *Princess Bride* (1987) bit of legend recollection, the writers add more minutes than humorous discourse all while possibly making us think twice upon exiting why it was added in the first place.

Depp in the past has tapped into the spiritualism of Native American culture in films like *Dead Man* (1995) and his little seen directorial debut, *The Brave* (1997), in which he portrayed an American Indian who agrees to star in a snuff film. Some may suggest that is a perfect metaphor for his work in *The Lone Ranger*. Depp was doing oddball work for over a decade before it reached its peak with his first Oscar nomination for *Pirates of the Caribbean: The Curse of the Black Pearl* (2003). As Tonto, Depp's commitment remains intact but proves to be an unavoidable distraction to the experience. With Armie Hammer alternately aloof and bland as the hero coming into his origin, the focus is more on Depp to add both personality and comic relief. Depending on one's sensitivity level of a Caucasian wearing war paint with a dead bird perched on his head and speaking broken English like one of the Go-Go Gophers from TV's *Underdog*, Tonto's amusement level may be muted. Then again an actual Native American in the role may have invoked similar complaints. Sometimes sidekicks just cannot get any respect.

Deserving of such is Verbinski's own commitment to the craft. As he displayed in his Oscar-winning animated feature, *Rango* (2011), respect for the history of the western genre and its Old West nostalgia is completely evident in *The Lone Ranger*. Grabbing an arc from *Once Upon a Time in the West* (1968), locations from *The Professionals* (1966) and *Rio Lobo* (1970), or an iconic predicament from the works of Sergio Carbucci, fans will have no shortage of identifiable relics to savor. The art direction has the authentic flavor that CGI landscapes often fail to replicate. Bojan Bazelli's cinematography is gloriously expansive which aids in the film's inarguable highlight, its action sequences. More frequently, directors are hedging their bets in their action, filming so up close and personal that it makes it easier to cut together but impossible for the viewer to drum up the intensity, spectacle and awe that comes with vastness. While sprinkled with briefer set pieces from the Ranger ambush to a nighttime attack on the railroad, it is the two train sequences that bookend the film that are astonishingly articulate in terms of scope and effort.

The Lone Ranger is a flawed film with the kind of production history that frequently causes a lot of pre-judging and labels of disaster if it does not live up to the greatest thing since sliced bread. It is not difficult to see the money being spent on the screen. A little harder to spot through the spectacle are the attempts at what goes into the creation of a legend; sometimes at the expense of a harsher truth. Over the years, a white man in a white hat as the symbol of non-violent justice may have pleased those in the golden age of television and radio where bullets resulted in no more than a "ting" sound as it connected to knock another man's gun out of his hand. The crew behind this Lone Ranger may have delivered thrills that would appease fans waiting for the iconic orchestral theme played to great effect in the climax. But they have also packaged it with occasionally brutal violence to remind viewers of those that were here before them during the formation of this country. As one man walks alone into the desert, has he left behind a myth of his own creation or kept it stirring so those who still want to believe in a yesteryear when United was as big a myth as any?

Erik Childress

CREDITS

Tonto: Johnny Depp
John Reid/The Lone Ranger: Armie Hammer
Latham Cole: Tom Wilkinson
Butch Cavendish: William Fichtner
Red: Helena Bonham Carter
Rebecca Reid: Ruth Wilson
Capt. Jay Fuller: Barry Pepper
Dan Reid: James Badge Dale
Origin: United States
Language: English
Released: 2013
Production: Jerry Bruckheimer; released by Walt Disney Pictures
Directed by: Gore Verbinski
Written by: Ted Elliott; Terry Rossio; Justin Haythe
Cinematography by: Bojan Bazelli
Music by: Hans Zimmer
Sound: Gary Rydstrom
Editing: James Haygood; Craig Wood

Costumes: Penny Rose
Production Design: Jess Gonchor
MPAA rating: PG-13
Running time: 149 minutes

REVIEWS

McGranaghan, Mike. *Aisle Seat.* July 5, 2013.
Nusair, David. *Reel Film Reviews.* July 5, 2013.
O'Hehir, Andrew. *Salon.com.* July 2, 2013.
Rea, Steven. *Philadelphia Inquirer.* July 3, 2013.
Rodriguez, Rene. *Miami Herald.* July 3, 2013.
Scott, A. O. *New York Times.* July 2, 2013.
Seitz, Matt Zoller. *RogerEbert.com.* July 3, 2013.
Snider, Eric D. *EricDSnider.com.* July 10, 2013.
Tobias, Scott. *The Dissolve.* July 11, 2013.
Villarreal, Phil. *COEDMagazine.com.* July 3, 2013.

QUOTES

John Reid: "Hi ho Silver, away!"
Tonto: "Never do that again."
John Reid: "Sorry."

TRIVIA

This is the first film to feature both Johnny Depp and Helena Bonham Carter that was not directed by Tim Burton.

AWARDS

Golden Raspberries 2013: Worst Remake/Sequel
Nominations:
Oscars 2013: Visual FX
Golden Raspberries 2013: Worst Actor (Depp), Worst Director (Verbinski), Worst Picture, Worst Screenplay

LONE SURVIVOR

Live to tell the story.
—Movie tagline
Based on true acts of courage.
—Movie tagline

Box Office: $123.4 Million

Whenever Hollywood has a success on its hands, the script pile is rummaged through to find a thematic follow-up. The "next" version of that hit is quickly greenlit to strike while the iron is hot. This usually results in the cinematic quality of a VHS copy; a semblance of the original but with a grainy, blurry overcast that may have one somewhat enjoying what they're watching even as they are aware that there is a better version out there. The harrowing opening half-hour of *Saving Private Ryan* (1998) led filmmakers to try and create an even more sustained battle sequence. This led to extended sequences

in *The Patriot* (2000), *Pearl Harbor* (2001), and even *The Lord of the Rings* (2001-03) trilogy. *Black Hawk Down* (2000) was nothing if not one giant action sequence based on a real-life ambush of American soldiers. Though put into production before the release and success of *Zero Dark Thirty* (2012), *Lone Survivor* follows in the grandiose tradition of the untold story that can now be told because of sudden monetary interest in the subject matter. Peter Berg's film thus arrives as an exercise in superb technical craftsmanship wrapped in the troubling uncertainty regarding its existence.

Operation Red Wings was a 2005 operation of America's armed forces to capture or kill Senior Taliban commander, Ahmad Shah. A team of four Navy SEALs were to be sent in as the first phase of the operation, purely for surveillance, to lock down their target's position and then signal for the cavalry awaiting word at the nearest base. Lt. Michael Murphy (Taylor Kitsch) was in charge of the crew which included Marcus Luttrell (Mark Wahlberg), Danny Dietz (Emile Hirsch), and Matt Axelson (Ben Foster). While their commanding officer, Erik Kristensen (Eric Bana), was resting and awaiting word from his men, their position in the mountains of Afghanistan was already being compromised.

Spotted by some local goat herders, the team is faced with an immediate moral quandary. Let the civilians go and risk being ratted out to the Taliban army lurking down below or eliminate them from the equation and risk being brought up on war crimes. The combination of irony and dramatic license over their ultimate decision will permeate throughout the rest of the film, beginning with them fighting for their lives. With radio communication failing, Murphy & Co. are forced to retreat through the rocky terrain. Outnumbered and with little chance for rescue, a fierce shootout entails until the film can unfortunately live up to its very title.

When the fictional Private Ryan was told to "earn this" opportunity to continue living, he was representative of the "greatest generation" who fought to preserve the world entire. For the majority of viewers unfamiliar with this story, *Lone Survivor* shows us precisely who that is being shipped back to base on their near last breath and ends in the same place. There is no reflection on the loss of his friends and no dramatic trauma of readjustment to civilian life. The absence of even a purely Oscar-baiting final breakdown leads to a larger question. Why was this story told?

The easy answer can be found in the montages that bookend the operation. Peter Berg opens with images of real-life SEAL training. Indeed, the amount of bullets, cliff dives, and bone bruises the four soldiers take fighting off the enemy offer the suggestion of superheroes who will not back down. The real Marcus Luttrell once

said "It's about brotherhood. No matter how bad it gets, you keep fighting just to protect the guy next to you." The op for Ahmad Shah could be taken as a metaphor for the hunt for Bin Laden. Each were terrorists who killed Americans—in this case, Marines—and each had a target on their back for not so much justice as pure red-blooded revenge. Like cops policing their own, the mission's singular purpose, was payback. As a film though, its singular purpose is to thrill an audience and that part *Lone Survivor* does in spades.

Just as the films of war have before it, Berg is committed to delivering one long and excruciating sequence of battle. When it begins there is no looking back and nearly no cutting away. Tobias A. Schliessler's cinematography is crisp and Berg's choreography of the action is stellar with all the moving parts in clear view as to appreciate the gravity of their predicament. Arguing that the action is even too slick for its own good allows a desensitized feeling akin to playing Call of Duty: Lone Survivor. The graphic intensity of the extended violence with a pre-determined outcome could suggest a well-staged snuff film with the carnage level of *The Passion of the Christ* (2004). Much as in Ridley Scott's *Black Hawk Down*, the unrelenting waste of soldiers behind enemy lines with no other objective other than to get out alive is palpable.

"It's nobody's business what we do down here. We do what we do, what we have to do," says Dietz during the film's one big moral quandary. Skeptics could cynically view the hero-triggering bookends as a call-to-arms recruitment video akin to *Act of Valor* (2012) starring "active-duty SEALs." They might also find it convenient that the one guy to make it out is also the one to argue the most humane option regarding their prisoners. Karmic justice aside, as a movie *Lone Survivor* is a skillful and technically-proficient one that thrusts the audience into the eye of battle with no way out. There are no *Captain Phillips* (2013) moments of shock on display here to balance the ingrained machismo of carrying on while carrying a half-dozen bullets inside their flesh. For all the shameful casualness of football being equated to war, Berg's *Friday Night Lights* (2004) is actually a more closely-felt examination of brotherhood on the field of battle. Those "soldiers" found time to cry after losing. If *Lone Survivor* fails to explore precisely what these guys were fighting for (other than the man next to them) then the least it should tell viewers is why they had to lose their lives.

Erik Childress

CREDITS

Marcus Luttrell: Mark Wahlberg
Michael Murphy: Taylor Kitsch
Danny Dietz: Emile Hirsch
Matt Axelson: Ben Foster
Erik Kristensen: Eric Bana
Origin: United States
Language: English
Released: 2013
Production: Sarah Aubrey, Randall Emmett, Akiva Goldsman, Norton Herrick, Stephen Levinson, Barry Spikings, Mark Wahlberg; Film 44; released by Universal Pictures Inc.
Directed by: Peter Berg
Written by: Peter Berg
Cinematography by: Tobias Schliessler
Music by: Steve Jablonsky
Sound: Wylie Stateman
Editing: Colby Parker, Jr.
Art Direction: Steve Cooper
Costumes: Amy Stofsky
Production Design: Tom Duffield
MPAA rating: R
Running time: 121 minutes

REVIEWS

Cline, Rich. *ContactMusic.com*. January 2, 2014.
Dowd, A. A. *The Onion A.V. Club*. December 24, 2013.
Duralde, Alonso. *The Wrap*. November 12, 2013.
Fine, Marshall. *Hollywood & Fine*. December 23, 2013.
McGranaghan, Mike. *FromTheBalcony*. December 26, 2013.
Morgenstern, Joe. *Wall Street Journal*. December 26, 2013.
Nicholson, Amy. *L.A. Weekly*. December 24, 2013.
Orndorf, Brian. *Blu-ray.com*. December 24, 2013.
Scott, A. O. *New York Times*. December 24, 2013.
Simon, Brent. *Paste Magazine*. December 28, 2013.

QUOTES

Shane Patton: "Anything in life worth doing is worth overdoing. Moderation is for cowards."

TRIVIA

Director Peter Berg had planned to make this film before *Battleship* (2012), but Universal Pictures wanted him to reverse the priorities.

AWARDS

Nominations:

Oscars 2013: Sound, Sound FX Editing
Writers Guild 2013: Adapt. Screenplay

THE LORDS OF SALEM

We've been waiting...we've always been waiting.
 —Movie tagline
The Lords are coming.
 —Movie tagline

Heretic. Witch. Devil.
—Movie tagline

Box Office: $1.2 Million

According to the quote from Philip French of *The Observer UK* that is emblazoned on the back of the DVD box, *The Lords of Salem* is "The Best Movie To Date By Director Rob Zombie." Technically, this may be a true statement because this fifth directorial effort from the former heavy metal icon is indeed his high-water mark behind the camera to date but that actually says more about just how lousy his previous stabs (not to mention slashes and gouges) at the filmmaking medium—*House of 1000 Corpses* (2003), *The Devil's Rejects* (2005), the patently unnecessary remake *Halloween* (2007) and its even-more-unnecessary follow-up *Halloween II* (2009)—than anything else. In other words, this one is just as dreadful, boring and incoherent as his other works. Only in connection with the oeuvre of Rob Zombie could that sentiment be considered progress.

The film, naturally, is set in Salem, Massachusetts, and after a prologue depicting, even more naturally, a coven of witches being burned alive, it shifts to contemporary times and introduces viewers to Heidi (Sherri Moon Zombie), a recovering addict/deejay who co-hosts the radio show *Salem Rocks*. One night, while hosting local historian Francis Matthais (Bruce Davison), Heidi receives a mysterious LP purporting to be from a group called The Lords. The droning tune sounds like someone playing a Kronos Quartet album through a trash compactor but, unbeknownst to her, it appears to have a mesmerizing effect on many of her female listeners.

While the curious Francis begins to investigate where the record came from and what it means, Heidi begins witnessing some strange goings-on, including weird visions of a witch (Meg Foster) inhabiting an apartment in her building that is supposed to be vacant, and soon finds herself hitting the crack pipe once again. However, it becomes apparent that not all of her visions may be chemically-induced and may have something to do with an oddly solicitous trio of women (Dee Wallace, Patricia Quinn and Judy Geeson) in her building and some long-buried secrets from her own murky past. In a twist that will shock positively no one, the coven from the prologue has returned with a vengeance with Heidi being an integral part to their diabolical plans to do whatever it is that they are hoping to achieve.

To give Rob Zombie his due, he does show some improvement as a filmmaker this time around. Having pushed the determinedly scuzzy and super-gruesome aesthetic of his previous films about as far as he possibly could, he has replaced the increasingly reductive southern-fried savagery with a far trippier approach is occasionally quite striking and which will no doubt remind viewers of a certain age of the wild cinematic freakouts that the late Ken Russell used to perpetrate in such cult classics as *The Devils* (1971), *Tommy* (1975), and *Altered States* (1980). Not surprisingly, the soundtrack is appropriately eerie and makes effective use of the Velvet Underground tune "All Tomorrow's Parties." He also deserves some credit for making a film that never seems to be pandering to the lowest common moviegoing denominator. For better or for worse, this is clearly his movie and there is the sense that he does not care if anyone in the audience likes or even understands what he is trying to achieve here.

Zombie's problem, as has been the case with all of his films, is that while he is a stone-cold genre fanatic who can certainly talk a good horror film, he is still clueless as to how to actually put his immense knowledge to any practical use. Once again, he seems incapable of telling even a slightly coherent story and while the hallucinatory approach does make some sense, most viewers will be left scratching their heads as to what is going on at any given point. Once again, he has entrusted his painfully one-note wife with a key dramatic role and once again she fails to make an impression in any scene in which she is not in some stage of undress. Once again, he has filled out the cast with familiar faces no doubt recruited from a local Convention-Con-Expo-Fest-A-Rama—besides those already mentioned, there are also appearances from the likes of Sid Haig, Maria Conchita Alonso, Andrew Prine, Barbara Crampton, and Michael Berryman—but has failed to give them anything of interest to do except flesh out the credit roll.

The biggest outrage comes at what might have been called the ending had it provided any sense of closure or resolution—instead, the film ends so abruptly and with so little explanation as to what has or will happen that it almost feels as if Zombie simply forgot to include the last reel in his final cut and no one noticed until it was too late to do anything about it. Even the now-infamous finale of *The Devil Inside* (2012) offered a more satisfying wrap-up than what Zombie has included here. Perhaps in part because of that half-assed conclusion, the film failed to raise much interest even amongst the pro-Zombie contingent and after its brief and unheralded run, Zombie began publicly hinting that he might be retiring from filmmaking altogether. If that does turn out to be the case, that would mean that for most moviegoers, *The Lords of Salem* will prove to have a happy ending after all.

Peter Sobczynski

CREDITS
Heidi Hawthorne: Sheri Moon Zombie
Herman Jackson: Ken Foree

Herman "Whitey" Salvador: Jeffrey Daniel Phillips

Alice Matthias: Maria Conchita Alonso

Francis Matthias: Bruce Davison

Margaret Moran: Meg Foster

Sonny: Dee Wallace

Origin: United States

Language: English

Released: 2013

Production: Jason Blum, Andy Gould, Oren Peli, Steven Schneider, Rob Zombie; Alliance Films, Automatik Entertainment, Blumhouse Entertainment, Haunted Movies, IM Global; released by Anchor Bay Entertainment Inc.

Directed by: Rob Zombie

Written by: Rob Zombie

Cinematography by: Brandon Trost

Music by: Griffin Boice; John 5

Sound: Dan Snow

Editing: Glenn Garland

Costumes: Leah Butler

Production Design: Jennifer Spence

MPAA rating: R

Running time: 101 minutes

REVIEWS

Buckwalter, Ian. *The Atlantic*. April 19, 2013.

French, Philip. *The Observer (UK)*. April 28, 2013.

Genzlinger, Neil. *The New York Times*. April 18, 2013.

Goss, William. *Film.com*. April 18, 2013.

Hunt, Drew. *Chicago Reader*. April 25, 2013.

Musetto, V. A. *New York Post*. April 19, 2013.

Olsen, Mark. *Los Angeles Times*. April 18, 2013.

Orndorf, Brian. *Blu-ray.com*. April 19, 2013.

Reed, Rex. *New York Observer*. April 17, 2013.

Vaux, Rob. *Mania.com*. April 19, 2013.

QUOTES

Reverend Jonathan Hawthorne: "As I write these very words, the witch, Margaret Morgan, gathers with her coven of six deep within the woods surrounding our beloved Salem. The blasphemous music echoes in my mind, driving me to the point of insanity. I, Jonathan Hawthorne, swear before the eyes of God, on this this day in the year of our Lord 1696, to destroy all persons who choose to pledge allegiance to the demon Satan and his spectral army!"

TRIVIA

Billy Drago is included in all cast listings for this movie despite his leaving the project before shooting began.

LORE

When your life is a lie, who can you trust?
—Movie tagline

Box Office: $970,325

Based on a section of Rachel Sieffert's acclaimed novel, *A Dark Room*, Cate Shortland's *Lore* is an exemplary coming-of-age drama and a surprisingly original and insightful take on WWII-era Germany. Shortland's feature debut, the similarly sensitive and sensuous coming-of-age drama *Somersault* (2004), brought her international attention, and launched the Hollywood careers of stars Abbie Cornish and Sam Worthington. *Lore* should have raised her profile as a prodigiously talented international filmmaker, but, outside Shortland's native Australia, it did not get the kind of attention it deserved on its release.

It is, admittedly, a challenging work. A member of the Hitler Youth and the daughter of an SS officer, teen-aged Lore (Saskia Rosendahl) is entitled and obliviously confident in her worldview. She is a thoroughly indoctrinated daughter of the Third Reich, and not an easy character with which to empathize, even as her beloved Fuhrer dies and her world shatters around her. Her absentee father (Hans-Jochen Wagner) returns to their palatial home long enough to shoot the family dog and bring Lore, her Mutti (Ursina Lardi, who played the equally troubled and unnamed Baroness in Michael Haneke's *The White Ribbon* [2009]) and his other four children to a farm in the country. There, perhaps for their own safety, perhaps because Mutti can no longer stand to be with him, he abandons them again.

Things get worse from there. Mutti struggles to feed the family, and is assaulted on a nighttime visit into town. Fearing that the Allied authorities will track her down, she also abandons her children, leaving Lore with little money and a few pieces of jewelry. The teen has to care for her siblings, and, when it is clear that they are no longer welcome at the farm, she is charged with getting them all safely to their grandmother's house across the country outside Hamburg. Together with sister Liesel (Nele Trebs), little brothers Gunter (Andre Frid) and Jurgen (Mika Seidel), and would-be nursing baby Peter (Nick Leander Holashke), and a boatload of misconceptions about the world and her place in it, Lore heads out on the treacherous trip through occupied Germany, from Bavaria to Hamburg. On the journey, they find starvation and brutality, and evidence of their beloved regime's atrocities.

Strangers offer varying degrees of compassion, but most are understandably concerned with their own survival. In a barn, Lore finds the bloodied body of a girl who has evidently been raped and murdered. Looking for Gunter in a nearby farmhouse, she finds a young man asleep on the floor. Lore is justifiably suspicious of him, and the children keep running into him as they make their way north. Eventually, they are stopped by American soldiers and asked to show papers. The young man steps forward to help them, revealing himself as

Thomas (Kai Malina), a Jew, and a survivor of Auschwitz. Lore is far from grateful for his aid. Taught to believe that Jews are parasites, she suspects Thomas's motives, and while he helps her family get food and avoid capture, she continues to display contempt for him.

Lore's evolving relationship with Thomas is the emotional and moral crux of the film. To Shortland's credit, she allows him to remain a mysterious and ambiguous figure. Unlike Lore, Thomas is prepared to do whatever is necessary to survive, and his motives for helping her family are never completely spelled out. While it becomes clear he means no harm to the smaller children, his interest in Lore, with her budding sexuality, has potentially threatening overtones. Malina's quiet, haunted portrayal is a perfect counterpoint to Rosendahl's more volatile turn.

Shortland's style is elliptical, quiet, observant, and very deliberate. She focuses as much on the atmosphere as on the characters themselves, which frequently—as when ashes begin to drift from the sky as Lore and Liesel play in the woods outside the farm—lend the film its own dark poetry. Images take precedence over dialogue. Her approach was similar in *Somersault*, but here, the stakes are much higher. Cinematographer Adam Arkapaw also shot Jane Campion's brilliant *Top of the Lake* (2013), and his work here is gorgeous. It is not a matter of aestheticizing misery and brutality. The visuals are tactile, putting viewers right there with Lore and her younger siblings, letting them experience the sights and sounds as they make the long, perilous journey through field and forest, travelling across Germany, hoping to find comfort and safety.

Lore is hardly lovable, but thanks to Rosendahl's layered and ultimately heartbreaking performance, she is believable in her adolescent petulance. The other children behave believably, too, even when it is no longer reasonable for them to behave like children. Shortland's film is admirably complex and remarkably restrained. Lore's re-education occurs very slowly, but by the end of the film, the audience can appreciate the painful journey she has been through.

Josh Ralske

CREDITS

Lore: Saskia Rosendahl
Liesel: Nele Trebs
Gunther: Andre Frid
Jurgen: Mika Seidel
Thomas: Kai-Peter Malina
Origin: Germany

Language: German
Released: 2013
Production: Liz Watts, Paul Welsh; Porchlight Films Prod.; released by Music Box Films
Directed by: Cate Shortland
Written by: Cate Shortland; Robin Mukherjee
Cinematography by: Adam Arkapaw
Music by: Max Richter
Sound: Sam Petty
Editing: Veronika Jenet
Costumes: Stefanie Bieker
Production Design: Silke Fischer
MPAA rating: Unrated
Running time: 109 minutes

REVIEWS

Bell, Josh. *Las Vegas Weekly*. April 18, 2013.
Covert, Colin. *Minneapolis Star Tribune*. March 14, 2013.
Denerstein, Robert. *Movie Habit*. March 24, 2013.
Groen, Rick. *Globe and Mail*. May 31, 2013.
Johanson, MaryAnn. *Flick Filosopher*. March 14, 2013.
Jones, J. R. *Chicago Reader*. March 8, 2013.
Kisonak, Rick. *Film Threat*. May 1, 2013.
Long, Tom. *Detroit News*. March 8, 2013.
Means, Sean. *Salt Lake Tribune*. March 22, 2013.
Moore, Roger. *Movie Nation*. March 15, 2013.

TRIVIA

The photographs in the wallet that Lore looks at are pictures of director Cate Shortland's husband's family.

LOVE IS ALL YOU NEED
(Den skaldede frisor)

Box Office: $1.6 Million

Watching *Love Is All You Need,* an attractively captured tale of mid-life romantic wish fulfillment, one has to figure that Diane Lane will at some point catch the film on cable TV and strongly consider firing off a miffed email to her agent, asking why was it again that they were not able to get her a meeting on this cultural bonbon. After all, the film has both an exotic setting (Italy) and the heartstring-tugging interpersonal setbacks (cancer, a husband's infidelity, etc.) that have marked solid, commercially well-received signposts in Lane's career, not to mention the sort of perfectly bland title that lends itself to mistaken lonely-hearts rentals (its original, translated Danish title is the considerably less sexy *The Bald Hairdresser*).

Directed by Oscar-winning filmmaker Susanne Bier, from a story conceived with screenwriter and frequent collaborator Anders Thomas Jensen, this languorously paced adult love story feels something like an overly work-shopped distillation of the comedies of writer-director Richard Curtis, drained of their effortless effervescence and replaced with lemons and a sugar substitute. It is not that *Love Is All You Need*—which was picked up for distribution by Sony Pictures Classics after its out-of-competition premiere at the 2012 Venice Film Festival, and pulled in $1.6 million during an early summer counterprogramming theatrical release—is bad, per se. The kind of movie where people stand pensively on adjacent balconies during magic hour but do not see each other, Bier's film has all kinds of pleasure around the edges. It never stops flirting with winning one over. Its winsomeness is compromised by degrees, however, by its demonstrativeness and overindulgence of supporting characters.

The story centers around Ida Hjort (Trine Dyrholm), a Danish hairdresser who, in the middle of a shaky breast cancer treatment and spotty recovery, discovers that her longtime husband Leif (Kim Bodnia) has been having an ongoing affair with his secretary. Meanwhile, their daughter Astrid (Milly Blixt Egelind) is set to marry Patrick (Sebastian Jessen), at a destination wedding at a sprawling palazzo in Sorrento, Italy. Not wanting to disrupt Astrid's special time, a distraught Ida makes plans to travel to Italy separately; en route she bumps into (quite literally, in an airport parking garage fender bender) Patrick's widowed father Philip (Pierce Brosnan), a supercilious, grumpy workaholic. When Leif shows up at the wedding with his mistress Tilde (Christiane Schaumburg-Muller), Ida is aghast, but resolves to put on a brave face. In Philip, she finds an unlikely shoulder upon which to lean, especially when it seems her cancer might be returning.

If its central premise and the aforementioned meet-cute suggest something fluffy, *Love Is All You Need* remains committed to juggling the saccharine and the serious throughout—sometimes too much so, to the point where scenes that abut one another feel like different takes from alternate tragic and comedic versions of the same story. The film unfolds in a more or less naturalistic style, but when it suits the narrative various characters seem utterly clueless as to how their behaviors might be seen or interpreted by others. This elicits a lot of bewilderment and frustration.

Leif is sketched broadly, as a total oaf ("I've lost eight pounds over this!" he self-centeredly wails), and Tilde is similarly unsympathetic in a role that could bring the movie a lot more tension and/or comedic payoff if only it were better sketched out. Patrick's aunt Benedikte (Paprika Steen), the sister of Philip's dead wife, fares better, perhaps owing to Steen's keen ability to locate the desperate, hormonally-charged loneliness in her character—a quality which unnerves Philip, and finally pushes him over the edge. But *Love Is All You Need* is otherwise peppered with all sorts of weird, slightly off-center supporting players—like Astrid's soldier brother, Kenneth (Micky Skeel Hansen), and Benedikte's bulimic daughter, Alexandra (Frederikke Thomassen)—who pop up intermittently and hijack the narrative in frustrating ways. Bier's film is best when focusing on Ida and Philip and, to a slightly lesser extent, Astrid and Patrick.

Love Is All You Need is probably the most amiable movie of Bier's filmography (she uses the song "That's Amore" as a leitmotif, deploying multiple versions of it across the soundtrack), and certainly the most visually inviting. Shot on location along the Amalfi Coast, its colors absolutely pop, from azure oceans and fertile outdoor greens to its perrywinkle-hued interior walls and the sienna-shingled rooftops of neighboring homes. Even familiar arguments are enlivened by cinematographer Morten Soborg's creative staging and framings.

Brosnan is a talented actor with a history of more wide-ranging appetites than one might suspect of an erstwhile James Bond. Still, his specialty is unflappability and a certain patrician demeanor, which he has put to good use in films like *The Thomas Crown Affair* (1999), *The Tailor of Panama* (2001), *After the Sunset* (2004), *The Ghost Writer* (2010), and more. Some of the movies in which he has most stretched himself, films like *Mamma Mia!* (2008) or *Salvation Boulevard* (2011), have had flashes of outlandish inspiration followed by the lingering sense of an artist slightly out of his depth. Ergo, while Brosnan captures the put-upon irritation of his character with great effect, and brings considerable sensitivity to *Love Is All You Need* (Brosnan lost a spouse to cancer in real life), the movie's late, grand-gesture emotional pivots remain a bit beyond his grasp.

Dyrholm, however, is a fresh and riveting presence, and *Love Is All You Need* connects most fruitfully as an adorned chariot for her. Dyrholm is not well known to American audiences, which is certainly a benefit. But she also captures Ida's vulnerabilities in full-hearted fashion without ever coming across as pitiable.

Overall, however, the film's tonal inconsistencies and prolonged running time prevent it from connecting outside of the demographic intersection of the NPR and AARP sets. The best of these types of movies capture life's bittersweet symphonies—the sheer absurdities which often lace and ring personal humiliations and setbacks. Bier's vision for *Love Is All You Need* possesses

both dark clouds and silver linings, but they too often feel arbitrary and at odds.

<div style="text-align:right">***Brent Simon***</div>

CREDITS

Ida: Trine Dyrholm
Philip: Pierce Brosnan
Patrick: Sebastian Jessen
Astrid: Molly Blixt Egelind
Leif: Kim Bodnia
Benedikte: Paprika Steen
Thilde: Christiane Schaumburg-Muller
Origin: Denmark, Sweden, Italy, France, Germany
Language: English, Danish, Italian
Released: 2013
Production: Sisse Graum Jorgensen, Vibeke Windelov; Zentropa Prods.; released by Sony Pictures Classics
Directed by: Suzanne (Susanne) Bier
Written by: Anders Thomas Jensen
Cinematography by: Morten Soborg
Music by: Johan Soderqvist
Sound: Lars Peter Rasmussen
Music Supervisor: Susan Jacobs
Editing: Morten Egholm
Art Direction: Tamara Marini
Costumes: Signe Sejlund
Production Design: Peter Grant
MPAA rating: R
Running time: 116 minutes

REVIEWS

Ehrlich, David. *Film.com.* May 1, 2013.
Ellingson, Annlee. *Paste Magazine.* May 4, 2013.
Felperin, Leslie. *Variety.* September 2, 2012.
Holden, Stephen. *New York Times.* May 2, 2013.
Kennedy, Lisa. *Denver Post.* May 24, 2013.
LaSalle, Mick. *San Francisco Chronicle.* June 6, 2013.
Mohan, Marc. *The Oregonian.* May 23, 2013.
Puig, Claudia. *USA Today.* May 2, 2013.
Sharkey, Betsy. *Los Angeles Times.* May 2, 2013.
Taylor, Ella. *NPR.* May 2, 2013.

TRIVIA

The original title of the film translates to "The Bald Hairdresser."

LOVELACE

X marks the legend.
—Movie tagline

The truth goes deeper than you think.
—Movie tagline

Box Office: $356,582

One's admiration of what *Lovelace* sets out to do is entirely dependent on whether or not one accepts and embraces the film's structure. Ultimately, Andy Bellin's screenplay boils down to a single transition at the film's halfway point. On one side of the shift is the eponymous character at what appears to be the zenith of her professional life, and on the other side, following the first of two title cards denoting a six-year jump, is the same woman but almost unrecognizable from how she appeared a few seconds prior to the leap. The film opens with a jumble of voices explaining who this woman is in the context of her most famous work, with the final voice asking, "Who's the real Linda Lovelace?" The start of the second half of the story echoes the beginning, with someone asking, "Is your name Linda Lovelace?"

In that question and in Linda's (Amanda Seyfried) uncertain response, everything the audience has been told and has seen comes into doubt. What is somewhat daring about the film is that both sides of the tale are true. It is all a matter of perspective, and directors Rob Epstein and Jeffrey Friedman give equal weight to those differing viewpoints, leaving it to the audience to come to the only moral conclusion that is possible to take away from the film.

The story opens in the year 1970 in a suburban town in Florida, where Linda Boreman has recently moved from Yonkers with her mother Dorothy (Sharon Stone), a domineering and judgmental woman with strong religious convictions, and father John (Robert Patrick), who has been so overpowered by the stronger half in his marriage that he comes across as a piece of decoration in the living room. Linda is naive and inexperienced in the ways of the world, even though she has already given birth to a child, whom her mother secretly put up for adoption. She—as she puts it—learned her lesson from "that one time," and even when her best friend Patsy (Juno Temple) convinces the owner of a roller rink to allow the two young women to dance on the stage where the band is performing, Linda does so with no small amount of trepidation.

Her life changes when she meets Chuck Traynor (Peter Sarsgaard), a charmer who runs a bar and restaurant. At least that is what he wants others to see of him. In reality, he is a manipulative man who owns a strip club, convinces Linda that he can be her salvation from her troubled home life, and eventually gets in trouble with the authorities when it is discovered that there is prostitution happening at his establishment. "He" does not owe money as punishment for the transgressions of which he claims to have no knowledge;

"they"—Linda and Chuck together as a married couple—do. Sarsgaard's performance keeps the character's despicable nature, which could easily be portrayed to excess, firmly in the realm of a dangerously pathetic man.

Chuck's plan is to use Linda's talent for fellatio—an act in which he trains her—as a means for her to become an actress in pornographic movies. The film goes behind the scenes on the production of the 1972 porno *Deep Throat*, which became a staple of popular culture—a crossover hit that the film states grossed over $600 million.

The scenes of the making of that movie are comic, with the movie's director Gerry Damiano (Hank Azaria) bragging about the 42-page script and Linda's co-stars spouting terrible puns. There is the sense of a community of comically self-aggrandizing outcasts—people who truly believe they are making art or will become famous outside of the pornography industry. It is disarmingly cheerful, and when the movie becomes a runaway success, there is an glowing glamour to the results, culminating in a private screening held by Hugh Hefner (James Franco) and Linda taking a bow for her adoring fans.

Almost immediately after the central transition, in which Linda is participating in a polygraph test to assure a publisher that the contents of a book she has written about Chuck are factual, the film reveals the far more violent, abusive, and dehumanizing relationship Linda had with Chuck during the period of filming *Deep Throat*. Everything from the tone to Eric Edwards cinematography (from a sunny to a grayer color palette) changes, and incidents that once seemed amusing become alarming as Bellin fills in the blanks in the first telling of the story.

Even with those key details revealed, *Lovelace* still has plenty of gaps to the story of its subject's life (most notably, the information about Linda's advocacy against pornography and domestic abuse do not appear until the film's coda) and the period when pornography gained a level of cultural legitimacy. This, though, is not a traditional biography. It is instead a dissection of the truth behind a famous—or infamous—person's public persona and what it has popularly become assumed to represent, and with its implementation of narrative deception that essentially implicates the audience in Linda's torment, the film gets across its point well enough.

Mark Dujsik

CREDITS

Linda Lovelace: Amanda Seyfried
Chuck Traynor: Peter Sarsgaard
Dorothy Boreman: Sharon Stone
John Boreman: Robert Patrick
Gerry Damiano: Hank Azaria
Anthony Romano: Chris Noth
Butchie Peraino: Bobby Cannavale
Harry Reems: Adam Brody
Patsy: Juno Temple
Hugh Hefner: James Franco
Nat Laurendi: Eric Roberts
Origin: United States
Language: English
Released: 2013
Production: Jim Young; released by Radius-TWC
Directed by: Robert Epstein; Jeffrey Friedman
Written by: Andy Bellin
Cinematography by: Eric Alan Edwards
Music by: Stephen Trask
Sound: Steve Morrow
Music Supervisor: Selena Arizanovic
Editing: Robert Dalva; Matt(hew) Landon
Art Direction: Gary Myers
Costumes: Karyn Wagner
Production Design: William Arnold
MPAA rating: R
Running time: 93 minutes

REVIEWS

Anderson, John. *Wall Street Journal*. August 8, 2013.
Berardinelli, James. *ReelViews*. August 11, 2013.
Dargis, Manohla. *New York Times*. August 8, 2013.
Denby, David. *New Yorker*. August 26, 2013.
Goodykoontz, Bill. *Arizona Republic*. August 8, 2013.
Kenigsberg, Ben. *A.V. Club*. August 8, 2013.
LaSalle, Mick. *San Francisco Chronicle*. August 9, 2013.
Phillips, Michael. *Chicago Tribune*. August 8, 2013.
Rabin, Nathan. *The Dissolve*. August 8, 2013.
Weber, Bill. *Slant Magazine*. July 26, 2013.

QUOTES

Chuck: "Fifty, maybe a hundred thousand."

Linda: "To do another f**k film?"

Chuck: "No, Linda, it's Shakespeare. I told them you do a great English accent, particularly with a c**k down your throat."

TRIVIA

Olivia Wilde was considered for the lead role at one time, but she declined the role due to scheduling conflicts.

M

MACHETE KILLS

Trained to kill. Left for dead. Back for more.
　—Movie tagline

Box Office: $8 Million

Someday, someone will write the definitive history of the new grindhouse experience in American cinema and no doubt *Machete* (2010) and *Machete Kills* will get a substantial amount of consideration. Like so much of Robert Rodriguez's work, his *Machete* franchise is based on the simple idea that people should have nothing more than fun when they go to the movies as long as that fun includes the ability to absorb a high body count. *Machete Kills* is more "fun" than most of the movies that Rodriguez has turned out in the last few years, taking the exploitation premise of the first film into truly gonzo territory. Time might not be kind to the *Machete* franchise if it continues but this leaves the series on a high note.

While attempting to thwart some crooked arms dealers in the US military, Machete Cortez (Danny Trejo) and Sartana Rivera (Jessica Alba) find themselves ambushed by even meaner thugs led by a mysterious, masked man who kills Rivera and leaves Machete to the not-so-tender mercies of corrupt lawman Sheriff Doakes (William Sadler). But before Doakes can act as judge, jury, and executioner, he gets a call from The President of the United States (Charlie Sheen, billed here as Carlos Estevez), who orders Machete brought to Washington. It seems that a rogue (and very crazy) Mexican citizen, Marcos Mendez (Demian Bichir), is threatening Washington with nuclear annihilation unless they do something about the corrupt Mexican govern-

ment and the drug lords. Accepting the offer of a free pass on his record and US citizenship, Machete embarks on his mission to save the free world.

Things become so convoluted from this point on that it is more or less pointless to attempt to reconstruct the plot. Viewers are taken on a journey that includes cloned martial arts artists, Lady Gaga, Antonio Banderas, and Cuba Gooding Jr. sharing the role of La Camaleon and points of homage to everything from James Bond to *Dr. Strangelove* (1964). The script is all over the place and ridden with cliches some of which are exploited to better effect than others. Most fun are many weird and eccentric characters followed by the endless amount of cleverly staged gore and death. Machete more than lives up to his name and barely ten minutes goes by in the film that fails to conclude in some otherwise unnecessary bit of hyper violent schtick.

For instance, Sofia Vergara plays Madame Desdemona, owner of a brothel that employs beautiful-but-deadly assassins. When Machete kidnaps one of her girls in search of Mendez, Desdemona dons her double-barreled bra, wreaking ammo-havoc on man and machine alike as she screams "Machete!" A breakout performance comes from Chilean stuntman and actor Marko Zaror, who plays Mendez's lead henchman. Zaror first came to notice in the States via his self-financed efforts *Kiltro* (2006) and *Mandrill* (2009), which he used to showcase his amazing fighting abilities. Since then he has appeared to great effect in actioners like *Mirage Man* (2007) and *Undisputed 3: Redemption* (2010). His incredibly fast foot work and imposing physicality makes him a joy to watch here, especially as the script gives

him the advantage of several fight scenes and death scenes since he plays a clone of himself.

Sadly, the only performance that is really lacking is Trejo's. He has a face for the ages but forced to carry the weight of a full film he comes across as too wooden, as if unsure of what to do with himself much of the time. The rest of the cast rounds out predictably. Mel Gibson is suitably nutty as arch villain Voz. A miscast but fun Sheen clearly enjoys playing the President.

The special effects are a bit of a letdown as well. Yes, the film is supposed to look and feel like a cheap exploiter but it looks and feels like some weird modern version of one, creating a digital splatter aesthetic that just fails to be visually compelling. People go back and watch those movies because they capture a feel. This film feels like it wants to cop one. In other words, *Machete Kills* fails to be visceral enough, demanding more from its audience than it is willing to give. It is cinematic proof that you can throw on all the film scratches you want to in post without making your film feel authentically part of anything.

Rodriguez starts his film out with a trailer for a *Machete* film in outer space. The only problem is that *Machete Kills Again...in Space* actually looks to be a better (or certainly more coherent) movie than what follows for the rest of *Machete Kills*' 107-minute runtime. But it should be said that for a film that cares so little for its own internal logic *Machete Kills* is hellbent on showing viewers every cheap trick in the book in order to keep them entertained.

Dave Canfield

CREDITS

Machete: Danny Trejo
Voz: Mel Gibson
Mendez: Demian Bichir
Luz: Michelle Rodriguez
Mr. President: Charlie Sheen
Desdemona: Sofia Vergara
Killjoy: Alexa Vega
Cereza: Vanessa Anne Hudgens
Miss San Antonio: Amber Heard
La Camaleon: Lady Gaga
El Camaleon 2: Cuba Gooding, Jr.
El Camaleon 3: Walton Goggins
Sheriff Doakes: William Sadler
El Camaleon 4: Antonio Banderas
Sartana: Jessica Alba
Origin: United States
Language: English

Released: 2013
Production: Aaron Kaufman, Rick Schwartz, Robert Rodriguez; Overnight Films; released by Open Road Films
Directed by: Robert Rodriguez
Written by: Kyle Ward
Cinematography by: Robert Rodriguez
Music by: Robert Rodriguez
Sound: Tim Rakoczy
Music Supervisor: Robert Rodriguez
Editing: Robert Rodriguez
Costumes: Nina Proctor
Production Design: Steve Joyner
MPAA rating: R
Running time: 107 minutes

REVIEWS

Buckwalter, Ian. *NPR.* October 10, 2013.
Cabin, Chris. *Slant Magazine.* October 4, 2013.
Fine, Marshall. *Hollywood & Fine.* October 9, 2013.
Goss, William. *Film.com.* September 23, 2013.
Guzman, Rafer. *Newsday.* October 10, 2013.
Johanson, MaryAnn. *Flick Filosopher.* October 6, 2013.
Kermode, Mark. *Observer [UK].* October 14, 2013.
Loder, Kurt. *Reason Online.* October 11, 2013.
Rothkopf, Joshua. *Time Out New York.* October 8, 2013.
Russo, Tom. *Boston Globe.* October 10, 2013.

QUOTES

Machete: "Machete don't tweet."

TRIVIA

This is the first film of Charlie Sheen's career in which he is credited under his real name, Carlos Estevez.

AWARDS

Nominations:
Golden Raspberries 2013: Worst Support. Actress (Gaga)

MAMA

A mother's love is forever.
—Movie tagline

Box Office: $71.6 Million

Mama, an impressive feature debut from writer/director Andres Muschietti and co-writer/producer Barbara Muschietti (who happen to be brother and sister), is, first and foremost, a film of visual power. In fact, *Mama*'s visuals are so impressive that it becomes easy to imagine it as a recently discovered silent film for

which sound has been added in post. Ethereal, unsettling, and not unlike a fairytale, the spectral motion of the film will lead most viewers to excuse minor logic lapses in the writing. Even with its minor flaws in place *Mama* will hold up on repeat viewings for fans of the macabre, and marks the Muschiettis as a filmmaking team to watch.

Two young sisters are kidnapped by their mentally unstable father Lucas (Nikolaj Coster-Waldau) during a murder suicide spree, and end up at an old abandoned cabin in the woods. Before the desperate man can act, the girls find a protector in the titular character of Mama, a ghost who, for reasons unknown, adopts them, keeping them close by and hidden. Years later, discovered by a pair of searchers hired by Jeffrey, (also Coster-Waldau), their father's twin brother, the now-feral sisters exit the woods to quickly bond with their uncle who seeks custody much to the displeasure of Jean (Jane Moffat), a relative who is convinced she should be the one raising them.

The court grants Lucas and his punk rock girlfriend Annabel (Jessica Chastain) custody on the condition that they move into a house used by Dreyfuss (Daniel Kash), the girl's psychiatrist. Dreyfuss clearly has his own agenda, seeing in the girls a once in a lifetime opportunity to further his own career. Complicating matters is the insecurity of Annabel who, even though she wants to support Jeffrey, is anything but sure she wants to be an instant mother. An uneasy family unit forms, occasionally interrupted by court-ordered visitations from the possessive Jean and Dreyfuss whose therapy sessions leave the girls aggressive and disturbed.

As the girls adapt it soon becomes clear that Mama has followed them from the woods and is growing more desperate in her attempts to hang onto them as the pair's devotion threatens to shift to their new family. Ghostly visitations and play dates escalate into an ever-more-aggressive intrusion into the adult world as Annabel tries vainly to convince Jeffrey something is in the house with them. The more maternal Annabel becomes the more dangerous Mama becomes and the more conflicted the two siblings become. Meanwhile, Dr. Dreyfuss has been secretly researching the origins of Mama, suspecting that she is more than just a psychological manifestation and Jean has stepped up her efforts to wrest the girl's away. When Mama's true origins are revealed a series of deadly confrontations ensue, and Annabel and the girls, are forced to choose what they want.

The predictably excellent Jessica Chastain and Nikolaj Coster-Waldau are somewhat hampered by the fact that their roles are fairly limited and predictably arced. Jeffrey becomes largely irrelevant once the girls are found and placed in the home and the somewhat self-centered

Annabel's embracing of motherhood seems de facto point of having her serve as a foil for Mama's wrath. Yet together, Mama and Anabell, do serve to provide a sense of motherhood as a whole: Fierce, determined, almost obsessive, yet simultaneously self-sacrificial.

The two leads are largely outshone by Isabelle Nelisse as Lilly and Megan Charpentier as the older Victoria who are required to slowly recover from their feral nature into a pair of increasingly conflicted and terrorized youngsters. Both straddle the line between those two worlds very convincingly. Such complex stuff is also handled well both in the writing and the direction which allows the girls a special bond that only two siblings who have an awful secret can share.

Mama herself is portrayed physically by Javier Botet, whose striking physicality has served films like *REC* (2007) and *The Last Circus* (2010) so well. Vocal duties are picked up (in a surprising turn) by Jane Moffat. The character is a perfect blend of motion capture, CGI elements and overall design inspired by Amadeo Modigliani's unsettling portraiture. A general rule with movie monsters is that less is often more. But the character of Mama is a ghoulish masterpiece commanding the screen whenever she appears and even managing to elicit a stilted sympathy by the film's final moments that offer a grace note of hope to all the primary participants of the story without seeming maudlin.

An eye for new talent is one of many things that has made Guillermo del Toro almost as important a producer as a director. *The Orphanage* (2007), *Splice* (2009), *Julia's Eyes* (2010), *While She Was Out* (2008), and *Don't Be Afraid of the Dark* (2011) are all eminently enjoyable genre movies. Impressed by the Muschietti's original short film *Mama* (2008), del Toro made himself Executive Producer here and his touch in some of the visual flourishes is unmistakable.

The film loses some momentum near the end. A sudden, too-convenient meeting on a dark forest road feels like a deus ex machina moment. The secret of Mama herself is never all that secret. But pointing out these flaws almost seems like nitpicking. This is a robust effort full of dark magic that stands tall indeed above other "mother as ghost" films such as *The Woman In Black* (2012) and director Frank LaLoggia's underrated *The Woman in White* (1988), offering ripe tragedy and melancholy that allows characters to grow and develop far beyond what many genre efforts even aim for.

Dave Canfield

CREDITS

Annabel: Jessica Chastain
Lucas: Nikolaj Coster-Waldau

Victoria: Megan Charpentier

Lilly: Isabelle Nelisse

Dr. Dreyfuss: Daniel Kash

Mama: Javier Botet

Jean Podolski: Jane Moffat

Origin: United States

Language: English

Released: 2013

Production: Barbara Muschietti; Toma 78; released by Universal Pictures Inc.

Directed by: Andres Muschietti

Written by: Andres Muschietti; Neil Cross; Barbara Muschietti

Cinematography by: Antonio Riestra

Music by: Fernando Velazquez

Sound: Gabriel Gutierrez

Editing: Michele Conroy

Costumes: Luis Sequeira

Production Design: Anastasia Masaro

MPAA rating: PG-13

Running time: 100 minutes

REVIEWS

Borders, Meredith. *Badass Digest.* April 3, 2013.

Donato, Matt. *We Got This Covered.* January 17, 2013.

Hunt, Drew. *Chicago Reader.* January 25, 2013.

Lasalle, Mick. *San Francisco Chronicle.* January 17, 2013.

Loder, Kurt. *Reason Online.* January 18, 2013.

Morgenstern, Joe. *Wall Street Journal.* January 17, 2013.

Thompson, Luke Y. *Topless Robot.* January 18, 2013.

Tookey, Christopher. *Daily Mail [UK].* February 22, 2013.

Uhlich, Keith. *Time Out New York.* January 15, 2013.

Verniere, James. *Boston Herald.* January 18, 2013.

QUOTES

Victoria: "Daddy, look! there's a woman outside the window. And she's not touching the floor."

MAN OF STEEL

Box Office: $281 Million

Back in 1938, the first issue of "Action Comics" gave the world a first real visual connection to someone who could have otherworldly powers and still look human. The notion that a mild-mannered, seemingly ineffectual individual could be hiding great powers beyond all reason opens up the doors for endless possibilities in terms of storyline, conflict and character development. The dual personality, both of which represent some from of "good" in the world, has been the basis of many stories of superheroes and their inner conflicts of being who they are, the powers they carry and the responsibilities that come with them. Superman, the simplest and most iconic in all of Americana, represents so many different ideals, values, and complexities of character to so many different people that it remains a daunting task to try and make a two-and-a-half hour movie something for everybody.

Superman has already been portrayed quite faithfully as the superhero whom everyone can trust, who fights for "truth, justice, and the American way" and who is not above rescuing a cat out of a tree. With Christopher Reeve in the title role in four films (only the first two are highly revered), *Superman* (1978) was the first to successfully depict a man flying in a realistic manner and it did so in a way that became almost poetic. The film (as well as *Superman II* [1981]) would become the standard against which most other superhero movies would be judged. Since then, however, superhero movies have become so ingrained into the culture that there have been more than anyone can count even in a single given year. They have also become darker, more complex, and certainly more technically advanced.

A big part of the success in the last decade has to do with the release of the first *Spider-Man* (2002), but also with Christopher Nolan's *Dark Knight* trilogy, from which *Man of Steel* takes its cue. Nolan took on Batman as a psychological study, a fable with overtones of a contemporary reality. The characters and their transformations were grounded in realism and intelligence not often seen on movie screens. Nolan, serving as one of the producers of *Man of Steel*, assembled a crew to help bring the same kind of realism to the story of Superman.

Just as it did in 1978, this film opens on Krypton. Instead of the elegant design of the ice planet, director Zack Snyder employs a more dreadful and somewhat plain looking planet that seems interchangeable with anything else seen on the Sy-Fy Channel. Of course, the planet is in ruins and in the midst of a civil war of sorts with the sinister General Zod (Michael Shannon) trying to stage a coup against the council and who is eventually sent to a permanent exile (along with his army) for treason. During this time, Jor-El (Russell Crowe) and his wife Lara (Ayelet Zurer) have conceived the first natural birth on Krypton in centuries. As the planet moves further and further toward annihilation, Jor-El sends their baby, Kal-El, to Earth, carrying with him the last remnants of the planet Krypton.

In one of the most jarring jump cuts in film history, the film shifts awkwardly to present-day Clark Kent (Henry Cavill) rescuing workers from a toxic fire on an oil rig, using his own superhuman strength to save them. Clark appears in much the same way Christian Bale did in the first act of *Batman Begins* (2005), dark and brood-

ing and, of course, with a beard. Not yet a mild-mannered reporter and certainly not yet a superhero in a red cape and blue tights, Clark drifts from place to place, stealing new clothes along the way, careful not to make a spectacle of himself. Flashbacks reveal that Clark had been found by two farmers, Martha (Diane Lane) and Jonathan Kent (Kevin Costner). Jonathan insisted to Clark as a boy that he would be perceived as something the people of Earth would not be ready for if he let his powers become too well-known. The space pod they found him in currently resides beneath their barn so as not to arouse suspicion from prying eyes.

Clark eventually winds up in Canada where an ambitious reporter Lois Lane (Amy Adams) tries to uncover and gather explanations for a large unidentifiable ship that has been submerged in ice. Clark makes his way into the ship and rescues Lois from a strange phantom that would have killed her. With Lois out of the ship, it flies away and Clark learns of his origin and identity from the ghostly image of his father, Jor-El. He, of course, learns that he was sent to Earth for a good reason, to help save the good people of the planet from peril whenever possible. Clark returns to Earth with a new sense of purpose, a new Superman suit and, of course, a nice shave.

Meanwhile, Lois has been trying to find Clark Kent to get more answers from him since he was the primary witness to the event that she has been forbidden to write about by her editor, Perry White (Laurence Fishburne). Also, unbeknownst to Clark, General Zod and his army have broken free from their exile and have made their way to Earth with the intent of taking it over and creating a new Krypton. But only the son of Jor-El can make that happen and right now, Clark Kent/Superman must wrestle with the inner conflict of whom he can trust more, Earthlings of Kryptonians?

Of course, it all builds up to a major showdown between Zod and Superman and the proceedings have a dead-seriousness in their presentation that worked for Nolan's *Dark Knight* films, but fails in execution here. The notion of Superman as a dark and tormented soul feels redundant and gives the film a joylessness that stands in stark contrast to Richard Donner and Richard Lester's films. The approach and the desire to not repeat the formula of the original films seems admirable, but the formula that Snyder and screenwriter David Goyer came up with bogs down what could have a been a fun and engaging ride. Instead, *Man of Steel* collapses under its own weight, but does so without exploring many of the themes of identity, destiny, and even faith (the amount of Christ imagery here almost exceeds that of *Superman Returns* [2006], which is quite an accomplishment).

Snyder has made one successful "superhero" movie before with *Watchmen* (2009), a multi-character piece that had strong stylistic choices and characters worth knowing. *Man of Steel* has little in the way of memorable personalities. Cavill comes off as a bit of a stiff as Clark Kent/Superman and Amy Adams is given nothing to do as Lois Lane. The chemistry between her and Cavill is virtually non-existent. As General Zod, Michael Shannon looks like he is having an okay time, but an actor of his stature and capabilities should have something more to be given than just being menacing. And the presence of Russell Crowe establishes (as it often does) that nothing fun or funny will happen during this film.

The visual palette of this film seems to inform the same experience. Although it comes from a big studio and has been given an almost unlimited budget, *Man of Steel* has the look of one of those b-grade sci-fi films that Lionsgate likes to release in January or September. It looks dark, grainy, and devoid of all life. Furthermore, the showdown in the third act finds many skyscrapers and buildings tumbling down to the ground as Superman and Zod battle it out with countless citizens of Metropolis dying in their wake. Many critics were understandably quick to compare the imagery to the horrors of 9/11. But Goyer and Snyder let the battle continue there. The Superman character that has been established in this film and all the films before it would have seen him fly away and take the battle away from the citizens and to a more remote location. Snyder, the auteur of the dimwitted and almost equally violent *Sucker Punch* (2011), apparently does not agree.

Man of Steel broke the box office records for June in its opening weekend, but its sequel had been given the greenlight from Warner Bros. long before the film opened. With Nolan no longer producing and directing Batman films anymore, Superman seems like the next logical tentpole release cash cow for the studio. The overall reaction from the critics and the public was mixed. The film does have many scenes that work, such as the scenes with Costner raising Clark to control his powers. Hans Zimmer's wonderful score will also be good to hear again in the coming films. And Nolan's tendency to stray far from formula will always be to this franchise's advantage. He should consider leaving the material in more capable hands and maybe consider reading just one issue of "Action Comics." Just for fun.

Collin Souter

CREDITS

Clark Kent/Superman: Henry Cavill
General Zod: Michael Shannon
Jonathan Kent: Kevin Costner

Jor-El: Russell Crowe
Lois Lane: Amy Adams
Martha Kent: Diane Lane
Perry White: Laurence Fishburne
Lara Lor-Van: Ayelet Zurer
Gen. Swanwick: Harry J. Lennix
Col. Nathan Hardy: Christopher Meloni
Dr. Emil Hamilton: Richard Schiff
Origin: United States
Language: English
Released: 2013
Production: Christopher Nolan, Charles Roven, Deborah
 Snyder, Emma Thomas; Syncopy; released by Warner
 Brothers
Directed by: Zack Snyder
Written by: David S. Goyer
Cinematography by: Amir M. Mokri
Music by: Hans Zimmer
Sound: Scott Hecker
Editing: David Brenner
Costumes: James Acheson; Michael Wilkinson
Production Design: Alex McDowell
MPAA rating: PG-13
Running time: 148 minutes

REVIEWS

Covert, Colin. *Minneapolis Star Tribune*. June 13, 2013.
Edelstein, David. *New York Magazine*. June 12, 2013.
Guzman, Refer. *Newsday*. June 14, 2013.
Hornaday, Ann. *Washington Post*. June 13, 2013.
Jones, J. R. *Chicago Reader*. June 13, 2013.
Kennedy, Lisa. *Denver Post*. June 14, 2013.
Long, Tom. *Detroit News*. June 14, 2013.
O'Hehir, Andrew. *Salon.com*. June 12, 2013.
Orr, Christopher. *The Atlantic*. June 14, 2013.
Seitz, Matt Zoller. *Chicago Sun-Times*. June 14, 2013.

QUOTES

Jonathan Kent: "You just have to decide what kind of man you
 want to grow up to be, Clark. Whoever that man is, he's
 going to change the world."

TRIVIA

Ben Affleck turned down directing the film because he wasn't
 experienced in VFX shots, stating "A lesson I've learned is
 to not look at movies based on budget, how much they'll
 spend on effects, or where they will shoot. Story is what's
 important."

MANDELA: LONG WALK TO FREEDOM

It is an ideal for which I am prepared to die.
 —Movie tagline

Box Office: $8.3 Million

The life of Nelson Mandela, one that represents the incredible potential of a human being, is a story that could easily devolve to cinematic canonization. In the latest film about his world-changing accomplishments, *Mandela: Long Walk to Freedom*, he not does receive such a treatment, as his purely human characteristics are not lost to unjust overprotection. However, it is his story itself that is not done proper justice in this recreation, due to imperfect assembly, but most importantly, a lack of continuation of Mandela's dynamic spirit.

Based on Mandela's 1995 autobiography, *Mandela: Long Walk to Freedom* presents the international leader's political beginnings as a popular counsel for the defense in 1942 Cape Town, South Africa, as portrayed by actor Idris Elba. While he progressively becomes a person of the people, he is also a man of numerous girlfriends, despite being married with children to a woman named Evelyn (Terry Pheto). Because of his influence, he is invited by a man named Walter Sisulu (Tony Kgoroge) to join the African National Congress, which he is uncertain about. He later witnesses a bus boycott lead by Walter and his ANC associates, and notices that people rally behind his words, and without the intent of violence.

In 1948, Apartheid becomes the supreme law, which spurs Nelson to make speeches and lead rallies about the unfair conditions. Before he storms a train depot, designated for "Europeans Only," he catches the eye of Winnie Madikizela (Naomie Harris). Soon after, Nelson approaches Winnie, the first black social worker in the area, and begins to court her.

After the two are married, Nelson joins the ANC after the massacre at Sharpeville in 1960, where civilians are killed for protesting a law that requires them to constantly carry around passes. When Nelson is jailed for his work in the ANC, which includes the bombing of different buildings, he is given a life sentence at a jail on Robben Island, of which he is told he will never escape. Winnie is soon thrown into jail as well for assaulting an officer snooping around her home. After sixteen months in solitary confinement, Winnie is released. While her husband tries to make a change from within his jail cell, she becomes the voice of violent non-fear against the government.

As someone not from South Africa, nor one with a similar facial structure to that of Mandela's, Elba provides an alpha presence in a performance that most of all captures the essence of the world leader. Dispensing wisdom throughout the script, in both voiceover and to other characters, Elba is able to keep this sharp-witted character from becoming non-human. Through

the delivery of a few excellent monologues, especially one in the third-act in which he provides symbolic forgiveness for his treatment, he provides a gripping stalwart portrayal. Elba illustrates how a man, gifted with intellect that he uses for public influence, could lead people together into the darkest of political conflicts, and similarly, how he could lead them out.

The subdued words of Elba's subdued Nelson are given a charge of equal yet opposite strength with Harris' Winnie, who provides a more outwardly enraged form of angst against the apartheid. In her scenes of post-jail pontification, she ferociously screams at the top of her lungs, her fist punching the air, her eyes suggest a purity of intensity. Though her character lacks in the same amount of care as Nelson, Harris passion ensures that Winnie's screen-time becomes a formidable representation of the argument that is against peace; one to stand right against the more celebrated teachings of her husband.

As a film project, prepared by South African producer Anant Singh since the autobiography's release, *Mandela: Long Walk to Freedom* is a collection of individual filmmaking promise. Boasting the largest budget of a film to be made in Africa, the movie uses many authentic locations for its events, with others that have been changed by time recreated in great detail by large crews within Cape Town Film Studios. With vista shots used to bookend the story, and numerous scenes involving the organization of hundreds of extras (some of whom witnessed the true events first-hand), the film is also captured in classic 35mm.

When these elements are assembled by British director director Justin Chadwick, the total result is not as strong as the truth behind Mandela's spirit may need. While screenwriter William Nicholson's script earns some edge by presenting Mandela's personal moral imperfections, Chadwick rarely shows an inspired outlook on the material. In the film's press notes, he references both the films of David Lean and *City of God* (2002) as aesthetic influences, but the energy of capturing an epic story with handheld camera intimacy is scant, and when presented it gives no charge to the rest of the film.

Similarly, while presenting this big picture built of many small details, poor assembly becomes a burden when trying to follow the many chapters of this story. The film's editing gets too economical with crucial details, such as the locations and reasons that are scantly defined when Mandela is involved with bombings by the ANC. Not only does this underwhelm the striking scenes themselves, but also the point of involving those who are unfamiliar with this part of Mandela's life into any type of debate. In another instance, one disturbing massacre scene is shown synonymously, but in indication of the film's broader dramatic intentions, it does bookend the scene with a baby crying.

When condensing certain passages of time to montages that mix film footage with actual news documentation, such events prove to be less succinctly informative than full scenes themselves. Audio clips, as placed on top of visuals, are of little assistance when it comes to placing the visuals to a certain time period or geography. When mixing in real footage of protests and struggle, sometimes an image of the real Mandela pops up, which also provides distraction to this film's own non-fictional vision.

Though aiming for grander heights, *Mandela: Long Walk to Freedom* remains a fair biopic about a great human being. The spirit of Mandela's efforts is in place, especially with Elba's help, but the movie lacks the attitude that is crucially within his revolution's DNA. Chadwick's film does not echo the world-changing fervor behind the chants or the clenched fists that fueled Mandela's greatest work, it simply shows them.

Nick Allen

CREDITS

Nelson Mandela: Idris Elba
Winnie Mandela: Naomie Harris
Walter Sisulu: Tony Kgoroge
Evelyn Mase: Terry Pheto
Origin: South Africa, United Kingdom
Language: English, Afrikaans, Xhosa
Released: 2013
Production: Anant Singh; released by Weinstein Company L.L.C.
Directed by: Justin Chadwick
Written by: William Nicholson
Cinematography by: Lol Crawley
Music by: Alex Heffes
Sound: Nico Louw
Editing: Rick Russell
Costumes: Diana Cilliers; Ruy Filipe
Production Design: Johnny Breedt
MPAA rating: PG-13
Running time: 139 minutes

REVIEWS

Calhoun, Dave. *Time Out New York*. November 26, 2013.
Lacey, Liam. *Globe and Mail*. December 24, 2013.
Long, Tom. *Detroit News*. December 26, 2013.
MacDonald, Moira. *Seattle Times*. December 24, 2013.
Merry, Stephanie. *Washington Post*. December 24, 2013.

Noveck, Jocelyn. *Associated Press*. November 28, 2013.
Orange, Michelle. *Village Voice*. November 26, 2013.
Rooney, David. *Hollywood Reporter*. December 24, 2013.
Sachs, Ben. *Chicago Reader*. December 26, 2013.
VanDenburgh, Barbara. *Arizona Republic*. December 25, 2013.

QUOTES

Nelson Mandela: "I have walked a long walk to freedom. It has been a lonely road, and it is not over yet. I know that my country, was not made to be a land of hatred. No one is born hating another person because the color of his skin. People learn to hate. They can be taught to love, for love comes more naturally to the human heart."

TRIVIA

Director Tom Hooper was at one time linked to this film and even met Nelson Mandela during development.

AWARDS

Golden Globes 2014: Song ("Ordinary Love")

Nominations:

Oscars 2013: Song ("Ordinary Love")
Golden Globes 2014: Actor—Drama (Elba), Orig. Score

MANIAC

I warned you not to go out tonight.
—Movie tagline

Box Office: $31,081

William Lustig's horror film *Maniac* (1980) earned itself a cult status thanks in large part to its groundbreaking gore effects from Tom Savini. It was a lurid and scuzzy affair, a movie that wallows in the muck and mire that only true horror aficionados can stomach for its 87-minute running time. The film also courted some controversy upon its release because of its treatment of women, who were the only victims in the film and the catalyst for the killer's murderous tendencies (he had mommy issues). The *Los Angeles Times* refused to run ads for it and several feminist groups rallied against the film. *Maniac* had been all but forgotten until a remake was written and produced by director Alexandre Aja, the auteur behind *High Tension* (2003), *The Hills Have Eyes* (2006) remake and the *Piranha* (2010) remake. Like those films, Aja, co-screenwriter Gregory Levasseur, and director Franck Khalfoun have not forgotten what made those films stand out and their sole purpose is to not only acknowledge the brand of horror, but to enhance it as well.

Unlike the original, Khalfoun literally tells the story of *Maniac* entirely from the point of view of the killer.

His voice is heard, but he is rarely seen. Khalfoun and cinematographer Maxime Alexandre lets the camera be the audience's eyes and ears, occasionally making the images become distorted depending on the killer's mental state. The maniac is named Frank (Elijah Wood) and the film opens with him staking out a club where a woman named Judy (Liane Balaban) exits and is harassed by some guys. "Leave her alone," Frank says to no one in particular. He then follows the girl in his car. She notices. "I see you, too," he says and continues to trail her ominously. He beats her home and lurks in the hallway of her apartment building ready to kill.

This is a typical night for Frank, who runs a mannequin store. He is primarily interested in collecting scalps for his mannequins. To meet women, he posts a profile on dating sites and engages in online conversations with women who find him somewhat charming and attractive. Frank meets Lucie (Megan Duffy), a heavily tattooed and pierced woman who warms up to Frank. When she asks why he does not have a girlfriend, he feels all eyes in the restaurant are on him and he excuses himself to go to the restroom where he takes some medication. They go back to her apartment where she puts on the song "Goodbye Horses," which horror fans will instantly recognize as Buffalo Bill's music of choice in *The Silence of the Lambs* (1991). She seduces him and the results are predictably deadly and horrifying.

Frank has a dialogue with himself that is along the lines of Gollum and Smeagol from *The Lord of the Rings: The Two Towers* (2002). There is clearly a voice in his head making him do these things. He also talks to his mannequins as though they were real people and gives them gifts from his killings. One morning he meets a French photographer named Anna (Nora Arnzezeder) who is interested in his shop. He invites her in and shows off his "artwork." He claims to have restored all these mannequins which are considered antiques. She takes a liking to him and his work and the two develop a friendship. This does not stop Frank from going about his usual routine of stalking beautiful women and collecting their scalps, but he does let her into his world. Just not the back of the store. Like the original, *Maniac* makes a point of flashbacking to Frank's youth in which his mother was a prostitute. He would watch her from a closet.

There is no "enjoying" *Maniac* the same way one would "enjoy" a Stephen King thriller or a George Romero film. *Maniac* is about probing the depths of a disturbed mind without getting too caught up in the intricacies of psychology. Frank has issues with women that stem from his mom abusing him and being a prostitute. End of story. What makes this film a little more interesting is the casting choice of Elijah Wood as Frank. As a dangerous psychopath, Wood would prob-

ably be nobody's first choice. At least, that was until Robert Rodriguez cast him as a silent and almost faceless killer in one of the segments of *Sin City* (2005). For Wood to take on this role as well shows a determination to rid himself of being boxed in as an actor to be cast solely as shy, awkward or innocent types. It is a choice that works because he comes off as so non-threatening. When he loses his mind, it is all the more startling and frightening.

Maniac is more an exorcise in style than anything else. As such, it works and some will find it hard to shake off. The film's POV usage is effective, as is Robin Coudert's synth-driven score, which harkens back to the *Maniac* of 1980. The film did not garner the same controversy upon its release as the original. Rather, it was given a quick and uneventful release on the midnight circuit after its festival run and was released simultaneously on On-Demand services for horror fans to discover on their own. Time will tell if it becomes a cult classic like the original. The casting of Wood certainly makes it a bit of a novelty. Remove that and the style and *Maniac* is simply as lurid and scummy as the detractors of the original claimed it to be.

Collin Souter

CREDITS

Frank Zitto: Elijah Wood
Anna: Nora Arnezeder
Lucie: Megan Duffy
Jessica: Genevieve Alexandra
Rita: Jan Broberg
Frank's mother: America Olivo
Origin: France, United States
Language: English
Released: 2012
Production: Thomas Langmann, William Lustig, Alexandre Aja; La Petite Reine, Studio 37; released by IFC Midnight
Directed by: Franck Khalfoun
Written by: Alexandre Aja; Gregory Levasseur
Cinematography by: Maxime Alexandre
Music by: Robin Coudert
Sound: Emmanuel Augeard
Editing: Franck Khalfoun
Costumes: Mairi Chisholm
Production Design: Stefania Cella
MPAA rating: Unrated
Running time: 90 minutes

REVIEWS

Abele, Robert. *Los Angeles Times*. June 27, 2013.
Dowd, A. A. *AV Club*. June 21, 2013.

Goss, William. *Film.com*. June 21, 2013.
Lewis, David. *San Francisco Chronicle*. July 5, 2013.
Packham, Chris. *Village Voice*. June 18, 2013.
Rodriguez, Rene. *Miami Herald*. July 25, 2013.
Shannon, Jeff. *Seattle Times*. July 11, 2013.
Smith, Kyle. *New York Post*. June 21, 2013.
Uhlich, Keith. *Time Out New York*. June 18, 2013.
Whitty, Stephen. *Newark Star-Ledger*. June 21, 2013.

QUOTES

Lucie: "You are totally not what imagined."
Frank: "Really? What did you imagine?"
Lucie: "Uh, fat, with long black hair and greasy skin full of acne."
Frank: "You should see the other picture I was about to send."

TRIVIA

The movie features the song "Good-bye Horses" by Q. Lazzarus. The song was also featured in *The Silence of the Lambs* (1991), another movie about a serial killer who skinned people and had issues with his mother.

METALLICA THROUGH THE NEVER

Experience Metallica like never before.
—Movie tagline

Box Office: $3.4 Million

When a band or artist reaches a particular height in popularity with mainstream audiences, there comes that inevitable lure by either the record label, the big movie studio or the singer's ego to put together either a concert film or something close to a narrative for the purpose of selling more albums or a soundtrack with new songs. The Beatles, of course, revolutionized the medium with Richard Lester's *A Hard Day's Night* (1964) and *Help!* (1965). Prince had both a narrative film and one of the strongest-selling soundtracks of all time with *Purple Rain* (1984). Elvis Presley, The Rolling Stones, Talking Heads, Bob Dylan, Madonna, U2, and even one-hit wonders such as The Spice Girls, The Jonas Brothers, and The Fat Boys have all made the leap from vinyl to (digital) celluloid. But Metallica has managed to not only reveal themselves quite unflatteringly in the documentary *Metallica: Some Kind of Monster* (2004), but now they have created a concert film that is also a narrative.

Any band can make a concert film, but working a narrative into the fold means taking a strong leap of

faith. It could easily backfire with fans and critics. No band wants to end up looking like Styx with their silly "Kilroy Was Here" film/album project in 1983. Or the worst of the worst, KISS throwing themselves blindly into a wrong-headed and cheap looking sci-fi film for television, *KISS Meets the Phantom of the Park* (1978). Even a band as seemingly infallible as Led Zeppelin has to answer for the nonsense that is *The Song Remains the Same* (1976). For a band such as Metallica, this late in their careers and who many believe to be past their prime, to take on a project like *Metallica Through the Never* (in IMAX 3-D, no less) takes courage, no matter what the result.

So, there are two films at play here. The concert film and the narrative that takes place within and outside the arena where the concert takes place. The streets outside the arena are conspicuously empty. The film begins by following a roadie on a skateboard named Trip (Dane NeHaan) as he walks through the backstage area where other roadies are assembling bleeding guitars (yes, guitars that are literally bleeding) and other large-size props that will be used in the show. Metallica takes the stage. Four guys—James Hetfield (vocals, guitar), Lars Ulrich (drums), Kirk Hammett (guitar, background vocals,) and Robert Trujillo (bass guitar, background vocals)—who have been amongst the revered and most distinctive heavy metal bands in history arrive on a stage that sits in the round on the main floor. It is a 360-degree experience for the audience with a floor that is an entire video wall beneath the band.

After the first song, the camera swoops over the audience and finds Trip enjoying the show when a manager taps him on the shoulder and tells him that he must run an errand that involves finding a truck that is out of gas and bringing it to the arena. Trip takes a container of gasoline with him and heads out to the empty streets to retrieve this truck. He sees many ominous signs that all is not well. There is a horse dragging a corpse, a massive car crash and a large group of people running from the police who are wearing riot gear. There is a sense of lawlessness in the streets that culminates with a group of rioters with bandanas over their faces facing off against the cops, who tap their shields to the beat of the Metallica song that is currently being performed. Eventually, Trip finds himself at the center of this madness that also involves a kind of talisman that may or may not be some kind of monster or guardian.

This story is interspersed with the concert and is told wisely without dialogue. The concert itself will be what draws fans to the film and the narrative only takes up about 30 to 40 percent of the running time. The concert itself makes great use of the IMAX 3-D format. It is as big a spectacle that has ever been mounted before

by the likes of U2, Madonna, Pink Floyd and The Rolling Stones. Lit-up crosses come up from beneath the stage; silk screens hover over the audience displaying images of war and chaos; light fixtures shaped like coffins hang from the ceiling with images of corpses and people being buried alive; even a large statue of Lady Justice during "...And Justice For All" gets assembled only to be toppled, miraculously not interrupting the song or hitting drummer Ulrich. The outside storyline collides with the concert toward the end, which gives a mostly convincing feeling that something has truly gone wrong with the show. It results in a backwards kind of showmanship that actually works pretty well.

The film was directed by Nimrod Antal who has helmed action, fantasy and horror movies in the past such as *Kontroll* (2003), *Vacancy* (2007), and *Predators* (2010). While the action scenes employ the tired and annoying device of slo-mo, the concert footage, in which 24 cameras were used, looks spectacular and is well cut and designed. Ultimately, that is what matters most here. The narrative never really justifies itself and most viewers will be completely confused as to what the storyline is supposed to mean in the grand scheme of things. But as a concert film, *Metallica Through the Never* works pretty well. At the center of the film is not the spectacle or the silly narrative, but a moment of pure joy on the band's faces when the audience takes over the singing. Through all the images of death, despair and chaos comes a moment when thousands of people can agree on one thing: their love for this band. Most fans will appreciate that moment and the film as a whole, but they might also be hitting the "skip" button a few times on their remote when watching it on DVD/BD in order to get to the next song.

Collin Souter

CREDITS

Trip: Dane DeHaan
Origin: United States
Language: English
Released: 2013
Production: Charlotte Clay Huggins; released by Picturehouse Entertainment
Directed by: Nimrod Antal
Written by: Nimrod Antal
Cinematography by: Gyula Pados
Sound: Mark A. Mangini
Editing: Joe Hutshing
Art Direction: Christopher Beach
Costumes: Carla Hetland
Production Design: Helen Jarvis

MPAA rating: R
Running time: 93 minutes

REVIEWS

Brown, August. *Los Angeles Times*. September 26, 2013.
Covert, Colin. *Minneapolis Star Tribune*. September 26, 2013.
Farber, Jim. *New York Daily News*. September 26, 2013.
Gleiberman, Owen. *Entertainment Weekly*. September 27, 2013.
Graham, Adam. *Detroit News*. September 27, 2013.
Rugg, Peter. *Village Voice*. September 24, 2013.
Russo, Tom. *Boston Globe*. September 26, 2013.
Scott, A. O. *New York Times*. September 26, 2013.
Smith, Kyle. *New York Post*. September 26, 2013.
Whitty, Stephen. *Newark Star-Ledger*. September 27, 2013.

QUOTES

Trip (the only time his voice is heard): "Hey! Hey!"

TRIVIA

The release date for the film, September 27, 2013, twenty-seventh anniversary of the death of Metallica member Cliff Burton.

MONSTERS UNIVERSITY

School never looked this scary.
—Movie tagline

Box Office: $268.5 Million

Any reasonable accounting of *Monsters University*, Pixar's fourteenth film, must at least acknowledge the turbulent nature of its winding path to the big screen. Telling the story of an odd-couple pair of monsters who help power their city's electricity by harnessing the screams of children in the human world, animated family film *Monsters, Inc.* (2001) was a $563 million worldwide smash hit, making distributor Disney understandably eager for a follow-up. Their enthusiasm to push ahead at all costs, and with little regard for the original creative team, contributed to much tension over several years, prior to Disney eventually purchasing Pixar outright in 2005. Following that, Pixar was returned the creative reins, and a decision was made that instead of a traditional sequel the follow-up to *Monsters, Inc.* would actually be a prequel, a first for the company.

Monsters University, then, carries a unique set of expectations: As a Pixar film and as the re-visitation of a popular but, at the remove of over a decade, slightly faded franchise. These might explain the nature of most reviews upon its summer release, which seemed to come with some variation on the same caveat: "Yes, it is by

and large entertaining, but it lacks much of the eccentric punch of the original movie." (Audiences, meanwhile, still flocked to the film, especially internationally; more than 64 percent of *Monsters University*'s $743 million cumulative gross came from overseas.) This criticism is not unwarranted. A college campus send-up is not what most would have necessarily envisioned as a continuation of the *Monsters, Inc.* franchise, but that is what *Monsters University* is, for better or worse—a frivolous, lightweight entertainment that, if it fails to scale the heights of its predecessor, at least connects in sunny fashion and still more frequently than the average animated fare.

Green, diminutive, one-eyed Mike Wazowski (Billy Crystal) has dreamed of being a respected "scarer" ever since he was little, and ordered his life accordingly. After a brief prologue which dutifully establishes him as an underdog dreamer, taking a classroom visit to the Monsters, Inc. factory floor which serves as a portal to the human world, *Monsters University* kicks off with Mike's enrollment in the titular college. He meets and gets along with roommate Randy Boggs (Steve Buscemi), but is almost immediately put off when he crosses paths with James "Sulley" Sullivan (John Goodman), a slacker legacy student with the sort of unearned, arrogant confidence that is a staple of some of Will Ferrell's best comedic creations.

The pair's bickering and competitive spirit—the hard-studying Mike is essentially a "scarer sabermetrician" while Sulley coasts by on his family name and imposing physical stature—plays out over the course of the first semester, but when the time comes for their final exam Mike and Sulley are both bounced from Monster University's elite scare program by the snooty headmistress, Dean Abigail Hardscrabble (Helen Mirren). Their way back in is a loophole, the Scare Games, in which Greek organizations compete in a series of contests to establish supremacy. Mike links up with the misfits of Oozma Kappa, consisting of Don (Joel Murray), Art (Charlie Day), Squishy (Peter Sohn), and the two-headed Terri/Terry (Sean Hayes and Dave Foley). With the fraternity needing one more member to compete in the Scare Games, Sulley opts in and Mike reluctantly accepts his membership. Together, they learn the virtues of cooperation and embracing different skill sets.

If the film's narrative sounds a little conventional, well, it is. Director Dan Scanlon, working from a script co-written with Robert Baird and Daniel Gerson, sketches out a story that lacks in deep pockets of originality or emotional parallelism with the human world. Despite the fact that it offers up some legitimate set piece fun, the idea of the Scare Games competition almost feels like a referential riff best suited for the work

of filmmakers Aaron Seltzer and Jason Friedberg, who have cranked out listless, air-quote parodies like *Date Movie* (2006), *Epic Movie* (2007), and *Meet the Spartans* (2008).

Similarly, an homage to *Carrie* (1976), as well as all the college satire more broadly, a lot of which echoes *Revenge of the Nerds* (1984), feel like a calculated attempt to "age up" the material, and play to an audience who might have been adolescent upon the initial release of *Monsters, Inc.*. Given the intelligence and meticulous story-breaking of the filmmakers and the rest of Pixar's staff, it provides exploitable opportunities for comedy, but it does not always feel innate. With Mike and Sulley so frequently at odds instead of merely different in temperament, the movie feels like a misread of what made the first film so special.

Luckily, Mike and Sulley each remain eminently watchable and amusing characters, individually and together, and the film's animation is characteristically gorgeous and of course complete with its share of background flourishes and in-jokes. In addition to a lush green campus, with leaf-lined streets and pock-mocked curbs, Scanlon and his animators get myriad details right, as when Mike picks up a photocopied Scare Games flyer that, even in barely glimpsed fashion, shows different typefaces and just the sort of faint lines of cut-and-pasted art that would mark such a handmade advertisement.

Monsters University is also the first Pixar film to utilize global illumination, a complex lighting system in which various algorithms take into account more reflected light from various surfaces within scenes. Matt Aspbury (director of photography, camera) and Jean-Claude Kalache (director of photography, lighting) work effectively in tandem, delivering some intriguing deep focus shots and outdoor shadow patterns that subtly change across the seasons.

The supporting vocal performances are winning, and of course Crystal and Goodman have a nice rapport. It is the latter's blithe overconfidence that is the film's secret weapon, however, keeping Sulley teasing jabs at Mike from ever leaving a bruising mark.

Through it all, longtime Pixar fixture Randy Newman's horn-infused, toe-tapping score, which at times recalls marching band music, keeps time for *Monsters University*, properly summoning forth for especially younger viewers all the right emotions for which the filmmakers are aiming. If part of its wrap-up is predestined, the movie's ending is also nicely modulated; there are consequences for rules-breaking and other actions, but obviously still enough uplift to put Mike and

Sulley on a natural trajectory to Monsters, Inc., where new adventures no doubt await them.

Brent Simon

CREDITS

Mike Wazowski: Billy Crystal (Voice)
James P. 'Sully' Sullivan: John Goodman (Voice)
Randall Boggs: Steve Buscemi (Voice)
Dean Hardscrabble: Helen Mirren (Voice)
Terri: Sean P. Hayes (Voice)
Terry: Dave Foley (Voice)
Squishy: Peter Sohn (Voice)
Prof. Knight: Alfred Molina (Voice)
Johnny Worthington: Nathan Fillion (Voice)
Claire Wheeler: Aubrey Plaza (Voice)
Origin: United States
Language: English
Released: 2013
Production: Pixar Animation Studios; released by Walt Disney Studios
Directed by: Dan Scanlon
Written by: Dan Scanlon, Daniel Gerson; Robert L. Baird
Music by: Randy Newman
Sound: Tom Myers
Editing: Greg Snyder
Production Design: Ricky Nierva
MPAA rating: G
Running time: 104 minutes

REVIEWS

Adams, Mark. *Screen International.* June 10, 2013.
Chang, Justin. *Variety.* June 9, 2013.
Dargis, Manohla. *New York Times.* June 20, 2013.
Kohn, Eric. *IndieWIRE.* June 10, 2013.
McCarthy, Todd. *Hollywood Reporter.* June 9, 2013.
Nashawaty, Chris. *Entertainment Weekly.* June 19, 2013.
Phillips, Michael. *Chicago Tribune.* June 20, 2013.
Puig, Claudia. *USA Today.* June 20, 2013.
Strauss, Bob. *Los Angeles Daily News.* June 19, 2013.
Weitzman, Elizabeth. *New York Daily News.* June 20, 2013.

QUOTES

Dean Hardscrabble: "It's my job to make great students greater, not make mediocre student less mediocre."

TRIVIA

When Randy tries to fit in with the other fraternities, he bakes cupcakes that have icing on them that spell out "Be My

Pal." This is only in the US version of the film, all other versions have happy faces on each cupcake.

Nominations:
British Acad. 2013: Animated Film

THE MORTAL INSTRUMENTS: CITY OF BONES

There is a world hidden within our own.
—Movie tagline
Worlds will collide August 21.
—Movie tagline
You have been chosen.
—Movie tagline

Box Office: $31.2 Million

There are few cinematic sights that are more depressing than that of a fantasy spectacular gone horribly wrong. There is something about the sight of millions of dollars and man-hours being devoted to an attempt to transport viewers into another world being wasted on something that cannot even be referred to as a noble failure that just saps the enthusiasm out of an audience to such a degree that they can barely muster the energy to head out to the lobby when it has finally lurched to its uninspiring conclusion. *The Mortal Instruments: City of Bones* is just that sort of film: A would-be franchise launch that spends so much energy constructing its convoluted mythology from parts ripped whole and bleeding from other sources (clearly none of the bones referred to in the portentous title are original in nature) that it has nothing left to help spin those elements into something interesting or even entertainingly derivative.

Based on the first novel of the popular young adult book series by Cassandra Clare (and apparently altered in many areas from its source), the film stars Lily Collins as Clary, a seemingly ordinary young woman whose entire life seems to be dedicated solely to bickering with her mother (Lena Headey) for no apparent reason and ignoring the increasingly romantic gestures of nerdy best pal Simon (Robert Sheehan). Everything changes for her on her birthday when she goes to a nightclub and sees sights slightly more bizarre than the ones normally found in such a place. She also catches the eye of pretty boy Jace (Jamie Campbell Bower), a so-called Shadowhunter who turns up later to help save her life from a couple of strange creatures in her apartment who have absconded

with her mother. (Yes, this is one of those movies where the writers try to create new and mystical words by jamming two regular ones together.)

It turns out that there is another world out there intermingled with ours, known as Downworld, that is filled with werewolves, vampires, faeries, demons and pansexual leather-clad warriors who sneeringly dismiss ordinary humans, who cannot see them, as "mundanes." Since Clary can see all these things, it is apparent that she is no mere mundane and becomes determined to find out who she really is while holing up with Jace and other Shadowhunters at an institute run by the kindly Hodge (Jared Harris). At seems that most of these creatures are all searching for an enchanted cup with vaguely defined powers that only she has the ability to find and, with the help of Jace and his fellow Shadowhunters, she sets off to recover it before the evil Valentine (Jonathan Rhys Meyers) can get his hands on it as part of some vaguely defined plan of presumably monstrous intentions.

It is more than a bit ironic that normal human beings are snarkily referred to as "mundanes" throughout *The Mortal Instruments: City of Bones* because the film itself never comes close to reaching that particular level of achievement. The screenplay adaptation by Jessica Postigo Paquette is such a jumble of drab exposition, ill-defined characters and incomprehensible narrative that most viewers will simply give up early on and spend their time listing all the other popular films, books and television show that this one blatantly rips off—among the unwitting donors are such franchises as *Harry Potter*, *Twilight*, *Buffy the Vampire Slayer*, *Underworld* and, in the most unintentionally hilarious moment in a movie filled with them, *Star Wars*—in the hopes that something will stick. Towards the end, the film simply devolves into a series of elaborate effects-filled set-pieces, which would not necessarily be a problem except for the fact that the visuals are pretty chintzy-looking and that director Harald Zwart (the auteur of *Agent Cody Banks* [2003] and the Jaden Smith version of *The Karate Kid* [2010]) is absolutely useless at presenting such material in an exciting or eye-catching manner.

To make matters worse, the heroine at the center of this tale is one of the least inspiring to come around in recent memory. Clary is supposed to be tough and resourceful but spends a good portion of her time either waiting to be rescued or flat-out fainting at the first sign of trouble. As Clary, Lily Collins is sweet and pretty enough but one wishes that the role could have been filled by someone who could bring some spark and excitement to the proceedings. And yet, she come across as Ms. Charisma when compared to co-star Bower, who is so blandly non-threatening throughout that he makes Christopher Atkins seem like Crispin Glover by

comparison. As for the rest of the cast, they stumble through their paces with the kind of visible embarrassment that suggests that they are less concerned with the potential end of the world than they are with the idea that the film might attract enough of an audience to warrant their participation in a sequel that ambitious producers announced plans for even before it was released. Lucky for them, the commercial response to *The Mortal Instruments: City of Bones* was so anemic that with luck, such a prospect will not be in anyone's future plans.

Peter Sobczynski

CREDITS

Clary Fray: Lily Collins
Jace Wayland: Jamie Campbell Bower
Alec Lightwood: Kevin Zegers
Isabelle Lightwood: Jemima West
Valentine Morgenstern: Jonathan Rhys Meyers
Simon Lewis: Robert Sheehan
Jocelyn Fray: Lena Headey
Magnus Bane: Godfrey Gao
Dorothea: CCH Pounder
Hodge: Jared Harris
Luke Garroway: Aidan Turner
Pangborn: Kevin Durand
Origin: Canada, Germany
Language: English
Released: 2013
Production: Don Carmody, Robert Kulzer; Constantin Film Produktion, Mr. Smith Productions, Unique Features; released by Screen Gems
Directed by: Harald Zwart
Written by: Jessica Postigo Paquette
Cinematography by: Geir Hartly Andreassen
Music by: Atli Orvarsson
Sound: Greg Chapman
Music Supervisor: Christoph Becker
Editing: Jacqueline Carmody
Art Direction: Anthony Ianni
Costumes: Gersha Phillips
Production Design: Francois Seguin
MPAA rating: PG-13
Running time: 130 minutes

REVIEWS

Abrams, Simon. *RogerEbert.com*. August 22, 2013.
Catsoulis, Jeanette. *New York Times*. August 21, 2013.
Chang, Justin. *Variety*. August 21, 2013.
Dujsik, Mark. *Mark Reviews Movies*. August 20, 2013.
Ebiri, Bilge. *Vulture*. August 21, 2013.
Gire, Dann. *Daily Herald*. August 22, 2013.
Keough, Peter. *Boston Globe*. August 22, 2013.
Olsen, Mark. *Los Angeles Times*. August 21, 2013.
Orndorf, Brian. *Blu-ray.com*. August 21, 2013.
Oursier, John. *Village Voice*. August 20, 2013.

QUOTES

Clary Fray: "Isn't this the part where you start tearing off pieces of your shirt to bind my wounds?"
Jace Wayland: "If you wanted me to take off my clothes all you had to do was ask."

TRIVIA

Lily Collins was previously a fan of the books, when she found out that a film adaptation was being made, she made numerous phone calls to ensure her role as Clary.

MOVIE 43

Comedy. Exposed.
 —Movie tagline
The biggest cast ever assembled for the most outrageous comedy ever made.
 —Movie tagline

Box Office: $8.8 Million

There are a lot of stars in *Movie 43*, an aggressively R-rated (for "raunchy") comedy anthology made up of 14 short film sketches. Of the feature's supposed 43 stars, some of them are big, award-winning names like Hugh Jackman, Kate Winslet, Richard Gere, and Halle Berry; some are up and comers like Emma Stone, Christopher Mintz-Plasse, and Chloe Grace Moretz; some of them are actors known more for dramatic work like Naomi Watts and Terrence Howard; while others like Jack McBrayer, Elizabeth Banks, and Jason Sudeikis have strong comedic bona fides.

There are also a lot of jokes in *Movie 43*, almost all of them intended to offend someone, anyone. Frankly quite a few of them are funny. Some are mildly humorous, some are chuckle-worthy, and some are very funny. And a lot of them are not; the clunkers ranging from groaningly lame to jaw-dropping and stomach-turning.

Many comedies are equally hit and miss, so why is this feature already considered by many to be a strong contender for Worst Film of All Time?

Some of it is execution. *Movie 43* was produced by Peter Farrelly (who also directed several parts) with the majority of the shorts written by Rocky Russo and Jeremy Sosenko. The film's pool of directors includes

Steven Brill, Griffin Dunne, Farrelly himself, James Gunn, and Brett Ratner. Most of the actors are game, giving their all to skits that collectively feel like they were pulled from a bin of banned *Saturday Night Live* sketches. But nearly every segment—like those one-joke *SNL* routines of the Bad Old Days—runs too long, spending too much time basking in its own outrageousness. There are laughs and yes, even clever bits, in nearly every short film, but by the time each reaches its conclusion (usually in one last crescendo-ing gross-out blast) any promising glimmers of humor are long-forgotten amid all the juvenile shock-value posturing.

Some of it could be a smidge of *schadenfreude*—at times it seems the only thing movie-goers like more than basking in the glow of their favorite actors is watching said actors trip up and tumble. *Movie 43* offers, depending on personal taste, up to 43 chances to see middling-to-big stars step deep into an agent-firing stink fest. (The film took four years to complete as its producers and directors waited for moments when all the performers in each segment had compatible availabilities in their schedules.)

Movie 43's biggest problem, however, is that like a habanero pepper, a little disgust-inducing boundary pushing goes a long way. You put the peppers on a dish, not eat a bowl of them for dinner. When the Farrelly Brothers made a feature-length film like *Kingpin* (1996) or *There's Something About Mary* (1998), they started with story and characters and then sprinkled (sometimes glopped) the gross-out gags in for strong comedic flavor. But *Movie 43* is 14 separate films, each about 6 minutes long, and each trying to cram more taboo, un-politically correct, foul-mouthed, violent, scatological, dirty-minded jokes into its running time than the last.

The result feels over-stuffed to the point of tedium; there is little "down time" between the increasingly over-the-top jokes for the humor to breathe (or likewise for the audience to catch its breath, or hold down its lunch.) Though the anthology comedy feature film has been around for decades (including revered entries such as *Kentucky Fried Movie* [1977] and *Monty Python's Meaning of Life* [1983]), *Movie 43* cannot help but feel as though it was made for a YouTube generation used to getting its video laughs in short online bursts rather than sitting through a whole film full of things like plot and character.

Not helping matters is the film's connective thread; a tediously unfunny framing device in which a down-and-out screenwriter named Charlie (Dennis Quaid) tries to pitch *Movie 43* and its various shorts to an appalled studio exec Griffin (Greg Kinnear). (Griffin shares his name and job title with Tim Robbins character in

Robert Altman's lauded film-industry satire *The Player* [1991], a nod that feels more like cheap blasphemy than sincere homage.) In clumsy meta fashion, the two characters repeatedly defend or balk at the "obscene, offensive" nature of Charlie's awful ideas. (Overseas, a different narrative device was used: three boys trying to locate a banned film—*Movie 43*—that is said to be so bad it will bring on the end of civilization.) That winking self-awareness makes the film's "a joke too far" comedy feel too "look at me!" smug, like a little kid who does something funny once by accident and then spends the rest of the day repeating it ad nauseam in hopes of getting more attention.

Still, some of the films manage to land a little social and pop-cultural commentary amid all the gross-outs. One about a couple (Naomi Watts and Liev Schreiber) trying to give their home-schooled son a taste of high-school with character-building experiences such as bullying and an incestuous first kiss gets sly digs in at how artificially holistic parenting techniques can go horribly awry. Actress-director Elizabeth Banks sharply aims her cringe-inducing tale of a teenage girl (Moretz) getting her first period at the clueless boorishness of men-boys. And while a tale of a frustrated 1950s high-school basketball coach (Howard) repeatedly hammers home the same wearying joke about racial athletic stereotypes against the cliches of the inspirational sports film, the sketch twists around to end on a wry bit of social-satire.

In most reviews of *Movie 43*, critics had a ball not just pouring on the hateful adjectives, but gleefully trying to recount the film's most cringe-inducing moments within the descriptive boundaries of family newspapers. Hugh Jackman has testicles on his neck! Anna Faris' sexual kink is for boyfriend Chris Pratt to do something foul to her! Batman and Robin talk dirty at a speed-dating event! A new digital music player looks like a life-size naked woman, but has a high speed fan hidden in a place that ends up maiming most of its male users! Stephen Merchant and Halle Berry up the ante on a game of Truth or Dare to new heights (or lows)!

Also worthy of note is that in pointing out which segments they felt were the film's strongest and weakest, various critics seemed to spread the love and the hate around evenly—nearly every short was someone's favorite and someone else's nadir. Once again we are reminded that comedy, even bad comedy, nearly always defies consensus.

Still, most critics piled mercilessly on *Movie 43*. Rare among those who liked the film was the *Washington Post*'s Michael O'Sullivan, who declared it "a near masterpiece of tastelessness." Most, however, shared damning sentiments along the lines of the *New York Times*' Stephen Holden, who said the movie, "brings

Hollywood's standards of comedy one step closer to the gutter," or Kim Newman of *Empire,* whose two-word verdict was "Just no." The film was released into the box-office doldrums of late January where it earned less than $9 million against its $6-million budget. (The international numbers were much better, bringing in $21 million overseas.) Despite all this, *Movie 43* has the uneven feel of a film that could conceivably find cult status among high school and college kids looking for the-dumber-the-better yuks (or yucks) and unashamed to laugh at the lowest of the low-brow.

Locke Peterseim

CREDITS

Charlie Wessler: Dennis Quaid
Griffin Schraeder: Greg Kinnear
Davis: Hugh Jackman
Beth: Kate Winslet
Seth MacFarlane: Seth MacFarlane
Samantha: Naomi Watts
Vanessa: Anna Faris
Jason: Chris Pratt
Neil: Kieran Culkin
Veronica: Emma Stone
Boss: Richard Gere
Arlene: Kate (Catherine) Bosworth
Brian: Jack McBrayer
Fake Robin: Justin Long
Fake Batman: Jason Sudeikis
Dad: Patrick Warburton
Fake Lois Lane: Uma Thurman
Leprechaun 1 & 2: Gerard Butler
Pete: Johnny Knoxville
Emily: Halle Berry
Donald: Stephen Merchant
Coach Jackson: Terrence Howard
Amy: Elizabeth Banks
Anson: Josh Duhamel
Origin: United States
Language: English
Released: 2013
Production: Ryan Kavanaugh, John Penotti, Charles B. Wessler, Peter Farrelly; GreeneStreet Films, Wessler Entertainment, Witness Protection Films; released by Relativity Media
Directed by: Elizabeth Banks; Bob Odenkirk; Steven Brill; Steve Carr; Rusty Cundieff; James Duffy; Griffin Dunne; Peter Farrelly; Patrik Forsberg; Will Graham; James Dunn; Brett Ratner; Jonathan Van Tulleken
Written by: Patrik Forsberg; Steve Baker; Rocky Russo; Jeremy Sosenko

Cinematography by: William Rexer; Matthew F. Leonetti; Daryn Okada
Music by: Tyler Bates; Christophe Beck; William Goodrum; Dave Hodge
Sound: Henry Auerbach; Ryan Collins; Nicholas Decristofaro
Music Supervisor: Bob Bowen; Happy Walters
Editing: Jonathan Van Tulleken; Debra Chiate; Suzy Elmiger
Costumes: Anna Bingemann; Roseanne Fiedler; Florence Kemper
Production Design: Toby Corbett; Jade Healy; Dina Lipton
MPAA rating: R
Running time: 94 minutes

REVIEWS

Bradshaw, Peter. *The Guardian.* January 29, 2013.
Burr, Ty. *Boston Globe.* January 27, 2013.
Edelstein, David. *New York/Vulture.* January 25, 2013.
Holden, Stephen. *New York Times.* January 25, 2013.
Toro, Gabe. *The Playlist.* January 25, 2013.
Hassannia, Tina. *Slant Magazine.* January 26, 2013.
Linden, Sheri. *Los Angeles Times.* January 28, 2013.
O'Sullivan, Michael. *Washington Post.* January 25, 2013.
Pinkerton, Nick. *Village Voice.* January 23, 2013.
Rabin, Nathan. *Onion A.V. Club.* January 25, 2013.

QUOTES

Fake Batman: "Excuse me, I'm gonna go do some batman-ing."

TRIVIA

George Clooney turned down a cameo as himself in a segment where he would have been shown to be bad at picking up women.

AWARDS

Golden Raspberries 2013: Worst Director (Brill), Worst Director (Carr), Worst Director (Cundieff), Worst Director (Duffy), Worst Director (Dunn), Worst Director (Dunne), Worst Director (Forsberg), Worst Director (Graham), Worst Director (Odenkirk), Worst Director (Ratner), Worst Director (Van Tulleken), Worst Picture, Worst Screenplay

Nominations:

Golden Raspberries 2013: Worst Actress (Berry), Worst Actress (Watts), Worst Director (Banks), Worst Director (Farrelly), Worst Ensemble Cast

MUCH ADO ABOUT NOTHING

Shakespeare knows how to throw a party.
 —Movie tagline

Box Office: $4.3 Million

Updating The Bard can be even trickier than simply staging his stuff as it was written. Add to that the translation of the work into screenplay format and it becomes easy to see why so few modern updates of William Shakespeare have any real life or charm. Strain too hard, and the charm of the material flies south. Treat the material less than reverently and be denounced as a would-be artiste. Writer/director Joss Whedon finds the middle ground by offering a version of *Much Ado About Nothing* that feels as breezy as a summer soiree in the Hamptons. If it were less than assuredly classy, it would almost be fit for the WB. But as it stands *Much Ado About Nothing* (2012) is really something. Whedon finds the soul of the play in modern day society without forsaking Shakespeare's timeless insights into human nature.

After a successful campaign against his black sheep brother Don John (Sean Maher), Don Pedro (Reed Diamond), and his two officers Benedick (Alexis Denisof) and Claudio (Frank Kranz) pay a visit to Pedro's friend, the governor of Messina, Leonato (Clark Gregg). The visit is fraught with romantic peril. Claudio has fallen in love with Hero (Jillian Morgese), Leonata's daughter. But while Don Pedro and Leonata work out the details, Benedick and the governor's niece Beatrice (Amy Acker) enter into an old feud over their failed love with such ferocity that Leonato, Claudio, and Hero bet one another they can reignite the fighting couple.

Don John, still embittered by defeat, returns with Borachio (Spencer Treat Clark) and Conrade (Riki Lindhome) in tow, and enters into a plot with them to prevent the marriage by shaming Hero, which leads to the possibility of a fatal duel of honor and an investigation by the idiot lawman Dogberry (Nathan Fillion).

The film sets Shakespeare's scenario in a tiny country cottage estate peopled with an awful lot of pretty folk, and that alone would feel emotionally sterile if the writer director failed to make his intentions so clear. This is a group of people who have everything materially but what they lack in wisdom or basic human charity is enough to get them in plenty of trouble. Human folly is the focus of Shakespeare's play and Whedon never strays far from his madding crowd. His one brilliant bit of reworking the dialogue involves scenes shot to highlight a past physical relationship between Beatrice and Benedick, making their feud all the more intense and the reignited love all the more enjoyable.

Performances keep the tone light; sometimes a little too light as when Alexis Denisof is seen leaping repeatedly up into view in some bay windows during a bit of comic business. But, on the whole, there is ample charm on display and the more serious moments involving the

duel come across with a just enough threat to work without derailing the tone. A serious standout is Amy Acker who lends Beatrice a sincere air of empowered femininity. Clark Gregg is wonderfully warm and authoritative as Leonato. The always dependable Nathan Fillion has the most difficult role in Dogberry. Shakespeare's dialogue for Dogberry invites a broader than broad theatrical approach whereas Whedon's realistic modern day setting here does not. Fillion finds a nice balance managing to make the detective seem as if he really could be that dumb and that self-important.

The simple black-and-white cinematography of Jay Hunter does enhance the on-the-cheap production but the film did feel at times like it wanted to break out on a bigger scale. This is, at its heart, a little indie project, showcasing an ensemble who are at the top of their game, rather than an art house offering that needs to call attention to technique. Whedon's treatment of the material makes this one of the most accessible of all the modern day movie mountings of Shakespeare ever. It might have been better to leave well enough alone and approach the material even more simply from a visual standpoint. As it is, the black-and-white aesthetic succeeds in adding more than arthouse airs but not enough to avoid being a probable distraction for some.

On the subject of distraction this mounting of *Much Ado* has much to say. There is an inherent classism built into the fabric of the story that Whedon exploits quite well by replacing Shakespeare's original soldiers with corporate raiders, and public officials with CEOs. There is an unmistakable critique of that culture which assumes that what is good business is also good living and good loving. Here is the American dream, set in motion. Rich digs, full fridge, nice clothes, and friends who are, mostly, just like each other. There is no other. The estate where the story takes place is a little bit of suburban heaven. The hell is that people are so messy leading to much ado. The nothing is that people can come to near killing blows despite all the advantages their unearned way of life supposedly affords them. The characters, in other words, are the nothing here. It is a version of the story that is quite pointed for a nation currently redefining notions of success outside gated communities. Yes, Whedon wants viewers to feel good at the end of the film but he also has things to say about why Shakespeare is still so relevant. The fact that he can get them said and still maintain the heart and happy tone of Shakespeare's insights into the joy of love is nothing short of wonderful to behold. Watching him do it with the people who helped him create the marvelous world's of *Buffy, Angel* and *Firefly* is a bit like watching Orson

Welles take his Mercury Radio Theater troupe with him to Hollywood.

Dave Canfield

CREDITS

Beatrice: Amy Acker
Benedick: Alexis Denisof
Claudio: Fran Kranz
Hero: Jillian Morgese
Leonato: Clark Gregg
Don Pedro: Reed Edward Diamond
Don John: Sean Maher
Dogberry: Nathan Fillion
Origin: United States
Language: English
Released: 2013
Production: Kai Cole, Joss Whedon; Bellwether Pictures; released by Roadside Attractions
Directed by: Joss Whedon
Written by: Joss Whedon
Cinematography by: Jay Hunter
Music by: Joss Whedon
Sound: Victor Ray Ennis
Editing: Daniel S. Kaminsky; Joss Whedon
Costumes: Shawna Trpcic
Production Design: Cindy Chao; Michele Yu
MPAA rating: PG-13
Running time: 109 minutes

REVIEWS

Burgin, Michael. *Paste Magazine*. June 27, 2013.
Edelstein, David. *New York Magazine*. May 27, 2013.
Garin, Nina. *San Diego Union Tribune*. June 21, 2013.
Goodykoontz, Bill. *Arizona Republic*. June 20, 2013.
Johanson, MaryAnn. *Flick Filosopher*. June 13, 2013.
Long, Tom. *Detroit News*. June 21, 2013.
MacDonald, Moira. *Seattle Times*. June 20, 2013.
Means, Sean. *Salt Lake Tribune*. June 22, 2013.
Ogle, Connie. *Miami Herald*. June 20, 2013.
Tynan, Alice. *Limelight*. July 13, 2013.

TRIVIA

The film was shot in only 12 days while director Joss Whedon was working on *Marvel's The Avengers* (2012).

MUD

Box Office: $21.6 Million

Mud features an ending that is not remotely believable. That its implausibility does not hurt the film

and, indeed, makes the viewer like the film even more, is a testament to the immense goodwill its excellent writing and acting has generated for its titular character.

Writer and director Jeff Nichol's superb script sets the viewer up to expect one kind of movie but delivers quite a different one. Two bored Arkansas teenagers, Ellis (Tye Sheridan) and Neckbone (Jacob Lofland), sneak out of their houses and board a tiny skiff. A recent flood has lodged a large fishing boat onto the tree tops of a nearby island and the boys have plans of making it their tree fort. Once on the island, they carefully traverse a river filled with water moccasins, and clamber up to the tree to their prize. However, once inside the boat, they find evidence that someone else has already claimed it. They find out who that someone else is when they return to their boat and find a ragged man (Matthew McConaughey) standing next to it with a .45 tucked into the back of his pants. He introduces himself as "Mud" and tells them that he is waiting on the island to meet his girlfriend and would the boys consider bringing him back some food? They agree but the circumstances of his residency on the island reveal themselves to be somewhat more complicated than as presented them by Mud when Ellis and his mother are stopped at a police checkpoint on the highway outside of town and shown a wanted sign with Mud's face on it. "What did he do?" asks Ellis. "Move along" responds the officer.

When one first encounters Mud and his dubious sounding explanation for being on the island, one assumes that the film is going to be a conventional coming-of-age film. Mud will initially present himself as a charismatic father figure and then slowly reveal himself to be a liar and con man, taking advantage of the kids and shattering their youthful innocence. Nichols' film does not do that at all; indeed it does quite the opposite. Mud is refreshingly honest with the boys. When asked why the police are looking for him, he tells them. "A piece of bad business," he sighs wearily and then explains that he has killed a man. Although his stated justification for doing so sounds like a self-serving rationalization, events show him to be telling the unvarnished truth. As a result of his actions some very bad men are looking for him and Mud wants to get the boat down from the trees, in running order and back in the river so he can escape the area with his girlfriend Juniper.

Much of the power of *Mud* belongs to McConaughey who is undergoing an amazing renaissance as an actor. After twenty years of paycheck rom-coms and C-level action movies like *Sahara* (2005), McConaughey seemed destined to ride out the rest of his career as Generation X's answer to Burt Reynolds. However, in recent years, the actor has started putting effort into acting again and taking chances with daring work in challenging films like *Bernie* (2011), *Killer Joe* (2011), *Magic*

Mike (2012), *Dallas Buyers Club* (2013), and *The Wolf of Wall Street* (2013). His renaissance continues with his subtle, charismatic performance as Mud. One of the biggest hurdles in the viewer's suspension of disbelief is that two fourteen-year-old boys would help an older man in such danger but Mud's openness and decency as conveyed by McConaughey overcomes this. McConaughey invests Mud with such sincerity and kindness that the viewer cannot help but like him despite the very poor decisions he has made. So successful is McConaughey that later in the film, when he reminds Ellis that despite what the boy might think, he is not a good man, the viewer, along with Ellis, does not believe him. McConaughey pulls off the extremely difficult feat of rendering a man who is a self-confessed murderer into an innocent.

He is aided by excellent work from a superb stable of actors. Along with McConaughey, Sheridan and Lofland get a majority of the screen time, always a dicey proposal with child actors but they carry the film admirably, delivering performances that feel completely authentic. The rest of the cast is filled with a character actor dream team. Sam Shepard plays Tom, a flinty and mysterious retiree who lives across the river from Ellis and who has a long past with Mud. Shepard delivers a three minute monologue on the origins of Mud's predicament that is a masterpiece of acting and writing, explaining Mud's situation with a concise insightfulness most other films couldn't capture in two hours of exposition. Reese Witherspoon, playing against type, is Juniper, the selfish woman motivating Mud's reckless actions and the underserving object of his devotions. Juniper cannot quite commit to Mud but is not above manipulating his devotion to her when it is of benefit to her. The always-excellent Sarah Paulson and Ray McKinnon (was any actor more born to play an Arkansas fisherman?) play Ellis' distracted parents, Mary Lee and Senior. The superb Michael Shannon (a Nichols' favorite) steals every scene he is in as Neckbone's uncle, Galen, a clam digger who is doing his best to be a father to his parentless nephew. Shannon's *Boardwalk Empire* colleague Paul Sparks plays Carver, the vengeance-seeking brother of the man Mud has killed and Joe Don Baker is his diabolical father, King.

As excellent as these actors all are, they are only capable of being as good as the lines they are given to speak. Fortunately, as he did with his equally superb previous films *Shotgun Stories* (2007) and *Take Shelter* (2011), Nichols thrills the viewer with Mud's subtle, authentic, convention-defying script. Mud's tale is not the only story the film is telling and the film is so well written that any of its subplots could easily take over to become the main narrative and the viewer would be just as invested and intrigued. The viewer does not get the

sense that one does with other films that the supporting characters exist solely to react to the main narrative without having their own lives and motivations. There is the story of Mary Lee and Senior who are contemplating divorce. Mary Lee has grown weary of life on the river and wants to move into town, an action which will allow the government to exercise eminent domain over her riverside home. Senior is opposed to this idea as the river is the source of his livelihood, though that livelihood is emasculatingly insufficient to support his family. There is the story of Ellis' awkward courting of an older girl, May Pearl (he is fourteen; she sixteen). There is the story of the relationship between Galen and his nephew and, of course, the story of the friendship between the Ellis and Neckbone.

What is so refreshing about these stories is that they defy expectation at nearly every turn. Nichols is committed to depicting life as it is, not the way endlessly repeated film cliches have conditioned viewers to expect life to play out on the screen. Senior and Mary Lee are going through their problems and the viewer's prejudices start making the viewer expect him to start beating his wife and son. Instead, at the very moment violence on his part seems most imminent, Mary Lee knocks his hat off his head and he settles down. When Galen spies the boys meeting with Mud, the viewer expects this to mean trouble. Surely, the guy who makes his money scraping the bottom of the riverbed for clams with his bare hands is going to exploit the situation for his own financial gain. Instead he quietly takes Ellis aside and, in a beautifully scripted moment, uses a ceiling fan which he found in the river as a metaphor to explain that the river brings both useful things and trash and you have got to make sure you know which is which. "My nephew looks up to you," he gently explains to Ellis, "don't get him into trouble he can't get out of." Galen wants to help his nephew, not himself. When Ellis feels betrayed by May Pearl, it is not the one-dimensional, plot-necessitated betrayal of a more conventional film but a genuine misunderstanding by someone who is new to love: "We've only gone out on one date" she reminds him after he has impulsively bloodied the nose of her new beau. Like any great work of narrative art the viewer gets the sense that *Mud*'s characters were living their complicated, unpredictable lives before the viewer was exposed to them and will continue to live those complicated, unpredictable lives after the viewer has departed. The viewer has simply been provided with the opportunity to drop into those lives for a couple of magical hours.

The most conventional aspect of *Mud* flows from the murderous blowback resulting from Mud's actions on behalf of Juniper. King and Carver are hunting Mud down and Mud warns the boys to steer very clear of

both, particularly King who, in a delightful turn of phrase, he calls "the triple-six, real-deal Scratch." Even in this most cliche rich of territory, Nichols avoids the predictable path. The viewer is acquainted with King's terrifying nature not from the over-the-top violence that a less imaginative film would supply but simply through the bone chilling vocabulary of the man. King is the kind of man who, closing his eyes and crouching on one knee, joins hands with his hired assassins in a prayer circle and says "let us pray for the death of the man who killed my son." It is the inevitable reckoning between Mud and these men that ultimately unmoors the film from the realm of believability, however it is a welcome departure given the fairly earned affection for the titular character generated by the two hours of superb film-making that has preceded it. *Mud* has earned the right to its romance.

Nate Vercauteren

CREDITS

Mud: Matthew McConaughey
Ellis: Tye Sheridan
Juniper: Reese Witherspoon
Neckbone: Jacob Lofland
Tom Blankenship: Sam Shepard
Galen: Michael Shannon
Mary Lee: Sarah Paulson
Origin: United States
Language: English
Released: 2012
Production: Lisa Marie Falcone, Sarah Green, Aaron Ryder; Brace Cove, Film Nation; released by Roadside Attractions
Directed by: Jeff Nichols
Written by: Jeff Nichols
Cinematography by: Adam Stone
Music by: David Wingo
Sound: Will Files
Editing: Julie Monroe
Costumes: Kari Perkins
Production Design: Richard A. Wright
MPAA rating: PG-13
Running time: 130 minutes

REVIEWS

Burr, Ty. *Boston Globe*. April 25, 2013.
D'Angelo, Mike. *The A.V. Club*. April 24, 2013.
Debruge, Peter. *Variety*. February 26, 2013.
Edelstein, David. *New York Magazine*. April 22, 2013.
Jolin, Dan. *Empire*. May 5, 2013.
Lumenick, Lou. *New York Post*. April 25, 2013.
Scott, A. O. *New York Times*. April 25, 2013.
Sharkey, Betsy. *Los Angeles Times*. April 25, 2013.
Sherstuhl, Alan. *Village Voice*. April 23, 2013.
Uhlich, Keith. *Time Out New York*. April 23, 2013.

QUOTES

Mud: "There are fierce powers at work in the world, boys. Good, evil, poor luck, best luck. As men, we've got to take advantage where we can."

TRIVIA

Around half the crew were Arkansas residents, the production also hired over 400 locals as extras.

AWARDS

Ind. Spirit 2014: Cast
Nominations:
Ind. Spirit 2014: Director (Nichols)

MUSCLE SHOALS

The incredible true story of a small town with a big sound.
 —Movie tagline

Box Office: $691,562

During one of many irresistible anecdotes in the highly entertaining documentary *Muscle Shoals*, R&B legend Wilson Pickett remembers the recording of the hit "Mustang Sally." "We was nitty gritty," he recalls. "Right down in the cold nitty gritty." It would have been easy and forgivable for first-time filmmaker Greg "Freddy" Camalier to sit back and let juicy bits of music history like that speak for themselves. Yet even if *Muscle Shoals* ultimately settles into a certain, electric vamp rather than continuing to find new ways to get funky, Camalier achieves something difficult: Articulating and demonstrating from where the soul of a song comes.

The doc's title comes from the small Alabama community that also gave birth to an almost comically long list of classic songs, including Aretha Franklin's "Respect" and The Rolling Stones' "Brown Sugar." Bob Dylan, Paul Simon, Rod Stewart, Carlos Santana, Willie Nelson, Lynyrd Skynyrd, and many, many more also recorded there. Why? It all started with Rick Hall, the founder of Fame Studios and a man whose greatest musical achievements, like so many iconic songs, sprung from pain. Throughout *Muscle Shoals*, Hall, who notes the impact of his impoverished upbringing, recounts one heartbreaking tragedy after another: His wife died in a car accident eighteen months into their marriage.

His younger brother died after falling into a tub of boiling water in which his mom was washing clothes. His father died after being trapped underneath the tractor Hall bought for him.

Rather than merely providing background information on the film's subject, these stories inform Hall's determination to make it in the music business and the type of sound his ears helped create. (Note: When Keith Richards calls someone tough, that compliment is hard to argue with.) With white musicians playing funk and soul music associated with black artists—Franklin says, "We just didn't expect them to be as funky or as greezy as they were," and no one better try and correct Franklin's use of the term "greezy"—Hall helped spark a feeling that connected his pain, the history of the people of Muscle Shoals, and the big-name artists who wanted a piece of the magic. In fact, as Camalier documents, Hall's backing band, known as the Swampers, helped generate Franklin's first million-selling hit ("I Never Loved a Man the Way I Loved You") and invigorated Etta James' career. These musicians and these studios—the Swampers eventually struck out on their own with record exec Jerry Wexler—were not just latching onto stars; they were creating them.

That said, U2 singer Bono has no business being the first interview subject featured in the film (talking about the studio "turning rust into gold"), and it is clear Camalier wanted to connect the material to the present day but did not know how to do so. No need to talk to John Paul White of the Civil Wars or Alicia Keys, an artist who is merely a pale imitation of the legitimate soul standard-bearers seen through *Muscle Shoals*. Alabama Shakes would have been a wise choice to show how a contemporary artist carries on the flavor of Hall's work.

Similarly, Camalier unwisely remains at a distance from certain tougher issues. Many note how Fame Studios existed outside the racial tension of George Wallace-era Alabama and no conflicts ever emerged inside the studio about the color of the musicians' skin, but how this oasis from bigotry naturally emerged deserves more than just a passing mention. It is as if the filmmaker was unwilling to stray too far from the artists, a hesitance also reflected in the film's interest in capturing the area of Muscle Shoals without actually engaging with the people themselves. Regardless of the classic music that emerged, the place is more than its musicians.

These concerns may not trouble most viewers of *Muscle Shoals*, however, which is heaven for fans of a certain kind of music. And, really, even someone who does not love, say, Percy Sledge's "When a Man Loves a Woman" must appreciate how much was accomplished here. Somewhat recalling a feature-length version of

VH1's *Behind the Music, Muscle Shoals* shows how a hit record is so much more than just the face on the cover and the voice on the tune. (In this the film brings to mind other appealing docs like *Standing in the Shadows of Motown* [2002] and *20 Feet From Stardom* [2013].) It is the horns and the rhythm section and the producer and the city and the groove; that intangible spice that sometimes distinguishes a highly produced product from an organic piece of music that is truly special.

Yes, rather than a creative, revolutionary documentary to suit its source, *Muscle Shoals* may be seen as merely a parade of great stories and great music. All studios and music docs should be so lucky to have that problem.

Matt Pais

CREDITS

Origin: United States
Language: English
Released: 2013
Production: Stephen Badger, Greg Camalier; released by Magnolia Pictures
Directed by: Greg Camalier
Cinematography by: Anthony Arendt
Sound: Eric Stefano; Randy Matuszewki
Music Supervisor: Jill Meyers
Editing: Richard Lowe
MPAA rating: PG
Running time: 111 minutes

REVIEWS

Dargis, Manohla. *The New York Times*. September 26, 2013.
Davis, Steve. *Austin Chronicle*. October 16, 2013.
DeLuca, Dan. *Philadelphia Inquirer*. October 11, 2013.
Goldstein, Gary. *Los Angeles Times*. October 10, 2013.
Feeney, Mark. *Boston Globe*. October 10, 2013.
Jenkins, Mark. *NPR*. September 27, 2013.
Perez, Rodrigo. *The Playlist*. August 13, 2013.
Phipps, Keith. *The Dissolve*. September 25, 2013.
Rothkopf, Joshua. *Time Out New York*. September 24, 2013.
Williams, Joe. *St. Louis Post-Dispatch*. October 24, 2013.

MUSEUM HOURS

Box Office: $558,593

Jem Cohen's *Museum Hours* represents a breakthrough for the talented filmmaker, who has worked in both narrative and documentary film, and here combines

those genres in a manner both seamless and completely ethical. *Museum Hours* combines terrific observational drama and keen insight into the nature of art, and how we engage with it.

Cohen is abetted by two superb central performances. Bobby Sommer plays Johann, a kindly guard at Vienna's Kunsthistorisches Art Museum, who also provides some voiceover narration, his mellifluous Germanic voice engagingly reminiscent of Werner Herzog's. Mary Margaret O'Hara plays Anne, who has come to Vienna from Montreal to visit a cousin who lies comatose in the hospital. Johann's voiceover describes seeing her in the museum several times and being curious about her. One afternoon, he sees her struggling with a map and offers his assistance. The pair strikes up a friendship, and throughout the rest of the film, explore the museum and the city together.

Cohen often uses non-synchronous dialogue and Johann's voiceover to drive the visuals, which only sometimes relate directly to what is being said. Early in the film, Johann discusses some debris on the ground in a painting by Pieter Bruegel the Elder, and Cohen immediately cuts to several shots of trash on the streets of Vienna, which Johann also catalogues. The effect—and it is one that is repeated throughout the film—is to conflate the beauty of the exalted Renaissance painter's work with the beauty overlooked in everyday surroundings. Bruegel's work is a focal point of the film, both because the museum has an impressive collection of his work, and because of the surprising modernity of his broad-ranging focus, as unexpected details are noticeable throughout his work, whether they were of religious iconography or of the simple affairs of peasant life. Thus, Cohen cannily and poetically encourages the viewer to see beauty in the mundane, and nobility in what is considered coarse. This is not presented in the portentously heavy-handed manner of that infamous "dancing plastic bag" in *American Beauty* (1999), but in a completely naturalistic and disarmingly straightforward way. Cohen draws his audience into the quiet, observant rhythms of the work.

Museum Hours is obviously not plot-driven. The plot mainly consists of Johann and Anne hanging out, travelling the city, as he enjoys returning to the spots he appreciates, seeing them through her eyes. Actually, he enjoys seeing them through his own eyes, as he admits in voiceover that it makes him realize how much time he spends sitting at home alone. While the movie focuses on these two very well-delineated, finely drawn characters, it is not character-driven, either. It is idea-driven, which is why the climax of the movie is a brief talk on Bruegel given to a group of tourists by a brilliant guest lecturer at the museum, Gerda Pachner (Ela Piplits), who explains the unique way the artist directs the

viewer's eye to bystanders and passerby, peasants, children, and animals which are not the purported subjects of his paintings. While Cohen illustrates her points with details from the artwork, Pachner beautifully explains the crux of what makes Bruegel such a relevant and politically daring artist, with the same quiet authority and appreciation employed by the filmmaker.

For a work that relies so heavily on simple, lovely imagery to illustrate its points, the movie is filled with fascinating talk. Johann describes a discussion with an art student who worked at the museum, and who saw the old still lifes as garish displays of wealth, and disparagingly compares them to today's hip-hop videos. These wordy passages are simultaneously intellectually stimulating and surprisingly moving.

While *Museum Hours* can be appreciated on a literal level, as a story of two people and their passing friendship, and a celebration of art and the institution of the museum itself, it is more than that. It is rare that a film inspires such contemplation on the nature of art and antiquity and its relation to our contemporary day-to-day existence, and Cohen accomplishes this feat with tremendous subtlety and grace, never crossing the line from intellectually curious observation into didacticism.

In a superb year for uniquely cinematic, reflexive filmmaking that transcends genre, *Museum Hours* can take its own proud place alongside Harmony Korine's *Spring Breakers* (2013) and Shane Carruth's *Upstream Color* (2013), works that insist that the movies are still a vital, dynamic, and powerful art form. In its own quiet but persuasive way, *Museum Hours* subverts expectations and shakes up the firmament of contemporary cinema.

Josh Ralske

CREDITS

Anne: Mary Margaret O'Hara
Johann: Bobby Sommer
Origin: Austria
Language: English, German
Released: 2013
Production: Paolo Calamita, Jem Cohen; released by The Cinema Guild
Directed by: Jem Cohen
Written by: Jem Cohen
Cinematography by: Jem Cohen; Peter Roehsler
Music by: Mary Margaret O'Hara
Editing: Jem Cohen; Marc Vives
MPAA rating: Unrated
Running time: 107 minutes

REVIEWS

Cataldo, Jesse. *Slant Magazine.* June 24, 2013.
Hornaday, Ann. *Washington Post.* August 15, 2013.

Jenkins, Mark. *NPR*. June 27, 2013.

Kohn, Eric. *IndieWire*. June 25, 2013.

Marsh, Calum. *Village Voice*. June 26, 2013.

Phillips, Michael. *Chicago Tribune*. November 15, 2013.

Scott, A. O. *New York Times*. June 27, 2013.

Smith Nehme, Farran. *New York Post*. June 28, 2013.

Turan, Kenneth. *Los Angeles Times*. August 15, 2013.

Vishnevetsky, Ignatiy. *The AV Club*. June 27, 2013.

AWARDS

Nominations:

Ind. Spirit 2014: Film Editing

N

NEBRASKA

Box Office: $17.1 Million

Alexander Payne's *Nebraska* opens with a striking black-and-white image, that of an elderly man (Bruce Dern) walking alone in the opposite direction of a highway off-ramp in Billings, Montana. This sums up Woodrow "Woody" Grant's life as it exists today. Seemingly alone in his own head and doing the opposite of what is expected of him even as he approaches senility. Later in the shot, a police car pulls up, an officer gets out and takes Woody down to the station where his son David (Will Forte) will come pick him up and take him back home where he lives with his wife, Kate (June Squibb), who greets him with "You dumb cluck!" Woody's purpose for starting out on a journey is simple, but foolish: He believes he has just won a million dollars from one of those Publisher's Clearing House-type deals that suckers people like Woody into subscribing to magazines. "If I had a million dollars," Kate says, "I'd put him in a home."

This is the logical conclusion many people would come to in regards to Woody. He does not always know what is going on around him, but he is not yet at the point where he has trouble recognizing people, places or things. He believes what people tell him and he believes that money is his. He only needs it for a couple things: a new truck and a new air compressor. His old air compressor was all but stolen from him when he lived in Hawthorne, Nebraska, where the rest of his family currently resides. If Woody wants to retrieve his winnings, the letter states, he must travel to the headquarters located in Lincoln, Nebraska. It is, of course, a fool's

errand. But Woody's son David takes pity on him and sees it as some kind of opportunity to bond with his father. It helps that David's life is also going nowhere.

The pair takes off on a road trip, stopping along the way to see Mount Rushmore. "It looks unfinished" is all Woody can come up with for this wonder of the world. The bulk of their trip takes place in Hawthorne, an economically depressed, shabby little town where everyone seems to know everyone else. People who live here have probably lived here all their lives, yet nobody can remember the names of the previous owners of any particular establishment. The most exciting evening event in a town such as this is the karaoke night at the local restaurant where the singing is mostly off-key. This is how Woody came to be who he is today. Low expectations from everyone around him yielded low expectations for himself and his two sons. David works in a home theater store while his other son Ross (Bob Odenkirk) seems to be faring better as a local news anchorman.

Woody and David stay with Woody's brother Ray (Rance Howard), his wife Martha (Mary Louise Wilson) and two conversationally-challenged sons Bart (Tim Driscoll) and Cole (Devin Ratray), both of who tease David for taking two entire days to travel from Montana to Nebraska. Word gets out that Woody has won a million dollars and, of course, people suddenly change their behavior around him. Everyone from Woody's past come out of the woodwork, particularly Ed Pegram (Stacy Keach), the man who took Woody's air compressor. To hear everyone tell it, Woody owes money and lots of it and now is his chance to put things right and settle some scores. Eventually, Kate and Ross show up in Hawthorne and no matter how many times they insist that

Woody actually did not win any money, nobody wants to hear that.

This is the kind of storyline that could have devolved into a farce of misunderstandings and complicated scenarios, but in the hands of director Alexander Payne, the storyline is secondary to the deep pain the characters harbor while going about their daily lives. Woody is cantankerous and often confused, but he knows his place and probably is well aware that the money is not coming. But it is something to live for. His wife Kate has no filter and she cannot stand having to look after him all the time anymore. She rarely has a kind thing to say about anyone and seems cheerfully above everyone else. David is clearly the most empathetic, perhaps racking up good karma points so as not to end up as alone and careless as his father. Ross tries to understand his father's plight and David's reasoning for always indulging in Woody's needs to do silly things like travel hundreds of miles to retrieve a prize that obviously will not be there. But he is not without understanding and actually seizes an opportunity, along with David, to steal back the long lost air compressor.

This is the first time Payne is working from a screenplay that he did not co-author. The film was written by Bob Nelson, who has primarily worked in television. But the material is classic Payne. It has numerous echoes of *About Schmidt* (2002), Payne's film that starred an uncharacteristically elderly Jack Nicholson on a roadtrip across middle America to attend his daughter's wedding, a daughter who resents him because of his low expectations of her. The Kathy Bates and Howard Hesseman characters from that film could easily be Woody and Kate Grant a decade or two earlier. *Nebraska* has the perfect scenario for which to bring together all of Payne's specialties: Family conflicts, local flavor and cringe-inducing passages of dialogue that contain far too many uncomfortable truths about human nature.

But Payne is also composing a sort of love letter to his home state of Nebraska in his own unique way. Just as Woody Allen depicted New York with big, gorgeous black-and-white imagery complimented by the pulsating music of George Gershwin in *Manhattan* (1979), Payne and his cinematographer Phedon Papamichael utilize black-and-white to capture the vastness of the American landscape as a way of showing just how small this town of Hawthorne really is. It is Payne's most beautiful looking film and yet it is not a beauty that demands to viewed as such. The score by Mark Orton is gentle and represents more of Woody's state of mind than the endless Nebraska plains. Payne has always had a gift for depicting middle American behavior and mannerisms, but through Papamichael's lens', it has never been more vivid.

Nebraska also represents a stunning showcase for Bruce Dern, who has made quite a distinguished career as one of America's best character actors. Few others could play Woody as he does. His lines are few and far between, but he makes the most of each one. Woody seems like a classic sort of Dern character: No-nonsense, a bit cranky and who would be hard-pressed to show anybody any signs of vulnerability, but everyone knows it lurks there somewhere. One particular moment shows Woody and his family revisiting his old homestead, which is now vacant and decrepit. He sums up his home and perhaps his own life as "just a bunch of old wood and some weeds." Payne, Nelson, and Dern are careful and wise not to underscore that sentiment (or any other, for that matter) too much. One never gets the sense that this is a piece of awards bait. Squibb is more than up to the task of being the outspoken force of nature and Forte, in a nice dramatic turn, easily makes David's choices in the story seem believable and warranted.

Dern in *Nebraska* brings to mind Richard Farnsworth in David Lynch's *The Straight Story* (1999), a late-career starrer for Farnsworth that also depicted an elderly man making a pilgrimage and settling some longstanding family matters once and for all. Both films depict the elderly as fully rounded characters with aching souls and not a lot of time left to heal old wounds. They tell stories of people that most executives in Hollywood would believe do not need to be told and they take place in parts of America that most people would drive right past. That off-ramp Woody walks on at the beginning of the film is conspicuously absent of cars taking detours (save for the policeman), but it is a road often travelled by Payne, a brilliant sort of behavior anthropologist who clearly knows these kinds of places and the people who inhabit them.

Collin Souter

CREDITS

Woody Grant: Bruce Dern
David Grant: Will Forte
Kate Grant: June Squibb
Ross Grant: Bob Odenkirk
Ed Pegram: Stacy Keach
Origin: United States
Language: English
Released: 2013
Production: Albert Berger, Ron Yerxa; Echo Lake Productions; released by Paramount Vantage
Directed by: Alexander Payne
Written by: Bob Nelson
Cinematography by: Phedon Papamichael

Music by: Mark Orton
Sound: Frank Gaeta
Editing: Kevin Tent
Art Direction: Sandy Veneziano
Costumes: Wendy Chuck
Production Design: J. Dennis Washington
MPAA rating: R
Running time: 115 minutes

REVIEWS

Burr, Ty. *Boston Globe.* November 26, 2013.
Calhoun, Dave. *Time Out.* December 2, 2013.
Covert, Colin. *Minneapolis Star Tribune.* November 26, 2013.
Goodykoontz, Bill. *Arizona Republic.* November 21, 2013.
Howell, Peter. *Toronto Star.* November 21, 2013.
Jones, J. R. *Chicago Reader.* November 21, 2013.
LaSalle, Mick. *San Francisco Chronicle.* November 21, 2013.
Long, Tom. *Detroit News.* November 27, 2013.
Rodriguez, Rene. *Miami Herald.* November 26, 2013.
Whitty, Stephen. *Newark Star-Ledger.* November 15, 2013.

QUOTES

Kate Grant: "I never knew the son of a bitch even wanted to be a millionaire! He should have thought about that years ago and worked for it!"

TRIVIA

Bryan Cranston auditioned for the role of David, but director Alexander Payne didn't feel that he was right for the part.

AWARDS

Ind. Spirit 2014: First Screenplay

Nominations:

Oscars 2013: Actor (Dern), Actress—Supporting (Squibb), Cinematog., Director (Payne), Film, Orig. Screenplay
British Acad. 2013: Actor (Dern), Cinematog., Orig. Screenplay
Golden Globes 2014: Actor—Mus./Comedy (Dern), Actress—Supporting (Squibb), Director (Payne), Screenplay
Ind. Spirit 2014: Actor (Dern), Actor—Supporting (Forte), Actress—Supporting (Squibb), Director (Payne), Film
Screen Actors Guild 2013: Actor (Dern)
Screen Actors Guild 2014: Actress—Supporting (Squibb)
Writers Guild 2013: Orig. Screenplay

NO

Adios, Mr. Pinochet.
 —Movie tagline

Box Office: $2.3 Million

No is a smartly engaging fictionalization of the advertising campaign that helped to peacefully depose Chilean dictator Augusto Pinochet. In 1988, under pressure from the world community, including its primary benefactor, the United States, the regime announced that they would hold a plebiscite, in which the population of Chile could vote "Yes," to keep Pinochet in power for another seven years, or "No," to force him to step down. Each side was given 15 minutes on television each day for 27 days preceding the election to promote their position.

Like director Pablo Larrain's two previous films, the despairing and depraved pitch black comedies *Tony Manero* (2008) and *Post Mortem* (2010), *No* is essentially about the Pinochet regime, but it is so different in tone and subject matter that a less observant viewer might not realize it was made by the same filmmaker.

Gael Garcia Bernal plays Rene Saavedra, an advertising wizard who has returned from exile in Mexico to sell soda pop and soap operas on television, taking advantage of the regime's implementation of neoliberal, pro-capitalist policies. Saavedra is no idealist: As the film opens, he is shown at a pitch meeting, explaining that Chile is ready for "the truth" and looking toward "the future," before showing an ad for a new cola called "Free." He lives a comfortable life promoting a slick, phony image of Chilean life.

When Urrutia (Luis Gnecco), the man in charge of the "No" campaign, comes seeking his services, Saavedra is reluctant to get involved, not least because the owner of the ad agency he works for, Lucho Guzman (the brilliant Alfredo Castro, who starred in Larrain's two previous films), is a top advisor to Pinochet's well-funded "Yes" campaign.

When Saavedra agrees to consult "No," perhaps in part because his estranged wife Veronica (Antonia Zegers, the director's wife) is a political activist who is frequently abused by the authorities, Guzman warns him that his relatively plush lifestyle is at risk. As the ads begin to run and "No" gains steam, Guzman does not fire Saavedra, but he becomes more overtly hostile, at one point suggesting that Saavedra has put himself and his young son Simon (Pascal Montero) in danger.

Saavedra tries to run a lighthearted, positive campaign, eventually deciding on the slogan, "Happiness is coming." In short, Saavedra's innovation is to sell democracy as though it was a soft drink. His colleagues, many of whom are ambivalent about participating in a potentially hopeless campaign that might just serve to legitimize the dictatorship, are resistant to Saavedra's ideas at first, preferring to focus on the brutality of life under Pinochet. Eventually, they come around, as slick

graphics, pointed jokes and jingles begin to win over the population.

Guzman has his own problems dealing with a "Yes" camp that resists his efforts to humanize Pinochet. When it becomes clear that "No" is besting them, Guzman is given full control, and uses his airtime to mock and discredit Saavedra's ads. Of course, he goes beyond that, using espionage, sabotage, censorship, and intimidation in an effort to stay ahead in the polls.

That strategizing and counter-strategizing is the heart of the film, and it makes for fascinating viewing. Bernal is likeable as the somewhat mercenary Saavedra, but Castro makes Guzman a fascinating character, vindictive and ruthless but also slyly charming. There is a lot of dark comedy in the machinations of these two men as they work against each other. But Larrain never lets viewers forget that the stakes are life and death. The worst abuses of the dictatorship might not make it into Saavedra's ads, but the movie is suffused with the nation's violent history and with the peril and paranoia of life under Pinochet.

Larrain elected to shoot the movie using a video camera from the era, in part so that his work could be seamlessly integrated with existing news footage. This effectively immerses the film in the time without calling undue attention to its period trappings. *No* is authentically '80s without being campy about it. As with Andrew Bujalski's *Computer Chess* (2013), using the video technology of the time, in all its flawed glory, lends an extra layer of thematic resonance to the visuals.

No serves as an upbeat exclamation point to close Larrain's Pinochet trilogy. There is a truly joyous aspect to its story of nonviolent triumph over brutality and oppression. But to the filmmaker's credit, he ends the movie with Saavedra's return to ordinary advertising, where he uses that same cynical language to sell his next campaign. There is an underlying suggestion that cold, hard capitalism is the final victor of Chile's peaceful revolution, and a decided ambivalence about what that means for the nation's future.

Josh Ralske

CREDITS

Rene Saavedra: Gael Garcia Bernal
Urrutia: Luis Gnecco
Lucho Guzman: Alfredo Castro
Veronica: Antonia Zegers
Origin: Chile
Language: Spanish
Released: 2012
Production: Daniel Marc Dreifuss, Juan de Dios Larrain, Pablo Larrain; Fabula, Participant Media; released by Sony Pictures Classics

Directed by: Pablo Larrain
Written by: Pedro Peirano
Cinematography by: Sergio Armstrong
Music by: Carlos Cabezas
Sound: Miguel Hormazabal
Editing: Andrea Chignoli
Art Direction: Estefania Larrain
Costumes: Francisca Roman
MPAA rating: R
Running time: 118 minutes

REVIEWS

Anderson, Soren. *Seattle Times*. March 28, 2013.
Burr, Ty. *Boston Globe*. March 7, 2013.
Howell, Peter. *Toronto Star*. March 14, 2013.
Lacey, Liam. *Globe and Mail*. March 15, 2013.
Meyers, Jeff. *Metro Times*. April 12, 2013.
Phillips, Michael. *Chicago Tribune*. March 7, 2013.
Rea, Steven. *Philadelphia Inquirer*. March 14, 2013.
Snider, Eric D. *Twitch*. July 13, 2013.
Tallerico, Brian. *Film Threat*. April 24, 2013.
Wilson, Calvin. *St. Louis Post-Dispatch*. March 28, 2013.

TRIVIA

Several people from the real "No" campaign in Chile were hired to play members of the "Yes" campaign in the film.

AWARDS

Nominations:

Oscars 2012: Foreign Film

NOW YOU SEE ME

Four amazing magicians. Three impossible heists. One billion dollars. This is no illusion.
—Movie tagline

Come in close, because the more you think you see, the easier it'll be to fool you.
—Movie tagline

Look closely, because the closer you think you are, the less you will actually see.
—Movie tagline

Box Office: $117.7 Million

Preposterousness caused at least as many jaws to drop in astonishment during screenings of *Now You See Me* as did any of its prestidigitation, with numerous viewers marveling at the film's audaciously-slight degree of believability even more than the sleight-of-hand and other tricks its magicians use in their brazen Robin

Hoodwinking. Indeed, director Louis Leterrier and the film's trio of screenwriters seem to have been as cocky about their own cleverness as do the audaciously-artful quartet onscreen. Those attending live stage shows of magic have long been captivated and exhilarated when what is impossible manifests itself before eyes wide with wonder. They know, of course, that what they have delightedly witnessed are mere-if-mesmerizing illusions, each with its own carefully-cloaked logical explanation. The choice here was to go ahead and repeatedly offer up such elucidating, rational revelations, and accepting them often requires the most profound suspension of one's disbelief. Apparently those behind the film thought that what time and time again amounts to intricate implausibility would come off as intriguingly ingenious, and many did indeed leave theaters impressed and sufficiently satisfied as the $75 million-budgeted film went on to grossing an unexpected $117.7 million in the U.S. and $351.7 million overall despite mixed reviews, leading to the announcement that a sequel would follow. Still, more than a few were irritated and derisive, put out by the way they had been taken in.

Now You See Me begins compellingly enough, as a mysterious hooded figure slips Tarot card invitations to four magicians of different specialties. J. Daniel Atlas (Jesse Eisenberg) is an obnoxiously condescending fast talker whose hands are as quick as his mind. Merritt McKinney (a chuckle-inducing Woody Harrelson) hypnotizes a woman and then shakes down her husband by threatening to snap his fingers and make her conscious—of the man's affair with his sister-in-law. Henley Reeves (Isla Fisher), once Daniel's assistant and girlfriend, is like a hot, shapely Houdini who expertly escapes from a tankful of piranhas that think of her more as supper than sexy. Finally, people on a water taxi are unaware that they are also being taken for a ride by Jack Wilder (Dave Franco, younger brother of James), a picker of both locks and pockets who relieves a man of his watch and wallet with surreptitious skill. When the four arrive at the appointed place and time, a hologram startlingly appears within a freezing, eerily-deserted New York apartment and, for reasons unknown, provides them with instructions for a series of stage appearances from a curiously-anonymous source. That they gallop off together to pack them in a year later in Las Vegas as the apocalyptically-monikered Four Horsemen seems to foreshadow that a day of reckoning may nearly be at hand for some unsuspecting marked men.

The MGM Grand is certainly an appropriate place to kick things off for this brash band of prodigious performers, as the show they put on and the larceny they pull off are indeed grandiose. A supposedly-random audience member appears to be teleported from this venue along the Strip to the vault of his bank along the Seine,

an amazing feat that becomes even more of a crowd-pleaser when millions of euros make the return trip and rain down in the theater. While those watching this presentation-within-a-presentation at their neighborhood multiplex could chalk it all up to movie magic, such audience members still had their curiosity piqued by this wondrous withdrawal: how within the context of the film can the success of this faraway theft committed in front of a live audience be explained? Frustratedly flummoxed within the frame is implausibly-rumpled FBI agent Dylan Rhodes (Mark Ruffalo), who boils even more when forced to team up with French Interpol agent Alma Dray (Melanie Laurent). She stops to fascinatedly delve into the art of magic and the mindset of its practitioners, while the no-nonsense, Fed simply aims to both singlemindedly and closedmindedly pursue them with his full head of steam. The romantic heat that is supposed to result from the friction between them is virtually imperceptible.

The Four Horsemen flamboyantly perform their next altruistic but nonetheless illegal act in New Orleans, puzzlingly choosing to bite—or, more precisely, bilk—the hand that feeds them with a pitilessness that makes them seem akin to the aforementioned flesh-eating fish. After smilingly taking the stage at their behest, benefactor Arthur Tressler (Michael Caine) is flabbergasted and none-too-happy as he watches his millions appear in the bank accounts of audience members whose legitimate insurance claims after Hurricane Katrina were callously denied by his company. Despite the fact that the scene has been sealed off by Dylan, all four protagonists make a smooth escape, and the rest of the film's running time amounts to a lot of just that: the FBI agent hot on their trail and increasingly the same under the collar because the illusionists somehow remain elusive. Through it all, Leterrier's camera seems in dire need of a tranquilizer as it shakes, swirls, swoops, and stalks about, often accompanied by purposefully pulse-pounding music. However, how much excitement, let alone suspense, can really be created with the authorities in such perpetually-ineffectual pursuit of the film's fugitive folk heroes?

"Audiences think they want to know how things are done, but they really don't," insisted *Now You See Me*'s head magic consultant Daniel Kwong in the film's production notes. One need not have read Kwong's expert assertion in order to have been mystified by the film's continual demystification. Deftly sidestepping the appearance of any disrespect to the time-honored Magician's Oath, its explanatory exposition is purposely put into the loose-lipped mouth of former magician and current "notorious debunker" Thaddeus Bradley (Morgan Freeman), who offers uniquely-perceptive perspective to a mountingly-impatient Dylan. While it is confi-

dently asserted here that the hand is faster than the eye, Leterrier and Co. appear to have been just as brazenly certain during segments in which Thaddeus' brain is picked that absurdity could be presented quicker than the brains of those watching could balk. However, the answers to "How?" often elicited a "Huh?" from moviegoers, the details being so outlandish and convoluted that some heads felt as if they were spinning like the merry-go-round that the Horsemen mount after their farewell performance in New York City. "The closer you look, the less you'll see," Daniel had said at the outset, words that increasingly take on additional and unintended meaning. Ophthalmologists likely saw a spike in business due to all the strain-inducing eye-rolling that resulted, particularly from the final revelation that pursuer Dylan was actually the planner, having laid the groundwork since his youth to someday avenge a personally-painful wrong. "The one thing I didn't count on was you," he sappily says to Alma, and the insinuation that his galling Gallic complication is now ardently wanted is as unabashedly unconvincing as anything else in *Now You See Me.*

David L. Boxerbaum

CREDITS

Michael Atlas: Jesse Eisenberg
Henley Reeves: Isla Fisher
Merritt Osbourne: Woody Harrelson
Jack Wilder: Dave Franco
Thaddeus Bradley: Morgan Freeman
Dylan Hobbs: Mark Ruffalo
Arthur Tressler: Michael Caine
Alma Vargas: Melanie Laurent
Origin: United States

Language: English
Released: 2013
Production: Bobby Cohen, Alex Kurtzman, Roberto Orci; K/O Paper Products, SOIXAN7E QUIN5E, See Me Louisiana; released by Summit Entertainment
Directed by: Louis Leterrier
Written by: Edward Solomon; Boaz Yakin
Cinematography by: Larry Fong
Music by: Tom Rowlands; Ed Simons
Sound: Jonathan Null
Editing: Robert Leighton; Vincent Tabaillon
Costumes: Jenny Eagan
Production Design: Peter Wenham
MPAA rating: PG-13
Running time: 115 minutes

REVIEWS

Bowles, Scott. *USA Today.* May 31, 2013.
Denby, David. *New Yorker.* May 6, 2013.
Feeney, Mark. *Boston Globe.* May 30, 2013.
Foundas, Scott. *Variety.* May 31, 2013.
Gleiberman, Owen. *Entertainment Weekly.* May 30, 2013.
Holden, Stephen. *New York Times.* May 30, 2013.
McCarthy, Todd. *Hollywood Reporter.* May 30, 2013.
Merry, Stephanie. *Washington Post.* May 30, 2013.
Rainer, Peter. *Christian Science Monitor.* May 31, 2013.
Travers, Peter. *Rolling Stone.* May 30, 2013.

QUOTES

J. Daniel Atlas: "What is magic? Focused deception. But deception meant to entertain."

TRIVIA

In the original draft of the script, there was no female member of the Four Horsemen.

O

OBLIVION

Earth is a memory worth fighting for.
—Movie tagline

Box Office: $89.1 Million

Science fiction is both the most expansive as well as the most limited genre in existence. At its best, the seemingly limitless imagination can show audiences a better future through technology while exploring the human condition that has survived or failed through such advancements. At its weakest, it can be one of a limited imagination trying to strive on a single idea that already exists in cinema's past. Joseph Kosinski's *Oblivion* wants to take viewers to the end of Earth and the duties of the final survivors to preserve what little is left. Only what is unearthed has already been mined from the fiction of even this generation, let alone the countless predecessors who imagined a future greater than this.

Always important in sci-fi to start with a year: It is 2077 and the planet has been attacked by "Scavengers," otherworldly invaders who destroyed the moon (or, at least, the matte painting of it), causing natural disasters that the planet could not sustain. Nuclear weapons were used as push back and it succeeded, but, naturally, at a price. Survivors were sent to live on an orbiting space station that remains powered as long as Earth's seawater continues to be converted into fusion. The narrator, Jack Harper (Tom Cruise), and his partner, Victoria (Andrea Riseborough) are part of the "effective team" assigned by their mission commander, Sally (Melissa Leo), to repair and maintain the drones that prevent the remaining invaders from attacking the operating fusion stations. This is just the prologue.

Also hinted at is Jack's belief that he is meant for something greater. Two weeks remain for his duty on Earth and he is going to miss the little things: A growing plant he discovers or another book for the collection he has amassed in a little getaway pad he has fashioned. "Earth is still my home," he opines in the prologue. Later, on his daily mission he discovers a crashed ship. As drones fire upon the hibernating crew, Jack rescues Julia (Olga Kurylenko) who looks remarkably like the woman he has been dreaming about. She clearly recognizes him as well though is hesitant to explain why until she obtains her flight recorder. Also being very secretive are another group of survivors led by Malcolm Beach (Morgan Freeman) who want to enlist Jack to their cause but not until he learns and accepts the all-important truth.

The appearance of such a plot turn as an "important secret" is designed to make an audience curious rather than active guessers. The more something is kept from viewers, the more they just have to know what it is. Fifty-four minutes is how long it takes for Freeman's Beach to make his first appearance. There is some playful mocking of what Jack is asked not to do by his superiors—"Don't go into the radiation zone." "Don't ask too many questions."—but no real answers. Despite what should be some trust issues between the two men, Beach instead jumps forward to his master plan and asking for Jack's help to carry it out. Subsequent persuasions are just as ludicrous since they are little more than a ploy for the filmmakers to delay the inevitable.

Beach could have simply provided the necessary exposition in an attempt to convince Jack with Kosinski and writers Karl Gajdusek and Michael Arndt delivering

the necessary visual gut punch which takes another twenty-plus minutes to arrive. Instead, the wait becomes more maddening, especially since the reveal contains more irony than shock, and anyone with a working knowledge of science-fiction from the last few decades will have figured it out long prior. From the beginnings of memory wipes and the push back against a mundane existence familiar to viewers of *Total Recall* (1990) up to an *Independence Day* (1996) inspired climax, the checklist in-between is enough to believe there is not a single original idea running throughout *Oblivion*. Whether Cruise's Jack is more Bruce Dern in *Silent Running* (1972) or Schwarzenegger's Douglas Quaid, or whether Freeman's Beach has been waiting decades to pattern his introduction and cryptic monologues after Morpheus in *The Matrix* (1999), nothing should infuriate sci-fi fans more than just how much is patterned directly from Duncan Jones' amazing *Moon* (2009).

Despite remaining one of the truest moviestars remaining in a dwindling era of them, Tom Cruise still possesses such likability on screen that viewers follow him even through the silliest or blandest of situations. The producers get top-dollar work from the visual effects artists and cinematographer Claudio Miranda, who each beautify the barren wasteland with enough blues and silvers to make the apocalypse actually look like a clean place to live. M80's score, while alternately ethereal and pulse-thumping, is also right on cue when it comes to cloning the compositions for Christopher Nolan's most recent epics. *Oblivion* is more interested in providing the occasional thrill or scenic view than the brand of idea-based science-fiction of *Blade Runner* (1982) or *Solaris* (1972). It is by no accounts a bad film, just an overtly familiar one whose greatest mistake is thinking that viewer memories had been wiped and thus becoming the alien force trying hard to pull one over.

Erik Childress

CREDITS

Jack Harper: Tom Cruise
Malcolm Beech: Morgan Freeman
Julia: Olga Kurylenko
Sykes: Nikolaj Coster-Waldau
Sally: Melissa Leo
Victoria: Andrea Riseborough
Origin: United States
Language: English
Released: 2013
Production: Peter Chernin, Dylan Clark, Barry Levine, Joseph Kosinski; Chernin Entertainment, Monolith Pictures; released by Universal Pictures Inc.
Directed by: Joseph Kosinski

Written by: Karl Gajdusek; Michael Arndt
Cinematography by: Claudio Miranda
Music by: Anthony Gonzalez; Joseph Tranese
Sound: Ren Klyce
Editing: Richard Francis-Bruce
Costumes: Marlene Stewart
Production Design: Darren Gilford
MPAA rating: PG-13
Running time: 124 minutes

REVIEWS

Berardinelli, James. *ReelViews*. April 18, 2013.
Edelstein, David. *Vulture*. April 22, 2013.
Jones, J. R. *Chicago Reader*. April 19, 2013.
McGranaghan, Mike. *Aisle Seat*. April 19, 2013.
O'Hehir, Andrew. *Salon.com*. April 19, 2013.
Orndorf, Brian. *Blu-ray.com*. April 20, 2013.
Rocchi, James. *GeekNation*. April 19, 2013.
Snider, Eric D. *EricDSnider.com*. July 12, 2013.
Tobias, Scott. *NPR*. April 18, 2013.
Turan, Kenneth. *Los Angeles Times*. April 18, 2013.

QUOTES

Jack Harper: "If we have souls, they are made of the love we share, undimmed by time and bound by death."

TRIVIA

Disney had originally acquired the rights to Joseph Kosinski's script in a heated auction but later realized that making a PG-rated film based on the script would require a lot of story changes. The rights were subsequently acquired by Universal Pictures.

OLDBOY

Ask not why you were imprisoned. Ask why you were set free.
—Movie tagline

Box Office: $2.2 Million

When Park Chan-wook's *Oldboy* (2003) erupted it was a revelation of style matched to some considerable substance; though some pondered how seriously they could take a film in which the protagonist eats a live squid in close-up. Difficult too was the level and type of violence in the film, which did much too help turn it into a cult hit and thus tended to negate how seriously it would be taken outside those cultural quarters. In Spike Lee's version of the story, Josh Brolin bends down to peer at a squid in an aquarium but does not eat it. This is a perfect signal for what is wrong with Spike

Lee's re-envisioning. It is a curiosity to be peered at but nothing more. This is a tepid, treatment of complex sensational material that has little reason to exist except that it offers a more accessible narrative, and a nice little twist at the end. Bottom line is that this film neither elaborates on the original nor pays proper homage.

Nineteen hundred and ninety-three is a bad year for Joe Doucett (Josh Brolin), a man unable to see past his own immediate desires. His ex-wife is sick of his absentee styled parenting, and, trusted with an important client to reel in, he seals the deal, only to ruin it by hitting on the client's wife when he thinks the client is out of earshot. Deciding to drown his sorrows (and conscience) at a bar owned by his pal he leaves, and is promptly knocked unconscious.

Waking up in what he initially believes is a hotel room, he quickly discovers he is being held captive. The room is sparsely decorated. He is given regular meals of Chinese dumplings and access to a TV, through which he learns he has been framed for the rape and murder of his ex-wife and that his daughter Mia has been given to another couple. Plunging into despair, he tries to kill himself but is stopped when a gas is pumped into the room knocking him out. This goes on for twenty years during which he cycles through his emotions until deciding to take charge of his situation. Using the TV to train himself to fight, he grows stronger, stops drinking and puts together a list of all the people who may have hated him enough to imprison him.

Twenty years later, it is 2013 and he sees Mia, now an adult, being interviewed on a program called *Unresolved Mysteries of Crime*. As she confesses that she could forgive him if they ever met again his resolve to escape his prison is boosted but he is once again drugged before he can act out. This time, however, he wakes up in an antique trunk which has been placed in the middle of a lush green field. He has been dressed in a nice suit, and discovers a cellphone and a large sum of cash.

In the distance, he sees a woman he thinks he recognizes and chases her as far as he can, only to lose her in a crowd outside a clinic, where he meets a nurse named Marie (Elizabeth Olsen). Sensing something wrong, she offers to help him but is rebuffed though he does take her card. Later, while relating the events of his imprisonment to Chucky, he at last hears directly from his captor (Sharlto Copley), which sends him into such a rage he races through his list trying to locate The Stranger only to collapse days later, defeated. Chucky finds Marie's card and she arrives to care for Joe. While there, she sees the dozens and dozens of letters written by Joe to his daughter, and joins him on his quest to find the restaurant that had served him the same meal of dumplings for over twenty years, sure that they are still bringing dumplings to the place where he was held. After many tries, they discover the eatery and Joe decides to follow a customer who has picked up a large order. When the location proves to be the place of his captivity, Joe goes on a quiet killing spree, working his way inexorably toward the man running the facility. The man's name is Chaney (Samuel L. Jackson), whom he tortures for information until he is forced to fight his way past twenty or so hired thugs. Arriving injured back at Chucky's he finds the bar is now occupied by The Stranger who offers him the following deal: If Joe can discover The Stranger's true identity and why he imprisoned Joe for all those years he will give Joe $20 million dollars and kill himself. If Joe cannot accomplish this within the specified timeframe, then The Stranger will kill Mia.

As Joe races against time, discovering more and more about the hidden relationship between himself and The Stranger, he and Marie become lovers. But Joe also discovers that The Stranger is not the only one who is not what he appears. More murder and more revelations lead to a soul-shattering denouement within the upper stories of The Stranger's palatial hi-rise.

The plot is virtually identical to that of the original film with a slight twist given to the revelation about The Stranger and a hard twist given to the fate of Joe. While potentially interesting, neither one is put to particularly interesting use and they add little to the overall effect of the film which is pretty tedious for anyone who has seen the original. There is also extensive use of CGI bloodwork, which mutes almost every moment of the film's near-constant violence. Thus, action scenes, which seem indifferently staged or simply cribbed here, have little to no payoff. But the real deal breaker is about midway through the runtime when it becomes evident that Spike Lee has nothing to add to the film visually. This is an American film in the sense that it takes zero risks while telling a supposedly exciting or cutting edge story.

Josh Brolin brings some craft to the role of Joe but, as rewritten, the character lacks the manic edge that helped make the melodramatic storyline believable the first time around. He seems less mad than simply driven. Elizabeth Olsen is given a denser back story to help fill out her character but the film does not use it to any particular advantage. She remains a pawn in the story.

Sharlto Copley seizes the chance to play a movie villain by the short hairs but he struts through his scenes like a weird peacock that knows it will be the center of attention no matter what it does. By the end of the film, his Stranger feels as posed as the rest of the piece. Samuel L. Jackson as Chaney offers the brightest splash of color in a cast of eccentric characters as the man who runs the lockup where Joe is held.

As this is a remake the question may be posed, "Will this film be interesting to those who have not seen the original?" The answer in such cases is almost always yes. It is easy to imagine audiences watching and enjoying, at least to some degree, this tedious film for the same reason they enjoy and popularize so many other unaccomplished movies every year. It is there. It provides distraction. What it does not do is begin to approach the philosophic complexity, or aesthetic value that made the original a classic.

Dave Canfield

CREDITS

Joe Doucett: Josh Brolin
Marie Sebastian: Elizabeth Olsen
Adrian/The Stranger: Sharlto Copley
Chaney: Samuel L. Jackson
Chucky: Michael Imperioli
Dr. Tom Melby: James Ransone
Origin: United States
Language: English
Released: 2013
Production: Doug Davison, Roy Lee, Spike Lee; 40 Acres and a Mule Filmworks, OB Productions, Vertigo Entertainment; released by FilmDistrict
Directed by: Spike Lee
Written by: Mark Protosevich
Cinematography by: Sean Bobbitt
Music by: Roque Banos
Sound: Michael Baird; Steve Aaron
Editing: Barry Alexander Brown
Art Direction: Peter Borck
Costumes: Ruth E. Carter
Production Design: Sharon Seymour
MPAA rating: R
Running time: 104 minutes

REVIEWS

Brody, Richard. *New Yorker*. December 2, 2013.
Chang, Justin. *Variety*. November 26, 2013.
Corliss, Richard. *TIME Magazine*. November 26, 2013.
Gilchrist, Todd. *The Wrap*. November 26, 2013.
Guzman, Rafer. *Newsday*. November 26, 2013.
Pevere, Geoff. *Globe and Mail*. November 27, 2013.
Rainer, Peter. *Christian Science Monitor*. November 27, 2013.
Scott, A. O. *New York Times*. November 26, 2013.
Whitty, Stephen. *Newark Star-Ledger*. November 26, 2013.
Zacharek, Stephanie. *Village Voice*. November 26, 2013.

QUOTES

Adrian: "Heaven make me free of it. The rest is silence."

Actor Josh Brolin personally created the film's title artwork.

OLYMPUS HAS FALLEN

When our flag falls our nation will rise.
 —Movie tagline
We are never stronger than when we are tested.
 —Movie tagline

Box Office: $98.9 Million

Olympus Has Fallen is a generic movie of a different era. Witnessing its displays of cliche heroism for means of shabby jingoism, one wonders if its script was scribbled out not long after the 1988 premiere of John McTiernan's revolutionary *Die Hard*, and locked into a time capsule for nearly twenty-five years.

One of the first films to present a vivid invasion of the White House post September 11th, the film states its thesis of "Stay Alert" immediately, as those are the words of advice from presidential bodyguard Mike Banning when he is boxing with President Benjamin Asher (Aaron Eckhart). However, it is uncertain how anyone could then protect themselves from the rogue tree branch that attacks a car in their presidential convoy on a winter night, which causes a fatal accident that sends the president's limo over the edge of an icy bridge with the First Lady (Ashley Judd) still inside.

Months after the tragedy, Banning is no longer in the Secret Service, and has taken a menial desk job. He finds himself back in heroic service when he witnesses a terrorist attack on Washington D.C., as a bomber plane unleashes a hail of gunfire at random civilians, and a fleet of armed men storm the White House. With this group of North Korean terrorists taking over the White House in the span of thirteen minutes, as led by Kang (Rick Yune), Banning is the country's last resort, using his previous job skills to retrieve the president's missing son Connor (Finley Jacobsen), while also freeing the president before he and his staff forfeit all of their nuclear codes to the enemy. He receives help from Speaker of the House Trumbull (Morgan Freeman), who assumes the presidency during these drastic times.

Butler, still chasing his dream of being a great action movie star from the 1990s, allows himself to be steered by the automatic coursing for which his character was created. Like the many men before him, he is a forgetful hardworking husband, disgraced underdog, and cracker-of-wise even in the most morbid of circumstances. Having both muscle and sarcasm for the genre's main requirements, Butler fills the job efficiently, albeit without adding any unique flavor.

For a movie centered around its gunplay, this film features a decent amount of heavy hitters; they certainly add a bit of pull to dramatic scenes that feel otherwise disposable, their characters as blatantly drawn out as anything else in this film. Eckhart has got the peaks of testosterone (and the regal chin) to fitfully immediately embody a believable image of a thoroughly American president. Freeman functions best as crowd-pleaser when he assumes presidential responsibilities, waving the movie's flag when he states "As a nation, we are never stronger than when we are tested." Yune is not so striking as the lead menace, as his lack of charisma is mistaken for a cold demeanor. The film's biggest standout is Melissa Leo, playing the president's Secretary of Defense. A bone-breaking and blood-drooling interrogation for her nuclear codes is one of the film's most intense scenes.

This anesthetizing debut script from married screenwriting team Creighton Rothenberger and Katrin Benedikt is even uglier in the hands of its specific producers, despite the contradictory wishful intent by its director. Key producers like Avi Lerner and Danny Lerner are clearly aiming to use the script as instructions to slap together a marquee project that fits their authorship, which has only upgraded from direct-to-video roots in terms of budget size. This film, like 2013's *The Big Wedding* or the two *Expendables* movies from 2010 and 2012 respectively, fits into their mission of churning out disposable and nostalgic B-movie events that are overpacked with talented actors, using their presence to create the illusion of being a significant event of genre nostalgia. To cater such a party, they have chosen Antoine Fuqua, a director who has previously visibly expressed appreciation for those who sacrifice in thankless service, from the Special-Ops at the center of *Tears of the Sun* (2003) to the mortified cops in *Brooklyn's Finest* (2009). Even with *Olympus Has Fallen*, Fuqua states clearly in the film's press notes that he wanted to use this story to honor the Secret Service. But the entire production, not just his subsequent lazy direction, only presents its new heroes as generic action surrogates, who are as synonymous and disposable as the terrorists who lay siege on the White House.

Fuqua enables the project's low standards with his own uninspired direction, numbing his action experience despite its red-blooded angst. Moments of combat are chopped for immediacy, not tension, without striking visuals to jolt its innocuous spectacle. It maintains B-movie status with a prolific sense of sloppiness, from the groups of extras that surround Speaker Trumbull who are but a blank chorus of men and women all with their heads in their hands, or the insert news clip with the grammatically incorrect headline, "Terrorist Attack The White House."

Fuqua's grandest moment comes not from any depictions of such heroism in the film, but with the spectacle of terrorism that aims to enlist its outraged audience for vengeance as reassertion of a nation's strength. Constructed to present viewers with a nightmarish front-door entrance to a symbol of all-American security, it is a brutal moment of land and air massacres with ruthless civilian casualties by acts of terrorism such as suicide bombings. It provides the film its few tinges of active discomfort, jolting the memories in post-9/11 psyches. However, fitting to the true plasticity of this project, its cheaper aspirations are shown naked when unfinished special effects distract from experiencing full horror in moments, such as the deadly collapse of the Washington Monument.

Proudly brandishing political weapon phrases like "the United States doesn't negotiate with terrorists" (also stated by Freeman) as placed alongside tough guy taffy dialogue, *Olympus Has Fallen* recognizes the modern national security nerves of its audience, but responds to them with a derivative experience. In terms of spectacle, Fuqua is too stubborn to think beyond of the *Die Hard* comparisons he certainly yearns for, ultimately servicing waning nostalgia for genre elements significantly more than the real-life heroes he also wants to revere.

Nick Allen

CREDITS

Mike Banning: Gerard Butler
President Benjamin Asher: Aaron Eckhart
Speaker Trumbell: Morgan Freeman
Kang: Rick Yune
Secret Service Director Lynn Jacobs: Angela Bassett
Sec. of Defense Ruth McMillan: Melissa Leo
Forbes: Dylan McDermott
Leah Banning: Radha Mitchell
Roma: Cole Hauser
Connor: Finley Jacobsen
Margaret Asher: Ashley Judd
Gen. Edward Clegg: Robert Forster
Origin: United States
Language: English
Released: 2013
Production: Alan Siegel, Danny Lerner, Gerard Butler; Millennium Films, Nu Image Films; released by FilmDistrict
Directed by: Antoine Fuqua
Written by: Creighton Rothenberger; Katrin Benedikt
Cinematography by: Conrad W. Hall
Music by: Trevor Morris
Sound: Mandell Winter

Editing: John Refoua
Costumes: Doug Hall
Production Design: Derek R. Hill
MPAA rating: R
Running time: 120 minutes

REVIEWS

Berardinelli, James. *Reel Views*. March 21, 2013.
Duralde, Alonso. *The Wrap*. March 21, 2013.
Graham, Adam. *Detroit News*. March 22, 2013.
Hornaday, Ann. *Washington Post*. March 22, 2013.
Hunt, Drew. *Chicago Reader*. March 28, 2013.
Morgenstern, Joe. *Wall Street Journal*. March 21, 2013.
Rea, Steven. *Philadelphia Inquirer*. March 21, 2013.
Scott, A. O. *New York Times*. March 21, 2013.
VanDenburgh, Barbara. *Arizona Republic*. March 21, 2013.
Weitzman, Elizabeth. *New York Daily News*. March 21, 2013.

QUOTES

Mike Banning: "Sorry about the house, sir."
President Benjamin Asher: "It's ok. I believe it's insured."

TRIVIA

The role of the Secret Service director was originally written for a man but director Antoine Fuqua persuaded Angela Bassett to audition and subsequently had the role re-written for her.

ONE DIRECTION: THIS IS US

Experience their lives on the road.
—Movie tagline

Box Office: $28.9 Million

The truth about propaganda (and what is marketing, but propaganda that serves commerce instead of ideology?), what makes propaganda work, is that it does not feel like propaganda if the recipient of it truly wants to believe what it is telling him or her.

One Direction: This is Us is ostensibly a concert-documentary about the internationally successful British boy band One Direction, directed by well-known documentarian Morgan Spurlock (himself no stranger to self-promotion and attention-grabbing publicity stunts with his films *Super-Size Me* [2004], *Where in the World is Osama Bin Laden* [2008], and *The Greatest Movie Ever Sold* [2011]). Like many recent pop-music concert documentaries, *This is Us* purports to give the viewers—namely the band's millions of dedicated, mostly female, mostly young fans, known as "Directioners"—a look

back at the band's (somewhat artificially constructed) origins and rapid rise to fame, as well as (seemingly equally artificial) peeks behind the scenes at their crazy rock-star lives; all of it interspersed among fan-pleasing concert performances.

Naturally, as with most recent pop-music concert documentaries, all of this is carefully sanitized and rubber-stamped by the band's handlers, promoters, and multi-media record-label conglomerates—including One Direction's mastermind, the media impresario and TV host Simon Cowell, who assembled the band during the 2010 season of Britain's *The X-Factor* talent show and produced the film. There is no drinking, no smoking, no swearing, no sexual or romantic pursuits and conquests. Carefully balancing the illusion of candor and a charmingly controlled sense of anti-authority rebelliousness, the film perpetuates exactly the image One Direction and the band's corporate minders want to present to the excitable, impressionable fans. One excitable, impressionable fan blubbers that she loves the band because, "They say what we want to hear," and *This is Us* is clearly the "us" the band wants viewers to see. (In 3D, naturally.)

Fortunately, like the band's exceedingly charming young members and their hummable-but-forgettable teen-dream songs, all of this carefully "honest" and "warts and all" mythmaking is pleasant enough to take in. Despite Spurlock's iconoclastic reputation, *This is Us* follows the same formula as other films about pop stars like Justin Bieber and Katie Perry: There are childhood photos, chats with proud parents, scenes of backstage hijinks, hanging out in hotel rooms, airport lounge naps, faux-authentic "days-off" activities, and of course a lot of footage of and interviews with screaming girls.

Part of those charming members' charm is that—in keeping with a certain tradition of British stiff-upper-lip stoicism, realism, and even fatalism—as they hop around the world from London to New York City's Madison Square Garden, to Europe, Japan, and Mexico City, they seem to genuinely know how lucky they are and how much of their amazing success is the fleeting stuff of pop-culture dreams. There is a nice campfire scene late in the film during which the lads muse philosophically beyond their late-teens/early-twenties years about how one day this will all come to an end. How much of that cocky-but-humble demeanor is genuine and how much is the result of training by media handlers is unclear, and *This is Us* is not the kind of film that is going to dig in to find out.

Though great pains are made to make One Direction feel like an ensemble of (working-class lad) equals (so that every fan can have his or her favorite), the band's clear stand out in terms of smoldering, sexy image and

grudging charisma is Harry Styles, a young Mick-Jagger swagger-alike who projects a likably sullen disbelief over it all, even as he clearly enjoys soaking up the benefits of teen fame. Meanwhile the rest of the band fit into neat stereotypes: Louis Tomlinson is the Nice Boy-Next Door; Irish Niall Horan is the Goofy Cut Up; Liam Payne is the Serious Dreamer; and Zayn Malik, of Pakistani descent, is the Mysterious Artist.

Little of Spurlock and his usual idiosyncratic style slips through all this pop-image creation. (This may be the first of Spurlock's films that he does not himself appear in.) There are a few cinematic quirks here and there, such as a scene in which a neuroscientist explains what happens to the dopamine levels in a teenage girl's brain when she gets happily excited over One Direction. On the less-flashy side, the film's most interesting segments are those with the boys' parents—one of the mothers notes with more than a hint of melancholy that, "they became like someone in a magazine or newspaper to you," while another wistfully says, "he went to an audition and never came home again." Nor is it confined to the mothers—there is a very touching moment as Liam's father talks about how much he misses his boy during what are usually father-son bonding years.

For a while, all this charm and familiar faux-candor carries even the non-fan viewer through the relatively engaging first half of *This is Us*. After that, however, the film becomes more of exactly the sort of same the fans cannot get enough of. In fact, in a move born more of crass commerce than fan-loving altruism, Sony Pictures/TriStar released a new version of *This is Us* into theaters two weeks after the original's debut—the special "Extended Fan Cut" contained 20 more minutes of footage, four new songs, and neatly guaranteed that die-hard Directioners would gladly pay up again to see the slightly altered film.

Despite the hip, indie-film cred Spurlock's presence is intended to bring to it, it would seem impossible and even irresponsible to call something like *One Direction: This is Us* a "documentary": This is pure marketing, pure propaganda. That does not necessarily make the film an overtly bad thing, though as promotional hagiography, it is probably not a must-see thing for anyone but Directioners and the pop-culture curious who want to see (a very sanitized version of) what all the screaming is about.

Locke Peterseim

CREDITS

Himself: Niall Horan
Himself: Zayn Malik
Himself: Liam Payne
Himself: Harry Styles
Himself: Louis Tomlinson
Origin: United States
Language: English
Released: 2013
Production: Simon Cowell, Ted Kenney, Adam Milano, Ben Winston, Morgan Spurlock; Syco Entertainment Ltd., Warrior Poets; released by Sony Pictures Entertainment
Directed by: Morgan Spurlock
Cinematography by: Neil Harvey
Music by: Simon Franglen
Sound: John Warhurst
Music Supervisor: Kier Lehman
Editing: Marrian Cho; Guy Harding; Cori McKenna; Wyatt Smith; Pierre Takal
MPAA rating: PG
Running time: 92 minutes

REVIEWS

Bale, Miriam. *New York Times*. August 29, 2013.
Bradshaw, Peter. *The Guardian*. August 29, 2013.
Dowd, A. A. *Onion A.V. Club*. August 29, 2013.
Hirsh, Marc. *Boston Globe*. August 29, 2013.
Koski, Genevieve. *The Dissolve*. August 29, 2013.
Lemire, Christy. *RogerEbert.com*. August 31, 2013.
Merry, Stephanie. *Washington Post*. August 29, 2013.
Nicholson, Amy. *Village Voice*. August 28, 2013.
Olsen, Mark. *Los Angeles Times*. August 29, 2013.
Zwecker, Bill. *Chicago Sun-Times*. August 29, 2013.

ONLY GOD FORGIVES

Time to meet the devil.
—Movie tagline

Box Office: $779,188

More comparable to his obscure stateside John Turturro-starring flop *Fear X* (2003) than sexy anti-action movie *Drive* (2011), *Only God Forgives* is a piece of stylized, ghostly atmosphere much more than it is a film with a specific narrative direction, or intent to excite anyone more than its director, Nicolas Winding Refn. Most importantly, it is a film that firmly exists within the context of Refn's realm of Eurotrash art, and solely for the reverence of his holy trinity of sex, violence, and cinema. But even with the purely Refn aesthetic never making any promises to its audience, it is a thoroughly compelling film experience.

Placing the audience into an omnipotent point of view, *Only God Forgives* plays out like the title deity's own recollection of a gruesome memory. In underground

Bangkok, ex-American Julian (Ryan Gosling) runs a Muay Thai boxing business, where he trains and makes money off fighters with his brother Billy (Tom Burke). When Billy is killed in cold blood for murdering a hooker, Julian's mother Crystal (a delightfully bizarre Kristen Scott Thomas) arrives in Bangkok, and urges her son to find the killer (a samurai sword-wielding cop named Chang, played by Vithaya Pansringarm). This begins a cycle of killings that lead Julian and Chang to a decisive boxing match.

In his second role for Refn, Gosling continues to play handsomely into the director's particular vision of who the perfect male protagonist should be. Like Tom Hardy's Charles Bronson in *Bronson* (2008), Mads Mikkelsen's One-Eye in *Valhalla Rising* (2009), or Gosling's previous Driver character, Julian is a rebellious outsider with mysterious repressions. Gosling plays him with brooding restraint; a definitive marionette to the impulsive atmosphere that Refn creates with his movies. In *Only God Forgives,* Gosling can be gentle, treading through these hallways like he is protective of them, but in certain moments will burst with disconcerting rage.

As Julian internally wrestles with his angst as previous Refn lead creations, he also carries much of the same flaws. Refn certainly is attracted to a type of masculine protagonist, but continues to be too stubborn to explore them. Instead he uses them most of all as genre set pieces who are spruced up by the inherent charisma brought in from their portrayers, especially with his more wordless heroes like One-Eye, Driver, or now Julian. In this regard, another Gosling role that is light on dialogue proves fairly serviceable to the movie, and not only because Refn can get people in seats on the promise of seeing Gosling's spectacular face on the big screen alone. The presence of Gosling, especially in this movie, provides a diversion; the audience can turn to him for the familiar when things get too weird, weirder than they ever did in *Drive*. But the joy to be found in this movie, as expressed directly by Refn, is the disarmament of this star's safety that he seems to provide.

With the humble presence of a side character who somehow found himself with more screen time, Pansringarm and the devastating blade he carries on his back present the film's element of unforgiving justice. Shown crooning ballads at karaoke on at least three occasions, he is a fitful embodiment of how this movie deals with its handling of genre. Even when his moments might be considered cheesy, he compels the viewer with his darkness, the audience's physical language paralyzed to simply watch.

With this movie coming with anticipation from those who enjoyed *Drive*, perhaps Refn shows his strongest awareness of playing against such expectations with the *Only God Forgives* soundtrack, using the same composer as that film but consciously diverting from using an electronic score. Bits of Cliff Martinez's score even begin to hint at that film's primary arrangement of drum machines or synthesizers, but soon change direction before any correlation can be made. Refn turns out to be quite the tease with these bits, especially with an authorship that is very familiar with scenes in which acts of violence are carried out to dance hall music, or even in dance halls themselves. (This movie's soundtrack, instead of offering more future cult hits like Kavinsky's "Nightcall," only provides viewers with Thai pop ballads, as performed in the extensive karaoke scenes.)

Lined by a slow narrative that complements Refn's emotional breaks, *Only God Forgives* is a rich piece of ambiance; images memorable in their beauty, brutality, or equal amounts of the two. With its thoroughly realized cinematography from Larry Smith, the film recognizes its most crucial element of soaking up its stylized atmosphere, as conveyed in the pensive footsteps of characters as they lead us on a tour through Refn's dark hallways, or the numerous tracking shots that film human beings like they are locations. As calm as this film may function, with even its characters looking like they walk in slow motion, this is a movie that is so tangible with its imagery that even long after the film is over, its vamping moments linger on the viewer.

If the gruesome piece of observation that is *Only God Forgives* is playfully pretentious, then such is certainly a celebration of another element of his film-making; he is the type of director that takes the idea of art creationism to a holier-than-all extent. With Refn as the god over his characters and their environments, they operate more like movie beings than human beings, as if they are constantly waiting for a standoff to happen, even if no one else in the room. For a director who claims to have no storyboards for his films, this particular visionary is fascinatingly in complete control of his characters and environments, like they are action figures. When a character is not being used, they remain still. Sitting quietly and observing, mirroring the mesmerized physicality of experiencing cinema itself.

Nick Allen

CREDITS

Julian: Ryan Gosling
Crystal: Kristin Scott Thomas
Chang: Vithaya Pansringarm
Billy: Tom Burke
Origin: Denmark, France
Language: English, Thai

Released: 2013

Production: Lene Borglum, Sidonie Dumas, Vincent Maraval; Bold Films, Filmi Vast, Gaumont Productions, Wild Bunch; released by Radius-TWC

Directed by: Nicolas Winding Refn

Written by: Nicolas Winding Refn

Cinematography by: Larry Smith

Music by: Cliff Martinez

Sound: Kristian Eidnes Andersen

Editing: Matthew Newman

Costumes: Wasitchaya Mocharakkul

Production Design: Beth Mickle

MPAA rating: R

Running time: 90 minutes

REVIEWS

Burr, Ty. *Boston Globe.* July 18, 2013.

Frosch, Jon. *The Atlantic.* May 28, 2013.

Hornaday, Ann. *Washington Post.* July 19, 2013.

Jones, J. R. *Chicago Reader.* July 18, 2013.

Morgenstern, Joe. *Wall Street Journal.* July 18, 2013.

Rodriguez, Rene. *Miami Herald.* July 19, 2013.

Roeper, Richard. *Chicago Sun-Times.* July 23, 2013.

Rooney, David. *Hollywood Reporter.* May 23, 2013.

Stewart, Sara. *New York Post.* July 18, 2013.

Whitty, Stephen. *Newark Star-Ledger.* July 19, 2013.

QUOTES

Julien: "It's a little more complicated than that, mother."

Crystal: "Meaning what, exactly?"

Julien: "Billy raped and killed a sixteen year old girl."

Crystal: "I'm sure he had his reasons."

TRIVIA

The name "Chang" is Thai for "Elephant," which is considered a sacred animal in Thailand due to its place in Buddhist mythology as possibly being the Father of Buddha itself.

OUT OF THE FURNACE

Sometimes your battles choose you.
—Movie tagline

Box Office: $11.3 Million

After delivering a 4-star film about a character as standard as a country singer with a drinking problem in 2009's *Crazy Heart*, writer-director Scott Cooper may have thought to himself, "With the right cast and proper grit, I can make excellence out of anything." That is the only way to explain the many great performances at

odds with the minimally explored ideas in Cooper's dark follow-up, *Out of the Furnace.*

Christian Bale, far more natural than his turn in the overrated *American Hustle* (2013), stars as Russell, a Pennsylvania steel mill worker whose dad spent his days the same way and, according to Russell's younger brother Rodney (Casey Affleck), paid with his life. Rodney has given a lot of himself too: The Iraq veteran returns to a life of no opportunity, and he would rather die than follow in his family's career path. "Liquid dinner?" Russell asks Rodney, who is far from the only soldier to come home and hit the bottle. "It's the dinner of champions," he replies.

Obviously, *Out of the Furnace* is a story of people, ahem, in the figurative furnace, which applies to both of these brothers in different ways. Russell spends years in prison after committing vehicular manslaughter while driving drunk, an example of one moment derailing a life also seen in 2011's *Another Earth*, to name just one example. He emerges—after essentially doing the same job inside as he did outside, it is worth noting—to find his girlfriend Lena (Zoe Saldana), who never visited him, is now with Chief Barnes (Forest Whitaker). Rodney, meanwhile, keeps digging deeper holes for himself, attempting to pay off his debt to local crime lord John Petty (Willem Dafoe) through bare-knuckle fighting, except Rodney cannot be trusted when asked to take a dive. He insists that John bring Rodney to fight in the Ramapo Mountains of New Jersey; John does not want to but ultimately relents, despite knowing nothing good can come from more time spent with the nasty Harlan DeGroat (Woody Harrelson).

In fact, representatives of the Ramapough Native American tribe filed a lawsuit in December 2013, claiming that *Out of the Furnace* presents a negative depiction of their people. Without commenting on the suit itself, it is easy to see why someone would take issue. In Cooper's film (co-written by Brad Ingelsby), the people of the region are shown as potentially inbred, amoral drug dealers who live outside the law and instill fear into the police. That is certainly what causes hesitation in Chief Barnes when Rodney goes missing, and it is why Russell takes it upon himself to search for the brother with whom, even as time passes and their facial hair changes, he has always been close.

Out of the Furnace is the sort of movie that receives raves only for its cast, and deservedly so. With the exception of Whitaker's distracting grumble, which seems like he wanted to show Bale his Batman impression, every other actor does his or her best to elevate the material. Harrelson is terrifying as a man who always works to assert his dominance. In the film's opening sequence, Harlan's menace at a drive-in movie theater sets the tone for

much of the violence and cold sense of justice to come. Later, a perfectly acted scene between Russell and Lena, in which she shows him that he will never get her back and he must find a way to be happy for the woman he loves even while he is being crushed, is intimate and specific in the ways much of the rest of *Out of the Furnace* feels vague and second-hand. Compared to something like 2010's *Winter's Bone*, *Out of the Furnace* lacks vivid characterizations and a commitment to telling a lived-in story rather than relying on familiar types in an unsettlingly realized community.

Are great performances enough to defend a movie's lack of moral examination or rich storytelling? Not really, though it matters that the ensemble of *Out of the Furnace* so effortlessly blends together, as opposed to the dulling effect of nearly everyone in *August: Osage County* dialing up the drama and emotion and canceling each other out. In *Out of the Furnace*, though, Cooper should have done more to explore the military's failure to help its veterans; John notes Rodney would be safer in Iraq, and Rodney, seemingly receiving no mental health treatment and minimal if any financial assistance, asserts that he is not the same man he was before he went overseas. Cooper also struggles to make a coherent statement about what it takes to hunt someone or something and should not just set up the late-2000s era and its widespread financial crisis with Ted Kennedy on TV assisting Barack Obama's campaign for the presidency. This worked better in 2012's underrated *Killing Them Softly*.

So someone watching *Out of the Furnace* closely will almost certainly see the holes and the cliches and wish strong performances like this were in service of something that had been more thoroughly thought out. As a rough vision of tough people who do not just look like rich actors growing beards and imitating a blue-collar perspective, however, *Out of the Furnace* still has the ability to singe.

Matt Pais

CREDITS

Russell Baze: Christian Bale
Rodney Baze, Jr.: Casey Affleck
Harlan DeGroat: Woody Harrelson
Lena Taylor: Zoe Saldana
John Petty: Willem Dafoe
Wesley Barnes: Forest Whitaker
Origin: United States
Language: English
Released: 2013
Production: Michael Costigan, Leonardo DiCaprio, Ryan Kavanaugh, Ridley Scott, Tony Scott; Appian Way; released by Relativity Media L.L.C.

Directed by: Scott Cooper
Written by: Scott Cooper; Brad Ingelsby
Cinematography by: Masanobu Takayanagi
Music by: Dickon Hinchliffe
Sound: John D. Morris
Music Supervisor: Bob Bowen
Editing: David Rosenbloom
Art Direction: Gary Kosko
Costumes: Kurt and Bart
Production Design: Therese DePrez
MPAA rating: R
Running time: 116 minutes

REVIEWS

Burr, Ty. *Boston Globe*. December 5, 2013.
Dargis, Manohla. *The New York Times*. December 3, 2013.
Jenkins, Mark. *NPR*. December 6, 2013.
Phillips, Michael. *Boston Globe*. December 5, 2013.
Puig, Claudia. *USA Today*. December 5, 2013.
Rabin, Nathan. *The Dissolve*. December 3, 2013.
Rodriguez, Rene. *Miami Herald*. December 5, 2013.
Roeper, Richard. *Chicago Sun-Times*. December 5, 2013.
Sharkey, Betsy. *Los Angeles Times*. December 3, 2013.
Williams, Joe. *St. Louis Post-Dispatch*. December 5, 2013.

QUOTES

Rodney Baze Jr.: "Working for a living? I gave my life for this country and what's it done for me? Huh? What's it done for me?"

TRIVIA

Actor Christian Bale actually learned how to operate a real furnace for his role in this the film and didn't use a double for his scenes inside the steel mill.

OZ THE GREAT AND POWERFUL

The land you know. The story you don't.
 —Movie tagline
Find yourself in Oz.
 —Movie tagline
Oz will amaze.
 —Movie tagline
In Oz, nothing is what it seems.
 —Movie tagline

Box Office: $234.9 Million

Oscar "Oz" Diggs (James Franco) is a carny magician, with big dreams and a decidedly small heart.

Undaunted by his torn costuming, he uses his cheap tricks to win the hearts of young females and con his helper Frank (Zach Braff) out of hard-earned wages. His only weak spot is old road flame Annie (Michelle Williams) who visits him at his wagon shortly after a disastrous performance in which he is harangued by a crowd angry with him for refusing to make a wheelchair bound child walk. Before Oz can respond to Annie's last attempt to win him over a cuckolded strongman comes to take revenge forcing the con man to flee in a hot air balloon just as a twister bears down on the carnival, picking up the balloon and flinging it into the truly magical world of Oz.

The magician's initial encounters with the region's fantastical flora and fauna leave him flummoxed. To make matters worse a beautiful young witch named Theodora (Mila Kunis) appears to tell him that he is the fulfillment of a prophecy, a wizard king expected to vanquish the Wicked Witch of the West. She becomes even more sure when he uses his con artistry to fend off the Wicked Witch's winged monkeys, and, in true form, Oz not only seduces her but encourage her in thinking she may one day be his queen.

The next day has them traveling on foot to the Emerald City. On its outskirts they meet Finley (Zach Braff), a winged Capuchin whom they rescue from a giant carnivorous plant and who pledges lifelong servitude to Oscar. While Oz desperately tries to quietly explain his true identity to Finley, so he can make an escape, they reach the city where he is introduced to Theodora's sister Evanora (Rachel Weisz) and shown to the throne room and the treasure room, which convinces him to try and make a go of being king. Evanora, however, is convinced that Oz is a fraud, and, after privately chiding Theodora, decides to send him on a deadly quest to kill the Wicked Witch before he can rightly claim the throne.

Oz and Finley soon set out for the Dark Woods, and, along the way, they encounter a girl made out of china (Joey King) in a town recently destroyed by the Witch's minions. Helping to repair the girl's smashed legs with glue, Oz finds himself with another steadfast companion, unwilling to leave his side, no matter the dangers of the Dark Woods ahead.

Deeper they trudge, evading one violent denizen after another when they see a hooded figure entering a cemetery. Realizing this must be the Wicked Witch, they quickly formulate a plan to separate her from her wand, knowing that if they break it in two the Witch will die. Suddenly the witch undoes her hood and Oz realizes she looks exactly like Annie. Introducing herself as Glinda (Michelle Williams) she explains that her sister Evanora is the true Wicked Witch. After killing their father, Evanora has secretly set herself up as a false ruler. Narrowly evading Evanora's armies, the foursome, using Glinda's magic, make their way back to Oz where Oscar is distressed to find only farmers, cobblers, and munchkins, who are all honor bound from ever killing anyone. Convinced by Glinda that the people need him now more than ever he sets about constructing a defense based on his inherent con man instincts.

Evanora, knowing the time has come to throw all of her weight into an attack on Oz and the would-be king, convinces Theodora that Oz seduced both of them simply to gain the crown. With Theodora's anger exploding, Evanora gives her a magic apple that permanently hardens Theodora's heart, kills the goodness within her, and turns her skin a ghoulish green. Setting her face against Oz and Oscar, Theodora sets out to lead Evanora's armies into battle, unaware that she may have met her match in the small town theatrics of a carny magician turned hero.

This ambitious film is by turns captivating and frustrating. A promise to revisit the land of Oz carries with it the weight of decades of cultural fascination and adoration. It helps to remember that Sam Raimi is hardly the first storyteller to try and go back to Oz. In fact, the author himself, Frank L. Baum had go after go at his own material in a whole shelf-breaking series of 14 books published between 1900 and 1920. Add on the 19 books generated by Ruth Plumly Thompson between 1921-1939, three by longtime Baum illustrator John R. Neill, and 4 more by various authors collectively published between 1941-1963, and the total runs no fewer than 40 books. That is a whole lot of Oz to draw on for storytelling purposes. It is, therefore ultimately, fairest, to judge *Oz the Great and Powerful* not by the much beloved and frame perfect *The Wizard of Oz* (1939) but by what, if anything, it is able to add to the already-rich notions of Baum's world and characters.

Raimi's main problem here is Mitchel Kapner's and David Lindsay-Abaire's screenplay, which contains enough plot for a solid miniseries, bulking the film out to an unnecessary and sometimes draggy 130 minutes. The resultant dialogue is also a little heavy on exposition. The story does build up to a surprisingly powerful climax though and even manages to invoke the mystery of film and story itself as a lie that tells the truth.

Visually, Raimi is absolutely at home. His trademark camera sweeps and swoops are perfect for exploring such a rich tapestry and at times the design of Oz and the Emerald city themselves seems rooted in classic Disney animation. A lot of CGI here is absolutely gorgeous, such as when Glinda transports the group using giant bubbles. But CGI is put to its best use via the way it is integrated with live-action characters. Mila Kunis is, a

more or less perfect young witch but transformation into a goblinesque monster is genuinely frightening. Characters that are entirely CGI such as the winged monkeys are powerfully re-imagined as vicious claw-footed baboons. The entirely CG China Doll character is a delicate treasure whose character arc leads through to empowerment.

Oddly the least compelling character here is Oz himself, whose arc seems defined from the beginning and never really veers far from what viewers will expect. Franco never really settles on a character here. Oz is heartless one moment and kind hearted the next and there is a sense that the character is a series of actions rather than motivations. He becomes a hero for reasons that are simply not clear enough for audiences to view him as legitimately great or powerful. He is instead a man who has finally allowed himself to have some real friends that he will stick by.

The message the film offers delves into the well-worn trope that by working together people can find something to believe in and accomplish much but *Oz The Great and Powerful* sells that notion far less powerfully than the notion that it would be glorious indeed to float off someday to Oz.

Dave Canfield

CREDITS

Oscar Diggs: James Franco
Glinda: Michelle Williams
Theodora: Mila Kunis
Evanora: Rachel Weisz
Frank/Finley: Zach Braff
Master Tinker: Bill Cobbs
Knuck: Tony Cox
Winkie Gate Keeper: Bruce Campbell
Frank/Finley: Zach Braff
China Girl: Joey King (Voice)
Origin: United States

Language: English
Released: 2013
Production: Joe Roth; Roth Films; released by Walt Disney Pictures
Directed by: Sam Raimi
Written by: David Lindsay-Abaire; Mitchell Kapner
Cinematography by: Peter Deming
Music by: Danny Elfman
Sound: Jussi Tegelman
Editing: Bob Murawski
Costumes: Gary Jones
Production Design: Robert Stromberg
MPAA rating: PG
Running time: 130 minutes

REVIEWS

Burr, Ty. *Boston Globe.* March 7, 2013.
Charity, Tom. *CNN.com.* March 8, 2013.
Cusey, Rebecca. *Patheos.* March 8, 2013.
Duralde, Alonso. *The Wrap.* March 5, 2013.
Foundas, Scott. *Village Voice.* March 5, 2013.
Larsen, Josh. *LarsenOnFilm.* March 11, 2013.
Myers, Randy. *San Jose Mercury News.* March 8, 2013.
Roeper, Richard. *Chicago Sun-Times.* March 7, 2013.
Turan, Kenneth. *Los Angeles Times.* March 7, 2013.
Weitzman, Elizabeth. *New York Daily News.* March 7, 2013.

QUOTES

Oz: "You can have a nice pile of bananas!"
Finley: "Oh, I see, because I'm a monkey I must love bananas!"
Oz: "You don't love bananas?"
Finley: "Of course I love bananas, I'm a monkey! Don't be ridiculous!"

TRIVIA

Michelle Williams's character Annie is marrying a man named John Gale. Director Sam Raimi has confirmed that Annie and John are intended to be the parents of Dorothy Gale, the main character in *The Wonderful Wizard of Oz.*

P

PACIFIC RIM

To fight monsters we created monsters.
　　—Movie tagline

Go big or go extinct.
　　—Movie tagline

Box Office: $101.8 Million

Critics who find Guillermo del Toro's *Pacific Rim* too loud, too bombastic, or too simple on a narrative level miss the genre-loving auteur's point completely. Del Toro was long ago a charter member of that society of creative people who recognize how rich an experience waits for those willing to use simple tools like giant robots, monsters, mad scientists, and melodrama to foster the public imagination. He is not only paying homage to kaiju and mech films and television shows which have been hugely influential but he is forging ahead, showing what those genres can accomplish on a larger scale.

In 2013, a fissure in the Pacific Ocean opens up a space-time portal, allowing a huge creature to emerge and destroy large portions of San Francisco before it can finally be stopped. Soon, other creatures emerge and attack cities all over the globe as it becomes apparent that the only thing that will protect mankind from extinction is the combined efforts of all nations. The "Jaeger Program" is created, utilizing huge mechanized robot suits which must be piloted by at least two people whose minds have been linked together in a state referred to as "The Drift." At first, it works brilliantly, and the various Jaeger pilots even become pop culture heroes as they defeat kaiju after kaiju.

Just a few years later, the giant monsters have increased in number and ferocity, demolishing shoreline safeguards and Jaegers alike. Well known Jaeger duo Raleigh (Charlie Hunnam) and Yancy Beckett (Diego Klattenhoff) experience disaster off the coast of Anchorage Alaska when Yancy is killed and their Jaeger, Gypsy Danger, is all but destroyed when they disobey direct orders in an attempt to save a fishing boat. Demoralized Raleigh leaves the Jaeger program and slowly it falls out of fashion with the governments that have funded it, who are now convinced the money would be better spent on more architectural reinforcements. Project head Stacker Pentecost (Idris Elba) disagrees and re-recruits Raleigh in a last ditch effort to save the Jaeger's and, he believes, mankind.

His first move, pairing the guilt ridden Raleigh with a new pilot, ends in chaos. Mako Mori (Rinko Kikuchi) is simply too unstable having suffered through kaiju attacks as a child. Together their memories prove too toxic to control. Meanwhile, the other pilots resent Raleigh's presence believing that he will inevitably get them killed. In the background, two of the project's lead scientists, the kaiju-obsessed Dr. Newton Geiszler (Charlie Day) and the twitchy Dr. Gottlieb (Burn Gorman), experiment with kaiju parts and mathematical simulations to try to predict where the crisis is heading with only a handful of Jaegers left and time running out. Pentecost finds himself forced to trust in Geiszler, the shaky team of Raleigh & Mako, and a mysterious dealer in black-market kaiju organs, Hannibal Chou (Ron Perlman).

Pacific Rim builds to a predictable climax but oh the fun in getting there. Nowhere in the *Transformers* films will one find characters as engaging as Hannibal

Chou, Dr. Gottlieb, or Mako Mori. If the narrative seems predictable there is a strong case to be made for why that is not a problem. Yes, viewers get a love interest, a secret relationship revealed between two main characters, and some last-minute change-of-heart from the project bully but what the characters embrace in the way of narrative cliche is handled here as tried-and-true genre convention. Del Toro knows viewers have seen these characters before but he also knows that they can be powerful stand-ins for those who want to imagine themselves up on that screen or better yet actually in the world he creates. And that world puts Michael Bay, Roland Emmerich, and other would-be spectacle pimps to shame.

No fantasist currently working has del Toro's grasp of design and overall visual style. *Pacific Rim* is full of things that could only come from this auteur and his team. The squishy, tentacular, ghoulish, and cute are on ample display. When Geiszler has to track Hannibal Chou to his lair, there's a wonderful fantasy world reveal where kaiju relics abound that is reminiscent of the Fairy market in *Hellboy II: The Golden Army* (2008). Likewise, there are a wild variety of glimmering, clanking, gleaming, whirring machines and tech to reinforce the notion that del Toro is every bit the master at world creation that Ray Harryhausen was. He has, over the course of a few feature films, created a universal oeuvre so richly detailed it will outlive whatever criticism people want to throw at it.

But what del Toro does differently here is a matter of scale. He has dealt with huge majestic visuals before but never sustained them for this length of time. The various robots and kaiju never seem less than hundreds of feet tall, the battles never seem less than truly epic. One could almost imagine Homer standing off to the side, writing down the details. Critics keep mentioning the film is designed with twelve-year-olds in mind but these moments are for six-year-olds in the best sense. They seem lifted whole cloth from the wide-eyed bathtub brawls of early childhood. The CGI is often hidden here by having battles take place at night in the rain. It would have been nice to see more action in broad daylight but it does beg the question of whether or not a giant monster or robot is less wonder-inducing simply because it is seen during a storm. In del Toro's hands the answer is a resounding no.

Dave Canfield

CREDITS

Raleigh Becket: Charlie Hunnam
Stacker Pentecost: Idris Elba
Mako Mori: Rinko Kikuchi
Dr. Newton Geiszler: Charlie Day
Hannibal Chau: Ron Perlman
Tendo Choi: Clifton (Gonzalez) Collins, Jr.
Origin: United States
Language: English
Released: 2013
Production: Jon Jashni, Mary Parent, Thomas Tull, Guillermo del Toro; Disney Double Dare You, Legendary Pictures; released by Warner Brothers
Directed by: Guillermo del Toro
Written by: Guillermo del Toro; Travis Beacham
Cinematography by: Guillermo Navarro
Music by: Ramin Djawadi
Sound: Scott Martin Gershin
Editing: Peter Amundson; John Gilroy
Costumes: Kate Hawley
Production Design: Andrew Neskoromny; Carol Spier
MPAA rating: PG-13
Running time: 131 minutes

REVIEWS

Buckwalter, Ian. *NPR.* July 11, 2013.
Goodykuntz, Bill. *Arizona Republic.* July 10, 2013.
Hoffman, Jordan. *Film.com.* July 8, 2013.
Hornaday, Ann. *Washington Post.* July 11, 2013.
Lacey, Liam. *Globe and Mail.* July 11, 2013.
Long, Tom. *Detroit News.* July 12, 2013.
O'Hehir, Andrew. *Salon.com.* July 11, 2013.
Scott, A. O. *New York Times.* July 11, 2013.
Turan, Kenneth. *Los Angeles Times.* July 10, 2013.
Uhlich, Keith. *Time Out New York.* July 9, 2013.

QUOTES

Herc Hansen: "We can either sit here and do nothing or grab those flare guns and do something really stupid."

TRIVIA

Approximately one hundred Kaijus and one hundred Jaegers were designed, but only a fraction of those appeared in the film.

AWARDS

Nominations:

British Acad. 2013: Visual FX

PAIN & GAIN

Their American dream is bigger than yours.
 —Movie tagline
This is a true story.
 —Movie tagline

Box Office: $49.9 Million

Some critics and, indeed, some of those involved directly or indirectly with the real-life case upon which the film was based participants, survivors, and the families and friends of victims have criticized Michael Bay's *Pain & Gain* for the dramatic license the film takes with the true story. To a degree, they have a point. Christopher Markus and Stephen McFeely's screenplay invents characters and changes events to different extents, especially in the film's climactic final arrest, which is admittedly a piece of fantasy that allows for one last chase, a good deal of destruction, and an opportunity for one victim to achieve some poetic justice.

Most of the documented changes are cosmetic (the type of car used to try to kill someone, one character standing in for multiple people, and other details that are on par in terms of significance with the first example), and while one could question the film's declarations that it is a true story, the film certainly gets the basics right. In fact, *Pain & Gain* is accurate enough to earn the dismay that this story, for the most part, and, more importantly, in spirit, actually happened the way it is portrayed here. (Pete Collins reported the story in a series of articles in the *Miami New Times* that were published a little over a year after the verdicts were announced).

One point that needs to be addressed is the way some have interpreted the adjustment of the film's central characters. In reality, they were, apparently, quite cruel and without any redeeming qualities. The film downplays this; they do atrocious, sometimes barbaric things, but there is not a sense of callousness to the characters. This could easily be a problem, save for the fact that Markus and McFeely do not find any reason to sympathize with them. Instead, they hold these men up for ridicule; three men who imagine themselves as criminal masterminds ("I watch a lot of movies," the leader tells one of his partners; "I know what I'm doing") but make mistakes that even a rank amateur would avoid.

This is the film's primary joke, but it is a good one and played for all it is worth. The gag is complemented by director Michael Bay's typical excess. Bay, whose oeuvre is, to put it kindly, typified by ambitious but hollow and idiotic flashiness, has found material that fits his style. The film is a reflection of its characters: A trio of vapid bodybuilders who are obsessed with materialistic wealth and shallow desires. They love the idea of the American Dream or, at least, what they consider that to entail. For them, it is fast cars, beautiful women, a lawn large enough to justify the purchase of a riding mower, and second chances that allow them to mess up things even more.

The leader of the pack is Daniel Lugo (Mark Wahlberg), a personal trainer who has already had a run-in with the law with a phony investment company. He gets a job at a Miami gym, and eventually, he starts as a trainer for Victor Kershaw (Tony Shalhoub), a wealthy entrepreneur. Lugo does not believe Kershaw deserves the money and possessions he has, so Lugo decides comes up with a plan to kidnap Kershaw, convince the man to sign over all of his assets to Lugo, and reap the benefits.

Lugo's accomplices are Paul Doyle (Dwayne Johnson), another ex-convict who has found religion and has come to Miami because he has no outstanding warrants in Florida, and Adrian Doorbal (Anthony Mackie), one of Lugo's clients who has "defeated phallus syndrome" from the use of steroids. They are incompetent (and impotent) from the start.

They try to abduct Kershaw from his house, but they do not take into consideration that he has company over for dinner. They try to kidnap him when he is going to his car, but Doyle and Doorbal stake out the wrong vehicle. When they finally do manage to take Kershaw, he almost immediately recognizes his personal trainer from the smell of his terrible cologne. The entire plan and all the torture they perpetrate on their victim is almost for naught because Lugo has never heard of a notary.

It is only because of pure, dumb luck that the trio is able to accomplish anything. After they get Kershaw's signature and a notary's seal, there is a disturbing sequence in which they thrice try and fail to kill Kershaw (crashing his car, setting it on fire, and, finally, running over him with a van), and it is at this point that the film's heretofore absent moral outrage begins to show itself. The way in which they try to murder but only maim Kershaw may have the setup of a gag (Three is, after all, the magic number in comedy), but it is so grotesque and gruesome that even the morally bankrupt thieves have a difficult time stomaching it. The audience has been trained to identify with or merely dismiss these goons, and during this sequence, through that identification, it has become impossible to dismiss them. They may be idiots, but there is still something dangerous in their idiocy.

The outrage is, admittedly, inconsistent, and once they have the money and all of Kershaw's possessions, they once again become fools. Lugo takes residence in Kershaw's home and starts a neighborhood watch. Doorbal marries a nurse (Rebel Wilson) who helped him with his medical condition. Doyle wastes his share on cocaine. Kershaw hires a private investigator named Ed DuBois (Ed Harris) after the police assume he is lying (He is a "difficult" victim, DuBois observes, and the

comical way Kershaw is presented can really only be forgiven because the name of the survivor has been changed), and he believes the three will strike again.

What follows is even more deranged than their previous scheme, and the film must stop for a moment to remind the audience that "This is still a true story." It is clear that *Pain & Gain* is repulsed by these men, and the tool the film employs to convey that is unadulterated mockery.

Mark Dujsik

CREDITS

Daniel Lugo: Mark Wahlberg
Paul Doyle: Dwayne "The Rock" Johnson
Adrian Doorbal: Anthony Mackie
Victor Kershaw: Tony Shalhoub
Ed Du Bois: Ed Harris
John Mese: Rob Corddry
Ramona Eldridge: Rebel Wilson
Johnny Wu: Ken Jeong
Origin: United States
Language: English
Released: 2013
Production: Ian Bryce, Donald DeLine, Michael Bay; De Line Pictures; released by Paramount Pictures Corp.
Directed by: Michael Bay
Written by: Christopher Markus; Stephen McFeely
Cinematography by: Ben Seresin
Music by: Steve Jablonsky
Sound: Erik Aadahl
Editing: Tom Muldoon; Joel Negron
Costumes: Colleen Kelsall; Deborah L. Scott
Production Design: Jeffrey Beecroft
MPAA rating: R
Running time: 129 minutes

REVIEWS

Brody, Richard. *New Yorker.* April 25, 2013.
Haglund, David and Wickman, Forrest. *Slate.* April 26, 2013.
Johanson, MaryAnn. *Flick Filosopher.* August 27, 2013.
Kenny, Glenn. *MSN Movies.* April 25, 2013.
LaVelle, Ciara. *Village Voice.* April 24, 2013.
Rabin, Nathan. *A.V. Club.* April 25, 2013.
Schager, Nick. *Slant Magazine.* April 24, 2013.
Scott, A. O. *New York Times.* April 2, 2013.
Simon, Brent. *Screendaily.* April 23, 2013.
Tobias, Scott. *NPR.* April 25, 2013.

QUOTES

Daniel Lugo: "Life's gonna give me another set. I know it will."

TRIVIA

Dwayne Johnson bulked up to nearly 300 pounds for his role in the film. Mark Wahlberg bulked up to 212 pounds. Anthony Mackie put on 17 pounds of muscle for the role and bulked up to 213 pounds.

PARANOIA

In a war between kings even a pawn can change the game.
—Movie tagline

Box Office: $7.4 Million

A hapless, tech-age, corporate espionage thriller that is more indistinctive and silly than sleek and of the zeitgeist, *Paranoia* plays the beefcake shirtlessness card early and often, almost as if everyone involved knows they are making a movie that, on an emotional and intellectual level, basically embraces a tween's view of the adult world, and will someday play in heavy midday rotation on basic cable television.

In this case it is the well-toned pectoral muscles of the non-Thor Hemsworth (Liam, younger brother of Chris) on display. It is a seeming rite of passage for male stars—films in which a young man of considerable rectitude grapples with the corruption of governmental or bureaucratic systems and betrayal by a friend and/or professional mentor, and in the process most likely takes off his shirt. Taking on a role Justin Timberlake no doubt turned down, Hemsworth follows in the footsteps of Ryan Phillippe in *Antitrust* (2001), Colin Farrell in *The Recruit* (2003) and Sam Worthington in *Man on a Ledge* (2012), to name but a few examples. Unfortunately, *Paranoia* (in which cleverness is rendered by showing two characters who are locked in a psychological battle of wills literally playing chess) is an abject lesson in moral-peddling genre filmmaking gone boring and wrong.

A mid-August release for distributor Relativity Media, *Paranoia* premiered to justifiably savage reviews, and was easily outstripped at the box office by three other films releasing wide that competitive weekend: *Jobs*, *Kick-Ass 2*, and *Lee Daniels' The Butler*. Finishing well outside of the top 10 with a $3 million bow, the movie disappeared quietly several weeks later, with a meager $7.4 million total domestic theatrical haul.

Set in present-day Manhattan, *Paranoia* stars Hemsworth as Adam Cassidy, a 27-year-old go-getter who works at the top tech company on the planet and lives with his ailing father Frank (Richard Dreyfus). With his chances at advancement blocked and his creative talents stifled, Adam strikes out at a pitch meeting and runs afoul of his demanding, humorless boss, Nicholas Wyatt

(Gary Oldman). After blowing off some steam with some friends at a bar using a company credit card, Adam is blackmailed by a pair of Wyatt's minions (Embeth Davidtz and Julian McMahon) into going to spy on Wyatt's business rival and former partner, Jock Goddard (Harrison Ford).

Conflicted but cornered, Adam agrees, and wins Goddard's attention and appreciation with a quickly arranged meeting highlighting the potential military applications of new GPS cell phone software. Adam then sets out to satisfy his true objectives, and steal the prototype of a revolutionary new cell phone. Since it makes for convenient and familiar dramatic friction, there is also chaste sex and inwardly reflected romantic remorse with Emma Jennings (Amber Heard), the strong-willed marketing department chief at Goddard's company, who does not know of Adam's duplicity.

Jason Hall and Barry L. Levy's plodding adaptation of Joseph Finder's novel of the same name makes one obvious and pedestrian choice after another. Leaning unimaginatively on voiceover narration to set up its story, *Paranoia* is the type of movie that cycles so quickly through yawning cliches like "people always tell you to be careful what you wish for," "the lights always look brighter on the other side of the river," and "but that world was gone" as to make one's head spin. It is also the type of movie where, after an implied threat is made pretty clear, a character nonetheless asks, "And if I say no?"

Hall and Levy try to pump up Adam's sympathetic relatability by having him have to cope with insurance coverage issues for his dad, and by also injecting a thin layer of "bridge-and-tunnel" classism into the material, but these choices feel like lame stabs at relevance (and additionally ignore the fact that Hemsworth is hardly the picture of blue-collar subjugation). There is also an attempt to foist another authoritative character into the proceedings, in the form of an investigating FBI agent played by Josh Holloway, but his inclusion as a moral and practical escape hatch for Adam is so transparent as to invite bewildered second-guessing from viewers flummoxed by the sheer idiocy of what they are watching unfold. Most damningly, however, *Paranoia*'s screenplay simply never locates much of a sense of jeopardy or intrigue. Given how easily and quickly Adam wins Goddard's trust, it is very easy to surmise that Goddard might have ulterior motives in his dealings with him.

Director Robert Luketic is at this point purely a hand-for-hire, the two buoyant highlights of his filmography, *Legally Blonde* (2001) and *21* (2008), almost completely erased by dreadful recent collaborations with Katherine Heigl, *The Ugly Truth* (2009) and *Killers* (2010). Functional competency, and certainly all the

backhandedness that implies, describes the high-water mark of the movie's look and tone, which is tony yet generic. Some notably terrible editing by Danny Cooper and Tracy Adams, however, renders a few moments of physical imperilment and menace utterly ridiculous.

Hemsworth, a physical specimen still generally at ease in scenes requiring him to speak authoritatively about some technological quirk, seems a pleasant enough guy, but he lacks the inner controls to communicate any sense of genuine desperation to which audience members might glom onto. Ford, his hair shaved down to a silver, stubbly buzz cut, relishes the seeming dichotomy between cutthroat businessman and inspirational visionary with a tragic personal story. Oldman, meanwhile, knows how to peddle top-grade jerkiness and smarm.

In fact, Ford and Oldman's scenes together are the movie's sole highlight. When they tear into one another—there is a great passive-aggressive scene in which they bump into each another at a restaurant, and another sequence before the finale in which things get more heated—it is as if the clouds of narrative stupidity part, and the dark heart of capitalistic excess and hubris is revealed. If the rest of *Paranoia* has cast its lot with a tedious story, poorly told, that audiences have already seen before, in these fleeting moments a viewer can easily get lose imagining something richer, focusing on Wyatt and Goddard's shared rise and terrible falling out.

Brent Simon

CREDITS

Adam Cassidy: Liam Hemsworth
Emma Jennings: Amber Heard
Nicolas Wyatt: Gary Oldman
Jock Goddard: Harrison Ford
Frank Cassidy: Richard Dreyfuss
Kevin: Lucas Till
Allison: Angela Sarafyan
Dr. Judith Bolton: Embeth Davidtz
Miles Meechum: Julian McMahon
Agent Gamble: Josh Holloway
Origin: United States
Language: English
Released: 2013
Production: William D. Johnson, Scott Lambert; Reliance Entertainment; released by Relativity Media L.L.C.
Directed by: Robert Luketic
Written by: Jason Hall; Barry L. Levy
Cinematography by: David Tattersall
Music by: Junkie XL
Sound: Scot MacMillan
Music Supervisor: Bob Bowen

Editing: Dany Cooper; Tracy Adams
Art Direction: Scott Anderson
Costumes: Luca Mosca
Production Design: David Brisbin; Missy Stewart
MPAA rating: PG-13
Running time: 106 minutes

REVIEWS

Barker, Andrew. *Variety.* August 9, 2013.
Burr, Ty. *Boston Globe.* August 15, 2013.
Duralde, Alonso. *The Wrap.* August 9, 2013.
Farber, Stephen. *Hollywood Reporter.* August 9, 2012.
Holden, Stephen. *New York Times.* August 15, 2013.
Rabin, Nathan. *TheDissolve.com.* August 15, 2013.
Sharkey, Betsy. *Los Angeles Times.* August 15, 2013.
Tallerico, Brian. *HollywoodChicago.com.* August 15, 2013.
Weinberg, Scott. *GeekNation.com.* August 16, 2013.
White, Dave. *Movies.com.* August 16, 2013.

QUOTES

Jock Goddard: "Privacy. Absolute myth. There's no such thing."

TRIVIA

Kevin Spacey turned down the role of Nicholas Wyatt in the film.

PARKER

To get away clean, you have to play dirty.
—Movie tagline

Box Office: $17.6 Million

"How do you sleep at night," the eponymous hero's partner in crime asks after learning of his plan to allow a group of thieves—who had previously taken money that was contractually his and then tried to kill him—to steal millions of dollars' worth of jewelry, rob them of their haul, and then kill them. It is not an accusatory question—merely a curious one. After all, she is new to this sort behavior. She is likely asking for herself. How is she going to sleep at night after participating in all of this illegal activity?

His answer—"I don't drink coffee after seven"—is not a helpful one, but in its jokey way, it is enlightening. This is a man with a clean conscience, and it will likely remain spotless after the events in the movie, which see him lying to almost everyone, stealing money and property from the mob and complete strangers, killing people (or, in one scene, forcing another person to kill for him), and scheming revenge against those who have wronged him.

From his behavior, it would be easy—too easy, in fact—to label Parker (Jason Statham) an amoral human being. Despite his actions, though, it would not be accurate. The reason is simple: a code. It may not be a socially acceptable one, but it is a code nonetheless. "I don't steal from people who can't afford it; I don't hurt people who don't deserve it," he tells a group of hostages from whom he and his crew are about to rob one million dollars in box office revenue from the Ohio State Fair. That is more than can be said about his cohorts in the heist, whose ineptitude leads to the death of an innocent fair-goer and who leave him for dead on the side of Kentucky road when he refuses to put up his share of the stolen money to fund their leader Melander's (Michael Chiklis) plan for another theft. It is really only through this comparison that anyone could reasonably call Parker a hero.

He is a fascinating character, though, even if he fits quite squarely into the types of roles that Statham, with his rock-solid way of holding himself and a glare that could intimidate even the hardest of men, usually plays. His creed is based entirely on rationalization—of convincing himself and other that he is, as he also tells the victims of the movie's first robbery, no different than anyone else. "Everyone steals," Parker tells Leslie Rodgers (Jennifer Lopez), a down-on-her-luck realtor who convinces the anti-hero to let her help him with his plan in order to pay off her various debts; it is only a matter of whether or not a person admits as much.

Parker is more than willing to admit it, and he is good at his work, too, primarily because of his rationality. That characteristic leads to another joke that serves as character development. During the opening robbery, in which Parker is disguised as a priest, he talks a security guard (Bill Slaughter) down from a panic attack. The guard is so taken by this thief's relative kindness that he reflexively responds, "Thank you, Father." He even has a rationale for revenge: If people do not follow the rules—that is, give him the money he is owed—then there is chaos, and "No one likes chaos."

The character is a bit of a conundrum; the movie is not. John J. McLaughlin's screenplay (based on the novel *Flashfire* by Richard Stark, one of the many pen names of author Donald E. Westlake) is a straightforward story—save for a few flashbacks that either establish expository information, such as the existence of his girlfriend Claire (Emma Booth) and her father and his partner Hurley (Nick Nolte) or iterating the reason Parker is out to get Melander and his fellow thieves—and wholly routine.

The simplicity of narrative works to a degree because Parker is a man of simplicity. He has a one-track mind, which, in this case, leads him to a string of

violent encounters. The most notable of them involves a brutal, close-quarters fight in a hotel room with a hired assassin (Daniel Bernhardt) for the Chicago mob, which has a family connection to Hardwicke (Micah A. Hauptman), one of Melander's men. The climax involves a non-threatening standoff between Parker and his cohorts, with Leslie diminished to the role of damsel in distress, in which the audience is already fully aware that Parker has removed the firing pins from all the villains' guns.

The rest of the story revolves around the relationship between Parker and Leslie, with the former not giving any obvious signs of how he feels and the latter quite enamored with the stranger even while he is donning a cowboy hat and adopting a ridiculous Texas accent (that Statham remains a charmer in these scenes speaks volumes of his screen persona). Their relationship is a non-starter, given that Parker's loyalty to Claire is without question. Their scenes together amount to one long tease, which reaches its peak when Parker forces Leslie to strip to her underwear to ensure that she is not wearing a wire while discussing the planned robbery with him.

Parker is a fine study of a man of questionable moral standing confined by the necessities of a straightforward plot. Parker, the character, has an undeniable roguish appeal; it only goes so far.

Mark Dujsik

CREDITS

Parker: Jason Statham
Leslie Rodgers: Jennifer Lopez
Melander: Michael Chiklis
Ross: Clifton (Gonzalez) Collins, Jr.
Carlson: Wendell Pierce
Hurley: Nick Nolte
Origin: United States
Language: English
Released: 2013
Production: Les Alexander, Steve Chasman, Sidney Kimmel, Jonathan Mitchell, Taylor Hackford; Anvil Films Production, Incentive Filmed Entertainment; released by FilmDistrict
Directed by: Taylor Hackford
Written by: John J. McLaughlin
Cinematography by: J. Michael Muro
Music by: David Buckley
Sound: Gregg Baxter; Myron Nettinga
Music Supervisor: Andy Ross; Curt Sobel
Editing: Mark Warner
Art Direction: Mara Lepere-Schloop
Costumes: Melissa Bruning

Production Design: Missy Stewart
MPAA rating: R
Running time: 118 minutes

REVIEWS

Berardinelli, James. *ReelViews.* January 25, 2013.
Douglas, Edward. *ComingSoon.net.* January 24, 2013.
Howell, Peter. *Toronto Star.* January 24, 2013.
Modell, Josh. *A.V. Club.* January 25, 2013.
Morgenstern, Joe. *Wall Street Journal.* January 24, 2013.
Orndorf, Brian. *Blu-ray.com.* January 25, 2013.
Scott, A. O. *New York Times.* January 24, 2013.
Singer, Matt. *ScreenCrush.* January 28, 2013.
Sobczynski, Peter. *RogerEbert.com.* January 23, 2013.
Zacharek, Stephanie. *NPR.* January 25, 2013.

QUOTES

Parker: "I don't steal from anyone who can't afford it, and I don't hurt anyone who doesn't deserve it."

TRIVIA

This is the first Parker film since author Donald E. Westlake's death in 2008. Westlake is credited under his pseudonym Richard Stark.

THE PAST
(Le Passe)

Box Office: $1.1 Million

A great storyteller is equal parts conductor and composer, one who must keep in mind rhythm and inflection while expressing from such a passionate imagination. Oscar-anointed writer/director Asghar Farhadi (*A Separation* [2011]) honors this notion with a maestro's touch in his film *The Past*, a deliberate low-key thriller with the psychological impact of Ingmar Bergman's chamber films. With conversations used acutely to piece together a disturbing memory that haunts all of the film's characters, Farhadi shows exceptional dramatic discipline in a story that aches with its internalized trauma.

Set in a non-photogenic and rainy take on Paris, *The Past* centers around a gravely dysfunctional family situation. Ahmad (Ali Mosaffa) travels from his homeland of Iran to France to meet up with his wife Marie-Anne (Berenice Bejo). Marie-Anne has two daughters, the young Lea (Jeanne Jestin) and high school student Lucie (Pauline Burlet), who are not Ahmad's biological children.

Though it has been four years since their separation, Marie-Anne needs Ahmad's signature to finalize

their divorce. Afterward, she plans to marry her current boyfriend Samir (Tahar Rassim, from 2009's *A Prophtet*). At their divorce hearing, Marie-Anne reveals to Ahmad that she is pregnant with Samir's child.

Along with her two daughters, Marie-Anne lives with Samir and his son Fouad (Elyes Aguis), a child from the wife in Samir's current marriage, Celine. Celine now lays alone in a hospital bed, comatose after drinking laundry detergent in a public suicide attempt eight months ago. The events that inspired Celine's suicide create the large shadow that haunts the extended family unit of *The Past*. With exactitude from Farhadi, her looming off-screen presence provides a strong metaphor for the family unit's own state of oblivion. While the film's title may be its most blunt force and only real flaw, these are characters that are strained by previous trauma, which further prevents them from having an optimistic future.

Farhadi directs his players to be robust in their cool temperament. Through his dialogue, they become viable fictional beings who can only express their grief in strictly hushed conversations. In a balance of how the performers give life to Farhadi's words, but also to the manner in which he carefully utilizes them, they do not provide a false note.

As the matriarch of this story's aching domestic drama, Bejo presents a disturbing image of a wife/girlfriend who becomes a tragedy of her own restlessness. As much as Farhadi's script provides acute details about her past relationships, her earlier consciousness is a richly ambiguous story.

While one may tempted to understand her as someone who simply loves feeling love more than they do settling down, such a thought is complicated when looking at the men of *The Past*. Their characters unable to move forward, especially with guilt of past failures, Mosaffa and Rahim express helplessness that is as pertinent as Marie-Anne's. As a trio, they create an extremely broken backstory where no immediate blame, or explanation, can be placed.

Farhadi's take on the damage of domestic dysfunction to children who do not have a sense of home is especially vivid, with moments of age-appropriate angst fine-tuned. Aguis' Fouad, revolting against parental order and rarely sleeping in the same bed, is dolefully restless. Burlet's teenager Lucie, even more directly involved in a past horror that could very well ruin her future with her family, squeaks out her inner despair through desperate tears in her gradual confessions to Ahmad. Like the adults in this movie, she has her own physical edginess, one that has her shuffling away from her parental figures as if retreating into disparity for domestic harmony.

After a gradual presentation in the first act of the way in which characters are stuck, *The Past* transitions to an immediate thriller with subtle settings and unassuming characters. With its title as dominant context, the film then begins to show more clearly the various knots of perspectives that are involved in such pain. These moments, in which characters interrogate each other, make for some of the film's most memorable scenes. The film's measured revelations of truth are more searing than one could expect.

Farhadi's most precious instrument when constructing this film is dialogue. It provides a very select amount of information for a character, but also in a larger sense, its wallops of tension. With the conversations in this script, Farhadi turns the creation of fictional conversation into an art form of precision itself. Characters are enlivened simply by the reality within the words they speak, and similarly with what they choose to not say. This is a film in which almost everything characters share with each other feels like a former secret.

In terms of visual sense, Farhadi uses his camera with a similar exactness. Extended static shots highlight the graveness of this fully human drama, and simultaneously allow the tension to situate with the firmness of a Michael Haneke film. In his most expressive visual touch, the clarity of glass windows and doors is used for audible irony; there are moments in which the film's sound cuts out when a viewer's accessibility to characters is blocked by glass. With editing, his pacing is similar to a careful city drive segmented by numerous traffic stops, meditative yet worrisome for what could be next.

Farhadi's aesthetics and dialogue make for a story whose strong pace parallels its desperate intrigue. *The Past* is an exhilarating quiet thriller reliant on character conversations, of which Farhadi is a master in their creation. With all other elements as well, Farhadi expresses his own craftiness in being able to manage characters within his remarkably realized tale; one of subtle, yet devastating chain reactions.

Nick Allen

CREDITS

Marie Brisson: Berenice Bejo
Samir: Tahar Rahim
Ahmad: Ali Mosaffa
Lucie: Pauline Burlet
Fouad: Elyes Aguis
Origin: France, Iran
Language: French
Released: 2013
Production: Alexandre Mallet-Guy; released by Sony Pictures Classics

Directed by: Asghar Farhadi
Written by: Asghar Farhadi
Cinematography by: Mahmoud Kalari
Music by: Evgueni Galperine
Sound: Thomas Desjonqueres
Editing: Juliette Welfling
Costumes: Jean-Daniel Vuillermoz
Production Design: Claude Lenoir
MPAA rating: PG-13
Running time: 130 minutes

REVIEWS

Burr, Ty. *Boston Globe*. January 9, 2014.
Dargis, Manohla. *New York Times*. December 19, 2014.
Edelstein, David. *Vulture*. December 24, 2014.
Kennedy, Lisa. *Denver Post*. January 24, 2014.
Long, Tom. *Detroit News*. February 13, 2014.
MacDonald, Moira. *Seattle Times*. February 7, 2014.
Morgenstern, Joe. *Wall Street Journal*. December 19, 2013.
Stamets, Bill. *Chicago Sun-Times*. January 17, 2014.
VanDenburgh, Barbara. *Arizona Republic*. January 23, 2014.
Weitzman, Elizabeth. *New York Daily News*. December 19, 2013.

QUOTES

Samir: "When two people see each other after four years and still fight together, it shows that there is something unsolved between them."

TRIVIA

Director Asghar Farhadi does not speak French and had to direct the movie using a translator.

AWARDS

Nominations:
Golden Globes 2014: Foreign Film

PEEPLES

She comes from good Peeples.
—Movie tagline

He's not one of the Peeples.
—Movie tagline

Box Office: $9.2 Million

Tyler Perry's latest predictable snorer relies too heavily on the considerable talents of Craig Robinson and David Alan Grier to be anything other than a time-waster; that said there are some chuckles to be had. It all depends on whether viewers can overlook the obvious

rehash of *Meet The Parents* (2000) dysfunction-on-parade plotting and embrace the light heartedness of two veteran comedians doing what they can with they have.

Convinced by his brother to crash his girlfriend's posh family gathering and propose, overwhelmingly-average Wade Walker (Craig Robinson) gets there only to question if he can ever fit in. He loves Grace (Kerry Washington) with all his heart but feels blocked at every turn. She does her best to avoid introducing him to the clan at all but finally relents. Her impossible to please dad Virgil, a judge, seems immovable and everything Wade does to please him leads to disaster. Not like the family needs any help in the disaster department. They bring a cornucopia of their own tics and quirks and eccentricities to the mix. Secret romances, resentments, bigotries, and a very preachy ending await everyone who introduces themselves to the Peeples.

The cast here is so over qualified it borders on the ridiculous. Craig Robinson is still best known for playing Darryl Philbin on the smash hit NBC sitcom *The Office* but his film career has been an active one for many years and includes two other major studio releases this year alone: *This is The End* (2013) and *Rapture-Palooza* (2013). In many ways, *Peeples* is tailor-made for his comedic style, which is heavy on non-plussed looks and disingenuous charm. He is free to do what he wants since the script makes so few demands on him but it is easy to understand why he has little problem finding work. The man is genuinely funny and able to take advantage of his physicality to elicit sympathy as well as giggles. He handles the lead role here with aplomb, and there is the hope that, inauspicious as it may be, *Peeples* is the beginning of something bigger for him.

David Alan Grier is far more hemmed in as Virgil the stuffy father of Robertson's love interest. There is a funny bit involving him being a nudist but most of the film simply has him scowling and doing his best to make Wade uncomfortable or coming to the wrong conclusion about something Wade has done. Lastly, Kerry Washington suffers in a profoundly unlikeable role as Grace, a fiancee who is more than willing to let her man go to jail to save face. What Wade sees in her beyond the obvious is the stuff of pure lazy screenwriting. She is a foil, not a character. Fun is had by Melvin Van Peebles and Diahann Carroll in the roles of Grandpa and Grandma, but, on the whole, the cast seems to be more interested in having fun than bringing the audience in on the gag.

As a directorial debut, this film falls strictly in the working-for-the-experience category. Tina Gordon Chism was best known as the screenwriter of *Drumline* (2002) and *ATL* (2006), which is a pedigree that makes her screenplay for *Peeples* perfectly understandable. This

is a simple genre effort, just as her two previous projects were. But she seems to be flailing here. There is nothing unique, no gimmick, no hook unless viewers are willing to count cribbing from endless other films.

Peeples has reportedly made less money (substantially less) than any other Tyler Perry-produced vehicle. For a film with a reported budget of just over fifteen million dollars, this is quite a feat since virtually everything Perry touches turns to gold no matter how bad it is. But the idea of beginning to differentiate between true movies and filmed entertainment is an interesting one that may well gain increased credibility as movies get more and more vanilla. It is already functionally impossible for critics to see every film released each year. Even in big cities. This may be the best proof they may not need to. *Peeples* can be said to scratch the same itch that someone's favorite brand of soda does. It is not there to provide nutrition or encourage good habits of consumption. It is simply there to be consumed.

Dave Canfield

CREDITS

Wade Walker: Craig Robinson
Grace Peeples: Kerry Washington
Virgil Peeples: David Alan Grier
Daphne Peeples: S. Epatha Merkerson
Grandpa Peeples: Melvin Van Peebles
Nana Peeples: Diahann Carroll
Origin: United States
Language: English
Released: 2013
Production: Tyler Perry; released by Lions Gate Entertainment Corp.
Directed by: Tina Gordon Chism
Written by: Tina Gordon Chism
Cinematography by: Alexander Gruszynski
Music by: Aaron Zigman
Editing: David Moritz
Production Design: Rick Butler
MPAA rating: PG-13
Running time: 95 minutes

REVIEWS

Germain, David. *Associated Press*. May 8, 2013.
Graham, Adam. *Detroit News*. May 10, 2013.
Hornaday, Ann. *Washington Post*. May 10, 2013.
Legel, Laremy. *Film.com*. May 11, 2013.
Linden, Sheri. *Hollywood Reporter*. May 7, 2013.
Puig, Claudia. *USA Today*. May 9, 2013.
Rainer, Peter. *Christian Science Monitor*. May 10, 2013.
Smith, Kyle. *New York Post*. May 10, 2013.
Webster, Andy. *New York Times*. May 9, 2013.
Wigon, Zachary. *Village Voice*. May 8, 2013.

TRIVIA

The cast was singing and dancing on set in between takes so much that the producers had to lock the piano during filming.

PERCY JACKSON: SEA OF MONSTERS

In demigods we trust.
 —Movie tagline

Box Office: $68.6 Million

By the numbers adventure here results in a moderately fun time-waster but the real question is how much longer Hollywood will mine the Harry Potter model of franchising and move into adapting other better works of young adult fiction that do more than mimic what has come before. This is a pleasant enough film, and better than *Percy Jackson and The Lightning Thief* (2010), but it also suffers greatly from a sense of event fatigue, smashing and bashing its way through an action-glutted plot that leaves not enough room for the development of characters beyond the inevitable "lesson learned" that ends the story.

Picking up where *Percy Jackson and The Lightning Thief* left off, the film begins with an expository sequence detailing the origins of Camp Half-Blood where Percy, half-god, son of Poseidon, and the other half-human children of mythological figures have taken refuge. When a crisis strikes, threatening the very existence of the camp, the headmasters of the school, Chiron (Anthony Stewart Head) and Mr. D (Stanley Tucci), send the daughter of Ares, Clarisse (Leven Rambin), to find the legendary Golden Fleece and use it to save the compound. But when Percy finds a prophecy that calls his role into question he launches out on his own to determine whether his destiny is to save or destroy Camp Half-Blood. Coming along to aid him are Annabeth (Alexandra Daddario), Grover (Brandon T. Jackson), and Tyson (Douglas Smith), his cyclopean half-brother. Their search will bring them into a deadly confrontation with Luke, whose betrayal of Camp Half-Blood has him searching for the fleece. Whoever finds it will determine the future of their once proud sanctuary.

The cast here is more than adequate even if the material seems like Cliff Notes. Part of the problem with the Potter franchise is it helped set in motion a method of adapting works for the screen that more or

less lifted action sequences out and jettisoned large swaths of character development and real plot. The end result feels exciting on first viewing but has little replay value. This was less true of the Potter films than it is of the films adapted from Rick Riordon's young adult novels. It might simply be a case of less oversight but a look at the resumes of the creative principles here seems to shed some light on how a process like this works when the writers and directors in question are simply journeyman-like.

Thor Freudenthal is previously known for *Diary of a Wimpy Kid* (2010) and *Hotel for Dogs* (2009) and directs here from an adapted screenplay by Marc Guggenheim whose previous work explains everything about how this film handles narrative. Guggenheim is primarily a TV writer. There is nothing inherently wrong with that, but his one big screen credit *Green Lantern* (2011), which he shared with three other writers, was one of the most action-driven and badly reviewed films of 2011. That has been the problem with this series since the beginning: The talent assembled to produce it.

Still, there are bright spots here and there. The young cast is more than up to the challenge of staring at green screens and imagining things that are not there. Nathan Fillion has a dandy of a cameo as Hermes running a UPS store as a front for the Olympus Parcel Service. Anthony Stewart Head and Stanley Tucci also bring the necessary gravitas to their elder statesmen roles here.

Much has been made, perhaps rightly, about the way the Potter films encouraged youngsters (and adults) to read more. Put in context it might be difficult to care much if all they wind up reading is more Harry Potter, or Twilight, or The Hunger Games books. An argument could be made here that movies based on kids' books are never anything more than entertaining time-wasters. But whether or not it is just too much to expect kids to pick up something substantial like Bullfinch' Mythology after watching Percy Jackson films is perhaps moot. What some would call mere entertainment in our culture serves a lot of different functions. Just ask Spielberg, or Rick Baker, or John Landis or most other filmmakers and artists what they were reading or watching at this age.

Looking at the spectacle here seems a good departing point. The special effects certainly bear mention. If this is a film intended mainly to distract 8-12 year olds there is little doubt it is pretty enough to do so. The constant action might be unbearable if it was less than compelling. This is no *Jurassic Park* (1993) but it is a lot of fun in the monster department. Impossible beasts abound and they leap, and pounce and roar very convincingly. Sure it helps that many of them can avoid

having to speak the cheesy dialogue the rest of the real-life cast is stuck with but it bears reminding that, in effect, they are really no different than that cast. Everyone and everything in this film is designed to elicit a "Wow!" as in "Wow, she's pretty." "Wow, he's handsome." "Wow! That special effect is mildly interesting." Only the youngest or most impressionable viewers will be called to heroic flights of imagination by watching this pulpy bit of young adult cine-fluff. Parents who have to sit through it had better get int ouch with their own inner child, ask Hera for patience, or risk feeling seriously fleeced.

Dave Canfield

CREDITS

Percy Jackson: Logan Lerman
Clarisse: Leven Rambin
Luke: Jake Abel
Tyson: Douglas Smith
Annabeth Chase: Alexandra Daddario
Grover Underwood: Brandon T. Jackson
Chiron: Anthony Head
Mr. D/Dionysus: Stanley Tucci
Thalia: Paloma Kwiatkowsi
Hermes: Nathan Fillion
Origin: United States
Language: English
Released: 2013
Production: Michael Barnathan, Chris Columbus, Karen Rosenfelt; 1492 Pictures, Sunswept Entertainment; released by Twentieth Century Fox Film Corp.
Directed by: Thor Freudenthal
Written by: Marc Guggenheim
Cinematography by: Shelly Johnson
Music by: Andrew Lockington
Sound: Michael McGee
Music Supervisor: Julia Michels
Editing: Mark Goldblatt
Art Direction: Helen Jarvis
Costumes: Monique Prudhomme
Production Design: Claude Pare
MPAA rating: PG
Running time: 106 minutes

REVIEWS

Debruge, Peter. *Variety.* August 6, 2013.
Golder, Dave. *SFX Magazine.* August 8, 2013.
Goss, William. *Film.com.* August 8, 2013.
Hartlaub, Peter. *San Francisco Chronicle.* August 7, 2013.
Puig, Claudia. *USA Today.* August 6, 2013.

Scherstuhi, Alan. *Village Voice.* August 7, 2013.

Starnes, Joshua. *ComingSoon.net.* August 16, 2013.

Turner, Matthew. *ViewLondon.* August 8, 2013.

Webster, Andy. *New York Times.* August 6, 2013.

Wirt, John. *Advocate (Baton Rouge, LA).* August 12, 2013.

QUOTES

Annabeth: "It's a Chariot of Damnation."

Grover: "Looks like a New York City cab."

Annabeth: "Same difference."

TRIVIA

Despite the fact that the film was shot on Super 35, the statement "Filmed in Panavision" is made in the end credits.

PHANTOM

You'll never see it coming.
—Movie tagline

Box Office: $1 Million

The premise of the naval thriller *Phantom* is so fascinating at its core that it seems as though someone would have to be trying very hard to make it into a film that was not gripping and interesting on some basic fundamental level. And yet, writer-director Todd Robinson has somehow managed to do just that by not trying very hard at all. Visually chintzy, dramatically inert and old-fashioned in the worst sense of the term, this dramatization of a little-known real-life event that almost triggered World War III clearly yearns to be the next *Das Boot* (1982) but cannot even muster the tension and excitement found on the old Captain Nemo ride at Disneyland.

Set in May of 1968, *Phantom* opens as an aging Soviet submarine captain Demi (Ed Harris) is given orders to ship out with his crew on the B67, an aging sub that is in the process of being sold off to the Chinese navy. for a new mission less than three weeks after the completion of their previous tour. The whole thing sounds a bit strange to Demi but as someone whose career never quite lived up to expectations and who is still traumatized by a tragic past incident that damaged him both physically and mentally, he realizes that this is his last chance to command a mission and end his career with some kind of dignity. As a result, when a small group led by Bruni (David Duchovny) boards the ship at the last minute carrying top secret orders, Demi questions nothing even when ambitious second-in-command Alex (William Fichtner) voices his suspicions that something seems off about them.

It turns out that Bruni and his men are there to test the Phantom, a new cloaking device that allows the sub to disguise its acoustic signal so that it registers on enemy radar as something other than what it really is. The test is a success but it is at this point that Bruni seizes command of the ship, locks away Demi and those loyal to him and reveals his true intentions; he plans to use the ship to launch a nuclear missile at an American target in the hopes of trigger a nuclear war between them and China (whom the sub now belongs to) that will leave Russia as the one true superpower. Demi now has to pull himself together and find a way to take back his ship from Bruni and prevent him from starting a nuclear holocaust.

This all sounds like gripping stuff but Robinson never figures out a way to make it work in cinematic terms. For starters, he kicks things off with a series of dry expositional scenes that seem to go on forever and which could have easily been eliminated since most of the information they contain is reiterated during the voyage. The talkiness continues once the sub sets off on its mission with endless scenes of actors in cramped conditions trading jargon-heavy dialogue that adds tons of detail to the proceedings that still never helps to bring the proceedings to life. Robinson is also unable to make the film work on visual terms either—instead of trying to find a way to work around the space limitations, Robinson stages his scenes in a flat manner that makes it look like a filmed stage play more often than not. And yet, those scenes are still more effective than the dreadful-looking CGI that has been deployed to depict the action outside the sub in moments that have all the visual panache of the screen savers that came with computers sold in 1998.

The biggest problem with *Phantom* is the odd and no doubt box-office-driven decision by Robinson to take a story that is told specifically from a Russian perspective and cast it entirely with American actors. On the one hand, Robinson has made the right call by just having everyone speak in their normal voices a la *The Hunt for Red October* (1990) instead of having them attempting Russian accents as Harrison Ford notoriously tried and failed to do in *K-19: The Widowmaker* (2002). On the other hand, Robinson has cast actors who, for the most part, are so patently unbelievable in their roles that they shatter whatever slight level of plausibility that he has managed to construct every time they speak. Duchovny is the worst offender by far in this regard. With his laid-back persona, he hardly seems capable of triumphing in a game of *Battleship*, let alone hijacking a submarine and destroying the U.S.A. and China with the push of a button as part of his twisted loyalty to his homeland.

The best thing about *Phantom* is the lead performance by Ed Harris as Demi. Here is one of those rare actors who seems almost incapable of ringing a false note and that ability is definitely an asset this time around. He may not look or sound particularly Russian but of all the actors, he is the only one who creates a character that is convincing enough to work around those details. Even when the film begins ticking off every possible sub movie cliché—from the accidental noises that could give away the position of the sub to the need to dive to potentially suicidal depths with the screws popping from the pressure—Harris brings so much realism and commitment to the proceedings, even after presumably guessing that this particular project would not be going down as one of the high-water marks of his career, that he almost makes them work. Alas, while his character does manage to save the world through his heroic efforts, not even Harris's efforts are enough to keep *Phantom* from sinking into a well-deserved oblivion.

Peter Sobczynski

CREDITS

Demi: Ed Harris
Bruni: David Duchovny
Alex: William Fichtner
Markov: Lance Henriksen
Pavlov: Johnathon Schaech
Semak: Jason Beghe
Tyrtov: Sean Patrick Flanery
Sophi: Dagmara Dominczyk
Origin: United States
Language: English
Released: 2013
Production: Pen Densham, Julian Adams; Trilogy Entertainment Group; released by RCR Distribution
Directed by: Todd Robinson
Written by: Todd Robinson
Cinematography by: Byron Werner
Music by: Jeff Rona
Sound: Trevor Gates
Editing: Terel Gibson
Costumes: Sherrie Jordan
Production Design: Jonathan A. Carlson
MPAA rating: R
Running time: 97 minutes

REVIEWS

Catsoulis, Jeanette. *New York Times*. February 28, 2013.
Chang, Justin. *Variety*. February 25, 2013.

Hornaday, Ann. *Washington Post*. March 1, 2013.
Maltin, Leonard. *Leonard Maltin's Picks*. March 4, 2013.
Olsen, Mark. *Los Angeles Times*. February 28, 2013.
Orndorf, Brian. *Blu-ray.com*. March 1, 2013.
Packham, Chris. *Village Voice*. February 26, 2013.
Reed, Rex. *New York Observer*. February 27, 2013.
Russo, Tom. *Boston Globe*. February 28, 2013.
Tobias, Scott. *AV Club*. February 28, 2013.

QUOTES

Demi: "Rum's a sailor's drink. Vodka, a politician's."

TRIVIA

The film reunites actors David Duchovny and Lance Henriksen, stars from TV series *The X-Files* and *Millennium*, both created and produced by Chris Carter.

PHILOMENA

These two unlikely companions are on a journey to find her long lost son.
—Movie tagline

Box Office: $34.6 Million

Back when they each first came to prominence, the idea of Stephen Frears directing and Steve Coogan starring in and co-writing (with Jeff Pope) something as safe and bland and as transparently awards-baiting as *Philomena* would have been unthinkable. Frears first came to international prominence with adventurous, gritty films like *The Hit* (1984), *My Beautiful Laundrette* (1985), and *Sammy and Rosie Get Laid* (1987), while Coogan made his transatlantic reputation with the outrageous, bourgeois morality-puncturing film *24 Hour Party People* (2002), and his Alan Partridge character, which also skewered middle-class, middlebrow mores. It is not hard to imagine the Steve Coogan who unflatteringly played himself as a shallow, showbiz-obsessed name-dropper in Jim Jarmusch's *Coffee and Cigarettes* (2003) viciously mocking the Steve Coogan who made *Philomena*.

That is not to say that *Philomena* is a bad movie; just that coming from these talents, it is a disappointment, and that they seem to be pandering to a certain audience, rather than playing to their strengths. In his late career, Frears has done this type of work from time to time, but even a prestigious, performance-driven film like *The Queen* (2006), while not as exciting as his early work, was made with a passion and vitality that this movie, for the most part, lacks.

The fact-based story is certainly well-worth telling. Coogan gives a well-measured performance as Martin

Sixsmith, a BBC-journalist-turned-civil servant who was essentially booted out of Tony Blair's Department of Transport over a scandal. While trying to decide on his next move, he meets Jane (Anna Maxwell Martin, very strong in a small role), who tells him the tragic story of her mother's lost child. Judi Dench gives the traditional good Judi Dench performance as Philomena Lee, who was sent to an abbey by her father as a teen after getting pregnant. In flashbacks, Philomena is forced to work to repay the nuns for taking her in, while they look for adoptive parents for her little boy, Anthony. As the innocently flirtatious, then despondent young Philomena, Sophie Kennedy Clark is good enough that it is conceivable that she could grow up to be Dench. The nuns built up such a sense of shame and sin in Philomena that for decades, she did not tell anyone about her son, though she thought of him every day.

Philomena tells Martin her story, and while "human interest" is not really the type of work that interests him, the somewhat snooty journalist cynically decides to take advantage of the opportunity to get a major story published. Over the course of the movie, he gradually comes to know and respect the reticent, innately decent Philomena. As he uncovers the scandalous facts of the case, and all the wrong the Catholic Church has done to Philomena, her son, and hundreds like them, he develops a sense of moral outrage and a passion for the story. While the ups and downs of Philomena's story are decidedly unpredictable, these character arcs feel very pat.

Martin's investigation takes the pair to the United States, where they make some surprising discoveries, many of them unhappy, about Anthony's fate. As Martin grows more emotionally involved in the case, Philomena, still feeling the shame pounded into that teenaged girl, begins to waver about making her story public.

Sadly, the movie never feels particularly passionate. It is uniformly well-acted and oddly pleasant, as though it were taking on the forgiveness and grace of Philomena herself, without any of her messy post-traumatic stress. Alexandre Desplat's score is unnecessarily treacly. For a film about so topical and potentially enraging a subject, it feels test-marketed and designed as a year-end weepie, with just enough of a political edge to get the attention of awards-giving bodies. It is telling that when the crux of Philomena's tragedy is revealed, the filmmakers choose to place the bulk of the blame upon a single, completely undeveloped character, who is pretty much a stock villain. Such a choice has some basis in fact, but the details are presented in a way that seems more interested in avoiding offense than in fully exploring the ramifications of the tale.

As year-end awards fodder goes, *Philomena* could have been a lot worse. It is buoyed by its cast, and the surprising chemistry between Dench and Coogan. Aside from their treatment of the story's "villain," the filmmakers do not make any major missteps. Frears' edge has certainly softened over the years, but *Tamara Drewe* (2010) showed he is still capable of interesting, complex work. Coogan, meanwhile, has shown tremendous talent, both as an actor and as a screenwriter. Hopefully, the somewhat bland and simplistic *Philomena* will someday be seen as merely an expansion of his palette, the kind of thing an artist does before returning to the type of exciting work that made him someone to watch in the first place.

Josh Ralske

CREDITS

Philomena: Judi Dench
Martin Sixsmith: Steve Coogan
Mary: Mare Winningham
Sally Mitchell: Michelle Fairley
Young Philomena: Sophie Kennedy Clark
Sister Hildegarde: Barbara Jefford
Mother Barbara: Ruth McCabe
Pete Olsson: Peter Hermann
Michael: Sean Mahon
Origin: United Kingdom
Language: English
Released: 2013
Production: Steve Coogan; BBC Films; released by Weinstein Company L.L.C.
Directed by: Stephen Frears
Written by: Steve Coogan; Jeff Pope
Cinematography by: Robbie Ryan
Music by: Alexandre Desplat
Sound: Oliver Tarney
Music Supervisor: Karen Elliott
Editing: Valerio Bonelli
Art Direction: Rod McLean
Costumes: Consolata Boyle
Production Design: Alan MacDonald
MPAA rating: PG-13
Running time: 98 minutes

REVIEWS

Cataldo, Jesse. *Slant Magazine*. November 15, 2013.
Edelstein, David. *Vulture*. November 22, 2013.
Holden, Stephen. *New York Times*. November 21, 2013.
LaSalle, Mick. *San Francisco Chronicle*. November 26, 2013.
Phipps, Keith. *The Dissolve*. November 21, 2013.

Rea, Steven. *Philadelphia Inquirer*. November 26, 2013.

Vishnevetsky, Ignatiy. *The AV Club*. November 21, 2013.

Weitzman, Elizabeth. *New York Daily News*. November 21, 2013.

Wloszczyna, Susan. *RogerEbert.com*. November 22, 2013.

Young, Deborah. *The Hollywood Reporter*. August 31, 2013.

QUOTES

Philomena: "I forgive you because I don't want to remain angry."

TRIVIA

The flashbacks which are done with home movies. Some of these were created specifically for the film but some are actual footage of the real Philomena's son.

AWARDS

British Acad. 2013: Adapt. Screenplay

Nominations:

Oscars 2013: Actress (Dench), Adapt. Screenplay, Film, Orig. Score

British Acad. 2013: Actress (Dench), Film

Golden Globes 2014: Actress—Drama (Dench), Film—Drama, Screenplay

Screen Actors Guild 2013: Actress (Dench)

THE PLACE BEYOND THE PINES

One moment can change your life.
 —Movie tagline

Box Office: $21.4 Million

Crime does not exist in a vacuum. It does not happen without repercussions. In fact, much of cinema and literature's best storytelling has been borne from the idea that it is the ripple effect of malicious intent (or sometimes even just criminal stupidity) that matters more than the incident itself. The latest from the fascinating young director Derek Cianfrance (*Blue Valentine* [2010]) is one of the most accomplished, complex, and entertaining pieces of storytelling in this subgenre of criminal impact in some time. Crime does not just impact criminals and victims; it extends to their families and influences generations above and below. When a travelling motorcycle stuntman named Luke Glanton (Ryan Gosling) meets the child he did not know existed, he is faced with a decision, and that choice sets in motion a drama of Shakespearian proportions. Thematically dense and remarkably ambitious, *The Place Beyond the Pines* is the kind of daring, adult drama that critics and audiences claim does not get made any more.

The last time Luke was Schenectady, showing off his riding skills and signing autographs, he slept with a woman named Romina (Eva Mendes). Since the coitus was over a year ago and Romina had no way of getting a hold of Luke, he is now an unexpected father. Although Romina had no way of knowing for sure that Luke would ever ride back into her life and so she has moved on as well. She has a man (Mahershala Ali), a waitress job, and a son. She does not want or need anything from Luke; this is unimportant to the headstrong young man. Luke will be a father; likely trying to make up for a lack of a patriarch in his own life. And so Luke quits his travelling gig and stays. He wants to take care of his boy and maybe even build an unexpected family with Romina. He gets a lackluster job as a mechanic, shacking up and hanging with a well-meaning redneck named Robin (Ben Mendelsohn). It is not a life that works for a man who has spent his days cheating death. Crime often looks most attractive to those most bored and so Luke engages when Robin suggests perhaps they rob a bank to get some spending money. Robin treats it as not a lifestyle. Do not get greedy. Do not do it too often. Get the cash and go back to normalcy. Luke has trouble with that second part.

At this point, halfway through the first act of a film that fits the "three-act structure of screenwriting" like a glove, it may feel like Cianfrance's film is going to be the story of the fall and eventual rehabilitation of a bank robber. Luke will go too far and the love for his wife and child will pull him back, right? Luke robs one bank, and then another, and then another, before crossing paths with a rookie cop named Avery Cross (Bradley Cooper) on a truly fateful day that sees the poor, new father's brains smashed on the pavement. Cianfrance, by killing his protagonist (and incredibly well-liked leading man) has thrown the viewer for a loop. It will not be the last time.

Like a great novel, *Pines* shifts focus. Cross is forced to deal with the investigation into Luke's death; the case will rattle his wife Jennifer (Rose Byrne), impact his father Al (Harris Yulin), and involve his truly shady colleague Deluca (Ray Liotta). Much like Luke, Avery is in the most important days of his life, making decisions that will impact for generations. Without spoiling much, *Pines* concludes in an emotional third chapter that features two teenagers (Emory Cohen and Dane DeHaan) who realize that their lives were sent on collision course by the choices made by Luke and Avery years earlier.

Cianfrance and his co-writers (Ben Coccio and Darius Marder) are playing with themes of fate and the sometimes confounding and illogical decisions that

people make and often excuse by claiming that they are doing the right things for their children. Is Luke trying to be a good father or is he greedy? Is Avery looking out for his son or using him? If Romina is not pregnant, Luke is probably still on the road. If Avery does not have a son, he would likely respond differently to the day his actions lead to Luke's death. As he did with *Valentine*, Cianfrance shows an interest in how just the existence of children changes the dynamic of relationships between adults. That film may have been a more straightforward marriage drama but it dealt with similar themes. This is a great example of a filmmaker expanding on what interests him cinematically instead of just telling the same story or ending up without a focus in his career.

The technical elements are nearly flawless. Most notably, the incredible cinematographer Sean Bobbitt (a Steve McQueen regular on films like *Shame* [2011] and *12 Years a Slave* [2013]) works with Cianfrance to create a palette that feels both realistic and lyrical. His work on *Slave* was highly acclaimed and Oscar-nominated but this is arguably just as strong; maybe stronger. Bobbit is commonly following his characters down winding roads or into dark woods, so perfectly captured as to be both foreboding and full of secrets. The result is cinematography that feels thematically consistent and enabling, instead of just functional. And Cianfrance tapped the great Mike Patton of Faith No More to create a brilliant score that underscores moments without feeling too oppressive.

Of course, Cianfrance's film is, first and foremost, a character piece. Gosling's work in Cianfrance's last film is arguably the best of his career (and Williams was Oscar-nominated in that film) but the director proves that that film was no mere fluke in terms of his skill with actors. Gosling is great, playing so many moments internally where other actors would have gone for the big emotion (Mendes often does go a little too big and Liotta does not really have another key, although that works for his character). However, believe it or not with an ensemble this pedigreed, Cooper steals the piece, doing the best work of his career by some stretch (and, yes, that includes both of his Oscar-nominated performances in *Silver Linings Playbook* [2012] and *American Hustle* [2013]). Avery is the most complex character that this increasingly-interesting actor has yet been given and he does not falter. Dane Dehaan continues to amass an impressive resume for a young actor, reminding this critic of a young Leonardo DiCaprio. Even small roles are memorably filled.

If one could find fault in *The Place Beyond the Pines* it may be that the film sometimes feels overwritten. Yes, the final act feels a bit forced and the entire narrative may have worked better as a novel than a film. The story gets so heavy on narrative, even in its long running time, that character motivation can get lost in the storytelling. However, any time that the film feels like it could sink under the weight of these criticisms, the performances and character-driven writing is strong enough to fill in the gaps. Cianfrance is uninterested in easy answers and the lack of them could frustrate viewers but cinema needs more filmmakers who refuse to so simply connect the dots, cross the "T"s, or dot the "I"s. It is more common in literature to leave open spaces for viewers to fill in with their own thoughts about the characters and the creator's themes. Cinema could use more films that feel this much like great literature.

Brian Tallerico

CREDITS

Luke: Ryan Gosling
Avery Cross: Bradley Cooper
Romina: Eva Mendes
Jennifer: Rose Byrne
Deluca: Ray Liotta
Bill Killcullen: Bruce Greenwood
Kofi: Mahershala Ali
Robin: Ben Mendelsohn
Al Cross: Harris Yulin
Jason: Dane DeHaan
AJ: Emory Cohen
Origin: United States
Language: English
Released: 2013
Production: Sidney Kimmel, Lynette Howell, Jamie Patricof; Hunting Lane Films, Silverwood Films; released by Focus Features L.L.C.
Directed by: Derek Cianfrance
Written by: Derek Cianfrance; Ben Coccio; Darius Marder
Cinematography by: Sean Bobbitt
Music by: Mike Patton
Sound: Dan Flosdorf
Editing: Jim Helton; Ron Patane
Costumes: Erin Benach
Production Design: Inbal Weinberg
MPAA rating: R
Running time: 141 minutes

REVIEWS

Churner, Leah. *Austin Chronicle*. April 10, 2013.
Jagernauth, Kevin. *The Playlist*. March 3, 2013.
Kohn, Eric. *Indiewire*. March 3, 2013.
Persall, Steve. *Tampa Bay Times*. April 10, 2013.
Phillips, Michael. *Chicago Tribune*. April 4, 2013.

Puig, Claudia. *USA Today*. March 28, 2013.
Rea, Steven. *Philadelphia Inquirer*. April 11, 2013.
Reed, Rex. *New York Observer*. March 26, 2013.
Roeper, Richard. *Chicago Sun-Times*. March 27, 2013.
Smith, Kyle. *New York Post*. March 28, 2013.

QUOTES

Robin: "If you ride like lightning, you're going to crash like thunder."

TRIVIA

According to actor Ryan Gosling, all of his bank robbery scenes were done in one take.

PLANES
(Disney's Planes)

From above the world of Cars.
 —Movie tagline

Box Office: $90.3 Million

The moment John Lasseter and Pixar produced *Cars* (2006) the entire model appeared to change over at Disney. It may be unfair to suggest that the all-powerful Disney empire was somehow shifting away from artistic quality toward the almighty dollar when it costs nearly a hundred dollars just to go see recreations at their theme parks except this was a company formed on a dream, a vision, and an artform that helped change the way we looked at motion pictures forever. They were reinvented again in 1995 with the release of *Toy Story* and a seemingly never-ending string of top-notch animated efforts that made its competitors look like flipbooks and thaumatropes. Nearly unanimously considered their first true misfire, *Cars* was nevertheless another big hit that tapped into every young boy's love in the toy industry. After the *Toy Story* trilogy ran its course, Pixar turned to *Cars 2* (2011), announced a number of scheduled sequels to their most popular films, and began a noticeable dip in storytelling, humor, and emotional gravitas that has left many wondering if that Pixar magic has all been spent. While not technically a Pixar endeavor, *Planes* was a Lasseter concept with a history of its journey to theaters that is a more interesting tale than what eventually landed on the big screen.

Dusty Crophopper (voiced by Dane Cook) is a plane with big dreams of becoming a racer. Someone may want to tell him that air racing is one of the few sports not regularly telecast on ESPN. If his name is not the biggest clue since Ann Margrock on *The Flintstones*, Dusty is also a cropduster and hardly suitable for speed-

induced flights of fancy. Despite practicing his aeronautics around his day job, Dusty's only supporter is his best friend, a fuel truck named Chug (Brad Garrett). With the forthcoming Wings Across the World race, Dusty sees an opportunity to prove his worth. Two problems though. The first is getting an old navy plane—of the military sort, not a clothing outlet freight carrier—Skipper Riley (Stacy Keach) for the necessary lessons. More importantly though—Dusty is afraid of heights.

That is precisely the one bit of true inspiration that Jeffrey M. Howard's screenplay introduces in *Planes*. Low-flying cropduster not used to extravagant altitudes makes a whole lot of sense though is hardly the kind of instant smile-inducer as the snail who can motor in *Turbo* (2013). Animation scripters have long recognized the need to appease their adult constituents with humorous reference points and when you think cropduster there is one indelible image that comes to mind. That of an errantly-controlled one chasing down Cary Grant through the fields in *North by Northwest* (1959). To miss or outright ignore that might be the entire filmmaking crew just not sinking to the most obvious reference point, but if one recognizes the voices of Val Kilmer and Anthony Edwards as a pair of Super Hornets who help our hero, clearly even the casting directors were not above trying to subtly slip one in for the elders.

Children under the age of five may be easily distracted by pretty colors and the belief that talking planes can fly. Every passing day above that brings with them a new question. During *Planes,* if parents are still awake, they may be backed into revealing a few answers depending on the advancement of their kids' movie watching habits. Some may wonder about the varying accents given to Dusty's friends and competitors in the race. Others may ask to go the bathroom as the racing scenes subside for a courtship between El Chupacabra (Carlos Alazraqui) and Rochelle (Julia Louis-Dreyfus) as well as Dusty's fixation on Ishani (Priyanka Chopra). Of all of Dusty's chief rival, Ripslinger's (Roger Craig Smith), attempts at sabotage during the film his most egregious may be spoiling the end of *Old Yeller* (1957). Your child's follow-up question could be ever more traumatic. Hopefully they are not at the stage to ask about Skipper's Macho Grande-like raid against the Japanese Navy and why planes, acting under their own orders, were at war. The opposing battleships are given no voice to explain their actions either.

Internal logic and suspension of disbelief against a world inhabited by actual homosapiens would not be so questioned if anything else in *Planes* was worth paying attention to. For a seven-leg race in an 82-minute film, the pod race sequence in *The Phantom Menace* (1999) took up nearly as much screen time and when Jon

Stevens' unintentionally-close-to-*South-Park*-esque anthem, *Fly*, is used on the soundtrack for the second straight montage, you will wish anything was grounded by that point. *Planes* was originally conceived as a direct-to-video release in line with DisneyToons studio's history of producing sequels to some of their most beloved titles like *Beauty and the Beast* (1991), *Aladdin* (1992), and *The Lion King* (1994). This is their first theatrical title since *Pooh's Heffalump Movie* (2005) and based on the quality of that as well as their cheaply-produced but lucrative home video line they should never be allowed to branch out further than a VHF-TV on Saturday mornings.

Toy Story 2 (1999) initially was believed to be going this same route, but after further thought put into the idea of discarded toys it turned into a bonafide modern classic; inarguably one of the best Pixar has produced. Filled with the rich irony that a new generation of animators did not pay attention to what is worth holding on to, the biggest decision the filmmakers seem to have wrestled with is who to replace Jon Cryer with once he departed as the voice of Dusty. Back in the day, a cartoon depicted a family of talking cars wrestling with their newborn insisting their outer shell should be that of a dangerous hot rod rather than a more blue collar taxi cab. Those seven minutes provided more humor, excitement, insight and emotion than any random collection of moments edited together in *Planes*.

Erik Childress

CREDITS

Dusty Crophopper: Dane Cook (Voice)
Chug: Brad Garrett (Voice)
Dottie: Teri Hatcher (Voice)
Ishani: Priyanka Chopra (Voice)
Skipper Riley: Stacy Keach (Voice)
Bulldog: John Cleese (Voice)
Rochelle: Julia Louis-Dreyfus (Voice)
Leadbottom: Cedric the Entertainer (Voice)
Ripslinger: Roger Craig Smith (Voice)
El Chupacabra: Carlos Alazraqui (Voice)
Origin: United States
Language: English
Released: 2013
Production: Traci Balthazor; DisneyToon Studios, Prana Studios; released by Walt Disney Pictures
Directed by: Klay Hall
Written by: Jeffrey M. Howard
Music by: Mark Mancina
Sound: Todd Toon; Rob Nokes
Music Supervisor: Brett Swain

Editing: Jeremy Milton
Production Design: Ryan L. Carlson
MPAA rating: PG
Running time: 91 minutes

REVIEWS

Bell, Josh. *Las Vegas Weekly*. August 8, 2013.
Calhoun, Dave. *Time Out*. August 13, 2013.
Gire, Dann. *Daily Herald*. August 8, 2013.
Goss, William. *Film.com*. August 9, 2013.
Greydanus, Steven D. *Decent Films Guide*. August 9, 2013.
Miller, Neil. *Film School Rejects*. August 9, 2013.
Minow, Nell. *Beliefnet*. August 8, 2013.
Robinson, Tasha. *Fearnet*. August 8, 2013.
Vaux, Rob. *Mania.com*. August 9, 2013.
Wloszczyna, Susan. *RogerEbert.com*. August 9, 2013.

QUOTES

Dusty Crophopper: "I've flown thousands and thousands of miles, and have never gone anywhere."

TRIVIA

Jon Cryer was originally cast as Dusty, but dropped out during production.

POST TENEBRAS LUX

Light after darkness.
　—Movie tagline

Box Office: $39,185

A little girl runs through a muddy field chasing dogs, cows, and donkeys, seeming happy until night falls, a storm comes, and her demeanor turns to fear. A bright, red devil walks through a door into a home, carrying a toolbox, and slowly moves down the hall to a bedroom. A man cuts down a tree. What do these three opening scenes have in common? What could they possibly have to do with one another? What message is their creator trying to convey? Carlos Reygada's divisive *Post Tenebras Lux* plays with form in ways that are bound to polarize. Some will find its slow-burn descent into darkness a commentary on man's relation to nature and the balance of good and evil. Some will cry pretentious foul, claiming there is little more here than a filmmaker playing with his audience. Both are right. *Post Tenebras Lux* is a defiantly weird movie; one that pushes away analysis or categorization the more one attempts to do so. All readings of it are true; all readings of it are false. And while that kind of filmmaking can easily frustrate, alienate, and aggravate a film's audience, it is important

to have filmmakers on the scene like Reygadas who are willing to push the envelope.

Juan (Adolfo Jimenez Castro) has moved to a very rural countryside with his family, including wife Natalia (Nathalia Acevedo) and two children. Just that sentence alone may imply more traditional narrative to this film that Reygadas requires or requests. Reportedly telling a very personal story, he links together episodic, surreal, and increasingly abnormal scenes with little concern for narrative thrust. One could easily read this film as a nightmare about long-lost memory of childhood, nature, and days past given reports of the personal aspect of the story. The star of *Post Tenebras Lux* on every level is the great Alexis Zabe, the cinematographer of Reygada's more-traditional and highly-acclaimed breakthrough *Silent Light*. Zabe shoots this corner of Mexico like a fever dream, often using unique fish lenses in which only a full-frame, 4:3 portion of the film is in focus and beautifully capturing the natural landscape around him.

An appreciation of *Post Tenebras Lux* comes back to filmic expectations. Every time Reygadas seems to dangle a narrative carrot, such as when he begins to focus a socially-conscious scalpel on the alcoholic and broke people in this community, he turns 90 degrees and heads in a different direction, sometimes eschewing narrative altogether. It is not just in the big beats but little ones. A man will be having a conversation, stand up and walk away as he continues to speak, and the camera will not follow him. He is working thematically not narratively. He does not care about the conversation's end but what placing the viewer in the center of it for a few minutes does to the tonal and thematic fabric of his piece overall.

All of it is an undeniably loaded batch of pretension. Even the most hardcore fans of the film would have to admit that it is a complex, arthouse kick to the groin; a film that almost defies the criticism of being overly pretentious by just embracing that aspect of its existence from the very beginning. It is a film about nature that is always reminded one that it is a film, from the odd visual choices to the episodic approach to storytelling; its auteur's fingerprints are on every single frame.

And yet it is also often mesmerizing. That opening scene with the little girl on the increasingly-darkening plain has a blend of childhood innocence and malevolence that is hard to capture in words. In fact, Reygadas' film is much stronger when its creator ignores plot and dialogue entirely, crafting imagery with Zabe that becomes haunting, lyrical, and mesmerizing.

Post Tenebras Lux is a film that is virtually impossible to argue about. One could easily see why it won Best Director at the 2012 Cannes Film Festival just as they could easily see why some arthouse movie goers headed for the exits before it was halfway over. For every

critic that adored it, another derided its filmmaker's art-house self-seriousness. Both are right. It is sometimes brilliant and sometimes maddening. It is both the work of a filmmaker willing to challenge the very form of his art and one who does not seem to understand that the viewer needs to get something out of the exchange as well. It is a film that provoke strong responses on either side of the aisle, and, no matter which side one sits on, the cinema world needs more filmmakers who are not just willing to challenge viewers but so obviously eager to do so.

Brian Tallerico

CREDITS

Juan: Adolfo Jimenez Castro
Natalia: Nathalia Acevedo
Seven: Willebaldo Torres
Origin: Mexico, France, Germany, Netherlands
Language: Spanish, French, English
Released: 2012
Production: Carlos Reygadas; Mantarraya Producciones, No Dream Cinema; released by Strand Releasing
Directed by: Carlos Reygadas
Written by: Carlos Reygadas
Cinematography by: Alexis Zabe
Sound: Gilles Laurent
Editing: Natalia Lopez
Production Design: Gerardo Tagle
MPAA rating: Unrated
Running time: 115 minutes

REVIEWS

Abele, Robert. *Los Angeles Times*. June 6, 2013.
Abrams, Simon. *The Playlist*. April 12, 2013.
Bale, Miriam. *New York Daily News*. May 2, 2013.
Bradshaw, Peter. *The Guardian*. April 12, 2013.
Dargis, Manohla. *New York Times*. April 30, 2013.
Ehrlich, David. *Film.com*. April 29, 2013.
O'Hehir, Andrew. *Salon.com*. May 1, 2013.
Uhlich, Keith. *Time Out New York*. April 30, 2013.
Weissberg, Jay. *Variety*. April 12, 2013.
Young, Neil. *The Hollywood Reporter*. April 12, 2013.

PRINCE AVALANCHE

Box Office: $205,139

For the past few years, director David Gordon Green has gone out of his way to carve a career for

himself based on unpredictability. From his debut, *George Washington* (2000), to his adaptation of Stewart O'Nan's novel *Snow Angels* (2007), Green found himself as an indie darling to those who closely followed his work, but with not quite as much support from cinephiles as he deserved. Even with unending support from his biggest admirers—Roger Ebert, chief among them—Green's films often failed to attract widespread acclaim and accolades that one would often see upon the release of a film by, say, Wes Anderson, David Lynch, or even Terrence Malick, of whom Green's early films have drawn fair comparison. So, it stands to reason he would want to shift gears and direct big-budget studio comedies, such as *Pineapple Express* (2008), *Your Highness* (2011), and *The Sitter* (2011).

While *Pineapple Express* turned out to be Green's biggest success at the box office (along with critical acclaim praising him for taking a broad comedy and still making it his own), the latter two proved to be dismal failures, particularly *Your Highness*, which cost a fortune, but failed on every conceivable level. The film is practically unwatchable and represents perhaps the most significant free-fall of quality from a director who maintained a pretty consistent track record. *The Sitter*, though only a slight improvement thanks to some genuinely funny moments and a few traces of Green's eccentricities on display, failed to attract much attention during the busy awards season, even from its core demographic. With two critical and commercial bombs in a row, Green needed to prove to his audience that he had not completely lost his way.

Prince Avalanche represents a return to form for the director, and while it may not be among his greatest works, it is certainly a welcome improvement in every way and demonstrates that he still has the skills to keep a viewer entranced, occasionally charmed, and that his films are worth more than one initial viewing. The film goes back to Green's indie roots, taking place in a rural backwoods area, seemingly stuck in time and far removed from any sort of pop culture or outside influence. One could watch Green's films (the early ones anyway) and not really know when they were made. The viewer is meant to invest in the characters as well as the physical landscape they inhabit, which becomes as much a part of the narrative as the dialogue.

But *Prince Avalanche*, a film based loosely on the Icelandic film *Either Way* (2011), does take place in a specific time. In the opening sequence, it becomes established that the story takes place in central Texas where wildfires burned several thousand acres and destroyed countless homes. The year is 1988. The film is not really about the wildfires, but about two men whose job it is to repair the roads by painting the yellow guidelines on them. The work is monotonous and necessitates some-

thing interesting to listen to or talk about in order to help the hours pass by more tolerably. The two men are Alvin (Paul Rudd) and Lance (Emile Hirsch), two average looking guys clad in overalls with a noticeable enough age difference.

Their first argument concerns what to listen to on the boombox while the time passes. Alvin needs to listen to his German translation tapes while Lance, the younger of the two, prefers 1980s hard rock. Alvin asserts that he is the boss and that Lance is simply an employee. As it happens, Alvin is dating Lance's girlfriend, Madison. During the downtime, he composes letters to her expressing his boredom and his uncertainty of Lance's abilities. "I believe he might have a learning disorder," he writes. He also notes that the rural country life has taught Lance little except that he misses the city life. He ends the letter in German with "True love is like a ghost. Everyone talks about it, but few have actually seen it,", a sentiment that echoes throughout the film. During this time, Lance ruins Alvin's old comic books by actually playing the crossword puzzles.

While the two get away from each other often enough, they remain confined on most nights by having to sleep in the same tent. They also get paid visits from time to time from a local truck driver (Lance DeGault) who offers them small pieces of wisdom and gladly supplies them with free hard liquor. When Lance states that he is incredibly bored because of the lack of women, the nameless truck driver advises him to make his way into town to meet some ladies on the weekends, but that he also has bad memories of doing that sort of thing back in the day.

Much of what Lance and Alvin talk about has to do with women. Alvin works to support Madison, who is a single mom with three kids. Lance talks about a woman he has had his eye on for a while who happens to be the girlfriend of his best friend. He has no qualms about breaking up their relationship in order for him to get a quick, physical thrill. Lance leaves Alvin for the weekend to pursue more such endeavors while Alvin gets much needed solitude, something he quite enjoys, much to Lance's bewilderment. "There's a difference between loneliness and being alone," Alvin states. During one weekend on his own, Alvin meets a nameless woman (Joyce Payne) whose house has burned down, save for a few walls. She speaks eloquently about how her memories have burned up along with the house.

When Lance returns from his weekend getaway, he seems like a different person, unwilling to engage in much conversation with Alvin, even when Alvin tries to talk to him on his level. Eventually, Alvin finds a letter from Madison that was meant to be delivered to him by Lance. The rest of the film finds Alvin and Lance com-

ing to grips with their current relationships and what they must do with themselves now that the women in their lives have let them down. Even with all the drama that takes place between these characters in their personal lives, the movie never deviates from the setting of being on the road. One could swear they were watching a film based on a play.

That is not to suggest the film is wall-to-wall dialogue. There are many beautiful, arresting visual passages throughout the film that has been one of Green's trademarks as a director and that which has invited comparisons to Mallick. Green has always had affection for the physical landscape and he is aided greatly by his cinematographer Tim Orr who can bring out every perfect shaft of light within every magic hour shot, while also complimenting the improvisational style employed by Green and his actors. Everything looks beautiful, but not too beautiful. Green is also accompanied by his longtime composer David Wingo and Explosions In the Sky, who worked with him on *Snow Angels*. Green, Orr and these composers help make a movie that seems like a play worth watching on the big screen.

The obvious companion piece to *Prince Avalanche* is Green's *All the Real Girls...* (2003). Alvin could very well be a grown-up version of Paul Schneider's character from that film, a guy that has been burned by love more than once, but who still has yet to recognize his own flaws when it comes to relationships. Alvin even has to contend with an unseen character who calls himself Buster Brown, an echo of the Bust-Ass character played by Danny McBride. Lance, meanwhile, has to face a life-changing dilemma similar to that of Shea Whighams' character in the 2003 film, one that will test his manhood and his ability to face true responsibility. The film also shares an ambiguously spiritual element with Green's *Undertow* (2004) and a final sequence that echoes *George Washington*.

But the film also has a goofy side that Green obviously has not shaken off. There are all sorts of hilarious, yet minor character nuances, both verbal and physical, that have always been a staple in his films. Alvin and Lance invent a ridiculous song of their own called "Bad Connections" (written by Rudd and Hirsch) that they sing with conviction during a time of jubilation. There is also a moment in which Alvin tries to convince Lance to go fishing, but he does not make a good case until he offers to loan Lance his swim trunks. Even during a heart-to-heart talk, Alvin sits in a lawn chair that is clearly meant for a 7-year-old.

It is too soon to say how *Prince Avalanche* will be judged within Green's body of work. If nothing else, it has proven that he can and will go back to his roots from time to time, but he still has a long to-do list of genres that he wants to attempt. His long-gestating remake of *Suspiria* could still see the light of day. And as with *Your Highness* and *The Sitter*, they could be failures. But perhaps there is a great deal of wisdom to be found in such endeavors. Green has stated that he does not intend to put his heart on his sleeve with every film. If he were, eventually, his films would become dishonest. Hopefully, he will never make another *Your Highness*, but its existence has made Green's career trajectory more of a fascinating anomaly, one that hopefully will bring his smaller films a bigger, wider, more appreciative audience.

Collin Souter

CREDITS

Alvin: Paul Rudd
Lance: Emile Hirsch
Origin: United States
Language: English
Released: 2013
Production: Craig Zobel, David Gordon Green; Dogfish Pictures; released by Magnolia Pictures
Directed by: David Gordon Green
Written by: David Gordon Green
Cinematography by: Tim Orr
Music by: David Wingo; Explosions in the Sky
Sound: Christof Gebert
Music Supervisor: Devoe Yates
Editing: Colin Patton
Art Direction: Joshua Locy
Costumes: Jill Newell
Production Design: Richard A. Wright
MPAA rating: R
Running time: 94 minutes

REVIEWS

Dowd, A. A. *A/V Club*. August 8, 2013.
Goss, William. *Film.com*. January 25, 2013.
Lane, Anthony. *New Yorker*. August 9, 2013.
Long, Tom. *Detroit News*. August 8, 2013.
Rea, Steven. *Philadelphia Enquirer*. August 8, 2013.
Sharkey, Betsy. *Los Angeles Times*. August 8, 2013.
Scott, A. O. *New York Times*. August 8, 2013.
Smith, Kyle. *New York Post*. August 9, 2013.
Tobias, Scott. *The Dissolve*. August 8, 2013.
Wagaman, Andrew. *Minneapolis Star Tribune*. August 8, 2013.

QUOTES

Alvin: "I was running, and then I reached the cliff, and all I know is I wanted to either fly or kill."

Based on a minimalist Icelandic film, this movie was shot in only 16 days.

PRISONERS

Every moment matters.
—Movie tagline
A hidden truth. A desperate search.
—Movie tagline

Box Office: $61 Million

Thrillers that fill the head as much as twist the gut are a rare and welcome thing, which is why *Prisoners* both triumphs and ultimately stumbles in the end. Well-scripted (to a point) by Aaron Guzikowski, the film is directed with sure-handed nuance and searing emotional intelligence by the French-Canadian director Denis Villeneuve. Impressive for the most part, *Prisoners* luckily earns enough points with its tightly crafted first half to buy its way through a final act that quickly fills up with genre short cuts and over-cooked "crazy-person" criminal behavior.

One Thanksgiving Day in cold and rainy Pennsylvania, two young girls go missing after dinner. Their parents (played by Hugh Jackman and Maria Bello, and Terrance Howard and Viola Davis) are naturally besides themselves with red-eyed, frantic worry. Enter the always-terrific Jake Gyllenhaal as Detective Loki, an enigmatic but dedicated sleuth. (He has tattoos and a murky past, but just as with his similar role in David Fincher's excellent *Zodiac* [2007], his deceptively wide eyes and crooked smile leave his motives and abilities slightly in question.)

Loki and the police quickly find a possible suspect, the developmentally arrested Alex (oily, squirmy Paul Dano exuding a predatory pathos), but despite quite a bit of circumstantial evidence and Alex's strange behavior, there's not enough to charge and hold him. So upon his release, Jackman's Keller Dover—a man's man survivalist and hunter-protector—takes matters—and Alex—into his own hands, kidnapping and torturing the terrified young man to find out what Keller feels Alex must know about the missing girls.

Prisoners has plenty of big, impressive performances from some very good actors, but center stage is Jackman, doing a fine job playing Keller as a stoic-but-caring family man whose God-fearing, Springsteen-loving belief in his role as the Provider and Protector is cross-fueled by a darker, hunter-survivalist paranoia rooted in his own childhood trauma. ("Be ready" Keller advises his older son, and sure enough, his basement is straight out of a doomsday prepper's handbook.)

Most of all, *Prisoners* feels like a horror film for "grown ups." There are no cheap shocks, no baroque gore or phantasmagoric beings—instead it plays off deeper fears of child abduction and parental (and legal) impotence in the face of the unthinkable. Most slasher horror films scare younger people with threats to the things they hold most dear: their young, healthy bodies. *Prisoners* goes after what scares parents the most: something happening to their kids.

Along the way, the film raises legitimate, complex questions about torture and morality, especially in the case of the classic Ticking Time Bomb. Keller torments and "interrogates" Alex in a way that is very purposefully intended to remind us of CIA rendition "black sites," except the ticking bomb is his and his friends' daughters' lives, not an impending terrorist attack.

Prisoners also circles back to Christian religion in multiple guises (a crucifix necklace here, a skeevy priest there), but for the most part faith is presented not as a way of coping with pain, but as justification for bringing it. It is also presented as a conduit for homicidal insanity, but the audience is meant to understand that the dark, twisted religious motivations of the film's eventual Big Bad Person are invalid, while Keller's salt-of-the-earth faith gives him righteous strength...to chain another human being up and beat his face to a pulp and then shower him with scalding water. So when this "good family man" declares his prisoner "no longer human," he becomes a man for whom religion has become not a salve in the face of despair, but rather an Old-Testament rationalization for demonic brutality. (Keller loves to recite "The Lord's Prayer," but eventually cannot quite spit out the "forgive them their trespasses" part.)

Most astutely and darkly, *Prisoners* lets the justification lines of torture blur from "we must do this horrible thing to get the information we need to save lives" into "even if this achieves nothing, it feels good as an outlet for our impotent rage." The film, however, eventually sweeps Keller's actions under the rug (literally). By the time we reach the film's impressive, somewhat ambiguous ending, he is back to being the Hero Father, not the Demon Torturer.

By that third act, Villeneuve and Guzikowski have set aside the thorny issues they so adroitly raised about faith and force and fall back on whodunit genre plot tropes that are in their own way comforting and reassuring. After an hour and a half of low-key attention to character and quietly drawn atmosphere and shapeless dread (not to mention moral murkiness), the last hour of the film trots out a few foot chases and car races and "super weirdo" fetish trappings (strewn around a suspect's "lair"), as well as a whole load of wildly contrived plot devices.

Prisoners starts with a truly unsettling examination of the unknowable, often hauntingly banal nature of even the most heinous crimes but begins to decorate itself with the usual baroque, *Silence of the Lambs* and *Seven*-style lurid flourishes. After all, when people talk about "the nature of evil," eventually they want that "nature" not to be some sad, pathetic, nondescript loser who's broken by all-too-mundane human failings, weaknesses, and mental illness, but rather a wildly florid (and yes, fascinating, even entertaining) "movie psycho weirdo," amped up with mysterious ritualistic trappings like puzzle mazes, dressed-up store mannequins, and yes, even live snakes. *Prisoners* neatly takes some of the darkest real-life fears, works them into a gut-wrenching tableau of paranoia and despair, and then transmutes it all into a more familiar "serial-killer" procedural that feels less real and less threatening.

Thanks to Villeneuve's restrained command of the screen and fine work from his actors, the film remains an effectively gripping and thrilling ride throughout. In doing so, however, it takes the horrific nightmare of child abduction and—after putting the audience through the wringer—makes that nightmare and all its attendant moral issues if not palatable, at least more emotionally and psychologically manageable. No matter how many Oscar-nominated actors are on hand and whatever art-house pedigree its director has, or how serious the subject matter and issues raised, by the end it feels as if *Prisoners* is not exploring fear but exploiting it, and in doing so becomes solid, safe mainstream entertainment rather than gut-wrenching, transcendent art.

Locke Peterseim

CREDITS

Keller Dover: Hugh Jackman
Detective Loki: Jake Gyllenhaal
Nancy Birch: Viola Davis
Grace Dover: Maria Bello
Franklin Birch: Terrence Howard
Holly Jones: Melissa Leo
Alex Jones: Paul Dano
Origin: United States
Language: English
Released: 2013
Production: Kira Pratt Davis; Alcon Entertainment; released by Warner Brothers
Directed by: Denis Villeneuve
Written by: Aaron Guzikowski
Cinematography by: Roger Deakins
Music by: Johan Johannsson
Sound: Alan Robert Murray

Music Supervisor: Deva Anderson
Editing: Joel Cox, Ph.D
Art Direction: Paul Kelly
Costumes: Renee April
Production Design: Patrice Vermette
MPAA rating: R
Running time: 153 minutes

REVIEWS

Denby, David. *The New Yorker.* September 23, 2013.
Edelstein, David. *New York/Vulture.* September 15, 2013.
Hornaday, Ann. *Washington Post.* September 19, 2013.
Lacey, Liam. *The Globe and Mail.* September 20, 2013.
Macinnes, Paul. *Guardian.* September 6, 2013.
Nicholson, Amy. *Village Voice.* September 18, 2013.
O'Hehir, Andrew. *Salon.* September 18, 2013.
Scott, A. O. *New York Times.* September 19, 2013.
Sharkey, Betsey. *Los Angeles Times.* September 19, 2013.
Vishnevetsky, Ignatiy. *Onion A.V. Club.* September 19, 2013.

QUOTES

Keller Dover: "Pray for the best, but prepare for the worst."

TRIVIA

Detective Loki (Jake Gyllenhaal) is clearly visible in several scenes sporting a Freemasons ring on his left hand.

AWARDS

Nominations:
Oscars 2013: Cinematog.

THE PURGE

Reminder all emergency services will be suspended for a 12-hour period during the purge.
—Movie tagline
One night a year, all crime is legal.
—Movie tagline
Survive the night.
—Movie tagline

Box Office: $64.4 Million

The background conceit of *The Purge*, in which the United States government annually grants the population free rein to commit any crime over a twelve-hour period, makes complete sense but only if one looks at it from perspective of class. In the near future, a political party known as the New Founding Fathers is in power. Their philosophy is one of right-wing class warfare:

There are, as the parlance of the modern right-wing movement has put it, "makers" and "takers."

This is a world for the "makers," who—with the financial ability to protect themselves with imposing security systems for their homes and to arm themselves with weapons—are essentially free from the dangers of the Annual Purge and have the best opportunity to partake in what amounts to a yearly hunt of the poor. The results, according to the movie's opening text, are low crime and unemployment rates. The first, one gathers, is due to the fact that the population waits to commit criminal acts when they are technically not criminal. This part of the background information is questionable, even though there is some logic to it.

The unemployment record is almost as tricky to justify, but if one takes into account that the government has implicitly made sport of the hunting of the poor and unemployed, there is little question as to how that phenomenon occurs. (Of course, there is the unspoken possibility that the official numbers are merely lies). The movie's opening imagery, a montage of security camera footage showing brutal murders hauntingly set to the calming melody of the "Clair de lune" movement from Claude Debussy's *Suite bergamasque,* shows that people are more than eager to partake in legitimized killing.

The setup of writer/director James DeMonaco's screenplay is so strong, in fact, that it is easy to give the movie extra credit for its willingness to address one of the more decisive debates of modern politics in broadly, incisively allegorical terms. The existence of an argument over whether or not the premise even makes sense suggests that it hits a nerve. One wants to dismiss it, and the reason the person offers is a reflection of their outlook on society and politics. Perhaps one does not believe there is an inherently violent aspect to human nature. Perhaps one wants to say the idea is silly because to accept it would be to accept that there is something dehumanizing about calling people in a certain economic situation "takers," "welfare queens," and "burdens."

The concept works, though, as the foundation of both agitprop and a thriller, and the movie's strongest section is its opening act, which explains the details in text and with talking heads on television while introducing a family that is about to live through the fifth annual incarnation of the Purge. The setting is a wealthy, suburban neighborhood (one can only imagine the carnage that would be unleashed in a major metropolitan area; perhaps that is for the sequel), where vases of blue flowers adorn the ends of driveways as a symbol of devotion to the Purge. James Sandin (Ethan Hawke) makes his living selling security systems to people looking to turn their home into a fortress for the occasion, and

business has been so good that he has been able to remodel his own home. His wife Mary (Lena Headey) hears some petty whining about the addition to her family home from a neighbor.

That piece of bitterness holds the movie's most diabolical insinuation of this system: There must and will always be "takers." The movie eventually follows through on the promise of this insinuation in a third-act reversal of fortune that hints at the sneaky commentary on this system that the movie could have been.

Instead, the movie squanders whatever allegorical capital it has built up once the Purge begins. The Sandin home is locked down and shuttered. Daughter Zoey (Adelaide Kane) hides her boyfriend (Tony Oller), who remains in the house—unbeknownst to Zoey—to kill her father (a cheap surprise that has no ramifications to the story or any of the central relationships). In an act of impromptu decency, son Charlie (Max Burkholder) raises the house's defense to let in a homeless stranger (Edwin Hodge) who is the intended target of a group of predatory prep-schoolers in masks (Rhys Wakefield plays the group's "polite" leader). At this point, the family is separated in the house, trying to find the wandering stranger in order to give him up to the hunters, who promise to break down the home's security system and kill everyone within if their demands are not met.

Until the climax, DeMonaco is doing little more than spinning the wheels of the barebones plot, keeping everyone apart for no discernible reason up to the point when James must decide what to do with the refugee—after torturing him into submission—as the killers outside wait for reinforcements. The actual standoff between the family and the invaders is sudden and filled with finely choreographed sequences of fierce violence.

After indulging in such rousing brutality, *The Purge* makes an abrupt and unconvincing shift in the aftermath toward a stance of non-violence. Even in the face of the movie's most ingenious twist, in which the neighbors come calling for those they perceive to be a plight upon their neighborhood, the two-faced hypocrisy the movie falls into leaves an ultimately dishonest impression.

Mark Dujsik

CREDITS

James Sandin: Ethan Hawke
Mary Sandin: Lena Headey
Zoey Sandin: Adelaide Kane
Charlie Sandin: Max Burkholder
Polite Leader: Rhys Wakefield
Bloody Stranger: Edwin Hodge
Origin: United States

Language: English

Released: 2013

Production: Michael Bay, Jason Blum, Andrew Form, Bradley Fuller, Sebastien Lemercier; Blumhouse Productions, Overlord Productions, Platinum Dunes, Why Not Productions; released by Universal Pictures Inc.

Directed by: James DeMonaco

Written by: James DeMonaco

Cinematography by: Jacques Jouffret

Music by: Nathan Whitehead

Sound: Kelly Cabral

Editing: Peter Gvozdas

Costumes: Lisa Norcia

Production Design: Melanie Jones

MPAA rating: R

Running time: 85 minutes

REVIEWS

Buckwalter, Ian. *NPR.* June 6, 2013.

Dargis, Manohla. *New York Times.* June 6, 2013.

Howell, Peter. *Toronto Star.* June 6, 2013.

Johanson, MaryAnn. *Flick Filosopher.* May 30, 2013.

Puig, Claudia. *USA Today.* June 6, 2013.

Putman, Dustin. *DustinPutman.com.* June 7, 2013.

Rodriguez, Rene. *Miami Herald.* June 6, 2013.

Tallerico, Brian. *HollywoodChicago.com.* June 6, 2013.

Vaux, Rob. *Mania.com.* June 7, 2013.

Vishnevetsky, Ignatiy. *A.V. Club.* June 6, 2013.

QUOTES

Polite Leader: "Our target for this year's purge is hiding in your home. You have one hour to find him and give him to us or we will kill all of you. We will be coming in."

TRIVIA

Over one-hundred different masks were considered for the freaks.

R

REALITY

Follow your dreams!
—Movie tagline

Box Office: $72,577

Matteo Garrone has quickly ascended to a coveted airspace on the international film scene largely through his success at the Cannes Film Festival. His incredible crime epic *Gomorrah* (2008) not only appeared on top ten lists of outlets as respected as the *New York Times, Los Angeles Times,* and *Entertainment Weekly* but won the Grand Prix award at that year's French festival. Four years later, Garrone's follow-up came with the natural expectations of following up a critical smash and fuel was thrown on the fires of anticipation when it won the Grand Prix again at the 2012 Cannes affair. Nine months later, *Reality* finally made the long trip stateside and, well, the response was akin to disappointment. *Reality* is far from an awful film—it really does nothing to pop the balloon on the idea that Garrone is still a major filmmaker—and is more defeated by its ambition than its execution but it serves as proof that hitting a home run in back-to-back at-bats can be nearly impossible

How appropriate that a film called *Reality* would open with an extremely abnormal event; something far from what most people would consider reality—a wedding in a horse-drawn carriage with people dressed like clowns and lords & ladies while music and even doves fill the air. This is no one's reality. And yet *Reality* than crashes back down to normalcy, carving out the story of a man who lives a relatively plain existence that would keep most men happy but who sees a glimpse of a heightened version of reality in his country's hit TV show, *Big Brother*. The result is similar to something like Federico Fellini remaking Martin Scorsese's *The King of Comedy* (1983) in the manner that Garrone's film dissects the cult of celebrity with a decidedly Italian flair.

To be fair, Luciano (Aniello Arena) has been encouraged to believe that he is one of the stand-out characters in his small town near Naples. He may merely be a fishmonger but he is one of those guys who everyone knows; who always has a joke; who is asked to entertain crowds. He is the most popular guy in every room and constantly told he needs to go on TV. There is one in every town in the world, and very few of them would actually work on TV. But he believes the madding crowd, and decides to take his jump to stardom when his daughter's favorite show, *Big Brother,* comes to town for an audition in a local mall. Luciano actually gets the callback to Rome, where he spends a very long time talking to the show's psychologist, and, well, it does not go well. Luciano takes the attention from the mental expert as interest; it is more morbid fascination. Garrone makes clear to the audience that Luciano is out of luck but the character seems to think the exact opposite.

From here, *Reality* essentially becomes a piece about a man going from popular, friendly, and happy to paranoid and unraveled by the allure of fame that will never come. Luciano snaps when he begins to think that producers may be watching him in everyday life as a fishmonger and that he needs to up his entertainment value. In some ways, Luciano even behaves like a better man, being kind to others in case they might be a TV producer. Here is where Garrone's film is at its most thematically ambitious. The reality TV producers are

arguably creating action within the protagonist that should come from more historically respected eyes of judgment. Modern times have replaced God with TV producers. Things get really problematic when Luciano sells his fish stand to spruce up the house for interviews that will probably never come.

The visual confidence of *Gomorrah* remains in *Reality*. Garrone has claimed that his main goal here was to make a traditional comedy, and that could not be further afield from his filmmaking aspirations for his last work. The tonal change of pace may be jarring. And Garrone makes an interesting stylistic choice, making the viewer observers to this reality by often keeping them behind the characters, almost eavesdropping like a reality TV camera. It is an interesting decision creatively but it can deaden the pace at times, keeping us at a distance for thematic purposes but never allowing the tragedy of this character's arc to register. *Reality* sometimes feels too much like a fait accompli as one never really considers Luciano is going to find what he so desperately needs here; it can be like watching a descent into madness, even with a surprisingly touching coda.

In terms of performance, Anella sometimes edges too far to character parody in his exaggerated line delivery but the rest of the cast, many of which were actually old ladies from this small town, beautifully ground the piece. No one here is bad and the film works on modest terms. It is just not the creative smash some were hoping for, largely due to pacing issues and a sense that Garrone is working with fascinating ideas but kind of bored by his actual narrative. The tonal balance between comedy and drama can also be remarkably out of whack. Satire, comedy, drama, tragedy—like reality TV, it has a little but of all of the above.

Brian Tallerico

CREDITS

Luciano: Aniello Arena
Maria: Loredana Simioli
Michele: Nando Paone
Origin: United States
Language: Italian
Released: 2013
Production: Domenico Proarci, Matteo Garrone; Archimede, Fandango, Garance Capital, Le Pacte; released by Oscilloscope Films
Directed by: Matteo Garrone
Written by: Matteo Garrone; Ugo Chiti; Maurizio Braucci; Massimo Gaudioso
Cinematography by: Marco Onorato

Music by: Alexandre Desplat
Sound: Maricetta Lombardo
Editing: Marco Spoletini
Costumes: Maurizio Millenotti
Production Design: Paolo Bonfini
MPAA rating: R
Running time: 116 minutes

REVIEWS

Bradshaw, Peter. *The Guardian*. March 8, 2013.
Cataldo, Jesse. *Slant Magazine*. March 11, 2013.
Crook, Simon. *Empire*. March 18, 2013.
Dawson, Tom. *Total Film*. March 15, 2013.
Lane, Anthony. *The New Yorker*. March 20, 2013.
Mohan, Marc. *Portland Oregonian*. March 8, 2013.
Smith Nehme, Farran. *New York Post*. March 14, 2013.
O'Hehir, Andrew. *Salon.com*. March 18, 2013.
Weitzman, Elizabeth. *New York Daily News*. March 14, 2013.
Young, Deborah. *The Hollywood Reporter*. March 8, 2013.

TRIVIA

Aniello Arena, the film's main protagonist, is serving a life sentence at the prison of Volterra for killing three people in Piazza Crocelle in Barra in 1981.

RED 2

The best never rest.
 —Movie tagline

Box Office: $53.3 Million

RED 2 is a pointless sequel and completely nondescript action movie that, like its predecessor, benefits greatly from smart casting. Whereas *RED* (2010) provided the actors with a confounding, silly, and unimportant plot with which they could have some fun within the confines of the broad archetypes of their characters, the second movie finds the screenwriting team of Jon and Erich Hoeber (returning from the first movie and, once again, working from the short comic book series by Warren Ellis and Cully Hamner) taking the throwaway plot a little more seriously than in the previous installment. Perhaps it is a symptom of the usual need to up the stakes for a sequel, with a weapon of mass destruction threatening to shift the balance of international power, and perhaps that over-the-top plot device is simply a symptom of the fact that the series' premise of "Retired, Extremely Dangerous" covert operatives pushed back into action due to forces of the past coming back to haunt them has simply run its course.

Whatever the reason, the characters are now mere shadows of their formerly, only semi-interesting selves.

The casting in the first movie was such a coup because so many of the actors were playing just on the edge of doing the unexpected. Take Morgan Freeman's role in the original (his presence is sorely missed here). He played an aged and ailing—slowly but surely dying of cancer—former CIA agent who is more surprised than saddened by his present state in life, but through his character's ruminations on his past, the movie possessed a slight acknowledgement of the conflict within every major player in the story in between the outlandish action sequences.

The characters that return here do not possess that same level of potential subversion. The screenwriters play it safe with these characters, and so, too, do the actors. There are no new revelations; everyone has settled into the routine of behavior and personality established in the first movie.

The story opens with Frank Moses (Bruce Willis, appearing particularly bored or distracted throughout the entire movie), the central ex-spook, and his girlfriend Sarah (Mary-Louise Parker, delightfully eager to participate in the action, which is the only genuinely expanded characterization of any of the established players) as they attempt to live in the bliss of everyday, domestic affairs, like shopping in bulk at a wholesale store. Sarah is already bored with ordinary life, so the appearance of Marvin (John Malkovich, toned down from his last appearance as the character) is a welcome one—only for her, though. After asking if the two of them want to accompany him on a mission, Marvin's car explodes in the parking lot.

At the funeral, government agents arrest Frank to question him about a decades-old assignment at the height of the Cold War, but everyone at the facility except Frank is killed by government "clean-up" men led by Horton (Neal McDonough). Frank, Sarah, and a not-dead Marvin reunite and plan to find the mysterious weapon from the past before anyone else can.

The ensuing globe-hopping is nothing more than an excuse to introduce new and re-introduce familiar characters. The new additions include Catherine Zeta-Jones as Katja, a former KGB agent who still works for the government and was—and remains—Frank's "kryptonite," and David Thewlis as the Frog, a secrets-seller who is also a wine connoisseur. Byung-hun Lee—effectively physical and icy—plays Han, the world's greatest assassin, and, Anthony Hopkins, clearly having a lot of fun with the devilishly deceptive character and ultimately standing out among both the new and old cast members, is Bailey, a "rock star of conceptual mass killing." Returning are Helen Mirren as the sociopathic but elegant Victoria, a killer who can have a thoughtful telephone conversation while dissolving the bodies of her victims in a bathtub full of acid, and Brian Cox as the strange Ivan.

The Hoebers and director Dean Parisot believe that the mere presence of all of these recognizable and/or immediately personable actors will compensate for the lack of imagination on display. They are incorrect, and the movie alternates between exposition-heavy scenes of backstabbing—with a side of double- and triple-crossing—and action sequences that are more obligatory than rousing.

There are plenty of shootouts to resolve differences (the movie's general devaluation of human life is slightly disturbing—more so than most bloodless Hollywood action comedies). A car chase down the streets of Paris, in which Sarah tries to prove her worth by catching the target before Frank can, has a single flash of inspiration, but even that moment is a reversed callback to a similar one in the first movie (Frank steps into the seat of a moving car without any effort, as opposed to stepping out of it). The whole of *RED 2* is similar in its approach: It provides the most minimal level of variation possible.

Mark Dujsik

CREDITS

Frank Moses: Bruce Willis
Marvin Boggs: John Malkovich
Sarah Ross: Mary-Louise Parker
Victoria: Helen Mirren
Miranda Wood: Catherine Zeta-Jones
Edward Bailey: Anthony Hopkins
Jack Horton: Neal McDonough
Ivan: Brian Cox
Han Cho Bai: Byung-hun Lee
The Frog: David Thewlis
Director Philips: Tim Pigott-Smith
Origin: United States
Language: English
Released: 2013
Production: Lorenzo di Bonaventura, Raphael Benoliel, Mark Vahradian; DC Entertainment, Etalon Films, NeoReel, Saints LA; released by Summit Entertainment
Directed by: Dean Parisot
Written by: Jon Hoeber; Erich Hoeber
Cinematography by: Enrique Chediak
Music by: Alan Silvestri
Sound: Chris Munro
Music Supervisor: John Houlihan
Editing: Don Zimmerman
Art Direction: Dominic Masters
Costumes: Beatrix Aruna Pasztor
Production Design: Jim Clay

MPAA rating: PG-13
Running time: 116 minutes

REVIEWS

Berardinelli, James. *ReelViews*. July 18, 2013.
Gire, Dann. *Daily Herald (Illinois)*. July 18, 2013.
Johanson, MaryAnn. *Flick Filosopher*. August 9, 2013.
LaSalle, Mick. *San Francisco Chronicle*. July 18, 2013.
Orndorf, Brian. *Blu-ray.com*. July 18, 2013.
Phillips, Michael. *Chicago Tribune*. July 18, 2013.
Putman, Dustin. *DustinPutman.com*. July 19, 2013.
Robinson, Tasha. *The Dissolve*. July 18, 2013.
Westhoff, Jeffrey. *Northwest Herald*. July 17, 2013.
Vaux, Rob. *Mania.com*. July 19, 2013.

QUOTES

Marvin: "What happens in the Kremlin stays in the Kremlin!"

TRIVIA

Anthony Hopkins and Brian Cox have both played the
character of Hannibal Lecter. Cox originated the part in
Manhunter (1986) while Hopkins played the part in *The
Silence of the Lambs* (1991), *Hannibal* (2001), and in *Red
Dragon* (2002).

REDEMPTION

All roads don't lead to salvation.
 —Movie tagline

London. 3:00am. Same streets, different city.
 —Movie tagline

Box Office: $36,895

Since emerging in his prototypical state as a bald
Cockney ruffian in Guy Ritchie's 1998 film *Lock, Stock,
and Two Smoking Barrels*, Jason Statham has become an
action genre archetype whose presence precedes itself,
fulfilling the most bland of genre-based scripts with his
machismo and direct dialogue reading. In attempts to
challenge the simplification many of his acting predeces-
sors have also battled (like Sylvester Stallone and Clint
Eastwood), Statham flexed dramatic muscles in 2005's
London directed by Hunter Richards, and 2007's *Re-
volver*, also by Ritchie, symbolizing his different ap-
proach in both films with a rare head of hair. Portraying
desperate men struggling to regain control of their mind
and body, these films brought in the lowest box office
receipts of his career. Moving forward from these failed
ventures, Statham dove onscreen-persona-first into the
action genre, absorbing numerous stock characters for
his perpetual mainstream charisma, simultaneously los-
ing the uniqueness he excited audiences with in 1998
the more he received work as an imaginary tough guy
for hire.

Fitting then, that he should play an ex-soldier (with
shaggy long hair) disturbed by his own atrocities in his
third dramatic attempt, *Redemption* (known with the
less direct title of *Hummingbird* outside of the United
States). Statham stars as Joey Jones, a not-so creatively
named bum who lives in a cardboard box in London
with his friend Isabel (Victoria Bewick) after suffering a
traumatic experience as a Special Forces soldier in
Afghanistan. One night Jones is chased from his
residential alleyway into an apartment abandoned by a
wealthy socialite named Damon (Danny Webb). Soon
after discovering that the apartment owner is not due to
return home for a few months, Jones elects to take
advantage of this serendipitous second chance.

After transforming his hair status from "greasy
homeless man" to "Jason Statham," Jones maneuvers
into the apartment owner's bank account, and dons his
upper-class garb. Initially, he gets an honest job in a
restaurant kitchen, but after roughing up a few unruly
customers, Jones is promoted to being a driver and debt
collector for a Chinese gang. While on this well-paying
but illegal gig creating a new life built on dishonesty,
Jones also makes a point to look back at where he came
from. He posts signs around the city hoping to hear
from his friend Isabel; he donates money to a shy nun
named Cristina (a gentle Agata Buzek), who provides
warm dinner for his friends from his previous under-
ground community. In the process he also starts an hon-
est friendship with Cristina, despite her trepidations
concerning the mystery of Jones' background.

When treating Cristina to a steak dinner, she
indirectly reveals to him that Isabel eventually began
working in a brothel, and was recently found murdered
in a river. This spurs Jones towards the raging interest of
revenge, ready to abandon the brief feelings of being a
good man.

Redemption marks the completion of an unofficial
trilogy from Steven Knight about his beloved London
underground, joining similarly themed films only writ-
ten by Knight, 2002's *Dirty Pretty Things* (directed by
Steven Frears) and 2007's *Eastern Promises* (directed by
David Cronenberg). The three films are bound by their
brutish romance for the location, focusing on the noi-
some operations that fuel the underworld's economy. In
comparison, Knight's reclaiming of the vision fails when
he plots his own tale out like it must follow a standard.
Similarly, he is overshadowed by two previous films
from more experienced directors, and now by his action
star.

In a role that utilizes his unmistakable Statham
charisma to the film's advantage, the actor becomes a
compelling surrogate in the film's title journey. Statham
delivers on two key dramatic scenes, the first is a display

of desperate anger maybe not seen since *Revolver*, in which he barks ferociously after flipping a table over. The second involves Statham flooding his eyeballs in a moment of vivid inner conflict; a piece of drama that Knight knows is a rarity, and a magnetic one. A testimony to his power as a dramatic actor, neither of these sequences discredits *Redemption* with maudlin accusations.

With his gritty fairytale of a lost soul who experiences being "a good man" as a last hurrah, Knight uses coincidences, or overly neat contrivances, to elevate the reality of this story. From Cristina's placement at the conveniently titled mission "Sisters of Redemption" to Joey's fall into good luck when he crashes into the apartment, *Redemption* frames its cause with clunky literal strides that stop right on the nose. It is a playful storytelling mentality, mostly in that it challenges the viewer to perceive whether they trust Knight enough to not accuse him of laziness. In this regard, Knight makes the presentation of events more sophisticated than the events themselves.

Knight is less excused for his more direct blunders, which go beyond a limp moment in which Statham threatens to rough up his former torturers with a spoon. A bookend involving drone footage (which are referred to in slang as "hummingbirds," which are then presented in a hallucination midway through the film) provides the same snide commentary about security in London that Knight provided with his screenplay for 2013's *Closed Circuit* directed by John Crowley. His overarching idea as well, that of muddled moral territory where no one is definitively good or bad, shows that the story needs freshness more than it does moral weight.

Though shown in montage packaging, *Redemption* has its more striking scenes when it shows what Statham is known for doing best—hurting people, but without the same allure of gratuitousness. Accompanied by a melancholy score from Dario Marianelli and Statham's facial expressions which show clearly the machine the man has become, *Redemption*'s acts of violence can be fitfully gruesome to watch. Pain is shown without justification, as viewers watch Jones brutalize people to question how much he has really revolutionized himself.

Considering that Knight chose this closing of a trilogy as his directorial debut, Statham is a curiously specific choice to play this character. With Statham the actor receiving more outward complications than the character Knight has written for him, Statham hijacks this project, coming away as its most intriguing facet. Perhaps he is also its most damning, as *Redemption* rhymed the distinct box office failure of the actor's aforementioned disasters. With both Knight and Statham powerless against the former films that overshadow their

more personal endeavors, *Redemption* struggles with whether man himself can significantly change, or only one's perception of him.

Nick Allen

CREDITS
Joey: Jason Statham
Cristina: Agata Buzek
Dawn: Vicky McClure
Mr. Choy: Benedict Wong
Mother Superior: Ger Ryan
Origin: United Kingdom
Language: English
Released: 2013
Production: Paul Webster, Guy Heeley; released by Lionsgate
Directed by: Steven Knight
Written by: Steven Knight
Cinematography by: Chris Menges
Music by: Dario Marianelli
Sound: Ian Wilson
Music Supervisor: Maggie Rodford
Editing: Valerio Bonelli
Art Direction: Stuart Kearns
Costumes: Louise Stjernsward
Production Design: Michael Carlin
MPAA rating: R
Running time: 100 minutes

REVIEWS
Bray, Catherine. *Time Out*. June 25, 2013.
Debruge, Peter. *Variety*. June 24, 2013.
Fear, David. *Time Out New York*. June 25, 2013.
Goldstein, Gary. *New York Times*. June 27, 2013.
Holden, Stephen. *New York Times*. June 27, 2013.
Long, Tom. *Detroit News*. June 28, 2013.
Lumenick, Lou. *New York Post*. June 28, 2013.
Neumaier, Joe. *New York Daily News*. June 27, 2013.
VanDenburgh, Barbara. *Arizona Republic*. June 27, 2013.
Whitty, Stephen. *Newark Star Ledger*. June 28, 2013.

QUOTES
Joey: "When I'm sober, when I'm healthy and well, I hurt people. I'm lethal. I drink to weaken the machine they made."

THE RELUCTANT FUNDAMENTALIST

When one day changes the world forever.
 —Movie tagline
Terror has two faces.
 —Movie tagline

Box Office: $519,535

The pivotal moment in Mohsin Hamid's short novel *The Reluctant Fundamentalist* comes when the narrator,

Changez (played by Riz Ahmed in the film), speaking to a nervous American in a cafe, describes his reaction to seeing the Twin Towers fall on TV. This is the pivotal moment in Changez's life. Up until then, he has been living the American dream as a Pakistani immigrant succeeding in the financial sector and living the high life in New York City. But at that moment, he feels a strange elation that surprises and disturbs him. He is not happy about the deaths of 3,000 immigrants, but he feels happy that someone has brought the arrogant power of the United States to its knees. This feeling shakes him to the core.

It is understandable that in her film adaptation of Hamid's book, director Mira Nair downplays that moment. It is certainly the kind of emotion that American audiences, even more than a decade after those horrific events, has trouble understanding. But the closer Nair gets to that sense of disenchantment with America, particularly its foreign policy, and the broad range of reactions to that feeling, even within a single conflicted person, the more useful and compelling *The Reluctant Fundamentalist* is as a film.

Hamid was involved with adapting his book to the screen, but the script was written by William Wheeler, and tacks on a ticking clock and other thriller elements that do not work as well as the deeply personal drama at its core, at least until the end, when it becomes clear that the relationship between Changez and Bobby (Liev Schreiber), the equally conflicted American journalist to whom he tells his tale, is part of a continuum, in terms of the West's view of Pakistan and that region of the world.

The film opens with the kidnapping of an American expatriate college professor, Rainier (Gary Richardson) in Lahore, Pakistan. Bobby arranges to interview Changez Khan, a professor at the same university. But Changez already knows that Bobby has been recruited by the CIA. The interview is essentially a ruse. Changez is perceived as a possible Muslim fundamentalist who might have been involved with the kidnapping, and the CIA is actually trying to turn Changez in time to rescue the kidnapped man. So Changez tells his story, as in the book, but there are all these bits of business going on in the background involving the CIA team led by Cooper (the always reliable Martin Donovan) and the race to save Rainier. While these elements might have been intended to add suspense and a sense of urgency to the proceedings, they mostly confuse things. Changez has an engrossing personal story, but why would a CIA operative let him spend two hours telling it when a man's life was on the line?

Changez is the son of a poet (Om Puri), and part of a fairly Westernized, once-wealthy family. He goes to America to attend Princeton, where he does well, and lands a highly coveted job at a valuation firm (consultants who help executives determine how to save money, usually by cutting jobs), working for Jim Cross (Kiefer Sutherland), who is impressed with Changez' canny ruthlessness.

Changez also meets and falls in love with Erica (Kate Hudson), a photo artist from a wealthy family, who is struggling to get over the tragic death of her ex-boyfriend. Hudson, whose career seemed to be on a downswing when the film was made, plays this difficult role with surprising subtlety and grace. Erica is stuck in her grief, and also can't quite get past Changez' "otherness," and their troubled romance is believable and moving.

At work, Changez does very well under Cross's wing, but on a business trip to the Philippines, he watches from his hotel room as the World Trade Center towers fall. He returns to the U.S. to find that his adoptive country's view of him has radically changed overnight. He's humiliatingly strip-searched at the airport, and later is harassed, and picked up and questioned by the FBI without cause. His view of America and of his job begins to change. Eventually he finds himself back in Lahore, teaching about radical fundamentalism and violent revolution.

It is a fascinating story, and Ahmed, in nearly every scene, delivers a captivating performance. It is refreshing to see a prominent international filmmaker seek out this kind of story, and Nair, who previously adapted the difficult novels *The Namesake* (2006) and *Vanity Fair* (2004) is to be commended for taking on such challenging and morally complex subject matter. It is not wholly successful. In their first moments together, Changez makes Bobby promise to listen to his whole story from beginning to end, "not just bits and pieces," so it is ironic that there is such choppiness to the storytelling, in part because Nair is trying to squeeze in all the elements of Changez's personal story, while also giving time to the somewhat contrived thriller plot. To anyone aware of the filmmaker's work, it should not be surprising that Changez and even Bobby's personal stories are handled more effectively than the genre aspects. That said, that storyline does lead to a poignant moment at the end that pointedly ties back into Changez's tale.

Josh Ralske

CREDITS

Changez: Riz Ahmed
Erica: Kate Hudson
Bobby Lincoln: Liev Schreiber

Jim Cross: Kiefer Sutherland

Abu: Om Puri

Origin: United States

Language: English

Released: 2013

Production: Lydra Dean Pilcher; Cine Mosaic, Mirabal Films, The Doha Film Institute; released by IFC Films

Directed by: Mira Nair

Written by: William Wheeler

Cinematography by: Declan Quinn

Music by: Michael Andrews

Sound: Manoj M. Goswami

Editing: Shimit Amin

Costumes: Arjun Bhasin

Production Design: Michael Carlin

MPAA rating: R

Running time: 130 minutes

REVIEWS

Adams, Sam. *The A.V. Club.* April 24, 2013.

Burr, Ty. *Boston Globe.* May 9, 2013.

Corliss, Richard. *Time.* April 29, 2013.

Mozaffar, Omer M. *RogerEbert.com.* June 11, 2013.

O'Sullivan, Michael. *Washington Post.* May 9, 2013.

Rainer, Peter. *Christian Science Monitor.* April 26, 2013.

Rea, Steven. *Philadelphia Inquirer.* May 9, 2013.

Roeper, Richard. *Chicago Sun-Times.* May 2, 2013.

Taylor, Ella. *NPR.* April 25, 2013.

Turan, Kenneth. *Los Angeles Times.* April 25, 2013.

QUOTES

Changez: "After 9/11, you could choose your side. I had my side chosen for me."

TRIVIA

The song, "Bijli Aye Ya Na Aye" is a Meesha Shafi's alternate version of the song "Batti Aye Ya Na Aye," which is by her previous band Overload. This led to a dispute between Shafi and Overload, as to who owns the copyright of the song.

RENOIR

Box Office: $2.3 Million

Movies about great artists tend to fall into one of two categories—the stories either follow them during the early days of their careers as they are just beginning to find their creative voice or capture them near the end as they are struggling to come up with one last masterpiece. Either way, the proceedings are usually interrupted by the arrival of a beautiful young woman who serves as a muse for the artist and, perhaps more important, supplies enough nudity to ensure the film's success on the arthouse circuit. With his latest film, *Renoir*, co-writer/director Gilles Bourdes gives viewers their money's worth with a story that presents one of each artistic type and plenty of muse-related nakedness to boot. The end result may not exactly reinvent the color wheel but is a solid and beautifully-made biopic that makes up for its lack of narrative drive with moments of quietly extraordinary beauty.

Set in a lush area of the French Riviera circa 1915, the film opens with noted impressionist Pierre-Auguste Renoir (Michel Bouquet) in the twilight of his career, still dedicated to performing his craft despite a worsening case of rheumatoid arthritis that makes performing his work an excruciating task. Despite the help of his young son, Coco (Thomas Doret), and an attentive all-female staff, Auguste cannot help but be distracted by the physical pain from his hands and the emotional pain of having his two older sons off fighting in World War I. Eventually, inspiration arrives in the form of Andree (Crista Theret), a gorgeous redhead who begins to serve as Auguste's new model. Andree also turns the head of Auguste's middle son, Jean (Vincent Rottiers), who has just returned home to convalesce after being injured in the war and before long, she inspires him to give serious thought to stepping out of his father's considerable shadow and pursuing his dream of taking up the new artistic medium of cinema.

Aside from illustrating the transition from the end of one career to the beginning of another and, to a certain extent, the early moments of the transition that would end with film being the dominant art form of the 20th century, *Renoir* is not a film that offers viewers much of in the way of a storyline. Instead, it is simply content to quietly observe the two Renoirs as they go about their different means of artistic expression and the ways in which they deal with and interact with Andree. Although the lack of any real dramatic urgency may drive some viewers to distraction, others will be relieved that they will not have to endure the clumsy exposition and ham-fisted epiphanies that often plague biopics. The absence of such elements means also allows viewers to more fully enjoy the elements that Bourdes clearly finds more important than narrative, such as the nicely modulated performances by Bouquet and Rottiers as the two Renoirs and Theret as the model who turns out to be more than just an exceptionally pretty face and the gorgeous cinematography by Mark Lee Ping-bing, who pulls off the considerable feat of making the entire film look like a Renoir painting.

Make no mistake, *Renoir* is no masterpiece along the lines of the superficially similar Jacques Rivette masterpiece *La Belle Noiseuse* (1991) or even a more

recent entry like the Fernando Trueba drama *The Artist & the Model* (2012) may come across as more dramatically and emotionally fulfilling. However, as a quiet but sure observation of the artistic process through the eyes of two of its more esteemed practitioners, it is a worthwhile endeavor. For those with no real working knowledge of either Renoir, it may not hold very much appeal but for those who are already fascinated with either one or both, *Renoir* should make a vivid impression.

Peter Sobczynski

CREDITS

Pierre-Auguste Renoir: Michel Bouquet
Jean Renoir: Vincent Rottiers
Andree Heuschling: Christa Theret
Claude "Coco" Renoir: Thomas Doret
Gabrielle: Romane Bohringer
Origin: France
Language: French, Italian
Released: 2012
Production: Olivier Delbosc, Marc Missonnier; Fidelite Films; released by Samuel Goldwyn Films
Directed by: Gilles Bourdos
Written by: Gilles Bourdos; Jerome Tonnerre
Cinematography by: Mark Ping Bin Lee
Music by: Alexandre Desplat
Sound: Valerie Deloof
Editing: Yannick Kergoat
Costumes: Pascaline Chevanne
Production Design: Benoit Barouh
MPAA rating: R
Running time: 111 minutes

REVIEWS

Bale, Miriam. *New York Daily News*. March 28, 2013.
Baumgarten, Marjorie. *Austin Chronicle*. May 10, 2013.
Burr, Ty. *Boston Globe*. May 2, 2013.
Denby, David. *New Yorker*. April 8, 2013.
Holden, Stephen. *New York Times*. March 28, 2013.
Kauffmann, Stanley. *The New Republic*. May 31, 2013.
McCarthy, Todd. *Hollywood Reporter*. May 31, 2013.
McCreadle, Marsha. *Village Voice*. March 28, 2013.
Morgenstern, Joe. *Wall Street Journal*. March 28, 2013.
Turan, Kenneth. *Los Angeles Times*. March 28, 2013.

TRIVIA

This was the official submission of France to the Oscars 2014 Best Foreign Language Film category.

RIDDICK

Rule the dark.
—Movie tagline

Survival is his revenge.
—Movie tagline

Box Office: $42 Million

This third film in the Riddick series (fourth if the animated *The Chronicles of Riddick: Dark Fury* [2004] counts) strikes a fine balance between the near artistry of the first *Pitch Black* (2000) and the unsatisfying excess of the last, *The Chronicles of Riddick* (2004). Writer/ director David Twohy tones down the faux epic feel of the latter and offers some of the fine characterization of the former. It is fun, at times wildly so, and visually reminiscent of 1980s schlock sci-fi like *Enemy Mine* (1985) or second tier John Carpenter like *Ghosts of Mars* (2001). Rest assured, no one is liable to remember much about it on initial viewing even if they are highly likely to pause the remote when it airs shows up on their TV.

Picking up five years after *The Chronicles of Riddick,* the film details Riddick's (Vin Diesel) fall from the position of leader of the Necromonger fleet. His unwillingness to adopt their faith forces him to bargain with Commander Vaako (Karl Urban), handing over the title of Lord Marshall in exchange for an escape ship. But when the ship lands instead on a desert planet and his escorts attempt to assassinate him, Riddick barely escapes with his life, killing them even as his leg is shattered and he passes out. He awakens later, alone, stranded on a hostile world.

As he tries to heal he soon finds he is not completely alone and must fight off the planets indigenous and often venomous life forms. Using makeshift weapons and the planet's natural environment to provide food and shelter, he tames one of the hyena-like creatures that constantly harasses him and creates a tenuous existence for himself through hunting. But when a massive approaching storm threatens to set a flood of deadly creatures loose from the soil Riddick realizes he has no choice but to find a way off the planet and he activates an emergency beacon broadcasting his identity to mercenaries throughout the universe.

Hungry for the bounty are two separate groups. One led by the money-hungry, vicious rogue Santana (Jordi Molla) and the other led by Boss Johns (Matt Nable), father of the bounty hunter who originally captured Riddick in *Pitch Black*, and who has his own reasons for trying to capture him alive. Each group is willing to kill the other to catch Riddick and he uses the conflict to orchestrate a daring escape attempt.

Twohy goes out of his way to notify the audience who is in charge of the production putting his name prominently in the actual scenery right at the beginning of the titles. This is no casual money grab. In fact, the opening sequence of the film, almost completely free of dialogue and showing Riddick in a desert survival

scenario, is so effective that viewers may wish the film stayed a dialogue-free, single-character exploration of one man against the elements. Twohy is one of those talents that was supposed to breakout a long time ago. He first came to prominence as a director with *The Arrival* (1996), a neat little science fiction thriller that opened the way for his next film, *Pitch Black*. That was followed by *Below* (2002) an above average ghost story set on a submarine. His next film, the box office debacle, *The Chronicles of Riddick*, left him in limbo.

But here he has an absolute blast. Think *First Blood* (1982) in outer space, or *Pitch Black*-lite. The emphasis is on fulfilling viewer expectation involving the tropes of space mercenaries, man against nature sci-fi and maintaining a high monster quotient. Plot holes galore barely make a dent in the enjoyability since the film clearly aims to be simple entertainment. Special effects here are solid to great but not photo realistic. Instead, the design of the film is geared towards creating an odd visual aesthetic that could be called clunky if it were less than grin-inducing. For instance scenes where Riddick and company rides the equivalent of space Harleys across alien landscapes and sunsets are clearly green screen, yet it all has a playful over-the-top effect. Likewise the alien creatures which, though obviously CG still manage to convey menace and physical presence even when the sound of fingers tapping on a keyboard in some lonely cubicle can almost be heard in the background. Riddick's tame hyena thing even manages to become a character with a soul instead of a convenient plot device.

Casting is to type and works just as well as the special effects. Diesel was born to play Riddick and picks the role up 13 years later without a hitch. The character is a physical embodiment of morality and individuality against society. Riddick does what he thinks is right even when it costs him but he will take a life to preserve his in a heartbeat and mete out his own justice readily. Yet there is a sense of goodness in the character as well, lines he will not cross, not even to save himself. Of the rest of the cast the easy standout is the beautiful Katee Sackhoff. Her tough as nails portrayal of the mercenary Dahl descends into cliche at times but there is always a glint in her eyes to sell the character and Sackhoff manages to hold her own against Diesel's powerful screen presence.

The Riddick saga has the makings of a solid franchise if Twohy and Diesel can accept him as a b-movie character and resist the urge to attempt anything operatic. With his mirror-eyes and on the narrative arc Riddick suggests a cross between Dirty Harry and the Fugitive. Take away that tension and the character loses the motivation that makes audiences root for him.

Dave Canfield

CREDITS

Riddick: Vin Diesel
Santana: Jordi Molla
Boss Johns: Matt Noble
Dahl: Katee Sackhoff
Moss: Bokeem Woodbine
Diaz: Dave Bautista
Vaako: Karl Urban
Lockspur: Raoul Trujillo
Vargas: Conrad Pla
Luna: Nolan Gerard Funk
Origin: United States, United Kingdom
Language: English
Released: 2013
Production: Ted Field, Vin Diesel; One Race Productions; released by Universal Pictures Inc.
Directed by: David N. Twohy
Written by: David N. Twohy
Cinematography by: David Eggby
Music by: Graeme Revell
Sound: Scott Martin Gershin
Music Supervisor: Brandon Thompson
Editing: Tracy Adams
Art Direction: Jean-Andre Carriere
Costumes: Simonetta Mariano
Production Design: Joseph C. Nemec, III
MPAA rating: R
Running time: 119 minutes

REVIEWS

Berardinelli, James. *ReelViews*. September 6, 2013.
Brayton, Tim. *Antagony & Ecstacy*. September 12, 2013.
Brunson, Matt. *Creative Loafing*. September 14, 2013.
Burr, Ty. *Boston Globe*. September 6, 2013.
Cook, Linda. *Quad City Times (Davenport, IA)*. September 28, 2013.
Kendrick, Ben. *ScreenRant*. September 6, 2013.
Kendrick, James. *Q Network Film Desk*. September 18, 2013.
Lane, Anthony. *New Yorker*. September 16, 2013.
Stamp, Tony. *Flicks.co.nz*. September 12, 2013.

QUOTES

Riddick: "Somewhere along the way, I lost a step. I got sloppy. Dulled my own edge. Maybe I went and did the worst crime of all, I got civilized."

R.I.P.D.

To protect and serve the living.
—Movie tagline
Defending our world one soul at a time.
—Movie tagline

Box Office: $33.6 Million

From the perspective of the major Hollywood studios, the summer of 2013 is not likely to go down as a high-water mark in the annals of moviemaking history, thanks to a slate of absurdly expensive projects that either failed to take in enough money to justify the massive expenditures required to produce and promote them (such as the troubled zombie epic *World War Z* [2013], which reportedly needed to pull in $500 million just so that it would break even) or were simply out-and-out failures (such as the misbegotten attempt to transform *The Lone Ranger* [2013] into another vehicle for Johnny Depp to derail with his increasingly tiresome eccentricities). Of all these disappointments perhaps none deserved their ignominious fate as much as *R.I.P.D.*, an overblown, effects-laden action/fantasy/buddy-cop comedy that misses all of its marks so spectacularly that one watches it wondering not where it all went wrong but why so many theoretically intelligent people thought that such a mess could have ever gone right in the first place.

The conceit of this film is that immediately after death, souls are whisked away to an otherworldly bureaucracy that determines whether they are to spend eternity upstairs or downstairs. However, some errant souls, known as deados, manage to elude the so-called Department of Eternal Affairs and continue to roam the Earth, growing more and more powerful and dangerous the longer they are out there. Charged with apprehending these free-range phantasms is the Rest In Peace Department, an elite squad of deceased cops working off their own past transgressions by tracking them down and bringing them back alive, so to speak.

The latest R.I.P.D. recruit is Nick Walker (Ryan Reynolds), a recently-deceased Boston cop whose brief flirtation with the dark side led to his being murdered by his thoroughly corrupt partner (Kevin Bacon). Upon arriving at the DEA, he is given the lay of the land by a ruthlessly efficient caseworker (Mary-Louise Parker) and teamed up with one Roycephus Pulsifer (Jeff Bridges),

an Old West lawman so garrulous that he makes Rooster Cogburn seem like the soul of reticence by comparison. Of course, the two have nothing in common but similar pulse rates but before long, they must prevent an effort by certain deados to reassemble an ancient contraption known as the Shaft of Jericho that, if allowed to operate, will allow them to take over the entire planet.

R.I.P.D. was clearly intended to provide viewers with offbeat fun and Universal Pictures with a new and lucrative franchise but winds up failing spectacularly at both of those goals, among others. Mixing comedy and costly special effects is always a dicey proposition because the spontaneity (or at least the illusion of such) required for the humor to work often is at odds with the elaborate technical precision needed to pull off the visual fireworks. *R.I.P.D.* tries to make both sides of the equation work but the result is a combination of the worst of both worlds. In the hands of a director with a genuine sense of cinematic style, it might have worked but under the direction of the uber-bland Robert Schwentke, a man whose oeuvre is so forgettable that one suspects that even he has to go to IMDB to identify his previous projects, none of the oddball elements jell and the film just lays one rotten egg after another.

The comedy doesn't work because the storyline is little more than a slapdash ripoff of *Men in Black* (1997) with a little bit of the long-forgotten zombie-cop comedy *Dead Heat* (1987) thrown in for good measure and the jokes demonstrate all the whimsy of an improvised sketch that has been allowed run on beyond the point of endurance. From an effects-related standpoint, the film is also a non-starter because while every scene is jam-packed with some form of technical wizardry, none of them are particularly memorable or amusing. Another major flaw is the aimless and decidedly unengaging performance from Reynolds, who looks simply bored at the antics surrounding him. (With the total failure of both this film and the dismal screen version of *The Green Lantern* (2011), his days as a potential franchise lead may well be numbered.)

However, even when Jeff Bridges gives a rare bad performance, he throws himself into it as completely as he does with his great ones. As Roycephus, Bridges stomps through the film like some unholy combination of Jeff Lebowski and Yosemite Sam and while the performance is arguably the dumbest of his entire career, he commits to it fully. Beyond his demented efforts, this is another example of a film so busy trying to set itself up as a potential franchise that it never gets around to creating a story of characters that audiences would want to see even once. *R.I.P.D.* is just a massive missed opportunity that is just as dead on arrival as the majority

of its characters but nowhere near as likely to be resurrected anytime soon.

Peter Sobczynski

CREDITS

Nick Walker: Ryan Reynolds
Roy Pulsipher: Jeff Bridges
Procter: Mary-Louise Parker
Nawlicki: Robert Knepper
Grandpa Chen: James Hong
Elliot: Mike O'Malley
Bobby Hayes: Kevin Bacon
Julia: Stephanie Szostak
Origin: United States
Language: English
Released: 2013
Production: Michael Fottrell, Neal H. Moritz, Mike Richardson; Dark Horse Entertainment, Original Film; released by Universal Pictures Inc.
Directed by: Robert Schwentke
Written by: Matt Manfredi; Phil Hay
Cinematography by: Alwin Kuchler
Music by: Christophe Beck
Sound: Dave McMoyler
Editing: Mark Helfrich
Costumes: Susan Lyall
Production Design: Alec (Alexander) Hammond
MPAA rating: PG-13
Running time: 96 minutes

REVIEWS

Boone, Steven. *RogerEbert.com.* July 24, 2013.
Corliss, Richard. *Time Magazine.* July 19, 2013.
Dargis, Manohla. *New York Times.* July 21, 2013.
Foundas, Scott. *Variety.* July 19, 2013.
McCarthy, Todd. *Hollywood Reporter.* July 19, 2013.
Olsen, Mark. *Los Angeles Times.* July 19, 2013.
Orndorf, Brian. *Blu-ray.com.* July 19, 2013.
Puig, Claudia. *USA Today.* July 19, 2013.
Rabin, Nathan. *The Dissolve.* July 19, 2013.
Stevens, Dana. *Slate.* July 19, 2013.

QUOTES

Proctor: "Until they pop, they look like regular people, so no one except us knows they're monsters inside. You see, if you slip through the cracks, and stay on Earth after you die, your soul rots. They rot, the world rots. Global warming, black plague, bad cell reception, get it?"

TRIVIA

Zach Galifianakis was originally cast in the Roy Powell role, but dropped out due to scheduling conflicts.

ROMEO & JULIET

The most dangerous love story ever told.
—Movie tagline

Box Office: $1.2 Million

It takes a lot of chutzpah for a writer to attempt to improve upon the writing of William Shakespeare, and according to accounts from various scholars of the immortal playwright's work, that is exactly what screenwriter Julian Fellowes has tried with *Romeo & Juliet*. The notion of adjusting Shakespeare's language is both insulting to the audience—presuming people will not understand it—and playing into the false belief that Shakespeare wrote in some alien form of the English language instead of the form in which he actually wrote: modern English—only somewhat varied from English speakers still use today.

Of course, only people who know the play by heart or those who decide to follow along with their copy of the text will notice the extent of the alterations (a few, like a character stating that the eponymous heroine has "good taste in men," are disarming and obvious). While that kind of in-depth analysis could be enlightening as to exactly what Fellowes believes is a hindrance to a modern audience's understanding of Shakespeare, it would hardly come close to fully explaining why director Carlo Carlei's version of one of Shakespeare's most famous plays is so decidedly underwhelming.

A major part of the movie's failure is in the language but not just in the changes. The chief problem is in how seemingly little Carlei and some of the actors (most notably, the leads) care about the language, revised or not. That leads to a two-fold death knell for the movie: A Shakespeare adaptation that does not allow the audience to savor the language—by far the biggest selling point—and a version of *Romeo and Juliet* in which the central love story does not work.

Recounting the story is superfluous, save for the necessity of identifying the players. The backdrop is fair Verona, where the Montague and Capulet families have been embroiled in an old rivalry. Romeo (Douglas Booth), a young man of the Montague clan, is pining over an unrequited love at the start of the tale. Juliet (Hailee Steinfeld) is the Capulet's teenage daughter whose father (Damian Lewis) intends her—after some convincing and a pair of killings—to be betrothed to Count Paris (Tom Wisdom) of the local ruling family. They meet at a ball held by the Capulets and start a whirlwind romance that will lead to a surprisingly high body count, including Romeo's friend Mercutio (Christian Cooke) and Juliet's cousin Tybalt (Ed Westwick).

That the story has been told countless times on screens both large and small would be unimportant if

Carlei had made his version distinct in any positive way, but even its most distinguishing feature—actors dressed in period attire (with costumes designed by Carlo Poggioli) with the movie shot on location in Italy—was already done in Franco Zeffirelli's far superior 1968 film. Except for a few scenes that are clearly shot in front of blue-screens replaced with gaudily over-lit backgrounds, the movie, featuring David Tattersall's strikingly naturalistic cinematography, is quite lovely.

Of course, the eye wanders to the "stages" upon which the actors are playing not only because of the locations and sometimes remarkable compositions (when Romeo falsely learns that Juliet has died, the scene is set against a fresco depicting the anguish of humanity as the gods look on without emotion—a bit of staging that is conspicuous in the best way) but also because, for the most part, the performances do not have a solid footing. Steinfeld has the bad habit of rushing through her lines, and Booth never accomplishes more in his performance than recitation. The fact that Fellowes has all but eliminated the play's vital soliloquies (Romeo's buildup to the balcony scene remains, but that is about it) does not help matters, and Carlei attempts to compensate for the absence of internal conflict by embellishing the bond between Romeo and Juliet with long stares, which are sometimes shot in slow-motion for redundant emphasis, and kisses.

The supporting cast never moves past their roles in regards to moving the plot forward, save for Paul Giamatti as the unintentionally troublesome Friar Laurence—the man whose rather ridiculous plan leads to the untimely deaths of the young lovers. Giamatti creates a sympathetic and relatable character from one who is little more than the provider of a plot device. His performance is the single unqualified success of *Romeo & Juliet*.

Mark Dujsik

CREDITS

Romeo: Douglas Booth
Juliet: Hailee Steinfeld
Lord Capulet: Damian Lewis
Lady Capulet: Natascha (Natasha) McElhone
Prince of Verona: Stellan Skarsgard
Lady Montague: Laura Morante
Lord Montague: Tomas Arana
Mercutio: Christian Cooke
Tybalt: Ed Westwick
Count Paris: Tom Wisdom
Benvolio: Kodi Smit-McPhee
Nurse: Lesley Manville

Friar Laurence: Paul Giamatti
Origin: United Kingdom
Language: English
Released: 2013
Production: Simon Bosanquet, Lawrence Elman, Doug Mankoff, Julian Fellowes; Echo Lake Entertainment; released by Relativity Media L.L.C.
Directed by: Carlo Carlei
Written by: Julian Fellowes
Cinematography by: David Tattersall
Music by: Abel Koreniowski
Sound: Lee Herrick
Music Supervisor: Karen Elliott
Editing: Peter Honess
Art Direction: Gianpaolo Rifino; Armando Savoia
Costumes: Carlo Poggioli
Production Design: Tonino Zera
MPAA rating: PG-13
Running time: 118 minutes

REVIEWS

Berardinelli, James. *ReelViews*. October 10, 2013.
Chang, Justin. *Variety*. October 8, 2013.
Dargis, Manohla. *New York Times*. October 10, 2013.
LaSalle, Mick. *San Francisco Chronicle*. October 10, 2013.
O'Hehir, Andrew. *Salon.com*. October 14, 2013.
Osenlund, R. Kurt. *Slant Magazine*. October 10, 2013.
Phillips, Michael. *Chicago Tribune*. October 10, 2013.
Robinson, Tasha. *The Dissolve*. October 10, 2013.
Stevens, Dana. *Slate*. October 11, 2013.

TRIVIA

Logan Lerman, Sam Claflin, Josh Hutcherson, and Benjamin Gur all auditioned for the role of Romeo.

ROOM 237

Some movies stay with you forever, and ever, and ever.
—Movie tagline

Box Office: $296,359

Rodney Ascher's hugely entertaining documentary is not an analysis of Stanley Kubrick's 1980 masterpiece, *The Shining*, so much as it is a tribute to the transfixing power of great art. Kubrick's reputation as a perfectionist suggests that every detail within the frame has a meaning and purpose, regardless of how inexplicable or accidental it may appear. Since postmodern criticism and Blu-ray players have opened the door to frame-by-frame interpretations unbound by directorial intent, it is

no surprise that the Internet has exploded with a rich array of bizarre, often absurd and always fascinating takes on Kubrick's work from his most obsessive fans.

By refusing to endorse or mock the impassioned opinions of these cinephiles, Ascher invites audiences to get lost in the twisted labyrinth of their theories. The loonier they are, the more entrancing they become, particularly when Ascher's brilliantly playful editing incorporates clips from other pictures, many of them directed by Kubrick. Viewers might start to find themselves drawing connections between seemingly unrelated details, much like Ascher's interview subjects, before breaking into incredulous laughter or, perhaps, forging their own personalized bond with Kubrick's endlessly enticing imagery.

Indeed, there are few films as beguilingly hypnotic as Kubrick's divisive, widely misunderstood adaptation of the hit 1977 horror novel by Stephen King, who hated the picture so much that he wrote his own version, an abysmally inept 1997 TV movie that makes a fleeting appearance in Ascher's film. King did not seem to understand that it was the ambiguity of Kubrick's vision that made his picture so deeply unsettling. Each shot bristles with such impeccable craftsmanship and full-throated conviction that it is impossible to not read into the possible layers of meaning conveyed through John Alcott's cinematography, Roy Walker's production design, Leslie Tomkins's art direction and a soundtrack comprised of atonal masterworks from Wendy Carlos, Rachel Elkind, Bela Bartok, Gyorgy Ligeti and the galvanizing Krzysztof Penderecki.

On the surface level, *The Shining* is simply about a frustrated writer, Jack Torrance, who agrees to be the winter caretaker at the secluded Overlook Hotel. Haunted by the hotel's demonic spirits, Jack goes insane and attempts to kill his wife, Wendy, and his son, Danny, who possesses psychic abilities that enable him to foresee impending danger. Denial plays a major role in the story, as characters witness horrifying events before wiping their memories clean in a desperate stab at self-preservation. Wendy decides to stay with Jack even after his inebriated temper tantrums leave their son with a broken arm. It is clear from the get-go that Jack had violent tendencies before he even stepped foot in the hotel, a plot alteration from King's novel magnified by Jack Nicholson's consistently demented performance.

Kubrick's deep interest in mankind's destructive behavioral patterns ends up transforming King's spooky yarn into a profoundly disturbing meditation on the human capacity for evil that has existed since the dawn of time. By not learning from one's own past, one is doomed to repeat it. By staring the Overlook's history straight in the face, rather than dismiss these supernatural

warning signs as "pictures in a book," Danny achieves enlightenment. The various references Kubrick makes to Native American genocide and racism indicate that the hotel's aesthetically pleasing foundation is built on the bloodshed and "wave of terror" that gave birth to America, a chapter in the nation's past often overlooked in history books. The ghosts justify their homicidal orders to Jack by stating that they are his "duty," a lie evocative of righteous patriotism utilized to pardon indefensible acts, such as those witnessed in Kubrick's wartime drama, *Paths of Glory* (1957). By literally retracing his father's footsteps in the snow-caked maze, Danny leads his mother to safety, leaving his brainwashed father frozen in time.

Journalist Bill Blakemore shares many of these theories, and ends up building the film's most compelling case, though the beauty of these interpretations is that none of them are provable in any literal sense. They are purely the result of each moviegoer's intimate relationship with the images and sounds Kubrick presents, and how they provoke the emotions and intellect of the avid observer. The interview subjects' heightened senses can often be traced back directly to their own backgrounds and expertise. Professor Geoffrey Cocks's knowledge of WWII history causes him to spot potential references Kubrick may have made to the Holocaust, particularly his repeated use of the number 42, perhaps referencing the year the Final Solution began. Blogger John Fell Ryan's decade-long work in a film archive sharpened his senses enough to spot malevolent forces in the Overlook that reveal themselves when Danny's Big Wheel suddenly jumps up an entire floor in order to place him in the claustrophobic hallway inhabited by the smirking twin girls.

Even the craziest theories are at the very least backed up with inarguable facts that could either be continuity errors or conscious choices on the part of Kubrick. Why does the entire carpet shift beneath Danny's feet after a perfectly placed ball rolls toward him from the open door of Room 237? Such an enormous change surely would have been the result of something more than a mere oversight. Playwright Juli Kearns argues that the carpet's morphing shapes are meant to entrap Danny, while author Jay Weidner makes it a part of his operatic conspiratorial case that the entire picture is Kubrick's veiled confession for having faked the 1969 moon landing footage. After all, Danny does happen to be wearing a knit sweater displaying the Apollo 11.

Anyone seeking answers to the mysteries of Kubrick's vision will leave *Room 237* empty-handed. This is a film about obsession itself, and the ways in which it can enclose movie buffs within a labyrinth comprised entirely of dead ends. Art is created in order for meaning to be extracted from it, but that does not necessarily

mean that the meaning one extracts has any meaning beyond what exists in one's own head. Mistaking that meaning for fact could lead to a dizzying detachment from reality lasting forever and ever and ever.

Matt Fagerholm

CREDITS

Origin: United States
Language: English
Released: 2013
Production: Tim Kirk; Highland Park Classics; released by IFC Films
Directed by: Rodney Ascher
Written by: Rodney Ascher
Music by: William Hutson; Jonathan Snipes
Sound: Joseph Tsai
Editing: Rodney Ascher
MPAA rating: Unrated
Running time: 102 minutes

REVIEWS

Bradshaw, Peter. *The Guardian*. February 10, 2013.
Dargis, Manohla. *The New York Times*. March 28, 2013.
Emerson, Jim. *Chicago Sun-Times*. April 3, 2013.
Jagernauth, Kevin. *The Playlist*. February 10, 2013.
McCarthy, Todd. *The Hollywood Reporter*. February 10, 2013.
Morgenstern, Joe. *Wall Street Journal*. April 4, 2013.
Murray, Noel. *The AV Club*. March 27, 2013.
O'Hehir, Andrew. *Salon.com*. March 29, 2013.
Tobias, Scott. *NPR*. March 28, 2013.
Turan, Kenneth. *Los Angeles Times*. February 10, 2013.

RUNNER RUNNER

You have no idea who you're playing with.
 —Movie tagline

Play. Or be played.
 —Movie tagline

The house always wins.
 —Movie tagline

Know when to walk away.
 —Movie tagline

Box Office: $19.3 Million

Sometimes the scariest enemy is the wolf in sheep's clothing. In the weakly-executed *Runner Runner,* Ben Affleck attempts to play his character, Ivan Block, as just that—as if he were one of the film's crocodiles lurking in the water, harmless when unseen and deadly when

visible in full form. Albert Brooks pulled this off wonderfully with his performance in *Drive* (2011) that should have earned considerably more awards attention than it received. If Brooks brought commitment and chilling menace to that role, Affleck brings failed charm that registers as detachment and cruelty that is both too obvious and not convincing enough.

Unfortunately, the rest of *Runner Runner* is no more credible. That starts with Richie Furst (Justin Timberlake), a Princeton grad student introduced as a finance whiz and then spontaneously turned into a greedy twit at the first opportunity for a big payday. Despite scenes with his unkempt, gambling-addicted father (John Heard), Richie never seems like the kind of guy who has been so deprived at a fulfilling and even mildly luxurious life that he would jump at any chance at hedonism. After all, he is played by Justin Timberlake, an actor who suggests effortless charisma, not an underdog forced to pull himself up by his teeth. It is understandable when Richie, an online poker promoter who gets cheated out of $17,000 on a site he promotes, heads from New Jersey to a conveniently timed convention in Costa Rica in hopes of convincing Ivan, the controversial and FBI-sought head honcho behind the site, to give back his money. It is ridiculous, however, when Ivan, who makes an extremely mild effort to hide his shadiness when not only offering Richie his lost funds but a high-paying job, gets a new client with minimal persuasion required. It is as if he went fishing and caught a 50-pounder seconds after dropping his line into the water.

What follows is a very *Wall Street* (1987)-esque story of money's corrupting abilities, something that should be news to approximately no one. Richie, on the other hand, seemingly does not realize the possibility that the Costa Rican police force could be influenced by Ivan's bank account, or, initially, that the stranger who runs the site that conned him would have anything less than spotless motives. The script comes from the writers of 1998's *Rounders,* and *Runner Runner* often feels like Brian Koppelman and David Levien cobbled together the story from bad ideas they discarded for their previous gambling-related thriller. (They also arrive about a decade late to the online gambling craze and should be fined for including the well-known mantra "The house always wins" twice.) To be fair, the writing team did do quite a nice job with their chips in the underrated and snazzy *Ocean's Thirteen* (2007).

There are a few sharp lines in *Runner Runner,* which helps keep things at a level closer to pathetic and harmlessly forgettable rather than upsettingly awful. Yet the film is so easy to pick apart it may as well be string cheese. Why does Richie, who should theoretically be working to impress his new boss and maybe cozy up to one of the countless beautiful women Ivan has presented

to him, thoughtlessly pursue the one woman (Gemma Arterton) with whom Ivan seems to have a relationship? Also, when an FBI agent (Anthony Mackie) has Richie kidnapped and threatens to prevent his return to the United States if he does not assist in bringing down his employer, Richie freaks out and immediately tells Ivan. Perhaps the new recruit thinks this shows loyalty, but what it really shows Ivan is that his new player/pawn will panic at the appearance of risk and make an impulsive decision. Maybe this is why Richie likes playing poker online, where no one can see his face.

Richie may be a newbie to this criminal world, but because he does not come off as a believable and likable character for the audience to relate to and root for, his gullibility and lack of backbone only sap the film's minimal dramatic tension and potentially miss an opportunity to capitalize on Richie's ambitiousness. If he is so seduced by dollar signs and willing, perhaps in spite of his subconscious better judgment, to go along with a dangerous power player, why not explore something darker that Richie discovers in himself when suddenly up close and personal with opponents far more formidable than leaders at Princeton? Instead, *Runner Runner*, whose lunges toward cool are only pale imitations, prefers cliche and the easy route of keeping Richie as the nice fish who accidentally landed in a polluted pond. Without spoiling the ending, know that the implication made by the protege's efforts to unseat the mentor make little sense when contextualized with everything that comes before and everything director Brad Furman neglects to show on screen.

Timberlake makes a legit movie star when tapping into what makes him such an appealing presence in his music career and talk-show appearances. His swagger in *The Social Network* and *Friends with Benefits* light up the room. In both *Runner Runner* and 2011's *In Time*, though, the need to suppress confidence in favor of consistent drama proves disastrous for films that really would not work with a better actor either. So the seemingly unshakable icon skirts blame once again by delivering a performance that lives down to the material. If even a portion of *Runner Runner* were that clever, this review would read much differently.

Matt Pais

CREDITS

Richie Furst: Justin Timberlake
Ivan Block: Ben Affleck
Rebecca: Gemma Arterton
Agent Shavers: Anthony Mackie
Harry Furst: John Heard
Origin: United States

Language: English
Released: 2013
Production: Leonardo DiCaprio, Stacey Sher, Michael H. Shamberg, Brian Koppelman, David Levien; New Regency; released by Twentieth Century Fox Film Corp.
Directed by: Brad Furman
Written by: Brian Koppelman; David Levien
Cinematography by: Mauro Fiore
Music by: Christophe Beck
Sound: Steven Ticknor
Editing: Jeff McEvoy
Art Direction: Sarah Contant
Costumes: Sophie de Rakoff
Production Design: Charisse Cardenas
MPAA rating: R
Running time: 91 minutes

REVIEWS

Brooks, Xan. *The Guardian*. September 26, 2013.
Burr, Ty. *Boston Globe*. October 3, 2013.
Hornaday, Ann. *Washington Post*. October 3, 2013.
Legel, Laremy. *Film.com*. October 4, 2013.
McCarthy, Todd. *The Hollywood Reporter*. September 25, 2013.
Osenlund, R. Kurt. *Slant Magazine*. October 4, 2013.
Rodriguez, Rene. *Miami Herald*. October 3, 2013.
Roeper, Richard. *Chicago Sun-Times*. October 3, 2013.
Scott, A. O. *New York Times*. October 3, 2013.
Tobias, Scott. *The Dissolve*. October 3, 2013.

QUOTES

Ivan Block: "That little voice in the back of your head right now, it's not conscience, it's fear."

RUSH

Everyone's driven by something.
—Movie tagline

Box Office: $26.9 Million

Great rivalries are fueled by hate. They may be built on the spirit of competition, but their enduring legacies are powered by either the rooting interest of one side or the ongoing debate between scholars and fans over who is truly more deserving of being called the best. In music, film, and other forms of art, the crowns are placed superficially by awards and the almighty dollar while more astute observers look deeper into true creative achievements. Only in sports can more direct one-on-one comparisons be drawn. Whether it be the Yankees and the Red Sox or the Chicago Bears and Green Bay Packers, the score at the end of a three-hour session can

establish an immediate victor and pave the course for a real trophy. When the battle is reduced to a sport of individual achievement, the rivalry can become even bitterer. One wonders if Ron Howard took this singular passion project with something a bit more in mind than who is eventually declared winner, because it sure is not anyone who has seen a movie about opposition before.

Briton James Hunt (Chris Hemsworth) and Austrian Niki Lauda's (Daniel Bruhl) rivalry began in 1970 on the Formula Three circuit when the former was responsible for a latter spinout and eventually won the race. Five years later, Lauda buys his way into Formula One at a time when Hunt's sponsorship was flailing. Resentment is natural, but Lauda's expertise in crafting a fast automobile makes him a formidable and nearly unbeatable opponent as well. When Hunt's team tries to match those engineering skills, they are penalized for non-compliance. The rivalry grows.

The key to such contention from an outside observer is to either place their interest in rooting for one or merely rooting against the other. Two subjects of respect hardly make for great drama and similar subjects of narcissistic villainy would sooner have viewers hoping for the popping of skulls rather than champagne. Hunt and Lauda are each middle-of-the-road characters, both with admirable traits and distance-driving personalities at times. Maybe geographical spectators can take pride in their hometown boy, but the rest of the audience is left struggling to wonder precisely what about this particular story is dramatically satisfying or simply something not experienced in cinema before.

While a cinematic pariah, *Days of Thunder* (1990) could be placed over *Rush*'s outline with very little overlap. Then again, so can most of the template for Tom Cruise's late 1980s brash protege/rivalry resume: The setup, the sponsorship hunt, "rubbin' is racing," a career-changing crash, and, eventually, respect. There is a difficulty in taking anything so uber-seriously during *Rush* when the circumstances of its plotting—even as a possible inspiration for previous films—feel like afterthoughts of very little consequence.

Rush appears to be more interested in its endgame message than truly offering insight into what makes these two men tick. Hunt is the handsome playboy, fond of the party and the ladies. Lauda is the one-track technical genius who, admittedly, looks like a rat. The women in their life get no further to their interior design. Hunt meets and marries model Suzy Miller (Olivia Wilde) just as fast as he discovers she is making time with Richard Burton. Lauda's relationship with socialite Marlene (Alexandra Maria Lara) gets a few more minutes although it is little more than a warm body to share the same insight about control and the acceptance

of a potential tragic fate doing something he loves that Tom Cruise's Cole Trickle delivered to his token lady.

With such a guarded view of the protagonists through a smoky veil of cliches, it is left to speculation if *Rush* is more an insight into the career of Ron Howard. Well-respected by his peers if not always his critics, the actor made his own leap to the big show through a showbiz family and other connections. Through hard work, he rose to the level of box office success and eventually an Oscar for *A Beautiful Mind* (2001). He has never slowed down, amassing over twenty features in thirty years and, still, a placement alongside the great directors of his time eludes him due to not having any particular style other than, generally, just winning. After Lauda's fiery crash, their similar hairstyles are merely a coincidence, but moving away from his most recent cinematographer, Salvatore Totino, to Danny Boyle's regular, Anthony Dod Mantle, *Rush* has a less slick, grainier aesthetic to its look. Unnecessary in the manner to prove that Howard is really going for his R-rating with more nudity and F-bombs than usual. It is the only thing differentiating *Rush* on Howard's resume aside from more lively characters, excitement, emotional weight, and screenplays that feel a lot less basic than the one delivered by Peter Morgan here.

Rush is no such statement on Howard's career other than as another example of subject matter more interesting to its creator than his followers. The racing scenes are unspectacular as they fail to incite the pure visceral thrill that audiences in the confines of a speed limit could experience as both an escape from the script's monotony and an acceptance to the lifestyle of these wannabe superhumans. After all of Hunt and Lauda's ping pong match of accusations, insults and chicken taunts and finally arriving at the all-along revelation of mutual respect it is easy to feel that viewers have just gone round and round the track with the same turns and arrived at the same finish line with no semblance of being rewarded for it.

Erik Childress

CREDITS

James Hunt: Chris Hemsworth
Niki Lauda: Daniel Bruhl
Suzy Miller: Olivia Wilde
Marlene Lauda: Alexandra Maria Lara
Nurse Gemma: Natalie Dormer
Origin: United States, United Kingdom
Language: English

Released: 2013

Production: Brian Grazer, Eric Fellner; Imagine Entertainment; released by Universal Pictures Inc.

Directed by: Ron Howard

Written by: Peter Morgan

Cinematography by: Anthony Dod Mantle

Music by: Hans Zimmer

Sound: Frank Kruse

Music Supervisor: Nick Angel

Editing: Daniel Hanley; Mike Hill

Art Direction: Patrick Rolfe

Costumes: Julian Day

Production Design: Mark Digby

MPAA rating: R

Running time: 123 minutes

REVIEWS

Berardinelli, James. *ReelViews*. September 24, 2013.

Burr, Ty. *Boston Globe*. September 25, 2013.

Duralde, Alonso. *The Wrap*. September 17, 2013.

Howell, Peter. *Toronto Star*. September 26, 2013.

Hunt, Drew. *Chicago Reader*. September 26, 2013.

Lane, Anthony. *New Yorker*. September 30, 2013.

Morgenstern, Joe. *Wall Street Journal*. September 19, 2013.

O'Hehir, Andrew. *Salon.com*. September 19, 2013.

Rothkopf, Joshua. *Time Out New York*. September 17, 2013.

Turan, Kenneth. *Los Angeles Times*. September 19, 2013.

QUOTES

James Hunt: "The closer you are to death, the more alive you feel. It's a wonderful way to live. It's the only way to drive."

TRIVIA

Chris Hemsworth auditioned for the role of James Hunt while filming *The Avengers* (2012) and impressed Ron Howard so much he was signed instantly.

AWARDS

British Acad. 2013: Film Editing

Nominations:

British Acad. 2013: Actor—Supporting (Bruhl), Sound

Golden Globes 2014: Actor—Supporting (Bruhl), Film—Drama

Screen Actors Guild 2013: Actor—Supporting (Bruhl)

S

SAFE HAVEN

You know it when you find it.
—Movie tagline

Box Office: $71.3 Million

Of all the films that have been made to date based on the literary output of the enormously popular schmaltz peddler Nicholas Sparks, *Safe Haven* is most certainly one of them. In fact, one could argue that it is essentially all of them in the sense that it often feels as if someone took all of those previous screen adaptations—including the likes of *Message in a Bottle* (1998), *The Notebook* (2004), *Dear John* (2010), and *The Lucky One* (2012)—and ran them through an industrial blender set on puree. While those with a taste for such things may have found the resulting concoction tasty enough (and there were enough of them to make it a decent-sized success at the box-office during its Valentine's Day release), more discerning viewers no doubt found themselves gagging on its nausea-inducing combination of inane storytelling, sickly sentimentality and a final twist so utterly idiotic that it made them long for the comparatively staid *deus ex treehouse* that concluded *The Lucky One*.

The story is set in the bucolic small town of Southport, North Carolina and kicks off with the arrival of mysterious stranger Katie (Julianne Hough), whom viewers already know is running from the kind of dire trouble that can only be revealed to them via a series of gradually expanding flashbacks. In a nod to her dark and troubled past, Katie rents herself an adorably ratty shack on the edge of town, where her only other neighbor is like-minded loner Jo (Cobie Smulders), and gets a job at the local restaurant, where she can slip into the anonymity that always comes with being the hot new blonde in a small town. Inevitably, she catches the eye of hunky local widower Alex (Josh Duhamel), who runs the local general store and is raising his young son and daughter while struggling to finally move on from the death of his beloved wife a few years earlier.

After Alex gets a look at Katie in her short-shorts, let it be said that his desire to move, among other things, expands greatly and he begins doing friendly things for her like sneaking out to her house in the middle of the night to leave a spare bicycle on her front door. Being all dark and tormented, Katie wants nothing to do with this at first but after putting up the requisite token resistance, she soon succumbs to his sleepy charms. Before long, she is gamboling in the surf with Alex and his family on a trip to the beach, getting caught out in the rain with him during a canoeing expedition and finally letting him into her heart and as many other body parts as the PG-13 rating will allow. Even the kids are on board with bringing Katie into their lives, though the son does a little bit of acting out that is quickly forgotten and which will no doubt seem quaint in a few years when his hormones kick in at full strength.

It all seems so perfect that it is only a matter of time before the other shoe drops and that shoe comes in the form of Tierney (David Lyons), a Boston cop whose borderline obsessive search for Katie has been punctuating the proceedings throughout. Even after his efforts cause him to lose his badge and shield, he tracks her down to Southport and while he is heading down there, Alex happens upon a wanted poster in the police station implicating Katie in a murder. Having given his heart to

someone who is not who she says she is and has a warrant out for her arrest, will Alex ever be able to love and trust Katie again? Will Katie be able to summon up the strength to face up to what really happened and reveal the truth to Alex instead of simply going on the run again? Assuming that the answers to the previous questions are "Yes!", will Alex, knowing that there is a dangerous psycho on the loose chasing after his new love, leave her and his young daughter all alone late at night so that the psycho can arrive out of nowhere to terrorize them both and he can return to save them in the *ta-da* nick of time? All of this is mere prelude to the aforementioned barking-mad finale no doubt inspired peals of "*Really?*" wherever it played.

At this point, the author of this review must confess that he actually knew the final twist of *Safe Haven* long before actually watching the movie. Yes, it is as ridiculous as advertised (without getting into too much detail, it essentially turns the entire film into the longest and weirdest episode of *How I Met Your Mother* ever made) but knowing the details ahead of time offer an intriguing approach for the viewer—does the rest of the film earn its final moments of sheer craziness or are they the only moments of genuine interest to be had? Sadly, it proves to be the latter because while the rest of the film is a dreadful bore that is only occasionally punctuated by moments of inadvertent hilarity. While it may not hit the loathsome depths of *The Notebook* or *The Lucky One*, it is such a drag in most areas that sitting through it might actually be even more of a chore in the long run.

The story consists of one ludicrous contrivance after another held together with dialogue so inane that a brief audio excerpt of the works of Mark Twain constitutes the best writing on display. (Second place might have gone to a book on display entitled *Practical Navigation for the Yachtsman* but alas, no samples from that one are offered.) All of this is presented by director Lasse Hallstrom—yes, Lasse Hallstrom—in a manner so pokily paced that it makes *The Turin Horse* (2012) seem like *Run Lola Run* (1999) by comparison. Considering that Hallstrom has actually adapted Sparks before with the equally lugubrious and ludicrous *Dear John*, one might think that he would know better than to sign on for a second helping—the results feel more like the work of an anonymous TV hack than of the man who once gave us the likes of *My Life as a Dog* (1987) so very long ago. Even from a visual standpoint, this film comes up short—every frame looks like a postcard, true, but always the kind of postcards that one sees sitting on the rack of a motel gift shop but never actually buys.

The only thing that may help keep some viewers going through *Safe Haven* until its nutso denouement is that some of the performances are so hilariously misconceived that they could serve as textbook examples of how not to cast roles. David Lyons, for example, is meant to be driven and obsessed but with his twitchy demeanor and sweat-soaked clothes, he more closely resembles one of the early victims in some plague movie just before they wind up infecting everyone in sight. As for Julianne Hough, she is cute as a button and appealing enough but seeing as how she is perhaps the least dark person imaginable, she is more than a little miscast here. That said, it must be noted that while many people in the history of film have uttered a variation of the phrase "I like the fact that I can hear myself think," hearing Hough say it is admittedly a singular experience. Of the actors, the one that comes off best is Duhamel and that is less because of his powerful presence (he is so bland at times that he feels like a placeholder until the real star can get there) but because one can sense that he knows that no matter how bad the film and his performance might be, the existence of the already infamous *Movie 43* (2013) meant that *Safe Haven* will only go down as his second-worst project of 2013.

Peter Sobczynski

CREDITS

Katie Feldman: Julianne Hough
Alex Wheatley: Josh Duhamel
Jo: Cobie Smulders
Kevin Tierney: David Lyons
Origin: United States
Language: English
Released: 2013
Production: Ryan Kavanaugh, Nicholas Sparks, Wyck Godfrey, Marty Bowen; Temple Hill; released by Relativity Media L.L.C.
Directed by: Lasse Hallstrom
Written by: Dana Stevens; Leslie Bohem
Cinematography by: Terry Stacey
Music by: Deborah Lurie
Sound: John Morris
Editing: Andrew Mondshein
Costumes: Leigh Leverett
Production Design: Kara Lindstrom
MPAA rating: PG-13
Running time: 115 minutes

REVIEWS

Chang, Justin. *Variety.* February 13, 2013.
Holden, Stephen. *New York Times.* February 13, 2013.
Hornaday, Ann. *Washington Post.* February 14, 2013.
Ogle, Connie. *Miami Herald.* February 14, 2013.
Orndorf, Brian. *Blu-Ray.com.* February 13, 2013.

Pais, Matt. *RedEye*. February 13, 2013.

Pols, Mary F. *Time Magazine*. February 14, 2013.

Puig, Claudia. *USA Today*. February 13, 2013.

Russo, Tom. *Boston Globe*. February 13, 2013.

Tobias, Scott. *AV Club*. February 14, 2013.

QUOTES

Jo: "The good thing Katie, is that life is full of second chances."

TRIVIA

Keira Knightley was almost cast in the lead role, but she ultimately declined to star in *Can a Song Save Your Life?* (2013).

SALINGER

Uncover the mystery but don't spoil the secrets!
—Movie tagline

Box Office: $575,775

Viewers who saw the dark fantasy *Donnie Darko* (2001) will recall the teaching tapes of character Jim Cunningham that posited a system of spiritual renewal based on dividing all human experience into the two categories of love and fear. *Salinger*, directed by Shane Salerno, does more or less the same thing with J.D. Salinger's life, asking viewers to come to conclusions about the author via simplistic anecdotes, sketchy history, and a uniting thread of fan gushing. The marketing for this documentary has suggested that Salerno's film reveals earth-shattering secrets about the man and his work but it barely touches reliably on either subject.

The fact that it all amounts to so little is forgivable; the attempt by Salerno to frame the film's conversation in stalker fashion is not. In fact the film starts with a photographer recounting his attempting to secretly snap a shot of J.D. Salinger as he picks up his mail. The resulting image, which was used in a national publication, could be any old man walking down the street, and that is the point this documentary misses. *Salinger* is a perfect example of how anyone can take anything and build ersatz mystery around it by playing both sides of life against one another.

No one who knows anything about Salinger would suggest he was an open book but the assessments of his character in this documentary range from downright mean-spirited to near-libelous on the negative side to fawning and mawkish on the positive. A variety of talking heads are given room to say too many things with little or no sorting of speculation from history. The film barely even bothers to separate out those who have academic credentials in assessing Salinger from those who merely feel he influenced them.

One person thinks Salinger played the recluse angle to make himself into a Howard Hughes-type figure and propagate a sense of mystery to help fan his popularity. Another claims his experiences in Buddhist spirituality transformed him into a sort of living saint whose writings were clearly divinely ordained. The film trots out the few famously mentally ill individuals who have used *Catcher in the Rye* as a sort of guide to help plan their crimes and then offers brief quotes from well-known figures like Edward Norton, Philip Seymour Hoffman, John Cusack, Martin Sheen, Tom Wolfe, and Gore Vidal when it wants to project literary or cultural gravitas.

Nowhere is there a sense of coherent filmmaking vision. Salinger's personal and literary history is divided up into confusing chunks that barely seem to have much to do with one another. Viewers will sense that they must be connected but the pacing is so uneven and the tone so choppy that it all becomes a faux intellectual melange. A major issue is the paucity of images available to Salerno to put on the screen. They are so scant that they are used over and over again, leading to fatigue long before the end of the film's 129-minute runtime. Lorne Balfe's score, also does a lot to set the wrong mood, inviting an emotional connection the film does not earn.

For instance. Viewers learn that Salinger's experiences in World War II put him in disturbing proximity to the Nazi death camps. But viewers learn this via stock images and footage of the camps and voiceovers that are accompanied by photographs of him during his service. It is then surmised that this shut him down emotionally with his work being the only thing that gave him any relief. There may very well be some truth to that. Salinger's short failed marriage to a German national, his experiences interviewing POWs, and entering the camps no doubt had a profound impact on him. But there is simply no direct record of exactly what that impact really was. The truth is that he was largely as silent on his war experiences as he was on most everything. *Salinger* ignores that, offering shots of his writing cabin, set away from the family home, as its only proof needed that PTSD was the real reason he ignored his family and locked himself away from days on end—behavior that is anything but odd when looking into the lives of famous writers.

Salinger also had problematic relationships with women, often very young women, and an intellectual aloofness that made longstanding friendship almost impossible. It is here that the film is at its most lecherous having neither the stones to call Salinger a manipulative user or the courage to defend his emotional

immaturity. If the truth was (and it probably is) somewhere in the middle the film ignores this possibility. No one with any opinion of Salinger's moral character is challenged about their own motives for talking about him and Salinger is no longer present or able to defend himself.

Here is *Salinger*'s great failing. Nowhere does the film have the courage to draw any new conclusions or elaborate effectively on what is already known. Sales facts are cited, talking heads blather on, without substance, about how widely read he is, how great a writer he was, and yet no one suggests the world might have been better off if he had simply been a better husband and father and gotten a little emotional help. No one even makes a clear argument for the world, or even Salinger, being better off because of the work.

Near the end of the film, a man describes his attempt to establish contact with Salinger after a long-distance drive. He talks of feeling compelled to talk to the author and finally tracks him down. Salinger seems genuinely, if naively, dumbfounded. Explaining that he is an author of fiction and not a psychologist or a guru, he leaves. The man, determined, pens a hasty letter telling Salinger how disappointed he was not to encounter a more enlightened response. This man may as well have been Salerno himself, making this documentary anyway after discovering nothing; compelled to leave his own note, not realizing how much better his viewers might be if he just left them alone.

Dave Canfield

CREDITS

Origin: United States

Language: English

Released: 2013

Production: Deborah Randall, Shane Salerno, Buddy Squires; released by Weinstein Company L.L.C.

Directed by: Shane Salerno

Cinematography by: Anthony Savini; Buddy Squires

Music by: Lorne Balfe

Sound: Mace Matiosian

Music Supervisor: Jonathan Weiss

Editing: Jeffrey Doe; Regis Kimble

MPAA rating: PG-13

Running time: 120 minutes

REVIEWS

Anderson, John. *Wall Street Journal*. September 12, 2013.
Anderson, Soren. *Seattle Times*. September 23, 2013.
Bumbray, Chris. *JoBlo's Movie Emporium*. September 26, 2013.
Denby, David. *New Yorker*. September 17, 2013.
McGinn, Dave. *Globe and Mail*. September 20, 2013.
Knight, Chris. *National Post*. September 19, 2013.
Rea, Stephen. *Philadelphia Inquirer*. September 19, 2013.
Scott, A. O. *New York Times*. September 5, 2013.
Swietek, Frank. *One Guy's Opinion*. September 23, 2013.
Verniere, James. *Boston Herald*. September 20, 2013.

THE SAPPHIRES

It's what's in the groove that counts.
—Movie tagline

Follow your heart.
—Movie tagline

Discover your soul.
—Movie tagline

One ambitious manager. Four unknown singers. The tour that put them on the charts wasn't even on a map.
—Movie tagline

Box Office: $2.4 Million

The Sapphires takes a fairly unique and fascinating story with an appealing cast, and, with depressing predictability, turns these elements into a very conventional and pretty much wholly unconvincing musical drama. As the opening titles explain, in the 1960s, Australia was a very segregated continent, rife with bigotry. Many Aboriginal people lived on reservations, and a government program had lighter-skinned Aborigines taken from their families, to live in institutions, or with white families, and to be taught "white ways." Early in the movie, mother hen Gail (Deborah Mailman) and her promiscuous sister Cynthia (Miranda Tapsell) leave the compound where they live to enter a talent show in town. Their younger sister Julie (Australian Idol runner-up Jessica Mauboy) is forbidden to go, because she's only 17, but she sneaks off to join them. The MC turns out to be a snarky alcoholic Irishman, Dave Lovelace (Chris O'Dowd), who loves soul music and does not share the crowd's disdain for Black folk. The girls sing a Merle Haggard song. Dave does not care for country music, but is impressed enough with their vocals that when they tell him about an audition to perform for American troops in Vietnam; he decides to manage them.

The three sisters decide to enlist a fourth girl, their cousin Kay (Shari Sebbens), whom they had sung with as a child, before she was "stolen" from the government. When her cousins go to see her, she is having a Tupperware party with some snooty white friends, and it is clear that she has not just assimilated into the dominant

culture, but is passing for white. Nevertheless, after a mere moment's hesitation and some bickering (always with the bickering, these girls), she abandons the life she has been living for years and years to join her cousins. This is a recurring motif in the film, where heavy emotional conflicts that would seem to be insurmountable are resolved with supernatural alacrity. As a result, none of the serious issues the film brings up, from institutional racism, to internalized racism, to female empowerment, to the sexual revolution, to the violence of the Vietnam War, carry much weight. They are all just mechanisms to get the movie to the next splashy musical number.

The group is resistant to Dave's admonitions at first. Recognizing that a Black country girl group will be a hard sell, he teaches them to sing R&B. Their rendition of "I Heard it Through the Grapevine" is polite and weak, but once Dave gives an inspirational speech explaining what soul music is all about, the girls quickly catch on.

The group passes their audition, and travels to Vietnam, where romance with soldiers, interpersonal conflicts, and the war itself threaten their growing success and their physical safety, but the drama is mostly glossed over, and none of it has much impact. One major character is actually wounded during a battle scene, but it is handled in such a clumsily manipulative way that it loses much of its dramatic impact.

Dave, a character invented for the screenplay, is essentially the "white male savior" that so many purportedly socially conscious films employ to their detriment, undermining their messages about empowerment. That said, O'Dowd is a charismatic comic actor, as he has proven as the male lead in *Bridesmaids* (2011) and on the Channel 4 sitcom *The IT Crowd* (2006-). The women who play the girl group are also mostly charming, though the script has a bit too much shrill bickering in it, seemingly in place of genuine drama, especially as nearly every crisis is resolved within a few minutes. They are also very good singers, naturally, and Mauboy, in particular, shines in the musical sequences. One might wish the filmmakers had been in a bit more creative in their song selection, but those scenes are nonetheless highlights of the movie.

Director Wayne Blair brings an upbeat energy to the musical numbers, but is hampered by a pedestrian script (by Keith Thompson and Tony Briggs) when the girls step offstage. Individual moments between actors, as when Gail discusses her role in the group with Dave, sometimes hit their mark, but for the most part, the movie just lurches along from one overly familiar beat to the next.

The movie is "inspired by a true story," and one of the women in the group was actually the mother of co-writer Tony Briggs, who adapted the script from his play. The film ends by showing the actual members of the group and briefly describing what happened later in their lives. Instead of rooting the film in reality, this epilogue merely inspires disparaging thoughts about how much more interesting the movie could have been, if it had hewn more closely to the reality of the women's lives. *The Sapphires* is not a terrible movie. It is good-natured, and features some talented performers and some fun moments, but it feels like a slick, superficial Hollywood-style take on subject matter that would have been far more compelling without all the usual gloss.

Josh Ralske

CREDITS

Dave Lovelace: Chris O'Dowd
Gail: Deborah Mailman
Julie: Jessica Mauboy
Kay: Shari Sebbens
Cynthia: Miranda Tapsell
Origin: United States
Language: English
Released: 2013
Production: Rosemary Blight, Kylie Do Fresne; Goalpost Pictures; released by Weinstein Company L.L.C.
Directed by: Wayne Blair
Written by: Tony Briggs; Keith Thompson
Cinematography by: Warwick Thornton
Music by: Cezary Skubiszewski
Sound: Andrew Plain
Editing: Dany Cooper
Art Direction: Janie Parker
Costumes: Tess Schofield
Production Design: Melinda Doring
MPAA rating: PG-13
Running time: 103 minutes

REVIEWS

Goodykoontz, Bill. *Arizona Republic.* April 4, 2013.
Lehmann, Megan. *The Hollywood Reporter.* March 3, 2013.
Lodge, Guy. *Variety.* March 15, 2013.
Minow, Nell. *Chicago Sun-Times.* March 27, 2013.
Morgenstern, Joe. *Wall Street Journal.* March 21, 2013.
Nashawaty, Chris. *Entertainment Weekly.* March 20, 213.
Ogle, Connie. *Miami Herald.* April 4, 2013.
Rabin, Nathan. *The A.V. Club.* April 20, 2013.
Smith, Anna. *Empire.* March 3, 2013.
Stewart, Sara. *New York Post.* March 22, 2013.

QUOTES

Dave: "Before we go then girls, when I met you you were doing all country and western thing and that's fine, we all make mistakes. But here is what we learn from that mistake. Country and western music is about loss. Soul music is also about loss. But the difference is in country and western music, they've lost, they've given up and they are just all whining about it. In soul music they are struggling to get it back, they haven't given up."

TRIVIA

The movie's co-writer and associate producer Tony Briggs is the son of Laurel Robinson, a member of the real-life The Sapphires group.

SAVING MR. BANKS

Where her book ended, their story began.
—Movie tagline

Box Office: $82.6 Million

Winds in the east,

Mist coming in.

Like something is brewing,

About to begin.

Can't put me finger on what lies in store,

But I feel what's to happen

All happened before.

The above words that begin *Saving Mr. Banks* were uttered nearly fifty years ago by Bert the Chimney Sweep in the opening minutes of Walt Disney's beloved big-screen production of *Mary Poppins* (1964). Due to van Dyke's adoption of that legendarily-notorious, cockeyed Cockney accent, more than a few sites online incorrectly quote his Bert as saying "fear" instead of "feel," even though the character says the word in question with a widening, anticipatory grin. In *Mary Poppins*, the lines reflect Bert's sensing of something special in the air yet again, and his old chum Mary is indeed readying herself to float down from a cloud to intrigue and improve another family with her mystifying, magical powers. As *Saving Mr. Banks* deals with the making of that earlier film, their repetition here not only establishes that connection at the outset, but also hints at what the film will gradually assert: That many elements of P.L. Travers' treasured tales are actually echoes from her past. If the author were alive in the present (she dies in 1996 at the age of 96), she might have chosen to ruefully recite the misquoted version while agitatedly awaiting the release of *Saving Mr. Banks*, as it could allude to a dread that she is about to be made miserable for the second time by distorting Disney uplift.

As *Mary Poppins* premiered at Hollywood's Grauman's Chinese Theater, it seemed much darker for Travers than for anyone else in attendance. Her heart sank and tears welled up in frustration because her worst fears had just been realized. Travers felt she had let down Mary Poppins (never just "Mary," mind you), after having resolutely protected the nanny since 1934 against all those who ardently wanted to get their hands on her and lead her to ruin. The author had kept a particularly passionate and persistent Walt Disney at bay for the two decades since he had made a promise to his daughters, both fans of Travers' books, to buy the film rights. However, Travers looked down her nose at his "silly cartoons," and particularly loathed what she saw as Disney's false, manipulative sentimentality. She did not want an infusion of syrupy-sweetness and light—his typical "jollification," as she called it—to spoil what she had purposely imbued with rich, mysterious and sometimes quite dark tones. Unfortunately for Travers, financial woes and consequent worries led to a different kind of both once she finally, grudgingly, and out of necessity agreed to give her art up for commerce.

The prospect of achieving comfortable wealth and being able to keep her much-loved home was reassuring to Travers, as was the script approval Disney had granted her, something he had never done before for anyone. Yet, after the arduous, highly-contentious adaptation process with which *Saving Mr. Banks* concerns itself, what resulted had Travers sobbing inconsolably. Upon actually coming face-to-face with frame after disheartening frame of such things as an inaccurately-attractive and otherwise quite different Mary Poppins in Julie Andrews, as well as the cheery, animation-augmented song and dance numbers she had vehemently deplored from the start, Travers sat there and felt more convinced than ever that she had been right about what had seemed to her to be so wrong. The only problem was that everyone around her clearly felt otherwise, and the author felt even more alone when Disney walked away from her during the subsequent reception after denying her naive request to have the animation excised before the film's release. A weary but wily Disney stated that he had maintained contractual control of the final cut, which trumped her script approval. Frostily emphasizing that "the ship has sailed," he both literally and figuratively moved on. The film was a big hit with both the public and critics, and won five Academy Awards, including one for Andrews.

After a half-century, Walt Disney Pictures latched onto a script already in development elsewhere and ushered to the screen a nervy, schmaltz-infused, and self-serving revision of these real-life events in *Saving Mr. Banks*. Long after Travers began decomposition, she underwent what Webster's defines as "Disneyfication."

"Well, they've done it to her again," said the BBC's Victoria Coren Mitchell. "What's ridiculous is that it's incredibly moving. The way that they sort everything out is very powerful." Indeed, one cannot rail about *Saving Mr. Banks'* purposeful lack of truth-telling and then turn around and deny the reality that it is entertaining throughout, quite effectively affecting and amusing due in large part to an award-worthy performance by Emma Thompson as Travers. The $35 million-budgeted film grossed more than double that amount and earned generally positive reviews that especially raved about Thompson; she was widely-considered when of the biggest snubs when the Oscar nominations were announced and her name was absent from Best Actress.

The very British but actually Australian-born author's formidability is felt from the moment she awakens and fixes viewers with a steely stare. There is also the revelation of her withering (but, at least for the audience, wonderfully-enjoyable) wit. However, her fears are also profoundly palpable from the start. "I know what he's going to do to her," she blurts out to her agent (Ronan Vibert), clearly distressed and foreseeing disaster. "She'll be cavorting and twinkling, careening toward a happy ending like a kamikaze." Signing the film rights over to Disney during her imminent two-week consultation trip to California will indeed keep her from going broke, but one quickly senses that doing so will in turn break her heart. Or is it already so? The film continuously toggles between the misery of the ensuing battle royal in sunny Burbank and Travers' marvelous and mournful memories of a Down Under childhood when she was still named Helen "Ginty" Goff (a promising, beguiling Annie Rose Buckley). In particular, she recalls the beloved father (a soulful Colin Farrell) who drank himself from her midst but not from a mind and heart that are revealed to have been in continuous pain since his premature death. (She would honor and forever keep him with her by adopting his first name as her last during a later reinvention of self.) There is also Travers' harrowing recollection of the night her mother (Ruth Wilson) awakened her, asked that she watch over the younger children, and then marched off to a nearby river to attempt suicide. In actuality, young Helen did not wade in and fetch her, but what is presented here, which shows a girl forced by circumstances to sound and act like the parent, made eyes as wet as the drenched characters.

After that incident, Travers' Aunt Ellie (Rachel Griffiths) arrives, and even before she puts down her decidedly-full carpetbag and parrot-head umbrella or say "Spit spot!" in a seemingly-familiar no-nonsense manner, a shot of her silhouette in the doorway makes it seem to viewers as if it is Mary Poppins who has arrived to restore order from chaos. This, coupled with the fact that

Travers Goff was a bank manager like Mr. Banks, head of the household that employs Mary Poppins in the books, makes one realize that these people live on through Travers' writings. Thus, there was a literal, loving meaning to Travers' statement that her characters are like family. No wonder Travers is so reluctant to lend them for even a second to others who could not possibly handle them with as much care and respect as she had, and she seems to fear that she might never quite get them back. Thus, when Disney (an enjoyable if only semi-convincing Tom Hanks), screenwriter Don DaGradi (Bradley Whitford), and genius songwriting brothers Richard and Robert Sherman (Jason Schwartzman and B.J. Novak) seem ready to take turns throttling Travers for her imperious, intractable, and perplexingly-persnickety ways, viewers filled in by flashbacks could sympathetically understand and forgive her for being so (deliciously) difficult.

However, what is less forgivable—and makes one feel inclined to embrace potently-prickly Travers all the more—is the outrageously unfair, image-burnishing revisionism that supplies a far-from-accurate and sappy ending. Upbeat Uncle Walt did not accompany Travers on a tour of Disneyland, although here "The Happiest Place on Earth" brings on the hint of a healing smile. She did not find "Let's Go Fly a Kite" so infectious that it led to the onset of toe-tapping followed by a full-blown case of delighted singing and dancing. Disney did not follow her to London in order to seal the deal after his sneaky use of semantics had made her furiously flee Burbank, and thus did not accomplish it with that heartfelt but rather grandiose and mushy (if intermittently moving) monologue about his own papa problems and the way "we storytellers" do nothing less than imaginatively restore order and hope. Finally, as mentioned earlier, the premiere of what Walt created did not bring on a long-overdue cathartic cry.

"Does it matter?"; so asked an exasperated Robert Sherman in response to one of Travers many complaints. Once informed, it is for each viewer of *Saving Mr. Banks* to decide. The *New Yorker* noted that director John Lee Howard "does what he did with *The Blind Side*, where he commandeered a true and jagged tale, tidied up the trauma, and made sure that everyone lived sappily ever after." While it is supposed to be the bitter medicine that is tough to swallow, here, at least for many of those who came to learn all that had actually transpired, it was instead that heaping spoonful of flavor-altering sugar.

David L. Boxerbaum

CREDITS
Walt Disney: Tom Hanks
P.L. Travers: Emma Thompson

Ralph: Paul Giamatti

Richard Sherman: Jason Schwartzman

Robert Sherman: B.J. Novak

Travers Goff: Colin Farrell

Aunt Ellie: Rachel Griffiths

Ginty: Annie Rose Buckley

Don DaGradi: Bradley Whitford

Margaret Goff: Ruth Wilson

Tommie: Kathy Baker

Origin: United States

Language: English

Released: 2013

Production: Alison Owen, Philip Steuer; released by Walt Disney Pictures

Directed by: John Lee Hancock

Written by: Kelly Marcel; Sue Smith

Cinematography by: John Schwartzman

Music by: Thomas Newman

Sound: Jon Johnson

Music Supervisor: Matthew Rush Sullivan

Editing: Mark Livolsi

Art Direction: Lauren E. Polizzi

Costumes: Daniel Orlandi

Production Design: Michael Corenblith

MPAA rating: PG-13

Running time: 125 minutes

REVIEWS

Burr, Ty. *Boston Globe*. December 17, 2013.

Felperin, Leslie. *Hollywood Reporter*. October 20, 2013.

Foundas, Scott. *Variety*. October 20, 2013.

Hornaday, Ann. *Washington Post*. December 12, 2013.

Lane, Anthony. *New Yorker*. December 16, 2013.

Morgenstern, Joe. *Wall Street Journal*. December 12, 2013.

Roeper, Richard. *Chicago Sun-Times*. December 12, 2013.

Scott, A. O. *New York Times*. December 12, 2013.

Travers, Peter. *Rolling Stone*. December 12, 2013.

Turan, Kenneth. *Los Angeles Times*. December 12, 2013.

QUOTES

Walt Disney: "George Banks and all he stands for will be saved. Maybe not in life, but in imagination. Because that's what we storytellers do. We restore order with imagination. We instill hope again and again and again."

TRIVIA

P.L. Travers never did warm up to the song "Let's Go Fly a Kite," as was depicted in the film. According to Richard M. Sherman, it was the song "Feed the Birds" that won her over.

AWARDS

Nominations:

Oscars 2013: Orig. Score

British Acad. 2013: Actress (Thompson), Costume Des., Orig. Score

Golden Globes 2014: Actress—Mus./Comedy (Thompson)

Screen Actors Guild 2013: Actress (Thompson)

SCARY MOVIE 5

Evil is coming. Bring protection.
 —Movie tagline

You've never seen activity like this.
 —Movie tagline

The supernatural is coming. Bring protection.
 —Movie tagline

Box Office: $32 Million

Immediately after expressing "No Shame," the tagline for Keenan Ivory Wayans' 2000 slasher movie spoof *Scary Movie* also teasingly promised audiences "No Sequel." To scant surprise, such was shown to be an indeed shameless falsity, as the box office success of *Scary Movie* fortified it into the disturbing commodity of franchise filmmaking horror it continues to be with its fourth sequel, *Scary Movie 5* (aka *Scary MoVie*).

Directed by Malcolm D. Lee with a significant amount of re-shoots later helmed by co-writer David Zucker, *Scary Movie 5* begins its shameless pop culture pillaging with an introductory scene in which C-list trivia answer Charlie Sheen is killed by a demonically possessed Lindsay Lohan whilst trying to make a sex tape with her. After this event, his children go missing for almost a year when they are discovered by rappers Snoop Lion and Mac Miller (playing themselves), and are then put under the foster care of Sheen's brother Dan (Simon Rex) and Dan's wife, Jody (Tisdale). The film's spoof attitude then kicks off when it parallels the plot of 2013 horror film *Mama*, as the lost kids exhibit animalistic behavior while making passing references to their previous care under a suspicious entity also named Mama.

In two subplots, Jody earns the lead role in a local production of "Swan Lake" (a la 2010's *Black Swan*) but has anxieties about another competitor Kendra (Erica Ash) attempting to steal her part. Meanwhile, Dan works at the Genetic Primate Research Center with an ape named Caesar (as in the same ape brought to life by Weta Digital and actor Andy Serkis in 2011's *Rise of the Planet of the Apes*) whose intelligence has been heightened by a serum that Dan has invented.

With blanketing reference to the *Paranormal Activity* films, Mama begins haunting the suburban home of

Dan and Jody, with the acts documented on security cameras, often shown in time lapse. In an attempt to stop the evil spirit, Jody journeys into her own dreams with the help of the subconscious machine from 2010's *Inception*, and later by reading from the Book of the Dead from 2013's *Evil Dead*.

If there is one glimmer of light to find in this bleak excuse for opening-weekend multiplex babysitting, it is the cartoonish earnestness on display from Tisdale and Rex (his third role in a *Scary Movie* film, but his first as Dan). The two of them are trapped in flat slapstick sequences, never one that is funny, but still display a visible amount of pep with their delusional characters. Tisdale's work especially is close to the commendable level of Anna Faris, who begat the *Scary Movie* franchise with her character Cindy and has since then been able to transition to more sophisticated but still dopey leads.

The rest of *Scary Movie 5* is an anally fixated black hole of social issues in the modern American pop culture universe-sexism, racism, homophobia, domestic violence, eating disorders, et al. Minorities appear in the film in their packaging of redundant stereotypes, as if the least amount of creative juju required from screenwriters Zucker and Pat Proft would begin with the image of a fat Latina maid, or an over-sexualized black woman dancing to hip hop music during a ballet audition, and not need to be elaborated on from there.

With the purpose of this franchise to leech off accomplished, timely artistic endeavors, *Scary Movie 5* is strangely challenged by the concept of timeliness. For a movie that includes references to the 2013 remake of *Evil Dead*, which was released in theaters a week after *Scary Movie 5* plopped into multiplexes, it also includes two predominant references to 2010 films, one of which is an arthouse drama already based on a Tchaikovsky ballet (*Black Swan*). Numerous questions abound concerning the relevancy such a film would have to mainstream audiences in 2013, without even trying to gauge what exact demographics are actually buying tickets to *Scary Movie 5*, or what else said demographics are watching if they are previously investing in films like *Scary Movie 5*.

With desperation to reach a running time of seventy minutes of actual narrative more than to create surprising comedic twists on more well-known film products, *Scary Movie 5* also picks from strange sources, or tries to cram two references into one. For example, an entire sequence is focused around E.L. James' novel *50 Shades of Gray*, despite the nonexistence of a film adaptation. In another moment, the famous command from 1951's *The Day the Earth Stood Still* becomes the magic phrase for the "Book of the Dead" when *Evil Dead* is referenced

thoroughly by *Scary Movie 5*, despite the extreme disassociation between the two original films.

More urgently unforgivable than spotty weekly studio fare and without the genuine spirit of the even the most ridiculed bad movies, *Scary Movie 5* continues to champion the franchise's bottom-barrel standards for mainstream filmmaking, in which filmmaking exists for nothing more than commercial satiation, either for the already spoiled teen demographic, or of project investors complicit with sponsoring short attention spans and limited imaginations. *Scary Movie 5* grotesquely feeds off the negative ideologies behind franchise filmmaking, in which movies inspire equally empty creations, while showing no shame in abusing the boundaries of creative adaptation-where the distinct difference is lost between teasing references and stealing. In its own pathetic manner of slinging toilet humor, *Scary Movie 5* attempts to humble the sophistication of films it heavily draws from, but simultaneously makes transparent why movies like *Black Swan* and *Inception* resonate with wide audiences for reasons that these *Scary Movie* films never will. Perhaps they would, however, if they were to pick on films their own size; the delightful meta carnage that awaits a *Scary Movie* spoof of another pointless *Scary Movie*.

Nick Allen

CREDITS

Jody: Ashley Tisdale
Dan: Simon Rex
Heather: Molly Shannon
Barbara: Heather Locklear
Himself: Charlie Sheen
Herself: Lindsay Lohan
Origin: United States
Language: English
Released: 2013
Production: Phil Dornfeld, David Zucker; Brad Grey Pictures, DZE; released by Dimension Films
Directed by: Malcolm Lee
Written by: David Zucker; Pat Proft
Cinematography by: Steven Douglas Smith
Music by: James L. Venable
Sound: Steven Iba
Editing: Sam Seig
Costumes: Keith G. Lewis
Production Design: Clark Hunter
MPAA rating: PG-13
Running time: 86 minutes

REVIEWS

Chang, Justin. *Variety*. April 12, 2013.
Duralde, Alonso. *The Wrap*. April 12, 2013.

Guzman, Rafer. *Newsday.* April 12, 2013.
Legel, Laremy. *Film.com.* April 12, 2013.
Merry, Stephanie. *Washington Post.* April 12, 2013.
Neumaier, Joe. *New York Daily News.* April 12, 2013.
Nicholson, Amy. *Los Angeles Times.* April 13, 2013.
Scheck, Frank. *Hollywood Reporter.* April 12, 2013.
Smith, Kyle. *New York Post.* April 12, 2013.
Webster, Andy. *New York Times.* April 14, 2013.

QUOTES

Jody Campbell: "Hi, we're looking for a book that can stop evil spirits."

TRIVIA

This is the only film in the entire *Scary Movie* franchise that does not feature any main characters from the previous films, specifically Cindy Campbell (Anna Faris) or Brenda Meeks (Regina Hall).

AWARDS

Nominations:

Golden Raspberries 2013: Worst Ensemble Cast, Worst Remake/Sequel, Worst Support. Actress (Lohan)

THE SECRET LIFE OF WALTER MITTY

Stop dreaming. Start living.
—Movie tagline

Box Office: $57.7 Million

A man's life is dull and full of the same, old routine, so he occasionally "zones out" and escapes to a state of mind in which he can imagine himself to be much more than a shy, boring man. Ben Stiller's *The Secret Life of Walter Mitty* never explains when or why its eponymous hero started this quirk, although it strongly implies that it is the result of pent-up regret over the life he expected to have but for which he lost the opportunity due to familial responsibilities after the death of his father. That is perhaps the only mystery left by the time Steve Conrad's screenplay, loosely based on the James Thurber short story of the same name, has ensured that nothing else is left to the imagination—either the hero's or the audience's.

After spending the first act establishing Walter Mitty's (Ben Stiller, who also directed) flights of fancy with sequences of ridiculous heroics and wish fulfillment, Conrad essentially drops the convention, save for a few moments in which he sees the object of his unrequited love, such as a scene where he imagines her singing and

playing David Bowie's "Space Oddity" on an acoustic guitar to urge him forward at the first major point of his adventure. The point is that there is no need for Walter to have his visions of personal grandeur because the adventure itself is full of so many opportunities for him to be the idealized version of himself about which he dreams.

The problem is that the scenarios he encounters are so incredibly far-fetched that the movie leaves doubt as to whether what he is experiencing is reality or fantasy. That doubt is unintentional. Stiller does ensure that the scenes inside Walter's head are differentiated from the real world, both as an actor (Walter is a wholly other character—more confident or melodramatic, depending on the situation—while zoned out) and director (there are clear cues for when the dream sequences start), but Conrad presents Walter with real-world scenarios that are nearly as ludicrous as his fantasies. The combination of them all throughout the movie—the piling up of coincidence after coincidence and challenge after challenge—gets to the point that the only honest resolution to the story would be if the entire venture has taken place inside Walter's mind.

Of course, it does not, and there is never any question that Walter fights off a great white shark, rides a longboard down a long and winding road, and outruns an erupting volcano after a stranger shows up at the last second to rescue him. These scenes, ultimately, are not much different than his early daydreams, except that they are only comparatively more believable than Walter diving headfirst from a train platform into a building that he senses is about to explode, fighting with his new boss (Adam Scott) in a battle during which they use street signs to surf down busy city streets, and winning over his co-worker Cheryl (Kristen Wiig) by telling her he has the disease the main character from *The Curious Case of Benjamin Button* (2008) has—but in reverse.

Walter needs the fantasies because, otherwise, he is pretty uninteresting and bordering on pathetic—signing up, for example, for an online dating service as a way to break the ice with Cheryl, a woman he sees every day at work. (It is the first of many, alarming instances of product placement throughout the movie; at least this one has the benefit of the sardonic wit of Patton Oswalt, who plays the customer service representative for the website, to ease the tackiness). He is in charge of "negative assets" at *Life* magazine, which is about to shut down its print edition in favor of exclusively online content. For the final issue, the transition group has decided to use a photo from famed photographer Sean O'Connell (Sean Penn)—a photograph he says is "the essence of life."

The treatment of that photograph in the third act is emblematic—appropriate on an inadvertently meta-level, given that the photo itself becomes a rather ham-fisted symbol—of the movie's ultimate discomfort with actual imagination. The missing negative is a MacGuffin; it serves no real purpose other than to start Walter on his quest to find it. Unfortunately, Conrad simply cannot leave the photo as a MacGuffin, and eventually, it is used twice over as a cheap metaphor. The first time it is an affirmation of Walter's inherent worth (what he has been searching for has been with/inside him all the while) that also happens to serve as an easy resolution to the plot; the second time, it simply iterates the point. The first revelation is annoying, but the second one is downright maddening. After spending so much effort keeping the content of the photograph a mystery and having Walter repeatedly state that the photo itself does not matter, Conrad goes ahead and makes the image in the mystery photograph the final summation of the movie.

The formerly secret image is either a pun ("the essence of *Life*)—at which point, revealing it is really useless—or contradictory to everything Walter has gone through (if his former self is the "essence of life," the adventure is for naught), and either way, it is final fatal flaw in a movie that has a string of them. *The Secret Life of Walter Mitty* begins as an endearing bit of whimsy and turns into a unbridled monster of pompous thematic posturing.

Mark Dujsik

CREDITS

Walter Mitty: Ben Stiller
Cheryl Melhoff: Kristen Wiig
Ted Hendricks: Adam Scott
Edna Mitty: Shirley MacLaine
Sean O'Connell: Sean Penn
Origin: United States
Language: English
Released: 2013
Production: Stuart Cornfeld, Samuel Goldwyn, Jr., Ben Stiller; released by Twentieth Century Fox Film Corp.
Directed by: Ben Stiller
Written by: Steve Conrad
Cinematography by: Stuart Dryburgh
Music by: Theodore Shapiro
Sound: Craig Henighan
Music Supervisor: George Drakoulias
Editing: Grey Hayden
Art Direction: David Swayze
Costumes: Sarah Edwards

Production Design: Jeff Mann
MPAA rating: PG
Running time: 114 minutes

REVIEWS

Ebiri, Bilge. *Vulture*. December 24, 2013.
Jones, Kimberley. *Austin Chronicle*. December 20, 2013.
Larsen, John. *LarsenOnFilm*. December 23, 2013.
Orndorf, Brian. *Blu-ray.com*. December 24, 2013.
Phillips, Michael. *Chicago Tribune*. December 24, 2013.
Puig, Claudia. *USA Today*. December 26, 2013.
Schager, Nick. *Slant Magazine*. October 6, 2013.
Scott, A. O. *New York Times*. December 24, 2013.
Vaux, Rob. *Mania.com*. December 25, 2013.
Whitty, Stephen. *Newark Star-Ledger*. December 24, 2013.

QUOTES

Sean O'Connell: "Beautiful things don't ask for attention."

TRIVIA

After the drunken helicopter pilot jokes that there "are like eight people in Greenland," we see only eight different people when Walter goes to Greenland.

SHADOW DANCER

Collette McVeigh—mother, daughter, sister, spy.
—Movie tagline

Box Office: $99,134

James Marsh's *Shadow Dancer* is a tense IRA thriller with striking performances throughout that still somehow fails to have a sum impact that matches the power of its individual line items. A film's success can be helped but cannot be defined by the quality of particular puzzle pieces as much as the whole picture. So, while Marsh's film features a few tense scenes, strong performances from three talented leads, and a nice sense of atmosphere, a lack of thrust in the narrative leaves it remarkably forgettable. It is an old-fashioned piece that could work as nostalgia or purely for fans of the performers but it fades from memory nearly before the credits have finished running.

Collette McVeigh (Andrea Riseborough) fights for the Irish Republican Army. It is a life she was forced into as a child; not a cause that chose to fight for. When she saw her younger brother laid out on their kitchen table after being shot in an IRA conflict in 1973, her life was forever changed. So, while she was led there by history and tragedy, it is a defining facet of her life and character. She, her family, her social circle—they are all

fighters for a cause. And Collette's life is thrown into turmoil when that cause and family history are used against her.

At the start of *Shadow Dancer*, McVeigh is a pawn in the IRA. She is first seen on a train, paranoid, skittish, and holding a suspicious bag that she clearly wants to leave somewhere. The bombing does not succeed and Collette is nabbed by MI5 in the form of the suave Mac (Clive Owen, as steely and smooth as ever), who presents the cautious heroine with a rock and a hard place: Go to jail for decades and leave her son behind or turn on her family and everything that she has fought for her entire life. Betray her ancestors or destroy her future. She does what most mothers would do, choosing to protect her child, and goes undercover for MI5 in the IRA, turning on her own brothers, Connor (Domhnall Gleeson, son of Brendan) and Gerry (Aiden Gillen, so subdued compared to his *Game of Thrones* performance that some may not even make the connection). The great Gillian Anderson nearly walks away from the film in a small role as Mac's superior at MI5. As Mac realizes the emotional minefield in which he has thrown poor Collette, he begins to sympathize. His superior has no such sympathy.

Whereas most writers and directors would have turned *Shadow Dancer* into a thriller at this point, Marsh and writer Tom Bradby seem more intrigued by the commonality of disruption on both sides of the conflict. Both the people at MI5 and in the IRA are beset constantly by paranoia, power struggles, and infighting. Marsh's film makes an interesting case that is disorganization on either team that keeps the game at a stalemate more than anything else. As Connor, Gerry, and the rest of the IRA members in Collette's world sense they have a mole and become suspicious of their own and Mac is forced to deal with misinformation and personality clashes at MI5, Marsh's film becomes a thriller about how groups fall apart and get nothing done not because of politics but through internal conflict. Everyone is being lied to and it is the lack of concrete, honest information that determines a fate more than anything else.

Marsh's best work as a director has been as a documentary filmmaker with works like *Man on Wire* (2008) and *Project Nim* (2011) and so he approaches his dramatic work with a factual, historical eye. *Shadow Dancer* is not unlike Marsh's *Red Riding: 1980* in the details and its subtle approach to drama. However, both films share common flaws: A lack of grit, actual tension, and the sense that this story is taking place in a bubble; on a sound stage or set. Marsh, like great non-fiction filmmakers, does an incredible job with what is directly in front of him but great filmmaking is not about scene-creating but world-creating and that is where he stumbles. It does not help him that Bradby's script,

based on his own book, seems a bit in love with itself, too intellectually self-satisfied to be any fun.

To be fair, Marsh clearly has some directorial skill with performance. Riseborough plays Collette as undeniably vulnerable but also backed by years of conviction and the pain that came not only from watching her brother die but watching her father close the door in her face as it happened. She carries the weight of that moment in every scene: The cause that took her brother and that she will not let take her son. It is a complex balance of the vulnerability of her position and the determination to escape it. Owen perfectly matches her, looking as if he stepped right off the set of a Carol Reed spy thriller, and their scenes together have a crackerjack energy that too much of the film lacks.

Again, these performances, the art direction, the complex story—all strong elements that still lack as a cohesive whole. The film is too slow in its burn and not explosive enough in its finale. Film goers admire and respect complex characters like the ones presented here but a writer and director still need to give them something interesting to do for that admiration to turn to entertainment.

Brian Tallerico

CREDITS

Collette McVeigh: Andrea Riseborough
Mac: Clive Owen
Kate Fletcher: Gillian Anderson
Gerry: Aidan Gillen
Connor: Domhnall Gleeson
Kevin Mulville: David Wilmot
Ma: Brid Brennan
Origin: Ireland, United Kingdom
Language: English
Released: 2012
Production: Chris Coen, Ed Guiney, Andrew Lowe; BBC Films, Element Pictures, Lipsync Productions, UKFS, Unanimous Pictures; released by Magnolia Pictures
Directed by: James Marsh
Written by: Tom Bradby
Cinematography by: Rob Hardy
Music by: Dickon Hinchliffe
Sound: Roland Heap
Editing: Jinx Godfrey
Costumes: Lorna Marie Mugan
Production Design: Jon Henson
MPAA rating: R
Running time: 101 minutes

REVIEWS

Abele, Robert. *Los Angeles Times*. May 30, 2013.

Bradshaw, Peter. *The Guardian*. April 12, 2013.

Fear, David. *Time Out New York*. May 28, 2013.

Houlihan, Mary. *Chicago Sun-Times*. June 20, 2013.

Lichman, John. *The Playlist*. April 12, 2013.

Ogle, Connie. *Miami Herald*. June 6, 2013.

Reed, Rex. *New York Observer*. May 28, 2013.

Schenker, Andrew. *Slant Magazine*. May 27, 2013.

Vishnevetsky, Ignatiy. *The A.V. Club*. May 29, 2013.

Weitzman, Elizabeth. *New York Daily News*. May 31, 2013.

QUOTES

Kate Fletcher: "Is this just because she has a pretty face?"

TRIVIA

Screenwriter and author of the original novel Tom Bradby appears as himself in news footage early in the movie, although he is credited on screen as Patrick Clacy.

SHORT TERM 12

Box Office: $1 Million

Destin Cretton's expansion of his acclaimed short film into a feature-length debut is one of the most accomplished dramatic premieres of the last several years. It is a film that displays a deep sense of character understanding that is too often missing from cinema; blockbuster or indie. Unlike most writers of films about deep, emotional wounds, Cretton understands that the scars take time to heal. Stopping internal bleeding from issues like parental abuse cannot happen with a montage or a well-timed monologue. It is a slow, gradual process that takes personal expression, external assistance, and, most of all, time. With one of the best performances of the year from the great Brie Larson and poignantly real emotional mining from young actors Keith Stanfield and Kaitlyn Dever, *Short Term 12* is an honest, emotional gem.

Some jobs are tougher than others. There are professions that demand physical exertion that is not feasible for all and then there are jobs that require an emotional commitment for which not everyone is equipped or prepared. Cretton's brilliant, moving, personal chronicle of his time in a short term care home for damaged teens details one such job. These are people who look out, and are often the final safety net, for temporarily abandoned kids. Their parents might be in rehab, jail, etc. and many of these wounded souls have been abused, addicted, and troubled to the point of pure heartbreak. How people who work in these homes do so without openly weeping every day is a question worth asking. These are places in which emotion sits there on the surface, always present in the room.

Cretton beautifully book-ends his film with two partnering scenes of talking, laughing, and storytelling outside of the home. It is Nate's (Rami Malek) first at Short Term 12, a facility for kids who are waiting to find a new home or until they can return to their own. Mason (John Gallagher, Jr.), the scruffy but charismatic chap who is clearly the social leader of the group, is telling Nate a story that reflects a policy—the workers cannot force kids to stay if they get off the property. Once they are gone, these workers cannot be put in the position of police officer. They can try and convince them to stay or return but not through force. Immediately, Cretton reveals his ability to use a scene in multiple levels. The joking nature of the story, which ends with Mason defecating in his pants, sets a tone of congeniality among the staff but it also sets up plot beats in the rules of the facility and places an emphasis on character and history. This is life at Short Term 12: Funny, kind of dangerous, and totally unpredictable.

The residents and other employees of Short Term 12 are revealed through a series of scenes and moments that could be called episodic but those episodes build to a sense of remarkable realism. Most of the episodes are linked by either Mason or his girlfriend/co-worker Grace (Brie Larson). Through their eyes, the audience meets the clearly-damaged Marcus (Keith Stanfield, who is the only cast member who made the trip from the original short film), a young man on the verge of leaving the home and suffering a bit of angst because of it. He raps a song to Mason that defines his pain in ways that dialogue never could and he lashes out violently when teased by Luis (Kevin Hernandez).

And then there is Jayden (Kaitlyn Dever), the new arrival at the facility that shatters the very-thin bubble that Grace has placed around her personal pain. Through the arrival of Jayden, who clearly reminds Grace of herself, and the revelation that Grace is pregnant, Grace's emotional wounds open just enough to cause some serious problems. Grace gets a little too close to Jayden's own pain, taking it on as her own, and the two come to a happier place, bit by bit, slowly as is the case with abuse victims.

Why do people cut themselves? Why do gentle souls often shut down when faced with outstretched, loving arms? And how do people deal with these questions day in and day out, knowing that they cannot save everyone? Destin Cretton's film is a small movie that takes on the very big issues that are often the underreported undercurrent of our society. There are ways to stop the bleeding and the worry and the depression; ways to take a helping hand and realize that the person reaching out has their own emotional reasons for doing so. And it is not manipulative or melodramatic. Love, artistic expression, and even aggression—all of these and more are

rungs on the ladder to normalcy. It is a movie that the viewer feels as much as they watch.

Every performance in *Short Term 12* feels genuine—especially the supporting work by Stanfield and Dever, two young performers who never resort to melodrama and only seek truth in their characters—but the film belongs to Brie Larson. She is the emotional elevation of the entire piece; always completely in the moment and refusing to deal in the artifice that would have been the foundation of the character for so many other actresses. It is an overused critical cliche but the actress disappears into the character, not merely through dialogue and action but in the quiet character decisions. She expresses worry and feeling through the most subtle choices, but also shines in the big moments.

Each year, if the industry is lucky, produces a major debut or two that shakes up the independent film scene. They herald the arrival of major writers, directors, and performers. In a decade, it is easy to imagine 2013 being remembered as the year that introduced the world to Destin Cretton and Brie Larson.

Brian Tallerico

CREDITS

Grace: Brie Larson
Mason: John Gallagher, Jr.
Jayden: Kaitlyn Dever
Jessica: Stephanie Beatriz
Nate: Rami Malek
Marcus: Keith Stanfield
Origin: United States
Language: English
Released: 2013
Production: Asher Goldstein, Ron Najor; released by Cinedigm Entertainment Group
Directed by: Destin Cretton
Written by: Destin Cretton
Cinematography by: Brett Pawluk
Music by: Joel West
Sound: Onnalee Blank
Editing: Nat Sanders
Art Direction: Grace Alie
Costumes: Joy Cretton
Production Design: Rachel Myers
MPAA rating: R
Running time: 96 minutes

REVIEWS

Debruge, Peter. *Variety.* April 10, 2013.
Freer, Ian. *Empire.* October 28, 2013.

Gleiberman, Owen. *Entertainment Weekly.* August 21, 2013.
Kang, Inkoo. *Village Voice.* August 20, 2013.
Kohn, Eric. *Indiewire.* June 7, 2013.
Rich, Jamie S. *Portland Oregonian.* September 5, 2013.
Roeper, Richard. *Chicago Sun-Times.* September 12, 2013.
Turan, Kenneth. *Los Angeles Times.* August 22, 2013.
VanDenburgh, Barbara. *Arizona Republic.* August 29, 2013.
Walsh, Katie. *The Playlist.* April 10, 2013.

QUOTES

Grace: "Why are you so nice to me?"
Mason: "You being serious now? Well, it's easy. It's because you are the weirdest, most beautiful person that I've ever met in my whole entire life."

TRIVIA

To convince director Destin Cretton to cast her, actress Brie Larson told him that she had applied to volunteer with disadvantaged children after reading the script in order to research the role. Larson revealed later that she had been rejected by every organization she had applied to.

AWARDS

Ind. Spirit 2014: Film Editing
Nominations:
Ind. Spirit 2014: Actor—Supporting (Stanfield), Actress (Larson)

SIDE EFFECTS

One pill can change your life.
—Movie tagline
This is your insanity on drugs.
—Movie tagline

Box Office: $32.2 Million

A year or so prior to the release of *Side Effects*, director Steven Soderbergh said that it would be his last film, at least theatrically. His real final film would be the made-for-cable biography film of Liberace, *Behind the Candelabra*, starring Michael Douglas and Matt Damon. Perhaps not surprisingly, these two films make for odd choices as career swan songs, particularly for a filmmaker as consistently prolific as he is. He certainly has many more years in him before he hits the typical age when directors start slowing down (Soderbergh is 51, as of this writing). *Side Effects* leans more along the lines of the director's more linear minded output than his experimental works. It never hits any extremes in either case (neither as light as an *Oceans* movie nor as heavily eccentric as *Solaris* [2002] or *Schizopolis* [1996]). But

Behind the Candelabra is pretty much a straightforward biopic, ending with the funeral of the flamboyant pianist, who proclaims "Too much of a good thing is wonderful!" Perhaps it is fitting that he bookend his career with two films about how sex changes the dynamics of emotional intimacy (his first film being *sex, lies, and videotape* [1989]).

But *Side Effects* is definitely an unmistakable Soderbergh product. Never one to shy away from current hot-button issues without easy answers, the first half of the film takes on the subject of the big pharmaceutical industry (or Big Pharma). It opens with simple shots of an apartment where the floor has bloody footprints. Then, "three months earlier." Emily Taylor (Rooney Mara) visits her husband Martin (Channing Tatum) in prison where he resides for insider trading. He will finally be released within days of this visit. The day after his release, Emily gets into her car, lost in her own feelings of despair, and willingly crashes it into a wall.

The film then introduces Dr. Jonathan Banks (Jude Law) who tends to Emily in the hospital. She has a concussion and Dr. Banks wants to give her a psychiatric evaluation and get to the bottom of her mental condition. She insists that she feels fine and just had a bad moment. He puts her on a drug that basically stops the brain from feeling sadness. He corresponds with a colleague of his, Dr. Victoria Siebert (Catherine Zeta-Jones), who treated Emily in the past a few years when Martin went to prison. She suggests putting Emily on a new drug called Ablixa. One night at a party, Emily hears from a friend that she tried it and it really helped.

The effects of depression do not wear off anytime soon for Emily. She cannot go to parties or stand near train tracks without considering a jump. She receives a prescription for Ablixa and it appears to do the trick, that is until a tragic event turns everything around in the worst possible way for Emily. Meanwhile, Dr. Banks has been given a high-paying job of testing out a new anti-depressant, a job that will require him to be away from his wife Dierdre (Vinessa Shaw) and son. He has to conduct a study with his patients and get them to try the drug.

But the tragedy takes its hold on Dr. Banks and everyone around him. His prescriptions for his patients come under heavy scrutiny from the law and he becomes the subject of an investigation. Anti-depressants such as Ablixa becomes the hot-button topic in the media with Dr. Banks getting hounded by the press asking him to make a statement. A case goes to trial and the story behind the drugs and their users gets deeper and deeper until nobody knows who is working for whom and what backroom deals have been made.

It is hard to describe the film without mentioning a major plot point, but Scott Z. Burns' screenplay carefully lets the audience in on its secrets a little bit at a time. Refreshingly this is not an easy film to predict, but the overall conclusion might be hard for a viewer to swallow, considering the maze of intrigue and deception that brings it to its arrival. It becomes one of those storylines where it must be asked just how could this have been thought up by these characters and how could they know everything would turn out this way? With such wide margins of error on many fronts, the plot goes from a sadly realistic portrait of a country overly dependent on untested prescription drugs to a Hitchcockian mind game made up of drastically far-reaching twists.

While such preposterous ideas would usually sink a film such as this, *Side Effects* still manages to work. Were it not for a auteur behind the camera, it might have become a forgettable piece of absurdity with elements of a guilty pleasure. But Soderbergh and his cast expertly make the material worth investing in, with each actor playing a real person and not a character written out of a screenwriting class. Mara has perhaps the toughest role here, but she perfectly plays the victim of circumstance while also conveying a deeply lost soul who cannot figure out what is happening to her internally and externally. Law is the perfect choice as Dr. Banks, a possible victim of his own undoing and a character who only knows what he is told by his seemingly trustworthy colleagues.

Soderbergh once again employs an alias as his own cinematographer (credited as Peter Andrews). His films have developed a look all their own with their icy blues, warm orange suns, and carefully framed static shots, but gone is the experimentation and the fragmented storytelling that have become a part of his creative canvas. There remains, however, an unmistakable coolness to the film. Soderbergh has always been more of a cerebral director than an emotional one, carefully keeping his audience at arm's length, but always engaging the intellect. His choice of often using composer Thomas Newman has always paid off handsomely, with Newman often looking to expand his musical compositions while matching Soderbergh's need to keep everything grounded (quite an accomplishment for Newman, who has composed some of the most astonishing musical landscapes for some of the most emotionally draining films ever made).

But followers of Soderbergh's work will notice a certain aspect of self-reflection in *Side Effects*. There exist many elements of his previous work within the framework of this seemingly simple mystery. The intimate scenes of Mara talking about her failed sex life in her marriage to her doctor recalls the early scenes of Andie McDowell talking to her therapist in *sex, lies, and*

videotape (1989). The plot reveal seems like a wholly contrived means to a financial end reminiscent of a heist in an *Ocean's* movie. The somewhat hypocritical Jude Law character here is not so far removed from Michael Douglas's character in *Traffic* (2000). Even the subject of corporate greed taking their toll on the American dream wedges its way into the narrative just as it did in *The Girlfriend Experience* (2009).

Perhaps then, this is another kind of farewell (for now) from Soderbergh. If he remains true to his word about retiring from theatrical releases (as of this writing, there is a TV miniseries in the works), *Side Effects* will most likely be looked upon as a good, but not quite great effort. But like many of his films, it does work better on a second viewing and there are clues within the film's construction that lead the viewer onto richer ground. *Side Effects* is bookended with a shot of the camera peering into an apartment of a complex character and ends with a similar shot in reverse as Soderbergh leaves the character who has nowhere else to go. In many ways, it sums up his career so far as one of cinema's most inquisitive social and cultural anthropologists, just looking into the windows of human beings, observing without judgment and then making his way onto the next window.

Collin Souter

CREDITS

Emily Hawkins: Rooney Mara
Martin Hawkins: Channing Tatum
Dr. Jonathan Banks: Jude Law
Dr. Victoria Siebert: Catherine Zeta-Jones
Dierdre Banks: Vinessa Shaw
Kayla: Mamie Gummer
Martin's Mother: Ann Dowd
Origin: United States
Language: English
Released: 2013
Production: Lorenzo di Bonaventura, Gregory Jacobs, Scott Z. Burns; Endgame Entertainment, di Bonaventura Pictures; released by Open Road Films
Directed by: Steven Soderbergh
Written by: Scott Z. Burns
Cinematography by: Steven Soderbergh
Music by: Thomas Newman
Sound: Larry Blake
Editing: Steven Soderbergh
Costumes: Susan Lyall
Production Design: Howard Cummings
MPAA rating: R
Running time: 106 minutes

REVIEWS

Buckwalter, Ian. *The Atlantic*. March 1, 2013.
Ebert, Roger. *Chicago Sun-Times*. February 7, 2013.
Gleiberman, Owen. *Entertainment Weekly*. February 7, 2013.
Howell, Peter. *Toronto Star*. February 8, 2013.
Long, Tom. *Detroit News*. February 8, 2013.
Orr, Christopher. *The Atlantic*. February 11, 2013.
Rodriguez, Rene. *Miami Herald*. February 8, 2013.
Scott, A. O. *New York Times*. February 7, 2013.
Walters, Ben. *Time Out*. March 5, 2013.
Whitty, Stephen. *Newark Star Ledger*. February 8, 2013.

QUOTES

Dr. Jonathan Banks: "Depression is an inability to construct a future."

TRIVIA

Steven Soderbergh has claimed that one of his influences while making this movie was the work of Adrian Lyne.

SIGHTSEERS

Killers have never been this close-knit.
 —Movie tagline
Fear has a wet nose.
 —Movie tagline
Killers have never been so average.
 —Movie tagline

Box Office: $35,722

British filmmaker Ben Wheatley's debut feature, *Down Terrace* (2009) was an intimate gangland drama seamlessly blended with the kitchen sink family drama heightened realism of Mike Leigh and Ken Loach. His follow-up, *Kill List* (2011) was an equally genre-bending exercise, blending a rough-and-tumble hitman buddy film with a bizarre occult story. With *Sightseers*, Wheatley has returned to a more seamless amalgam. This time, he mashes up a funky, couple-discovering-themselves-on-a-country-jaunt uncomfortable comedy—a descendant of Leigh's classic *Nuts in May* (1976)—with a gory, sardonic killing spree movie, along the lines of Oliver Stone's *Natural Born Killers*, but more restrained and, well, good. It also owes a little to the Ealing comedies of the 1950s, while managing to remain its own unique thing.

Tina (Alice Lowe) decides to go on holiday in a caravan with her new boyfriend Chris (Steve Oram). This serves to get her out from under the skirt of her overbearing mother, Carol (Eileen Davies), who is aggressively mourning the loss of her beloved terrier,

Poppy, especially unpleasant to Tina because she inadvertently caused the dog's death. As Tina packs to leave, Carol feels abandoned, and lays the guilt on pretty thick. She also warns Tina about the potential dangers of her road trip, and expresses her distrust of Steve. When all that fails, and Tina is in the driveway ready to leave, Carol calls her daughter a murderer. "It was an accident," Tina protests. "So were you," Carol replies. Soft Cell's "Tainted Love" starts playing on the soundtrack, and so the tone is hilariously set for the film.

Wheatley manages the rare trick of making a movie that is both laugh-out-loud funny and genuinely unsettling. It starts with the talents of his two leads, who also co-wrote the script (Wheatley and his writing partner Amy Jump also took a pass at it), then improvised much of the dialogue as Wheatley shot the movie. Chris and Tina could have been standard types, but Oram and especially Lowe do excellent, nuanced work, individuating them. Because the slightest upset could provoke them to murder, their petty jealousies and mundane spats—even the dull choices Chris has made for their sightseeing journey—take on immense significance, and Wheatley maximizes the comic potential of that incongruity.

Lowe and Oram claim their parents and the long argument-filled caravan trips of their youth inspired them to create these characters. Chris and Tina seem like an ordinary new couple out exploring Northern England and each other, but the methodical control-freak Chris is secretly a serial killer. His tourism choices highlight his longing for an ideal English past that never was. Deeply affronted by rudeness or condescension, he withdraws into a seething ball of rage and plots deadly revenge. It is clear from the way Wheatley depicts his first act of violence—"accidentally" backing over a litterbug with his caravan at a tram museum—that the film is going to take these actions seriously. Yes, the offender was kind of a jerk, but seeing him lying under the caravan with blood spurting copiously from his throat, with his wife and teenage son screaming in horror and agony as they run toward him, all in slow motion, any sense of gratuitous satisfaction withers quickly, and the laughs catch in the throat.

The pair next encounter a smug upper-class couple, Ian (Jonathan Aris) and Janice (Monica Dolan), at a campsite. Seeing the couple's terrier, Banjo, Tina flashes back to Poppy's death, and wants to believe that Banjo is some sort of reincarnation. Janice freaks out when Tina tries to feed Banjo a potato chip, and when Chris, who aspires to write a book, finds out that Ian is working on his third, Ian's unhappy fate is sealed. In a bravura sequence, Wheatley intercuts Chris murdering Ian on a gorgeous cliffside at dawn with an ersatz shaman ritual on the campground, which Tina tellingly

fantasizes about joining, and with Janice making breakfast and cutting her foot on a piece of the plate that Chris passive-aggressively broke in their caravan the previous day.

When Banjo shows up at their caravan later, as Chris is packing up to hightail it out of there, Tina insists that they take the dog, which she soon starts calling "Poppy", with them. Later, as she looks through the photos on the camera Chris took from his victim, her amusing confusion and jealousy at finding naked pictures of Janice gives way to the realization of what Chris has done.

As *Sightseers* continues, the couple's journey grows increasingly violent and disturbing, but it never loses its comic edge. The comedy moves into a higher gear, in fact, as Tina becomes aware of Chris's actions. At first, she's horrified, but all the rage she's suppressed during her unhappy home life soon bubbles up to the surface. Lowe portrays this dark awakening and growing self-awareness with a surprising subtlety that makes it all the more hilarious. The couple's idyllic tandem murder spree soon runs into trouble. Tina is far less methodical in her actions than Chris, and suddenly, she won't allow herself to be controlled by him. Their happiness is further threatened when Chris meets and befriends Martin (Richard Glover), a fellow traveller who has invented what Chris calls a "cara-pod," a sort of mini-tent on wheels that Martin trails behind his bicycle. Threatened by Chris's disapproval of her methods, and by this new friendship, Tina takes action.

Thanks to the performances and Wheatley's sharp direction, it is not possible to either fully empathize with Chris and Tina, amusingly described in a radio news report on one of their crimes as "a ginger-faced man" and "an angry woman," nor to completely dismiss them as murderous psychopaths. In their run-of-the-mill resentments and seemingly genuine bond to one another, they remain fascinating, funny, and disturbing characters, and they propel the tale forward to its perfectly realized darkly comic end.

Josh Ralske

CREDITS

Tina: Alice Lowe
Chris: Steven H. Oram
Carol: Eileen Davies
Ian: Jonathan Aris
Janice: Monica Dolan
Origin: United Kingdom
Language: English
Released: 2012

Production: Claire Jones, Nira Park, Andrew Starke; BFI;
 released by Big Talk Pictures
Directed by: Ben Wheatley
Written by: Alice Lowe; Steven H. Oram
Cinematography by: Laurie Rose
Music by: Mr. Jim Williams
Sound: Martin Pavey
Editing: Ben Wheatley; Robin Hill; Amy Jump
Art Direction: Blair Barnette; Andrew Ranner
Costumes: Rosa Dias
Production Design: Janey Levick
MPAA rating: Unrated
Running time: 88 minutes

REVIEWS

Burr, Ty. *Boston Globe*. May 16, 2013.
Cataldo, Jesse. *Slant Magazine*. May 8, 2013.
Darby, Alexa. *Britflicks*. March 25, 2013.
Kemp, Philip. *Sight & Sound*. December 2012.
Marsh, Calum. *The House Next Door*. September 11, 2012.
Newman, Kim. *Empire*. November 12, 2012.
O'Malley, Sheila. *RogerEbert.com*. May 8, 2013.
Rothkopf, Joshua. *Time Out NY*. May 7, 2013.
Tobias, Scott. *NPR*. May 9, 2013.
Young, Neil. *The Hollywood Reporter*. May 25, 2012.

QUOTES

Chris: "He's not a person, he's a *Daily Mail* reader!"

TRIVIA

The trams at Crich mostly ran along the streets of cities in United Kingdom before the 1960s, with some trams rescued and restored (even from other countries) as the systems closed.

THE SILENCE

Box Office: $99,654

The strength of this German-based crime drama lies in a simple showcasing of grief and guilt. Part police procedural and part melodrama the film flows toward a tragic end that is reminiscent of better films like *The Pledge* (2001) or *The Woodsman* (2004) but it definitely belongs in the same series of conversations those films provoke. It is a powerful examination of the consequence (and occasional non-consequence) of choice, and the power of isolation to provoke selfdestruction amongst both the guilty and the innocent.

It is 1986 and an eleven-year-old girl named Pia (Helene Luise Doppler) is raped and murdered by a man named Peer (Ulrich Thomsen) while his hesitant partner in crime Timo (Wotan Wilke Mohring) watches silently from a parked car. The two are never caught and Timo flees in terror soon after, much to the worry of Peer. The crime goes unsolved, deeply affecting all who come into contact with its details, especially lead investor Mittich (Burghart Klausner).

Twenty-three years later, to the day, a 13-year-old girl named Sinikka (Anna Lene Klenke) is murdered in the same spot just as Mittich retires. Blocked from pursuing his interest in the case by the stubborn new senior detective Grimmer (Oliver Stokowski), Mittich attempts to work behind the scenes with David Jahn, a detective assigned to the case. Jahn (Sebastian Blomberg), still grieving the death of his own wife, is emotionally unstable, and the case stalls leaving Grimmer to hold out false hope to Sinikka's parents in an effort to stem the political fallout from the failed investigation. Frustrated, Mittich calls on Pia's mother, leading to an affair, redoubling his own resolve to solve the case.

Timo meanwhile assumes that the new murder is a message from Peer and senses that his careful facade of married man, devoted father, and career as an architect is in danger. In desperation, he seeks Peer out only to discover an unremarkable underachiever of a man who bears not a trace of remorse for his actions. Instead of remorse Peer hands Timo a copy of the DVD that started the pair down their dark shared road so long ago. Unable to resist temptation Timo plays the tape, which shows a young girl being sexually abused, and is immediately overcome with shame driving him to the door of Pia's mother. But instead of confessing he asks awkward questions which lead Jahn and Mittich to track him back to his home where they discover evidence of his crimes. A desperate search for him begins, but as his life quickly unravels and he travels to his final destination Peer begins to fade into the background. Grimmer remains unbowed. The families remain devastated. Mittich and Jahn remain sure the case is not completely solved. All is silence and there is a sense in which the universe itself seems to have spoken.

There are all sorts of very effective moments here evocative of the film's title. Each character brings a sense of isolation into a narrative that is concerned by that which stops understanding short. Questions of culpability reign supreme in any crime thriller but here they subordinate themselves to the brokenness of people who are often, even themselves, unsure of why they have made the choices that led them to where they are.

Ultimately, the innocent and the guilty only have silence.

Many will assume *The Silence*'s back and forth construction is an attempt to elevate a mundane narrative into arthouse territory. It is true that the timeline of *The Silence* moves around a lot. Director/screenwriter Baran bo Odar could have chosen to underscore the passage of time less confusingly for viewers but he is up to more than theatrics here. His flashbacks are a way of moving viewers back and forth from memory to present reality, asking viewers to consider the history of the individual. Odar certainly coaxes fine performances out of his cast whose muted characterizations leave viewers the chance to interpret motive, intuit affections, and most of all, the chance to cry out themselves when someone should speak or be mystified into realizing there are not always easy answers when it comes to cosmic justice.

Burghart Klausner's performance is deeply suited to the kindness and naivete of his character, Mittich. Though he is often used as a stern authority figure (*The White Ribbon* [2009]) he has also shown great effectiveness in more sympathetic roles in underrated lower profile films like *Requiem* (2006). In short, he is emerging as an important character actor and *The Silence* will likely loom large on his resume.

Ulrich Thomsen will be the most recognizable to American audiences for his roles in mainstream fare like *The Thing* (2011) or the breakout foreign language hit *Fear Me Not* (2008) and he is certainly well known, almost type cast as a heavy these days. But his part here is written well enough to make him seem like more than just another sociopath. Peer is a manipulator not a cypher and the story puts him into devastating position to do just that to everyone he comes into contact with. But even he cannot see the final outcome of the game he plays and grieving too will be a part of his story.

The adjective "haunting" gets trotted out here because it fits. *The Silence* is a movie that manages to not only evoke emotion but make it linger, particularly those emotions that wrestle so fervently with notions of how things should be, how people are connected, and why evil is not always answered in the way it seems it should be.

Dave Canfield

CREDITS

Peer Sommer: Ulrich Thomsen
Timo Friedrich: Wotan Wilke Mohring
Elena Lange: Katrin Sass
David Jahn: Sebastian Blomberg

Krischan: Burghart Klaussner
Origin: Germany
Language: German
Released: 2010
Production: Frank Evers, Jantje Friese, Maren Luthje, Florian Schneider, Jorg Schulze; Cine Plus, Luthje & Schneider Filmproduktion; released by Music Box Films
Directed by: Baran bo Odar
Written by: Baran bo Odar
Cinematography by: Nikolaus Summerer
Music by: Michael Kamm
Sound: Christopher Ulbich
Editing: Robert Rzesacz
Costumes: Katharina Ost
Production Design: Christian M. Goldbeck; Yesim Zolan
MPAA rating: Unrated
Running time: 118 minutes

REVIEWS

Hewitt, Chris. *St. Paul Pioneer Press*. March 28, 2013.
Kauffmann, Stanley. *The New Republic*. March 27, 2013.
MacDonald, Moira. *Seattle Times*. March 28, 2013.
Mohan, Marc. *Oregonian*. May 17, 2013.
O'Hehir, Andrew. *Salon.com*. March 6, 2013.
Riley, John A. *Electric Sheep*. October 26, 2011.
Schenker, Andrew. *Slant Magazine*. March 2, 2013.
Scott, A. O. *New York Times*. March 7, 2013.
Taylor, Ella. *NPR*. March 7, 2013.
Turan, Kenneth. *Los Angeles Times*. March 7, 2013.

TRIVIA

The license plates seen throughout the film are fake as no German city/county has ever issued plates starting with "FA."

A SINGLE SHOT

> *A single shot. A thousand consequences.*
> —Movie tagline
> *One chance. One secret. One mistake.*
> —Movie tagline

Box Office: $18,642

A gritty, atmospheric backwoods noir, David M. Rosenthal's *A Single Shot* fits into the same genre as the Coen brothers' *No Country for Old Men* (2007), Sam Raimi's *A Simple Plan* (1998), and Debra Granik's *Winter's Bone* (2010). It does not quite reach the cinematic heights of those works, but is an engrossing thriller, and features some outstanding performances.

Matthew F. Jones adapted his own acclaimed novel for the movie, which stars the brilliant Sam Rockwell as

John Moon, who has fallen on hard times since his family's farm was repossessed. His wife Jess (Kelly Reilly) has left him, taking their baby. Moon has lost his job, and lives in a ramshackle house in the woods outside a depressed West Virginia town. He sustains himself by poaching deer from the nearby wildlife sanctuary. As the film begins, he goes out hunting, tracking a deer deep into the woods, where in a fateful moment, he shoots at some rustling in the brush, accidentally killing a young woman (Christie Burke). He finds her campsite nearby, and a strongbox filled with cash. Moon elects to hide the body and keep the money, hoping it will help him reclaim his family.

This is obviously the kind of movie where finding a box of money can only bring misery, and indeed it does. There is a psychopathic boyfriend (Jason Isaacs) looking for the girl, and a bevy of other unsavory types in the mix, including William H. Macy as Pitt, a uniquely sleazy, glad-handing small town lawyer in a terrible toupee and a worse suit, Joe Anderson as "Hen," a scary redneck ex-con who may have been involved in a local brutal murder years ago, and Jeffrey Wright as Simon, Moon's best friend, an alcoholic struggling to come to grips with his own dark past. As Moon's world devolves into a paranoid nightmare, it seems that threats to his life could be coming from any direction.

Offering a fleeting glimmer of hope, Ted Levine plays Cecil, who bought the Moon family farm from the bank, and kindly offers John a steady job there when his son goes away to college. John politely demurs, saying he will get back to him. At this point, he has found that cash, but it's clear that even if he had not, Moon might be too proud to take even a good job working on the farm that once belonged to his family. Cecil's daughter, Abbie (Ophelia Lovibond), meanwhile, has clearly had a crush on Moon for some time, and urges him to take the job. Later, she gets more forward with him about her desires, but by then, it's far too late: he is deep into a deadly drama from which there seems to be no turning back.

Rosenthal, working with Spanish cinematographer Eduard Grau shoot the local woods and mountains in shades of grey, frequently drenched in rain or shrouded in fog, and the mood they inspire ranges from melancholy to eerie menace. The scenes in the woods are sometimes shot like a horror film, with Icelandic Atli orvarsson's occasionally overemphatic score adding to that sense. But Rockwell, as the completely lost, taciturn, basically good but desperate Moon, is the movie's rock solid core, and he keeps the focus on the essential humanity of the character.

Rockwell is the rattled-but-essentially-still center, and the other actors dance around him. Macy somehow

manages to play a genuine person underneath that ridiculous getup. He is a scheming wretch, essentially, but when, in a later scene, Rockwell punches him in the face and his wig slips from its perch, his lost dignity has meaning and poignancy. At the emotional climax of the film (as opposed to the narrative climax, which comes later), Wright delivers one of the most astonishing soliloquies of his exemplary career (and this is an actor who knows his Shakespeare), as the falling-down-drunk Simon tries to explain to an angry Moon how he has reached such personal low—how an earlier moral failing has irrevocably destroyed him. The speech is delivered in a heavy drawl with a drunken slur. It is a bit of a struggle to understand, but the emotions behind it come through with startling clarity. Some have accused Wright of overacting, which is insane. This is just the precise right amount of acting. It fits the story and the milieu perfectly, and Wright delivers Jones's twisted dialogue beautifully. This scene alone makes the movie worth watching, whatever its flaws. It is magnificent. But to Rosenthal and Jones's credit, as jaw-droppingly good as Wright's turn is, it is of a piece with the rest of the film.

It goes on inexorably to its grim conclusion, the one any savvy audience member could foresee the moment John Moon picked up that money. On one level, *A Single Shot* is a standard morality tale, but it is told with enough dark wit and colorful detail to make it memorable.

Josh Ralske

CREDITS

John Moon: Sam Rockwell
Simon: Jeffrey Wright
Pitt: William H. Macy
Moira Moon: Kelly Reilly
Waylon: Jason Isaacs
Obediah: Joe Anderson
Cecile: Ted Levine
Origin: United States
Language: English
Released: 2013
Production: Chris Coen, Aaron L. Gilbert, Keith Kjarval, Jeff Rice; Bron Studios, Demarest Films, Media House Capital, Unanimous Pictures, Unified Pictures; released by Tribeca Film Institute
Directed by: David M. Rosenthal
Written by: Matthew F. Jones
Cinematography by: Eduard Grau
Music by: Atli Ovarsson
Sound: Roland Heap
Editing: Dan Robinson

Art Direction: Cheryl Marion
Costumes: Beverly Wowchuk
Production Design: David Brisbin
MPAA rating: R
Running time: 116 minutes

REVIEWS

Chaney, Jen. *The Dissolve.* August 25, 2013.
Garrett, Stephen. *Time Out New York.* September 17, 2013.
Goodykoontz, Bill. *Arizona Republic.* September 19, 2013.
Hachard, Tomas. *NPR.* September 20, 2013.
Kohn, Eric. *IndieWire.* September 18, 2013.
Lemire, Christy. *RogerEbert.com.* September 20, 2013.
Linden, Sheri. *Los Angeles Times.* September 18, 2013.
MacDonald, Scott. *The A.V. Club.* September 18, 2013.
Schager, Nick. *Slant Magazine.* July 24, 2013.
Scherstuhl, Alan. *Village Voice.* September 17, 2013.

QUOTES

John Moon: "I don't wanna a divorce. I just want my family back."

TRIVIA

Michael Fassbender, Thomas Haden Church, Forest Whitaker, Alessandro Nivola, Emily Mortimer, Juliette Lewis, Jennifer Jason Leigh, Terrence Howard, James Badge Dale, Juno Temple, and Leslie Mann were all considered and cast in various roles during production but eventually dropped out.

THE SMURFS 2

Box Office: $71 Million

In complete defiance of everything good, decent and noble that cinema can artistically represent in an ideal world, Hollywood saw fit to offer up *The Smurfs* (2011), a garish live-action/animated hybrid that brought the sickeningly adorable and shockingly durable blue-skinned creations of Belgian illustrator Peyo to the big screen and even did so in the majesty of post-conversion 3-D to boot. The resulting film was atrocious, as practically anyone whose age had stretched into double-digits could readily attest, but with a worldwide gross of over a half-billion dollars (possibly fueled in part by stoners turning up on the mistaken assumption that it was some kind of sequel/spinoff of *Avatar* [2009]), parents around the globe began steeling themselves for an all-but-inevitable sequel. To be scrupulously fair, the imaginatively-titled *The Smurfs 2* is actually a slightly more agreeable production than its predecessor, though that is mostly due to the fact that

its mere existence comes as less of a brutal shock to the system this time around than to any intrinsic qualities. For the most part, however, it is just another piece of lifeless, joyless product that clearly put more energy and creativity into the marketing than in its efforts to tell a compelling story.

Said story opens with Smurfette (voice of Katy Perry), the lone female Smurf, feeling bluer than usual because she is convinced that all the other Smurfs of Smurf Village have forgotten her birthday. At the same time, the evil Gargamel (Hank Azaria), who actually created Smurfette as a fearsome creature designed to destroy the hated Smurfs until Papa Smurf (Jonathan Winters) imbued her with the power of love and goodness, is now a world-renowned magician whose illusions are generated by generous doses of Smurf essence. With his stores of the precious substance running perilously low, Gargamel hits upon the idea of killing two Smurfs with one stone (metaphorically speaking, alas) by opening an inter-dimensional portal between the two worlds, sending his two failed experiments in self-Smurf creation—bad seeds Vexy (Christina Ricci) and Hackus (J.B. Smoove)—to bring Smurfette back to Paris, where he is now performing, and exploiting her sense of abandonment in an effort to trick her into forking over the recipe for Smurf essence. Memo to Gargamel: Skip the magic act and concentrate on the inter-dimensional portals as a basis for your business model.

Evidently, reruns of old sitcoms do not reach the Smurf village because if they had, Smurfette presumably would have realized that her fellow Smurfs were actually planning a surprise birthday party for her. (By the way, if you think the word "Smurf" is being overused in this review that is nothing compared to its deployment in the film proper.) Once the other Smurfs discover what has happened, Papa recruits an elite squad of Smurfs to enact a rescue mission but those plans go sideways as he, Clumsy (Anton Yelchin), Grouchy (George Lopez) and Vanity (John Oliver, whose turn here probably inspired many inspired jokes among his colleagues on *The Daily Show*, which he was co-hosting when the film was released) get zapped to the human world instead. After a quick pit stop to pick up their friends from the previous film, new parents Patrick (Neil Patrick Harris) and Grace (Jayma Mays), along with his wacky stepfather (Brendan Gleeson, in what can only be explained as the result of some form of ill-advised wager gone sour), they are off to France to rescue Smurfette from Gargamel. However, when they arrive, they are horrified to discover that she has fallen under the thrall of her real creator and may not want to come back after all. (In one of the many jokes that will fly over the heads of younger viewers and under those of older ones, she is described as suffering from "Smurfholm Syndrome.")

The previous incarnations of *The Smurfs* were relatively benign creations that, with their bright colors and easily digestible storylines, were pitched frankly at very young audiences. Inevitably, the films, especially this one, have proven to be coarser affairs that spend more time on creating elaborate special-effects set-pieces in which the gooey contents of bakeries are splattered, people are inexplicably transformed into ducks and a Ferris Wheel can roll down the streets of Paris without causing any visible damage or even raising a single eyebrow amongst passerby while offering up self-consciously ironic humor like the aforementioned Smurfholm Syndrome joke. The trouble is that the slapsticky stuff gets very old very quickly—the visuals are expensively produced but make very little impression—and the wink-wink humor jibes badly with the more theoretically sincere moments on display. None of the vocal contributions are particularly memorable—Katy Perry may have a voice tailor-made for cranking out exquisite pop confections but it is far less compelling when she is merely talking—and most of the visible actors go through their paces of people content that their house payments for the next few months have been taken care of. The lone exception to this is Azaria, who is not especially good or funny as Gargamel but who certainly throws himself into the part with more zeal than most other actors might have been able to muster under the circumstances.

Of course, the very notion of reviewing *The Smurfs 2* is inherently ridiculous—those who actually want to see it are too young to read reviews in the first place while others will be attending almost entirely to prove that they are good parents, guardians or older siblings. Because it is bright and colorful and simplistic enough for them to grasp, younger viewers may enjoy it, especially if they have never actually seen a movie before. For everyone else, it will prove to be a dreary slog that will inspire maybe two thoughts tops. First, they will note with a certain amount of depression that this, of all things, would prove to be the last credit for a genius like the late, great Jonathan Winters. Second, they may idly wonder what job Patrick has that pays him well enough so that he can fly himself and his family to Paris at a moment's notice and offers hours flexible enough that he can do so without worrying about checking in or getting fired for never being around. Talk about a real fantasy.

Peter Sobczynski

CREDITS

Grace Winslow: Jayma Mays
Victor Doyle: Brendan Gleeson
Patrick Winslow: Neil Patrick Harris
Odile Anjelou: Sofia Vergara
Gargamel: Hank Azaria (Voice)
Smurfette: Katy Perry (Voice)
Papa Smurf: Jonathan Winters (Voice)
Clumsy Smurf: Anton Yelchin (Voice)
Gutsy Smurf: Alan Cumming (Voice)
Vexy: Christina Ricci (Voice)
Hackus: J.B. Smoove (Voice)
Origin: United States
Language: English
Released: 2013
Production: Veronique Culliford, Jordan Kerner; Kerner Entertainment Company, NeoReel; released by Sony Pictures Entertainment Inc.
Directed by: Raja Gosnell
Written by: David Ronn; David N. Weiss
Cinematography by: Phil Meheux
Music by: Heitor Pereira
Sound: Robert L. Sephton
Editing: Sabrina Plisco
Costumes: Veronique Marchessaut; Rita Ryack
Production Design: Bill Boes
MPAA rating: PG
Running time: 105 minutes

REVIEWS

Cabin, Chris. *Slant Magazine.* July 29, 2013.
Ebiri, Bilge. *Vulture.* July 31, 2013.
Foundas, Scott. *Variety.* July 28, 2013.
Genzlinger, Neil. *New York Times.* July 31, 2013.
King, Loren. *Boston Globe.* July 31, 2013.
Lowe, Justin. *Holllywood Reporter.* July 28, 2013.
Olsen, Mark. *Los Angeles Times.* July 31, 2013.
Orndorf, Brian. *Blu-ray.com.* July 31, 2013.
Robinson, Tasha. *The Dissolve.* July 30, 2013.
Schrager, Nick. *Village Voice.* July 30, 2013.

QUOTES

Grouchy Smurf: "Every time a smurf toots, someone smiles."

TRIVIA

Sofia Vergara filmed a cameo reprising her role of Odile Anjelou from the first film, but the scene was ultimately deleted.

AWARDS

Nominations:

Golden Raspberries 2013: Worst Remake/Sequel

SNITCH

How far would you go to save your son?
—Movie tagline

Box Office: $42.9 Million

Marketed as a straightforward action programmer, Ric Roman Waugh's *Snitch* provides a much more cerebral experience than suggested by its previews. With the exception of a ludicrous climax inspired by *The Fast and The Furious* franchise, *Snitch* is a surprisingly thought-provoking exploration of the injustice of mandatory minimum sentencing drug laws in America.

The film opens with a dumb kid, 18-year-old Jason Collins (Rafi Gavron), booting up his laptop and being pressured by his friend via Skype to accept a large package of ecstasy pills. The two teens have collaborated on some very low level marijuana sales to their friends but suddenly his friend, out of the blue, is pressuring him to "hold on" to a large quantity of a far more serious drug. Jason is hesitant but eventually agrees after intense goading from his friend. The package soon arrives in the mail and, in addition to the large bag of ecstasy pills it contains a blinking red light. Jason's friend has set him up. Just as he sees the homing device, police, led by the fabulously-goateed Agent Cooper (Barry Pepper), storm the house and arrest him.

Meanwhile, Jason's father, John (Dwayne Johnson) is on the phone at the trucking business he owns, talking to his accountant about wanting to leverage all of his assets to expand his business. The phone conversation confirms two qualities about John Collins that will help explain his subsequent actions: he's a risk taker and someone who has made his work his whole life, to the exclusion of his family. His first marriage ended in divorce and he's been a very small part of his son's life since. As he heads out of the office for the weekend his phone rings.

Soon a bewildered John finds himself at the police station with his ex-wife Sylvie (an utterly wasted Melina Kanakaredes, all of whose scenes take place at the police station either sobbing or verbally attacking her husband) getting some very unwelcome news from Jason's attorney. Assuming that a first offense from a youthful offender will mean a light sentence or even probation, John and Sylvie are shocked to learn that the felony their son is being charged with brings with it a mandatory minimum 10-year sentence. Unless, of course, like the friend who got him arrested in the first place, Jason can set up someone he knows who is dealing drugs.

Waugh and Justin Haythe's script does a good job of making the viewer burn with the same feeling of injustice as John and his wife, largely by simply having the lawyer describe how the mandatory minimum sentencing laws work in real life America, every day of the week. Arguably enacted with good intentions, the laws were the product of frustration on the part of lawmakers and investigators with low-level drug dealers who refused to roll on their higher ups. To increase the incentive to cut a deal, the law increased the sentences for the low level dealers: ten long years without any discretion on the judge's part to reduce it. But if you roll on your higher up, maybe it goes away. That makes sense for the circumstances for which it was designed (pressuring low level professional criminals to roll on their high level professional criminal bosses) but Jason's situation is a far cry from those circumstances. Despite intense lobbying from his father, Jason refuses to set up the one other person he knows who deals drugs, a person who he barely knows and who is even more innocent than he is.

A desperate John pulls all the strings he has and soon finds himself in the office of Joanne Keeghan (Susan Sarandon, playing against type and enjoying herself immensely as a ruthless, office seeking federal prosecutor) who has the power to lessen or even eliminate the charges against his son. Sorry, she shrugs, there is nothing she can do...unless of course, his son can reel in a bigger fish. My son refuses, John explains, but what about me?

In the expected movie, John Collins would be Arnold Schwarzenegger. After ingratiating himself with the bad guys (and clipping a few of their criminal competitors to demonstrate his bona fides), the bad guys would be tipped off that he is a snitch, kill someone he loved and then Collins would mow them all down, in an operatic action set piece like the climax of *Raw Deal* (1986). Based on a true story, *Snitch* takes a more realistic approach, at least throughout most of its running time. After a misstep in which he clumsily attempts to buy drugs on a street corner and is beaten up and robbed by amused drug dealers, John reviews his employees' records and finds that one of his employees, Daniel Cruz (Jon Bernthal) is an ex-con with two drug convictions. He approaches Daniel about providing an introduction to his past criminal associates. Daniel wisely refuses. He has two convictions and a third will send him away forever under the three-strikes laws. Like John, Daniel has his own young son who he doesn't want to abandon by getting convicted for a third time. However, Daniel also worries about the influences on his son of the dangerous neighborhood they are forced to live in due to his economic circumstances. The money John is offering him to connect him with his past associates

would change all that and soon he is reluctantly introducing him to his old partner in crime, Malik (Michael Kenneth Williams doing his best with a disappointingly bland gangster).

Why, Malik would like to know, does an upstanding citizen like John Collins want to get into the drug trade? It's a good question and John gives him a good answer. His business has been hit very hard by the economic crash and he will do anything to save it. Malik accepts John's explanation and his offer to run drugs across the border in his company's semis with a couple of conditions: John has to make the first run personally and Daniel has to go with him. Soon, John and Daniel are heading to Mexico with Agent Cooper and his officers listening in.

What follows is a taut sequence of events which feature a lot more interesting questions than action set pieces. How does a person who is not a criminal ingratiate himself with criminals? Would you drive a semi full of drugs over the border if it meant saving your son? Is it wrong to goad a good man with two strikes against him back into crime in order to save your son? Is it ethical to charge a teenager with a law that was not really designed for the crime he committed and then allow an innocent man to go into extreme danger to save him?

No one will mistake *Snitch* for an episode of *Frontline*, however it is a far cry from the conventional action film its previews made it out to be and it packs a surprisingly strong punch about the abuse of mandatory minimum sentencing laws in America. A revealing post script indicates that Jason's tale (based on the true life story of Joey Settembrino) is hardly unique. Would it be a better film if it stuck more closely to the real life facts upon which it was based? Certainly. But, by the same token, Waugh, Haythe, and Johnson deserve some credit. For the price of a couple of unbelievable fire fights and car chases they have exposed far more people to an important and under examined issue than a hundred documentaries would have.

Nate Vercauteren

CREDITS

John Matthews: Dwayne "The Rock" Johnson
Joanne Keeghan: Susan Sarandon
Juan Carlos Pintera: Benjamin Bratt
Agent Billy Cooper: Barry Pepper
Daniel James: Jon Bernthal
Jeffrey Steele: Harold Perrineau, Jr.
Malik: Michael K(enneth) Williams
Sylvie Collins: Melina Kanakaredes
Jason Collins: Rafi Gavron

Origin: United States
Language: English
Released: 2013
Production: Nigel Sinclair, Matt Jackson, Jonathan King, Dwayne "The Rock" Johnson; Exclusive Media Group, Participant Media; released by Summit Entertainment
Directed by: Ric Roman Waugh
Written by: Ric Roman Waugh; Justin Haythe
Cinematography by: Dana Gonzales
Music by: Antonio Pinto
Editing: Jonathan Chibnall
Art Direction: Joe Lemmon
Costumes: Kimberly Adams-Galligan
Production Design: Vincent Reynaud
MPAA rating: PG-13
Running time: 112 minutes

REVIEWS

Anderson, Melissa. *Village Voice*. February 21, 2013.
Debruge, Peter. *Variety*. February 19, 2013.
Holden, Stephen. *The New York Times*. February 21, 2013.
Lumenick, Lou. *New York Post*. February 21, 2013.
Phillips, Michael. *Chicago Tribune*. February 21, 2013.
Rabin, Nathan. *The A.V. Club*. February 20, 2013.
Roeper, Richard. *Chicago Sun Times*. February 20, 2013.
Rothkopf, Joshua. *Time Out New York*. February 22, 2013.
Russo, Tom. *Boston Globe*. February 21, 2013.
Tobias, Scott. *NPR*. February 22, 2013.

QUOTES

John Matthews: "I admire you so much. The stand you're taking. You didn't take the easy way out. Not setting up one of your friends. I couldn't do what you did. So it looks like you're the one teaching me what real character and integrity is all about. I love you, son."

TRIVIA

Tanya Ballinger, the wife of director Ric Roman Waugh, makes a brief cameo at the party in the beginning of the movie, as the woman enjoying cupcakes.

SOMETHING IN THE AIR
(Après mai)

Box Office: $71.9 Million

The filmography of acclaimed French director Olivier Assayas is one of the more eclectic ones in recent

memory—sometimes he will offer up genteel dramas such as *Cold Water* (1994), *Late August, Early September* (1998), and *Summer Hours* (2008) and then he will turn around and present viewers with formally radical art-house freak-outs like *Irma Vep* (1996), *Demonlover* (2002), and *Boarding Gate* (2007). With his latest effort, *Something in the Air*, Assayas has chosen to look inward to tell a deeply personal tale of art, politics and love amongst a group of French teenagers trying to continue the good fight in the wake of the events of May 1968. Although one can find connections between its ideas and themes and others in the Assayas' oeuvre, it mostly finds him branching off in a new and more open direction and the result is one of the best and most deeply affecting works of his entire career.

Set in 1971, this semi-autobiographical tale follows the adventures of Gilles (Clement Metayer), a teenaged wannabe artist who finds himself caught up in the still-thriving radical student movement, partly because of a desire to change the world and, no doubt, partly to impress pretty classmates like his sexy girlfriend Laure (Carole Combs) and good friend Christine (Lola Creton). After a violent clash with police during a demonstration, Gilles and his friends step up their activities but when one of their actions violently backfires and seriously injures a security guard, he and the others decide to spend the summer in the Italian countryside laying low amidst other young radicals. For a while, it is a paradise of intense bull sessions and free love and a romance even develops between Gilles and Christine after Laure dumps him.

As the summer unfolds, however, the bloom eventually begins to come off the radical rose and what once looked like an idealized situation grows into an increasingly tiresome and frustrating clash of differing ideologies in which all other concerns are deemed secondary to the cause. Not even Gilles' resurgent interest in filmmaking is exempt as he finds himself wrestling between following the notions of conventional cinema or embracing the more radical approach espoused by Christine and the film collective with whom she has aligned herself. By the end of the summer, the increasingly disenchanted Gilles must decide whether to continue to embrace a cause that he no longer truly burns for or to reject those once-cherished notions in order to live the kind of life he once held in such contempt.

Unlike a lot of the previous films that have chronicled this particular era in more romantic terms, such as Bernardo Bertolucci's *The Dreamers* (2004), Assayas has taken a somewhat more radical approach by telling his story in a deliberately restrained manner that eschews empty nostalgia for a more nuanced, warts-and-all look at the events and characters he is depicting. There are moments of triumph to be sure but he also takes pains to include both the consequences of those acts and the reality of this type of situation once the initial excitement has faded away. What is especially impressive is the way that he expertly communicates all the phases of Gilles' emotional growth from the heady early days to his gradual disenchantment with the entire scene to his final emergence as the new person who has been formed as a result of these events.

At the same time, Assayas does a wonderful job of evoking the period without resorting to the usual cliches, thanks to the lovely contributions of cinematographer Eric Gautier, his production designer and an impressive soundtrack of cannily-chosen obscurities from the era that smartly underscore the emotions of the scenes without coming across as being too on-the-nose for their own good. He is also aided immeasurably by the performances by the cast of largely unknown young performers (Creton is probably the most familiar face of the bunch through her appearances in *Bluebird* [2009] and *Goodbye First Love* [2011]) whose naturalness only adds to the documentary-like feel of the proceedings.

Something in the Air is one of the best films to date from one of the greats on the world cinema scene and one of the most affecting coming-of-age films to come along in a long time. It manages to tell a specific story of the pangs of adolescence that is tied remarkably into a specific time and yet manages to do so in such a universal way that anyone, regardless of when or where they grew up, will be able to relate to the ideas and emotions that it invokes. Simply put, this is a great film.

Peter Sobczynski

CREDITS
Gilles: Clement Metayer
Christine: Lola Creton
Alain: Felix Armand
Laure: Carole Combes
Leslie: India Menuez
Origin: United States
Language: English
Released: 2013
Production: Charles Gillibert, Nathanael Karmitz; France 3 Cinema, MK2, Vortex Sutra; released by IFC Films
Directed by: Olivier Assayas
Written by: Olivier Assayas
Cinematography by: Eric Gautier
Sound: Nicolas Moreau
Editing: Luc Barnier
Costumes: Jurgen Doering
Production Design: Francois-Renaud Labarthe, Paki Meduri
MPAA rating: Unrated
Running time: 122 minutes

REVIEWS

Burr, Ty. *Boston Globe*. May 9, 2013.

Jenkins, Mark. *NPR*. May 2, 2013.

Lane, Anthony. *The New Yorker*. May 6, 2013.

Morgenstern, Joe. *Wall Street Journal*. May 10, 2013.

O'Hehir, Andrew. *Salon.com*. May 2, 2013.

Rooney, David. *Hollywood Reporter*. April 29, 2013.

Scott, A. O. *New York Times*. May 2, 2013.

Schrager, Nick. *Slant*. October 4, 2012.

Sharkey, Betsy. *Los Angeles Times*. May 3, 2013.

Zacharek, Stephanie. *Village Voice*. April 30, 2013.

SOUND CITY

Real to reel.
—Movie tagline

Box Office: $422,417

Two documentaries with similar, semi-obscure, niche-appeal subjects in one year does not necessarily a cinematic trend make (three, maybe; four, certainly), but it is interesting that 2013 saw not one, but two documentaries about legendary music recording studios. In addition to Greg "Freddy" Camalier's *Muscle Shoals* (2013) there is *Sound City*: former Nirvana drummer, current Foo Fighters songwriter-singer-guitarist, and first-time director Dave Grohl's ode to Sound City, the structurally non-descript (aggressively seedy) Van Nuys, California, studio where Nirvana recorded their groundbreaking album *Nevermind* in 1990.

Selecting a recording studio as the hook for a music documentary makes sense. Unlike writing or painting, recording music is a collaborative effort between numerous people both behind the microphones and behind the mixing board, and the output—lots of great tunes—lends itself to entertaining non-fiction filmmaking. And unlike most film or TV studios, a specific recording studio often projects its own style and tone onto the works created within.

In documenting a studio's output and influence from the late 1960s through the 1990s, *Sound City* also highlights how the studio recording experience is a symbiotic relationship: The studio, its equipment, acoustics, employees, and general atmosphere can bring a new sound flavor and focus to a musician or band's work, while the subsequent success and popularity of albums recorded at the studio are essential to making the facility commercially and creatively viable into the future.

Given the powerful, nostalgic place Sound City holds in his heart (and his career), it is no surprise that neophyte documentary maker Grohl errs on the side of

romanticizing, even mythologizing the studio's history. Still, the first hour of the film is an engaging Cali-centric trip down memory lane (complete with bawdy tales out of school involving drugs, sex, and law enforcement) that also serves as a handy overview of the Los Angeles-based music industry itself. Grohl introduces the studio's founders Joe Gottfried and Tom Skeeter, and Neil Young shares stories of recording *After the Gold Rush* at the site. Even more importantly in the studio's history, the film walks through the series of fortunate events that led to Stevie Nicks and Lindsey Buckingham recording there in the mid-1970s, followed eventually by Fleetwood Mac.

It was the massive success of the latter's 1977 *Rumours* album, which had one track recorded at Sound City, that brought a flood of musicians to the studio's tacky wood paneled, shag-carpeted, never-cleaned halls, tucked away amid back-alley industrial squalor in the San Fernando Valley. The honor roll, represented in a series of present-day interviews, includes Tom Petty and the Heartbreakers, Pat Benatar, REO Speedwagon, and Rick Springfield (who not only recorded at Sound City, but was the first wildly successful act signed and managed by the studio's owners).

Grohl's film also does a fine job of painting the sometimes mysterious, almost magical balance of art and science that goes into recording music; spending equal amounts of time giving laypersons' explanations of equipment and studio methods while probing the often-tumultuous creative process. Long sections of the film turn the spotlight on the core of the Sound City "sound": its gigantic, very-limited-edition Neve 8028 recording counsel and a cavernous recording space (converted from an old box factory) that accidentally lent itself to a unique and coveted drum sound.

With mismatched "sons of Sound City" Petty and Springfield as central pivot figures, the second half of *Sound City* moves out of the hazy 1970s and into the 1980s, when electronic drums and Sunset Boulevard hair bands became ascendant. The film takes time to talk to former Sound City staffers, the folks who ran the front desk, set up the studio equipment, and sometimes even married the rock stars. The period also saw the studio nearly crippled by its dedication to remaining analog in an increasingly digital/compact-disc age—that is until three grungy kids from Seattle and producer Butch Vig showed up in a van in spring of 1990.

The runaway success of Nirvana's *Nevermind* reinvigorated Sound City creatively and financially and brought a new generation of musicians through the doors. During the reminiscing in this section of the documentary, Grohl shifts from awestruck fan to first-person participant as he talks to peers and fellow Sound

City alums like Metallica's Lars Urich, The Pixies' Frank Black, producer Rick Rubin, and Nine Inch Nails' Trent Reznor.

Aside from documenting a particular studio's aural output (and aesthetic idiosyncrasies), *Sound City* also lays out a road map of the music industry's highs and lows over four decades. So as the industry itself struggles with the shift from physical product to digital downloads, the documentary chronicles the eventual fall of Sound City in the 2000s, as professional studios, flight-deck-style tape boards like the Neve, and the art of analog tape recording were erased by the rise of ubiquitous home-recording electronic aids like Pro Tools and auto tuning.

Sound City finally closed its doors in the late 2000s, and at this point in the story, Grohl's film completely shifts tone and focus, the fascinating history-telling of the first hour replaced by present-day footage of Grohl himself buying the studio's famous Neve console. He then gathers a bunch of Sound City alums (including Nicks, Petty, Springfield, and Reznor) to cut a new album in Grohl's own recording facility. Eventually even Paul McCartney shows up to replace the late Kurt Cobain as a reunited Nirvana records new tunes on the old, familiar Neve.

Parts of this extended final section shed some interesting light on how new music is felt out and pulled together in the studio, but the present-day section loses the film's earlier musty, mythic vibe and starts to feel more like it is marketing Grohl's latest musical project. Still, by the end of the film, Sound City the studio is gone, but Grohl has rescued both the Neve board and the facility's checkered legend. The closing whiff of self-serving sales pitch isn't enough to undo the film's earnest good-hearted goodwill, but it does send *Sound City* the movie out on a somewhat muddled note.

Sound City played in almost art-houses during February and earned less than half a million dollars total during its theatrical run, but it received generally positive reviews from critics.

Locke Peterseim

CREDITS

Origin: United States
Language: English
Released: 2013
Production: John Ramsay, Dave Grohl; Roswell Films; released by Variance Films
Directed by: Dave Grohl
Written by: Mark Monroe
Cinematography by: Kenny Stoff

Sound: Lihi Orbach
Editing: Paul Crowder
MPAA rating: Unrated
Running time: 108 minutes

REVIEWS

Addiego, Walter. *San Francisco Chronicle*. February 1, 2013.
Buckwalter, Ian. *NPR*. January 31, 2013.
Cohen, Howard. *Miami Herald*. January 31, 2013.
Cross, Charles. *Seattle Times*. February 21, 2013.
Gee, Catherine. *The Telegraph*. February 19, 2013.
Genzlinger, Neil. *New York Times*. January 30, 2013.
Howell, Peter. *Toronto Star*. January 30, 2013.
Scherstuhl, Alan. *Village Voice*. January 30, 2013.
Turan, Kenneth. *Los Angeles Times*. January 31, 2013.
Walsh, Katie. *The Playlist*. January 29, 2013.

QUOTES

David Grohl: "Why can't it always be this easy?"
Paul McCartney: "It is."

THE SPECTACULAR NOW

Box Office: $6.9 Million

Touching, funny, and remarkably real in ways that films about teenagers increasingly fail to be, James Ponsoldt's Sundance hit *The Spectacular Now*, adapted from the beloved book by Tim Tharp from *(500) Days of Summer* (2009) authors Scott Neustadter and Michael H. Weber, is a special film. It captures a truth about the formative years of journey from teen to man that its peers fail to come close to grasping. Every generation gets a major filmmaker who knows how to speak to and from its youth in distinctly artistic ways that are relatable across generations. The 1980s had the genius of Cameron Crowe, most notably in his similar-to-this-film structurally *Say Anything...* (1989), and the 2010s may have James Ponsoldt. Yes, this film is that good.

Sutter (Miles Teller, in a breakthrough performance) is one of the most popular kids not just in his high school but his entire community. He greets everyone with a smile, a joke, and often a drink. He is sleeping with one of the most beautiful and popular girls in school, Cassidy (Brie Larson, who used this as the first half of a one-two punch of indie cinema greatness with the even-better *Short Term 12* [2013]), and has a social skill set that will define him as a king of adolescence but may not translate to college and beyond. To be blunt, Sutter may be peaking. And, unlike so many Homecom-

ing Kings who never regain that glory, he has a chance to become aware of this peak and fight against his alcoholic high school days becoming the ones that define him. The fact is that a kid who is too cool for the room and always slightly buzzed is fun in high school but gets a lot less interesting and harder to employ as they get older. Sutter will learn this lesson but he will have to drag someone down to realize that he has a reason to care about more than the "now."

In many ways, Aimee (Shailene Woodley) gives Sutter a mirror in which to check himself. She is a relatively unpopular girl at Sutter's high school, who he literally stumbles into a relationship with after waking up from a night of drinking on her front lawn. He joins her in the morning paper route and a unique friendship and eventual love is formed. Why is Sutter drawn to a girl who most of his friends will not talk to much less date? Why is Aimee interested in the kind of often-abrasive jerk who she has probably been advised to avoid? Who knows? It is left up to audience interpretation but she softens his darker side and he helps her break out of her shell. While they make up one of the more memorable partnerships of 2013, this is not a typical starry-eyed Young Adult romance. As graduation day nears and their relationship intensifies, Sutter is presented with a crossroads. He digs deep, tracking down his estranged father (a spectacular Kyle Chandler), sees another mirror or perhaps a crystal ball into his future, and is faced with a final decision. The closing scenes of Ponsoldt's film are masterful in their understanding of human nature and yet also display a filmmaker unwilling to tie up difficult issues into a neatly-packaged bow.

The success of Neustadter and Weber's fantastic script comes back to something that does not seem like rocket science and yet so often proves difficult for teen films—not talking down to an audience. The teens are not treated like horny idiots and the adults are more than mere plot devices. Sutter, Aimee, Cassidy, and everyone around them feel real. They are not born from a focus group or crafted for the lowest common denominator. They have that intangible quality that makes them feel like they existed before the film started rolling and will continue post-credits. And so Ponsoldt's film has an undercurrent of truth through every scene. There is an extended "courtship scene" as Sutter and Aimee walk away from a party, separating themselves from their peers and falling in love, that is absolutely thrilling not because of scripted action that feels forced upon its characters but the honesty of the dialogue between two fully-realized characters.

The best script in history will not work without the right cast and Ponsoldt found two of the best of their generation in Teller and Woodley. Woodley, the young star of 2011's *The Descendants* and 2014's *Divergent* has

range and depth that separates her but the film belongs to Teller. It is more a performance that works because of what this talented young man does not do than what he does. He constantly battles against the stereotypes that could have sunk this role—the alcoholic, the cocky teen, the angry young man, etc. Teller also captures he cautious, scared way in which young men who often seem fearless really hides that which scares them. It is one of the best performances of 2013.

It comes back to respect: The respect that Teller and Woodley have for real people like Sutter and Aimee; the respect that the writers have for their characters; the respect that Ponsoldt has for his audience. It hums with emotion, honesty, and palpable truth. By taking its characters seriously, the filmmakers and performers have crafted a film that deserves to be taken seriously as well.

Brian Tallerico

CREDITS

Aimee Finicky: Shailene Woodley
Sutter Keely: Miles Teller
Holly Keely: Mary Elizabeth Winstead
Cassidy: Brie Larson
Sara: Jennifer Jason Leigh
Tommy: Kyle Chandler
Mr. Aster: Andre Royo
Dan: Bob Odenkirk
Origin: United States
Language: English
Released: 2013
Production: Michelle Krumm, Andrew Lauren, Shawn Levy, Tom McNulty; 21 Laps, Global Produce; released by A24
Directed by: James Ponsoldt
Written by: Scott Neustadter; Michael H. Weber
Cinematography by: Jess Hall
Music by: Rob Simonsen
Sound: Ryan Collins; Thomas Curley; Jim Hawkins
Editing: Darrin Navarro
Costumes: Peggy Stamper
Production Design: Linda Sena
MPAA rating: R
Running time: 95 minutes

REVIEWS

Berardinelli, James. *ReelViews*. August 2, 2013.
Burr, Ty. *Boston Globe*. August 15, 2013.
Ebert, Roger. *RogerEbert.com*. August 2, 2013.
LaSalle, Mick. *San Francisco Chronicle*. August 8, 2013.
Nelson, Rob. *Variety*. February 28, 2013.
Neumaier, Joe. *New York Daily News*. August 1, 2013.

Puig, Claudia. *USA Today*. August 1, 2013.
Roeper, Richard. *Chicago Sun-Times*. August 9, 2013.
Scherstuhl, Alan. *Village Voice*. July 30, 2013.
Sharkey, Betsy. *Los Angeles Times*. August 1, 2013.

QUOTES

Sutter: "The best thing about now, is that there's another one tomorrow."

TRIVIA

Nicholas Hoult was considered for the lead role before Miles Teller was cast.

AWARDS

Nominations:

Ind. Spirit 2014: Actress (Woodley), Screenplay

SPRING BREAKERS

A little sun can bring out your dark side.
 —Movie tagline

Wish you were here.
 —Movie tagline

Good girls gone bad.
 —Movie tagline

Spring break, bitches.
 —Movie tagline

Bad girls do it well.
 —Movie tagline

Box Office: $14.1 Million

There are no consequences in dreams. Terrible things can happen. Events can fold into each other, fraying and repeating and delighting and horrifying. But the end is always a return to something safe and real and, in many cases, less exciting.

So goes the fantastic hypnosis of *Spring Breakers*, an experiential film that makes triumphant use of countless dualities without ever asserting moral high ground or universal judgment. Certain filmmakers might have depicted beer-covered breasts, corn-rowed rappers, and strip club mayhem as a cautionary tale, the inevitable downfall of partying gone wrong. Not writer-director Harmony Korine. With his most mainstream work to date—which says more about the bizarre niche-ness of his previous films than his latest effort, which is not exactly fun for the whole family—Korine creates a thumping pastiche of life experience in which identities are fluid and everything is open to interpretation.

Highlighting the polar opposite notion of relatively innocent students descending, literally and figuratively, to the beaches of Florida for maximum debauchery, former Disney princesses Selena Gomez and Vanessa Hudgens star as college girls who are similar and different. Suiting her name, Faith (Gomez) attends religious meetings and maintains a modest demeanor. Candy (Hudgens) licks the penis she draws on her notebook during class and, after she and Brit (Ashley Benson) rob a restaurant in a breathtaking sequence shot from the getaway car outside, coos, "Seeing all this money makes my pussy wet."

Yet both of these lifelong friends want to escape the academic routine and feel total freedom in an environment where constant intoxication and relentless pursuit of hedonism are the norm, not the exception. So Faith, Candy, Brit, and Cotty (Korine's wife Rachel) journey to St. Petersburg, Florida, where the liquor flows like water and the beaches tumble with the scantily clad, sun-drenched vigor of youthful independence run wild. Korine does not present this as the linear transition from ordinary, mundane and socially accepted scholastic pursuits to the sinful, uninhibited (and underage) indulgence of everything most parents do not want to believe their kids even know about, much less choose to do. Instead, the impressionistic *Spring Breakers*, with a huge assist from the ace score by wub-wub master Skrillex and composer Cliff Martinez (*Drive* [2011]), turns vacation into a breathing organism and a level-headed examination of deliberately thoughtless behavior. Think of it like a movie or a video game, the girls say before the robbery that nets the money they need for their trip. This could be taken as a commentary on how media impacts viewers, though Korine uses it more as one of many ways young people step outside the versions of themselves society has cultivated in order to become (or is it return to?) the person they actually want to be.

After a lot of partying and a few days in jail, much of the characters' spring break centers on Alien (James Franco), a self-described rapper/hustler who bails out the girls because, hey, everyone needs bailing out sometimes. He is the ultimate mix of twisted charm—"They kicked me out of school," he says, "I thought that was great"—and underlying menace. In Franco's extraordinary performance, Alien both lives up to his motto of coming from another planet while embodying everything wonderful and terrible about the communities that thrive on spring breakers. To Alien, whose real name is Al, the vacationers are the scum, temporarily infiltrating his home for a taste of his everyday life before running away to their definition of normal. He, of course, flourishes in the attention of the kids who drunkenly sing along when he is on stage. Hearing those strangers' voices is humbling, he says, while his face suggests that this humbling moment only elevates his pride and ego.

Since writing 1995's *Kids* and his directorial debut *Gummo* (1997), Korine has built his career on sub-cultural observation. Yet as a filmmaker, his increasing fixation on the exaggerated situations of traditionally non-Hollywood characters has made him more of an underground hero than a storyteller with the crossover appeal of, say, Gus Van Sant. With *Spring Breakers*, Korine has almost done Van Sant's version of an MTV special, considering the unusual, communal beauty of the party and the little-discussed desirability of the crash. Sure, when the quartet of young women is arrested, Faith notes that this was not supposed to happen; it is not what they came for. In some ways, though, it seems that the people in *Spring Breakers*, to varying degrees, tiptoe toward the line at which they would become uncomfortable or make a mistake. A story is not much of a story without something extreme happening, and no one goes to a densely populated, boozy spring break destination for a major dose of the average.

Meanwhile, the setting becomes a character, morphing based on who is around and the degree to which potential disaster hangs in the air. This world subsists on the economic boon brought by the spring breakers, yet it also constantly seems on the verge of consuming them along with their cash, blending the sea of college partiers into a seedier element represented not so much by the grills that adorn Alien and his twin pals' teeth but by the look that comes across their faces after sitting down with their new female friends in bikinis. They look almost like wolves preparing to feast, and Korine generates plenty of non-exploitative tension out of the question of how far this situation will go, and who is actually holding the power. His actresses all carry the load, differentiating their characters enough to matter but not enough that any outsize, disparate personalities contradict the notion that at spring break, the search for self blends into a mass of people simultaneously searching for anonymity. For perhaps the first time, Gomez, who has yet to prove with her voice or her stage presence that she deserves to be a pop star, demonstrates that she can hold her own as an actress and contribute to headier projects than fluff like *Monte Carlo* (2011).

Wild parties happen at school, too, Korine is careful to demonstrate. However, it is only in the supposed safety of spring break that these freewheeling folks claim they can discover who they truly are, even as they are shedding most of what defines them on a day-to-day basis. The imagined becomes the actual; fake guns become real guns and bullets fly. What is anyone really capable of, and what actions have lasting impacts? The film communicates truth through fiction and a nightmare through a dream without ever mocking anyone's path. A different and far less successful example of addressing youth gone wild arrived later in 2013 in Sofia

Coppola's disappointing *The Bling Ring*, which also showed teenagers doing irresponsible things but presented its events through a lens of disgust. How foolish and shallow these people are, Coppola seemed to say.

On the contrary, Korine sees a generation raised on music videos and pop stars and does not necessarily claim that their perspectives are right or wrong. He merely sees life as endless role-playing and dares to accept multi-faceted human nature that is rarely permitted after graduation, usually to the chagrin of the graduates. That does not mean that the St. Petersburgs or the Cancuns of the world ever die out; a new crop is always on the horizon. Spring break is forever, but spring breakers all have to go home sometime. There is only so long someone can leave themselves until the getaway becomes the norm, necessitating an escape from the escape. And everyone has their own definition of which existence is their chosen reality.

Matt Pais

CREDITS

Faith: Selena Gomez
Candy: Vanessa Anne Hudgens
Brit: Ashley Benson
Cotty: Rachel Korine
Alien: James Franco
Origin: United States
Language: English
Released: 2013
Production: Chris Hanley, David Zander; MUSE Productions, Radar Pictures; released by A24
Directed by: Harmony Korine
Written by: Harmony Korine
Cinematography by: Benoit Debie
Music by: Cliff Martinez
Sound: Aaron Glascock
Editing: Douglas Crise
Costumes: Heidi Bivens
Production Design: Elliott Hostetter
MPAA rating: R
Running time: 94 minutes

REVIEWS

Burr, Ty. *Boston Globe*. March 21, 2013.
Dargis, Manohla. *New York Times*. March 14, 2013.
Foundas, Scott. *Village Voice*. March 12, 2013.
Persall, Steve. *Tampa Bay Times*. March 20, 2013.
Phillips, Michael. *Chicago Tribune*. March 21, 2013.
Puig, Claudia. *USA Today*. March 20, 2013.
Rea, Stephen. *Philadelphia Inquirer*. March 21, 2013.

Rodriguez, Rene. *Miami Herald*. March 25, 2013.
Roeper, Richard. *Chicago Sun-Times*. March 18, 2013.
Tobias, Scott. *The A.V. Club*. March 13, 2013.

QUOTES

Alien: "I'm Alien. My real name is Al, but truth be told, I'm not from this planet."

TRIVIA

Emma Roberts was originally cast in the film but the script required her character to indulge in a three-way sex scene, causing her to drop out due to unspecified "creative differences."

AWARDS

Nominations:

Ind. Spirit 2014: Cinematog.

THE SQUARE
(Al midan)

Box Office: $124,244

Winner of the audience awards at both the Sundance and Toronto Film Festivals, director Jehane Noujaim's stirring documentary *The Square* provides a snapshot portrait of the 2011 Egyptian Revolution and its ongoing reverberations from the perspective of those on the ground, who helped liberate a nation with YouTube video postings and other social media.

Unfolding in a cinema verite style, the film is a look at the landmark Arab Spring protests in Tahrir Square (the source of the movie's title) that toppled the 29-year reign of autocratic President Hosni Mubarak, and the ensuing fragile unity and difficult realities faced day-to-day by different groups of people working to shape Egypt's infant democracy. In detailing the struggle for basic security and safety alongside the accountability of new governmental institutions, Noujaim offers up a compelling rendering of power grabs laid upon power grabs, as well as hope's push and pull with radical transformation and the encroachment of corruption.

Lacking narration or much in the way of a structural frame, *The Square* casts its lot with cinematic immersion theory, banking on the fact that viewers will respond to its palpable energy and immediacy, which slot as two of its best qualities. Among the movie's protagonists are secular protesters like twentysomething idealist Ahmed Hassan, as well as avowed Muslim Brotherhood member and father of four Magdy Ashour. Though Ashour dif-

fers substantively in political opinions with Hassan and actor/human rights activist Khalid Abdalla, he finds common ground with them in a shared disdain for despotic torture and other abuses of power; the latter's father was once imprisoned under Mubarak, and now lives in exile, while Ashour himself was jailed by Mubarak's secret police. Other central figures include singer-songwriter Ramy Essam, whose anthems capture a surging sense of change and optimism; Aida El Kashef, a filmmaker who cofounds a citizen journalism organization to combat state propaganda; and Ragia Omran, who works to try to make sure imprisoned protesters are apprised of and afforded their legal rights.

While it does show some images of gruesome violence, *The Square* does not expend a lot of time or energy prosecuting a detailed case against either Mubarak or an overzealous, autonomous military that later tries to enforce martial law. Using smuggled in, handheld cameras and a decidedly low-fi, outlaw aesthetic, the movie captures the sweeping spirit and pungent aroma of rebellion in the air. Still, a lot of its strongest insights stem from conversational exchanges and are thus for the most part remarkably composed and measured, which lend the film both grace and weight. It would be easy to get entirely swept up in the surrounding violence and chaos, but Noujaim's film does not submit to rudderless madness. In throwing a light on interesting people who embody different philosophies about what Egypt's future should look like, and in investing less in the tilt of physical conflict and sadism and more in the social comprehension that, as one figure puts it, "there is something fundamental inside people that is now moving them," *The Square* elicits stronger viewer sympathy.

As the director of *Startup.com* (2001), with Chris Hegedus, and *Control Room* (2004), Noujaim has considerable experience sifting through current events whose relevance still has not calcified into common wisdom, let alone history. The former film examined the dotcom craze and bust of the late 1990s, while the latter assayed the fourth estate's role in reporting the Iraq War. With *The Square*, though, she tackles what is likely her most difficult subject yet. Following the film's Sundance premiere in January, events on the ground in Egypt over the course of 2013 proved similarly tumultuous, with the overthrow of democratically elected President Mohamed Morsi and suspension of the country's one-year-old constitution by the Egyptian military. Eight-plus minutes of additional material was added for its autumnal theatrical release, but Noujaim has deemed the film an "ongoing and open work," which seems to augur more updates as circumstances warrant.

A good number of other recent nonfiction films—perhaps most notably *The Green Wave* (2012), which examined the populist protests that rocked Iran—have

spotlighted portions of the broader Arab Spring, the revolutionary wave of protests, demonstrations and in some cases ongoing civil war that swept across the Arab world starting in December of 2010. *The Square* opts not to give any sense of wider perspective, which may feel a bit like being tossed in the deep end of a pool for those unversed in current geopolitical events, or frustrating in a different way for those wishing for more contextualization. Still, *The Square* is an impactful snapshot of the very basic human yearning for dignity and freedom. It affirms these truths as self-evident.

Brent Simon

CREDITS

Origin: United States, Egypt

Language: Arabic

Released: 2013

Production: Karim Amer; No ujaim Films, Roast Beef Productions, Worldview Entertainment; released by Participant Media

Directed by: Jehane Noujaim

Cinematography by: Muhammad Hamdy

Music by: Jonas Colstrup; H. Scott Salinas

Editing: Mohamed El Manasterly; Christopher de la Torre; Pierre Haberer

MPAA rating: Unrated

Running time: 95 minutes

REVIEWS

D'Angelo, Mike. *AV Club*. October 24, 2013.
Fear, David. *Time Out New York*. October 22, 2013.
Greenberg, James. *Hollywood Reporter*. January 24, 2013.
Morgenstern, Joe. *Wall Street Journal*. October 31, 2013.
Orange, Michelle. *Village Voice*. October 23, 2013.
Robinson, Tasha. *The Dissolve*. October 24, 2013.
Schager, Nick. *Slant Magazine*. September 25, 2013.
Scott, A. O. *New York Times*. October 24, 2013.
Turan, Kenneth. *Los Angeles Times*. October 31, 2013.
Weissberg, Jay. *Variety*. November 3, 2013.

QUOTES

Revolutionary: "The leaders play on top. The people pay the price for everything. The people always pay the price."

TRIVIA

The film is both the first Kickstarter film to be nominated for an Oscar, but it is also the first film released by Netflix to receive a nomination.

AWARDS

Directors Guild 2013: Documentary Director (Noujaim)

Nominations:

Oscars 2013: Feature Doc.
Ind. Spirit 2014: Feature Doc.

STAND UP GUYS

They don't make 'em like they used to.
 —Movie tagline

Box Office: $3.3 Million

Film is often referred to as a time capsule of various eras. Viewers can gaze back upon an old movie as it dates itself with its fashion styles, pop culture references or even the mood towards its President. Those with a greater attachment to such films may actually reflect upon where they were at that time; reminiscing of a period in their own lives when age was something that happened to their parents. At some point, though growing up sets in, tastes in entertainment change and the movie stars of the time that once seemed like elders become peers. Watching big-screen heroes get older can be a humbling, almost graceful representation of aging to a place where more wisdom can be garnered. However, if *Stand Up Guys* is any indication, all men are headed for are limp genitals and death.

Twenty-eight years ago, Val (Al Pacino) went to jail. Now an old man, he is being released and picked up by his equally-aged partner, Doc (Christopher Walken). The pair were mob enforcers back in the day and have survived long enough to become retired strongmen. Once a quick clean-up and coffee is out of the way, Val is ready to "party." That is code for a trip to the local brothel where even their once-trusted madam has moved to Florida to avoid the cold. There are greater obstacles in Val's way, however, other than failing equipment. Doc has been ordered by his boss, Claphands (Mark Margolis), to finish Val off himself by the next morning or his minutes are numbered as well.

Val senses what his friend is up to and decides to embrace his fate, leaving one last night between friends. After stealing a car, they pick up their former getaway driver, Hirsch (Alan Arkin); "rescuing" him from the nursing home in which he resides. Living up to the adage of fast cars and fast women, it is back to the brothel where the virility of their comrade is just a warm-up to what they find in the trunk. Coincidence being the overriding theme of the evening, Doc and Val also run into Hirsch's nurse daughter (Julianna Margulies) and a waitress (Addison Timlin) who has a closer relationship to one of them than even she knows; a revelation so nonchalantly out of left field it is impossible to attach any emotional significance to it.

Putting golden-age stars together to play the young man's crime game has proven successful in the past. *Go-*

ing in Style (1979) teamed up George Burns, Art Carney, and Lee Strasberg to break the monotony of old age with a bank robbery. The reuniting of Burt Lancaster and Kirk Douglas in *Tough Guys* (1986) blended the same brand of culture shock, tedium and glory day re-examination. None of those characters though felt like cartoons for simple amusement. It provided ample opportunity for fish-out-of-water humor without the reduction of respect for who they were as people within a fiction or the context of their career that fans carry with them. Noah Haidle in his debut screenplay also fails to milk the impending tension of murder amongst friends as fellow playwright Martin McDonagh so marvelously explored during *In Bruges* (2008).

Christopher Walken has been able to coast in quirky supporting parts for years simply by bringing his unique persona to not just every role but each line reading. His presence has always been welcome and has only been enhanced lately when written a character faced with his own mortality such as in *A Late Quartet* (2012) and, once again, Martin McDonagh's *Seven Psychopaths* (2012). There is nothing for Walken's Doc to be here other than an observer on an all-night bender; a reaction shot waiting for a moment. Pacino's performance is sadder for all the wrong reasons. Unlike his defiant, quirk-filled take on *Phil Spector* (2013), the guilt-ridden characters of his past like the older Michael Corleone of *The Godfather Part III* (1990) or where his sleep-deprived face served a purpose during *Insomnia* (2002), Pacino appears closer to a hospice patient too boring to receive visitors. The film briefly comes alive with the appearance of Arkin, who can produce a post-mortem funny bone reaction like few others. His role is so unfortunately brief though that it would be reasonable to suggest Arkin improvised his final scene in the hopes that no one would notice he still had pages to fulfill.

"We seem to have reached the age where life stops giving us things and starts taking them away." That piece of wisdom was given to another aging icon in *Indiana Jones and the Kingdom of the Crystal Skull* (2008). The best that Haidle can offer these screen legends is to paraphrase Roddy Piper's most memorable line from *They Live* (1988). Twice. This trio can take comfort that the film is so forgettable that it can easily blend into their resumes and glossed over without a second look; forgiven as just an opportunity to make a movie together and hang out. Alas, the times when the camera were not rolling likely proved more befitting of an opportunity to discuss geriatrics, chew gum, and have a few laughs. *Stand Up Guys* is no more a swan song for its stars than *Last Vegas* (2013) is for its aging foursome. Certainly

hope it is not anyway because it would be sad to see icons ride into such a fake sunset.

Erik Childress

CREDITS

Valentine: Al Pacino
Doc: Christopher Walken
Hirsch: Alan Arkin
Nina: Julianna Margulies
Claphands: Mark Margolis
Wendy: Lucy Punch
Sylvia: Vanessa Ferlito
Oxana: Katheryn Winnick
Origin: United States
Language: English
Released: 2012
Production: Sidney Kimmel, Gary Lucchesi, Tom Rosenberg, Jim Tauber; Lakeshore Entertainment; released by Lions Gate Entertainment Corp.
Directed by: Fisher Stevens
Written by: Noah Haidie
Cinematography by: Michael Grady
Music by: Lyle Workman
Editing: Mark Livolsi
Costumes: Lindsay McKay
Production Design: Maher Ahmad
MPAA rating: R
Running time: 95 minutes

REVIEWS

Cline, Rich. *Shadows on the Wall.* July 5, 2013.
Ebert, Roger. *Chicago Sun-Times.* January 31, 2013.
Hornaday, Ann. *Washington Post.* February 1, 2013.
Johanson, MaryAnn. *Boston Globe.* June 28, 2013.
Kisonak, Rich. *Film Threat.* February 6, 2013.
LaSalle, Mick. *San Francisco Chronicle.* February 1, 2013.
Morgenstern, Joe. *Wall Street Journal.* January 31, 2013.
Simon, Alissa. *Variety.* January 22, 2013.
Simon, Brent. *Screen International.* February 1, 2013.
Tobias, Scott. *NPR.* January 31, 2013.

QUOTES

Val: "They say we die twice. Once when the breath leaves our body, and once when the last person we know says our name."

AWARDS

Nominations:
Golden Globes 2013: Song ("Not Running Anymore")

STAR TREK INTO DARKNESS

Beyond the darkness, lies greatness.
—Movie tagline

In our darkest hour, when our leaders have
 fallen, a hero will rise.
 —Movie tagline

They have one chance to save us all.
 —Movie tagline

Earth will fall.
 —Movie tagline

Box Office: $228.8 Million

The smartest and bravest thing that J.J. Abrams did in association with the new *Star Trek* series is to ditch it to take the reins of the new *Star Wars* series. Some joking aside, it took some guts to craft a storyline that would throw a monkey wrench into a universe that had already spanned five decades; not counting the centuries of fiction within. By corrupting the very timeline generations had come to love, study, and live, Abrams & Co. were now free to not just craft an origins story but do a literal reboot that would not stranglehold them to pre-existing events. For the long-awaited and highly secretive second chapter, the makers have subscribed to the "more is more" mantra of sequels. The action quotient is significantly elevated, the stakes are higher, the villain is more ruthless and on top of all that, the frustration level is greater than any red alert can warn about.

Right off the bat, *Star Trek Into Darkness* shows that there is no element of the series' mythology that is off limits. General Order Number One—otherwise known as the Prime Directive—is violated when the Enterprise saves an alien civilization from volcanic extinction, exposing them to their own technological advancements. They are also not the only ones in need of saving. The direct violation was in line with rescuing Spock (Zachary Quinto), who was willing to give his life for the many who outweigh him. Kirk (Chris Pine) is stripped of his command by Admiral Pike (Bruce Greenwood) but is soon-reinstated when multiple terrorist actions are being committed against Starfleet.

The known perpetrator is a former Starfleet agent named John Harrison (Benedict Cumberbatch). Having fled to Klingon territory, Kirk and his crew are assigned by Admiral Marcus (Peter Weller) to hunt down and kill him. He even provides him with seventy-two prototype torpedoes. Spock, McCoy (Karl Urban), and Uhura (Zoe Saldana) are against an outright execution while Scotty (Simon Pegg) resigns his post after being denied access to an inspection of the newly-boarded weaponry. Also ready to be boarded is the Admiral's comely daughter, Carol (Alice Eve), a science officer who in one timeline will create a process that allows a rebirth of a dying planet by destroying everything that went into making it in the first place.

Into Darkness had a long production history that included a full year's delay from its original tentpole re-lease date and a lot of speculation as to who would play the rumored villain. Much denial came out of the Abrams camp that fans were on to the direction the film was heading, and the true identity of the villainous John Harrison is kept as far as one hour into the movie. Therefore, by the time the other shoe falls, it is hardly news to true fans and may only trigger a passing remembrance at best to the new fans they had hoped to lure in by creating a fresh timeline in the first place. John Harrison...is...KHAN! But most viewers knew that already.

It is important to know who Khan is in the mythology since he is not just a catalyst to all of the Enterprise's dark adventure this time around but also the trigger to where it all goes wrong in terms of screenwriting. Khan's wrath is well-documented but it is the wrath he inspires in his opponents that are most notable. No Trekker can forget Shatner's Kirk defiantly yelling his name to the stars. The abandonment of principle (and cool) in the face of immeasurable evil is an oft-explored cinematic theme and one this screenplay hints at. Most of it is just surface-level metaphor; throwing out a book-end label, calling it an arc, and allowing it to float rather than linger substantially. But it is the draining of basic human logic in its characters and what has come before that should be unforgivable to anyone who has invested more than two hours in the Trek universe.

For mere plot sticklers, Khan's "superblood" is laced with gene-healing dynamics. A vile of it is enough to heal a recruit's child, so suffice to say that his comrades have the same powers. So while the pacifist Spock—after taking name-yelling duties from Kirk—hunts down Khan to engage in a bloody fistfight he is then ordered to grapple with the capture-or-kill theme (for about 1.5 seconds) while the frantic doctor forgets all the dormant blood lying safely in grasp of such a pending emergency. This is the same Spock who earlier gets to jump forward and cheat the plot by once again contacting Old Spock to discover that the seemingly well-intentioned Khan is actually "the most dangerous adversary the Enterprise ever faced." Too bad Spock Jr. could not just stream the episode of "Space Seed," in which Khan was introduced as a friend-turned-villain in 1967.

To see the role reversal that screenwriters Roberto Orci, Alex Kurtzman, and Damon Lindelof attempt to pull off in this climax within the alternate relationship without the history of *Star Trek II: Wrath of Khan* (1982) and which has spent the better part of two films becoming more adversarial than selfless is the grandest screenwriting betrayal of all (and a slap to the head of not just the best film of the series but one of the greatest science-fiction films ever). The sheer meaninglessness of the film's tears with a foreshadowed deus ex machina in waiting does not allow the gravitas of the moment to

weigh on people's minds in-between movies. The grave on the regenerative Genesis was less a hopeful tease than the cumulative image of aging, death and rebirth that Nicholas Meyer so perfectly peppered throughout *The Wrath of Khan*. *Into Darkness* plays more like a snarky punchline told by a bad comedian.

Abrams certainly does his best to distract from the deeply-flawed screenwriting. There is enough well-paced running, jumping, shooting, flying, and punching to maybe allow the uninitiated into believing they have seen an above-average sci-fi actioner. With Trek mantras such as the Prime Directive's "to explore and observe, not to interfere" and Old Spock's "Your path is yours to walk and yours alone" now feeling like ironic footnotes than the last traces of wisdom from the original timeline, perhaps "live long and prosper" is not part of the new *Trek* universe's vocabulary. After all, "the needs of the many outweigh the needs of the few." By the end of *Into Darkness*, it seems that truer words were never spoken.

Erik Childress

CREDITS

Capt. James T. Kirk: Chris Pine
Spock: Zachary Quinto
Nyota Uhura: Zoe Saldana
Bones McCoy: Karl Urban
Hikaru Sulu: John Cho
Pavel Chekhov: Anton Yelchin
Khan: Benedict Cumberbatch
Scotty: Simon Pegg
Christopher Pike: Bruce Greenwood
Dr. Carol Marcus: Alice Eve
Marcus: Peter Weller
Origin: United States
Language: English
Released: 2013
Production: Bryan Burk, J.J. (Jeffrey) Abrams, Roberto Orci, Alex Kurtzman, Damon Lindelof; released by Paramount Pictures Corp.
Directed by: J.J. (Jeffrey) Abrams
Written by: Roberto Orci; Alex Kurtzman; Damon Lindelof
Cinematography by: Dan(iel) Mindel
Music by: Michael Giacchino
Sound: Ben Burtt
Editing: Maryann Brandon; Mary Jo Markey
Art Direction: Ramsey Avery
Costumes: Michael Kaplan
Production Design: Scott Chambliss
MPAA rating: PG-13
Running time: 129 minutes

REVIEWS

Bayer, Jeff. *The Scorecard Review.* May 21, 2013.
Berardinelli, James. *ReelViews.* May 16, 2013.
Larsen, Josh. *LarsenOnFilm.* May 16, 2013.
McGranaghan, Mike. *Film Racket.* May 16, 2013.
Nusair, David. *Reel Film Reviews.* June 28, 2013.
O'Hehir, Andrew. *Salon.com.* May 15, 2013.
Rodriguez, Rene. *Miami Herald.* May 14, 2013.
Scott, A. O. *The New York Times.* May 15, 2013.
Snider, Eric D. *EricDSnider.com.* July 12, 2013.
Stevens, Dana. *Slate.* May 16, 2013.

QUOTES

Christopher Pike: "That's a technicality."
Spock: "I am Vulcan, sir. We embrace technicality."
Christopher Pike: "Are you giving me attitude, Spock?"
Spock: "I am expressing multiple attitudes simultaneously. To which are you referring?"

TRIVIA

When the Vengeance fires on the Enterprise while they are both travelling at warp speed, one can fleetingly see R2-D2 being sucked out into space along with various debris, tools, and Enterprise crewmen.

AWARDS

Nominations:

Oscars 2013: Visual FX
British Acad. 2013: Visual FX

STILL MINE

Still devoted. Still determined.
—Movie tagline

Box Office: $1.2 Million

Writer/director Michael McGowan brings a Vaseline-lensed comfort to *Still Mine* that could easily frustrate or even infuriate those who have embraced the more warts-and-all approach to aging seen in much-darker films of the current era like Sarah Polley's *Away From Her* (2006) and Michael Haneke's *Amour* (2012). Whereas those films pulled their no punches in their replication of the complex emotional terrain that must be navigated by those with elderly loved ones, McGowan's film often feels a bit more like a Hallmark Special Presentation on NBC. And that may not be as much of a criticism as it first sounds. While this narrative feels a bit too polished, two stellar performances bring enough realism and gravity to the proceedings that the melodrama becomes more easily forgivable.

The always-underrated and talented James Cromwell (*Babe* [1995], *The Green Mile* [1999]) stars in this based-on-a-true-story Canadian production about an average man who tried to do something above-average for his wife before it was too late to do so. Cromwell plays Craig Morrison, an eighty-something farmer faced with a number of challenges late in life. Like so many small farmers, an increase in government regulations in his industry is forcing Morrison into less navigable financial straits. He may even have to shutter his farm. Faced with the end of his profession, Morrison is confronted with an even-greater hurdle when he realizes that his wife Irene (a still-luminous Genevieve Bujold) is slowly losing her mental faculties. Conversations do not register, memories disappear, and the love of his life seems to scare more easily than ever. How can a man tasked with keeping his livelihood from sinking beneath the financial waters also plan to be there for wife who is increasingly in need of assistance? As a gift to Irene, Craig decides that he is going to use part of his multi-acre property to build a tiny home for them to move into and live out their remaining years, looking through a beautiful bay window at the gorgeous scenery around them. It will be a lovely home and Craig seems firmly aware that it will be their final place of calm repose.

Construction on one's own property as a gift to a dying love one should be cut and dry, right? Think again. Believe it or not, one cannot build a home on their own property with their own two hands without surmounting mountains of red tape. The days in which someone could cut down a tree and build an abode with their bare hands have been long passed. Now, lumber needs to be stamped, inspections need to be passed for safety, permits need to be obtained, and a variety of other hoops need to be jumped through and Craig does not have the patience nor the time. Instead of being left alone to worry about his construction and his wife (and himself, for that matter), Craig's time is consumed by government bureaucrats who seem willing to take an octogenarian to court and even bulldoze the last thing he wanted to build from the ground up.

As one can easily perceive, the home that Craig is trying to build takes on deeply symbolic tones: What a man tries to do for his family and himself but cannot due to outside forces. While he builds with his hands, that which he cannot control (like his wife's sanity) crumbles around him. It would have actually improved the film if McGowan investigated this layer of his narrative a bit more thoroughly but *Still Mine* understandably becomes a pretty emotional piece before that happens. The emotions of the piece are handled well, particularly in the grounded performance of Cromwell, but McGowan's dialogue is often a bit too on-the-nose. Almost every scene of legal trouble has the feel of cliche or TV writing from the heyday of the movie-of-the-week weepie. With such complex visions of old age as Polley and Haneke's films in the recent cinematic mind's eye, this one feels even thinner.

Still Mine then serves as an example of how two incredible talents can power a cliched screenplay over critical thought. For every scene that feels a little forced, there is a beautiful moment between the two lead characters, often something that was clearly a decision of Bujold or Cromwell. The square-jawed actor has built such a career from old-fashioned, "solid" characters that there is something even more heartbreaking about seeing those walls broken down. It is as emotionally raw a performance that Cromwell has given. With Bujold, he takes a narrative that could have easily devolved into melodrama and grounds it in believable emotion. There is truth in these performances that so many films like this one lack. At its best, the film has the echo of something private, like the camera has been allowed into the lives of two people who have honestly adored each other for decades. If anything, the legal/bureaucracy issues of McGowan's film distract from the personal tragedy at its core. For while not every viewer will have to deal with red tape surrounding home construction, age and the associated problems that come with it are the concerns of all audience members lucky enough to see such twilight days with someone they love.

Brian Tallerico

CREDITS

Craig Morrison: James Cromwell
Irene Morrison: Genevieve Bujold
Gary Fulton: Campbell Scott
Origin: United States
Language: English
Released: 2013
Production: Michael McGowan, Jody Colero; Mulmur Feed Co. Production; released by Samuel Goldwyn Films
Directed by: Michael McGowan
Written by: Michael McGowan
Cinematography by: Brendan Steacy
Music by: Hugh Marsh
Sound: Stephen Bourne
Music Supervisor: Jody Colero
Editing: Roderick Deogrades
Art Direction: David Gruer
Costumes: Sarah Millman
Production Design: Tamara Deverell
MPAA rating: PG-13
Running time: 102 minutes

REVIEWS

Baumgarten, Marjorie. *Austin Chronicle.* September 25, 2013.
Emerick, Laura. *Chicago Sun-Times.* July 26, 2013.

Goldstein, Gary. *Los Angeles Times.* July 10, 2013.
Goodykoontz, Bill. *Arizona Republic.* July 18, 2013.
Holden, Stephen. *New York Times.* July 18, 2013.
Lumenick, Lou. *New York Post.* July 18, 2013.
O'Sullivan, Michael. *Washington Post.* July 18, 2013.
Rea, Steven. *Philadelphia Inquirer.* August 1, 2013.
Reed, Rex. *New York Observer.* July 16, 2013.
Wilson, Chuck. *Village Voice.* July 9, 2013.

QUOTES

Craig Morrison: "Age is an abstraction, not a straitjacket."

STOKER

Do not disturb the family.
—Movie tagline

Innocence ends.
—Movie tagline

Box Office: $9.4 Million

Chan-wook Park's *Stoker* is an exercise in Hitchcockian style bereft of suspense. Perhaps it is appropriate for a picture about the inescapable nature of genetically wired fate to be completely lacking in any shred of spontaneity. Though Hitchcock shares Park's love of storyboards, his visual jigsaw puzzles were designed to engage audiences in the moment-to-moment experiences of his protagonists. Viewers winced at the oncoming headlights as Marion Crane drove through the stormy night and later ducked at the sight of a threatening bread knife.

The characters in *Stoker* are not meant to be relatable. They are meant to be gawked at like a stuffed bird, forever frozen in its malevolent pose. Every sequence is treated like the shower scene in *Psycho* (1960), with vital bits of information being deliberately withheld for a subsequent payoff. Yet unlike the shower scene, which brilliantly conveyed the disorientated perspective of its doomed heroine, Park's needlessly murky montages are meaningless excuses to amp up the tension where there is none. The characters already know what lurks behind every corner, and though the audience is kept in the dark about it, it is a good bet they can guess what resides there too.

Those familiar with the Master of Suspense will already have half the film figured out in its opening minutes, as long lost Uncle Charlie, played by Matthew Goode, pays a visit to the funeral of his brother, Richard. It is not for nothing that Charlie's name is identical to that of the suavely charming ladykiller played by Joseph Cotton in Hitchcock's 1943 masterpiece, *Shadow of a Doubt.* Both men are masters of seduction as they infiltrate the innocent lives of their loved ones while holding their homicidal tendencies in check. Though it might seem a trifle unfair to compare both films, it must be said that the gradually unhinged nuances in Cotton's performance are infinitely more frightening than Goode's gleaming eyes, which confirm his sociopathic madness from the get-go.

What made *Doubt* so deeply unsettling was the way in which it explored the relationship between Charlie and his adoring niece, whose idealistic vision of her uncle is corrupted once she discovers his true nature. The major twist in *Stoker,* courtesy of its somewhat promising debut script by *Prison Break* star Wentworth Miller, lies in the psyche of Richard's daughter, India, portrayed with icy radiance by the consistently mesmerizing Mia Wasikowska. Rather than be frightened by Charlie's hidden identity, India is merely intrigued, even as the bodies start piling up. Turns out Charlie has unlocked something within India that has remained dormant for years, thus propelling her on a coming-of-age journey guaranteed to delight her elder doppelganger, Morticia Addams.

Decked out in stringy black hair designed to frame her ghostly pale skin, India resembles the unholy spawn of Beetlejuice and Lydia, had they consummated their forced marriage. She looks so alien and remote that it is entirely a testament to Wasikowska's work that the viewer feels anything for her at all, apart from tongue-in-cheek unease. In a way, the actress's performance is a morbid variation on her beguiling turn in Cary Fukunaga's *Jane Eyre* (2011), which was also about a young woman at war with her conflicting feelings for a much older gentleman caller. With the exquisite subtlety she sported ever since her debut on HBO's *In Treatment,* Wasikowska invites the audience to experience her wounded angst and budding sensuality in every lingering glance and soft gasp. Unfortunately, Park's maddeningly overwrought style undermines her efforts at nearly every turn.

Consider the sequence where India ventures into the cellar to retrieve ice cream from a coffin-shaped freezer. Editor Nicolas De Toth, best known for action fare like *Live Free or Die Hard* (2007) fractures the scene to the point where it appears as if India's life is flashing before her eyes. She raises a hanging light and lets it swing back and forth for no reason other than to pay homage to Vera Miles in the fruit cellar. So much emphasis is placed on objects and self-conscious edits that India's reaction to what she discovers in the cellar is entirely lost, never allowing Wasikowska's performance to register. Confidence is obviously an essential trait for a director to possess, but Park is so in love with his technique that he risks suffocating the life out of it.

At its worst, *Stoker* is as airless and embalmed as a *Star Wars* prequel, yet there are just enough moments of inspiration to warrant a viewing from cinephiles, albeit only one. Not surprisingly, the best scenes are often the ones simply containing Wasikowska, as she grapples with the storm brewing in her mind, soul, and loins. The most effective and dizzyingly erotic scene in the film is a piano duet scored by Philip Glass that India imagines performing with Charlie. As he wraps his arms around her, harmonizing with her song in perfect synchronicity, Wasikowska suddenly finds the notes taking on a life of their own, with melodic embellishments matching the fluttering of her heart. Similarly powerful is the extended shower scene where India gets off on the memory of a horrific act committed in her honor. With a less exemplary performer at their center, neither of these scenes would have been a fraction as potent.

Aside from one caustic monologue delivered in an unbroken take directly into the lens, Nicole Kidman is more or less wasted in the role of India's shrewish mother, Evelyn. The rapid speed with which she tumbles into an affair with Charlie so soon after her husband's passing suggests malevolent undertones that amount to little more than a red herring. The distance that grew between Evelyn and Richard is given no context apart from expository dialogue that is distressingly one-note. Evelyn keeps complaining about Richard's tendency to take India on hunting trips, which predictably proves to foreshadow inevitable flashbacks to said trips. It is as if Evelyn had no history to draw on apart from what is explicitly portrayed in flashbacks. In fact, none of the characters' lives seem to extend beyond the reach of what remains confined in the frame.

Of course, Park's own specialty are revenge fantasies like his 2003 landmark, *Oldboy,* where the characters' lives follow a structural trajectory as grimly ironic as any Greek tragedy. These films can be grand, shattering and thanks to Park's hyper-stylized signature, kinetically thrilling, but since the characters' fate is preordained, they are not exactly suspenseful. That is why Park's sensibilities do not mix well with those of Hitchcock, a man more interested in reinventing the wheel than riffing on old standards. Everything in *Stoker* feels secondhand, even the most fleeting of images, such as India's restrained reaction to Charlie's ghastly confession, which she punishes with a single slap to the face, purchased directly from Sissy Spacek in *Badlands* (1973). Not since Martin Scorsese's *Shutter Island* (2010) has a great filmmaker appeared so burdened by the influence of others. It just goes to show that even the finest artists can confuse poignant homage with tedious regurgitation.

No matter how painstakingly gorgeous the compositions are by cinematographer Chung-hoon Chung, they simply take the form of a well-orchestrated prison entrapping the performers in a series of dutifully blocked postures. Like India, Park seems to have confused freedom with confinement and maturation with resignation. How can there be any room for suspense in a formula of such plodding certainty? Hitchcock's films were about teasing the viewer with questions that kept them perched on the edge of their seat while clutching the arm of the person next to them. There was a great deal of deliciously perplexing ambiguity regarding where the story would ultimately end up. With *Stoker,* there is not even a shadow of a doubt.

Matt Fagerholm

CREDITS

India Stoker: Mia Wasikowska
Charlie Stoker: Matthew Goode
Evelyn Stoker: Nicole Kidman
Richard Stoker: Dermot Mulroney
Gwendolyn Stoker: Jacki Weaver
Whip Taylor: Alden Ehrenreich
Chris Pitts: Lucas Till
Origin: United States
Language: English
Released: 2013
Production: Ridley Scott, Tony Scott, Michael Costigan; Indian Paintbrush, Scott Free Productions; released by Fox Searchlight
Directed by: Chan-wook Park
Written by: Wentworth Miller
Cinematography by: Chung-hoon Chung
Music by: Clint Mansell
Sound: Chuck Michael
Editing: Nicolas De Toth
Costumes: Kurt and Bart
Production Design: Therese DePrez
MPAA rating: R
Running time: 99 minutes

REVIEWS

Burr, Ty. *Boston Globe.* February 28, 2013.

Edelstein, David. *New York Magazine (Vulture).* February 25, 2013.

Gonzalez, Ed. *Slant Magazine.* February 23, 2013.

Kohn, Eric. *indieWIRE.* February 5, 2013.

Morgenstern, Joe. *Wall Street Journal.* February 28, 2013.

O'Hehir, Andrew. *Salon.com.* February 28, 2013.

Perez, Rodrigo. *The Playlist.* February 5, 2013.

Phillips, Michael. *Chicago Tribune.* February 28, 2013.

Robinson, Tasha. *The A.V. Club.* February 27, 2013.

Schager, Nick. *Village Voice.* February 26, 2013.

STORIES WE TELL

Box Office: $1.6 Million

When Sarah Polley, the writer/director of *Away From Her* (2006) and *Take This Waltz* (2011) (and star of films like *Go* [1999] and *Dawn of the Dead* [2004]) sat down with her family to dig deep into the roots of her own family tree, even she could not have really known what she would unearth. And yet Polley's resulting masterful documentary is no mere familial expose. It becomes something much greater as Polley turns her personal story into a remarkable examination of how people tell stories from generation to generation, how the revelation of secrets can have a stunning ripple effect, and even adds something to the debate on nature vs. nurture; that which is hereditary vs. that which is learned. Polley uses her own quest for answers to illuminate why and how people tell stories in the first place; primarily how they do so through the art form she knows so well: Film. It is not just action, inaction, or standard parenting but how one share's their history that impacts future generations. This is Polley's best film to date and one that casts her previous dramatic work in a new, personal light.

One can sense that Sarah Polley is playing with the very form of the biographical documentary from early in *Stories We Tell*, although just how much she is doing so is not readily apparent until a final-act "twist." The subject is two-fold—young Sarah and her relationship with a mother she did not know named Diane, who passed away when Polley was very young. It makes perfect sense that Polley would want to speak to her siblings and father about a woman that they knew better than she was allowed by a cruel twist of morbid fate. Polley begins to come to an understanding that her mother was a melancholy person, but why? Was it due to the constraints placed on a theatrical career that she always dreamed of having before motherhood intervened? Was Diane Polley happy with her family? As Polley digs deeper into her mother's hopes and dreams having been replaced by diapers and married life, *Stories We Tell* could have easily become merely a series of interviews; talking-head clips of the people who knew Diane best as reflected by the daughter who wishes she had more time with mommy. The gap between the present and a past stolen by death would be traversed and audiences would likely walk out smiling and wanting to call their mothers before the Hallmark holiday.

Stories We Tell is a more ambitious film. From the beginning, Polley subverts the process by exposing it. Michael, her father, is shown not merely in interview segments but in a recording booth, reading the story of his love and life as Sarah sits at a sound board. She makes adjustments and even asks for alternate takes. One of Polley's brothers jokingly asks if he looks good on film and the exchange does not hit the cutting room floor as it would in a typical bio-doc. Viewers are being constantly reminded that this is a story within a story—a narrative that is being crafted from truth; not the precision of actual truth itself. It is Michael Polley's interpretation of history, first and foremost, but that story is also being crafted, edited, and directed by Sarah Polley.

Do not mistake this analysis of Polley's work her to imply that *Stories We Tell* is a dry examination of the impact of the filmmaking process on history. It is anything but, as it turns out that Polley has a stunning family history to reveal; one that will not be spoiled here but shakes up her entire family. The mystery of Polley's upbringing, the reason her mother remained so distant, etc.—these are the kind of investigative pieces that make for great long-form magazine articles but Polley takes it a step further by turning her story into film. It is not just about her family tree but the importance of retelling its history through cinema that interests Polley and elevates her work overall.

As one looks back on Polley's work after seeing her personal history, her highly-acclaimed fictional films feel completely fresh and new. It is impossible not to consider the infidelity at the core of *Take This Waltz* in a different vein when one hears about how Diane longed for a new life away from the Polley family. And knowing that Sarah lost her mother at a young age makes the heartbreak of *Away From Her* that much more palpable. If anything, this trio of films now stands as a trilogy with the documentary tying up the themes of the first two chapters. It also proves that Sarah Polley is a very special filmmaker, one of the rare breed who knows how to take the personal and make it universal.

Brian Tallerico

CREDITS

Origin: Canada
Language: English

Released: 2013
Production: Anita Lee; National Film Board of Canada; released by Roadside Attractions
Directed by: Sarah Polley
Written by: Sarah Polley
Cinematography by: Iris Ng
Music by: Jonathan Goldsmith
Sound: David Rose
Editing: Mike Munn
Costumes: Sarah Armstrong
Production Design: Lea Carlson
MPAA rating: PG-13
Running time: 108 minutes

REVIEWS

Dargis, Manohla. *New York Times*. May 9, 2013.
Dowd, A. A. *The A.V. Club*. May 8, 2013.
Goodykoontz, Bill. *Arizona Republic*. June 6, 2013.
Jolin, Dan. *Empire*. June 24, 2013.
O'Hehir, Andrew. *Salon.com*. December 25, 2013.
O'Malley, Sheila. *RogerEbert.com*. June 6, 2013.
Puig, Claudia. *USA Today*. May 16, 2013.
Rothkopf, Joshua. *Time Out New York*. May 7, 2013.
Turan, Kenneth. *Los Angeles Times*. May 16, 2013.
Zacharek, Stephanie. *Village Voice*. May 7, 2013.

QUOTES

Storyteller: "When you're in the middle of a story, it isn't a story at all but rather a confusion, a dark roaring, a blindness, a wreckage of shattered glass and splintered wood, like a house in a whirlwind or else a boat crushed by the icebergs or swept over the rapids, and all aboard are powerless to stop it. It's only afterwards that it becomes anything like a story at all, when you're telling it to yourself or someone else."

AWARDS

Writers Guild 2013: Documentary Screenplay
Nominations:
Directors Guild 2013: Documentary Director (Polley)

T

TEXAS CHAINSAW 3D

Evil wears many faces.
—Movie tagline

Box Office: $34.3 Million

Seven films into a franchise getting ready to celebrate its fortieth anniversary, the Texas Chainsaw producers have decided they need 3D. Perhaps they have decent instincts. The failed 2003 reboot of the series was an unpleasant mess that substituted gore for the cosmic apocalypse and raw power of the 1974 original and squandered the powerful presence of R. Lee Ermey. But the 3D, though well utilized, is a minor asset here. The film simply has no need of it. *Texas Chainsaw 3D* is an unfortunately titled film in that it is the best the series has had to offer since Tobe Hooper's marvelous (and equally ill-titled) horror satire *Texas Chainsaw Massacre 2* (1986). While *The Texas Chainsaw Massacre: The Beginning* (2006) made a game effort to develop Leatherface's anti-hero status it was ultimately content to present the origins of a larger-than-life monster. *Texas Chainsaw 3D* manages more pathos for the character, gives the town a nice antagonistic back story, and offers plenty of solid horror film thrills and a gloriously Grand Guignol finish.

Shortly after the events of the original *Texas Chainsaw Massacre*, the townsfolk of Newt, Texas have gathered to exact mob justice on the Sawyer clan for their heinous crimes. As the Sawyers are ambushed and their home burnt to the ground, Gavin (David Born) and Arlene Miller (Sue Rock) discover Loretta Sawyer (Dodie Brown) and her infant child, Edith. Murdering

Loretta, the pair raise Edith as their own, renaming her Heather.

Years later, Heather (Alexandra Daddario), unaware of her heritage, is informed that her grandmother has left her sole heir. Travelling to Newt with boyfriend Ryan (Tremaine Neverson) and friends Nikki (Tania Raymonde) and Kenny (Keram Malicki-Sanchez), she discovers the truth from the Sawyer family lawyer Farnsworth (Richard Riehle) who hands her the keys to the family home. Together with recently-acquired hitchhiker Darryl (Shaun Sipos), an excited exploration of the vintage home begins, culminating in a decision to spend the night. But as the group leaves to collect food and other supplies, Darryl stays behind, looting until, after breaking into a locked room, Leatherface (Dan Yaeger) appears.

When the group gets back, they decide to ignore the obvious signs of looting and settle in for the night, unaware of Leatherface's presence. As the group is dispatched, Heather wakes up in the killer's lair, eventually escaping to a nearby graveyard but unable to help her remaining friends. A nearby carnival gives her the opportunity to alert police who lose him in a mad dash through the carnival grounds.

A member of the original lynch mob town, Mayor Burt Hartman (Paul Rae) sends a police officer to the Sawyer home to find and kill Leatherface just as Heather discovers her true connection to the Sawyer clan. Fleeing the police station, she is caught by Hartman's son Deputy Carl (Scott Eastwood) and taken by him to the Sawyer family slaughterhouse to lure Leatherface into a trap. Upon discovering that Heather is his cousin, Leath-

erface frees her, entering into a pitched battle between himself and his old nemesis.

Unlike the other sequels, this installment has a sense of history and humor about itself. A few key cast members of the franchise have cameos playing members of the Sawyer clan including Gunnar "Leatherface" Hansen, John "Grandpa" Dugan, and Bill "Chop Top" Moseley. Marylin "Sally Hardesty" Burns even turns up as the dead body of Verna, Heather's grandmother. Such cameos go by quickly without drawing too much attention to themselves, which is in keeping with the producer's stated intention of drawing homage to what has gone before. So does the use of kill-and-chase footage from the original 1974 film in the titles. Bodies jump out of freezers and metal doors slam. During the fairground chase, Leatherface runs into a character from the *Saw* films carrying a tiny chainsaw. The two waggle their chainsaws threateningly at one another and then run off in their separate directions. None of this is distracting and fans will have a fun time re-watching the film to spot it all.

One visual issue is the treatment of Leatherface. The old lipsticked human skin mask has been discarded in favor of a gnarlier but less effective design that has been in vogue ever since the first sequel. Meant to approximate human skin, it feels too substantial, less like tanned leather than flesh. Leatherface is also in darkness too much of the time. The most effective scenes with the character involve well-lit killings and skinnings near the end of the film, especially the sequence that involves him stitching his human face mask onto his own actual face. Dan Yaeger reportedly sought out Gunner Hansen for tips on lifting Leatherface out of stereotype and does well here. He comes across as a hulking force and a wounded soul.

Weaknesses that might kill the film for some include CGI blood and a few too many characters who do what is required rather than what is smart or even logical. But a clever fan could probably make a case for all the character's motivations and decisions here. The film is written consistently around the concept of family ties and blood bonds, juxtaposing the corrupt and brutal town leaders against a tight knit clan in a culture where family is all but worshipped. "The saw is family" is a phrase often associated with the franchise, and how different the Sawyers are than the world around them is in question; as is the idea that they may just be better at surviving in a world where everybody is meat.

Dave Canfield

CREDITS

Heather Miller: Alexandra Daddario
Leatherface: Dan Yeager

Ryan: Trey Songz
Deputy Carl Hartman: Scott Eastwood
Nikki: Tania Raymonde
Farnsworth: Richard Riehle
Drayton Sawyer: Bill Moseley
Origin: United States
Language: English
Released: 2013
Production: Carl Mazzocone; Millennium Films, Nu Image Films; released by Lions Gate Entertainment Corp.
Directed by: John Luessenhop
Written by: Adam Marcus; Debra Sullivan; Kirsten Elms
Cinematography by: Anastas Michos
Music by: John (Gianni) Frizzell
Sound: Trevor Jolly
Music Supervisor: Selena Arizanovic
Editing: Randy Bricker
Costumes: Mary McLeod
Production Design: William A. "Bill" Elliott
MPAA rating: R
Running time: 92 minutes

REVIEWS

Beifuss, John. *Commercial Appeal.* January 15, 2013.
Bibbiana, William. *CraveOnline.* January 4, 2013.
Ebiri, Bilge. *Vulture.* January 7, 2013.
Howell, Peter. *Toronto Star.* January 4, 2013.
JimmyO. *JoBlo's Movie Emporium.* January 4, 2013.
Olsen, Mark. *Los Angeles Times.* January 5, 2013.
Leydon, Joe. *Variety.* January 4, 2013.
Nusair, Anthony. *Reel Film Reviews.* February 1, 2013.
Tobias, Scott. *AV Club.* January 4, 2013.
Vaux, Rob. *Mania.com.* January 4, 2013.

QUOTES

Darryl: "Family's a messy business. Ain't nothing thicker than blood."

TRIVIA

This film features four actors returning from previous installments in the franchise, surpassing the record of three set by *Texas Chainsaw Massacre: The Next Generation.*

THANKS FOR SHARING

Life is a journey you never have to take alone.
—Movie tagline

Box Office: $1.1 Million

The world needs more movies like *Thanks For Sharing*, the directorial debut of screenwriter Stuart

Blumberg. Specifically, the modern-day Hollywood studio system needs more movies like this one, a serio-comic roundelay about three sex addicts in the same support group, and the people impacting their sobriety. *Thanks For Sharing* is not a perfect film by any stretch of the imagination, but in an environment of safe, pre-fabricated narratives, this ramshackle delight is the type of film that studios would be wise not to leave to the realm of independent producers. It has heart, smart, and fallible characters in a rather believably muddled world, where anger & frustration, amusement & elation exist together and rub up against one another in sometimes unusual ways.

Following its 2012 premiere at the Toronto Film Festival, *Thanks For Sharing* was acquired for distribution by Roadside Attractions, and slated for theaters in mid-September. A casualty to a misguided marketing strategy and the buzz of Joseph Gordon-Levitt's somewhat similarly themed directorial debut opening one week later—*Don Jon* (2013), a much edgier, cocksure romantic comedy about a guy addicted to pornography—*Thanks For Sharing* would fail to seal the deal with many moviegoers, grossing just over $1 million at the box office.

Adam (Mark Ruffalo), a New York City-based environmental consultant with five years in recovery, is serious about his sobriety. He owns an outdated flip phone with no Internet browsing capabilities, and has the television removed from his hotel room whenever he travels for business. Adam draws strength from his mentor and sponsor Mike (Tim Robbins), who is a generally solid presence—if also coping with some control and trust issues of his own while he and his wife Katie (Joely Richardson) reintegrate their son Danny (Patrick Fugit), an erstwhile prescription drug abuser, back into their lives. Neil (Josh Gad), an emergency room doctor with a smothering mother (Carol Kane), is Adam's mentee, but given that his month-long participation in recovery is the result of a court order following an inappropriate incident on a subway, Neil is testing his sponsor's patience by not taking the work entirely seriously.

When Adam meets cute with Phoebe (Gwyneth Paltrow), an athletic cancer survivor, it seems like he is finally ready to take the next step in his recovery Mike has been urging, and start dating again. He and Phoebe have a good deal in common and seem to have the basis for a fairly stable relationship. But when she offhandedly mentions that a previous boyfriend's alcoholism has put her off ever again dating anyone with an addiction, Adam freezes up and swallows his secret. As Neil befriends the damaged Dede (Alecia Moore, aka pop singer Pink) and starts to finally grasp the value of being of service to others, an increasingly unsettled Adam finds his hold on sobriety growing more tenuous.

Many more doors opened for Blumberg with the Academy Award-nominated screenplay for *The Kids Are All Right* (2010), but he cut his teeth on *Keeping the Faith* (2000) and *The Girl Next Door* (2004), two very funny, underrated comedies that each put fun spins on genre convention and showed an ability to wring laughs out of potentially uncomfortable material. *Thanks For Sharing*, co-written with Matt Winston (son of special effects wizard Stan Winston), is shot through with that same banter-filled, rebellious instinct. Balanced between the unwholesome mania of *Shame* (2011) and the more darkly comedic, undomesticated rhythms of *Choke* (2008), two other recent tales of sex addicts, the film charts roughly a conventional romantic comedy course, but amidst the choppy waters of lives less ordinary.

It is a bit shaggy (at 112 minutes, the movie could use an editorial haircut), especially in the third act. There is a stunningly miscalculated scene in which Phoebe, just after Adam opens up to her about his disease, attempts to plow ahead with an aggressive seduction. And when things go dark and sideways in the story, they do so quickly, in a way that cannot help but feel a bit like an emotional exercise rigged from the get-go.

Mostly, however, *Thanks For Sharing* really works, because its backdrop is fresh for ensemble exploration and it treats sex addiction with the forthrightness and sincerity it deserves. There are quips aplenty with leavening insight ("Feelings are like children—you don't want them driving the car, but you don't want to stuff them in the trunk either," Mike counsels Adam). And there are also broader scenes lined with payoffs equal parts wrong and amusing. (When Neil gets busted trying to take up-skirt shots of a colleague, he impulsively explains his actions by saying it is part of a documentary he is working on entitled *What the Ground Sees*.)

The performances here are engaging, if also a bit uneven and sometimes defined by their character's function within the script. It is one of the weird contradictions of a film about sex addiction that its platonic and family relationships are much more strongly sketched than its amorous ones. Paltrow has a few fun scenes with Ruffalo, but also comes across as a bit flinty and hard-edged. Robbins is great, though. By turns wry and rueful, he shares a genuine rapport with Fugit (also quite good), in one of the film's stronger subplots. Gad, meanwhile, steals the show, providing much of the more overt comedy.

Ruffalo, then, is the emotionally unsettled anchor of *Thanks For Sharing*, and he embodies Adam's woundedness and perturbedness with full-bodied charm. Assisting matters is composer Christopher Lennertz's score, which captures the grace notes of characters working

toward self-betterment, but also the nervous energy of strong feelings being held uncomfortably at bay. The circumstances may be different and more extreme than most viewers, but they are recognizably human in their depiction of the struggle with change, and enough to make viewers want to thank Blumberg and his collaborators for sharing.

Brent Simon

CREDITS

Adam: Mark Ruffalo
Mike: Tim Robbins
Phoebe: Gwyneth Paltrow
Neil: Josh Gad
Katie: Joely Richardson
Danny: Patrick Fugit
Dede: Alecia Moore
Roberta: Carol Kane
Origin: United States
Language: English
Released: 2013
Production: Miranda de Pencier, David Koplan, Bill Migliore, Leslie Urdang, Dean Vanech; Class 5 Films, Olympus Pictures; released by Roadside Attractions
Directed by: Stuart Blumberg
Written by: Stuart Blumberg; Matt Winston
Cinematography by: Yaron Orbach
Music by: Christopher Lennertz
Sound: Lewis Goldstein
Music Supervisor: Robin Urdang
Editing: Anne McCabe
Costumes: Peggy Anita Schnitzer
Production Design: Beth Mickle
MPAA rating: R
Running time: 112 minutes

REVIEWS

Anderson, Jeffrey. *San Francisco Examiner*. September 20, 2013.
Debruge, Peter. *Variety*. September 9, 2012.
Jones, Kimberley. *Austin Chronicle*. September 20, 2013.
Macdonald, Moira. *Seattle Times*. September 19, 2013.
Mohan, Marc. *The Oregonian*. September 17, 2013.
O'Sullivan, Michael. *Washington Post*. September 19, 2013.
Persall, Steve. *Tampa Bay Times*. September 17, 2013.
Puig, Claudia. *USA Today*. September 19, 2013.
Rooney, David. *Hollywood Reporter*. September 10, 2012.
Sharkey, Betsy. *Los Angeles Times*. September 19, 2013.

QUOTES

Mike: "Feelings are like kids. You don't want them driving the car, but you don't want to stuff them in the trunk, either."

TRIVIA

Gwyneth Paltrow admitted that she was embarrassed and felt uncomfortable filming the stripping scene.

THIS IS THE END

Nothing ruins a party like the end of the world.
—Movie tagline

Box Office: $101.5 Million

Depicting the end of the world has always opened up juicy opportunities for filmmakers to explore not only the latest in groundbreaking visual effects but the basic humanity that either wins out or is set back with a medieval mindset amongst the surviving individuals. As Earth veers closer in some minds to destroying itself through changes in climate, close-passing space debris, and general psychotics itching to do it themselves, the subject has once again become cinematic fodder. From the more introspective paranoia of *Melancholia* (2011) to the grandiose destruction of *2012* (2009), despite the depressive nature of their outcomes people have always enjoyed living out their worst fears through the cathartic escape of the movies. So why not add some laughter to it? That is what Seth Rogen and Evan Goldberg have done with their unique directorial debut confronting the very selfish existence so many try to hide through the prism of those we love in character but lambast when they are not like us.

Seth Rogen plays himself as does everyone in the film with a recognizable name and face. His old friend Jay Baruchel is coming to Los Angeles to hang with him for a few days. After an afternoon consisting of Jay's favorite things to do around a living room, Seth suggests going over to James Franco's newly-designed home where he is having a party. Jay is reluctant having not maintained the kind of friendships that Seth has since settling in Hollywood. Franco cannot even remember Jay's name. Craig Robinson and Emma Watson think he is a hipster who dismisses populism. Jay talks about how much he hates his *Knocked Up* (2007) co-star Jonah Hill who is making every effort to be nice to him. Then all hell breaks loose. Literally.

Giant tremors begin wreaking havoc all over town. Large blue beams of light are sucking people up into the sky. Sinkholes are taking them underground and a lot of Judd Apatow productions are about to be put in turnaround. Among the survivors of the initial onslaught are Rogen, Baruchel, Franco, Robinson, and Hill who hole themselves up in James' house and await rescue. Their generous rations—even divided five ways—take an immediate hit the next morning thanks to party crasher Danny McBride. With a loss in supplies and an

uneasy sense that they are indeed on their own, the sextet are left to pass the time with one of the only instincts they possess as actors—to make movies. Though their personal confessionals reveal some hurtful thoughts towards their colleagues it may be the other side of forgiveness that could be the key to surviving this whole mess.

Rogen and Goldberg's screenplay does not pattern itself as a traditional parody or even satire of apocalyptic cliches. To expect such levels of snickering would distract from their more arcane-referenced humor and attempts at a narrative that reaches beyond just laughing at what their predecessors have done. That does not mean that they are always grasping for highbrow intellectualism either. Drug humor has a practically unavoidable single note to its presentation. Smoke, ingest, do wacky things and eat. These scenes are among the most rote and feel like filler in place of sections that could have been better used to perform more "sweded" versions of their resume as the video clerks did in *Be Kind Rewind* (2008). In their *Pineapple Express* (2008), the casual drug culture of stoners did find creativity through inventive performances and a story that was also ultimately about the perils and joys of true friendship.

Through the occasional effects and sexual-laden humor sprinkled throughout, Rogen and Goldberg are working through their most familiar of story arcs. Their first screenplay, *Superbad* (2007), underlined the growing apart of two friends (named Seth and Evan) headed for college and yet the overlying fear of that separation. *Pineapple Express* explored the co-dependent relationship between a subpoena processor and his drug dealer; one recoiling and the other reaching out for human interaction. Even misfires like *The Green Hornet* (2011) and *The Watch* (2012) were about the essential need for male bonding in an advancing age where there is less time to finally do something meaningful. *This is the End* may just be the encapsulation of everything they have written to date.

The success that can come so quickly to those in Hollywood can come crashing down on them in the midst of just one major disaster. Their big houses and vanity spending left as a shell of a bankable career. For the regular person not prone to soak up the everyday gossip of celebrity magazines or paparazzi-led shows with puffy feature stories this might appear to be just the sort of vanity project that egotistic stars can get away with. Not one of them is unscathed though playing the versions of themselves and while that may lead to the giddy anticipation of seeing one or more meet a grisly demise it provides an arc that allows more a hopeful conclusion to their predicament.

The project was initially conceived as a short film entitled *Jay & Seth vs. The Apocalypse* with Rogen, Baruchel, a single room and a lot of arguing. When picked up as a feature film, the story expanded beyond its low-budget lark roots and arrives with an overriding mystery as to what is causing all the destruction. Is it aliens, natural disasters, something more biblical or a collaboration of all of the above? As the movie spins its wheels with clues and blind reaction shots there is the realization that the film on some level may be exploring what will truly save Hollywood and what will ultimately destroy it. That the answer is not too far removed from *Ghostbusters II* (1989), one of the more disappointing sequels the magic factory has offered audiences, only adds to the inside irony that adds further appreciation to what is surrounding the hysterically vulgar interaction between the survivors.

In 2013 alone, filmmakers have offered up the futuristic fleeing of this uninhabitable planet in *After Earth*, the zombie-plagued continents of *World War Z* and the similarly-themed wait-out-indoors of *It's a Disaster* and the satirically-tinged *The World's End*. The manner in which Rogen and Goldberg have gathered their friends (and other celebrity cameos) together makes *This is the End* somehow feel more epic than any of them. While direct references to *The Exorcist* (1973) are crafted and more subtle ones are memory-tested on knowledge of *The Mist* (2007) and even *Navy SEALs* (1990), while the collection of perishable stars recalls the Irwin Allen spectaculars of the 1970s. *This is the End* takes the audience through the final days over 100 minutes using laughter to blanket the horrors and a simple message of decency that if everyone can finally understand maybe then the world can all enjoy the pleasures of Heaven together.

Erik Childress

CREDITS

Himself: Seth Rogen
Himself: James Franco
Himself: Jonah Hill
Himself: Jay Baruchel
Himself: Danny McBride
Himself: Craig Robinson
Himself: Michael Cera
Herself: Emma Watson
Origin: United States
Language: English
Released: 2013
Production: Evan Goldberg, James Weaver, Seth Rogen; Mandate Pictures, Point Grey Pictures; released by Sony Pictures Entertainment Inc.
Directed by: Seth Rogen; Evan Goldberg

Written by: Seth Rogen; Evan Goldberg
Cinematography by: Brandon Trost
Music by: Henry Jackman
Sound: Michael Babcock
Editing: Zene Baker
Costumes: Danny Glicker
Production Design: Chris Spellman
MPAA rating: R
Running time: 107 minutes

REVIEWS

Bell, Josh. *Las Vegas Weekly*. June 13, 2013.
Burr, Ty. *Boston Globe*. June 11, 2013.
Dowd, A. A. *The Onion A.V. Club*. June 12, 2013.
Gire, Dann. *Daily Herald*. June 14, 2013.
Kenny, Glenn. *MSN Movies*. June 18, 2013.
McGranaghan, Mike. *Film Racket*. June 12, 2013.
Nusair, David. *Reel Film Reviews*. July 2, 2013.
O'Hehir, Andrew. *Salon.com*. June 11, 2013.
Ranson, Kevin A. *MovieCrypt.com*. June 15, 2013.
Weinberg, Scott. *Fearnet*. June 12, 2013.

QUOTES

Danny McBride: "Hermione just stole all of our sh*t. And Jay suggested that we rape her. I think the only reason he did that is because he knows he's about two minutes away from becoming the house bitch himself."

TRIVIA

According to Seth Rogen, the plot his character suggests in the movie when he is asked what *Pineapple Express 2* would be about is actually his real life idea for the sequel.

THOR: THE DARK WORLD

Box Office: $206 Million

Marvel Studios, the motion picture arm of the legendary comic book company, kicked off a superhero movie renaissance with 2008's *Iron Man*, a critical and popular smash, which allowed the studio to embark on an ambitious plan. Marvel wanted to control the cinematic destinies of their most popular superheroes and create an interconnected movie universe where those heroes could interact on-screen. (At least, the characters whose movie rights they still owned, thus making Spider-Man and the X-Men ineligible for the Marvel movie-verse.) It was a plan that paid off in the long run, resulting in several box office hits, including 2012's *The Avengers*, one of the highest grossing films of all time.

However, there were some missteps along the way. Perhaps the most notable misstep was 2010's *Iron Man 2*, the sequel to their flagship film, which, despite decent box office results, was largely regarded as a creative disappointment. The film was scattered, derivative, and dull, lacking the spark of Tony Stark's first adventure. *Thor: The Dark World*—the sequel to 2010's *Thor*—was the first non-Iron Man sequel produced by Marvel Studios and so it raised the question, "Would *Thor 2* suffer the same fate as *Iron Man 2*?" Unfortunately, the answer is "yes."

The original *Thor* was a movie that probably should not have worked. While a millionaire playboy with his own personal robot suit definitely sounds like a Hollywood action movie, the story of a Norse god who falls to Earth and fights mythological creatures with a giant hammer sounds like a decidedly harder sell to a movie-going audience. Despite the years of excellent comic book history behind him, Thor is a character who tap-dances on that thin line between "cool" and "silly." Get the character right and he is an iconic hero for the ages. Get the character wrong and he's Fabio with a sledgehammer. Fortunately, director Kenneth Branagh did a fantastic job in translating the character for film, ably balancing the silly and serious sides of the superhero. There was a refreshing sense of self-awareness about Chris Hemsworth's heroic demigod that made Thor both fun and engaging. Branagh and his screenwriters also made the smart decision to turn Thor's origin story into a hybrid between an alien-first contact story and a star-crossed romance. (And executed that plan much more successfully than Zack Snyder did when he adopted the same strategy for 2013's *Man of Steel*.) Although, yes, there were massive, magical battles on the Rainbow Bridge of Bifrost between Thor and his trickster brother Loki (Tom Hiddleston), there were also tender scenes between Hemsworth and Natalie Portman that felt more like John Carpenter's *Starman* (1984) than a traditional Viking tale. Branagh's film had a very definite character arc for Hemsworth, introducing audiences to Thor as a headstrong braggart and placing him through a series of trials that stripped him to his core, taught him humility and responsibility, and showed the audience how he became a hero.

Regrettably, unlike Branagh, *Thor: The Dark World* director Alan Taylor, best known for his stellar work on HBO's *Game of Thrones*, has no real idea what to do with Thor on a character level. His Thor seemingly exists only to pose like a hero and hit things with a hammer when necessary, which is frustrating after the previous film established the character and his motivations so distinctly. The original *Thor* was a romance, ending with Thor and his beloved Jane Foster (Portman) separated by an uncrossable expanse of space. *Thor: The Dark*

World is simply a "hero needs to save the world" story where romance and character growth do not really come into play. Hemsworth still saved the world in the original *Thor*, but those moments that revealed the man behind the hammer were what made the movie special. *Thor: The Dark World* attempts to expand the scope of the universe, but that outward sprawl definitely comes at a cost.

The sequel opens with Thor's father Odin (Anthony Hopkins) giving a history lesson about the origins of the universe. Apparently, in the beginning, there was darkness and, in this darkness, a race of dark elves thrived, led by the evil Malekith (Christopher Eccleston). But, once the rest of the universe emerged into the light, this enraged Malekith, who wanted to destroy all non-dark-elf life using an ancient weapon called the Aether (a distant cousin to the Tesseract, i.e. the mystical deus ex machina from *The Avengers*). Odin's father defeated Malekith, who everyone assumed died, and hid the Aether away (for reasons only a Hollywood screenwriter could explain). Cut to the present day where Thor is travelling around the Nine Realms, cleaning up the unrest his brother Loki stirred up in the first movie. Following *The Avengers*, Loki is now imprisoned in Asgard, pitied only by his adoptive mother Frigga (Rene Russo). Thor is pensive, thinking always of Jane Foster and worrying his friends with his newfound humility. Meanwhile, Jane Foster has been tracking a rare planetary alignment in the hope that her data might lead her to a way to reunite with Thor. Jane's investigations lead her to a series of strange spatial wormholes in London, one of which somehow leads her to the secret hiding place of the Aether. (Stupid, unexplained coincidences like this one are depressingly common in *Thor: The Dark World*. In fact, they drive most of the story.) The ancient sentient weapon occupies Jane's body, which wakes the slumbering Malekith and inspires Thor to go visit his long-distance girlfriend, if only to bring her back to Asgard to try to rid her of her Aether possession.

Hemsworth and Portman, who had such fun chemistry in the original Thor, are given nothing to play in their reunion scenes. Thor appears matter-of-factly and teleports Jane back to his homeworld. He barely cracks a smile. Jane briefly plays hard to get, but just looks happy to see him. To call it unsatisfying would be a massive understatement. All of the romance—the romance that drove the first film—immediately fizzles out of their relationship as these two star-crossed lovers greet each other with the dead-faced equivalent of a "Hey, what's up?" Things get worse when Thor and Jane return to Asgard and it quickly becomes apparent that the film is more interested in Dark Elf invasion plans than anything having to do with the title character. Malekith attacks Asgard, looking for Jane Foster, so he can retrieve

the Aether. Thor and his friends fight back. Shower, rinse, repeat. Malekith needs to obtain the Aether before the Convergence because that is the only time he can use it to destroy the universe, apparently. After Malekith kills someone precious to both Thor and Loki, the two brothers team up to take down the evil elf, each for their own purpose. It all leads up to a final confrontation in London that has some silly fun with teleporting wormholes, but, in the end, is just a lot of CGI bombast and noise.

Thor: The Dark World is a visually impressive film and Hiddleston, per usual, gleefully chews the scenery as Loki, however, the level of stagnation in the storytelling is almost overwhelming. Thor's hammer is more expressive than Thor. He watches loved ones die and barely reacts. He is reunited with his long-lost love and barely reacts. There is not a single moment of character development or evolution. In fact, there is a scene toward the end of *Thor: The Dark World* when Odin offers to make Thor king of Asgard and Thor humbly declines that is completely baffling. Thor's hesitancy to take the throne or his looming decision to become king had never been addressed anywhere in the film. That could have been an interesting internal dilemma for the character to struggle with during the story, but, as it stands, it is a complete non-issue. *Thor: The Dark World* is infinitely more interested in The Dark World than it is in Thor and that's a shame.

Iron Man 2 was a terribly disappointing film, but, to their great credit, Marvel Studios was able to craft a brilliantly inventive and entertaining *Iron Man 3*, reinvigorating the character of Tony Stark and giving the hero a real emotional and personal journey to endure. One hopes that Marvel will be able to utilize that same strategy if they plan to make a *Thor 3*, because the farther they move away from The Dark World, the better.

Tom Burns

CREDITS

Thor: Chris Hemsworth
Jane Foster: Natalie Portman
Loki: Tom Hiddleston
Odin: Anthony Hopkins
Malekith: Christopher Eccleston
Frigga: Rene Russo
Darcy Lewis: Kat Dennings
Erik Selvig: Stellan Skarsgard
Heimdall: Idris Elba
Origin: United States
Language: English

Released: 2013

Production: Kevin Feige; Marvel Studios; released by Walt Disney Studios

Directed by: Alan Taylor

Written by: Chris Yost; Christopher Markus; Stephen McFeely

Cinematography by: Kramer Morgenthau

Music by: Brian Tyler

Sound: Shannon Mills

Music Supervisor: Dave Jordan

Editing: Dan Lebental; Wyatt Smith

Art Direction: Raymond Chan

Costumes: Wendy Partridge

Production Design: Charles Wood

MPAA rating: PG-13

Running time: 112 minutes

REVIEWS

Burr, Ty. *Boston Globe*. November 7, 2013.
Catsoulis, Jeannette. *New York Times*. November 7, 2013.
Corliss, Richard. *Time*. November 7, 2013.
Fear, David. *Time Out New York*. November 6, 2013.
LaSalle, Mick. *San Francisco Chronicle*. November 7, 2013.
Morgenstern, Joe. *Wall Street Journal*. November 7, 2013.
Nicholson, Amy. *Village Voice*. November 5, 2013.
Puig, Claudia. *USA Today*. November 7, 2013.
Rodriguez, Rene. *Miami Herald*. November 7, 2013.
Smith, Kyle. *New York Post*. November 6, 2013.

QUOTES

Loki: "Well done, you just decapitated your grandfather!"

TRIVIA

This is the first Marvel Cinematic Universe film not set in the United States.

THE TO DO LIST

She's going from straight A's to her first F.
—Movie tagline

Box Office: $3.5 Million

There are enough enjoyable, amusing, and darkly laudable things going on in *The To Do List* that it is an easy film to root for. It just takes a little more work—and patience and even denial—to actually like it.

The movie has a couple simple hooks: What if you took the typical boy-loses-virginity teen sex comedy and put a girl on the bawdy, mishap-filled quest instead? And for good measure, set it in the early 1990s, com-

plete with all the expected pre-Internet, pre-cell phone cultural jokes? If any of that sounds appealing to a viewer, then there may be just enough going on in *The To Do List* to carry the film's otherwise formulaic, often-sloppy efforts along for them.

Written and directed by first-time feature filmmaker Maggie Carey, the very R-rated (for language, not nudity) *The To Do List* stars Aubrey Plaza as Brandy Klark, an uptight super student who, upon graduation from high school (as valedictorian, naturally) and drunken exposure to a studly surfer boy (Scott Porter), decides to spend her pre-college summer self-educating herself on all the (meticulously detailed and labeled) carnal activities she had skipped while focused on her academics. Hence her sexual "to-do list," which is mostly an excuse to rattle off a cavalcade of smutty words and phrases.

Carey relentlessly plays out all those semi-fresh angles, sometimes with a chuckle, sometimes with a groan. Pop culture is far enough along at this point that "empowered" women aggressively seeking sexual satisfaction while saying and doing crude and gross things involving body fluids is no longer much of a shocking novelty. Likewise, the film's self-conscious parade of early '90s musical and cultural references quickly grows tiresome. (Look at the pagers! Grunge! Wine coolers! Jean skorts! The Spin Doctors!) Occasionally the film uses one of its '90s tunes sincerely instead of as kitsch, and one of the few times the '90s gimmick works is when Brandy tries to look up her newly discovered cornucopia of sexual slang not on the (not-yet available) Internet's Urban Dictionary, but rather in (bound paper editions of) the *Encyclopaedia Britannica*.

The element of *The To Do List* that works best is the idea of a career-minded, type-A control freak approaching human sexuality and youthful exploration as a sort of naughty research project. That is thanks mostly to Plaza's engagingly oddball presence at the center of the film. A gifted dead-pan comic actress, Plaza usually plays chilly, repressed, or otherwise closed-off queens of detached irony. She does not have much to work with in Brandy—the protagonist, like most of the film's characters, is painted in broad, often contradictory strokes—but Plaza's sardonic charm, with its mix of clueless arrogance and exotic dorkiness, keeps *The To Do List* rolling on long after the sex and '90s jokes have run dry.

Plaza gets decent assistance from the film's solid supporting cast, including Alia Shawkat and Sarah Steele as Brandy's more worldly girlfriends, Johnny Simmons as the Nice Guy she coolly uses to cross items off her list, and especially Carey's husband Bill Hader as her aimless, stoner boss. Connie Britton and Clark Gregg also do well with the familiar "befuddled parents" roles.

Overall, however, *The To Do List* feels scattered and unfocused, as if it is hung up between wanting to be an indie-spirited subversive satire and wanting to indulge and pander to the lower instincts of the more popular raunchy teen sex comedies. That mix is not impossible to pull off—films like *Risky Business* and more recently *Easy A* deftly blend smarts, style, and sex—but Carey cannot seem to bring it all together. She and cinematographer Doug Emmett give their film a bright, flat, plastic look, and that visual obviousness does little to help shake The To Do List from ultimately feeling formulaic.

The To Do List had a limited theatrical run for a few weeks at the end of July and beginning of August, bringing in about $3.5 million at the box office. Critical reactions were average. Some critics embraced the film, such as the *New York Times'* Neil Genzlinger, who wrote, "This movie is smarter and better acted and just plain funnier than most of its predecessors in the my-first-time genre, no matter which sex is losing what." A few actively hated it—Mick LaSalle of the *San Francisco Chronicle* felt it was, "a romantic comedy with no romance and little comedy, but with an ugliness of spirit that's surprising and unrelenting." Most reviewers, however, fell into the middle-ground, with many of them wishing the film was as good as the sum of its parts. *Slate's* Dana Stevens seemed to sum up that attitude, writing, "This thin, floppy comedy never quite became the high-spirited summer sex romp it clearly set out to be. I haven't quite figured out yet why *The To Do List* doesn't work, when so many elements within it seem to."

Locke Peterseim

CREDITS

Brandy Klark: Aubrey Plaza
Fiona: Alia Shawkat
Wendy: Sarah Steele
Cameron: Johnny Simmons
Rusty Waters: Scott Porter
Willy: Bill Hader
Duffy: Christopher Mintz-Plasse
Amber: Rachel Bilson
Mrs. Klark: Connie Britton
Mr. Klark: Clark Gregg
Origin: United States
Language: English
Released: 2013
Production: Sharla Sumpter, Mark Gordon, Tom Lassally, Brian Robbins, Jennifer Todd, Greg Walter; 3 Arts Entertainment; released by CBS Films
Directed by: Maggie Carey

Written by: Maggie Carey
Cinematography by: Doug Emmett
Music by: Raney Shockne
Sound: Dennis Grzesik
Music Supervisor: Howard Par
Editing: Paul Frank
Art Direction: Eric Berg
Costumes: Tracye Gigi Field
Production Design: Ryan Berg
MPAA rating: R
Running time: 104 minutes

REVIEWS

Genzlinger, Neil. *New York Times*. July 25, 2013.
Jones, Kimberley. *Austin Chronicle*. July 24, 2013.
LaSalle, Mick. *San Francisco Chronicle*. July 25, 2013.
Merry, Stephanie. *Washington Post*. July 26, 2013.
Ogle, Connie. *Miami Herald*. July 25, 2013.
Phipps, Keith. *The Dissolve*. July 25, 2013.
Scherstuhl, Alan. *Village Voice*. July 22, 2013.
Sharkey, Betsy. *Los Angeles Times*. July 25, 2013.
Stevens, Dana. *Slate*. July 28, 2013.
Wloszczyna, Susan. *RogerEbert.com*. July 26, 2013.

QUOTES

Judge Klark: "There are doors we don't do. The back door is one of them."

TRIVIA

All of the teenagers in the film are played by adults, most of them are over the age of 25.

TO THE WONDER

Box Office: $587,615

From his stunning debut with *Badlands* (1973), the films of Terrence Malick have always divided viewers between those who find his works to be impressionistic tone poems that blend heady philosophical concerns with ravishing visual beauty and which prefer to convey drama and emotion through visual means rather than spelling them out and those who find them to be pretentious twaddles in which such concerns as plot and character development have been arbitrarily junked in order to fill the frame with endless shots of pretty young girls twirling through gently blowing wheat fields. With the release of his sixth feature film, *To The Wonder*—coming less than two years after his previous effort, the highly acclaimed *The Tree of Life* (2011)—even some of his most dedicated followers found themselves confused

and alienated by a work that struck them as perhaps too enigmatic even by his standards and it quickly disappeared from theaters. It may indeed be the least satisfying entry in his oeuvre to date but even lesser Malick still stands far above the pack and despite its flaws, the film still has plenty of cinematic riches to bestow on anyone willing to accept it on its admittedly unique terms.

Set in the present day (another mild shock for Malick followers as his films have, with the exception of the contemporary Sean Penn material in *The Tree of Life*, always been set in the past), the film stars Olga Kurylenko as Marina, a Ukrainian divorcee living in France with her ten-year-old daughter Tatiana (Tatiana Chiline). As the story begins, she has met and fallen in love with Neil (Ben Affleck), an American traveler on an extended holiday. As they go from Normandy's Mont Saint-Michel to the streets and shops of Paris, it is clear that Marina is head over heels for the guy, and, while Neil may not be quite as demonstrative, he does have a certain affection for both her and her daughter. When it comes time for him to return home to Oklahoma, where he works as an environmental inspector, he invites her and Tatiana to join him and they happily accept.

At first, all seems well but, after a while, it becomes evident that Neil is having second thoughts about this decision. Things soon begin to deteriorate between the couple and when Marina's visa expires, she and Tatiana return home to France while Neil eventually begins to take up with old acquaintance Jane (Rachel McAdams). However, this new relationship soon leaves him feeling restless and dissatisfied as well and it too falls apart. Eventually, he reestablishes contact with Marina and when he learns that she is having troubles, he brings her back to Oklahoma in the hopes of making a fresh start only to find the old problems cropping up again. Hovering on the outskirts of the story during all of this is Father Quintana (Javier Bardem), a local priest who is himself immersed in an existential funk due to his own personal crisis of faith.

All of this sounds simple enough but it has been presented in the highly enigmatic manner that has become Malick's default storytelling mode as of late. For starters, viewers do not even learn the names of the central characters until the end credits begin to roll. There are precious few scenes in which those characters actually exchange lines of dialogue and when they do, they are presented in a hushed and halting manner that makes it seem as if viewers are eavesdropping on the lives of these people but which is often too inaudible to discern what is being said. Ben Affleck, for example, delivers what has to be the fewest lines from a male lead in a major American film that did not feature Charles Bronson in a starring role. The others have a little more

to work with but if you took away all the voice-over, all of the stars were probably off-book by the time of the first script read-through.

On the other hand, there *is* plenty of voiceover—mostly courtesy of Marina (whose lines are almost entirely delivered in French) though all the main characters get a crack at it at some point—and after a while, the suspicion may begin to grow amongst viewers that much of it was added in at some point in order to spackle over large holes created during the extensive editing process. (As per usual with Malick, he shot far more than he used and this time around, filming scenes with Jessica Chastain, Rachel Weisz, Michael Sheen, Amanda Peet, and Barry Pepper but not one of them appears in the final cut.) According to IMDB, Malick supposedly shot the film without a formal script and while that sounds more like a sarcastic jab than anything else, it must be said that if there was ever a film where that might have been the case, *To the Wonder* is certainly it. Most of these voiceovers are delivered while the characters wander through landscapes meant to mirror their psyches—Neil is often seen in muddy surroundings silently mourning an ailing Mother Earth that represents his inability to connect with those around him while Marina twirls cheerfully through fields, lawns and beaches with such carefree abandon that an exceptional shameless person might suggest that she has either been possessed by the spirit of Natalie Merchant or that she has a serious gamboling problem.

To the Wonder is such an overt channeling of the peculiar cinematic style of its creator that there are times when it teeters dangerously close to looking like an astonishingly detailed and resolutely straight-faced spoof of his entire oeuvre and if it had been made by virtually any other filmmaker working today, it would almost certainly have been dismissed across the board as a pretentious mess that has no clear idea of what it wants to say or how it wants to say it. And yet, despite its overt flaws, it is an undeniably compelling moviegoing experience and those willing to give it the chance of a repeat viewing will find it to be even more fascinating the second time around when they are able to work around its odd structure and fully embrace what lies beneath. This is one of the most deeply felt films to come along in some time—even if one did not already know ahead of time that the story being told was semi-autobiographical in nature, they would have immediately suspected it because every scene teems with a sense of the awkward and unruly nature of human emotion that can only be gleaned from direct experience.

This is not a film where everyone is glib and well-spoken and where all their personal problems do not follow convenient narrative arcs on the way to pat conclusions. Malick's extension of the non-linear narra-

tive approach that he utilized in *The Tree of Life* proves to be an interesting through-point for what might have otherwise been a conventional tale of a transatlantic romance gone bust. And, of course, like all of Malick's films, every frame is visually ravishing as cinematographer Emmanuel Lubezki creates one breathtaking image after another that effectively captures both the vast expanses and infinite possibilities of romantic bliss and the claustrophobic nature of what happens when it all goes bad.

By the conventions of contemporary America cinema, *To the Wonder* does not "work" for the most part. There is not much of a story and what little there is of it is not especially gripping, the characters are largely ciphers (aside from Marina, who Kurylenko brings vibrantly to life through her undeniably engaging performance), and it does not so much end as simply fade into the ether. And yet, even though it is not an entirely satisfying film in many ways, watching Malick working in a minor key is undeniably fascinating and proves that even a second-tier effort from him adds up to a far richer moviegoing experience than the top-shelf offerings of practically anyone else out there these days. It may not be for most people and even many of those that it might actually be for may find themselves put off by it at times. For those who are willing to embrace its wonders despite its flaws and ramblings, *To the Wonder* is worth the effort and then some.

Peter Sobczynski

CREDITS

Neil: Ben Affleck
Marina: Olga Kurylenko
Jane: Rachel McAdams
Father Quintana: Javier Bardem
Origin: United States
Language: English
Released: 2012
Production: Nicolas Gonda, Sarah Green; Brothers K Productions; released by Magnolia Pictures
Directed by: Terrence Malick
Written by: Terrence Malick
Cinematography by: Emmanuel Lubezki
Music by: Hanan Townshend
Sound: Craig Berkey
Editing: A. J. Edwards; Keith Fraase; Shane Hazen; Christopher Roldan; Mack Yoshikawa
Costumes: Jacqueline West
Production Design: Jack Fisk
MPAA rating: R
Running time: 112 minutes

REVIEWS

Chang, Justin. *Variety*. April 8, 2013.
Denby, David. *The New Yorker*. April 15, 2013.
Dujsik, Mark. *Mark Reviews Movies*. April 12, 2013.
Ebert, Roger. *Chicago Sun-Times*. April 10, 2013.
Kauffmann, Stanley. *The New Republic*. June 13, 2013.
McCarthy, Todd. *The Hollywood Reporter*. September 3, 2012.
Reed, Rex. *The New York Observer*. April 10, 2013.
Scott, A. O. *The New York Times*. April 11, 2013.
Stevens, Dana. *Slate*. April 11, 2013.
Zacharek, Stephanie. *The Village Voice*. April 9, 2013.

QUOTES

Anna: "Life's a dream. In dream you can't make mistakes. In dream you can be whatever you want."

TRIVIA

At the Venice Film Festival, the film was met with both boos and cheers.

A TOUCH OF SIN
(Tian zhu ding)

Box Office: $154,005

Given the political climate of the country in which it was shot, it is something of a miracle that Jia Zhangke's *A Touch of Sin* even exists. China has long been known as a country that does not allow creative criticism of its people or power structure through cinema. And yet here is Jia's dissection of the undercurrent of violence in his country that has started to flow more consistently due to the growing chasm between the haves and the have-nots. Each chapter in this quartet of interlocking stories centers on people pushed to the edge by a society that does not seem to mind if they go over it. It is not exactly a positive look at the social infrastructure of China; it is a harrowing, riveting piece of major filmmaking.

The moments of violence in Jia's script have a clear focus. A woman who works at a massage parlor/sauna is beaten with money by a man who demands she service him as a prostitute. A coal miner goes through life stunned that the villagers around him pay honor to a man who has given nothing back to them and failed to fulfill his promises to elevate the community. A young worker is injured on the job and given nothing in compensation because he happened to be making "small talk" at the time. An aimless young man fights the boredom of his existence with gunfire. Many have read Jia's interrelated stories, all based on real events, as a

commentary on the influence of capitalism in China, and that element is hard to deny, but he has also made an entertaining, complex cinematic vision that has drawn comparisons to the tonal balance of someone like Quentin Tarantino that seems appropriate.

Pulling real-life stories from around his country, Jia attempts to weave a narrative tapestry that can sometimes feel a bit too studious. In an effort to display how these moments of violence among average people are happening everywhere, there are long shots of people travelling. These are not problems of one part of the country or small villages—they are everywhere. And some of the visual symbolism can be a bit too underlined (when Jia frames a horse stuck in the mud being whipped to near-death by its owner, the commentary on the coal miners being treated the same in a less-direct manner feels a bit too on-the-nose) but this is still a fascinating piece of storytelling. It is a film that constantly teeters on the edge of going too far, whether it is with its violence, scope, or message, but always pulls itself back. It is a tightrope act.

Jia opens with a scene of violence right out of a Sergio Leone Western. A man rides up on a motorcycle and is beset upon an open road by three thugs looking for a made-up toll. He pulls out a gun and shoots the trio. The source of violence and even death is one that is never clear. And Jia sets up a narrative tenet by nearly letting one of the thugs escape his unexpected murderer. In the world of *A Touch of Sin*, people almost get away from the cultural quicksand that is pulling them to violence but not quite.

While the film definitely says something important about the current socio-economic state of China, the four stories of *A Touch of Sin* feel all-too-possible in other parts of the world as well. While much of the experience of Jia's film will be associated with the film's striking imagery, it is worth noting that Jia won the screenwriting award at the 2013 Cannes Film Festival, due in no small part to his ability to make his narrative humane and relatable to many cultures and ethnicities. When Jia's frustrated miner dares to challenge the power structure that all of his friends and peers allow to continue unchallenged, his motives feel germane to the Occupy Wall Street movement and other battles for economic equality around the world. And so when Jia then takes the character a step further to an expected murderous end, the viewer understands the journey. Like so many, he needs to be heard in a world that so often fails to hold people in power to their promises. It is important that the final segment is the most melancholic, least frenetic, least stylish of the segments; it feels like Jia is calling for a little bit of peace just through the somberness of the way he chooses to end his film. If he opens with a film style that feels like Leone or Tarantino, he

has climbed down from cinematic homage to something more realistic by the final act; daring viewers to forget the fact that these stories are all tragically true ones.

Brian Tallerico

CREDITS

Dahai: Wu Jiang
Xiao Hui: Lanshan Luo
Zhou San: Baoqiang Wang
Xiao Yu: Tao Zhao
Origin: China
Language: Chinese, English
Released: 2013
Production: Shozo Ichiyama; Office Kitano; released by Koch Lorber Films
Directed by: Jia Zhangke
Written by: Jia Zhangke
Cinematography by: Yu Likwai
Music by: Giong Lim
Sound: Yang Zhang
Editing: Matthieu Laclau; Xudong Lin
Art Direction: Weixin Liu
MPAA rating: Unrated
Running time: 113 minutes

REVIEWS

Cabin, Chris. *Slant Magazine*. September 28, 2013.
Dargis, Manohla. *New York Times*. October 3, 2013.
Dowd, A. A. *The A.V. Club*. October 2, 2013.
Jenkins, Mark. *NPR*. October 4, 2013.
Marsh, Calum. *Film.com*. September 23, 2013.
O'Hehir, Andrew. *Salon.com*. November 4, 2013.
Stamets, Bill. *Chicago Sun-Times*. November 21, 2013.
Tobias, Scott. *The Dissolve*. October 2, 2013.
Turan, Kenneth. *Los Angeles Times*. October 10, 2013.
Zacharek, Stephanie. *Village Voice*. October 1, 2013.

TRIVIA

Director Zhangke Jia makes a cameo appearance in the third story as a patron of the brothel. He can be seen walking down a hallway from behind talking on a cell phone, smoking a cigar. At the end of the shot he turns to survey the line of girls in the hallway.

AWARDS

Nominations:

Ind. Spirit 2014: Foreign Film

TOUCHY FEELY

Box Office: $36,128

Touchy Feely is one of those easygoing indie comedies about relationships that seem to be the specialty

of directors such as Joe Swanberg, Nicole Holofcener, and Lynn Shelton, the director of this film. Shelton comes from the Mumblecore school of filmmaking, a lo-fi approach that carries with it moments of improvisation, slow build-ups to reveal the storyline, and everyone behaving the way normal people actually behave, almost giving it a documentary-like feel. But *Touchy Feely* is a little more scripted than that and much of its cast will be instantly recognizable to those who follow all aspects of indie filmmaking. These films contain likable characters in real-life situations, but are not terribly ambitious cinematically. Most of the time, *Touchy Feely* is not any kind of exception to any rules, but it knows its characters thoroughly, empathizes with them and, generally likes them.

The film centers on a masseuse named Abby (Rosemarie DeWitt), whose brother Paul (Josh Pais) is a dentist with a fledgling practice and a no-frills lump of a human being who is only too happy to be in his office getting work done. Abby, at one point, describes him as "depleted" and "wan." His daughter, Jenny (Ellen Page) wants him to branch out more and do what it takes to get new clients, but she also has to break free of her father's dental practice and be her own person. Abby's boyfriend Jesse (Scoot McNairy) pressures her to move in with him since she is at his apartment every day anyway. He asks her in front of her whole family during dinner. She agrees but is incredibly reluctant because she feels Jesse is her rebound from a previous relationship.

Abby confides in another massage therapist named Bronwyn (Allison Janney), who encourages her to go through with it. Abby also wants Bronwyn to work on Paul to get him to loosen up. Jenny, meanwhile, takes it upon herself to give one of her friends a teeth cleaning even though she is not technically qualified. A few days later she tells her father that he cured her friend of his lockjaw problem. She makes a point of saying this in front of a client who just so happens to have a relative with the same problem. Eventually, business starts booming as word gets around that Paul is a master at curing dental ailments. He denies having this ability, but the clients insist "that's okay. Just do what you did for the last guy who was in here."

Abby, meanwhile, begins to have issues about being touched. At one point, she stops by Jesse's workplace and takes him to the back room where she asks him to remove his shirt and kiss her. The second he touches her, she runs out of the place. Abby does not know what to make of this sudden resistance to connection. Bronwyn prescribes some ecstasy for her in order to loosen her up. This further confuses Jesse who is still reeling from their previous bizarre encounter. The film's funniest scene occurs when Paul finally makes a visit to Bronwyn for a special therapeutic massage. When asked to put himself in a special place, he insists that his office is the one place in his life where he feels at peace. Not a sandy beach. His office.

Like Nicole Holofcener, whose film *Enough Said* (2013) also focused on a masseuse, Shelton often utilizes a theme to unite her characters, in this case the power of non-sexual touch as a source of healing. Paul's way of healing is more mechanical and consists of rules, which makes it a comfortable means of helping people without getting too intimate (since nobody can talk while getting a dental exam anyway). Bronwyn's way of healing others is more abstract, perhaps even fraudulent, the type who talks about things like toxins and personal energy fields as a way of navigating someone's personal state of mind. She might not even believe her own logic. Why else would she hand over some ecstasy pills as a cure-all?

These themes are explored intelligently and without the use of the obvious. Perhaps a lesser film would have worked in a character who relied on a cell phone or computer for human contact but *Touchy Feely* explores its themes a little more cinematically than is common for this genre. It is not content to simply converse about these issues, particularly when a new character is introduced late in the film, a former boyfriend of Abby's named Adrian (Ron Livingston). So many of these story threads make their turning points as another character sings "Is it a blessing or a curse/To be found, to be found." By the film's end, the answer is clearly both, since *Touchy Feely* is as much about unrequited love as it is about unfulfilled living. But these characters clearly need each other in their lives even if they cannot heal one another.

Collin Souter

CREDITS

Abby: Rosemarie DeWitt
Paul: Josh Pais
Jenny: Ellen Page
Jesse: Scoot McNairy
Bronwyn: Allison Janney
Origin: United States
Language: English
Released: 2013
Production: Steven Schardt; released by Magnolia Pictures
Directed by: Lynn Shelton
Written by: Lynn Shelton
Cinematography by: Benjamin Kasulke
Music by: Vinny Smith
Sound: Kelsey Wood

Editing: Lynn Shelton
Costumes: Carrie Stacey
Production Design: John Lavin
MPAA rating: R
Running time: 111 minutes

REVIEWS

Adams, Sam. *Time Out New York.* September 3, 2013.

D'Angelo, Mike. *AV Club.* September 5, 2013.

Demara, Bruce. *Toronto Star.* October 11, 2013.

Gleiberman, Owen. *Entertainment Weekly.* September 5, 2013.

Hartl, John. *Seattle Times.* September 12, 2013.

Lacey, Liam. *Globe and Mail.* October 11, 2013.

Linden, Shari. *Los Angeles Times.* September 12, 2013.

Lucca, Vincent. *Village Voice.* September 3, 2013.

Lumenick, Lou. *New York Post.* September 6, 2013.

Sartin, Hank. *RogerEbert.com.* September 6, 2013.

TRIVIA

At one point, writer/director Lynn Shelton toyed with the idea that Ron Livingston's character wasn't real, but that idea was scrapped.

TRANCE

Box Office: $2.3 Million

The heist film has been twisted and tangled every which way that the blueprint could be taught by now in a kindergarten screenwriting class. Get a target, put together a colorful team of intermingling skill sets, and then doubleback upon the forward motion of the storytelling to fool not just the antagonist but the audience as well. The gravity-bound turns of the genre have become so commonplace that filmmakers have started taking viewers into the human mind as Christopher Nolan did so brilliantly with *Inception* (2010) or literally trying to make things disappear as in Louis Leterrier's ineptly concocted *Now You See Me* (2013). Director Danny Boyle and longtime collaborator John Hodge did their own set of lifting from Joe Ahearne's 2001 telefilm with *Trance* but are beset in throwing everything at an audience to give them a uniquely ludicrous, if crazily satisfying, cinematic experience.

Simon (James McAvoy) is an art auctioneer in London who knows the storied history of art theft around his parts. Used to be one could walk right in, hit a couple people on the head and walk out with a priceless painting. Nowadays there is a plan. Simon's job is to obtain the object before the criminals do and secure it in a backstage safe. When the day comes for him to

put this very simple plan in motion, Simon ignores the first rule of his employers—"Don't be a hero"— and tries to disengage the ring leader himself. Franck (Vincent Cassel) rewards his bravery with a blow to the head and gets away, but without the painting.

Franck and his gang track down Simon after a stay in the hospital only to discover that he has developed amnesia as a result and cannot remember where he stashed the valuable. In the hopes of unlocking what is inside his head, the gang takes Simon to Elizabeth Lamb (Rosario Dawson), who specializes in hypnotherapy. It takes only one session for her to realize that Simon is under the gun and making appointments to find more than his keys. Her efforts to protect Simon put her in close contact with Franck whom she must somehow convince to loosen the threatening hold he has on her client so he can loosen up enough to produce what everyone wants.

Maintaining the labyrinthine turns that *Trance* takes from here is a juggling act on the part of everyone involved. Even without the barest of missteps that can collapse the story upon itself, viewers could still find themselves checking out of its ridiculous psychology long before it douses itself in overdrive fuel to rocket past the point of no return. Boyle is smart enough to keep focused on the characters more than the buried motivations ready to turn the plot. Only hinting at who knows what and when, Boyle and Hodge intend to draw the viewer into the very hypnosis that is designed to make them forget about those hints and drive them faster towards the ultimate truth. With Rosario Dawson's silken voice as a guide, it is very easy for the men watching to wonder if they are in the middle of a dream or being equally manipulated by her presence.

Dawson's performance is a key to the success of *Trance* and it is one of her very best. Confident but equally vulnerable in a room full of thugs, she has to inspire sympathy for her predicament while avoiding any inference that she could be the femme fatale, preying on their desires and fears. McAvoy has just as tricky a minefield as Simon who begins the film as the smart-if-dopey wannabe hero and then goes through a process of stripping away his innocence and enjoying the transference of power into a cocky lout. Trapped in the middle is Cassel who wisely plays Franck as more of a gentleman gangster; calm, reasonable and charming. Behind that exterior, Cassel never lets viewers quite know which direction he is going to shift from scene to scene. When he says he is not going to kill Simon for the trouble he has caused, he is believable, even as things begin to spiral out of control. That is a unique take on a character that most scripts would present as a constant menace and threat of excessive violence.

"Everyone knows amnesia is bollocks," says one character, likely mimicking the thoughts of viewers who have had a few experiences with the soap opera contrivance. Boyle deliberately turns his focus to the reasons for that amnesia and tries to make viewers forget about the Macguffin that is gliding everyone towards a furiously fiery climax. Thoughts drift towards movies that explored similar territory from *Inception* to *Eternal Sunshine of the Spotless Mind* (2004). Just for good measure they throw in a little of the gory insanity of *Videodrome* (1983) to make sure that viewers are all paying attention. Here is a movie that lifts viewers up for a treble-pulsating journey of Rick Smith's music through soothing whispers that also dares them to think about and rewind its casual insanity over and over again.

Erik Childress

CREDITS

Simon: James McAvoy

Franck: Vincent Cassel

Elizabeth: Rosario Dawson

Origin: United Kingdom

Language: English

Released: 2013

Production: Christian Colson, Danny Boyle; Cloud Eight Films, Decibel Films, Film4 Library, Pathe; released by Fox Searchlight

Directed by: Danny Boyle

Written by: John Hodge; Joe Ahearne

Cinematography by: Anthony Dod Mantle

Music by: Rick Smith

Sound: Glenn Freemantle

Editing: Jon Harris

Costumes: Suttirat Anne Larlarb

Production Design: Mark Tildesley

MPAA rating: R

Running time: 101 minutes

REVIEWS

Bell, Josh. *Las Vegas Weekly*. April 11, 2013.

Burr, Ty. *Boston Globe*. April 11, 2013.

Dequina, Michael. *TheMovieReport.com*. May 6, 2013.

Duralde, Alonso. *The Wrap*. April 5, 2013.

Larsen, Josh. *LarsenOnFilm*. April 11, 2013.

Orndorf, Brian. *Blu-ray.com*. April 11, 2013.

Phillips, Michael. *Chicago Tribune*. April 11, 2013.

Putman, Dustin. *DustinPutman.com*. April 11, 2013.

Singer, Matt. *Screencrush*. April 12, 2013.

Vonder Haar, Pete. *Houston Press*. April 14, 2013.

QUOTES

Simon: "No piece of art is worth a human life."

TRIVIA

Michael Fassbender was cast as Franck but dropped out due to scheduling conflicts. Colin Firth was then briefly considered for the part before Vincent Cassel was ultimately cast.

TURBO

Slo no mo.
—Movie tagline

He's fast. They're furious.
—Movie tagline

Better fast than furious.
—Movie tagline

Wired for speed.
—Movie tagline

Box Office: $83 Million

For the past few years, the animation giant Pixar has been languishing in sub-par material and getting too caught up in the trap of going back to the well and cranking out some sequels instead of the highly original output they had long been known for. *Toy Story 3* (2010) was certainly a worthy finale to the series, but then came their low point, *Cars 2* (2011), a sequel to their weakest film yet, and *Monsters University* (2013), a prequel to *Monsters, Inc.* (2001) that lacked even the slightest bit of ambition (at least *Cars 2* had a specific genre in mind). Their only original film since *Up* (2009) was *Brave* (2012), which purportedly was a story of a female warrior asserting herself, but instead turned out to be a retread of several weak Disney films, most notably *Brother Bear* (2003).

Pixar's young fans do not seem to mind, since the films consistently make money, but their closest contemporary DreamWorks Animation has now gone to the Pixar playbook to tell a story of an unlikely hero with their film *Turbo*. It is an imitation that should actually be looked at as a form of flattery rather than a lack of imagination. Writer-Director David Soren (making his feature debut) and his co-writers Darren Lemke and Robert D. Siegel have borrowed from the kind of thing Pixar used to do really well. While nowhere near on par with Pixar's best, *Turbo* has the feeling of a group of animators and storytellers who have cracked the code and have come up with something fun and refreshing in its own right.

The unlikely hero is a snail named Theo (voiced by Ryan Reynolds) who dreams of racing in the Indy 500. He lives with other snails near a suburban home. They all work at "the plant" where they harvest tomatoes and have a factory system worked out. They have long, boring meetings involving safety, which are often interrupted by a random crow flying in and snatching one of

he worker snails. Theo's brother Chet (voiced by Paul Giamatti) cannot understand Theo's obsession and wishes he would stop staying up late inside the house and watching videos of Guy Gagne (voiced by Bill Hader), the current Indy 500 champion. "The sooner you accept your miserable existence, the happier you'll be," Chet says to Theo.

One night, after a mis-hap involving Theo's race against a lawnmower, Theo decides to leave the house. A series of unfortunate events leads him to the streets where a race between two real cars along the lines of a Fast and the Furious movie takes place. For simply being in the wring place at the wrong time, Theo gets sucked into the car's engine and ends up ingesting every possible fluid until he flies out the tailpipe. Suddenly, Theo finds he can actually move faster than most cars should be allowed to, up to 200 mph if necessary. He also has headlights in his eyes and a car alarm in case anyone tries to pick him up. He now has the power to race against real cars, leaving a bright, blue streak in his wake that anyone can see.

In one of the wildest plot conveniences in recent years, Theo and Chet wind up in a strip mall taco food truck where one of the owners, Tito (voiced by Michael Pena), happens to have a hobby involving snail racing. Tito has five funny, good-natured snails with all sorts of car-like bling attached to his pets just to give them style, but once Theo puts himself in one of their races, the dynamic changes and Tito has the same dream as Theo, to enter him as a legitimate racer in the Indy 500. But Tito has a brother not unlike Chet, a skeptic named Angelo (voiced by Luis Guzman) who cannot take another one of Tito's publicity stunts to help drive business to the failing mini mall. But Tito is determined, much like Theo who has earned the nickname Turbo.

The storyline of Turbo is rather slight since it does not contain much in the way of an antagonist. Everything happens rather agreeably until midway through the third act during the big race (no surprise who that antagonist turns out to be). The story, such as it is, borrows elements of Pixar's *Ratatouille* (2007), in which a small creature served as inspiration to an actual human; *Finding Nemo* (2003), in which two main characters venture into the unknown to fulfill a greater destiny; and, quite obviously, *A Bug's Life* (1998), which also told the story of a bug who yearned to do more with his life than be a timecard-punching worker. Turbo would also find himself at home in *The Incredibles* (2004), given his superhuman abilities. The *Cars* (2006) element is almost too obvious to mention.

But the imitation is done well and Turbo works because of its commitment from the cast and crew. This is not in the same crass, snarky vein as *Shark Tale* (2004),

DreamWorks' insufferable answer to *Finding Nemo*. There are plenty of gags in Turbo that work, particularly the running gag with the crow snatching up snails, as well as the multiple use of the snails' eyes, which are sometimes used as arms. Soren and his team of animators even do the same behind-the-scenes homework as Pixar by employing a renowned cinematographer, in this case Christopher Nolan's cinematographer Wally Pfister, to help with some of the more elaborate racing sequences, all of which are beautifully executed and strangely believable. The voice work from the cast may not be the most inspired, but perhaps more importantly, it also does not distract. The choice to set the story in as specific a location as Van Nuys, California is also a nice touch.

Turbo may lack ambition in terms of its storyline, but it was a welcome surprise in a year where jus about every other animated film felt lacking. The film opened to lukewarm reviews and an indifferent public. Its target audience (kids, obviously) were still too caught up in the shenanigans of the little, yellow minions in *Despicable Me 2*, which opened just two weeks earlier and all but stomped its competition. A seemingly innocuous movie about a racing snail never had a chance, not even after Pixar delivered its laziest film yet with *Monsters University*. Turbo, at the time of its release, was a rare case of an imitation being better than the real thing.

Collin Souter

CREDITS

Turbo: Ryan Reynolds (Voice)
Chet: Paul Giamatti (Voice)
Tito: Michael Pena (Voice)
Whiplash: Samuel L. Jackson (Voice)
Burn: Maya Rudolph (Voice)
Angelo: Luis Guzman (Voice)
Guy Gagne: Bill Hader (Voice)
Smoove Move: Snoop Dogg (Voice)
Bobby: Richard Jenkins (Voice)
Kim Ly: Ken Jeong (Voice)
Paz: Michelle Rodriguez (Voice)
Origin: United States
Language: English
Released: 2013
Production: Lisa Stewart; DreamWorks Animation; released by Twentieth Century Fox Film Corp.
Directed by: David Soren
Written by: David Soren; Darren Lemke; Robert Siegel
Cinematography by: Chris Stover
Music by: Henry Jackman
Sound: Richard King

Editing: James Ryan
Production Design: Michael Isaak
MPAA rating: PG
Running time: 96 minutes

REVIEWS

Bernard, Linda. *Toronto Star.* July 17, 2013.
Chaney, Jen. *Washington Post.* July 17, 2013.
Covert, Colin. *Minneapolis Star Tribune.* July 17, 2013.
Guzman, Rafer. *Newsday.* July 16, 2013.
Kenny, Glenn. *MSN Movies.* July 19, 2013.
MacDonald, Moira. *Seattle Times.* July 17, 2013.
Minnow, Nell. *Chicago Sun-Times.* July 17, 2013.
Neumaier, Joe. *New York Daily News.* July 17, 2013.
Schager, Nick. *Village Voice.* July 16, 2013.
Scott, A. O. *New York Times.* July 16, 2013.

QUOTES

Whiplash: "I'm gonna pretend I didn't hear what I clearly just
heard."

TRIVIA

An IndyCar was parked inside the DreamWorks studio during
production to provide artists immediate access to the race
cars featured in the film.

12 YEARS A SLAVE

*The extraordinary true story of Solomon
Northup.*
—Movie tagline

Box Office: $49.1 Million

Steve McQueen's film work (*Hunger* [2008], *Shame*
[2011]) has always been tactile and experiential. With
12 Years a Slave, adapted from Solomon Northrup's har-
rowing 1853 memoir by screenwriter John Ridley, Mc-
Queen has moved into new territory. While the film
maintains McQueen's aesthetic, with sumptuous visuals
captured in long takes, and, like his previous features,
deals with far-reaching moral themes, it has a newfound
narrative drive. It is both his most powerful and his
most accessible work to date, and from the director of
Hunger, that is really saying something.

Chiwetel Ejiofor stars as Northrup, and the film
opens with him already in bondage, being instructed on
the harvesting of sugarcane by an overseer. Early in the
film, he tries to fashion a pen from a stick, and ink
from the juice of a few blackberries, and quickly grows
frustrated. By showing his desperation, deprivation, and
despair, before flashing back to the details of his kidnap-

ping, McQueen prepares his audience for the horrific
journey to come.

Northrup, a free man, leaves his family in Saratoga,
New York and falls in with two dandyish performers,
Brown (Scoot McNairy) and Hamilton (Taran Killam),
who hire him as a musician, bring him to Washington,
DC, and betray him, turning him over to vicious slave
traders. He wakes up in chains in a bare room, and
when he angrily explains his situation to his captors, he
is beaten bloody. Throughout the early part of the film,
he is repeatedly warned not to tell anyone that he is
from New York, or that he is a free man with a family.
He is ordered to answer to the name the slavers give
him, Platt. Northrup quickly learns how dangerous it
would be to resist his captors, when another man
(Michael Kenneth Williams) onboard his slave ship tries
to prevent a rape and is murdered without a second
thought.

McQueen then shows a pivotal flashback of
Northrup and his family in Saratoga, preparing for a
trip his wife is taking. An awe-struck young man, Jasper
(Marcus Lyle Brown), follows Northrup and his family
into a shop, and watches intently as Northrup is served
by the white shop owner. An older white man comes in
to retrieve Jasper, apologizing to the shopkeeper, and it
becomes clear that the young man is a slave. The scene
does not serve a major purpose in terms of the narrative,
but it is key to McQueen's thematic concerns. It shows
that Northrup had led a life of privilege, and did not
normally encounter or think of the enslavement of his
people. As the film cuts back to Northrup's increasing
torment, this scene throws it all into sharp relief, and is
the first undeniable indication that McQueen's film is
not simply about history, but is meant to interrogate the
viewer's passivity regarding injustice.

In Louisiana, Northrup is sold to Ford (Benedict
Cumberbatch), along with Eliza (Adepero Oduye), a
distraught mother separated from her two young
children. At Ford's plantation, Northrup quickly
establishes himself as an intelligent, talented slave, and
gains the master's favor. Ford responds to his ideas, and
gives him a fiddle, and Northrup is grateful. Meanwhile,
Eliza cannot get over the despair of losing her two
children. She wails and sobs constantly, causing
consternation for Ford and his wife (Liza J. Bennett).

In one of the most powerful and thought-provoking
scenes in a film that excels in both of those qualities,
Northrup grows angry with Eliza as they sit outside the
slave quarters, and shouts at her to stop crying. His
frustration is understandable. Her wailing also makes
the audience uneasy. When Eliza expresses her lack of
concern about disturbing Ford and his wife, Northrup
defends Ford as a decent man. Eliza points out that

Ford must know that Northrup is not supposed to be there, but keeps him as his property. She is correct, of course, but Northrup refuses to see that while Ford may be kind, he is engaged in a great evil. In the book, Northrup spends a lot of time praising Ford for his religious devotion and his relative kindness, but the book was for a different time. The movie makes it very clear how delusional this thinking is. Unable to convince Northrup of Ford's failings as a human being, Eliza finally pleads, simply and heartbreakingly, "Solomon, let me weep for my children." Again, McQueen and Ridley have cannily implicated the audience for their impatience with the character's grief. The filmmakers clearly mean to make their audience uncomfortable, because a film about slavery which did not make the audience uncomfortable would be an abject failure.

While Northrup impresses Ford, he runs afoul of Ford's head carpenter, Tibeats (Paul Dano in the typical Paul Dano craven creep role), who clearly resents Northrup's intelligence and his self-possession. When he is unfairly berated by Tibeats, Northrup argues, enraging him. When Tibeats tries to beat Northrup, he instinctively fights back, and chases the carpenter away. Tibeats returns with two men, intent on lynching Northrup. They beat him, tie the noose around his neck, and hang him from a high tree branch. Ford's overseer, Chapin (J.D. Evermore), bearing a rifle, interrupts them, and threatens to kill them if they proceed, not out of any sense of decency, but because Ford is still paying off the note he used to purchase Northrup, and will be out the money if Northrup is killed. In a uniquely brutal, astonishing, and brilliantly realized sequence, the men run off, and Chapin sends for his boss, leaving Northrup hanging from the branch, hands tied behind his back, on his toes, barely finding purchase in the mud underneath him. Gradually, the life of the plantation resumes around him. Slaves perform their jobs without so much as a glance in his direction, slave children play in the background, Ford's wife and Chapin look at him from a distance, and the sky slowly darkens. McQueen shoots Northrup in long shots, with life continuing on around him, and in close-ups of his desperate face, with passerby and onlookers in the distance. Again, the filmmakers implicate the audience with this scene, as people so accustomed to the horrors of the world around them, they can act as though they cannot see what is right before their eyes.

Ford could be a decent man, but he is trapped in an inherently evil structure. He saves Northrup from Tibeats, only to sell him to Epps (McQueen regular Michael Fassbender), a cotton farmer with a reputation for brutalizing his slaves. Epps works his slaves relentlessly, and Northrup is beaten frequently for not meeting Epps' capricious standards for production. Northrup makes an abortive, nearly fatal attempt to run away, and later risks certain death by secretly attempting to have a letter sent to his family and friends in New York.

Northrup also finds himself on the periphery of a depraved love triangle. Patsey (Lupita Nyong'o in a remarkable feature debut) is an amazingly skilled hand in the cotton fields and a beautiful young woman. The depraved, frequently drunken Epps is clearly besotted with her, arousing the ire of his wife (Sarah Paulson). Epps alternately extols Patsey's virtues as a worker, flies into jealous rages over her whereabouts, and rapes her. While Epps is all hot, demented passion, his wife coldly mistreats and assaults the poor woman at every opportunity. There is a comical scene, with an ever-present underlying sense of dread, when Epps drunkenly attacks Northrup over an unheard comment to Patsey. He drunkenly chases Northrup about, slipping and falling in the pigsty and generally degrading himself until his wife intervenes. Eventually, his wife's rage and Epps' own jealous possessiveness converge in a painfully brutal, ugly scene in which Epps has Patsey stripped bare and tied to a post, and orders Northrup to whip her.

Among its virtues, the film finally brought Ejiofor the attention his consistently detailed, vibrant work as an actor has long merited. McQueen makes great use of Ejiofor's soulfulness, with long shots focusing on his eyes as Northrup undergoes his ordeal. The rest of the cast matches Ejiofor's outstanding work. McQueen's only misstep was in casting Brad Pitt as the Canadian carpenter Bass, who attempts to help Northrup gain his freedom. While the character is true to the one Northrup describes in the book, Pitt's presence in this pivotal role is a minor distraction. Then again, without the participation of Pitt and his Plan B production company, McQueen might not have been able to make this amazing film.

Stunningly shot by Sean Bobbitt, the visual sumptuousness of the film, reminiscent of Terrence Malick's best work in its patient focus on the beauties of the natural world, doesn't romanticize the subject matter's essential gruesomeness. On the contrary, it provides a gracefully ironic counterpoint to that ugliness. The gorgeousness of the presentation actually enhances the emotional impact of the horrifying human interaction on display.

The filmmakers concern themselves with the way the institution of slavery destroys even those who profit from it, but their primary concern is with slavery's unwilling victims, as shown in the scene in which a distraught, desperate, hopeless Patsey asks Northrup to end her life. *12 Years a Slave* becomes her story as much as Northrup's, to the extent that despite Northrup's fate, it is impossible for a thinking person to see the

film's story as triumphant. This is an appropriately devastating drama about an institution that destroyed the lives of all who came into contact with it, even if they did not realize it. Beyond the basic power of the narrative, McQueen and Ridley adapted Northrup's story in a way that makes it startlingly contemporary and relevant. *12 Years a Slave* is not only an emotionally devastating, brutally truthful vision of America's past; it is an rousing, consciousness-raising cri de coeur against passivity and complacency in the face of brutality.

Josh Ralske

CREDITS

Solomon Northup: Chiwetel Ejiofor
Edwin Epps: Michael Fassbender
Patsey: Lupita Nyong'o
Mistress Epps: Sarah Paulson
Tibeats: Paul Dano
Ford: Benedict Cumberbatch
Judge Turner: Bryan Batt
Theophilus Freeman: Paul Giamatti
Brown: Scoot McNairy
Robert: Michael K(enneth) Williams
Armsby: Garret Dillahunt
Radburn: Bill Camp
Mistress Shaw: Alfre Woodard
Bass: Brad Pitt
Origin: United States
Language: English
Released: 2013
Production: Dede Gardner, Anthony G. Katagas, Jeremy Kleiner, Arnon Milchan, Brad Pitt, Steve McQueen; Regency Enterprises; released by Fox Searchlight
Directed by: Steve McQueen
Written by: John Ridley
Cinematography by: Sean Bobbitt
Music by: Hans Zimmer
Sound: Ryan Collins; Robert Jackson
Editing: Joe Walker
Art Direction: David L. Stein
Costumes: Patricia Norris
Production Design: Adam Stockhausen
MPAA rating: R
Running time: 134 minutes

REVIEWS

Burr, Ty. *Boston Globe*. October 24, 2013.
Dargis, Manohla. *New York Times*. October 17, 2013.
Davis, Steve. *Austin Chronicle*. November 1, 2013.
Dowd, A. A. *The AV Club*. October 17, 2013.

Hornaday, Ann. *Washington Post*. October 17, 2013.
O'Hehir, Andrew. *Salon*. October 17, 2013.
Phillips, Michael. *Chicago Tribune*. October 16, 2013.
Rea, Steven. *Philadelphia Inquirer*. October 25, 2013.
Stevens, Dana. *Slate*. October 17, 2013.
Tobias, Scott. *The Dissolve*. October 15, 2013.

QUOTES

Solomon Northup: "I will not fall into despair! I will keep myself hardy until freedom is opportune!"

TRIVIA

Of the seven titles directed by Steve McQueen through July 2013, this is the first which does not have a one-word title.

AWARDS

Oscars 2013: Actress—Supporting (Nyong'o), Adapt. Screenplay, Film
British Acad. 2013: Actor (Ejiofor), Film
Golden Globes 2014: Film—Drama
Ind. Spirit 2014: Actress—Supporting (Nyong'o), Cinematog., Director (McQueen), Film, Screenplay
Screen Actors Guild 2013: Actress—Supporting (Nyong'o)
Nominations:
Oscars 2013: Actor (Ejiofor), Actor—Supporting (Fassbender), Costume Des., Director (McQueen), Film Editing, Production Design
British Acad. 2013: Actor—Supporting (Fassbender), Actress—Supporting (Nyong'o), Adapt. Screenplay, Cinematog., Director (McQueen), Film Editing, Orig. Score, Production Design
Directors Guild 2013: Director (McQueen)
Golden Globes 2014: Actor—Drama (Ejiofor), Actor—Supporting (Fassbender), Actress—Supporting (Nyong'o), Director (McQueen), Orig. Score, Screenplay
Ind. Spirit 2014: Actor (Ejiofor), Actor—Supporting (Fassbender)
Screen Actors Guild 2013: Actor (Ejiofor), Actor—Supporting (Fassbender), Cast

20 FEET FROM STARDOM

Meet the unsung heroes behind the greatest music of our time.
—Movie tagline

Box Office: $4.9 Million

Do not pity the background singer. There exist few professions in the entertainment industry wherein someone can share a stage with Bruce Springsteen for a month and then Stevie Wonder a month after that, sing-

ing the same songs they sing no less. Not just singing them, but enhancing them, making the choruses that much more memorable, or the responses to the calls that much more infectious and meaningful. The background singer gets all the joys of being on stage and singing to a large crowd, but never the hassle of paparazzi or an overly intrusive publicity machine following their every personal move. If they are good—really good—they can make a living at it. But precious few can make the claim of being a professional background singer.

Morgan Neville's documentary *20 Feet From Stardom* tells several stories about careers fulfilled, careers stalled and careers short-lived as several back-up singers share their worldview of the profession that might be seeing a decline in sisterhood thanks to technological advances such as Auto Tune, a device that pretty much spells doom for the profession. But Neville's film does not waste time finger pointing or making redundant statements on the woes of the music industry. His film is a celebration of music in its purest form with several subjects that have plenty of engaging stories to tell with what is likely one of the best soundtracks a movie could ever hope for.

The film bounces around from singer to singer and their stories of near-stardom (or being near the stardom). But it also sheds light on the history of the background singer. Perhaps not surprisingly, most background singers seen on TV in the early days were white and looked all too tasteful. Then came The Blossoms, featuring Darlene Love, who would later become lauded as one of rock's finest voices, thanks in large part to her collaborations with super producer Phil Spector, creator of the Wall of Sound. Spector can claim responsibility for putting Love's name on the map, but he is also responsible for keeping it from going to the top of the charts. Spector schemed to use Love's voice on a song by The Crystals, a song for which she never received voice credit. Furthermore, he tricked her into signing a contract when she was more than ready to leave him. Eventually, she stopped singing and took jobs cleaning houses.

There is a happy ending for Love and there are plenty of other rich stories to be told in the film. Claudia Lennear sang back-up for The Rolling Stones and was one of the original Ikettes, singing back-up for Ike Tuner. She claims that Ike treated his background singers as "hos" and he was their pimp. Their act pushed the boundaries of what was expected from background singers at the time, turning a musical necessity and enhancement into a sexual sideshow. Lennear made an attempt at a solo career with an album called *Phew!* which failed to make an impression commercially. She now works as a Spanish teacher.

One of the more fun stories comes from Merry Clayton who ended up singing one of the most iconic choruses in the Rolling Stones catalog, the startling "Rape and murder, it's just a shot away, it's just a shot away" from the song "Gimme Shelter." Clayton was summoned in the middle of the night by the band to come and record the track, which she did while being clad in pajamas and while being several months pregnant. She nailed it in just a couple takes. Clayton also has one of the funnier verite moments in the film when Neville asks her to turn off her music in the car (presumably so he will not have to secure the rights to more songs), to which Clayton replies, "How can you ask a diva to turn her music off in the car?"

There are plenty of other stories and subjects in the film, not all of whom are African American women. Neville notes that Luther Vandross was once a background singer for David Bowie. Vandross has obviously done well for himself since. But it is a common theme in these peoples' lives that they come from a background in the church, their fathers being preachers while they sang in the choruses. It is precisely this gospel influence that many artists want in their own music and it is that kind of musical training that sets the stage in their lives. At the start of the film, Bruce Springsteen makes it clear that in order to be a lead singer or the star of your own show, you have to be a complete narcissist, have a giant ego and have unstoppable drive. Lisa Fischer, who has been on every Rolling Stones tour since 1989, actually did win a Grammy for her solo work, but took too long to have a follow-up record and has since gone back to singing back-up wherever she is needed.

Neville's film is essential for any music fan. He has assembled quite an impressive roster of high-profile talents including Springsteen, Mick Jagger, Stevie Wonder, and Bette Midler, all of whom clearly owe a debt of gratitude to these women for making their songs richer and even more memorable. Neville's film is like that of a singer doing a freestyle improv on the mic. It goes in several different directions without much or a predetermined arc. It is directionless, but never to a fault. It is a celebration, but never feels like a "fan film." If anything, it will win fans of the work these people do and might cause one to take notice next time they hear a song while driving in their car, a song they thought they knew, but will now know more than ever.

Collin Souter

CREDITS

Origin: United States
Language: English
Released: 2013

Production: Gil Friesen, Caitrin Rogers, Morgan Neville; released by Weinstein Company L.L.C.

Directed by: Morgan Neville

Cinematography by: Nicola Marsh; Graham Willoughby

Sound: Al Nelson

Editing: Douglas Blush; Kevin Klauber; Jason Zeldes

MPAA rating: PG-13

Running time: 91 minutes

REVIEWS

Burr, Ty. *Boston Globe.* June 27, 2013.

Edelstein, David. *New York Magazine.* June 10, 2013.

Fear, David. *Time Out New York.* June 11, 2013.

Goss, William. *Film.com.* April 22, 2013.

Howell, Peter. *Toronto Star.* July 4, 2013.

Jones, J. R. *Chicago Reader.* July 11, 2013.

Long, Tom. *Detroit News.* July 5, 2013.

Stewart, Sara. *New York Post.* June 14, 2013.

Turan, Kenneth. *Los Angeles Times.* June 13, 2013.

Whitty, Stephen. *Newark Star-Ledger.* June 14, 2013.

AWARDS

Oscars 2013: Feature Doc.

Ind. Spirit 2014: Feature Doc.

21 & OVER

Finally.
 —Movie tagline
Blackout the date.
 —Movie tagline

Box Office: $25.7 Million

No movie is an orphan, but some reveal their lineage more readily than others. At first blush, *21 & Over* seems like just another rowdy, randy teen comedy, this time pegged to the legal drinking age in most states. The posters and promotional campaign for the film, however, heavily touted it as being from the writers of *The Hangover* (2009), Jon Lucas and Scott Moore, who each make their directorial debut here. The result was a tidy $26 million in theaters, against an additional healthy $16 million abroad (more on this later). And the truth is that while a movie like this is hardly ever going to be a hit with critics (even the original *American Pie* [1999], reasonably considered a genre standard-bearer, is barely rated fresh on Rotten Tomatoes), for a while *21 & Over* actually does a good job of keeping its crudity appealing, before the wheels come off and it just becomes mock-outrageous and familiar.

The film centers around Jeff Chang (Justin Chon), a seemingly committed if definitely anxious college student whose stern father (François Chau) still casts a long shadow over his life. When his two best friends from high school, garrulous dropout Miller (Miles Teller) and the buttoned-up Casey (Skylar Astin), show up to celebrate his 21st birthday with a night out on the town, Jeff reluctantly assents, even though he has an important interview early the next morning.

Things quickly get out of hand, though. Jeff drinks until he becomes unresponsive; his friends try to take him home, but cannot remember where he lives. Having met Jeff's friend Nicole (Sarah Wright) at the first bar to which they went, Casey and Miller try to track her down, figuring she will know. Hijinks ensue, and after antagonizing Nicole's jock boyfriend, Randy (Jonathan Keltz), Casey and Miller lose track of Jeff. Along the way, they discover that the rosy shine he has put on his college career may not at all be true, and that he may in fact have been suicidal.

For a good, long while, *21 & Over* surfs along courtesy of its gonzo sensibility and arbitrary, caffeinated patter ("Sometimes I wear flannel, and feel like a lumberjack"), even if its treatment of female characters is wince-inducing (upon first meeting Miller and Casey, Nicole announces that she "can't get to sleep without flicking the bean," which is something that no girl has said, ever). In its breezy, devil-may-care fashion, the movie captures early twenty-something whimsy, and there are enough amusing gags, throw-away jokes and reversals in the first act to keep viewers laughing and engaged.

Lucas and Moore have a generally good grasp on rapid-fire amoral mayhem (which reaches its apex or nadir, depending on one's point-of-view, in a slow-motion vomiting sequence atop a mechanical bull). There is even a pinch of racial humor (Miller and Casey always refer to Jeff by his full name, Jeff Chang), which captures the way in which particularly young guys often bust on one another, highlighting their differences. Eventually, though, the guys get separated, and *21 & Over* is torn asunder by divergent impulses: continue along on this raucous, rocketing party train, or have characters learn and realize things, and "grow" over the course of this one crazy evening.

The problem is that the movie has neither the intelligence nor the fortitude to handle its suicide narrative strand, comedically or otherwise. A bit with marauding sorority girls seeking revenge against Miller and Casey for a bumbling misunderstanding in which the duo made some of its pledges kiss runs its course long before Lucas and Moore let it drop, while other material comes off as derivative (such as Jeff's impending medical school interview, nipped from *Harold & Kumar Go To White Castle* [2004]), and without much unique spin. Homo-

erotic tension between Randy and one of his underlings is also insipid (even in the context of a movie like this), and the whole notion of it suddenly dawning on Nicole what a tool Randy is, and giving Casey some attention is just a bridge too far—both familiar and implausible.

Improbable as it may seem, given its conceit, *21 & Over* just yields to tired and conventional choices, deployed without much panache. Crucially, too, the type of realization of the dissolution of a platonic male friendship, or anxiety over the possibility of the same, that smarty informed similarly fratty comedies like *Superbad* (2007) and *This is the End* (2013) does not have the same depth or convincingness here. When Casey and Miller have a big argument near the end where the former concludes that they are not friends anymore, it rings false, coming across as an empty dramatic ploy.

What helps make *21 & Over* work, to the extent that it does, is some decent joke writing and a pair of its lead performances. If Astin is little more than an affable preppy stand-in (think Breckin Meyer, with a straighter nose) and Wright strikes an empty, affected air-quote sexy pose, Chon engagingly captures the polarities of his under-written character, and throws himself into bits of physical comedy and humiliation with utter abandon. Meanwhile, Teller, who made such an impression in quiet, reserved fashion in *Rabbit Hole* (2010), here channels Vince Vaughn's manic, loquacious energy, where a full second of silence is viewed as the enemy. He is clearly the heart of the film, as well as its breakout star—something confirmed by both his rich work in *The Spectacular Now* (2013) and future high-profile bookings.

As an interesting sidebar, *21 & Over* stands to make a mark or at least occupy a unique place in film history trivia. Distributor Relativity Media, in a sidebar financing deal with a consortium of Chinese companies for the $12-million comedy, tasked Lucas and Moore with shooting a significant number of scenes for a customized version of the film released only in China. In it, Jeff is actually an exchange student, something totally at odds with the high school history that the characters have in the version released in the rest of the world. Thus, framed with bookends that show Jeff at his home school, chastened and having learned a lesson, *21 & Over* becomes a cautionary tale of the hedonistic West, with Miller and Casey the corrupting influences. Make of that oddity what one will.

Brent Simon

CREDITS

Jeff Chang: Justin Chon
Casey: Skylar Astin

Miller: Miles Teller
Nicole: Sarah Wright
Randy: Jonathan Keltz
Dr. Chang: Francois Chau
Origin: United States
Language: English
Released: 2013
Production: David Hoberman, Ryan Kavanaugh, Todd Lieberman; Virgin Produced; released by Relativity Media L.L.C.
Directed by: Jon Lucas; Scott Moore
Written by: Jon Lucas; Scott Moore
Cinematography by: Terry Stacey
Music by: Lyle Workman
Sound: Javier Bennassar; Mandell Winter
Editing: John Refoua
Costumes: Christine Wada
Production Design: Jerry Fleming
MPAA rating: R
Running time: 93 minutes

REVIEWS

Debruge, Peter. *Variety*. February 28, 2013.
Duralde, Alonso. *The Wrap*. March 1, 2013.
Hartlaub, Peter. *San Francisco Chronicle*. February 28, 2013.
Johnson, Boris. *Screen International*. February 28, 2013.
McCarthy, Todd. *Hollywood Reporter*. February 28, 2013.
Olsen, Mark. *Los Angeles Times*. February 28, 2013.
Puig, Claudia. *USA Today*. February 28, 2013.
Rabin, Nathan. *AV Club*. February 28, 2013.
White, Dave. *Movies.com*. March 4, 2013.
Zacharek, Stephanie. *Village Voice*. February 28, 2013.

QUOTES

Miller: "Oh, my God! Did we just kill Jeff Chang again?"

TRIVIA

Justin Chon is actually ten years older than his character at the time of the film's release.

2 GUNS

Box Office: $75.6 Million

Some movies reveal their badness slowly like a bottle of fine wine with a hairline fracture. Others signal it immediately like a skunky beer. *2 Guns* falls firmly into the latter category. The trouble starts as soon as the characters open their mouths. The film opens with two motor-mouthed crooks casing a bank from the vantage point of a diner across the street. There is an extended,

rat-tat-tat exchange between the two with the waitress about whether they will be ordering pancakes or eggs. One crook orders eggs for himself and his partner. No, the other crook responds, he does not want eggs; he wants the pancakes and, in fact, so does his partner. Pancakes? The first crook asks incredulously, no, that's crazy, they will both have the eggs. The scene is supposed to be hilarious; Riggs and Murtaugh for the 21st century. Instead, it is excruciating. On the way out, one of the crooks lazily tosses a lighter over his shoulder onto the stove which blows the joint up while they are standing in front of it. *2 Guns* wants to be an old-school action comedy movie like *Lethal Weapon* (1987) but does not have enough wit to pull off the comedy or enough innovation to pull off the action.

The culprit is a smug, overly-complicated script that fails to deliver funny dialogue, fun action or even a remotely believable story. The two crooks are Bobby Trench (Denzel Washington) and Marcus Stigman (Mark Wahlberg), who have teamed up to rob a bank holding drug money owned by vicious crime lord Papi Greco (Edward James Olmos). However, it turns out that Trench is not a criminal; he is actually an undercover DEA agent who is robbing the bank to obtain evidence of tax evasion to prosecute Greco. But wait, it turns out that Stigman is not a criminal either. He is actually an undercover Naval intelligence officer robbing the bank under orders from his agency for the same reason.

When they actually rob the bank it turns out that the bank does not have just the expected $3 million in drug money but an additional $40 million of mystery cash which it turns out belongs to the CIA. It looks like the two guys who were trying to set each other up were set up themselves by their own agencies to steal money from a third agency. Or were they? The two have to figure it out fast because the CIA is hot on their trail and it is not the CIA of popular conception. The CIA is not led by a straight arrow, by-the-book bureaucrat intent on keeping a low profile but rather a bolo tied, cowboy-hatted sociopath (Bill Paxton) who obtains information by murdering DEA agents in broad daylight and shooting witnesses in the kneecaps after delivering sub, sub-par Elmore Leonard speeches about the proper etiquette of engaging in "Russian Roo-lette."

What follows is an overly-complicated, unfunny slog in which the two buddies engage in a string of fist-fights, gunfights and failed comedic exchanges while trying to find the $43 million (which, of course, has gone missing) before the Mexican mafia, the CIA and the U.S. Navy finds them. Eventually, of course, everything is lazily resolved via the obligatory huge firefight involving all the film's characters.

The film is chockfull of good actors—Denzel Washington, Mark Wahlberg, Bill Paxton, Edward James Olmos, Fred Ward, James Marsden, all gamely trying to earn their paychecks. There is nothing wrong with a paycheck movie of course, but the resulting film still has to be passably entertaining and even the most talented actors cannot overcome a script that presents unremarkable observations between characters as side splitting jokes:

Bobby Trench: "You ever heard the saying, 'never rob a bank across from the diner that has the best donuts in three counties?'"

Marcus Stigman: "That's not a saying."

Bobby Trench: "Yes, it is."

Marcus Stigman: "I get what you're saying but it's not a saying."

Bobby Trench: "It is a saying."

Marcus Stigman: "Okay."

Bobby Trench: "It's a saying now."

Exacerbating the agony of the film's dialogue is the smug, self-satisfied manner in which it is delivered. Washington and Wahlberg appear to believe they are providing comedy on par with *Blazing Saddles/Young Frankenstein* (1974) era Mel Brooks. This is a shame because the two play so well off one another that a script that capitalized on their genuine chemistry and timing would really be something.

2 Guns' terrible script would matter less if the film at least succeeded as a slam bang action movie. As Roger Ebert once pointed out, by way of John Candy, "stuff blowing up real good" goes a long way. Unfortunately, most of the film's budget appears to have been spent on the actors' paychecks. The action is unimaginative and cheap, consisting of conventionally staged shootouts and a couple of car explosions. A movie with such a ridiculous a premise and such terrible dialogue needs to have villains shooting rocket launchers from hang-gliders and cars flying through exploding buildings and landing on helicopters. Shoot-outs and a couple of parked cars blowing up is not enough.

The problem with *2 Guns* is not just that it is a bad movie but that it is a bad movie that thinks it is far funnier and cleverer than it actually it is. Everyone involved is rolling like they are in *Get Shorty* (1995) when, in fact, it is a whole lot closer to *Hudson Hawk* (1991). Saying unfunny lines really fast with a smug smirk does not make the lines any funnier. One gets the sense that everyone involved told their agent that "it's time for me to do my Elmore Leonard movie" without anyone then

actually ensuring that the resulting film in any way captured that master writer's wit, style or sensibility.

Nate Vercauteren

CREDITS

Robert 'Bobby' Trench: Denzel Washington
Michael 'Stig' Stigman: Mark Wahlberg
Deb: Paula Patton
Earl: Bill Paxton
Quince: James Marsden
Papi Greco: Edward James Olmos
Admiral Tuwey: Fred Ward
Jessup: Robert John Burke
Origin: United States
Language: English
Released: 2013
Production: Andrew Cosby, Randall Emmett, George Furla, Norton Herrick, Marc Platt, Ross Richie, Adam Siegel; released by Universal Pictures Inc.
Directed by: Baltasar Kormakur
Written by: Blake Masters
Cinematography by: Oliver Wood
Music by: Clinton Shorter
Sound: Willie Burton
Music Supervisor: Scott Vener
Editing: Michael Tronick
Art Direction: Kevin Hardison
Costumes: Laura Jean Shannon
Production Design: Beth Mickle
MPAA rating: R
Running time: 109 minutes

REVIEWS

Burr, Ty. *Boston Globe*. August 1, 2013.
Dargis, Manohla. *The New York Times*. August 1, 2013.
Foundas, Scott. *Variety*. July 30, 2013.
Henderson, Odie. *RogerEbert.com*. August 2, 2013.
Jenkins, Mark. *NPR*. July 31, 2013.
Kenigsberg, Ben. *The A.V. Club*. July 31, 2013.
Morgenstern, Joe. *The Wall Street Journal*. August 1, 2013.
Turan, Kenneth. *Los Angeles Times*. July 30, 2013.
Uhlich, Keith. *Time Out New York*. July 30, 2013.
Zacharek, Stephanie. *Village Voice*. July 30, 2013.

QUOTES

Bobby: "You never heard the saying, never rob a bank across from a diner with the best donuts in three counties?"

The film was shipped to theaters under the code name "Duel Action."

TYLER PERRY'S A MADEA CHRISTMAS
(A Madea Christmas)

Ho no she didn't.
—Movie tagline

Ho, ho, ho.
—Movie tagline

This little fool thinks she's getting a damn pony.
—Movie tagline

Jolly, fat, old. Who were you expecting?
—Movie tagline

Box Office: $52.5 Million

For any hackneyed sitcom series that manages to last more than a few weeks, the Christmas season means that there will almost certainly be a holiday-themed episode designed to tickle the funny bone and touch the heart in equally uninspired ways, usually involving homages to *A Christmas Carol* or *It's a Wonderful Life* (1946) or visits to or from wacky distant relatives that have never been heard from before and who will almost certainly never be seen again. Therefore, it was perhaps inevitable that Tyler Perry's terrifyingly popular series of films featuring his ever-obnoxious character Madea—easily the most sitcommy of current film franchises—would one day deck viewers with boughs of holly alongside the usual loud-mouthed humor and half-assed homilies via a holiday frolic for viewers of all ages and the lowest of expectations.

However, even those who have inexplicably enjoyed or at least tolerated the previous adventures of Madea at family reunions, in jail, and in witness relocation may find themselves taken aback by the utter cruddiness of *Tyler Perry's A Madea Christmas*, a holiday horror so profound in every way that it makes such previous Yuletide nightmares as *Christmas with the Kranks* (2004), *Deck the Halls* (2006), and *Four Christmases* (2008) seem nearly watchable by comparison. Yes, these are films that are made for a certain audience that is willing to overlook their obvious artistic flaws because they work for them on some fundamental level but this one is so sloppy, so lazy, and so ineptly constructed and executed that even they are unlikely to give it much of a pass, not even in the spirit of the season.

In this one, Madea (once again essayed by Perry in a drag getup that would not fool a blind child) is coaxed by vague relative and general busybody Eileen (Anna

Marie Horsford) to accompany her to rural Bucktussle, Alabama to pay a surprise Christmas visit on her daughter, Lacey (Tika Sumpter), and discover why her golden child has moved to such a shabby backwater to live on a farm and teach at the local schoolhouse instead of coming home and marrying her slick and newly-divorced high school boyfriend (JR Lemon). What they do not know is that Lacey recently eloped with Conner (Eric Lively), a scientific genius who is trying to bring his family farm back to life with his book learning and such. Oh yeah, he is also white and since Lacey knows how badly her mother will react to that bit of information, she has so far neglected to her that she is married—when Mom, Madea and the ex arrive, Conner is explained away as "the farmhand." Of course, considering that Conner is so ignorant of basic farming skills that he mistakes a bull for a cow come milking time, there may be other reasons why Lacey is keeping quiet about the nuptials.

Although the notion of Eileen acting ignorant toward her unwitting in-law while Madea riffs and scats all over the place would seem to be enough to fill any ordinarily awful movie, Perry has lots more gibberish to offer. There is the arrival of Conner's cheerfully gauche parents (Larry the Cable Guy and Kathy Najimy), who know about the marriage but who are perfectly willing to go along with the farmhand ruse. There is the local Christmas Jubilee that is threatened with cancellation because of financial considerations until Lacey gets corporate sponsorship for the event via the ex. Alas, not only does the town find out too late that the company footing the bill is the same one that has built a dam that caused their current economic woes, they are forbidden to mention anything to do with religion during the festivities. There is an adorable lad (Noah Urrea) who wants to sing in the jubilee but whose bullying father (Chad Michael Murray) would prefer that the lad work in the fields instead of doing all that fancy schooling. As a final few garnishes of loathsomeness, the film also provides a running joke involving the KKK, a sight gag in which Madea literally strings up a bratty little girl on a handy cross in her schoolroom and such choice lines of dialogue as "He's just a farm boy," "It's only Christmas," and "I am working on a new strain of corn that uses less water."

Of course, Perry has been supplying viewers with strains of corn for years now but never has the yield been as shabby as it is this time around. The riff on *Guess Who's Coming to Dinner* (1967) is ridiculously dated throughout and while there is the intriguing germ of an idea of the upscale African-American woman being the condescending racist, Perry has no idea of what to do with it. He also tries to work in a timely anti-bullying theme at certain points but after the pointless

opening sequence in which Madea is inexplicably hired to work in a department store and relentlessly tears into customers with the temerity to actually want to do some shopping, the pleas for tolerance and loving each other tend to feel a bit hollow. Then again, considering the fact that none of *Tyler Perry's A Madea Christmas* makes sense on even a scene-by-scene basis, it is probably not surprising to learn that the big themes are a bit muddled as well.

Even in terms of simple cinematic grammar, it comes up woefully short—even someone who had never made a film before would be hard-pressed to turn in something as slapdash as Perry has done here. He allows scenes to go on forever, oftentimes to allow him to go on and on with improvised comedic riffs of such ineptitude that Vince Vaughn would advise him to get to the point. In other scenes, he keeps things going on even after obvious flubs in the dialogue—to be fair, Perry's writing is so bad that those hiccups could actually be in the script proper. Instead of properly transitioning between scenes with such fundamentals as establishing shots and the like, he treats us to holiday-themed wipes that gives the whole thing the air of a home movie that is outdone only by everything else.

Things get so bad in *Tyler Perry's A Madea Christmas* that when Larry the Cable Guy shows up, it almost feels like he has arrived to class up the proceedings. To see him and Perry going toe to toe with their respective schticks does provoke a queasy sense of fascination—imagine what *Heat* (1995) might have been like if Al Pacino and Robert De Niro were a couple of grotesque niche comedians unloading their shopworn material on each other during the diner scene while everything grinds to a halt around them. At first, Larry comes across as the less objectionable of the two, if only because he manages to refrain from shouting every single line. Alas, whatever dignity he managed to retain is stripped away a few minutes later when he appears topless for one extended scene that will have most viewers reaching for the heartburn medicine that he shills in TV ads. In the one moment of audience consideration on display, Perry works in at least two references to the product in question in Larry's dialogue to help viewers make the pain—at least of the physical nature—stop.

To sum up, *Tyler Perry's A Madea Christmas* has a few flaws.

Peter Sobczynski

CREDITS

Madea: Tyler Perry
Kim: Kathy Najimy

Tanner: Chad Michael Murray

Eileen: Anna Maria Horsford

Lacey: Tika Sumpter

Connor: Eric Lively

Buddy: Larry the Cable Guy

Origin: United States

Language: English

Released: 2013

Production: Ozzie Areu, Tyler Perry; Tyler Perry Studios; released by Lionsgate

Directed by: Tyler Perry

Written by: Tyler Perry

Cinematography by: Alexander Gruszynski

Music by: Christopher Young

Sound: Michael D. Wilhoit

Music Supervisor: Joel High

Editing: Maysie Hoy

Costumes: Johnetta Boone

Production Design: Eloise Crane

MPAA rating: PG-13

Running time: 100 minutes

REVIEWS

Barker, Andrew. *Variety.* December 12, 2013.

Corliss, Richard. *Time Magazine.* December 13, 2013.

Ebiri, Bilge. *Vulture.* December 13, 2013.

Gibron, Bill. *Film Racket.* December 13, 2013.

Keough, Peter. *Boston Globe.* December 16, 2013.

Neumaier, Joe. *New York Daily News.* December 13, 2013.

Olsen, Mark. *Los Angeles Times.* December 16, 2013.

Orndorf, Brian. *Blu-Ray.com.* December 13, 2013.

Rapold, Nicolas. *New York Times.* December 13, 2013.

Schreck, Frank. *Hollywood Reporter.* December 13, 2013.

AWARDS

Golden Raspberries 2013: Worst Actress (Perry)

Nominations:

Golden Raspberries 2013: Worst Director (Perry), Worst Ensemble Cast, Worst Picture, Worst Screenplay, Worst Support. Actor (Larry the Cable Guy)

TYLER PERRY'S TEMPTATION: CONFESSIONS OF A MARRIAGE COUNSELOR

(Temptation: Confessions of a Marriage Counselor)

Sedeuction is the devil's playground.
—Movie tagline

Betrayal burns forever.
—Movie tagline

Box Office: $52 Million

When re-reading the Bible to his audience, filmmaker Tyler Perry is a movie-evangelist who preaches his words with great vengeance and furious obviousness, his entertainment factor feeding on the repressions of his viewers. Just as they are meant to be amused by the sins of his female franchise character Madea but ultimately educated by her lessons, they are now due to say ten "Hail Perrys" after being tricked into witnessing unsexy adultery in his latest film, yet another decisive tale where obviousness is his primary storytelling tool and motivation.

Tyler Perry's Temptation: Confessions of a Marriage Counselor kicks off with a woman named Lisa (Andrea Moore) confessing to Judith (Jurnee Smollett-Bell), a marriage counselor, about a temptation she has with a man who is not her husband. With hopes of putting her client in a moral place, Judith shares the story of her "sister" (who is revealed to actually be a younger Judith) and the marriage she had with a man named Brice (Lance Gross), who she had been romantically connected to since they were wholesome Christian children in the suburbs.

Judith tells of how her "sister" and Brice got married in their twenties and then moved from the country to Washington D.C.. Judith started to pursue her dream of opening her own marriage counseling practice by working at matchmaking company, alongside a woman named Ava (Kim Kardashian), who constantly provides her important fashion advice like "That's not make-up, that's make-down." Meanwhile, Brice has embarked on his dream of working at small pharmacy, where he develops a friendship with Melinda (played by Brandy Norwood); an individual who lives in fear of her mysterious and abusive ex-lover.

While working to connect single wealthy people, she begins to deal exclusively with Harley (Robbie Jones), a self-made multi-millionaire who operates his own social media service, but still needs help in meeting women. That is, unless he is also in the business of seducing matchmakers, which he attempts to do with Judith by preying on her insecurities of her marriage, specifically that concerning her one-name list of sexual partners. Push comes to shove, flirtation comes to temptation, and Judith gives into the sinful offerings of Harley, with Brice not having a lot of awareness to either his wife's marital angst, or her strange reasons for leaving the apartment. When Judith and Brice finally have a separation, Brice turns to Melinda for friendship, and finds out that the awful man of her past is none other

than Harley, who also gave her HIV when he cheated on her.

Their exchanges made up of roughly-delivered, bad dialogue, the film's crucial love triangle is paralyzed by performances completely numbed by Perry's direct intentions. These are not characters that give way for expansion, but fulfill archetypes with no space for anything else. The concept of following a character through a specific arc is null-and-void, as these Perry moral marionettes are on a course the viewer is intentionally supposed to be knowledgeable of. And for a film adorned with the Garden of Eden buzzword "temptation," Perry unplugs the heater on sexual tension between Smollett-Bell, as they share facial reactions (her blank stares, his grin) more than they do moments of palpable chemistry.

Perhaps Perry's most striking instrument in his story is HIV, wielded here as a tool of damnation that comes with the same logistics of a slasher rule, where those who commit sin must be punished. There is something remarkably slimy as well in equating HIV to an answer for promiscuity, considering that scientifically the disease is not transmitted solely through acts against God. In this film, it is his boogeyman; his cold water that he wants to pour on his audience for thinking that they can watch a story about adultery, and not face some type of moral accountability themselves. (The same goes with the film's shirtless men and hourglass figures, which cheaply tempts its viewers to look, despite Perry's other sexual politics).

Speaking of hourglass figures, this makes the placement of Kim Kardashian even more curious, outside of its likely explanation of stunt casting. For a character whose superficiality nudges the innocent Judith into her title deus ex machina, she suffers no symbolic fate. The playful irony is then that of Kardashian's own pop cultural narrative, one which involves her status as a 21st century sex symbol/heathen, which viewers will likely be previously more conscious of than any of the actors in this film. With her placement in a Perry film, especially one that dooms a woman to death for having sex outside of marriage, he shows that there are only certain extents to which he will dare moralize. In a smaller scale, Kardashian's character isn't even humbled for believing in her own superficiality; even a pompous boss played by Vanessa Williams is put in her place for having a fake French accent.

The aesthetic experience of *Tyler Perry's Temptation: Confessions of a Marriage Counselor* is a tease from Perry about the story's more fitting placement on television; it is a traitor's move that gives one more point to the advancement of TV storytelling over those that can be experienced, for a higher price, at the cinema. A soap opera misplaced into multiplexes, the film lacks any component that demands a specific film experience. Perry wields a brutal two-hour running time as the only bid for this story to justify a film length, even though the plot did languish previously on stage (when it was known as "The Marriage Counselor").

Other elements owe less directly to soap operas or TV, but simply to bad filmmaking. A comically fake effect of breaking glass (when Brice slams his car door) takes the sting of anger projected at the moment; numerous shots lag after their appropriate running time, in need of more precise cutting from editor Maysie Hoy.

This frankness umbrellas numerous aesthetic components in the film—the production design (by Eloise Crane Stammerjohn) cheaply aims to show Judith's busyness with rogue Chinese food boxes on her desk. Similarly, she too is also a character who is donned with glasses to indicate intellect, as with her husband. And as the film travels a worn-down path, Perry even complements a montage of Judith's temptation with "In Love with Another Man" by Jazmine Sullivan, a literal externalization of Judith's already obvious thoughts, a song that does not enhance understanding of her emotions, but scream them back at the audience.

The lesson that Perry aims to teach is closed incontestably as well, when its undisguised audience surrogate/bookending listener Lisa provides the understanding that he demands from his viewers by saying, "Thank you so much for sharing this story with me. I am going to end this almost affair and stay with my husband." A cherry on top, *Tyler Perry's Temptation: Confessions of a Marriage Counselor* confirms its complete resilience to subtlety when it hilariously begins to roll the credits immediately after a final melodramatic exchange is made, as if it were a punch-line to a two-hour unfunny joke of mistaken self-righteousness.

Nick Allen

CREDITS

Judith: Jurnee Smollett
Brice: Lance Gross
Janice: Vanessa Williams
Melinda: Brandy Norwood
Sarah: Ella Joyce
Ava: Kim Kardashian
Harley: Robbie Jones
Origin: United States
Language: English
Released: 2013
Production: Ozzie Areu, Paul Hall, Tyler Perry; Tyler Perry Co.; released by Lionsgate

Directed by: Tyler Perry
Written by: Tyler Perry
Cinematography by: Alexander Grusynski
Music by: Aaron Zigman
Sound: Michael D. Wilhoit
Editing: Maysie Hoy
Costumes: Johnetta Boone
Production Design: Eloise Stammerjohn
MPAA rating: PG-13
Running time: 111 minutes

REVIEWS

Bale, Miriam. *New York Daily News*. March 29, 2013.
Chaney, Jen. *Washington Post*. April 1, 2013.
Foundas, Scott. *Variety*. March 29, 2013.
Guzman, Rafer. *Newsday*. March 29, 2013.
Olsen, Mark. *Los Angeles Times*. March 29, 2013.

Schager, Nick. *Time Out New York*. March 29, 2013.
Scheck, Frank. *Hollywood Reporter*. March 29, 2013.
Sobczynski, Peter. *Chicago Sun-Times*. April 1, 2013.
Webster, Andy. *New York Times*. March 29, 2013.

QUOTES

Sarah: "That man is the devil! He will take you to hell with him!"
Judith: "Well, at least I'll enjoy the ride!"

TRIVIA

Tyler Perry wrote the role of Ava specifically for Kim Kardashian.

AWARDS

Golden Raspberries 2013: Worst Support. Actress (Kardashian)

U

UNFINISHED SONG
(Song for Marion)

Open your heart. Find your voice.
—Movie tagline
Music is the cure for the common crank.
—Movie tagline

Box Office: $1.7 Million

A sweet-natured but hardly subtle slice of hokum, *Unfinished Song* is the veritable definition of a white-collar retiree's arthouse dramedy, so much so that it should come with a sticker of AARP endorsement on its home video box art. Commingling a few nicely sketched ruminations on aging and regret with broader, cornball, crowd-pleasing instincts, writer-director Paul Andrew Williams seemingly takes the premise of the nonfiction film *YoungHeart* (2007), about a New England senior citizen's chorus which sings contemporary pop songs, and marries it to nipped bits of comedy and interpersonal friction from other offerings of boomer cinematic catnip like *Quartet* (2012) and *The Best Exotic Marigold Hotel* (2012).

Generally if not fervently embraced by critics, *Unfinished Song* (released in its native United Kingdom as *Songs For Marion*) was given a Stateside summer release by the Weinstein Company—seemingly the perfect distributor to pull off a healthy counterprogramming insurgent run. It never cracked more than 100 theaters, however, and finished with a respectable but hardly overwhelming box office take of just over $1.7 million.

Arthur Harris (Terence Stamp, wonderfully dour) is a curmudgeonly British retiree whose entire existence is wrapped up in his beloved, cancer-stricken wife Marion (Vanessa Redgrave). Despite or maybe because of her condition, Marion finds joy and solace via participation in a local singing group, overseen by music teacher Lizzy (Gemma Arterton), who self-effacingly adopt the jokey moniker of the OAPZ, or old-age pensioners. To Arthur, this is only a waste of time and a source of potential embarrassment.

When Marion's illness suffers a recurrence, however, and their doctor advises only "chips and ice cream" (code for making peace with mortality), Arthur is faced with the prospect of losing his wife, as well as an impending change in the nature of his relationship with his semi-estranged son James (Christopher Eccleston). Reconnecting to music and striking up an unlikely friendship with Lizzy, Arthur comes out of his shell a bit and discovers that his interest in living may not expire with Marion after all.

Williams' previous directorial experience leans more toward the horror genre, though studded with quirky characterizations or other blended elements, as with *The Cottage* (2008) and *Cherry Tree Lane* (2010). It is a shame, then, that *Unfinished Song* does not display a bit more idiosyncratic personality. There is not the weight or force of distinctively memorable characters here, or even a hard-won quality to the movie's overtly peddled sentimentality and triumph-of-the-underdog uplift, the latter of which comes by way of, yes, a singing contest in which Lizzy enters the OAPZ.

Stamp's instincts cut away from the treacly, though, which is of enormous benefit to the film. Just on a physical level, his face is like some great monument to disaffection, with cold eyes and naturally downturned corners

of the mouth. The striking nature of the physical manifestation of his emotional constipation in scenes with Eccleston says more about the withholding relationship between Arthur and James than all of the boilerplate dialogue that Williams cooks up. Even if its story beats feel carefully and predictably plotted, one never tires of watching Stamp; he is the film's anchor.

And, in fact, it is the smartly tuned performances of the three other main actors in addition to Stamp that most recommend *Unfinished Song*. Arterton, for her part, brings a sunny charm to Lizzy, while Eccleston eschews surface-level anger, showcasing a smarter, more layered adolescent hurt that has calcified into adult frustration. Redgrave, in imbuing her character with both stubbornness and a teasing nature to match her fragility, is able to provide edifying glimpses of the Arthur with whom Marion fell in love, and who remains shuttered away from so much of the world.

Unfortunately, on a narrative level, there is not much in the way of surprise or originality in *Unfinished Song*. Marion's sickness and especially the aforementioned singing contest lend the movie a certain yawning trajectory. Even if a viewer had not seen any of the dozens of other films it recalls, he or she could rather easily guess its plot developments.

And the musical sequences—in which there is much demonstrativeness, and terrible hand pantomiming to songs like Salt-n-Pepa's "Let's Talk About Sex," Motorhead's "Ace of Spades" and Gnarls Barkley's "Crazy"— are less wild and exuberant presentations of recaptured youth and vitality than generally mere signifiers of the same. The rearrangements themselves come across as haphazard, karaoke-style aural jottings instead of actual, thought-out re-imaginations, and it does not help when Williams and costume designer Jo Thompson outfit the characters in hip-hop garb for one sequence, absent any further explanation or exploration within the story (a shopping scene which conceivably could have been amusing). If one wants to see Stamp croon a Billy Joel ballad or Arterton give a brief tutorial on how to do the robot, however, *Unfinished Song* may be their only chance.

Brent Simon

CREDITS

Arthur Harris: Terence Stamp
Marion Harris: Vanessa Redgrave
Elizabeth: Gemma Arterton
James: Christopher Eccleston
Brenda: Anne Reid
Origin: United Kingdom

Language: English
Released: 2012
Production: Ken Marshall, Philip Moross; Coolmore Productions, Egoli Tossell Film, Film House Germany, Steel Mill Pictures; released by Weinstein Company L.L.C.
Directed by: Paul Andrew Williams
Written by: Paul Andrew Williams
Cinematography by: Carlos Catalan
Music by: Laura Rossi
Sound: Srdjan Kurpjel
Editing: Dan Farrell
Costumes: Jo Thompson
Production Design: Sophie Becher
MPAA rating: PG-13
Running time: 93 minutes

REVIEWS

Abele, Robert. *Los Angeles Times*. June 19, 2013.
Addiego, Walter. *San Francisco Chronicle*. June 28, 2013.
Holden, Stephen. *New York Times*. June 20, 2013.
Jakicic, Cathy. *Milwaukee Journal Sentinel*. July 11, 2013.
Keough, Peter. *Boston Globe*. June 27, 2013.
Macdonald, Moira. *Seattle Times*. July 4, 2013.
Means, Sean. *Salt Lake Tribune*. July 25, 2013.
Phillips, Michael. *Chicago Tribune*. June 27, 2013.
Puig, Claudia. *USA Today*. June 20, 2013.
Scott, Mike. *The Times-Picayune*. July 25, 2013.

QUOTES

Arthur Harris: "You know how I feel about enjoying things."

UPSIDE DOWN

Two worlds. One future.
 —Movie tagline

Box Office: $105,095

High concepts rarely get as unintentionally goofy as the one for *Upside Down*. Consider the kind of pitch meetings writer/director Juan Solanas had to endure when describing this thing; the barely-contained laughter with which he must have dealt. The story has the kind of backwards logic that has to be described more than once within the script, just so the audience can keep up with the film's dizzying concepts. One can almost picture a trap door lurking under Solanas and a producer about to hit the button. But would Solanas fall upwards or downwards? Such a silly question actually has a logical, straight-faced answer in *Upside Down*. Somehow, investors fell for this madness and Solanas actually got his vision on screen. Love it or hate it, its very existence is something of a miracle.

The film opens with a narration that the viewer might think is some kind of put-on. It is not. Adam (Jim Sturgess) speaks of how much wonder there is in the stars (because there are so many of them) and there is one star that makes him think of a very special person. Her name is Eden (Kirsten Dunst) and that is also not meant to be a joke. Adam comes from a different solar system, one with twin gravities. Two planets whirling around one sun. Each has its own gravity. In the same awestruck breath, Adam explains the three laws of this gravity, then ponders "what if love is stronger than gravity?" That gets answered later, of course. For now, the viewer only needs to know that there exists an affluent world (named Up Top) and a desolate world (named Down Below) and they exist on top of one another. One world appears upside down from the other. The only way the two worlds can communicate is through "Transworld," a tower that rests between them. It gets better.

The rich people world sucks up most of the electricity. The poor world, where Adam lives, has to scrap together whatever they can to create electricity in their world. The story starts with Adam as a boy living with his Aunt. From her, he learns of something called "pink bees," bees that eat flowers from both worlds. One day, while Adam looks for some pink bees and enjoys some inverted rain (again, not a joke), he throws a model airplane. It is caught by young Eden in the other world. They each exchange an upside down glance. They become friends and when they get older, he ties a rope around her and pulls her down to his world. But she will remain upside down. It gets better.

Their love is forbidden. During a flight of fancy between them, they get shot down and Adam gets taken away from his Aunt. About ten years later, Adam works as a beauty cream chemist and happens to see Eden on a television game show and learns that she works for Transworld. Adam gets a job at Transworld where he has to look at everyone on the ceiling just to talk to them. He intends to use Transworld as a means of getting a patent on his anti-aging cream. He makes a friend named Bob (Timothy Spall), a stamp collector and they strike a deal. Adam will get Bob stamps from his world if Bob (re)introduces him to Eden. Adam finds Eden and she has no memory of him. Her co-worker explains to him "Oh, it's just her amnesia." But they hit it off (again) anyway. They go out and he tries to jog her memory, but to no avail. And it gets better.

But it really has to be seen to be believed, a sentiment that carries multiple meanings. Visually, the film has some extraordinary moments. With the overabundance of special effects films over the past few decades, almost all of which have a DVD extra explaining how they did it, it is a rare thing for a viewer to watch a film and wonder, "how did they do that?" *Upside Down* has such moments. Solanas puts images on the screen that have their own unique poetry to them, the kind of designs that come from dreams, paintings, and only the most beautiful of children's books. The sprawling cityscapes and offices that permeate both sides of the screen recall those seen in Fritz Lang's *Metropolis* (1927), Ridley Scott's *Blade Runner* (1982), and Steven Spielberg's *Minority Report* (2002). Solanas and cinematographer Pierre Gill never let the film get too pretty or slick either. With the buildings' rough edges and the bluish tint that almost constantly fills the frame, the world of *Upside Down* looks appropriately well-worn and strangely unpolished.

Unfortunately, the movie is just as weak and laughable when it comes to everything else. With such contrivances as an awkward beauty cream sub-plot, gravity weights that get too hot to handle and floating pancakes made of pink bees, the project almost feels ghostwritten by a lightheaded M. Night Shyamalan. But even before those elements are introduced, it completely dooms itself from the outset with Sturgess narrating as though he had just been cast opposite Kirk Cameron in a faith-based science fiction film. The unbearable earnestness with which he describes this world and his longing for Eden causes the film to collapse just minutes into the proceedings. No amount of visual wizardry from here on in can rescue it.

The film's sincerity is not its biggest problem. Almost all of the dialogue serves as a means to over explain everything. Solanas clearly has affection for his characters and the world they inhabit, at least judging solely by how he presents them, and the direction he has given poor Sturgess and Dunst, but they have no personality or chemistry. They may as well be star-crossed narrators. The supporting characters do no better. The always reliable and likable Timothy Spall, copping an American accent, has been given scenes so laughable and contrived that even he cannot make them work. They all give the kind of embarrassing performances they probably hope will be buried in obscurity for future generations.

Upside Down barely reached any kind of audience upon its release. There is always the possibility of it having a cult following, but more likely it will be looked upon as a kind of contemporary equivalent to *Jonathan Livingston Seagull* (1973), the kind of beautiful looking train wreck that tries harder to sell the viewer a pile of metaphors for humanity than a story about characters with whom anyone can truly connect. Nobody will criticize this film for its visual splendor or even its originality. But instead of pondering the duality of parallel universes, expounding upon the existence of heaven and hell in modern times or even rooting for the forbid-

den lovers to find each other (which they do over and over and over again), the only metaphor viewers will be able to form in their heads while watching *Upside Down* is a visual, that of Solanas getting himself dressed up nice and sharp only to urinate in his own face.

Collin Souter

CREDITS

Adam: Jim Sturgess
Eden: Kirsten Dunst
Bob Boruchowitz: Timothy Spall
Origin: United States
Language: English
Released: 2013
Production: Claude Leger, Dimitri Rassam, Aton Soumache, Jonathan Vanger, Alexis Vonarb; Onyx Films, Transfilm, Upside Down Film; released by Millennium Entertainment L.L.C.
Directed by: Juan Diego Solanas
Written by: Juan Diego Solanas
Cinematography by: Pierre Gill
Music by: Benoit Charest
Sound: Olivier Calvert
Editing: Paul Jutras
Art Direction: Isabelle Guay
Costumes: Nicoletta Massone
Production Design: Alex McDowell
MPAA rating: PG-13
Running time: 100 minutes

REVIEWS

Freeney, Mark. *Boston Globe*. March 13, 2013.
Goldstein, Gary. *Los Angeles Times*. March 14, 2013.
Gleiberman, Owen. *Entertainment Weekly*. March 13, 2013.
Howell, Peter. *Toronto Star*. April 25, 2013.
Jones, J. R. *Chicago Reader*. March 14, 2013.
O'Sullivan, Michael. *Washington Post*. March 15, 2013.
Pais, Matt. *RedEye*. March 14, 2013.
Robinson, Tasha. *AV Club*. March 14, 2013.
Smith, Kyle. *New York Post*. March 15, 2013.
Sobczynski, Peter. *Chicago Sun-Times*. March 15, 2013.

QUOTES

Adam: "Up-top, they always win, And down-below, we always fail."

TRIVIA

Emile Hirsch was originally in talks to star in the film.

UPSTREAM COLOR

Box Office: $444,098

Shane Carruth's daring, challenging, mesmerizing *Upstream Color* attempts to alter viewer expectations of the very form of filmic storytelling. The question is simple: Can a film be more poetry than prose? Can a director use elements like sound, montage, symbolic imagery, and other non-narrative ingredients to craft a story; to elicit an emotional response. *Upstream Color* frustrates some audiences in the same way that untraditional narratives like Terrence Malick's *The Tree of Life* (2011) and David Lynch's *Mulholland Drive* defy easy categorization. And yet just as many were enraptured by this unforgettable film. Blending *Walden*, science fiction, romance, and issues of control vs. free will, *Upstream Color* is like a classical composition with themes that repeat but no actual lyrics. And yet Carruth taps emotional currents without using the traditional tools of character or an easily discernible plot. What is *Upstream Color* about? Even asking the question is too traditional for a film like Carruth's.

While one is tempted to try and craft a review as formatively unique as Carruth's film, this is the point where plot must be conveyed. And, at least to start, there is a very discernible story within this puzzle of a film. Carruth's work opens with a cycle of images meant to set tone and immediately throw viewers into a different filmic headspace: A man carries papers that have been crafted into strands that look like DNA. Cut to a shot of the man throwing them into a bin with a recycling logo. Cut to shots of bicycle wheels spinning, a steering wheel, and one starts to get a visual motif of circles, cycles, motions that repeat, etc. It is a visual theme that will continue throughout the film, a piece of work that, no matter how one interprets it, has connections to circle of life and repeated, cyclical patterns of humanity and possibly even a higher, spiritual order.

The man with the folder DNA-esque paper is malevolent. It is quickly revealed that he can control others. First, he works with a pair of teens who can first mimic each other's actions with their eyes closed. They then partake in a fight in which each seems to know one another's movement as it is happening; possibly even before. And yet the revelation that this is a world in which mind control exists should not lead one to believe that this is a sci-fi chunk of philosophy a la *The Matrix* (1999) or its numerous clones. If anything, these early scenes of minds being given over to another should serve as a model for the viewer. Just give in. Just go with it.

The unnamed man, referred to as "Thief" in the credits, kidnaps the film's protagonist, a woman named Kris (the captivating and perfect Amy Seimetz in arguably the most underrated, physical, fearless performance of 2013). Kris is the kind of beautiful, big city professional who looks like she a lot of her life together until it is literally stolen. The man takes control of her (and, yes, it seems safe to begin reading themes of religion—

free will versus a higher, controlling power—here) and treats Kris like an evil hypnotist. At first, it seems almost like a game as he convinces Kris that the pitcher of ice cubes in front of her contains the blinging light of the sun. However, it quickly turns much darker as Kris empties her bank accounts for him and literally signs away her life. And then things get really freaky when "The Sampler" (Andrew Sensenig) appears to harvest something from Kris (a soul, perhaps?) and puts it in the body of a pig. A comment on medical manipulation? Reincarnation? All of the above? None of the above? Who knows? But it is nonetheless captivating.

With her life literally ruined from within, Kris is left shattered but with no choice but to try and move on. She gets a new apartment, a new job, and meets a man named Jeff (charismatically played by Carruth himself) and the two form a relatively straightforward couple during the second act, easily the film's most straightforward. In fact, Carruth's film almost becomes a love story, a tale of redemption for a woman who lost her self-control. And then, like the Thief, Carruth pulls that rug out from underneath the viewer as Kris and Jeff start to have the same memories; before a final act that includes no dialogue for over twenty minutes.

Whatever one may think of a film that is so purposefully defiant of audience expectations to the degree that it could be frustrating in its pretentiousness, this an undeniable technical accomplishment. Carruth is more than director, serving as cinematographer, co-editor with fellow filmmaker David Lowery (*Ain't Them Bodies Saints* [2013]), composer of the film's essential and beautiful score, co-star, and cinematographer. He also assisted with the award-winning sound design. In many scenes, it would not be a stretch to say that this sound design is the "star," the role usually filled by a character. Rain, the sound of metal, the noise of pigs, the din of traffic—every decision is carefully made in a film this meticulously constructed. And all of these ingredients become more essential because of the elusive nature of Carruth's plotting. There are major portions of the film where the score, the way it is edited, and the beauty of Carruth's remarkable eye for composition are the characters.

Which should not be read as any sort of diminishment of Seimetz's breathtaking work. She goes through such a wide range of emotion and character with less dialogue than most Supporting Actress nominees. Even in that final half-hour, when she is stripped of the traditional performer tool of dialogue, this is a well-rounded, engaging performance. Carruth, as a performer, takes an intentional back seat, giving himself a less memorable character. He even shoots many of the scenes between the two of them by keeping focus on her. One never loses the sense that this is her story, although one could

easily see Carruth being a charismatic performer in someone else's work as well.

As cliched as it may sound, *Upstream Color* can be as effective as the Thief's form of mind control if the viewer allows it to be so. It is a film that can influence dreams and returns to memory like a song. It is a work that lingers and grows significantly upon repeat viewing. Scenes that felt cold on initial experience provoke a different reaction the second time through. And it is a film to discuss, dissect, and debate. Whatever one thinks about its overall success, it is difficult to disagree with the thought that cinema would be better off with more films worthy of heated discussion.

Brian Tallerico

CREDITS

Jeff: Shane Carruth
Kris: Amy Seimetz
The Sampler: Andrew Sensenig
Thief: Thiago Martins
Origin: United States
Language: English
Released: 2013
Production: Casey Gooden, Ben LeClair, Shane Carruth; released by erbp
Directed by: Shane Carruth
Written by: Shane Carruth
Cinematography by: Shane Carruth
Music by: Shane Carruth
Sound: Peter Horner
Editing: Shane Carruth
Production Design: Thomas Walker
MPAA rating: Unrated
Running time: 96 minutes

REVIEWS

Abrams, Simon. *Chicago Sun-Times*. April 3, 2013.
Goodykoontz, Bill. *Arizona Republic*. April 25, 2013.
Goss, William. *Film.com*. February 26, 2013.
Johnston, Trevor. *Time Out London*. August 27, 2013.
Keough, Peter. *Boston Globe*. April 11, 2013.
Kohn, Eric. *IndieWire*. February 5, 2013.
Marsh, Calum. *Slant Magazine*. March 19, 2013.
Mohan, Marc. *Portland Oregonian*. April 18, 2013.
Tobias, Scott. *The A.V. Club*. April 3, 2013.
Turan, Kenneth. *Los Angeles Times*. April 11, 2013.

QUOTES

Thief: "I have to apologize. I was born with a disfigurement where my head is made of the same material as the sun."

TRIVIA

The film that Kris is editing at the beginning of the movie is *A Topiary*, the film that Shane Carruth had begun production on before deciding to film *Upstream Color* instead.

AWARDS

Nominations:

Ind. Spirit 2014: Director (Carruth), Film Editing

V

V/H/S/2
(S-VHS)

Who's tracking you?
—Movie tagline

Box Office: $21,833

There are many ways to judge an anthology feature but it always comes down to on indisputable factor - percentages. The average genre film with a three-act structure can succeed or fail based on how the flaws stack up over the full running time. A poor conclusion can sometimes negate the strong work of the first two-thirds. An inconsistent middle act may still be book-ended by strong writing, acting, and ideas that themati-cally satisfy its intentions. Anthologies are all about the numbers. *Twilight Zone: The Movie* (1983) got almost universal pans for its first two chapters but enormous praise for its last two. Does one recommend the mixed bag on the strength of its best moments or does its wraparound story keep it just below the line? *The ABCs of Death* (2013) stretched anthologies to the extreme, both in its taboo boundaries and for literally using the alphabet to tally up 26 short films by various directors. Part of its inspiration was the first *V/H/S* (2012), a col-lective gathering of low-budget filmmakers bringing their tales of horror together for the genre junkies of the festival circuit. Despite being much less than a mixed bag of obvious shocks and ironic twists, it was successful enough amongst fans to have a sequel in the works by the time it was sold at Sundance. Less chapters this time around help with the percentages, and, overall, it is a better collective of a film, but how much better?

The wraparound story that binds the shorts together is not far removed from the original, and only slightly less stupid. A pair of private investigators looking for a missing student breaks into his home, discover a room full of VHS tapes, and begin to watch them. The first, "Phase I Clinical Trials," directed by Adam Wingard (*You're Next* [2013]), involves a guy (Casey Adams) who has a camera installed in his head after losing an eye. Next thing he knows he is having visions from beyond the living. In "A Ride in the Park" from the producers of *The Blair Witch Project* (1999), Eduardo Sanchez and Gregg Hale, a cyclist wears his own camera on his helmet when he encounters what looks to be the beginning of a zombie outbreak. Gareth Evans teams with Timo Tjah-janto on "Safe Haven" about a news crew's visit to an Indonesian cult. Finally, Jason Eisener presents "Slumber Party Alien Abduction" about, well, the title says it all.

One of the many problems with the first *V/H/S* was a substandard substitution for fresh ideas with "LOUD NOISES!" Going back to the *Twilight Zone* TV series, fans already know to expect endings of doom and contradiction so the writing was already on the wall the moment each segment began. Whatever ingenuity was crafted became more in tune with how to evolve the found-footage aspect of the genre rather than the sto-rylines themselves. The repetition got old really fast and only the segment involving a girl Skyping with her boyfriend had the proper slow burn and surprises neces-sary to keep viewers on true tilt. *V/H/S/2* corrects some of those mistakes.

Though not right away. Wingard's segment, the first full one, has a little fun bringing a new spin to intimate privacy but as with nearly all transplants in

horror films, the past those parts come with are never pretty and even less shocking. As is recommended to one of the prologue's investigators, it is best to watch these tapes in a certain sequence to properly affect them. This comes to fruition in the second segment which is both a technical marvel and a whole lot of fun. In an era where zombies have infected nearly all manner of pop culture and media, to find any fresh take is an accomplishment all its own. Sanchez and Hale weave humor, paranoia, violence and stunt work into what is the best segment of both films. Up to that point.

One could go back and forth determining which is the true beauty of this compilation but there is no debate over which is the most insane. Gareth Evans took martial arts violence to glorious new extremes in *The Raid: Redemption* (2012). Taking viewers into the inner workings of a cult might seem like a step back until we realize he is just setting up to witness the unleashing of hell on Earth. The pacing of his segment is magnetic, the imagery is horrific, and the payoff trumps most feature-length horror entities. And if it had all ended there, this sequel would have been a solidly-built, three-part roller-coaster ride.

Alas, it ends with Eisener, whose best work remains the fake trailer that became the worn-out and ugly welcome that was *Hobo with a Shotgun* (2012) and his short film, *Treevenge* (2008), about Christmas foliage fighting back against being chopped down. Shorts are right in Eisener's wheelhouse and his alien abduction finale starts out fun with a dog-cam and kids disrupting their older sister's uninvited friends. Yet when the true uninvited arrive, it dissolves into another mixture of shaky camera, disorientating light, and feedback-inducing shrieking through the speakers up until its unpleasant end.

Where does that leave the final taste in someone's mouth to recommend *V/H/S/2* to a friend? Order is paramount if one is to invest a full order of time in watching the film front-to-back. Films like this are groomed more for home viewing where one can skip around to their favorite chapters on the DVD and ignore the negative parts of its sum total. None of the filmmakers may be prone to say it to each other's faces, but clearly an outside eye can determine the most feasible progression of the shorts. Horror is all about raising the stakes and the classics that have lived on through time save many of their best gut punches for their finales. If *V/H/S/2* had ended with the one-two-punch of the zombies and cults instead of the loud aliens and the oh-yeah-there's-still-a-wraparound-story-to-wrap-up, horror fans may have left the theater on such a high that they would declare it a classic in its own right. Considering the entire package, it is a must-see for fans for the middle segments which are unfortunately wedged between two pieces of stale bread.

Erik Childress

CREDITS

Larry: Lawrence Michael Levine
Ayesha: Kelsey Abbott
Herman: Adam Wingard
Clarissa: Hannah Hughes
Biker: Jay Saunders
Father: Epy Kusnandar
Adam: Fachry Albar
Lena: Hannah Al-Rashid
Jen: Samantha Gracie
Gary: Rylan Logan
Randy: Cohen King
Origin: United States, Canada
Language: English
Released: 2013
Production: Gary Binkow, Bras Miska; released by Magnet Releasing
Directed by: Adam Wingard; Simon Barrett; Eduardo Sanchez; Greg Hale; Timo Tjahjanto; Gareth Evans; Jason Eisener
Written by: Simon Barrett; Timo Tjahjanto; Gareth Evans; Jason Eisener; Jamie Nash; John Davies
Cinematography by: Tarin Anderson; Abdul Dermawan Habir; Stephen Scott; Seamus Tierney; Jeff Wheaton
Music by: James Guymon; Steve Moore; Aria Prayogi; Fajor Yuskemal
Sound: Brett Hinton
Editing: David Gels; Bob Rose; Adam Wingard; Eduardo Sanchez; Gareth Evans; Jason Eisener
Costumes: Avon Dorsey; Autumn Steed
Production Design: Thomas Hammock
MPAA rating: Unrated
Running time: 96 minutes

REVIEWS

Dowd, A. A. *The Onion A.V. Club.* July 11, 2013.
Gire, Dann. *Daily Herald.* July 25, 2013.
Goss, William. *MSN Movies.* March 21, 2013.
Kohn, Eric. *indieWIRE.* June 6, 2013.
Nusair, David. *Reel Film Reviews.* September 2, 2013.
Putman, Dustin. *DustinPutman.com.* June 10, 2013.
Rabin, Nathan. *The Dissolve.* July 11, 2013.
Rodriguez, Rene. *Miami Herald.* July 19, 2013.
Taylor, Drew. *The Playlist.* July 12, 2013.
Weinberg, Scott. *FEARnet.* March 11, 2013.

WALKING WITH DINOSAURS 3D

Box Office: $35.8 Million

The mostly animated adventure *Walking With Dinosaurs* is a combination of an educational film about dinosaurs and a narrative adventure film about dinosaurs. There seems to be an effort here to teach young viewers about the kinds of creatures that used to exist back in the cretaceous period, but with a deep fear of boring them. Likewise, there is an effort here to entertain those same viewers, but the periodic insertions of information about said dinosaurs within the frame seem to exist in order to pad the film out since its empty storyline seems to meander quite a bit. Entertaining while educating can be tricky and while the motives here are admirable, the end result is a tepid and irritating film, the likes of which are better suited for those at the Nature division of Walt Disney Studios, the brand behind recent educational nature films such as *Earth* (2009), *African Cats* (2011), and *Chimpanzee* (2012).

The film opens with a hardly-necessary live-action preamble involving a teenager named Ricky (Charlie Rowe), his little sister and paleontologist uncle (Karl Urban) all heading up to Alaska to dig up dinosaur bones. The dialogue is strictly expository. Once the car is parked, Ricky's sister and uncle go off exploring while Ricky stays behind to mope around. With him is an old dinosaur tooth left behind by his sister. A raven flies in and informs Ricky that this dinosaur tooth is the key to opening up the past. It tells a story that happened 70 million years ago and this bird, Alex (voiced by John Le-

guizamo), is going to tell Ricky the whole story whether he likes it or not.

It begins with a pachyrhynosaurus, the runt of the litter named Patchi (voiced by Justin Long). He is often made to feel inferior to his older brother, Scowler (voiced by Skyler Stone). Patchy has a bit of wanderlust in him. He flees the nest early in the film, gets into trouble with some small yellow creatures (known as hespyronicus) and eventually gets rescued by his mother. His father is the stoic and silent leader of the clan named Bulldust and "nobody messes with him." Patchi also notices a female of his species named Juniper (voiced by Tiya Sircar), whom he sees once, but does not see again until much later in the film. He visits the same waterfall every day in hopes of seeing her there again. But there comes a time of a big migration whereby Patchi, his family and the rest of the herd must change location.

During this time, a forest fire accidentally catches while at the same time, the herd get attacked by Gorgosaurus (which look like the close cousin of a T-Rex). During this attack, Patchi and Scowler's parents get killed. The two must now fend for themselves on this journey. Luckily, they run into Juniper and her family and they pretty much stick with them. Patchi and Juniper develop a close friendship and Scowler teases Patchi for having a new girlfriend. Patchi also has an odd disfiguration in his horns, a hole that emits a strange whistle when he moves his head. Eventually, of course, other mishaps ensue that separate Scowler, Patchi and Juniper from the rest of the herd and they must make the journey on their own. Soon, Scowler becomes the leader of another herd, which causes some sibling rivalry,

but the story is ultimately about Patchi's ability to find the courage within himself to become a leader.

The film has many educational sidebars throughout. Anytime a new creature appears, a disembodied voice (usually a child) informs the viewer as to whether this creature was a herbivore or a carnivore, how big or how small it was and its predators and/or prey. These moments have significantly more value than the weak storyline being sold here. They are certainly easier to follow. Part of what makes *Walking With Dinosaurs* such a failure has to do with the fact that, while these creatures are animated, they are given no life whatsoever. Their mouths never move when they talk. The actors providing the voices do so almost as an afterthought. Presumably, this makes it much easier to translate for overseas audiences and do not require much effort when re-dubbing, but that is no excuse. For a film like *Homeward Bound: The Incredible Journey* (1993), where they had actual animals, but not the technology yet to give them moving mouths, this technique is okay. It works. But for an animated film in 2013, it smacks of laziness. It does not help matters much when two main characters—Patchi and Alex—narrate the story and sometimes fight over who is supposed to be narrating, all during a wide shot that consists of other creatures talking, making it unclear as to who is saying what.

The film also fails because of its childish tone. Sure, this is a movie for young people, but even younger viewers will be put off by how baby-ish this comes across at times. The constant barrage of poop and fart jokes do not help matters. *Walking With Dinosaurs* is based on a very popular educational BBC series narrated very effectively by Kenneth Branagh. For all its visual splendor—and there are many visually beautiful moments—*Walking With Dinosaurs* feels too much like a Happy Meal version of something more substantial. For exciting dinosaur adventures, one is better off sticking with *King Kong* (both 1933 and 2005), Steven Spielberg's *Jurassic Park* (1993) Disney's *Dinosaur* (2000), and Don Bluth's animated *The Land Before Time* (1988).

Collin Souter

CREDITS

Uncle Zack: Karl Urban (Voice)
Alex: John Leguizamo (Voice)
Patchi: Justin Long (Voice)
Origin: United States
Language: English
Released: 2013
Production: Mike Devlin, Amanda Hill, Deepak Nayar; BBC Worldwide Americas Inc.; released by Twentieth Century Fox Film Corp.

Directed by: Barry Cook; Neil Nightingale
Written by: John Collee
Cinematography by: John Brooks
Music by: Paul Leonard-Morgan
Sound: Paul Pirola
Music Supervisor: Season Kent
Editing: John Carnochan
MPAA rating: PG
Running time: 87 minutes

REVIEWS

Barnard, Linda. *Toronto Star*. December 19, 2013.
Genzlinger, Neil. *New York Post*. December 19, 2013.
Gilchrist, Todd. *The Wrap*. December 23, 2013.
Kang, Inkoo. *Village Voice*. December 20, 2013.
Lumenick, Lou. *New York Post*. December 20, 2013.
Merry, Stephanie. *Washington Post*. December 19, 2013.
Morgenstern, Joe. *Wall Street Journal*. December 19, 2013.
Neumaier, Joe. *New York Daily News*. December 19, 2013.
Russo, Tom. *Boston Globe*. December 19, 2013.
Sachs, Ben. *Chicago Reader*. December 19, 2013.

QUOTES

Juniper: "I think I just stepped in some fear!"

TRIVIA

Animation Director Marco Marenghi was an animator on the original *Walking with Dinosaurs* documentary series.

WAR WITCH
(Rebelle)

Box Office: $70,544

War Witch may be the most powerful film ever made about the experience of child rebels in Africa. To call it a movie, to examine it purely aesthetically, is to distract people from what they should do while watching it. It is a film viewers should approach with the desire to feel what it has to say, to be touched, and to be made different as a result. Writer director Kim Nguyen tells a coming-of-age story steeped in deep magic about children thrust into a situation that could be called adult if the word inhuman were less apt a descriptor. This is the film's main strength: Through the force of its central character, 12-year-old Komona, viewers experience her heart, her mind, and her imagination as they absorb her experiences. It is a monumental achievement.

Komona (Rachel Mwanza), is abducted by rebels from her African village during a civil war and forced

into becoming a child soldier. Given a choice to kill her parents with an AK-47 or watch them be killed slowly with a machete she tearfully complies and is taken deep into the jungle for training. Starved and beaten to weaken her will, Komona retreats inward living on the comfort her imagination provides and marveling at the visions provided by her intake of "magic milk," a tree sap the rebels drink. Those visions include white-eyed, white-painted ghosts who wander the war torn area of the camp and the fight zones. Sometimes they are people she has known, like her parents, and, in her first firefight, they warn her to run just before an explosion of enemy fire annihilates her squad. Her improbable escape garners the attention of the rebel leader The Great Tiger who ensconces her as his "war witch," a living supernatural talisman whose predictions will help guide his military campaigns.

Komona's visions are as mysterious to her as they are to everyone else. It is only a matter of time before she is cast aside, most probably killed, and this danger brings Magician (Serge Kanyinda), a fellow rebel and albino boy, to her side. At first Magician befriends her with treats and "magic milk" but after a near disastrous firefight convinces Komona to flee the rebel army with him, a cross country trek ensues in which he professes his love for her. Leery, she tells him she will only marry him if he can prove his love by bringing her a quite-possibly-mythical white rooster.

Their travels present a rest from the horrors of war, and, though Magician is unable to find the rooster, the pair are able to find refuge with his uncle, Butcher (Ralph Prosper), a man deeply traumatized by the unspeakable atrocities rebels committed against his own family. What follows are a fragile few moments of peace that last only until soldiers, sent by The Great Tiger, to retrieve his war witch, capture Komona who is then used as a sex slave. After becoming pregnant, Komona takes her own destiny in hand, wreaking a horrifying vengeance on her captor and escaping once more, intent on giving her child a clean spiritual slate by finding her parents' remains and burying them.

The intensity of nature all around these characters would be distracting if Nguyen treated it as anything less than a pure extension of the characters' emotional state. Lush, oppressive, mysterious, sometimes all at once, the jungle hides danger, reveals beauty, and unleashes a hallucinatory power over their perception of reality. Sometimes that power takes on a physical nature, such as when the children are introduced to the magic milk. But often viewers are invited simply to feel what the children feel, surrounded, lost, sweaty, tangled by the desire to belong, the terror of what lies ahead and the despair of what has gone before to bring them to this place. It becomes almost impossible not to see the jungle as a metaphor for them and even their entire region.

Yet as great as the cinematography by Nicolas Bolduc is there is no doubting *War Witch* is a film first and foremost about its characters. The performers disappear here. Komona is onscreen constantly and though the film gives her scant dialogue, favoring instead her voiceover as her time with the rebels is revealed in flashback, there is a grace and simplicity in her observations that bring her to vibrant life. Rachel Mwanza is a revelation but then again all the performers here simply disappear into their roles.

When the film focuses on Magician it underscores the importance of magic to the story. Albinos have a reputation as magical creatures in African tribal culture that leaves them vulnerable to being killed by those who believe they can take on magical powers by eating certain of their body parts. While this is never spelled out in the film, magician's search for the mythical white rooster could easily be understood as Magician's search for himself. Komona's request that he prove his love by finding the bird has to do with protecting her innocence. Magician's discouragement at being unable to find it has to do with facing reality which he feels is the one thing that has kept them from harm. The requirement for love is that they meet in the middle if they are to do more than simply survive, in other words they need magic that can only be worked by the two of them together. The film is full of people invoking magic for more or less selfish reasons but only in these two characters is magic used as something that is about embracing the other. A cogent commentary on the African wars to be sure.

African pop music is used throughout, particularly in the middle third of the film, to great effect, giving much needed relief. The middle section of *War Witch* in general is replete with good humor and human warmth but never invokes sentiment for its own sake. Instead, Nguyen is inviting viewers to become lost in the magic of what could be; what the characters, the children, hope for in a part of the world where hope is a rare commodity. These are simple things that too many take for granted; things that should be far more accessible than a white rooster. Nguyen's film was nominated for the 2012 Academy Award for Foreign Language Film and cinema lovers would do well to keep his work in their sights. He is simply a person who needs to keep making movies.

Dave Canfield

CREDITS
Komona: Rachel Mwanza
Magician: Serge Kanyinda

Great Tiger: Mizinga Mwinga
Origin: Canada
Language: Lingala, French
Released: 2012
Production: Pierre Even, Marie-Claude Poulin; Item 7, Shen Studio; released by Tribeca Film Institute
Directed by: Kim Nguyen
Written by: Kim Nguyen
Cinematography by: Nicolas Bolduc
Sound: Martin Pinsonnault
Editing: Richard Comeau
Costumes: Eric G. Poirier
MPAA rating: Unrated
Running time: 90 minutes

REVIEWS

Douglas, Edward. *ComingSoon.net*. February 26, 2013.
Felperin, Leslie. *Variety*. January 10, 2013.
Hoffman, Jordan. *Film.com*. February 27, 2013.
Holden, Stephen. *New York Times*. February 28, 2013.
Long, Tom. *Detroit News*. June 13, 2013.
Mandel, Nora Lee. *Film-Forward.com*. March 7, 2013.
Neumaier, Joe. *New York Daily News*. March 1, 2013.
Nash, Cara. *FILMNK (Australia)*. March 21, 2013.
Robinson, Tasha. *AV Club*. February 28, 2013.
Turan, Kenneth. *Los Angeles Times*. March 7, 2013.

TRIVIA

This was the official entry of Canada to the Best Foreign Language Film at the 85th Academy Awards 2013.

AWARDS

Nominations:

Oscars 2012: Foreign Film
Ind. Spirit 2013: Foreign Film

WARM BODIES

Cold body. Warm heart.
—Movie tagline

He's still dead but he's getting warmer.
—Movie tagline

There's nothing hotter than a girl with brains.
—Movie tagline

Dead sexy.
—Movie tagline

Bros before brains.
—Movie tagline

Box Office: $66.4 Million

There was a time when zombies were associated with one and only one name—George A. Romero. Since his invention of the genre with *Night of the Living Dead* (1968) many filmmakers have taken their spin on munching-flesh creatures, mostly using their entire budgets to squeeze every last bit of gore out of the proceedings. Danny Boyle reinvented the stamina of the troubled genre with the infected populace of *28 Days Later* (2003) in the same year that saw the launch of *The Walking Dead* comic book by Robert Kirkman. The next year, Zack Snyder surprised everyone by delivering a fast, scary update of Romero's sequel, *Dawn of the Dead* (2004) and audiences were introduced to Edgar Wright and Simon Pegg having both fun and allegiance to the genre with *Shaun of the Dead* (2004). It is no coincidence that Romero himself jumped back into the game with his politically-charged *Land of the Dead* (2005) and two subsequent chapters. For fans, to know zombies are to love them. But is it possible for that love to go the other way?

Instead of the huddled-together survivalists gathering strength, this apocalypse is viewed through the eyes of "R" (Nicholas Hoult), an undead teenage boy wandering around the airport among his fellow zombies. His mind narrates with the lucid thoughts of human experience but his vocal capacity is reduced to simple grunts and groans when communicating with his undead friend "M" (Rob Corddry, in his finest screen work to date) as they search for fresh food. A similar reconnaissance mission is coming their way, led by Julie Griglio (Teresa Palmer) and her boyfriend, Perry (Dave Franco). An ambush ensues and "R" gets his teeth into a brain which allows him to absorb the memories of the deceased. If his attraction to Julie was not already love at first sight, it is the first bite into someone who already loved her that seals the deal.

"R" is compelled to protect Julie from the rest of the zombie horde, hiding her in the airplane he calls home. Initially resistant from this visibly gentle creature, Julie slowly begins to grasp that he is different from the others who have been hunting humans. Far from the skeletal "bonies" who have lost all traces of humanity, "R" is now developing emotions that hit his heart like a defibulator. Selling this medical miracle to the living is hardly an easy one, especially when Julie's father (John Malkovich) is the leader of the remaining militia.

This is not the first time film has explored this territory. *My Boyfriend's Back* (1993) tracked a recently-zombified teenager and his quest to woo his longtime crush while parts of him fell off. Plus who can forget the dead boyfriends of *Return of the Living Dead* (1985)—as well as *Part II* (1988)—guilting their living girlfriends into eating their brains? Jonathan Levine's adaptation of Isaac Marion's novel takes the trickier task of finding

sincerity in the notion without tapping into the creepier recesses of our mind or dumbing it down into the simplistic tween logistics of what love is. That the film succeeds in this accomplishment is a miracle in itself.

The comparisons to the *Twilight* series are self-evident except where it comes to acting, storytelling, thrills, and emotional consequence. "R" is an undead shell of a former self yet develops a personality beyond the pale skin and hypnotic eyes. Hoult's performance is somehow more spirited here in his herky-jerky movements and limited speech than as the titular hero of *Jack the Giant Slayer* (2013). Unlike Bella Swan, Palmer's Julie is someone with a purpose who learns to love rather than establishing herself as some clueless drama queen who falls into amour as a thrill to overcome her boredom. She too is learning what it is like to be human again. Surrounded by so much death, the simple pleasures of driving a car, swigging a beer, or listening to albums equally reinvigorate a girl in the midst of rebellious disagreements with her father's newfound philosophies.

Much like *Fido* (2006), in which a young boy comically keeps a zombie as his pet, Levine finds the appropriate balance in tone between taking the zombie plague and their threat seriously and acknowledging the absurdity of the growing affection. The first hour with "R" playing the role of protector effectively drives the story before settling in for its action climax and equal threats from the living. With a foundation that not-so-subtly reflects the star-crossed conflict of a certain Shakespeare piece—right down to a late-night balcony visit—*Warm Bodies* could have stepped wrong in a variety of ways. Aided in part by music cues that instantly inject all manner of irony, adrenaline, and directly-referenced parody, this is a film that nevertheless still respects the inherited knowledge of zombie films; showing there is still room to grow in the genre as "R" suggests that "the brain is the best part."

Erik Childress

CREDITS

R: Nicholas Hoult
Julie: Teresa Palmer
M: Rob Corddry
General Grigio: John Malkovich
Perry Kelvin: Dave Franco
Kevin: Cory Hardrict
Nora: Analeigh Tipton
Origin: United States
Language: English
Released: 2013

Production: Todd Lieberman, David Hoberman; Mandeville Films; released by Summit Entertainment
Directed by: Jonathan Levine
Written by: Jonathan Levine
Cinematography by: Javier Aguirresarobe
Music by: Marco Beltrami
Sound: Martyn Zub
Editing: Nancy Richardson
Costumes: George L. Little
Production Design: Martin Whist
MPAA rating: PG-13
Running time: 97 minutes

REVIEWS

Dowd, A. A. *Time Out Chicago*. February 1, 2013.
Fine, Marshall. *Hollywood & Fine*. February 4, 2013.
Gonsalves, Rob. *eFilmCritic*. March 13, 2013.
Johanson, MaryAnn. *Flick Filosopher*. February 11, 2013.
Lybarger, Dan. *Arkansas Democrat-Gazette*. February 1, 2013.
McGranaghan, Mike. *Aisle Seat*. February 1, 2013.
McWeeny, Drew. *HitFix*. January 31, 2013.
Nusair, David. *Reel Film Reviews*. May 20, 2013.
O'Hehir, Andrew. *Salon.com*. February 1, 2013.
Weinberg, Scott. *FearNet*. February 1, 2013.

QUOTES

R: "What am I doing with my life? I'm so pale. I should get out more. I should eat better. My posture is terrible. I should stand up straighter. People would respect me more if I stood up straighter. What's wrong with me? I just want to connect. Why can't I connect with people? Oh, right, it's because I'm dead."

TRIVIA

The actors portraying the zombies in this film chose not to blink, which was particularly uncomfortable for actor Nicholas Hoult who did a few long scenes without blinking. Later in the film (when the zombies start turning more human), they start blinking again.

THE WAY WAY BACK

We've all been there.
—Movie tagline

Box Office: $21.5 Million

At a certain vulnerable age or state of mind, many things seem impossible. Forget the scientific likelihood that, say, someone could pass another person on a water slide; the basic ability to feel confident and fit in seems like a statistical long shot. That is until the time and place, and everyone has it, that changes everything. For

shy 14-year-old Duncan (Liam James) in *The Way Way Back*, that shift occurs at Water Wizz water park, a refreshingly old-school hangout where fun takes priority over rules. That is because Owen (Sam Rockwell), the manager, serves as more of a comedian than an enforcer. Yet part of what makes Rockwell's performance one of the year's canniest supporting turns is that Owen is not a clown. (In fact, the guy hates clowns, and he is no hypocrite.) Though no one would be wrong in calling him irresponsible, he is also someone who creates happiness where unnecessary rigidity could be and supports Duncan when no one else does.

It is easy to see why whenever he can the awkward teenager sneaks off to the park, which serves an opposite function as the anguished wasteland of *Adventureland* (2009). Vacationing with his mom Pam (Toni Collette) at her boyfriend Trent's (Steve Carell) northeastern beach house for the season, Duncan gets treated like a nuisance. Trent's shallow daughter Steph (Zoe Levin) resents his presence, and Trent's boozy sister Betty (Allison Janney, delightfully batty) tries to pawn off her young son Peter (River Alexander) on Duncan. Fortunately, Betty has another child, Susanna (AnnaSophia Robb), who is a little older than Duncan but far more down to earth than Steph and her clueless friends, whose idea of tragedy is living in a one-room apartment. As if.

Where Jim Rash and Nat Faxon's Oscar-winning script with Alexander Payne for *The Descendants* (2011) struggled to balance comedy and drama or properly address certain aspects of familial bickering, the pair's script for *The Way Way Back* (which they also directed) delicately blends big laughs and painful revelations without causing viewer whiplash. Duncan's journey should be relatable to anyone who has ever felt out of place, and anyone who claims a lack of familiarity there is either very lucky or, more likely, a liar. Perhaps it is a stretch for Duncan to obtain the nickname "Pop 'n Lock" after dancing for a group of park-goers, and perhaps Rash and Faxon should not have resorted to a scene of black people teaching a white guy how to shake it. (Somewhere out there, Will Smith is still trying to get Kevin James to control his wild gesticulations in *Hitch* [2005], to say nothing of the offensive racial stereotypes in junk like *Bringing Down the House* [2002]).

It still feels nothing short of joyous to watch this kid become not some kind of illogical hero but merely a better, stronger version of himself, enabled by a mentor and rewarded by an environment where he is welcome. It is a huge change from his time with Trent, who in Carell's chillingly, subtly cruel performance aims to chip away at Duncan's few strands of emotional stability until he cracks. When Trent, whose unpleasant competitive streak comes out during a game of CandyLand, says to Duncan, "One day we could become a family," he means it as a threat, not an olive branch. Meanwhile Duncan's mom tolerates her boyfriend, his friendship with Kip (Rob Corddry) and Trent's possible interest in Kip's better half Joan (Amanda Peet) because she knows she deserves better but, at her age and lot in life, may not believe she can get it. Particularly next to the film's many hilarious, uplifting scenes that practically soar, these moments in which Pam clings to a low level of satisfaction are devastating.

Refusing the temptation to settle is a theme nicely threaded through *The Way Way Back*, whose familiar coming-of-age pieces can also be seen as timeless, even as water park employee Lewis (Rash) repeatedly claims he will soon leave to pursue his dreams—but never actually does. (He is like the personification of country singer Kacey Musgraves' excellent "Blowin' Smoke.") In fact, many of the adult characters here are flailing, desperate proof that adulthood does not always bring contentment and perspective, so it is never too early to take charge of life. Even if that just means kissing the girl and feeling good enough to make others take notice.

These lessons can only come from experience, of course, and James, an ideal embodiment of Duncan's figurative yet visible outer shell, nails the posture of an introvert and the progress of a boy becoming ... well, not a man, but a guy who no longer seems magnetized to the wall. In the smile-inducing *The Way Way Back*, life is a permanent effort to sort out the good and kind from the selfish and bad, and have the courage to pick from the right pile.

Matt Pais

CREDITS

Duncan: Liam James
Pam: Toni Collette
Trent: Steve Carell
Owen: Sam Rockwell
Betty: Allison Janney
Susanna: AnnaSophia Robb
Caitlin: Maya Rudolph
Kip: Rob Corddry
Joan: Amanda Peet
Roddy: Nat Faxon
Lewis: Jim Rash
Origin: United States
Language: English
Released: 2013
Production: Tom Rice, Kevin J. Walsh; Odd Lot Entertainment, Sycamore Pictures, The Walsh Company; released by Fox Searchlight

Directed by: Nat Faxon; Jim Rash
Written by: Nat Faxon; Jim Rash
Cinematography by: John Bailey
Music by: Rob Simonsen
Sound: Perry Robertson
Editing: Tatiana S. Riegel
Costumes: Michelle Matland; Ann Roth
Production Design: Mark Ricker
MPAA rating: PG-13
Running time: 103 minutes

REVIEWS

Burr, Ty. *Boston Globe*. July 4, 2013.
Goodykoontz, Bill. *Arizona Republic*. July 11, 2013.
Mohan, Marc. *Portland Oregonian*. July 11, 2013.
Morgenstern, Joe. *Wall Street Journal*. July 4, 2013.
Persall, Steve. *Tampa Bay Times*. July 17, 2013.
Phillips, Michael. *Chicago Tribune*. July 4, 2013.
Pols, Mary. *Time*. July 5, 2013.
Scott, A. O. *New York Times*. July 4, 2013.
Smith, Anna. *Time Out London*. August 27, 2013.
Tobias, Scott. *The Dissolve*. July 10, 2013.

QUOTES

Owen: "It's called delegation, baby. I read about it in a book about it."

TRIVIA

Actor Sam Rockwell would often improvise and joke around on the water park loudspeaker during scenes. One time, forgetting that there were children around, he made an inappropriate joke about herpes, which upset the owner of the park. Rockwell had to go and apologize so that they could continue filming.

WE ARE WHAT WE ARE

Blood is the strongest bond.
—Movie tagline

Box Office: $81,381

Jim Mickle created waves on the arthouse horror scene with his accomplished directorial work on *Mulberry Street* and *Stake Land*, two films with undeniable flaws but the clear hand of a confident director. The sad fact is that a month-long film festival could be programmed with small movies that critics called "promising" from directors who we barely heard from again. That is how few filmmakers actually fulfill on that critical appellation. And so it is with even more joy that Jim Mickle's *We Are What We Are* took the horror world by storm. With a sense of visual storytelling that deserves comparison to Guillermo Del Toro's horror work in films like *Cronos* and *The Devil's Backbone*, Mickle's Southern Gothic has the atmosphere and confidence that are so often missing from American scary movies. It simply looks great. Well, as great as a movie about a family of cannibals can look.

The Parkers eat people. It is hinted at and revealed early enough that one cannot really consider that a spoiler and the title's riff on "You are what you eat" kind of gives it away for anyone who thinks about it for too long. The Parkers have been eating people for generations. It is essentially a tenet of their religion, something the family has been practicing for decades after surviving a particularly brutal winter, and dictated by a book written by ancestor Alyce Parker. They believe that ritualized cannibalism washes away sin, keeping them from the grip of evil. Of course, it also makes them crazy, although the children have not yet gone as far down the rabbit hole of lunacy as their parents. When the matriarch dies, it creates drama because the next generation has not yet gone as far down the pier of cannibalism-induced insanity as the older one. And so the Parker's secrets begin to rise to the surface, not unlike the bones the rainwater unearths and sends trickling down the river.

Frank Parker (Bill Sage) is the patriarch in this wonderfully non-period specific piece. It clearly takes place in relatively modern times and yet Parker could be a ranch owner out of a Western with his swaggering style. He is the most committed of the lot now that his wife has passed away, deep in mourning and yet more convinced than ever that it is the Parker faith that will save them. The ceremony will go on. And so Frank's daughters—Iris (Ambyr Childers) and Rose (Julia Garner)—have to take a more active role in the rituals; also known as kidnapping, murdering, and using people parts as ingredients for the family stew.

A tale of a family's secrets being unraveled needs an outsider and Mickle's comes in the form of Doc Barrow (the fantastic Michael Parks, a great character actor who has not been given a part this juicy in years), who finds what he thinks is a bone in the river after a few days of rain. His own daughter is among the bizarrely-high-per-capita number of missing people in his small town, and so he wonders if this human remain is not related to her disappearance. Barrow encourages Sheriff Meeks (Nick Damici) and Deputy Anders (Wyatt Russell, son of Kurt Russell and Goldie Hawn) to dig a little deeper into what is buried in their community.

Unlike so much modern horror, *We Are What We Are* is not a story of twists or surprising endings. It is not a piece of final act "gotcha moments," a trend that has drained horror of any build-up or natural character

development. The straightforward narrative allows for actual tension, atmosphere, and brilliant character work by Mickle and his cast. While the performers are great, this is Jim Mickle's movie. From the opening shot of Mrs. Parker slipping underwater to the dinner scenes that are staged and set for the perfect amount of tension-building, Mickle shows his amazing growth in terms of visual composition. Every technical elements feels carefully considered, and Mickle often allows the images to tell the tale instead of the dialogue. He even avoids (for the most part) the grotesque angle that other directors would have chosen, shooting his film more like a Southern Gothic than a tale of blood and guts.

His cast helps greatly. Childers and Garner are perfect, delivering the kind of engaging turns that ground a film like this one in something worth caring about. Childers perfectly conveys the world weariness of a teenage girl who knows that her youth is over and a nightmarish life is about to begin. Childers grounds the piece but Garner mesmerizes as the girl who is young enough to somehow find the strength to fight back. The wrongness of what they are doing has not yet overwhelmed her. Sage casts a striking figure but the show belongs to Parks, when it comes to the adults. He is captivating.

We Are What We Are has some slow passages but it is as close to a perfect American horror film as the genre has seen in a few years. Deliberate, stylized, atmospheric, and failing to fall into so many of the cliched traps of the genre, it fulfills everything nice writers thought about Jim Mickle's potential from his first two films.

Brian Tallerico

CREDITS

Iris Parker: Ambyr Childers
Rose Parker: Julia Garner
Frank Parker: Bill Sage
Marge: Kelly McGillis
Doc Barrow: Michael Parks
Origin: United States
Language: English
Released: 2013
Production: Rodrigo Bellott, Andrew Corkin, Linda Moran, Jack Turner, Nicholas Shumaker; Belladonna Productions, Memento Digital, Venture Forth; released by Entertainment One
Directed by: Jim Mickle
Written by: Jim Mickle; Nick Damici
Cinematography by: Ryan Samul
Music by: Jeff Grace
Sound: Lewis Goldstein
Music Supervisor: Linda Cohen
Editing: Jim Mickle
Art Direction: Ada Smith
Costumes: Liz Vastola
Production Design: Russell Barnes
MPAA rating: R
Running time: 105 minutes

REVIEWS

Buckwalter, Ian. *NPR*. September 27, 2013.
Derakhshani, Tirdad. *Philadelphia Inquirer*. October 11, 2013.
Goodykoontz, Bill. *Arizona Republic*. October 17, 2013.
Goss, William. *Film.com*. September 25, 2013.
Kiang, Jessica. *The Playlist*. August 29, 2013.
Kohn, Eric. *IndieWire*. August 29, 2013.
O'Hehir, Andrew. *Salon.com*. September 25, 2013.
Rooney, David. *The Hollywood Reporter*. August 29, 2013.
Savlov, Marc. *Austin Chronicle*. October 9, 2013.
Vishnevetsky, Ignatiy. *The A.V. Club*. September 25, 2013.

WE'RE THE MILLERS

If anyone asks.
 —Movie tagline

Box Office: $150.4 Million

While *Saturday Night Live* has helped launch the leading-man careers of numerous repertory players, big-screen stardom is not a sure thing. For every Eddie Murphy, Mike Myers, and Will Ferrell, there is a Jim Breuer, Chris Kattan, or Horatio Sanz. *We're the Millers*, though, augurs well for 38-year-old Jason Sudeikis' future. A comedy of alternating peaks and valleys ultimately undone by a fuzzy focus and questionable *raison d'etre*, the movie is nonetheless an appealing showcase for the actor's uniquely charming blend of sunniness and frustration.

A huge late summer hit for distributor Warner Bros,, *We're the Millers* raked in just under $148 million domestically and another $108 million overseas, giving Sudeikis, on the heels of his *SNL* departure, his second $100 million big screen hit (and third if you count his voice work in the animated *Epic* [2013]). If critical reaction was decidedly lukewarm, the movie's playability with audiences (Warner Bros. even added screens in its second and third weeks of release) rendered that point largely moot. Viewers seem to have vetted Sudeikis, and given their approval.

We're the Millers centers on thirty-something David Clark (Sudeikis), an amiably self-absorbed, small-time Denver marijuana dealer who does not at all mind that

his old college friends have long since settled down with families. His penchant for keeping a low-profile is spoiled after he tries to help out a couple local teenagers and ends up in the process getting jumped by some punks, who steal both his cash and his stash. In order to pay off his massive debt, David's supplier, Brad Gurdlinger (Ed Helms), tasks him with picking up a large shipment of weed on a tight deadline from a Mexican cartel.

Lacking options, David hatches a plan. Reckoning a happy, nuclear unit will arouse less suspicion returning north across the border, he rents a large RV and recruits a cash-strapped neighbor, stripper Rose O'Reilly (Jennifer Aniston), as well as the two teens who helped land him in trouble in the first place—dorky 18-year-old virgin Kenny (Will Poulter) and headstrong 15-year-old runaway Casey (Emma Roberts)—to pose along with him as an all-American family vacationing over the Fourth of July weekend. Along the way they meet a couple of earnest tourists, Don and Edie Fitzgerald (Nick Offerman and Kathryn Hahn), along with their teenage daughter, Melissa (Molly Quinn). When Brad's assignment proves part of a larger deceit, madcap hijinks and assorted misunderstandings ensue.

A lot of Hollywood productions employ a legion of writers, but this seems especially true of comedies, where every joke has to survive a gauntlet of demi-producers and studio suits who are convinced they have a funnier idea than what has already been committed to the page. *We're the Millers* is no exception. Originated by writers Bob Fisher and Steve Faber, the project was fast-tracked at New Line after the huge success of that duo's *Wedding Crashers* (2005), at the time the highest-grossing R-rated comedy ever. Will Arnett was attached for a good while, but disagreements over tone and a series of lukewarm, uncredited rewrites helped stall things. (New Line's absorption by corporate parent Warner Bros. in 2008 did not help matters either.) Eventually, Sean Anders and John Morris, who collaborated on *Sex Drive* (2008), would take a crack at the story, sharing final screenplay credit with Fisher and Faber.

The result of all this tinkering is a movie that manages to shoehorn in plenty of naughty bits, and definitely earn some laughs of appreciative shock, but feels a lot less cogent and of a single, sincere voice. The banter itself is sometimes referential (an amusing epithet is tossed at a character described as a "real-life Flanders"), but mostly barbed, and built around conflict.

Still, even as *We're the Millers* flirts with bickering misadventure, it does not fully commit to a comedic examination of (in this case mock) familial extremes, a la something like *Little Miss Sunshine* (2006). Similarly, the movie could cohere as a sharp satire of American mun-

danity, another tack with which it momentarily flirts. Alas, the tension between these competing agendas never feels resolved or integrated. Instead, *We're the Millers* just aims for broad comedic set pieces before ultimately pivoting into some merely half-earned maturity—as if viewers lapping up jokes about swinging, incest, and gay panic either need or expect moral dawning in a movie like this.

Some of its more outrageous bits (Luis Guzman as a cop who wants his bribe in the form of oral sex or a sequence in which Kenny suffers a spider bite to the testicle) more or less work, but many others fall flat, owing to laborious set-up or inept construction. There is a shootout at the Mexican border so lazily staged by director Rawson Marshall Thurber that it registers as almost figurative rather than literal, like some gambit an animated TV show might deploy, with no thought or worry of how it impacts future continuity.

The film's manic, almost pathological insistence on raised narrative stakes, involving DEA scrutiny and the pursuit of an armed Mexican drug cartel, comes off as sketch comedy on steroids, and undercuts any more sincere, character-based treatment of the same basic story. Worst is a burgeoning attraction between Dave and Rose. While it is not quite a full-fledged love story, it is a bridge too far. Less make-nice wisdom would do this film good.

The degree to which *We're the Millers* connects owes in large part to its cast. As he did in *Horrible Bosses* (2011), Sudeikis ably showcases the sort of besieged-wiseacre Everyman quality that fits comfortably, hand-in-glove, with mainstream comedy. There is a thin sheen of smarminess that emanates from David's condescension to those around him, but it never overwhelms the material. Poulter, meanwhile, has an amazingly blank and innocent visage, lending tremendous credibility to the awkwardness of Kenny's plight with members of the opposite sex. And Offerman and Hahn are superlative bit players.

Aniston and Roberts, however, fare less well. The latter is undermined by a fantasy construct of her character (Casey is emotionally damaged but retains the good looks of a Revlon spokesperson), while Aniston is a bit too put together and eagerly accepting of Rose's awakened maternal instincts, which is another shortcoming of the stitched-together script. Admittedly, she is required to do some stupid things to keep the plot lurching forward. (The movie grinds to a halt for a striptease sequence, set to Aerosmith's "Sweet Emotion," that is supposed to serve as a diversion for the group.) But as with a lot of her film work (rare exceptions include *The Good Girl* [2002], *Friends with Money* [2006], and *Management* [2009]), Aniston seems chiefly concerned

with letting people know that, by gosh, she still looks really good for her age.

Agreeable enough to merit a look-see rental for fans of the on-screen talent involved, *We're the Millers* is a movie almost perfectly halved raucous entertainment and frustrating shortcomings. It is also a good example of the potential shortfalls of crafting and delivering, from the inside out, the movie one believes viewers want to see, rather than creating honest characters and putting them through the paces of an interesting scenario. It generates some laughs, but not of the truly lasting and memorable variety.

Brent Simon

CREDITS

David Clark: Jason Sudeikis
Rose O'Reilly: Jennifer Aniston
Casey Mathis: Emma Roberts
Kenny Rossmore: Will Poulter
Brad Gurdlinger: Ed Helms
Don Fitzgerald: Nick Offerman
Edie Fitzgerald: Kathryn Hahn
Melissa Fitzgerald: Molly C. Quinn
Origin: United States
Language: English
Released: 2013
Production: Chris Bender, Vincent Newman, Tucker Tooley, Happy Walters; Bender Spin K, Heyday Films, Newman/Tooley Films; released by New Line Cinema Corp.
Directed by: Rawson Marshall Thurber
Written by: Bob Fisher; Steve Faber; Sean Anders; John Morris
Cinematography by: Barry Peterson
Music by: Theodore Shapiro; Ludwig Goransson
Sound: Jonathan S. Gaynor
Music Supervisor: George Drakoulias
Editing: Mike Sale
Art Direction: Elliott Glick
Costumes: Shay Cunliffe
Production Design: Clayton Hartley
MPAA rating: R
Running time: 110 minutes

REVIEWS

Chang, Justin. *Variety.* August 6, 2013.
Grierson, Tim. *Deadspin.* August 6, 2013.
Hazelton, John. *Screen Daily.* August 6, 2013.
Honeycutt, Kirk. *Honeycutt's Hollywood.* August 9, 2013.
LaSalle, Mick. *San Francisco Chronicle.* August 7, 2013.
McCarthy, Todd. *Hollywood Reporter.* August 6, 2013.
O'Hehir, Andrew. *Salon.com.* August 8, 2013.

Puig, Claudia. *USA Today.* August 7, 2013.
Scott, A. O. *New York Times.* August 6, 2013.
Sragow, Michael. *Orange County Register.* August 8, 2013.

QUOTES

Scottie P.: "You know what I'm sayin?"
David Clark: "Well, I'm awake and I speak English, so yeah I know what you're saying."

TRIVIA

Despite the subject matter, no character in the film is ever seen consuming marijuana.

WHAT MAISIE KNEW

Box Office: $1.1 Million

Modern-day political conservatism, in its rabidly judgmental and at times quite ugly embrace of an ever-constrictive set of acceptable social rules by which to live, has done much to turn off those under 35 to its message. And yet, were they not so fervently anti-science and vitriolic in other respects, so-called traditional-values candidates for public office could and would likely find much common ground with Millennials, if only they possessed the actual real-world compassion to match the label they claim rhetorically. After all, divorce remained a constant, steady presence for American children who came of age in the 1980s and 1990s. If a kid was not the product of a split household, then surely they had friends who were, and witnessed firsthand the often petty behavior of adults, and the sad, ruinous consequences it had on so many peers. Children indisputably thrive in nuclear families, or at the very least need two stable parents who can functionally interact and create and maintain an ordered world.

A modernized version of Henry James' 1897 novel of the same name, *What Maisie Knew* provides a snapshot of this fact. An uncommonly perceptive look at the impact of divorce on a child, intelligent and heartrending in equal measure, co-directors Scott McGehee and David Siegel's film ranks as one of the more under-recognized dramas of the past several years—a work that, as its title suggests, assays the raised temperatures that children absorb absent of a grasp of particular facts in a chaotic situation. Following its world premiere at the 2012 Toronto Film Festival, distributor Millennium Entertainment quickly secured domestic rights and gave the movie an early summer arthouse release, where it grossed just over $1 million in theaters.

Set in New York City, *What Maisie Knew* centers on a contentious split between Susanna (Julianne Moore),

an aging rocker with a self-destructive streak, and her British-born art dealer husband Beale (Steve Coogan). The pair shares a six-year-old daughter, Maisie (Onata Aprile), whose naturally sweet temperament is an oasis of serenity amidst the rancor swirling all around her. Matters in her parents' split are certainly not helped by the fact that Maisie's father is set to marry their former nanny, Margo (Joanna Vanderham). In an act seemingly rooted in reprisal as much as actual love, Susanna impetuously announces her own union with a young bartender, Lincoln (Alexander Skarsgard). Then a strange thing happens: while Susanna prepares for a tour and a nasty custody battle ensues, these two new step/surrogate parents provide an unexpected level of constancy and steadiness for Maisie.

It is not quite as punishing an exercise in forced adolescent subjectivity as *Ponette* (1996), which starred Victoire Thivisol as a four-year-old girl coping with the death of her mother in a car crash. But *What Maisie Knew* is very much a movie that taps into the devastating erosion of innocence. While the film obviously changes the setting to modern day and additionally eliminates several characters and shrinks the period of examined turmoil for Maisie (the verb tense of the title could be changed, in fact), the novel's major themes—of selfishness, dysfunction and emotional displacement and dislocation—remain intact. In their adaptation, screenwriters Nancy Doyne and Carroll Cartwright root the work in realism and the inner psychology of its characters, but mitigate some of the source material's moral judgment.

Co-directors McGehee and Siegel have past experience with both literary adaptations and narratives centered around secrets and lapsed judgments of fractured families, most notably with *The Deep End* (2001) and *Bee Season* (2005). They put that knowledge to effective use here. *What Maisie Knew* is so wrenching in large part because it does not over-rely on heavy, conventional drama, but instead balances its adult push-and-pull with the more plaintive, moon-faced uncertainty of a child, as she attempts to reconcile all these sudden changes around her. It also captures life's mixed tonalities, allowing for moments of humor to abut misguided or outright tragic parenting choices, as when Beale excites Maisie by inviting her to come to England with him, only to quickly rescind his offer.

The performances are uniformly gripping and smartly modulated, in no small part because the script and filmmakers allow for all its characters to have flaws and moments of redemption. Coogan is a much better dramatic actor than he is often given credit for being, and he and especially Moore tap into their characters' possessiveness—how their sincere love for their daughter is by degrees warped via their increasing animosity for

one another, casting Maisie as a bobbing cork upon the raging sea of their stormy separation. Skarsgard, channeling a pinch of the same out-of-his-element, nice-guy doubt and indecision that Steve Zahn frequently expresses so well, is the vehicle through which viewers fall in love with Maisie. Of course, none of this would much matter if *What Maisie Knew* had at its center a towheaded, overly demonstrative kid, the sort often plugged into mainstream studio movies to merely mug and evoke surface-level reaction. Aprile, though, is wonderfully walked through a sensitive, natural performance that tugs at heartstrings organically.

With cinematographer Giles Nuttgens, the filmmakers trade in bright colors and open spaces, to better showcase the film's settings as imaginatively experienced by a little girl. Subjects are often situated to the left or right of the frame, to create a sense of unease. Purely as a drama, *What Maisie Knew* elicits enormous sympathy and panic for the wellbeing of its central character. More than that, however, McGehee and Siegel seem driven to explore the question of what makes a parent. They are also smart enough to know that it is not merely a matter of biological province.

Brent Simon

CREDITS

Susanna: Julianne Moore
Beale: Steve Coogan
Lincoln: Alexander Skarsgard
Margo: Joanna Vanderham
Maisie: Onata Aprile
Origin: United States
Language: English
Released: 2012
Production: Daniel Crown, William Teitler; released by Millennium Entertainment L.L.C.
Directed by: Scott McGehee; David Siegel
Written by: Nancy Doyne; Carroll Cartwright
Cinematography by: Giles Nuttgens
Music by: Nick Urata
Sound: Eliza Paley
Music Supervisor: Chris Douridas
Editing: Madeleine Gavin
Costumes: Stacey Battat
Production Design: Kelly McGehee
MPAA rating: R
Running time: 99 minutes

REVIEWS

Burr, Ty. *Boston Globe*. May 23, 2013.

Chang, Justin. *Variety*. September 8, 2012.
Edelstein, David. *New York Magazine*. May 3, 2013.
Hornaday, Ann. *Washington Post*. May 23, 2013.
Neumaier, Joe. *New York Daily News*. May 2, 2013.
Puig, Claudia. *USA Today*. May 23, 2013.
Scott, A. O. *New York Times*. May 2, 2013.
Sharkey, Betsy. *Los Angeles Times*. May 16, 2013.
Smith, Kyle. *New York Post*. May 3, 2013.
VanDenBurgh, Barbara. *Arizona Republic*. May 23, 2013.

QUOTES

Lincoln: "I'm her...sorta...like...Maisie's stepfather."

TRIVIA

Julianne Moore has said that she drew on Courtney Love and Patti Smith for inspiration for her character in this film.

WHITE HOUSE DOWN

It will start like any other day.
—Movie tagline

Box Office: $73.1 Million

Two-thousand and thirteen was a banner year for overlong movies about the White House being taken over by terrorists who pretend to want money but actually desire something far more deadly and sinister, and who have their own disgruntled Secret Service man working the inside, and are thwarted partly by a precocious child that knows more about the building than any of the grown-ups. *Olympus Has Fallen* (2013), the classy one despite the presence of Gerard Butler in the lead, beat *White House Down* to theaters by about two months, and did slightly better at the box office. It did well enough to spur talk of a sequel, *London Has Fallen*.

Olympus took a more staid, grim approach to its far-fetched story, with a stone-faced Aaron Eckhart as the traumatized president, and heavyweights like Morgan Freeman, Melissa Leo, Angela Bassett, and Robert Forster doing their part to fight off the bad guys, a fictional group of Koreans with no legitimate connection to the North Korean government, lest anyone in Pyongyang be offended, one supposes.

While it also boasts an impressive cast, *White House Down* is far more loose-limbed and kookier, with the same type of free-wheeling tone that director Roland Emmerich brought to such disaster movies as *2012* (2009), *The Day After Tomorrow* (2004), and, of course, *Independence Day* (1996), which is directly referenced in the movie by a goofy but—it turns out—heroic White House tour guide, Donnie (Nicholas Wright). As with *Tomorrow*, the lighthearted tone feels out of place and

unsavory in this story, which, while ridiculous, is somewhat grounded in real world politics. *White House Down* ends on a similarly distasteful and inappropriate triumphalist note. Both films even end with a helicopter ride, as our protagonists happily speed away from the carnage and the deaths of many of their friends and co-workers while admiring the bird's eye view.

The movie's connection to the real world, and actual consequences of violence and destruction, is predictably tenuous. More unexpected is its off-the-wall, kitchen sink, almost slapstick tone. The dynamic duo of Channing Tatum and Jamie Foxx come off as a mix between John McClane—like *Olympus*, this is essentially *Die Hard* (1988) in the White House—and cartoon mouse Tom of Tom and Jerry, as they dodge military-grade killers along with bullets, explosions, rocket launchers, falling helicopters, and more, while propensity for a semi-clever quip never flags. It is easy to imagine the screenwriter, James Vanderbilt, sitting with Emmerich and trying to figure out how to fit a car chase into a movie set almost entirely within a single building. They found a way! Yes, *White House Down* includes a scene where Cale (Tatum) and President Sawyer (Foxx) drive the presidential limo around the White House lawn as they're chased by baddies, shot at with rocket launchers, and return fire with their own. You know, with the rocket launcher they keep in a case in the back of the president's limousine.

Cale is a Capitol Policeman assigned to protect Speaker of the House Raphelson (Richard Jenkins). He only got that position because Raphelson is the uncle of a soldier whose life Cale saved in Afghanistan. Determined to win the love and respect of his daughter, Emily (Joey King) who's obsessed with the president, Cale calls in another favor, and interviews for a job with the Secret Service. His interviewer turns out to be an old college flame, Carol Finnerty (Maggie Gyllenhaal) who remembers Cale as a ne'er-do-well dropout. The interview does not go well. Afterward, he and Emily join a White House tour led by the predictably gung-ho Donnie, and run into the president, shortly before all hell breaks loose.

The terrorist plot, such as it is, involves blowing up the capitol building, so that the bad guys can waltz through the White House, killing ever Secret Service agent and cop in sight. They're led by Emile Stenz (Jason Clarke), an ex-black ops military guy resentful because his country has disavowed him. Their second-in-command, for some reason, is apparently Killick (Kevin Rankin, who plays far too many of these roles), a hootin' and hollerin' white supremacist. Also joining Team Evil is Tyler (Jimmi Simpson), a notorious hacker. It is a hodgepodge of America's most wanted pulled together by the mission leader, Walker (James Woods), who also

happens to be the retiring head of the Secret Service. It is nearly as surprising that Woods turns out to be playing a bad guy as it was when Dylan McDermott turned out to be a traitor in *Olympus Has Fallen.*

Taking over the White House is a cakewalk for these guys, and they quickly take all the tourists hostage, and eventually begin negotiating their demands, with Raphelson, Finnerty, and Joint Chiefs General Caulfield (Lance Reddick). But while Walker is leading President Sawyer to the rest of his team, Cale intercepts them and rescues the president. The two then spend much of the rest of the film evading the terrorists, fighting when they have to, and, as in *Die Hard,* picking off the bad guys one by one, until, predictably, Stenz finally realizes that he is holding his nemesis's daughter hostage. The terrorists' true motives have something to do with a Mideast peace treaty Sawyer has orchestrated, and evil, unseen arms manufacturers, but the politics of a movie like this are a cynical afterthought, at best. Foxx plays a sort of dream version of Barack Obama, one who takes on the warmongering DC power structure his first term in office, and is also handy with the very heavy weaponry the movie's unseen villains build.

Tatum has proven himself adept at bringing a modest charm to nearly any type of inane script. Foxx captures the easy charisma of a man who no one could ever have expected to be president. Clarke was superb as the CIA's lead torturer in *Zero Dark Thirty* (2012), but he is not given much to work with here. Stenz is a two-dimensional tough guy baddie. Woods is not exactly convincing, but he has more to do, as Walker deals with the emotional turmoil of turning against everything he has spent his life protecting. Simpson is always fun to watch. At first, it seems like the incongruously impish Tyler will serve as comic relief, but it soon becomes clear that the movie is supposed to be set at just his level of brazen ridiculousness. While *White House Down* is far longer than it needs to be, it does not drag. It is even fun, sporadically. It is just rather distasteful in not taking any of the carnage it presents the least bit seriously. That also makes it difficult to become emotionally invested in Cale's bond with Emily, and it is such a cartoon that there is never much doubt about the survival of its heroes. The glee the movie takes in its military firepower only adds to the sense that its purported message of peace is a fig leaf over what it really means to say.

That said, *White House Down* is certainly the type of silly action movie that one might enjoy, with low expectations and in the right frame of mind. Emmerich knows his way around an exploding helicopter, and Vanderbilt did write the script for David Fincher's *Zodiac* (2007), so it is possible to imagine that he is being this preposterous on purpose. If not for its fetishistic brutal-ity and destruction and its exceptionally high body count, this might have been a passable popcorn movie.

Josh Ralske

CREDITS

John Cale: Channing Tatum
President James Sawyer: Jamie Foxx
Emily Cale: Joey King
Stenz: Jason Clarke
Walker: James Woods
Finnerty: Maggie Gyllenhaal
Raphelson: Richard Jenkins
Gen. Caulfield: Lance Reddick
Vice President Hammond: Michael Murphy
Origin: United States
Language: English
Released: 2013
Production: Bradley J. Fischer, Larry Franco, Laeta Klogridis, Roland Emmerich, James Vanderbilt, Harald Kloser; Centropolis Entertainment; released by Columbia Pictures
Directed by: Roland Emmerich
Written by: James Vanderbilt
Cinematography by: Anna Foerster
Music by: Harald Kloser
Sound: Jamey Scott
Editing: Adam Wolfe
Costumes: Lisy Christi
Production Design: Kirk M. Petruccelli
MPAA rating: PG-13
Running time: 131 minutes

REVIEWS

Kenny, Glenn. *MSN Movies.* June 28, 2013.
McCreadie, Marsha. *RogerEbert.com.* June 28, 2013.
Nashawaty, Chris. *Entertainment Weekly.* June 26, 2013.
Puig, Claudia. *USA Today.* June 26, 2013.
Rabin, Nathan. *The Dissolve.* July 10, 2013.
Rooney, David. *Hollywood Reporter.* March 10, 2013.
Turan, Kenneth. *Los Angeles Times.* June 26, 2013.
Uhlich, Keith. *Time Out NY.* June 26, 2013.
Vern. *OutlawVern.com.* June 30, 2013.
Vishnevetsky, Ignatiy. *The AV Club.* June 27, 2013.

QUOTES

Cale: "Can you not hit me in the head with a rocket when I'm trying to drive?"

TRIVIA

The White House Tour Guide mentions hat they're in the part

of the building that was blown up in *Independence Day*. Director Roland Emmerich also directed *Independence Day*.

THE WIND RISES
(Kaze tachinu)

We must live.
—Movie tagline

Box Office: $2 Million

Even if a fan of the work of Hayao Miyazaki, the most important and influential animation director alive, had no idea that *The Wind Rises* was to be his last film, they would sense it by watching. The story, the tone, the themes, the imagery—every beat of this masterwork has the tone of a final act, to the point that it almost feels like an ode to artistry and what one can never really hold on to, even in the final days of their careers. Miyazaki's mesmerizing film is about a man who creates something through his passion and skill, bringing his dreams to life, and then his creations are sent out into the world and used for destructive purpose. While Miyazaki's films are not one-to-one equitable to fighter planes, the parallel is clear. Both men put their lives into their work and then have no say in how it used, interpreted, or carried on the wind. With Miyazaki's most classically beautiful eye since *Spirited Away* (2001), *The Wind Rises* is a gorgeous film, made only more so when one considers it as the final act to an amazing career.

Based on the real life of airplane engineer Jiro Horikoshi is Miyazaki's least fantastical film in decades. There are no fairy tale creatures as audiences have seen in his recent fare, more typical of children's animation. And yet there is a sense of that same storyteller, whether it is in the dreams of Horikoshi's youth or the magical way in which Miyazaki portrays a sense of movement, whether it is trains speeding through gorgeous countryside or, of course, planes rising on the wind. This may not be a traditional fantasy but it clearly comes from someone well-versed in that filmic language.

The film opens with Jiro as a young boy, dreaming of planes dropping bombs that look like animals. He is seeing visions of his future, and his country's dark times to come during World War II. Knowledgeable audiences will know that this boy dreaming of flying machines will design the plane that attacks the United States on Pearl Harbor. Although the very pacifistic Miyazaki is not making a blatantly anti-war film; and suggestions that this film is lesser because of that fact are naive, misguided, and simply stupid as they presume that both a historical stance for the filmmaker that is untrue and that he has to meet a certain "standard" of wartime criticism instead of telling the story he chooses to tell. It is

silly to think that this film is not capturing something about best intentions used for dark purposes given dreams of flying machines that inevitably turn to nightmares and the final scenes of crushed, burning metal.

Dismissing that easily dismissed criticism, Miyazaki's film becomes the story of an engineer turning his dreams into reality. He regularly engages in said dreams with one of Japan's legendary engineers, a boisterous fellow named Caproni, who begins to serve as a spirit guide of sorts (again, the fantasy background of Miyazaki never completely fades), and even falls in love with a young woman named Naoko. He meets his beauty on the day of The Great Kanto Earthquake, a "meet-cute" that fits into Miyazaki's career-long motif of how life's greatest moments can come with little foreshadowing. And he falls in love with Naoko despite knowing that her days are limited. She will die sooner than she should and, again, Miyazaki's theme of that which one pours his life into—in this case, a relationship—also being somewhat outside of their control resonates.

The Wind Rises is a film that is constantly turning its narrative, weaving in and out of dreams and reality, hitting major moments like the earthquake but then returning to the relatively average story of a romance. It is not merely the story of a man who pours his heart, soul, and dreams into his craft, as it could have been in many other filmmaker's hands. Miyazaki frames Jiro's story in a way that no other director would have done, making it his own and universal in the process. He has made a film that is a chapter of history, a love story, a commentary on the artistic process, and a piece of artwork so beautiful that half of the mostly hand-drawn cels in it could be framed and hung on a wall. As cliched and inaccurate as this critical phrasing often is, this really is a piece of work that operates on multiple levels. One completely unfamiliar with the true story reflected or Miyazaki's oeuvre could still appreciate it as pure art (and Joe Hishashi's spectacular score elevates that appreciation) but it is a work that gets deeper the more one knows about how it came into existence, seventy years after the war that would change the world and decades after one of cinema's most important filmmakers began to influence countless animators beneath him. Like so many great films, *The Wind Rises* will continue to grow over the years with new audiences and new appreciations. It is a film with timeless themes—love, war, and, underneath it all, it represents the majestic and beautiful power of cinema.

Brian Tallerico

CREDITS

Jiro: Hideaki Anno (Voice)

Naoko: Miori Takimodo (Voice)

Honjo: Hidetoshi Nishijima (Voice)

Kurokawa: Masahiko Nishimura (Voice)

Kastrup: Stephen Alpert (Voice)

Caproni: Mansai Nomura (Voice)

Origin: Japan

Language: Japanese, French, German, Italian

Released: 2013

Production: Studio Ghibli; released by Touchstone Pictures

Directed by: Hayao Miyazaki

Written by: Hayao Miyazaki

Music by: Joe Hisaishi

Sound: Koji Kasamatsu

Editing: Takeshi Seyama

Art Direction: Yoji Takeshige

MPAA rating: PG-13

Running time: 126 minutes

REVIEWS

Burr, Ty. *Boston Globe*. February 20, 2014.

Cataldo, Jesse. *Slant Magazine*. September 21, 2013.

Corliss, Richard. *Time*. February 20, 2014.

Foundas, Scott. *Variety*. September 12, 2013.

Ingram, Bruce. *Chicago Sun-Times*. February 20, 2014.

Lumenick, Lou. *New York Post*. November 7, 2013.

Lyttleton, Oliver. *The Playlist*. September 12, 2013.

Phillips, Michael. *Chicago Tribune*. February 20, 2014.

Turan, Kenneth. *Los Angeles Times*. November 7, 2013.

Young, Deborah. *The Hollywood Reporter*. September 12, 2013.

QUOTES

Caproni: "Airplanes are beautiful, cursed dreams, waiting for the sky to swallow them up."

TRIVIA

Human voices are largely used in this film mainly as sound effects, such as engine roars and earthquake sounds.

THE WOLF OF WALL STREET

Box Office: $114.6 Million

One of the marks of a truly great filmmaker is the ability to create works that still manage to provoke and outrage viewers even at an age when they could be comfortably resting on their laurels. Luis Bunuel did it with a string of late-period masterpieces that included *Belle du Jour* (1967), *The Discreet Charm of the Bourgeoise* (1972), and *That Obscure Object of Desire* (1977) and John Huston wound up his career with such unexpected knockouts as *Under the Volcano* (1983), *Prizzi's Honor* (1985), and *The Dead* (1987). With his latest effort, *The Wolf of Wall Street*, Martin Scorsese joins that particular club with a brash and bold examination of greed run amok that was so relentless and unsparing in its depiction of the mindset of one particularly audacious money-grubbing monster that it divided critics and viewers alike over whether or not it glorified the behavior that it demonstrated over the course of three solid hours. As a result, what hit multiplexes as one of the most eagerly anticipated entries in the end-of-year glut quickly became the most controversial as well as one of the best.

The film tells the rags-to-riches-to-immense-riches-to-slightly-less-immense-riches story of Jordan Belfort (Leonardo DiCaprio). As the story begins in the mid-1980s, he is a fresh-faced kid from the Bronx ready to make a name for himself at the prestigious Wall Street financial firm of L.F. Rothschild. Although little more than a glorified phone dialer for the established brokers, he catches the eye of one of the firm's top traders (Matthew McConaughey), who treats him to a boozy-and-drug-fueled lunch (Jordan declines both, pretty much the only time he will do so for the duration of the film) that only serves to further excite the young man and his dreams of conquering the business. Alas, his first day at work after getting his broker's license is none other than Black Monday—the date in October 1987 when the stock market took its biggest hit since the Great Depression—and before long, the firm is gone and he is out of a job.

Struggling to find a job in an industry that is simply not hiring, Jordan eventually comes across a rinky-dink brokerage being run out of a Long Island strip mall that tries to push virtually worthless penny stocks on working-class investors who do not know any better. The prospects are not exactly inviting but with his skills at manipulating clients by playing to their greed and the incentive of a 50 percent commission for every deal, he is quickly making money hand over fist. Before long, he strikes out on his own by opening his own brokerage firm with the name of Stratton Oakmont disguising the fact that he is still hyping the same worthless stock, albeit to a richer clientele, and that his initial staff consists almost entirely of miscreants with no financial background, led by Donnie Azoff (Jonah Hill), a nebbish who attaches himself to Jordan out of the blue and becomes his right-hand man.

As the money continues to pour in, Jordan's personal and professional lives soon begin hitting excesses that would make Caligula himself blush out of sheer embarrassment. He quickly dumps his sweet-natured first wife (Cristina Milloti) in order to marry a gorgeous

Brit model (Margot Robbie) while snorting, popping or guzzling enough intoxicants to paralyze Buffalo. Work is a daily debauch in which the business at hand is interrupted by such distractions as strippers, marching bands and dwarf-tossing contests. The bad-boy reputations of Stratton Oakmont and its founder eventually catch the attention of the authorities and FBI investigator Patrick Denham (Kyle Chandler) starts looking into both for evidence of illegalities. After a meeting with Denham goes spectacularly wrong, the signs seem to be indicating to Jordan that he should get out while he can and try to survive on more money than even he could plausibly spend in a lifetime. Instead, Jordan embarks on a risky move to soldier on and protect his assets by hiding them overseas with the help of his wife's aunt (Joanna Lumley) and an oily Swiss banker (Jean Dujardin). Even as his entire life begins to collapse around him, Jordan's sense of untouchability—bolstered ever further by his drug intake—compels him to continue to press his luck with alternately hilarious and horrifying results.

In the hands of many filmmakers, *The Wolf of Wall Street* might have been an ordinary cautionary tale about the perils of greed and excess told from an objective perspective that would serve to remind viewers about what was right and wrong about what they were seeing. At many points during the proceedings, side characters would have remarked to each other about what a bad person Jordan was and how his relentless pursuit of money above all else was a gruesome perversion of the cherished American ideals of the free enterprise system. There would have been several scenes in which *Law & Order* characters would have explained at length as to exactly what he was doing that was wrong. There would have been numerous looks at the victims of his various schemes and how their lives and finances were destroyed because they put their trust in someone who turned out to be a rotter. Most significantly, the ending no doubt would have Jordan finally learning the error of his ways after losing everything in a manner that would leave moviegoers with a comfortable and easy-to-grasp moral lesson to take with them as they leave the multiplex.

This approach might have made for a perfectly decent movie but Scorsese has a much different take on the material up his sleeve and *The Wolf of Wall Street* is all the better for it. Instead, he has made the far riskier decision to tell Belfort's story exclusively through his singular and highly subjective perspective by using his talents, not to mention those of such esteemed collaborators as editor Thelma Schoonmaker, cinematographer Rodrigo Prieto, and music supervisor Robbie Robertson, to convey the atmosphere of heady excess in cinematic terms. This was an enormous gamble but it is one that pays off beautifully here as Scorsese effortlessly taps into

the monstrous mindset of his main character and brings it to life in all of its hideously gaudy glory. Freed of the stylistic constraint that he has worked under in his last couple of features, he lets it all hang out here and the result is some of the most kinetic and exciting filmmaking of his entire career.

Right from the start, he hits the ground running to show us the world through the eyes of Jordan—a guy who no doubt saw his entire life as some kind of screen epic along the lines of *Scarface* (1983) or Scorsese's own *Goodfellas* (1990)—and over the course of the next three hours, he never slackens the pace for an instant. Although many have compared *The Wolf of Wall Street* to *Goodfellas*—and it does indeed have the jangled energy of that film's sequence with the helicopters and the sauce stirring writ extra-large—but it actually bears stronger similarities to other entries in the Scorsese canon. For example, it shares with the largely misunderstood drama *Casino* (1995) both an epic length and a penetrating unveiling of how massive financial shenanigans devised solely to separate suckers from their money by playing on their greed are allowed to not only play out but to thrive, at least for a time, under the cloak of respectability. Like *The Departed* (2006) it shows an outrage towards how people are willing to turn themselves into monsters in the singular pursuit of money and power at any cost. And like *Shutter Island* (2009), it offers viewers to immerse themselves completely into the mindset of a total sociopath without even realizing it until it is too late—the only difference is that the character in *Shutter Island* eventually learns that he is indeed mentally ill while Jordan never has that moment of self-realization.

And because Scorsese and Winter never provide Jordan with that moment of self-realization—nor any that explicitly condemns him or his behavior—many observers have suggested that *The Wolf of Wall Street* is actually a grandiose glorification of the bad behavior that it depicts in such lavish detail. For viewers who need the morals of their stories to be spoon-fed to them, this absence could be troubling at first but it proves to be the correct move for any number of reasons. From a dramatic standpoint, it works because Scorsese has seen enough movies of this type to know that the scenes in which the moral is spelled out are usually the dullest and so he has scrapped almost all of them. (Reiner does have a couple of moments in which he speaks of reason and they are inevitably among the least interesting on display.) From a character standpoint, such an element would make no sense because Jordan was not the self-aware type and any scene painting him as such would have felt forced. Most importantly, Scorsese trusts his audience to understand the point he is trying to make without having to hold their hands and that whatever

fun they may have in the early going will soon dissipate as the excesses grow to the truly staggering. Anyone coming out of this film believing it to be an endorsement of what it depicts clearly has not paid any attention to what they have just watched—they are like the people who came out of *Taxi Driver* (1976) believing Travis Bickle to be some kind of folk hero instead of a still-ticking time bomb.

The other big risk in making a film like *The Wolf of Wall Street* is the need to find an actor who can play the role of Jordan in a way that lets him come across as the brash and ballsy stud he thought himself to be while still suggesting the obnoxious boor that he must have seemed to anyone outside of his purview. In his fifth collaboration with Scorsese, DiCaprio pulls off that high-wire act with a edgy turn that is not only the best work that he has done with Scorsese but the best performance of his entire career. Something about Jordan and his sociopathic tendencies clearly struck a chord with him because this is the most energetic and alive that he has ever been—he is on the screen for virtually every scene and he hits every physical and emotional beat with such precision that he is practically vibrating throughout from the sheer excitement of doing so. All of the other actors in the large cast are equally impressive and in the lone significant female role, newcomer Robbie makes enough of an impression that you wish that she came across as something more than just an appendage. Then again, that may have been the point.

The Wolf of Wall Street is the major American film of 2013—impeccably acted, cleverly written and brilliantly put together by a director working at the peak of his considerable powers. Even the fact that it has inspired so much controversy is a testament to its excellence in the sense that nobody would have cared if it had been just an ordinary mediocrity like *Boiler Room* (2000), a barely-remembered drama that was also inspired in part by Belfort's story. If there is a drawback to be had, it is that a scumbag like Jordan Belfort does not deserve to have anything as good as this connected to his name.

Peter Sobczynski

CREDITS

Jordan Belfort: Leonardo DiCaprio
Donnie Azoff: Jonah Hill
Naomi Lapaglia: Margot Robbie
Mark Hanna: Matthew McConaughey
Patrick Denham: Kyle Chandler
Max Belfort: Rob Reiner
Brad: Jon Bernthal
Manny Rifkin: Jon Favreau
Jean Jacques Saurel: Jean Dujardin
Aunt Emma: Joanna Lumley
Theresa: Cristin Milioti
Leah Belfort: Christine Ebersole
Capt. Ted Beecham: Shea Whigham
Chantalle: Katarina Cas
"Rugrat": P.J. Byrne
Toby Welch: Ethan Suplee
Origin: United States
Language: English
Released: 2013
Production: Riza Aziz, Leonardo DiCaprio, Martin Scorsese; Appian Way; released by Paramount Pictures Corp.
Directed by: Martin Scorsese
Written by: Terence Winter
Cinematography by: Rodrigo Prieto
Sound: Eugene Gearty
Music Supervisor: Robbie Robertson
Editing: Thelma Schoonmaker
Art Direction: Chris Shriver
Costumes: Sandy Powell
Production Design: Bob Shaw
MPAA rating: R
Running time: 180 minutes

REVIEWS

Burr, Ty. *Boston Globe.* December 24, 2013.
Denby, David. *The New Yorker.* December 23, 2013.
Edelstein, David. *Vulture.* December 23, 2013.
Foundas, Scott. *Variety.* December 17, 2013.
McCarthy, Todd. *Hollywood Reporter.* December 17, 2013.
Nelson, Max. *Film Comment.* December 16, 2013.
Reed, Rex. *New York Observer.* December 18, 2013.
Scott, A. O. *New York Times.* December 24, 2013.
Seitz, Matt Zoller. *RogerEbert.com.* December 26, 2013.
Zacharek, Stephanie. *Village Voice.* December 19, 2013.

QUOTES

Jordan Belfort: "Let me tell you something. There's no nobility in poverty. I've been a poor man, and I've been a rich man. And I choose rich every f**king time."

TRIVIA

The actors snorted crushed B vitamins for scenes involving the use of cocaine.

AWARDS

Golden Globes 2014: Actor—Mus./Comedy (DiCaprio)
Nominations:
Oscars 2013: Actor (DiCaprio), Actor—Supporting (Hill), Adapt. Screenplay, Director (Scorsese), Film

British Acad. 2013: Actor (DiCaprio), Adapt. Screenplay, Director (Scorsese), Film Editing
Directors Guild 2013: Director (Scorsese)
Golden Globes 2014: Film—Mus./Comedy
Writers Guild 2013: Adapt. Screenplay

THE WOLVERINE

When he's most vulnerable, he's most dangerous.
 —Movie tagline

The hero. The fugitive. The warrior. The survivor. The legend.
 —Movie tagline

The fight of his life will be for his own.
 —Movie tagline

When enemies rise...when immortality ends...the ultimate battle begins.
 —Movie tagline

Box Office: $132.6 Million

When it comes to superhero franchises, *The Wolverine* is an odd bird. For starters, it is a sort of sequel to *X-Men Origins: Wolverine* (2009), but not really, since it does not so much as follow from that over-complicated origin story as step back and reboot the solo film series for the character (who first appeared on-screen in the *X-Men* films in 2000, 2003, and 2006) with what feels more like a self-contained stand-alone tale than another cog in the franchise machinery.

The film's true oddity, however—and perhaps its most interesting angle—is how it goes about said rebooting: For much of its running time, as directed by James Mangold, from a script by Mark Bomback and Scott Frank, *The Wolverine* strips away the superhero genre tropes (colorful costumes, lurid villains, and massive energy blasts and plot devices) surrounding its story and central character, Logan (Hugh Jackman), a human with a mutant healing power that has allowed him to live for over a century as well as pop-out claws that have been, like the rest of his skeleton, coated in an unbreakable alloy.

What is left is a relatively lean and mean crime thriller that follows Logan, first seen hiding out from his own killer nature in the Canadian wilderness, as he is hauled off to Tokyo and drawn into vicious corporate intrigue involving Yashida (Haruhiko Yamanouchi) a Japanese soldier he met during World War II, now the dying CEO of massive tech company.

Not that Logan spends the film sipping green tea and strolling Zen garden. It is not long before he finds himself on the run, protecting Yashida's daughter Mariko

(Tao Okamoto) from assassins and ninjas. The catch is that someone has secretly put a drain on Logan's healing powers. The good news is that his growing ability to die relieves the guilt and angst-ridden hero of the burden of immortality. The bad news is Logan can now die. (Though he is still enough of a movie hero to run around for hours after being shot in the leg.)

The Wolverine spends a little time poking around in Logan's tormented psyche, examining the blessing and curse of his rapidly fading powers and dallying with the nature of life and an "honorable death." (An opening sequence set in Nagasaki, Japan, on August 9, 1945, is particularly well done.) For the most part, however, Mangold devotes himself to crafting a trim, focused thriller. During the first half of the film, the fact that its hero can still pop razor-sharp from his knuckles is treated as a useful tool, not the main point. (Although Logan's claws do come in handy during a terrifically staged fight sequence atop a bullet train; one of the rare cases where a movie battle's obvious action gimmick serves the scene, rather than the other way around.)

As with Wolverine's prior appearances in the *X-Men* films and *Origins*, the strength of the screen creation is a combination of the elegantly brutal nature of his powers and the way Jackman plays Logan with weary, haunted resignation; tough-guy stoicism; and gruff humor. It is one of the rare superhero performances that embraces the out-sized nature of a genre hero without pushing him out of his humanity and into over-the-top parody. Jackman gets reliable support and tonal contrast from his two female co-stars: Okamoto's demure but unwilting strength as Mariko, and a nifty bright-goth turn from Rila Fukushima as Yukio, a fellow mutant whose look and demeanor fittingly owe more to Asian pop culture than American superhero comics.

Mangold handles all this with serviceable style and tonal awareness, managing the visual shift from rugged snowy wild to dreamy Tokyo neon with a steady, polished hand. For a while the director (along with cinematographer Ross Emery and editor Michael McCusker) seems content to let his camera freely roam and linger, sparing the viewer the usual uneven flips between "too rushed" and "too padded" that so often dominate superhero action movies. The first half of *The Wolverine* moves deliberately rather than desperately pushing buttons. For a while, it is mercifully free of the usual sort of "fan-service" insider winking that invades so many comic-book adaptations, and like its battered and beaten title character, the film often looks relatively rough and real instead of coated with the clean, flat, plastic surfaces so many of these films sport.

Then, as *The Wolverine* rounds its way toward its third act, all of that nuance and restraint is tossed aside.

428

The film, which until then had been a fascinating study in how to make a super-hero movie not feel like a super-hero movie, is quickly jerked into an equally fascinating study in how a big-budget franchise tent-pole cannot be allowed to roam completely free of the standard, worn-out trimmings. Suddenly in the last half hour there are giant silver robots, glowing energy beams, a shiny secret lab, villains in garish costumes with ludicrous evil powers (Svetlana Khodchenkovaas a wicked-ridiculous snake woman called Viper), and heroes dangling from ledges. As all that makes the film start to feel its two-hour-plus length, the viewer is reminded that yes, they are still watching an oversized summer super-hero movie after all.

That final-act descent into superhero silliness does not fully diminish the film's earlier pleasures, but it says a lot about the worn-down, overused superhero genre that the best parts of *The Wolverine* are those that do not feel like a superhero movie. It also says a lot that these days no superhero film, no matter how carefully crafted to avoid it, can be allowed to stray from that overly-familiar formula for too long.

The Wolverine performed well at the box office during its late-July 2013 release, earning nearly $415 million worldwide. Critical response was a little more mixed, but generally above average. Michael O'Sullivan of the *Washington Post* found it, "A refreshing summer cocktail of action-movie staples [that] combines the bracingly adult flavor of everyone's favorite mutant antihero...with the fizzy effervescence of several mixers from the cabinet of Japanese genre cinema: noirish yakuza crime drama, samurai derring-do and ninja acrobatics," and *Salon*'s Andrew O'Hehir wrote, "Taken on its own terms *The Wolverine* is the cleanest, least pretentious and most satisfying superhero movie of the summer."

Locke Peterseim

CREDITS

Logan/Wolverine: Hugh Jackman
Mariko Yashida: Tao Okamoto
Yukio: Rila Fukushima
Kenuichio Harada/Silver Samurai: Will Yun Lee
Viper: Svetlana Khodchenkova
Jean Grey: Famke Janssen
Shingen Yashida: Hiroyuki (Henry) Sanada
Noburo Mori: Brian Tee
Origin: United States
Language: English
Released: 2013
Production: Hutch Parker, Lauren Shuler Donner, Hugh Jackman; Donners' Company; released by Twentieth Century Fox Film Corp.

Directed by: James Mangold
Written by: Mark Bomback; Scott Frank
Cinematography by: Ross Emery
Music by: Marco Beltrami
Sound: John A. Larsen
Editing: Michael McCusker
Costumes: Isis Mussenden
Production Design: Francois Audouy
MPAA rating: PG-13
Running time: 126 minutes

REVIEWS

Barnes, Henry. *The Guardian*. July 18, 2013.
Dowd, A. A. *Onion A.V. Club*. July 25, 2013.
Jones, Kimberley. *Austin Chronicle*. July 24, 2013.
LaSalle, Mick. *San Francisco Chronicle*. July 25, 2013.
Lemire, Christy. *RogerEbert.com*. July 26, 2013.
Mohan, Marc. *Portland Oregonian*. July 25, 2013.
O'Hehir, Andrew. *Salon*. July 25, 2013.
O'Sullivan, Michael. *Washington Post*. July 26, 2013.
Scott, A. O. *New York Times*. July 25, 2013.
Zacharek, Stephanie. *Village Voice*. July 25, 2013.

QUOTES

Jean Grey: "What are you doing? This isn't going to end well. Everyone you love dies."

TRIVIA

To prepare for the role, actor Hugh Jackman asked Dwayne Johnson for advice on bulking up. Johnson suggested that Jackman could gain a pound a week over six months by eating 6,000 calories a day of "an awful lot of chicken, steak, and brown rice."

WORLD WAR Z

Remember Philly!
—Movie tagline

Box Office: $202.4 Million

Twenty minutes into its running time, *World War Z* starts to reveal itself as the generic and broken film that it is. By this point in the film, it has become apparent to all sentient residents of the earth that zombies that can run as fast as the comic book superhero the Flash are attacking all humans in all parts of the world; one bite converting a person into the undead in 10 seconds. Hu-

man civilization is falling apart everywhere fast. That is not the disappointing part. That part comes shortly after former United Nations official Gerry Lane (Brad Pitt) shoots a man to death in a grocery store who was trying to rape his wife while a nearby cop ignores both the attempted rape and the shooting to continue participating in looting the store along with approximately 10,000 other desperate people. At that moment, Lane receives a call from his old boss at the United Nations, offering to extract him and his family by helicopter and whisk them off to an aircraft carrier safely in the middle of the ocean, thousands of miles away from land and the rapidly expanding zombie horde that is destroying the world. With that offer, Lane has just won the Willy Wonka golden ticket, a prize approximately 100 percent of the world's population would slit his and his family's throat for the opportunity to have. "Never," Lane replies.

Even though the world is literally ending, the agency took Lane away from his family one too many times before the zombie apocalypse and he will never submit his family to that again, even to save that family's life. Lane's nonsensical, action film cliche of a response, tells the viewer everything he or she needs to know about the rest of the film they are going to see. *World War Z* is a generic, would-be crowd pleaser that fails to succeed in even being a complete film. It seems to have been constructed by the filmmakers creating four unrelated CGI action set pieces and then connecting those scenes together using the absolute bare minimum of exposition, character and plot. (The plot of *World War Z* is as follows: Brad Pitt flies to a country and gets attacked by zombies. He then learns that he needs to fly to another country to be attacked by zombies).

The four action sequences are fun as far as it goes (the film's sole innovation to the genre seems to be a plot-selective hive mentality which allows the fast moving zombies to stack up on each other to get over city walls) but it is the vast stretches of time between each action sequence that are dead on arrival. Unfortunately, that connective tissue is needed to make the viewer care about the characters trying to survive the cool action scenes. Without caring, the action scenes do not have any emotional impact.

The culprit is a terrible script by Mathew Michael Carnahan, Drew Goddard, and Damon Lindelhof, that is a million miles away from the Max Brooks novel upon which the film is based (or more accurately simply shares a name with). The subtlety, satire, and slow moving zombies of Brook's book have been replaced by a generic, turbo-fueled zombie threat (for some reason being turned into the undead makes a person capable of running faster than they could while alive) replete with Roland Emmerich-esque lines of people fleeing catastrophe down metropolitan streets, paper thin characters,

and dialogue so uninvolving and minimalistic it seems to have been expressly designed for an international audience for whom English was not a first (or second) language. Pitt's character has no personality and undergoes no character development. Everyone else in the film is a character outline. The immensely talented Mireille Enos is utterly wasted in a by the numbers crying-wife-waiting-by-the-phone role. Why is it that films made in 2013 continue to conform to sex roles that were cliches 50 years ago? Instead of making her character a scientist or fellow UN official who could accompany her husband or, gasp, even have her own subplot, the tired screenplay makes Enos spend the film sitting on a bed, weeping and waiting for her husband to call. Only the ruthless dictates of a generic summer blockbuster with international aspirations would be capable of reducing such a talented actress from such a well-written show (AMC's *The Killing*) to such a pathetic role.

Lane's unbelievable response to his boss's offer to save him and his family also gets at the script required stupidity of humanity's response to the zombie threat throughout the film. The flaw with most entries into the zombie genre is that they require humans to act in distinctly non-human ways to generate the suspense and danger in fighting what should in most cases be a pretty manageable foe. If humans over history have become good at anything it is fighting with each other and fending each other off. In that regard, zombies should be a no brainer. They cannot think, plan, communicate, collaborate, or use weapons. They can shamble (sometimes very quickly) and bite people. That is about it. In the real world, how long would it be before everyone resided in huge castle like fortresses surround by deep moats full of fire?

Yet in *World War Z*, humans are shown over and over again making elementary, plot-necessitated errors. For example, Jerusalem has fared much better than other cities in their response to the apocalypse. As one of the few cities that took the warnings of the threat seriously, Jerusalem has constructed huge walls to keep the zombies at bay. Unfortunately, the city apparently called it a day after building the walls and its only other defenses appear to consist of sending a couple of choppers out to survey the army of undead amassing outside. This turns out to be a bad idea when, despite everyone knowing that the zombies are attracted to noise, no one thinks to tell a bunch of recently arrived refuges (who have all somehow arrived by ground vehicles in a city surrounded by millions of zombies) not to sing in celebration of their arrival. Soon undead are surging over the wall. The real reason, of course, for the lack of defenses and singing is because Brad Pitt just arrived and the plot requires the undead to magically become a

threat so he is forced to hop on a plane to the next country.

However, the most surprising and distressing aspect of *World War Z* is not its terrible writing and annoying lack of logic, it is that it is not even really a complete film. A more accurate title for it would be *World War Z, Part A*. Originally planned to culminate with a massive battle against the zombies in the snows of Moscow, the film experienced extensive re-shoots which result instead in a cat and mouse skulk at a research facility that is at odds with the tone of the film which preceded it. Most enraging of all, just as the viewer is expecting to view the fruits of Lane's discovery at the facility be applied to the zombie hordes which he has been fleeing from for two hours, the film cuts awkwardly Lane reuniting with his family and a Pitt voice over informing us that his actions have bought the world some time but the end of the war is not at hand; "not even close." Catch the exciting conclusion in two years folks! There is nothing wrong with sequels, of course, but it is also reasonable to expect the initial film to be a satisfying, self-contained story with a beginning, middle, and end, not just a lazy intro that only tells half a story. In this respect, *World War Z* is one of the most presumptuous films in recent memory. The viewer has not even been treated to a complete story with the first film and is being arrogantly asked to line up for the next two.

World War Z is a generic, incomplete film that lucked into worldwide commercial success due to the apparent indestructibility of the zombie genre. It is a remarkable and depressing demonstration of the resilience of that genre that an entry this lackluster and incompetent was capable of achieving such underserved success.

Nate Vercauteren

CREDITS

Gerry Lane: Brad Pitt
Karen Lane: Mireille Enos
Capt. Speke: James Badge Dale
Segen: Daniella Kertesz
Jurgen: Ludi Boeken
Origin: United States
Language: English
Released: 2013
Production: Ian Bryce, Dede Gardner, Jeremy Kleiner, Brad Pitt; Apparatus Productions, Latina Pictures, Plan B Entertainment; released by Paramount Pictures Corp.
Directed by: Marc Forster
Written by: Matthew Michael Carnahan; Drew Goddard; Damon Lindelof

Cinematography by: Robert Richardson
Music by: Marco Beltrami
Sound: Tobias Poppe
Editing: Roger Barton; Matt Chesse
Costumes: Mayes C. Rubeo
Production Design: Nigel Phelps
MPAA rating: PG-13
Running time: 116 minutes

REVIEWS

Burr, Ty. *Boston Globe*. June 19, 2013.
Dowd, A. A. *The A.V. Club*. June 19, 2013.
Foundas, Scott. *Variety*. June 4, 2013.
Fear, David. *Time Out New York*. June 18, 2013.
Scott, A. O. *The New York Times*. June 20, 2013.
Seitz Zoller, Matt. *RogerEbert.com*. June 21, 2013.
Semlyen, Nick de. *Empire*. June 3, 2013.
Smith, Kyle. *New York Post*. June 18, 2013.
Turan, Kenneth. *The Los Angeles Times*. June 20, 2013.
Zacharek, Stephanie. *Village Voice*. June 17, 2013.

QUOTES

Jurgen Warmbrunn: "Most people don't believe something can happen until it already has. That's not stupidity or weakness, that's just human nature."

TRIVIA

A deleted storyline featured Gerry's wife having an affair with the para jumper from the rescue scene earlier in the film.

THE WORLD'S END

One night. Six friends. Twelve pubs. Total annihilation.
—Movie tagline

Good food. Fine ales. Total Annihilation.
—Movie tagline

Prepare to get annihilated.
—Movie tagline

Box Office: $26 Million

The "Cornetto Trilogy" does not contain the typical three-film structure associated with cinematic entities. Though it includes familiar elements and returning cast members, the name stems from a passing joke that turned into free promotional ice cream for the filmmakers and the hope that it would continue. Edgar Wright and Simon Pegg may never have uttered the "T" word when they were filming their zombie comedy, *Shaun of the Dead* (2004), nor when they dreamed up their salute to American action films and British detective stories

with *Hot Fuzz* (2007). They may be big kids with a creamy, geeky center but their latest is proof that they are not above growing up either. Leave it to them to use the Earthly invasion of robots as a catalyst to craft one of the most unique treatments of alcoholism ever committed to film.

In his youth, Gary King (Pegg), was the de facto leader of a group of friends who followed and worshipped his cool antics. In their first transition to adults, the fivesome attempted to crack the "Golden Mile" of their small town of Newton Haven: 12 pubs, 12 pints each. Despite an evening of memories, the quest was a failure and over the years the friends would go their separate ways; some for the better, some for the worse. Oliver (Martin Freeman), Peter (Eddie Marsan), Steven (Paddy Considine), and Gary's former best mate, Andrew (Nick Frost) have gone on to marriage and good jobs while Gary is recounting the film's prologue in a rehab facility.

Determined to correct this gap in his legend, Gary revisits his old friends to convince them to join him on a do-over. Reluctance abounds, particularly in wounds Andrew carries from his last encounter with Gary, but the gang takes the leap and heads back home. Visiting them on their big evening is Oliver's sister, Sam (Rosamund Pike) who was a highlight of the original pub crawl for Gary and a lowlight of regrets for Steven who still carries a torch for her. As the night moves on and grievances are aired, the gang makes a startling discovery that they are not the only Newton Haven residents who have changed for the better. Or the worse.

Much like Robert Rodriguez's *From Dusk Till Dawn* (1996), Edgar Wright's film takes an abrupt left turn into fantasy carnage, switching genres with the casualness of opening a curtain. What begins as a reunion piece like *That Championship Season* (1982) quickly turns into a sci-fi survival narrative more in tune with *Invasion of the Body Snatchers* (1956) than *The Big Chill* (1983). But not much more. Though the dynamics of the humor and their motivations have changed, the underlying pain that the characters entered their robot-battling hours with continues to linger. Developing a rapport with the audience through a carefully constructed first act is one thing, but what Wright and company have continued to succeed at in this series of films is the seamless blend of satire and homage into a narrative that can equally exist on its own with the classics of its genre.

Intact is the very paranoia that came with the Siegel, Kaufmann, or Ferrara versions of the original Jack Finney tale of replicating aliens. With the who-is-who and identity tests on hand, Wright and Pegg were likely equally influenced by John Carpenter's version of *The*

Thing (1982) as well. Yet the core of the very being of the invaders strikes to the underlying surrender of the human race in the *Body Snatchers* films. The "red" ideology of the 1950s may have been deemed as pure evil at the time, but the substitution of any other way of life can easily strike up the same kind of fear. *The World's End* strikes closer to the 1978 version when self-help gurus and psychology were masking trauma and began to develop their own cult followings. Allowing the fate of our world to fall into the hands of a selfish hedonist is just part of the greater irony at work here.

The first time the adult Gary is introduced, there is a funny jump cut from glory days to misplaced reminiscence. This leads to one red flag of discovery after another about his life, especially where his friends are involved. There is genuine melancholy amidst the laughs as details of Gary's self-preservation are revealed. A short monologue about Peter's encounter with a former bully rings with the heartbreaking truth that the worst moments of the past may have made nobody stronger. Who needs a drink now?

Drunk or sober, *The World's End* offers a variety of pleasures for anyone looking for a good time at the movies. Expanding his reach thematically is only part of Wright's growth as he has also upped his game when it comes to his action scenes. The final act of *Hot Fuzz* remains one of the most satisfyingly complete packages of a lifetime, but the individual melees that he constructs this time around are a wonder of editing and choreography. A bathroom brawl between ten people immediately charges up the film's next gear but then is just as quickly going to have an audience trying to pinpoint the edit marks of a bravura sequence that looks like a single take. Later on, Wright dazzles with a similar style while employing the kind of joy a little kid in a cowboy hat might experience witnessing his first full-on western saloon fight. Again, the precision composition of Gary just trying to finish his pint has the grace of Buster Keaton and the prescient sadness of a one track mind who can only find shelter at the bottom of a glass.

The intrinsic journey of the pub crawl is Gary's path to salvation even if it may spell doom for the rest of humanity. 12 pubs. 12 steps. Gary's initiation of the reunion comes from his rock bottom and it will be fascinating in future viewings to piece together just whether he was being proactive in his own recovery or not; his behavior a familiar smokescreen to maintain the appearance of his legend. Gary is personally unaware he is headed straight towards his own conscious contact with a higher power and the possibility of a spiritual awakening. The Cornetto Trilogy may be one for a very specific age growing up through fantasy, but never out of it. Though maybe only a trilogy by the loosest of

strands, it is the kind that endures through the ages for the next generation to appreciate.

Erik Childress

CREDITS

Gary King: Simon Pegg
Andy Knightley: Nick Frost
Oliver Chamberlain: Martin Freeman
Steven Prince: Paddy Considine
Peter Page: Eddie Marsan
Sam Chamberlain: Rosamund Pike
Basil: David Bradley
Guy Shepherd: Pierce Brosnan
Origin: United Kingdom
Language: English
Released: 2013
Production: Eric Fellner, Nira Park; Working Title Films; released by Focus Features L.L.C.
Directed by: Edgar Wright
Written by: Simon Pegg; Edgar Wright
Cinematography by: Bill Pope
Music by: Steven Price
Sound: Colin Nicolson
Music Supervisor: Nick Angel
Editing: Paul Machliss

Art Direction: Peter Dorme
Costumes: Guy Speranza
Production Design: Marcus Rowland
MPAA rating: R
Running time: 109 minutes

REVIEWS

Adams, Mark. *Screen International*. July 8, 2013.
Bibbiani, William. *CraveOnline*. July 22, 2013.
Cline, Rich. *Contactmusic.com*. July 18, 2013.
Edelstein, David. *New York Magazine*. August 12, 2013.
Todd, Gilchrist. *The Playlist*. July 2, 2013.
Goss, William. *Film.com*. July 20, 2013.
Huddleston, Tom. *Time Out*. July 15, 2013.
Johanson, MaryAnn. *Flick Filosopher*. July 19, 2013.
Kohn, Eric. *indieWIRE*. June 12, 2013.
Weinberg, Scott. *FEARnet*. August 1, 2013.

QUOTES

Gary King: "What the f**k does WTF mean?"

TRIVIA

The main characters surnames all have royal/court connections: (Gary) King, (Andy) Knightly, (Peter) Page, (Steven) Prince, and (Oliver) Chamberlain.

Y

YOU'RE NEXT

Did you remember to lock your door?
—Movie tagline

The animals will hunt you.
—Movie tagline

Hunt sweet hunt.
—Movie tagline

The pack is back.
—Movie tagline

Don't bother locking the doors. Animals don't use doors.
—Movie tagline

Box Office: $18.5 Million

Films can have issues getting from production to theatrical release for a variety of reasons. When they do have issues, those problems become an important part of their history, affecting the context the films appear in as they make their all-important first impressions. In the case of *You're Next*, a release lag that would have killed a lesser film has only served to remind viewers who saw it early on at special screenings and festivals what a smart, funny, and thrilling ride it offers. Yes, there have been other home invasion horrors since then; many of them quite good. *You're Next* even had the disadvantage of finally being released uncomfortably close to the very interesting and effective *The Purge* (2013). But even for viewers who have seen *The Strangers* (2008), *Funny Games* U.S. (2007), and *Ils* (2006), *You're Next* should be enormously entertaining. It offers a constant stream of riffs on the home invasion scenario along with a num-

ber of inventively staged and often very funny gore/action sequences. It also has a cast to die for.

Director Adam Wingard seems very well aware indeed of what horror fans want in a film titled *You're Next* but he also mixes those expectation meeting moments with twists, turns, and character arcs that will likely seem new even if viewers have seen them before. His style is simply that adroit. Thus a scene at the very beginning of the film, in which a couple is killed after sex is anything but boring and will likely induce laughter or horror, depending on how much experience viewers have with the genre. What other filmmakers would include out of laziness Wingard includes because he loves the genre and knows how to milk its tropes.

After the initial murder, viewers meet Paul Davison (Rob Moran) and his wife Aubrey (Barbara Crampton), who arrive at their out-of-the-way country home and immediately begin hearing things, following mysterious noises, and preparing for a family weekend reunion. Gathering to meet them and introduced at intervals are Crispian (AJ Bowen), his Australian girlfriend Erin (Sharni Vinson), Crispian's brother Drake (Joe Swanberg), Drake's wife Kelly (Margaret Laney), Crispian's other brother Felix (Nicholas Tucci), Felix's girlfriend Zee (Wendy Glenn), Crispian's younger sister Aimee (Amy Seimetz), and her documentarian boyfriend Tariq (Ti West). It sounds like a lot of characters and they do all play to type. The family is by turns rude, clueless, self-absorbed, etc. But once everyone sits down to the titular family dinner the cast is quickly and with great skill downsized in a series of mostly spectacular suspense horror sequences featuring a series of masked intruders who invade the home.

Wingard has a couple of other earlier moments (besides the murder that offers up the film's title in lieu of any opening credits) that let viewers in on how bad things are going to get but just when it seems like the film will be nothing but a standard, if creatively mounted, slasher flick, it turns out that one of the characters has a special knack for fighting off the bad guys. Adam Wingard's previous film *A Horrible Way To Die* (2010), a darker-than-dark horror-cum-drama effort, betrayed none of the flair he shows here for mining Simon Barrett's excellent screenplay for comedy.

But the real star here is Australian actress, Sharni Vinson who breathes ragged survivalist life into what could have been a standard final girl role. This is the stuff of breakout stardom and if Vinson is lucky enough to encounter other scripts worthy of her talents she should expect to find ample praise from critics. She moves from guaranteed to die by the second reel to warrior status in an absolutely organic manner meeting the potential of and surpassing the material with which she is given to work.

Special effects are excellent throughout and achieved through practical means rather than CGI, and definitely help the film pay homage to the late-eighties/early-nineties cinema it so clearly references. Blenders, piano wire, and arrows are put to the kind of use that will neatly divide the audience here (the easily queasy need not apply). Wisely, the director uses the graphic violence to create a sense of adventure and mirth rather than aim for pure scares. The camerawork here seems like its own special effect going for the jugular only when it will elicit exactly what it should. This is no haphazard exploration of the limits of gore cinema but a well-considered bit of smart-aleck satire that manages to entertain, gross-out, and challenge viewers all at once.

Since this, Wingard has noodled around with anthologies (*V/H/S* [2012], *V/H/S 2* [2013], and *The ABCs of Death* [2012]) that do little to showcase the talent on display here. Hopefully, a new project will emerge soon. What he has done here with Barrett is remarkable in that *You're Next* could have been a simple imitation of any number of films. Its wry structure suggests Wes Craven's *Scream* (1996) and though it falls short of being quite that clever, it is every bit as fun, as if the pair were signaling that the horror genre need not defend or even explain itself as long as it does what it should: scare us, make us laugh and add a little red-blooded life to a storytelling form that will be around a long time after it is.

Dave Canfield

CREDITS

Erin: Sharni Vinson
Crispian: AJ Bowen
Drake: Joe Swanberg
Felix: Nicholas Tucci
Zee: Wendy Glenn
Kelly: Margaret Laney
Aimee: Amy Seimetz
Tariq: Ti West
Paul Davison: Rob Moran
Aubrey Davison: Barbara Crampton
Origin: United States
Language: English
Released: 2013
Production: Keith Calder, Simon Barrett; HanWay Films; released by Lions Gate Entertainment Corp.
Directed by: Adam Wingard
Written by: Simon Barrett
Cinematography by: Andrew Droz Palermo
Music by: Kyle McKinnon
Sound: Andy Hay
Music Supervisor: Jonathan McHugh
Editing: Adam Wingard
Art Direction: Nathan Truesdell
Costumes: Emma Potter
Production Design: Thomas Hammock
MPAA rating: R
Running time: 94 minutes

REVIEWS

Abele, Robert. *Los Angeles Times*. August 22, 2013.
Catsoulis, Jeannette. *New York Times*. August 22, 2013.
Derakhshani, Tirdad. *Philadelphia Inquirer*. August 23, 2013.
Gilchrist, Todd. *Comic Book Resources*. August 23, 2013.
Howell, Peter. *Toronto Star*. August 23, 2013.
Keough, Peter. *Boston Globe*. August 22, 2013.
McGranahan, Mike. *Aisle Seat*. August 30, 2013.
Rothkopf, Joshua. *Time Out New York*. August 21, 2013.
Snider, Eric D. *Film.com*. October 1, 2011.
Urbancich, John. *Sun Newspapers of Cleveland*. August 22, 2013.

QUOTES

Erin: "Grab anything that might make a good weapon."

TRIVIA

Simon Barrett, the Tiger Mask Killer, is also the screenwriter.

List of Awards

Academy Awards

Film: *12 Years a Slave*
Animated Film: *Frozen*
Director: Alfonso Cuaron (*Gravity*)
Actor: Matthew McConaughey (*Dallas Buyers Club*)
Actress: Cate Blanchett (*Blue Jasmine*)
Supporting Actor: Jared Leo (*Dallas Buyers Club*)
Supporting Actress: Lupita Nyon'o (*12 Years a Slave*)
Original Screenplay: Spike Jonze (*Her*)
Adapted Screenplay: John Ridley (*12 Years a Slave*)
Cinematography: Emmanuel Lubezki (*Gravity*)
Editing: Alfonso Cuaron, Mark Sanger (*Gravity*)
Art Direction: Catherine Martin, Beverley Dunn (*The Great Gatsby*)
Visual Effects: Timothy Webber, Chris Lawrence, David Shirk, Neil Corbould (*Gravity*)
Sound: Skip Lievsay, Niv Adiri, Christopher Benstead, Chris Munro (*Gravity*)
Sound Editing: Glenn Freemantle (*Gravity*)
Makeup: Adruitha Lee, Robin Mathews (*Dallas Buyers Club*)
Costume Design: Catherine Martin (*The Great Gatsby*)

Original Score: Steven Price (*Gravity*)
Original Song: "Let It Go" (Kristen Anderson-Lopez, Robert Lopez *Frozen*)
Foreign Language Film: *The Great Beauty*
Documentary, Feature: *20 Feet from Stardom*
Documentary, Short Subject: *The Lady in Number 6: Music Saved My Life*
Short Film, Animated: *Mr Hublot*
Short Film, Live Action: *Helium*

British Academy of Film & Television Awards

Animated Film: *Frozen*
Film: *12 Years a Slave*
Outstanding British Film: *Gravity*
Director: Alfonso Cuaron (*Gravity*)
Original Screenplay: Eric Warren Singer, David O. Russell (*American Hustle*)
Adapted Screenplay: Steve Coogan, Jeff Pope (*Philomena*)
Actor: Chiwetel Ejiofor (*12 Years a Slave*)
Actress: Cate Blanchett (*Blue Jasmine*)
Supporting Actor: Barkhad Abdi (*Captain Phillips*)
Supporting Actress: Jennifer Lawrence (*American Hustle*)

Editing: Daniel P. Hanley, Mike Hill (*Rush*)
Cinematography: Emmanuel Lubezki (*Gravity*)
Production Design: Catherine Martin, Beverley Dunn (*The Great Gatsby*)
Costume Design: Catherine Martin (*The Great Gatsby*)
Makeup: Evelyne Noraz, Lori McCoy-Bell, Kathrine Gordon (*American Hustle*)
Sound: Skip Lievsay, Niv Adiri, Christopher Benstead, Chris Munro (*Gravity*)
Visual Effects: Timothy Webber, Chris Lawrence, David Shirk, Neil Corbould (*Gravity*)
Music: Steven Price (*Gravity*)
Outstanding Debut by a British Writer, Director, or Producer: Kieran Evans (*Kelly + Victor*)
Best Documentary Film: *The Act of Killing*
Foreign Film: *The Great Beauty*
Short Animation: *Sleeping with the Fishes*
Short Film: *Room 8*

Directors Guild of America Awards

Outstanding Directorial Achievement in Motion Pictures: Alfonso Cuaron (*Gravity*)
Outstanding Directorial Achievement in Documentary: Jehane Noujaim (*The Square*)

Golden Globes

Film, Drama: *12 Years a Slave*

Film, Musical or Comedy: *American Hustle*

Animated Film: *Frozen*

Director: Alfonso Cuaron (*Gravity*)

Actor, Drama: Matthew McConaughey (*Dallas Buyers Club*)

Actor, Musical or Comedy: Leonardo DiCaprio (*The Wolf of Wall Street*)

Actress, Drama: Cate Blanchett (*Blue Jasmine*)

Actress, Musical or Comedy: Amy Adams (*American Hustle*)

Supporting Actor: Jared Leto (*Dallas Buyers Club*)

Supporting Actress: Jennifer Lawrence (*American Hustle*)

Screenplay: Spike Jonze (*Her*)

Score: Alex Ebert (*All Is Lost*)

Song: "Ordinary Love" (Bono, Adam Clayton, The Edge, Larry Mullen Jr., Brian Burton, *Mandela: Long Walk to Freedom*)

Foreign Language Film: *The Great Beauty*

Golden Raspberry Awards

Worst Picture: *Movie 43*

Worst Director: Elizabeth Banks, Steven Brill, Steve Carr, Rusty Cundieff, James Duffy, Griffin Dunne, Peter Farrelly, Patrik Forsberg, Will Graham, James Gunn (*Movie 43*)

Worst Actor: Jaden Smith (*After Earth*)

Worst Actress: Tyler Perry (*Tyler Perry's A Madea Christmas*)

Worst Supporting Actor: Will Smith (*After Earth*)

Worst Supporting Actress: Kim Kardashian (*Temptation: Confessions of a Marriage Counselor*)

Worst Screenplay: Rocky Russo, Jeremy Sosenko, Ricky Blitt, Bill O'Malley, Will Graham, Jack Kukoda, Matt Portenoy, Claes Kjellstrom, Jonas Wittenmark, Tobias Carlson, Will Carlough, Jonathan van Tulleken, Elizabeth Shapiro, Patrik Forsberg, Olle Sarri, Jacob Fleisher, Greg Pritikin, James Gunn (*Movie 43*)

Worst Screen Combo: Jaden Smith, Will Smith (*After Earth*)

Worst Remake, Rip-Off or Sequel: *The Lone Ranger*

Independent Spirit Awards

Film: *12 Years a Slave*

First Film: *Fruitvale Station*

Director: Steve McQueen (*12 Years a Slave*)

Actor: Matthew McConaughey (*Dallas Buyers Club*)

Actress: Cate Blanchett (*Blue Jasmine*)

Supporting Actor: Jared Leto (*Dallas Buyers Club*)

Supporting Actress: Lupita Nyong'o (*12 Years a Slave*)

Screenplay: John Ridley (*12 Years a Slave*)

First Screenplay: Bob Nelson (*Nebraska*)

Cinematography: Sean Bobbitt (*12 Years a Slave*)

Editing: Nat Sanders (*Short Term 12*)

Foreign Film: *Blue Is the Warmest Color*

Documentary: *20 Feet from Stardom*

Truer than Fiction Award: *Let the Fire Burn*

Robert Altman Award: *Mud*

John Cassavetes Award: *This Is Martin Bonner*

Screen Actors Guild Awards

Actor: Matthew McConaughey (*Dallas Buyers Club*)

Actress: Cate Blanchett (*Blue Jasmine*)

Supporting Actor: Jared Leto (*Dallas Buyers Club*)

Supporting Actress: Lupita Nyong'o (*12 Years a Slave*)

Ensemble Cast: *American Hustle*

Writers Guild of America Awards

Original Screenplay: Spike Jonze (*Her*)

Adapted Screenplay: Billy Ray (*Captain Phillips*)

Documentary Screenplay: Sarah Polley (*Stories We Tell*)

Obituaries

Brian Ackland–Snow (March 31, 1940–March 30, 2013). English production designer Brian Ackland–Snow won an Oscar in 1986 for his work the Merchant/Ivory film *A Room with a View* (1985). He would never go on to top that achievement but did some other regular film design work, including *Maurice* (1987), *Without a Clue* (1988), and *Haunted* (1995). Before his Oscar win, he served as the Art Director on *Death on the Nile* (1978), *Dracula* (1979), *The Dark Crystal* (1982), and *Superman III* (1983).

Rona Anderson (August 3, 1926–July 23, 2013). Scottish stage, film and television actress Rona Anderson became in icon in the 1940s and 1950s but will likely be most remembered for *The Prime of Miss Jean Brodie* (1969). Anderson started, as so many do, working on stage in Glasglow and throughout Scotland and the rest of the United Kingdom as a young starlet in the 1940s. Her film debut would come in 1948 in *Sleeping Car to Trieste* and her life would change a year later when she starred with Gordon Jackson in *Floodtide* (1949). The two would marry and would stay betrothed until his death in 1990. Other notable film highlights include *Scrooge* (1951), *Home to Danger* (1951), and *Man with a Gun* (1958). She would do television work in the in the 1960s and 1970s before essentially retiring. She passed away on July 23rd.

James Avery (November 27, 1945–December 31, 2013). The final celebrity to pass away in 2013 will be forever remembered for his TV work, most notably helping to launch the career of Will Smith when he played his uncle Philip in the hit *The Fresh Prince of Bel–Air*. A vast majority of Avery's work happened on the small screen but he also had a few film appearances over the years. Avery's television work will always outshine his big screen work but he parlayed his small screen success into a career that includes parts in *The Brady Bunch Movie* (1995), *The Prince of Egypt* (1998), *Dr. Dolittle 2* (2001), and even the upcoming *Wish I Was Here* (2014), from director Zach Braff.

Conrad Bain (February 4, 1923–January 14, 2013). Canadian actor Conrad Bain will forever hold a hallowed place in TV history as Phillip Drummond on the beloved *Diff'rent Strokes* but he had a notable film career before turning to TV in the 1970s. After serving in the Canadian Army in WWII, Bain graduated from the New York American Academy of Dramatic Arts in 1948 (a classmate of Don Rickles). He worked on stage at Stratford in Canada before moving on to Broadway shows in the 1950s and 1960s. Most of his film roles were minor but he appeared in *Coogan's Bluff* (1968), *I Never Sang For My Father* (1970), *Bananas (1971)*, *The Anderson Tapes* (1971), and *Up the Sandbox* (1972). He passed away from natural causes in California just weeks before his 90th birthday.

Nino Baragli (October 1, 1925–May 29, 2013). Born in Rome as Giovanni Baragli, editor Nino Baragli would go on to win two David Di Donatello Awards for Best Editing for *The Voice of the Moon* (1991) and *Mediterraneo* (1992) and a Silver Ribbon in 1998 for his lengthy career that saw work on over 200 productions, including films by Federico Fellini, Pier Paolo Pasolini, Sergio Leone, Bernardo Bertolucci and many more. He's one of the more notable Italian film editors in all of history; arguably the MOST notable. Notable credits from an incredible career include *Django* (1966), *The Good, the Bad and the Ugly* (1966), *Hellbenders* (1967), *Once Upon a Time in the West (1968)*, *The Decameron* (1971), *Duck, You Sucker (aka A Fistful of Dynamite)* (1971), *The Canterbury Tales* (1972), *Arabian Nights* (1974), *Salo, or the 120 Days of Sodom* (1975), *Caligula* (1979), and *Once Upon a Time in America* (1984).

Antonia Bird (May 27, 1951–October 24, 2013). Survived by her husband, Ian Ilet, Antonia Bird passed away suddenly at the age of 62 after struggling with a rare form of thyroid cancer. Mostly known for TV work in England in the 1980s, Bird got her start behind the camera as a major director of the highly–influential and beloved *EastEnders* for the BBC. She moved to film in 1994 with the premiere of the controversial and acclaimed *Priest*, which

stared Linus Roache as a Catholic Priest stuck between his calling and his homosexuality. She moved on to garner acclaim for *Mad Love* (1995), *Face* (1997), and *Ravenous* (1999) before moving back to the world of TV in the 2000s, including helming episodes of *Cracker* and *MI–5*.

Karen Black (July 1, 1939–August 8, 2013). A staple of the golden age of cinema in the 1960s and 1970s, Karen Blanche Ziegler was born in Park Ridge, Illinois to a mother who was a prizewinning children's novelist. She made her Broadway debut in 1965 but transitioned to film easily, appearing in 1966 in Francis Ford Coppola's *You're a Big Boy Now*. She regularly appeared on TV in the 1960s but her film career took off when she was cast alongside Dennis Hopper and Peter Fonda in the wildly popular *Easy Rider* (1969). From there, Black has a string of major roles in *Five Easy Pieces* (1970), *The Great Gatsby* (1974), *Airport 1975* (1974), *The Day of the Locust* (1975), *Nashville* (1975), *Family Plot* (1976), and *Capricorn One* (1978). She was nominated for an Oscar for Best Supporting Actress for *Five Easy Pieces*. The 1980s, partially inspired by her work in *Trilogy of Terror* (1975), turned Karen Black into a horror icon, and the actress appeared in a number of low–budget horror films over the course of the rest of her career, never quite returning to the peak of her fame in the 1970s. The films may have gotten smaller but Black worked consistently for decades, often appearing in more than one movie a year up until her death at the age of 74 from ampullary cancer.

Eileen Brennan (September 3, 1932–July 28, 2013). Verla Eileen Regina Brennan was born in Los Angeles in 1932 and would go on to a decades–long career in film, television, and theater, winning a Golden Globe and Emmy, while also garnering an Oscar nomination. Brennan cut her teeth on stage, appearing on Broadway in the 1960s, including creating the role of Irene Malloy in the original production of *Hello, Dolly!* in 1964 before making her film debut in *Divorce American Style* (1967). She was a staple of the 1970s, appearing in *The Last Picture Show* (1971), *The Sting* (1973), *Daisy Miller* (1974), *At Long Last Love* (1975), *Murder by Death* (1976), and more before peaking with her Oscar–nominated work in 1980's *Private Benjamin*. She reprised the role in the TV version of the film, winning an Emmy and Golden Globe. An accident took her out of the public eye for some time but she would work consistently until her death, appearing in *Clue* (1985) before really seguing into regular TV work that would commonly see her get nominated for Emmys for Outstanding Guest Actress (a feat she pulled off for *Newhart* in 1989, *thirtysomething* in 1991, and *Will & Grace*).

Richard Briers (January 14, 1934–February 17, 2013). A television staple in the history of British TV, Richard David Briers was born in Surrey, England in 1934. He served in the RAF in the 1950s before studying acting in a class that included Peter O'Toole and Albert Finney, making his stage debut in 1959. Numerous television roles followed while Briers' love for the British stage never left him either. Film success was more elusive, although Briers did appear regularly with friend from the stage scene, Kenneth Branagh, including in the actor/writer/director's *Henry V* (1989), *Peter's Friends* (1992), *Much Ado About Nothing* (1993), *Frankenstein* (1994), and *Hamlet* (1996). He acted

all the way up to the end, appearing in *Cockneys vs. Zombies* (2012) the year before his death. He was so popular in his home country that BBC Radio dedicated a day to him after his passing in which numerous people introduced his BBC recordings. The national treasure passed away from cardiac arrest at the age of 79.

Jacqueline Brookes (July 24, 1930–April 26, 2013). American film, television, and stage actress Jacqueline Victoire Brookes was born in Montclair, New Jersey in 1930 and earned her most acclaim on stage after graduating from London's Royal Academy of Dramatic Arts. She also served as a teacher at the Circle in the Square Theatre School from 1974 until her death and was a lifelong member of The Actors Studio. Her film career was more limited than her stage one but she did appear in a few notable films, including *The Gambler* (1974), *The Entity* (1981), *Ghost Story* (1981), *Sea of Love* (1989), *The Naked Gun 2: The Smell of Fear* (1991), *The Good Son* (1993), and *Losing Isaiah* (1995). She passed away from the age of lymphoma at the age of 82.

Dennis Burkley (September 10, 1945–July 14, 2013). Born in Van Nuys, California, Burkley appeared at dozens of films and TV series over four decades, never gaining household name status but proving to be a reliable character actor in a variety of genres, often using his large six (6' 3" & 300 lbs) to his advantage. His most regular work was later in life as a voice actor on FOX's animated *King of the Hill*. He passed away from a heart attack in his home and is survived by his wife of over 35 years. Film credits include *The Call of the Wild* (1976), *Mask* (1985), *Murphy's Romance* (1985), *No Way Out* (1987), *The End of Innocence* (1990), *The Doors* (1991), *Tin Cup* (1996), and *Hollywood Homicide* (2003).

Patrice Chereau (November 2, 1944–October 7, 2013). Although celebrated in his native France for his work in the theater—he was directing for the stage at the age of 19—Chereau also received international acclaim for his occasional forays into the cinema. Chereau made his film directing debut with the thriller *The Flesh of the Orchid* (1975) and followed that up nearly a decade later with *L'Homme Blesse* (1983), a dark drama about a relationship between an older male prostitute and a teenage boy. His biggest film was *Queen Margot* (1994), a sweeping historical epic based on the Alexandre Dumas novel that won the Special Jury Prize and Best Actress (for Virna Lisi) awards at Cannes as well as five Cesar awards. The international success of the film earned Chereau offers to do any number of similar projects but he spurned all of them, preferring instead to do smaller dramas such as *Those Who Love Me Can Take the Train* (1998) and *Intimacy* (2001), a drama about a couple that meet once a week for passionate but anonymous sex that became controversial when rumors spread that the action between co–stars Mark Rylance and Kerry Fox was not simulated. His last film was *Persecution* (2009) but he continued working in the theater until his death on October 7 in Paris from lung cancer.

Nigel Davenport (May 23, 1928–October 25, 2013). English stage, television, and film actor Arthur Nigel Davenport grew up in an academic family, appearing on stage at the Savoy Theatre and Royal Court Theatre in the 1950s. He quickly transitioned to film and television, including a

small part in *Look Back in Anger* (1959) before more memorable parts in *The Entertainer* (1960) with Laurence Olivier and Michael Powell's *Peeping Tom* (1960). Other memorable roles include parts in *A Man For All Seasons* (1966), *Mary, Queen of Scots* (1971), *The Island of Dr. Moreau* (1977), *Chariots of Fire* (1981), *A Christmas Carol* (1984), and *Greystoke: The Legend of Tarzan, Lord of the Apes* (1984). Nigel Davenport reportedly read the lines of HAL 9000 off–camera during the filming of Stanley Kubrick's masterpiece *2001: A Space Odyssey* (1968), later to be dubbed by Douglas Rain.

Deanna Durbin (December 4, 1921–April 20, 2013). Born Edna Mae Durbin, few people could have predicted that this sweet–natured Winnipeg native would go on to become one of Hollywood's biggest box–office draws while still in her teens. After moving from Canada to California with her parents as a child, she would eventually sign a contract with MGM in 1936, at the age of 14, and made her screen debut that year in *Every Sunday* (1936), in which she appeared alongside fellow future star Judy Garland. The studio let their option lapse and she quickly snapped up by Universal and cast as prototypical all–American girl–next––door Penny Craig in the musical comedy *Three Smart Girls* (1936). The film was a smash hit at the box–office—it is said that she single–handedly rescued the studio from the point of bankruptcy—and when follow–ups like *One Hundred Men and a Girl* (1937), *That Certain Age* (1938) and *Mad About Music* (1938) proved to be equally successful, she became one of the most popular stars of her era and, along with MIckey Rooney, was awarded a special Juvenile Oscar in 1939. Between 1936 and 1948, she would make 23 films, including two additional turns as Penny Craig in *Three Smart Girls Grow Up* (1939) and *Hers to Hold* (1943), but she never felt particularly comfortable in the spotlight, especially in the wake of two brief and unsuccessful marriages, and after making *For the Love of Money* (1948), she astounded everyone by simply walking away from the entire industry. Instead, she lived outside of France with her third and final husband, film director Charles David (a union lasting from 1950 until his death in 1999), and remained a screen icon to many despite her absence until her passing on April 20 at the age of 91.

David Early (May 30, 1938–March 23, 2013). Pittsburgh actor David Early will be best remembered for his horror movie work, including George A. Romero's timeless and essential *Dawn of the Dead* (1978). He passed away from cancer at his daughter's home at the age of 74 but appeared in dozens of (mostly horror) films in the past 35 years, including *Creepshow* (1982), *Monkey Shines (1988), The Silence of the Lambs* (1991), *Innocent Blood* (1992), and *The Dark Half (1993).*

Roger Ebert (June 18, 1942–April 4, 2013). Roger Joseph Ebert was born in Urbana, Illinois in 1942 to a bookkeeper and electrician. He would go on to move to Chicago and become arguably the most important film critic in the history of his form. He revolutionized the way people not only write about movies but how the average movie goer approaches them. With his TV show, *Sneak Previews,* which became *Siskel & Ebert At the Movies,* he brought the art of film criticism to the masses, proving he could be incredibly smart without coming across as pretentious. He was the

smartest person in nearly every room but never told everyone that. He published over two dozen books and served as film critic for the *Chicago Sun–Times* from 1967 until his death. He was the first film critic to win the Pulitzer Prize for Criticism. His reviews were syndicated around the world. Ebert also dabbled in film, writing Russ Meyer's *Beyond the Valley of the Dolls* (1970), a notoriously campy send–up of the counter–culture movement. Filmmakers and writers watched Ebert develop another side to his persona when he was diagnosed with cancer, pulling him from the public eye but allowing him new depth as he shared his personal pain with his readers. His passing was mourned by filmmakers, writers, and anyone who has ever given a movie a thumb up.

David R. Ellis (September 8, 1952–January 7, 2013). Director/stuntman/actor David Ellis passed away at a relatively young age in Johannesburg, South Africa. No cause of death has been released. He was a supporting actor at a young age but really founded his career on stunt work, including *The Invasion of the Body Snatchers* (1978), *Scarface* (1983), *Fatal Attraction* (1987), *Lethal Weapon* (1987), *Star Trek V: The Final Frontier* (1989), *Days of Thunder* (1990) and more. He was even doing stunt work on films that were released posthumously, including *R.I.P.D.* (2013), *47 Ronin* (2013), and *Winter's Tale* (2014). As a director, Ellis has a spotty record but showed an affinity for fun genre films, directing *Final Destination 2* (2003), *Cellular* (2004), *Snakes on a Plane* (2006), *The Final Destination* (2009), and *Shark Night* (2011).

Dennis Farina (February 29, 1944–July 22, 2013). Chicago–born actor Dennis Farina started his career as a police officer in the Windy City for almost two decades before transitioning to an incredible career that often called on his reputation as a tough, "average Joe" from a working–class, Midwest city. Regularly playing mobster or cop, Farina will be best–remembered for his debut role in Michael Mann's *Thief* (1981), scene–stealing work in the beloved *Midnight Run* (1988), great supporting performance in *Get Shorty* (1995), and years of work on TV as a regular on *Law & Order* (from 2004–06) and hosting *Unsolved Mysteries* from 2008–10. Other major film credits include *Manhunter* (1986), *Out of Sight* (1998), *Saving private Ryan* (1998), *Snatch* (2000), and a great leading turn in the independent and under–seen *Last Rites of Joe May* (2011). He worked all the way up to the final chapter of his life, appearing on FOX's *New Girl* and as a regular on HBO's *Luck* from Michael Mann and David Milch. He actually cemented his TV reputation decades earlier with the brilliant–but–canceled *Crime Story,* a show that would go on to influence the cop show in immeasurable ways. He passed away from a pulmonary embolism at his home in Scottsdale, Arizona.

Syd Field (December 19, 1935–November 17, 2013). When one hears the phrase "screenwriting guru," the name Syd Field is typically the first to pop to mind. He revolutionized the way that writers approached the script form, impacting numerous film schools and trains of thought with his theories on what makes a successful script. Field developed the three–act structure that has defined modern screenwriting in books like *Screenplay, The Screenwriter's Workbook, Selling the Screenplay: The Screenwriter's Guide to Hollywood,* and more. He passed away from cancer at the age of 77.

Joan Fontaine (October 22, 1917–December 15, 2013). A true legend from the Golden Age of Hollywood, Joan de Beauvoir de Haviland was born in Tokyo, where her British father worked as a businessman, and later moved to California with older sister Olivia and their mother, a one–time actress who pushed both of her daughters into the business as well. Under the name of Joan Burfield—chosen so as not to compete with her already–established sister——she made her screen debut in *No More Ladies* (1935) but received a tepid response. A couple of years later, she appeared under her more familiar name for the first time in *You Can't Beat Love* (1937) and was soon appearing in such classics as *The Women* (1939), *Gunga Din* (1939) and *Rebecca* (1940), for which she received her first Oscar nomination. The next year, she was again nominated for her performance in another Alfred Hitchcock film, *Suspicion* (1941), and this time, she would win the Best Actress Oscar—a victory that would be the only time that an actor won an Oscar for a Hitchcock film and would instigate a feud with de Haviland (who was also nominated that year for *Hold Back the Dawn*) that would last for the rest of their lives despite de Haviland going on to win two Oscars of her own. Throughout the 1940s, Fontaine would appear in such hits as *Jane Eyre* (1943) and receive another Oscar nomination for *The Constant Nymph* (1943) but by the next decade, she began appearing more frequently on stage and on television than on the big screen, where she appeared in the likes of *Ivanhoe* (1952), *Voyage to the Bottom of the Sea* (1961) and *Tender is the Night* (1962). After one final film appearance in *The Witches* (1966), she would spend the next couple of decades appearing on television before formally retiring in 1994. She passed away at the age of 96 of natural causes.

Bryan Forbes (July 22, 1926–May 8, 2013). British director/screenwriter/actor Bryan Forbes, CBE was born John Theobald Clarke in West Ham, Essex in 1926. He trained as an actor at the Royal Academy of Dramatic Art, served in the military in World War II, and went on to appear in British films in the 1950s before being offered screenwriting work that same decade on *The Black Knight* (1954), *The Cockleshell Heroes* (1955), *The League of Gentlemen* (1959), and more. He formed a production company in 1959 with the future legend Richard Attenborough. His directorial debut came in 1961 with *Whistle Down the Wind*, which was nominated for four BAFTA Awards. His next directorial effort, *The L–Shaped Room* (1962) would earn star Leslie Caron an Oscar nomination, a BAFTA Award, and a Golden Globe. He continued to dominate in the 1960s, directing *King Rat* (1965), *The Whisperers* (1967), and *Deadfall* (1968), but he will perhaps be best–remembered for 1975's *The Stepford Wives* and 1978's *International Velvet*. He was still publishing novels into his 80s, passing way at his home after a long illness.

Steve Forrest (September 25, 1925–May 18, 2013). One of those dependable journeyman actors who was a familiar face to audiences, even if they couldn't quite place his name, Forrest (nee William Forrest Andrews) was born in Huntsville, Texas in 1925 and after serving in World War II, he went out to California to visit his brother, actor Dana Andrews, and decided to try his own hand at acting. After studying theater at UCLA, he landed a contract at MGM and after a few bit parts, he made his first big impression in the screen adaptation of Edna Ferber's *So Big* (1953), a film which earned him a Golden Globe for New Star of the Year. After that, he worked steadily in film and television in films such as *Heller in Pink Tights* (1960), *Flaming Star* (1960), *The Longest Day* (1962), *North Dallas Forty* (1979), *Mommie Dearest* (1981), *Spies Like Us* (1985) and the immortal *Amazon Women on the Moon* (1987). However, he would become best known to audiences for his portrayal of Lt. Hondo Harrelson on the television show *SWAT*.

Jesus Franco (May 12, 1930–April 2, 2013). Although the full number of credits for the insanely prolific Spanish cult filmmaker may never be known—he (or one of his known pseudonyms) is credited with directing at least 180 features and there are numerous others that are suspected to be his as well—he will certainly go down in the record books as one of the busiest directors in cinema history. Born in Madrid in 1930, he worked as a director, actor and novelist while going to school in Spain before going off to France to study directing at the Sorbonne. Upon returning, he worked his way up through the Spanish film industry as a composer and as an assistant director before getting a chance to make his own movies. He worked almost exclusively in the low–budget horror and sex film genres and managed to lend a distinct personal style—one that favored dreamy eroticism, gruesome violence, weirdo plotting, funky music and a heavy reliance on zoom lenses—to the material and because he worked cheaply and quickly (there were times in which actors would discover scenes that were intended for one film that they were contracted for turning up in other projects), he was able to pursue his own peculiar cinematic obsessions. Although his work never broke through into the mainstream, fans of Eurosleaze epics continue to cherish the likes of *The Awful Dr. Orlof* (1962), *99 Women* (1969), *Venus in Furs* (1969), *Eugenie. . .the Story of Her Journey Into Perversion* (1970), *Vampyros Lesbos* (1971) and *She Killed in Ecstasy* (1971), the latter two starring the stunning Soledad Miranda, a collaboration that inspired his best work until her tragic early death in a car accident in 1970. A couple of years later, he would meet and begin working with Lina Romay, an actress with a strong resemblance to Miranda who served as his muse and collaborator both on and off the screen—they would eventually marry in 2008 and stay together until her death in 2012. In later years, he began shooting most of his movies for the direct–to–video market and continued working until he passed away from complications arising from a stroke on April 2 at the age of 82.

Stuart Freeborn (September 5, 1914–February 5, 2013). British make–up artist Stuart Freeborn may not have been a household name but his designs impacted the world when he helped with the creation of Yoda from *Star Wars* (1977) and its sequels. Freeborn started his career working at Denham Studios on *Oliver Twist* (1948) with the future Obi–Wan, Alec Guinness. He would go on to aid in the design of most of the Lucas–verse characters, including Chewbacca, Yoda, and Jabba the Hutt. He was also the make–up artist on Stanley Kubrick's *Dr. Strangelove: Or How I Learned to Stop Worrying and Love the Bomb* (1964)

and *2001: A Space Odyssey* (1968). He lived to the stunning age of 98, able to see how his designs have forever altered filmed science fiction.

Annette Funicello (October 22, 1942–April 8, 2013). One of the most beloved American cultural icons of the 1950s and 1960s, not to mention a first crush for countless adolescent boys, the Utica, New York–born Funicello began her trip to stardom when Walt Disney happened to see a ballet school recital that she was performing in and asked her to audition to be one of the so–called "Mouseketeer" for his upcoming children's television show *The Mickey Mouse Club.* The show was an instant hit and Annette quickly became the most popular of the 24 Mouseketeers—there was even a recurring segment on the show devoted entirely to her character—and she even became a pop star with hits like 1959's "Tall Paul." When the show went off the air in 1958, Disney kept her under contract and she soon became a regular fixture on his other television endeavors as well as feature films such as *The Shaggy Dog* (1959), *Babes in Toyland* (1961) and *The Monkey's Uncle* (1965). While still under contract to Disney, Funicello was hired by American International Pictures producer Sam Arkoff to appear with fellow young star Frankie Avalon in a low–budget teen musical entitled *Beach Party* (1963)—Disney's only request in exchange for allowing her participation was that she wear a bathing suit that covered her navel. The film was a hit and kicked off a series of cheerfully campy films featuring the duo that included *Muscle Beach Party* (1964), *Bikini Beach* (1964), *Beach Blanket Bingo* (1965) and *How to Stuff a Wild Bikini* (1965). After a few more appearances in increasing forgettable films—not to mention a turn in the infamous Monkees freak–out *Head* (1968)—she largely gave up the big screen to become a regular performer on stage and television and also became the popular pitchwoman for Skippy Peanut Butter. She made one last foray to the big screen with *Back to the Beach* (1987), an unexpectedly hilarious and winning spoof of the old beach party movies that reunited her with Avalon. In 1992, she announced that she was suffering from multiple sclerosis and, following an appearance in a television movie based on her life, she retired to become a spokesperson from the disease that she would die of complications from on April 8.

James Gandolfini (September 18, 1961–June 19, 2013). The great character actor James Joseph Gandolfini Jr. was born in Westwood, New Jersey to two Italians and the actor would help redefine both Jersey and Italian–American history when he signed on to play Tony Soprano on HBO's *The Sopranos*, arguably the most influential TV show of all time. Long before he stepped into Tony's comfortable slippers, Gandolfini earned a Bachelor of Arts from Rutgers University before studying for two years at the The Gately Poole Conservatory. His film breakthrough came in Tony Scott's *True Romance* (1993) as a sociopathic hitman who beat Patricia Arquette's character nearly to death. The career didn't really stop from there, appearing in *Terminal Velocity* (1994), *Get Shorty* (1995), *Crimson Tide* (1995), *The Juror* (1996), *Night Falls on Manhattan* (1997), *She's So Lovely* (1997), and *Midnight in the Garden of Good and Evil* (1997) before landing the key role in the HBO drama that would earn him three Emmys from 1999 to 2007. After *The Sopranos*, James Gandolfini would take more charac-

ter–driven parts and seemed truly primed to find the success he found on the small screen on the big one but a heart attack took him at a tragically young age. Other notable film roles include *The Man Who Wasn't There* (2001), *Romance & Cigarettes* (2006), *In the Loop* (2009), *Where the Wild Things Are* (2009), *Killing Them Softly* (2012), *Zero Dark Thirty* (2012), and *Not Fade Away* (2012). One of his most acclaimed roles proved to be the last major one of his career, as Gandolfini earned numerous critical awards for the role Albert in Nicole Holofcener's *Enough Said* (2013).

Gary David Goldberg (June 25, 1944–June 22, 2013). TV writer/producer Gary David Goldberg tried to transition to film but never had nearly the influence there as he did on TV with several major programs to his credit, including the two shows that made Michael J. Fox a star. In 1982, after writing on *The Bob Newhart Show* and *Lou Grant* (for which he won an Emmy), Goldberg created *Family Ties*, which put him on the map forever. Goldberg would continuously use his life and upbringing as a basis for films like *Dad* (1989), *Bye Bye Love* (1995), and *Must Love Dogs* (2005), and shows like *Brooklyn Bridge* and *Spin City*. He died of brain cancer in Montecito, California.

Richard Griffiths (July 31, 1947–March 28, 2013). Winner of multiple stage awards for his work in the hit play *The History Boys*, Richard Griffiths was a legendary actor who was also well–known for a series of scene–stealing supporting characters in film that includes Vernon Dursley in the *Harry Potter* films, Uncle Monty in *Withnail and I* (1987), and King George II in *Pirates of the Caribbean: On Stranger Tides* (2011). Griffiths broke through and earned national attention when he appeared in a BBC drama called *Bird of Prey* in the 1980s. The performance drew enough attention that he appeared in a number of major film productions, including *The French Lieutenant's Woman* (1981), *Chariots of Fire* (1981), and *Gandhi* (1982). Other memorable film appearances came in *The Naked Gun 2: The Smell of Fear* (1991), *Funny Bones* (1995), *Sleepy Hollow* (1997), and the film version of *The History Boys* (2006). He even appeared in Richard Curtis' *About Time* (2013) posthumously. He died from complications after heart surgery at the age of 65.

Haji (January 24, 1946—August 9, 2013). Although she only made a handful of films throughout her career, the Filipino–British beauty cemented her place in cult film history thanks to her five screen collaborations with legendary filmmaker Russ Meyer. Born in Quebec in 1946, the former Barbarella Catton moved to California, where she dropped out of school at the age of 14 to become a topless dancer under a nickname given to her by an uncle. It was there that she met Meyer and he immediately cast her as the lead in his latest sexploitation film, "Motorpsycho!" (1965) and then followed that up with a role as one of the three ass–kicking babes at the center of the "Faster Pussycat! Kill! Kill! (1965), a cult classic that would eventually become embraced as a favorite by schlock connoisseurs and feminist film critics alike. In later years, she would work with Meyer again on "Good Morning. . .and Goodbye!" (1967), "Beyond the Valley of the Dolls" (1970) and "Supervixens" (1975) and also appeared in films ranging from the monster mash "Bigfoot" (1970) to John Cassavetes' "The Killing of a Chinese Bookie." In later years, she worked only sporadi-

cally—her last credit was for "Killer Drag Queens on Dope" (2003) and after taking ill while eating at a restaurant in Newport Beach, she passed away on August 9.

Gerry Hambling (June 14, 1926–February 5, 2013). British film editor Gerald Hambling will be most remembered for the work he did with Alan Parker on nearly all of his films, winning BAFTAs for three of them: *Midnight Express* (1978), *Mississippi Burning* (1988), and *The Commitments* (1991). He was nominated three other times for the BAFTA and was nominated six times for the Oscar (the three above plus *Fame* , *In the Name of the Father* , and *Evita*). Other major credits for Hambling includes *Bugsy Malone* (1976), *Pink Floyd the Wall* (1982), *Shoot the Moon* (1982), *Birdy* (1984), *Angel Heart* (1987), *The Boxer* (1997), and *Angela's Ashes* (1999). In 1998, Hambling received the American Cinema Editors Career Achievement Award. He was 86 when he passed away.

Helen Hanft (April 4, 1934–May 30, 2013). New York–born actress Helen Hanft was a Big Apple stage staple who caught the eye of Woody Allen, appearing in small roles in a number of his films. She also became a staple in the work of another notable New Yorker's films, those of Paul Mazursky. Hanft was a pioneer in the experimental theater scene, earning the title of "the Ethel Merman of off–off––Broadway". After making waves with her large personality and headlining hit indie plays off–Broadway, she transitioned to film and TV, appearing in *Next Stop, Greenwich Village* (1976), *Manhattan* (1979), *Stardust Memories* (1980), *Arthur* (1981), *The Purple Rose of Cairo* (1985), *Moonstruck* (1987), *New York Stories* (1989), *Used People* (1992), *North* (1994), and three iterations of *Law & Order* in the late 1990s and early 2000s. She passed away at the age of 79.

Julie Harris (December 2, 1925–August 24, 2013). The legendary Julia Ann Harris won five Tony Awards, three Emmy Awards, and a Grammy Award while also being nominated for an Academy Award, winning the National Medal of Arts, and being inducted into the American Theatre Hall of Fame. Few people have earned the title "legend" as completely as Julie Harris, who was born in Grosse Point, Michigan to a nurse and an investment banker. She trained at the Perry–Mansfield Performing Arts School & Camp in the 1930s before attending Yale School of Drama for a year. After a successful stage career, Julie Harris transitioned seamlessly to film, earning an Oscar nomination for her first performance in *The Member of the Wedding* (1952). She became a fixture in film in the 1950s and 1960s, appearing in *I Am a Camera* (1955), *East of Eden* (1955), *Requiem for a Heavyweight* (1962), *The Haunting* (1963), *Harper* (1966), *Reflections in a Golden Eye* (1967), and both the stage and film versions of *Cabaret* (1972). Over her career, Harris received a record–setting TEN Tony nominations, winning five of them. She was also a series regular on *Knots Landing* in the 1980s, earning ELEVEN nominations in her time on the small screen (and winning three). She was honored with a Kennedy Center honor in 2005, where President George W. Bush said, "It's hard to imagine the American stage without the face, the voice, and the limitless talent of Julie Harris." She narrated documentaries and worked all the way up to near her death,

appearing on stage as recently as 2008. Harris passed away of heart failure, survived by her son Peter.

Ray Harryhausen (June 29, 1920–May 7, 2013). It is impossible to underestimate the influence that visual effects maestro Harryhausen had on the world of film—there is not a single person working in the sci–fi, fantasy or horror genres today who was not inspired in some way by his dazzling creations. Born in Los Angeles in 1920, Harryhausen stumbled upon his life's calling when he saw the monster movie classic *King Kong* (1933) and became obsessed with finding out how the ape was brought to life. His research brought him into contact with stop–motion animation expert Willis O'Brien and encouraged him to pursue the time–consuming animation process as a career. Although an attempt at making a feature film named *Evolution* eventually fell apart, enough was shot to serve as a demo reel that would land him a job with producer George Pal working on his Puppetoon shorts. After serving in the army in World War II, where he served as an animator in army training films, he returned to Hollywood to work under O'Brien on *Mighty Joe Young* (1949). Although O'Brien would get the credit despite having done little of the actual work, the film attracted enough notice for Harryhausen to get hired to provide the visual effects for *The Beast of 20,000 Fathoms* (1953) and his depiction of a dinosaur–like creature stomping through a modern city dazzled audiences despite the low budget that he was working with. Because Harryhausen worked alone and because the stop–motion technique that he utilized was a painstakingly slow process, it often took him several years to complete a project but the end results—including *The 7th Voyage of Sinbad* (1958), *Jason and the Argonauts* (1963), *First Men in the Moon* (1964), *Valley of the Gwangi* (1969), *The Golden Voyage of Sinbad* (1973) and *Sinbad and the Eye of the Tiger* (1977)—were always worth it, if only for his contributions. With the quantum leap in special effects technology brought about by *Star Wars* and *Close Encounters of the Third Kind*, stop–motion was deemed to be too time–consuming and after one last film, the fantasy *Clash of the Titans* (1981), he retired. Despite the innovations that he brought to the industry, he never received an Oscar until he was finally voted a special lifetime achievement award in 1992. Harryhausen passed away in London on May 7 at the age of 92.

Anthony Hinds (September 19, 1922–September 30, 2013). British screenwriter and producer Anthony Hinds was the son of the founder of Hammer Film Productions, William Hinds, and became a major writer for the influential horror movie house under the name John Elder. He started as a producer at his father's company after serving in World War II with low–budget films like *The Dark Road* (1947). He helped put the company on the new stage when he adapted a BBC mini–series into a hit film called *The Quatermass Xperiment* (1955). He went from producing to writing in the 1960s, delivering scripts for films like *The Curse of the Werewolf* (1961), *The Phantom of the Opera* (1962), *The Evil of Frankenstein* (1964), *The Mummy's Shroud* (1967), *Dracula Has Risen From the Grave* (1968), and *Frankenstein and the Monster from Hell* (1973) under the name John Elder.

Ruth Prawer Jhabvala (May 7, 1927–April 3, 2013). German born British and American novelist, Ruth Prawer Jhabvala made her largest impact in the world of film with her collaborations with Ismail Merchant and James Ivory, which won her two Oscars—*A Room with a View* (1985) and *Howards End* (1992). She was also Oscar–nominated for *The Remains of the Day* (1993). Jhabvala had a gift with character, making stories of largely unrelatable periods in time feel current because of her ability to convey timeless themes. Other notable scripts included *Quartet (1981), The Bostonians* (1984), *Mr. and Mrs. Bridge* (1990), *Jefferson in Paris* (1995), *The Golden Bowl* (2000), and, her final work, *The City of Your Final Destination* (2008). Few writers could take unwieldy, dense novels and make them sing on screen like Jhabvala.

Fay Kanin (May 9, 1917–March 27, 2013). Fay Mitchell was born in 1917 in New York City and would go on to a decades–long career in Hollywood, including a stint as the President of the Academy of Motion Picture Arts and Sciences from 1979 to 1983. A very young Mitchell started working as a story editor for RKO in the golden age of studio film. She married Michael Kanin, a writer himself, in the 1940s, and took his name. The two regularly worked together, adapting *Sunday Punch* in 1942, and writing both film and theatre for years to come, finding their most fame in the 1950s with *My Pal Gus* (1952), *Rhapsody* (1954), *The Opposite Sex* (1956), and *Teacher's Pet* (1958), which earned the pair an Oscar nomination for the comedy starring Clark Gable and Doris Day. Like so many great writers of their day, the pair was blacklisted by the Red Scare, which hurt their careers. She would go on to write for television in the 1970s, winning Emmys for *Tell Me Where It Hurts* in 1974 and *Friendly Fire* in 1978.

Jim Kelly (May 5, 1946–June 29, 2013). Born in Paris, Kentucky in 1946, the athletic Kelly became a world champion in karate in the early 1970s and eventually opened his own dojo. He was hired to help train actor Calvin Lockhart for the film *Melinda* (1972) and was rewarded with a small on–screen role. From there, he was cast alongside Bruce Lee and John Saxon in *Enter the Dragon* (1973), a martial arts epic that would go on to become an international hit and a cult classic. Throughout the rest of the decade, Kelly would appear in a series of blaxploitation film favorites—*Black Belt Jones* (1974), *Golden Needles* (1974), *Take a Hard Ride* (1975), *One Down, Two to Go* (1976)—but despite his popularity amongst fans of the genre, he never seemed to be that interested in screen stardom (*Black Belt Jones* would be his only lead role in a film.) After one last appearance in *Mr. No Legs* (1979), he essentially retired from the screen and went on to success as a professional tennis player.

Mickey Knox (December 24, 1921–November 15, 2013). With nearly 80 films to his credit, American actor Abraham Knox never became a household name because he was one of many blacklisted during the McCarthy era, forcing him out of his profession all the way to Italy, where he was credited with an English language adaptation of Sergio Leone's *The Good, the Bad and the Ugly* (1966). Notable film credits pre–blacklist included *Angels in Disguise* (1949), *The Accused* (1949), and *Garden of Eden* (1954). He would also appear in *Bolero* (1984) and *The Godfather Part III*

(1990). Woody Harrelson's character in Quentin Tarantino's script for *Natural Born Killers* (1994) is reportedly based on the actor.

Tom Laughlin (August 10, 1931–December 12, 2013). Perhaps the only actor/writer/director/producer/political activist/perennial fringe party presidential candidate/movie marketing visionary in the history of Hollywood, Tom Laughlin was born in 1931 in Milwaukee and made his film debut in a small role in *Tea & Sympathy* (1956) and would follow that up the next year with a lead role in *The Delinquents* (1957), a project in which he butted heads with the director, a then–unknown Robert Altman. Over the next few years, he would appear in films such as *South Pacific* (1958), *Gidget* (1958) and *Tall Story* (1960) and would make his debut as a writer–director with *The Proper Time* (1962). With his next project, the biker film *Born Losers* (1967), he would introduce the character of an ass–kicking half–breed pacifist who he would return with *Billy Jack* (1971). After becoming dissatisfied with how its distributor, American–International Pictures, was handling it, he would take over the distribution himself—although critically maligned, the film (or at least the ad campaign) struck a chord with young audiences and it became a huge hit at the box–office. With the inevitable follow–up *The Trial of Billy Jack* (1974), Laughlin proposed a distribution approach that was virtually unheard of at the time—instead of being gradually rolled out around the country, it would open in hundreds of theaters at the same time with an ad campaign that relied heavily on television advertising. Once again, critics lambasted the end result but it was another huge hit and helped rewrite the rules of modern movie marketing. From there, however, things began going downhill rapidly. His period western *The Master Gunfighter* (1975) made money but not as much as his previous films, while the Watergate–influenced *Billy Jack Goes to Washington* (1977) was a notorious flop that lost millions after its aborted release. He would make a couple of additional screen appearances in *The Big Sleep* (1978) and *The Legend of the Lone Ranger* (1981) but his later years saw him concentrating on aborted third–party presidential campaigns and attempts to make a fifth "Billy Jack" film—*The Return of Billy Jack* began filming in 1985 but was shut down after Laughlin was injured during a stunt. Laughlin passed away on December 12th as a result of complications from pneumonia.

Ed Lauter (October 30, 1938–October 16, 2013). Actor and stand–up comedian Edward Matthew Lauter II appeared in more than 200 films and TV series over 40 years. Like a lot of New York–born actors, Lauter began his career on the stage, appearing on Broadway in 1968; making his screen debut in an episode of *Mannix* in 1971 and film debut in 1972 in *Dirty Little Billy*. He almost immediately became a gigantic presence in cinema, serving as one of the most notable character actors of his era. Lauter had a clear desire to work constantly, appearing in six films in 1972 alone. He would alternate film and TV roles for decades to come, making memorable appearances in *The Longest Yard* (1974), *King Kong* (1976), *Magic* (1978), *Death Hunt* (1981), *Born on the Fourth of July* (1989), *My Blue Heaven* (1990), *The Rocketeer* (1991), *Seabiscuit* (2003), and *The Artist* (2011).

Lauter said in an interview in *The Los Angeles Times*, "A lot of people say, "I know you," but they don't know my name. But I've had a great run."

Elmore Leonard (October 11, 1925–August 20, 2013). Few American novelists were as influential as the great Elmore John Leonard, Jr., a writer who transcended genre and saw many of his most popular works turned into feature films (and a hit FX TV show, *Justified*). Leonard started his career writing genre pieces, beginning with Westerns in the 1950s and moving into crime fiction shortly thereafter, redefining the form with his brand of wit and unforced cool. At last count, over two dozen of his works had been turned into feature films, including two versions of *3:10 to Yuma* (1959, 2007), *Hombre* (1967), two versions of *The Big Bounce* (1969, 2004), *Stick* (1985), *52 Pick–Up* (1986), *Get Shorty* (1995), *Jackie Brown* (1997), *Touch* (1997), *Out of Sight* (1998), and *Killshot* (2009). Winner of multiple awards, Leonard worked as a novelist until his death from complications caused by a stroke at the age of 87.

Richard LeParmentier (July 16, 1946–April 15, 2013). American actor Richard LeParmentier was never a household name but appeared in two landmark films as Admiral Motti in *Star Wars, Episode IV: A New Hope* (1977) and Lt. Santino in *Who Framed Roger Rabbit* (1988). He had a relatively limited career but also appeared in a James Bond movie (*Octopussy*) and a superhero one (*Superman II*). He died suddenly at the age of 66 from undisclosed causes. He is survived by three children.

Harry Lewis (April 1, 1920–June 9, 2013). Los Angeles staple Harry Lewis was a supporting actor who arguably had a bigger influence with his chain of restaurants: Hamburger Hamlet. Lewis was a contract player in the 1940s, appearing in *Dive Bomber* (1941), *The Unsuspected* (1947), *Key Largo* (1948), and *Gun Crazy* (1949). The restaurant chain he founded with his wife pulled him out of feature work but he did TV guest buts for the next three decades. He was 93 when he passed away, survived by the same wife with whom he founded that chain of hamburger joints 60 years earlier.

Bigas Luna (March 19, 1946–April 6, 2013). Born in Barcelona, Spain, Juan Jose Bigas Luna is most well–known for his blend of the culinary and the erotic in cinema but he also introduced the cinematic world to Javier Bardem and Penelope Cruz, two future Oscar winners and international superstars. Luna was an artist in the 1960s but moved into short filmmaking in the 1970s with a series of erotic shorts. He basically existed on the fringe of Spanish cinema until really breaking through internationally in the 1990s with the "Iberian Trilogy"—*Jamon Jamon* (1992), *Huevos de Oro* (1993), and *La Teta ya La Luna* (1994). *Jamon* starred Bardem and Cruz, and won the Silver Lion at the Venice Film Festival in 1992. He passed away from leukemia.

Arthur Malet (September 24, 1927–May 18, 2013). British character actor Vivian R. Malet (aka Arthur) was born in Hampshire, England and started his career on the American stage in the 1950s. He rose to prominence in the 1960s, breaking through as Mr. Dawes in *Mary Poppins* (1964) before going on to a career that would include over 100 credits, most of them on major, influential TV shows from the 1960s through the 2000s. He took minor roles in major films like *In the Heat of the Night* (1967), *Vanishing Point* (1971), *Young Frankenstein* (1974), *Heaven Can Wait* (1978), and *Halloween* (1978), *Hook* (1991), and *Toys* (1992), while also doing some great voice work in films like *The Secret of NIMH* (1982), *The Black Cauldron* (1985), and *Anastasia* (1997). Malet passed away of natural causes at the age of 85.

Richard Matheson (February 20, 1926–June 23, 2013). American author and screenwriter Richard Burton Matheson is credited with forever altering the horror, fantasy, and science fiction world, primarily with his literature but also with some very notable contributions to pop culture in film and television. He will be best remembered as the author of the 1954 novel *I Am Legend*, which helped launch the zombie genre and has been made into a film multiple times. Many of his other novels were turned into films over the years and Matheson served as a writer on *The Twilight Zone*, crafting the legendary "Nightmare at 20,000 Feet" with William Shatner. He also adapted his 1971 short story into the film that would become the debut work of Steven Spielberg, *Duel* (1971). Matheson also worked with Roger Corman on a series of films adapted from works by Edgar Allen Poe, wrote for *Star Trek* and the legendary *Kolchak: The Night Stalker*. His short stories were the basis for the anthology hit *Trilogy of Terror* (1975). It's cliché but Matheson was way ahead of his time and helped guide the genres he loved to the place they are today.

Mariangela Melato (September 19, 1941–January 11, 2013). One of the film world's leading international sex symbols during the 1970s, Melato was born in Milan in 1941 and developed an artistic bent that would eventually lead her to make her stage acting debut in 1960 at the age of 19. After spending most of the decade working on the stage, Melato was eventually cast by cult filmmaker Pupi Avati in what would become her screen debut, *Thomas egli indemoniati* (1969). From there, she began to work regularly in films and would eventually by cast by Lina Wertmuller in the role of Giancarlo Gianni's mistress in the politically oriented comedy *The Seduction of Mimi* 1972). The film was a big hit around the world and led to two more collaborations with Wertmuller and Gianni in *Love and Anarchy* (1973) and *Swept Away by an Unusual Destiny in the Blue Sea of August* (1974) as well as other films like the Claude Chabrol–directed *Nada* (1974). Melato then came to America in an attempt to become a star in Hollywood and was cast as the diabolical General Kala in the sci–fi epic *Flash Gordon* (1980) and as the female lead in the contemporary screwball comedy *So Fine* (1981). Neither film was especially successful (though the former would go on to be a cult favorite) and Melato quickly returned to Europe, where she devoted the majority of her career to working on the stage and on television.

Edouard Molinaro (May 13, 1928–December 7, 2013). French film director and screenwriter Molinaro was primarily a comedy director, achieving a career peak with the smash hit and Academy Award–nominated *La Cage aux Folles* (1978). Other notable credits include *Oscar* (1967), *Hibernatus* (1969), *Mon oncle Benjamin* (1969), *Dracula and Son* (1976), *La Cage aux Folles II* (1980), and *Just the Way You Are* (1984). He was awarded a Prix Rene Clair for his excellent film work in 1996.

Cory Monteith (May 11, 1982–July 13, 2013). Canadian actor Cory Allen Michael Monteith succumbed to his addiction to drugs at a young age, leaving legions of young fans of his work on FOX's *Glee* while also appearing in a few films that hinted that he might have had the range for a long career. He will certainly be most–remembered for his work on the FOX musical but he also had over a dozen film credits including *Deck the Halls* (2006), *Final Destination 3* (2006), *Monte Carlo* (2011), and, of course, *Glee: The 3D Concert Movie* (2011). At the age of 31, Monteith died of a deadly mix of heroin, alcohol, and other substances that led to an overdose.

Frank Morriss (September 10, 1927–July 3, 2013). Film and television editor Frank E. Morriss had more than fifty film and television credits, highlighted by a regular working relationship with the legendary director John Badham. He earned two Oscar nominations for his editing work: *Blue Thunder* (1983) and *Romancing the Stone* (1984). Other collaborations with Badham include *American Flyers* (1985), *Short Circuit* (1986), *Another Stakeout* (1993), *Incognito* (1997), *Brother's Keeper* (2002), and *Evel Knievel* (2002).

Hal Needham (March 6, 1931–October 25, 2013). Born in Memphis in 1931, Hal Needham worked in jobs ranging from paratrooper to treetopper to billboard model for Marlboro before making his way to Hollywood and landing a job as a stunt double for Richard Boone on the TV show *Have Gun, Will Travel*. Throughout the 1960s and 1970s, he would become the most accomplished stuntman and stunt coordinator around, amassing hundreds of film and television credits, and a collection of injuries including no fewer than 56 broken bones and numerous industry innovations such as the use of air bags. Having helped to create a screenplay for a car crash comedy about a good ol' boy smuggling cases of Coors beer while avoiding police pursuit, long–time acquaintance Burt Reynolds agreed to star in what would be Needham's directorial debut, *Smokey & the Bandit* (1977), and the result, though critically lambasted, was a box–office smash. Over the next few years, Needham, often in collaboration with Reynolds, would go on to direct a series of stunt–heavy comedies and action films that included the stuntman homage *Hooper* (1978), the live–action cartoon *The Villain* (1979), the perfunctory sequel *Smokey and the Bandit Part II* (1980), the cross––country car chase epic *The Cannonball Run* (1981), the bizarre futuristic action thriller *Megaforce* (1982), the stock–car extravaganza *Stroker Ace* (1983), the severely desultory *The Cannonball Run II* (1984) and the wrestling comedy *Body Slam* (1986). Although he would direct the occasional project for television after that, Needham devoted much of his time to helping bring more attention to the craft of stuntmen and in 2012, he was rewarded for his tireless efforts when the Academy Award Board of Governors voted to present him with a special Lifetime Achievement Oscar for his contributions to the industry.

Milo O'Shea (June 2, 1926–April 2, 2013). Irish character actor O'Shea was born in Dublin to a singer and a ballet teacher. He began his career on stage before moving into film in the 1960s. He appeared on BBC sitcoms and dramas, while also maintaining a stage presence to the degree that he earned a Tony nomination in 1968. In that same decade, he appeared memorably in major films of the period, including *Romeo and Juliet* (1968), *Barbarella* (1968), in which he played the notoriously memorable Dr. Durand Durand, and Vincent Price's *Theatre of Blood* (1973). Other notable work came in *The Verdict* (1982), *The Purple Rose of Cairo* (1985), *Only the Lonely* (1991), and *The Butcher Boy* (1997).

Peter O'Toole (August 2, 1932–December 14, 2013). Indisputably one of the most talented and important actors that ever lived, Peter O'Toole may forever now be the answer to the tragic trivia question of who is the best performer to never receive an Oscar. Despite seven Academy Award nominations, O'Toole never took home the golden statue, although his importance to his craft was never in question. After years on stage, and an education at the Royal Academy of Dramatic Art, Peter James O'Toole made his film debut in 1959 but really broke through three years later in the film that would earn him his first Academy Award nomination, the epic *Lawrence of Arabia* (1962). Six more nods would follow in his career, earning him the title of the most–nominated actor without a win—*Becket* (1964), *The Lion in Winter* (1968), *Goodbye, Mr. Chips* (1969), *The Ruling Class* (1972), *The Stunt Man* (1980), *My Favorite Year* (1982), and *Venus* (2006). He did win four Golden Globes, a BAFTA, an Emmy, and an Honorary Academy Award. Other notable film roles came in *What's New Pussycat* (1965), *Lord Jim* (1965), *Caligula* (1979), *Club Paradise* (1986), *The Last Emperor* (1987), *High Spirits* (1988), *Troy* (2004), and as the notorious critic Anton Ego in Pixar's *Ratatouille* (2007). Peter O'Toole had a nearly unmatched range, moving seamlessly from comedy to drama; period to contemporary, supporting roles to lead ones. O'Toole was an outspoken opponent of conflict, protesting both the Korean and Vietnam Wars. He also battled severe alcoholism but gave up the bottle in the late 1970s after health problems related to his drinking nearly killed him. He passed away in London at the age of 81.

Nagisa Oshima (March 31, 1932–January 15, 2013). One of the leading directors of the Japanese New Wave movement that came about as a response to the realistic style that was the preference of the day, Oshima was born in Kyoto on March 31, 1932 and went to work at the Shochiku studio as an apprentice in 1954. He quickly rose through the ranks and before the decade was out, he directed his first film, *A Town of Love and Hope* (1959). For the next fifteen years, he worked steadily in film and television, often on projects that dealt with contemporary Japanese society and its existence in the face of growing post–war Westernization. With his *In the Realm of the Senses* (1976), a shocking and sexually explicit dramatization of a real–life incident involving a passionate sexual affair between a man and one of his servants that eventually spirals violently out of control, he created an international scandal that made his name known around the world but which also brought the law down upon him when he was charged with violating Japanese obscenity laws by publishing the film's screenplay. He would be acquitted after a long court battle but for the remainder of his career, he would work infrequently. The later films included *Empire of Passion* (1978), a sort of continuation of the themes of his previous success, *Merry Christmas, Mr. Lawrence* (1983), a WWII drama set in a

prison camp that attracted attention due to the casting of David Bowie, then at the height of his career, in a supporting role and *Max mon amour* (1986), a comedy chronicling the romance between Charlotte Rampling and an ape. After one final film, *Gohatto* (1999)—which starred Takeshi Kitano, one of countless Japanese filmmakers whom he had influenced over the years—he retired for good. Oshima passed away at the age of 80 on January 15.

Kumar Pallana (December 23, 1918–October 10, 2013). Born in Indore, India, Kumar Valavhadas Pallana came to acting late in life and largely due to the coincidence of future filmmaker and star Wes Anderson and Owen Wilson frequenting his Indian restaurant, Cosmic Cup, when they lived in Dallas, Texas. Anderson would go on to cast Pallana in four of his films—*Bottle Rocket* (1996), *Rushmore* (1998), *The Royal Tenenbaums* (2001), and *The Darjeeling Limited* (2007). He broke out of the Anderson universe a few times, also appearing in Steven Spielberg's *The Terminal* (2004), *Romance & Cigarettes* (2005), and *Another Earth* (2011). Pallana made his film debut in Anderson's first film at the age of 78, proving that one never knows where life will take them.

Eleanor Parker (June 26, 1922–December 9, 2013). Born in Cedarville, Ohio in 1922, Parker made her way to Hollywood and made her first film, *They Died With Their Boots On* (1941) when she was only 18—alas, her scenes were cut from the finished film and she would not make her official screen debut for another year until the release of *Busses Room* (1942). Throughout the 1940s and 1950s, she would be a regular presence on the big screen and while she would earn praise for films like *Scaramouche* (1952), *The Man With the Golden Arm* (1952) and *The Naked Jungle* (1954) and Oscar nominations for *Caged* (1950), *Detective Story* (1951) and *Interrupted Melody* (1955), she never quite became the major star that many expected her to be. In the 1960s, she would give her best–remembered performance as Baroness Schroeder in *The Sound of Music* (1965) and pop up in films like *The Oscar* (1966) and *An American Dream* (1966) but would, like many actresses of a certain age at the time, appear more frequently on television and on the stage. Her last big–screen performance would be in the Farrah Fawcett–Majors bomb *Sunburn* (1979) and after increasingly rare television appearances, she would retire in 1991.

Don Payne (May 5, 1964–March 26, 2013). North Carolina–born writer and producer William Donald Payne made his bones as a writer of *The Simpsons* before transitioning into feature films and really gained a following with his work in the superhero genre, including penning a few of the Marvel Universe's most successful films. In the mid–2000s, Payne continued working on the FOX animated hit as he moved in to the world of film, writing *My Super Ex–Girlfriend* (2006), *Fantastic Four: Rise of the Silver Surfer* (2007), *Thor* (2011), and *Thor: The Dark World* (2013). He passed away from bone cancer at his home at the incredibly young age of 48. He is survived by two sons and a daughter.

Lou Reed (March 2, 1942–October 27, 2013). Although better known as one of the most powerful musical voices of his generation, first as a member of the seminal rock group the Velvet Underground and then as an acclaimed solo artist, the Brooklyn–born Reed also made his mark in the

cinema as well. Over the years, his songs graced the soundtracks of any number of movies, perhaps most famously when a key sequence of the controversial cult film *Trainspotting* (1996) was scored to his "Perfect Day," but from time to time, he would appear in front of the camera as well. After popping up in a number of the "screen tests" shot in the late 1960s by one–time patron Andy Warhol, Reed made his formal acting debut as a record producer loosely inspired by Phil Ramone in Paul Simon's misfired music industry expose *One–Trick Pony* (1980). A couple of years later, he did a hilarious turn as a Dylan–like music legend in the underrated rock comedy *Get Crazy* (1983). With his cooler–than–cool look and dependably deadpan voice, he was usually cast as either himself or as some thinly disguised version of himself, as was the case with *Faraway, So Close* (1993), *Blue in the Face* (1995), *Lulu on the Bridge* (1998), *Prozac Nation* (2001) and *Palermo Shooting* (2008). He also carved out a side niche as the voice of the chief villain in such mildly absurd animated fantasies as *Rock & Rule* (1983), in which he played the diabolical Mok, and the Luc Besson productions *Arthur's Great Adventure* (2009) and *Arthur 3: War of the Two Worlds* (2010), in which he replace fellow art rocker David Bowie as the malevolent Matazzard. Reed would pass away in his beloved New York at the age of 71 of complications from liver failure on October 27.

Harry Reems (August 27, 1947–March 19, 2013). Although Harry Reems would become one of the most prolific male performers in the adult film industry—he is estimated to have appeared in over 140 films—it would be his performance in one specific title that would thrust him into the annals of screen history. Born Herbert Streicher in 1947, he left his Bronx birthplace and eventually made his way to Hollywood where he landed small roles in films like *The Cross and the Switchblade* (1970) and *Klute* (1971) and then, under a series of names, he began appearing in pornographic films. In 1972, he was hired as part of the lighting crew for a pornographic film *Deep Throat* (1972) and when one of the actors didn't show up, he filled in for one day of shooting. The unexpected result was a film that pushed the adult film industry into the mainstream and made stars out of Reems (who was given his lasting nom de plume by *Deep Throat* director Gerard Damiano) and co–star Linda Lovelace. His newfound fame also led to his prosecution and conviction in 1976 on charges of distributing obscene materials across state lines—the first time in which an actor was prosecuted simply for acting in a film. With support from stars like Warren Beatty and Jack Nicholson, the conviction was overturned by the U.S. Supreme Court the next year and the charges were eventually dropped. Although Reems would periodically attempt to break through into the mainstream—he was hired to play the role of the coach in the hit musical *Grease* (1978) until the studio, worried about how his reputation might tarnish their project, replaced him with Sid Caesar—he would continue to make porno films until the late 1980s and then more or less disappeared. He later turned up in the documentary *Inside Deep Throat* (2005) and revealed that after battling personal demons, he cleaned up, got married and was working as a real estate agent in Utah. Reems died on March 19 of pancreatic failure.

Elliott Reid (January 16, 1920–June 21, 2013). New York actor Edgeworth Blair Reid made his professional debut at the age of 15 when he debuted on the radio program *The March of Time*. He became a radio staple in the form's golden age, transitioning to a lifetime as a notable character in film and television for decades, spanning numerous genres and generations. He will probably be best remembered as Jane Russell's love interest in *Gentlemen Prefer Blondes* (1953), and Professor Shelby Ashton in two Disney smashes, *The Absent Minded Professor* (1961) and *Son of Flubber* (1963). Other film credits weren't as common as television ones in later years but he also appeared in *The Thrill of It All* (1963), *Blackbeard's Ghost* (1968), and *Young Einstein* (1988). He passed away from heart failure at the age of 93.

Jay Robinson (April 14, 1930–September 27, 2013). B–movie actors often blend into their overdone genre but Jay Robinson found a way to stand out in such cheesy affairs as *The Robe* (1953) and *Demetrius and the Gladiators* (1954). Like nearly every actor of his generation, Robinson began his acting career on the stage, finding his way to Broadway in the 1950s before moving into film. After the aforementioned roles, he appeared in *The Virgin Queen* (1955) with Bette Davis, *My Man Godfrey* (1957) with David Niven, and Woody Allen's *Everything You Always Wanted to Know About Sex* (*But Were Afaird to Ask)* (1972). He did a lot of TV over the years but never really made a big name for himself, appearing in small roles in films like *Big Top Pee–wee* (1988), *Ghost Ship* (1992), and *Bram Stoker's Dracula* (1992). He was married to Pauline Flowers from 1960 until her death in 2002 and remarried Gloria Casas in 2004. He is survived by one son.

Paul Rogers (March 22, 1917–October 6, 2013). English actor Paul Rogers was born in 1917 in Plympton, England, training at the Michael Chekhov Theatre Studio before serving in the Royal Navy in World War II. After his service, he went back to appear in many West End and Broadway productions, winning a Tony in the 1960s and serving as a member of the Royal Shakespeare Company for many years. Notable film appearances include roles in *The Beachcomber* (1954), *Beau Brummel* (1954), *Our Man in Havana* (1959), *The Trials of Oscar Wilde* (1960), *Billy Budd* (1962), *The Shoes of the Fishermen* (1968), *The Looking Glass War* (1969), and *Oscar and Lucinda* (1997). Roger passed away at the age of 96 in London.

Eddie Romero (July 7, 1924–May 28, 2013). One of the most influential and acclaimed filmmakers of his homeland, Edgar Sinco Romero was named National Artist of the Philippines in 2003. While most of his work centered on the history and culture of his country, he also made English language films that became cult classics of the low–budget 1970s era, including *Black Mama, White Mama* (1972), *Twilight People* (1973) (a film that Quentin Tarantino cited as influential), *The Woman Hunt* (1973), *Savage Sisters* (1974), and *Sudden Death* (1977). After that period, he went back to the Philippines and directed all the way up to the 2000s. He died of a blood clot and prostate cancer in May, survived by three children.

Mickey Rose (May 20, 1935–April 7, 2013). This Brooklyn––born comedy writer is best known for his collaborations with Woody Allen, whom he met and became friends with

when they met in high school. After working on the writing staff for *The Sid Caesar Show* (1963), Rose then helped to co–write some of the routines that would first launch Allen into fame as a stand–up comedian and later helped Allen comedically redub an obscure Japanese spy movie into the wild spoof *What's Up, Tiger Lily?* (1966). He then co–wrote Allen's first two official films, *Take the Money and Run* (1969) and *Bananas* (1971). From there, Rose returned to television and worked on a number of shows, including *The Dean Martin Comedy Hour*, *The Odd Couple* and *The Tonight Show Starring Johnny Carson*, wrote the screenplay for the comedy *I Wonder Who's Killing Her Now?* (1975 and apparently did uncredited screenwriting work on the Disney superhero satire *Condorman* (1981). Rose also has a single directing credit for the slasher movie spoof *Student Bodies* but whether he actually directed any of it is still open to debate—it is said that Michael Ritchie, who was the producer, actually directed some or all of the film but since there was a Director's Guild strike going on, he gave the directing credit to Rose, who wrote the screenplay, and used the pseudonym "Alan Smithee" for his own producing credit. Regardless of who made it, the film was a flop at the time of its release but has developed a small but devoted cult over the years thanks to its position as a one–time cable television staple. Rose died in Beverly Hills of colon cancer on April 7.

Otto Sander (June 30, 1941–September 12, 2013). German film, theater, and voice actor Otto Sander was born in Hanover, Germany and served in the military in the 1960s before making his acting debut in the Dusseldorf chamber plays. He went to Munich to become a full–time actor and appeared on stage for the next several decades. He has only a few internationally–known film credits but they are in very notable works in German movie history, including the shell–shocked commander in Wolfgang Petersen's *Das Boot* (1981) and the role of Cassiel in Wim Wenders' *Wings of Desire* (1987) and the sequel *Faraway, So Close!* (1993).

Alan Sharp (January 12, 1934–February 8, 2013). Born in Alyth, Scotland, Alan Sharp began his career as a novelist in the 1960s but will be best–remembered for screenwriting work on over a dozen films across decades and genres of cinema. Raised in Greenock, Scotland, Sharp bounced around for decades before moving to London to become a writer in his thirties. His first novel was published in 1965, followed by a second in 1967, but he left literature behind to move to Hollywood and start screenwriting. He became a crucial figure in the auteur–centric movement of the day, most notably making waves with Arthur Penn's *Night Moves* (1975) and Sam Peckinpah's *The Osterman Weekend* (1982). He is survived by his fourth wife, Harriet Sharp, eight children and 14 grandchildren. Other major credits include *The Hired Hand* (1971), *Ulzana's Raid* (1972), *Damnation Alley* (1977), and *Rob Roy* (1995), which returned him to his Scottish roots.

Mel Smith (December 3, 1952–July 19, 2013). British performer Melvin Kenneth Smith was more well–known for work in television, including the hit *Not the Nine O'Clock News* in the U.K. but he did make a few notable film appearances, even directing a handful of films. Smith started his career at Oxford University on the stage, developing his hit BBC series shortly thereafter. The success

of that show and *Alas Smith and Jones* led to the founding of TalkBack Productions with his comedic partner Griff Rhys Jones, which would go on to produce TV comedy for decades. After a few appearances on camera, including a memorable bit as an albino in *The Princess Bride* (1987), Smith made a notable comedy directorial debut with Jeff Goldblum's *The Tall Guy* (1989). Later efforts weren't as critically acclaimed and include *Radioland Murders* (1994), *Bean* (1997), and *High Heels and Low Lifes* (2001). He also starred in the memorable *Brain Donors* in 1992.

Jean Stapleton (January 19, 1923–May 31, 2013). Born Jeanne Murray in New York City, Jean Stapleton (born Jeanne Murray) would revolutionize television with Carroll O'Connor on *All in the Family*. She was born to a salesman and an opera singer in 1923 and studied at Hunter College in the 1940s before making her New York debut off–Broadway in 1941. She appeared in numerous Broadway musicals over the years (sometimes appearing in their film adaptations, including *Damn Yankees!* and *Bells Are Ringing*), while also guest–starring on several hit TV series. She was a small screen fixture by the time she got the part that would really define her legacy. Television dominated Stapleton's career for its vast majority, appearing in guest roles all the way up to the 2000s, but she also appeared in 1996's *Michael* and 1998's *You've Got Mail*.

Graham Stark (January 2, 1922–October 29, 2013). Although he would never achieve the name recognition of many of his co–stars, the New Brighton–born Stark would become a familiar face to anyone with a passing interest in British comedy of the 1950s and 1960s. He began his career at BBC radio, occasionally filling in for Spike Milligan in episodes of the groundbreaking *The Goon Show* when Milligan was unable to appear. Having made an uncredited appearance in *Spy of Blood* (1939), Stark made his official screen debut in *Emergency Call* (1952) and soon became a regular fixture on the film scene, usually in comedies such as *The Millionairess* (1960), *Mouse on the Moon* (1963), *The Wrong Box* (1966), *Casino Royale* (1967), *The Magic Christian* (1969) and *The Prisoner of Zenda* (1979), though he also appeared in more dramatic efforts from time to time. His most fruitful collaboration was with director Blake Edwards, who cast him in every installment of the long–running *Pink Panther* series from *A Shot in the Dark* (1964) to the swan song *Son of the Pink Panther* (1993)—only Herbert Lom and Burt Kwouk made more appearances in the series—as well as in films like *Victor/Victoria* (1982) and *Blind Date* (1987). After one final film, *The Incredible Adventures of Marco Polo* (1998), Stark retired from films and passed away in London on October 29 at the age of 91.

Gilbert Taylor (April 12, 1914–August 23, 2013). Before going on to a career as one of the most innovative cinematographers in film history, the British–born Taylor got his start as a cameraman in World War II charged with helping to document RAF bombing raids and the liberation of concentration camps. After shifting his focus to commercial filmmaking, he made his debut as a feature cinematographer with *Guinea Pig* (1948) and soon contributed his talents to such groundbreaking films as *The Dam Busters* (1955), *A Hard Day's Night* (1964), *Dr. Strangelove, or How I Learned to Stop Worrying and Love the Bomb*

(1964), *Frenzy* (1972) and multiple collaborations with filmmaker Roman Polanski: *Repulsion* (1965), *Cul–de–Sac* (1966) and *Macbeth* (1971). When the British film industry slowed to a crawl in the early 1970s, Taylor assumed his career was ending and actually opened a dairy farm as a way of making a living. A couple of years later, his career would get a second wind when he shot two of the biggest hits of the era, *The Omen* (1976) and *Star Wars* (1977). From them on, he worked steadily on such titles as *Damien: The Omen II* (1978), *Dracula* (1979), *Flash Gordon* (1980), *Venom* (1982) and *Lassiter* (1984) before retiring after his last project, *The Bedroom Window* (1987). (Shockingly, despite the landmark titles on his resume, he would never even receive an Oscar nomination for his work). Taylor passed away on August 23 at the age of 99.

Del Tenney (1930–February 21, 2013). Although he would only direct a handful of films throughout his career, Del Tenney's name is still revered in certain cinematic circles for creating one of the most infamous so–bad–they're–good monster movies ever made. Born in Macon City, Iowa in 1930, Tenney relocated to California with his parents at the age of 12 and would eventually break into the film industry by working as an extra on movies like *Stalag 17* (1953) and *The Wild One* (1953). Eventually, he would relocate to New York to work in the theater and eventually drifted down to Connecticut, where he would make his cinematic base beginning with serving as a producer and uncredited co–director on the little–seen thriller *Violent Midnight* (1963). He then hit upon the brilliant idea of taking two genres that were currently cleaning up at the box–office—low–budget monster movies and the beach party movies featuring Frankie Avalon and Annette Funicello—and combining them into the powerful story of a group of sea monsters created by radioactive waste that lay siege to a nearby beach community before it is discovered that salt can kill them. The resulting film, *The Horror of Party Beach* (1964), was one of the cheesiest things ever made, even by B–movie standards, but it was a hit at the box–office and gained new life decades later when it was cited by Harry & Michael Medved in their best–selling book "The Fifty Worst Films of All Time" and mercilessly mocked on a popular episode of *Mystery Science Theatre 3000*.

Larri Thomas (January 23, 1932–October 20, 2013). American actress and dancer Lida L. Thomas was born in Wayne, Pennsylvania, eventually becoming of the "Goldwyn Girls," ladies picked by Samuel Goldwyn to appear in the ensemble of the company's films, including *Guys and Dolls* (1955), *South Pacific* (1958), *The Music Man* (1962), *Robin and the 7 Hoods* (1964) and Disney's *Mary Poppins* (1964). She was also the stand–in for Julie Andrews for *The Sound of Music* (1965) and appeared in several films with Dean Martin. Thomas passed away after a fall at her home at the age of 81.

Audrey Totter (December 20, 1917–December 12, 2013). Born in Joliet, Illinois, Audrey Mary Totter would go on to become an MGM contract star in the 1940s and 1950s after a career start as a radio play star. She became a staple of the noir genre at its peak, working with legends like Lana Turner, Robert Taylor, Ray Milland, and Clark Gable. Major credits include *The Postman Always Rings Twice* (1946), *The Unsuspected* (1947), *The Set–Up* (1949), *Ten-*

sion (1950), and, in the beginning of the end, *FBI Girl* (1951). As with so many actresses of her era, the film roles dried up when the genre heat moved on and Totter left her MGM deal when she no longer liked the parts she was getting. She moved to TV in the 1950s, appearing sporadically on the smaller screen all the way up an appearance on *Murder, She Wrote* in 1987. Totter was married to the same man for over four decades. She was nearly 96 when she passed.

Luciano Vincenzoni (March 7, 1926–September 22, 2013). Italian screenwriter Luciano Vincenzoni helped change history with his work on Sergio Leone's legendary Spaghetti Westerns, *For a Few Dollars More* (1965), *The Good, the Bad and the Ugly* (1966), and *Duck, You Sucker! (aka A Fistful of Dynamite)* (1971). He also worked as a script doctor on dozens of other films in his more than five decades in the business and landed screenwriting credit on Arnold Schwarzenegger's *Raw Deal* (1986).

Paul Walker (September 12, 1973–November 30, 2013). American actor and heartthrob Paul William Walker IV was born in Glendale, California to a fashion model and a Golden Gloves champion from the same town. Although he's rarely included in this sub–category, Walker was a child star, appearing as a toddler in a television commercial for Pampers and modeling at the age of two. He appeared as a child on TV shows throughout the 1980s, including *Highway to Heaven*. *Who's the Boss?*, and *The Young and the Restless*. He transitioned to film in the 1990s, making a memorable impact and causing young ladies to squeal in films like *Pleasantville* (1998), *Varsity Blues* (1999), *She's All That* (1999), and *The Skulls* (2000). Paul Walker's career and level of fame would be changed forever when he was cast as an undercover cop infiltrating a ring of drag racers opposite Vin Diesel in the smash *The Fast and the Furious* (2001). The film would spawn five sequels and counting, with Walker appearing in all but part three, and he was shooting the seventh chapter of vehicular mayhem when he passed away. While his career will be defined by these films, he made a memorable impact in other works in the 2000s, including *Joy Ride* (2001), *Into the Blue* (2005), *Running Scared* (2006), and *Eight Below* (2006). Paul Walker died tragically and unexpectedly as the result of a car accident after a charity event for his Reach Out Worldwide organization.

Esther Williams (August 8, 1921–June 6, 2013). The woman who would one day be known as "America's Mermaid" was born in Inglewood, California in 1921 and dedicated herself to competitive swimming from an early age, eventually winning three United States National championships in the process. She was eventually discovered by a talent scout at MGM and brought to studio head Louis B. Mayer, who was then looking for someone who could serve as his studio's equivalent of the then–popular skater–turned––movie star Sonja Henie. After making her debut as a girlfriend of Mickey Rooney in the programmer *Andy Hardy's Double Life* (1942), she then appeared in *Bathing Beauty* (1944), a frothy entertainment that provided viewers with extended swimming sequences that were presented in the same manner as the musical numbers that the studio was famous for at the time. The film was a hit and Williams would take the plunge again and again in a series of similar

movies, including *Ziegfeld Follies* (1945), *On an Island with You* (1948), *Million Dollar Mermaid* (1952) and *Dangerous When Wet* (1953), the latter featuring a famous segment that her swimming with none other than cartoon favorites Tom & Jerry. After a while, the appeal of these films began to dry up and when Williams tried to shift to more dramatic roles that didn't require chlorination, such as *The Unguarded Moment* (1956) and *The Big Show* (1961), it was discovered that her swimming skills far outshone her acting talents and that audiences had little interest in seeing her working dry. After one last feature, *The Magic Fountain* (1963), she retired for good, though she made an engaging appearance three decades later as one of the talking heads in the documentary *That's Entertainment III* (1994). Williams passed away on June 6 at the age of 91.

Michael Winner (October 30, 1935–January 21, 2013). English film director, producer, and restaurant critic for *The Sunday Times*, Robert Michael Winner was born in Hampstead to a Jewish family. He began his career by assistant directing BBC television programs in the 1950s before getting his chance to direct himself with *Shoot to Kill* in 1960. He was a very fashionable director in the swinging 1960s, helming *Some Like It Cool* (1961), *Out of the Shadow* (1961), *The Cool Mikado* (1962), *Play It Cool* (1962), and *West 11* (1963). He began a quarter–century partnership with the legendary Oliver Reed in 1964 with *The System. In the 1970s, Winner went to Hollywood and made a few films with the luminaries of the day including Burt Lancaster and Robert Duvall in Lawman* (1971), Marlon Brando in *The Nightcomers* (1972), and Charles Bronson in *Chato's Land* (1972) and *The Mechanic* (1972). Everything would change in 1974 when Winner and Bronson would collaborate again on the wildly popular *Death Wish*. The wild success of that film pushed Winner even further into action films and he would go on to direct *The Sentinel* (1977), the remake of *The Big Sleep* (1978), and, of course, *Death Wish II* (1982). Things went downhill in the 1980s—he did make *Death Wish III* (1985), much to everyone's dismay—and Winner essentially withdrew from the film scene, eventually becoming a restaurant critic in his later years.

Jonathan Winters (November 11, 1925–April 11, 2013). Although he would go on to become one of the most beloved and influential comedians of his time, the Ohio–born Winters, following a stint with the Marines during World War II, originally studied to become a cartoonist and only turned to comedy as a way of winning a local talent contest. He discovered a flair for wild improvisation and this led to work as a local disk jockey. After numerous appearances on radio and television, he began recording a series of best–selling comedy albums that featured him in the guise on numerous characters. Although his improvisatory genius made him a favorite performer on stage and on *The Tonight Show*, these skills were deemed a liability in Hollywood and as a result, his screen career was a bit scattershot. After contributing a voice to the long–forgotten animated feature *Alakazam the Great* (1960), he made his official screen debut in the gargantuan comedy *It's a Mad, Mad, Mad, Mad World* and his scenes—especially one in which he single–handed tears an entire gas station apart—were generally considered to be

among the highlights of the overstuffed enterprise. He followed that up with a scene–stealing bit in the brilliant black comedy *The Loved One* (1965) and over the years would turn up in bit parts in films such as *The Russians are Coming, The Russians are Coming* (1966), *The Fish That Saved Pittsburgh* (1979), *The Flintstones* (1994) and *The Shadow* (1994). At the same time, his legend as a comedian continued to grow and avowed acolyte Robin Williams got him cast in a recurring role on the sitcom *Mork & Mindy* as, of all things, his son. Having begun his screen career as a voiceover artist, he ended it the same way by serving as the voice of Papa Smurf in the kiddie films *The Smurfs* (2011)

and *The Smurfs 2* (2013). Winters passed away of natural causes on April 11.

Aubrey Woods (April 9, 1928–May 7, 2013). He will forever be Bill the Candy Man from *Willy Wonka & the Chocolate Factor* (1971) for an entire generation; the man who sold the candy with the golden tickets. Woods had a large number of theatrical credits in the U.K. along with major work in radio plays on the BBC. Major film credits include *Nicholas Nickleby* (1947), *Just Like a Woman* (1967), and *The Abominable Dr. Phibes* (1971). He is survived by his wife Gaynor, to whom he was married for over five decades.

Selected Film Books of 2013

Bailey, Jason. *Pulp Fiction: The Complete Story of Quentin Tarantino's Masterpiece*. Voyageur Press, 2013. The history of Quentin Tarantino's beloved, breakthrough film is chronicled yet again with obsessive detail down to casting information, deleted scenes, and artwork inspired by the film.

Bean, Kendra and Claire Bloom. *Vivien Leigh: An Intimate Portrait*. Running Press, 2013. An expert on Vivien Leigh with works on the actress that have been published by the British Film Institute tackles the iconic star with the help of the Laurence Olivier Archives, which reportedly shed new light on the star with new access to letter, diaries, medical records, and more.

Benecke, Joanna. *100 Reasons to Love Ryan Gosling*. Plexus Publishing, 2013. One-hundred photos of the beloved star of *Drive* (2011), *The Notebook* (2004), and *The Place Beyond the Pines* (2012) do most of the work in this tongue-in-cheek paperback that serves the actor's many fans well.

Biskind, Peter. *My Lunches with Orson: Conversations between Henry Jaglom and Orson Welles*. Metropolitan Books, 2013. Writer/director Henry Jaglom spent a lot of time with friend and legend Orson Welles in his later years and the luminary allowed Jaglom to record the conversations, which have now been turned into a reflective tome on a past friendship and the art of cinema.

Braverman, Barry. *Video Shooter: Mastering Storytelling Techniques*. Focal Press, 2013. A cinematographer with over thirty years of experience in television and film offers his insight in this latest volume on the art of the visual image. Braverman worked on *The Darjeeling Limited* (2007), *Moonrise Kingdom* (2012), among others.

Burgundy, Ron. *Let Me Off at the Top!: My Classy Life and Other Musings*. Crown Archetype, 2013. An in-character spoofing of the celebrity biographical documentary designed to tie in with the theatrical release of *Anchorman 2: The Legend Continues* (2013).

Carter, Graydon. *Vanity Fair 100 Years: From the Jazz Age to Our Age*. Harry N. Abrams, 2013. The Editor of *Vanity Fair* presents a coffee table book of some of the great art, illustrations, feature writing, interviews, and photography from the legendary magazine.

Chojnacki, Matthew. *Alternative Movie Posters: Film Art from the Underground*. Schiffer Publishing, 2013. A great coffee table book of the some of the best movie posters of all time from the obscure to the blockbuster. Includes more than 200 posters from over 100 groundbreaking artists from twenty countries.

Christensen, Aaron and William Lustig. *Hidden Horror: A Celebration of 101 Underrated and Overlooked Fright Flicks*. Kitley's Krypt, 2013. A new compendium of essays on the art of the scary movie that includes films from multiple generations and from countries far and wide. Everyone loves their horror.

Clements, Jonathan. *Anime: A History* British Film Institute, 2013. The co-author of *The Anime Encyclopedia*. and the editor of *Manga Max* offers yet another look at the history of the form he clearly knows and loves.

Cohen, David S. and Guillermo Del Toro. *Pacific Rim: Man, Machines, and Monsters*. Insight Editions, 2013. A Variety writer and the talented man behind *Pacific Rim* (2013) and many more craft a companion piece to the Summer blockbuster.

Cousins, Mark. *The Story of Film*. Pavilion, 2013. A companion piece to the multi-piece documentary series that attempts to chronicle the entire history of the art form from black-and-white silent works to today's blockbusters.

Craddock, Jim. *VideoHound's Golden Movie Retriever 2014*. Gale, 2013. An annual compendium of star ratings and capsule reviews of thousands of movies from all over the world.

Cross, David, Bob Odenkirk and Brian Posehn. *Hollywood Said No! Orphaned Film Scripts, Bastard Scenes, and Aban-*

doned *Darlings from the Creators of Mr. Show.* Grand Central Publishing, 2013. The brilliant team behind HBO's *Mr. Show* never quite found the same fame in the world of feature films but it wasn't for lack of trying. This volume chronicles some of the failed ideas and aborted productions from the guys who changed sketch comedy on television.

Crystal, Billy. *Still Foolin' Em: Where I've Been, Where I'm Going, and Where the Hell Are My Keys?* Henry Holt and Co., 2013. Years after breaking through in *Soap* and *Saturday Night Live*, the star and regular Oscar host gets an autobiographical volume that doubles as both a book of humorous insights and window into the process of a comedy legend.

Debreceni, Todd. *Special Makeup Effects for Stage and Screen: Making and Applying Prosthetics.* Focal Press, 2013. A makeup effects master on films like *Contact* (1997), *Batman and Robin* (1997), and many more offers his insight into the process of using prosthetics to make magic.

Del Toro, Guillermo and Marc Zicree. *Guillermo Del Toro Cabinet of Curiosities: My Notebooks, Collections, and Other Obsessions.* Harper Design, 2013. The genius behind *Mimic* (1997), *The Devil's Backbone* (2001), *Pan's Labyrinth* (2006), and *Pacific Rim* (2013) offers amazing accessibility to his notebooks, drawings, and collections of memorabilia, giving incredible insight into his process simply by showing so much of what goes into it.

DK Publishing. *Star Wars: Complete Vehicles.* DK Children, 2013. Another compendium of machines from the Star Wars movies with a foreword by John Knoll, Visual Effects Supervisor at Lucasfilms Industrial Light & Magic. There are some new photos but this is primarily recycled material.

Dotti, Luca, Ludovica Damiani and Sciascia Gambaccini. *Audrey in Rome.* Harper Design, 2013. Audrey Hepburn's son Luca Dotti assembles a personal, intimate collection of one of the most beloved stars of all time.

Duncan, Paul and Steve Schapiro. *The Godfather Family Album.* Taschen, 2013. A special photographer on the sets of *The Godfather Trilogy* had amazing access to the cast and crew of these legendary films with over 400 color and black & white images for fans of the Francis Ford Coppola classics.

Edwards, Gavin. *Last Night at the Viper Room: River Phoenix and the Hollywood He Left Behind.* It Book, 2013. River Phoenix passed away at the age of 23, succumbing to an overdose in front of West Hollywood's storied club. This book doubles as a look at the actor's incredible career at such a young age and examines his entire generation of actors and the influence he had on them.

Elberse, Anita. *Blockbusters: Hit-making, Risk-taking, and the Big Business of Entertainment.* Henry Holt and Co., 2013. A Harvard Business School professor tackles the financial aspect of not just moviemaking but blockbuster events across various mediums, including music, TV, and literature.

Evans, Peter and Ava Gardner. *Ava Gardner: The Secret Conversations.* Simon & Schuster, 2013. Two years before her death in 1988, the legendary Ava Gardner gave Peter Evans permission to ghostwrite her autobiography but the project fell apart. The conversations and transcripts of a

woman coming to terms with her own life and legacy have finally been formed into a book.

Evans, Robert. *The Fat Lady Sang.* It Books, 2013. The legendary producer and author of the incredible *The Kid Stays in the Picture*, a definitive volume in understanding the importance of film in the 1970s, finally follows it up.

Evans, Robert. *The Kid Stays in the Picture: A Notorious Life.* It Books, 2013. A Hollywood memoir so beloved that it turned into an acclaimed documentary has been updated and revised to coincide with its author's second vlume, *The Fat Lady Sang.*

Feldman, Corey. *Coreyography: A Memoir.* St. Martin's Press, 2013. The controversial child star of films like *The Goonies* (1985), *Stand by Me* (1986), and *The Lost Boys* (1987) offers a history of his peaks and valleys in the glaring spotlight of Hollywood fame.

Fisher, Jude. *The Hobbit: The Desolation of Smaug Visual Companion.* Houghton Mifflin Harcourt, 2013. A companion piece to the 2013 blockbuster from writer/director Peter Jackson with an introduction by star Richard Armitage and over 100 illustrations.

Franco, James. *A California Childhood.* Insight Editions, 2013. The actor/director refuses to do anything straightforward and so he plays with the very concept of memoir offering photos, sketched, paintings, poems, and stories.

Frankel, Glenn. *The Searchers: The Making of an American Legend.* Bloomsbury USA, 2013. The writer presents more than a historical accounting of the production of the 1956 John Wayne classic but offers insight and research into the real story on which the Western was based. The result is a look at how Hollywood interprets and, in many ways, reshapes history.

Ganly, Jackie Valinda. *Tragic Hollywood, Beautiful, Glamorous and Dead.* CreateSpace, 2013. The writer examines the morbid, death-obsessed side of Hollywood, including stories about Natalie Wood, Errol Flynn, and Los Angeles hauntings.

Ghez, Didier, Bob McLain and Diane Disney Miller. *Disney's Grand Tour: Walt and Roy's European Vacation, Summer 1935.* Theme Park Press, 2013. In 1935, Roy and Walt Disney went to Europe with their wives aboard a luxury liner and the authors note how it influenced what they would go on to produce as pioneers of the form of animation.

Gladstone, B. James and Robert Wagner. *The Man Who Seduced Hollywood: The Life and Loves of Greg Bautzer, Tinseltown's Most Powerful Lawyer.* Chicago Review Press, 2013. Believe it or not, there was a time when being an attorney to the stars held its own cultural cachet and Greg Bautzer was once considered one of Hollywood's most eligible bachelors, once linked to Joan Crawford, Lana Turner, Ginger Rogers, Ava Gardner, and more of the golden era's most beautiful actresses.

Goldman, Michael, Ethan Wayne and Jimmy Carter. *John Wayne: The Genuine Article.* Insight Editions, 2013. A veteran industry journalist collaborates with John Wayne's youngest son for another look at the legendary actor.

Henry, David and Joe Henry. *Furious Cool: Richard Pryor and the World That Made Him.* Algonquin Books, 2013. A

biography of the legendary stand-up and movie star that traces his history and legacy through the people that influenced him to the generation that followed that consider him a comedy leader.

Hewitt, John and Gustavo Vazquez. *Documentary Filmmaking: A Contemporary Field Guide*. Oxford University Press, 2013. Two professors offer a skills-oriented look at the process of making non-fiction films from inception to distribution in this updated edition of a notable reference guide.

Houston, Cissy. *Remembering Whitney*. Harper, 2013. Poignant, tender, and heartbreaking, Whitney Houston's mother remembers the star of music and cinema and sheds light on both her personal demons and professional career.

Javins, Marie and Stuart Moore. *Marvel's Thor: The Dark World—The Art of the Movie*. Marvel, 2013. Another massive, thick, coffee-table book for fans of the Marvel movies that aggregates the key images and behind-the-scenes details of another massive blockbuster. This one includes exclusive concept artwork, behind-the-scenes photographs, production stills, and in-depth interviews with those involved with *Thor: The Dark World* (2013).

Johnson, Mindy. *Tinker Bell: An Evolution*. Disney Editions, 2013. How did a little fairy who didn't even have her iconic name in the original source material become such an iconic figure in children's cinema? Tinker Bell has her own line of films now and serves as nearly as much of an icon for Walt Disney as Mickey Mouse. How did that happen? This book explains.

Jones, Brian Jay. *Jim Henson: The Biography*. Ballantine Books, 2013. The man who helped define childhood for millions of people around the world gets a loving, informative biography from an expert in the field.

Kenworthy, Christopher. *Master Shots Vol. 3: The Director's Vision: 100 Setups, Scenes and Moves for Your Breakthrough Movie*. Michael Wiese Productions, 2013. A traditional reference book filled with images that are designed to walk the layman through the filmmaking process. Are you a young director who wants to make movies? Here's a good place to start.

Krizanovich, Karen. *Infographic Guide to the Movies*. Cassell, 2013. Our infographic-obsessed world gets a whole book of stats and trivia put into visual form.

Landis, Deborah Nadoolman. *Hollywood Costume*. Harry N. Abrams, 2013. A chronicle of the most beloved costume designs in film history from Adrian to Edith Head to Sandy Powell. A book published in conjunction with an exhibit at the Victoria and Albert Museum in London.

Lange, Artie. *Crash and Burn*. Touchstone, 2013. The star of low-rent comedies like *Dirty Work* (1998) and *Beer League* (2006) gets a biography that chronicles his darker years near the end of his run on the *Howard Stern Show*, that crashed and burned in a wave of drugs and a terrifying suicide attempt.

Langella, Frank. *Dropped Names: Famous Men and Women As I Knew Them* Harper Perennial, 2013. The great actor Frank Langella avoids the traditional biography route by sharing stories of his encounters with luminaries like Rita

Hayworth, Elizabeth Taylor, Laurence Olivier, and many more. Langella has been in the industry for decades and has the life experience to offer a unique look at Hollywood royalty.

Levison, Louise. *Filmmakers and Financing: Business Plans for Independents*. Focal Press, 2013. This Variety Magazine produced book offers financial guidance to novice filmmakers trying to get a production off the ground on their own from the expertise of a UCLA teacher close to the business.

Lucas, George. *Star Wars: Frames*. Harry N. Abrams, 2013. A massive coffee table book (with the appropriate price tag) in which George Lucas went back through all six films, highlighting key images from each, to the tune of over 1,400 stills personally selected and many of them dissected from a filmmaking viewpoint by the master himself.

Lucasfilm LTD, Doug Chian and Joe Johnston. *Star Wars Art: Concept*. Harry N. Abrams, 2013. A storyboard and concept artist on the original *Star Wars* trilogy offers his concepts from the influential films in this installment in the "Star Wars Art" series.

MacLaine, Shirley. *What If: A Lifetime of Questions, Speculations, Reasonable Guesses, and a Few Things I Know For Sure*. Atria Books, 2013. Shirley MacLaine just never stops writing books, arguably known as much for her self-help and spiritual advice as her acting. Here's yet another semi-biographical, semi-inspirational piece from the living legend.

Maltin, Leonard. *Leonard Maltin's 2014 Movie Guide*. Signet, 2013. Another massive reference book for Maltin's reviews, this one totaling over 1,600 pages.

Matzen, Robert. *Fireball: Carole Lombard and the Mystery of Flight 3*. Paladin Communications, 2013. The queen of screwball comedies was taken far too young and so her career as an actress was cut tragically short when she died in a plane accident in 1942. This meticulously researched piece examines the tragic final flight.

Maurer, Joan Howard and Michael Jackson. *Curly: An Illustrated Biography of the Superstooge*. Chicago Review Press, 2013. The daughter of the legendary Moe Howard offers a look back at one of the most beloved and inspired of The Three Stooges.

Miller-Zarneke, Tracey. *The Art of Cloudy with a Chance of Meatballs 2: Revenge of the Leftovers*. Cameron + Company, 2013. Yet another companion piece to an animated film that offers behind-the-scenes information and plenty of stills for fans of the family hit.

McCarthy, Cormac. *The Counselor: A Screenplay*. Vintage International, 2013. The author of the Ridley Scott film and hit novels like *All the Pretty Horses* and *No Country For Old Men* presents his script, perhaps proving as the film did that it would have worked better as a novel.

Nashawaty, Chris and John Landis. *Crab Monsters, Teenage Cavemen, and Candy Stripe Nurses: Roger Corman: King of the B Movie*. Harry N. Abrams, 2013. A chronicle of the life and times of the brilliant Roger Corman, a man who turned his love for cinema into an on-the-job training school for dozens of men and women who would become film pioneers from Ron Howard to Joe Dante to Martin Scorsese, and dozens more.

Nathan, Ian and Arnold Schwarzenegger. *Terminator Vault: The Complete Story Behind the Making of The Terminator and Terminator 2: Judgment Day*. Voyageur Press, 2013. A behind-the-scenes look at two of the most influential science fiction films of all time by one of the editors of *Empire*.

Obst, Lynda. *Sleepless in Hollywood: Tales from the New Abnormal in the Movie Business*. Simon & Schuster, 2013. Another memoir from the veteran producer and author 17 years after her wildly popular *Hello, He Lied*.

Osborne, Robert. *85 Years of the Oscar: The Official History of the Academy Awards*. Abbeville Press, 2013. Another edition of the reference book that looks at the Oscars year-by-year with hundreds of photos and tons of details about Hollywood's favorite night.

Paik, Karen. *The Art of Monsters University*. Chronicle Books, 2013. A worker in the development department of Pixar sheds some light on the company's latest production in yet-another tie-in or companion piece for an animated hit.

Penley, Constance, Celine Parrenas Shimizu and Mireille Miller-Young. *The Feminist Porn Book: The Politics of Producing Pleasure*. The Feminist Press at CUNY, 2013. A look at the porn industry and the way sex is represented on film that approaches the form not just from the way feminism reacts to porn but how many feminists work within the industry to create it.

Rabiger, Michael and Mick Hurbis-Cherrier. *Directing: Film Techniques and Aesthetics*. Focal Press, 2013. A director and teacher offer yet another take on how to turn your idea into an actual film.

Reynolds, Debbie and Dorian Hannaway. *Unsinkable: A Memoir*. William Morrow, 2013. One of cinema's dancing, singing, and acting legends, Debbie Reynolds, gets a biography.

Rinzler, J.W. and Brad Bird. *The Making of Star Wars: Return of the Jedi*. LucasBooks, 2013. A thirtieth anniversary tribute to the close of the most influential film trilogy of all time, complete with an introduction by one of the kings of the Pixar brain trust, Brad Bird.

Rinzler, J.W. and Iain McCaig. *Star Wars Storyboards: The Prequel Trilogy*. Harry N. Abrams, 2013. A companion piece to the already-released look at the original trilogy from the executive editor at Lucasfilms Ltd.

Rudin, Jen. *Confessions of a Casting Director: Help Actors Land Any Role with Secrets from Inside the Audition Room*. It Books, 2013. An insightful look into the process of getting a key role in a film from an award-winning casting director who worked for The Walt Disney Company for years.

Salisbury, Mark. *Elysium: The Art of the Film*. Titan Books, 2013. A mediocre sci-fi film actually makes for a more interesting companion coffee table book thanks to Neill Blomkamp's stunning production design and detailed approach to his craft.

Schneider, Steven Jay. *1001 Movies You Must See Before You Die*. Barron's Educational Series, 2013. Another update to the surprisingly popular book that claims to be the definitive tome on what one needs to see before shuffling off this mortal coil. It's up to almost 1,000 pages!

Schwarzenegger, Arnold. *Total Recall: My Unbelievably True Life Story*. Simon & Schuster, 2013. What does any aging star do after a scandal dulls their career? Write a book! And name it after one of your hit movies! And so, here it is with the story of Ah-nuld's life.

Seitz, Matt Zoller. *The Wes Anderson Collection*. Harry N. Abrams, 2013. The Editor-in-Chief of RogerEbert.com analyzes the career of Wes Anderson from *Bottle Rocket* (1996) to *Moonrise Kingdom* (2012) complete with interviews with Anderson related to each film and incredible behind-the-scenes photography and information.

Sestero, Greg and Tom Bissell. *The Disaster Artist: My Life Inside The Room, the Greatest Bad Movie Ever Made*. Simon & Schuster, 2013. Widely recognized as the best worst movie ever made, Tommy Wiseau's *The Room* has become a staple on the midnight movie scene. Why NOT write a book about its production and bizarre rise to fame?

Sibley, Brian. *The Hobbit: The Desolation of Smaug Official Movie Guide*. Mariner Books, 2013. Another companion piece to a blockbuster film. You can't really make an international hit any more without a coffee table book.

Sklar, Martin. *Dream It! Do It! My Half-Century Creating Disney's Magic Kingdoms*. Disney Editions Deluxe, 2013. A Walt Disney employee, mostly at the actual kingdoms, since 1956, Martin Sklar has a unique perspective on the Mouse House legacy.

Smith, Kevin. *Tough Sh*t: Life Advice from a Fat, Lazy Slob Who Did Good*. Gotham, 2013. The enfant terrible of the indie movie scene returns with another volume of movie-making and life-living insight mostly geared to fans but funny enough to possibly create a few new ones.

Solomon, Charles, John Lasseter, Chris Buck and Jennifer Lee. *The Art of Frozen*. Chronicle Books, 2013. A coffee table book for the Oscar-winning Disney smash with behind-the-scenes photos, details on the productions, and lovingly-rendered stills.

Stewart, Creek. *The Unofficial Hunger Games Wilderness Survival Guide*. Living Ready, 2013. The owner of Willow Haven Outdoor, a survival group, approaches the books and movies of the story of Katniss Everdeen from a unique angle.

Stillman, William and Jay Scarfone. *The Wizard of Oz: The Official 75th Anniversary Companion*. Harper Design, 2013. The commemorative volume tied into the anniversary of one of the most beloved films of all time.

Szpunar, John. *Xerox Ferox: The Wild World of the Horror Film Fanzine*. Headpress, 2013. An examination of the publications that helped spur the B-movie movement.

Takei, George. *Lions and Tigers and Bears: The Internet Strikes back (Oh Myyy!) (Volume 2)*. Oh Myyy! Limited Liability Company, 2013. Five decades in show business has granted the *Star Trek* star enough stories and anecdotes to allow for a second volume in his autobiography.

Thomson, David. *Moments That Made the Movies*. Thames & Hudson, 2013. The legendary writer examines not overall films but the scenes, dialogue exchanges, and images that have defined motion picture history.

Ulin, Jeffrey C. *The Business of Media Distribution: Monetizing Film, TV, and Video Content in an Online World*. Focal

Press, 2013. Hey, look, another examination of the film industry. Just what we needed. At least this one approaches the subject from the angle of the modern, online delivery system.

Urwand, Ben. *The Collaboration: Hollywood's Pact with Hitler.* Belknap Press, 2013. Did Hollywood agree to not make films that demeaned Hitler during WWII? The author investigates the role the movie business played in protecting the German leader during a time when it should have been exposing him.

Vieira, Mark A. and Sharon Stone. *George Hurrell's Hollywood: Glamour Portraits 1925-1992.* Running Press, 2013. A legendary writer-photographer is chronicled through this coffee table book of his most notable issues.

Vieira, Mark A. *Majestic Hollywood: The Greatest Films of 1939.* Running Press, 2013. One of the most important years in film history gets a 75th anniversary appreciation.

Director Index

J.J. (Jeffrey) Abrams (1966-)
 Star Trek Into Darkness

Woody Allen (1935-)
 Blue Jasmine

Pedro Almodovar (1951-)
 I'm So Excited

Fede Alvarez (1978-)
 Evil Dead

Brad Anderson (1964-)
 The Call

Kaare Andrews
 The ABCs of Death

Peter Andrews (1963-)
 See *Steven Soderbergh*

Nimrod Antal (1973-)
 Metallica Through the Never

Michael Apted (1941-)
 56 Up

Dante Ariola
 Arthur Newman

Rodney Ascher
 Room 237

Olivier Assayas (1955-)
 Something in the Air

Ramin Bahrani
 At Any Price

Elizabeth Banks (1974-)
 Movie 43

Simon Barrett
 V/H/S/2

Zal Batmanglij
 The East

Noah Baumbach (1969-)
 Frances Ha

Michael Bay (1965-)
 Pain & Gain

Lake Bell (1979-)
 In a World...

Peter Berg
 Lone Survivor

Pablo Berger
 Blancanieves

Luc Besson (1959-)
 The Family

Angela Bettis (1975-)
 The ABCs of Death

Suzanne (Susanne) Bier (1960-)
 Love Is All You Need

Shane Black (1961-)
 Iron Man 3

Wayne Blair
 The Sapphires

Neill Blomkamp (1979-)
 Elysium

Stuart Blumberg (1969-)
 Thanks for Sharing

Baran bo Odar
 The Silence

Andria Bogliano
 The ABCs of Death

Gilles Bourdos (1963-)
 Renoir

David Boyd
 Home Run

Danny Boyle (1956-)
 Trance

Steven Brill (1962-)
 Movie 43

Callan Brunker
 Escape From Planet Earth

Chris Buck
 Frozen

Andrew Bujalski
 Computer Chess

Rama Burshtein
 Fill the Void

Greg Camalier
 Muscle Shoals

Cody Cameron
 Cloudy with a Chance of Meatballs 2

Maggie Carey
 The To Do List

Carlo Carlei (1960-)
 Romeo & Juliet

Steve Carr
 Movie 43

Shane Carruth (1972-)
 Upstream Color

Lucien Castaing-Taylor
 Leviathan

Helene Cattet
 The ABCs of Death

Jimmy Hayward
 Free Birds

Brian Helgeland (1961-)
 42

Jerusha Hess (1980-)
 Austenland

Walter Hill (1942-)
 Bullet to the Head

Oliver Hirschbiegel (1957-)
 Diana

Nicole Holofcener (1960-)
 Enough Said

Gavin Hood (1963-)
 Ender's Game

Ron Howard (1954-)
 Rush

Jeff Howlett
 A Band Called Death

Allen Hughes (1972-)
 Broken City

Noboru Iguchi
 The ABCs of Death

Peter Jackson (1961-)
 The Hobbit: The Desolation of
 Smaug

Spike Jonze (1969-)
 Her

Neil Jordan (1950-)
 Byzantium

Wong Kar-Wai (1958-)
 The Grandmaster

Abdellatif Kechiche (1960-)
 Blue is the Warmest Color

Franck Khalfoun
 Maniac

Abbas Kiarostami (1940-)
 Like Someone in Love

Jee-woon Kim (1964-)
 The Last Stand

Steven Knight (1959-)
 Redemption

Harmony Korine (1974-)
 Spring Breakers

Baltasar Kormakur (1966-)
 2 Guns

Joseph Kosinski (1974-)
 Oblivion

John Krokidas (1973-)
 Kill Your Darlings

Richard LaGravenese (1959-)
 Beautiful Creatures

Pablo Larrain
 No

Francis Lawrence (1971-)
 The Hunger Games: Catching
 Fire

Benson Lee
 Battle of the Year

Jennifer Lee (1968-)
 Frozen

Malcolm Lee (1970-)
 The Best Man Holiday
 Scary Movie 5

Spike Lee (1957-)
 Oldboy

Kasi Lemmons (1961-)
 Black Nativity

Adam Leon
 Gimme the Loot

Louis Leterrier (1973-)
 Now You See Me

Jonathan Levine
 Warm Bodies

Shawn Levy (1968-)
 The Internship

Ray Lilly (1937-)
 See Richard Curtis

Justin Lin (1973-)
 Fast & Furious 6

Tobias Lindholm
 A Hijacking

Richard Linklater (1960-)
 Before Midnight

David Lowery
 Ain't Them Bodies Saints

Sam Lowry (1963-)
 See Steven Soderbergh

Jon Lucas
 21 & Over

John Luessenhop
 Texas Chainsaw 3D

Baz Luhrmann (1962-)
 The Great Gatsby

Robert Luketic (1973-)
 Paranoia

Thomas Cappelen Maaling
 The ABCs of Death

Kevin MacDonald (1967-)
 How I Live Now

Terrence Malick (1943-)
 To the Wonder

James Mangold (1964-)
 The Wolverine

James Marsh (1963-)
 Shadow Dancer

Scott McGehee
 What Maisie Knew

Michael McGowan (1966-)
 Still Mine

Adam McKay (1968-)
 Anchorman 2: The Legend Con-
 tinues

Steve McQueen (1969-)
 12 Years a Slave

Jim Mickle
 We Are What We Are

Goro Miyazaki (1967-)
 From Up on Poppy Hill

Hayao Miyazaki (1941-)
 The Wind Rises

John Moore (1970-)
 A Good Day to Die Hard

Randy Moore
 Escape From Tomorrow

Scott Moore
 21 & Over

Alexandre Moors
 Blue Caprice

Anders Morgenthaler
 The ABCs of Death

Cristian Mungiu
 Beyond the Hills

Andres Muschietti
 Mama

Mira Nair (1957-)
 The Reluctant Fundamentalist

Morgan Neville
 20 Feet from Stardom

Kim Nguyen
 War Witch

Andrew Niccol (1964-)
 The Host

Jeff Nichols (1978-)
 Mud

Neil Nightingale
 Walking with Dinosaurs 3D

Yoshihiro Nishimura
 The ABCs of Death

Jehane Noujaim (1974-)
 The Square

Joe Swanberg (1981-)
 All the Light in the Sky
 Drinking Buddies
David E. Talbert (1964-)
 Baggage Claim
Alan Taylor (1965-)
 Thor: The Dark World
Rawson Marshall Thurber (1975-)
 We're the Millers
Michael Tiddes
 A Haunted House
Timo Tjahjanto
 The ABCs of Death
 V/H/S/2
Johnnie To
 Drug War
Andrew Traucki
 The ABCs of Death
Jeff Tremaine
 Jackass Presents: Bad Grandpa
Jon Turteltaub (1963-)
 Last Vegas
David N. Twohy (1955-)
 Riddick
Jean-Marc Vallee
 Dallas Buyers Club
Jonathan Van Tulleken
 Movie 43
Gore Verbinski (1964-)
 The Lone Ranger

Nacho Vigalondo
 The ABCs of Death
Denis Villeneuve
 Prisoners
Thomas Vinterberg (1969-)
 The Hunt
Jordan Vogt-Roberts
 The Kings of Summer
Margarethe von Trotta (1942-)
 Hannah Arendt
Ariel Vromen (1973-)
 The Iceman
Jeff Wadlow (1976-)
 Kick-Ass 2
James Wan
 Insidious: Chapter 2
James Wan (1977-)
 The Conjuring
Melanie Ward (1937-)
 See Richard Curtis
Ric Roman Waugh (1968-)
 Snitch
Peter Webber (1968-)
 Emperor
Chris Wedge (1957-)
 Epic
Paul Weitz (1965-)
 Admission
John Wells
 August: Osage County

Jake West
 The ABCs of Death
Ti West
 The ABCs of Death
Ben Wheatley
 The ABCs of Death
 Sightseers
Joss Whedon (1964-)
 Much Ado About Nothing
Paul Andrew Williams
 Unfinished Song
Lana Wilson
 After Tiller
Adam Wingard
 The ABCs of Death
 V/H/S/2
 You're Next
Tommy Wirkola (1979-)
 Hansel & Gretel: Witch Hunters
Edgar Wright (1974-)
 The World's End
Yudai Yamaguchi
 The ABCs of Death
Justin Zackham
 The Big Wedding
Jia Zhangke
 A Touch of Sin
Rob Zombie (1966-)
 The Lords of Salem
Harald Zwart (1965-)
 The Mortal Instruments: City of
 Bones

Screenwriter Index

Jane Adams (1940-)
All the Light in the Sky

Jane Ellen Adams (1940-)
See *Jane Adams*

Roberto Aguirre-Sacasa
Carrie

Joe Ahearne (1963-)
Trance

Alexandre Aja (1978-)
Maniac

Woody Allen (1935-)
Blue Jasmine

Pedro Almodovar (1951-)
I'm So Excited

Fede Alvarez (1978-)
Evil Dead

Rick Alvarez
A Haunted House

Hossein Amini (1966-)
47 Ronin

Sean Anders
We're the Millers

Kaare Andrews
The ABCs of Death

Nimrod Antal (1973-)
Metallica Through the Never

Marie Arana (1949-)
Girl Rising

Michael Arndt
The Hunger Games: Catching
Fire
Oblivion

Rodney Ascher
Room 237

Olivier Assayas (1955-)
Something in the Air

Ramin Bahrani
At Any Price

Doreen Baingana
Girl Rising

Robert L. Baird
Monsters University

Steve Baker
Movie 43

Bob Barlen
Escape From Planet Earth

Simon Barrett
The ABCs of Death
V/H/S/2
You're Next

Zal Batmanglij
The East

Noah Baumbach (1969-)
Frances Ha

Travis Beacham
Pacific Rim

Will Beall
Gangster Squad

Simon Beaufoy (1967-)
The Hunger Games: Catching
Fire

Lake Bell (1979-)
In a World...

Andy Bellin (1968-)
Lovelace

Katrin Benedikt
Olympus Has Fallen

Peter Berg
Lone Survivor

Pablo Berger
Blancanieves

Luc Besson (1959-)
The Family

Shane Black (1961-)
Iron Man 3

Vera Blasi
Emperor

Neill Blomkamp (1979-)
Elysium

Stuart Blumberg (1969-)
Thanks for Sharing

Baran bo Odar
The Silence

Andria Bogliano
The ABCs of Death

Leslie Bohem (1952-)
Safe Haven

Mark Bomback (1971-)
The Wolverine

Craig Borten
Dallas Buyers Club

Gilles Bourdos (1963-)
Renoir

Julian Fellowes (1949-)
 Romeo & Juliet

Will Ferrell (1968-)
 Anchorman 2: The Legend Continues

Sean Finegan
 Getaway

Bob Fisher
 We're the Millers

Dan Fogelman
 Last Vegas

Aminatta Forna
 Girl Rising

Patrik Forsberg
 Movie 43

Bruno Forzani
 The ABCs of Death

Scott Frank (1960-)
 The Wolverine

Carl Franklin (1949-)
 Bless Me, Ultima

Karl Gajdusek (1968-)
 Oblivion

Chris Galletta
 The Kings of Summer

Matteo Garrone (1968-)
 Reality

Ed Gass-Donnelly (1977-)
 The Last Exorcism Part II

Massimo Gaudioso (1958-)
 Reality

Philip Gelatt
 Europa Report

Daniel Gerson
 Monsters University

Greta Gerwig
 Frances Ha

Drew Goddard
 World War Z

Evan Goldberg (1982-)
 This Is the End

Jonathan M. Goldstein (1969-)
 Cloudy with a Chance of Meatballs 2
 The Incredible Burt Wonderstone

Joseph Gordon-Levitt (1981-)
 Don Jon

David S. Goyer (1965-)
 Man of Steel

David Gordon Green (1975-)
 Prince Avalanche

Tony Grisoni (1952-)
 How I Live Now

Marc Guggenheim (1970-)
 Percy Jackson: Sea of Monsters

Aaron Guzikowski
 Prisoners

Noah Haidie
 Stand Up Guys

Shannon Hale
 Austenland

Jason Hall
 Paranoia

Christopher Hampton (1946-)
 Adore

Xu Haofeng
 The Grandmaster

Lee Hardcastle
 The ABCs of Death

James V. Hart (1960-)
 Epic

Ethan Hawke (1971-)
 Before Midnight

Phil Hay
 R.I.P.D.

Carey Hayes (1961-)
 The Conjuring

Chad Hayes (1961-)
 The Conjuring

Justin Haythe (1973-)
 The Lone Ranger
 Snitch

Jimmy Hayward
 Free Birds

Brian Helgeland (1961-)
 42

Tim Herlihy (1966-)
 Grown Ups 2

Jerusha Hess (1980-)
 Austenland

Brin Hill
 Battle of the Year

John Hodge (1964-)
 Trance

Erich Hoeber
 RED 2

Jon Hoeber
 RED 2

Nicole Holofcener (1960-)
 Enough Said

Gavin Hood (1963-)
 Ender's Game

Jeffrey M. Howard
 Planes

Noboru Iguchi
 The ABCs of Death

Brad Ingelsby
 Out of the Furnace

Peter Jackson (1961-)
 The Hobbit: The Desolation of Smaug

Stephen Jeffreys (1950-)
 Diana

Anders Thomas Jensen (1972-)
 Love Is All You Need

Zou Jingzhi
 The Grandmaster

Becky Johnston
 Arthur Newman

Matthew F. Jones
 A Single Shot

Spike Jonze (1969-)
 Her

William Joyce (1957-)
 Epic

Mitchell Kapner
 Oz the Great and Powerful

Wong Kar-Wai (1958-)
 The Grandmaster

Zarghuna Kargar (1982-)
 Girl Rising

Pamela Katz
 Hannah Arendt

Abdellatif Kechiche (1960-)
 Blue is the Warmest Color

Tim Kelleher
 Grudge Match

Jason Keller (1971-)
 Escape Plan

Abbas Kiarostami (1940-)
 Like Someone in Love

David Klass
 Emperor

Andrew Knauer
 The Last Stand

Steven Knight (1959-)
 Closed Circuit
 Redemption

Johnny Knoxville (1971-)
 Jackass Presents: Bad Grandpa

Yoshihiro Nishimura
The ABCs of Death

Steven H. Oram
Sightseers

Roberto Orci (1973-)
Star Trek Into Darkness

Greg O'Toole
After Tiller

Jessica Postigo Paquette
The Mortal Instruments: City of Bones

Verena Paravel
Leviathan

Chris Parker
Battle of the Year

Gregg Maxwell Parker
Getaway

Stacie Passon
Concussion

Cinco Paul
Despicable Me 2

Craig Pearce
The Great Gatsby

Drew Pearce
Iron Man 3

Simon Pegg (1970-)
The World's End

Pedro Peirano
No

Tyler Perry (1969-)
Tyler Perry's A Madea Christmas
Tyler Perry's Temptation: Confessions of a Marriage Counselor

Michael Petroni
The Book Thief

Todd Phillips (1970-)
The Hangover, Part III

Sarah Polley (1979-)
Stories We Tell

Jeff Pope
Philomena

R.F.I. (Ronnie) Porto
Blue Caprice

Sally Potter (1947-)
Ginger & Rosa

Pat Proft (1947-)
Scary Movie 5

Mark Protosevich (1961-)
Oldboy

Jim Rash
The Way Way Back

Billy Ray
Captain Phillips

Rhett Reese
G.I. Joe: Retaliation

Nicolas Winding Refn (1970-)
Only God Forgives

Carlos Reygadas (1971-)
Post Tenebras Lux

John Ridley (1965-)
12 Years a Slave

Erica Rivinoja
Cloudy with a Chance of Meatballs 2

Todd Robinson
Phantom

Seth Rogen (1982-)
This Is the End

David Ronn
The Smurfs 2

Terry Rossio (1960-)
The Lone Ranger

Creighton Rothenberger
Olympus Has Fallen

Rodney Rothman (1974-)
Grudge Match

Simon Rumley
The ABCs of Death

David O. Russell (1959-)
American Hustle

Rocky Russo
Movie 43

Chris (Christopher) Sanders (1960-)
The Croods

Adam Sandler (1966-)
Grown Ups 2

Rodo Sayagues
Evil Dead

Dan Scanlon
Monsters University

Ken Scott
Delivery Man

Martha Shane
After Tiller

Lynn Shelton
Touchy Feely

Cate Shortland (1968-)
Lore

M. Night Shyamalan (1970-)
After Earth

Robert Siegel
Turbo

Sebastian Silva (1979-)
Crystal Fairy & the Magical Cactus

Eric Singer
American Hustle

Josh Singer
The Fifth Estate

Petter Skavlan
Kon-Tiki

Sue Smith
Saving Mr. Banks

Juan Diego Solanas
Upside Down

Edward Solomon (1961-)
Now You See Me

Jill Soloway
Afternoon Delight

David Soren
Turbo

Paolo Sorrentino (1970-)
The Great Beauty

Jeremy Sosenko
Movie 43

Srdjan Spasojevic
The ABCs of Death

Sylvester Stallone (1946-)
Homefront

Andrew Stern
Disconnect

Jared Stern
The Internship

Dana Stevens
Safe Haven

Scott Charles Stewart
Dark Skies

Peter Strickland
Berberian Sound Studio

Danny Strong (1974-)
Lee Daniels' The Butler

Morton Stultifer (1937-)
See Richard Curtis

Debra Sullivan
Texas Chainsaw 3D

Joe Swanberg (1981-)
All the Light in the Sky
Drinking Buddies

David E. Talbert (1964-)
Baggage Claim

Sooni Taraporevala
 Girl Rising

Manjushree Thapa
 Girl Rising

Keith Thompson
 The Sapphires

Timo Tjahjanto
 V/H/S/2

Jerome Tonnerre
 Renoir

Joelle Touma
 The Attack

Jeff Tremaine
 Jackass Presents: Bad Grandpa

Brian Tucker
 Broken City

David N. Twohy (1955-)
 Riddick

Loung Ung (1970-)
 Girl Rising

James Vanderbilt
 White House Down

Vince Vaughn (1970-)
 The Internship

Nacho Vigalondo
 The ABCs of Death

Thomas Vinterberg (1969-)
 The Hunt

Dimitrie Vojnov (1981-)
 The ABCs of Death

Margarethe von Trotta (1942-)
 Hannah Arendt

Ariel Vromen (1973-)
 The Iceman

Jeff Wadlow (1976-)
 Kick-Ass 2

Ka-Fai Wai
 Drug War

Melisa Wallack
 Dallas Buyers Club

Fran Walsh (1959-)
 The Hobbit: The Desolation of
 Smaug

James Wan
 Insidious: Chapter 2

Kyle Ward (1969-)
 Machete Kills

Melanie Ward (1937-)
 See Richard Curtis

Ric Roman Waugh (1968-)
 Snitch

Marlon Wayans (1972-)
 A Haunted House

Michael H. Weber
 The Spectacular Now

David N. Weiss
 The Smurfs 2

Paul Wernick
 G.I. Joe: Retaliation

Ti West
 The ABCs of Death

Leigh Whannell (1977-)
 Insidious: Chapter 2

Joss Whedon (1964-)
 Much Ado About Nothing

William Wheeler
 The Reluctant Fundamentalist

Matthew Whiteley
 Jobs

Gary Whitta
 After Earth

Paul Andrew Williams
 Unfinished Song

Lana Wilson
 After Tiller

Matt Winston
 Thanks for Sharing

Terence Winter
 The Wolf of Wall Street

Tommy Wirkola (1979-)
 Hansel & Gretel: Witch Hunters

Melanie Wistar
 Home Run

Fred Wolf (1964-)
 Grown Ups 2

Skip Woods
 A Good Day to Die Hard

Edgar Wright (1974-)
 The World's End

J.H. (Joel Howard) Wyman (1967-)
 Dead Man Down

Boaz Yakin (1944-)
 Now You See Me

Yudai Yamaguchi
 The ABCs of Death

Nai-Hoi Yau
 Drug War

Chris Yost
 Thor: The Dark World

Xi Yu
 Drug War

Justin Zackham
 The Big Wedding

Jia Zhangke
 A Touch of Sin

Rob Zombie (1966-)
 The Lords of Salem

David Zucker (1947-)
 Scary Movie 5

Cinematographer Index

Editor Index

Jinx Godfrey
How I Live Now
Shadow Dancer

Mark Goldblatt
Percy Jackson: Sea of Monsters

Alfonso Goncalves
At Any Price

Timothy A. Good (1974-)
Dead Man Down

Elliot Greenberg
Escape Plan

Jeff Groth
The Hangover, Part III

Peter Gvozdas
Dark Skies
The Purge

Pierre Haberer
The Square

Catherine Haight
Afternoon Delight

Robert Hall
The ABCs of Death

Eddie Hamilton
Kick-Ass 2

Daniel Hanley
Rush

Guy Harding
One Direction: This Is Us

Jon Harris
Trance

Lee Haxall
The Incredible Burt Wonderstone

Grey Hayden
The Secret Life of Walter Mitty

James Haygood
The Lone Ranger

Shane Hazen
To the Wonder

Alan Heim
Bless Me, Ultima

Mark Helfrich
R.I.P.D.

Jim Helton
The Place Beyond the Pines

James Herbert
Gangster Squad

Dylan Highsmith
Fast & Furious 6

Mike Hill
Rush

Robin Hill
Sightseers

Suzanne Hines
A Haunted House

Tracy Hoff
Girl Rising

Darren T. Holmes
The Croods

Peter Honess (1945-)
Romeo & Juliet

Kim Horton
56 Up

Maysie Hoy
Tyler Perry's A Madea Christmas
Tyler Perry's Temptation: Confessions of a Marriage Counselor

Joe Hutshing
Metallica Through the Never

Janus Billeskov Jansen
The Act of Killing
The Hunt

Veronika Jenet
Lore

Amy Jump
Sightseers

Paul Jutras
Upside Down

Daniel S. Kaminsky
Much Ado About Nothing

Brian A. Kates (1972-)
Kill Your Darlings

Virginia Katz
The Fifth Estate

Andy Keir
Epic

Steven Kemper
The Last Stand

Yannick Kergoat
Renoir

William Kerr
Grudge Match

Franck Khalfoun
Maniac

Bahman Kiarostami
Like Someone in Love

Regis Kimble
Salinger

Kevin Klauber
20 Feet from Stardom

Joe Klotz
Lee Daniels' The Butler

Robert Komatsu
Jobs

Alexander Kopit
Europa Report

Matthew Kosinski
Jackass Presents: Bad Grandpa

Matthieu Laclau
A Touch of Sin

Ghalia Lacroix
Blue is the Warmest Color

Matt(hew) Landon
Escape From Planet Earth
Lovelace

Jennifer Lane
Frances Ha

Albertine Lastera
Blue is the Warmest Color

Tony Lawson
Byzantium

Dan Lebental
Thor: The Dark World

Robert Leighton
Now You See Me

Jean-Marie Lengelle
Blue is the Warmest Color

Alisa Lepselter
Blue Jasmine

Allen Leung
Drug War

Xudong Lin
A Touch of Sin

Mark Livolsi
Saving Mr. Banks
Stand Up Guys

Natalia Lopez
Post Tenebras Lux

Richard Lowe (1942-)
Muscle Shoals

Richard G. Lowe (1942-)
See Richard Lowe

Sam Lowry (1963-)
See Steven Soderbergh

Paul Machliss
The World's End

Diego Macho
Crystal Fairy & the Magical Cactus

James Ryan
 Turbo

Robert Rzesacz
 The Silence

Jose Salcedo
 I'm So Excited

Mike Sale
 We're the Millers

Eduardo Sanchez (1968-)
 V/H/S/2

Nat Sanders
 Short Term 12

Mark Sanger
 Gravity

Pietro Scalia
 The Counselor

Thelma Schoonmaker (1945-)
 The Wolf of Wall Street

Sam Seig
 Scary Movie 5

Takeshi Seyama
 From Up on Poppy Hill
 The Wind Rises

Brian Shaw
 Evil Dead

Michael P. Shawver
 Fruitvale Station

Lynn Shelton
 Touchy Feely

Terilyn Shropshire
 Black Nativity

Tim Silano
 The Canyons

Sebastian Silva (1979-)
 Crystal Fairy & the Magical Cactus

Lee Smith (1960-)
 Elysium
 Ender's Game

Lee Harold Smith (1962-)
 See Lee Smith

Wyatt Smith
 One Direction: This Is Us
 Thor: The Dark World

Greg Snyder
 Monsters University

Joan Sobel
 Admission

Steven Soderbergh (1963-)
 Side Effects

Marco Spoletini
 Reality

Kevin Stitt
 42

Martin Stoltz
 Kon-Tiki

Crispin Struthers
 American Hustle

Sofia Subercaseaux
 Crystal Fairy & the Magical Cactus

Joe Swanberg (1981-)
 All the Light in the Sky
 Drinking Buddies

Vincent Tabaillon
 Now You See Me

Troy Takaki
 Baggage Claim

Pierre Takal
 One Direction: This Is Us

Kevin Tent
 Nebraska

Peter Teschner
 Identity Thief

Frederic Thoraval
 Dead Man Down

Camille Toubkis
 Blue is the Warmest Color

Cristiano Travaglioli
 The Great Beauty

Michael Tronick
 2 Guns

Takanori Tsujimoto
 The ABCs of Death

Jean-Marc Vallee
 Dallas Buyers Club

Jonathan Van Tulleken
 Movie 43

Matt Villa
 The Great Gatsby

Marc Vives
 Museum Hours

Christian Wagner
 Fast & Furious 6

Joe Walker
 12 Years a Slave

Mark Warner
 Parker

Stan Webb
 Cloudy with a Chance of Meatballs 2

Andrew Weisblum
 The East

Juliette Welfling
 The Past

Ben Wheatley
 Sightseers

Joss Whedon (1964-)
 Much Ado About Nothing

Brent White
 Anchorman 2: The Legend Continues
 The Heat

Martin Wichmann
 The ABCs of Death

John. Wilson
 The Book Thief

Adam Wingard
 V/H/S/2
 You're Next

Scott Winlaw
 Escape From Planet Earth

Adam Wolfe
 White House Down

Craig Wood
 The Lone Ranger

Yudai Yamaguchi
 The ABCs of Death

Aaron Yanes
 Europa Report

Toby Yates
 Bless Me, Ultima

Mack Yoshikawa
 To the Wonder

Avi Youabian
 The Call

Jason Zeldes
 20 Feet from Stardom

Dan Zimmerman
 A Good Day to Die Hard

Dean Zimmerman
 The Internship

Don Zimmerman
 RED 2

Lucia Zucchetti
 Closed Circuit

Lauren Zuckerman
 Don Jon

Eric Zumbrunnen
 Her

Art Director Index

Kevin R. Adams
 Free Birds

Michael Ahern
 Europa Report

Grace Alie
 Short Term 12

Scott Anderson (1959-)
 Paranoia

Tony Au
 The Grandmaster

Ramsey Avery
 Star Trek Into Darkness

Blair Barnette
 Sightseers

Toni Barton
 The Big Wedding

Christopher Beach (1959-)
 Metallica Through the Never

Christopher John Beach (1959-)
 See *Christopher Beach*

Eric Berg
 The To Do List

Greg Berry
 Ender's Game

David Bleich
 Cloudy with a Chance of Meat-
 balls 2

Gilles Boillot
 The Family

Peter Borck
 Oldboy

Alex Cameron
 The Counselor

Charlie Campbell
 The Call

Ryan Carlson
 Planes

Jean-Andre Carriere
 Riddick

Raymond Chan
 Thor: The Dark World

Alexios Chrysikos
 Kill Your Darlings

Sarah Contant
 Runner Runner

Quito Cooksey
 Arthur Newman

Steve Cooper
 Lone Survivor

Bill Crutcher
 The Book Thief

Ann Cummings
 Girl Rising

Elizabeth Cummings
 Don Jon

Charlo Dalli
 Captain Phillips

Adam Davis
 The Hunger Games: Catching
 Fire

Jennifer Dehghan
 Disconnect

Peter Dorme
 The World's End

Idoia Esteban
 The ABCs of Death

Christina Eunji Kim
 Broken City

Robert Fechtman
 The Hunger Games: Catching
 Fire

Ashley Fenton
 In a World...

Sarah Finlay
 Berberian Sound Studio

Luke Freeborn
 Enough Said

Gary Freeman (1945-)
 47 Ronin

Jason Garner
 Insidious: Chapter 2

Mark Garner
 Last Vegas

James Gelarden
 Escape Plan

Michael Giaimo
 Frozen

Elliott Glick
 Anchorman 2: The Legend Con-
 tinues
 We're the Millers

Michael E. Goldman
 Blue Jasmine

Music Director Index

Ryan Amon
 Elysium

Michael Andrews
 The Heat
 The Reluctant Fundamentalist

Craig Armstrong (1959-)
 The Great Gatsby

Yitzhak Azulay
 Fill the Void

Lorne Balfe
 Girl Rising
 Salinger

Roque Banos (1968-)
 Evil Dead
 Oldboy

Nathan Barr
 The Big Wedding

Tyler Bates
 Movie 43

Jeff Beal (1963-)
 Blackfish

Christophe Beck (1972-)
 Frozen
 The Hangover, Part III
 The Internship
 Movie 43
 R.I.P.D.
 Runner Runner

Marco Beltrami (1966-)
 Carrie
 A Good Day to Die Hard
 Warm Bodies

The Wolverine
World War Z

Joseph Bishara
 The Conjuring
 Dark Skies
 Insidious: Chapter 2

Phillip Blackford
 The ABCs of Death

Griffin Boice
 The Lords of Salem

Tim Boland
 A Band Called Death

Simon Boswell (1956-)
 The ABCs of Death

Jon Brion (1963-)
 Delivery Man

Nicholas Britell
 Gimme the Loot

David Buckley
 Parker

Justin Caine Burnett (1973-)
 Getaway

Carter Burwell (1955-)
 The Fifth Estate

Carlos Cabezas
 No

Andy Cabic
 After Tiller

Brendan Canning
 The Canyons

Shane Carruth (1972-)
 Upstream Color

Benoit Charest
 Upside Down

Keefus Ciancia
 Diana

Stanley Clarke (1951-)
 The Best Man Holiday

Jonas Colstrup
 The Square

Robin Coudert
 Maniac

John Debney (1956-)
 The Call
 Jobs

Alexandre Desplat (1961-)
 Philomena
 Reality
 Renoir

Ramin Djawadi (1974-)
 Pacific Rim

Alex Ebert
 All is Lost

Nikolaj Egelund
 The Hunt

Danny Elfman (1953-)
 American Hustle
 Epic
 Oz the Great and Powerful

Ilan Eshkeri
 Austenland

Kyle McKinnon
 You're Next

Andre Mergenthaler
 Hannah Arendt

Ryan Miller
 In a World...
 The Kings of Summer

Steve Moore
 V/H/S/2

Nobuhiko Morino
 The ABCs of Death

Trevor Morris (1970-)
 Olympus Has Fallen

Barb Morrison
 Concussion

Mark Mothersbaugh (1950-)
 Cloudy with a Chance of Meat-
 balls 2
 Last Vegas

Mowg
 The Last Stand

Nico Muhly (1981-)
 Kill Your Darlings

Kou Nakagawa
 The ABCs of Death

John Nau
 Anchorman 2: The Legend Con-
 tinues

Javier Navarrete (1956-)
 Byzantium

Sarah Neufeld
 Blue Caprice

Eric Neveux (1972-)
 The Attack

Randy Newman (1943-)
 Monsters University

Thomas Newman (1955-)
 Saving Mr. Banks
 Side Effects

Mary Margaret O'Hara
 Museum Hours

Orange Mighty Trio
 All the Light in the Sky

Mark Orton
 Nebraska

Atli Orvarsson
 Hansel & Gretel: Witch Hunters
 The Mortal Instruments: City of
 Bones

John Ottman (1964-)
 Jack the Giant Slayer

Atli Ovarsson
 A Single Shot

Owen Pallett
 Her

Mike Patton
 The Place Beyond the Pines

Daniel Pemberton
 The Counselor

Heitor Pereira
 Despicable Me 2
 The Smurfs 2

Julio Pillado
 The ABCs of Death

Antonio Pinto
 The Host
 Snitch

Aria Prayogi
 V/H/S/2

Steven Price
 Gravity
 The World's End

Trevor Rabin (1954-)
 Grudge Match

Mary Ramos
 Beautiful Creatures

Kennard Ramsey
 Kevin Hart: Let Me Explain

Brian Reitzell (1966-)
 The Bling Ring

Sam Retzer
 A Band Called Death

Graeme Revell (1955-)
 Riddick

Graham Reynolds (1971-)
 Before Midnight

Max Richter
 Disconnect
 Lore

Johannes Ringen
 The ABCs of Death

Robert Rodriguez (1968-)
 Machete Kills

Jeff Rona (1957-)
 Phantom

Atticus Ross
 Broken City

Leopold Ross
 Broken City

Laura Rossi
 Unfinished Song

Tom Rowlands
 Now You See Me

Reza Safinia
 Filly Brown

H. Scott Salinas
 The Square

Gustavo Santaolalla (1951-)
 August: Osage County

Claudia Sarne
 Broken City

Theodore Shapiro (1971-)
 The Secret Life of Walter Mitty
 We're the Millers

Raney Shockne
 The To Do List

Howard Shore (1946-)
 The Hobbit: The Desolation of
 Smaug

Clinton Shorter (1971-)
 2 Guns

Alan Silvestri (1950-)
 The Croods
 RED 2

Ed Simons
 Now You See Me

Rob Simonsen (1978-)
 The Spectacular Now
 The Way Way Back

Cezary Skubiszewski
 The Sapphires

Rick Smith (1959-)
 Trance

Vinny Smith
 Touchy Feely

Jonathan Snipes
 Room 237

Johan Soderqvist (1966-)
 Kon-Tiki
 Love Is All You Need

Sam Spiegel
 Jackass Presents: Bad Grandpa

Colin Stetson
 Blue Caprice

Pedro Subercaseaux
 Crystal Fairy & the Magical Cac-
 tus

Satoshi Takebe
 From Up on Poppy Hill

Joby Talbot (1971-)
 Closed Circuit

Performer Index

Kelsey Abbott
 V/H/S/2

Jake Abel (1987-)
 The Host
 Percy Jackson: Sea of Monsters

F. Murray Abraham (1939-)
 Dead Man Down

Roy Abramsohn
 Escape From Tomorrow

Nathalia Acevedo
 Post Tenebras Lux

Amy Acker (1976-)
 Much Ado About Nothing

Amy Adams (1974-)
 American Hustle
 Her
 Man of Steel

Jane Adams (1940-)
 All the Light in the Sky

Jane Ellen Adams (1940-)
 See Jane Adams

Joey Lauren Adams (1971-)
 Blue Caprice

Barkhad Adbi
 Captain Phillips

Ben Affleck (1972-)
 Runner Runner
 To the Wonder

Casey Affleck (1975-)
 Ain't Them Bodies Saints
 Out of the Furnace

Dianna Agron (1986-)
 The Family

Elyes Aguis
 The Past

Riz Ahmed (1982-)
 Closed Circuit
 The Reluctant Fundamentalist

Adewale Akinnuoye-Agbaje (1967-)
 Bullet to the Head

Hannah Al-Rashid
 V/H/S/2

Carlos Alazraqui
 Planes (*V*)

Jessica Alba (1981-)
 Escape From Planet Earth (*V*)
 Machete Kills

Fachry Albar
 V/H/S/2

Jaimie Alexander (1984-)
 The Last Stand

Genevieve Alexandra
 Maniac

Mahershala Ali (1974-)
 The Place Beyond the Pines

Roger Allam (1953-)
 The Book Thief

Laz Alonso (1974-)
 Battle of the Year

Maria Conchita Alonso (1957-)
 The Lords of Salem

Stephen Alpert
 The Wind Rises (*V*)

Reymond Amsalem
 The Attack

Gillian Anderson (1968-)
 From Up on Poppy Hill (*V*)
 Shadow Dancer

Joe Anderson (1982-)
 A Single Shot

Naveen Andrews (1971-)
 Diana

Jennifer Aniston (1969-)
 We're the Millers

Hideaki Anno
 The Wind Rises (*V*)

Aziz Ansari (1983-)
 Epic (*V*)

Christina Applegate (1971-)
 Anchorman 2: The Legend Continues

Onata Aprile
 What Maisie Knew

Tomas Arana (1959-)
 Romeo & Juliet

Carlos Areces
 I'm So Excited

Aniello Arena
 Reality

Raul Arevalo
 I'm So Excited

Moises Arias (1994-)
 Despicable Me 2 (*V*)
 The Kings of Summer

Jonathan Aris
 Sightseers

Alan Arkin (1934-)
 Grudge Match
 The Incredible Burt Wonderstone
 Stand Up Guys

Felix Armand
 Something in the Air

Richard Armitage (1971-)
 The Hobbit: The Desolation of
 Smaug

Nora Arnezeder
 Maniac

Gemma Arterton (1986-)
 Byzantium
 Hansel & Gretel: Witch Hunters
 Runner Runner
 Unfinished Song

Tadanobu Asano (1973-)
 47 Ronin

Pilou Asbaek (1982-)
 A Hijacking

Armand Assante (1949-)
 Dead Man Down

Skylar Astin (1987-)
 21 & Over

Eileen Atkins (1934-)
 Beautiful Creatures

Essence Atkins (1972-)
 A Haunted House

Hank Azaria (1964-)
 Lovelace
 The Smurfs 2 (*V*)

Kevin Bacon (1958-)
 R.I.P.D.

Kathy Baker (1950-)
 Saving Mr. Banks

Alec Baldwin (1958-)
 Blue Jasmine

Christian Bale (1974-)
 American Hustle
 Out of the Furnace

Eric Bana (1968-)
 Closed Circuit
 Lone Survivor

Antonio Banderas (1960-)
 Machete Kills

Elizabeth Banks (1974-)
 The Hunger Games: Catching
 Fire
 Movie 43

David Banner
 Lee Daniels' The Butler

Javier Bardem (1969-)
 The Counselor
 To the Wonder

Ben Barnes
 The Big Wedding

Justin Bartha (1978-)
 The Hangover, Part III

Jay Baruchel (1982-)
 This Is the End

Angela Bassett (1958-)
 Black Nativity
 Olympus Has Fallen

Gabriel Basso
 The Kings of Summer

Jason Bateman (1969-)
 Disconnect
 Identity Thief

Bryan Batt
 12 Years a Slave

Dave Bautista (1969-)
 Riddick

Stephanie Beatriz
 Short Term 12

Jason Beghe (1960-)
 Phantom

Nicole Beharie
 42

Berenice Bejo
 The Past

Zoe Belkin
 Carrie

Ashley Bell (1986-)
 The Last Exorcism Part II

Kristen Bell (1980-)
 Frozen (*V*)

Lake Bell (1979-)
 In a World...

Maria Bello
 Prisoners

Maria Bello (1967-)
 Grown Ups 2

L.J. Benet
 Dark Skies

Annette Bening (1958-)
 Ginger & Rosa

Ashley Benson (1989-)
 Spring Breakers

Ingrid Bolso Berdal
 The ABCs of Death (*V*)

Gael Garcia Bernal (1978-)
 No

Jon Bernthal (1977-)
 Snitch
 The Wolf of Wall Street

Halle Berry (1968-)
 The Call
 Movie 43

Paul Bettany (1971-)
 Iron Man 3 (*V*)

Demian Bichir (1963-)
 The Heat
 Machete Kills

Rachel Bilson (1981-)
 The To Do List

Harley Bird
 How I Live Now

Lucas Black (1982-)
 42

Elizabeth Blackmore
 Evil Dead

Tammy Blanchard (1976-)
 Blue Jasmine

Cate Blanchett (1969-)
 Blue Jasmine
 Girl Rising (*N*)

Mary J. Blige (1971-)
 Black Nativity

Sebastian Blomberg (1972-)
 The Silence

Orlando Bloom (1977-)
 The Hobbit: The Desolation of
 Smaug

Marc Blucas (1972-)
 The Big Wedding

Emily Blunt (1983-)
 Arthur Newman

Jonah Bobo (1997-)
 Disconnect

Kim Bodnia
 Love Is All You Need

Ludi Boeken
 World War Z

Romane Bohringer (1974-)
 Renoir

Sarah Bolger (1991-)
 From Up on Poppy Hill (*V*)

Helena Bonham Carter (1966-)
The Lone Ranger

Douglas Booth (1992-)
Romeo & Juliet

Lindy Booth (1979-)
Kick-Ass 2

Chadwick Boseman
42

Kate (Catherine) Bosworth (1983-)
Homefront
Movie 43

Javier Botet
Mama

Michel Bouquet (1926-)
Renoir

AJ Bowen
You're Next

Jamie Campbell Bower (1988-)
The Mortal Instruments: City of
Bones

David Bradley (1942-)
The World's End

Zach Braff (1975-)
Oz the Great and Powerful (V)

Alice Braga (1983-)
Elysium

Russell Brand (1975-)
Despicable Me 2 (V)

Brandy (1979-)
See Brandy Norwood

Benjamin Bratt (1963-)
Despicable Me 2 (V)
Snitch

Ewen Bremner (1971-)
Jack the Giant Slayer

Brid Brennan (1955-)
Shadow Dancer

Abigail Breslin (1996-)
The Call
Ender's Game

Jordana Brewster (1980-)
Fast & Furious 6

Beau Bridges (1941-)
From Up on Poppy Hill (V)

Chris Bridges (1977-)
Fast & Furious 6

Jeff Bridges (1949-)
R.I.P.D.

Connie Britton (1968-)
The To Do List

Jim Broadbent (1949-)
Closed Circuit

Jan Broberg
Maniac

Adam Brody (1980-)
Lovelace

Josh Brolin (1968-)
Gangster Squad
Oldboy

Amanda Brooks (1981-)
The Canyons

Pierce Brosnan (1953-)
Love Is All You Need
The World's End

Israel Broussard (1994-)
The Bling Ring

Chris Brown (1989-)
Battle of the Year

Clancy Brown (1959-)
John Dies at the End

Dorian Brown
Home Run

Daniel Bruhl (1978-)
The Fifth Estate
Rush

Annie Rose Buckley
Saving Mr. Banks

Rebecca Budig (1973-)
Getaway

Genevieve Bujold (1942-)
Still Mine

Rasha Bukvic (1979-)
A Good Day to Die Hard

Sandra Bullock (1964-)
Gravity
The Heat

Robert John Burke (1961-)
2 Guns

Tom Burke (1981-)
Only God Forgives

Max Burkholder (1997-)
The Purge

Pauline Burlet
The Past

Steve Buscemi (1957-)
Grown Ups 2
The Incredible Burt Wonderstone
Monsters University (V)

Gerard Butler (1969-)
Movie 43
Olympus Has Fallen

Yancy Butler (1970-)
Kick-Ass 2

Asa Butterfield (1997-)
Ender's Game

Agata Buzek
Redemption

P.J. Byrne
The Wolf of Wall Street

Rose Byrne (1979-)
Insidious: Chapter 2
The Internship
The Place Beyond the Pines

James Caan (1939-)
Cloudy with a Chance of Meat-
balls 2 (V)

Daniel Gimenez Cacho (1961-)
Blancanieves

Nicolas Cage (1964-)
The Croods (V)

Michael Caine (1933-)
Now You See Me

Monica Calhoun (1971-)
The Best Man Holiday

James Callis (1971-)
Austenland

Javier Camara (1967-)
I'm So Excited

Christian Camargo (1971-)
Europa Report

Bill Camp
12 Years a Slave

Bruce Campbell (1958-)
Oz the Great and Powerful (C)

Bobby Cannavale (1971-)
Blue Jasmine
Lovelace

Peter Capaldi (1958-)
The Fifth Estate

Susanna Cappellaro
Berberian Sound Studio

Gina Carano (1982-)
Fast & Furious 6

Steve Carell (1962-)
Anchorman 2: The Legend Con-
tinues
Despicable Me 2 (V)
The Incredible Burt Wonderstone
The Way Way Back

Mariah Carey (1969-)
Lee Daniels' The Butler

Keith Carradine (1951-)
 Ain't Them Bodies Saints
Jim Carrey (1962-)
 The Incredible Burt Wonderstone
 Kick-Ass 2
Diahann Carroll (1935-)
 Peeples
Shane Carruth (1972-)
 Upstream Color
Katarina Cas
 The Wolf of Wall Street
Max Casella (1967-)
 Blue Jasmine
Vincent Cassel (1967-)
 Trance
Adolfo Jimenez Castro
 Post Tenebras Lux
Alfredo Castro
 No
Georgina Cates (1975-)
 Jackass Presents: Bad Grandpa
Jim Caviezel
 Escape Plan
Henry Cavill (1983-)
 Man of Steel
Cedric the Entertainer (1964-)
 A Haunted House
 Planes (V)
Michael Cera (1988-)
 Crystal Fairy & the Magical Cactus
 This Is the End
Anna Chancellor (1965-)
 How I Live Now
Kyle Chandler (1965-)
 Broken City
 The Spectacular Now
 The Wolf of Wall Street
Chen 'Chang Chen' Chang (1976-)
 The Grandmaster
Katie Chang
 The Bling Ring
Megan Charpentier
 Mama
Jessica Chastain (1981-)
 Mama
Francois Chau (1959-)
 21 & Over
Don Cheadle (1964-)
 Iron Man 3

Michael Chernus
 Captain Phillips
Morris Chestnut (1969-)
 The Best Man Holiday
 The Call
 Identity Thief
 Kick-Ass 2
Michael Chiklis (1963-)
 Parker
Ambyr Childers
 We Are What We Are
John Cho (1972-)
 Identity Thief
 Star Trek Into Darkness
Justin Chon (1981-)
 21 & Over
Priyanka Chopra
 Planes (V)
Sarita Choudhury (1966-)
 Admission
Anders Baasmo Christiansen
 Kon-Tiki
Julie Christie (1941-)
 The Company You Keep
Jamie Chung (1983-)
 The Hangover, Part III
Eddie Cibrian (1973-)
 The Best Man Holiday
Louis CK (1967-)
 American Hustle
 Blue Jasmine
Sam Claflin (1986-)
 The Hunger Games: Catching Fire
Sophie Kennedy Clark
 Philomena
Spencer Treat Clark (1987-)
 The Last Exorcism Part II
Jason Clarke (1969-)
 The Great Gatsby
 White House Down
Patricia Clarkson (1959-)
 The East
Andrew Dice Clay (1957-)
 See *Andrew Silverstein*
John Cleese (1939-)
 Planes (V)
Adelaide Clemens (1989-)
 The Great Gatsby
George Clooney (1961-)
 Gravity

Bill Cobbs (1935-)
 Oz the Great and Powerful
Emory Cohen (1990-)
 The Place Beyond the Pines
Lynne Cohen (1944-)
 The Hunger Games: Catching Fire
Toni Collette (1972-)
 Enough Said
 The Way Way Back
Clifton (Gonzalez) Collins, Jr. (1970-)
 Pacific Rim
 Parker
Lily Collins (1989-)
 The Mortal Instruments: City of Bones
Miriam Colon (1945-)
 Bless Me, Ultima
Carole Combes
 Something in the Air
Paddy Considine (1974-)
 The World's End
Steve Coogan (1965-)
 Despicable Me 2 (V)
 Philomena
 What Maisie Knew
Dane Cook (1972-)
 Planes (V)
Christian Cooke
 Romeo & Juliet
Jennifer Coolidge (1963-)
 Austenland
Bradley Cooper (1975-)
 American Hustle
 The Hangover, Part III
 The Place Beyond the Pines
Chris Cooper (1951-)
 August: Osage County
Dominic Cooper (1978-)
 Dead Man Down
Sharlto Copley (1973-)
 Elysium
 Europa Report
 Oldboy
Rob Corddry (1971-)
 Escape From Planet Earth (V)
 In a World...
 Pain & Gain
 Warm Bodies
 The Way Way Back
Miranda Cosgrove (1993-)
 Despicable Me 2 (V)

Nikolaj Coster-Waldau (1970-)
 Mama
 Oblivion

Kevin Costner (1955-)
 Man of Steel

Jai Courtney
 A Good Day to Die Hard

Brian Cox (1946-)
 RED 2

Tony Cox (1958-)
 Oz the Great and Powerful

Barbara Crampton (1962-)
 You're Next

Kenneth Cranham (1944-)
 Closed Circuit

Lola Creton (1993-)
 Something in the Air

James Cromwell (1940-)
 Still Mine

David Cross (1964-)
 Kill Your Darlings

Russell Crowe (1964-)
 Broken City
 Man of Steel

Tom Cruise (1962-)
 Oblivion

Penelope Cruz (1974-)
 The Counselor

Billy Crystal (1947-)
 Monsters University (*V*)

Kieran Culkin (1982-)
 Movie 43

Benedict Cumberbatch (1977-)
 August: Osage County
 The Fifth Estate
 The Hobbit: The Desolation of
 Smaug (*V*)
 Star Trek Into Darkness
 12 Years a Slave

Alan Cumming (1965-)
 The Smurfs 2 (*V*)

Jane Curtin (1947-)
 The Heat

Jamie Lee Curtis (1958-)
 From Up on Poppy Hill (*V*)

Vondie Curtis-Hall (1956-)
 Black Nativity

John Cusack (1966-)
 Lee Daniels' The Butler

Alexandra Daddario (1986-)
 Percy Jackson: Sea of Monsters
 Texas Chainsaw 3D

Willem Dafoe (1955-)
 Out of the Furnace

James Badge Dale (1978-)
 Iron Man 3
 The Lone Ranger
 World War Z

Jack Dalton
 Escape From Tomorrow

Matt Damon (1970-)
 Elysium

Paul Dano (1984-)
 Prisoners
 12 Years a Slave

Tony Danza (1951-)
 Don Jon

Robert Davi (1951-)
 The Iceman

Embeth Davidtz (1965-)
 Europa Report
 Paranoia

Eileen Davies
 Sightseers

Geena Davis (1957-)
 In a World...

Hope Davis (1964-)
 Disconnect

Viola Davis (1952-)
 Beautiful Creatures
 Ender's Game
 Prisoners

Bruce Davison (1946-)
 The Lords of Salem

Rosario Dawson (1979-)
 Trance

Charlie Day (1976-)
 Pacific Rim

Robert De Niro (1943-)
 The Big Wedding
 The Family
 Grudge Match
 Last Vegas

Melissa De Sousa (1967-)
 The Best Man Holiday

James Deen
 The Canyons

Michael Degan
 Hannah Arendt

Dane DeHaan (1987-)
 Kill Your Darlings
 Metallica Through the Never
 The Place Beyond the Pines

Simon Delaney
 Delivery Man

Julie Delpy (1969-)
 Before Midnight

Judi Dench (1934-)
 Philomena

David Denham (1973-)
 After Earth

Alexis Denisof (1966-)
 Much Ado About Nothing

Kat Dennings (1986-)
 Thor: The Dark World

Johnny Depp (1963-)
 The Lone Ranger

Bruce Dern (1936-)
 From Up on Poppy Hill (*V*)
 Nebraska

Kaitlyn Dever
 Short Term 12

James Devoti (1979-)
 Home Run

Rosemarie DeWitt (1974-)
 Touchy Feely

Reed Edward Diamond (1964-)
 Much Ado About Nothing

Cameron Diaz (1972-)
 The Counselor

Jorge Diaz
 Filly Brown

Melonie Diaz (1984-)
 Fruitvale Station

Leonardo DiCaprio (1974-)
 The Great Gatsby
 The Wolf of Wall Street

Kim Dickens (1965-)
 At Any Price

Vin Diesel (1967-)
 Fast & Furious 6
 Riddick

Taye Diggs (1972-)
 Baggage Claim
 The Best Man Holiday

John DiLeo (1961-)
 The Family

Garret Dillahunt (1964-)
 12 Years a Slave

Monica Dolan
 Sightseers

Will Ferrell (1968-)
 Anchorman 2: The Legend Continues
Miguel Ferrer (1954-)
 Iron Man 3
Larry Fessenden (1963-)
 All the Light in the Sky
Tina Fey (1970-)
 Admission
William Fichtner (1956-)
 Elysium
 The Lone Ranger
 Phantom
Nathan Fillion (1971-)
 Monsters University (V)
 Much Ado About Nothing
 Percy Jackson: Sea of Monsters
Colin Firth (1960-)
 Arthur Newman
Laurence Fishburne (1963-)
 Man of Steel
Elsie Fisher
 Despicable Me 2 (V)
Frances Fisher (1952-)
 The Host
Isla Fisher (1976-)
 The Great Gatsby
 Now You See Me
Sean Patrick Flanery (1965-)
 Phantom
Cristina Flutur
 Beyond the Hills
Lasse Fogelstrom
 The Hunt
Dan Fogler (1976-)
 Europa Report
Dave Foley (1963-)
 Monsters University (V)
Jane Fonda (1937-)
 Lee Daniels' The Butler
Santino Fontana
 Frozen (V)
Colin Ford (1996-)
 Disconnect
Harrison Ford (1942-)
 Ender's Game
 42
 Paranoia
Ken Foree (1948-)
 The Lords of Salem

Robert Forster (1941-)
 Olympus Has Fallen
Will Forte (1970-)
 Cloudy with a Chance of Meatballs 2 (V)
 Nebraska
Ben Foster (1980-)
 Ain't Them Bodies Saints
 Kill Your Darlings
 Lone Survivor
Jodie Foster (1963-)
 Elysium
Meg Foster (1948-)
 The Lords of Salem
Matthew Fox (1966-)
 Emperor
Vivica A. Fox (1964-)
 Home Run
Jamie Foxx (1967-)
 White House Down
Dave Franco (1985-)
 Now You See Me
 Warm Bodies
James Franco (1978-)
 The Iceman
 Lovelace
 Oz the Great and Powerful
 Spring Breakers
 This Is the End
Brendan Fraser (1968-)
 Escape From Planet Earth (V)
James Frecheville
 Adore
Martin Freeman (1971-)
 The Hobbit: The Desolation of Smaug
 The World's End
Morgan Freeman (1937-)
 Last Vegas
 Now You See Me
 Oblivion
 Olympus Has Fallen
Paul Freeman (1943-)
 Getaway (V)
Andre Frid
 Lore
Nick Frost (1972-)
 The World's End
Patrick Fugit (1982-)
 Thanks for Sharing
Rila Fukushima
 The Wolverine

Nolan Gerard Funk
 The Canyons
Nolan Gerard Funk (1986-)
 Riddick
Cosimo Fusco
 Berberian Sound Studio
Josh Gad (1981-)
 Frozen (V)
 The Internship
 Jobs
 Thanks for Sharing
Gal Gadot (1985-)
 Fast & Furious 6
Lady Gaga
 Machete Kills
Dana Gaier
 Despicable Me 2 (V)
Zach Galifianakis (1969-)
 The Hangover, Part III
John Gallagher, Jr. (1984-)
 Short Term 12
Kyle Gallner (1986-)
 Beautiful Creatures
Luke Ganalon
 Bless Me, Ultima
James Gandolfini (1961-2013)
 Enough Said
 The Incredible Burt Wonderstone
Godfrey Gao
 The Mortal Instruments: City of Bones
Macarena Garcia (1988-)
 Blancanieves
Troy Garity (1973-)
 Gangster Squad
Jennifer Garner (1972-)
 Dallas Buyers Club
Julia Garner
 We Are What We Are
Brad Garrett (1960-)
 Planes (V)
Uri Gavriel (1955-)
 The Attack
Rafi Gavron (1989-)
 Snitch
Ivailo Geraskov
 Getaway
Richard Gere (1949-)
 Movie 43
Ricky Gervais (1961-)
 Escape From Planet Earth (V)

Getaway
The Purge

Sally Hawkins (1976-)
Blue Jasmine

Salma Hayek (1966-)
Girl Rising (*N*)
Grown Ups 2

Sean P. Hayes (1970-)
Monsters University (*V*)

Anthony Head (1954-)
Percy Jackson: Sea of Monsters

Lena Headey (1976-)
The Mortal Instruments: City of
Bones
The Purge

Glenne Headly (1955-)
Don Jon

Amber Heard (1986-)
Machete Kills
Paranoia

John Heard (1946-)
Runner Runner

Anne Heche (1969-)
Arthur Newman

Lucas Hedges
Arthur Newman

Garrett Hedlund (1984-)
Inside Llewyn Davis

Katherine Heigl (1978-)
The Big Wedding

Jonathan Morgan Heit
Escape From Planet Earth (*V*)

Ed Helms (1974-)
The Hangover, Part III
We're the Millers

Chris Hemsworth (1983-)
Rush
Thor: The Dark World

Liam Hemsworth (1990-)
The Hunger Games: Catching
Fire
Paranoia

Christina Hendricks (1975-)
Ginger & Rosa

Lance Henriksen (1940-)
Phantom

Dolores Heredia (1966-)
Bless Me, Ultima

Roberto Herlitzka (1937-)
The Great Beauty

Peter Hermann (1967-)
Philomena

Barbara Hershey (1948-)
Insidious: Chapter 2

Louis Herthum
The Last Exorcism Part II

Ty Hickson
Gimme the Loot

Tom Hiddleston
Thor: The Dark World

Jonah Hill (1983-)
This Is the End
The Wolf of Wall Street

Ciaran Hinds (1953-)
Closed Circuit

Emile Hirsch (1985-)
Lone Survivor
Prince Avalanche

Douglas Hodge (1960-)
Diana

Edwin Hodge (1985-)
The Purge

Gaby Hoffman (1982-)
Crystal Fairy & the Magical Cac-
tus

Philip Seymour Hoffman (1967-
2014)
The Hunger Games: Catching
Fire

Alexandra Holden (1977-)
In a World...

Tom Holland (1996-)
How I Live Now

Tom Hollander (1969-)
About Time

Josh Holloway (1969-)
Battle of the Year
Paranoia

James Hong (1929-)
R.I.P.D.

Anthony Hopkins (1937-)
RED 2
Thor: The Dark World

Niall Horan
One Direction: This Is Us

Anna Maria Horsford (1948-)
Tyler Perry's A Madea Christmas

Julianne Hough (1988-)
Safe Haven

Nicholas Hoult (1989-)
Jack the Giant Slayer
Warm Bodies

Tenille Houston
The Canyons

Terrence Howard (1969-)
The Best Man Holiday
The Company You Keep
Dead Man Down
Lee Daniels' The Butler
Movie 43
Prisoners

Yi Huang
Drug War

Vanessa Anne Hudgens (1988-)
Machete Kills
Spring Breakers

Jennifer Hudson (1981-)
Black Nativity

Kate Hudson (1979-)
The Reluctant Fundamentalist

Hannah Hughes
V/H/S/2

Charlie Hunnam (1980-)
Pacific Rim

Isabelle Huppert (1955-)
Dead Man Down

William Hurt (1950-)
The Host

Jack Huston (1982-)
American Hustle
Kill Your Darlings

Josh Hutcherson (1992-)
Epic (*V*)
The Hunger Games: Catching
Fire

Michael Imperioli (1966-)
The Call
Oldboy

Jeremy Irons (1948-)
Beautiful Creatures

Max Irons (1985-)
The Host

Oscar Isaac (1980-)
Inside Llewyn Davis

Jason Isaacs (1963-)
A Single Shot

Hugh Jackman (1968-)
Movie 43
Prisoners
The Wolverine

Johnny Knoxville (1971-)
Jackass Presents: Bad Grandpa
The Last Stand
Movie 43

Sebastian Koch (1962-)
A Good Day to Die Hard

Boris Kodjoe (1973-)
Baggage Claim

David Koechner (1962-)
Anchorman 2: The Legend Continues
A Haunted House

Louis Koo
Drug War

Rachel Korine (1986-)
Spring Breakers

Fran Kranz (1983-)
Much Ado About Nothing

Lenny Kravitz (1964-)
The Hunger Games: Catching Fire
Lee Daniels' The Butler

Zoe Kravitz (1988-)
After Earth

Diane Kruger (1976-)
The Host

Mila Kunis (1983-)
Oz the Great and Powerful

Olga Kurkulina
Kick-Ass 2

Olga Kurylenko (1979-)
Oblivion
To the Wonder

Epy Kusnandar
V/H/S/2

Ashton Kutcher (1978-)
Jobs

Paloma Kwiatkowsi
Percy Jackson: Sea of Monsters

Shia LaBeouf (1986-)
The Company You Keep

Ka Tung Lam
Drug War

Suet Lam
Drug War

Diane Lane (1965-)
Man of Steel

Margaret Laney
You're Next

Alexandra Maria Lara (1978-)
Rush

Larry the Cable Guy (1963-)
Tyler Perry's A Madea Christmas

Thomas Bo Larsen (1963-)
The Hunt

Brie Larson (1989-)
Short Term 12
The Spectacular Now

Sanaa Lathan (1971-)
The Best Man Holiday

Jacob Latimore (1996-)
Black Nativity

Melanie Laurent (1983-)
Now You See Me

Taylor Lautner (1992-)
Grown Ups 2

Jude Law (1972-)
Side Effects

Jennifer Lawrence (1990-)
American Hustle
The Hunger Games: Catching Fire

Julie Fain Lawrence
Concussion

Cung Le
The Grandmaster

Cloris Leachman (1930-)
The Croods (V)

Byung-hun Lee (1970-)
RED 2

Will Yun Lee (1971-)
The Wolverine

John Leguizamo (1964-)
Kick-Ass 2
Walking with Dinosaurs 3D (V)

Jennifer Jason Leigh (1963-)
Kill Your Darlings
The Spectacular Now

Harry J. Lennix (1964-)
Man of Steel

Melissa Leo (1960-)
Oblivion
Olympus Has Fallen
Prisoners

Logan Lerman (1992-)
Percy Jackson: Sea of Monsters

Jared Leto (1971-)
Dallas Buyers Club

Tony Leung Chiu-Wai (1962-)
The Grandmaster

Lawrence Michael Levine
V/H/S/2

Ted Levine (1958-)
A Single Shot

Jane Levy (1989-)
Evil Dead

Damian Lewis (1971-)
Romeo & Juliet

Juliette Lewis (1973-)
August: Osage County

Nico Liersch
The Book Thief

Evangeline Lilly (1979-)
The Hobbit: The Desolation of Smaug

Hamish Linklater (1976-)
42

Ray Liotta (1955-)
The Iceman
The Place Beyond the Pines

Eric Lively (1981-)
Tyler Perry's A Madea Christmas

Ron Livingston (1968-)
The Conjuring
Drinking Buddies

Heather Locklear (1962-)
Scary Movie 5

Jacob Lofland
Mud

Rylan Logan
V/H/S/2

Lindsay Lohan (1986-)
The Canyons
Scary Movie 5

Justin Long (1978-)
Movie 43
Walking with Dinosaurs 3D (V)

Nia Long (1970-)
The Best Man Holiday

Jennifer Lopez (1970-)
Parker

Caity Lotz
Battle of the Year

Julia Louis-Dreyfus (1961-)
Enough Said
Planes (V)

Alice Lowe
Sightseers

Sophie Lowe (1990-)
Adore

Jessica Lucas (1985-)
Evil Dead

Ludacris (1977-)
 See *Chris Bridges*

Derek Luke (1974-)
 Baggage Claim

Joanna Lumley (1946-)
 The Wolf of Wall Street

Diego Luna (1979-)
 Elysium

Lanshan Luo
 A Touch of Sin

Jane Lynch (1960-)
 Afternoon Delight
 Escape From Planet Earth (*V*)

David Lyons (1976-)
 Safe Haven

Seth MacFarlane (1973-)
 Movie 43

Justina Machado (1972-)
 The Call

George MacKay (1992-)
 How I Live Now

Anthony Mackie (1979-)
 Gangster Squad
 Pain & Gain
 Runner Runner

Shirley MacLaine (1934-)
 The Secret Life of Walter Mitty

William H. Macy (1950-)
 A Single Shot

Roma Maffia (1958-)
 The Call

Tobey Maguire (1975-)
 The Great Gatsby

Annet Mahendru
 Escape From Tomorrow

Sean Maher (1975-)
 Much Ado About Nothing

Sean Mahon
 Philomena

Deborah Mailman (1972-)
 The Sapphires

Rami Malek (1981-)
 Short Term 12

Zayn Malik
 One Direction: This Is Us

Kai-Peter Malina (1989-)
 Lore

John Malkovich (1953-)
 RED 2
 Warm Bodies

Soren Malling
 A Hijacking

Jena Malone (1984-)
 The Hunger Games: Catching
 Fire

Aasif Mandvi (?-1966)
 The Internship

Leslie Mann (1972-)
 The Bling Ring

Thomas Mann (1991-)
 Beautiful Creatures

Lesley Manville (1956-)
 Romeo & Juliet

Rooney Mara (1985-)
 Ain't Them Bodies Saints
 Her
 Side Effects

Mark Margolis (1939-)
 Stand Up Guys

Julianna Margulies (1966-)
 Stand Up Guys

Anamaria Marinca
 Europa Report

Ken Marino (1968-)
 In a World...

Brit Marling (1982-)
 The East

Eddie Marsan (1968-)
 Jack the Giant Slayer
 The World's End

James Marsden (1973-)
 Lee Daniels' The Butler
 2 Guns

Demetri Martin (1973-)
 In a World...

Margo Martindale (1951-)
 August: Osage County
 Beautiful Creatures

Benito Martinez (1971-)
 Bless Me, Ultima

Thiago Martins
 Upstream Color

Jessica Mauboy (1989-)
 The Sapphires

Jodhi May (1975-)
 Ginger & Rosa

Rob Mayes
 John Dies at the End

Jayma Mays (1979-)
 The Smurfs 2

Joseph Mazzello (1983-)
 G.I. Joe: Retaliation

Rachel McAdams (1976-)
 About Time
 To the Wonder

James McAvoy (1979-)
 Trance

Jack McBrayer
 Movie 43

Danny McBride (1976-)
 This Is the End

Ruth McCabe
 Philomena

Holt McCallany (1964-)
 Bullet to the Head
 Gangster Squad

Melissa McCarthy (1970-)
 The Hangover, Part III
 The Heat
 Identity Thief

Vicky McClure
 Redemption

Matthew McConaughey (1969-)
 Dallas Buyers Club
 Mud
 The Wolf of Wall Street

Dylan McDermott (1962-)
 Olympus Has Fallen

Neal McDonough (1966-)
 RED 2

Natascha (Natasha) McElhone
 (1969-)
 Romeo & Juliet

Danny McEvoy
 How I Live Now

Kelly McGillis (1957-)
 We Are What We Are

John C. McGinley (1959-)
 42

Ewan McGregor (1971-)
 August: Osage County
 Jack the Giant Slayer

Ian McKellen (1939-)
 The Hobbit: The Desolation of
 Smaug

Bret McKenzie (1976-)
 Austenland

Julian McMahon (1968-)
 Paranoia

Scoot McNairy
 Touchy Feely
 12 Years a Slave

Ian McShane (1942-)
 Jack the Giant Slayer

Janet McTeer (1962-)
 Hannah Arendt

Tim Meadows (1961-)
 Grown Ups 2

Colm Meaney (1953-)
 Free Birds (*V*)

Derek Mears
 Hansel & Gretel: Witch Hunters

Fred Melamed (1956-)
 In a World...

Christopher Meloni (1961-)
 42
 Man of Steel

Ben Mendelsohn (1969-)
 Adore
 The Place Beyond the Pines

Eva Mendes (1974-)
 The Place Beyond the Pines

India Menuez
 Something in the Air

Idina Menzel (1971-)
 Frozen (*V*)

Stephen Merchant (1974-)
 Movie 43

S. Epatha Merkerson (1952-)
 Peeples

Ryan Merriman (1983-)
 42

Clement Metayer
 Something in the Air

Mads Mikkelsen (1965-)
 The Hunt

Axel Milberg
 Hannah Arendt

Cristin Milioti
 The Wolf of Wall Street

Jonny Lee Miller (1972-)
 Byzantium

Max Minghella (1985-)
 The Internship

Christopher Mintz-Plasse (1989-)
 Kick-Ass 2
 The To Do List

Ilyena Vasilievna Mironov (1945-)
 See Helen Mirren

Dame Helen Mirren (1945-)
 See Helen Mirren

Helen Mirren (1945-)
 Monsters University (*V*)
 RED 2

Radha Mitchell (1973-)
 Olympus Has Fallen

Matthew Modine (1959-)
 Jobs

Jane Moffat
 Mama

Jay Mohr (1970-)
 The Incredible Burt Wonderstone

Wotan Wilke Mohring (1967-)
 The Silence

Alfred Molina (1953-)
 Monsters University (*V*)

Angela Molina (1955-)
 Blancanieves

Jordi Molla (1968-)
 Riddick

Jason Momoa (1979-)
 Bullet to the Head

Kaori Momoi (1952-)
 Emperor

Maika Monroe
 At Any Price

Sheri Moon Zombie (1970-)
 The Lords of Salem

Q. Moonblood (1946-)
 See Sylvester Stallone

Alecia Moore (1979-)
 Thanks for Sharing

Julianne Moore (1961-)
 Carrie
 Don Jon
 What Maisie Knew

Rob Moran (1963-)
 You're Next

Laura Morante (1956-)
 Romeo & Juliet

Chloe Grace Moretz (1997-)
 Carrie
 Girl Rising (*N*)
 Kick-Ass 2

Jillian Morgese
 Much Ado About Nothing

Erin Moriarty
 The Kings of Summer

Glenn Morshower (1959-)
 After Earth

Ali Mosaffa (1966-)
 The Past

Denis Moschitto
 Closed Circuit

Bill Moseley (1951-)
 Texas Chainsaw 3D

Wagner Moura (1976-)
 Elysium

Colin Moy
 Emperor

Bobby Moynihan
 Delivery Man

Mr. Wiggles (1977-)
 See Chris Bridges

Carey Mulligan (1985-)
 The Great Gatsby
 Inside Llewyn Davis

Dermot Mulroney (1963-)
 Jobs
 Stoker

Michael Murphy (1938-)
 White House Down

Chad Michael Murray (1981-)
 Fruitvale Station
 Tyler Perry's A Madea Christmas

Rachel Mwanza
 War Witch

Mizinga Mwinga
 War Witch

Kathy Najimy (1957-)
 Tyler Perry's A Madea Christmas

Nas (1973-)
 See Nasir Jones

Liam Neeson (1952-)
 Girl Rising (*N*)

Sam Neill (1948-)
 Escape Plan

Isabelle Nelisse
 Mama

Sophie Nelisse
 The Book Thief

Tim Blake Nelson (1965-)
 Blue Caprice

Julianne Nicholson (1971-)
 August: Osage County

Jackson Nicoll
 Jackass Presents: Bad Grandpa

Bill Nighy (1949-)
 About Time
 Jack the Giant Slayer

Toshiyuki Nishida
 Emperor

Hidetoshi Nishijima
 The Wind Rises (*V*)

Masahiko Nishimura
 The Wind Rises (*V*)

Alessandro Nivola (1972-)
 American Hustle
 Ginger & Rosa

Matt Noble
 Riddick

Amaury Nolasco (1970-)
 A Good Day to Die Hard

Nick Nolte (1941-)
 Gangster Squad
 Parker

Mansai Nomura
 The Wind Rises (*V*)

Eduardo Noriega (1973-)
 The Last Stand

Brandy Norwood (1979-)
 Tyler Perry's Temptation: Confessions of a Marriage Counselor

Chris Noth (1956-)
 Lovelace

B.J. Novak (1979-)
 Saving Mr. Banks

Lupita Nyong'o (1983-)
 12 Years a Slave

Michael Nyqvist (1960-)
 Disconnect
 Europa Report

Dylan O'Brien (1991-)
 The Internship

Bob Odenkirk (1962-)
 Nebraska
 The Spectacular Now

Chris O'Dowd
 Epic (*V*)
 The Sapphires

Nick Offerman (1970-)
 In a World...
 The Kings of Summer
 We're the Millers

Jakob Oftebro
 Kon-Tiki

Mary Margaret O'Hara
 Museum Hours

Denis O'Hare (1962-)
 Dallas Buyers Club

Tao Okamoto
 The Wolverine

Sophie Okonedo (1969-)
 After Earth

Tadashi Okuno
 Like Someone in Love

Gary Oldman (1958-)
 Paranoia

America Olivo
 Maniac

Edward James Olmos (1949-)
 Filly Brown
 2 Guns

Elizabeth Olsen (1989-)
 Kill Your Darlings
 Oldboy

Mike O'Malley (1966-)
 R.I.P.D.

Shaquille O'Neal (1972-)
 Grown Ups 2

Steven H. Oram
 Sightseers

Julia Ormond (1965-)
 The East

Kent Osborne
 All the Light in the Sky

David Otunga
 The Call

Clive Owen (1965-)
 Shadow Dancer

David Oyelowo (1976-)
 Lee Daniels' The Butler

Al Pacino (1940-)
 Stand Up Guys

Ellen Page (1987-)
 The East
 Touchy Feely

Myles Paige
 Computer Chess

Josh Pais (1964-)
 Touchy Feely

Adrianne Palicki (1983-)
 G.I. Joe: Retaliation

Teresa Palmer (1986-)
 Warm Bodies

Gwyneth Paltrow (1973-)
 Iron Man 3
 Thanks for Sharing

Vithaya Pansringarm
 Only God Forgives

Nando Paone
 Reality

Ray Park (1974-)
 G.I. Joe: Retaliation

Mary-Louise Parker (1964-)
 RED 2
 R.I.P.D.

Nate Parker (1979-)
 Ain't Them Bodies Saints

Sarah Jessica Parker (1965-)
 Escape From Planet Earth (*V*)

Michael Parks (1943-)
 We Are What We Are

Elsa Pataky (1976-)
 Fast & Furious 6

Robert Patrick (1958-)
 Gangster Squad
 Identity Thief
 Lovelace

Paula Patton (1975-)
 Baggage Claim
 Disconnect
 2 Guns

Sarah Paulson (1974-)
 Mud
 12 Years a Slave

Bill Paxton (1955-)
 2 Guns

Bruce Payne (1958-)
 Getaway

Liam Payne
 One Direction: This Is Us

Guy Pearce (1967-)
 Iron Man 3

Gerald Peary
 Computer Chess

Josh Peck (1986-)
 Battle of the Year

Amanda Peet (1972-)
 Identity Thief
 The Way Way Back

Simon Pegg (1970-)
 Star Trek Into Darkness
 The World's End

Michael Pena (1976-)
 American Hustle
 Gangster Squad
 Turbo (*V*)

Sean Penn (1960-)
 Gangster Squad
 The Secret Life of Walter Mitty

Barry Pepper (1970-)
 Broken City
 The Lone Ranger
 Snitch

Ron Perlman (1950-)
Pacific Rim

Harold Perrineau, Jr. (1963-)
The Best Man Holiday
Snitch

Katy Perry (1984-)
The Smurfs 2 (*V*)

Tyler Perry (1969-)
Tyler Perry's A Madea Christmas

Alex Pettyfer (1990-)
Lee Daniels' The Butler

Michelle Pfeiffer (1957-)
The Family

Terry Pheto
Mandela: Long Walk to Freedom

Jeffrey Daniel Phillips
The Lords of Salem

Lou Diamond Phillips (1962-)
Filly Brown

Joaquin Rafael (Leaf) Phoenix
(1974-)
Her

Wendell Pierce (1962-)
Parker

Tim Pigott-Smith (1946-)
RED 2

Rosamund Pike (1979-)
The World's End

Chris Pine (1980-)
Star Trek Into Darkness

Pink (1979-)
See Alecia Moore

Freida Pinto (1984-)
Girl Rising (*N*)

Brad Pitt (1963-)
The Counselor
12 Years a Slave
World War Z

Conrad Pla (1966-)
Riddick

Oliver Platt (1960-)
Ginger & Rosa

Aubrey Plaza (1984-)
Monsters University (*V*)
The To Do List

Amanda Plummer (1957-)
The Hunger Games: Catching
Fire

Amy Poehler (1971-)
Free Birds (*V*)

Pere Ponce (1964-)
Blancanieves

Scott Porter (1979-)
The To Do List

Natalie Portman (1981-)
Thor: The Dark World

Jose(p) Maria Pou (1944-)
Blancanieves

Will Poulter (1993-)
We're the Millers

CCH Pounder (1952-)
The Mortal Instruments: City of
Bones

Chris Pratt (1979-)
Delivery Man
Her
Movie 43

Lou Taylor Pucci (1985-)
Evil Dead

Lucy Punch (1977-)
Stand Up Guys

Om Puri (1950-)
The Reluctant Fundamentalist

Dennis Quaid (1954-)
At Any Price
Movie 43

Molly C. Quinn (1993-)
We're the Millers

Zachary Quinto (1977-)
Star Trek Into Darkness

Daniel Radcliffe (1989-)
Kill Your Darlings

Josh Radnor (1974-)
Afternoon Delight

Tahar Rahim
The Past

Leven Rambin (1990-)
Percy Jackson: Sea of Monsters

Kevin Rankin (1976-)
Dallas Buyers Club

James Ransone (1979-)
Oldboy

Noomi Rapace (1979-)
Dead Man Down

Michael Rappaport (1970-)
The Heat

Jim Rash
The Way Way Back

Tania Raymonde (1988-)
Texas Chainsaw 3D

Lance Reddick (1969-)
White House Down

Robert Redford (1937-)
All is Lost
The Company You Keep

Vanessa Redgrave (1937-)
Lee Daniels' The Butler
Unfinished Song

Keanu Reeves (1964-)
47 Ronin

Anne Reid (1935-)
Unfinished Song

Kelly Reilly (1977-)
A Single Shot

Rob Reiner (1945-)
The Wolf of Wall Street

Robert Reiner (1945-)
See Rob Reiner

Jeremy Renner (1971-)
American Hustle
Hansel & Gretel: Witch Hunters

Gloria Reuben (1964-)
Admission

Simon Rex (1974-)
Scary Movie 5

Ryan Reynolds (1976-)
The Croods (*V*)
R.I.P.D.
Turbo (*V*)

Jonathan Rhys Meyers (1977-)
The Mortal Instruments: City of
Bones

Giovanni Ribisi (1974-)
Gangster Squad

Christina Ricci (1980-)
The Smurfs 2 (*V*)

Joely Richardson (1965-)
Thanks for Sharing

Tequan Richmond (1992-)
Blue Caprice

Alan Rickman (1946-)
Lee Daniels' The Butler

Richard Riehle (1948-)
Texas Chainsaw 3D

Patrick Riester
Computer Chess

Sam Riley (1980-)
Byzantium

Khoolaid Rios
Filly Brown

Andrea Riseborough (1981-)
Disconnect

Oblivion
Shadow Dancer

AnnaSophia Robb (1993-)
The Way Way Back

Margot Robbie
About Time
The Wolf of Wall Street

Tim Robbins (1958-)
Thanks for Sharing

Dallas Roberts (1970-)
Dallas Buyers Club

Emma Roberts (1991-)
We're the Millers

Eric Roberts (1956-)
Lovelace

Julia Roberts (1967-)
August: Osage County

Craig Robinson (1971-)
Peeples
This Is the End

Nick Robinson
The Kings of Summer

Chris Rock (1966-)
Grown Ups 2

Rock, The (1972-)
See Dwayne 'The Rock' Johnson

Kaden Rockett
Dark Skies

Sam Rockwell (1968-)
A Single Shot
The Way Way Back

Genesis Rodriguez (1987-)
Identity Thief
The Last Stand

Gina Rodriguez
Filly Brown

Katelynn Rodriguez
Escape From Tomorrow

Michelle Rodriguez (1978-)
Fast & Furious 6
Machete Kills
Turbo (V)

Seth Rogen (1982-)
This Is the End

Elisabeth Rohm (1973-)
American Hustle

Lala Romero
Filly Brown

Saoirse Ronan (1994-)
Byzantium

The Host
How I Live Now

Saskia Rosendahl
Lore

Gavin Rossdale (1965-)
The Bling Ring

Emmy Rossum (1986-)
Beautiful Creatures

Cecilia (Celia) Roth (1958-)
I'm So Excited

Vincent Rottiers (1986-)
Renoir

Andre Royo (1968-)
The Spectacular Now

Paul Rudd (1969-)
Admission
Anchorman 2: The Legend Continues
Prince Avalanche

Maya Rudolph (1972-)
Grown Ups 2
Turbo (V)
The Way Way Back

Mark Ruffalo (1967-)
Now You See Me
Thanks for Sharing

Geoffrey Rush (1951-)
The Book Thief

Alex Russell
Carrie

Keri Russell (1976-)
Austenland
Dark Skies

Rene Russo (1954-)
Thor: The Dark World

Amy Ryan (1970-)
Escape Plan

Ger Ryan
Redemption

Winona Ryder (1971-)
Homefront
The Iceman

Katee Sackhoff (1980-)
Riddick

William Sadler (1950-)
Iron Man 3
Machete Kills

Danielle Safady
Escape From Tomorrow

Bill Sage (1962-)
We Are What We Are

Zoe Saldana (1978-)
Out of the Furnace
Star Trek Into Darkness

Andy Samberg (1978-)
Cloudy with a Chance of Meatballs 2 (V)

Xavier Samuel (1983-)
Adore

Hiroyuki (Henry) Sanada (1960-)
47 Ronin
The Wolverine

Chris (Christopher) Sanders (1960-)
The Croods (V)

Adam Sandler (1966-)
Grown Ups 2

Tobias Santelmann
Kon-Tiki

Angela Sarafyan
Paranoia

Susan Sarandon (1946-)
The Big Wedding
The Company You Keep
Snitch

Peter Sarsgaard (1971-)
Blue Jasmine
Lovelace

Katrin Sass (1956-)
The Silence

Jay Saunders
V/H/S/2

Johnathon Schaech (1969-)
Phantom

Christiane Schaumburg-Muller
Love Is All You Need

Richard Schiff (1959-)
Man of Steel

Liev Schreiber (1967-)
Lee Daniels' The Butler
The Reluctant Fundamentalist

Elena Schuber
Escape From Tomorrow

Robin Schwartz
Computer Chess

Jason Schwartzman (1980-)
Saving Mr. Banks

Arnold Schwarzenegger (1947-)
Escape Plan
The Last Stand

David Schwimmer (1966-)
The Iceman

Adam Scott (1973-)
The Secret Life of Walter Mitty

Campbell Scott (1962-)
Still Mine

Jill Scott (1972-)
Baggage Claim

Kristin Scott Thomas (1960-)
Only God Forgives

Shari Sebbens
The Sapphires

Jon Seda (1970-)
Bullet to the Head

Mika Seidel
Lore

Amy Seimetz
Upstream Color
You're Next

Andrew Sensenig
The Last Exorcism Part II
Upstream Color

Toni Servillo
The Great Beauty

Lea Seydoux (1985-)
Blue is the Warmest Color

Amanda Seyfried (1985-)
The Big Wedding
Epic (*V*)
Lovelace

Jane Seymour (1951-)
Austenland

Sarah Shahi (1980-)
Bullet to the Head

Tony Shalhoub (1953-)
Pain & Gain

Michael Shannon (1974-)
The Iceman
Man of Steel
Mud

Molly Shannon (1964-)
Scary Movie 5

Chaim Sharir
Fill the Void

William Shatner (1931-)
Escape From Planet Earth (*V*)

Vinessa Shaw (1976-)
Side Effects

Alia Shawkat (1989-)
The To Do List

Wallace Shawn (1943-)
Admission

Lin Shaye (1944-)
Insidious: Chapter 2

Robert Sheehan (1988-)
The Mortal Instruments: City of
Bones

Charlie Sheen (1965-)
Machete Kills
Scary Movie 5

Michael Sheen (1969-)
Admission

Irit Sheleg
Fill the Void

Ben Shenkman (1968-)
Concussion

Sam Shepard (1943-)
August: Osage County
Mud

Tye Sheridan (1996-)
Mud

Ko Shibasaki (1981-)
47 Ronin

Maggie Siff
Concussion

Augustin Silva
Crystal Fairy & the Magical Cac-
tus

Jose Miguel Silva
Crystal Fairy & the Magical Cac-
tus

Juan Andres Silva
Crystal Fairy & the Magical Cac-
tus

Sebastian Silva (1979-)
Crystal Fairy & the Magical Cac-
tus

Andrew Silverstein (1957-)
Blue Jasmine

Loredana Simioli
Reality

J.K. Simmons (1955-)
Dark Skies
Jobs

Johnny Simmons
The To Do List

Ty Simpkins
Insidious: Chapter 2

Alexander Skarsgard (1976-)
Disconnect
The East
What Maisie Knew

Gustaf Skarsgard
Kon-Tiki

Stellan Skarsgard (1951-)
Romeo & Juliet
Thor: The Dark World

Christian Slater (1969-)
Bullet to the Head

Kodi Smit-McPhee (1996-)
Romeo & Juliet

Douglas Smith (1985-)
Percy Jackson: Sea of Monsters

Jaden Smith (1998-)
After Earth

Roger Craig Smith
Planes (*V*)

Will Smith (1968-)
After Earth

Jurnee Smollett (1986-)
Tyler Perry's Temptation: Confes-
sions of a Marriage Counselor

J.B. Smoove (1964-)
The Smurfs 2 (*V*)

Cobie Smulders (1982-)
Delivery Man
Safe Haven

Yuliya Snigir (1983-)
A Good Day to Die Hard

Snoop Dogg (1971-)
Turbo (*V*)

Peter Sohn
Monsters University (*V*)

Bobby Sommer
Museum Hours

Trey Songz (1984-)
Texas Chainsaw 3D

Tonia Sotiropoulou
Berberian Sound Studio

David Spade (1964-)
Grown Ups 2

Timothy Spall (1957-)
Ginger & Rosa
Upside Down

Octavia Spencer (1970-)
Fruitvale Station

June Squibb (1935-)
Nebraska

Sylvester Stallone (1946-)
Escape Plan

Sylvester Stallone (1946-)
Bullet to the Head
Grudge Match

Sylvester Enzio Stallone (1946-)
See Sylvester Stallone

Josh Stamberg (1970-)
Afternoon Delight

Nele Trebs
 Lore

Danny Trejo (1944-)
 Machete Kills

Raoul Trujillo (1955-)
 Riddick

Nicholas Tucci
 You're Next

Stanley Tucci (1960-)
 The Hunger Games: Catching
 Fire
 Jack the Giant Slayer
 Percy Jackson: Sea of Monsters

Aidan Turner (1983-)
 The Mortal Instruments: City of
 Bones

Glynn Turner (1947-)
 John Dies at the End

Tyrese (1978-)
 See Tyrese Gibson

Karl Urban (1972-)
 Riddick
 Star Trek Into Darkness
 Walking with Dinosaurs 3D (*V*)

Melvin Van Peebles (1932-)
 Peeples

Gus Van Sant (1952-)
 The Canyons

Joanna Vanderham
 What Maisie Knew

Rupert Vansittart
 Austenland

Vince Vaughn (1970-)
 Delivery Man
 The Internship

Alexa Vega (1988-)
 Machete Kills

Carlo Verdone (1950-)
 The Great Beauty

Maribel Verdu (1970-)
 Blancanieves

Sofia Vergara (1972-)
 Escape From Planet Earth (*V*)
 Machete Kills
 The Smurfs 2

Iszabela Vidovic
 Homefront

Alicia Vikander
 The Fifth Estate

Pruitt Taylor Vince (1960-)
 Beautiful Creatures

Sharni Vinson (1983-)
 You're Next

Jon Voight (1938-)
 Getaway

Arnold Vosloo (1962-)
 G.I. Joe: Retaliation

Mark Wahlberg (1971-)
 Broken City
 Lone Survivor
 Pain & Gain
 2 Guns

Rhys Wakefield
 The Purge

Christopher Walken (1943-)
 Stand Up Guys

Paul Walker (1973-2013)
 Fast & Furious 6

Dee Wallace (1948-)
 The Lords of Salem

Dee Wallace Stone (1948-)
 See Dee Wallace

Christoph Waltz (1956-)
 Epic (*V*)

Baoqiang Wang
 A Touch of Sin

Patrick Warburton (1964-)
 Movie 43

Fred Ward (1943-)
 2 Guns

David Warshofsky (1959-)
 Captain Phillips

Denzel Washington (1954-)
 2 Guns

Isaiah Washington, IV (1963-)
 Blue Caprice

Kerry Washington (1977-)
 Girl Rising (*N*)
 Peeples

Tashiana Washington
 Gimme the Loot

Mia Wasikowska (1989-)
 Stoker

Michaela Watkins (1971-)
 Afternoon Delight
 In a World...

Emily Watson (1967-)
 The Book Thief

Emma Watson (1990-)
 The Bling Ring
 This Is the End

Muse Watson (1948-)
 The Last Exorcism Part II

Naomi Watts (1968-)
 Adore
 Diana
 Movie 43

Marlon Wayans (1972-)
 A Haunted House
 The Heat

Jacki Weaver (1947-)
 Stoker

Annika Wedderkopp
 The Hunt

Robin Weigert (1969-)
 Concussion

Rachel Weisz (1971-)
 Oz the Great and Powerful

Peter Weller (1947-)
 Star Trek Into Darkness

Jemima West (1987-)
 The Mortal Instruments: City of
 Bones

Ti West (1980-)
 You're Next

Ed Westwick (1987-)
 Romeo & Juliet

Leigh Whannell (1977-)
 Insidious: Chapter 2

David Wheeler (1963-)
 See David Thewlis

Shea Whigham (1969-)
 The Wolf of Wall Street

Forest Whitaker (1961-)
 Black Nativity
 The Last Stand
 Lee Daniels' The Butler
 Out of the Furnace

Bradley Whitford (1959-)
 Saving Mr. Banks

Isiah Whitlock, Jr. (1954-)
 Europa Report

Daniel Lawrence Whitney (1963-)
 See Larry the Cable Guy

Ricky Whittle
 Austenland

Wiley Wiggins (1976-)
 Computer Chess

Shea Wigham
 American Hustle

Kristen Wiig (1973-)
 Despicable Me 2 (*V*)
 The Secret Life of Walter Mitty

Gabriella Wilde (1989-)
 Carrie

Olivia Wilde (1984-)
 Drinking Buddies
 The Incredible Burt Wonderstone
 Rush

Tom Wilkinson (1948-)
 The Lone Ranger

Clarence Williams, III (1939-)
 Lee Daniels' The Butler

Michael K(enneth) Williams (1966-)
 Snitch
 12 Years a Slave

Michelle Williams (1980-)
 Oz the Great and Powerful

Robin Williams (1952-)
 The Big Wedding
 Lee Daniels' The Butler

Vanessa Williams (1963-)
 Tyler Perry's Temptation: Confessions of a Marriage Counselor

Wade Andrew Williams (1961-)
 Gangster Squad

Chase Williamson (1988-)
 John Dies at the End

Odd Magnus Williamson
 Kon-Tiki

Bruce Willis (1955-)
 G.I. Joe: Retaliation
 A Good Day to Die Hard
 RED 2

David Wilmot
 Shadow Dancer

Owen Wilson (1968-)
 Free Birds (V)
 The Internship

Owen Cunningham Wilson (1968-)
 See Owen Wilson

Patrick Wilson (1973-)
 The Conjuring
 Insidious: Chapter 2

Rebel Wilson (1986-)
 Pain & Gain

Ruth Wilson (1982-)
 The Lone Ranger
 Saving Mr. Banks

Thomas F. Wilson (1959-)
 The Heat

Oprah Winfrey (1954-)
 Lee Daniels' The Butler

Adam Wingard
 V/H/S/2

Katheryn Winnick (1977-)
 Stand Up Guys

Mare Winningham (1959-)
 Philomena

Kate Winslet (1975-)
 Movie 43

Mary Elizabeth Winstead (1984-)
 A Good Day to Die Hard
 The Spectacular Now

Jonathan Winters (1925-2013)
 The Smurfs 2 (V)

Tom Wisdom (1973-)
 Romeo & Juliet

Reese Witherspoon (1976-)
 Mud

Susse Wold
 The Hunt

Nat Wolff (1994-)
 Admission

Benedict Wong (1970-)
 Redemption

Elijah Wood (1981-)
 Maniac

Alfre Woodard (1953-)
 12 Years a Slave

Bokeem Woodbine (1973-)
 Riddick

Nicholas Woodeson
 Hannah Arendt

Shailene Woodley (1991-)
 The Spectacular Now

James Woods (1947-)
 Jobs
 White House Down

Jeffrey Wright (1965-)
 Broken City
 The Hunger Games: Catching Fire
 A Single Shot

Robin Wright (1966-)
 Adore

Sarah Wright (1983-)
 21 & Over

Robin Wright Penn (1966-)
 See Robin Wright

Daniel Wu
 Europa Report

Karolina Wydra
 Europa Report

Charles Henry Wyson
 Home Run

Hadas Yaron
 Fill the Void

Jose Maria Yazpik (1970-)
 I'm So Excited

Dan Yeager
 Texas Chainsaw 3D

Anton Yelchin (1989-)
 From Up on Poppy Hill (V)
 The Smurfs 2 (V)
 Star Trek Into Darkness

Harris Yulin (1937-)
 The Place Beyond the Pines

Rick Yune (1971-)
 Olympus Has Fallen

Elodie Yung (1981-)
 G.I. Joe: Retaliation

Kyra Zagorsky
 The ABCs of Death

Steve Zahn (1968-)
 Dallas Buyers Club

Antonia Zegers
 No

Kevin Zegers (1984-)
 The Mortal Instruments: City of Bones

Catherine Zeta-Jones (1969-)
 Broken City
 RED 2
 Side Effects

Jin Zhang
 The Grandmaster

Tao Zhao
 A Touch of Sin

Zhang Ziyi
 The Grandmaster

Ayelet Zurer (1969-)
 Man of Steel

Subject Index

Peeples
12 Years a Slave

Aging
All the Light in the Sky
56 Up
Grudge Match
Jackass Presents: Bad Grandpa
Last Vegas
Nebraska
RED 2
Stand Up Guys
Still Mine

AIDS/HIV
Dallas Buyers Club

Aircraft or Air Travel
I'm So Excited
Planes
The Wind Rises

Alcoholic Beverages
Drinking Buddies
The World's End

Alcoholism
Home Run
Nebraska

Alien Beings
Dark Skies
The Host
Man of Steel
Pacific Rim
Star Trek Into Darkness

American South
Beautiful Creatures
Mud
Muscle Shoals
Safe Haven

Animals
Blackfish

Animation & Cartoons
Cloudy with a Chance of Meatballs 2
The Croods
Despicable Me 2
Epic
Escape From Planet Earth
Free Birds
Frozen
Monsters University

Planes
Turbo
Walking with Dinosaurs 3D
The Wind Rises

Apartheid
Mandela: Long Walk to Freedom

Art or Artists
Blue is the Warmest Color
Museum Hours

Asia
The Act of Killing

Australia
The Sapphires

Automobiles
Fast & Furious 6
Getaway
Sightseers

Automobiles—Racing
At Any Price
Rush
Turbo

Baseball
42
Home Run

Biography
Diana
The Fifth Estate
42
Jobs
Mandela: Long Walk to Freedom
Rush
Salinger
The Wolf of Wall Street

Birds
Free Birds

Black Culture
The Best Man Holiday
Black Nativity
Kevin Hart: Let Me Explain
Tyler Perry's A Madea Christmas
Tyler Perry's Temptation: Confessions of a Marriage Counselor

Blackmail
Dead Man Down

Boats or Ships
All is Lost
Captain Phillips

Books or Bookstores
Austenland
The Book Thief
The Hobbit: The Desolation of Smaug
Saving Mr. Banks

Bounty Hunters
Hansel & Gretel: Witch Hunters
Mud

Boxing
Grudge Match
Out of the Furnace

Broadcast Journalism
Anchorman 2: The Legend Continues

Business or Industry
At Any Price
Jobs
Paranoia
The Wolf of Wall Street

Cannibalism
Texas Chainsaw 3D
We Are What We Are

Child Abuse
Girl Rising
The Hunt
Short Term 12
The Silence

Childhood
The Book Thief

Children
Jackass Presents: Bad Grandpa
Mama
What Maisie Knew

China
The Grandmaster
A Touch of Sin

Christmas
The Best Man Holiday
Black Nativity
Tyler Perry's A Madea Christmas

College

Kill Your Darlings
21 & Over

Comedy

Anchorman 2: The Legend Continues
Austenland
Delivery Man
Grudge Match
The Hangover, Part III
Identity Thief
The Incredible Burt Wonderstone
The Internship
Jackass Presents: Bad Grandpa
The Kings of Summer
Last Vegas
Movie 43
R.I.P.D.
Sightseers
Spring Breakers
The To Do List
21 & Over
We're the Millers
The World's End

Comedy Performance

Kevin Hart: Let Me Explain

Comedy-Drama

Admission
The Best Man Holiday
Blue Jasmine
Frances Ha
Reality
Thanks for Sharing

Coming of Age

The Kings of Summer
Something in the Air

Computers

Disconnect
The Fifth Estate
Jobs

Confidence Games

American Hustle

Contract Killers

Bullet to the Head
Dead Man Down
The Iceman

Crime Drama

American Hustle
Arthur Newman
Broken City
Bullet to the Head
Dead Man Down
Drug War
Gangster Squad
The Iceman
Pain & Gain
Parker
The Place Beyond the Pines
Prisoners
Redemption
The Reluctant Fundamentalist
Runner Runner
The Silence
A Touch of Sin
2 Guns
The Wolf of Wall Street

Crime or Criminals

Identity Thief
The Last Stand
Parker
Stand Up Guys
A Touch of Sin

Dance

Battle of the Year

Death & the Afterlife

August: Osage County
Girl Rising
Lone Survivor

Devils

The Last Exorcism Part II

Dinosaurs

Walking with Dinosaurs 3D

Divorce

Enough Said
What Maisie Knew

Doctors

After Tiller
Dallas Buyers Club

Documentary Films

The Act of Killing
After Tiller
A Band Called Death
Blackfish

56 Up
Girl Rising
Kevin Hart: Let Me Explain
Leviathan
Metallica Through the Never
Muscle Shoals
One Direction: This Is Us
Room 237
Salinger
Sound City
Stories We Tell
20 Feet from Stardom

Drama

Ain't Them Bodies Saints
All the Light in the Sky
Arthur Newman
Before Midnight
Byzantium
The Canyons
Disconnect
The Fifth Estate
Short Term 12
Thanks for Sharing
12 Years a Slave
Tyler Perry's Temptation: Confessions of a Marriage Counselor

Drug Abuse

John Dies at the End
Lovelace

Drugs

The Counselor
Dallas Buyers Club
Drug War
Homefront
I'm So Excited
Side Effects
Snitch
We're the Millers

Engagement

Peeples

Family

August: Osage County
Black Nativity
The Croods
Delivery Man
Despicable Me 2
Escape From Planet Earth
Escape From Tomorrow
The Family
Frozen
A Good Day to Die Hard

Inteligence Service Agencies
The Fifth Estate

International Relations
The Reluctant Fundamentalist

Interviews
Salinger
Stories We Tell
20 Feet from Stardom

Inventors or Inventions
Iron Man 3

Israel
The Attack

Italy
Berberian Sound Studio
Love Is All You Need
Reality
Romeo & Juliet

Japan
Emperor
Like Someone in Love
The Wind Rises
The Wolverine

Journalism
The Company You Keep
Philomena

Judaism
The Book Thief

Kidnappers or Kidnappings
The Call
Jack the Giant Slayer
Oldboy
Prisoners

Las Vegas
The Incredible Burt Wonderstone

Law or Lawyers
Closed Circuit
The Counselor

Live Action/Animation Combinations
The Smurfs 2

Los Angeles
Gangster Squad

In a World...
This Is the End

Mafia
The Family

Magic
Frozen
The Incredible Burt Wonderstone
Now You See Me
Oz the Great and Powerful

Marriage
Before Midnight
The Best Man Holiday
Broken City
Girl Rising
Grown Ups 2
A Haunted House
Mandela: Long Walk to Freedom
Side Effects
Thanks for Sharing
Tyler Perry's Temptation: Confessions of a Marriage Counselor
The Wind Rises

Martial Arts
47 Ronin
The Grandmaster

The Meaning of Life
Home Run

Men
All is Lost
The Hangover, Part III
Mandela: Long Walk to Freedom
This Is the End

Mental Health
Berberian Sound Studio
Short Term 12

Mexico
The Counselor
Machete Kills
Post Tenebras Lux

Middle East
The Attack
Lone Survivor
The Past

Midlife Crisis
Blue Jasmine

Military: Army
Emperor
G.I. Joe: Retaliation

Mothers
Carrie
Tyler Perry's A Madea Christmas

Motorcycles
The Place Beyond the Pines

Museums
Museum Hours

Music
Black Nativity
Inside Llewyn Davis
Metallica Through the Never
Muscle Shoals
One Direction: This Is Us
The Sapphires
Sound City

Mystery & Suspense
The Canyons
Oldboy
Paranoia
Stoker

Mythology or Legend
Percy Jackson: Sea of Monsters
Thor: The Dark World

Native Americans
The Lone Ranger

New York City
Anchorman 2: The Legend Continues
Broken City
Dead Man Down
What Maisie Knew

Nuns or Priests
Philomena
To the Wonder

Occult
The Conjuring
Evil Dead

Ocean Dangers
A Hijacking

Europa Report
Gravity
Her
The Host
The Hunger Games: Catching Fire
Man of Steel
Oblivion
Pacific Rim
Riddick
Star Trek Into Darkness
Upside Down
The World's End

Science or Scientists

Europa Report

Sex or Sexuality

Blue is the Warmest Color
The Canyons
Dead Man Down
I'm So Excited
Post Tenebras Lux
Something in the Air
Spring Breakers
Thanks for Sharing
The To Do List

Slavery

12 Years a Slave

Space Exploration or Outer Space

Europa Report
Gravity
Riddick
Star Trek Into Darkness

Spain

Blancanieves

Spies and Espionage

RED 2

Spies or Espionage

G.I. Joe: Retaliation

Sports

Home Run

Suburban Dystopia

Dark Skies

Suicide

Romeo & Juliet

Super Heroes

Iron Man 3
Kick-Ass 2
Man of Steel
Thor: The Dark World

Survival

After Earth
All is Lost
Captain Phillips
Gravity
This Is the End
Warm Bodies

Teaching or Teachers

The Hunt

Technology

Her
The Internship
Paranoia

Television

Anchorman 2: The Legend Continues
Reality

Terrorism

The Attack
Olympus Has Fallen
Star Trek Into Darkness

Texas

Texas Chainsaw 3D

Thanksgiving

Free Birds

Thrillers

The Call
Closed Circuit
The Company You Keep
Dark Skies
Drug War
The East
Getaway
Now You See Me
Olympus Has Fallen
The Purge
Side Effects
Snitch
Trance
White House Down

Time Travel

About Time
Free Birds

Tornadoes

Oz the Great and Powerful

Transvestites or Transsexuals

Dallas Buyers Club

True Crime

The Bling Ring
The Iceman
Kill Your Darlings
Pain & Gain

True Stories

Captain Phillips
The Conjuring
Dallas Buyers Club
Emperor
42
Philomena
12 Years a Slave

Vacations

Before Midnight

Veterans

Redemption

Vigilantes

Kick-Ass 2

War Between the Sexes

Anchorman 2: The Legend Continues

War: General

Ender's Game
47 Ronin
The Grandmaster
Lone Survivor
Out of the Furnace

Washington, D.C.

White House Down

Westerns

The Lone Ranger

Wilderness Areas

Prince Avalanche

Witchcraft

Hansel & Gretel: Witch Hunters
Oz the Great and Powerful

Title Index

This cumulative index is an alphabetical list of all films covered in the volumes of the *Magill's Cinema Annual*. Film titles are indexed on a word-by-word basis, including articles and prepositions. English leading articles (A, An, The) are ignored, as are foreign leading articles (El, Il, La, Las, Le, Les, Los). Acronyms appear alphabetically as if regular words. Common abbreviations in titles file as if they are spelled out. Proper names in titles are alphabetized beginning with the individual's first name. Titles with numbers are alphabetized as if the numbers were spelled out. When numeric titles gather in close proximity to each other, the titles will be arranged in a low-to-high numeric sequence. Films reviewed in this volume are cited in bold; films reviewed in past volumes are cited with the *Annual* year in which the review was published. Original and alternate titles are cross-referenced to the American release title. Titles of retrospective films are followed by the year, in brackets, of their original release.

A

A corps perdu. *See* Straight for the Heart.

A. I.: Artificial Intelligence 2002

A la Mode (Fausto) 1995

A Lot Like Love 2006

A Ma Soeur. *See* Fat Girl.

A nos amours 1984

Abandon 2003

ABCD 2002

ABCs of Death, The 2014

Abduction 2012

Abgeschminkt! *See* Making Up!.

About a Boy 2003

About Adam 2002

About Last Night… 1986

About Schmidt 2003

About Time 2014

Above the Law 1988

Above the Rim 1995

Abraham Lincoln: Vampire Hunter 2013

Abrazos rotos, Los. *See* Broken Embraces.

Abre Los Ojos. *See* Open Your Eyes.

Abril Despedacado. *See* Behind the Sun.

Absence of Malice 1981

Absolute Beginners 1986

Absolute Power 1997

Absolution 1988

Abyss, The 1989

Accepted 2007

Accidental Tourist, The 1988

Accompanist, The 1993

Accordeur de tremblements de terre, L'. *See* Piano Tuner of Earthquakes, The.

Accused, The 1988

Ace in the Hole [1951] 1986, 1991

Ace Ventura: Pet Detective 1995

Ace Ventura: When Nature Calls 1996

Aces: Iron Eagle III 1992

Acid House, The 2000

Acqua e sapone. *See* Water and Soap.

Across the Tracks 1991

Across the Universe 2008

Act of Killing, The 2014

Act of Valor 2013

Acting on Impulse 1995

Action Jackson 1988

Actress 1988

Adam 2010

Adam Sandler's 8 Crazy Nights 2003

Adam's Rib [1950] 1992

Adaptation 2003

Addams Family, The 1991

Addams Family Values 1993

Addicted to Love 1997

Addiction, The 1995

Addition, L'. *See* Patsy, The.

Adjo, Solidaritet. *See* Farewell Illusion.

Adjuster, The 1992

Adjustment Bureau, The 2012

All Over Me 1997

All Quiet on the Western Front [1930] 1985

All the King's Men 2007

All the Light in the Sky 2014

All the Little Animals 2000

All the Pretty Horses 2001

All the Rage. *See* It's the Rage.

All the Real Girls 2004

All the Right Moves 1983

All the Vermeers in New York 1992

All's Fair 1989

All-American High 1987

Allan Quatermain and the Lost City of Gold 1987

Alley Cat 1984

Alligator Eyes 1990

Allnighter, The 1987

Almost an Angel 1990

Almost Famous 2001

Almost Heroes 1999

Almost You 1985

Aloha Summer 1988

Alone. *See* Solas.

Alone in the Dark 2006

Alone with Her 2008

Along Came a Spider 2002

Along Came Polly 2005

Alpha and Omega 2011

Alpha Dog 2008

Alphabet City 1983

Alpine Fire 1987

Altars of the World [1976] 1985

Alvin and the Chipmunks 2008

Alvin and the Chipmunks: Chip-wrecked 2012

Alvin and the Chipmunks: The Squeakquel 2010

Always (Jaglom) 1985

Always (Spielberg) 1989

Amadeus 1984, 1985

Amanda 1989

Amantes. *See* Lovers.

Amantes del Circulo Polar, Los. *See* Lovers of the Arctic Circle, The.

Amantes pasajeros, Los. *See* I'm So Excited.

Amants du Pont Neuf, Les 1995

Amateur 1995

Amateur, The 1982

Amazing Grace 2008

Amazing Grace and Chuck 1987

Amazing Panda Adventure, The 1995

Amazing Spider-Man, The 2013

Amazon Women on the Moon 1987

Ambition 1991

Amelia 2010

Amelie 2002

Amen 2004

America 1986

American, The 2011

American Anthem 1986

American Beauty 2000

American Blue Note 1991

American Buffalo 1996

American Carol, An 2009

American Chai 2003

American Cyborg: Steel Warrior 1995

American Desi 2002

American Dream 1992

American Dreamer 1984

American Dreamz 2007

American Fabulous 1992

American Flyers 1985

American Friends 1993

American Gangster 2008

American Gothic 1988

American Haunting, An 2007

American Heart 1993

American History X 1999

American Hustle 2014

American in Paris, An [1951] 1985

American Justice 1986

American Me 1992

American Movie 2000

American Ninja 1984, 1991

American Ninja 1985

American Ninja II 1987

American Ninja III 1989

American Outlaws 2002

American Pie 2000

American Pie 2 2002

American Pop 1981

American President, The 1995

American Psycho 2001

American Reunion 2013

American Rhapsody, An 2002

American Stories 1989

American Splendor 2004

American Summer, An 1991

American Taboo 1984, 1991

American Tail, An 1986

American Tail: Fievel Goes West, An 1991

American Teen 2009

American Wedding 2004

American Werewolf in London, An 1981

American Werewolf in Paris, An 1997

American Women. *See* The Closer You Get.

America's Sweethearts 2002

Ami de mon amie, L'. *See* Boyfriends and Girlfriends.

Amin: The Rise and Fall 1983

Amistad 1997

Amityville Horror, The 2006

Amityville II: The Possession 1981

Amityville 3-D 1983

Among Giants 2000

Among People 1988

Amongst Friends 1993

Amor brujo, El 1986

Amores Perros 2002

Amos and Andrew 1993

Amour 2013

Amour de Swann, Un. *See* Swann in Love.

Amours d'Astrée et de Céladon, Les. *See* Romance of Astree and Celadon, The.

Amreeka 2010

Anaconda 1997

Analyze That 2003

Analyze This 2000

Anastasia 1997

Back to School 1986

Back to the Beach 1987

Back to the Future 1985

Back to the Future Part II 1989

Back to the Future Part III 1990

Back-Up Plan, The 2011

Backbeat 1995

Backdraft 1991

Backfire 1987

Backstage 1988

Backstage at the Kirov 1984

Bad Behaviour 1993

Bad Blood 1989

Bad Boy, The 1985

Bad Boys 1982

Bad Boys 1995

Bad Boys 2 2004

Bad Company (Harris) 1995

Bad Company (Schumacher) 2003

Bad Dreams 1988

Bad Education 2005

Bad Girls 1995

Bad Guys 1986

Bad Influence 1990

Bad Lieutenant 1992

Bad Lieutenant: Port of Call New Orleans 2010

Bad Manners 1997

Bad Medicine 1985

Bad Moon 1996

Bad News Bears, The 2006

Bad Santa 2004

Bad Teacher 2012

Bagdad Cafe 1988

Baggage Claim 2014

Bagman. *See* Casino Jack.

Bail Jumper 1990

Bait 2001

Baja Oklahoma 1988

Bakjwi. *See* Thirst.

Bal, Le 1984

Balance, La 1983

Ball of Fire 1987

Ballad of Jack and Rose, The 2006

Ballad of Little Jo, The 1993

Ballad of the Sad Cafe, The 1991

Ballast 2009

Ballistic: Ecks vs. Sever 2003

Balls of Fury 2008

Balto 1995

Balzac and the Little Chinese Seamstress 2006

Balzac et la petite tailleuse Chinois *See* Balzac and the Little Chinese Seamstress

Bamba, La 1987

Bambi [1942] 1984

Bamboozled 2001

Band Called Death, A 2014

Band of the Hand 1986

Band Wagon, The [1953] 1981

Band's Visit, The 2009

Bandit Queen 1995

Bandits 1988

Bandits 2002

Bandslam 2010

Bandwagon 1997

Banger Sisters, The 2003

Bangkok Dangerous 2009

Bank Job, The 2009

Banlieue 13: Ultimatum. *See* District 13: Ultimatum.

B.A.P.s 1997

Bar Esperanza 1985

Bar Girls 1995

Baraka 1993

Baran 2002

Barb Wire 1996

Barbarian Invasions, The 2004

Barbarians, The 1987

Barbarosa 1982

Barbary Coast [1935] 1983

Barbershop 2003

Barbershop 2: Back in Business 2005

Barcelona 1995

Bare Knuckles. *See* Gladiator.

Barefoot Contessa, The [1954] 1981

Barfly 1987

Bari, Al. *See* Innocent, The.

Barjo 1993

Bark! 2003

Barney's Great Adventure 1999

Barney's Version 2011

Barnyard 2007

Bartleby 2003

Barton Fink 1991

BASEketball 1999

Bashu, the Little Stranger 1990

Basic 2004

Basic Instinct 1992

Basic Instinct 2 2007

Basileus Quartet 1984

Basket, The 2001

Basket Case II 1990

Basket Case III: The Progeny 1992

Basketball Diaries, The 1995

Basquiat 1996

Bastille 1985

Bat 21 1988

Batman [1989] 1995

Batman and Robin 1997

Batman Begins 2006

Batman Forever 1995

Batman: Mask of the Phantasm 1993

Batman Returns 1992

Bats 2000

Battement d'Aniles du Papillon, Le, *See* Happenstance.

Batteries Not Included 1987

Battle for Terra 2010

Battle in Seattle 2009

Battle: Los Angeles 2012

Battle of Shaker Heights, The 2004

Battle of the Year 2014

Battlefield Earth 2001

Battleship 2013

Battlestruck 1982

Baule les Pins, La. *See* C'est la vie.

Baxter, The 2006

Bay, The 2013

Be Cool 2006

Be Kind Rewind 2009

Beach 1985

Beach, The 2001

Beach Girls, The 1982

Beaches 1988

Bean 1997

Beans of Egypt, Maine, The 1995

Beast, The 1988

Beast in the Heart, The. *See* Don't Tell.

Bear, The (Annaud) 1989

Bear, The (Sarafian) 1984

Beast Within, The 1982

Beastly 2012

Beastmaster, The 1982

Beastmaster II 1991

Beasts of the Southern Wild 2013

Beat, The 1987

Beat Generation-An American Dream, The 1987

Beat Street 1984

Beating Heart, A 1992

Beating of the Butterfly's Wings, The *See* Happenstance.

Beats, Rhymes & Life: The Travels of a Tribe Called Quest 2012

Beau Mariage, Le 1982

Beau Pere 1981

Beau Travail 2001

Beaufort 2009

Beaumarchais: The Scoundrel 1997

Beautician and the Beast, The 1997

Beautiful 2001

Beautiful Boy 2012

Beautiful Creatures 2002

Beautiful Creatures 2014

Beautiful Dreamers 1991

Beautiful Girls 1996

Beautiful Mind 2002

Beautiful People 2001

Beautiful Thing 1996

Beauty and the Beast 1991

Beauty Shop 2006

Beaver, The 2012

Beavis and Butt-head Do America 1996

Bebe's Kids 1992

Bebes. *See* Babies.

Because I Said So 2008

Because of Winn-Dixie 2006

Becky Sharp [1935] 1981

Becoming Colette 1992

Becoming Jane 2008

Bed and Breakfast 1992

Bed of Roses 1996

Bedazzled 2001

Bedroom Eyes 1986

Bedroom Window, The 1987

Bedtime for Bonzo [1951] 1983

Bedtime Stories 2009

Bee Movie 2008

Bee Season 2006

Beefcake 2000

Beerfest 2007

Beethoven 1992

Beethoven's Second 1993

Beetlejuice 1988

Before and After 1996

Before Midnight 2014

Before Night Falls 2001

Before Sunrise 1995

Before Sunset 2005

Before the Devil Knows You're Dead 2008

Before the Rain 1995

Beginners 2012

Begotten 1995

Beguiled, The [1971] 1982

Behind Enemy Lines 2002

Behind the Sun 2002

Beijing Bicycle 2003

Being at Home with Claude 1993

Being Flynn 2013

Being Human 1995

Being John Malkovich 2000

Being Julia 2005

Bel Ami 2013

Belfast, Maine 2001

Believers, The 1987

Belizaire the Cajun 1986

Bella Martha. *See* Mostly Martha.

Belle Epoque 1995

Belle Noiseuse, La 1991

Bellflower 2012

Bellman and True 1988

Bells Are Ringing [1960] 1983

Belly of an Architect 1987

Beloved 2003

Beloved Rogue [1927] 1983

Below 2004

Benchwarmers, The 2007

Bend It Like Beckham 2004

Benefit of the Doubt 1993

Bengali Night, The 1988

Benji: Off the Leash! 2005

Benji the Hunted 1987

Benny and Joon 1993

Bent 1997

Beowulf 2008

Beowulf & Grendel 2007

Berberian Sound Studio 2014

Berkeley in the Sixties 1990

Berlin Alexanderplatz 1983

Bernadette 1988

Bernie 2013

Berry Gordy's The Last Dragon 1985

Bert Rigby, You're a Fool 1989

Beshkempir: The Adopted Son 2000

Besieged 2000

Best Defense 1984

Best Exotic Marigold Hotel, The 2013

Best Friends 1982

Best in Show 2001

Best Intentions, The 1992

Best Laid Plans 2000

Best Little Whorehouse in Texas, The 1982

Best Man, The 1999

Best Man, The 2000

Best Man Holiday, The 2014

Best of the Best 1989

Best of the Best II 1993

Best of Times, The 1986

Best of Youth, The 2006

Best Revenge, The 1996

Best Seller 1987

Best Worst Movie 2011

Best Years of Our Lives, The [1946] 1981

Bestia nel cuore, La. *See* Don't Tell.

Betrayal 1983

Blackout. *See* I Like It Like That.

Blackthorn 2012

Blade 1999

Blade II 2003

Blade Runner 1982

Blade: Trinity 2005

Blades of Glory 2008

Blair Witch Project, The 2000

Blame It on Night 1984

Blame It on Rio 1984

Blame It on the Bellboy 1992

Blancanieves 2014

Blank Check 1995

Blankman 1995

Blassblaue Frauenschrift, Eine. *See* Woman's Pale Blue Handwriting, A.

Blast 'em 1995

Blast from the Past 2000

Blaze 1989

Bless Me, Ultima 2014

Bless the Child 2001

Bless Their Little Hearts 1991

Blessures Assassines, Les. *See* Murderous Maids.

Blind Date 1987

Blind Fairies *See* Ignorant Fairies

Blind Fury 1990

Blind Side, The 2010

Blind Swordsman: Zatoichi, The. *See* Zatoichi.

Blindness 2009

Bling Ring, The 2014

Blink 1995

Bliss 1986

Bliss 1997

Blob, The 1988

Blood and Chocolate 2008

Blood and Concrete 1991

Blood and Wine 1997

Blood Diamond 2007

Blood Diner 1987

Blood in Blood Out 1995

Blood, Guts, Bullets and Octane 2001

Blood Money 1988

Blood of Heroes, The 1990

Blood Salvage 1990

Blood Simple 1985

Blood Wedding 1982

Blood Work 2003

Bloodfist 1989

Bloodhounds of Broadway 1989

BloodRayne 2007

Bloodsport 1988

Bloody Sunday 2003

Blow 2002

Blow Dry 2002

Blow Out 1981

Blown Away 1995

Blue (Jarman) 1995

Blue (Kieslowski) 1993

Blue Caprice 2014

Blue Car 2004

Blue Chips 1995

Blue City 1986

Blue Crush 2003

Blue Desert 1991

Blue Ice 1995

Blue Iguana, The 1988

Blue in the Face 1995

Blue is the Warmest Color 2014

Blue Jasmine 2014

Blue Kite, The 1995

Blue Like Jazz 2013

Blue Monkey 1987

Blue Skies Again 1983

Blue Sky 1995

Blue Steel 1990

Blue Streak 2000

Blue Thunder 1983

Blue Valentine 2011

Blue Velvet 1986

Blue Villa, The 1995

Bluebeard's Eighth Wife [1938] 1986

Blues Brothers 2000 1999

Blues Lahofesh Hagadol. *See* Late Summer Blues.

Boat, The. *See* Boot, Das.

Boat is Full, The 1982

Boat That Rocked, The. *See* Pirate Radio.

Boat Trip 2004

Bob le Flambeur [1955] 1983

Bob Marley: Time Will Tell. *See* Time Will Tell.

Bob Roberts 1992

Bobby 2007

Bobby Jones: Stroke of Genius 2005

Bodies, Rest, and Motion 1993

Body, The 2002

Body and Soul 1982

Body Chemistry 1990

Body Double 1984

Body Heat 1981

Body Melt 1995

Body of Evidence 1993

Body of Lies 2009

Body Parts 1991

Body Rock 1984

Body Shots 2000

Body Slam 1987

Body Snatchers 1995

Bodyguard, The 1992

Bodyguards, The. *See* La Scorta.

Boesman & Lena 2001

Bogus 1996

Boheme, La [1926] 1982

Boiler Room 2001

Boiling Point 1993

Bolero (Derek) 1984

Bolero (Lelouch) 1982

Bollywood/Hollywood 2003

Bolt 2009

Bom Yeorum Gaeul Gyeoul Geurigo...Bom. *See* Spring, Summer, Autumn, Winter...And Spring.

Bon Plaisir, Le 1984

Bon Voyage 1995

Bon Voyage (Rappenaeau) 2005

Bone Collector, The 2000

Bonfire of the Vanities, The 1990

Bongwater 1999

Bonne Route. *See* Latcho Drom.

Boogeyman 2006

Brideshead Revisited 2009

Bridesmaid, The 2007

Bridesmaids 2012

Bridge of San Luis Rey, The [1929] 1981

Bridge of San Luis Rey, The 2006

Bridge on the River Kwai, The [1957] 1990

Bridge to Terabithia 2008

Bridges of Madison County, The 1995

Bridget Jones: The Edge of Reason 2005

Bridget Jones's Diary 2002

Brief Encounter [1946] 1990

Brief History of Time, A 1992

Bright Angel 1991

Bright Lights, Big City 1988

Bright Star 2010

Bright Young Things 2005

Brighton Beach Memoirs 1986

Brimstone and Treacle 1982

Bring It On 2001

Bring on the Night 1985

Bringing Down the House 2004

Bringing Out the Dead 2000

Brittania Hospital 1983

Broadcast News 1987

Broadway Damage 1999

Broadway Danny Rose 1984

Brodre. *See* Brothers.

Brokeback Mountain 2006

Brokedown Palace 2000

Broken April. *See* Behind the Sun.

Broken Arrow 1996

Broken Blossoms [1919] 1984

Broken City 2014

Broken Embraces 2010

Broken English 1997

Broken Flowers 2006

Broken Hearts Club, The 2001

Broken Lizard's Club Dread. *See* Club Dread.

Broken Rainbow 1985

Broken Vessels 1999

Broken Wings 2005

Bronson 2010

Bronx Tale, A 1993

Brooklyn Castle 2013

Brooklyn's Finest 2011

Brother (Balabanov) 1999

Brother (Kitano) 2001

Brother Bear 2004

Brother from Another Planet, The 1984

Brother of Sleep 1996

Brotherhood of the Wolf 2003

Brothers 2006

Brothers 2010

Brothers, The 2002

Brothers Bloom, The 2010

Brothers Grimm, The 2006

Brother's Keeper 1993

Brother's Kiss, A 1997

Brothers McMullen, The 1995

Brothers Solomon, The 2008

Brown Bunny, The 2005

Brown Sugar 2003

Browning Version, The 1995

Bruce Almighty 2004

Bruce Lee Story, The. *See* Dragon.

Brüno 2010

Bu-Su 1988

Bubba Ho-Tep 2004

Bubble 2007

Bubble Boy 2002

Buche, La [2000] 2001

Buck 2012

Bucket List, The 2009

Buckminster Fuller: Thinking Out Loud 1996

Bucky Larson: Born to Be a Star 2012

Buddy 1997

Buddy Boy 2001

Buddy Buddy 1981

Buddy System, The 1984

Buena Vista Social Club, The 2000

Buffalo 66 1999

Buffalo Soldiers 2004

Buffy the Vampire Slayer 1992

Bug 2008

Bug's Life, A 1999

Bugsy 1991

Building Bombs 1995

Bull Durham 1988

Bulldog Drummond [1929] 1982

Bullet to the Head 2014

Bulletproof (Carver) 1988

Bulletproof (Dickerson) 1996

Bulletproof Heart 1995

Bulletproof Monk 2004

Bullets Over Broadway 1995

Bullhead 2013

Bullies 1986

Bullshot 1985

Bully 2002

Bully 2013

Bully Project, The. *See* Bully.

Bulworth 1999

Bum Rap 1988

'Burbs, The 1989

Burglar 1987

Burglar, The 1988

Buried 2011

Buried on Sunday 1995

Burke and Hare 2012

Burke and Wills 1987

Burlesque 2011

Burn After Reading 2009

Burnin' Love 1987

Burning Plain, The 2010

Burning Secret 1988

Burnt by the Sun 1995

Bushwhacked 1995

Business of Fancydancing, The 2003

Business of Strangers, The 2002

Busted Up 1987

Buster 1988

But I'm a Cheerleader 2001

Butcher Boy, The 1999

Butcher's Wife, The 1991

Butler, The. *See* Lee Daniels' The Butler.

Butter 2013

Butterfield 8 [1960] 1993

Butterflies 1988

Cloak and Dagger 1984

Clock, The 1981

Clockers 1995

Clockstoppers 2003

Clockwatchers 1999

Clockwise 1986

Close My Eyes 1991

Close to Eden 1992

Close Your Eyes 2005

Closed Circuit 2014

Closer 2005

Closer You Get, The 2001

Closet, The 2002

Closet Land 1991

Cloud Atlas 2013

Cloudy with a Chance of Meaballs 2010

Cloudy with a Chance of Meatballs 2 2014

Cloverfield 2009

Club Dread 2005

Club Earth. *See* Galactic Gigolo.

Club Paradise 1986

Clue 1985

Clueless 1995

Coach Carter 2006

Cobb 1995

Cobra 1986

Cobra Verde 1988

Coca-Cola Kid, The 1985

Cocaine Wars 1986

Cocktail 1988

Coco avant Chanel. *See* Coco Before Chanel.

Coco Before Chanel 2010

Cocoon 1985

Cocoon: The Return 1988

Code 46 2005

Code Inconnu: Recit Incomplet de Divers Voyages. *See* Code Unknown.

Code Name: The Cleaner 2008

Code of Silence 1985

Code Unknown 2003

Coeur en hiver, Un 1993

Coeur qui bat, Un. *See* Beating Heart, A.

Coeurs. *See* Private Fears in Public Places.

Coffee & Cigarettes 2005

Cold Comfort 1989

Cold Comfort Farm 1995

Cold Creek Manor 2004

Cold Feet (Dornhelm) 1989

Cold Feet (Van Dusen) 1984

Cold Fever 1996

Cold Heaven 1992

Cold Light of Day, The 2013

Cold Moon 1995

Cold Mountain 2004

Cold Souls 2010

Cold Steel 1987

Coldblooded 1995

Collapse 2010

Collateral 2005

Collateral Damage 2003

Collection, The 2013

Collector, The 2010

College Road Trip 2009

Colombiana 2012

Colonel Chabert 1995

Colonel Redl 1985

Color Adjustment 1995

Color Me Kubrick 2008

Color of Money, The 1986

Color of Night 1995

Color Purple, The 1985

Colorado Territory [1949] 1985

Colors 1988

Colpo di Luna. *See* Moon Shadow.

Combat Shock 1986

Combination Platter 1995

Come and Get It [1936] 1981

Come Back to the Five and Dime Jimmy Dean, Jimmy Dean 1982

Come See the Paradise 1990

Come Undone 2002

Comebacks, The 2008

Comedian Harmoniest: Six Life Stories, The 1995

Comedy of Power 2008

Comfort and Joy 1984

Comfort of Strangers, The 1991

Comic Book Confidential 1988

Coming to America 1988

Commandments 1997

Commando 1985

Commando Squad 1987

Comme une image. *See* Look at Me.

Commitments, The 1991

Committed 2001

Common Bonds 1995

Communion 1989

Como Agua Para Chocolate. *See* Like Water for Chocolate.

Company, The 2005

Company Business 1991

Company Man 2002

Company Men, The 2011

Company of Strangers, The. *See* Strangers in Good Company.

Company of Wolves, The 1985

Company You Keep, The 2014

Competition [1963] 1985

Complex World 1995

Compliance 2013

Complot, Le. *See* To Kill a Priest.

Compromising Positions 1985

Computer Chess 2014

Con Air 1997

Conan O'Brien Can't Stop 2012

Conan the Barbarian 1982

Conan the Barbarian 2012

Conan the Destroyer 1984

Conceiving Ada 2000

Concert, The 2011

Concussion 2014

Coneheads 1993

Confessions of a Dangerous Mind 2003

Confessions of a Shopaholic 2010

Confessions of a Teenage Drama Queen 2005

Confidence 2004

Confidences trop intimes. *See* Intimate Strangers.

Confidentially Yours 1984

Criminal Law 1988, 1989

Criminal Lovers 2004

Crimson Tide 1995

Crisscross 1992

Critical Care 1997

Critical Condition 1987

Critters 1986

Critters II 1988

Crna macka, beli macor. *See* Black Cat, White Cat.

"Crocodile" Dundee 1986

"Crocodile" Dundee II 1988

"Crocodile" Dundee in Los Angeles 2002

Crocodile Hunter: Collision Course, The 2003

Cronos 1995

Croods, The 2014

Crooked Hearts 1991

Crooklyn 1995

Cropsey 2011

Cross Country 1983

Cross Creek 1983

Cross My Heart 1987

Crossed Tracks. *See* Roman de gare.

Crossing Delancey 1988

Crossing Guard, The 1995

Crossing Over 2010

Crossing the Bridge 1992

Crossover Dreams 1985

Crossroads 1986

Crossroads 2003

Crouching Tiger, Hidden Dragon 2001

Croupier [1997] 2001

Crow: City of Angels, The 1996

Crow, The 1995

Crucible, The 1996

Crude Oasis, The 1995

Cruel Intentions 2000

Cruel Story of Youth [1960] 1984

Crumb 1995

Crush (Maclean) 1993

Crush (McKay) 2003

Crush, The (Shapiro) 1993

Crusoe 1988

Cry Baby Killers, The [1957]

Cry Freedom 1987

Cry in the Dark, A 1988

Cry in the Wild, The 1990

Cry, the Beloved Country 1995

Cry Wolf [1947] 1986

Cry_Wolf 2006

Cry-Baby 1990

Crying Game, The 1992

Crystal Fairy & the Magical Cactus 2014

Crystal Heart 1987

Crystalstone 1988

Cucaracha, La 2000

Cuckoo, The 2004

Cujo 1983

Cup, The 2001

Cup Final 1992

Curdled 1996

Cure, The 1995

Cure in Orange, The 1987

Curious Case of Benjamin Button, The 2009

Curious George 2007

Curly Sue 1991

Current Events 1990

Curse of the Golden Flower 2007

Curse of the Jade Scorpion, The 2002

Curse of the Pink Panther 1983

Cursed 2006

Curtains 1983

Cut and Run 1986

Cutthroat Island 1995

Cutting Edge, The 1992

Cyborg 1989

Cyclo 1996

Cyclone 1987

Cyrano de Bergerac 1990

Cyrus 2011

Czlowiek z Marmuru. *See* Man of Marble.

Czlowiek z Zelaza. *See* Man of Iron.

D

Da 1988

Da Vinci Code, The 2007

Dad 1989

Dad On the Run 2002

Daddy and the Muscle Academy 1995

Daddy Day Camp 2008

Daddy Day Care 2004

Daddy Nostalgia 1991

Daddy's Boys 1988

Daddy's Dyin' 1990

Daddy's Little Girls 2008

Dadetown 1996

Daffy Duck's Quackbusters 1988

Dai zong shi, Yi. *See* Grandmaster, The.

Dakhtaran-e Khorshid. *See* Daughters of the Sun.

Dakota 1988

Dallas Buyers Club 2014

Damage 1992

Damned in the U.S.A. 1992

Damned United, The 2010

Damsels in Distress 2013

Dan in Real Life 2008

Dance Flick 2010

Dance Maker, The 2000

Dance of the Damned 1989

Dance with a Stranger 1985

Dance with Me 1999

Dancer in the Dark 2001

Dancer, Texas Pop. 81 1999

Dancer Upstairs, The 2004

Dancers 1987

Dances with Wolves 1990

Dancing at Lughnasa 1999

Dancing in the Dark 1986

Dangerous Beauty 1999

Dangerous Game (Ferrara) 1995

Dangerous Game (Hopkins) 1988

Dangerous Ground 1997

Dangerous Liaisons 1988

Dangerous Lives of Altar Boys, The 2003

Dangerous Love 1988

Dangerous Method, A 2012

Dangerous Minds 1995

Dangerous Moves 1985

Decalogue, Parts 5 & 6, The [1988] 2001

Decalogue, Parts 7 & 8, The [1988] 2001

Decalogue, Parts 9 & 10, The [1988] 2001

Deceived 1991

Deceiver 1999

Deceivers, The 1988

December 1991

Deception 1993

Deception 2009

Deck the Halls 2007

Decline of the American Empire, The 1986

Decline of Western Civilization Part II, The 1988

Deconstructing Harry 1997

Deep Blue Sea 2000

Deep Blue Sea, The 2013

Deep Cover 1992

Deep Crimson 1997

Deep End, The 2002

Deep End of the Ocean 2000

Deep Impact 1999

Deep in the Heart 1984

Deep Rising 1999

Deepstar Six 1989

Deer Hunter, The 1981

Def by Temptation 1990

Def-Con 4 1985

Def Jam's How to Be a Player 1997

Defending Your Life 1991

Defense Play 1988

Defenseless 1991

Defiance 2009

Defiant Ones, The [1958] 1992

Definitely, Maybe 2009

Defying Gravity 2000

Deja Vu 1999

Deja Vu 2007

Delicatessen 1992

Delirious 1991

Deliver Us from Eva 2004

Delivery Man 2014

Delta, The 1997

Delta Farce 2008

Delta Force, The 1986

Delta Force II 1990

Delta of Venus 1995

Delusion 1991

Demoiselle d'honneur, La. *See* Bridesmaid, The.

Demolition Man 1993

Demonlover 2004

Demons 1986

Demons in the Garden 1984

Den Goda Viljan. *See* Best Intentions, The.

Denise Calls Up 1996

Dennis the Menace 1993

Den skaldede frisor. *See* Love is All You Need.

Departed, The 2007

Departures 2010

Depuis Qu'Otar est Parti. *See* Since Otar Left…

Der Stand der Dinge. *See* State of Things, The.

Der Untergang. *See* Downfall.

Derailed 2006

Dernier Combat, Le 1984

Desa parecidos, Los. *See* Official Story, The.

Descendants, The 2012

Descent, The 2007

Desert Bloom 1986

Desert Blue 2000

Desert Hearts 1986

Designated Mourner, The 1997

Desire (Salt on Our Skin) 1995

Desire and Hell at Sunset Motel 1992

Desperado 1995

Desperate Hours 1990

Desperate Measures 1999

Desperate Remedies 1995

Desperately Seeking Susan 1985

Despicable Me 2011

Despicable Me 2 2014

Destinees Sentimentales. *See* Sentimental Destiny.

Destiny in Space 1995

Destiny Turns on the Radio 1995

Detachment 2013

Detective 1985

Deterrence 2001

Detour [1946] 1985

Detroit Rock City 2000

Deuce Bigalow: European Gigolo 2006

Duece Bigalow: Male Gigolo 2000

Deuces Wild 2003

Devil 2011

Devil and Daniel Johnston, The 2007

Devil in a Blue Dress 1995

Devil Inside, The 2013

Devil Wears Prada, The 2007

Devil's Advocate, The 1997

Devil's Backbone, The 2002

Devil's Double, The 2012

Devil's Own, The 1997

Devil's Rejects, The 2006

Devotion [1944] 1981

Diabolique 1996

Diagonale du fou. *See* Dangerous Moves.

Dialogues with Madwomen 1995

Diamond Skulls. *See* Dark Obsession.

Diamond's Edge 1990

Diana 2014

Diarios de motocicleta. *See* Motorcycle Diaries, The.

Diary of a Hitman 1992

Diary of a Mad Black Woman 2006

Diary of a Mad Old Man 1987

Diary of a Seducer 1997

Diary of a Wimpy Kid 2011

Diary of a Wimpy Kid: Dog Days 2013

Diary of a Wimpy Kid: Rodrick Rules 2012

Diary of the Dead 2009

Dice Rules 1991

Dick 2000

Dick Tracy 1990

Dickie Roberts: Former Child Star 2004

Dictator, The 2013

Did You Hear About the Morgans? 2010

Donna della luna, La. *See* Woman in the Moon.

Donnie Brasco 1997

Donnie Darko 2003

Donny's Boy. *See* That's My Boy.

Don't Be a Menace to South Central While Drinking Your Juice in the Hood 1996

Don't Be Afraid of the Dark 2012

Don't Come Knocking 2007

Don't Cry, It's Only Thunder 1982

Don't Move 2006

Don't Say a Word 2002

Don't Tell 2007

Don't Tell Her It's Me 1990

Don't Tell Mom the Babysitter's Dead 1991

Don't Tempt Me! *See* No News from God.

Don't Touch the Axe. *See* Duchess of Langeais, The.

Doom 2006

Doom Generation, The 1995

Doomsday 2009

Door in the Floor, The 2005

Door to Door 1984

Doors, The 1991

Dopamine 2004

Doppia ora, La. *See* Double Hour, The.

Dorm That Dripped Blood, The 1983

Dorothy and Alan at Norma Place 1981

Double, The 2012

Double Dragon 1995

Double Edge 1992

Double Happiness 1995

Double Hour, The 2012

Double Impact 1991

Double Indemnity [1944] 1981, 1986, 1987

Double Jeopardy 2000

Double Life of Veronique, The 1991

Double Take 2002

Double Team 1997

Double Threat 1993

Double Trouble 1992

Double Vie de Veronique, La. *See* Double Life of Veronique, The.

Doublure, La. *See* Valet, The.

Doubt 2009

Doug's First Movie 2000

Down and Out in Beverly Hills 1986

Down by Law 1986

Down in the Delta 1999

Down in the Valley 2007

Down Periscope 1996

Down Terrace 2011

Down the Hill. *See* Footnote.

Down to Earth 2002

Down to You 2001

Down Twisted 1987

Down With Love 2004

Downfall 2006

Downtown 1990

Dracula. *See* Bram Stoker's Dracula.

Dracula: Dead and Loving It 1995

Dracula 2001. *See* Wes Craven Presents: Dracula 2001.

Drag Me to Hell 2010

Dragnet 1987

Dragon 1993

Dragon Chow 1988

Dragonball: Evolution 2010

Dragonfly 2003

Dragonheart 1996

Dragonslayer 1981

Draughtsman's Contract, The 1983

Dream a Little Dream 1989

Dream Demon 1988

Dream for an Insomniac 1999

Dream House 2012

Dream Lover (Kazan) 1986

Dream Lover (Pakula) 1995

Dream of Light 1995

Dream Team, The 1989

Dream With the Fishes 1997

Dreamcatcher 2004

Dreamchild 1985

Dreamer: Inspired by a True Story 2006

Dreamers, The 2005

Dreamgirls 2007

Dreamlife of Angels, The 2000

Dreams. *See* Akira Kurosawa's Dreams.

Dreams with Sharp Teeth 2009

Dreamscape 1984

Dredd 2013

Drei Sterne. *See* Mostly Martha.

Dresser, The 1983

Dressmaker, The 1988

Drifter, The 1988

Drifting 1984

Drillbit Taylor 2009

Drinking Buddies 2014

Drive 1992

Drive 2012

Drive Angry 2012

Drive Me Crazy 2000

Driven 2002

Driving Miss Daisy 1989

Drole de Felix. *See* Adventures of Felix, The.

Drop Dead Fred 1991

Drop Dead Gorgeous 2000

DROP Squad 1995

Drop Zone 1995

Drowning by Numbers 1988

Drowning Mona 2001

Drug War 2014

Drugstore Cowboy 1989

Drumline 2003

Drunks 1997

Dry Cleaning 2000

Dry White Season, A 1989

D3: The Mighty Ducks 1996

Duchess, The 2009

Duchess of Langeais, The 2009

Duck Season 2007

Ducktales, the Movie 1990

Dude, Where's My Car? 2001

Dudes 1987

Dudley Do-Right 2000

Due Date 2011

Duel in the Sun [1946] 1982, 1989

Duet for One 1986

Duets 2001

Empire of the Sun 1987

Empire Records 1995

Empire Strikes Back, The [1983] 1997

Emploi du Temps, L. *See* Time Out.

Employee of the Month 2007

Emporte-Moi. *See* Set Me Free.

Empty Mirror, The 2000

Enchanted 2008

Enchanted April 1992

Enchanted Cottage, The [1945] 1981

Encino Man 1992

Encore. *See* One More.

End of Days 2000

End of Innocence, The 1990

End of Old Times, The 1992

End of the Affair 2000

End of the Line (Glenn) 1987

End of the Line (Russell) 1988

End of the Spear 2007

End of Violence, The 1997

End of Watch 2013

Endangered Species 1982

Ender's Game 2014

Endurance 2000

Enduring Love 2005

Endgame 1986

Endless Summer II, The 1995

Enemies, A Love Story 1989

Enemy at the Gates 2002

Enemy Mine 1985

Enemy of the State 1999

Enemy Territory 1987

Enfant, L'. *See* Child, The.

English Patient, The 1996

Englishman Who Went Up a Hill But Came Down a Mountain, The 1995

Enid Is Sleeping. *See* Over Her Dead Body.

Enigma (Szwarc) 1983

Enigma (Apted) 2003

Enough 2003

Enough Said 2014

Enron: The Smartest Guys in the Room 2006

Enter the Ninja 1982

Enter the Void 2011

Entity, The 1983

Entrapment 2000

Entre les murs. *See* Class, The.

Entre nous 1984

Envy 2005

Epic 2014

Epic Movie 2008

Equilibrium 2003

Equinox 1993

Eragon 2007

Eraser 1996

Erendira 1984

Erik the Viking 1989

Erin Brockovich 2001

Ermo 1995

Ernest Goes to Camp 1987

Ernest Goes to Jail 1990

Ernest Rides Again 1993

Ernest Saves Christmas 1988

Ernest Scared Stupid 1991

Eros 2006

Erotique 1995

Escanaba in da Moonlight 2002

Escape Artist, The 1982

Escape from Alcatraz [1979] 1982

Escape from L.A. 1996

Escape from New York 1981

Escape From Planet Earth 2014

Escape from Safehaven 1989

Escape From Tomorrow 2014

Escape Plan 2014

Escape 2000 1983

Escort, The. *See* Scorta, La.

Especially on Sunday 1993

Esperame en el cielo. *See* Wait for Me in Heaven.

Espinazo de Diablo, El. *See* Devil's Backbone, The.

Est-Ouest. *See* East-West.

Esther Kahn 2003

Et maintenant on va ou? *See* Where Do We Go Now?

E.T.: The Extra-Terrestrial 1982

Etat sauvage, L' [1978] 1990

Ete prochain, L'. *See* Next Summer.

Eternal Sunshine of the Spotless Mind 2005

Eternity and a Day 2000

Ethan Frome 1993

Etoile du nord 1983

Eu Tu Eles. *See* Me You Them.

Eulogy 2005

Eulogy of Love. *See* In Praise of Love.

Eureka 1985

Eureka 2002

Europa 1995

Europa, Europa 1991

Europa Report 2014

Eurotrip 2005

Evan Almighty 2008

Eve of Destruction 1991

Evelyn 2003

Even Cowgirls Get the Blues 1995

Evening 2008

Evening Star 1996

Event Horizon 1997

Events Leading Up to My Death, The 1995

Ever After: A Cinderella Story 1999

Everlasting Piece, An 2002

Everlasting Secret Family, The 1989

Every Breath 1995

Every Little Step 2010

Every Man for Himself [1979] 1981

Every Time We Say Goodbye 1986

Everybody Wins 1990

Everybody's All-American 1988

Everybody's Famous! 2002

Everybody's Fine 1991

Everybody's Fine 2010

Everyone Says I Love You 1996

Everyone's Hero 2007

Everything is Illuminated 2006

Everything Must Go 2012

Eve's Bayou 1997

Evil Dead 2014

Evil Dead, The 1983

Evil Dead II 1987

Evil That Men Do, The 1984

Father 1995

Father Hood 1993

Father of the Bride (Minnelli) [1950] 1993

Father of the Bride (Shyer) 1991

Father of the Bride Part II 1995

Fathers and Sons 1992

Father's Day 1997

Fausto. *See* A la Mode.

Fauteuils d'orchestre. *See* Avenue Montaigne.

Favor, The 1995

Favour, the Watch, and the Very Big Fish, The 1992

Fay Grim 2008

Fear 1988

Fear 1996

Fear and Loathing in Las Vegas 1999

Fear, Anxiety and Depression 1989

Fear of a Black Hat 1995

Feardotcom 2003

Fearless 1993

Fearless. *See* Jet Li's Fearless.

Feast of July 1995

Feast of Love 2008

Federal Hill 1995

Fedora [1978] 1986

Feds 1988

Feed 1992

Feel the Heat 1987

Feeling Minnesota 1996

Felicia's Journey 2000

Felix 1988

Fellini: I'm a Born Liar 2004

Female Perversions 1997

Femme d'a Cote, La. *See* Woman Next Door, The.

Femme de Chambre du Titanic, La. *See* Chambermaid of the Titanic.

Femme de mon pote, La. *See* My Best Friend's Girl.

Femme Fatale 2003

Femme Nikita, La 1991

Femmes de personne 1986

FernGully: The Last Rainforest 1992

Ferris Bueller's Day Off 1986

Festival Express 2005

Festival in Cannes 2003

Feud, The 1990

Fever 1988

Fever Pitch 1985

Fever Pitch 2000

Fever Pitch 2006

Few Days with Me, A 1988

Few Good Men, A 1992

Fido 2008

Field, The 1990

Field of Dreams 1989

Fierce Creatures 1997

15 Minutes 2002

Fifth Element, The 1997

Fifth Estate, The 2014

50 First Dates 2005

51st State, The. *See* Formula 51.

54 1999

50/50 2012

Fifty-Fifty 1993

56 Up 2014

Fifty-two Pick-up 1986

Fight Club 2000

Fighter 2002

Fighter, The 2011

Fighting 2010

Fighting Back 1982

Fighting Temptations, The 2004

Fill the Void 2014

Fille coupée en deux, La. *See* Girl Cut in Two, A.

Fille du RER, La. *See* Girl on the Train, The.

Filles ne Savent pas Nager, Les. *See* Girls Can't Swim.

Filly Brown 2014

Film Socialisme 2012

Film Unfinished, A 2011

Fils, Le. *See* Son, The.

Filth and the Fury, The 2001

Fin aout debut septembre. *See* Late August, Early September.

Final Analysis 1992

Final Approach 1991

Final Cut 2005

Final Destination 2001

Final Destination, The 2010

Final Destination: Death Trip 3D. *See* Final Destination, The.

Final Destination 2 2004

Final Destination 3 2007

Final Destination 4. *See* Final Destination, The.

Final Destination 5 2012

Final Fantasy: The Spirits Within 2002

Final Friday, The. *See* Jason Goes to Hell.

Final Option, The 1983

Final Sacrifice, The. *See* Children of the Corn II.

Final Season 1988

Final Season, The 2008

Find Me Guilty 2007

Finders Keepers 1984

Finding Forrester 2001

Finding Nemo 2004

Finding Neverland 2005

Fine Mess, A 1986

Fine Romance, A 1992

Finestra di Fronte, La. *See* Facing Windows.

Finzan 1995

Fiorile 1995

Fire and Ice (Bakshi) 1983

Fire and Ice (Bogner) 1987

Fire Birds 1990

Fire Down Below 1997

Fire from the Mountain 1987

Fire in Sky 1993

Fire This Time, The 1995

Fire Walk with Me. *See* Twin Peaks: Fire Walk with Me.

Fire with Fire 1986

Fired Up! 2010

Fireflies in the Garden 2012

Firefox 1982

Firehead 1991

Firelight 1999

Firemen's Bell, The [1967] 1985

Fireproof 2009

Firestorm 1999

Forever 1995

Forever, Lulu 1987

Forever Mary 1991

Forever Young 1992

Forget Paris 1995

Forgetting Sarah Marshall 2009

Forgotten, The 2005

Formula 51 2003

Forrest Gump 1995

Forsaken, The 2002

Fort Apache [1948] 1983

Fort Apache, the Bronx 1981

Fortress 1993

Fortune Cookie, The [1966] 1986

40 Days and 40 Nights 2003

40 Year Old Virgin, The 2006

48 Hrs. 1982

47 Ronin 2014

42 2014

Foster Daddy, Tora! 1981

Fountain, The 2007

Four Adventures of Reinette and Mirabelle 1989

Four Brothers 2006

Four Christmases 2009

Four Days in September 1999

Four Feathers, The 2003

Four Friends 1981

Four Lions 2011

4 Little Girls 1997

4 luni, 3 saptâmani si 2 zile. *See* 4 Months, 3 Weeks and 2 Days.

4 Months, 3 Weeks and 2 Days 2009

Four Rooms 1995

Four Seasons, The 1981

Four Weddings and a Funeral 1995

1492: Conquest of Paradise 1992

1408 2008

Fourth Kind, The 2010

4th Man, The 1984

Fourth Protocol, The 1987

Fourth War, The 1990

Fox and the Hound, The 1981

Foxfire 1996

Foxtrap 1986

Fracture 2008

Frailty 2003

Frances 1982

Frances Ha 2014

Frank and Ollie 1995

Frank Miller's Sin City. *See* Sin City.

Frankenhooker 1990

Frankenstein. *See* Mary Shelley's Frankenstein.

Frankenstein Unbound. *See* Roger Corman's Frankenstein Unbound.

Frankenweenie 2013

Frankie & Alice 2011

Frankie and Johnny 1991

Frankie Starlight 1995

Frantic 1988

Fraternity Vacation 1985

Frauds 1995

Freaked 1993

Freakonomics 2011

Freaky Friday 2004

Fred Claus 2008

Freddie as F.R.O.7 1992

Freddy Got Fingered 2002

Freddy vs. Jason 2004

Freddy's Dead 1991

Free and Easy 1989

Free Birds 2014

Free Enterprise 2000

Free Radicals 2005

Free Ride 1986

Free Willy 1993

Free Willy II: The Adventure Home 1995

Free Willy III: The Rescue 1997

Freebie, The 2011

Freedom On My Mind 1995

Freedom Writers 2008

Freedomland 2007

Freejack 1992

Freeway 1988

Freeway 1996

Freeze—Die—Come to Life 1995

French Connection, The [1971] 1982

French Kiss 1995

French Lesson 1986

French Lieutenant's Woman, The 1981

French Twist 1996

Frequency 2001

Fresh 1995

Fresh Horses 1988

Freshman, The 1990

Freud [1962] 1983

Frida 2003

Friday 1995

Friday After Next 2003

Friday Night 2004

Friday Night Lights 2005

Friday the 13th 2010

Friday the 13th, Part III 1982

Friday the 13th, Part IV 1984

Friday the 13th, Part VI 1986

Friday the 13th Part VII 1988

Friday the 13th Part VIII 1989

Fried Green Tomatoes 1991

Friend of the Deceased, A 1999

Friends & Lovers 2000

Friends With Benefits 2012

Friends with Kids 2013

Friends with Money 2007

Fright Night 1985

Fright Night 2012

Frighteners, The 1996

Fringe Dwellers, The 1987

From Beyond 1986

From Dusk Till Dawn 1996

From Hell 2002

From Hollywood to Deadwood 1988

From Paris With Love 2011

From Prada to Nada 2012

From Swastikas to Jim Crow 2001

From the Hip 1987

From Up on Poppy Hill 2014

Front, The [1976] 1985

Frosh: Nine Months in a Freshman Dorm 1995

Frost/Nixon 2009

Frozen 2011

Frozen 2014

Frozen Assets 1992

Frozen River 2009

Fruhlingssinfonie. *See* Spring Symphony.

Fruit Machine, The 1988

Fruitvale Station 2014

Fu-zung cen. *See* Hibiscus Town.

Fucking Amal. *See* Show Me Love.

Fugitive, The 1993

Full Blast 2001

Full Frontal 2003

Full Metal Jacket 1987

Full Monty, The 1997

Full Moon in Paris 1984

Full Moon in the Blue Water 1988

Full of It 2008

Fun Down There 1989

Fun Size 2013

Fun With Dick and Jane 2006

Funeral, The 1987

Funeral, The (Ferrara) 1996

Funny About Love 1990

Funny Bones 1995

Funny Farm (Clark) 1983

Funny Farm (Hill) 1988

Funny Games 2009

Funny People 2010

Furry Vengeance 2011

Further Adventures of Tennessee Buck, The 1988

Future, The 2012

G

Gabbeh 1997

Gabriela 1984

Gabrielle 2007

Gaby—A True Story 1987

Gadjo Dilo 1999

Gake no une no Ponyon. *See* Ponyo.

Galactic Gigolo 1988

Galaxy Quest 2000

Gallipoli 1981

Gambler, The 2000

Game, The 1989

Game, The 1997

Game Plan, The 2008

Game 6 2007

Gamer 2010

Gamin au velo, Le. *See* Kid with a Bike, The.

Gandhi 1982

Gang-Related 1997

Gangs of New York 2003

Gangster No. 1 2003

Gangster Squad 2014

Garage Days 2004

Garbage Pail Kids Movie, The 1987

Garbo Talks 1984

Garde a vue 1982

Garden, The 1995

Garden State 2005

Gardens of Stone 1987

Garfield 2005

Garfield: A Tail of Two Kitties 2007

Gas Food Lodging 1992

Gate, The 1987

Gate II 1992

Gatekeepers, The 2013

Gattaca 1997

Gaudi Afternoon 2002

Gay Divorcee, The [1934] 1981

Gegen die Wand. *See* Head-On.

Genealogies D' Un Crime. *See* Genealogies of a Crime.

Genealogies of a Crime 1999

General, The 1999

General's Daughter, The 2000

Genghis Blues 2000

Gentilezza del tocco, La. *See* Gentle Touch, The.

Gentle Touch, The 1988

Gentlemen Broncos 2010

Gentlemen Don't Eat Poets 1997

Gentlemen's Agreement [1947] 1989

Genuine Risk 1990

George A. Romero's Diary of the Dead. *See* Diary of the Dead.

George A. Romero's Land of the Dead 2006

George Balanchine's The Nutcracker 1993

George of the Jungle 1997

George's Island 1991

Georgia 1988

Georgia 1995

Georgia Rule 2008

Germinal 1993

Geronimo 1993

Gerry 2004

Get Back 1991

Get Bruce! 2000

Get Carter 2001

Get Crazy 1983

Get Him to the Greek 2011

Get Low 2011

Get on the Bus 1996

Get Over It! 2002

Get Real 2000

Get Rich or Die Tryin' 2006

Get Shorty 1995

Get Smart 2009

Getaway 2014

Getaway, The 1995

Geteilte Liebe. *See* Maneuvers.

Getting Away with Murder 1996

Getting Even 1986

Getting Even With Dad 1995

Getting It Right 1989

Getting to Know You 2001

Gettysburg 1993

G-Force 2010

Ghare Bhaire. *See* Home and the World, The.

Ghost 1990

Ghost and the Darkness, The 1996

Ghost Dad 1990

Ghost Dog: The Way of the Samurai 2000

Ghost in the Shell II: Innocence 2005

Ghosts of Girlfriends Past 2010

Ghost Rider 2008

Ghost Rider: Spirit of Vengeance 2013

Ghost Ship 2003

Ghost Writer, The 2011

Ghosts Can't Do It 1990

Ghosts of Mississippi 1996

Ghosts...of the Civil Dead 1988

Ghost Story 1981

Ghost Town 1988

Ghost Town 2009

Ghost World 2002

Ghosts of Mars. *See* John Carpenter's Ghosts of Mars.

Ghostbusters 1984

Ghostbusters II 1989

G.I. Jane 1997

G.I. Joe: Retaliation 2014

G.I. Joe: The Rise of Cobra 2010

Giant [1956] 1993, 1996

Gift, The (Lang) 1983

Gift, The (Raimi) 2001

Gift From Heaven, A 1995

Gig, The 1986

Gigli 2004

Gimme the Loot 2014

Ginger Ale Afternoon 1989

Ginger and Fred 1986

Ginger & Rosa 2014

Ginger Snaps 2002

Gingerbread Man, The 1999

Giornata speciale, Una. *See* Special Day, A.

Giovane Toscanini, II. *See* Young Toscanini.

Girl Cut in Two, A 2009

Girl from Paris, The 2004

Girl in a Swing, The 1988

Girl in the Picture, The 1986

Girl in Progress 2013

Girl, Interrupted 2000

Girl Next Door, The 2001

Girl Next Door, The (Greenfield) 2005

Girl on the Train, The 2011

Girl Rising 2014

Girl 6 1996

Girl Talk 1988

Girl Who Kicked the Hornet's Nest, The 2011

Girl Who Played with Fire, The 2011

Girl with a Pearl Earring 2004

Girl with the Dragon Tattoo, The 2011

Girl with the Dragon Tattoo, The 2012

Girl with the Hungry Eyes, The 1995

Girl with the Red Hair, The 1983

Girlfight 2001

Girlfriend Experience, The 2010

Girls Can't Swim 2003

Girls School Screamers 1986

Girls Town 1996

Give My Regards to Broad Street 1984

Giving, The 1992

Gladiator (Herrington) 1992

Gladiator (Scott) 2001

Glamazon: A Different Kind of Girl 1995

Glamour 2002

Glaneurs et la Glaneuse, Les. *See* Gleaners and I, The.

Glass House, The 2002

Glass Menagerie, The 1987

Glass Shield, The 1995

Gleaming the Cube 1989

Gleaners and I, The 2002

Glee: The 3D Concert Movie 2012

Glengarry Glen Ross 1992

Glimmer Man, The 1996

Glitter 2002

Gloire de mon pere, La. *See* My Father's Glory.

Gloomy Sunday 2004

Gloria (Cassavetes) [1980] 1987

Gloria (Lumet) 2000

Glory 1989

Glory Road 2007

Gnomeo & Juliet 2012

Go 2000

Go Fish 1995

Go Now 1999

Goal! The Dream Begins 2007

Goat, The 1985

Gobots 1986

God Bless America 2013

God Doesn't Believe in Us Anymore 1988

God Grew Tired of Us 2008

God Is Great, I'm Not 2003

God Is My Witness 1993

God Said "Ha"! 2000

Goddess of 1967, The 2003

Godfather, Part III, The 1990

Gods and Generals 2004

Gods and Monsters 1999

Gods Must Be Crazy, The 1984

Gods Must Be Crazy II, The 1990

God's Will 1989

Godsend 2005

Godzilla 1985 1985

Godzilla 1997

Godzilla 2000 2001

Gohatto. *See* Taboo.

Goin' to Chicago 1991

Going All the Way 1997

Going Berserk 1983

Going the Distance 2011

Going Undercover 1988

Goin' South 1978

Gold Diggers: The Secret of Bear Mountain 1995

Golden Bowl, The 2002

Golden Child, The 1986

Golden Compass, The 2008

Golden Gate 1995

Golden Seal 1983

Goldeneye 1995

Gomorrah 2010

Gone 2013

Gone Baby Gone 2008

Gone Fishin' 1997

Gone in Sixty Seconds 2001

Gone With the Wind [1939] 1981, 1982, 1997

Gong fu. *See* Kung Fu Hustle.

Gonza the Spearman 1988

Good Boy! 2004

Good Burger 1997

Good Bye Cruel World 1984

Good Bye, Lenin! 2005

Good Day to Die Hard, A 2014

Good Deeds. *See* Tyler Perry's Good Deeds.

Good Evening, Mr. Wallenberg 1995

Good German, The 2007

Good Girl, The 2003

Groove 2001

Gross Anatomy 1989

Grosse Fatigue 1995

Grosse Pointe Blank 1997

Ground Truth, The 2008

Ground Zero 1987, 1988

Groundhog Day 1993

Grown Ups 2011

Grown Ups 2 2014

Grudge, The 2005

Grudge 2, The 2007

Grumpier Old Men 1995

Grumpy Old Men 1993

Grudge Match 2014

Grune Wuste. *See* Green Desert.

Guard, The 2012

Guardian, The 1990

Guardian, The 2007

Guarding Tess 1995

Guatanamera 1997

Guelwaar 1995

Guerre du Feu, La. *See* Quest for Fire.

Guess Who 2006

Guess Who's Coming to Dinner? [1967] 1992

Guest, The 1984

Guests of Hotel Astoria, The 1989

Guilt Trip, The 2013

Guilty as Charged 1992

Guilty as Sin 1993

Guilty by Suspicion 1991

Guinevere 2000

Gulliver's Travels 2011

Gummo 1997

Gun in Betty Lou's Handbag, The 1992

Gun Shy 2001

Gunbus. *See* Sky Bandits.

Guncrazy 1993

Gunfighter, The [1950] 1989

Gung Ho 1986

Gunmen 1995

Gunner Palace 2006

Guru, The 2004

Guy Named Joe, A [1943] 1981

Guy Thing, A 2004

Guys, The 2003

Gwendoline 1984

Gwoemul. *See* Host, The.

Gyakufunsha Kazoku. *See* Crazy Family, The.

Gymkata 1985

H

H. M. Pulham, Esq. [1941] 1981

Hable con Ella. *See* Talk to Her.

Hackers 1995

Hadesae: The Final Incident 1992

Hadley's Rebellion 1984

Haevnen. *See* In a Better World.

Hail Mary 1985

Hairdresser's Husband, The 1992

Hairspray 1988

Hairspray 2008

Haizi wang. *See* King of the Children.

Hak hap. *See* Black Mask

Hak mau. *See* Black Cat.

Half-Baked 1999

Half Moon Street 1986

Half of Heaven 1988

Halfmoon 1996

Hall of Fire [1941] 1986

Halloween (Zombie) 2008

Halloween II 2010

Halloween III: Season of the Witch 1982

Halloween IV 1988

Halloween V 1989

Halloween VI: the Curse of Michael Myers 1995

Halloween H20 1999

Halloween: Resurrection 2003

Hall Pass 2012

Hamburger 1986

Hamburger Hill 1987

Hamlet (Zeffirelli) 1990

Hamlet (Branagh) 1996

Hamlet (Almereyda) 2001

Hamlet 2 2009

Hammett 1983

Hana-Bi. *See* Fireworks.

Hancock 2009

Hand That Rocks the Cradle, The 1992

Handful of Dust, A 1988

Handmaid's Tale, The 1990

Hangfire 1991

Hanging Garden, The 1999

Hanging Up 2001

Hangin' with the Homeboys 1991

Hangover, The 2010

Hangover Part III, The 2014

Hangover Part II, The 2012

Hanky Panky 1982

Hanna 2012

Hanna K. 1983

Hannah and Her Sisters 1986

Hannah Arendt 2014

Hannah Montana: The Movie 2010

Hannibal 2002

Hannibal Rising 2008

Hanoi Hilton, The 1987

Hans Christian Andersen's Thumbelina 1995

Hansel and Gretel 1987

Hansel & Gretel: Witch Hunters 2014

Hanussen 1988, 1989

Happening, The 2009

Happenstance 2002

Happily Ever After 1993

Happily Ever After 2006

Happily N'Ever After 2008

Happiness 1999

Happy Accidents 2002

Happy End 2001

Happy Endings 2006

Happy Feet 2007

Happy Feet Two 2012

Happy '49 1987

Happy Gilmore 1996

Happy Hour 1987

Happy New Year 1987

Happy, Texas 2000

Happy Times 2003

Happy Together 1990

Happy Together 1997

Heavy 1996

Heavyweights 1995

Hecate 1984

Hedwig and the Angry Inch 2002

Heidi Fleiss: Hollywood Madame 1996

Heights 2006

Heist, The 2002

Helas Pour Moi 1995

Held Up 2001

Hell High 1989

Hell Ride 2009

Hellbent 1989

Hellbound 1988

Hellboy 2005

Hellboy II: The Golden Army 2009

Heller Wahn. *See* Sheer Madness.

Hello Again 1987

Hello, Dolly! [1969] 1986

Hello I Must Be Going 2013

Hello Mary Lou 1987

Hellraiser 1987

Hellraiser III: Hell on Earth 1992

Hellraiser IV: Bloodline 1996

Help, The 2012

Henna 1991

Henri Langlois: The Phantom of the Cinematheque 2006

Henry 1990

Henry and June 1990

Henry IV 1985

Henry V 1989

Henry Fool 1999

Henry Poole in Here 2009

Her 2014

Her Alibi 1989

Her Name Is Lisa 1987

Herbes folles, Les. *See* Wild Grass.

Herbie: Fully Loaded 2006

Hercules 1983

Hercules II 1985

Herdsmen of the Sun 1995

Here Come the Littles 1985

Here Comes the Boom 2013

Here On Earth 2001

Hereafter 2011

Here's to Life 2002

Hero 1992

Hero 2004

Hero 2005

Hero and the Terror 1988

Hesher 2012

He's Just Not That Into You 2010

He's My Girl 1987

Hey Arnold! The Movie 2003

Hexed 1993

Hibiscus Town 1988

Hidalgo 2005

Hidden. *See* Cache.

Hidden, The 1987

Hidden Agenda 1990

Hidden Hawaii 1995

Hide and Seek 2006

Hideaway 1995

Hideous Kinky 2000

Hiding Out 1987

Hifazaat. *See* In Custody.

High Art 1999

High Crimes 2003

High Fidelity 2001

High Heels 1991

High Heels and Low Lives 2002

High Hopes 1988, 1989

High Lonesome: The Story of Bluegrass Music 258

High Risk 1995

High Road to China 1983

High School 2013

High School High 1996

High School Musical 3: Senior Year 2009

High Season 1988

High Spirits 1988

High Tension 2006

High Tide 1987

Higher Ground 2012

Higher Learning 1995

Highlander 1986

Highlander 2: The Quickening 1991

Highlander 3: The Final Dimension 1995

Highlander: Endgame 2001

Highway Patrolman 1995

Highway 61 1992

Highway to Hell 1992

Hijacking, A 2014

Hijacking Hollywood

Hijo se la Novia, El. *See* Son of the Bride.

Hi-Lo Country, The 2000

Hilary and Jackie 1999

Hills Have Eyes, The 2007

Hills Have Eyes II, The 2008

Himmel uber Berlin, Der. *See* Wings of Desire.

Histories d'amerique. *See* American Stories.

History Boys, The 2007

History Is Made at Night [1937] 1983

History of Violence, A 2006

Hit, The 1985

Hit and Run 2013

Hit and Runway 2002

Hit List 1989

Hit the Dutchman 1995

Hitch 2006

Hitchcock 2013

Hitcher, The 1986

Hitcher, The (Meyers) 2008

Hitchhiker's Guide to the Galaxy, The 2006

Hitman 2008

Hitman, The 1991

Hive, The. *See* Call, The.

Hoax, The 2008

Hobbit: An Unexpected Journey, The 2013

Hobbit: The Desolation of Smaug, The 2014

Hobo with a Shotgun 2012

Hocus Pocus 1993

Hodejegerne. *See* Headhunters.

Hoffa 1992

Holcroft Covenant, The 1985

Hold Back the Dawn [1941] 1986

Hold Me, Thrill Me, Kiss Me 1993

Holes 2004

Holiday [1938] 1985

Holiday, The 2007

Holiday Inn [1942] 1981

Hollow Man 2001

Hollow Reed 1997

Hollywood Ending 2003

Hollywood Homicide 2004

Hollywood in Trouble 1986

Hollywood Mavericks 1990

Hollywood Shuffle 1987

Hollywood Vice Squad 1986

Hollywoodland 2007

Holy Blood. *See* Santa Sangre.

Holy Innocents, The 1985

Holy Man 1999

Holy Motors 2013

Holy Rollers 2011

Holy Smoke 2000

Holy Tongue, The 2002

Hombre [1967] 1983

Home Alone 1990

Home Alone II: Lost in New York 1992

Home Alone III 1997

Home and the World, The 1985

Home at the End of the World, A 2005

Home for the Holidays 1995

Home Free All 1984

Home Fries 1999

Home Is Where the Heart Is 1987

Home of Our Own, A 1993

Home of the Brave 1986

Home on the Range 2005

Home Remedy 1987

Homeboy 1988

Homefront 2014

Homegrown 1999

Homer and Eddie 1990

Home Run 2014

Homeward Bound 1993

Homeward Bound II: Lost in San Francisco 1996

Homework 1982

Homework. *See* Art of Getting By, The.

Homicide 1991

Homme et une femme, Un. *See* Man and a Woman, A.

Hommes et des dieux, Des. *See* Of Gods and Men.

Hondo [1953] 1982

Honey 2004

Honey, I Blew Up the Kid 1992

Honey, I Shrunk the Kids 1989

Honeybunch 1988

Honeydripper 2008

Honeymoon Academy 1990

Honeymoon in Vegas 1992

Honeymooners, The 2006

Hong Gaoliang. *See* Red Sorghum.

Honky Tonk Freeway 1981

Honkytonk Man 1982

Honneponnetge. *See* Honeybunch.

Honor Betrayed. *See* Fear.

Honorable Mr. Wong, The. *See* Hatchet Man, The.

Honour of the House 2001

Hoodlum 1997

Hoodwinked 2007

Hoodwinked Too! Hood vs. Evil 2012

Hook 1991

Hoop Dreams 1995

Hoosiers 1986

Hoot 2007

Hop 2012

Hope and Glory 1987

Hope and Pain 1988

Hope Floats 1999

Hope Springs 2013

Horrible Bosses 2012

Horror Show, The 1989

Hors de prix. *See* Priceless.

Hors la Vie 1995

Horse of Pride, The 1985

Horse Whisperer, The 1999

Horseman on the Roof, The 1996

Horton Hears a Who! *See* Dr. Seuss' Horton Hears a Who!

Host, The 2008

Host, The 2014

Hostage 2006

Hostel 2007

Hostel: Part II 2008

Hot Chick, The 2003

Hot Dog...The Movie 1984

Hot Fuzz 2008

Hot Pursuit 1987

Hot Rod 2008

Hot Shots! 1991

Hot Shots! Part Deux 1993

Hot Spot, The 1990

Hot to Trot 1988

Hot Tub Time Machine 2011

Hotel Colonial 1987

Hotel De Love 1997

Hotel for Dogs 2010

Hotel New Hampshire, The 1984

Hotel Rwanda 2005

Hotel Terminus 1988

Hotel Transylvania 2013

Hotshot 1987

Hottest State, The 2008

Hound of the Baskervilles, The 1981

Hours, The 2003

Hours and Times, The 1992

House 1986

House II 1987

House Arrest 1996

House at the End of the Street 2013

House Bunny, The 2009

House of Cards 1993

House of D 2006

House of Flying Daggers 2005

House of Fools 2004

House of Games 1987

House of Luk 2001

House of Mirth 2002

House of 1,000 Corpses 2004

House of Sand and Fog 2004

House of the Devil, The 2010

House of the Spirits, The 1995

House of Wax 2006

House of Yes, The 1997

House on Carroll Street, The 1988

House on Haunted Hill 2000

House on Limb, A. *See* Tottering Lives.

House on Sorority Row, The. *See* Sorority Row.

House Party 1990

House Party II 1991

House Party III 1995

House Where Evil Dwells, The 1982

Houseboat [1958] 1986

Houseguest 1995

Household Saints 1993

Householder, The 1984

Housekeeper, A 2004

Housekeeper, The 1987

Housekeeping 1987

Housesitter 1992

How Do You Know 2011

How I Got into College 1989

How I Killed My Father 2004

How I Live Now 2014

How She Move 2009

How Stella Got Her Groove Back 1999

How to Deal 2004

How to Eat Fried Worms 2007

How to Get Ahead in Advertising 1989

How to Get the Man's Foot Outta Your Ass. *See* Baadasssss!

How to Lose a Guy in 10 Days 2004

How to Lose Friends & Alienate People 2009

How to Make an American Quilt 1995

How to Make Love to a Negro Without Getting Tired 1990

How to Survive a Plague 2013

How to Train Your Dragon 2011

Howard the Duck 1986

Howard's End 1992

Howl 2011

Howling, The 1981

Howling III, The. *See* Marsupials, The.

Howl's Moving Castle 2006

Hsi Yen. *See* Wedding Banquet, The.

Hsimeng Jensheng. *See* Puppetmaster, The.

H2: Halloween 2. *See* Halloween II.

Hudson Hawk 1991

Hudsucker Proxy, The 1995

Hugh Hefner: Once Upon a Time 1992

Hugo 2012

Hugo Pool 1997

Huit Femmes. *See* 8 Women.

Hulk 2004

Human Centipede: First Sequence, The 2011

Human Centipede II (Full Sequence), The 2012

Human Nature 2003

Human Resources 2002

Human Shield, The 1992

Human Stain, The 2004

Humongous 1982

Humpday 2010

Hunchback of Notre Dame, The 1996

Hungarian Fairy Tale, A 1989

Hunger, The 1983

Hunger Games, The 2013

Hunger Games: Catching Fire, The 2014

Hungry Feeling, A 1988

Hunk 1987

Hunt, The 2014

Hunt for Red October, The 1990

Hunted, The 1995

Hunted, The 2004

Hunter, The 2013

Hunters of the Golden Cobra, The 1984

Hunting Party, The 2008

Huo Yuan Jia. *See* Jet Li's Fearless.

Hurt Locker, The 2010

Hurlyburly 1999

Hurricane, The 2000

Hurricane Streets 1999

Husbands and Wives 1992

Hush (Darby) 1999

Hush! (Hashiguchi) 2003

Hustle & Flow 2006

Hyde Park on Hudson 2013

Hyenas 1995

Hypnotic. *See* Close Your Eyes.

Hysteria 2013

I

I Am 2012

I Am David 2005

I Am Legend 2008

I Am Love 2011

I Am My Own Woman 1995

I Am Number Four 2012

I Am Sam 2002

I Can Do Bad All By Myself 2010

I Can't Sleep 1995

I Capture the Castle 2004

I Come in Peace 1990

I Demoni. *See* Demons.

I Don't Buy Kisses Anymore 1992

I Don't Know How She Does It 2012

I Don't Want to Talk About It 1995

I Dreamed of Africa 2001

I Got the Hook-Up 1999

"I Hate Actors!" 1988

I Hate You, Dad. *See* That's My Boy.

I Heart Huckabees 2005

I Hope They Serve Beer in Hell 2010

I Know What You Did Last Summer 1997

I Know Where I'm Going [1945] 1982

I Know Who Killed Me 2008

I Like It Like That 1995

I Love Trouble 1995

I Love You 1982

I Love You, Beth Cooper 2010

I Love You, Don't Touch Me 1999

I Love You, I Love You Not 1997

I Love You, Man 2010

I Love You Phillip Morris 2011

I Love You to Death 1990

I, Madman 1989

I Married a Shadow 1983

I Now Pronounce You Chuck and Larry 2008

I Only Want You to Love Me 1995

I Ought to Be in Pictures 1982

Joan Rivers: A Piece of Work 2011

Jobs 2014

Jocks 1987

Jodaelye Nader az Simin. *See* Separation, A.

Joe Dirt 2002

Joe Gould's Secret 2001

Joe Somebody 2002

Joe the King 2000

Joe Versus the Volcano 1990

Joe's Apartment 1996

Joey 1985

Joey Takes a Cab 1991

John and the Missus 1987

John Carpenter's Ghosts of Mars 2002

John Carpenter's The Ward. *See* Ward, The.

John Carpenter's Vampires 1999

John Carter 2013

John Dies at the End 2014

John Grisham's the Rainmaker 1998

John Huston 1988

John Huston and the Dubliners 1987

John Q 2003

John Tucker Must Die 2007

Johnny Be Good 1988

Johnny Dangerously 1984

Johnny English 2004

Johnny English Reborn 2012

Johnny Handsome 1989

Johnny Mnemonic 1995

Johnny Stecchino 1992

Johnny Suede 1992

johns 1997

Johnson Family Vacation 2005

Joke of Destiny, A 1984

Jonah Hex 2011

Jonas Brothers: The 3D Concert Experience 2010

Joneses, The 2011

Joseph Conrad's the Secret Agent 1996

Josh and S.A.M. 1993

Joshua 2008

Joshua Then and Now 1985

Josie and the Pussycats 2002

Journey into Fear [1943] 1985

Journey of August King 1995

Journey of Hope 1991

Journey of Love 1990

Journey of Natty Gann, The 1985

Journey to Spirit Island 1988

Journey to the Center of the Earth 2009

Journey 2: The Mysterious Island 2013

Joy Luck Club, The 1993

Joy of Sex 1984

Joy Ride 2002

Joyeux Noel 2007

Joyful Noise 2013

Joysticks 1983

Ju Dou 1991

Juana la Loca. *See* Mad Love.

Judas Kiss 2000

Judas Project, The 1995

Jude 1996

Judge Dredd 1995

Judgement in Berlin 1988

Judgement Night 1993

Judy Berlin 2001

Judy Moody and the Not Bummer Summer 2012

Juice 1992

Julia 2010

Julia Has Two Lovers 1991

Julian Po 1997

Julia's Eyes 2012

Julie & Julia 2010

Julien Donkey-Boy 2000

Jumanji 1995

Jument vapeur, La. *See* Dirty Dishes.

Jump Tomorrow 2002

Jumper 2009

Jumpin' at the Boneyard 1992

Jumpin' Jack Flash 1986

Jumpin' Night in the Garden of Eden, A 1988

Jumping the Broom 2012

Junebug 2006

Jungle Book, The 1995

Jungle Book 2, The 2004

Jungle Fever 1991

Jungle2Jungle 1997

Junior 1995

Juno 2008

Jurassic Park 1993

Jurassic Park III 2002

Juror, The 1996

Jury Duty 1995

Jusan-nin no shikaku. *See* 13 Assassins.

Just a Kiss 2003

Just a Little Harmless Sex 2000

Just Another Girl on the I.R.T. 1993

Just Between Friends 1986

Just Cause 1995

Just Friends 2006

Just Go with It 2012

Just Like a Woman 1995

Just Like Heaven 2006

Just Looking 2002

Just Married 2004

Just My Luck 2007

Just One of the Guys 1985

Just One Time 2002

Just the Ticket 2000

Just the Way You Are 1984

Just Visiting 2002

Just Wright 2011

Just Write 1999

Justice in the Coalfields 1996

Justin Bieber: Never Say Never 2012

Juwanna Mann 2003

K

K-9 1989

K-19: The Widowmaker 2003

K-PAX 2002

Kaboom 2012

Kadisbellan. *See* Slingshot, The.

Kadosh 2001

Kaena: The Prophecy 2005

Kafka 1991

Kalifornia 1993

Kama Sutra: A Tale of Love 1997

Letters from Iwo Jima 2007

Letters to Juliet 2011

Leviathan 1989

Leviathan 2014

Levity 2004

Levy and Goliath 1988

Ley del deseo, La. *See* Law of Desire, The.

L'heure d'été. *See* Summer Hours.

Liaison Pornographique, Une. *See* Affair of Love, An.

Liam 2002

Lianna 1983

Liar, Liar 1997

Liar's Moon 1982

Liberal Arts 2013

Libertine, The 2007

Liberty Heights 2000

Licence to Kill 1989

License to Drive 1988

License to Wed 2008

Lie Down With Dogs 1995

Liebestraum 1991

Lies 1986

Life 2000

Life, Above All 2012

Life After Love 2002

Life and Nothing But 1989

Life and Times of Allen Ginsberg, The 1995

Life and Times of Judge Roy Bean, The [1972] 1983

Life Aquatic with Steve Zissou, The 2005

Life as a House 2002

Life As We Know It 2011

Life Before Her Eyes, The 2009

Life Classes 1987

Life During Wartime 2011

Life in the Food Chain. *See* Age Isn't Everything.

Life in the Theater, A 1995

Life Is a Long Quiet River 1990

Life Is Beautiful 1999

Life Is Cheap 1989

Life Is Sweet 1991

Life Less Ordinary, A 1997

Life Lessons. *See* New York Stories.

Life of Adele, The. *See* Blue is the Warmest Color.

Life of David Gale, The 2004

Life of Pi 2013

Life on a String 1992

Life on the Edge 1995

Life or Something Like It 2003

Life Stinks 1991

Life with Father [1947] 1993

Life with Mikey 1993

Life Without Zoe. *See* New York Stories.

Lifeforce 1985

Lift 2002

Light Ahead, The [1939] 1982

Light It Up 2000

Light Keeps Me Company 2001

Light of Day 1987

Light Sleeper 1992

Lighthorsemen, The 1987

Lightning in a Bottle 2005

Lightning Jack 1995

Lightship, The 1986

Like Crazy 2012

Like Father Like Son 1987

Like Mike 2003

Like Someone in Love 2014

Like Water for Chocolate 1993

Lili Marleen 1981

Lilies 1997

Lilies of the Field [1963] 1992

Lillian 1995

Lilo & Stitch 2003

Lily in Love 1985

Limbo 2000

Limey, The 2000

Limitless 2012

Limits of Control, The 2010

Lincoln 2013

Lincoln Lawyer, The 2012

Line One 1988

Lingua del Santo, La. *See* Holy Tongue, The.

Linguini Incident, The 1992

Linie Eins. *See* Line One.

Link 1986

L'instinct de mort. *See* Mesrine.

Lion King, The 1995

Lionheart (Lettich) 1991

Lionheart (Shaffner) 1987

Lions for Lambs 2008

Liquid Dreams 1992

Liquid Sky 1983

Lisa 1990

Listen to Me 1989

Listen Up 1990

Little Big League 1995

Little Bit of Heaven, A 2013

Little Black Book 2005

Little Buddha 1995

Little Children 2007

Little Devil, the 1988

Little Dorrit 1988

Little Drummer Girl, The 1984

Little Fockers 2011

Little Giants 1995

Little Indian, Big City 1996

Little Jerk 1985

Little Man 2007

Little Man Tate 1991

Little Men 1999

Little Mermaid, The 1989

Little Miss Sunshine 2007

Little Monsters 1989

Little Nemo: Adventures in Slumberland 1992

Little Nicky 2001

Little Nikita 1988

Little Noises 1992

Little Odessa 1995

Little Princess, A 1995

Little Rascals, The 1995

Little Secrets 1995

Little Secrets (Treu) 2003

Little Sex, A 1982

Little Shop of Horrors [1960] 1986

Little Stiff, A 1995

Little Sweetheart 1988

Little Thief, The 1989

Love Affair 1995

Love After Love 1995

Love Always 1997

Love and a .45 1995

Love and Basketball 2001

Love and Death in Long Island 1999

Love and Human Remains 1995

Love and Murder 1991

Love and Other Catastrophes 1997

Love and Other Drugs 2011

Love & Sex 2001

Love at Large 1990

Love Child, The 1988

Love Child: A True Story 1982

Love Come Down 2002

Love Crimes 1992

Love Don't Cost a Thing 2004

Love Field 1992

Love Guru, The 2009

Love Happens 2010

Love in Germany, A 1984

Love in the Afternoon [1957] 1986

Love in the Time of Cholera 2008

Love in the Time of Money 2003

Love Is a Dog from Hell 1988

Love is All You Need 2014

Love Is the Devil 1999

love jones 1997

Love/Juice 2001

Love Letter, The 2000

Love Letters 1984

Love Liza 2004

Love Potion #9 1992

Love Ranch 2011

Love Serenade 1997

Love Song for Bobby Long, A 2006

Love Songs 2009

Love Stinks 2000

Love Story, A. *See* Bound and Gagged.

Love Streams 1984

Love the Hard Way 2004

Love, the Magician. *See* Amor brujo, El.

Love! Valour! Compassion! 1997

Love Walked In 1999

Love Without Pity 1991

Lovelace 2014

Loveless, The 1984, 1986

Lovelines 1984

Lovely & Amazing 2003

Lovely Bones, The 2010

Lover, The 1992

Loverboy 1989

Loverboy 2007

Lovers 1992

Lovers of the Arctic Circle, The 2000

Lovers on the Bridge 2000

Love's a Bitch. *See* Amores Perros.

Love's Labour's Lost 2001

Loves of a Blonde [1965] 1985

Lovesick 1983

Loving Jezebel 2001

Low Blow 1986

Low Down, The 2002

Low Down Dirty Shame, A 1995

Low Life, The 1996

Lucas 1986

Lucia, Lucia 2004

Lucia y el Sexo. *See* Sex and Lucia.

Lucie Aubrac 2000

Luckiest Man in the World, The 1989

Lucky Break 2003

Lucky Number Slevin 2007

Lucky Numbers 2001

Lucky One, The 2013

Lucky Ones, The 2009

Lucky You 2008

Luftslottet som sprängdes. *See* Girl Who Kicked the Hornet's Nest, The.

L'Ultimo Bacio. *See* Last Kiss, The.

Luminous Motion 2001

Lumumba 2002

Lumumba: Death of a Prophet 1995

Luna Park 1995

Lunatic, The 1992

Lunatics: A Love Story 1992

Lune Froide. *See* Cold Moon.

Lunga vita alla signora! *See* Long Live the Lady!

Lurkers 1988

Lush Life 1995

Lust, Caution 2008

Lust for Life [1956] 1991

Lust in the Dust 1985

Luther 2004

Luzhin Defence, The 2002

Lymelife 2010

M

M. Butterfly 1993

Ma Femme Est une Actrice. *See* My Wife Is an Actress.

Ma Vie en Rose 1997

Mac 1993

Mac and Me 1988

Macaroni V 1988

MacArthur's Children 1985

Maccheroni. *See* Macaroni.

MacGruber 2011

Machete 2011

Machete Kills 2014

Machine Gun Preacher 2012

Machinist, The 2005

Macht der Bilder, Die. *See* Wonderful, Horrible Life of Leni Riefenstahl, The.

Mack the Knife 1990

Macomber Affair, The [1947] 1982

Mad City 1997

Mad Dog and Glory 1993

Mad Dog Coll. *See* Killer Instinct.

Mad Dog Time 1996

Mad Love 1995

Mad Love 2003

Mad Max Beyond Thunderdome 1985

Mad Money 2009

Madagascar 2006

Madagascar: Escape 2 Africa 2009

Madagascar Landing. *See* Aventure Malgache.

Madagascar Skin 1996

Madagascar 3: Europe's Most Wanted 2013

Maniac 2014

Maniac Cop 1988

Manic 2004

Manifesto 1989

Manito 2004

Mannequin 1987

Mannequin Two 1991

Manny & Lo 1996

Manon des sources. *See* Manon of the Spring.

Manon of the Spring 1987

Man's Best Friend 1993

Mansfield Park 2000

Mao's Last Dancer 2011

Map of the Human Heart 1993

Mapantsula 1988

Mar Adentro. *See* Sea Inside, The.

Marc Pease Experience, The 2010

March of the Penguins 2006

Marci X 2004

Margaret 2012

Margaret's Museum 1997

Margarita Happy Hour 2003

Margin Call 2012

Margot at the Wedding 2008

Maria Full of Grace 2005

Maria's Lovers 1985

Mariachi, El 1993

Mariages 2003

Marie 1985

Marie Antoinette 2007

Marie Baie des Anges. *See* Marie from the Bay Angels.

Marie from the Bay Angels 1999

Marilyn Monroe 1987

Marine, The 2007

Marine Life 2001

Marius and Jeannette 1999

Marius et Jeannette: Un Conte de L'Estaque. *See* Marius and Jeannette.

Marked for Death 1990

Marlene 1986

Marley 2013

Marley & Me 2009

Marmaduke 2011

Marooned in Iraq 2004

Marquis 1995

Marriages. *See* Mariages.

Married Life 2009

Married to It 1993

Married to the Mob 1988

Marrying Man, The 1991

Mars Attacks! 1996

Mars Needs Moms 2012

Marsupials, The 1987

Martha and Ethel 1995

Martha and I 1995

Martha Marcy May Marlene 2012

Martha, Ruth, and Edie 1988

Martian Child 2008

Martians Go Home 1990

Marusa No Onna. *See* Taxing Woman, A.

Marvel's The Avengers. *See* Avengers, The.

Marvin & Tige 1983

Marvin's Room 1996

Mary and Max 2010

Mary Reilly 1996

Mary Shelley's Frankenstein 1995

Masala 1993

Mask 1985

Mask, The 1995

Mask of the Phantasm. *See* Batman: Mask of the Phantasm.

Mask of Zorro, The 1999

Masked and Anonymous 2004

Masque of the Red Death 1989

Masquerade 1988

Mass Appeal 1985

Massa'ot James Be'eretz Hakodesh. *See* James' Journey to Jerusalem.

Master, The 2013

Master and Commander: The Far Side of the World 2004

Master of Disguise 2003

Master of the Crimson Armor. *See* Promise, The.

Masterminds 1997

Masters of the Universe 1987

Matador, The 2007

Match Point 2006

Matchmaker, The 1997

Matchstick Men 2004

Material Girls 2007

Matewan 1987

Matilda 1996

Matinee 1993

Matrix, The 2000

Matrix Reloaded, The 2004

Matrix Revolutions, The 2004

Matter of Struggle, A 1985

Matter of Taste, A 2002

Maurice 1987

Maverick 1995

Max 2003

Max Dugan Returns 1983

Max Keeble's Big Move 2002

Max Payne 2009

Maxie 1985

Maximum Overdrive 1986

Maximum Risk 1996

May Fools 1990

Maybe Baby 2002

Maybe…Maybe Not 1996

McBain 1991

McHale's Navy 1997

Me and Isaac Newton 2001

Me and My Gal [1932] 1982

Me and Orson Welles 2010

Me and the Kid 1993

Me and Veronica 1995

Me and You and Everyone We Know 2006

Me, Myself & Irene 2001

Me Myself I 2001

Me Without You 2003

Me You Them 2002

Mean Creek 2005

Mean Girls 2005

Mean Season, The 1985

Meatballs II 1984

Meatballs III 1987

Meatballs IV 1992

Mechanic, The 2012

Medallion, The 2004

Money Man 1995

Money Pit, The 1986

Money Talks 1997

Money Train 1995

Money Tree, The 1992

Moneyball 2012

Mongol 2009

Mongolian Tale, A 1997

Monkey Shines 1988

Monkey Trouble 1995

Monkeybone 2002

Monsieur Hire 1990

Monsieur Ibrahim 2004

Monsieur Lazhar 2013

Monsieur N 2006

Monsignor 1982

Monsoon Wedding 2003

Monster 2004

Monster, The 1996

Monster House 2007

Monster in a Box 1992

Monster-in-Law 2006

Monster in the Closet 1987

Monster Squad, The 1987

Monsters 2011

Monster's Ball 2002

Monsters, Inc. 2002

Monsters University 2014

Monsters vs. Aliens 2010

Montana Run 1992

Monte Carlo 2012

Montenegro 1981

Month by the Lake, A 1995

Month in the Country, A 1987

Monty Python's The Meaning of Life 1983

Monument Ave. 1999

Moolaade 2005

Moon 2010

Moon in the Gutter 1983

Moon Over Broadway 1999

Moon over Parador 1988

Moon Shadow [1995] 2001

Moonlight and Valentino 1995

Moonlight Mile 2003

Moonlighting 1982

Moonrise Kingdom 2013

Moonstruck 1987

More Than A Game 2010

Morgan Stewart's Coming Home 1987

Moriarty. *See* Sherlock Holmes.

Morning After, The 1986

Morning Glory 1993

Morning Glory 2011

Morons from Outer Space 1985

Mort de Mario Ricci, La. *See* Death of Mario Ricci, The.

Mortal Instruments: City of Bones, The 2014

Mortal Kombat 1995

Mortal Kombat II: Annihilation 1997

Mortal Thoughts 1991

Mortuary Academy 1988

Morvern Callar 2003

Mosca addio. *See* Moscow Farewell.

Moscow Farewell 1987

Moscow on the Hudson 1984

Mosquito Coast, The 1986

Most Dangerous Game, The [1932] 1985

Most Dangerous Man in America: Daniel Ellsberg and the Pentagon Papers, The 2011

Most Fertile Man in Ireland, The 2002

Most Wanted 1997

Mostly Martha 2003

Mother 1996

Mother 2011

Mother, The 2005

Mother and Child 2011

Mother Lode 1983

Mother Night 1996

Mother Teresa 1986

Motherhood 2010

Mothering Heart, The [1913] 1984

Mother's Boys 1995

Mothman Prophecies, The 2003

Motorama 1993

Motorcycle Diaries, The 2005

Moulin Rouge 2002

Mountain Gorillas 1995

Mountains of Moon 1990

Mountaintop Motel Massacre 1986

Mouse Hunt 1997

Mouth to Mouth 1997

Movers and Shakers 1985

Movie 43 2014

Moving 1988

Moving the Mountain 1995

Moving Violations 1985

MS One: Maximum Security. *See* Lockout.

Much Ado About Nothing 1993

Much Ado About Nothing 2014

Mud 2014

Mui du du Xanh. *See* Scent of Green Papaya, The.

Mujeres al borde de un ataque de nervios. *See* Women on the Verge of a Nervous Breakdown.

Mulan 1999

Mulholland Drive 2002

Mulholland Falls 1996

Multiplicity 1996

Mumford 2000

Mummy, The 2000

Mummy Returns, The 2002

Mummy: Tomb of the Dragon Emperor, The 2009

Munchie 1995

Munchies 1987

Munich 2006

Muppets, The 2012

Muppet Christmas Carol, The 1992

Muppets from Space 2000

Muppet Treasure Island 1996

Muppets Take Manhattan, The 1984

Mur, Le. *See* Wall, The.

Murder at 1600 1997

Murder by Numbers 2003

Murder in the First 1995

Murder One 1988

Murderball 2006

Murderous Maids 2003

Muriel's Wedding 1995

Murphy's Law 1986

Murphy's Romance 1985

Muscle Shoals 2014

Muse, The 2000

Muses Orphelines, Les. *See* Orphan Muses, The.

Museum Hours 2014

Music and Lyrics 2008

Music Box 1989

Music for the Movies: Bernard Herrmann 1995

Music From Another Room 1999

Music of Chance, The 1993

Music of the Heart 2000

Music Tells You, The 1995

Musime si Pomahat. *See* Divided We Fall.

Musketeer, The 2002

Must Love Dogs 2006

Mustang: The Hidden Kingdom 1995

Musuko. *See* My Sons.

Mutant on the Bounty 1989

Mute Witness 1995

Mutiny on the Bounty [1962] 1984

My African Adventure 1987

My American Cousin 1986

My Apprenticeship. *See* Among People.

My Architect 2005

My Baby's Daddy 2005

My Beautiful Laundrette 1986

My Best Fiend 2000

My Best Friend 2008

My Best Friend Is a Vampire 1988

My Best Friend's Girl 1984

My Best Friend's Girl 2009

My Best Friend's Wedding 1997

My Big Fat Greek Wedding 2003

My Bloody Valentine 3D 2010

My Blue Heaven 1990

My Blueberry Nights 2009

My Boss's Daughter 2004

My Boyfriend's Back 1993

My Chauffeur 1986

My Cousin Rachel [1952] 1981

My Cousin Vinny 1992

My Crazy Life. *See* Mi Vida Loca.

My Dark Lady 1987

My Demon Lover 1987

My Dinner with Andre 1981

My Family (Mi Familia) 1995

My Father Is Coming 1992

My Father, the Hero 1995

My Father's Angel 2002

My Father's Glory 1991

My Favorite Martian 2000

My Favorite Season 1996

My Favorite Year 1982

My Fellow Americans 1996

My First Mister 2002

My First Wife 1985

My Foolish Heart (1949) 1983

My Giant 1999

My Girl 1991

My Girl II 1995

My Heroes Have Always Been Cowboys 1991

My Idiot Brother. *See* Our Idiot Brother.

My Left Foot 1989

My Life 1993

My Life and Times with Antonin Artaud 1996

My Life as a Dog [1985] 1987

My Life in Pink. *See* Ma Vie en Rose.

My Life in Ruins 2010

My Life So Far 2000

My Life Without Me 2004

My Life's in Turnaround 1995

My Little Pony 1986

My Mom's a Werewolf 1989

My Mother's Castle 1991

My Mother's Courage

My Mother's Smile 2006

My Name is Joe 2000

My Neighbor Totoro 1993

My New Gun 1992

My New Partner 1985

My One and Only 2010

My Other Husband 1985

My Own Private Idaho 1991

My Reputation [1946] 1984, 1986

My Science Project 1985

My Sister's Keeper 2010

My Son, My Son, What Have Ye Done 2011

My Son the Fanatic 2000

My Sons 1995

My Soul to Take 2011

My Stepmother Is an Alien 1988

My Summer of Love 2006

My Super Ex-Girlfriend 2007

My Sweet Little Village 1986

My True Love, My Wound 1987

My Tutor 1983

My Twentieth Century 1990

My Uncle's Legacy 1990

My Voyage to Italy 2003

My Week With Marilyn 2012

My Wife Is an Actress 2003

Mysterious Skin 2006

Mystery, Alaska 2000

Mystery Date 1991

Mystery of Alexina, The 1986

Mystery of Rampo 1995

Mystery of the Wax Museum [1933] 1986

Mystery Men 2000

Mystery Science Theater 3000: The Movie 1996

Mystery Train 1989

Mystic Masseur, The 2003

Mystic Pizza 1988

Mystic River 2004

Myth of Fingerprints, The 1998

N

Nacho Libre 2007

Nader and Simin, a Separation. *See* Separation, A.

Nadine 1987

Nadja 1995

Naked 1993

Naked Cage, The 1986

Naked Gun, The 1988

Naked Gun 2 1/2, The 1991

Naked Gun 33 1/3: The Final Insult 1995

Night Catches Us 2011

Night Crossing 1982

Night Falls on Manhattan 1997

Night Friend 1988

Night Game 1989

Night in Heaven, A 1983

Night in the Life of Jimmy Reardon, A 1988

Night Listener, The 2007

'night, Mother 1986

Night of the Comet 1984

Night of the Creeps 1986

Night of the Demons II 1995

Night of the Hunter, The [1955] 1982

Night of the Iguana, The [1964] 1983

Night of the Living Dead 1990

Night of the Pencils, The 1987

Night of the Shooting Stars, The 1983

Night on Earth 1992

Night Patrol 1985

Night Shift 1982

Night Song [1947] 1981

Night Visitor 1989

Night Watch 2007

Night We Never Met, The 1993

Nightbreed 1990

Nightcap. *See* Merci pour le Chocolat.

Nightfall 1988

Nightflyers 1987

Nighthawks 1981

Nighthawks II. *See* Strip Jack Naked.

Nightmare at Shadow Woods 1987

Nightmare Before Christmas, The 1993

Nightmare on Elm Street, A 2011

Nightmare on Elm Street, A 1984

Nightmare on Elm Street: II, A 1985

Nightmare on Elm Street: III, A 1987

Nightmare on Elm Street: IV, A 1988

Nightmare on Elm Street: V, A 1989

Nightmares III 1984

Nights in Rodanthe 2009

Nightsongs 1991

Nightstick 1987

Nightwatch 1999

Nil by Mouth 1999

Nim's Island 2009

9 2010

Nine 2010

9 1/2 Weeks 1986

9 Deaths of the Ninja 1985

Nine Months 1995

Nine Queens 2003

976-EVIL 1989

1918 1985

1969 1988

1990: The Bronx Warriors 1983

1991: The Year Punk Broke 1995

Ninety Days 1986

Ninja Assassin 2010

Ninja Turf 1986

Ninotchka [1939] 1986

Ninth Gate, The 2001

Nixon 1995

No 1999

No 2014

No Country for Old Men 2008

No End in Sight 2008

No Escape 1995

No Fear, No Die 1995

No Holds Barred 1989

No Looking Back 1999

No Man of Her Own [1949] 1986

No Man's Land 1987

No Man's Land 2002

No Mercy 1986

No News from God 2003

No Picnic 1987

No Reservations 2008

No Retreat, No Surrender 1986

No Retreat, No Surrender II 1989

No Secrets 1991

No Small Affair 1984

No Strings Attached 2012

No Such Thing 2003

No Way Out 1987, 1992

Nobody Loves Me 1996

Nobody Walks 2013

Nobody's Fool (Benton) 1995

Nobody's Fool (Purcell) 1986

Nobody's Perfect 1990

Noce en Galilee. *See* Wedding in Galilee, A.

Noche de los lapices, La. *See* Night of the Pencils, The.

Nochnoi Dozor. *See* Night Watch.

Noel 2005

Noises Off 1992

Nomads 1986

Non ti muovere. *See* Don't Move.

Nora 2002

Norbit 2008

Nordwand. *See* North Face.

Normal Life 1996

Norte, El 1983

North 1995

North Country 2006

North Face 2011

North Shore 1987

North Star, The [1943] 1982

Northfork 2004

Nostalgia 1984

Nostradamus 1995

Not Another Teen Movie 2002

Not Easily Broken 2010

Not Fade Away 2013

Not for Publication 1984

Not of This Earth 1988

Not Quite Paradise 1986

Not Since Casanova 1988

Not Without My Daughter 1991

Notebook, The 2005

Notebook on Cities and Clothes 1992

Notes on a Scandal 2007

Nothing but Trouble 1991

Nothing in Common 1986

Nothing Personal 1997

Nothing to Lose 1997

Notorious 2010

Notorious Bettie Page, The 2007

Notte di San Lorenzo, La. *See* Night of the Shooting Stars, The.

Notting Hill 2000

Nouvelle Eve, The. *See* New Eve, The.

November 2006

Novocaine 2002

Now. *See* In Time.

Now and Then 1995

Now You See Me 2014

Nowhere 1997

Nowhere Boy 2011

Nowhere in Africa 2004

Nowhere to Hide 1987

Nowhere to Run 1993

Nowhereland. *See* Imagine That.

Nueve Reinas. *See* Nine Queens.

Nuit de Varennes, La [1982] 1983, 1984

Nuits Fauves, Les. *See* Savage Nights.

Nuits de la pleine lune, Les. *See* Full Moon In Paris.

Number One with a Bullet 1987

Number 23, The 2008

Nuns on the Run 1990

Nurse Betty 2001

Nutcracker Prince, The 1990

Nutcracker, The 1986

Nutcracker, The. *See* George Balanchine's the Nutcracker.

Nuts 1987

Nutty Professor, The 1996

Nutty Professor 2: The Klumps 2001

O

O 2002

O Brother, Where Art Thou? 2001

O' Despair. *See* Long Weekend, The.

Oak, The 1995

Oasis, The 1984

Obecna Skola. *See* Elementary School, The.

Oberst Redl. *See* Colonel Redl.

Object of Beauty, The 1991

Object of My Affection, The 1999

Oblivion 1995

Oblivion 2014

Observe and Report 2010

Obsessed 1988

Obsessed 2010

Obsluhoval jsem anglického krále. *See* I Served the King of England.

O.C. and Stiggs 1987

Oceans 2011

Ocean's Eleven 2002

Ocean's Thirteen 2008

Ocean's Twelve 2005

Oci Ciornie. *See* Dark Eyes.

October Baby 2013

October Sky 2000

Octopussy 1983

Odd Life of Timothy Green, The 2013

Odd Man Out [1947] 1985

Oedipus Rex 1995

Oedipus Rex [1967] 1984

Oedipus Wrecks. *See* New York Stories.

Of Gods and Men 2012

Of Human Bondage [1946] 1986

Of Love and Shadows 1996

Of Men and Mavericks. *See* Chasing Mavericks.

Of Mice and Men 1992

Of Unknown Origin 1983

Off Beat 1986

Off Limits 1988

Off the Menu: The Last Days of Chasen's 1999

Office Killer 1997

Office Party 1989

Office Space 2000

Officer and a Gentleman, An 1982

Official Story, The 1985

Offret. *See* Sacrifice, The.

Oh God, You Devil 1984

O'Hara's Wife 1982

Ojos de Julia, Los. *See* Julia's Eyes.

Okuribito. *See* Departures.

Old Dogs 2010

Old Explorers 1991

Old Gringo 1989

Old Joy 2007

Old Lady Who Walked in the Sea, The 1995

Old School 2004

Oldboy 2006

Oldboy 2014

Oleanna 1995

Oliver and Company 1988

Oliver Twist 2006

Olivier Olivier 1993

Olympus Has Fallen 2014

Omen, The 2007

On Deadly Ground 1995

On Golden Pond 1981

On Guard! 2004

On the Edge 1986

On the Line 2002

On the Other Side. *See* Edge of Heaven, The.

On the Road 2013

On the Town [1949] 1985

On Valentine's Day 1986

Once 2008

Once Around 1991

Once Bitten 1985

Once More 1988

Once Were Warriors 1995

Once Upon a Crime 1992

Once Upon A Forest 1993

Once Upon a Time in America 1984

Once Upon a Time in Anatolia 2013

Once Upon a Time in Mexico 2004

Once Upon a Time in the Midlands 2004

Once Upon a Time...When We Were Colored 1996

Once We Were Dreamers 1987

Ondine 2011

One 2001

One, The 2002

One and a Two, A. *See* Yi Yi.

One Crazy Summer 1986

One Day 2012

One Day in September 2001

One Direction: This Is Us 2014

One False Move 1992

One Fine Day 1996

Penn and Teller Get Killed 1989

Pennies from Heaven 1981

People I Know 2004

People Like Us 2013

People on Sunday [1929] 1986

People Under the Stairs, The 1991

People vs. George Lucas, The 2012

People vs. Larry Flynt, The 1996

Pepi, Luci, Bom 1992

Percy Jackson & the Olympians: The Lightning Thief 2011

Percy Jackson: Sea of Monsters 2014

Perez Family, The 1995

Perfect 1985

Perfect Candidate, A 1996

Perfect Getaway, A 2010

Perfect Host, The 2012

Perfect Man, The 2006

Perfect Match, The 1987

Perfect Model, The 1989

Perfect Murder, A 1999

Perfect Murder, The 1988

Perfect Score, The 2005

Perfect Son, The 2002

Perfect Storm, The 2001

Perfect Stranger 2008

Perfect Weapon, The 1991

Perfect World, A 1993

Perfectly Normal 1991

Perfume: The Story of a Murderer 2008

Perhaps Some Other Time 1992

Peril 1985

Peril en la demeure. *See* Peril.

Perks of Being a Wallflower, The 2013

Permanent Midnight 1999

Permanent Record 1988

Persepolis 2009

Personal Best 1982

Personal Choice 1989

Personal Services 1987

Personal Velocity 2003

Personals, The 1983

Persuasion 1995

Pervola, Sporen in die Sneeuw. *See* Tracks in the Snow.

Pest, The 1997

Pet Sematary 1989

Pet Sematary II 1992

Pete Kelly's Blues [1955] 1982

Peter Ibbetson [1935] 1985

Peter Pan 2004

Peter Von Scholten 1987

Peter's Friends 1992

Petit, Con. *See* Little Jerk.

Petite Bande, Le 1984

Petite Veleuse, La. *See* Little Thief, The.

Peyote Road, The 1995

Phantasm II 1988

Phantom 2014

Phantom, The 1996

Phantom of the Opera, The (Little) 1989

Phantom of the Opera, The (Schumacher) 2005

Phantoms 1999

Phar Lap 1984

Phat Beach 1996

Phat Girlz 2007

Phenomenon 1996

Philadelphia 1993

Philadelphia Experiment, The 1984

Philadelphia Experiment II, The 1995

Philomena 2014

Phobia 1988

Phone Booth 2004

Phorpa. *See* Cup, The.

Physical Evidence 1989

Pi 1999

Piaf 1982

Pianist, The 2003

Pianiste, La. *See* Piano Teacher, The.

Piano, The 1993

Piano Piano Kid 1992

Piano Teacher, The 2003

Piano Tuner of Earthquakes, The 2007

Picasso Trigger 1988

Piccolo diavolo, II. *See* Little Devil, The.

Pick-Up Artist, The 1987

Pickle, The 1993

Picture Bride 1995

Picture Perfect 1997

Picture This: The Life and Times of Peter Bogdanovich in Archer City, Texas 1995

Pie in the Sky 1996

Pieces of April 2004

Piel que habito, La. *See* Skin I Live In, The.

Pigalle 1995

Piglet's Big Movie 2004

Pigs and Pearls. *See* Montenegro.

Pile ou face. *See* Heads or Tails.

Pillow Book, The 1997

Pimp, The 1987

Pineapple Express 2009

Pinero 2002

Pink Cadillac 1989

Pink Flamingos [1972] 1997

Pink Floyd the Wall 1982

Pink Nights 1991

Pink Panther, The 2007

Pink Panther 2, The 2010

Pinocchio 2003

Pinocchio and the Emperor of the Night 1987

Pipe Dream 2003

Piranha 3D 2011

Piranha 3DD 2013

Pirate, The [1948] 1985

Pirate Movie, The 1982

Pirate Radio 2010

Pirates! Band of Misfits, The 2013

Pirates of Penzance, The 1983

Pirates of the Caribbean: At World's End 2008

Pirates of the Caribbean: Dead Man's Chest 2007

Pirates of the Caribbean: On Stranger Tides 2012

Pirates of the Caribbean: The Curse of the Black Pearl 2004

Pirates Who Don't Do Anything: A VeggieTales Movie, The 2009

Pit and the Pendulum, The 1991

Pitch Black 2001

Pitch Black 2: Chronicles of Riddick. *See* Chronicles of Riddick, The.

Pitch Perfect 2013

Pixote 1981

Pizza Man 1991

Pizzicata 2000

Placard, Le. *See* Closet, The.

Place Beyond the Pines, The 2014

Place in the Sun, A [1951] 1993

Place in the World, A 1995

Places in the Heart 1984

Plague, The 1995

Plague Sower, The. *See* Breath of Life, A.

Plain Clothes 1988

Plan B 1997

Planes 2014

Plancs, Trains and Automobiles 1987

Planet 51 2010

Planet of the Apes 2002

Planet Terror. *See* Grindhouse.

Platform 2004

Platoon Leader 1988

Play It to the Bone 2001

Play Misty for Me [1971] 1985

Playboys, The 1992

Player, The 1992

Players Club, The 1999

Playing by Heart 1999

Playing for Keeps 1986

Playing for Keeps 2013

Playing God 1997

Playing the Field. *See* Playing for Keeps.

Please Give 2011

Pleasantville 1999

Pledge, The 2002

Plenty 1985

Plot Against Harry, The 1990

Plouffe, Les 1985

Ploughman's Lunch, The 1984

Plump Fiction 1999

Plunkett and Macleane 2000

Pocahontas 1995

Poetic Justice 1993

Poetry 2012

Point Break 1991

Point of No Return 1993

Pointsman, The 1988

Poison 1991

Poison Ivy 1992

Pokayaniye. *See* Repentance.

Pola X 2001

Polar Express, The 2005

Police 1986

Police Academy 1984

Police Academy II 1985

Police Academy III 1986

Police Academy IV 1987

Police Academy V 1988

Police Academy VI 1989

Police, Adjective 2010

Polish Bride, The 2000

Polish Wedding 1999

Politist, Adj. *See* Police, Adjective.

Pollock 2001

Poltergeist 1982

Poltergeist II 1986

Poltergeist III 1988

POM Wonderful Presents: The Greatest Movie Ever Sold 2012

Pomme, La. *See* Apple, The.

Pompatus of Love, The 1996

Ponette 1997

Pontiac Moon 1995

Ponyo 2010

Ponyo on the Cliff by the Sea. *See* Ponyo.

Pooh's Heffalump Movie 2006

Poolhall Junkies 2004

Pootie Tang 2002

Popcorn 1991

Pope Must Die, The 1991

Pope of Greenwich Village, The 1984

Porgy and Bess [1959] 1992

Porky's 1982

Porky's II: The Next Day 1983

Pornographic Affair, An. *See* Affair of Love, An.

Porte aperte. *See* Open Doors.

Portrait Chinois 2000

Portrait of a Lady, The 1996

Poseidon 2007

Positive I.D. 1987

Posse 1993

Possession 2003

Possession, The 2013

Possible Worlds 2001

Post Coitum 1999

Post Coitum, Animal Triste. *See* Post Coitum.

Post Grad 2010

Post Grad Survival Guide, The. *See* Post Grad.

Post Tenebras Lux 2014

Postcards from America 1995

Postcards from the Edge 1990

Poster Boy 2007

Postman, The (Radford) 1995

Postman, The (Costner) 1997

Postman Always Rings Twice, The 1981

Potiche 2012

Pound Puppies and the Legend of Big Paw 1988

Poupees russes, Les. *See* Russian Dolls.

Poussière d'ange. *See* Angel Dust.

Powaqqatsi 1988

Powder 1995

Power 1986

Power, The 1984

Power of One, The 1992

Powwow Highway 1988

Practical Magic 1999

Prairie Home Companion, A 2007

Prancer 1989

Prayer for the Dying, A 1987

Prayer of the Rollerboys 1991

Preacher's Wife, The 1996

Precious: Based on the Novel 'Push' by Sapphire 2010

Predator 1987

Predator II 1990

Predators 2011

Prefontaine 1997

Prelude to a Kiss 1992

Premium Rush 2013

Premonition 2008

Prenom, Carmen. *See* First Name, Carmen.

Presidio, The 1988

Presque Rien. *See* Come Undone.

Prestige, The 2007

Presumed Innocent 1990

Pret-a-Porter. *See* Ready to Wear.

Pretty Baby [1978] 1984

Pretty in Pink 1986

Pretty Persuasion 2006

Pretty Woman 1990

Prettykill 1987

Prey for Rock and Roll 2004

Priatiel Pakoinika. *See* Friend of the Deceased, A.

Price Above Rubies, A 1999

Price of Glory 2001

Price of Milk 2002

Priceless 2009

Prick Up Your Ears 1987

Pride 2008

Pride and Glory 2009

Pride and Prejudice 2006

Priest 1995

Priest 2012

Priest of Love 1981

Primal Fear 1996

Primary Colors 1999

Primary Motive 1995

Prime 2006

Prince and Me, The 2005

Prince Avalanche 2014

Prince of Darkness 1987

Prince of Egypt, The 1999

Prince of Pennsylvania, The 1988

Prince of Persia: The Sands of Time 2011

Prince of the City 1981

Prince of Tides, The 1991

Princess Academy, The 1987

Princess and the Frog, The 2010

Princess and the Goblin, The 1995

Princess and the Warrior, The 2002

Princess Bride, The 1987

Princess Caraboo 1995

Princess Diaries, The 2002

Princess Diaries 2, The 2005

Principal, The 1987

Principio da Incerteza, O. *See* Uncertainty Principle, The.

Prison 1988

Prisoners 2014

Prisoners of the Mountain 1998

Prisoners of the Sun 1991

Private Fears in Public Places 2008

Private Function, A 1985

Private Investigations 1987

Private Life of Sherlock Holmes, The [1970] 1986

Private Lives of Pippa Lee, The 2010

Private Parts 1997

Private School 1983

Private Worlds [1935] 1982

Prize Winner of Defiance, Ohio, The 2006

Prizzi's Honor 1985

Problem Child 1990

Problem Child II 1991

Producers, The 2006

Professional, The 1995

Program, The 1993

Programmed to Kill 1987

Project Greenlight's Stolen Summer. *See* Stolen Summer.

Project Nim 2012

Project X 1987

Project X 2013

Prom 2012

Prom Night 2009

Prom Night II. *See* Hello Mary Lou.

Promesse, La 1997

Prometheus 2013

Promise, The 1995

Promise, The 2007

Promised Land 1988

Promised Land 2013

Promised Life, The 2005

Promotion, The 2009

Proof (Moorhouse) 1992

Proof 2006

Proof of Life 2001

Prophecy, The 1995

Prophet, A 2011

Proposal, The 2010

Proposition, The 1999

Proposition, The 2007

Proprietor, The 1996

Prospero's Books 1991

Protocol 1984

Przesluchanie. *See* Interrogation, The.

P.S. I Love You 2008

Psych-Out [1968] 1995

Psycho (Hitchcock) [1960] 1981

Psycho (Van Sant) 1999

Psycho II 1983

Psycho III 1986

Psycho Beach Party 2001

Puberty Blues 1983

Public Access 1995

Public Enemies 2010

Public Eye, The 1992

Puerto Rican Mambo (Not a Musical), The 1995

Pulp Fiction 1995

Pulse 2007

Pump Up the Volume 1990

Pumping Iron II 1985

Pumpkin 2003

Pumpkinhead 1988

Punch-Drunk Love 2003

Punchline 1988

Puncture 2012

Punisher, The 2005

Puppet Masters, The 1995

Puppetmaster, The 1995

Puppetoon Movie 1987

Puppies [1957] 1985

Pure Country 1992

Pure Luck 1991

Purgatory 1989

Purge, The 2014

Purple Haze 1983

Purple Hearts 1984

Purple Noon [1960] 1996

Real Men 1987

Real Steel 2012

Real Women Have Curves 2003

Reality 2014

Reality Bites 1995

Reaping, The 2008

Rear Window [1954] 2001

Reason to Believe, A 1995

Rebel 1986

Rebelle. *See* War Witch.

Rebound 2006

[Rec] 2 2011

Reckless 1984

Reckless 1995

Reckless Kelly 1995

Reckoning, The 2005

Recruit, The 2004

Recruits 1986

Red 1995

RED 2011

Red Cliff 2010

Red Corner 1997

Red Dawn 1984

Red Dawn 2013

Red Dragon 2003

Red Eye 2006

Red Firecracker, Green Firecracker 1995

Red Heat 1988

Red Hill 2011

Red Hook Summer 2013

Red Lights 2013

Red Planet 2001

Red Riding Hood 2012

Red Riding Trilogy, The 2011

Red Riding: 1980. *See* Red Riding Trilogy, The.

Red Riding: 1983. *See* Red Riding Trilogy, The.

Red Riding: 1974. *See* Red Riding Trilogy, The.

Red Road 2008

Red Rock West 1995

Red Scorpion 1989

Red Sonja 1985

Red Sorghum 1988

Red State 2012

Red Surf 1990

Red Tails 2013

RED 2 2014

Red Violin, The 1999

Redbelt 2009

Redemption 2014

Redl Ezredes. *See* Colonel Redl.

Reds 1981

Redwood Pigeon 1995

Reefer and the Model 1988

Ref, The 1995

Reflecting Skin, The 1991

Reform School Girls 1986

Regarding Henry 1991

Regeneration 1999

Reign of Fire 2003

Reign Over Me 2008

Reindeer Games 2001

Reine Margot, La. *See* Queen Margot.

Rejuvenator, The 1988

Relax, It's Just Sex 2000

Relentless 1989

Relic, The 1997

Religion Hour, The. *See* My Mother's Smile.

Religulous 2009

Reluctant Fundamentalist, The 2014

Remains of the Day, The 1993

Remember Me 2011

Remember the Titans 2001

Remo Williams 1985

Renaissance Man 1995

Rendez-vous 1988

Rendezvous in Paris 1996

Rendition 2008

Renegades 1989

Renoir 2014

Reno 911!: Miami 2008

Rent 2006

Rent-a-Cop 1988

Rent Control 1984

Rented Lips 1988

Repentance 1987

Replacement Killers, The 1999

Replacements, The 2001

Repo Man 1984

Repo Men 2011

Repo! The Genetic Opera 2009

Repossessed 1990

Requiem for a Dream 2001

Requiem for Dominic 1991

Rescue, The 1988

Rescue Dawn 2008

Rescuers Down Under, The 1990

Reservation Road 2008

Reservoir Dogs 1992

Resident Alien: Quentin Crisp in America 1992

Resident Evil 2003

Resident Evil: Afterlife 2011

Resident Evil: Apocalypse 2005

Resident Evil: Extinction 2008

Resident Evil: Retribution 2013

Respiro 2004

Ressources Humaines. *See* Human Resources.

Restless 2012

Restless Natives 1986

Restoration 1995

Restrepo 2011

Resurrected, The 1995

Resurrecting the Champ 2008

Retour de Martin Guerre, Le. *See* Return of Martin Guerre, The.

Return, The 2007

Return of Horror High 1987

Return of Martin Guerre, The 1983

Return of Superfly, The 1990

Return of the Jedi 1983, 1997

Return of the Living Dead, The 1985

Return of the Living Dead II 1988

Return of the Living Dead III 1993

Return of the Musketeers, The 1989

Return of the Secaucus 7 1982

Return of the Soldier, The 1983

Return of the Swamp Thing, The 1989

Return to Me 2001

Return to Never Land 2003

Romeo is Bleeding 1995

Romeo Must Die 2001

Romper Stomper 1993

Romuald et Juliette. *See* Mama, There's a Man in Your Bed.

Romulus, My Father 2009

Romy & Michelle's High School Re-union 1997

Ronin 1999

Rooftops 1989

Rookie, The 1990

Rookie, The 2003

Rookie of the Year 1993

Room 237 2014

Room with a View, A 1986

Roommate, The 2012

Roommates 1995

Rory O'Shea Was Here 2006

Rosa Luxemburg 1987

Rosalie Goes Shopping 1990

Rosary Murders, The 1987

Rose Garden, The 1989

Rosencrantz and Guildenstern Are Dead 1991

Rosewood 1997

Rosie 2000

Rouge of the North 1988

Rough Cut 1982

Rough Magic

Roughly Speaking [1945] 1982

Rouille et d'os, De. *See* Rust and Bone.

'Round Midnight 1986

Rounders 1999

Rover Dangerfield 1991

Row of Crows, A. *See* Climate for Killing, A.

Roxanne 1987

Roy Rogers: King of the Cowboys 1995

Royal Affair, A 2013

Royal Tenenbaums, The 2002

Royal Wedding [1951] 1985

Rubin and Ed 1992

Ruby 1992

Ruby in Paradise 1993

Ruby Sparks 2013

Rude Awakening 1989

Rudo y Cursi 2010

Rudy 1993

Rudyard Kipling's the Second Jungle Book 1997

Rugrats Go Wild! 2004

Rugrats in Paris: The Movie 2001

Rugrats Movie, The 1999

Ruins, The 2009

Rules of Attraction, The 2003

Rules of Engagement 2001

Rum Diary, The 2012

Rumba, La. *See* Rumba, The.

Rumba, The 1987

Rumble Fish 1983

Rumble in the Bronx 1996

Rumor Has It... 2006

Rumpelstiltskin 1987

Run 1991

Run, Fatboy, Run 2009

Run Lola Run 2000

Run of the Country, The 1995

Runaway Bride 2000

Runaway Jury 2004

Runaway Train 1985

Runaways, The 2011

Rundown, The 2004

Rundskop. *See* Bullhead.

Runestone, The 1992

Runner Runner 2014

Running Brave 1983

Running Free 2001

Running Hot 1984

Running Man, The 1987

Running on Empty 1988

Running Scared 1986

Running Scared 2007

Running with Scissors 2007

Rupert's Land 2001

Rush 1991

Rush 2014

Rush Hour 1999

Rush Hour 2 2002

Rush Hour 3 2008

Rushmore 1999

Russia House, The 1990

Russian Dolls 2007

Russia's Wonder Children 2001

Russkies 1987

Russlands Wunderkinder. *See* Russia's Wonder Children.

Rust and Bone 2013

Rustler's Rhapsody 1985

Rustling of Leaves, A 1990

Ruthless People 1986

RV 2007

Ryan's Daughter [1970] 1990

S

S.F.W. 1995

Sabrina [1954] 1986

Sabrina 1995

Sacrifice, The 1986

Saddest Music in the World, The 2005

Sade 2004

Safe 1995

Safe 2013

Safe Conduct 2003

Safe Haven 2014

Safe House 2013

Safe Journey. *See* Latcho Drom.

Safe Passage 1995

Safety Not Guaranteed 2013

Safety of Objects, The 2003

Sahara 2006

Sahara (McLaglen) 1984

St. Elmo's Fire 1985

Saint, The 1997

Saint Clara 1997

Saint of Fort Washington, The 1993

Saison des Hommes, La. *See* Season of Men, The.

Salaam Bombay! 1988

Salinger 2014

Salmer fra Kjokkenet. *See* Kitchen Stories.

Salmon Fishing in the Yemen 2013

Salmonberries 1995

Salome's Last Dance 1988

Season of the Witch 2012

Seasons 1995

Second Best 1995

Second Chance, The 2007

Second Sight 1989

Second Skin 2003

Second Thoughts 1983

Secondhand Lions 2004

Secret Admirer 1985

Secret Garden, The 1993

Secret in Their Eyes, The 2011

Secret Life of Bees, The 2009

Secret Life of Walter Mitty, The [1947] 1985

Secret Life of Walter Mitty, The 2014

Secret Lives of Dentists, The 2004

Secret Love, Hidden Faces. *See* Ju Dou.

Secret of Kells, The 2011

Secret of My Success, The 1987

Secret of NIMH, The 1982

Secret of Roan Inish, The 1995

Secret of the Sword, The 1985

Secret Places 1985

Secret Policeman's Third Ball, The 1987

Secret Window 2005

Secret World of Arrietty, The 2013

Secretariat 2011

Secretary 2003

Secreto de sus ojos, El. *See* Secret in Their Eyes, The.

Secrets 1984

Secrets & Lies 1996

Seduction, The 1982

See No Evil 2007

See No Evil, Hear No Evil 1989

See Spot Run 2002

See You in the Morning 1989

Seed of Chucky 2005

Seeing Other People 2005

Seeker: The Dark Is Rising, The 2008

Seeking a Friend for the End of the World 2013

Seeking Justice 2013

Segunda Piel. *See* Second Skin.

Selena 1998

Self Made Hero, A 1998

Semi-Pro 2009

S'en Fout la Mort. *See* No Fear, No Die.

Sender, The 1982

Senna 2012

Sensations 1988

Sense and Sensibility 1995

Sense of Freedom, A 1985

Senseless 1999

Sentimental Destiny 2002

Sentinel, The 2007

Separate Lies 2006

Separate Vacations 1986

Separation, A 2012

Seppan 1988

September 1987

September Dawn 2008

September Issue, The 2010

Serendipity 2002

Serenity 2006

Sgt. Bilko 1996

Seraphim Falls 2008

Serbuan maut. *See* Raid: Redemption, The.

Serial Mom 1995

Series 7: The Contenders 2002

Serious Man, A 2010

Serpent and the Rainbow, The 1988

Servants of Twilight, The 1995

Serving Sara 2003

Sesame Street Presents: Follow That Bird 1985

Session 9 2002

Sessions, The 2013

Set It Off 1996

Set Me Free 2001

Seto uchi shonen yakyudan. *See* MacArthur's Children.

Seunlau Ngaklau. *See* Time and Tide.

Seven 1995

Seven Hours to Judgement 1988

Seven Men from Now [1956] 1987

Seven Minutes in Heaven 1986

Seven Pounds 2009

Seven Psychopaths 2013

Seven Women, Seven Sins 1987

Seven Year Itch, The [1955] 1986

Seven Years in Tibet 1998

17 Again 2010

Seventh Coin, The 1993

Seventh Sign, The 1988

Severance 1989

Sex and Lucia 2003

Sex and the City: The Movie 2009

Sex and the City 2 2011

Sex Drive 2009

Sex, Drugs, and Democracy 1995

Sex, Drugs, Rock and Roll 1991

sex, lies and videotape 1989

Sex: The Annabel Chong Story 2001

Sexbomb 1989

Sexy Beast 2002

Shades of Doubt 1995

Shadey 1987

Shadow, The 1995

Shadow Army, The. *See* Army of Shadows.

Shadow Conspiracy, The

Shadow Dancer 2014

Shadow Dancing 1988

Shadow Magic 2002

Shadow of the Raven 1990

Shadow of the Vampire 2001

Shadow of the Wolf 1993

Shadowboxer 2007

Shadowlands 1993

Shadows and Fog 1992

Shadrach 1999

Shaft 2001

Shag 1988

Shaggy Dog, The 2007

Shakedown 1988

Shakes the Clown 1992

Shakespeare in Love 1999

Shaking the Tree 1992

Shall We Dance? 1997

Shall We Dance? 2005

Shallow Grave 1995

Silent Rage 1982

Silent Tongue 1995

Silent Touch, The 1995

Silent Victim 1995

Silk Road, The 1992

Silkwood 1983

Silver City (Sayles) 2005

Silver City (Turkiewicz) 1985

Silver Linings Playbook 2013

Silverado 1985

Simon Birch 1999

Simon Magnus 2002

Simon the Magician 2001

Simone 2003

Simpatico 2000

Simple Men 1992

Simple Plan, A 1999

Simple Twist of Fate, A 1995

Simple Wish, A 1997

Simply Irresistible 2000

Simpsons Movie, The 2008

Sin City 2006

Sin Nombre 2010

Sin Noticias de Dios. *See* No News from God.

Sinbad: Legend of the Seven Seas 2004

Since Otar Left 2005

Sincerely Charlotte 1986

Sinful Life, A 1989

Sing 1989

Singin' in the Rain [1952] 1985

Singing Detective, The 2004

Singing the Blues in Red 1988

Single Man, A 2010

Single Shot, A 2014

Single White Female 1992

Singles 1992

Sinister 2013

Sioux City 1995

Sirens 1995

Sister Act 1992

Sister Act II 1993

Sister, My Sister 1995

Sister, Sister 1987

Sisterhood of the Traveling Pants, The 2006

Sisterhood of the Traveling Pants 2, The 2009

Sisters. *See* Some Girls.

Sitcom 2000

Sitter, The 2012

Siu lam juk kau. *See* Shaolin Soccer.

Siulam Chukkau. *See* Shaolin Soccer.

Six Days, Seven Nights 1999

Six Days, Six Nights 1995

Six Degrees of Separation 1993

Six Pack 1982

Six-String Samurai 1999

Six Ways to Sunday 2000

Six Weeks 1982

16 Blocks 2007

Sixteen Candles 1984

Sixteen Days of Glory 1986

Sixth Day, The 2001

Sixth Man, The 1997

Sixth Sense, The 2000

Sixty Glorious Years [1938] 1983

'68 1987

Skeleton Key, The 2006

Ski Country 1984

Ski Patrol 1990

Skin Deep 1989

Skin I Live In, The 2012

Skins 2003

Skinwalkers 2008

Skipped Parts 2002

Skulls, The 2001

Sky Bandits 1986

Sky Blue 2006

Sky Captain and the World of Tomorrow 2005

Sky High 2006

Sky of Our Childhood, The 1988

Skyfall 2013

Skyline 1984

Skyline 2011

Slacker 1991

Slackers 2003

Slam 1997

Slam Dance 1987

Slap Shot [1977] 1981

Slapstick 1984

Slate, Wyn, and Me 1987

Slave Coast. *See* Cobra Verde.

Slave Girls from Beyond Infinity 1987

Slaves of New York 1989

Slaves to the Underground 1997

Slayground 1984

SLC Punk 2000

Sleazy Uncle, The 1991

Sleep With Me 1995

Sleepers 1996

Sleeping Beauty 2012

Sleeping with the Enemy 1991

Sleepless in Seattle 1993

Sleepover 2005

Sleepwalk with Me 2013

Sleepwalkers. *See* Stephen King's Sleepwalkers.

Sleepwalking 2009

Sleepy Hollow 2000

Sleepy Time Gal, The 2002

Sleuth 2008

Sliding Doors 1999

Sling Blade 1996

Slingshot, The 1995

Slipping Down Life, A 2005

Slither 2007

Sliver 1993

Slow Burn 2008

Slugs 1988

Slumdog Millionaire 2009

Slums of Beverly Hills 1999

Small Faces 1996

Small Soldiers 1999

Small Time Crooks 2001

Small Wonders 1996

Smart People 2009

Smash Palace 1982

Smashed 2013

Smell of Camphor, Fragrance of Jasmine 2001

Smile Like Yours, A 1997

Smiling Fish and Goat on Fire 2001

Smilla's Sense of Snow 1997

Spaceballs 1987

Spacecamp 1986

Spaced Invaders 1990

Spacehunter: Adventures in the Forbidden Zone 1983

Spalding Gray's Monster in a Box. *See* Monster in a Box.

Spanglish 2005

Spanish Prisoner, The 1999

Spanking the Monkey 1995

Sparkle 2013

Spartacus [1960] 1991

Spartan 2005

Spawn 1997

Speaking in Strings 2000

Speaking Parts 1990

Special Day, A 1984

Special Effects 1986

Specialist, The 1995

Species 1995

Species 2 1999

Spectacular Now, The 2014

Specter of the Rose [1946] 1982

Speechless 1995

Speed 1995

Speed Racer 2009

Speed 2: Cruise Control 1997

Speed Zone 1989

Spellbinder 1988

Spellbound [1945] 1989

Sphere 1999

Spice World 1999

Spices 1989

Spider 2004

Spider-Man 2003

Spider-Man 3 2008

Spider-Man 2 2005

Spiderwick Chronicles, The 2009

Spies like Us 1985

Spike of Bensonhurst 1988

Spirit, The 2009

Spirit of '76, The 1991

Spirit of St. Louis, The [1957] 1986

Spirit: Stallion of the Cimarron 2003

Spirited Away 2004

Spitfire Grill, The 1996

Splash 1984

Splendor 2000

Splice 2011

Split 1991

Split Decisions 1988

Split Image 1982

Split Second 1992

Splitting Heirs 1993

Sponge Bob Square Pants Movie, The 2005

Spoorloos. *See* Vanishing, The.

Spread 2010

Spring Break 1983

Spring Breakers 2014

Spring Forward [2000] 2001

Spring, Summer, Autumn, Winter...And Spring 2005

Spring Symphony 1986

Sprung 1997

Spun 2004

Spy Game 2002

Spy Hard 1996

Spy Kids 2002

Spy Kids: All the Time in the World in 4D 2012

Spy Kids 2: The Island of Lost Dreams 2003

Spy Kids 3-D: Game Over 2004

Spy Next Door, The 2011

Squanto: A Warrior's Tale 1995

Square, The 2011

Square, The 2014

Square Dance 1987

Squeeze 1997

Squeeze, The 1987

Squid and the Whale, The 2006

Stacking. *See* Season of Dreams.

Stage Beauty 2005

Stake Land 2012

Stakeout 1987

Stakeout II. *See* Another Stakeout.

Stalag 17 [1953] 1986

Stand and Deliver 1988

Stand by Me 1986

Stand Up Guys 2014

Standard Operating Procedure 2009

Stander 2005

Standing in the Shadows of Motown 2003

Stanley and Iris 1990

Stanley Kubrick: A Life in Pictures 2002

Stanno tutti bene. *See* Everybody's Fine.

Stanza de Figlio, La. *See* Son's Room, The.

Star Chamber, The 1983

Star 80 1983

Star Is Born, A [1954] 1983, 1985

Star Kid 1999

Star Maker, The 1996

Star Maps 1997

Star Trek 2010

Star Trek Into Darkness 2014

Star Trek II: The Wrath of Khan 1982

Star Trek III: The Search for Spock 1984

Star Trek IV:The Voyage Home 1986

Star Trek V: The Final Frontier 1989

Star Trek VI: The Undiscovered Country 1991

Star Trek: First Contact 1996

Star Trek: Generations 1995

Star Trek: Insurrection 1999

Star Trek: Nemesis 2003

Star Trek: The Motion Picture [1979] 1986

Star Wars: Episode I—The Phantom Menace 2000

Star Wars: Episode II—Attack of the Clones 2003

Star Wars: Episode III—Revenge of the Sith 2006

Star Wars: Episode IV—A New Hope [1977] 1997

Star Wars: The Clone Wars 2009

Starchaser 1985

Stardom 2001

Stardust 2008

Stardust Memories [1980] 1984

Stargate 1995

Starman 1984

Strip Jack Naked (Nighthawks II) 1995

Stripes 1981

Stripped to Kill 1987

Stripped to Kill 2 1989

Stripper 1986

Striptease 1996

Stroker Ace 1983

Stryker 1983

Stuart Little 2000

Stuart Little 2 2003

Stuart Saves His Family 1995

Stuck On You 2004

Student Confidential 1987

Stuff, The 1985

Stupids, The 1996

Submarine 2012

Substance of Fire, The 1996

Substitute, The 1996

Suburbans, The 2000

Suburban Commando 1991

Suburbia 1984

subUrbia 1997

Subway 1985

Subway to the Stars 1988

Such a Long Journey 2001

Sucker Punch 2012

Sudden Death 1985

Sudden Death 1995

Sudden Impact 1983

Sudden Manhattan 1997

Suddenly, Last Summer [1959] 1993

Suddenly Naked 2002

Sugar 2010

Sugar & Spice 2002

Sugar Cane Alley 1984

Sugar Hill 1995

Sugar Town 2000

Sugarbaby 1985

Suicide Kings 1999

Suitors, The 1989

Sukkar banat. *See* Caramel.

Sullivan's Pavilion 1987

Sum of All Fears, The 2003

Sum of Us, The 1995

Summer 1986

Summer Camp Nightmare 1987

Summer Catch 2002

Summer Heat 1987

Summer Hours 2010

Summer House, The 1993

Summer Lovers 1982

Summer Night with Greek Profile, Almond Eyes, and Scent of Basil 1987

Summer of Sam 2000

Summer Palace 2009

Summer Rental 1985

Summer School 1987

Summer Stock [1950] 1985

Summer Story, A 1988

Summertime [1955] 1990

Sunchaser 1996

Sunday 1997

Sunday in the Country, A 1984

Sunday's Child 1989

Sunday's Children 1995

Sunset 1988

Sunset Boulevard [1950] 1986

Sunset Park 1996

Sunshine 2001

Sunshine (Boyle) 2008

Sunshine Cleaning 2010

Sunshine State 2003

Super 2012

Super, The 1991

Super 8 2012

Super Mario Bros. 1993

Super Size Me 2005

Superbad 2008

Supercop 1997

Superfantagenio. *See* Aladdin.

Supergirl 1984

Superhero Movie 2009

Superman II 1981

Superman III 1983

Superman IV 1987

Superman Returns 2007

Supernova 2001

Superstar 1991

Superstar 2000

Sur 1988

Sur Mes Levres. *See* Read My Lips.

Sure Fire 1993

Sure Thing, The 1985

Surf II 1984

Surf Nazis Must Die 1987

Surf Ninjas 1993

Surf's Up 2008

Surfwise 2009

Surrender 1987

Surrogate, The. *See* Sessions, The.

Surrogates 2010

Surveillance 2010

Survival Quest 1990

Survival of the Dead 2011

Surviving Christmas 2005

Surviving the Game 1995

Surviving Picasso 1996

Survivors, The 1983

Suspect 1987

Suspect Zero 2005

Suspended Animation 2004

Suspicious River 2002

Suture 1995

S-VHS. *See* V/H/S/2

Swamp, The. *See* Cienaga, La.

Swamp Thing 1982

Swan Lake 1991

Swan Princess, The 1995

Swann in Love 1984

S.W.A.T. 2004

Sweeney Todd: The Demon Barber of Fleet Street 2008

Sweet and Lowdown 2000

Sweet Country 1987

Sweet Dreams 1985

Sweet Emma, Dear Bobe: Sketches, Nudes 1995

Sweet Hearts Dance 1988

Sweet Hereafter, The 1997

Sweet Home Alabama 2003

Sweet Liberty 1986

Sweet Lorraine 1987

Sweet Nothing 1996

Teenage Mutant Ninja Turtles III 1993

Teeth 2009

Telephone, The 1988

Tell No One 2009

Telling Lies in America 1997

Témoins, Les. *See* Witnesses, The.

Temp, The 1993

Tempest 1982

Tempest, The 2011

Temporada de patos. *See* Duck Season.

Temps qui changent, Les. *See* Changing Times.

Temps qui reste, Les. *See* Time to Leave.

Temps Retrouve. *See* Time Regained.

Temptation: Confessions of a Marriage Counselor. *See* Tyler Perry's Temptation: Confessions of a Marriage Counselor.

Temptress Moon 1997

Ten 2004

Ten Things I Hate About You 2000

10,000 B.C. 2009

10 to Midnight 1983

10 Years 2013

Tenacious D in the Pick of Destiny 2007

Tender Mercies 1983

Tenebrae. *See* Unsane.

Tenue de soiree. *See* Menage.

Tequila Sunrise 1988

Terminal, The 2005

Terminal Bliss 1992

Terminal Velocity 1995

Terminator, The 1984

Terminator Salvation 2010

Terminator 2 1991

Terminator 3: Rise of the Machines 2004

Termini Station 1991

Terminus. *See* End of the Line.

Terms of Endearment 1983

Terri 2012

Terror Within, The 1989

Terrorvision 1986

Tess 1981

Test of Love 1985

Testament 1983

Testimony 1987

Tetro 2010

Tetsuo: The Iron Man 1992

Tex 1982, 1987

Texas Chainsaw 3D 2014

Texas Chainsaw Massacre, The (Nispel) 2004

Texas Chainsaw Massacre, Part II, The 1986

Texas Chainsaw Massacre: The Beginning, The 2007

Texas Comedy Massacre, The 1988

Texas Killing Fields 2012

Texas Rangers 2003

Texas Tenor: The Illinois Jacquet Story 1995

Texasville 1990

Thank You and Good Night 1992

Thank You for Smoking 2007

Thanks for Sharing 2014

That Championship Season 1982

That Darn Cat 1997

That Night 1993

That Old Feeling 1997

That Sinking Feeling 1984

That Thing You Do! 1996

That Was Then…This Is Now 1985

That's Entertainment! III 1995

That's Life! 1986, 1988

That's My Boy 2013

The au harem d'Archi Ahmed, Le. *See* Tea in the Harem.

Thelma and Louise 1991

Thelonious Monk 1988

Then She Found Me 2009

Theory of Flight, The 1999

There Goes My Baby 1995

There Goes the Neighborhood 1995

There Will Be Blood 2008

There's Nothing Out There 1992

There's Something About Mary 1999

Theremin: An Electronic Odyssey 1995

They All Laughed 1981

They Call Me Bruce 1982

They Drive by Night [1940] 1982

They Live 1988

They Live by Night [1949] 1981

They Might Be Giants [1971] 1982

They Still Call Me Bruce 1987

They Won't Believe Me [1947] 1987

They're Playing with Fire 1984

Thiassos, O. *See* Traveling Players, The.

Thief 1981

Thief, The 1999

Thief of Hearts 1984

Thieves 1996

Thin Blue Line, The 1988

Thin Ice 2013

Thin Line Between Love and Hate, A 1996

Thin Red Line, The 1999

Thing, The 1982

Thing, The 2012

Thing Called Love, The 1995

Things Are Tough All Over 1982

Things Change 1988

Things to Do in Denver When You're Dead 1995

Things We Lost in the Fire 2008

Think Big 1990

Think Like a Man 2013

Third World Cop 2001

Thirst 2010

Thirteen 2004

13 Assassins 2012

Thirteen Conversations About One Thing 2003

Thirteen Days 2001

Thirteen Ghosts 2003

13 Going On 30 2005

Thirtieth Floor, The 2000

Thirtieth Warrior, The 2000

30 Days of Night 2008

30 Minutes or Less 2012

35 Shots of Rum 2011

Thirty Two Short Films About Glenn Gould 1995

To Be or Not to Be 1983

To Begin Again. *See* Volver a empezar.

To Die For 1989

To Die For 1995

To Die Standing (Crackdown) 1995

To Do List, The 2014

To Gillian on Her 37th Birthday 1996

To Kill a Mockingbird [1962] 1989

To Kill a Priest 1988

To Live 1995

To Live and Die in L.A. 1985, 1986

To Protect Mother Earth 1990

To Render a Life 1995

To Return. *See* Volver.

To Rome with Love 2013

To Sir with Love [1967] 1992

To Sleep with Anger 1990

To the Wonder 2014

To Wong Foo, Thanks for Everything! Julie Newmar 1995

Todo Sobre Mi Madre. *See* All About My Mother.

Together 2002

Together 2004

Tokyo Pop 1988

Tokyo-Ga 1985

Tom and Huck 1995

Tom and Jerry 1993

Tom & Viv 1995

Tomb Raider. *See* Lara Croft: Tomb Raider.

Tomboy 1985

Tombstone 1993

Tomcats 2002

Tommy Boy 1995

Tomorrow [1972] 1983

Tomorrow Never Dies 1997

Tomorrow's a Killer. *See* Prettykill.

Too Beautiful for You 1990

Too Hot to Handle [1938] 1983

Too Much 1987

Too Much Sleep 2002

Too Much Sun 1991

Too Outrageous! 1987

Too Scared to Scream 1985

Too Soon to Love [1960]

Tooth Fairy 2011

Tootsie 1982

Top Dog 1995

Top Gun 1986

Top of the Food Chain 2002

Top Secret 1984

Topio stin omichi. *See* Landscape in the Mist.

Topsy-Turvy 2000

Tora-San Goes to Viena 1989

Torajiro Kamone Uta. *See* Foster Daddy, Tora!

Torch Song Trilogy 1988

Torinoi lo, A. *See* Turin Horse, The.

Torment 1986

Torn Apart 1990

Torn Curtain [1966] 1984

Torque 2005

Torrents of Spring 1990

Tortilla Soup 2002

Total Eclipse 1995

Total Recall 1990

Total Recall 2013

Totally F***ed Up 1995

Toto le heros. *See* Toto the Hero.

Toto the Hero 1992

Tottering Lives 1988

Touch 1997

Touch and Go 1986

Touch of a Stranger 1990

Touch of Evil [1958] 1999

Touch of Larceny, A [1959] 1986

Touch of Sin, A 2014

Touch the Sound 2006

Touching the Void 2005

Touchy Feely 2014

Tough Enough 1983

Tough Guys 1986

Tough Guys Don't Dance 1987

Tougher than Leather 1988

Touki-Bouki 1995

Tourist, The 2011

Tous les matins du monde 1992

Toward the Within 1995

Tower Heist 2012

Town, The 2011

Town and Country 2002

Town is Quiet, The 2002

Toxic Avenger, The 1986

Toxic Avenger, Part II, The 1989

Toxic Avenger, Part III, The 1989

Toy, The 1982

Toy Soldiers (Fisher) 1984

Toy Soldiers (Petrie) 1991

Toy Story 1995

Toy Story 3 2011

Toy Story 2 2000

Toys 1992

Trace, The 1984

Trance 2014

Traces of Red 1992

Track 1988

Tracks in the Snow 1986

Trade 2008

Trade Winds [1939] 1982

Trading Hearts 1988

Trading Mom 1995

Trading Places 1983

Traffic 2001

Tragedia di un umo ridiculo. *See* Tragedy of a Ridiculous Man.

Tragedy of a Ridiculous Man 1982

Trail of the Lonesome Pine, The. *See* Waiting for the Moon.

Trail of the Pink Panther 1982

Train de Vie. *See* Train of Life.

Train of Life 2000

Training Day 2002

Trainspotting 1996

Traitor 2009

Trancers 1985

Transamerica 2006

Transformers 2008

Transformers, The 1986

Transformers: Dark of the Moon 2012

Transformers: Revenge of the Fallen 2010

Transporter 3 2009

Transporter 2 2006

Transsiberian 2009

Transylvania 6-5000 1985

Trapped 2003

Trapped in Paradise 1995

Traps 1995

Traveling Players, The [1974] 1990

Traveller 1997

Travelling Avant 1987

Travelling North 1987

Traviata, La 1982

Tre fratelli. *See* Three Brothers.

Treasure Island 2001

Treasure of the Four Crowns 1983

Treasure of the Sierra Madre, The [1948] 1983

Treasure Planet 2003

Tree of Life, The 2012

Trees Lounge 1996

Trekkies 2000

Tremors 1990

Trenchcoat 1983

Trespass 1992

Trespass 2012

Trial, The 1995

Trial and Error 1997

Trial by Jury 1995

Tribulations of Balthasar Kober, The 1988

Trick 2000

Trick or Treat 1986

Trigger Effect, The 1996

Trilogia: To Livadi pou dakryzei. *See* Weeping Meadow.

Trilogy: After the Life, The 2005

Trilogy: An Amazing Couple, The 2005

Trilogy: On the Run, The 2005

Trilogy: Weeping Meadow, The. *See* Weeping Meadow.

Trip, The 2012

Trip to Bountiful, A [1953] 1982

Trip to Bountiful, The 1985

Triplets of Belleville, The 2004

Trippin' 2000

Trishna 2013

Tristan & Isolde 2007

Tristram Shandy: A Cock and Bull Story 2007

Triumph of Love, The 2003

Triumph of the Spirit 1989

Trixie 2001

Trmavomodry Svet. *See* Dark Blue World.

Trois Couleurs: Blanc. *See* White.

Trois Couleurs: Bleu. *See* Blue.

Trois Couleurs: Rouge. *See* Red.

Trois Hommes et un couffin. *See* Three Men and a Cradle.

Trojan Eddie 1997

Trol Hunter, The. *See* Trollhunter.

Troll 1986

Trollhunter 2012

Trolljegeren. *See* Trollhunter.

Trolosa. *See* Faithless.

TRON 1982

TRON: Legacy 2011

Troop Beverly Hills 1989

Trop belle pour toi. *See* Too Beautiful for You.

Tropic Thunder 2009

Tropical Rainforest 1992

Trouble at the Royal Rose. *See* Trouble with Spies, The.

Trouble Bound 1995

Trouble in Mind 1985

Trouble with Dick, The 1987

Trouble with Spies, The 1987

Trouble with the Curve 2013

Troubles We've Seen: A History of Journalism in Wartime, The 2006

Troublesome Creek: A Midwestern 1997

Trout, The 1983

Troy 2005

Truce, The 1999

Trucker 2010

True Believer 1989

True Blood 1989

True Colors 1991

True Confessions 1981

True Crime 2000

True Grit 2011

True Heart Susie [1919] 1984

True Identity 1991

True Lies 1995

True Love 1989

True Romance 1993

True Stories 1986

Truite, La. *See* Trout, The.

Truly, Madly, Deeply 1991

Truman Show, The 1999

Trumpet of the Swan, The 2002

Trust 1991

Trust 2012

Trust Me 1989

Trust the Man 2007

Trusting Beatrice 1993

Truth About Cats & Dogs, The 1996

Truth About Charlie, The 2003

Truth or Consequences: N.M., 1997

Truth or Dare 1991

Tsotsi 2007

Tuck Everlasting 2003

Tucker 1988

Tucker & Dale vs. Evil 2012

Tuff Turf 1985

Tully 2004

Tumbleweeds 2000

Tune, The 1992

Tune in Tomorrow... 1990

Tunel, El. *See* Tunnel, The.

Tunnel, The 1988

Turandot Project, The 2002

Turbo 2014

Turbo: A Power Rangers Movie, 1997

Turbulence, 1997

Turin Horse, The 2013

Turistas 2007

Turk 182 1985

Turn It Up 2001

Turner and Hooch 1989

Turning Paige 2003

Turtle Beach 1995

Turtle Diary 1985, 1986

Turtles are Back...In Time, The. *See* Teenage Mutant Ninja Turtles III.

Tuxedo, The 2003

TV Set, The 2008

Vermont is for Lovers 1995

Verne Miller 1987

Veronica Guerin 2004

Veronika Voss 1982

Very Annie Mary 2003

Very Long Engagement, A 2005

Vertical Limit 2001

Vertical Ray of the Sun, The 2002

Vertigo [1958] 1996

Very Bad Things 1999

Very Brady Sequel, A 1996

Very Harold & Kumar 3D Christmas, A 2012

Very Thought of You, The 2000

Vesnicko ma strediskova. *See* My Sweet Little Village.

Veuve de Saint-Pierre, La. *See* Widow of Saint-Pierre, The.

V/H/S 2013

V/H/S/2 2014

Via Appia 1991

Viaggio d'amore. *See* Journey of Love.

Vibes 1988

Vice Squad 1982

Vice Versa 1988

Vicky Cristina Barcelona 2009

Victim [1961] 1984

Victor/Victoria 1982

Victory 1981

Victory. *See* Vincere.

Videodrome 1983

Vie Apres l'Amour, La. *See* Life After Love.

Vie continue, La 1982

Vie d'Adele, La. *See* Blue is the Warmest Color.

Vie de Boheme, La 1995

Vie en Rose, La 2008

Vie est rien d'autre, La. *See* Life and Nothing But.

Vie est un long fleuve tranquille, La. *See* Life Is a Long Quiet River.

Vie Promise, La. *See* Promised Life, The.

Vierde Man, De. *See* 4th Man, The.

View from the Top 2004

View to a Kill, A 1985

Village, The 2005

Village of the Damned 1995

Ville est Tranquille, La. *See* Town is Quiet, The.

Vince Vaughn's Wild West Comedy Show: 30 Days & 30 Nights—Hollywood to the Heartland 2009

Vincent and Theo 1990

Vincere 2011

Violets Are Blue 1986

Violins Came with the Americans, The 1987

Violon Rouge, Le. *See* Red Violin, The.

Viper 1988

Virgen de los Sicanos, La. *See* Our Lady of the Assassins.

Virgin Queen of St. Francis High, The 1987

Virgin Suicides, The 2001

Virtuosity 1995

Virus 2000

Vision Quest 1985

Visions of Light 1993

Visions of the Spirit 1988

Visit, The 2002

Visiting Hours 1982

Visitor, The 2009

Visitor, The. *See* Ghost.

Vital Signs 1990

Volcano 1997

Volere, Volare 1992

Volunteers 1985

Volver 2007

Volver a empezar 1982

Vor. *See* Thief, The.

Vow, The 2013

Voyage du ballon rouge, Le. *See* Flight of the Red Balloon.

Voyager 1992

Voyages 2002

Voyeur 1995

Vroom 1988

Vulture, The 1985

Vzlomshik. *See* Burglar, The.

W

W. 2009

Wackness, The 2009

Waco: The Rules of Engagement 1997

Wag the Dog 1997

Wagner 1983

Wagons East! 1995

Wah-Wah 2007

Waist Deep 2007

Wait for Me in Heaven 1990

Wait Until Spring, Bandini 1990

Waiting... 2006

Waiting for Gavrilov 1983

Waiting for Guffman 1997

Waiting for 'Superman' 2011

Waiting for the Light 1990

Waiting for the Moon 1987

Waiting to Exhale 1995

Waitress 1982

Waitress (Shelly) 2008

Waking Life 2002

Waking Ned Devine 1999

Waking the Dead 2001

Walk Hard: The Dewey Cox Story 2008

Walk in the Clouds, A 1995

Walk Like a Man 1987

Walk on the Moon, A 1987

Walk on the Moon, A (Goldwyn) 2000

Walk the Line 2006

Walk to Remember, A 2003

Walker 1987

Walking and Talking 1996

Walking After Midnight 1988

Walking Dead, The 1995

Walking Tall 2005

Walking with Dinosaurs 3D 2014

Wall, The 1986

Wall Street 1987

Wallace & Gromit: The Curse of the Were-Rabbit 2006

WALL-E 2009

Wall Street: Money Never Sleeps 2011

Waltz Across Texas 1983

Waltz with Bashir 2009

Wandafuru raifu. *See* After Life.

Wanderlust 2013

Wannsee Conference, The 1987

Wannseekonferenz, Die. *See* Wannsee Conference, The.

Wanted 2009

Wanted: Dead or Alive 1987

War 1988

War (Arwell) 2008

War, The 1995

War Against the Indians 1995

War and Love 1985

War at Home, The 1997

War Horse 2012

War, Inc. 2009

War of the Buttons 1995

War of the Roses, The 1989

War of the Worlds 2006

War Party 1988

War Room, The 1993

War Tapes, The 2007

War Witch 2014

War Zone, The 2000

Ward, The 2012

WarGames 1983

Warlock 1989, 1990

Warlock: The Armageddon 1993

Warm Bodies 2014

Warm Nights on a Slow Moving Train 1987

Warm Summer Rain 1989

Warm Water Under a Red Bridge 2002

Warning Bandits 1987

Warning Sign 1985

Warrior 2012

Warrior Queen 1987

Warriors of Heaven and Earth 2005

Warriors of Virtue 1997

Wash, The 1988

Washington Heights 2004

Washington Square 1997

Wassup Rockers 2007

Watch It 1993

Watch, The 2013

Watcher, The 2001

Watchers 1988

Watchmen 2010

Water 1986

Water 2007

Water and Soap 1985

Water Drops on Burning Rocks 2001

Water for Elephants 2012

Water Horse: Legend of the Deep, The 2008

Waterboy, The 1999

Waterdance, The 1992

Waterland 1992

Waterloo Bridge [1940] 1981

Waterworld 1995

Wavelength 1983

Waxwork 1988

Way, The 2012

Way Back, The 2011

Way Down East [1920] 1984

Way of the Gun, The 2001

Way Way Back, The 2014

Way We Laughed, The 2002

Way We Were, The [1973] 1981

waydowntown 2001

Wayne's World 1992

Wayne's World II 1993

W.E. 2012

We All Loved Each Other So Much 1984

We Are Marshall 2007

We Are What We Are 2014

We Bought a Zoo 2012

We Don't Live Here Anymore 2005

We Need to Talk About Kevin 2012

We Never Die 1993

We of the Never Never 1983

We Own the Night 2008

We the Living 1988

We Think the World of You 1988

We Were Soldiers 2003

Weather Man, The 2006

Weather Underground, The 2004

Wedding, A [1978] 1982

Wedding Banquet, The 1993

Wedding Bell Blues 1997

Wedding Crashers 2006

Wedding Date, The 2006

Wedding Gift, The 1995

Wedding in Galilee, A 1987

Wedding Planner, The 2002

Wedding Singer, The 1999

Weeds 1987

Weekend at Bernie's 1989

Weekend at Bernie's II 1993

Weekend Pass 1984

Weekend Warriors 1986

Weekend with Barbara und Ingrid, A 1995

Weeping Meadow 2006

Weight of Water, The 2003

Weininger's Last Night 1995

Weird Science 1985

Weisse Band, Das. *See* White Ribbon, The.

Welcome Home 1989

Welcome Home Roscoe Jenkins 2009

Welcome Home, Roxy Carmichael 1990

Welcome in Vienna 1988

Welcome to Collinwood 2003

Welcome to Mooseport 2005

Welcome to Sarajevo 1997

Welcome to the Dollhouse 1996

Welcome to the Rileys 2011

Welcome to Woop Woop 1999

Wendigo 2003

Wendy and Lucy 2009

We're Back 1993

We're No Angels [1955] (Curtiz) 1982

We're No Angels (Jordan) 1989

We're Talkin' Serious Merry 1992

We're the Millers 2014

Wes Craven Presents: Dracula 2000 2001

Wes Craven Presents: They 2003

Wes Craven's New Nightmare 1995

West Beirut 2000

West Beyrouth. *See* West Beirut.

West of Memphis 2013

Western 1999

Wet and Wild Summer. *See* Exchange Lifeguards.

Wet Hot American Summer 2002

Wetherby 1985

Wettest County in the World, The. *See* Lawless.

Whale Rider 2004

Whales of August, The 1987

What a Girl Wants 2004

What About Bob? 1991

What Dreams May Come 1999

What Happened to Kerouse? 1986

What Happened Was… 1995

What Happens in Vegas 2009

What Just Happened 2009

What Lies Beneath 2001

What Maisie Knew 2014

What Planet Are You From? 2001

What the (Bleep) Do We Know? 2005

What Time Is It There? 2002

What to Expect When You're Expecting 2013

What Women Want 2001

Whatever 1999

Whatever It Takes (Demchuk) 1986

Whatever It Takes (Raynr) 2001

Whatever Works 2010

What's Cooking? 2001

What's Eating Gilbert Grape 1993

What's Love Got To Do With It 1993

What's the Worst That Could Happen? 2002

What's Your Number? 2012

When a Man Loves a Woman 1995

When a Stranger Calls 2007

When Brendan Met Trudy 2002

When Did You Last See Your Father? 2009

When Father Was Away on Business 1985

When Harry Met Sally 1989

When in Rome 2011

When Love Comes 2000

When Nature Calls 1985

When Night is Falling 1995

When the Cat's Away 1997

When the Party's Over 1993

When the Whales Came 1989

When the Wind Blows 1987

When We Were Kings 1997

When Will I Be Loved 2005

Where Angels Fear to Tread 1992

Where Are the Children? 1986

Where Do We Go Now? 2013

Where Spring Comes Late 1988

Where the Boys are '84 1984

Where the Day Takes You 1992

Where the Green Ants Dream 1985

Where the Heart Is (Boorman) 1990

Where the Heart Is (Williams) 2001

Where the Heart Roams 1987

Where the Money Is 2001

Where the Outback Ends 1988

Where the River Runs Black 1986

Where The Rivers Flow North 1995

Where the Truth Lies 2006

Where the Wild Things Are 2010

Wherever You Are 1988

While You Were Sleeping 1995

Whip It 2010

Whispers in the Dark 1992

Whistle Blower, The 1987

Whistleblower, The 2012

White 1995

White Badge 1995

White Balloon, The 1996

White Boys 2000

White Chicks 2005

White Countess, The 2006

White Dog 1995

White Fang 1991

White Fang II: Myth of the White Wolf 1995

White Girl, The 1990

White House Down 2014

White Hunter, Black Heart 1990

White Man's Burden 1995

White Material 2011

White Men Can't Jump 1992

White Mischief 1988

White Nights 1985

White Noise 2006

White of the Eye 1987, 1988

White Oleander 2003

White Palace 1990

White Ribbon, The 2010

White Rose, The 1983

White Sands 1992

White Sister, The [1923] 1982

White Squall 1996

White Trash 1992

White Winter Heat 1987

Whiteout 2010

Who Framed Roger Rabbit 1988

Who Killed the Electric Car? 2007

Who Killed Vincent Chin? 1988

Who Knows? *See* Va Savoir.

Who Shot Pat? 1992

Whole Nine Yards, The 2001

Whole Ten Yards, The 2005

Whole Wide World, The 1997

Whoopee Boys, The 1986

Whore 1991

Who's Afraid of Virginia Wolf? [1966] 1993

Who's Harry Crumb? 1989

Who's That Girl 1987

Who's the Man? 1993

Whose Life Is It Anyway? 1981

Why Did I Get Married? 2008

Why Did I Get Married Too? 2011

Why Do Fools Fall In Love 1999

Why Has Bodhi-Dharma Left for the East? 1995

Why Me? 1990

Why We Fight 2007

Wicked Lady, The 1983

Wicked Stepmother 1989

Wicker Man, The [1974] 1985

Wicker Man, The 2007

Wicker Park 2005

Wide Awake 1999

Wide Sargasso Sea 1993

Woman's Pale Blue Handwriting, A 1988

Woman's Tale, A 1991

Wombling Free [1979] 1984

Women, The 2009

Women in Trouble 2010

Women on the Verge of a Nervous Breakdown 1988

Women's Affair 1988

Wonder Boys 2001

Wonderful Days. *See* Sky Blue.

Wonderful, Horrible Life of Leni Riefenstahl, The 1995

Wonderland (Saville) 1989

Wonderland (Winterbottom) 2001

Wonderland (Cox) 2004

Won't Back Down 2013

Woo 1999

Wood, The 2000

Woodsman, The 2005

Woodstock 1995

Wordplay 2007

Words, The 2013

Working Girl 1988

Working Girls 1987

World According to Garp, The 1982

World and Time Enough 1996

World Apart, A 1988

World Gone Wild 1988

World Is Not Enough, The 2000

World of Henry Orient, The [1964] 1983

World Trade Center 2007

World Traveler 2003

World War Z 2014

World's End, The 2014

World's Fastest Indian, The 2007

World's Greatest Dad 2010

Worth Winning 1989

Wraith, The 1986

Wrath of the Titans 2013

Wreck-It Ralph 2013

Wrestler, The 2009

Wrestling Ernest Hemingway 1993

Wristcutters: A Love Story 2008

Wrong Couples, The 1987

Wrong Guys, The 1988

Wrong Is Right 1982

Wrong Man, The 1995

Wrong Turn 2004

Wrongfully Accused 1999

Wu ji. *See* Promise, The.

Wu jian dao. *See* Infernal Affairs.

Wuthering Heights 2013

Wyatt Earp 1995

X

X. *See* Malcolm X.

X-Files, The 1999

X-Files: I Want to Believe, The 2009

X-Men, The 2001

X-Men: First Class 2012

X-Men: The Last Stand 2007

X-Men Origins: Wolverine 2010

X2: X-Men United 2004

Xero. *See* Home Remedy.

Xiao cai feng. *See* Balzac and the Little Chinese Seamstress.

Xica [1976] 1982

Xica da Silva. *See* Xica.

Xingfu Shiguang. *See* Happy Times.

Xiu Xiu, The Sent Down Girl 2000

Xizao. *See* Shower, The.

XX/XY 2004

XXX 2003

XXX: State of the Union 2006

Y

Y tu mama tambien 2003

Yaaba 1990

Yards, The 2001

Yari No Gonza Kasane Katabira. *See* Gonza the Spearman.

Yatgo Ho Yan. *See* Mr. Nice Guy.

Year My Voice Broke, The 1987, 1988

Year of Comet 1992

Year of Living Dangerously, The 1983

Year of the Dog 2008

Year of the Dragon 1985

Year of the Gun 1991

Year of the Horse 1997

Year of the Quiet Sun, A 1986

Year One 2010

Yearling, The [1946] 1989

Yella 2009

Yellowbeard 1983

Yen Family 1988, 1990

Yentl 1983

Yes 2006

Yes, Giorgio 1982

Yes Man 2009

Yesterday. *See* Quitting.

Yi Yi 2001

Yihe yuan. *See* Summer Palace.

Ying xiong. *See* Hero.

Yogi Bear 2011

Yol 1982

Yor: The Hunter from the Future 1983

You Again 2011

You, Me and Dupree 2007

You Can Count on Me 2001

You Can't Hurry Love 1988

You Don't Mess with the Zohan 2009

You Got Served 2005

You Kill Me 2008

You So Crazy 1995

You Talkin' to Me? 1987

You Toscanini 1988

You Will Meet a Tall Dark Stranger 2011

Young Adam 2005

Young Adult 2012

Young@Heart 2009

Young Dr. Kildare [1938] 1985

Young Doctors in Love 1982

Young Einstein 1988

Young Guns 1988

Young Guns II 1990

Young Poisoner's Handbook, The 1996

Young Sherlock Holmes 1985

Young Soul Rebels 1991

Young Victoria, The 2010

Youngblood 1986

Your Friends & Neighbors 1999